Janson's History of Art

THE WESTERN TRADITION

Seventh Edition

VOLUME I

PENELOPE J. E. DAVIES

WALTER B. DENNY

FRIMA FOX HOFRICHTER

JOSEPH JACOBS

ANN M. ROBERTS

DAVID L. SIMON

PEARSON
Prentice
Hall

UPPER SADDLE RIVER, NEW JERSEY 07458

LIBRARY OF CONGRESS CATALOGING-IN-PUBLICATION DATA

Janson, H. W. (Horst Woldemar),
 Janson's history of art: the western tradition/Penelope J. E. Davies . . . [et al.]—7th ed.
 p.cm
 Includes bibliographical references and index.
 ISBN 0-13-193455-4
 1. Art—History. I. Title: History of art. II. Davies, Penelope J. E., 1964-III.
Janson, H.W. (Horst Woldemar), 1913–History of art. IV. Title

709—dc22 2005054647

Editor-in-Chief: **SARAH TOUBORG**
Sponsoring Editor: **HELEN RONAN**
Editor in Chief, Development: **ROCHELLE DIOGENES**
Senior Development Editor: **ROBERTA MEYER**
Development Editors: **KAREN DUBNO, CAROLYN VIOLA-JOHN**
Editorial Assistant: **JACQUELINE ZEA**
Editorial Intern: **AIZA KEESEY**
Media Project Manager: **ANITA CASTRO**
Director of Marketing: **BRANDY DAWSON**
Assistant Marketing Manager: **ANDREA MESSINEO**
Marketing Assistant: **VICTORIA DeVITA**
AVP, Director of Production and Manufacturing: **BARBARA KITTLE**
Senior Managing Editor: **LISA IARKOWSKI**
Senior Production Editor: **HARRIET TELLEM**
Production Assistant: **MARLENE GASSLER**
Manufacturing Manager: **NICK SKLITSIS**
Manufacturing Buyer: **SHERRY LEWIS**
Creative Design Director: **LESLIE OSHER**
Art Directors: **NANCY WELLS, AMY ROSEN**
Interior and Cover Design: **BTDNYC**
Design Layout: **GAIL COCKER-BOGUSZ**
Line Art Coordinator: **MARIA PIPER**
Line Art Studio: **ARGOSY PUBLISHING INC.**
Cartographer: **CARTOGRAPHICS**
Text Research and Permissions: **MARGARET GORENSTEIN**
Pearson Imaging Center
 Manager: **JOSEPH CONTI**
 Project Coordinator: **CORRIN SKIDDS**
 Scanner Operators: **RON WALKO AND CORRIN SKIDDS**
Picture Editing, Research and Permissions:
 LAURIE PLATT WINFREY, FAY TORRES-YAP
 MARY TERESA GIANCOLI, CRISTIAN PEÑA, Carousel Research, Inc.
Director, Image Resource Center: **MELINDA REO**
Manager, Rights and Permissions: **ZINA ARABIA**
Manager, Visual Research: **BETH BRENZEL**
Image Permission Coordinator: **DEBBIE LATRONICA**
Copy Editor: **STEPHEN HOPKINS**
Proofreaders: **BARBARA DEVRIES, NANCY STEVENSON, PATTI GUERRIERI**
Text Editor: **CAROL PETERS**
Composition: **PREPARÉ**
Cover Printer: **PHOENIX COLOR CORPORATION**
Printer/Binder: **RR DONNELLEY**

COVER PHOTO: *Portrait of a Woman*, from Hawara in the Fayum, Lower Egypt. ca. 110–130 CE. Encaustic on wooden panel. Royal Museum of Scotland © Trustees of the National Museum of Scotland.

Pearson Education LTD Pearson Education, Canada, Ltd
Pearson Education Australia PTY, Limited Pearson Educación de Mexico, S.A. de C.V.
Pearson Education Singapore, Pte. Ltd Pearson Education-Japan
Pearson Education North Asia Ltd Pearson Education Malaysia, Pte. Ltd

10 9 8 7 6 5 4 3 2 1

ISBN: 0-13-193468-6

Brief Contents

Contents

PART ONE
THE ANCIENT WORLD

1. Prehistoric Art

2. Ancient Near Eastern Art

3. Egyptian Art

4. Aegean Art

PART TWO
THE MIDDLE AGES

11. Romanesque Art

12. Gothic Art

13. Art in Thirteenth- and Fourteenth-Century Italy 433

Preface

WELCOME TO THE SEVENTH EDITION OF JANSON'S CLASSIC TEXTBOOK, officially renamed *Janson's History of Art* to reflect its relationship to the book that introduced many generations of students to art history. For many of us who teach introductory courses in the history of art, the name Janson is synonymous with the subject matter we present.

When Prentice Hall first published the *History of Art* in 1962, John F. Kennedy occupied the White House, and Andy Warhol was an emerging artist. Janson offered his readers a strong focus on Western art, an important consideration of technique and style, and a clear point of view. The *History of Art,* said Janson, was not just a stringing together of historically significant objects, but the writing of a story about their interconnections—a history of styles and of stylistic change. Janson's text focused on the visual and technical characteristics of the objects he discussed, often in extraordinarily eloquent language. Janson's *History of Art* helped to establish the canon of art history for many generations of scholars.

Although largely revamped, this new edition follows Janson's lead in important ways: It is limited to the Western tradition, with the addition of a chapter on Islamic art and its relationship to Western art. (Those of us with early Janson editions will remember that Islamic art was included in the first edition.) It keeps the focus of the discussion on the object, its manufacture, and its visual character. It considers the contribution of the artist as an important part of the analysis. This edition is organized along the lines established by Janson, with separate chapters on the Northern European Renaissance, the Italian Renaissance, Baroque art, and the High Renaissance, with stylistic divisions for key periods of the modern era. This edition also creates a narrative of how art has changed over time in the cultures that Europe has claimed as its patrimony and that Americans have claimed through their connection to Europe.

WHAT'S NEW IN *JANSON'S HISTORY OF ART?*

"The history of art is too vast a field for anyone to encompass all of it with equal competence."

—H. W. JANSON, from the Preface to the first edition of *History of Art*

Janson's History of Art, seventh edition, is the product of careful revision by a team of scholars with different specialties, bringing great depth to the discussions of works of art. We incorporate new discoveries in our fields into the text, including new archeological finds, such as the Charioteer of Motya; new documentary evidence, such as that pertaining to Uccello's *Battle of San Romano;* and new interpretive approaches, such as the importance of nationalism in the development of Romanticism.

New Organization and Contextual Emphasis

Most of the chapters have been reorganized to integrate the media into chronological discussions instead of discussing them in isolation from one another, which reflected the more formalistic approach used in earlier editions. Even though we draw connections among works of art, as Janson did, we emphasize the patronage and function of works of art and the historical circumstances in which they were created. We explore how works of art have been used to shore up political or social power.

Interpreting Cultures

Western art history encompasses a great many distinct chronological and cultural periods, which we wish to treat as distinct entities. So we present Etruscan art as evidence for Etruscan culture, not as a precursor of Roman or a follower of Greek art. Recognizing the limits of our knowledge about certain periods of history, we examine how art historians draw conclusions from works of art. The boxes called *The Art Historian's Lens* allow students to see how the discipline works. They give students a better understanding of the methods art historians use to develop art-historical arguments. *Primary Sources,* a distinguishing feature of Janson for many editions, have been incorporated throughout the chapters to support the analysis provided and to further inform students about the cultures discussed.

Women in the History of Art

Another important feature of this edition of *Janson's* is the greater visibility of women, whom we discuss as artists, as patrons, and as an audience for works of art. Inspired by contemporary approaches to art history, we also address the representation of women as expressions of specific cultural notions of femininity or as symbols.

Objects, Media, and Techniques

Many new objects have been incorporated into this edition to reflect changes in the discipline. Approximately 25 percent of the objects we discuss are new to the book. The mediums we discuss have been expanded to include not only modern art forms such as installations and earth art, but also the so-called minor arts of earlier periods—such as tapestries, metalwork, and porcelain. Discussions in the *Materials and Techniques* boxes illuminate this dimension of art history.

The Images

Not only have new objects been introduced, but every reproduction in the book also has been refreshed and expertly examined for fidelity to the original. We have obtained new photographs directly from the holding institutions to ensure that we have the most accurate and authoritative illustrations. Every image that could be obtained in color has been acquired. To further assist both students and teachers, we have sought permission for electronic educational use so that instructors who adopt *Janson's History of Art* will have access to an extraordinary archive of high quality (over 300 dpi) digital images for classroom use. (See below for more detail on the Prentice Hall Digital Art Library.)

Chapter by Chapter Revisions

With six different specialists examining every chapter, and an exhaustive peer review process, the revisions to the text are far too extensive to enumerate in detail. Every change aims to make the text more useful to instructors and students in art history classrooms. The following list includes the major highlights of this new edition:

INTRODUCING ART

Completely new, this section provides models of art-historical analysis and definitions of art-historical terms, while providing an overview of the important questions in the discipline.

CHAPTER 1: PREHISTORIC ART

Lengthened to include more information on the various contexts in which works of art are found. Expands upon the methods scholars (both art historians and anthropologists) use to understand artwork. Offering a wider range of interpretations, the text clarifies why scholars reconstruct the prehistoric world as they do.

CHAPTER 2: ANCIENT NEAR EASTERN ART

Expanded and reorganized to isolate cultures flourishing contemporaneously in the ancient Near East.

CHAPTER 3: EGYPTIAN ART

Includes an updated discussion of the Egyptian worldview, and relates Egyptian artworks to that view. Incorporates a greater number of works featuring women, such as the extraordinary *Portrait of Queen Tiy.*

CHAPTER 4: AEGEAN ART

Examines how we construct our knowledge of an ancient society through studying works of art and architecture. Focuses also on individuals who contributed to our understanding of these societies, such as Heinrich Schliemann and Sir Arthur Evans.

CHAPTER 5: GREEK ART

Significant new artworks have been added to this chapter, such as the spectacular Charioteer of Motya. The organization is altered radically to adhere more closely to a chronological, rather than medium-based, sequence. Expands discussions of the architecture of the Athenian Akropolis and Hellenistic art as a whole.

CHAPTER 6: ETRUSCAN ART

Discussion of Etruscan art is altered in order to characterize it as a visual culture in its own right rather than as an extension of Greek art or a precursor of Roman art. The palatial architecture at Murlo is included.

CHAPTER 7: ROMAN ART

Features a greatly expanded section on art of the Republic, and a greater discussion of architecture in general. New works, such as the magnificent Theater of Pompey, are included. The organization is also radically altered to follow a chronological, rather than medium-based, sequencing.

CHAPTER 8: EARLY CHRISTIAN AND BYZANTINE ART

Accentuates changes and political dimensions in Early Christian art that occurred when Christianity became an accepted religion of the Roman Empire. Architecture is discussed in greater depth, stressing how the buildings were experienced. The iconography (i.e., meaning) of the forms employed is examined. The chapter expands the discussion of icons and of the iconoclastic controversy.

CHAPTER 9: ISLAMIC ART

Reintroduces Islamic art to the text. Seeks both to give a good general overview of Islamic art and to emphasize the connections between Islamic art and the art of the European West. The many common values of both types of art are examined.

CHAPTER 10: EARLY MEDIEVAL ART

Enlarges discussion of early minor arts. Discusses Irish manuscripts more thoroughly in terms of meaning and in relationship to Roman art. Expands the discussion of Charlemagne's political and social goals and the use of art to further that agenda. Places more emphasis on how women were viewed and represented.

CHAPTER 11: ROMANESQUE ART

Expands discussion of the art of the pilgrimage road, including Sant Vincenç at Cardona and Saint-Genis-des-Fontaines. Focuses on the role of women as subject and patron. Reorganization of chapter allows integration of the various mediums to promote understanding that, despite intrinsic differences, the works demonstrate common aspirations as well as fears.

CHAPTER 12: GOTHIC ART

Reconfigured to remove Italian art (now in Chapter 13) and some International Style monuments (now in Chapter 14). Treats development of Gothic architecture more cogently by the introduction of new examples (e.g., the interiors of Notre-Dame of Laon and Notre-Dame of Paris). Discussion of Sainte-Chapelle and Spanish Gothic art is added.

CHAPTER 13: ART IN THIRTEENTH- AND FOURTEENTH-CENTURY ITALY

Separates the thirteenth-and fourteenth-century Italian situation from the rest of Europe to highlight its specific role as a bridge between medieval and Renaissance art. New works include Simone Martini's *Annunciation* and Andrea da Firenze's *Way of Salvation* in the Spanish Chapel. New section added on northern Italy in the fourteenth century.

CHAPTER 14: ARTISTIC INNOVATIONS IN FIFTEENTH-CENTURY NORTHERN EUROPE

Now placed before the Italian fifteenth-century chapter, the new structure of the chapter integrates works of art of a particular time and place to emphasize historical context. Updates discussions of key works. Treats printmaking and the printed book in detail.

CHAPTER 15: THE EARLY RENAISSANCE IN FIFTEENTH-CENTURY ITALY

Situates art in specific moments or geographic regions and discusses different mediums in relation to their context. Emphasizes role of patronage. Introduces new sections on art outside of Florence. Treats *cassone* panels and other works of art for domestic contexts. Fra Angelico's *Annunciation* at San Marco, Brunelleschi's *Ospedale degli Innocenti,* Piero della Francesca's work for the court of Urbino, and Mantegna's *Camera Picta* in Mantua are included.

CHAPTER 16: THE HIGH RENAISSANCE IN ITALY, 1495–1520

Explains why a group of six key artists continue to be treated in monographic fashion. Focuses on the period 1495–1520, removing late Michelangelo and Titian to Chapter 17. Leonardo's drawing of the *Vitruvian Man* and Michelangelo's Roman *Pietà* are added. Updates discussions of art, including Leonardo's *The Virgin of the Rocks* and Giorgione's *The Tempest.*

CHAPTER 17: THE LATE RENAISSANCE AND MANNERISM IN SIXTEENTH-CENTURY ITALY

Follows a geographic structure, starting with Florence under the Medici dukes, and then moves among the regions of Rome, northern Italy, and Venice. Stresses courtly and papal patronage, as well as the founding of the Accademia del Disegno in Florence. Integrates late Michelangelo and Titian into these discussions. New discussions included for Bronzino, Titian's *Venus of Urbino,* and the work of Lavinia Fontana.

CHAPTER 18: RENAISSANCE AND REFORMATION IN SIXTEENTH-CENTURY NORTHERN EUROPE

Describes works of art in five different geographical regions. Considers the spread of Italian Renaissance style and the development of local traditions, among discussions of the Reformation and other crises. Includes new discussion of the *Isenheim Altarpiece.*

CHAPTER 19: THE BAROQUE IN ITALY AND SPAIN

Examines Caravaggio's and Bernini's roles in the Counter-Reformation. Discusses religious orders and the papacy, and develops an understanding of the role of women, women artists, the poor, street people, and the full nature of seventeenth-century life. New works include Bernini's *Baldacchino* and his *bozzetto* for a sculpture, as well as the portrait of *Juan de Pareja* by Velaszquez and Gentileschi's *Self-Portrait as the Allegory of Painting.*

CHAPTER 20: THE BAROQUE IN THE NETHERLANDS

Examines political and religious differences and artistic connections in the Netherlands. Explores the importance of Rubens through an examination of his workshop. The concept of an open market is treated in a discussion of the Dutch landscape, the still life, and the genre painting of Northern Europe. Works by Judith Leyster and Clara Peeters added, and with Rachel Ruysch the discussion focuses on the new status of these women artists.

CHAPTER 21: THE BAROQUE IN FRANCE AND ENGLAND

Considers concept of classicism in the paintings of Poussin and the architecture of Jones and Wren. New works include Poussin's *Death of Germanicus* and *Landscape with St. John on Patmos,* as well as Le Brun's diagram of facial expressions and Wren's steeple of St. Mary-Le-Bow.

CHAPTER 22: THE ROCOCO

Explores the Age of Louis XV using new examples by Watteau and Fragonard, including *Gersaint's Signboard* and *The Swing.* Pastel painting by Rosalba Carriera and Vigée-Lebrun's *Portrait of Marie Antoinette with Her Children* are introduced. An example of Sèvres porcelain emphasizes the importance of decorative arts in this era.

CHAPTER 23: ART IN THE AGE OF THE ENLIGHTENMENT, 1750–1789

Rewritten to focus more on the time period from roughly 1750 to 1789 than on Neoclassicism in particular. Emphasizes Neoclassicism's reliance on logic, morality, and the Classical past, while also pointing to the burgeoning importance placed on emotion, the irrational, and the sublime. Includes works by Mengs, Batoni, Hamilton, Wright of Derby, Gabriel, and Peyre.

CHAPTER 24: ART IN THE AGE OF ROMANTICISM, 1789–1848

This entirely restructured chapter defines Romanticism and emphasizes the importance of emotion, individual freedom, and personal experience. It examines imagination, genius, nature, and the exotic. Puts Romanticism into the context of the perceived failures of the Enlightenment and French Revolution. More strongly states the idea of nationalism as a Romantic theme.

CHAPTER 25: THE AGE OF POSITIVISM: REALISM, IMPRESSIONISM, AND THE PRE-RAPHAELITES, 1848–1885

Organizes around the concept of Positivism, the reliance on hard fact, and the dramatic social transformations that artists recorded. Expands the photography discussion. Focuses on the use of iron in engineering and architecture, especially in the Crystal Palace and the Eiffel Tower. Associates Rodin with Symbolism. Includes Daumier and Millet in the discussion of Realism.

CHAPTER 26: PROGRESS AND ITS DISCONTENTS: POST-IMPRESSIONISM, SYMBOLISM, AND ART NOUVEAU, 1880–1905

Emphasizes historical context rather than the Modernist tradition. Stresses disturbing psychology of the period and its manifestation in art. Places Frank Lloyd Wright here and into the context of the Chicago School. Photography section now includes Käsebier's *Blessed Art Thou Among Women,* which is dealt with in a feminist context. Includes a work by Lartigue.

CHAPTER 27: TOWARD ABSTRACTION: THE MODERNIST REVOLUTION, 1904–1914

First of three chapters on modern art that are radically restructured using chronology; internally reorganized on a thematic basis. Emphasizes the social forces that resulted in radical formal and stylistic developments between 1904 and 1914 that culminated in abstractionism. Places significant emphasis on Duchamp. Additions include Braque's *The Portuguese* and Duchamp's *Nude Descending a Staircase, No. 2.* Significantly revamps American art.

CHAPTER 28: ART BETWEEN THE WARS

Structured around the impact of World War I and the need to create utopias and uncover higher realities, especially as seen in Surrealism.

Treats Dada chronologically and geographically. Includes lengthy discussion of Duchamp in New York, with *Fountain* added. Represents films as seen in the work of Man Ray and Dali. Integrates discussion of Mondrian and De Stijl architecture, as well as Bauhaus artists and architects.

CHAPTER 29: POSTWAR TO POSTMODERN, 1945–1980

Emphasizes the impact Cage and Rauschenberg had on the development of American Art. Adds Conceptual Art of Brecht and the happenings and environments of Kaprow. Other additions include Ruscha, Flavin, and Serra, with new explorations of Paik and Hesse. Focuses on ethnic identity and gender issues with the newly added artists David Hammons and Judy Chicago.

CHAPTER 30: THE POSTMODERN ERA: ART SINCE 1980

Presents the concept of Postmodernism in clear, simple terms. Emphasizes the period's pluralism and the view of art as having no limits. Adds architects Venturi, Moore, Johnson, Hadid, Libeskind, and Piano; and artists Basquiat, Holzer, Polke, Viola, Gonzalez-Torres, Smith, Hirst, and Cai Guo-Qiang.

The **BIBLIOGRAPHY** has been thoroughly updated by Mary Clare Altenhofen, Fine Arts Library, Harvard College Library.

NEW FEATURES OF EVERY CHAPTER

THE INTRODUCTORY ART HISTORY STUDENT IS TRYING TO MASTER MANY DIFFERENT SKILLS—*Janson's History of Art* assists students with its beautiful reproductions and strong narrative approach. It also includes new boxed features to enhance student learning:

- **MATERIALS AND TECHNIQUES**
- **THE ART HISTORIAN'S LENS**
- **ART IN TIME**
- **PRIMARY SOURCES**
- **SUMMARIES**

MATERIALS AND TECHNIQUES:
Illustrations and explanations of processes used by artists.

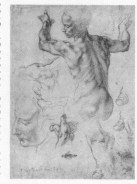

Drawings

M edieval artists had used the technique of drawing to record monuments they had seen or to preserve compositions for future use. These drawings were usually made with pen and ink on parchment. During the Renaissance, the increasing availability of paper expanded the uses of drawings and encouraged artists to use a variety of media in making them.

Pen and ink on paper were used most often, as the liquid ink could be transferred to the paper using a sharp quill pen or stylus. Sometimes the forms drawn with ink were further elaborated with a wash (usually diluted ink) applied with a brush. Some artists preferred to work with liquid media and thin brushes to render all the forms.

Artists also drew on the relatively rough surface of paper using charcoal or chalk. These naturally occurring materials are both dry and crumbly enough to leave traces when the artist applies them to the paper. The lines they leave can be thick or thin, rendered with carefully descriptive marks, or with quick evocative strokes. Artists could smudge these soft media to soften contours and fill in shadows, or to produce parallel lines called hatching to describe shadows. See, for example, the variety of strokes Michelangelo used to make the red chalk study for the *Libyan Sibyl* on the Sistine Chapel ceiling.

More difficult to master was the technique of silverpoint. This entailed using a metal stylus to leave marks on a surface. Silver was the most prized metal for this technique, though lead was also used. Mistakes could not be undone, so it took great skill to work in silverpoint. To make silver leave traces on paper, the paper had to be stiffened up by coating it with a mixture of finely ground bone and size (a gluelike substance). Such coatings were sometimes tinted. When the silver stylus is applied, thin delicate lines are left behind that darken with age.

Renaissance artists also expanded the uses of drawings. Apprentices learned how to render forms using drawings; artists worked out solutions to visual problems with drawings. Drawings were also used to enable artists to negotiate contracts and to record finished works as a kind of diary or model book.

Artists also made cartoons, or full-scale patterns, for larger works such as frescoes or tapestries (see fig. 16.27). Transferring designs from drawings onto larger surfaces could be achieved in a number of ways. A grid could be placed over the design to serve as a guide for replicating the image on a larger scale. Or cartoons for frescoes could be pricked along the main lines of the design; through these tiny holes a powder was forced to reproduce the design on the wall. This is called pouncing.

In the sixteenth century, drawings became prized in their own right and were collected by artists, patrons, and connoisseurs. The drawing was thought to reveal something that a finished work could not: the artist's process, the artist's personality, and, ultimately, the artist's genius.

Michelangelo. *Studies for the Libyan Sibyl.* Red chalk, 11⅜ × 8⅜." (28.9 × 21.4 cm). The Metropolitan Museum of Art, New York. The Purchase, Joseph Pulitzer Bequest, 1924 (24.197.2)

Michelangelo's deep study of ancient sculpture, which he hoped to surpass. Since the cleaning of the frescoes in the 1980s, scholars have come to appreciate the brilliance of Michelangelo's colors, and the pairing of complementary colors he used in the draperies. (See *The Art Historian's Lens,* page 573.)

A similar energy pervades the center narratives. *The Fall of Man* and *The Expulsion from the Garden of Eden* (fig. 16.20) show the bold, intense hues and expressive body language that characterize the whole ceiling. Michelangelo's figures are full of life, acting out their epic roles in sparse landscape settings. To the left of the Tree of Knowledge, Adam and Eve form a spiral composition as they reach toward the forbidden fruit,

while the composition of *The Expulsion from the Garden of Eden* is particularly close to Masaccio's (see fig. 15.18) in its intense drama. The nude youths (*ignudi*) flanking the main sections of the ceiling play an important visual role in Michelangelo's design. They are found at regular intervals, forming a kind of chain linking the narratives. Yet their meaning remains uncertain. Do they represent the world of pagan antiquity? Are they angels or images of human souls? They hold acorns, a reference to the pope's family name, delle Rovere (Rovere means "oak"). The ignudi also support bronze medallions that look like trophies, reminding the viewer of Julius's military campaigns throughout Italy.

CHAPTER 16 THE HIGH RENAISSANCE IN ITALY, 1495–1520 **571**

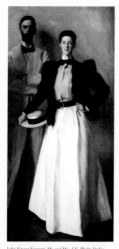

An Artist's Reputation and Changes in Art Historical Methodology

A change in the methodology of art history can sometimes affect scholars' attitudes toward artists, sometimes resurrecting figures who had once been renowned but had gradually disappeared from the history books. A case in point is the American painter John Singer Sargent (1856–1925). In his day, he was one of the most famous and financially successful artists. He can even be considered the quintessential American artist, for he lived and worked in Europe and his art appeared to embrace the European values that so many nouveau riche Americans aspired to emulate.

Sargent was born and raised in Florence, studied at the École des Beaux-Arts in Paris, and by 1879 was winning medals at the salons. In part due to the encouragement of novelist Henry James, he moved permanently to London in 1886. He made his first professional trip to America in 1887, and immediately became the portraitist to high society, painting William Henry Vanderbilt of New York and Isabella Stewart Gardner of Boston, among others. By 1892, he was the most fashionable portraitist in London and perhaps on the Continent as well. Sargent's success was in part based on the luxuriousness of his imagery—expensive fabrics and furnishings—reinforced by his dramatic sensual brushwork.

Sargent was a proponent of the avant-garde. He befriended Claude Monet and acquired his paintings as well as Manet's. His own work reflects the painterly bravura of Manet, and like Manet he admired Velázquez. He also made numerous Impressionist landscapes and urban views, often in watercolor. Ironically, Sargent fell into oblivion because of the Modernism that evolved in the twentieth century. His consummate handling of paint may have had the abstract qualities that the Modernists admired, but his work was perceived as conservative. It failed to offer anything new. Worse yet, his avant-garde brushwork was carefully packaged in the old-fashioned formulas of society portraiture.

Sargent's reevaluation began in the 1950s, with a renewed appreciation of the paint handling in his Impressionist watercolors. In succeeding decades his reputation gradually inched its way up as Modernism was replaced by Post-Modernism and its broader values (see Chapter 30). Representational art became fashionable again, and art historians began to appreciate art for the way in which it reflected the spirit of its age. Sargent's portraiture was now perceived as the embodiment of Victorian and Edwardian society and of the later Gilded Age.

For example, gender studies, which began appearing in the 1970s, looked at his daring presentation of women, as can be seen in his 1897 portrayal of New York socialite Edith Stokes in *Mr. and Mrs. I. N. Phelps Stokes*. Instead of giving us a demure and feminine woman, Sargent presents a boldly aggressive Mrs. Stokes, who represents the "New Woman" who emerged in the 1890s (see page 903). In a period when the women's movement was fiercely advocating equal rights, many women were asserting their independence and challenging conventional gender roles. This New Woman was independent and rebelled against the conventional respectability of the Victorian era that sheltered women in domesticity. She went out in public; she was educated, and she was athletic, spirited,

and flaunted her sexual appeal. Not only did she wear comfortable clothes, she even wore men's attire, or a woman's shirtwaist based on a man's shirt. Instead of self-sacrifice, she sought self-fulfillment. Sargent presents Edith Stokes as just such a woman, even having her upstage her husband. For its time, this was a radical presentation of a woman and a reflection not only of the sitter's personality and identification with women's issues but also of Sargent's willingness to buck portrait conventions and societal expectations.

John Singer Sargent. *Mr. and Mrs. I.N. Phelps Stokes*, 1897. Oil on canvas, 84⅜″ × 39⅝″ (214 × 101 cm). Metropolitan Museum of Art, New York. Bequest of Edith Minturn Phelps Stokes (MRS. I. N.), 1938. (38.104)

THE ART HISTORIAN'S LENS: Topics that provide a glimpse into the working methods of art historians.

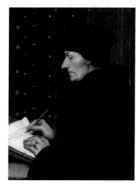

- 1502—Peter Henlein of Nuremberg invents pocket watch
- ca. 1509—Grünewald's *Isenheim Altarpiece*
- 1521—Diet of Worms condemns Luther
- 1525—Peasants' War ignited by Reformation
- 1526—**Albrecht Dürer's *Four Apostles* presented to city of Nuremberg**
- 1555—Peace of Augsburg between Catholics and Lutherans

1509, twenty years later Henry was seeking to annul their union, for they had failed to produce a male heir to the throne. Thwarted by the Catholic Church, he broke away from Catholicism and established himself as the head of the Church of England. His desire for a male heir to the throne led Henry into a number of marriages, most of which ended either in divorce or in the execution of his wife. He had three children, who succeeded him as Edward VII, Mary I, and Elizabeth I.

Holbein's *Henry VIII* (fig. 18.27) of 1540 captures the supreme self-confidence of the king. He uses the rigid frontality that Dürer had chosen for his self-portrait to convey the almost divine authority of the absolute ruler. The king's physical bulk creates an overpowering sense of his ruthless, commanding personality. The portrait shares with Bronzino's *Eleonora of Toledo* (fig. 17.7) an immobile pose, an air of unapproachability, and the

18.26. Hans Holbein the Younger. *Erasmus of Rotterdam*. ca. 1523. Oil on panel, 16⅝ × 12⅜″ (42 × 31.4 cm). Musée du Louvre, Paris

The spread of the Reformation disrupted the Humanist circle in Basel. By 1525, followers of Zwingli preached the sole authority of Scripture, while more radical reformers preached that images were idols. To escape this climate, Holbein sought employment elsewhere. He had traveled to France in 1523–1524, perhaps intending to offer his services to Francis I. Hoping for commissions at the court of Henry VIII, Holbein went to England in 1527. He presented the portrait of Erasmus as a gift to the humanist Thomas More, who became his first patron in London. Erasmus, in a letter recommending Holbein to More, wrote: "Here [in Basel] the arts are out in the cold." By 1528, when Holbein returned to Basel, violence had replaced rhetoric. He witnessed Protestant mobs destroying religious images, a scene Erasmus described in a letter: "Not a statue has been left in the churches . . . or in the monasteries; all the frescos have been whitewashed over. Everything which would burn has been set on fire, everything else hacked into little pieces. Neither value nor artistry prevailed to save anything." Holbein resolved to return to London.

ENGLAND: REFORMATION AND POWER

Holbein's patron in England was the ambitious Henry VIII, who reigned from 1509 to 1547. Henry wanted England to be a power broker in the conflicts between Francis I of France and the Emperor Charles V, although his personal situation complicated these efforts. Married to Catherine of Aragon in

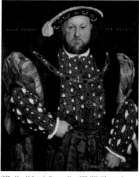

18.27. Hans Holbein the Younger. *Henry VIII*. 1540. Oil on panel. 32⅝ × 29″ (82.6 × 74.5 cm). Galleria Nazionale d'Arte Antica, Rome

ART IN TIME: Frequent chronologies situate the works of art in their era of origin.

Karel van Mander Writes About Pieter Bruegel the Elder

From *The Painter's Treatise (Het Schilder Boeck)* 1604

Van Mander's biography of Pieter Bruegel the Elder remains an important source of information about the artist, whose talent he appreciated fully.

On his journeys Bruegel did many views from nature so that it was said of him, when he traveled through the Alps, that he had swallowed all the mountains and rocks and spat them out again, after his return, on to his canvases and panels, so closely was he able to follow nature here and in her other works. . . .

He did a great deal of work [in Antwerp] for a merchant, Hans Franckert, a noble and upright man, who found pleasure in Bruegel's company and met him every day. With this Franckert, Bruegel often went out into the country to see peasants at their fairs and weddings. Disguised as peasants they brought gifts like the other guests,

claiming relationship or kinship with the bride or groom. Here Breugel delighted in observing the droll behavior of the peasants, how they ate, drank, danced, capered, or made love, all of which he was well able to reproduce cleverly and pleasantly. . . . He represented the peasants—men and women of the Campine and elsewhere—naturally, as they really were, betraying their boorishness in the way they walked, danced, stood still, or moved.

. . . An art lover in Amsterdam, Sieur Herman Pilgrims, owns a *Peasant Wedding* painted in oils, which is most beautiful. The peasants' faces and the limbs, where they are bare are yellow and brown, sunburnt; their skins are ugly, different from those of town dwellers . . .

. . . Many of his compositions of comical subjects, strange and full of meaning, can be seen engraved; but he made many more works of this kind in careful and beautifully finished drawings to which he had added inscriptions. But as some of them were too biting and sharp, he had them burnt by his wife when he was on his deathbed, from remorse or fear that she might get into trouble and have to answer for them. . . .

SOURCE: DUTCH AND FLEMISH PAINTERS BY KAREL VAN MANDER. TR. CONSTANT VANDE WALL (MANCHESTER, NH: AYER COMPANY PUBLISHERS, 1936)

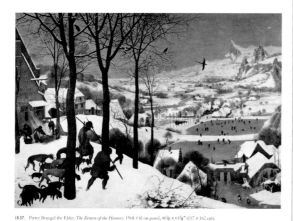

18.37. Pieter Bruegel the Elder. *The Return of the Hunters*. 1568. Oil on panel, 46⅛ × 63⅞″ (117 × 162 cm). Kunsthistorisches Museum, Vienna

PRIMARY SOURCES: Historical documents place art and artists more securely in the context of their time.

SUMMARIES at the end of each chapter highlight key concepts.

SUMMARY

In the last half of the eighteenth century, Western culture entered the modern era. People were continually adapting to shifting political values, changing socioeconomic conditions, and new scientific theories. Political rebellions occurred in America and France, gradually shifting power from a hereditary royalty and into the hands of citizens. Evolving philosophical outlooks spurred land reform, scientific discoveries, and technological advancements—and vice versa—resulting in the Industrial Revolution in England that eventually spread worldwide. Society was progressing, and a burgeoning middle class demanded new luxuries, including art. The roots of these changes can be traced to the Enlightenment, a new method of critical thinking that developed in the eighteenth century. Enlightenment thought brought about the establishment of basic human rights, a new moral order, and modern science. Rationalism ruled, with theories based on experience and observation. Living in the modern world today, we continue to feel the effects of these powerful upheavals.

Art reflected this complex era. Styles old and new mingled and evolved. Traces of the Rococo and Baroque remained as new trends emerged. The dominant style, Neoclassicism, emphasized logic and rationality and often featured moralistic themes borrowed from the ancient Greeks and Romans. Romanticism, a simultaneous thread in art, advocated emotion, imagination, and the supremacy of Nature.

ROME TOWARD 1760: THE FONT OF NEOCLASSICISM

Rome, home to treasures from antiquity and the Renaissance, held sway as the world's art center. The city attracted not only a flood of artists seeking inspiration but also the wealthy traveling on the "Grand Tour" of Italy. Fueled by recent archeological discoveries, notably those of Herculaneum and Pompeii, a renewed interest in antiquity gripped scholars and artists. In his influential writings, art critic Johann Winckelmann encouraged a new appreciation of Greek art by espousing its moral and aesthetic superiority. The austere brushwork of Anton Raphael Mengs, the strong linearity of Pompeo Batoni's portraits, and the dramatic solemnity of Gavin Hamilton's moralistic themes laid the foundations of the Neoclassical style.

ROME TOWARD 1760: THE FONT OF ROMANTICISM

Meanwhile, Romanticism emerged. Printmaker and publisher Giovanni Battista Piranesi celebrated ancient Roman civilization in dramatic *vedute* (views) of awe-inspiring monumental architecture that embodied the sublime, a quality associated with vastness, obscurity, power, and infinity that produced feelings of awe, fright, even terror. British statesman Edmund Burke defined the sublime in his treatise *A Philosophical Inquiry into the Origin of Our Ideas of the Sublime and Beautiful*. Piranesi and others increasingly embraced the sublime, reflecting a new audience demand for art that evoked intense emotion, even fright or horror, and that transported them emotionally.

NEOCLASSICISM IN ENGLAND

Antimonarchists and many intellectuals of England, steeped in the Enlightenment, identified with the ancient Romans and emulated that civilization's

government, literature, and art. By extension, they invented Neoclassical art. Neoclassicism was only just gaining popularity, however, and several styles or influences often appeared simultaneously in the same work. Many English artists borrowed themes from Greek and Roman art and literature, although not always those with moralistic messages. Angelica Kauffmann's paintings reflect these dichotomies as she vacillated between erotic and virtuous themes. Rococo grace and Neoclassical austerity.

The tradition of contemporary history painting was born during this period as well. With Enlightenment emphasis on the logical, artists like Benjamin West and John Singleton Copley began conceiving convincing ways to show historic contemporary events through the depiction of accurate costumes and settings. West's *The Death of General Wolfe* and Copley's *Watson and the Shark* offer abundant truthful details mixed with Classical poses, calm dignity, and moral overtones—hallmarks of Neoclassical style.

The Classical revival in architecture appeared in England as early as 1715, with the publication of Colen Campbell's treatise *Vitruvius Britannicus*, and eventually spread to America. Campbell espoused the architecture of the ancients and their descendants, notably Antonio Palladio, and the demand for Palladian-inspired country villas exploded. The Classical revival extended to urban planning, as seen in the resort town of Bath, as well as to décor, embodied in the interiors designed by Robert Adam.

EARLY ROMANTICISM IN ENGLAND

In England, the desire of some people for logic and empiricism coexisted with an equally strong urge for emotion and subjective experiences. In architecture and landscape design, Neoclassical evocations of noble antiquity joined with Romanticism's delight in the exotic and the desire to elicit powerful emotions. The British taste for the sublime translated successfully into garden design, where it combined especially well with the interesting variety of the picturesque and the layered meanings of associationism, both concepts fully developed in England. The concurrent Gothic revival also reflected Romantic sensibilities, with its emphasis on the sublime emotions evoked by melancholic spaces. Painters also felt the dual pull of Neoclassicism and Romanticism. George Stubbs and Joseph Wright often fused both trends, whereas Heinrich Fuseli fully adopted sublime terror, carrying us dramatically into the Romantic era.

NEOCLASSICISM IN FRANCE

France experienced a similar reaction to the Enlightenment, and art began shifting from Rococo flamboyance toward Neoclassical elegance and austerity. In architecture, this Classical revival featured austere geometry and monumental scale, characteristic of structures by Marie-Joseph Peyre and Claude-Nicolas Ledoux. French painters and sculptors formulated their own response to the influential mainstream of thought. Jean-Baptiste Greuze's genre paintings, the sensation of the Paris Salons in the 1760s, embodied Enlightenment emphasis on logic and naturalism, while Jean-Antoine Houdon's sculpted portraits show realistic, classicized versions of the sitter. Yet the climax of French Neoclassicism is the moralizing history paintings of Jacques-Louis David, notably his *Oath of the Horatii*. Building on the *tableau vivant* made popular by Greuze, David creates a dramatic composition of noble beauty, but one where the undercurrents of horror reflect a taste for the Romantic as well.

Acknowledgments

We are grateful to the following academic reviewers for their numerous insights and suggestions on improving Janson:

Susan Altman, Middlesex County College
Michael Amy, Rochester Institute of Technology
Dixon Bennett, San Jacinto College South
Barbara Bushey, Hillsdale College
Barbara Dodsworth, Mercy College
Karl Fugelso, Towson University
Tessa Garton, College of Charleston
Alyson Gill, Arkansas State University
Andrew L. Goldman, Gonzaga University
Marilyn Gottlieb-Roberts, Miami Dade College
Oleg Grabar, Institute for Advanced Study
William Greiner, Olivet Nazarene University
Anthony Gully, Arizona State University
Jean R. Harry, Luzerne County Community College
Andrew Hershberger, Bowling Green State University
Fredrika Jacobs, Virginia Commonwealth University
Victor Katz, Holyoke Community College
Hee-Young Kim, University of Alabama
Ellen Konowitz, SUNY New Paltz
Marybeth Koos, Elgin Community College
Danajean Mabry, Surry Community College
Marian Mazzone, College of Charleston
Charles Morscheck, Drexel University
Andrew M. Nedd, Savannah College of Art and Design
Andrea Pearson, Bloomsburg University
William H. Peck, Detroit Institute of Art
Rob Prestiano, Angelo State University
Wendy Robertson, Humboldt State University
Cynthia Robinson, Cornell University
Susan Ryan, Louisiana State University
Cathy Santore, New York City College of Technology
Carl Sederholm, Brigham Young University
Stephanie Spencer, North Carolina State University
Esther Tornai Thyssen, Sage College of Albany
Lee Ann Turner, Boise State University
Jens T. Wollesen, University of Toronto

Individual chapters of the text were subjected to a rigorous review process by expert reviewers. We thank the following for their incredibly detailed and careful fact-finding analyses of the manuscript:

Ann Jensen Adams, University of California, Santa Barbara
Bernadine Barnes, Wake Forest University
Susan Cahan, University of Missouri-St. Louis
Maura Coughlin, Brown University
Roger J. Crum, University of Dayton
Sharon Dale, Penn State University-Erie, Behrend College
Michael T. Davis, Mount Holyoke College
Marian Feldman, University of California, Berkeley
Laura Gelfand, The University of Akron
Anne Higonnet, Barnard College
Eva Hoffman, Tufts University
Jeffery Howe, Boston College
Charles T. Little, Metropolitan Museum of Art
Patricia Mainardi; Graduate Center, CUNY
Robert Mattison, Lafayette College
David Gordon Mitten, Harvard University
Robert Mode, Vanderbilt University
Elizabeth Otto, SUNY Buffalo
Nassos Papalexandrou, University of Texas-Austin
Pamela Patton, Southern Methodist University
John Pedley, University of Michigan
Elizabeth M. Penton, Durham Technical Community College
Jane Peters, University of Kentucky
Gay Robins, Emory University
Wendy Roworth, University of Rhode Island
John Beldon Scott, University of Iowa
Kenneth E. Silver, Department of Fine Arts, New York University
Catherine Turill, California State University, Sacramento
Eric R. Varner, Emory University
Nancy L. Wicker, University of Mississippi
Jeryldene M. Wood, University of Illinois

SPECIAL THANKS go to Peter Kalb of Ursinus College and Elizabeth Mansfield of the University of the South for their tremendous contributions as editorial consultants.

THE CONTRIBUTORS WOULD LIKE TO THANK THE FOLLOWING INDIVIDUALS FOR THEIR ADVICE AND ASSISTANCE IN DEVELOPING THIS EDITION:
C. Edson Armi, Lea Cline, Holly Connor, Oleg Grabar, Ann Sutherland Harris, Asma Husain, Anthony F. Janson, Calvin Kendall, Frank Lind, Andrea Pearson, Chris Reed, John Beldon Scott, Sonia C. Simon, and Bruce Weber. We would also like to thank the group of talented editors and staff at Pearson Education for all their hard work in bringing this edition to life. Special thanks go to Sponsoring Editor Helen Ronan and Senior Development Editors Roberta Meyer, Karen Dubno, and Carolyn Viola-John. We are also grateful to Production Manager Lisa Iarkowski, Production Editor Harriet Tellem, and the team responsible for acquiring images. Deep thanks go, too, to Sarah Touborg for overseeing the project and bringing this group of collaborators together.

Faculty and Student Resources for Teaching and Learning with *Janson's History of Art*

PRENTICE HALL is pleased to present an outstanding array of high quality resources for teaching and learning with *Janson's History of Art*. Please contact your local Prentice Hall representative for more details on how to obtain these items, or send us an email at art@prenhall.com.

DIGITAL AND VISUAL RESOURCES

 THE PRENTICE HALL DIGITAL ART LIBRARY. Instructors who adopt *Janson's History of Art* are eligible to receive this unparalleled resource. Available in a two-DVD set or a 10-CD set, *The Prentice Hall Digital Art Library* contains every image in *Janson's History of Art* in the highest resolution (over 300 dpi) and pixellation possible for optimal projection and easy download. Developed and endorsed by a panel of visual curators and instructors across the country, this resource features over 1,600 images in jpeg and in PowerPoint, an instant download function for easy import into any presentation software, along with a zoom feature, and a compare/contrast function, both of which are unique and were developed exclusively for Prentice Hall.

 ONEKEY. is Prentice Hall's exclusive course management system that delivers all student and instructor resources all in one place. Powered by WebCt and Blackboard, OneKey offers an abundance of online study and research tools for students and a variety of teaching and presentation resources for instructors, including an easy-to-use gradebook and access to many of the images from the book.

 ART HISTORY INTERACTIVE CD-ROM. *1,000 Images for Study & Presentation* is an outstanding study tool for students. Images are viewable by title, by period, or by artist. Students can quiz themselves in flashcard mode or by answering any number of short answer and compare/contrast questions.

CLASSROOM REPSONSE SYSTEM (CRS) IN CLASS QUESTIONS. Get instant, classwide responses to beautifully illustrated chapter-specific questions during a lecture to gauge students comprehension—and keep them engaged. Contact your local Prentice Hall sales representative for details.

 COMPANION WEBSITE. Visit www.prenhall.com/janson for a comprehensive online resource featuring a variety of learning and teaching modules, all correlated to the chapters of *Janson's History of Art*.

FINE ART SLIDES AND VIDEOS. are also available to qualified adopters. Please contact your local Prentice Hall sales representative to discuss your slide and video needs. To find your representative, use our rep locator at www.prenhall.com.

 VANGO NOTES: Study on the go with VangoNotes--chapter reviews from your text in downloadable mp3 format. You can study by listening to the following for each chapter of your textbook: Big Ideas: Your "need to know" for each chapter; **Practice Test:** A check for the Big Ideas—tells you if you need to keep studying; **Key Terms:** audio "flashcards" to help you review key concepts and terms; Rapid Review: A quick drill session—use it right before your test. VangoNotes are flexible; download all the material directly to your player, or only the chapters you need.

PRENTICE HALL TEST GENERATOR is a commercial-quality computerized test management program available for both Microsoft Windows and Macintosh environments.

PRINT RESOURCES

 TIME SPECIAL EDITION: ART. Featuring stories like "The Mighty Medici," "When Henri Met Pablo," and "Redesigning America," Prentice Hall's TIME Special Edition contains thirty articles and exhibition reviews on a wide range of subjects, all illustrated in full color. This is the perfect complement for discussion groups, in-class debates, or writing assignments. With the TIME Special Edition, students also receive a three-month pass to the TIME archive, a unique reference and research tool.

UNDERSTANDING THE ART MUSEUM by Barbara Beall. This handbook gives students essential museum-going guidance to help them make the most of their experience seeing art outside of the classroom. Case studies are incorporated into the text, and a list of major museums in the United States and key cities across the world is included.

ARTNOTES PLUS. An invaluable slide and study guide for students, ArtNotes Plus contains all of the images from the book in thumbnail form with caption information to illuminate their "art in the dark" experience. In addition, ArtNotes Plus features study questions and tips for each chapter of the book.

 ONESEARCH WITH RESEARCH NAVIGATOR helps students with finding the right articles and journals in art history. Students get exclusive access to three research databases: The New York Times Search by Subject Archive, ContentSelect Academic Journal Database, and Link Library.

INSTRUCTOR'S MANUAL AND TEST ITEM FILE is an invaluable professional resource and reference for new and experienced faculty, containing sample syllabi, hundreds of sample test questions, and guidance on incorporating media technology into your course.

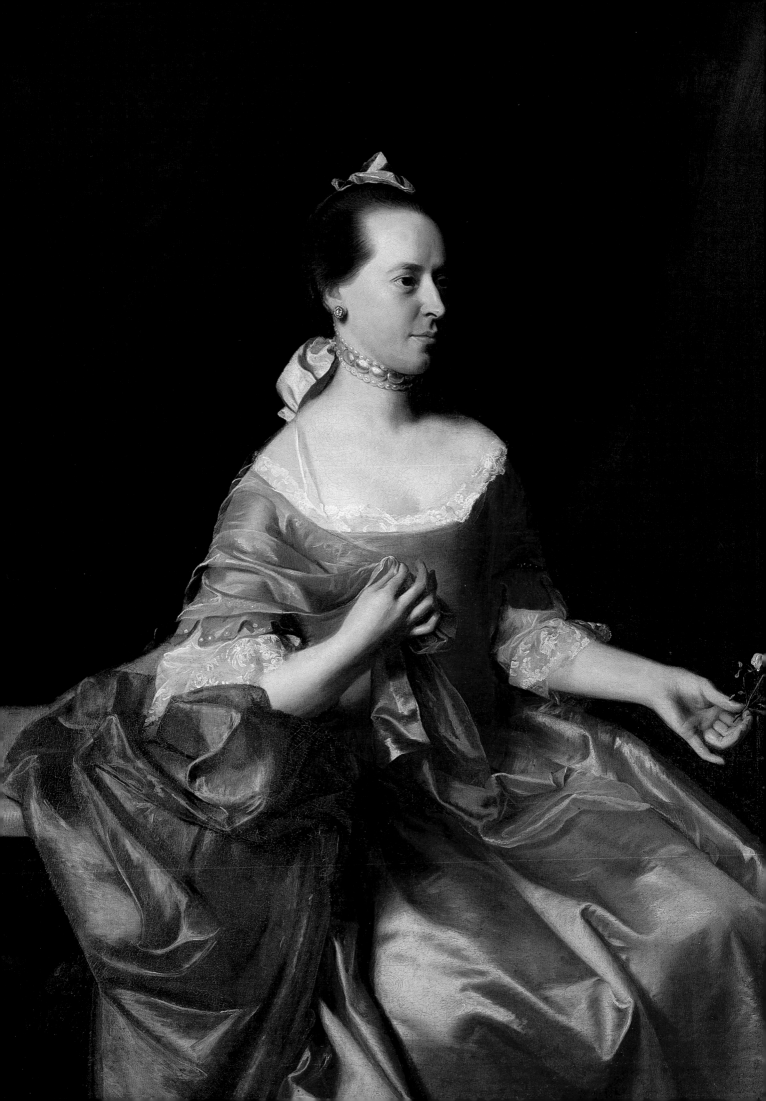

Introducing Art

WHO WAS FREELOVE OLNEY SCOTT? Her portrait (fig. I.1) shows us a refined-looking woman, born, we would guess, into an aristocratic family, used to servants and power. We have come to accept John Singleton Copley's portraits of colonial Bostonians, such as *Mrs. Joseph Scott,* as accurate depictions of his subjects and their lifestyles. But many, like Mrs. Scott, were not what they appear to be. Who was she? Let's take a closer look at the context in which the painting was made.

ART IN CONTEXT

Copley was one of the first American painters to make a name for himself throughout the American colonies and in England. Working in Boston from about 1754 to 1774, he became the most sought after portraitist of the period. Copley easily outstripped the competition of "face painters," as portraitists were derogatorily called at the time, most of whom earned their living painting signs and coaches. After all, no successful British artist had any reason to come to America, for the economically struggling colonies were not a strong market for art. Only occasionally was a portrait commissioned, and typically, artists were treated like craftsmen rather than intellectuals. Like most colonial portraitists, Copley was self-taught, learning his trade by looking at black-and-white prints of paintings by the European masters.

As we can see in *Mrs. Joseph Scott,* Copley was a master at painting textures, all the more astonishing when we realize that he had no one to teach him the tricks of the painter's trade. His illusions are so convincing, we think we are looking at real silk, ribbons, lace, pearls, skin, hair, and marble. Copley's contemporaries also marveled at his sleight of hand. No other colonial painter attained such a level of realism.

I.1. John Singleton Copley, *Mrs. Joseph Scott.* ca.1765.
Oil on canvas, 69½ × 39½″ (176.5 × 100 cm).
Collection of The Newark Museum, Newark, New Jersey. 48.508

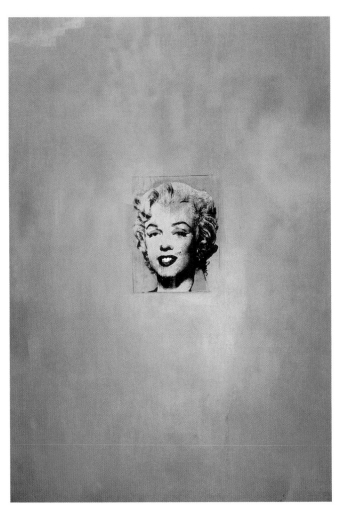

I.2. Andy Warhol. *Gold Marilyn Monroe*. 1962. Synthetic polymer paint, silk-screened, and oil on canvas, 6'11¼" × 4'7" (2.12 × 1.39 m). The Museum of Modern Art, New York, Gift of Philip Johnson. © 2006 Andy Warhol Foundation for the Visual Arts/©Artists Rights Society (ARS), New York, ™/© 2005 Marilyn Monroe, LLC by CMG Worldwide Inc., Indianapolis, Indiana 46256 USA.www.MarilynMonroe.com

However, Copley's job was not just to make a faithful copy of what he saw, but to project an image of Mrs. Scott as a woman of impeccable character, limitless wealth, and aristocratic status. The flowers she holds are a symbol of fertility, faithfulness, and feminine grace, indicating that she is a good mother and wife, and a charming woman. Her expensive dress was imported from London, as was her necklace. Copley may have elevated her status a bit more by giving her a pose taken from one of the prints of British or French royalty that he undoubtedly had on hand.

Not only is Mrs. Scott's pose borrowed, but most likely her dress and necklace, as well, for the necklace appears on three other women in Copley portraits. In other words, it was a studio prop. In fact, except for Mrs. Scott's face, the entire painting is a fiction designed to aggrandize the wife of a newly wealthy Boston merchant, who made a fortune selling provisions to the occupying British army. The Scotts were *nouveau riche* commoners, not titled aristocrats. By the middle of the eighteenth century, rich Bostonians wanted to distinguish themselves from their less successful neighbors. Now, after a century of trying to escape their British roots (from which many had fled to secure religious free-

dom), they sought to imitate the British aristocracy, even to the point of taking tea in the afternoon and owning English Spaniels, a breed that in England only aristocrats were permitted to own.

Mr. Scott commissioned this painting of his wife and a portrait of himself, not just to record their features, but to showcase the family's wealth. These pictures were extremely expensive and therefore status symbols, much like a Mercedes or a diamond ring from Tiffany's is today. The portraits were displayed in the public spaces of the house where they could be readily seen by visitors. Most likely they hung on either side of the mantle in the living room, or in the entrance hall. They were not intended as intimate affectionate resemblances destined for the private spaces in the home. If patrons wanted cherished images of their loved ones, they would commission miniature portraits, like the one in fig. 18.28 by Nicholas Hilliard. Miniatures captured the likeness of the sitter in amazing detail and were often so small they could be encased in a locket that a woman would wear on a chain around her neck, or a gentleman would place in the inner breast pocket of his coat, close to the heart. But the scale and lavishness of Copley's portrait add to its function as a status symbol.

If Mrs. Scott's portrait is rich with meaning, so is another image of a woman produced almost 200 years later: Andy Warhol's *Gold Marilyn Monroe* (fig. I.2) of 1962. In a sense, the

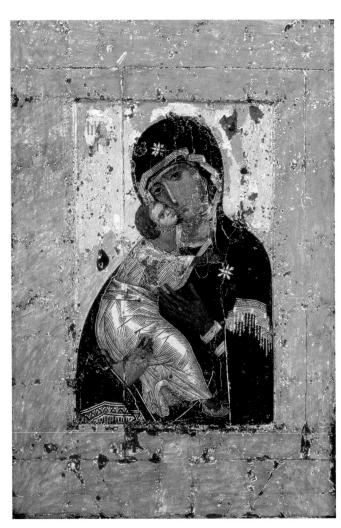

I.3. *Virgin of Vladimir*. Icon, probably from Constantinople. Faces only, 12th century; the rest has been retouched. Tempera on panel, height approx. 31" (78 cm). Tretyakov Gallery, Moscow

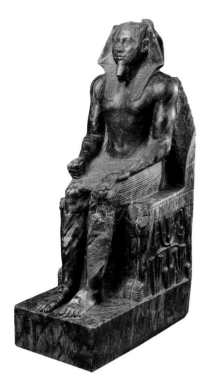

I.4. *Khafra,* from Giza. ca. 2500 BCE. Diorite, height 66″ (167.7 cm). Egyptian Museum, Cairo

painting may also be considered a portrait, because it portrays the famous 1950s film star and sex symbol. Unlike *Mrs. Joseph Scott,* however, the painting was not commissioned by Monroe or her family. Warhol chose the subject himself and made the painting to be exhibited in a commercial art gallery, where it could be purchased by a private collector for display in a home. Of course, he hoped ultimately it would end up in a museum, where a great number of people would see it—something Copley never considered because public museums did not exist in his day. In contrast to Copley, Warhol was not obliged to flatter his subject. Nor did he painstakingly paint this picture to create an illusionistic image. *Gold Marilyn Monroe* has no details and no sense of texture, as hair and flesh appear to be made of the same material—paint. Instead, the artist found a famous newspaper photograph of the film star and silkscreened it onto canvas, a process that involves first mechanically transferring the photograph onto a mesh screen and then pressing printing ink through the screen onto canvas. He then surrounded Marilyn's head with a field of broadly brushed gold paint.

Warhol's painting is a pastiche of the public image of Monroe as propagated by the mass media. He even imitates the sloppy, gritty look and feel of color newspaper reproductions of the period, for the four process colors of printing were often misregistered, that is, they did not align properly with the image. The Marilyn we are looking at is the impersonal celebrity of the media, supposedly glamorous with her lush red lipstick and bright blond hair but instead appearing pathetically tacky because of the garish color (blond hair becomes bright yellow) and grimy black ink. Her personality is impenetrable, reduced to a public smile. The painting was prompted, in part, by Monroe's recent suicide. The real Marilyn suffered from depression, despite her glamorous image. Warhol has brilliantly expressed the indifference of the mass media that glorifies celebrities by saturating a celebrity-thirsty public with their likenesses, but tells

us nothing meaningful about them and shows no concern for them. Marilyn Monroe's image is about promoting a product, much as the jazzy packaging of Brillo soap pads or Campbell's soup cans is designed to sell a product without telling us anything about the product itself. The packaging is just camouflage. Warhol floats Marilyn's face in a sea of gold paint, imitating icons of Christ and the Virgin Mary that traditionally surround these religious figures in a spiritual aura of golden, heavenly light (fig. I.3). But Warhol's revered Marilyn is sadly dwarfed in her celestial gold, adding to the poignancy of this powerful portrait, which so trenchantly comments on the enormous gulf between public image and private reality.

As we examine the circumstances in which *Mrs. Joseph Scott* and *Gold Marilyn Monroe* were created, we begin to understand how important context is to the look and meaning of works of art, and therefore, to the stories they tell. Although Copley and Warhol shared the context of being American artists, they worked in very different times, with diverse materials and techniques, and for a different type of clientele, all of which tremendously affected the look and meaning of their portraits. Because their art, like all art, served a purpose, it was impossible for either of them to make a work that did not represent a point of view and tell a story, sometimes many stories. Like great works of literature or music, memorable works of art tell powerful stories whose meanings become clearer when we explore the layers of context in which the works were made.

Many factors determine the style and meaning of a work of art and contribute to its powerful presence. For centuries, art created with a political or religious agenda had been used by the state and the church to promote an image of superiority and authority. Ancient Egyptian rulers understood art's power and used it to project their own, sometimes clothing their power in benevolence. Monumental stone sculptures typically depicted Egyptian kings and queens with one hand open for mercy, the other closed in a fist (seen in profile in fig. I.4). Religious images, such as Raphael's *Alba Madonna* (see fig. I.5), expressed the idealized, perfected state of existence that its pious patron

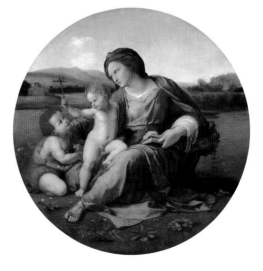

I.5. Raphael. *Alba Madonna.* ca. 1510. Oil on panel, diameter 37¼″ (94 cm). National Gallery of Art, Washington, DC. Andrew Mellon Collection

1.6. The Great Sphinx, Giza. ca 2570–2544 BCE. Sandstone, height 65′ (19.81 m)

1.7. Grant Wood. *American Gothic.* 1930. Oil on board, 24⅞ × 24¾″ (74.3 × 62.4 cm). The Art Institute of Chicago, Friends of American Art Collection. Art © Grant Wood/Licensed by VAGA, New York

believed was attainable through Catholicism. Art meant for domestic settings, such as many landscape paintings or still lifes of fruit, dead game, or flowers, also carry many messages. Such images are far from simple attempts to capture the splendor and many moods of nature or to show off the painter's finesse at creating a convincing illusionistic image. The carefully rendered natural and man-made objects in Clara Peeters's *Still-Life of Fruit and Flowers* (fig. 20.11) remind a viewer of the pleasures of the senses, but also of their fleeting nature.

Art also has the power to evoke entire historical periods. Images of the pyramids and the Great Sphinx (fig. **I.6**), for example, conjure up the grandeur we associate with ancient Egyptian civilization. Similarly, Grant Wood's famous 1930 painting *American Gothic* (fig. **I.7**) reinforces the perception that humorless, austere, hardworking farmers populated the American Midwest at that time. In the context of popular mythology, the painting has virtually become an emblem of rural America.

Changing Contexts, Changing Meanings

American Gothic has also become a source of much sarcastic humor for later generations, which have adapted the famous pitchfork-bearing farmer and his sour-faced daughter for all kinds of agendas unrelated to the artist's message. Works of art are often appropriated by a viewer to serve in contexts that are quite different from those initially intended, and, as a result, the meanings of such works change radically. The reaction of some New Yorkers to *The Holy Virgin Mary* (fig. **I.8**) by Chris Ofili reflects the power of art to provoke and spark debate, even outrage. The work appeared in an exhibition titled *Sensation: Young British Artists from the Saatchi Collection,* presented at the Brooklyn Museum in late 1999. Ofili, who is British of African descent, made an enormous picture depicting a black Virgin Mary. He used dots of paint, glitter, map pins, and images of genitalia taken from popular magazines to suggest fertility. In African traditions, many representations of females are about fertility. In his painting, Ofili blended an African theme with Christian imagery, inadvertently offending many Westerners unfamiliar with the artist's cultural heritage. Instead of hanging on the wall, this enormous painting rested on two large wads of elephant dung, an arrangement that the artist had used many times for his large canvases since 1991. Elephant dung is held sacred in Zimbabwe, and for Ofili, a devout Catholic, the picture was about the elemental sacredness of the Virgin.

Many art historians, critics, and other viewers found the picture remarkably beautiful—glittering and shimmering with a delicate, ephemeral otherworldly aura. Many Catholic viewers, however, were repulsed by Ofili's homage to the Virgin with its so-called pornographic details. Instead of viewing the work through Ofili's eyes, they placed the painting within the context of their own experience and beliefs. Consequently, they interpreted the depiction of the dung and genitalia (and probably even a black Virgin, although this was never mentioned) as sacrilegious. Within days of the opening of the exhibition, the painting had to be put behind a large Plexiglas barrier. One artist hurled horse manure at the facade of the Brooklyn Museum, claiming "I

I.8. Chris Ofili. *The Holy Virgin Mary.* 1996. Paper collage, oil paint, glitter, polyester resin, map pins, and elephant dung on linen, 7′11″ × 5′11⅞″ (2.44 × 1.83 m). The Saatchi Gallery, London. © Chris Ofili

was expressing myself creatively"; another museum visitor sneaked behind the Plexiglas barrier and smeared the Virgin with white paint in order to hide her. But the greatest attack came from New York's Mayor Rudolph Giuliani, a Catholic, who was so outraged he tried to eliminate city funding for the museum. Ultimately, he failed, but only after a lengthy lawsuit by the museum. The public outrage at Ofili's work is one episode in a long tradition that probably goes back to the beginning of image making. Throughout history, art has often provoked outrage, just as it has inspired pride, admiration, love, and respect. The reason is simple. Art is never an empty container; rather, it is a vessel loaded with meaning, subject to multiple interpretations, and always representing someone's point of view.

Social Context and Women Artists

Because the context for looking at art constantly changes, as society changes, our interpretations and insights into art and entire periods evolve as well. For example, when the first edition of this book was published in 1962, women artists were not included, which was typical for textbooks of the time. America, like most of the world, was male-dominated, and history focused on men. Women of that era were expected to be wives and mothers. If they worked, it was to add to the family's income. They were not supposed to become artists, and the few known exceptions were not taken seriously by historians, who were mostly male. The femi-

nist movement, beginning in the mid 1960s, overturned this restrictive perception of women's roles. As a result, in the last 40 years, art historians—many of them women—have "rediscovered" countless women artists. Many of these women were outstanding artists, held in high esteem during their lifetimes, despite having to struggle to overcome powerful social and even family resistance against women becoming professional artists.

One of these rediscovered women artists is the seventeenth-century Dutch painter Judith Leyster, a follower, if not a student, of Frans Hals. Over the centuries, all of Leyster's paintings were attributed to other artists, including Hals and Gerrit van Honthorst. Or the paintings were labeled "artist unknown." At the end of the nineteenth century, however, Leyster was rediscovered through an analysis of her signature, documents, and style, and her paintings were gradually restored to her name. It was only with the feminist movement that she was elevated from a minor figure to one of the more accomplished painters of her generation, one important enough to be included in the history of art. The feminist movement inspired a new context for evaluating art, one that had an interest in celebrating rather than denying women's achievements, and which was concerned with studying issues relating to gender and how women are portrayed in the arts.

A work like Leyster's *Self-Portrait* (fig. I.9), from about 1633, is especially fascinating from this point of view. Because of its size and date, this may have been the painting the artist submitted as her presentation piece for admission into the local painters' guild, the Guild of St. Luke of Haarlem. Women were not encouraged to join the guild, which was a male preserve reinforcing the professional status of men. Nor did women artists generally take

I.9. Judith Leyster. *Self-Portrait.* ca. 1633. Oil on canvas, 29⅜″ × 25⅝″ National Gallery of Art, Washington, DC. (72.3 × 65.3 cm). Gift of Mr. and Mrs. Robert Woods Bliss

on students. Leyster bucked both restrictive traditions as she carved out a career for herself in a man's world. In her self-portrait, she presents herself as an artist, armed with many brushes, suggesting her deft control of the medium, which the presentation picture itself was meant to demonstrate. On the easel is a painting that is a segment of a genre scene (a glimpse of daily life), the type of painting for which she is best known. We must remember that at this time, artists rarely showed themselves working at their easels, toiling with their hands. They wanted to separate themselves from mere artisans and laborers, presenting themselves as belonging to a higher class. As a woman defying male expectations, however, Leyster needed to clearly declare that she was indeed an artist. So she cleverly elevates her status by not dressing as an artist would when painting. Instead, she appears, as her patrons do in their portraits, well dressed and well off. Her mouth is open, in what is called a "speaking likeness" portrait, giving her a casual but self-assured animated quality, as she appears to converse on equal terms with a visitor or viewer. Leyster, along with Artemisia Gentileschi and Elizabeth Vigée-Lebrun, who also appear in this book, was included in a major 1976 exhibition entitled *Women Artists 1550–1950,* which was presented in Los Angeles and Brooklyn, New York, and which played a major role in establishing the importance of women artists.

RECOGNIZING ART

Earlier generations of art historians focused almost entirely on three art forms: sculpture, architecture, and painting, together called the "fine arts." Yet recently, as artists have expanded the materials from which they make art, art historians study a wider variety of media used to express ideas. If we attempt to define art, we realize that it is not simply about a physical form. What we can see or touch in a work of art is only part of the story. The first chapter of this book discusses remarkable prehistoric paintings covering the walls of caves in Spain and France, some dating to ca. 30,000 BCE. The *Hall of the Bulls* (fig. **I.10**) appears on a wall in Lascaux Cave in the Dordogne region of France, and dates from ca. 16,000 BCE. Although we believe these works served some type of function for the people who made them, the animals they so naturalistically depicted on the walls of their caves were produced before the advent of writing, and we have no idea whether people at the time also thought of these expertly painted forms as we do—as works of art. Did they even have a concept of "art": a special category of communication in which the image played a role other than that of a simple everyday sign, such as a hiker's mark for danger carved on a tree?

In addition to its physical form, then, the question "How do we recognize art?" also depends on how we know something is art—either as an abstract idea or through our senses. The theory that art is also an intellectual product is a very old notion in Western culture. When the Italian Renaissance artist Michelangelo was carving the *David* (see fig. 16.13), he believed his role as sculptor was to use his artistic ability to "release" the form hidden within the block of marble he was working on. And the twentieth-

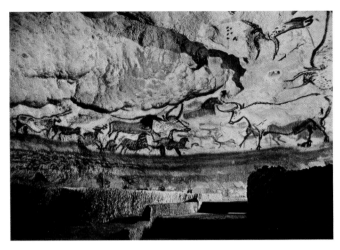

I.10. *Hall of the Bulls,* ca. 15,000–10,000 BCE. Lascaux, Dordogne, France

century Spanish Surrealist painter Salvador Dali once mischievously remarked that the ideas for his dreamlike paintings (see fig. 28.18) traveled down from the surrounding atmosphere through his generous handlebar moustache. Even those of us who know very little about art and its history have ideas about what art is simply because we have absorbed them through our culture. In 1919, the humorous and brilliant Parisian Marcel Duchamp took a roughly 8 by 4-inch reproduction of Leonardo da Vinci's *Mona Lisa* in the Louvre Museum in Paris and drew a mustache on the sitter's face (fig. **I.11**). Below he wrote the letters *L.H.O.O.Q.,* which when pronounced in French is *elle a chaud au cul,* which translates, "She has hot pants." With this phrase, Duchamp was poking fun at the public's fascination with the mysterious smile on the Mona Lisa, which began to intrigue everyone in the nineteenth century and had, in Duchamp's time, eluded suitable explanation. Duchamp irreverently suggests that her sexual identity is ambiguous and that she is sexually aroused. With the childish gesture of affixing a moustache to the Mona Lisa, Duchamp also attacked bourgeois reverence for Old Master painting and the notion that oil painting represented the pinnacle of art.

Art, Duchamp is saying, can be made by merely placing ink on a mass-produced reproduction. It is not strictly oil on canvas or cast bronze or chiseled marble sculpture. Artists can use any imaginable media in any way in order to express themselves. He is announcing that art is about ideas that are communicated visually, and not necessarily about the materials it is made from or how closely it corresponds to current tastes. In this deceivingly whimsical work, which is rich with ideas, Duchamp is telling us that art is anything that someone wants to call art, which is not the same as saying it is good art. Furthermore, he is proclaiming that art can be small; *L.H.O.O.Q.* is a fraction of the size of its source, the *Mona Lisa.* By appropriating Leonardo's famous picture and interpreting it very differently from traditional readings, Duchamp suggests that the answer to the question "How do we recognize art?" is not fixed forever, that it can change and be assigned by artists, viewers, writers, collectors, and museum curators, who use it for their own purposes. Lastly, and this is certainly one of Duchamp's many wonderful contributions to art, he is telling us that art can be fun; it can defy conventional

1.11. Marcel Duchamp. *Mona Lisa (L.H.O.O.Q.).* (1919) Rectified readymade; pencil on a reproduction. 7 × 4⅞″ (17.8 × 12 cm). Private collection. © Artists Rights Society (ARS), New York/ADAGP, Paris/Succession Marcel Duchamp

notions of beauty, and while intellectually engaging us in a most serious manner, it can also provide us with a smile, if not a good laugh.

Art and Aesthetics: Changing Ideas of Beauty

One of the reasons that Duchamp selected the *Mona Lisa* for "vandalizing" had to be that many people considered it the most beautiful painting ever made. Certainly, it was one of the most famous paintings in the world, if not the most famous. In 1919, most people who held such a view had probably never seen it and only knew it from reproductions, probably no better than the one Duchamp used in *L.H.O.O.Q.!* And yet, they would describe the original painting as beautiful, but not Duchamp's comical version. Duchamp called such altered found objects as *L.H.O.O.Q.* "assisted readymades" (for another example, see *The Fountain,* fig. 28.2). He was adamant when he claimed that these works had no aesthetic value whatsoever. They were not to be considered beautiful, and they were selected because they were

aesthetically neutral. What interested Duchamp were the ideas that these objects embodied once they were declared art.

L.H.O.O.Q. and the question of its beauty raises the issue of *aesthetics,* which is the study of beauty, its origins and its meanings, principally by philosophers. In the West, an interest in aesthetic concepts dates back to ancient Greece. The Greeks' aesthetic theories reflected ideas and tendencies of their culture. In calling a sculpture such as the *Kritios Boy* beautiful (fig. **I.12**), the Greeks meant that the statue reflected what was generally agreed to be an embodiment of the morally good or perfect: a well-proportioned young male. Even more, this idealized form, both good and beautiful, was thought to inspire positive emotions that would reinforce the character of the good citizen who admired it—an important function in the frequently turbulent city-states.

In the modern world, art historians, as well as artists, are also influenced by a variety of aesthetic theories that ultimately mirror contemporary interests about the direction of society and culture. As our world has come to appear less stable and more fragmented, aesthetic theories about what is true, good, or beautiful also have come to stress the relative nature of aesthetic concepts rather than seeing them as eternal and unchangeable. Many art historians now argue that a work of art can hold up under several, often conflicting interpretations of beauty or other aesthetic

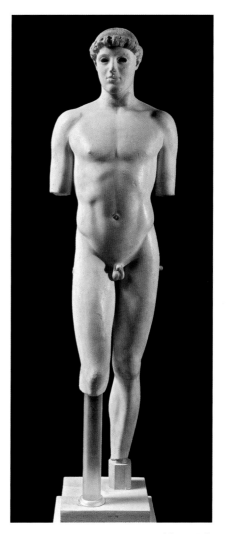

1.12. *Kritios Boy.* ca. 480 BCE. Marble. Height 46″ (116.7 cm). Akropolis Museum, Athens

concepts, if those interpretations can be reasonably defended. Thus, despite his claim, Duchamp's assisted readymades can be perceived as beautiful, in ways, of course, that are quite different from those of Leonardo's *Mona Lisa*. The beauty in Duchamp's works derives from their appeal to the intellect; if we understand his messages, his objects appear clever and witty, even profound. His wit and insights about art transformed a slightly altered cheap black-and-white reproduction into a compelling work of art, in a way that is very different from Leonardo's. The qualities that attract us to the *L.H.O.O.Q.*—its cleverness and wit—differ sharply from the skills and values that are inherent in Leonardo's *Mona Lisa*. The intriguing ideas and wit that surround the *L.H.O.O.Q.* place it above a mere youthful prank, and point to a new way of looking at art. Duchamp's innovative rethinking of the nature of art has had a profound effect on artists and aesthetic theory ever since it was made. Our appreciation of Robert Rauschenberg's *Odalisk* (fig. 29.10), created in the late 1950s out of a combination of found materials, including a pillow and a stuffed chicken, and playfully pasted with discarded materials full of sexual allusion, is unthinkable without Duchamp's work.

Quality: In the Mind or the Hand?

Terms like quality and originality are often used in discussing works of art, especially in choosing which works to include or exclude in a book like this. What is meant by these terms, however, varies from critic to critic. For example, in the long history of art, technical finesse or craft has often been viewed as the most important feature to consider in assessing quality. To debunk the myth that quality is all about technique and to begin to get at what it is about, we return to Warhol's *Gold Marilyn Monroe*. The painting is rich with stories: We can talk about how it raises issues about the meaning of art or the importance of celebrity, for example. But Warhol begs the question of the significance of technical finesse in art making, an issue raised by the fact that he may not have even touched this painting himself! We have already seen how he appropriated someone else's photograph of Marilyn Monroe, not even taking his own. Warhol then instructed his assistants to make the screens for the printing process. They also prepared the canvas, screened the image with the colors Warhol selected, and most likely painted the gold to Warhol's specifications, although we do not know this for sure.

By using assistants to make his work, Warhol is telling us that quality is not about the artist's technical finesse or even the artist's physical involvement in making the work, but about how well the artist communicates an idea using visual language. One measure of quality in art is the quality of the statement being made, or its philosophy, as well as the quality of the technical means for making the statement. Looking at *Gold Marilyn Monroe* in the flesh at New York's Museum of Modern Art is a powerful experience. Standing in front of this 6-foot-high canvas, we cannot help but feel the empty glory of America's most famous symbol of female sexuality and stardom. Because the artist's vision, and not his touch, is the relevant issue for the making of this particular work, it is of no consequence that Warhol most likely never laid a hand to the canvas, except to sign the back. We will short-

ly see, however, that the artist's touch has often been seen as critical to the perception of originality in a work of art.

Warhol openly declared that his art was not about his technical ability when he called his Manhattan studio "The Factory." He was telling us that art is a commodity, and that he is manufacturing a product, even mass producing his product. The Factory churned out over a thousand, if not thousands, of paintings and prints of Marilyn Monroe, all based on the same newspaper photograph. All Warhol did, for the most part, was sign them, his signature reinforcing the importance many people place on the signature itself as being an essential part of the work. Ironically, most Old Master paintings, dating from the fourteenth through the eighteenth centuries, are not signed, and in fact, artists for centuries used assistants to help make their pictures.

Peter Paul Rubens, an Antwerp painter working in the first half of the seventeenth century and one of the most famous artists of his day, had an enormous workshop that cranked out many of his pictures, especially the large works. His assistants were often artists specializing in flowers, animals, or clothing, for example, and many went on to become successful artists in their own right. Rubens would design the painting, and then assistants, trained in his style, would execute their individual parts. Rubens would come in at the end and finish the painting as needed. The price the client was willing to pay often determined how much Rubens himself participated in the actual painting of the picture; many of his works were indeed made entirely by him. Rubens's brilliant flashy brushwork was in many respects critical to the making of

1.13. Pablo Picasso. Detail of *Guernica*. 1937. Oil on canvas, 11′6″ × 25′8″ (3.51 × 7.82 m). Museo Nacional Centro de Arte Reina Sofia, Madrid. On permanent loan from the Museo del Prado, Madrid. © Estate of Pablo Picasso/Artists Rights Society (ARS), New York

the picture. Not only was his handling of paint considered superior to that of his assistants, the very identity of his paintings, their very life so to speak, was linked to his personal way of applying paint to canvas, almost as much as it was to his dramatic compositions. For his buyers, Rubens's brushwork complemented his subject matter, even reinforced it. Despite the collaborative nature of their production, the artworks made in Rubens's workshop were often striking combinations of the ideas and the powerful visual forms used to communicate them. In that combination lies their originality.

Concepts like beauty, quality, and originality, then, do not refer only to physical objects like pretty, colorful pictures or a perfectly formed marble figure. They are ideas that reside in content and in the perception of how successfully the content is communicated visually. Some of the most famous and most memorable paintings in the history of art depict horrific scenes, such as beheadings (see fig. 19.5), crucifixions (see fig. 18.13), death and despair (see figs. 24.18 and 24.20), emotional distress (see fig. 29.9), and the brutal massacre of innocent women and children (fig. I.13)). Duchamp's *L.H.O.O.Q.* and Warhol's *Gold Marilyn Monroe* are powerful and riveting. Some would even argue that their complex ideas and unexpected presentations make these works beautiful.

Photography as Art

The first edition of this book did not include photography among the media discussed. Now, four decades later, the artistic merit of photography seems self-evident. When photography was invented in 1839, the art world largely dismissed it as a mechanical process that objectively recorded reality. It was seen as a magical way to capture the detailed likenesses of people and objects without undergoing long artistic training. And, although some artists were intrigued by the often accidental and impersonal quality of the images it produced, the new medium was perceived by many critics as not having sufficient aesthetic merit to be seen in the lofty company of the major forms of fine art—painting and sculpture. Anyone, it seemed, could take a photograph. George Eastman's invention of the hand-held Kodak camera in 1888, allowed photography to become every man's and woman's pastime.

Photography has struggled for a long time to shed its popular, mechanical stigma. In the 1890s, some photographers, like Gertrude Käsebier, attempted to deny the hard, mechanical look of their art by making their prints appear soft, delicate, and fluid (see fig. 26.46). But at the beginning of the twentieth century, Paul Strand and others began to embrace black-and-white photography's hard-edge detail and the abstract results made possible by creative cropping. His *Wire Wheel* of 1917 (fig. 28.43) celebrates the machine age as well as the newest movements in the media of painting and sculpture. By the 1940s, black-and-white photography had gained some status as an art form, but it was not until the 1960s, when photography became an important part of the art school curriculum, that black-and-white photography began to take its place as one of the major art forms. It has taken color photography even longer to achieve serious consideration. But now,

along with video and film, both black-and-white and color photography have been elevated to an important medium. Pictures from the nineteenth and twentieth centuries that once had interested only a handful of photography insiders are intensely sought after, with many museums rushing to establish photography departments and amass significant collections. In other words, it has taken well over 100 years for people to get beyond their prejudice against a mechanical process and develop an eye for the special possibilities and beauty of the medium.

We need only look at a 1972 photograph entitled *Albuquerque* (fig. **I.14**) by Lee Friedlander to see how photography may compete with painting and sculpture in artistic merit. In *Albuquerque,* Friedlander portrays a modern America that is vacuous and lifeless, which he suggests is due to technology. How does he do this? The picture has a haunting emptiness. It has no people, and it is filled with strange empty spaces of walkway and street that appear between the numerous objects that pop up everywhere. A hard, eerie geometry prevails, as seen in the strong verticals of the poles, buildings, hydrant, and wall. Cylinders, rectangles, and circles are everywhere. (Notice the many different rectangles on the background building, or the rectangles of the pavement bricks and the foreground wall.)

Despite the stillness and emptiness, the picture is busy and restless. The vertical poles and the strong vertical elements on the house and building establish a vibrant staccato rhythm. The energy of this rhythm is reinforced by the asymmetrical composition that has no focus or center, as well as by the powerful intersecting diagonals of the street and the foreground wall. (Note how the shadow of the fire hydrant runs parallel to the street.) Disturbing features appear throughout the composition. The street sign—which cannot be seen because it is cropped at the top of the print—casts a mysterious shadow on the wall. A pole visually cuts the dog in two, and the dog has been separated from his attribute, the fire hydrant, as well as from his absent owner. The fire hydrant, in turn, appears to be mounted incorrectly, because it sticks too far out of the ground. The car on the right has been brutally cropped, and a light pole seems to sprout strangely from its hood. The telephone pole in the center of the composition is

I.14. Lee Friedlander. *Albuquerque.* 1972. Gelatin silver print, 11 × 14″. © Lee Friedlander

crooked, as though it has been tilted by the force of the cropped car entering from outside the edge of the picture (of course, the car is parked and not moving). Why do we assume this empty, frenetic quality is human-made? Because the work is dominated by the human-made and by technology. We see telephone poles, electrical wires, crosswalk signs, an ugly machinelike modular apartment building, sleek automobiles, and a fire hydrant. Cropped in the lower left foreground is the steel cover to underground electrical wiring.

Everywhere, nature has been cemented over, and besides a few scraggly trees in the middle ground and distance, only the weeds surrounding the hydrant thrive. In this brilliant print, Friedlander captures his view of the essence of modern America: the way in which technology, a love of the artificial, and a fast, fragmented lifestyle have spawned alienation and a disconnection with nature and spirituality. As important, he is telling us that modernization is making America homogeneous. The title tells us we are in Albuquerque, New Mexico, but without the title, we are otherwise in Anywhere, U.S.A.

Friedlander did not just find this composition. He very carefully selected it and he very carefully made it. He not only needed the sun, he had to wait until it was in the right position (otherwise, the shadow of the fire hydrant would not align with the street). When framing the composition, he very meticulously incorporated a fragment of the utility cover in the left lower foreground, while axing a portion of the car on the right. Nor did the geometry of the picture just happen; he made it happen. Instead of a soft focus that would create an atmospheric blurry picture, he has used a deep focus that produces a sharp crisp image filled with detail, allowing, for example, the individual rectangular bricks in the pavement to be clearly seen. The strong white tones of the vertical rectangles of the apartment building, the foreground wall, and the utility box blocking the car on the left edge of the picture were probably carefully worked up in the darkroom, as was the rectangular columned doorway on the house. Friedlander has exposed the ugliness of modern America in this hard, cold, dry image, and because of the power of its message he has produced an extraordinarily beautiful work of art.

Architecture as Art

Architecture, although basically abstract and dedicated to structuring space in a functional way, can also be a powerful communicator of ideas. For example, we see Gianlorenzo Bernini expressing complex ideas in 1656 when he was asked by Pope Alexander XVII to design a large open space, or piazza, in front of St. Peter's cathedral in Rome. Bernini obliged, creating a space that was defined by a row of columns (a colonnade) resembling arms that appear to embrace visitors, offering comfort (fig. **I.15**) and encouraging worshipers to enter the building. Bernini's design made the building seem to welcome all visitors into a universal (Catholic) church. At about the same time, the French architect Claude Perrault was commissioned to design the East facade of Louis XIV's palace, the Louvre in Paris (fig. **I.16**). The ground floor, where the day-to-day business of the court was carried out, was designed as a squat podium. The second floor,

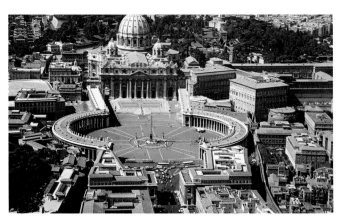

I.15. St. Peter's, Rome. Nave and facade by Carlo Maderno, 1607–1615; colonnade by Gianlorenzo Bernini, designed 1657

where Louis lived, was much higher and served as the main floor, proclaiming Louis's grandeur. Perrault articulated this elevated second story with a design that recalled Roman temples, thus associating Louis XIV with imperial Rome and worldly power. The controlled symmetry of the design further expresses Louis's control over his court and nation.

In the modern era, an enormously wealthy businessman, Solomon R. Guggenheim, indulged his passion for modern art by commissioning architect Frank Lloyd Wright to design a museum in New York City. One of the boldest architectural statements of the mid-twentieth century, Wright's Solomon R. Guggenheim Museum is located on upper Fifth Avenue, overlooking Central Park (fig. **I.17**). The building, erected from 1956 to 1959, is radically different from the surrounding residential housing, thus immediately declaring that its function is different from theirs. Indeed, the building is radically different from most anything built up until that time. We can say that the exterior announces that it is a museum, because it looks as much like a gigantic sculpture as a functional structure.

Wright conceived the Guggenheim in 1945 to create an organic structure that deviated from the conventional static rectangular box filled with conventional static rectangular rooms. Beginning in the early twentieth century, Wright designed houses that related to the landscape and nature, both in structure and material (fig. 26.42). The structure of his buildings, whether domestic or commercial, reflects the very structure of nature, which he saw as a continuous expansion. His buildings radiate out from a central core or wrap around a central void, but in

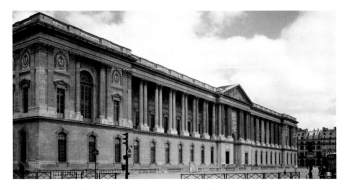

I.16. Louis Le Vau, Claude Perrault, and Charles Le Brun. East front of the Louvre, Paris. 1667–1670

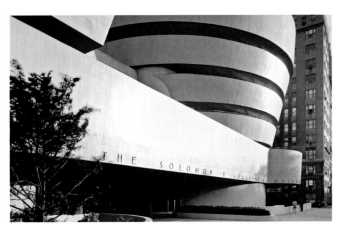

1.17. Frank Lloyd Wright. The Solomon R. Guggenheim Museum, New York. 1956–1959. David Heald © The Solomon Guggenheim Foundation, New York. © Frank Lloyd Wright Foundation, Scottsdale, AZ/Artists Rights Society (ARS), New York

1.18. Frank Lloyd Wright. Interior of the Solomon R. Guggenheim Museum, New York. 1956–59. Robert Mates © The Solomon Guggenheim R. Foundation, New York. © Frank Lloyd Wright Foundation, Scottsdale, AZ/Artists Rights Society (ARS), New York

either case, they are meant to expand or grow like a leaf or crystal, with one form opening up into another.

The Guggenheim is based on a natural form. It is designed around a spiral ramp (fig. **I.18**), which is meant to evoke a spiral shell. The structure also recalls a ceramic vase. It is closed at the bottom and open at the top, and as it rises it widens, until it is capped by a light-filled glass roof. When referring to the Guggenheim, Wright often cited an old Chinese aphorism, "The reality of the vase is the space inside." For the most part, the exhibition space is one enormous room formed by the spiral viewing ramp. Wright wanted visitors to take the elevator to the top of the ramp, and then slowly amble down its 3 percent grade, gently pulled by gravity. Because the ramp was relatively narrow, viewers could not get too far back from the works of art and were forced to have an intimate relationship with the objects. At the same time, they could look back across the open space of the room to see where they had been, comparing the work in front of them to a segment of the exhibition presented on a sweeping distant arc. Or they could look ahead as well, to get a preview of where they were going. The building has a sense of continuity and mobility that Wright viewed as an organic experience. Looking down from the upper reaches of the ramp, we can see the undulation of the concave and convex forms that reflect the subtle eternal movement of nature. Wright even placed a pool on the ground floor, facing the light entering from the skylight high above. Regardless of their size, no other museum has succeeded in creating a sense of open space and continuous movement as Wright did in the Guggenheim. Nor does any other museum have the same sense of communal spirit; at the Guggenheim everyone is united in one big room (see fig. I.18).

EXPERIENCING ART

This book offers you an introduction to many works of art, and provides reproductions of most of them. Yet your knowledge of the objects will be enlarged when you see the works firsthand. No matter how accurate the reproductions in this book—or any other—are, they are just stand-ins for the actual objects. We hope you will visit some of the museums where the originals are displayed. But keep in mind that looking at art, absorbing its full impact takes time and repeated visits. Occasionally, you might do an in-depth reading of an individual work. This would involve carefully perusing details and questioning why they are there. Ideally, the museum will help you understand the art. Often, there are introductory text panels that tell you why the art in a particular exhibition or gallery has been presented together, and there are often labels for individual works that provide further information. Major temporary exhibitions generally have a catalogue, which adds yet another layer of information and interpretation. But text panels, labels, and catalogues generally reflect one person's reading of the work, and there are usually many other ways to approach or think about it.

Although the museum is an effective way to look at art and certainly the most efficient, art museums are relatively new. Indeed, before the nineteenth century, art was not made to be viewed in museums, but in homes, churches, or government buildings. Today we find works of art in galleries, corporate lobbies and offices, places of worship, and private homes. You may find art in public spaces, from subway stations and bus stops to plazas, from libraries and performing art centers to city halls. University and college buildings are often filled with art, and the buildings themselves are art. The chair you are sitting in and the building where you are reading this book are also works of art, maybe not great art, but art all the same, as Duchamp taught us. Even the clothes you are wearing are art. Wherever you find art, it is telling you something and making a statement.

Art is not a luxury, as many people would have us believe, but an integral part of daily life. It has a major impact on us, even when we are not aware of it; we feel better about ourselves when we are in environments that are visually enriching and exciting. Most important, art stimulates us to think. Even when it provokes and outrages us, it broadens our experience by making us question our values, attitudes, and worldview. This book is an introduction to this fascinating field that is so intertwined with our lives. After reading it, you will find that the world will not look the same.

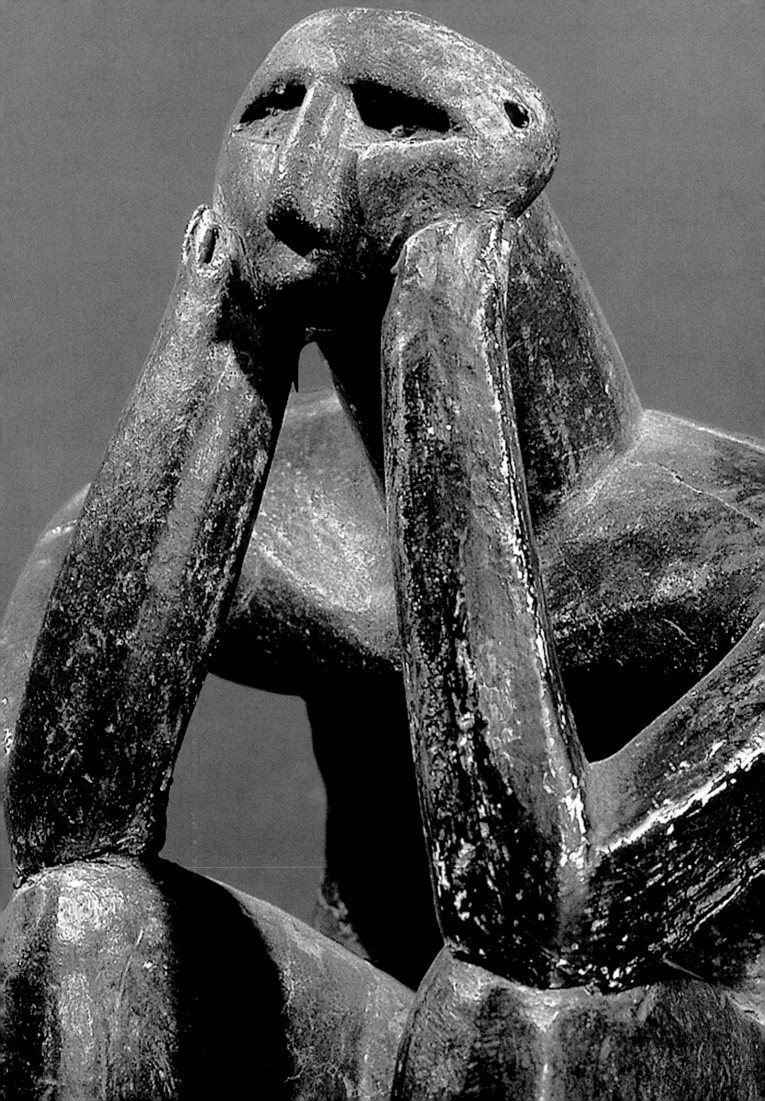

Prehistoric Art

WHEN MODERN HUMANS FIRST ENCOUNTERED PREHISTORIC CAVE paintings in the 1870s, they literally could not believe their eyes. Although the evidence indicated that the site at Altamira in Spain dated to around 13,000 BCE, the paintings had been executed with such skill and sensitivity that historians initially considered them forgeries

(see fig 1.1). Since then, some 200 similar sites have been discovered all over the world. As recently as 1994, the discovery of a painted cave in southeastern France (see fig. 1.2) brought hundreds more paintings to light and pushed back the date of prehistoric painting even further, to approximately 30,000 BCE. Some carved objects have been discovered that are equally old.

These oldest forms of art raise more questions than they answer: Why did prehistoric humans expend the time and energy to make art? What functions did these visual representations serve? What do the images mean? A twenty-first–century viewer of prehistoric art may admire the vitality and directness of these works, yet still find it difficult to understand this ancient and alien world. For this prehistoric era there are no texts for historians to consult, so the tools of science and anthropology have contributed to the art historian's attempt to interpret these powerful forms of art, providing evidence for the dates of prehistoric objects and theories for their functions. With new finds being reported with regularity, the study of prehistoric art continues to develop and refine its interpretations and conclusions.

Though fully modern humans have lived on the earth for over 100,000 years, the dates assigned to the earliest objects classed as "art" go back about 40,000 years. Earlier humans had

crafted tools out of stone and fragments of bone, but what inspired them to make detailed representations of forms found in nature? Some scholars suppose that image making and symbolic language as we know it are the result of the new structure of the brain associated with *homo sapiens sapiens*. Art emerges at about the time that fully modern humans moved out of Africa and into Europe, Asia, and Australia, encountering—and eventually displacing—the earlier Neanderthals (*homo neanderthalensis*) of western Eurasia. On each of these continents, we have found evidence of representational artwork or of body decoration contemporary with *homo sapiens sapiens*. Tens of thousands of works survive from this time before history, the bulk of which have been discovered in Europe. Many are breathtakingly accomplished.

The skill with which the earliest datable objects are executed may have been the product of a lengthy and lost period of experimentation in the techniques of carving and painting, so the practice of art making may be much older than the surviving objects. Some scholars disagree. This group argues that a neurological mutation related to the structure of the brain opened up the capacity for abstract thought, and that symbolic language and representational art were a sudden development in human evolution. Whatever led to the ability to create art, whether a gradual evolutionary process, or a sudden mutation, it had an enormous impact on the emergence of human culture, including the making of naturalistic images. Such works force

Detail of figure 1.23, Male figure from Cernavoda

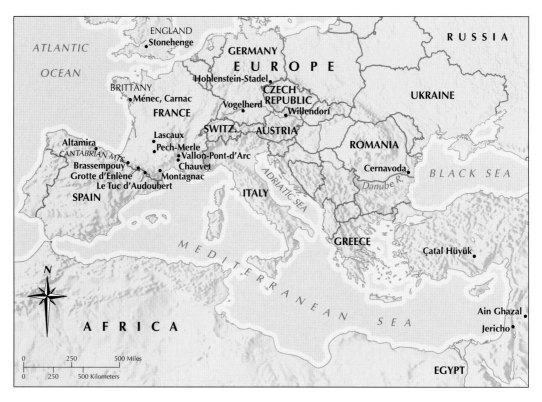

Map 1.1. Prehistoric Europe and the Near East

us to reevaluate many of our assumptions about art and the creative process, and raise fundamental questions, not least of which is why human beings make art at all.

PALEOLITHIC ART

Upper Paleolithic painting, drawing, and sculpture appeared over a wide swath of Eurasia, Africa, and Australia at roughly the same time, between 10,000 and 40,000 years ago (see map 1.1). This time span falls in the Pleistocene era, more commonly known as the Ice Age, when glaciers (the extended polar ice caps), sometimes 10,000 feet thick, covered much of northern Europe, North America, and Eurasia. The Lower and Middle Paleolithic periods extend back as far as 2 million years ago, when earlier species of the *homo genera* lived. While these cultures did make patterned stone tools, they did not make notations or representational imagery of any kind. The end of the most recent Ice Age corresponded with the movement of fully modern humans out of Africa and into Europe, newly habitable as the warming climate caused the glaciers to recede.

Prehistoric paintings were first recognized in 1878 in a cave named Altamira, in the village of Santillana del Mar in northern Spain. Accompanying her father, Count Don Marcelino Sanz de Sautuola, as he scoured the ground for flints and animal bones, 12-year-old Maria looked up to spy bison, painted in bold black outline and filled with bright earth colors (fig. **1.1**), on the ceiling of the cave. There, and in other more recently discovered caves, the painted and engraved images depict animals as the dominant subject. The greatest variety discovered so far is in the vast cave complex of Chauvet, named after one of the three spelunkers who discovered it in 1994, near Vallon-Pont-d'Arc in southeastern France. Here the 427 animal representations found to date depict 17 species, including lions, bears, and aurochs, in black or red outlines (figs. **1.2**, **1.3**), sometimes polychromatic (containing several colors) and with the use of shading. Here also can be found a finger engraving of a long-eared owl (fig. **1.4**). Marks and shapes appearing to be signs of some sort accompany the animals, or appear alone, such as those shown next to the *Chinese Horse* at Lascaux in the Dordogne region of France (fig. **1.5**). These have been interpreted as weapons or traps, or even insects. Human hands are occasionally stamped in paint on the cave walls, but are usually shown in negative silhouette (see *Materials and Techniques*, page 5). In rare instances, there are larger human or partly human forms. At Chauvet, for instance, archaeologists identified the lower half of a woman painted on a projection of rock. At Les Trois Frères, a site in the French Pyrénées, a human body with its interior muscles and anatomy depicted supports an animal head with antlers. At Lascaux, a male stick figure with a birdlike head lies between a woolly rhinoceros and a disemboweled bison, with a bird-headed stick or staff nearby (fig. **1.6**).

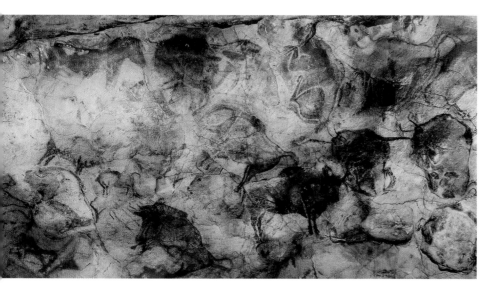

1.1. *Wounded Bison.* ca. 15,000–10,000 BCE. Altamira, Spain

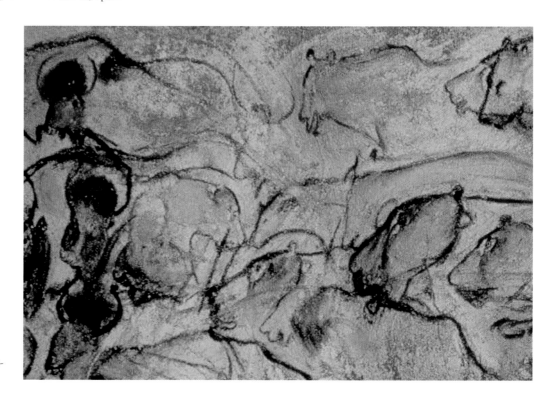

1.2. *Lions and Bison.*
End Chamber, Chauvet Cave.
ca. 30,000–28,000 BCE. Vallon-Pont-
d'Arc, Ardèche Gorge, France

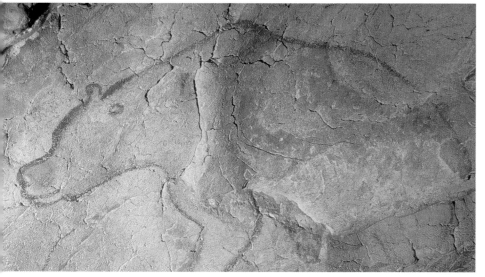

1.3. *Bear.* Recess of the Bears,
Chauvet Cave. ca. 30,000–28,000 BCE.
Vallon-Pont-d'Arc, Ardèche Gorge,
France

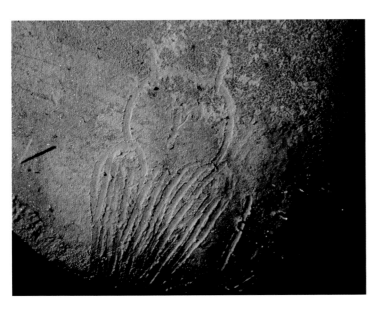

1.4. *Long-Eared Owl.* Chauvet Cave.
ca. 30,000–28,000 BCE. Vallon-Pont-d'Arc,
Ardèche Gorge, France

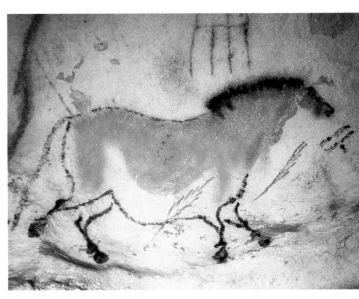

1.5. *Chinese Horse.* Lascaux Cave.
ca. 15,000–13,000 BCE. Dordogne, France

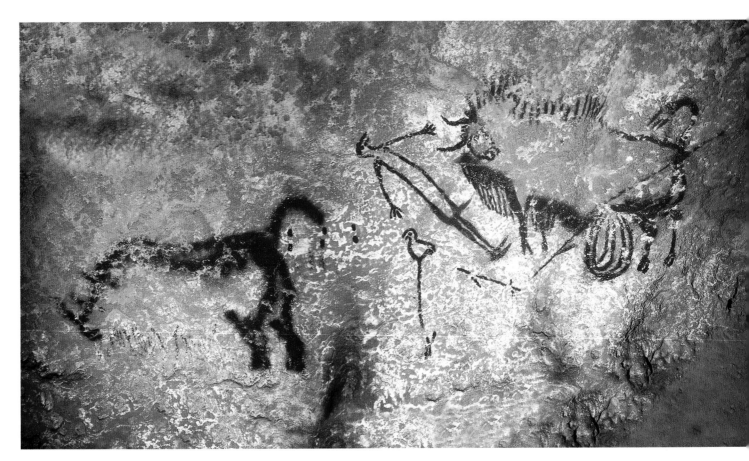

1.6. *Rhinoceros, Wounded Man, and Bison.* Lascaux Cave. ca. 15,000–13,000 BCE. Dordogne, France

Cave Painting

Artists working in Paleolithic caves used a wide variety of techniques to achieve the images that have survived. Often working far from cave entrances, they illuminated the darkness using lamps carved out of stone and filled with fat or marrow. Archaeologists have found several of these lamps at Lascaux and elsewhere. Sometimes, when the area of rock to be painted was high above ground level, they may have built scaffolds of wood, stabilized against the wall by driving the poles into the limestone surface.

They prepared the surface by scraping the limestone with stone tools, bringing out its chalky whiteness as a background. Some images were then engraved on the wall, with a finger if the limestone was soft enough, or, where it was harder, with a sharp flint. Sometimes they combined this technique with the application of color. Black was created using vegetal charcoal and perhaps charred bones. Ochre, a natural iron ore, provided a range of vivid reds, browns, and yellows. For drawing—outlines of animals, for instance—the charcoal and ochre were deployed in chunks, like a crayon; to generate paint, they ground the minerals into powder on a large flat stone. By heating them to extremely high temperatures, they could also vary the shades of red and yellow. These mineral powders could then be blown through tubes of animal bone or reed against a hand held up with fingers splayed to the rock surface to make hand silhouettes.

To fill in animal or human outlines with paint, they mixed the powders with blenders, which consisted of cave water, saliva, egg white, vegetal or animal fat, or blood; they then applied the colors to the limestone surface, using pads of moss or fur, and brushes made of fur, feather, or chewed stick. Some scholars understand, by experimentation, that pigment was often chewed up in the mouth and then blown or spit directly onto the walls to form images. In some cases, like the spotted horse of Pech-Merle or at Chauvet, paint was applied in dots, leading to what some scholars describe as a "pointilliste" effect. This was achieved by covering the palm with ochre before pressing it against the limestone.

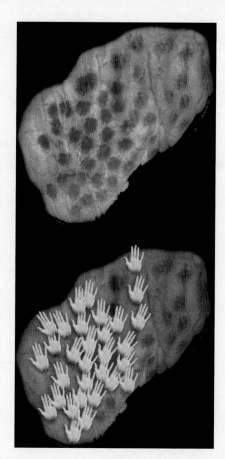

Hand Dots in the Brunel Chamber at Chauvet. Large dots were made by covering the palm with paint and applying it to the wall. In places, fingers are just visible.

Analysis of these marks has yielded rich results: Not only can individual artists be identified by their handprint, but it has even been possible to determine that women and adolescents were at work as well as men.

When they first assessed the Altamira paintings toward the end of the nineteenth century, experts declared them too advanced to be authentic and dismissed them as a hoax. Indeed, though cave art may represent the dawn of art as we know it, it is often highly sophisticated. Like their counterparts at Chauvet and elsewhere, the bison of Altamira were painted from memory, yet their forms demonstrate the painters' acute powers of observation, and an equal skill in translating memory into image. Standing at rest, or bellowing or rolling on the ground, the bison behave in these paintings as they do in the wild. The painters' careful execution enhances the appearance of nature: Subtle shading expresses the contour of a bison's belly, for instance, or a lioness's head, and the forward contour of an animal's far leg is often rendered with a lighter hue to suggest distance. Within the silhouette that defines the shape of the animal, the artist varies the effect of light on the form to suggest its weight or volume. This device, called **modeling**, makes the form look more life like.

Initially, scholars assigned relative dates to cave paintings by using a stylistic analysis, dating them according to the degree of **naturalism** they displayed, that is, how closely the image resembled the actual subject in nature. As naturalism was considered at that time the most advanced form of representation, the more naturalistic the image, the more evolved and, therefore, the more recent it was considered to be. Radiocarbon dating exposed the flaws in this approach. Judged to be more recent in the overall sequence on account of their remarkable naturalism, some of the paintings at Chauvet proved to be among the earliest on record, dating to the Aurignacian period of 32,000 years ago. Indeed, it would be a mistake to assume that naturalism was a Paleolithic artist's—or any artist's—inevitable or only goal. A consistent use of conventions in depicting individual species (bulls at Lascaux depicted in profile but with frontal horns, for instance) defies nature; these are not **optical images**, showing an animal as one would actually see it, but **composite** ones, offering many of the details that go toward making up the animal portrayed, though not necessarily in anatomically accurate positions. As the stick man at Lascaux may illustrate, artists may have judged their success by standards quite removed from naturalism.

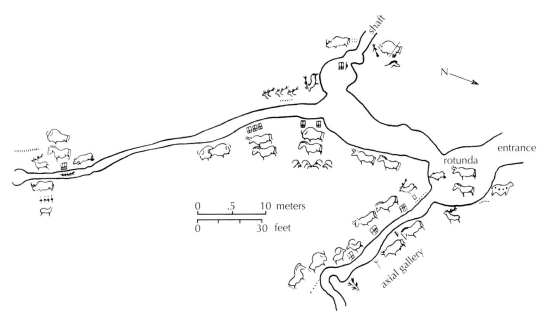

1.7. Schematic plan of Lascaux Cave system (based on a diagram by the Service de l'Architecture, Paris)

Interpreting Prehistoric Painting

As majestic as these paintings can be, they are also profoundly enigmatic: What purpose did they serve? The simplest view, that they were merely decorative—"art for art's sake"—is highly unlikely. Most of the existing paintings and engravings are readily accessible, and many more that once embellished caves that open directly to the outside have probably perished. But some, at Lascaux and elsewhere, lie deep inside extended cave systems, remote from habitation areas and difficult to reach (fig. 1.7). In these cases, the power of the image may have resided in its making, rather than in its viewing: According to some historians who have attempted to interpret these images, the act of painting or incising the image may have served some ritual or religious purpose.

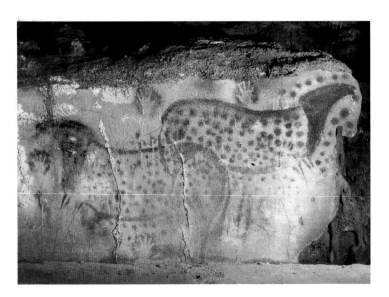

1.8. *Spotted Horses and Human Hands*. Pech-Merle Cave. Dordogne, France. Horses ca. 16,000 BCE; Hands ca. 15,000 BCE; Limestone, approximate length 11′2″ (3.4 m)

Art historians often use contemporaneous written texts to supplement their understandings of art. Prehistoric art, however, dates to a time before writing had developed. Works of art are, in fact, among our only "texts" for learning about prehistoric humans. From their initial discovery, scholars turned to approaches developed by ethnographers (anthropologists who study cultural behavior) to interpret these cave paintings and engravings. Most often, the inspiration for these works has been attributed to magico-religious motives. Thus early humans may have perceived an image as equivalent to the animal it represented, and, therefore, to create or possess the image was to exert power over what it portrayed. Image making could have been considered as a force of sympathetic magic, which might improve the success of a hunt. Gouge marks on cave walls indicate that in some cases spears were cast at the images (fig. 1.8). Similarly, artists may have hoped to stimulate fertility in the wild—ensuring a continuous food supply—by depicting pregnant animals. A magico-religious interpretation might explain the choice to make animals appear lifelike, as well as to fix them within outlines; and yet human fear of being affected by the same magic may account for the decidedly unnaturalistic, abstract quality of the "stick figure" at Lascaux.

More recent theories concerning shamanism—a belief in a parallel spirit world that can be accessed through alternative states of consciousness—have built upon these interpretations, suggesting that an animal's "spirit" was especially evident where a bulge in the wall or ceiling suggested its shape, as with the *Spotted Horses* (fig. 1.8) at Pech-Merle in southwestern France. The artist's or shaman's power merely brought that spirit to the surface. Some scholars have cast the paintings in a central role in early religion, as images for worship, while other interpretations have focused on a painting's physical context. This means examining relationships between figures to determine, in the absence of an artificial

frame, a ground-line or a landscape, whether multiple animal images indicate individual specimens or signify a herd. Such examinations attempt to determine whether these images represent a mythical truth for early communities. Do Lascaux's *Rhinoceros, Wounded Man, and Bison* (fig. 1.6) constitute separate images or the earliest known narrative, telling the gory tale of a hunt or a heroic man's death or possibly a shaman's encounter with his spirit creature? The purpose of engraving multiple animals on top of one another, as at Les Trois Frères (fig. **1.9**), may have been to record animal migrations throughout the passing seasons.

Considering physical context also means recognizing that a cave 15 feet deep and another one over a mile deep are completely different spaces, possibly used for different purposes. Similarly, physical context suggests that the paintings in the spacious Hall of the Bulls at Lascaux and the stick man at the same site, located at the bottom of a 16-foot well shaft, may have functioned quite differently. It also means factoring in the experiential aspect of caves, that is, recognizing that a prehistoric viewer had to contend with a precarious path, eerie flickering lights, echoes near and distant, and the musty smells that permeate subterranean spaces, all of which added texture to the experience of seeing these images (fig. **1.10**).

1.9. Overlapping animal engravings. ca. 40,000–10,000 BCE. Les Trois Frères, France. Rubbing of the panel done by Abbé Breuil from Begohen Collection

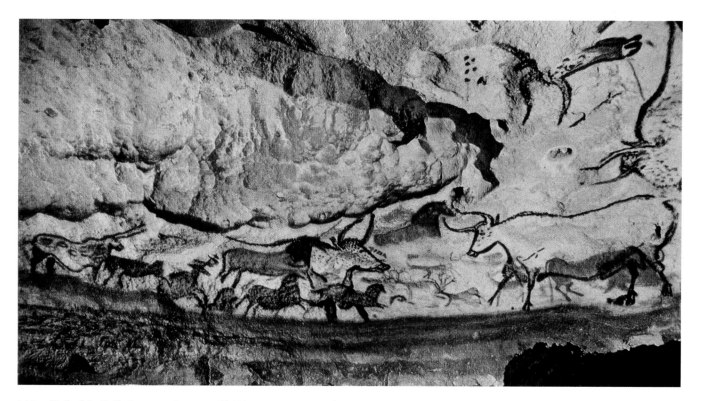

1.10. *Hall of the Bulls.* Lascaux Cave. ca. 15,000–10,000 BCE. Dordogne, France

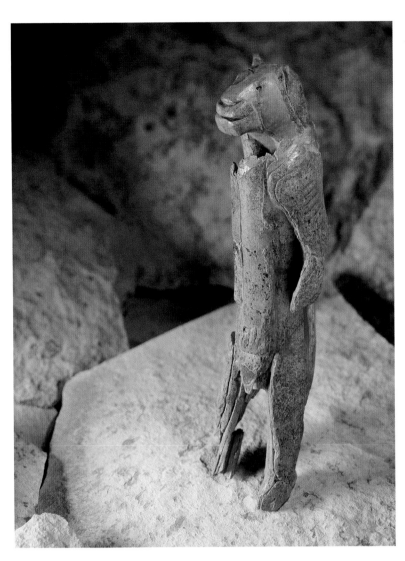

Most important, recent interpretations have acknowledged that one explanation may not suffice for all times and places. For instance, even if sympathetic magic makes some sense of the *Chinese Horse* from Lascaux with its distended belly (see fig. 1.5), it does little to explain the art at Chauvet, where fully 72 percent of the animals represented were not hunted, as far as can be discerned from the organic remains found in the cave.

Paleolithic Carving

Prehistoric artists also carved and modeled sculptures and **reliefs** in a variety of materials. A large carved figure from Hohlenstein-Stadel in Germany (fig. **1.11**) is slightly more recent than the paintings of Chauvet. At just under a foot high, it represents a standing creature, half human and half feline, crafted out of mammoth ivory. Despite its poor state of preservation, it is clear that creating this figure, with rudimentary stone tools, was an arduous business, involving splitting the dried mammoth tusk, then scraping it into shape and using a sharp flint blade to incise such features as the striations on the arm and the muzzle. Strenuous polishing followed, using powdered hematite (an iron ore) as an abrasive. Exactly what the figure represents is unclear. Like the hybrid figures painted on cave walls, it may represent a human dressed up as an animal,

maybe for hunting purposes. Some prehistorians have named these composite creatures shamans or "sorcerers," who could contact the spirit world through ritualistic behavior.

As in cave paintings, animals were a frequent subject for sculpture. The miniature horse from a cave in Vogelherd along the Danube River in Germany from the Aurignacian period, and the interlocked ibexes of the Magdalenian period, date to the beginning and end of the Upper Paleolithic era (fig. **1.12** and fig. **1.13**). (See *Informing Art*, page 10.) The horse is one of many portable carvings in woolly mammoth ivory dating to around 28,000 BCE. A small hole between its front legs suggests that it was a pendant. The ibexes, carved from reindeer antler around 13,000 BCE, functioned as a spear-thrower. Attached to a spear by the hook at the end of its shaft, it allowed a hunter to propel the weapon more effectively. In both cases, the sculptor had an eye for strong outlines and finished the surface with painstaking care, marking the ibexes' coats with nicks from a stone tool and working up a high polish. Both objects were clearly intended for a functional purpose.

Just as cave artists sometimes transformed bulges in rock walls into painted animals, so, deep within a cave at Le Tuc d'Audoubert in the French Pyrénées, around 13,000 BCE, a sculptor built up a natural outcropping of rock with clay to produce two bison (fig. **1.14**), with a calf originally standing by

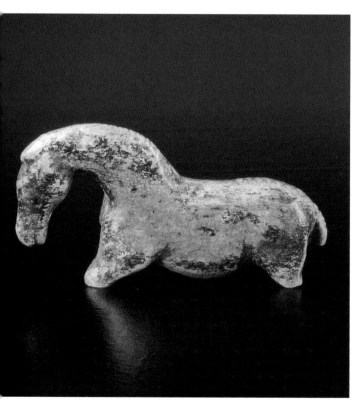

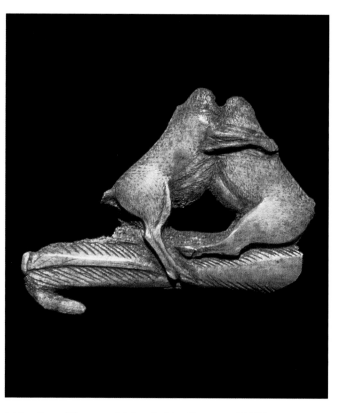

1.12. *Horse.* Vogelherd Cave. ca. 28,000 BCE. Germany. Mammoth ivory, height 2″ (5 cm). Institut für Urgeschichte, Universität Tübingen

1.13. *Spear Thrower with Interlocking Ibexes.* ca. 16,000 BCE. Grotte d'Enlène, Ariège, France. Reindeer antler, $3\frac{1}{2} \times 2\frac{3}{4}$″ (9 × 7 cm). Musée de l'Homme, Paris

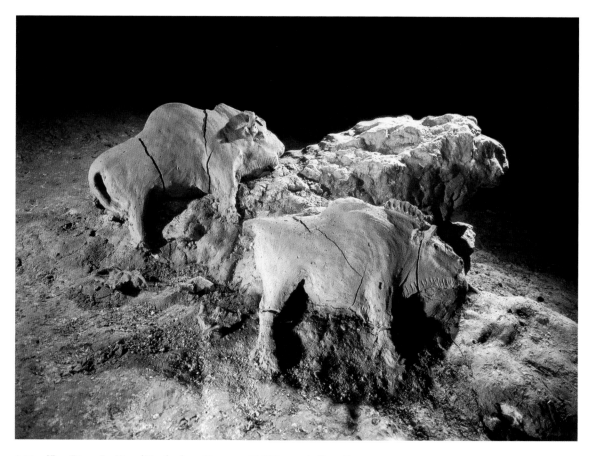

1.14. *Two Bison.* Le Tuc d'Audoubert Cave. ca. 13,000 BCE. Ariège, France. Clay, length $23\frac{5}{8}$″ (60 cm)

Telling Time: Labels and Periods

While geologists have developed methods for dividing time based on the age of the Earth, historians have used the human activity of tool making as the defining feature when measuring human time. For the era before the written word (prehistory), the patterns apparent in stone tools serve as the basis for distinguishing different cultures in prehistory. The Stone Age stretches from about 2 million years ago to about 4,000 years ago.

This broad span of time has been divided into the Paleolithic or Old Stone Age (from the Greek *palaio-*, meaning "ancient," and *lithos*, meaning "stone"), the Mesolithic or Middle (*meso-*) Stone Age, and the Neolithic or New (*neo-*) Stone Age. The Paleolithic era spans from 2 million years ago to about 10,000 BCE and the Mesolithic from about 10,000 to 8000 BCE. The Neolithic era spans from about 8000 BCE to about 2000 BCE. At some time during the third millennium BCE, stone tools were replaced by tools made of metal in some parts of the world, ushering in the Bronze Age in Europe and Asia.

Specific human cultures reached these phases at different times: The beginning of the Neolithic era appears to start earlier in western Asia than in Europe, for example. Yet the broad span of the Paleolithic era requires further refinement, and excavations of Paleolithic sites provide another framework for dividing time. The oldest material is at the bottom of an excavation, so the oldest Paleolithic era is called the Lower Paleolithic (ending about 100,000 years ago). The middle layers of Pale-

olithic excavations—thus the Middle Paleolithic era—date from 100,000 years ago to about 40,000 years ago. The most recent layers in such excavations are called the Upper Paleolithic, and date from about 40,000 BCE to around 8000 BCE.

Many sites and different types of tools and tool-making technologies have been used to identify specific culture groups within the Upper Paleolithic period. For example, the Aurignacian culture is named for Aurignac—a site in western France. The objects from this culture date from about 34,000 to 23,000 BCE. The Gravettian culture is named for La Gravette—a site in southwestern France, and dates from about 28,000 to 22,000 BCE. The most recent of these cultures is the Magdalenian, named for a prehistoric site in southwestern France called La Magdaleine, with dates ranging from around 18,000 to 10,000 BCE. Many of these terms were coined in the nineteenth century, when the study of prehistoric culture first took root.

THE PALEOLITHIC AGE

Lower Paleolithic	**2,000,000–100,000 BCE**
Middle Paleolithic	**100,000–40,000 BCE**
Upper Paleolithic	**40,000–10,000 BCE**
Aurignacian	34,000–23,000 BCE
Gravettian	28,000–22,000 BCE
Solutrean	22,000–18,000 BCE
Magdalenian	18,000–10,000 BCE
Mesolithic	**10,000–8000 BCE**
Neolithic	**8000–2000 BCE**

the front legs of the right-hand figure. Each sculpture is about two feet long; their forms swell and taper to approximate the mass of a real bison's form. Yet, despite the three-dimensional character of the representations (notice the fullness of the haunch and shoulder and the shaggy manes), the sculptures share conventions with cave paintings: They are rendered in fairly strict profile, viewable from one side only. Once again the function of the object is unclear: Were such sculptures tools for hunting? Among the human footprints found near this group are those of a 2-year-old child. These, along with a baby's handprint in a cave at Bedeilhac in France, and women's handprints at Chauvet, caution us against reconstructing Paleolithic works of art as the ritual centerpieces of a male-dominated hunting society.

Women were frequent subjects in prehistoric sculpture, especially in the Gravettian period (see *Informing Art*, above), when they far outnumbered men as subject material. In the late nineteenth century, a group of 12 ivory figurines were found together in the Grotte du Pape at Brassempouy in southern France. Among them was the *Dame à la Capuche* or *Woman from Brassempouy* (fig. **1.15**) of about 22,000 BCE. The sculpture is almost complete as it is, depicting only a head and long elegant neck. At merely 1½ inches long, it would rest comfortably in the hand, where it may have been most commonly viewed. Also hand-sized is the limestone carving of the nude *Woman of Willendorf* of Austria, dating somewhat earlier, from about

28,000 to 25,000 BCE (fig. **1.16**). Discovered in 1908, her figure still bears traces of ocher rubbed onto the carved surface. Both figurines are highly abstract. Instead of attempting to render the human figures with the naturalism found in the representations of animals, the artist reduced the female form to basic shapes. On the *Woman from Brassempouy*, the artist rendered the hair schematically with deep vertical gouges crossed by shallow horizontal lines, softened by vigorous polishing. There is no mouth and only the mere suggestion of a nose; the eyes are evocatively suggested by hollowed-out, overhanging eye sockets and holes cut on either side of the bridge of the nose. The quiet power and energy of the figure reside in the dramatic way its meticulously polished surface responds to shifting light, suggesting movement, elegance, and liveliness.

In the case of the *Woman of Willendorf*, the abstract quality of the work appears to stress a potent fertility. This kind of abstraction appears in many other figurines as well; indeed, some incomplete figurines depict only female genitalia. Clearly, facial features are not a priority: The schematically rendered hair covers the entire head. Instead, the emphasis rests on the figure's reproductive qualities: Diminutive arms sit on pendulous breasts, whose rounded forms are echoed in the extended belly and copious buttocks. Genitalia are shown between large thighs. The emphasis on the reproductive features suggests that the sculpture may have been a fertility charm, yet the intention may have been to ensure a successful birth outcome rather than an

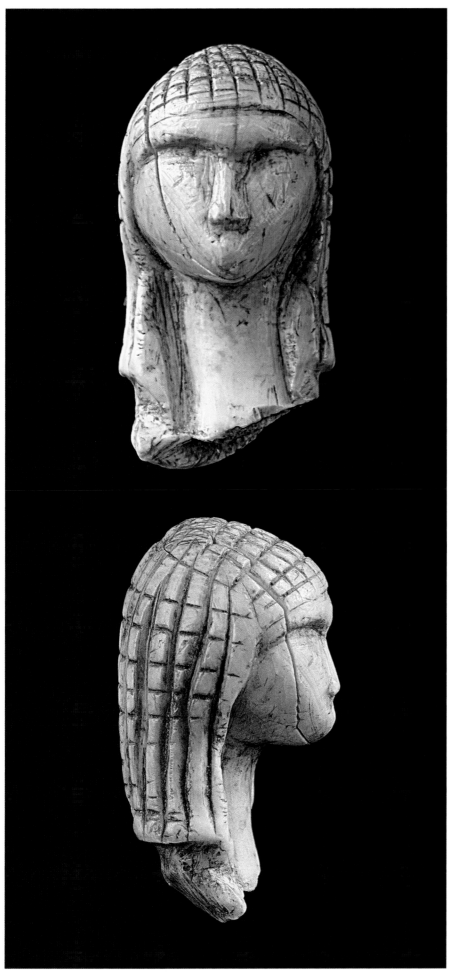

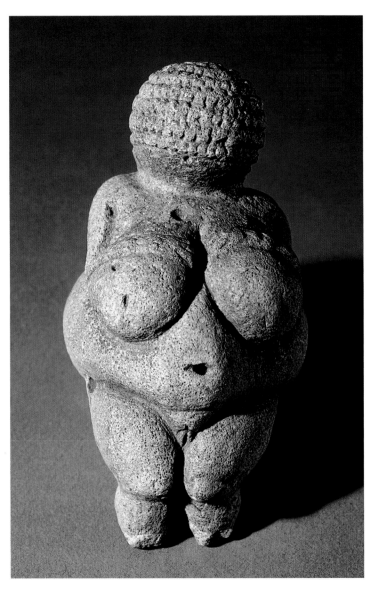

1.16. *Woman of Willendorf.* ca. 28,000–25,000 BCE. Limestone, height 4⅜″ (11.1 cm). Naturhistorisches Museum, Vienna

increase in numbers of pregnancies. Perhaps she was a doll, or a venerable ancestor. In a period when food was scarce, a woman with these proportions may well have been exceptional.

The uncertainty of our interpretation of figures like the *Woman from Brassempouy* and the *Woman of Willendorf* has been further complicated by the terminology applied to them in the past. The *Woman of Willendorf*, like many other Paleolithic female figurines, was named a "Venus" figure. The term dates back to the discovery of the first female figurines in the mid-nineteenth century. Venus is the Roman version of the Greek goddess Aphrodite, who was portrayed as a nude female; nineteenth-century archeologists saw these figures as similar in function, if not in form, to the Roman goddess. Contemporary scholars are still debating the meaning of these female figures, and avoid such anachronisms in terminology. We do not know whether this figure represents a specific woman, or a generic or ideal woman. Indeed, the figure may not represent the idea of woman at all, but rather the notion of reproduction or, as some scholars have argued, the fertile natural world itself.

NEOLITHIC ART

Around 10,000 BCE, the Earth's climate gradually began to warm, and the ice that had covered almost a third of the present-day globe began to recede. As melting glaciers created oceans, land masses were separated by water, and Europe developed more or less the geography it has today. The warming climate encouraged both new vegetation and changing animal populations: Reindeer migrated north, from modern France to Scandinavia; woolly mammoths and many other species became extinct. These changes in plant and animal life inevitably caused human habits to change. The new cultural age that marks the Neolithic period is characterized by a changing relationship between humans and their environment. Whereas previously they had built small huts and found shelter and ritual spaces in caves where the landscape allowed, in the Neolithic period, or New Stone Age, they began to build more substantial structures, settling in fixed places selected for favorable qualities, such as a good water supply, rather than moving with the seasons. Instead of hunting in the wild and gathering what nature supplied, they domesticated animals and plants. The change was gradual and occurred at different moments in different places; indeed, in some areas of the world, hunting and gathering are still the way of life today.

Settled Societies and Neolithic Art

The earliest evidence of these adjustments to environmental shifts is in the fertile regions of the eastern Mediterranean and Mesopotamia, between the Euphrates and Tigris rivers. A small settlement developed in the ninth millennium BCE by the River Jordan at the site of Jericho, of biblical fame, in the present West Bank territory. Over time its inhabitants built houses of sun-baked mud brick on stone foundations. They plastered the floors and crafted roofs of branches and earth. Skeletal remains indicate that they buried the bodies of their dead beneath the floors, though they treated the heads differently. Skulls were displayed above ground, reconstructed with tinted plaster to resemble flesh, with eyes of seashell fragments (fig. **1.17**). The subtlety of their modeling, with its gradation of planes and ridges, and the close observation of the interplay between flesh and bone, make these works remarkably lifelike, each as individual as the skulls they encased. Whether these funerary practices reveal an attitude about the afterlife is unclear; at the least, they suggest a respect for the dead or perhaps ancestor worship. As the town grew, expanding to cover some ten acres, and as neighboring settlements came to present a threat, so too a desire for protection developed. Thus, around 7500 BCE, the people of Jericho, now numbering over 2,000, dug a wide ditch and raised a solid stone wall around their town, 5 feet thick and over 13 feet high. Into it they set a massive circular tower, perhaps one of several, 28 feet tall and 33 feet in diameter at the base, with a staircase inside providing access to the summit (fig. **1.18**). With this fortification system, built with only the simplest stone tools, monumental architecture was born.

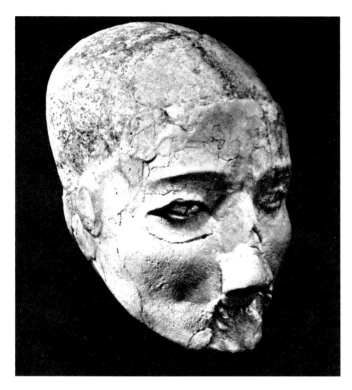

At Ain Ghazal, near Amman in Jordan, over 30 fragmentary plaster figures, dating to the mid-seventh millennium BCE, represent a starkly different sculptural tradition from the Jericho heads (fig. **1.19**). Some are only bust size, but the tallest statues, when restored, stand up to 3 feet tall, and constitute the first known large-scale sculptures. Conservators have studied the construction technique of these figures, and concluded that large size was the motivating force behind their design, directly resulting in their flat, shallow appearance. These investigations have shown that artists applied plaster to bundles of fresh reeds, bound with cordage, which they kept horizontal during the assembly process. They added the legs separately, then applied paint and set in cowrie shells for eyes, darkened with bitumen (a black, tarlike substance) for pupils. Once the plaster was dry, they stood the fragile figures upright and probably added wigs and clothing. Like the Jericho heads, they may have represented ancestors. However, as some of the bodies are two-headed, these figures may have had a mythical function.

1.17. Neolithic plastered skull. ca. 7000 BCE. Jericho, Jordan. Lifesize. Archaeological Museum, Amman

1.18. Early Neolithic wall and tower. ca. 7500 BCE. Jericho, Jordan

1.19. Human figures. ca. 6750–6250 BCE. Ain Ghazal, Jordan. Height of larger figure 33″ (84 cm). Department of Antiquities, Amman

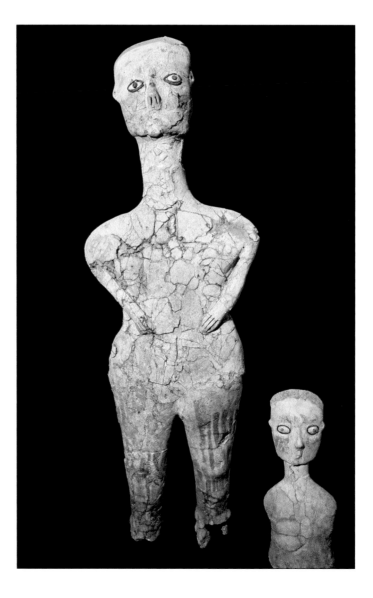

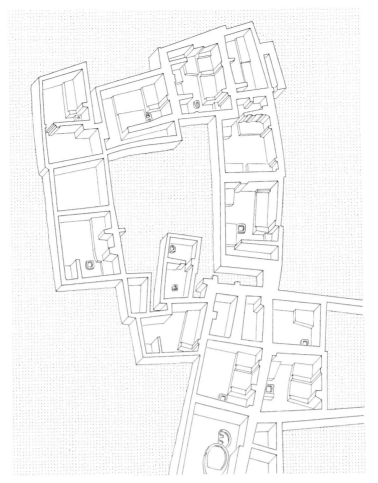

0 5 10 25 meters

0 25 50 75 feet

1.20. Reconstruction of Çatal Hüyük, Turkey

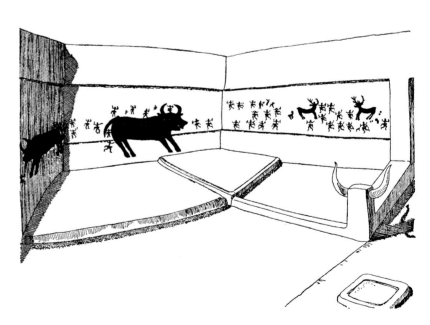

1.21. *Animal Hunt.* Restoration of Main Room, Shrine A.III.1.
ca. 6000 BCE. Çatal Hüyük (after Mellaart)

ÇATAL HÜYÜK In Anatolia (modern Turkey) excavations since 1961 have revealed a Neolithic town at Çatal Hüyük, dating from about 7500 BCE, a thousand years more recent than Jericho (see map 1.1). Flourishing through trade in ores—principally obsidian, a highly valued glasslike volcanic stone, which, when chipped away, made strong, sharp blades—the town developed rapidly through at least 12 successive building phases between 6500 and 5700 BCE. Its most distinctive feature is that it had no streets, and the houses had no doors at ground level: Each mud brick and timber house stood side by side with the next, accessed by ladder through a hole in the roof that doubled as a smoke vent (fig. 1.20). The advantages of this design were both structural—each house buttressing the next—and defensive, since any attacker would have to scale the outer walls and then face resistance on the rooftops. The rooms inside accommodated all activities, from working and cooking to sleeping, on platforms lining the walls. As at Jericho, burials were beneath the floor.

Some of the rooms at Çatal Hüyük were decorated with bulls' horns and plaster breasts, perhaps to signify fertility (fig. 1.21). Some archeologists believe that the more ornate rooms functioned as shrines, but this remains speculation. It is clear, however, that most of the rooms were plastered, and often they were painted. Many of the paintings depict animal hunts, with small human figures running around disproportionately large bulls or stags. The images have a static quality, quite unlike the earlier cave paintings that seem in constant motion.

One very unusual painting, found in an early room, appears to depict rows of irregular blocklike houses, and probably represents Çatal Hüyük itself (fig. 1.22). Above the town, a bright red feature spotted with black and topped with black lines and dots, may represent Hasan Dag, a twin-peaked volcano in view of the town. Unlike cave paintings, where no location is indicated, if this site has been properly interpreted, the focus of this painting is landscape, making it the first of its kind. The painting may indicate a strong sense of community in this early settlement, whose members identified specifically with place.

OVEN-FIRED POTTERY During the Neolithic period, a number of new technologies developed that collectively suggest the beginnings of specialization. As the community could depend on a regular food supply, some members could devote time to acquiring special skills. The new technologies included pottery, weaving, and some smelting of copper and lead. Pottery survives best, since oven-fired pottery is extremely durable, often surviving as discarded shards. Though absent from early Jericho, a great variety of clay vessels painted with abstract forms have been found in regions stretching from Mesopotamia, where pottery may have originated in the sixth millennium BCE, to Egypt and Anatolia, where it survives at Çatal Hüyük (see map 1.1). Pottery has also been discovered at other settlements in Anatolia's central plateau. Archeologists have also found pottery from this period in the Balkans, and by about 3500 BCE the technology of pottery making appears in western Europe.

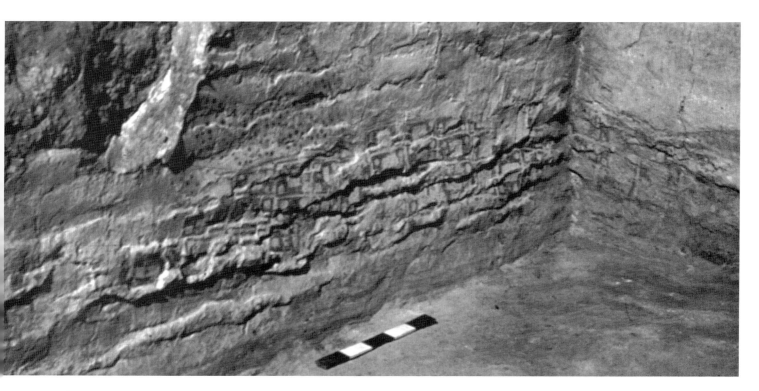

1.22. *View of Town and Volcano.* ca. 6000 BCE. Wall painting, Shrine VII.14. Çatal Hüyük

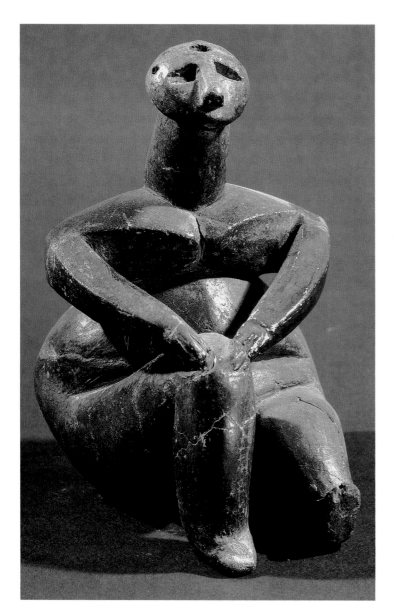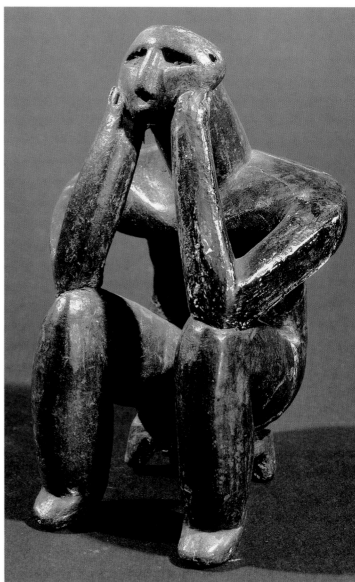

1.23. Female and male figures. ca. 3500 BCE. Cernavoda, Romania. Ceramic, height 4$\frac{1}{2}$″ (11.5 cm). National Museum of Antiquities, Bucharest

In Europe, artists also used clay to fashion figurines, such as a woman and man from Cernavoda in Romania, dating from about 3500 BCE (fig. **1.23**). Like the *Woman of Willendorf* and the Ain Ghazal figurines, they are highly abstract, yet here the forms are more linear than rounded: The woman's face is a flattened oval poised on a long, thick neck, and sharp edges articulate her corporeality—across her breasts, for instance, and at the fold of her pelvis. The elbowless arms meet where her hands rest on her raised knee, delineating a triangle and enclosing space within the sculptural form. This in turn emphasizes the figurine's three-dimensionality, encouraging a viewer to look at it from several angles, moving around it or shifting it in the hand. It is the pose that the abstraction highlights; yet, tempting as it may be to interpret it, perhaps as

coquettishness, we should be cautious about reading meaning into it, since gestures can have dramatically different meanings from one culture to another. Found in a tomb, the woman and the accompanying man may represent the deceased, or a companion or mourner for the dead; perhaps they were gifts that had a separate purpose before burial.

Architecture in Europe: Tombs and Rituals

In Europe, concerns about ceremonial burial and ritual, rather than protection, inspired monumental architecture. Individual dwellings were mostly framed in wood, with walls of wattle (branches woven into a frame) and daub (mud or earth dried

around the wattle) and roofs of thatch, which rarely survive. Yet Neolithic people of western and northern Europe defined spaces for tombs and rituals with huge blocks of stone known as **megaliths**. Often they were mounted in a **post-and-lintel** arrangement (with two upright stones supporting a third horizontal capstone). (See fig. 1.25.) Using this method, they constructed tombs for the dead with one or more chambers, termed *dolmen* tombs, that were both impressive and durable. Other sites, which scholars believe were used as ritual centers, marked out horizontal space in distinct ways. Between 4250 and 3750 BCE at Ménec, in the Carnac region on the south coast of Brittany (see map 1.1), over 3,000 megaliths were set upright at regular intervals in long, straight rows, stretching out over 2 miles. Typically, the smaller stones of about 3 feet in height stand on the eastern end, and, gradually, the height of the stones increases, reaching over 13 feet at the western end (fig. **1.24**). The lines' east–west orientation leads scholars to argue that they gauged the sun's position in the sky at different times of year, functioning as a calendar for an agrarian people whose sustenance depended on the sun's cycle. Quarrying, shaping, transporting, and erecting these blocks was an extraordinary feat, requiring the effective organization of manpower, quite apart from remarkable engineering expertise. The resulting monument, with its simple repeated forms both identical in shape and different as they increased in size, both still and yet cast into motion

ART IN TIME

ca. 10,000 BCE—Earth's climate gradually begins to warm

ca. 7500 BCE—Jericho's fortification system; beginning of monumental architecture

ca. 3500 BCE—Pottery manufacturing appears in Western Europe

ca. 2100 BCE—Final phase of the construction at Stonehenge

by the sun's slow and constant passage, has a calm grandeur and majesty that imposes quiet order on the open landscape.

Often, megaliths appear in circles, known as **cromlechs**. This is the most common arrangement in Britain, where the best-known megalithic structure is Stonehenge, on the Salisbury Plain (figs. **1.25** and **1.26**). What now appears as a unified design is in fact the result of at least four phases of construction, beginning with the excavation of a huge ditch defining a circle some 330 feet in diameter in the white chalk ground, with an embankment of over 6 feet running around the inside. A wide avenue lined with stones led northeast from the circle to a pointed grey sandstone (*sarsen*) megalith, known today as the *heel stone*. Further megaliths were brought inside the circle, so that by about 2100 BCE, Stonehenge had grown into a horseshoe-shaped arrangement of five sarsen *triliths* (two upright stones supporting a third horizontal one). Encircling them was a ring of upright

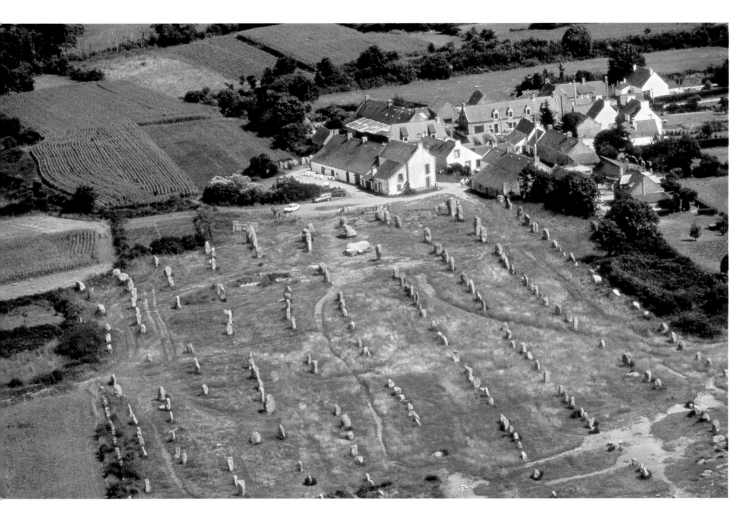

1.24. Menhir alignments at Ménec. ca. 4250–3750 BCE. Carnac, France

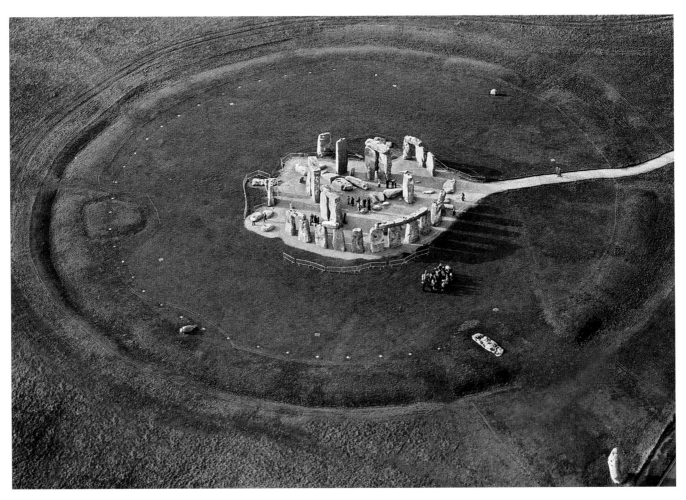

1.25. *Stonehenge* (aerial view). ca. 2100 BCE. Salisbury Plain, Wiltshire, England. Diameter of circle 97′ (29.6 m)

blocks capped with a continuous lintel, and between the rings was a circle of smaller bluestone blocks.

Exactly what Stonehenge signified to those who constructed it over the centuries remains a tantalizing mystery. Many prehistorians believe that it, too, functioned at least in part to mark the passing of time. Given its monumentality, most also concur that it had a ritual function; its careful circular arrangement supports this conjecture, as circles are central to rituals in many societies. Indeed, these two qualities led medieval observers to believe that Stonehenge was created by King Arthur's magician, Merlin, and it continues to draw crowds on summer solstices. What is certain, however, is that, like Ménec, Stonehenge represents tremendous manpower organization and engineering skill. The largest sarsen trilith, at the center of the horseshoe, soars 24 feet, supporting a lintel 15 feet long and 3 feet thick. The sarsen blocks weigh up to 50 tons apiece, and traveled 23 miles from the Marlborough Downs; the bluestones originated 200 miles away, in the Welsh Preseli Mountains. Just as impressive is that, in their finished state, the blocks reveal evidence of meticulous stone working. Holes hollowed out of the capstones fit snugly over projections on the uprights (forming a mortise and tenon joint), to make a stable structure. Moreover, the blocks are tailored to produce the kind of refinements usually associated with the Parthenon of Classical

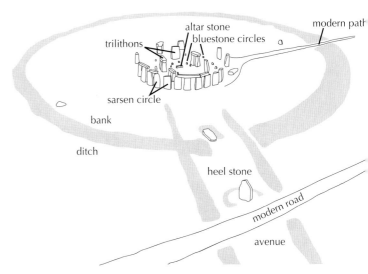

1.26. Diagram of original arrangement of stones at Stonehenge

Athens (see fig. 5.39): Upright megaliths taper in toward the top, with a central bulge, creating a visual impression of the weight they bear, and capturing an energy that gives life to the stones. The lintels are worked in two directions, their faces inclining outward by about 6 inches to appear vertical from the ground, while at the same time they curve around on the horizontal plane to make a smooth circle.

SUMMARY

Humans began to express themselves visually during the prehistoric age. They left behind no written records to explain their intentions, however, and thus prehistoric art raises as many questions as it answers. Even so, by the end of the era, people had established techniques of painting, sculpting, and pottery making, and they had begun to construct monumental works of architecture. They also developed a strong sense of the power of images and spaces. They had a recognition of both how to produce impressive shapes, such as those at Altamira and other caves, and how to alter space in sophisticated ways, as seen in the megaliths at Ménec and elsewhere.

PALEOLITHIC ART

During the Stone Age, humans subsisted by hunting animals and gathering other available foods. Yet they found the time—and had the need—to make art. Paleolithic art survives mostly in two forms: paintings on cave walls and smaller objects carved from bone or stone. Its most frequent subject is the animal—most often those animals that people depended on for food. These renderings of animal forms are incredibly lively and naturalistic, though their function and meaning are not well understood. In comparison, when the human figure is depicted, it is much more abstract.

NEOLITHIC ART

During the Neolithic period, humans domesticated animals and raised their own plants for food, leading to a more settled way of life. Architecture was made from more permanent materials than the earlier Paleolithic dwellings. The formation of human communities resulted in increased specialization and new technologies, such as pottery making. Sculpted and painted representations give evidence of developing religious practices and concern for the dead. Other innovations include large-scale stone structures for burial and other monuments, which many scholars see as tools for marking the passage of the seasons.

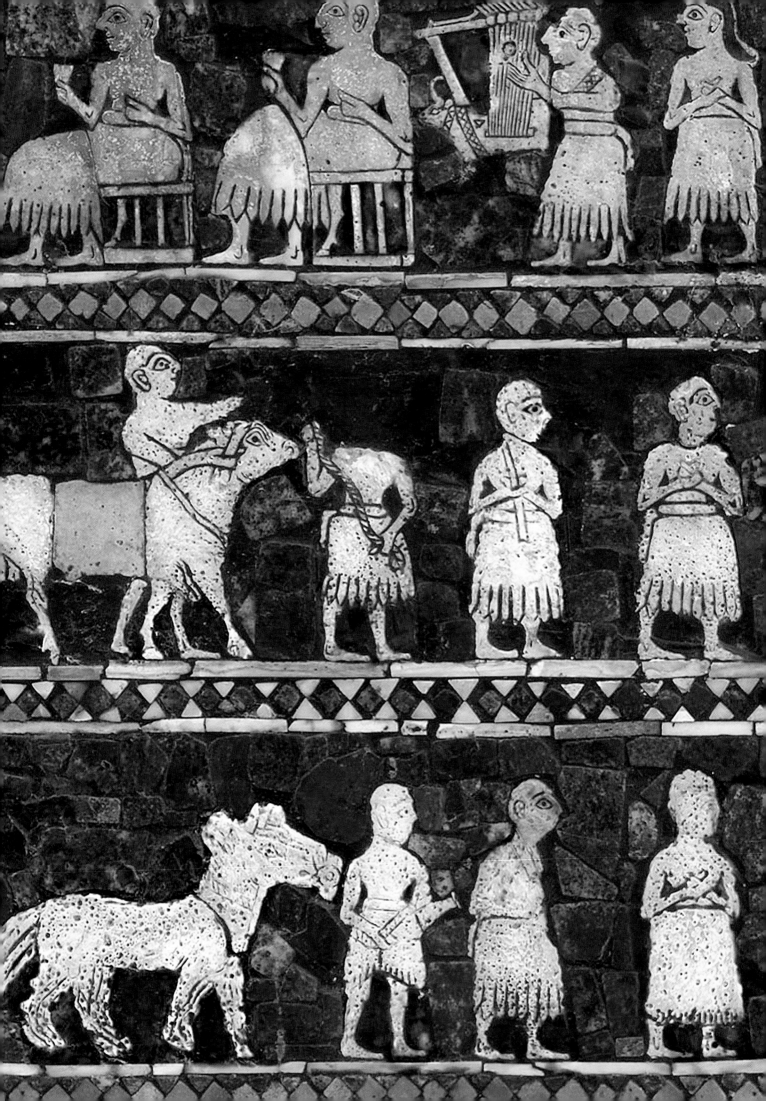

Ancient Near Eastern Art

GROWING AND STORING CROPS AND RAISING ANIMALS FOR FOOD, THE signature accomplishments of Neolithic peoples, would gradually change the course of civilization. Not long before they were freed from following wild animal herds and gathering food to survive, people began to form permanent settlements. By the end of the Neolithic era, these

settlements grew beyond the bounds of the village into larger urban communities. Small rural communities appeared throughout western Asia, but in the fourth millennium BCE, large-scale urban communities of as many as 40,000 people began to emerge in Mesopotamia, the land between the Tigris and the Euphrates rivers. The development of cities had tremendous ramifications for the development of human life and for works of art.

The "land between the rivers" offered many opportunities for the Neolithic farmer. Although today the region is largely an arid plain, written, archaeological, and artistic evidence indicates that at the dawn of civilization it was covered with lush vegetation. By mastering irrigation techniques, populations there were able to exploit the rivers and their tributaries to enrich the fertile soil even further. New technologies and inventions, including the wheel and the plow, and the casting of tools in copper and bronze, increased food production and facilitated trade. As these communities grew and flourished, they developed into city-states with distinct patterns of social organization to address the problems of urban life. The specialization of labor, trade, and economic exchange, the mechanisms for the resolution of disputes, and the construction of defensible walls all required a central authority and government, which developed in response to these needs.

Detail of figure 2.8, *Royal Standard of Ur*

The efficient administration that accompanied this social organization probably generated what may have been the earliest writing system, beginning around 3400 to 3200 BCE, consisting of pictograms pressed into clay with a stylus for the purpose of creating inventories. By around 2900 BCE, the Mesopotamians had refined the pictograms into a series of wedge-shaped signs known as **cuneiform** (from *cuneus*, Latin for wedge). This system was used for early administrative accounts and the Sumerian *Epic of Gilgamesh* in the late third millennium BCE. Cuneiform writing continued through much of the ancient era in the Near East and formed a cultural link between a variety of groups who established power in the region. Different groups adopted cuneiform writing to record their own languages. With the invention of writing, we enter the realm of history.

The geography of Mesopotamia had other profound effects on the civilizations that grew there. Unlike the narrow, fertile strip of the Nile Valley, protected by deserts on either side, where urban communities also began to thrive at around this time, Mesopotamia is a wide, shallow trough, crisscrossed by the two rivers and their tributaries and with few natural defenses. Easily entered from any direction, the region was constantly traversed by people wanting to exploit its fertile soil. Indeed, the history of the ancient Near East is a multicultural one, with city-states constantly warring with one another and only sometimes uniting under a single ruler. Despite frequent

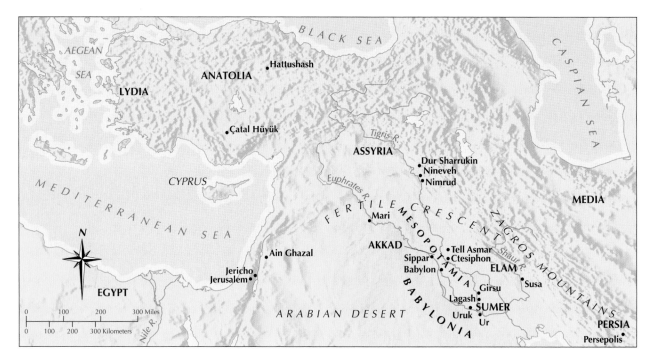

Map 2.1. The Ancient Near East

shifts of power, however, Mesopotamian visual culture retains a surprisingly constant character. Two dominant themes emerge: Art was used to effect and reflect political power; Mesopotamians also used visual narrative, exploring strategies for telling stories through art.

SUMERIAN ART

The first major civilization in Mesopotamia was in the southern region of Sumer, near the junction of the Tigris and Euphrates rivers, where several city-states were founded at some point before 4000 BCE (see map 2.1). These cities flourished under Sumerian control until about 2340 BCE. Just who the Sumerians were is unknown; often scholars can establish linkages between peoples through common linguistic traditions, but Sumerian is not related to any other known tongue. Archeological excavations since the middle of the nineteenth century have unearthed many early clay tablets with cuneiform writing that includes inventories and lists of kings, as well as poetry (fig. **2.1**). Many of the earliest excavations concentrated on Sumerian cities mentioned in the Bible, like Ur (the birthplace of Abraham) and Uruk (the biblical Erech). Along with architecture and writing, works of art in the form of pottery, sculpture, and relief inform us about Sumerian society.

For Sumerians, life itself depended on appeasing the gods, who controlled natural forces and phenomena, such as weather and water, the fertility of the land, and the movement of heavenly bodies. Each city had a patron deity, and the residents owed it both devotion and sustenance. The god's earthly steward was the city's ruler, who directed an extensive administrative staff

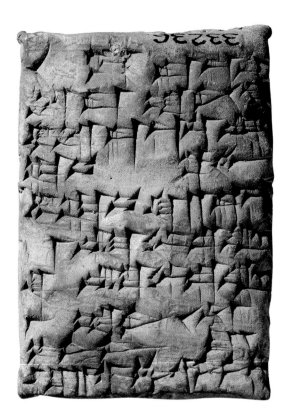

2.1. Babylonian deed of sale. ca. 1750 BCE. This deed graphically shows the impressions made by the stylus in the soft clay. Department of Western Asiatic Antiques, No. 33236. The British Museum, London

Mud Brick

Mud brick was made primarily from local clay. Raw clay absorbs water, and then cracks after drying. As a binding agent and to provide elasticity and prevent cracking, Sumerian builders would add vegetable matter, such as straw, to the clay. By forcing the mud mixture into wooden frames, the brick makers obtained uniformly rectangular bricks. Once molded, the bricks were knocked out of the frames and placed in the sun to bake. To erect walls, builders joined the bricks together with wet clay. One disadvantage of mud brick is that it is not durable. The Sumerians would therefore seal important exterior walls with bitumen, a tar-like substance, or they would use glazed bricks. Interior walls were sometimes covered with plaster.

Mud brick is not a material that readily excites the imagination today (in the way that, for instance, marble does), and because it is so highly perishable, it has rarely survived from ancient times to indicate how Sumerian temples might once have looked. However, more recent comparanda like the kasbahs south of Morocco's Atlas mountains, at Aït Ben Haddou and elsewhere, reveal the extraordinary potential of the material. There, the easy pliability of mud brick allows for a dramatic decorative effect that is at once man-made and in total harmony with the natural colors of the earth. Notice too the geometric designs echoed in the woodwork of doorways and windows. First constructed in the sixteenth century CE, these buildings undergo constant maintenance (recently funded by UNESCO) to undo the weather's frequent damage. Naturally, Sumerian temples may have looked quite different, but the kasbahs serve as a useful reminder that mud bricks are capable of magnificent results.

Mud-brick kasbahs at Aït Ben Haddou, Morocco

Mud bricks at Aït Ben Haddou, Morocco

based in the temple. As the produce of the city's land belonged to the god, the temple staff took charge of supplying farmers with seed, work animals, and tools. They built irrigation systems, stored the harvest, and distributed it to the people. Centralized food production meant that much of the population could specialize in other trades. In turn, they donated a portion of the fruits of their labor to the temple. (This system is called theocratic socialism.)

Temple Architecture: Linking Heaven and Earth

The temple was the city's architectural focus. Good stone was scarce, and the Sumerians built predominantly with mud brick, covered with plaster. (See *Materials and Techniques*, above).

Scholars distinguish two different types of Sumerian temple. "Low" temples sat at ground level. Usually their four corners were oriented to the cardinal points of the compass. The temple was tripartite: A rectangular cella was lined on its two long sides with rooms serving as offices, priests' quarters, and storage areas. The essential characteristics of "high" temples were similar, except that a platform raised the building above ground level; these platforms were gradually transformed into squat, stepped pyramids known as **ziggurats**. The names of some ziggurats—such as Etemenanki at Babylon, which translates as "House temple, bond between heaven and earth"— suggest that they may have been built as a link or portal to the heavens, a place where priest and god could commune.

Being approximately 40 to 50 feet high (at Warka and Ur), ziggurats functioned analogously as mountains. Rising out of the flat plain, mountains held a sacred status for Sumerians. They carried priests close to divine power, and were the source of water flowing to the valleys. A place of refuge in times of flooding, they also symbolized the Earth's generative power. Indeed, the Sumerian mother goddess was known as the Lady of the Mountain. Significantly, the raised platforms of high

2.2. Remains of the "White Temple" on its ziggurat. ca. 3500–3000 BCE. Uruk (Warka), Iraq

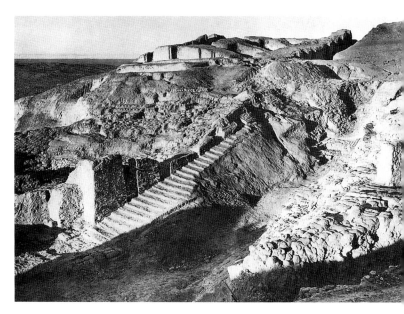

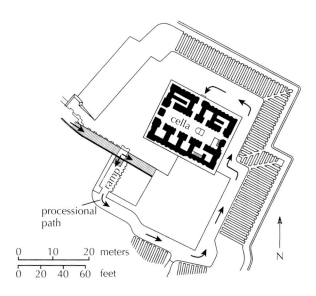

2.3. Plan of the "White Temple" on its ziggurat (after H. Frankfort)

processional path

0 10 20 meters
0 20 40 60 feet

N

cella

ramp

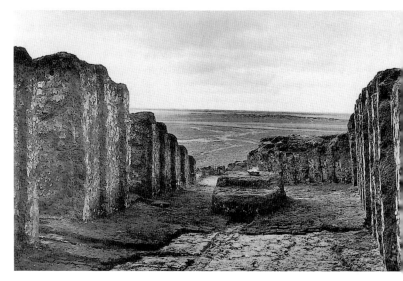

2.4. Interior of the cella of the "White Temple"

temples made them more visible. Mesopotamian texts indicate that the act of seeing was paramount. In seeing an object and finding it pleasing, a god might act favorably toward those who made it. The desired response of a human audience, in turn, was wonder. Finally, there was probably a political dimension to the high platform also: It emphasized and maintained the priests' status by visually expressing their separation from the rest of the community. The ziggurat and temple precincts dominated the Sumerian city.

Around 3500 BCE, the city of Uruk (present-day Warka and the biblical Erech) emerged as a center of Sumerian culture, flourishing from trade in its agricultural surplus. One of its temples, the "White Temple," named for its white-washed brick surfaces, was probably dedicated to the sky-god Anu, chief of the Sumerian gods (fig. **2.2**). The temple sits on a 40-foot mound constructed by filling in the ruins of older temples with brickwork, suggesting that the site itself was sacred (fig. **2.3**). Recessed brickwork articulated its sloped sides. A system of stairs and ramps led counterclockwise around the mound, culminating at an entrance in the temple's long north side. This

indirect approach is a characteristic feature of Mesopotamian temple architecture (in contrast to the direct axial approach typical in Egypt), and the winding ascent mirrored a visitor's metaphorical ascent into a divine realm. From three sides, members of the community could also witness the ceremonial ascent of the elite group of priests and leaders who had exclusive access to the temple. Enough survives of the temple's superstructure to indicate that thick walls with frequent buttressing surrounded a central, rectangular hall called a **cella** housing a stepped altar (fig. **2.4**). Along the two longsides of the cella were several smaller rooms, creating an overall tripartite layout typical of the earliest temples.

Uruk was the home of the legendary king Gilgamesh, hero of the epic poem that describes his adventures. In the epic, Gilgamesh is credited with building the city walls and the Eanna, the temple of Inanna or Ishtar. In the Eanna precinct, archeologists found several temples whose walls were decorated with colored stone or painted clay cones set into plaster to form mosaic patterns. (See *Primary Source*, page 25.) The poem describes the temple's gleaming walls, built with "kiln-fired

The Gilgamesh Epic

One of the earliest written epics, the Gilgamesh epic survives on cuneiform tablets. Although the earliest texts to survive come from Akkadian tablets, written after 2150 BCE, the text itself dates to the Sumerian era, about 2800 BCE. The surviving parts of the epic recount the tale of Gilgamesh, the king of Uruk, who first battles, then befriends the wild man Enkidu. When his friend dies, Gilgamesh goes in search of a way to defeat death, but instead returns to Uruk, accepting his own mortality. This excerpt from the beginning of the poem describes (with gaps from the sources) Gilgamesh's accomplishments as king.

Anu granted him the totality of knowledge of all.
He saw the Secret, discovered the Hidden,
he brought information of (the time) before the Flood.
He went on a distant journey, pushing himself to exhaustion,
but then was brought to peace.
He carved on a stone stela all of his toils,
and built the wall of Uruk-Haven,
the wall of the sacred Eanna Temple, the holy sanctuary.

Look at its wall which gleams like copper(?),
inspect its inner wall, the likes of which no one can equal!
Take hold of the threshold stone—it dates from ancient times!
Go close to the Eanna Temple, the residence of Ishtar,
such as no later king or man ever equaled!
Go up on the wall of Uruk and walk around,
examine its foundation, inspect its brickwork thoroughly.
Is not (even the core of) the brick structure made of
 kiln-fired brick,
and did not the Seven Sages themselves lay out its plans?
One square mile is devoted to city, one to palm gardens,
 one to lowlands, the open area(?) of the Ishtar Temple,
three leagues and the open area(?) of Uruk it
 (the wall) encloses.
Find the copper tablet box,
open the . . . of its lock of bronze,
undo the fastening of its secret opening.
Take out and read the lapis lazuli tablet
how Gilgamesh went through every hardship.

SOURCE: *THE EPIC OF GILGAMESH*, TR. MAUREEN GALLERY KOVACS (STANFORD, CA: STANFORD UNIV. PRESS, 1989)

brick." Gilgamesh purportedly carved his tale on a stone marker—which suggests the importance of narrative in Sumerian culture.

Sculpture and Inlay

The cella of Uruk's White Temple would once have contained a cult statue, which is now lost. But a female head dating to about 3100 BCE, found in the Eanna sanctuary of Inanna (goddess of love and war) at Uruk, may offer a sense of what a cult statue looked like (fig. 2.5). Flat on the back, the face is carved of white limestone, and details were once added in precious materials: a wig, perhaps of gold or copper, secured by the ridge running down the center of the head, and eyes and eyebrows made of colored materials. Despite the absence of these features, the sculpture has not lost its power to impress: The abstraction of its large eyes and dramatic brow contrasts forcefully with the delicate modeling of the cheeks. The head was once attached to a body, presumably made of wood, and the full figure must have stood near life-size.

TELL ASMAR About 500 years after the Uruk head, sculptors began to create a class of limestone, alabaster, and gypsum figures, well illustrated by a group excavated in the 1930s at a temple at Tell Asmar (fig. 2.6). Ranging in size from several inches to $2\frac{1}{2}$ feet high, these figures probably originally stood in the temple's cella. The figures had been purposely buried near the altar along with other objects, perhaps when the temple was rebuilt or redecorated. Their identities are somewhat controversial: Some scholars have identified the two larger figures as cult statues of Abu and his consort. Most consider the entire group to represent worshipers, who dedicated them in the sanctuary in the hope of being perpetually present before the divinity. Some statues of this kind from elsewhere are even inscribed with the dedicator's name and that of the god.

All but one of the figures in this group stand in a static pose, with hands clasped between chest and waist level. The style is decidedly abstract: On most of the standing male figures, horizontal or zigzag ridges define long hair and a full beard; the arms hang from unusually wide shoulders; hands are clasped around a cup; narrow chests widen to broad waists; and the legs are cylindrical. The male figures wear fringed skirts hanging from a belt in a stiff cone shape, while the women have full-length drapery.

2.5. *Female Head.* ca. 3200–3000 BCE. Uruk (Warka), Iraq. Limestone, height 8″ (20.3 cm). Iraq Museum, Baghdad

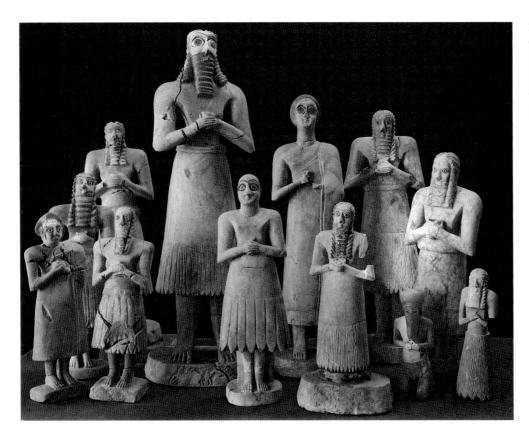

2.6. Statues from the Abu Temple. ca. 2700–2500 BCE. Tell Asmar, Iraq. Limestone, alabaster, and gypsum, height of tallest figure approx. 30″ (76.3 cm). Iraq Museum, Baghdad, and The Oriental Institute Museum of the University of Chicago

Both the poses and the costumes represent conventions of Sumerian art that later Mesopotamians adopted. Most distinctive are the faces, dominated by wide, almost round eyes, accentuated by dark inlays of lapis lazuli and shells set in bitumen, and by powerful eyebrows meeting over the bridge of the nose. It is all too tempting to read these and other Mesopotamian sculptures through a lens tinted by Christian thought and to see the enlarged eyes as a window to the soul. However, such an interpretation misunderstands the specific cultural context of these images. Scholars infer from surviving texts that seeing was a major channel of communication with gods, and that the sculptures were responding to the god's awe-inspiring nature with eyes wide open in admiration.

THE ROYAL CEMETERY AT UR The Sumerian city of Ur in southern Mesopotamia attracted archeologists because of its biblical associations, but it was in the city's extensive cemetery that Leonard Woolley discovered a wide variety of Sumerian objects in excavations during the 1920s. The cemetery was well preserved under the walls of Nebuchadnezzar II's later city, and contained some 1,840 burials dating between 2600 and 2000 BCE. Some were humble, but others were substantial subterranean structures and contained magnificent offerings, earning them the designation of "Royal Graves," even though scholars remain uncertain whether the deceased were royalty, priests, or members of another elite. The wealthiest burials were accompanied by so-called Death Pits. Foremost among them was the Great Death Pit, in which the bodies of 74 soldiers, attendants, and musicians were interred, apparently drugged before lying down in the grave as human sacrifices. Even in death, the elite maintained

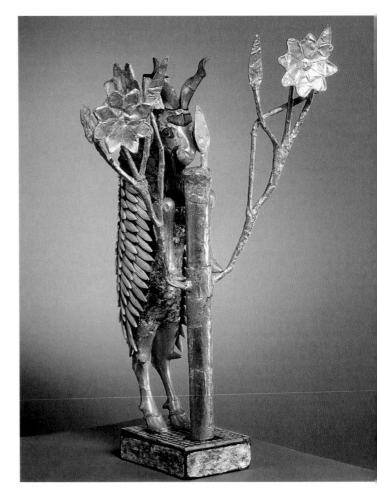

2.7. *Goat in Thicket (Ram and Tree)*, one of the pair from the Great Death Pit in the Royal Cemetery of Ur. ca. 2600 BCE. Muqaiyir, Iraq. Wood, gold, lapis lazuli, height 20″ (50.8 cm). University Museum, University of Pennsylvania, Philadelphia

the visible trappings of power and required the services of their retainers. These finds suggest that Sumerians may have believed in an afterlife.

Woolley found many kinds of grave goods in the Royal Cemetery, such as weapons, jewelry, and vessels. Many of the objects display the great skill of Sumerian artists in representing nature. Among them is a pair of wild goats rearing up on their hind legs against a flowering tree, probably used as stands for offerings to a deity (fig. **2.7**). Gold leaf is the dominant material, used for the goat's head, legs, and genitals, as well as for the tree and a cylindrical support strut rising from the goat's back. Lapis lazuli on its horns and neck fleece complements the shell fragments decorating the body fleece and the ears of copper. The base is an intricately crafted pattern of red limestone, shell, and lapis lazuli. Images on cylinder seals show that a bowl or saucer would have been balanced on the horns and the support cylinder. The combination of the goat (sacred to the

god Tammuz), and the carefully arranged flowers (rosettes sacred to Inanna), suggests that the sculpture reflects Sumerian concerns about fertility, both of plants and animals.

Visual Narratives

Two objects found within the Royal Cemetery at Ur offer glimpses of the early development of visual narrative in Mesopotamia. The so-called *Royal Standard of Ur*, of about 2600 BCE, consists of four panels of red limestone, shell, and lapis lazuli inlay set in bitumen, originally attached to a wooden framework (fig. **2.8**). The damaged side panels depicted animal scenes, while the two larger sections show a military victory and a celebration or ritual feast, each unfolding in three superimposed **registers**. Reading from the bottom, the "war" panel shows charioteers advancing from the left, pulled by *onagers* (wild asses), and riding over enemy bodies. In the middle register, infantry soldiers do battle and escort prisoners of

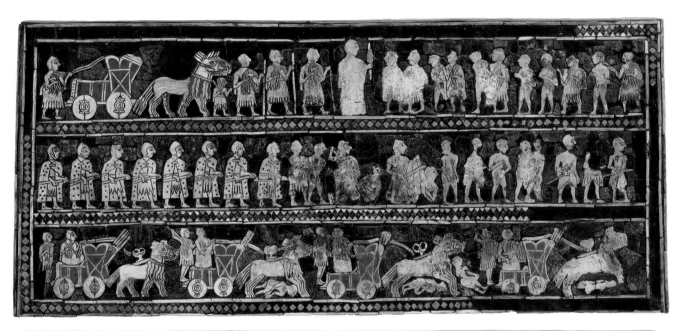

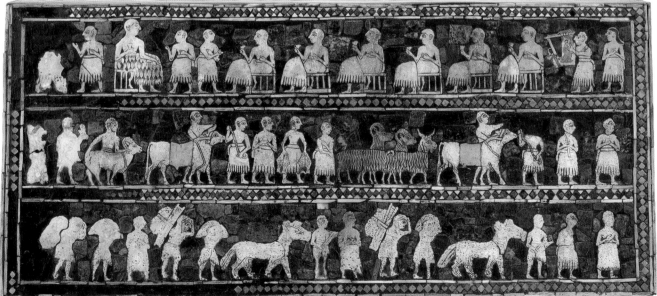

2.8. *Royal Standard of Ur*, front and back sides. ca. 2600 BCE. Wood inlaid with shell, limestone, and lapis lazuli, height 8″ (20.3 cm). The British Museum, London

war, stripped of armor and clothing. At the top, soldiers present the prisoners to a central figure, whose importance the artist signals not just through his position but through his larger size, a device known as **hieratic scale**; his head even breaks through the register's frame to emphasize his importance. In the "peace" panel, figures burdened with booty accompany onagers and, in the center, animals for the banquet, which is already under way in the top register. Seated figures raise their cups to the sound of music from a nearby harpist and singer; a larger figure toward the left of the scene is presumably a leader or king, perhaps the same figure as on the war side. Thus the panels tell a story, unfolding moment by moment as the eye follows the registers, guided by the figures' motion. Despite the action, however, the images have a static quality, emphasized by each figure's isolation (a staccato treatment):

Their descriptive forms (half frontal, half profile) rarely overlap with one another. This, and the contrasting colored materials, give the narrative an easy legibility, even from a distance.

On excavating the *Royal Standard of Ur*, Woolley envisioned it held aloft on a pole as a military standard, and named it accordingly. In fact, it is unclear what the object was used for; it may have been the sounding-box for a stringed instrument, an object that was commonly found in burials. In one of the cemetery's most lavish graves, the grave of "Queen" Pu-abi, Woolley discovered a lyre decorated with a bull's head of gold gilt and lapis lazuli, dating to around 2600 BCE (fig. 2.9), comparable to the lyre depicted on the "standard." On its sounding box, a panel of shell inlaid in bitumen depicts a male figure in a heraldic composition, embracing two human-faced bulls and facing a viewer with a full frontal glare (fig. 2.10). In lower registers, animals perform human tasks such as carrying foodstuffs and playing music. These scenes may have evoked a myth or fable known to contemporary viewers either in written or oral form, perhaps one associated with a funerary context. In some cultures, fantastic hybrid creatures, such as the bulls or the man with a braided, snakelike body in the bottom scene, served the **apotropaic** function of turning away evil forces.

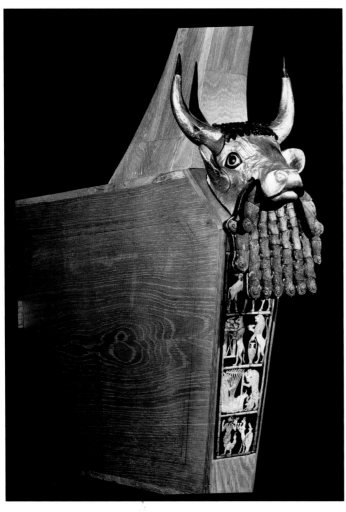

2.9. Bull Lyre, from the tomb of Queen Pu-abi, Ur (Muqaiyir), Iraq. ca. 2600 BCE. Wood with gold, lapis lazuli, bitumen, and shell, reassembled in modern wood support. University Museum, University of Pennsylvania, Philadelphia

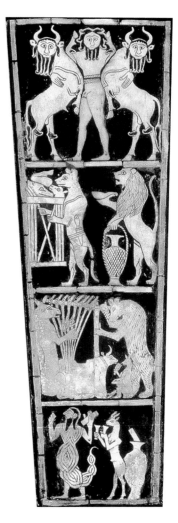

2.10. Inlay panel from the soundbox of lyre, from Ur (Muqaiyir), Iraq. ca. 2600 BCE. Shell and bitumen, $12\frac{1}{4} \times 4\frac{1}{2}''$ (31.1 × 11.3 cm). University Museum, University of Pennsylvania, Philadelphia

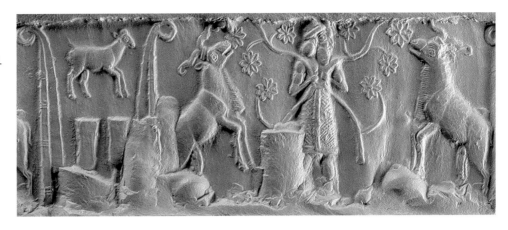

2.11. *Priest-King Feeding Sacred Sheep*, from vicinity of Uruk (Warka), Iraq. ca. 3300 BCE. Marble cylinder seal, height 2⅛″ (5.4 cm); diameter 1¾″ (4.5 cm). Staatliche Museen zu Berlin, Preussischer Kulturbesitz, Vorderasiatisches Museum

Cylinder Seals

The Mesopotamians also produced vast numbers of cylinder seals, used by the administration to seal jars and secure storerooms. The seals were cylindrical objects usually made of stone, with a hole running through the center from end to end. A sculptor carved a design into the curved surface of the seal, so that when it was impressed on soft clay, a raised, reverse image would unfold, repeated as the cylinder was rolled along. Great quantities of seals and sealings (seal impressions) have survived. Many are of modest quality, reflecting their primarily administrative purpose, but the finest examples display a wealth of detail and a high level of sculptural expertise. With subjects ranging from divine and royal scenes to monumental architecture, animals, and daily activities, the seals provide important information about Mesopotamian existence and values. The example illustrated here appears to show the feeding of the temple herd, which provided a significant portion of the temple's wealth (fig. **2.11**). The human figure's distinctive costume and hat may identify him as a priest-king; some scholars have seen the large vessels as a reference to sacred offerings, and one such vase, measuring nearly three feet in height, was found in the Eanna precinct at Uruk, dating to ca. 3200 BCE.

ART OF AKKAD

Around 2350 BCE, Sumerian city-states began to fight over access to water and fertile land. Gradually, the social organization of the Sumerian city-states was transformed as local "stewards of the god" positioned themselves as ruling kings. The more ambitious tried to enlarge their domains by conquering their neighbors. In many places, Semitic-speaking people (those who used languages in the same family as Hebrew and Arabic) gradually assumed positions of power in the south. Although they adopted many features of Sumerian civilization, they were less bound to the tradition of the city-state. Sargon (meaning "true king") conquered Sumer, as well as northern Syria and Elam (to the east of Sumer) in about 2334 BCE (see map 2.1). With Sargon's power, based in the city of Akkad (a site still unknown, but probably to the northwest of Sumer, near modern Baghdad), Akkadian became the language of authority in Mesopotamia. Sargon's ambitions were both imperial and dynastic. As the absolute ruler of an empire, he combined Sumerian and Akkadian deities in a new pantheon, hoping to break down the

traditional link between city-states and their local gods, and thereby unite the region in loyalty to his personal rule. Under his grandson, Naram-Sin, who ruled from 2254 to 2218 BCE, the Akkadian empire stretched from Sumer in the south to Elam in the east, and then to Syria in the west and Nineveh in the north.

Sculpture: Power and Narrative

Under the Akkadians, the visual arts were increasingly used to establish and reflect the monarch's power, as can be seen in other eras of art history. The most impressive surviving Akkadian work of this kind is a magnificent copper portrait head found in a rubbish heap at Nineveh, dated between 2250 and 2200 BCE and sometimes identified as Naram-Sin himself (fig. **2.12**). The face derives its extraordinary power from a number of sources:

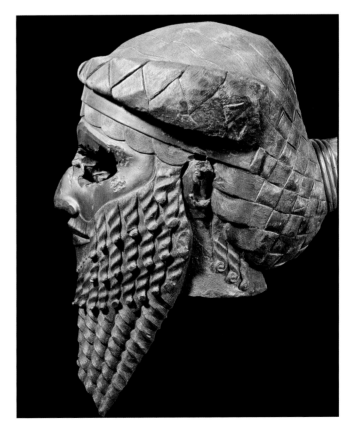

2.12. *Head of an Akkadian Ruler* from Nineveh (Kuyunjik), Iraq. ca. 2250–2200 BCE. Bronze, height 12″ (30.7 cm). Iraq Museum, Baghdad

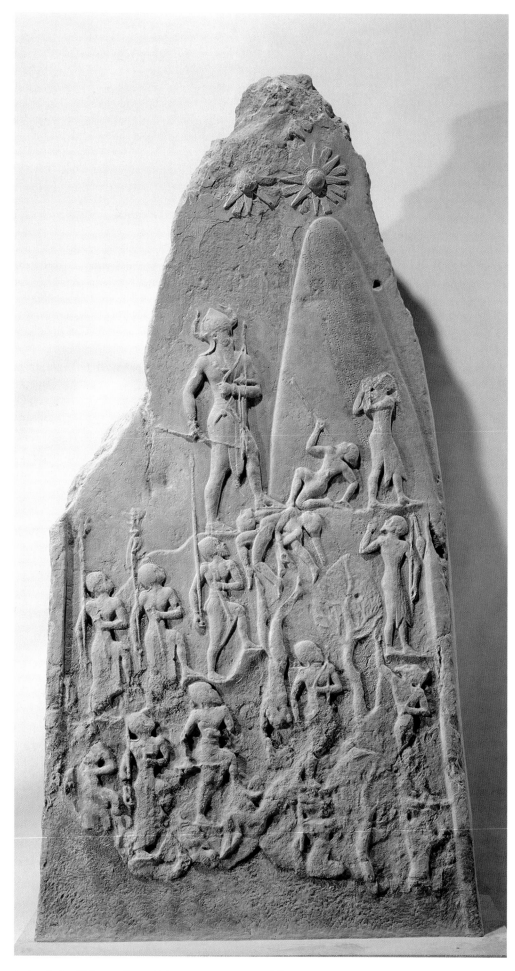

2.13. Stele of Naram-Sin. r. 2254–2218 BCE. Height 6′6″ (2 m). Musée du Louvre, Paris

It was designed to be seen from the front, and this **frontality** makes it appear unchanging and eternal. The abstract treatment of beard and hair (which is arranged like a Sumerian king's) contrasts with the smooth flesh to give the head a memorable simplicity and a strong symmetry, which denote control and order. The intricate, precise patterning of hair and beard testify to the metalworker's expertise in hollow casting (see *Materials and Techniques*, page 124). Furthermore, at a time before metallurgy was widely understood, the use of cast metal for a portrait demonstrated the patron's control of a technology primarily associated with weaponry. In its original form, the portrait probably had eyes inlaid with precious and semiprecious materials, as other surviving figures do. The damage to the portrait was probably incurred during the Medes' invasion of Nineveh in 612 BCE. The enemy gouged out its eyes and hacked off its ears, nose, and lower beard, as if attacking the person represented. Many cultures, even in our own day, practice such acts of ritualized vandalism as symbolic acts of violence or protest.

The themes of power and narrative combine in a 6 ½-foot **stele** (upright marker stone) erected in the Akkadian city of Sippar during the rule of Naram-Sin (fig. **2.13**). The stele commemorates Naram-Sin's victory over the Lullubi, people of the Zagros mountains in eastern Mesopotamia, in high relief. This time the story is not narrated in registers; instead, ranks of soldiers, in composite view, climb the wavy contours of a wooded mountain. Their ordered march contrasts with the enemy's chaotic rout: As the victorious soldiers trample the fallen foe underfoot, the defeated beg for mercy or lie contorted in death. Above them is the king, whose large scale and central position make his identity clear. He stands isolated against the background, next to a mountain peak that suggests proximity to the divine. His horned crown, formerly an exclusive accoutrement of the gods, marks him as the first Mesopotamian king to deify himself (an act that his people did not unanimously welcome). The bold musculature of his limbs and his powerful stance make him a heroic figure. Solar deities shine auspiciously overhead, as if witnessing his victory.

The stele of Naram-Sin still communicated its message of power over a thousand years later. In 1157 BCE, the Elamites

ART IN TIME

ca. 2350 BCE—Conflict begins among Sumerian city-states over access to water and fertile land

After 2150 BCE—Earliest surviving Akkadian tablets of the *Epic of Gilgamesh*

ca. 2100 BCE—The Great Ziggurat at Ur built, commissioned by King Urnammu

of southwestern Iran invaded Mesopotamia and seized the stele as war booty. An inscription on the stele records that they installed it in the city of Susa (see map 2.1). By capturing the defeated city's victory monument, they symbolically stole Naram-Sin's former glory and doubly defeated their foe.

NEO-SUMERIAN REVIVAL

The rule of the Akkadian kings came to an end when a mountain people, the Guti, descended from the northeast onto the Mesopotamian Plain and gained control of it. The cities of Sumer rose up in retaliation and drove them out in 2112 BCE, under the leadership of King Urnammu of Ur (the present-day city of Muqaiyir and the birthplace of Abraham), who reestablished Sumerian as the state language and united a realm that was to last a hundred years. As part of his project of renewal, he also returned to building on a magnificent scale.

Architecture: The Ziggurat of Ur

Part of Urnammu's legacy is the Great Ziggurat at Ur of about 2100 BCE, dedicated to the moon god, Sumerian Nanna (Sin in Akkadian) (fig. **2.14**). Its 190- by 130-foot base soared to 50 feet in three stepped stages. The base was constructed of solid mud brick and faced with baked bricks set in bitumen, a tarry material used here as mortar. Although not structurally functional, thick **buttresses** (vertical supporting elements) articulate the walls, giving an impression of strength. Moreover, a multitude of lines pointing upwards from all directions add a dynamic energy

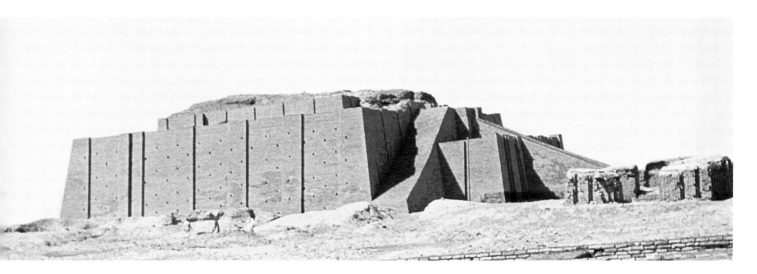

2.14. Great Ziggurat of King Urnammu, Ur. ca. 2100 BCE. Muqaiyir, Iraq

Texts on Gudea Figures from Lagash and Surrounding Areas, ca. 2100

Gudea, the ruler of Lagash, commissioned numerous temples and many figures of himself to be placed in the temples. Many of these figures (compare figs. 2.15 and 2.16) are inscribed with cuneiform texts that provide insight into the function of each image.

I n this excerpt, the god Ningirsu speaks to Gudea, encouraging him to rebuild his temple:

When, O faithful shepherd Gudea,
Thou shalt have started work for me on Eninnu, my royal abode,

I will call up in heaven a humid wind.
It shall bring thee abundance from on high
And the country shall spread its hands upon riches
 in thy time.
Prosperity shall accompany the laying of the foundations of
 my house.
All the great fields will bear for thee;
Dykes and canals will swell for thee;
Where the water is not wont to rise
To high ground it will rise for thee.
Oil will be poured abundantly in Sumer in thy time,
Good weight of wool will be given in thy time.

SOURCE: H. FRANKFORT, *THE ART AND ARCHITECTURE OF THE ANCIENT ORIENT*, 4TH ED. (NEW HAVEN: YALE UNIVERSITY PRESS, 1970, P. 98).

to the monument's appearance. Three staircases, now reconstructed, converged at the fortified gateway to the temple. Each 100 steps long, one was set perpendicular to the temple, the other two parallel to the base wall. From the gateway, a fourth staircase (which has perished) rose to the temple proper, which does not survive. The stairways may have provided an imposing setting for ceremonial processions. The surviving foundations are not extensive enough to reconstruct the buildings on top of the ziggurat.

Sculpture: Figures of Gudea

Contemporary to Urnammu's rule in Ur, Gudea became ruler of neighboring Lagash (in present-day Iraq), one of the smaller Sumerian city-states that had retained its independence after the collapse of Akkad. Being careful to reserve the title of king for Lagash's city-god, Ningirsu, Gudea promoted the god's cult through an ambitious rebuilding of his temple. According to

inscriptions, Gudea dreamed that Ningirsu ordered him to build the temple after the Tigris River had failed to rise.

Nothing remains of the building, but some 20 examples survive of distinctive statues representing Gudea, which he had dedicated at the temple and in other shrines of Lagash and vicinity (figs. **2.15** and **2.16**). The statues are a mark of his piety, and they also continue the Akkadian tradition that exalted the king's person. The statues testify to Gudea's enormous wealth, as they are carved of diorite, a dark stone that was as rare and expensive as it was hard to work. Whether standing or seated, the statues are remarkably consistent in appearance: Clothed in a long garment draped over one shoulder, and often wearing a thick woolen cap,

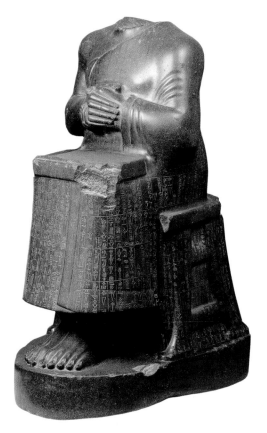

2.15. Head of Gudea, from Lagash (Telloh), Iraq, ca. 2100 BCE. Diorite, 9⅛″ (23.18 cm) high. Museum of Fine Arts, Boston. Francis Bartlett Donation of 1912. 26.289

2.16. Seated statue of Gudea holding temple plan, from Girsu (Telloh), Iraq. ca. 2100 BCE. Diorite, height approx. 2′5″ (73.66 cm). Musée du Louvre, Paris

Gudea clasps his hands across his front in a pose similar to statues from Tell Asmar of 500 years earlier. Like those figures, Gudea's eyes are wide open, in awe. The highly polished surface and precise modeling allow light to play upon the features, showcasing the sculptors' skills. The rounded forms emphasize the figures' compactness, giving them an impressive monumentality.

In the life-size seated example shown in figure 2.16, Gudea holds the ground plan of the temple on his lap. Inscriptions on the statue reveal that, to ensure the temple's sanctity, the king had to scrupulously obey the god's instructions. These inscriptions also give Gudea's motivation for building the temple: By obeying the god, he would bring good fortune to his city. (See *Primary Source,* page 32.) Consequently, the king purified the city and swept away the soil on the temple's site exposing the bedrock. He then laid out the temple according to the design revealed to him by Ningirsu, the god of Girsu (present-day Telloh), and helped manufacture and carry mud bricks.

BABYLONIAN ART

The late third and early second millennia BCE were a time of turmoil in Mesopotamia, as city states warred, primarily over access to waterways. The region was then unified for over 300 years under the rule of a Babylonian dynasty. During the reign of its most famous ruler, Hammurabi (r. 1792–1750 BCE), the city of Babylon assumed the dominant role formerly played by Akkad and Ur. Combining military prowess with a deep respect for Sumerian tradition, Hammurabi positioned himself as "the favorite shepherd" of the sun-god Shamash, stating his mission "to cause justice to prevail in the land and to destroy the wicked and evil, so that the strong might not oppress the weak nor the weak the strong." Under Hammurabi and his successors, Babylon became the cultural center of Sumer, and the city retained this prestige for more than a thousand years after its political power had waned.

The Code of Hammurabi

Hammurabi is best known for his law code. It survives as one of the earliest written bodies of law, engraved on a black basalt stele reaching over 7 feet tall (fig. **2.17**). Like the stele of Naram-Sin, the Elamites carried Hammurabi's stele off to Susa. The text, consisting of 3,500 lines of Akkadian cuneiform, begins with an accounting of the temples Hammurabi restored. The largest portion is then devoted to matters of commercial and property law, rulings on domestic issues, and questions of physical assault, detailing penalties to be exacted on noncompliers (including the renowned Old Testament principle of 'an eye for an eye'). (See *Primary Source*, page 34.) The text concludes with a paean on Hammurabi as peacemaker.

At the top of the stele, Hammurabi is depicted in relief, standing with his arm raised in greeting before an enthroned Shamash, whose shoulders emanate sun rays. The sun-god extends his hand, which holds the rope ring and the measuring rod of kingship; this single gesture unifies both the scene's composition and the implied purpose of the two protagonists. The image is a variant of the "introduction scene" found on cylinder seals, where a

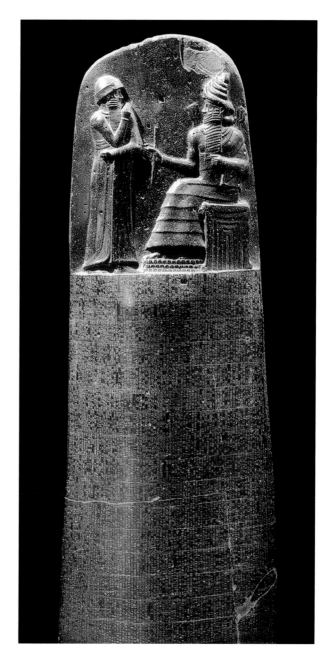

2.17. Upper part of stele inscribed with the Law Code of Hammurabi. ca. 1760 BCE. Diorite, height of stele approx. 7′ (2.1 m); height of relief 28″ (71 cm). Musée du Louvre, Paris

goddess leads a human individual with his hand raised in address before a seated godlike figure who bestows his blessing. Although a supplicant, Hammurabi appears without the benefit—or need—of a divine intercessor, implying an especially close relationship with the sun-god. Although this scene was carved four centuries after the Gudea statues, it is closely related to them in both style and technique. The exceptionally high relief enabled the sculptor to render the eyes in the round, so that Hammurabi and Shamash fix one another in an intense gaze. All the same, the image shares conventions with Akkadian relief, such as the use of a composite view. Yet the smaller scale of Hammurabi compared with the seated god expresses his status as "shepherd" rather than god himself. The symmetrical composition and smooth surfaces result in a legible image of divinely ordained power that is fully in line with Mesopotamian traditions.

The Code of Hammurabi

Inscribed on the stele of Hammurabi in figure 2.17, the Code of Laws compiled by King Hammurabi offers a glimpse at the lives and values of Babylonians in the second millennium BCE.

Prologue

When Anu the Sublime, King of the Anunaki, and Bel, the lord of Heaven and earth, who decreed the fate of the land, assigned to Marduk, the over-ruling son of Ea, God of righteousness, dominion over earthly man, and made him great among the Igigi, they called Babylon by his illustrious name, made it great on earth, and founded an everlasting kingdom in it, whose foundations are laid so solidly as those of heaven and earth; then Anu and Bel called by name me, Hammurabi, the exalted prince, who feared God, to bring about the rule of righteousness in the land, to destroy the wicked and the evil-doers; so that the strong should not harm the weak; so that I should rule over the black-headed people like Shamash, and enlighten the land, to further the well-being of mankind....

The Code of Laws [excerpts]

If any one bring an accusation against a man, and the accused go to the river and leap into the river, if he sink in the river his accuser shall take possession of his house. But if the river prove that the accused is not guilty, and he escape unhurt, then he who had brought the accusation shall be put to death, while he who leaped into the river shall take possession of the house that had belonged to his accuser....

If any one bring an accusation of any crime before the elders, and does not prove what he has charged, he shall, if it be a capital offense charged, be put to death....

If any one steal the property of a temple or of the court, he shall be put to death, and also the one who receives the stolen thing from him shall be put to death....

If any one steal cattle or sheep, or an ass, or a pig or a goat, if it belong to a god or to the court, the thief shall pay thirtyfold; if they belonged to a freed man of the king he shall pay tenfold; if the thief has nothing with which to pay he shall be put to death...

If any one break a hole into a house (break in to steal), he shall be put to death before that hole and be buried...

If any one be too lazy to keep his dam in proper condition, and does not so keep it; if then the dam break and all the fields be flooded, then shall he in whose dam the break occurred be sold for money, and the money shall replace the corn which he has caused to be ruined....

If any one be on a journey and entrust silver, gold, precious stones, or any movable property to another, and wish to recover it from him; if the latter do not bring all of the property to the appointed place, but appropriate it to his own use, then shall this man, who did not bring the property to hand it over, be convicted, and he shall pay fivefold for all that had been entrusted to him...

If a man wish to separate from a woman who has borne him children, or from his wife who has borne him children: then he shall give that wife her dowry, and a part of the usufruct of field, garden, and property, so that she can rear her children. When she has brought up her children, a portion of all that is given to the children, equal as that of one son, shall be given to her. She may then marry the man of her heart...

If a son strike his father, his hands shall be hewn off.

If a man put out the eye of another man, his eye shall be put out.

If he break another man's bone, his bone shall be broken.

If a builder build a house for some one, and does not construct it properly, and the house which he built fall in and kill its owner, then that builder shall be put to death.

If it kill the son of the owner, the son of that builder shall be put to death.

If it kill a slave of the owner, then he shall pay slave for slave to the owner of the house....

SOURCE: *WORLD CIVILIZATIONS ONLINE CLASSROOM* "THE CODE OF HAMMURABI" TRANSLATED BY L. W. KING (1910). EDITED BY RICHARD HOOKER WWW.WSU.EDU:8080/2DEE. © 1996.

NOTE: THE EPILOGUE OF *THE CODE OF HAMMURABI*, APPEARS ON P. 230.

ASSYRIAN ART

Babylon fell around 1595 BCE to the Hittites, who had established themselves in Anatolia (modern Turkey). The Hittites then departed leaving a weakened Babylonian state open to other invaders: the Kassites from the northwest and the Elamites from the east. Although a second Babylonian dynasty rose to great heights under Nebuchadnezzar I of Isin (r. 1125–1104 BCE), the Assyrians more or less controlled southern Mesopotamia by the end of the millennium. Their home was the city-state of Assur, named for the god Ashur, located on the upper course of the Tigris.

Art of Empire: Expressing Royal Power

Under a series of able rulers, beginning with Ashur-uballit (r. 1363–1328? BCE), the Assyrian realm expanded, in time covering not only Mesopotamia but surrounding regions as well. At its height, in the seventh century BCE, the Assyrian empire stretched from the Sinai Peninsula to Armenia; even Egypt was successfully invaded about 670 BCE (see map 2.1). The Assyrians drew heavily on the artistic achievements of the Sumerians and Babylonians, but adapted them to their own purpose. Theirs was clearly an art of empire: propagandistic and public, designed to proclaim and sustain the supremacy of the Assyrian civilization, particularly through representations of military power. The Assyrians continued to build temples and ziggurats based on Sumerian models, but their architectural emphasis shifted to royal palaces. These grew to unprecedented size and magnificence, loudly expressing a royal presence and domination.

The expression of Assyrian royal power began well outside the palace, as we can see in the plan for the city of Dur Sharrukin (present-day Khorsabad, Iraq), where Sargon II (r. 721–705 BCE) had his royal residence (fig. 2.18). Much of the city remains unexcavated. It covered an area of nearly a square mile, enclosed

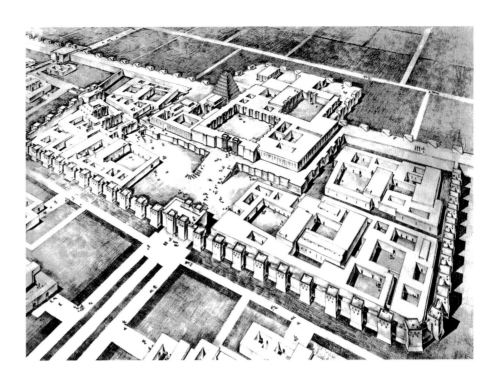

2.18. Reconstruction drawing of the citadel of Sargon II, Dur Sharrukin (Khorsabad), Iraq. ca. 721–705 BCE. After Charles Altman

within an imposing mud-brick fortification wall. To reach the palace, a visitor had to cross the city, passing through exposed plazas and climbing wide ramps. On the northwest side, a walled and turreted citadel enclosed the ziggurat and the palace, shutting them off from the rest of the town and emphasizing their dominant presence. Both structures were raised up on a mound 50 feet high, placing them above the flood plain and expressing the king's elevation above the rest of society. The ziggurat had at least four stages, each about 18 feet high, each of a different color, with a spiral ramp winding around it to the top. Enclosing the temple within the palace makes clear the privileged relationship between the king and the gods.

The palace complex comprised about 30 courtyards and 200 rooms, and this impressive scale was accompanied by monu-mental imagery. At the gateways stood huge, awe-inspiring guardian figures known as **lamassu**, in the shape of winged, human-headed bulls (fig. **2.19**). The illustration here shows the lamassu of Khorsabad during excavation in the 1840s; masons subsequently sawed up one of the pair for transportation to the Louvre in Paris. The massive creatures are almost carved in the round, yet the addition of a fifth leg, visible from the side, reveals that the sculptor conceived of them as deep relief sculptures on two sides of the stone block, so that the figures are legible both frontally and in profile. Carved out of the limestone, they are, in a sense, one with the building. Texts indicate that lamassu were also cast in bronze, but later melted down so that none now survive. With their tall, horned headdresses and deep-set eyes, and with the powerful muscularity of their legs

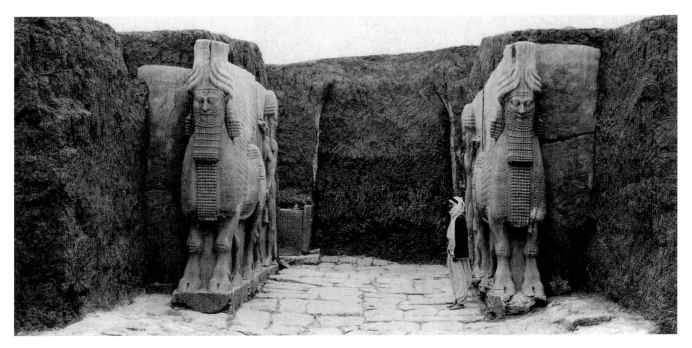

2.19. Gate of the Citadel of Sargon II, Dur Sharrukin (photo taken during excavation). 742–706 BCE. (Khorsabad), Iraq

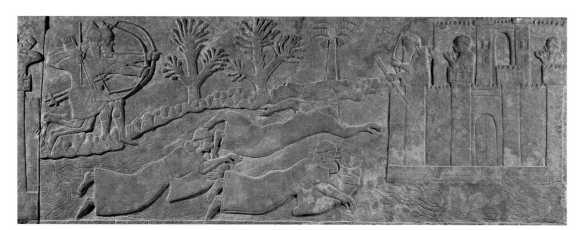

2.20. *Fugitives Crossing River,* from the Northwest Palace of Ashurnasirpal II, Nimrud (Calah), Iraq. ca. 883–859 BCE. Alabaster relief, height approx. 39″ (98 cm). The British Museum, London

and bodies set off by the delicate patterning of the beard and feathers, they towered over an approaching visitor, embodying the king's fearful authority. The Assyrians may have believed the hybrid creatures had the power to ward off evil spirits.

Once inside a royal palace, a visitor would confront another distinctive feature of Assyrian architecture: the upright gypsum slabs called **orthostats**, with which the builders lined the lower walls. Structurally, the slabs protected the mud brick from moisture and wear, but they served a communicative purpose as well. On their surfaces, narrative images in low relief, painted in places for emphasis, glorified the king with detailed depictions of lion hunts in royal gardens and military conquests (with inscriptions giving supplementary information). The Assyrian forces march indefatigably onward, meeting the enemy at the empire's frontiers, destroying his strongholds, and carrying away booty and prisoners-of-war. Actions take place in a continuous band, propelling a viewer from scene to scene, and repetition creates the impression of an inevitable Assyrian triumph. The illustrated detail (fig. **2.20**), from the Palace of Ashurnasirpal II (r. 883–859 BCE) at Nimrud (ancient Kalah, biblical Calah, Iraq), shows the enemy fleeing an advance party by swimming across a river on inflatable animal skins. In their fortified city, an archer—possibly the king—and two women look on with hands raised in emotion. Landscape elements are interspersed with humans, yet there is no attempt to capture relative scale, or

to depict all elements from a single viewpoint. This suggests that the primary purpose of the scenes was to recount specific enemy conquests in descriptive detail; depicting them in a naturalistic way was not a major concern.

As in Egypt (discussed in Chapter 3), royal lion hunts were staged events on palace grounds. Animals were released from cages into a square formed by troops with shields. Earlier Mesopotamian rulers hunted lions to protect their subjects, but by the time of the Assyrians, the activity had become more symbolic than real, ritually showcasing the king's strength and serving as a metaphor for military prowess. One of the best known sections of Assyrian relief comes from the North Palace of Ashurbanipal (r. 668–627 BCE) at Nineveh, dating to roughly 645 BCE (fig. **2.21**). The king races forward in his chariot with bow drawn, leaving wounded and dead lions in his wake. As attendants plunge spears into its chest, a wounded lion leaps at the chariot, its body hurled flat out in a clean diagonal line, its claws spread and mouth open in what appears to be pain combined with desperate ferocity. Clearly, the sculptor ennobled the victims of the hunt, contrasting the limp, contorted bodies of the slain animals with the taut leaping lion and the powerful energy of the king's party. Yet we should not conclude that the artist necessarily intended to evoke sympathy for the creatures, or to comment on the cruelty of a staged hunt; it is more likely that by ennobling the lions the sculptor glorified their vanquisher, the king, even more.

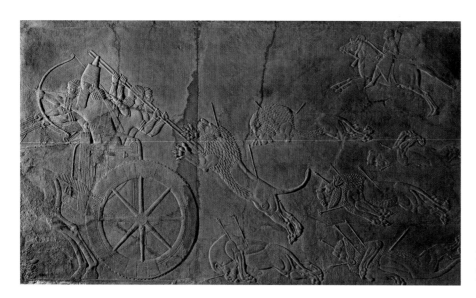

2.21. Lion Hunt relief, from reign of Ashurbanipal. ca. 645 BCE. The British Museum, London

LATE BABYLONIAN ART

Perpetually under threat, the Assyrian Empire came to an end in 612 BCE, when Nineveh fell to the Medes (an Indo-European–speaking people from western Iran) and the resurgent Babylonians. Under the Chaldean dynasty, the ancient city of Babylon had a final brief flowering between 612 and 539 BCE, before it was conquered by the Persians. The best known of these Late Babylonian rulers was Nebuchadnezzar II (r. 604–ca. 562 BCE), the builder of the biblical Tower of Babel, which soared 270 feet high and came to symbolize overweening pride. He was also responsible for the renowned Hanging Gardens of Babylon, considered by the second century BCE to be one of the wonders of the ancient world.

The Royal Palace

The royal palace at Babylon was on almost the same scale as Assyrian palaces, with five huge courtyards surrounded by numerous reception suites. For its decoration, the Late Babylonians adopted the use of baked and glazed brick, molded into individual shapes, instead of facing their structures with carved stone. Glazing brick involved putting a film of glass over the brick's surface. Late Babylonians used it both for surface ornament and for reliefs on a far greater scale.

ART IN TIME

ca. 1792–1750 BCE—Babylon ruled by Hammurabi

ca. 1595 BCE—The Hittites conquer Babylon

ca. 668–627 BCE—Assyrian construction of the North Palace of Ashurbanipal

The vivid coloristic effect of glazed brick appears on the courtyard facade of the Throne Room and the Processional Way leading to the Ishtar Gate and the gate itself, now reassembled in Berlin (fig. *2.22*). Against a deep blue background, a procession of bulls, dragons, and other animals, set off in molded brick, is contained within a framework of brightly colored ornamental bands. The animals portrayed were sacred: White and yellow snake-necked dragons were sacred to Marduk, the chief Babylonian god; yellow bulls with blue hair to Adad, the god of storms; and white and yellow lions to Ishtar herself, goddess of love and war. Unlike the massive muscularity of the lamassu, their forms are light and agile-looking, arrested in a processional stride that slowly accompanies ceremonial processions leading to the gate's arched opening.

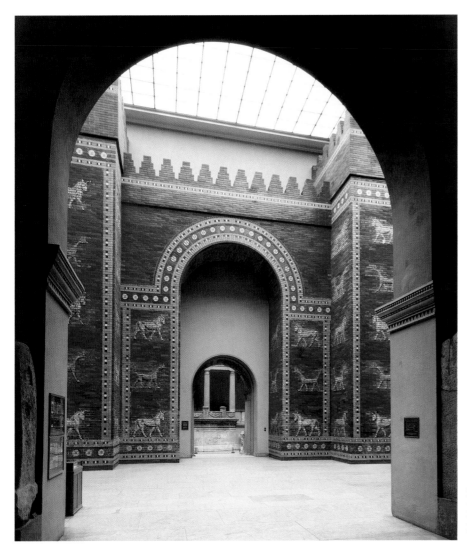

2.22. Ishtar Gate (restored), from Babylon, Iraq. ca. 575 BCE. Glazed brick. Staatliche Museen zu Berlin, Preussischer Kulturbesitz, Vorderasiatisches Museum

REGIONAL NEAR EASTERN ART

Alongside the successive cultures of Mesopotamia, a variety of other cultures developed in areas beyond the Tigris and Euphrates. Some of these peoples invaded or conquered contemporaneous cultures in Mesopotamia, as did the Hittites in the north and the Iranians in the east. Others, such as the sea-going Phoenicians on the Mediterranean coast to the west, traded with the cultures of Mesopotamia and in so doing spread Mesopotamian visual forms to Africa and Europe. Their material culture reflects contacts with Mesopotamian traditions.

The Hittites

When Babylon was overthrown in 1595 BCE, it was the Hittites who were responsible. An Indo-European–speaking people, the Hittites had probably entered Anatolia (present-day Turkey) from southern Russia in the late third millennium BCE and settled on its rocky plateau as one of several independent cultures that developed separately from Mesopotamia. Emerging as a power around 1800 BCE, they rapidly expanded their empire under Hattusilis I 150 years later. Coming into contact with the traditions of Mesopotamia, the Hittites adopted cuneiform writing for their language, preserving details of their history on clay tablets. In addition to invading Mesopotamia, the Hittites established an empire that extended over most of modern Turkey and Syria, which brought them into conflict with the imperial ambitions of Egypt. The Hittite Empire reached its apogee between 1400 and 1200 BCE. Its capital, Hattusa, near the present-day Turkish village of Bogazköy, was protected by fortifications constructed of huge, irregularly shaped stones, widely available in the region. Flanking the gates to the city were massive limestone lions and other guardian figures protruding from the blocks that formed the jambs of the doorway (fig. **2.23**). The lion gates at Bogazköy are 7 feet high, and though badly weathered, these figures still impress visitors with their frontal positioning and ferocity. The later Assyrian lamassu (see fig. 2.19) were probably inspired by these powerful guardians.

The Phoenicians

The Phoenicians, too, contributed a distinctive body of work to Near Eastern art. Living on the eastern coast of the Mediterranean in the first millennium BCE in what is now Lebanon, they developed formidable seafaring skills, which enabled them to found settlements further west in the Mediterranean (most notably on the North African coast and in Spain). They became a linchpin and an active participant in a rapidly growing trade in objects—and ideas—between east and west. The Phoenicians were especially skilled in working metal and ivory, incorporating motifs from Egypt and the eastern Mediterranean coast, and in making colored glass. The open-work ivory plaque illustrated here dates to the eighth century BCE, and was found in

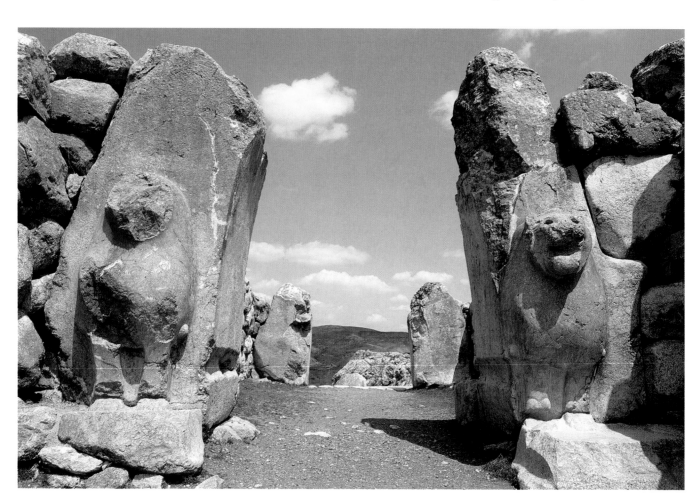

2.23. The Lion Gate. ca. 1400 BCE. Bogazköy, Anatolia (Turkey)

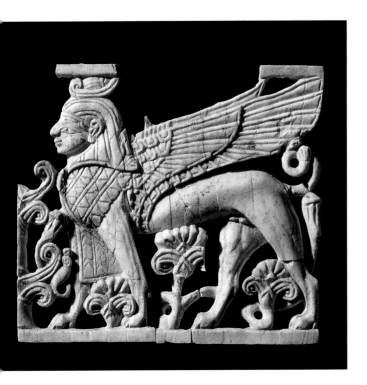

2.24. Ivory plaque depicting a winged sphinx. Phoenician. ca. eighth century BCE. Found at Fort Shalmaneser, Nimrud (ancient Kalhu), northern Iraq. The British Museum

Fort Shalmaneser at Nimrud, the Assyrian capital where it had probably been taken as booty by the conquering Assyrian kings (fig. **2.24**). It captures an Egyptian winged sphinx poised in profile, and though the details are all Egyptian—its wig and apron, the stylized plants—its double crown has been reduced to fit neatly within the panel, suggesting that it was a quality of "Egyptianness" that was important rather than an accurate portrayal of Egyptian motifs. The rounded forms and profile presentation translate the Egyptian motif into a visual form more familiar to Mesopotamian eyes.

IRANIAN ART

East of Mesopotamia, Iran had been inhabited since Neolithic times, starting in about 7000 BCE, when it was a flourishing agricultural center. During that period, Iran became a gateway for migrating tribes from the Asiatic steppes to the north as well as from India to the east. While distinctive, the art of ancient Iran reflects many intersections with the cultures of Mesopotamia.

Early Iranian Art

An example from the region, from a pottery-producing center at Susa on the Shaur River, is the handleless beaker in figure **2.25**, dating to about 4000 BCE. Its thin shell of pale yellow clay is decorated with brown glaze showing an ibex (mountain goat), whose forms are reduced to a few dramatic sweeping curves. The circles of its horns reflect in two dimensions the cup's three-dimensional roundness. Racing hounds above the ibex are stretched out to become horizontal streaks, and vertical lines below the vessel's rim are the elongated necks of a multitude of birds. This early example of Iranian art demonstrates

ART IN TIME

1400–1200 BCE—Apogee of the Hittite Empire

612 BCE—Nineveh falls to the Medes and resurgent Babylonians; end of the Assyrian Empire

ca. 604–562 BCE—Reign of the Late Babylonian ruler Nebuchadnezzar II

ca. 575 BCE—Babylonian construction of the Ishtar Gate

the skill of the potter in both the construction of the cup and its sensitive painted design. It foretells the later love of animal forms in the nomadic arts of Iran and Central Asia.

The early nomadic tribes left no permanent structures or records, but the items they buried with their dead reveal that they ranged over a vast area—from Siberia to central Europe, from Iran to Scandinavia. The objects were made of wood, bone, or metal, and share a common decorative vocabulary, including animal motifs used in abstract and ornamental ways.

2.25. Painted beaker, from Susa. ca. 5000–4000 BCE. Height 11¼″ (28.3 cm). Musée du Louvre, Paris

These belong to a distinct kind of portable art known as nomad's gear, including weapons, bridles, buckles, **fibulae** (large clasps or brooches), and other articles of adornment, as well as various kinds of vessels.

The Persian Empire: Cosmopolitan Heirs to the Mesopotamian Tradition

During the mid-sixth century BCE, the entire Near East came to be dominated by the small kingdom of Parsa to the east of lower Mesopotamia. Under Cyrus the Great (r. 559–530/29 BCE), ruler of the Achaemenid dynasty, the Persians overthrew the king of the Medes, then conquered major parts of Asia minor in ca. 547 or 546 BCE, and Babylon in 538 BCE. Cyrus assumed the title "King of Babylon," along with the broader ambitions of Mesopotamian rulers.

The empire he founded continued to expand under his successors. Egypt fell in 525 BCE, while Greece narrowly escaped Persian domination in the early fifth century BCE. At its height, under Darius I (r. 521–486 BCE) and his son Xerxes (r. 485–465 BCE), the Persian Empire in its territorial reach far outstripped the Egyptian and Assyrian empires combined. Its huge domain endured for two centuries, during which it developed an efficient administration and monumental art forms.

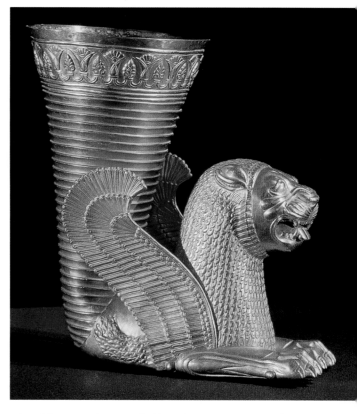

2.27. Rhyton. Achaemenid. 5th–3rd centuries BCE. Gold. Archaeological Museum, Tehran, Iran

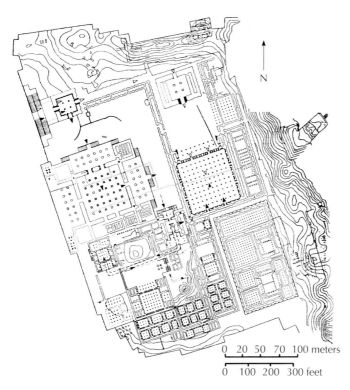

2.26. Plan of Palace of Darius and Xerxes, Persepolis. 518–460 BCE. Solid triangles show the processional route taken by Persian and Mede notables; open triangles indicate the way taken by heads of delegations and their suites

Persian religious beliefs were related to the prophecies of Zoroaster (Zarathustra) and were based on the dualism of good and evil, embodied in Ahuramazda (Light) and Ahriman (Darkness). The cult of Ahuramazda focused its rituals on fire altars in the open air; consequently, Persian kings did not construct religious architecture. Instead they concentrated their attention and resources on royal palaces, at once vast and impressive.

PERSEPOLIS The most ambitious of these palaces, at Parsa or Persepolis, was begun by Darius I in 518 BCE. It was enlarged by subsequent rulers (fig. **2.26**). Set on a plateau in the Zagros highlands, it consisted of a great number of rooms, halls, and courts laid out in a grid plan, fortified and raised on a platform. The palace is a synthesis of materials and design traditions from all parts of the far-flung empire, resulting in a message of internationalism. Darius boasts in his inscriptions that its timber came from Lebanon (cedar), Gandhara and Carmania (yaka wood), and its bricks from Babylon. Items used within the palace (such as the **rhyton** or ritual cup in fig. **2.27**), were of Sardian and Bactrian gold, Egyptian silver, and ebony, and Sagdianan lapis lazuli and carnelian. To work these materials, the Achaemenids brought in craftsmen from all over the empire, who then returned to their respective homes taking this international style with them. The rhyton in figure 2.27 belongs to the tradition of Mesopotamian hybrid creatures. Made of gold, it is shaped as a senmurv, a mythical creature with the body of a lion sprouting griffin's wings and a peacock's tail.

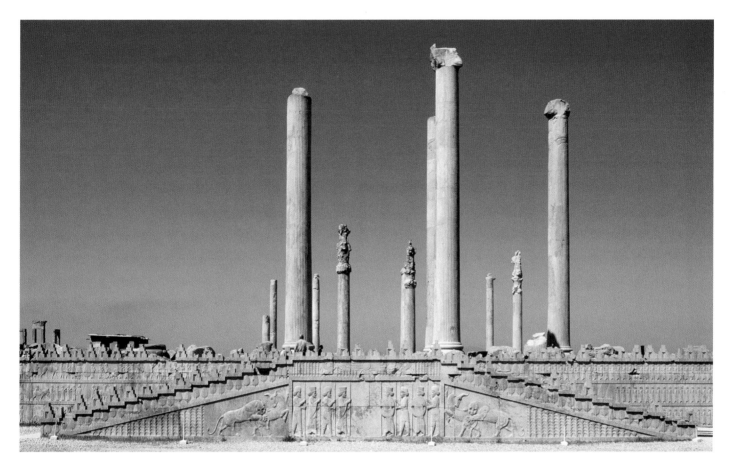

2.28. Audience Hall of Darius and Xerxes. ca. 500 BCE. Persepolis, Iran

Visitors to the palace were made constantly aware of the theme of empire, beginning at the entrance. At the massive "Gate of all the Lands" stood colossal winged, human-headed bulls, like the Assyrian lamassu (see fig. 2.19). Inside the palace, columns were used on a magnificent scale. Entering the 217-foot-square Audience Hall of Darius and Xerxes, or *apadana*, the visitor would see 36 columns, soaring 40 feet up to support a wooden ceiling. A few still stand today (fig. **2.28**). The concept of massing columns may come from Egypt; certainly Egyptian elements are present in the vegetal (plantlike) detail of their bases and capitals. The form of the shaft, however, echoes the slender, fluted column shafts of Ionian Greece (see fig. 5.9). Crowning the column capitals are "cradles" for ceiling beams composed of the front parts of two bulls or similar creatures (fig. **2.29**). The animals are reminiscent of Assyrian sculptures, yet their truncated, back-to-back arrangement recalls animal motifs of Iranian art, such as the rhyton.

2.29. Bull capital, from Persepolis. ca. 500 BCE. Musée du Louvre, Paris

Losses Through Looting

The archaeologist's greatest nemesis is the looter, who pillages ancient sites to supply the world's second largest illicit business: the illegal trade in antiquities. The problem is worldwide, but recent publicity has focused on Iraq, where thousands of archaeological sites still await proper excavation. Looters are often local people, living in impoverished conditions but supported and organized by more powerful agents; just as frequently, looters work in organized teams, arriving on site with jackhammers and bulldozers, wielding weapons to overcome whatever meager security there might be. Often employing the most sophisticated tools, such as remote sensing and satellite photographs, they move quickly and unscrupulously through a site, careless of what they destroy in their search for treasure. Loot changes hands quickly as it crosses national borders, fetching vast sums on the market. Little or none of this fortune returns to local hands.

Even more is at stake in these transactions than the loss of a nation's heritage. Only a fraction of the value of an archaeological find resides in the object itself. Much more significant is what its *findspot* can tell archaeologists, who use the information to construct a history of the past. An object's location within a city or building reveals how it was used. A figurine, for instance, could be a fertility object, doll, or cult image, depending on its physical context. The exact level, or stratum, at which an object is found discloses when it was in use. On some sites, stratigraphy yields very precise dates. If an object is discovered far from its place of manufacture, its findspot can even document interactions between cultures.

The 1970 UNESCO Convention requires members to prohibit the importation of stolen antiquities from other member states and offers help in protecting cultural property that is in jeopardy of pillage. To date, 103 countries have joined the convention, though the U.S. has yet to ratify it.

Looters at the archaeological site of Isin, Southern Iraq, January 2004

Reliefs embellishing the platform of the Audience Hall and its double stairway proclaim the theme of harmony and integration across the multicultural empire, in marked contrast to the military narratives of the Assyrians (fig. **2.30**). Long rows of marching figures, sometimes superimposed in registers, represent the empire's 23 subject nations, as well as royal guards and Persian dignitaries. Each of the subject nations wears indigenous dress and brings a regional gift—precious vessels, textiles—as tribute to the Persian king. Colored stone and metals applied to the relief added richness to the wealth of carved detail. The relief is remarkably shallow, yet by keeping the figures' roundness to the edge of their bodies (so that they cast a shadow), and by cutting the background away to a level field, the sculptors created the impression of greater depth. Where earlier Mesopotamian reliefs depict figures that mixed profile and frontal views, most of these figures are depicted in true profile, even though some figures turn their heads back to address those who follow. The repetition of the walking human form contributes to a powerful dynamic quality that guides a visitor's path through the enormous space. The repetition also lends the reliefs an eternal quality, as if preserving the action in perpetual time. This would be especially fitting if, as some scholars believe, the relief represents the recurring celebration of the New Year Festival.

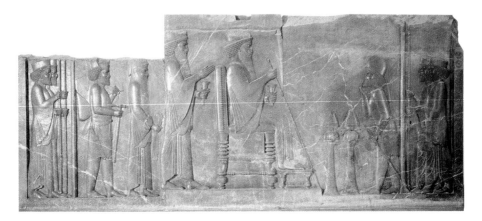

2.30. *Darius and Xerxes Giving Audience.* ca. 490 BCE. Limestone, height 8′4″ (2.5 m). Archaeological Museum, Tehran, Iran

The Achaemenid synthesis of traditions at Persepolis demonstrates the longevity and flexibility of the Near Eastern language of rulership. On a grand scale, the palace provides a dramatic and powerful setting for imperial court ritual.

Mesopotamia Between Persian and Islamic Dominion

Rebuffed in its attempts to conquer Greece, the Persian Empire eventually came under Greek and then Roman domination, but like many parts of the Greek and Roman empires, it retained numerous aspects of its own culture. The process began in 331 BCE with the victory of Alexander the Great (356–323 BCE) over the Persians. He burnt the palace at Persepolis in an act of symbolic defiance. His realm was divided among his generals after his death eight years later, and Seleukas (r. 305–281 BCE) inherited much of the Near East. The Parthians, who were Iranian nomads, succeeded the Seleucids, gaining control over the region in 238 BCE. Despite fairly constant conflict, the Parthians fended off the Romans until a brief Roman success under Trajan in the early second century CE, after which Parthian power declined. The last Parthian king was overthrown by one of his governors, Ardashir or Artaxerxes, in 224 CE. Ardashir (d. 240 CE) founded the Sasanian dynasty, named for a mythical ancestor, Sasan, who claimed to be a direct descendent of the Achaemenids, and this dynasty controlled the area until the Arab conquest in the mid-seventh century CE.

Ardashir's son, Shapur I (r. 240–272 CE), proved to be Darius's equal in ambition, and he linked himself directly to Darius. He greatly expanded the empire, and even succeeded in defeating three Roman emperors in the middle of the third century CE. Shapur commemorated two of these victories in numerous reliefs, including the immense example carved into rock at Naksh-i-Rustam, near Persepolis, where Darius I and his successors had located their rock-cut tombs (fig. 2.31). The subject is a recognizable type: For Romans, this was a stock scene, in which the victor, on horseback, raises his hand in a gesture of mercy to the defeated "barbarian," who kneels before him in submission. This gives the relief an ironic dimension, for the vic-

ART IN TIME

ca. 559–530/529 BCE—Rule of Cyrus the Great, who leads Persians
to overthrow the Medes

ca. 518—**Construction of the Persian palace at Persepolis begins**

ca. 406 BCE—Death of Greek playwright Sophocles,
author of *Oedipus Tyrannus*

331 BCE—Alexander the Great defeats the Persians

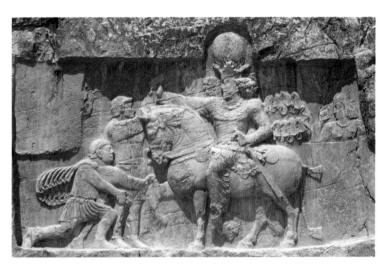

2.31. *Shapur I Triumphing over the Roman Emperors Philip the Arab and Valerian.* 260–272 CE. Naksh-I-Rustam (near Persepolis), Iran

torious Shapur expropriates his enemy's iconography of triumph. Elements of style are typical of late or provincial Roman sculpture, such as the linear folds of the emperor's billowing cloak. But Shapur's elaborate headdress and clothing, his heavily caparisoned horse, and his composite pose are distinctly Near Eastern.

Roman and Near Eastern elements are combined again in Shapur I's palace (242–272 CE) at Ctesiphon, near Baghdad, with its magnificent brick, barrel-vaulted audience hall or *iwan* (fig. 2.32). The exploitation of the arch to span huge spaces was a Roman practice (see fig. 7.68), and it was used here to enclose a

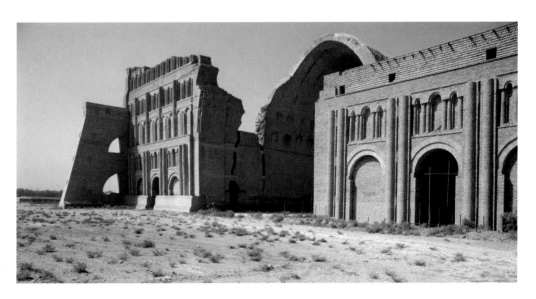

2.32. Palace of Shapur I. 242–272 CE. Ctesiphon, Iraq

space 90 feet high. The facade also reflects Roman models. The registers of arched blank windows or **blind arcades** may derive from Roman facades, such as in the stage buildings in theaters or ornamental fountains (see fig. 7.8). Yet the symmetry and the shallow depth of the arcades create a distinctly eastern surface pattern, subordinated to an awe-inspiring entry way. Shapur I continued the Near Eastern tradition of large-scale royal building.

Metalwork continued to flourish in the Sasanian period, executed in a variety of techniques. Hunting scenes were a popular subject, as seen in figure **2.33**, a late fifth-century CE silver bowl probably representing King Peroz I hunting gazelles.

The bowl was turned on a lathe, and the king and his prey were hammered out from behind (a technique known as *repoussé*) and emphasized in gilt. Details, such as the horns of the animals and the pattern on the quiver, are inlaid with niello, a compound of sulphur. The hunting subject continues a tradition known to Assyrians, and to Egyptians and Romans. Much Sasanian ware was exported to Constantinople (see map 8.1) and to the Christian West, where it had a strong effect on the art of the Middle Ages. Similar vessels would be manufactured again after the Sasanian realm fell to the Arabs in the mid-seventh century CE, and served as a source of design motifs for Islamic art as well (see Chapter 9).

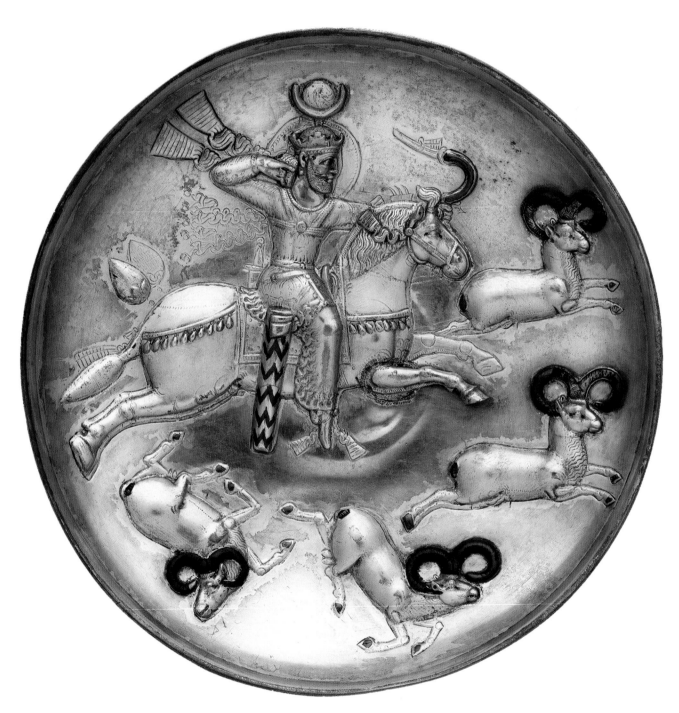

2.33. *King Peroz I Hunting Gazelles.* 457–483 CE.
Silver gilt, engraved, embossed, and inlaid with niello, diameter 8⅝″ (21.9 cm), height 1⅞″ (4.6 cm).
The Metropolitan Museum of Art, New York, Fletcher Fund, 1934 (34.33)

SUMMARY

During the last four millennia BCE, numerous civilizations rose and fell in the fertile lands of Mesopotamia and the neighboring lands in western Asia. Still, their art forms are surprisingly constant. Artists and architects were hired to express the authority of gods and rulers; in doing so, they also played a vital role in maintaining that authority. They produced a multitude of monuments, ranging from magnificent temples and palaces to relief and free-standing sculpture, often on a dizzying scale, as well as small but intricately carved cylinder seals and works in precious metals, ivory, and stone. They also explored sophisticated strategies for telling stories, and for guiding a visitor's movement through space. Mesopotamian art is deeply informed by the constant movement of peoples, objects, and ideas that characterized the time. Even today, deprived of its cultural and political context, it is an art of tremendous power.

SUMERIAN ART

Sumerian art and culture provided a model of visual communication that later groups entering Mesopotamia adapted to their own needs. Sumerian ziggurats offered imposing and highly visible platforms for religious structures and rituals. Surviving examples of Sumerian figure sculpture demonstrate a refined but abstract approach to representing the figure, whether in hard materials that were carved or in more pliable materials that were modeled or cast. The expensive materials used in grave goods for Sumerian elites express the level of resources they controlled as well as their power. Sumerian objects also reveal that culture's interest in telling stories in legible terms. Along with writing, Sumerians recorded aspects of their culture in carved seals.

ART OF AKKAD

At its height, the Empire of Akkad encompassed lands from Sumer to Syria to Nineveh. Akkadian rulers absorbed characteristics of Sumerian art but altered its imagery to create their own language of power; figural representations harked back to Sumerian precedents but expressed the authoritarian nature of Akkadian kingship. One of the most impressive surviving works is the magnificent copper portrait head found at Nineveh.

NEO-SUMERIAN REVIVAL

As the third millenium BCE came to an end, the cities of Sumer returned to the Sumerian language and blended their old artistic traditions with those of the Akkadian traditions. Building great ziggurats to local gods was an act of piety and of power. Following the example of the Akkadians, these Sumerian rulers took pains to represent themselves in permanent materials and in monumental form.

BABYLONIAN ART

After a period of war and turmoil, the region was unified under the rule of the Babylonian dynasty. The most famous ruler of this period was Hammurabi, who combined military prowess with a respect for Sumerian tradition. He is best known for his law code, which is one of the earliest surviving written bodies of law. During this time, the city of Babylon became the cultural center of Sumer.

ASSYRIAN ART

Assyria conquered southern Mesopotamia by the end of the first millennium BCE and in time expanded its boundaries to stretch from the Sinai Peninsula to Armenia. The theme of Assyrian art is the power of the ruler, and both walled cities and sprawling palaces reflect its military culture. Large guardian figures protected the palaces, while numerous reliefs on the walls recounted in great detail the victories and virtues of the king.

LATE BABYLONIAN ART

Before it was conquered by the Persians, the ancient city of Babylon had a brief reflowering. The best known of the Late Babylonian rulers is Nebuchadnezzar II, who was responsible for the famed Hanging Gardens. The royal palace built at this time was decorated with colorful glazed bricks, decorated with a procession of hundreds of sacred animals.

REGIONAL NEAR EASTERN ART

Alongside the variety of cultures within Mesopotamia were various other cultures that developed in areas beyond the Tigris and Euphrates. Some of these groups were invaders or conquerors, and others were traders. Two distinct civilizations among those that flourished alongside and interacted with the Mesopotamian civilizations were the Hittites and the Phoenicians.

IRANIAN ART

Located east of Mesopotamia, ancient Iran became a gateway for migrating tribes, and its art reflects these many intersections. Under the ruler Cyrus the Great, the Persians came to dominate their neighbors and eventually—during the reigns of Darius and his son Xerxes—the entire Near East. One remarkable artistic achievement of the ancient Iranians was the grand palace at Persepolis, which was burnt by a later conqueror, Alexander the Great.

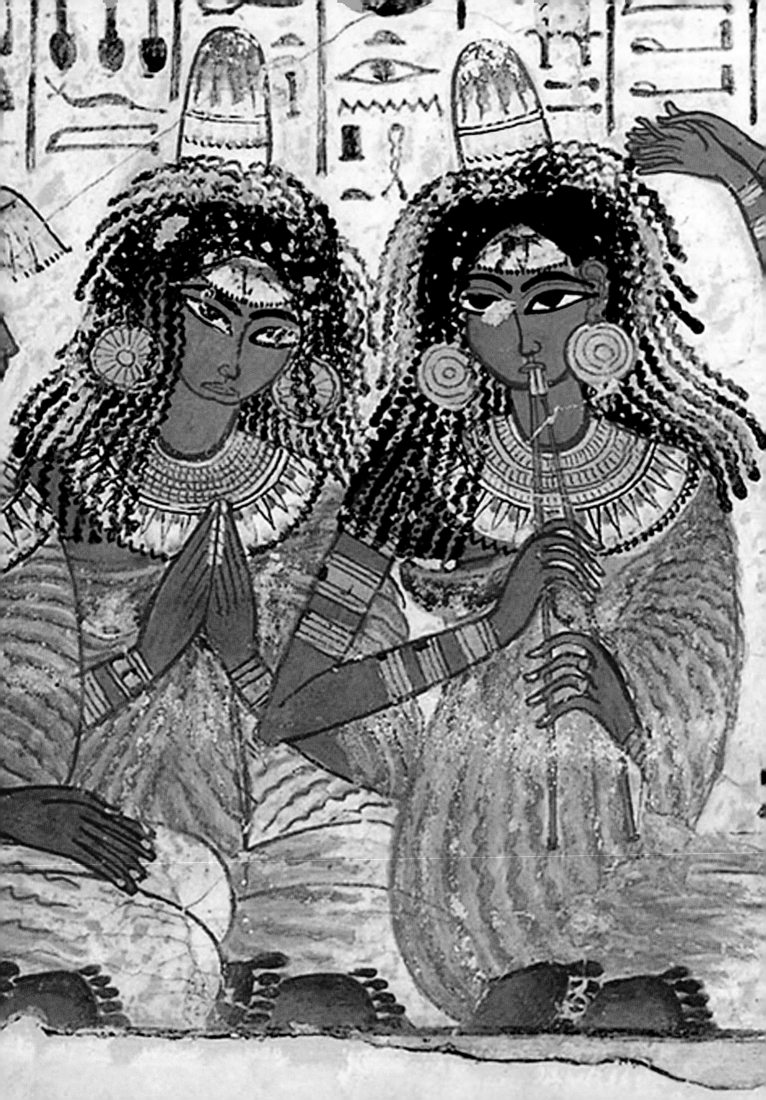

Egyptian Art

EGYPT HAS FASCINATED THE WEST FOR MILLENNIA. THE ANCIENT GREEKS and the Romans knew and admired Egypt, and their esteem passed to collectors and scholars in the Renaissance. Napoleon's incursions into Egypt at the end of the eighteenth century brought artifacts and knowledge back to France and stimulated interest throughout Europe.

European-sponsored excavations have been going on in Egypt since the nineteenth century, sometimes, as with the discovery in 1922 of the tomb of King Tutankhamen, with spectacular results. Modern excavations and research continue to intrigue the contemporary world.

One reason that ancient Egypt enthralls us is the exceptional technique and monumental character of its works of art. Most of these objects come from the monumental tombs that the Egyptians constructed. Egyptian tombs were built to assure a blissful afterlife for the deceased, and the paintings, sculptures, and other objects in them had an eternal purpose. Works of art were meant to accompany the deceased into eternity. Thus, Egyptian art is an art of permanence, not of change. In fact, the Greek philosopher Plato claimed that Egyptian art had not changed in 10,000 years. The reality is more complex, but it is fair to say that Egyptian artists did not strive for change or originality. Rather, they adhered to traditional formulations that expressed specific ideas, so continuity of form and subject is a characteristic of ancient Egyptian art.

Egyptian artists made art mainly for the elite patrons of a society that was extremely hierarchical. Contemporary with the Egyptian development of writing around 3000 BCE was the development of a political and religious system that placed a god-king (called a pharaoh from the New Kingdom on) in

Detail of figure 3.33, *Musicians and Dancers*

charge of the physical and spiritual well-being of the land and its people. Many of the best-known and most evocative works of Egyptian art were made for these powerful rulers. Royal art expresses the multifaceted ways that the king was envisioned: as a human manifestation of the gods, as a god in his own right, as beneficent ruler, and as an emblem of life itself. Royal projects for the afterlife dominated the Egyptian landscape and provided the model for all elite burials. Because the kings commissioned some of Egypt's most impressive tombs, the imagery of kingship intersected with the imagery of the afterlife in powerful ways.

These two categories of art—royal commissions and funerary objects—constitute most of the surviving Egyptian art. Egyptian religion accounts for the predominance of both types of art, and so does the land's geography. Established along the course of the Nile River in North Africa and protected by the surrounding desert, or "red land," Egypt was comprised of two distinct regions. Upper Egypt, in the south, includes the Nile Valley between present-day Aswan and the beginning of the Delta, near ancient Memphis and present-day Cairo. In lower Egypt, in the north, the Nile fans out into a delta. The Nile floods annually, inundating the land on either side along the river. As it recedes, the water leaves a dark strip of soil fertilized by silt. The result is a rich soil that the Egyptians called the "black land." It was irrigated and farmed and regularly produced surplus food. This allowed the Egyptians to diversify and develop a complex culture.

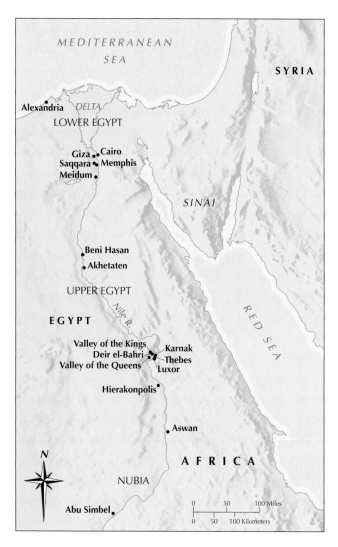

Map 3.1. Ancient Egypt

Egypt's agrarian society depended on the annual flooding of the Nile to survive. The king had to assure the continuity of life through intercession with the gods, who often represented natural forces. The chief deity was the sun, worshiped as the god Ra-Horakhty. But for the Egyptians concerned with a good afterlife, the deities Osiris, his consort Isis, and their son Horus played key roles. The gods took many forms: Ra might appear as a falcon-headed man; Osiris—who was killed and resurrected— as a mummy. The king himself was called the son of Ra and the human embodiment of Horus. As an equal to the gods, he controlled the land, the future, and the afterlife. A large priesthood, an administrative bureaucracy, and a strong military assisted him, but the king could call on anyone to serve him.

PREDYNASTIC AND EARLY DYNASTIC ART

The origins of Egyptian culture stretch back into the Neolithic period. By at least 5000 BCE, humans were growing crops and domesticating animals in the Nile Valley. Settlements there were gradually transformed into urban centers. In Upper Egypt, independent cities shared a rich culture that archaeologists know as

Naqada II/III (from the location where it was first discovered). With time, the culture of Upper Egypt spread northward, ultimately dominating the centers of Lower Egypt. Within a few centuries the cultures of Upper and Lower Egypt were united, and, so tradition has it, the first king of the first dynasty founded the city of Memphis, at the mouth of the Nile Delta (see map 3.1).

The division of Egypt into two distinct regions, Upper and Lower, arises from the Egyptian worldview. Egyptians saw the world as a set of dualities in opposition: Upper and Lower Egypt, the red land of the desert and the black land of cultivation, the god of the earth (Geb) balanced by the sky (Nut), Osiris (the god of civilization) opposed to Seth (the god of chaos). The forces of chaos and order had to be balanced by the king, who must bring *ma'at* (harmony or order) to the world. Recognizing this worldview has led some scholars to reconsider the traditional explanation that Upper and Lower Egypt were independent regions that were unified by King Narmer in the predynastic period. Instead, they have argued that this division was an imaginative construction of the past that came out of the dualistic worldview. Artists would have had to find a visual means to communicate this story of Egypt's origins.

The Palette of King Narmer

The concept of the king as unifier was expressed in the *Palette of King Narmer* (fig. **3.1**), dated around 3000 BCE. The Palette is a stone tablet with a depression at the center for grinding protective paint applied around the eyes. Its size—more than two feet high—implies that it was not for ordinary use, but probably used in a ceremony to grind eye makeup for a cult statue. This ritual function may explain where it was found. Archaeologists discovered the Palette in the temple of Hierakonpolis, where it had been buried along with other offerings to the god Horus.

The Palette is carved on both sides in registers (rows) in shallow relief. At the top of each side, in the center, Narmer's name is written in **hieroglyphs**, within an abstract rendering of the king's palace. Hieroglyphs were a writing system the Egyptians developed at about the same time as the Mesopotamians were inventing cuneiform. Named by the Greeks, who saw them as sacred writings, from *hieros* (sacred), and *graphein* (to write), they were used in both religious and administrative contexts. The Egyptians themselves called them "god's words." On either side of the hieroglyphs, heads of cows represent the sky goddess, locating the king in the sky. On one side of the Palette (shown on the left), King Narmer holds a fallen enemy by the hair, as he raises his mace—an emblem of kingship—against him with the other. The king is shown in the composite view that will be the hallmark of Egyptian two-dimensional art: with a frontal view of eye, shoulders, and arms, but a profile of head and legs. He wears the white crown of Upper Egypt and from the belt of his kilt hangs the tail of a bull, a symbol of power that Egyptian kings would wear as part of their ceremonial dress for 3,000 years. The large scale of his figure compared with others immediately establishes his authority. For his part, the enemy, like the two defeated enemies in the bottom register, is stripped of clothing as an act of humiliation. Behind the king, and standing on his own ground-line, is an attendant carrying the king's sandals.

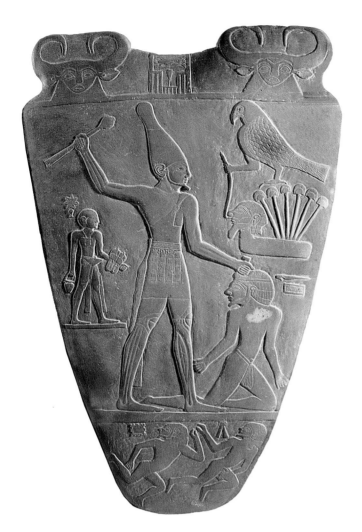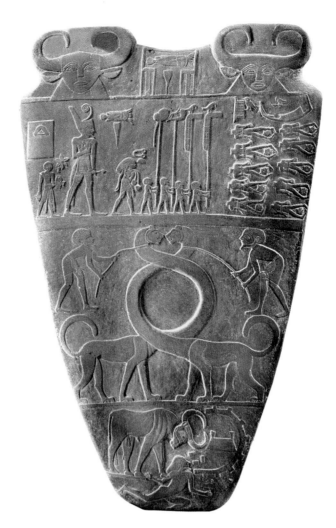

3.1. *Palette of King Narmer* (both sides), from Hierakonpolis. ca. 3150–3125 BCE. Slate, height 25″ (63.5 cm). Egyptian Museum, Cairo

Hieroglyphs identify both the sandal-carrier and the enemy. To the right of Narmer appears a falcon resting on a papyrus stand, which grows from a human-headed strip of land; the falcon holds a rope tethered to the face.

On the other side of the Palette (on the right in fig. 3.1), Narmer appears in the highest register, this time wearing the red crown of Lower Egypt. Flanked by the sandal carrier and a long-haired figure, he follows a group of four standard-bearers to inspect the decapitated bodies of prisoners, arranged with their heads between their legs. In the larger central register, two animals, each roped in by a male figure, twist their long necks to frame a circle in the composition. The symmetrical, balanced motif may represent "*ma'at*" (order). Though their significance in this context is uncertain, similar beasts occur on contemporary Mesopotamian cylinder seals, and may have influenced this design. In the lowest register, a bull representing the king attacks a city and tramples down the enemy. The Palette is significant because it communicates its message by combining several different types of signs into one object. Some of these signs—the king, attendants, and prisoners—are literal representations. Others are symbolic representations, such as the depiction of the king as a bull, denoting his strength. Pictographs, small symbols based on abstract representations of concepts, encode further information: In the falcon and papyrus

group, the falcon represents the god Horus, whom the Egyptians believed the pharaoh incarnated, while the human-headed papyrus stand represents Lower Egypt, where papyrus grew abundantly. A possible interpretation is that this pictograph expresses Narmer's control of that region. Finally, the artist included identifying texts in the form of hieroglyphs. Together, these different signs on the *Palette of King Narmer* drive home historically important messages about the nature of Egyptian kingship: The king embodied the unified Upper and Lower Egypt, specified in the differing crowns he wears on either side of the Palette. Though human, he occupied a divine office, as shown by the placement of his name in the sky, the realm of Horus, a celestial deity.

By the Fifth Dynasty, Horus was perceived as the son of Isis and Osiris. Osiris was the mythical founder of Egypt. His brother Seth (god of chaos) murdered and dismembered him, and scattered his remains. Osiris's consort, Isis, eventually recovered and reassembled them to create the first mummy, from which she conceived her son, Horus, who avenged his father's death by besting Seth in a series of contests. Egyptians saw the king as Horus's manifestation on earth; as such, he provided a physical body for the royal life force (*ka*) that passed from monarch to succeeding monarch. Positioned at the pinnacle of a highly stratified human hierarchy (indicated by his

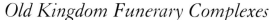

ART IN TIME

ca. 5000 BCE—Human settlements along the Nile Valley

ca. 3500 BCE—Pottery manufacturing appears in western Europe

ca. 3000 BCE—The ancient Egyptian *Palette of King Narmer*

ca. 2900 BCE—Mesopotamians begin using cuneiform writing

Old Kingdom Funerary Complexes

During the Old Kingdom, buildings that housed the day-to-day activities of the living were constructed mainly of perishable materials, with the result that little survives. The bulk of archeological evidence comes instead from the funerary sphere, that is, from tombs. The great majority of the population were probably buried in shallow desert graves, but the elite had the resources to build elaborate funerary monuments and provide for their trappings. The survival of these tombs is no accident; they were purposely constructed to last through eternity.

These structures had several important functions. As in many cultures, tombs served the living by giving the deceased a permanent marker on the landscape. They indicated the status of the dead and perpetuated a memory of them. Early elite and royal burials were generally marked by a rectangular mud-brick or stone edifice (fig. **3.2**), known today as a *mastaba*, from the Arabic word for "bench." Its exterior sloping walls were plastered and painted to evoke a niched palace facade. This super-structure might be solid mud brick or filled with rubble, but sometimes it housed storerooms for equipment needed in funerary rituals or a funerary chapel. These monuments also served a critical function in ensuring the preservation of a deceased individual's life force, or *ka*. Egyptians considered the *ka* to live on in

scale), the king stood between mortals and gods, a kind of lesser god, and his role was to enforce order over its opposing force, chaos, which he does here by overcoming foreign foes and establishing visible authority over them.

THE OLD KINGDOM: A GOLDEN AGE

The *Palette of King Narmer* offers an image of kingship that transcends earthly power, representing the king as a divinity as well as a ruler. The kings of the Old Kingdom (Dynasty Three to Dynasty Six, ca. 2649 to 2150 BCE) found more monumental ways to express this notion. Their dynasties and their works of art would be emulated for the following two millennia. (See *Informing Art*, page 51.)

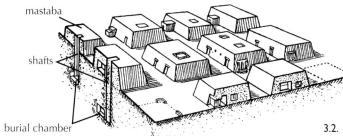

3.2. Group of mastabas (after A. Badawy). 4th Dynasty

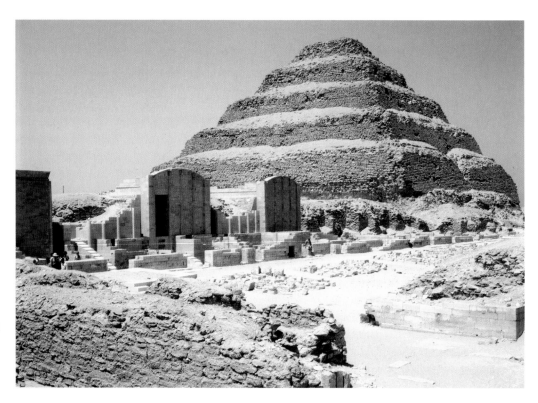

3.3. Imhotep. Step Pyramid and Funerary Complex of King Djoser, Saqqara. 3rd Dynasty. ca. 2681–2662 BCE

Major Periods in Ancient Egypt

In Egyptian society, a king's life was the measure of time. To organize the millennia of Egyptian culture, scholars use a chronology devised in the third century BCE by the priest-historian Manetho, who wrote a history of Egypt in Greek for Ptolemy I, based on Egyptian sources. He divided the list of Egyptian kings into thirty-one dynasties, beginning with the First Dynasty shortly after 3000 BCE. Modern scholars have organized the dynasties into kingdoms, beginning with the Old Kingdom, from roughly 2649 BCE to 2150 BCE. The period before this, between prehistory and the First Dynasty, is known as the predynastic period. Further subdivisions include the Middle Kingdom (ca. 2040–1640 BCE) and the New Kingdom (ca. 1550–1070 BCE). The actual dates for these broad periods and even for the reigns of kings are still being debated, as Manetho's list offered only a relative chronology (that is, the order in which kings succeeded one another) rather than absolute dates.

MAJOR PERIODS IN ANCIENT EGYPT

Before	Predynastic
ca. 2920 BCE	
ca. 2640–2469 BCE—Early Dynastic (Dynasties 1, 2)	
ca. 2649–2150 BCE—Old Kingdom (Dynasties 3–6)	
ca. 2040–1640 BCE—Middle Kingdom (Dynasties 11, 12)	
ca. 1550–1070 BCE—New Kingdom (Dynasties 18–20)	

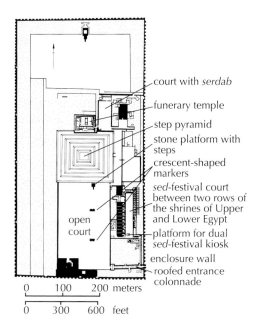

3.4. Plan of the funerary district of King Djoser, Saqqara (Claire Thorne, after Lloyd and Müller)

3.5. Transverse section of the Step Pyramid of King Djoser, Saqqara

the grave, and in order to do so, it required a place to reside for eternity. This is why embalmers went to such great lengths to preserve the body through mummification (a process that was only perfected in the Eleventh and Twelfth Dynasties). The mummified body, usually placed within a **sarcophagus** (a stone coffin) was interred in a burial chamber at some depth below the *mastaba*, surrounded by chambers for funerary equipment. Should the embalmers' efforts fail and the body decay, a statue could serve as a surrogate home for the *ka*, and so was placed within the burial chamber. Egyptians also equipped their tombs with objects of daily life for the *ka* to enjoy.

THE FUNERARY COMPLEX OF KING DJOSER Out of this tradition the first known major funerary complex emerges, that of the Third Dynasty King Djoser (Netjerikhet), at Saqqara (figs. **3.3**, **3.4**, and **3.5**), who ruled between 2630–2611 BCE. On the west side of the Nile, Saqqara was the **necropolis**, or city of the dead, of the capital city of Memphis in Lower Egypt. Encircling the entire complex is a rectangular enclosure wall of stone

stretching over a mile in length and 33 feet high. Dominating it, and oriented to the cardinal points of the compass, is a stepped pyramid, seen in fig. 3.3 and in a transverse section in fig. 3.5. It began as a 26-foot high mastaba, which originally would have been concealed by the enclosure wall. Over the course of years it rose to its towering 204-foot high form, as progressively diminishing layers of masonry were added, resulting in a staircase, perhaps the means by which the king could ascend to the gods. The treads of the "steps" incline downwards and the uprights outwards, giving the structure an impressively stable appearance. A chamber excavated about 90 feet into the rock beneath the pyramid and lined with Aswan granite contained the burial, accompanied by other chambers for provisions. North of the pyramid was a labyrinthine funerary temple, where offering rituals were performed for the dead king.

The buildings in the burial complex reproduce the palace architecture inhabited by the living king. In the palace, large courts were used to celebrate rituals of kingship. Similarly, a large court to the south of the pyramid may have housed rituals

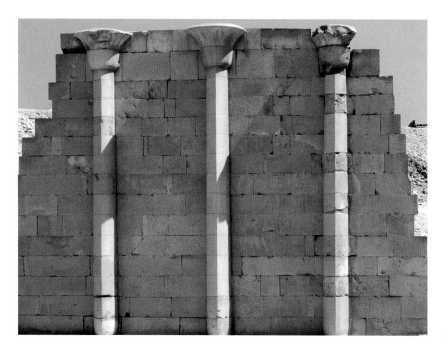

3.6. Papyrus-shaped half-columns, North Palace, Funerary Complex of King Djoser, Saqqara

of receiving tribute or asserting royal dominion. The smaller oblong court to its east, flanked by shrines of Upper and Lower Egypt, may have been the site of the *sed*-festival, a ceremony that celebrated the king's 30-year jubilee and rejuvenated his power. Both sets of rituals were thought to be enacted by the dead king. Unlike the structures in a palace, many of the buildings in the funerary complex are nonfunctional: Of 14 gateways indicated in the niched enclosure wall, which evokes a palace facade, only one (on the southeast corner) allows entrance, while the rest are false doors. Similarly, chapels dedicated to local gods were simply facades with false doors, their rooms filled with rubble, sand, or gravel. Furthermore, while palaces were built of perishable materials—primarily mud brick—the funerary complex, constructed entirely in limestone, was built to last. Masons dressed the limestone blocks of the enclosure wall to resemble the niched facades of mud-brick architecture. Additionally, the reconstructed facade of a shrine echoes the form of an Upper Egyptian tent building, with tall poles supporting a mat roof that billows in the wind. Engaged columns imitate the papyrus stems or bundled reeds that Egyptian builders used to support mud-brick walls, with capitals shaped to resemble blossoms (fig. **3.6**). Paint over the stone lintels disguises them as wood, and inside the tomb chamber, blue and green tiles covered false doors to imitate rolled up reed matting.

Instead of being used by the living, many elements of the complex served as permanent settings for the dead king to perpetually enact rituals of kingship—rituals that maintained order among the living. The pharaoh's presence in the complex was assured by the installation of a life-sized seated statue of him in a *serdab* (an enclosed room without an entrance) to the east of the funerary temple. Two holes in the *serdab*'s front wall enabled his *ka*, residing in the statue, to observe rituals in his honor and draw sustenance from offerings of food and incense. The entire complex was oriented north-south, and the king's

statue looked out toward the circumpolar stars in the northern sky. Within the precinct dominated by the step pyramid that assisted the ascension of the king toward the sun, his *ka* would remain eternally alive and vigilant.

Inscriptions on fragments of statues found within the complex preserve the name of the mastermind behind its construction, a high official in Djoser's court named Imhotep, who is often identified as the first named architect in history. High priest of the sun-god Ra, Imhotep was credited with advancing Egyptian culture through his wisdom and knowledge of astronomy, architecture, and medicine, and he was so highly regarded within his own time and beyond that he was deified. This complex, the first large-scale building constructed entirely in stone, preserves at least one of his legacies.

The Pyramids at Giza: Reflecting a New Royal Role

Other kings followed Djoser's lead, but during the Fourth Dynasty, ca. 2575–2465, funerary architecture changed dramatically. To the modern eye, the most obvious change is the shift from a step pyramid to a smooth-sided one. A pyramid at Meidum attributed to Sneferu, the founder of the Fourth Dynasty, underlines the deliberateness of the transformation: Originally a step pyramid, its steps were later filled in to produce smooth sides.

The best known pyramids, however, are the three Great Pyramids at Giza (fig. **3.7**), built in commemoration of Sneferu's son, Khufu (the first and largest pyramid), Khafra (a moderately smaller pyramid), and Menkaure (the smallest pyramid). Throughout the ages since their construction, the pyramids have continued to fascinate and enchant—and for good reason. Their lasting grandeur derives both from their sheer monumentality (Khafra's covers 13 acres at the base, and even today rises to a

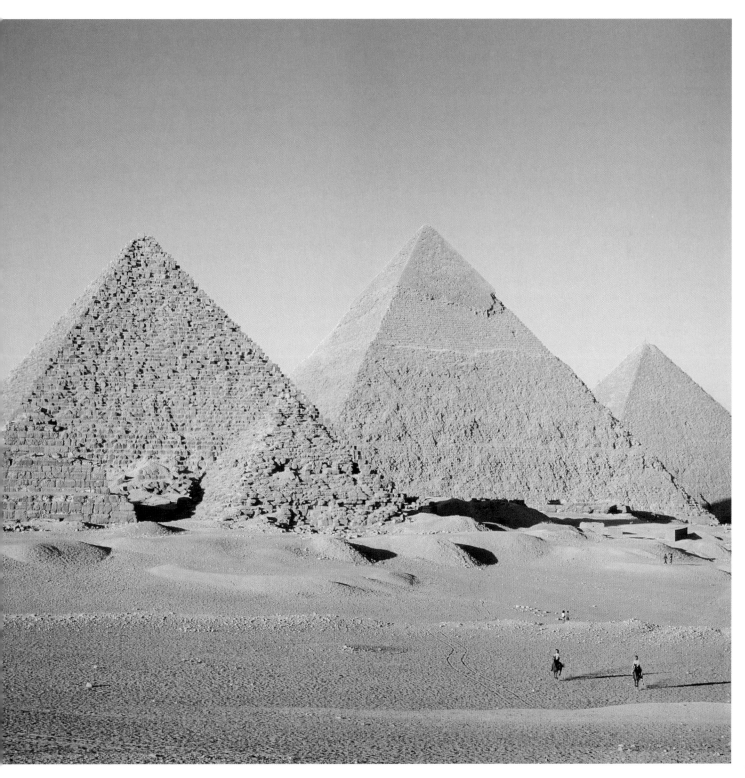

3.7. The Pyramids of Menkaure, ca. 2533–2515 BCE, Khafra, ca. 2570–2544 BCE, and Khufu, ca. 2601–2528 BCE, Giza

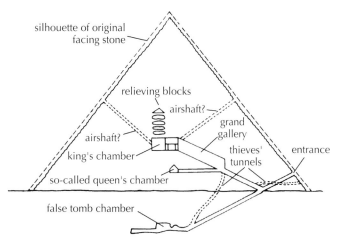

silhouette of original facing stone

relieving blocks

airshaft?

airshaft?

grand gallery

king's chamber

thieves' tunnels

entrance

so-called queen's chamber

false tomb chamber

3.8. North–south section of Pyramid of Khufu (after L. Borchardt)

height of about 450 feet) and from their extraordinary simplicity. On a square plan, their four surfaces, shaped as equilateral triangles, taper up from the desert sand toward the sky. At any time of day, one side will hold the sun's full glare, while another is cast into shadow. Before Islamic builders plundered their stone, each pyramid was dressed with white limestone, preserved only on the pinnacle of the Pyramid of Khafra; at the tip, moreover, each was covered with a thin layer of gold. On Khafra's pyramid, a course of red granite set off the limestone's whiteness at ground level. The entrance to each pyramid was on its north face, and somewhere within the solid stone mass, rather than below ground, a burial chamber was concealed in the hopes of foiling tomb-robbers (fig. **3.8**). Encircling each pyramid was an enclosure wall, and clustered all around are several smaller pyramids and mastabas for members of the royal family and high officials.

Like Djoser's complex at Saqqara and most subsequent royal burials, Fourth Dynasty burials were located on the Nile's west bank, the side of the setting sun, across from living habitations on the east bank (fig. **3.9**). Yet unlike Djoser's complex, with its compact form laid out on a north–south axis, those at Giza were set out on an extended east–west axis. At the start of the funeral ceremony, the body was transported westward across the Nile. Once beyond the land under cultivation, the procession reached the valley temple, connected to the Nile by a canal. The valley temple of Khafra features a central T-shaped hallway, where walls and pillars of costly red Aswan granite were set off by floors of white calcite. Light cascaded in through slits in the upper walls and the red granite roof.

Running west from the valley temple into the desert for about a third of a mile, a raised and covered causeway led to the funerary temple, adjoined to the pyramid's east face, where the dead king's body was brought for embalming, and where the living perpetuated the cult for his *ka*. Again, a rich variety of hard stone made for a vivid coloristic effect; relief sculptures probably also decorated the funerary temples, but have mostly perished with time. Next to the valley temple of Khafra stands the Great Sphinx, carved from an outcropping of rock left after quarrying stone (fig. **3.10**). (Like the word *pyramid*, *sphinx* is a Greek term.) Damage inflicted under Islamic rule, when residents were uncomfortable with human representation in art, has obscured details of its face, and the top of the head is missing, but scholars believe that a portrait of Khafra (or possibly Khufu) was combined with the crouching body (and thus strength) of a lion. Its huge scale also expresses the king's power.

The change in funerary architecture suggests a shift in the way Egyptians conceived of their ruler. The smooth-sided pyramid was the shape of the *ben-ben*, the sacred stone

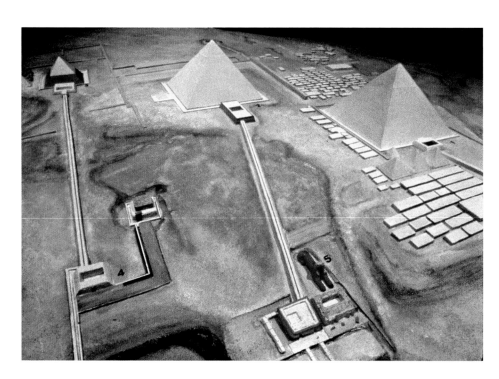

3.9. Model of the Great Pyramids at Giza: (1) Menkaure, (2) Khafra, (3) Khufu

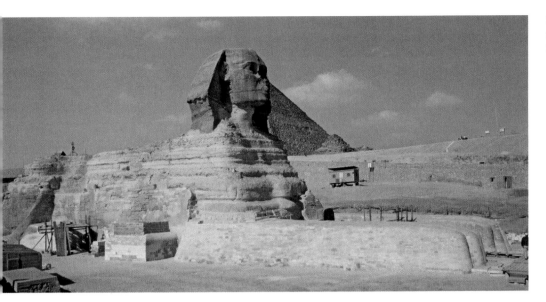

3.10. The Great Sphinx. ca. 2570–2544 BCE. Giza. Sandstone, height 65′ (19.8 m)

relic in Heliopolis, center of the sun cult. This may indicate that these monumental tombs emphasized the solar aspect of the pharaoh's person; indeed, this change in building practice coincides more or less with the pharaoh's adoption of the title "son of Ra" (the sun-god). The change in orientation for the complexes also meant that the pharaoh's funerary temple did not face the northern stars, as before, but the rising sun in the east, signifying eternity through its daily rising and setting. In contrast to the funerary complex for Djoser (see figs. 3.3 and 3.4), the complex at Giza contains no buildings for reenacting rituals of kingship, suggesting that the perpetual performance of these rituals was no longer the dead king's task. Now, his role was to rise to the sun-god on the sun's rays, perhaps symbolized by the pyramid's sloping sides, and to accompany him on his endless cycle of regeneration.

Texts written on the interiors of some later Old Kingdom pyramids express this conception of the role of the king vividly. These pyramid texts were chants or prayers inscribed on the walls inside the pyramid. The *Primary Source* on page 56, from the pyramid of Unis in Saqqara, dates to about 2320 BCE and describes the king's resurrection and ascension.

Representing the Human Figure

Indentations in the paving of the hall in the valley temple of Khafra show that a series of 23 seated statues of the king once lined its walls. Archeologists discovered one of these almost intact and six in poorer condition, interred in the temple floor. The best-preserved statue represents the seated king in a rigidly upright and frontal pose (fig. **3.11**). This pose allowed him to watch—and thus, in a sense, take part in—rituals enacted in his honor; frontality gave him presence. Behind him, the falcon Horus spreads his wings protectively around his head. Like the *Palette of King Narmer*, this sculpture neatly expresses the qualities of kingship. Horus declares the king his earthly manifestation and protégé, and the king's muscular form indicates his power. The smooth agelessness of his face bespeaks his eternal nature, while the sculpture's compact form gives it a

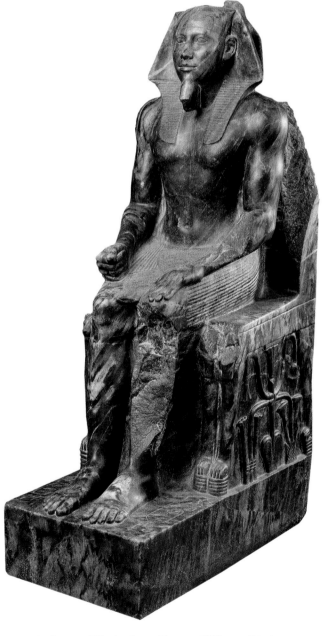

3.11. *Sculpture of Khafra,* from Giza. ca. 2500 BCE. Diorite, height 66″ (167.7 cm). Egyptian Museum, Cairo

Excerpt from the Pyramid Text of Unis (r. 2341–2311 BCE)

King Unis of the Fifth Dynasty built a pyramid at Saqqara on the walls of which were inscribed a series of incantations and prayers for the afterlife of the pharaoh. So-called Pyramid Texts such as these were placed in tombs throughout Egyptian history for both royal and nonroyal burials. Some of their formulas were adapted for different versions of the Book of the Dead. Though their earliest survival is about 2320 BCE, the prayers may have been composed much earlier.

The Resurrection of King Unis

A pale sky darken, stars hide away,
Nations of heavenly bowmen are shaken,
Bones of the earth gods tremble—
All cease motion, are still, for they have looked upon Unis,
 the King,

Whose soul rises in glory, transfigured, a god,
Alive among his fathers of old time, nourished by ancient
 mothers.

The King, this is he! Lord of the twisty ways of wisdom
(whose very mother knew not his name),
His magnificence lights the black sky,
His power flames in the Land of the Risen—
Like Atum his father, who bore him;
And once having born him, strong was the Son more than the Father!

The *Kas* of the King hover about him;
Feminine spirits steady his feet;
Familiar gods hang over him;
Uraei (cobras) rear from his brow;
And his guiding Serpent precedes:
"Watch over the Soul! Be helpful, O Fiery One!"
All the mighty companions are guarding the King!

SOURCE: *ANCIENT EGYPTIAN LITERATURE: AN ANTHOLOGY.* TR. JOHN I. FOSTER (AUSTIN, TX: UNIVERSITY OF TEXAS PRESS, 2001)

solidity that suggests permanence. Intertwined plants—papyrus and perhaps sedge—carved between the legs of his chair are indigenous to Lower and Upper Egypt, indicating the territorial reach of royal authority. Even the material used to carve his image expresses the king's control of distant lands. The stone, diorite, was brought from the deserts of Nubia. A hard stone, it lends itself to fine detail and a high polish, and the strong Egyptian light coming in through the louvred ceiling of the temple and reflected off the white calcite pavement must have made the figure glisten impressively.

A slightly later, three-quarter life-size group carved from schist represents King Menkaure and his chief wife Khamerernebty II (fig. **3.12**). Like the statue of Khafra, it is carved in one piece with an upright back slab, and it exhibits a similar rigid frontality. One reason for this may have been the sculpture's intended location and function. Like the Khafra sculpture, the group may have come from the king's valley temple.

Menkaure and his queen Khamerernebty share several characteristics. Of almost identical height, both are frozen in a motionless stride with the left foot forward. Menkaure's headdress echoes the form of Khamerernebty's hair, and though the king is more muscular than his queen, both bodies are characterized by smooth surfaces and a high polish, even though one is draped and the other half nude. (The queen wears a thin dress, hemmed at her ankles.) These common qualities establish an appearance of unity, and king and queen are further unified by the queen's embrace.

In some cases, traces of paint on sculptures show that sculptors added details with color, but whether they always did so to statues carved in high-quality hard stone is a matter of debate. A pair of Fourth Dynasty sculptures representing the seated Rahotep and his wife Nofret, from a mastaba tomb at Meidum, are carved from limestone, a softer stone than diorite, which does not yield such fine surface detail (fig. **3.13**). Here, the artist painted skin tones, hair, garments,

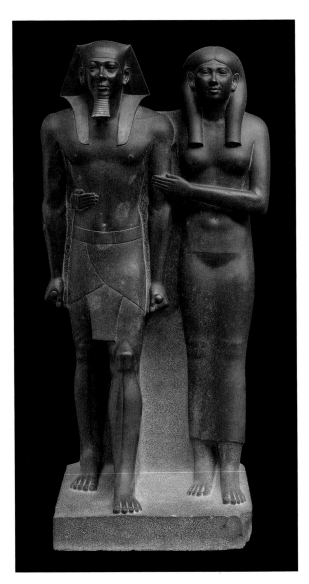

3.12. *Sculpture of Menkaure and His Wife, Queen Khamerernebty II,* from Giza. ca. 2515 BCE. Slate, height 54½″ (138.4 cm). Museum of Fine Arts, Boston. Harvard–Museum of Fine Arts Expedition

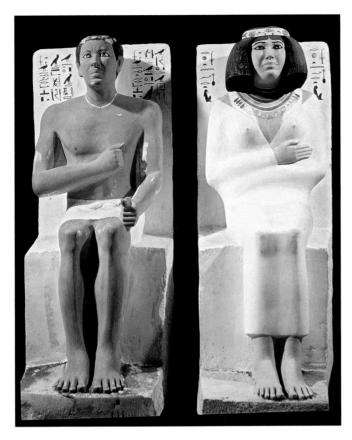

3.13. *Sculpture of Prince Rahotep and His Wife, Nofret.* ca. 2580 BCE. Painted limestone, height 47¼″ (120 cm). Egyptian Museum, Cairo

human image. Traces of such guidelines are still visible on reliefs and paintings. The system of guidelines began in the Fifth Dynasty with a grid of one vertical line, running through the body at the point of the ear, and as many as seven horizontal lines dividing the body according to a standard module. Over time, the guidelines changed, but the principle of this "canon" remained: Although body part measurements could change from person to person, the relationship between parts stayed constant. With that relationship established, an artist who knew the measurement of a single body part could depict a human portrait at any scale, taking the proportions of other essential forms from copybooks. Unlike the system of perspective we know today, where a figure's size suggests its distance from a viewer, in the Egyptian canon, size signaled social status.

Elite male officials were depicted in two kinds of ideal images, each representing a different life stage. One is a youthful, physically fit image, like Hesy-ra or Khafra. The other is a mature

and jewelry, using the standard convention of a darker tone for a male, a lighter tone for a female. Inscriptions identify the pair and describe their social status: He is a government official and she is a "dependent of the king." Rock crystal pupils so animate the eyes that, in later years, robbers gouged the eyes out of similar figures before looting the tombs they occupied. Like the royal portraits, these figures are represented frontally and with ritualized gestures.

Rigid frontality is the norm for royal and elite sculptures in the round. In relief and painting, there is also a remarkable consistency in stance among royal and elite sculptures. The standard stance, as illustrated on a wooden stele found in the mastaba of a court official of Djoser, Hesy-ra, at Saqqara, is altogether unnaturalistic (fig. **3.14**). As on the *Palette of King Narmer* (fig. 3.1), frontal shoulders and arms and a frontal kilt combine with a profile head (with a frontal eye) and legs; the figure has two left feet, shown with high arches and a single toe. The representation is conceptual or intellectual rather than visual: The artist depicts what the mind knows, not what the eye sees. This artificial stance contributes to the legibility of the image, but it also makes the figure static.

THE CANON In royal and elite sculpture in the round, and in relief and painting, body proportions are also consistent enough that scholars believe artists used guidelines for designing the

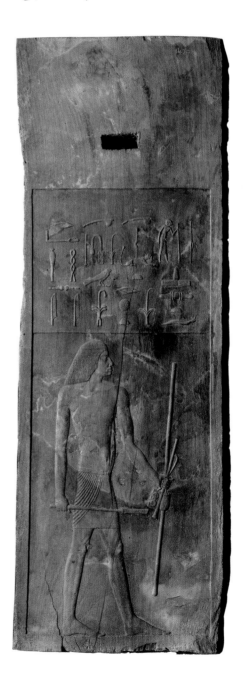

3.14. *Relief Panel of Hesy-ra,* from Saqqara. ca. 2660 BCE. Wood, height 45″ (114.3 cm). Egyptian Museum, Cairo

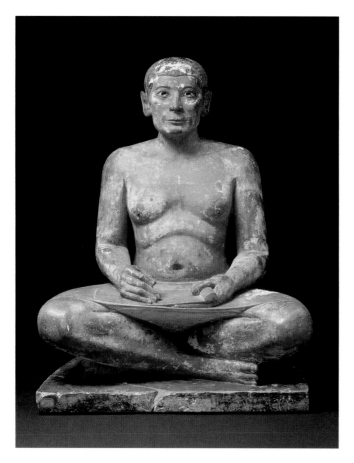

3.15. *Sculpture of Seated Scribe,* from Saqqara. ca. 2400 BCE. Limestone, height 21″ (53.3 cm). Musée du Louvre, Paris

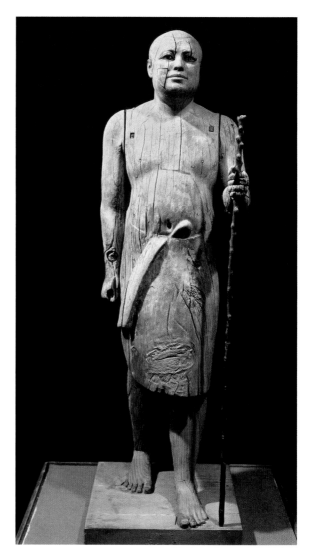

3.16. *Sculpture of Ka-Aper,* from Saqqara. ca. 2450–2350 BCE. Wood, height approx. 3′7″ (109 cm) Egyptian Museum, Cairo

image, often indicated by a paunch, rolls of fat, or slack muscles, and signs of age on the face. A painted limestone figure of a scribe, perhaps named Kay, from his mastaba at Saqqara, is an example of the second type (fig. **3.15**). The scribe is rigidly upright and frontal, like Khafra, but unlike the ageless monarch, his body shows signs of slackening, in the sallow cheeks, sagging jaw, and loose stomach. Since Egyptian society was mostly illiterate, a scribe occupied an elevated position; indeed, seated on the floor, the figure is depicted in the act of writing, the skill in which his status resided. The image suggests his social status: It shows an official who has succeeded in his career, eats well, and relies on subordinates to work on his behalf. A wooden statue of an official named Ka-Aper, also from his mastaba at Saqqara, displays the same phenomenon (fig. **3.16**). Despite the frozen stride, and even stripped of paint, the portrait appears extraordinarily lifelike, with its rock crystal eyes and sensitively carved face; the double chin and generous paunch add to its naturalism, as does the absence of a backslab. Like the scribe, Ka-Aper bears the insignia—the staff—of his office.

These conventions of pose, proportion, and appearance applied only to the highest echelons of society—royalty and courtiers. By contrast, the lower the status of the being represented, the more relaxed and naturalistic their pose. Once the conventions were established, ignoring them could even result in a change of meaning for a figure, especially a change of status, from king or official to servant or captive. The correlation between rank and degree of naturalism is neatly encapsulated in fine low

relief paintings in the tomb chapel of Ti, a high official during the Fifth Dynasty, at Saqqara (fig. **3.17**). In the section illustrated here, Ti stands on a boat in a thicket of papyrus, observing a hippopotamus hunt. He stands rigidly in the traditional composite view, legs and head in profile, torso and eye frontal, while hunters, shown on a smaller scale, attack their prey from a second boat in a variety of active poses that more closely resemble nature. Zigzagging blue lines beneath the boats denote the river, where hippopotami and fish—on the lowest rung of the natural world—move freely. Similarly, nesting birds and predatory foxes move freely in the papyrus blossoms overhead.

PAINTINGS AND RELIEFS Like statues in tombs, paintings and reliefs such as these played a role in the Egyptian belief system. Images such as *Ti Watching a Hippopotamus Hunt* allowed the deceased to continue the activities he or she had enjoyed while alive. Yet they also functioned on various metaphorical levels. The conquest of nature, for instance, served as a metaphor for triumph over death. Death was Osiris's realm, as god of the underworld, but so was the Nile his realm because of Osiris's regeneration after Seth had murdered him.

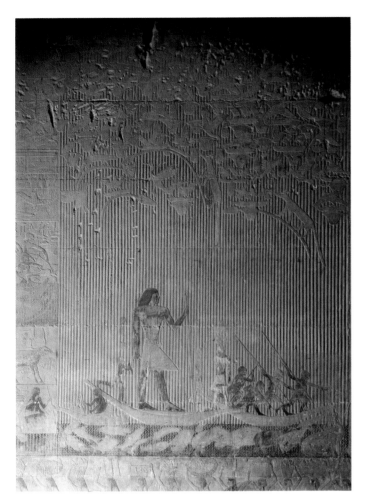

3.17. *Ti Watching a Hippopotamus Hunt.* ca. 2510–2460 BCE. Painted limestone relief, height approx. 45″ (114.3 cm). Tomb of Ti, Saqqara

This led to the turbulent First Intermediate Period lasting over a century, when local or regional overlords fostered antagonisms between Upper and Lower Egypt. The two regions were reunited again in the Eleventh Dynasty, as King Nebhepetra Mentuhotep or Mentuhotep II (ca. 2061–2010 BCE) gradually reasserted regal authority over all of Egypt. The Eleventh and Twelfth Dynasties make up the Middle Kingdom (ca. 2040–1640 BCE), and much of the art of the period deliberately echoed Old Kingdom forms, especially in the funerary realm. This art asserted continuity with earlier rulers, but sculptures of members of the royal family also show breaks with tradition.

Royal Portraiture: Changing Expressions and Proportions

A fragmentary quartzite sculpture of Senwosret III (r. 1878–1841 BCE) suggests a break with convention in the way royalty is depicted (fig. **3.18**). Rather than sculpting a smooth-skinned, idealized face, untouched by time—as had been done

Osiris, after all, was the god of fertility and resurrection, to whom the deceased could be likened. And, because Isis hid Horus in a papyrus thicket to protect him from Seth, a papyrus stand was considered a place of rebirth, much like the tomb itself. Traditionally, too, a boat was the vehicle that carried the *ka* through its eternal journey in the afterlife. By contrast, the hippopotamus, which destroyed crops, was often viewed as an animal of evil and chaos and thus as the embodiment of the destructive Seth, who governed the deserts.

The entire painting may have been encoded with meaning specific to its funerary context. Other Old Kingdom tomb paintings depict family members buried alongside the principal tomb owner, or as company for the *ka* in the afterlife. Some scenes depict rituals of the cult of the dead or portray offerings and agricultural activities designed to provide the *ka* with an eternal supply of food. In these scenes, the deceased typically looks on, but does not take part.

THE MIDDLE KINGDOM: REASSERTING TRADITION THROUGH THE ARTS

The central government of the Old Kingdom disintegrated with the death of the Sixth Dynasty King Pepy II in around 2152 BCE.

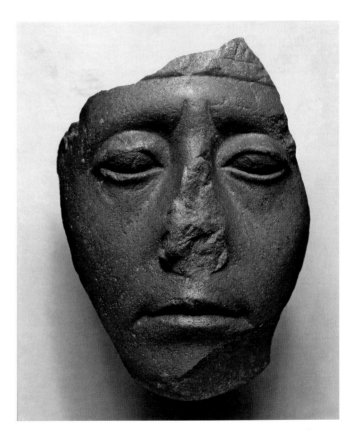

3.18. *Sculpture of Senwosret III* (fragment). ca. 1850 BCE. Quartzite, height 6¹⁄₂″ (16.5 cm). The Metropolitan Museum of Art, New York. Purchase, Edward S. Harkness Gift, 1926 (26.7.1394)

Facial expressions or signs of age, however, signify quite different things to different societies, and it is equally likely that the tight-lipped expression reflects a new face of regal authority, projecting firm resolve. The aged face tended to be combined with a youthful, powerful body.

More naturalistic facial expression in royal images was not the only Middle Kingdom innovation. The canon of proportions changed too. If we compare the Old Kingdom sculpture of Queen Khamerernebty (fig. 3.12) with a sculpture of Lady Sennuwy (fig. **3.19**), the wife of a provincial governor, found at Kerma in Upper Nubia, the change in proportions is clear. During the Middle Kingdom, women were increasingly depicted with narrower shoulders and waists, and slimmer limbs. Males were depicted with proportionally smaller heads, and without the tight musculature of their Old Kingdom counterparts. These subtle changes distinguish representations of the human body from period to period.

Funerary Architecture

The pattern of burials among court officials and other members of the elite stayed relatively constant during the Middle Kingdom, with most preferring burial in sunken tombs and mastabas. Especially popular at this time were rock-cut tombs, which were already known in the Old Kingdom. Fine examples still exist at Beni Hasan, the burial place of a powerful ruling family of Middle Egypt in the Eleventh and Twelfth Dynasties (fig. **3.20**). The tombs were hollowed out of a terrace

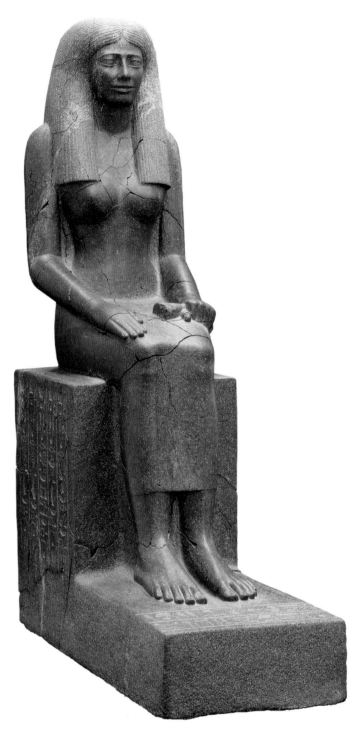

3.19. *Sculpture of the Lady Sennuwy.* ca. 1920 BCE. Granite, height 67³⁄₄″ (172 cm), depth 45⁷⁄₈″ (116.5 cm). Museum of Fine Arts, Boston. Harvard University-Boston Museum of Fine Arts Expedition. Photograph © 2006, Museum of Fine Arts, Boston. 14.720

for over 1,000 years—the artist depicted a king with signs of age. The king has a creased brow, drooping eyelids, and lines beneath the eyes. Scholars have described the image as "introspective," and read it against the background of Senwosret III's difficult campaign of military expansion in Nubia to the south, seeing the imperfections as visible signs of the king's stress.

3.20. Rock-Cut Tombs at Beni Hasan, B-H 3-5, 11th and 12th Dynasties. ca. 1950–1900 BCE

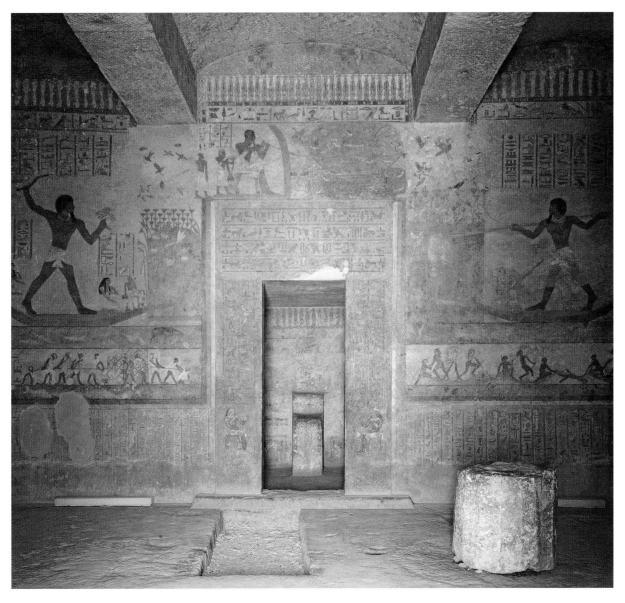

3.21. Interior Hall of Rock-Cut Tomb, B-H 2, Beni Hasan. 12th Dynasty. ca. 1950–1900 BCE

of rock on the east bank of the Nile and offered stunning views across the river. Inside, an entrance vestibule led to a columned hall and burial chamber, where a statue of the deceased stood in a niche (fig. **3.21**). As in Old Kingdom tombs, painted relief decorated the walls. The section illustrated in figure **3.22**, from the restored tomb of Khnum-hotep, shows workers restraining and feeding oryxes (a type of antelope caught in the desert and raised in captivity as a pet).

3.22. *Feeding the Oryxes.* ca. 1928–1895 BCE. Detail of a wall painting. Tomb of Khnum-hotep, Beni Hasan

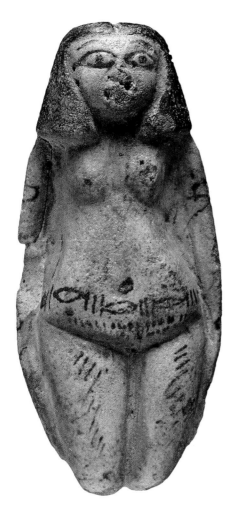

3.23. *Female Figurine,* from Thebes. Faience. 12th–13th Dynasties.
Height 3⅓″ (8.5 cm). The British Museum, London.
Courtesy of the Trustees

As in the Old Kingdom, tomb paintings were believed to
provide nourishment, company, and pastimes for the dead. A
wide variety of objects were placed in tombs along with the
dead, including objects made of **faience**, a glass paste fired to a
shiny opaque finish. The figurine shown in figure **3.23** came
from a tomb in Thebes, and represents a schematized woman.
Her legs stop at the knees, possibly to restrict her mobility, or
because they were not essential to her function. Instead, her
breasts and pubic area are delineated, and a painted cowrie
shell girdle emphasizes her belly and hips. Her function may

well have been as a fertility charm, to enhance family continu-
ity among the living and regeneration of the dead into a new
life in the beyond. The blue-green color of the faience was asso-
ciated with fertility, the goddess Hathor, and regeneration.

Patrons in the Middle Kingdom revived some of the forms
and practices of the Old Kingdom to assert a link to the golden
days of the past. Yet stability was not to endure. As the central
authority weakened after about 1785 BCE, local governors
usurped power. During the Twelfth Dynasty, immigrants from
Palestine moved into the Nile Delta, gradually gaining control
of the area and forcing the king to retreat southward to
Thebes. This group was known as the Hyksos (from the
Egyptian for "rulers of foreign lands"), and the era of their
control is known as the Second Intermediate Period.

THE NEW KINGDOM: RESTORED GLORY

The Hyksos were finally expelled from Egypt by Ahmose
(1550–1525 BCE), first king of the Eighteenth Dynasty. The 500
years after their expulsion, the Eighteenth, Nineteenth, and
Twentieth Dynasties, have been designated the New Kingdom,
a time of renewed territorial expansion and tremendous pros-
perity for Egypt, and a time when the arts flourished. Tremen-
dous architectural projects were carried out along the full length
of the Nile, centering on the region of Thebes (modern Luxor).
Of these projects, many secular buildings, including palaces and
forts, were made of mud brick and have since perished. Stone
tombs and temples, however, retain a small measure of their
former glory.

Royal Burials in the Valley of the Kings

A major difference between the Old Kingdom and the New
may be seen in their burial practices. Having witnessed the loss
of order that allowed royal burials to be robbed, Eighteenth
Dynasty kings abandoned the practice of marking their tombs
with pyramids. Instead, tombs were excavated out of the rock
face in the Valley of the Kings west of Thebes, with their
entrances concealed after burial. Excavations have revealed that
in these tombs a corridor led from the entrance deep into the
rock to the burial chamber, which was flanked by storage
rooms. The burial chamber was decorated with paintings of the
king with Osiris, Anubis, and Hathor, funerary deities who
assured his passage into the next world. Rituals of the funerary
cult took place apart from the tomb, over a rocky outcropping to
the east, at a temple on the edge of the land under cultivation.

HATSHEPSUT'S TEMPLE The best preserved example of
a New Kingdom funerary temple is that of the female king
Hatshepsut, built by her architect Senenmut (ca. 1478–1458
BCE) as shown in figure **3.24**. Hatshepsut was the chief wife—
and half sister—of Thutmose II. On his death in 1479 BCE,
power passed to Thutmose III, his young son by a minor wife.
Designated regent for the young king, Hatshepsut ruled with
him as female king until her death in 1458 BCE, claiming that
her father, Thutmose I, had intended her as his successor.

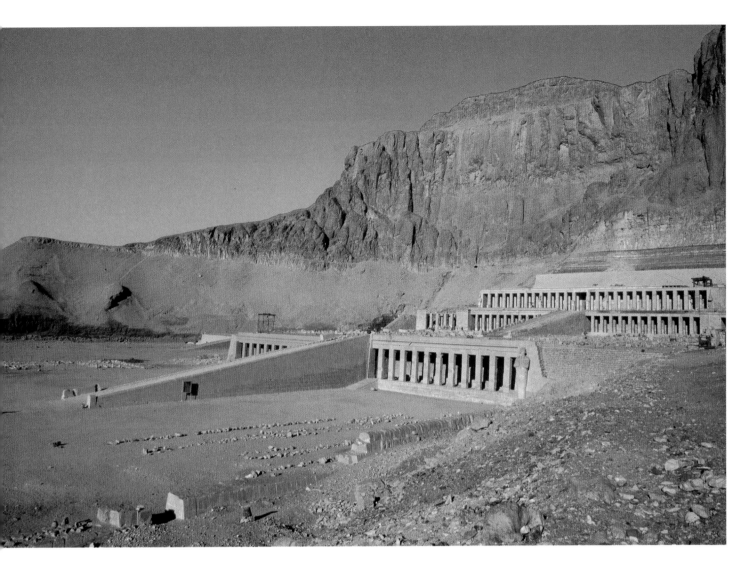

3.24. Temple of Hatshepsut, Deir el-Bahri. ca. 1478–1458 BCE

Nestled in the cliffside at Deir el-Bahri, Hatshepsut's temple sat beside the spectacular Eleventh Dynasty temple of Mentuhotep II (fig. **3.25**), who had reunited Egypt over 500 years earlier during the Middle Kingdom. The architects who designed Hatshepsut's temple may have modeled some of its features after this earlier temple, with its terraces extending into the cliff face, topped with a pyramid or a mastaba. Once joined by a causeway to a valley temple beside the Nile, Hatshepsut's temple is a striking response to its setting. Its ascending white limestone courts, linked by wide ramps on a central axis, echo the desert's strong horizontal ground-line and the cliff top above. A multitude of vertical lines, meanwhile, established by the bright light and shadows of the colonnades, harmonize with the fissures

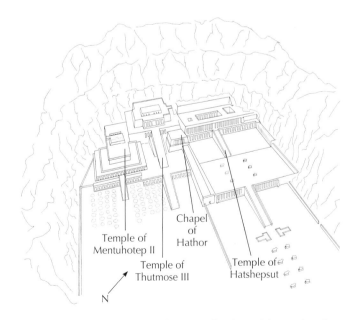

3.25. Reconstruction of Temples, Deir el-Bahri, with temples of Mentuhotep II, Thutmose III, and Hatshepsut (after a drawing by Andrea Mazzei, Archivio White Star, Vercelli, Italy)

of the cliff. With its clean contours, the royal structure imposes order on the less regularized forms of nature, just as the king's role was to impose order on chaos. Trees lined the entrance leading up to the temple, with paired sphinxes facing each other. At the furthest reach of the temple, cut into the rock, a principle sanctuary was dedicated to Amun-Ra, god of the evening sun. Smaller chapels honored Anubis, god of embalming, and Hathor, goddess of the west. An altar dedicated to Ra-Horakhty stood on the upper terrace.

Throughout the complex, painted relief sculptures brought the walls to life, depicting battles, a royal expedition to the land of Punt in search of myrrh trees for the terraces, and scenes of Thutmose I legitimizing his daughter's unusual rule. Sculptures of the king and deities abounded. The red granite example shown in figure **3.26**, one of eight colossal statues from the third court, depicts Hatshepsut kneeling as she makes an offering of two jars. Since kingship was defined as a male office, she is dressed in the regalia of a male king: a kilt, a false beard, and the White Crown. Although in some images she is visibly female, in this and many others she appears without breasts.

Sometime after Hatshepsut's death, Thutmose III constructed his own temple between his mother's and Mentuhotep's, with the purpose of eclipsing Hatshepsut's. He designated his own temple as the destination of Amun's divine boat in the Festival of the Wadi, held at Deir el-Bahri. One result of his efforts was the destruction of many images of Hatshepsut and the replacement of her name with his in some of the inscriptions in her temple. Nonetheless, Hatshepshut's temple remains a monument to her memory.

Temples to the Gods

Besides building funerary temples for themselves, Eighteenth Dynasty kings expended considerable resources on temples to the gods, such as the Theban divine triad: Amun, his consort Mut, and their son Khons. At Karnak and nearby Luxor, successive kings constructed two vast temple complexes to honor the triad, and on special festivals the gods' images were conveyed on divine boats along waterways between the temples.

THE TEMPLE OF AMUN-RA At the temple of Amun-Ra at Karnak, a vast wall encircled the temple buildings (fig. **3.27**). Entering the complex, a vistor walked through massive **pylons** or gateways built as monuments to individual kings. (Sometimes, these were dismantled as building proceeded over the years.) As a ceremonial procession moved within the buildings, the pylons marked its progress deeper and deeper into sacred space. Within the complex, a vast **hypostyle** hall was the farthest point of access for all but priests and royalty (fig. **3.28**). Here, a visitor would be awed by a forest of columns, their sheer mass rendering the human form almost

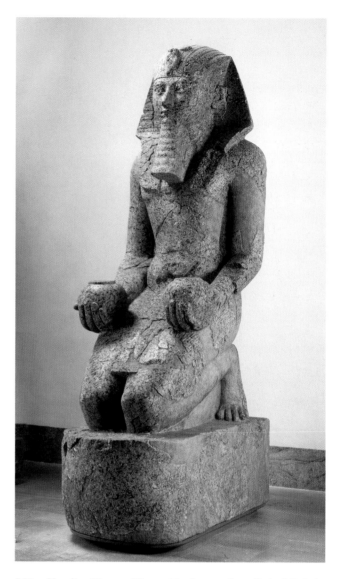

3.26. *Kneeling Figure of Queen Hatshepsut,* from Deir el-Bahri. ca. 1473–1458 BCE. Red granite, height approx. 8′6″ (2.59 m). Metropolitan Museum of Art, New York. Rogers Fund, 1929 (29.3.1)

insignificant. The columns were closely spaced to support a ceiling of stone lintels. Unlike wooden lintels, these had to be kept short to prevent them from breaking under their own weight. The architect nonetheless made the columns far heavier than they needed to be, with the effect that a viewer senses the overwhelming presence of stone all around, heavy, solid, and permanent.

Essential to the temple's ritual functioning was its metaphorical value, symbolizing the world at its inception. The columns of the hypostyle hall represented marsh plants in stylized form: Their capitals were designed to emulate the shape of both papyrus flowers and buds—so that the building evoked the watery swamp of chaos out of which the mound of creation emerged. The temple was thus the king's exhortation in stone to the gods to maintain cosmic order.

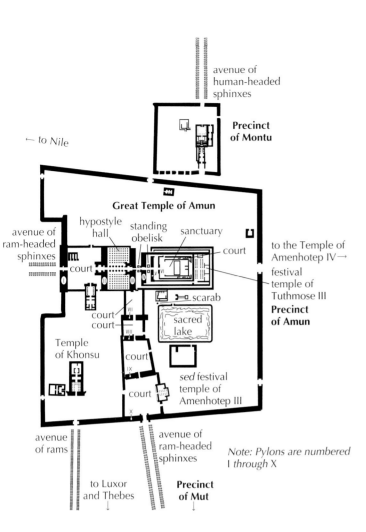

avenue of human-headed sphinxes

← *to Nile*

Precinct of Montu

Great Temple of Amun

avenue of ram-headed sphinxes

hypostyle hall

standing obelisk

sanctuary

court

court

to the Temple of Amenhotep IV →

festival temple of Tuthmose III

Precinct of Amun

scarab

court court

sacred lake

Temple of Khonsu

court

court

sed festival temple of Amenhotep III

avenue of rams

avenue of ram-headed sphinxes

Note: Pylons are numbered I through X

to Luxor and Thebes ↓

Precinct of Mut ↓

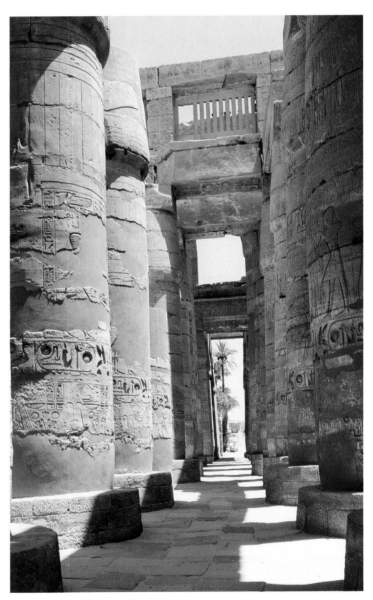

3.28. Hypostyle Hall of Temple of Amun-Ra, Karnak, Thebes. ca. 1290–1224 BCE

Beyond the hall, a sacred lake allowed the king and priests to purify themselves before entering the temple proper. They proceeded through smaller halls, sun-drenched courts, and processional ways decorated with **obelisks**, tall stone markers topped by pyramid-shaped points, as well as chapels where they would pause to enact ceremonies. Every day the priests would cleanse and robe the images of the gods, and offer sacred meals to nourish them. These rituals were conducted by the king and the priests away from the public eye, gaining power for being shrouded in mystery.

Throughout the complex, the pylons and walls of the halls and the enclosure walls were covered by a distinctively Egyptian form of decoration: **sunken relief**. Rather than carving away the surface around figures to allow them to emerge from the stone, the sculptor cut sharp outlines into the surface of the stone, and modeled the figures within the outlines and below the level of the background. Light shining onto the surface then cast shadows into the outlines, bringing the figures to life without compromising the solid planar appearance of the wall. This type of relief was especially popular for decorating hard stone, since it required less carving away.

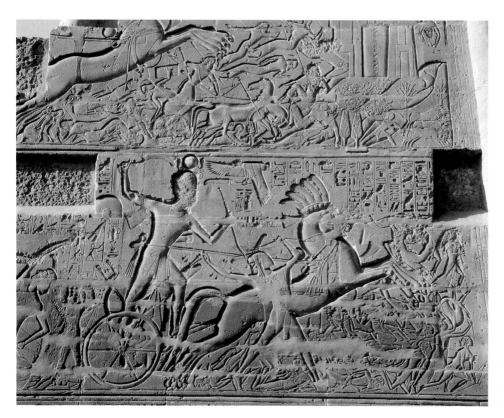

3.29. *Seti I's Campaigns,* Temple of Amun at Karnak, Thebes (exterior wall, north side of hypostyle). ca. 1280 BCE. Sandstone, sunken relief, Egypt

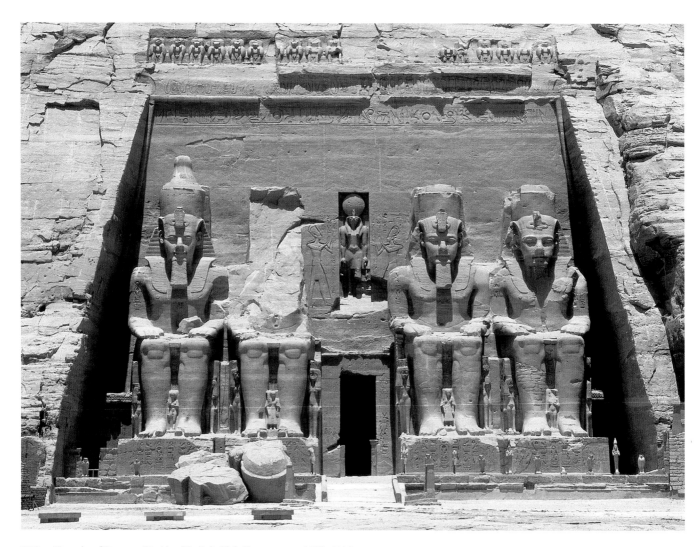

3.30. Temple of Ramses II, Abu Simbel. 19th Dynasty. ca. 1279–1213 BCE

The subject of the reliefs at Karnak was the king's relationship with the gods. The section illustrated in figure **3.29**, from the north exterior wall of the hypostyle hall, shows in an upper register Seti I sacking the Hittite city of Kadesh on the Orontes River, and, in a lower register, hunting, an activity that symbolized military prowess, as it would among the Assyrians (see fig. 2.21). Following convention, the king and his horse-drawn chariot remain frozen against a background filled with hieroglyphs and soldiers, who are much smaller in scale than the king in order to glorify his presence. The figures of the king and his horse are also cut deeper than surrounding figures, so that their outlines are bolder than the rest. Victory seems assured by the king's might and the ruthless efficiency of his forces, although neither battle was, in fact, decisive. By conquering foreign forces, the king established order, *ma'at*.

ABU SIMBEL Seti I's son, Ramses II, who ruled for 67 years during the Nineteenth Dynasty (ca. 1290–1224 BCE), commissioned more architectural projects than any other Egyptian king, including a monumental temple dedicated to himself and Amun, Ra-Horakhty, and Ptah, carved into the sandstone at Abu Simbel on the west bank of the Nile (fig. **3.30**). Location alone made an eloquent statement: With the temple, the king marked his claim to the land of Kush in Lower Nubia, which was the source for the precious resources of gold, ivory, and animal pelts. A massive rock facade substitutes for a pylon, where four huge seated statues of the king almost 70 feet high flank the doorway, dwarfing any approaching visitor. Between the statues' legs, small figures represent members of the royal family. A niche above the entrance holds an image of the sun-god, who is shown as a falcon-headed figure crowned by a sun disk. Flanking this three-dimensional figure are images in relief of Ramses holding out to the god an image of Ma'at, the goddess of order. The image thus demonstrates the king's role as keeper of terrestrial order at the request of the gods. On the interior of the temple, more colossal figures of Ramses were shaped from the same rock as the columns behind them. Their size (32 feet high) and frontality presented an awesome sight to the priests who conducted rituals inside (fig. **3.31**).

Ramses commissioned a second, complementary temple about 500 feet away from his own, in honor of his wife Nefertari and Hathor, a goddess of the afterlife. Here, too, sculptors cut figures into the rock as a facade for the temple, which was colossal in scale but significantly smaller than Ramses' temple. The topographical relationship between the two temples may be significant. Their central axes, when extended forward, intersected in the Nile's life-giving waters, so their locations may express the generative force associated with the royal couple. This relationship is hardly visible today, as the construction of the Aswan Dam in the 1960s submerged the Ramses temple site, leading engineers to move the temple upward nearly 700 feet in order for it to stand above flood levels.

Block Statues

In the New Kingdom a type of sculpture known since the late Old Kingdom experienced new popularity. This was the block statue, where the body, seated on the ground with knees drawn up to the chest and wrapped in a cloak, is reduced to a cubic abstraction. Above the block appears a portrait head, while feet protrude at the bottom; sometimes arms are folded across the knees. Like the more conventional full-body sculptures, these images functioned as seats for the *ka* in the tomb. When they first appear in the Sixth Dynasty, the figures are found in model funerary boats, transporting the dead to the cult center of Osiris at Abydos. They may, therefore, represent the deceased as a being sanctified by this journey in the afterlife. The example illustrated in figure **3.32** may have come from the temple at Karnak. It presents two portraits. Above is the head of Senenmut, a high official in the court of Hatshepsut and Thutmose III and master of works for the temple at Deir el-Bahri. Below Senenmut's head is a very small head, representing Nefrua, daughter of Hatshepsut and

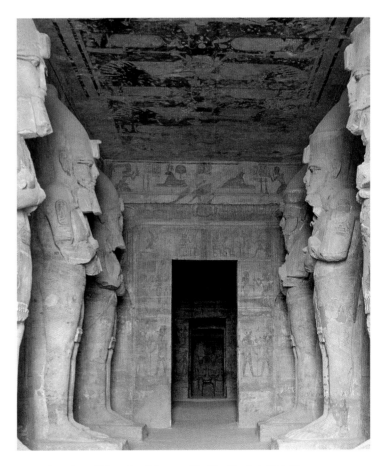

3.31. Interior of Temple of Ramses II, Abu Simbel. 19th Dynasty. ca. 1279–1213 BCE

ART IN TIME

ca. 1595 BCE—The Hittites conquer Babylon
ca. 1550–1525 BCE—Rule of King Ahmose; expulsion of the
Hyksos from Egypt
**ca. 1458 BCE—King Hatshepsut dies; her tomb was
designed by Senenmut**
**ca. 1290–1224 BCE—Rule of King Ramses II, who
commissioned a monumental temple
at Abu Simbel**

Thutmose II. Her head emerges from the block in front of Senenmut's face, as if held in an embrace, perhaps reflecting his protective role as her tutor. Omitting anatomical features in favor of the block form left an ample surface for a hieroglyphic text of prayers or dedications.

Images in New Kingdom Tombs

Artists continued to embellish tomb chapels with paintings evoking similar scenes to their Old Kingdom and Middle Kingdom counterparts. In the New Kingdom, however, additional images showed the deceased worshiping deities, most typically Osiris and Anubis, whose interventions could ease their transition to the next world. They would also paint scenes showing a banquet in the tomb chapel that was part of the annual festival of the Wadi at Thebes, when the living would cross to the west bank of the Nile and feast with the dead. Music and dancing were part of the celebration, and a fragment of painting from the tomb of Nebamun at Thebes (ca. 1350 BCE) shows that hierarchical conventions established in the Old Kingdom 1,000 years previously were still in use (fig. **3.33**). While the elite diners sit in rigid composite view in the upper register, musicians and dancers below move freely in pursuit of their crafts. A flute player and a clapper have fully frontal faces, and they even turn the soles of their feet to face a viewer—an extreme relaxation of elite behavior. The nude dancers twist and turn, and the loosened, separated strands of the entertainers' long hair suggests motion. The freedom of movement inherent in these figures has suggested to some scholars that works from contemporary Crete may have been available for these painters to study. Elsewhere, paintings have been attributed outright to artists from this Aegean island

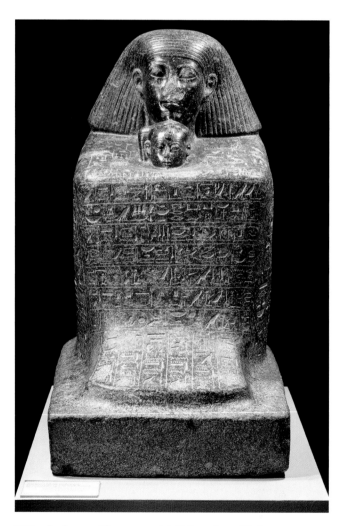

3.32. *Sculpture of Senenmut with Nefrua,* from Thebes. ca. 1470–1460 BCE. Granite, height approx. 3′1/2″ (107 cm). Äegyptisches Museum, Berlin

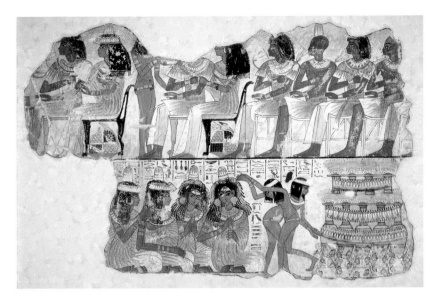

3.33. *Musicians and Dancers,* fragment of a wall painting from the Tomb of Nebamun, Thebes. 1350 BCE. Height 24″ (61 cm). The British Museum, London. Courtesy of the Trustees

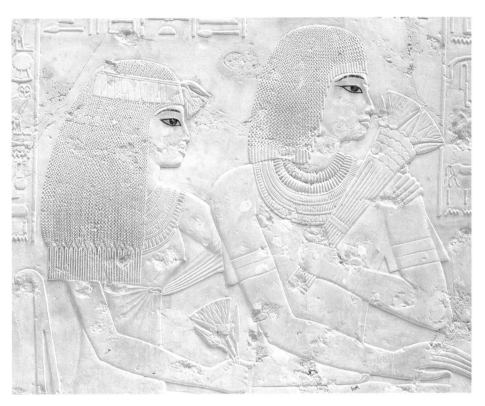

3.34. *Mai and His Wife, Urel.* ca. 1375 BCE. Detail of a limestone relief. Tomb of Ramose, Thebes

culture. On the right side, jars indicate that wine was plentiful. Music, dance, and wine were sacred to Hathor, goddess of the West, who could lead the dead through the dangerous liminal phase between death and the afterlife.

New Kingdom artists and patrons also followed Middle and Old Kingdom precedents in designing tomb images. Some reliefs executed for the unfinished tomb in Thebes of Ramose, the vizier for Amenhotep III (ca. 1375 BCE), follow these traditions (fig. **3.34**). The craftsmanship is particularly skilled in this image, which depicts Ramose's brother, Mai, and his wife, Urel. The relief is shallow, but the carving distinguishes different textures masterfully. The composite postures and the gestures of the wife embracing her husband reflect conventions going back at least to the Old Kingdom, though the canon of proportions differs from earlier objects, and some of the naturalism seen in

other New Kingdom works informs the profiles of this couple. Here the united front that husband and wife present through eternity may be compared to a New Kingdom love song that extols the joy of spending "unhurried days" in the presence of one's beloved. (See *Primary Source* on page 70.)

AKHENATEN AND THE AMARNA STYLE

Ramose was the vizier to Amenhotep III, who increased devotion to the sun-god during his reign (1391–1353 BCE). In temple complexes at Karnak and elsewhere, the king built wide open-air courtyards where the sun could be worshiped in its manifestation as a disk (or Aten) in the sky. Devotion to Aten grew more pronounced under his son, Amenhotep IV. Stressing the life-giving force of the sun, Amenhotep IV began to visualize

PRIMARY SOURCE

Love Song

This "Love Song" is written on an ostrakon *(a writing tablet) now in the Cairo Museum. The poem dates to the New Kingdom, sometime between 1300 and 1100 BCE.*

Your love, dear man, is as lovely to me
As sweet soothing oil to the limbs of the restless,
As clean ritual robes to the flesh of gods,
As fragrance of incense to one coming home
Hot from the smells of the street.

It is like nipple-berries ripe in the hand,
Like the tang of grainmeal mingled with beer,
Like wine to the palate when taken with white bread.

While unhurried days come and go,
Let us turn to each other in quiet affection,
Walk in peace to the edge of old age.
And I shall be with you each unhurried day,
A woman given her one wish: to see
For a lifetime the face of her lord.

SOURCE: *LOVE SONGS OF THE NEW KINGDOM.* TR. BY JOHN I. FOSTER (AUSTIN, TX: UNIVERSITY OF TEXAS PRESS, 1974)

the god not as the traditional falcon-headed figure, but as a disk, radiating beams terminating in hands. The young pharaoh's attempts to introduce this new cult to traditional religious centers, such as Thebes, were thwarted by a powerful conservative priesthood. In response, Amenhotep IV established a new city devoted entirely to Aten on the Nile's east bank in central Egypt. He named his new city Akhetaten, meaning horizon of Aten (now known as Amarna), and changed his own name to Akhenaten, meaning "beneficial to Aten." Akhenaten's belief in Aten as the source of life found expression in the "Hymn to Aten" sometimes attributed to him. This text (excerpted in end of Part I *Additional Primary Sources*) expresses joy in the rising of the sun each day by describing the world coming to life again at its appearance. Disdaining and refuting the other traditional cults, Akhenaten seems to have intended the cult of Aten to be monotheistic, thus enraging the priests of other cults. His new cult and fledgling city lasted only as long as its founder; after his death the city was razed to the ground. Still, archeological remains suggest that Akhenaten built temples in the contemporary style, using massive pylons and obelisks, as at Karnak, but with an emphasis on open-air courts beneath the sun's glare.

The Amarna Style

Sculptures of Akhenaten and his family break with long-established conventions for depicting royal subjects. In numerous depictions, the figure of Akhenaten exhibits radically different proportions from those of previous kings. Images such as the colossal figure of Akhenaten installed at the temple of Amun-Ra in Karnak between 1353 and 1335 represent the king with narrow shoulders lacking in musculature, with a marked pot belly, wide hips, and generous thighs (fig. **3.35**). His large lips, distinctive nose and chin, and narrow eyes make his face readily recognizable. Scholars have found these unusual portraits puzzling. Some dismiss the images as caricatures, yet such expensive and prominent images must have had the king's

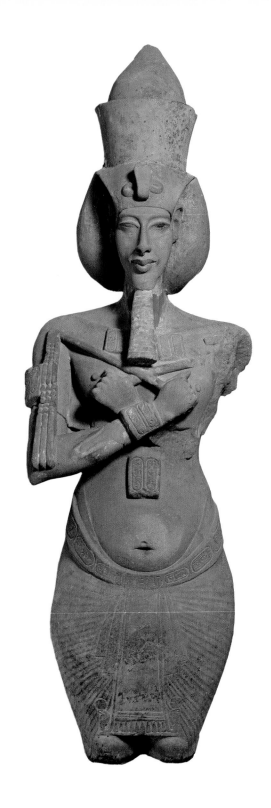

3.35. *Sculpture of Akhenaten,* from Karnak, Thebes. 1353–1335 BCE. Sandstone, height approx. 13′ (3.96 m). Egyptian Museum, Cairo

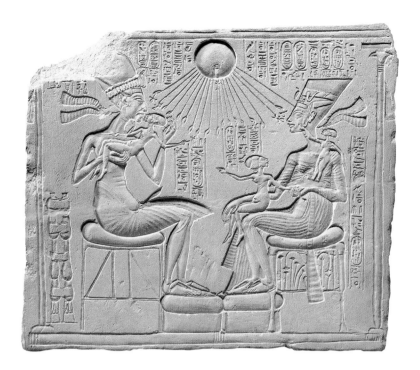

3.36. *Akhenaten and His Family.* ca. 1355 BCE. Limestone, $12^3/_4 \times 15^1/_4''$ (31.1 × 38.7 cm). Staatliche Museen zu Berlin, Preussischer Kulturbesitz, Ägyptisches Museum

approval. There have also been attempts to diagnose a medical condition from these representations; the king's features have been read as symptoms of Frolich's Syndrome, a hormonal deficiency that produces androgynous characteristics. A more likely explanation is that his "feminized" appearance was intended to capture the androgynous fertile character of Aten as life-giver. The style was not restricted to the king's image, but influenced representations of court officials and others as well.

Group representations of Akhenaten with his family—his consort Nefertiti and three oldest daughters—are remarkable for an apparent intimacy among the figures. This is clear on a sunken relief scene on an altar stele, the kind that Egyptians would have erected in small shrines in their homes and gardens (fig. **3.36**). Beneath the disk of the sun, its life-giving beams are depicted as lines radiating downward with hands at their terminals. The king and his consort sit facing each other on stools. Attenuated reed columns suggest that the scene takes place within a garden pavilion, which is stocked with wine jars. They hold three lively daughters, who clamber on their laps and in their arms, uniting the composition with animated gestures that reach across the relief in marked contrast to the static scenes of other times. The deliberate emphasis on the daughters' childishness marks a change: In the past, children had been represented by a hieroglyphic pictograph of an adult in miniature, sucking on a finger. The emphasis on children epitomizes the regeneration that the royal couple represent, and especially the king as manifestation of the sun-god, Aten.

QUEEN TIY The surprising transience implicit in the children's youthfulness and animated gestures found in figure 3.36 also characterizes a one-third life-size portrait of Akhenaten's mother Queen Tiy, chief wife of Amenhotep III. The sculpture elegantly portrays an aging woman (fig. **3.37**). Using the dark wood of the yew tree, with precious metals and semiprecious stones for details, the artist achieved a delicate balance between idealized features and signs of age. Smooth planes form the cheeks and abstract contours mark the eyebrows, which arch over striking eyes inlaid with ebony and alabaster. Yet we also see careful hints at advancing years in the down-turned mouth and the modeled lines running from the sides of the nose to the mouth.

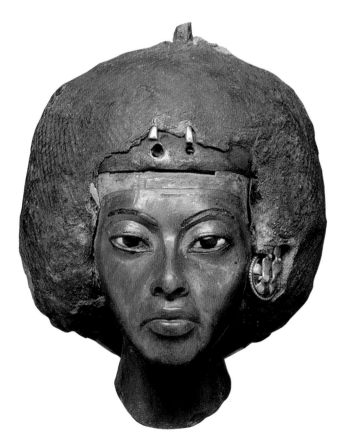

3.37. *Sculpture of Queen Tiy,* from Kom Medinet el-Ghurab. ca. 1352 BCE. Yew, ebony, glass, silver, gold, lapis lazuli, cloth, clay, and wax. Height $3^3/_4''$ (9.4 cm). Staatliche Museen zu Berlin, Preussischer Kulturbesitz, Ägyptisches Museum

The sculpture went through two stages of design: Initially, the queen wore gold jewelry and had a silver headdress decorated with golden cobras, which identified her with the funerary goddesses Isis and Nephthys. This headdress was subsequently concealed under a wig embellished with glass beads, and topped with a plumed crown, the attachment for which is still extant. Although the sculpture was discovered with funerary paraphernalia for her husband Amenhotep III, these changes indicate that it was adapted to suit the beliefs of Akhenaten's new monotheistic religion. Even a small image played an important role in such rituals.

PORTRAITS OF NEFERTITI As with Akhenaten's images, early depictions of his wife Nefertiti emphasize her reproductive capacity by contrasting a slender waist with large thighs and buttocks. Sculptures from the second half of Akhenaten's reign, however, are less extreme. At Amarna archeologists discovered the studio of the king's chief sculptor, whom court records call "the king's favorite and master of the works." It yielded sculptures at every stage of production: heads and limbs of quartzite and jasper, and torsos of royal statues to which they could be affixed. Plaster casts were found, modeled from clay or wax studies taken from life. The most famous of the sculptures discovered there is a bust of Nefertiti, plastered over a limestone core and painted—a master sculpture, perhaps, from which other images could be copied (fig. **3.38**). The sculpture's left eye lacks the inlay of the right, showing that the bust remained unfinished, but its extraordinary elegance derives from a command of geometry that is at once precise—the face is completely symmetrical—and subtle. This piece and another similar head were abandoned in the workshop when the sculptor moved from Amarna to Memphis after Akhenaten's death in 1335 BCE. The passing of Akhenaten was a death knell for both his cult and for the city he founded.

Tutankhamen and the Aftermath of Amarna

Shortly after Akhenaten's death, a young king ascended the throne. Married to Akhenaten's daughter, perhaps even one of Akhenaten's sons, Tutankhaten was only 9 or 10 when he became king. Perhaps under the influence of the priests of Amun, the young king restored the royal residence to Memphis and resurrected the traditional cults that Akhenaten had neglected. He changed his name to Tutankhamen to reflect the restoration of the king's association with Amun. His reign marked a return to the orthodox religion of Egypt, though he seems to have died without warning at the age of 19. His sudden death has inspired numerous theories about murder and conspiracy, but the most recent scientific studies of his mummy point to natural causes.

Tutankhamen's greatest fame results not from his life, but from his death and the discovery of his tomb in 1922 by the British archeologist Howard Carter. Although it had been

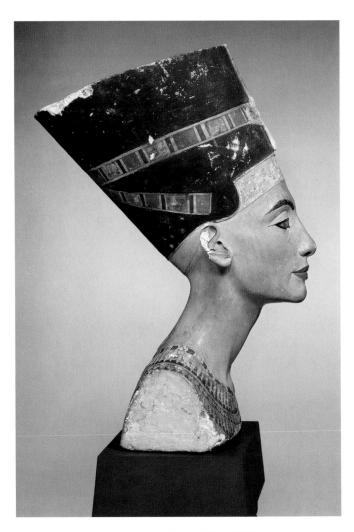

3.38. *Sculpture of Queen Nefertiti*. ca. 1348–1336/5 BCE. Limestone, height 19″ (48.3 cm). Staatliche Museen zu Berlin, Preussischer Kulturbesitz, Ägyptisches Museum

robbed twice, much of the tomb was untouched. With its stairway, corridor, and four chambers, the tomb is uncharacteristically small for a royal burial, leading scholars to suppose that a nonroyal tomb might have been co-opted for the king at the time of his unexpectedly early death. All the same, offerings buried with him lacked nothing in volume or quality. Indeed, the immense value of the objects makes it easy to understand why grave robbing has been practiced in Egypt ever since the Old Kingdom. The tomb contents included funerary equipment, such as coffins, statues, and masks, as well as items used during his lifetime, such as furniture, clothing, and chariots. On many of the objects Tutenkhamen is depicted battling and overcoming foreign enemies, as part of his kingly duty to maintain order amid chaos. The king's mummified corpse was preserved in three coffins, the innermost of which (fig. **3.39**), weighs over 250 pounds in gold. Even more impressive is the exquisite workmanship of its cover, with its rich play of colored inlays against polished gold surfaces. The amount and quality of the objects in the burial of a minor king like Tutankhamen make one lament the loss of the burial finery of more powerful and long-lived pharaohs.

The Book of the Dead

This text is an incantation from Plate III of the Papyrus of Ani in the British Museum, from the latter half of Eighteenth Dynasty. It accompanies the weighing of the soul illustrated in the closely related The Book of the Dead of Hunefer *(see fig. 3.40).*

Saith Thoth the righteous judge of the cycle of the gods great who are in the presence of Osiris: Hear ye decision this. In very truth is weighed the heart of Osiris, is his soul standing as a witness for him; his sentence is right upon the scales great. Not hath been found wickedness [in] him any; not hath he wasted food offering in the temples; not hath he done harm in deed; not hath he let go with his mouth evil things while he was upon earth.

Saith the cycle of the gods great to Thoth [dwelling] in Hermopolis [the god's cult-center along the Nile in Upper Egypt]: Decreed is it that which cometh forth from thy mouth. Truth [and] righteous [is] Osiris, the scribe Ani triumphant. Not hath he sinned, not hath he done evil in respect of us. Let not be allowed to prevail Amemet [Ammut, the devourer of souls] over him. Let there be given to him cakes, and a coming forth in the presence of Osiris, and a field abiding in Sekhet-hetepu [Field of Peace] like the followers of Horus.

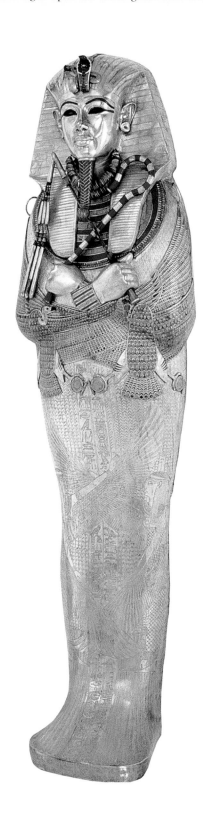

The process of restoring the old religion was continued by Tutankhamen's short-lived successor, the aged Ay. He married Tutenkhamen's widow, perhaps to preserve, rather than usurp, the throne. The restoration of the old religion was completed under Horemheb, who had been head of the army under Tutankhamen and became the last king of the Eighteenth Dynasty. He set out to erase all traces of the Amarna revolution, repairing shattered images of the gods and rebuilding their temples; but the effects of Akhenaten's rule could be felt in Egyptian art for some time to come.

PAPYRUS SCROLLS: *THE BOOK OF THE DEAD*

Inscriptions on walls and furnishings accompanied royal burials like Tutankhamen's, but in the Middle Kingdom the desire to include the prayers and incantations that accompanied kings to the afterlife spread to other classes of patrons. By the New Kingdom patrons commissioned scribes to make illustrated funerary texts such as *The Book of the Dead*, (see *Primary Source*, above) which first appeared in the Eighteenth Dynasty. This text is a collection of over 200 incantations or spells that ultimately derived from the Coffin Texts of the Middle Kingdom, which were copied onto scrolls made of papyrus reeds. The popularity of the *Book of the Dead* in the New Kingdom represents a change in Egyptian beliefs about the afterlife: Any member of the elite could enjoy an afterlife, as long as the deceased had lived in accordance with *ma'at* and could pass tests imposed by the gods of the underworld. Relatives of the deceased generally placed a version of the *Book of the Dead* inside the coffin or wrapped within the mummy bandaging itself in order to ensure that the deceased had the knowledge required to pass the test and progress to the hereafter. Among the scenes depicted in the book are the funeral procession, the weighing of the heart, and the provision of nourishment for the dead.

3.39. Cover of the coffin of Tutankhamen. 18th Dynasty. Gold, height 72″ (182.9 cm). Egyptian Museum, Cairo

ART IN TIME

ca. 1400–1200 BCE—Apogee of the Hittite Empire

ca. 1353–1335 BCE—Rule of king Akhenaten; new religious
center at Amarna

**ca. 1348–1336/5 BCE—Plaster and limestone portrait bust
of Akhenaten's wife, Nefertiti**

One of the finest surviving examples is *The Book of the Dead of Hunefer*, dating from about 1285 BCE. The scene illustrated here (fig. **3.40**) represents the weighing of the heart and judgment of the dead by Osiris in Chapter 125 (see *Primary Source*, page 73). It conforms to a well-defined type that many workshops shared. Derived from traditional tomb painting, its imagery has been adapted to the format of the scroll to be a continuous narrative, with protagonists repeated in one scene after another without a dividing framework. At the left, Anubis, the jackal-faced guardian of the underworld, leads Hunefer into the Hall of the Two Truths. Anubis then weighs Hunefer's heart, contained in a miniature vase, against the ostrich feather of Ma'at, goddess of truth and justice, who symbolized divine order and governed ethical behavior. Ma'at's head appears on the top of the scales. Thoth, the ibis-headed scribe, records the outcome. Looking on with keen interest is

Ammut. Made up of the parts of various ferocious beasts—the head of a crocodile, the body and forelegs of a lion, and the hind quarters of a hippopotamus—she was the devourer of those whose unjust life left them unworthy of an afterlife.

The deceased had to swear to each of the deities seen overhead that he or she had lived according to *Ma'at*. Having been declared "true of voice," he is presented by Horus to his father, Osiris, shown with kingly emblems and wrapped in a white mummylike shroud, seated in a pavilion floating above a lake of *natron*, a salt used for preserving the body. Accompanying him are Isis and her sister Nephthys, mother of Anubis and protector of the dead. In front of the throne, the four sons of Horus stand on a white lotus blossom, symbol of rebirth. Also known as the four gods of the cardinal points, they protected the internal organs that were removed as part of the embalming process and placed in containers known as *canopic jars*. Above, Horus, identified by his sacred *udjat* eye (which restored Osiris to health), bears an ostrich feather, representing the favorable judgment of Ma'at. In the afterlife, as on earth, the desire for order was paramount.

LATE EGYPT

Tutankhamen's revival of the cult of Amun and the ancient sources of *The Book of the Dead* demonstrate that New Kingdom Egyptians deeply venerated the traditions of the past.

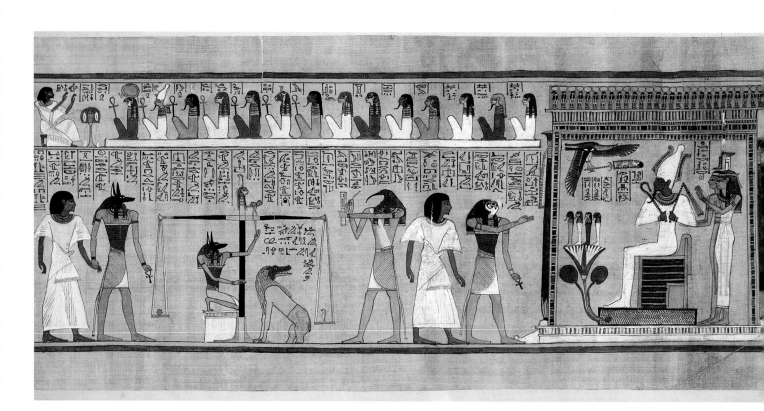

3.40. *The Weighing of the Heart and Judgment by Osiris,* from *The Book of the Dead of Hunefer*. 1285 BCE. Painted papyrus, height 15⅝″ (39.5 cm). The British Museum, London

Building the Pyramids

In spite of much research, many aspects of pyramid design remain a mystery to Egyptologists. Elevations of other types of building—palaces and pylons, for instance—are preserved on the walls of New Kingdom tombs and temples, and a few plans survive. Pyramid architects may have worked from similar guidelines, but no definitive plans exist for their construction. Orienting the pyramids to the cardinal points of the compass appears to have been critical, and was probably achieved by observation of the stars. The greatest deviation is a meager 3 degrees east of north, in the Pyramid of Djoser.

During the Old and Middle Kingdoms, a pyramid's core was built out of local limestone. Quarries are still visible around the Great Pyramids and the Great Sphinx (see fig. a and fig. 3.10). For the casing (the outer surface), Tura limestone and Aswan granite were brought from quarries some distance away, as these are not local materials. Using copper tools, levers, and rope, workers cut channels in the rock and pried out blocks averaging $1\frac{1}{2}$ to 5′ (.5 to 1.5 meters) but sometimes much larger.

Somehow these blocks were hauled overland, on hard-packed causeways built for that purpose. Some scholars believe teams of men or oxen pulled them on sleds. This view is based primarily upon a tomb painting showing 172 men dragging a huge statue of the Twelfth Dynasty Djehutihopte on a sled. When a team of documentary filmmakers attempted to replicate the process using blocks of stone, it proved extraordinarily slow and cumbersome. Yet estimates of 2.3 million stone blocks in the Pyramid of Khufu, constructed within 23 years, suggest that quarries must have moved stone at tremendous rates: approximately 1,500 men had to produce at least 300 blocks a day. In Hatshepsut's mortuary temple, Petrie discovered models of wooden cradles in the shape of a quarter circle. If four cradles were fitted to the four sides of a block of stone, these frames would have allowed a small team of men to roll a block relatively quickly.

Archeological remains of pyramids indicate that methods of construction evolved over time. In early pyramids, a buttressing technique was used, with inclined layers around a central core, diminishing in height from inside out (fig. b). A smooth outer casing of cut stones was then set at an angle to the ground. When this technique proved unstable at the beginning of the Fourth Dynasty, architects turned to courses of stone, built up layer by layer. Outer casing blocks were cut as right-angled trapezoids and set level to the ground as the pyramid rose (fig. c). Scholars believe that workers constructed ramps to raise blocks into place as the monument grew. These would have been dismantled after use, leaving little trace in the archeological record. A linear ramp leading up to one face of the pyramid, made out of debris left over from building, is the simplest solution. As the pyramid grew, however, the slope would have become so steep that steps would have been needed for workers to haul up the blocks. At this point, blocks could have been maneuvered only with levers. A spiraling ramp, which worked its way around the pyramid at a shallower incline, would have concealed the base corners of the pyramid, making calculations difficult for surveyors, and such a ramp would have been hard to construct at the highest levels. Another alternative is a ramp zigzagging up one side of the monument. One scholar proposes that sand and rubble ramps were used for roughly the lowest sixth of the Great Pyramid, followed by stone ramps at the higher levels, resting on the untrimmed outer steps. As the ramps were removed, the outer casing blocks would have been smoothed out to form a slope.

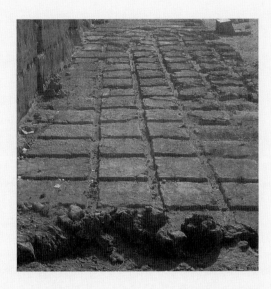

(a) Limestone quarry to the north of Khafra Pyramid

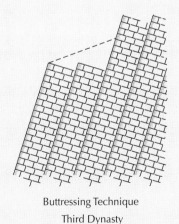

Buttressing Technique
Third Dynasty

(b) Buttressing Technique

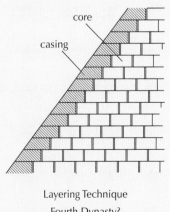

Layering Technique
Fourth Dynasty?

(c) Layering Technique

Interpreting Ancient Travel Writers

A great many Greeks went to Egypt; some, as might be expected, for business, some to serve in the army, but also some just to see the country itself.

—Herodotus

One of the primary sources available to art historians is the writing of ancient travelers. Despite the dangers of travel in antiquity, from shipwrecks to thievery, Egypt became a prime destination for curiosity seekers, beginning around 1500 BCE, and peaking during the first and second centuries CE. Locals did what they could to entice travelers. In Roman times, men from Busiris, near Giza, would climb the pyramids' slippery slopes as a tourist attraction. Some early travelers painted or scratched their names on works of art, among them Hadrian's wife Sabina. Others made a crucial—if complex—contribution to our knowledge of ancient monuments by writing about their journeys. Born in the early fifth century BCE in Halicarnassos (modern Bodrum, Turkey), Herodotus spent the best part of his adulthood traveling throughout the Mediterranean and the Near East. His account of his Egyptian travels still sur-vives. In the late first century BCE, the Greek geographer Strabo also wrote a valuable description of his experiences in Egypt and elsewhere.

These authors saw the "great wonders" first hand, at a time when much more survived of them than today. Often their accounts supply vital information for reconstructions, or other details, such as the names of artists, architects, or patrons, but it is an easy mistake to accept their words uncritically. Often, these ancient travelers had different priorities from the modern art historian, and this fact would certainly have affected the accuracy of their accounts. Herodotus, for instance, was much more interested in religion than in works of art or architecture. This results in considerably less detailed or accurate information about artistic monuments than we might desire. It is also all too easy to forget that even ancient travelers visited Egypt at least a millennium after the pyramids and other monuments had been built. Furthermore, they relied on traditions handed down by guides and other locals, who, research shows, were often misinformed. Herodotus insists that the blocks of Khufu's pyramid were all at least 30 feet long, when three feet would have been more accurate. He also attributes the work to slaves, thus denigrating Khufu as a tyrant. Local priests may have broadcast this view in the fifth century BCE to please their Persian rulers. A long tradition among scholars of giving greater credence to classical texts than other types of evidence has led, in many instances, to an undue acceptance of ancient authors' words as "truth," even when archeological evidence paints a different picture.

Even as Ramses II extended the borders of his realm to the south and the east during his reign, the cult centers at Luxor and Karnak absorbed great wealth and exerted great influence. About 1076 BCE, barely 70 years after the end of the reign of Ramses III, priests exerted more and more power, until the cult of Amun dominated Egypt during the Twenty-first Dynasty. Thereafter, successive groups of foreigners, including Nubians, Persians, and Macedonians controlled the area.

The final phase of ancient Egypt belongs to the history of Greece and Rome. Alexander the Great conquered Egypt and then founded the city of Alexandria before his death in 323 BCE. His general, Ptolemy (d. 284 BCE), became king of the region, and established a dynasty that lasted nearly 300 years, until the death of Ptolemy XIV, Cleopatra's son by the Roman dictator Julius Caesar. In 30 BCE, the Roman ruler Octavian, soon to be the Roman Emperor Augustus, claimed Egypt as a Roman province. Nevertheless, Egypt flourished economically under the Greeks and Romans. In the Ptolemaic period, Alexandria became one of the most vibrant centers of culture and learning in the Hellenistic world, and its port ensured a lively trade, reaching as far as China and India. In Roman times, the Nile's life-giving waters made Egypt the chief source of grain in the empire, earning it the title of Rome's granary.

But in addition to this commercial function, Egypt provided Rome and its successors with inspiring models of kingly power and imagery that lasted through the ages. For some 3,000 years, from the era of the pyramids to the time of the Ptolemies, Egyptian kings built magnificent structures that expressed their wealth and their control over the land and its resources. All aspects of royal patronage demonstrated the intimate link between the king and the gods. Building in stone and on a grand scale, Egyptian kings sought to impress a viewer with the necessity and inevitability of their rule. The formulas for representing the power of the king are as old as Egypt itself.

Egyptian kings and other elite patrons built structures for both the living and the dead. The objects and images placed in their tombs for the afterlife offer a modern viewer a glimpse of the material goods that they enjoyed in their lifetimes. The tombs provided safe haven for the body and the soul (*ka*) of the deceased. They were built to endure, and they were equipped with numerous representations of the dead. These representations were also designed to last by virtue of being made of the most permanent of materials. Permanence was also sought through the consistent use of conventions for representing the patron. The longevity of Egyptian art forms testifies to the longevity of Egyptian social structure, political organization, and beliefs.

SUMMARY

Ancient Egypt flourished along the Nile River in North Africa. Its society was extremely hierarchical, and artists produced paintings, sculptures, and other objects—many of which have survived the millennia in an excellent state of preservation—for elite patrons, including the all-powerful god-kings and their royal families. Exceptional technique and monumentality are common characteristics of Egyptian art, which quickly developed a conservative tradition of form and subject.

Complex religious beliefs and rituals stressed the importance of the afterlife, and much of the wide range of ancient Egyptian art objects produced over thousands of years were made for the elaborate tombs of the ruling class. Modern excavations and research continue to add new finds and information to this bounty.

PREDYNASTIC AND EARLY DYNASTIC EGYPT

Although historians continue to debate the specific chronology of ancient Egypt, modern scholars group the dynasties into three major periods: the Old, Middle, and New Kingdoms. The periods preceding the Old Kingdom are referred to as predynastic and early dynastic Egypt. The art of the first dynasties of Egyptian rule established a pattern that patrons and artists would follow for millennia. Elite patrons commissioned funerary structures and furnishings as well as sculptures and paintings that depicted them in idealized and timeless forms.

THE OLD KINGDOM

The Old Kingdom endured for five centuries, and its rulers commissioned works of art that would be emulated for the following two millennia. Artists followed a formula for representing idealized human figures according to an evolving set of proportions. And since Egyptians believed that the *ka*, or life force, of an individual lived on in the grave, embalmers went to great lengths to preserve the body for eternity after death. Among the most significant achievements of the Old Kingdom are the burial complex of Djoser at Saqqara and the three massive pyramids built at Giza, each tomb representing the ruler's immense religious and political power.

THE MIDDLE KINGDOM

The Middle Kingdom lasted roughly four hundred years, following a period of governmental disintegration that occurred at the end of the Old Kingdom. It was a time during which artists deliberately echoed Old Kingdom forms, especially in the funerary realm, but one innovation of the Middle Kingdom was a more naturalistic expression on royal images. Also popular during this time were rock-cut tombs, rather than pyramids, for the burial of the elite. Like their predecessors, these tombs have elaborately designed and brightly painted wall relief decorations.

THE NEW KINGDOM

Lasting roughly five centuries, the New Kingdom followed the expulsion of the Hyksos from Egypt. It was an era of renewed territorial expansion and tremendous prosperity, and the arts flourished. Major building projects were carried out along much of the Nile, especially around Thebes (present-day Luxor). Monumental funerary complexes were built for rulers, including the magnificent and well-preserved cliffside temple of Hatshepsut. Kings spent considerable sums on structures dedicated to the gods, too, such as the massive temple of Amun-Ra at Karnak and the famed temple at Abu Simbel, which honored the gods and the god-king who commissioned it, Ramses II.

AKHENATEN AND THE AMARNA STYLE

The King Akhenaten established a new city devoted to the sun-god Aten at Akhetaten (now called Amarna). Refuting other traditional religious cults, Akhenaten intended the cult of the Aten to be monotheistic, which enraged the priests of the other religious cults. The new cult and its city were razed after Akhenaten's death, though portraits of the king, his wife Nefertiti, and their family survive. These works break with long-established conventions of portraiture and include rare examples of apparent intimacy among the figures. Akhenaten was succeeded by short-lived kings, including Tutankhamen, whose tomb—when discovered in 1922—was found to house a staggering volume of exquisite treasures.

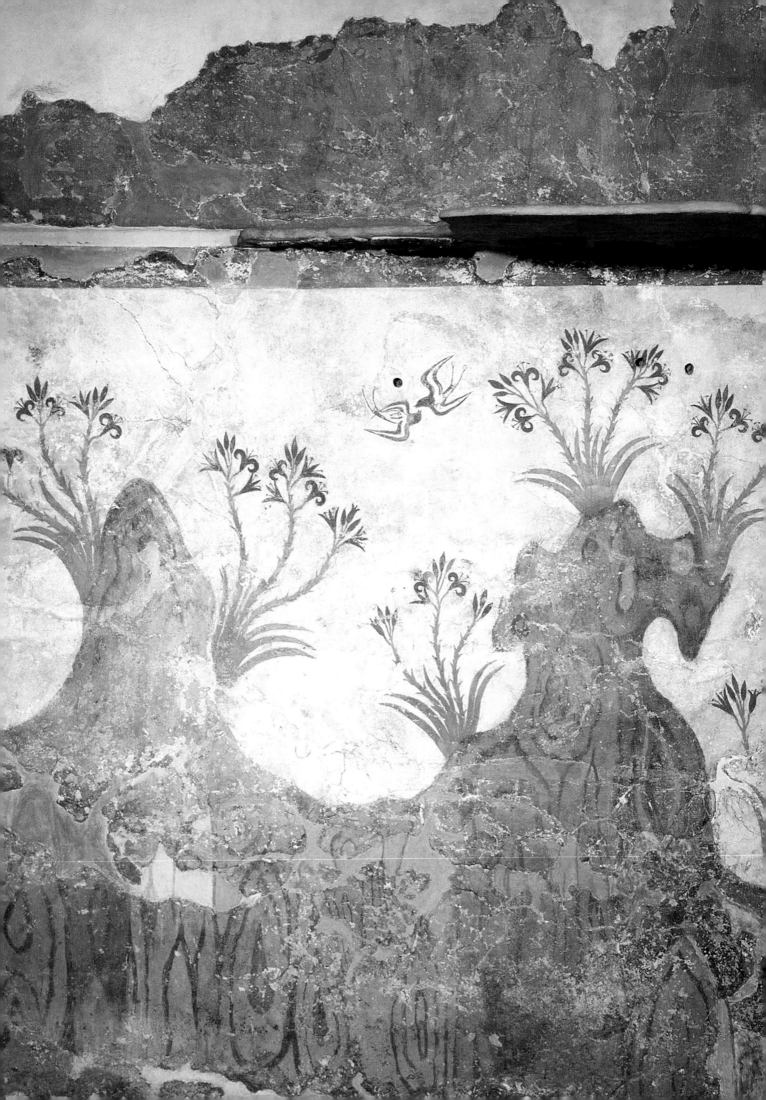

Aegean
Art

THE MEDITERRANEAN WAS ONE OF THE PRIMARY HIGHWAYS THAT connected the cultures of antiquity. With Egypt and North Africa on the south, Asia on the east and Europe on the west and north, this body of water brought disparate cultures into contact for both trade and war. One branch of the Mediterranean between Greece and Turkey, called the Aegean

Sea by the Greeks, was the site of a legendary war and its aftermath, at Troy (see map 4.1). Several closely related but distinct cultures developed on islands and peninsulas adjacent to the Aegean in the third and second millennia BCE.

The Cycladic culture was named for the islands forming an irregular circle north of Crete. The British archeologist Sir Arthur Evans named the culture on the island of Crete Minoan, for the legendary King Minos, son of the Greek god Zeus, and a mortal princess, Europa. The culture on the mainland is called Helladic, from the Greek *Hellas*, the name of a legendary ancestor. Together, these separate cultures formed a civilization we know today as Aegean, after the sea that both separates and unites them.

Until the second half of the nineteenth century, Aegean civilization was known principally from the *Iliad* and the *Odyssey*, epic tales of gods, kings, and heroes attributed to the eighth-century BCE Greek poet Homer. His story of the siege of Troy and its aftermath still excites the modern imagination. Prompted by these stories, and curious to determine whether they had a factual basis, Heinrich Schliemann, a German archeologist, excavated sites in Asia Minor and Greece during the 1870s. Taking his lead from the German, Arthur Evans began excavations in Crete, beginning in 1900. Since then, a great deal of

Detail of figure 4.9, *Spring Fresco*

archeological evidence has come to light, some consistent with, but much contradicting, Homer's tales. Although writing has been found in Minoan and Mycenaean contexts, scholars can decipher little of it. (Note the absence of *Primary Sources* in this chapter.) Consequently, we understand less about Aegean civilization than we do about the cultures of Egypt or the ancient Near East.

There is evidence of human habitation throughout the Aegean as early as the Paleolithic period, though settlements spread and grew mainly in the Neolithic and Early Bronze Ages. Scholars divide the Aegean Bronze Age into three phases: Early, Middle, and Late, each of which is further subdivided into three phases, I, II, and III. Archeologists often prefer these relative dates over absolute dates, because the chronology of the Aegean Bronze Age is so open to debate. The Early phase (ca. 3000–2000 BCE) corresponds roughly to the Predynastic and Old Kingdom period of Egypt, and Sumerian and Akkadian culture in Mesopotamia. The Middle phase (ca. 2000–1600 BCE) is contemporaneous with the Middle Kingdom in Egypt and the rise of Babylon in Mesopotamia. And the Late phase (ca. 1600–1100 BCE) occurs at the same time as the Second Intermediate Period and the start of the New Kingdom in Egypt, the Hittite overthrowing of Babylon, and the rise of the Assyrians in Mesopotamia. A mass destruction of Aegean sites, from a cause still unknown to us, led to significant depopulation in about 1200 BCE, and,

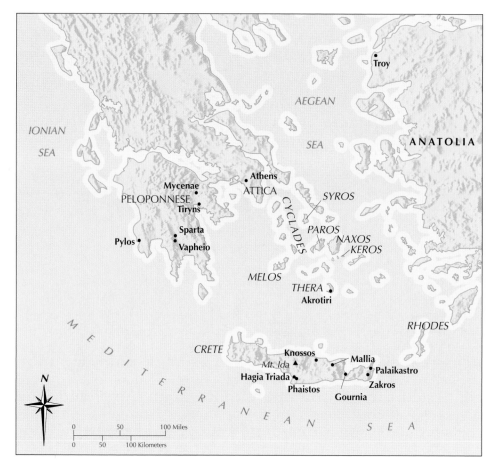

Map 4.1. The Bronze Age Aegean

despite a slight resurgence, by 1100 BCE the Aegean Bronze Age had come to an end.

These cultures each produced distinct art forms. Stylized marble representations of the human figure and frescoes are paramount in the Cyclades. Large palaces with elaborate adornments on their walls dominate on Crete. Citadels and grave goods remain from the Greek mainland. Because we can read and understand only a small part of Minoan and Mycenaean writing, their works of art provide valuable insights into their practices and ideals. That the tales of Homer and Greek myths look back to these cultures testifies to their importance to the development of later Greek culture.

EARLY CYCLADIC ART

Information about the culture of the Cyclades comes entirely from the archeological record. Only a limited range of objects survive, but this record indicates that wealth accumulated on the Cycladic islands early in the Bronze Age as trade developed, especially in obsidian, a dark volcanic stone.

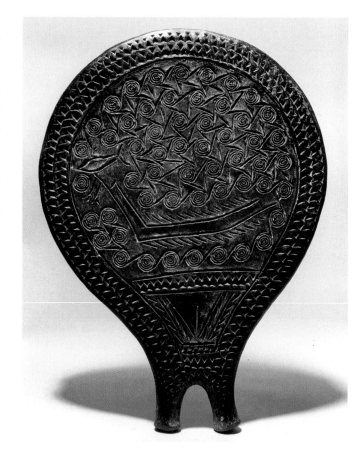

4.1. "Frying pan," from Chalandriani, Syros. Early Cycladic II. ca. 2500–220 BCE. Terra cotta, diameter 11″ (28 cm), depth 2⅜″ (6 cm). National Archaeological Museum, Athens

One mark of this growing wealth is found in funerary practice. In the beginning of the Early Bronze Age in the Cyclades, around 2800 BCE, the islanders started to bury their dead in stone-lined pits sealed with stone slabs, known as cist graves. Although they lacked large-scale markers, some of these graves contained offerings, such as weapons, jewelry, and pottery. Pottery was handmade in the Early Cycladic period. In addition to drinking and eating vessels, potters produced flat round objects with handles, known today as "frying pans" because of their shape (fig. **4.1**). They were decorated with incised or stamped spirals and circles, and sometimes with abstract renderings of ships. The frying pans may have been palettes for mixing cosmetics, or, once polished, they may have served as an early kind of mirror.

Some Cycladic burials included striking figures, usually female, carved from the local white marble. The Early Cycladic II example illustrated here represents the most common type (fig. **4.2**). The figure is nude, with arms folded across the waist, and toes extended. The flat body is straight-backed, while a long, thick neck supports a shieldlike face at a slight angle. The

ART IN TIME

ca. 2800 BCE—Cycladic islanders start to bury dead in
 stone-lined pits
ca. 2500 BCE—White marble Cycladic figurines
ca. 2575–2465—Ancient Egypt's Fourth Dynasty; construction of the
 three Great Pyramids at Giza

artist used abrasives, probably emery from the island of Naxos, to distinguish some of the details on the figure, such as a long, ridgelike nose, small pointed breasts, a triangular pubic area, and eight toes. Traces of pigments on a few surviving figures indicate that other details were painted on, including eyes, hair, jewelry, and body markings similar to tattoos.

The figures are of many sizes (the largest reaching 5 feet long and the smallest only a few inches), but their form is consistent enough that scholars speak of a governing canon of proportions, as they do of Egyptian sculptures (see Chapter 3). All the same, a number of them are clearly outside this canon.

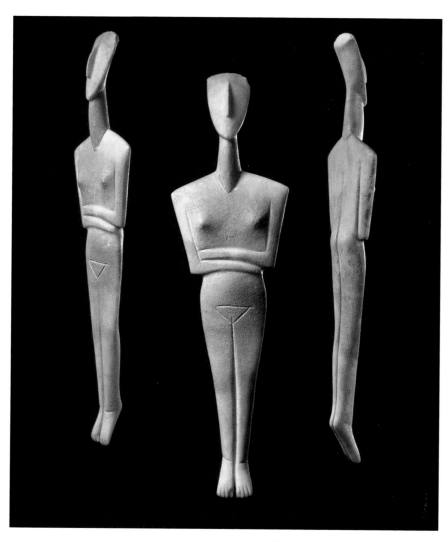

4.2. Figure, Cyclades. ca. 2500 BCE. Marble. Height 15$\frac{3}{4}$″ (40 cm). Nicholas P. Goulandris Foundation. Museum of Cycladic Arts, Athens. N.P. Goulandris Collection, No. 206

Some of the figures appear to be pregnant, some are male, and a distinct group depicts musicians, such as flute players or the harp player illustrated in figure **4.3**.

What did these figures represent, and what was their function? Scholars have offered several possible answers. For many years, archeologists called them Cycladic "idols," and pictured them playing a central role in a religion focusing on a mother goddess. More recently scholars have offered at least two plausible explanations for the figures' functions. Perhaps they were manufactured purely for funerary purposes, representing servants or surrogates for human sacrifices, or even for the body of the deceased. Alternatively, they may have functioned in Cycladic daily life before burial, possibly within household shrines. Although most have been found in a reclining position, they may also have been propped upright. The largest figures may have been cult statues. Some examples show signs of repair with wire, which is a strong indication that they were used—and cherished—before being deposited in graves.

Most likely, no single explanation applies to all of them. The greatest obstacle to determining their significance and function is our lack of knowledge about their **provenance**, that is, where and how they were found and their subsequent history. The style of the figures, particularly their simplicity and

clear geometry, appeals to a twentieth and twenty-first century aesthetic that favors understated and unadorned geometric forms. Those qualities and the luscious white marble used to form the figures have led to their widespread appearance on the art market, often without any record of archeological context. To have a clearer sense of how to interpret these figures, archeologists need to study them within their original contexts, whether that is in a burial context or in living quarters.

The carved figures of women and musicians that survive from these Aegean islands seem to look back to Paleolithic and Neolithic figures, such as the *Woman of Willendorf* (fig. 1.16). Yet the characteristic pattern of these figures—the canon that they followed—is distinct to these islands (and to Crete, where some examples have surfaced). The tradition of making figural imagery in the marble native to these islands would become a dominant feature of later Greek art.

MINOAN ART

Archeologists have found a wider range of objects and structures on Crete than on the Cyclades. This large island, lying south of the Cyclades, and about 400 miles northwest of Alexandria, Egypt, stretches over 124 miles from east to west, divided by mountain ranges, and with few large areas of flat, arable land (see map 4.1). Consequently, communities tended to be small and scattered. The island's geography, then, along with continuous migration throughout the Bronze Age, encouraged diversity and independence among the population. Centuries later, Homer assessed the island in this way: "There are many men in it, beyond counting, and 90 cities. They have not all the same speech; their tongues are mixed. There dwell Achaeans, there great-hearted native Cretans, there Cydonians, and Dorians in three divisions, and noble Pelasgians."

Homer and the Greeks associated Crete with the legendary King Minos, subsequently the Bronze Age culture on the island has become known as Minoan. The major flowering of Minoan art occurs about 2000 BCE, when Crete's urban civilizations constructed great "palaces" at Knossos, Phaistos, and Mallia. At this time, too, the first Aegean script, known as Linear A, appeared. Scholars call this the First Palace period, comprising what is known as Middle Minoan I and II. Little evidence of this sudden spurt of large-scale building remains, as all three early centers were heavily damaged, probably by an earthquake, in about 1700 BCE. A short time later, the Minoans built new and even larger structures on the same sites. This phase constitutes the Second Palace period, which includes Middle Minoan III and Late Minoan IA, and IB. These centers, too, were demolished by an earthquake in about 1450 BCE. After that, the palaces at Phaistos and Mallia were abandoned, but the Mycenaeans, who gained control of the island almost immediately, occupied Knossos.

The Palace at Knossos

The buildings of the Second Palace period are our chief source of information for Minoan architecture. The largest is the structure at Knossos, which its excavator, Arthur Evans, dubbed the Palace of Minos (figs. **4.4** and **4.5**). In fact, the city

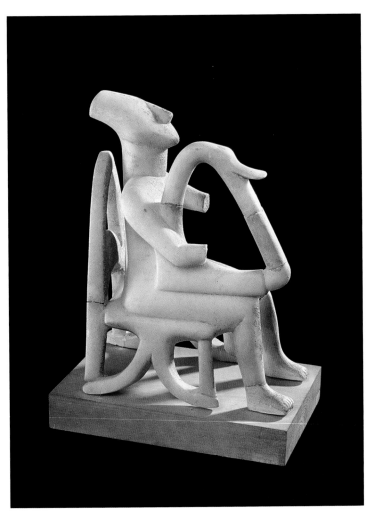

4.3. *Harpist*, from Amorgos, Cyclades. Latter part of the 3rd millennium BCE. Height 8½″ (21.5 cm). Museum of Cycladic Art, Athens

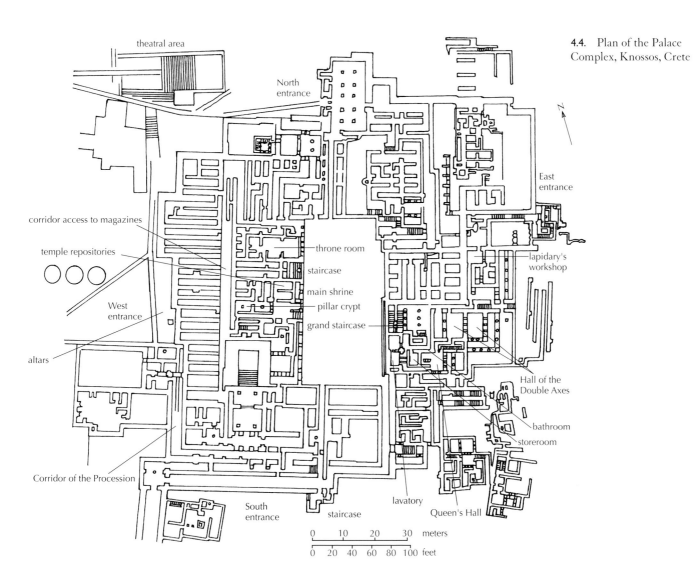

4.4. Plan of the Palace Complex, Knossos, Crete

theatral area

North entrance

East entrance

corridor access to magazines

temple repositories

throne room

staircase

main shrine

pillar crypt

grand staircase

lapidary's workshop

West entrance

altars

Hall of the Double Axes

Corridor of the Procession

bathroom

storeroom

lavatory

South entrance

staircase

Queen's Hall

0 10 20 30 meters
0 20 40 60 80 100 feet

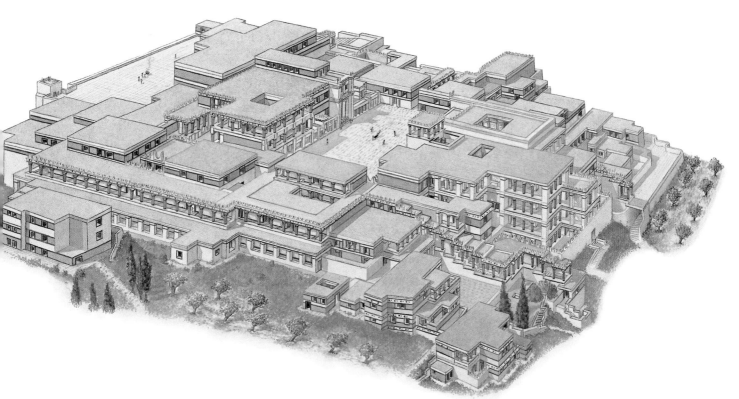

4.5. Reconstruction of the Palace Complex, Knossos, Crete

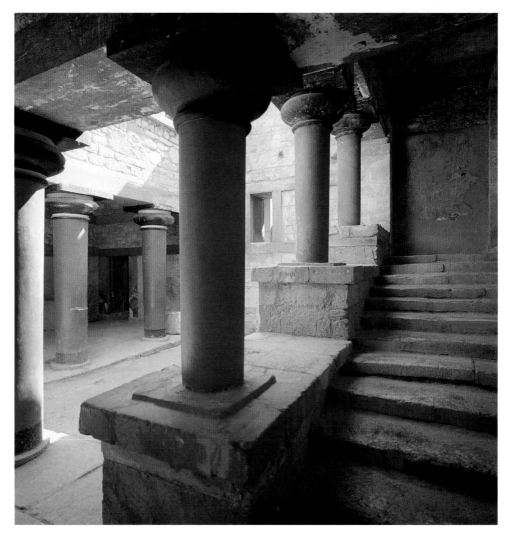

4.6. Staircase, east wing, Palace Complex. ca. 1500 BCE. Knossos, Crete

of Knossos may have been the most powerful Cretan center of the Middle and Late Bronze Age, with its most impressive structures dating between 1700 and 1400 BCE. Much of the palace was reconceived and reconstructed in concrete by Arthur Evans, who worked there between 1900 and 1932 (see *The Art Historian's Lens*, page 85). The palace consisted of courts, halls, workshops, storerooms (housing vast clay jars for oil and other provisions), and perhaps residential quarters, linked by corridors, staircases, and porticoes. Interior spaces were lit and ventilated by frequent light wells (as seen in fig. **4.6**). Other amenities in the palace included a system of clay pipes for drainage.

Walls were framed with timbers and constructed of rubble masonry or mud brick. Some of the walls were of ashlar masonry, giving them a more ornamental appearance. Columns, often made of wood with a stone base, supported the porticoes. Their form was unusual: A smooth shaft tapered downward from a generous cushionlike capital. Often the shaft was oval in cross-section rather than round. Wall paintings suggest that both components were painted,

the capital black and the shaft red or white. The origin of this type of column remains a mystery.

At first glance, the palace's plan (see fig. 4.4) has a confusing and haphazard appearance. Its mazelike quality probably explains why later Greek legend referred to the palace as the labyrinthine home of the Minotaur, the half-human, half-bull creature who devoured Athenian youths offered to him in tribute and whom Theseus killed after penetrating the maze. The island geography may have served as a natural defense for the palace. No exterior fortifications protected it from attack, so the mazelike arrangement of rooms may have been part of an internal defensive strategy; certainly entrances were not emphasized.

Nevertheless, the palace's design does have an underlying logic. Its core is a large central court, onto which important rooms opened. The court divides the plan on an approximately north–south axis. On the west side, a corridor running north–south separates long, narrow storerooms on the far west from rooms of less uniform shapes closer to the court; the latter rooms may have performed a

Two Excavators, Legend, and Archeology

In the mid-nineteenth century, most scholars believed that Homer's epic tales, the *Iliad* and the *Odyssey*, of the Trojan War and its aftermath, were merely the stuff of legend. But just a few decades later, that view had radically changed. Two extraordinary men were key figures in bringing about that change. One of them was Heinrich Schliemann (1822–1890). The German-born son of a minister, Schliemann became quite wealthy through a succession of business ventures and retired at the age of 41. From a young age he had been fascinated by Homer's world of gods and heroes, vowing to learn ancient Greek (one of about 15 languages he would eventually master). He became convinced that Homer's poetry was supported by a historical framework, and during his extensive travels, Schliemann learned that a handful of archeologists thought the Turkish site of Hissarlik was the probable site of Homer's Troy. After gaining permission from the Turkish government to excavate there, he began working officially in 1871. Among the spectacular finds he described in print was "Priam's Treasure," a hoard of vessels, jewelry, and weapons made of precious metals and named after Homer's king of Troy. Then, turning his attention to Mycenae, Schliemann discovered the shaft graves of Circle A, some of which contained magnificent objects, such as the gold mask in figure 4.27.

Schliemann was also intrigued by the site of Knossos on Crete, but he was unable to purchase the land. The opportunity fell instead to Arthur Evans (1851–1941), son of a renowned British naturalist, and himself the Keeper of the Ashmolean Museum at Oxford. By 1900 he had begun excavating the so-called Palace of Minos at Knossos with extraordinary results. In 1911, in recognition of his contribution to the field of archeology, Evans was knighted.

Scholars have judged these two early archeologists very differently. Schliemann's excavation technique was deemed destructive and Schliemann himself considered little more than a treasure hunter. Some scholars question whether he discovered Priam's Treasure as a hoard, or whether he assembled sporadic finds to make more of a news splash. Tales of his excavations have been embellished into myth in their own right. By some accounts, Schliemann had his Greek wife Sofia model ancient jewelry; it was also said that, after finding a gold mask at Mycenae, he telegraphed a Greek newspaper with the words "I have gazed on the face of Agamemnon." Only recently have scholars recognized the unfairness of assessing Schliemann by modern scientific standards, and they have acknowledged his critical role in igniting scholarly and popular interest in the pre-Hellenic world.

Evans's reputation has fared better than Schliemann's, largely because of his close attention to *stratigraphy*, that is, using layers of deposit in excavations to gauge relative time. This technique had been developed by geologists in the seventeenth and eighteenth centuries and is still used today in a refined form. Evans used it to assess the relative positions of walls and other features, and it led him to establish a relative chronology for the site as a whole. His designations of Early, Middle, and Late Minoan periods defined an essential historical framework for the Aegean world as a whole in the Bronze Age. Evans's work at Knossos included a considerable amount of reconstruction. His interventions help to make the site comprehensible to laypeople, but can also mislead an unknowing viewer. In fact, much of what a visitor sees at Knossos was built, not by Minoans, but by Evans. One significant consequence of Evans's restorations at Knossos is that they have kindled debate among conservators about how much to restore and how to differentiate visually between ancient ruin and modern reconstruction.

ceremonial role. An east–west corridor divides the east wing into (perhaps) a workshop area on the north side, and grander halls on the south. The palace appears to grow outwards from the court, and using flat (rather than pitched) roofs would have greatly facilitated the building of additions. Compared to Assyrian and Persian palaces, such as the palace of Sargon II (fig. 2.18) or the palace of Darius and Xerxes at Persepolis (fig. 2.26), the overall effect of the Palace at Knossos is modest; individual units are relatively small and the ceilings low. Still, the richly decorated walls of some of the interiors created an elegant appearance. We should also remember that much of what remains belongs to subterranean or ground-floor levels, and archaeologists have long believed that grander rooms existed on an upper level, which have not survived.

Exactly how the palaces of Crete functioned, and who lived in them, is debated even today. Arthur Evans described the complex as a "palace" (assigning royal names to various rooms) when he first excavated it, and the term stuck, regardless of its accuracy. Evans conceived of the complex as

a palace or an elite residence for several reasons. Partly, he was reacting to other recent discoveries on the Mycenaean mainland, described subsequently, and partly to the presence of a grand Throne Room. But the social and political realities of Evans's own homeland may have been even more influential. He would have been very familiar with the many large palaces commanded by the extended royal family of late Victorian England. In fact, excavation of the complex at Knossos suggests that many kinds of activities occurred there. Extensive storage areas support a hypothesis that the palace was a center of manufacturing, administration, and commerce. Additionally, ceremonial places, such as the great court with its triangular raised causeway, and small shrines with religious paraphernalia, suggest that political and ritual activities occurred there too. There is no reason to believe that the Minoans segregated these activities as neatly as we tend to do today. Moreover, we have no evidence suggesting that the functions of the various palaces, at Knossos and elsewhere, were identical, or that they remained constant over time.

Wall Paintings: Representing Rituals and Nature

Grand rooms within the palaces at Knossos and elsewhere were decorated with paintings. Most of them were found in extremely fragmentary condition, so what we see today is the result of extensive restoration, which may not always be entirely reliable. The frescoes are characterized by vibrant mineral colors, applied to wet or dry plaster in broad washes without shading; wide bands of geometric patterns serve as elaborate frames. The subjects that appear most frequently among the paintings at Knossos go a long way toward supporting a hypothesis of ritual activity there. For instance, a miniature Second Palace Period painting, dating to around 1500 BCE, depicts a crowd of spectators attending a ritual or a game (fig. **4.7**) and is known as the *Grandstand Fresco*. A tripartite building appears in the center. Scholars identify this structure as a shrine because of the stylized bulls' horns on its roof and in front of its facade. On either side sit two groups of animated women, bare-breasted and dressed in flounced skirts. Above and below, countless disembodied heads, rendered with simple, impressionistic black strokes, denote the crowd in a shorthand technique, on a swath of brown for males and white for females. They are smaller in scale than the central women, suggesting lesser importance. The fresco may represent an event that took place in the palace's central court, as remains of a tripartite shrine were found on the west side of the court.

Many other Minoan paintings use nature as their subject. A painting found in fragments in a light well has been restored to a wall in the room Arthur Evans called The Queen's Megaron in Knossos' east wing (fig. **4.8**). Blue and yellow dolphins swim peacefully against a blue-streaked cream background, cavorting with small fish. Within the upper and lower frames, multi-lobed green forms represent plants or rocks. Sinuous outlines suggest the creatures' form, while the curving, organic elements throughout the composition animate the painting. Such lively representations of natural forms occur frequently in Minoan art in a variety of media. The many images of sea creatures probably reflect the Minoans' keen awareness of and respect for the sea. The casualness of Minoan images contrasts forcefully with the rigidity and timelessness of many Egyptian representations, though there is good evidence for contact between Minoan artists and Egypt.

PAINTED LANDSCAPES IN A SEASIDE TOWN In the middle of the second millennium BCE, a volcano erupted on the Cycladic island of Thera (present-day Santorini), about 60 miles north of Crete. The eruption covered the town of Akrotiri in a deep layer of volcanic ash and pumice. Beginning in 1967, excavations directed by Spyridon Marinatos and then Christos Doumas uncovered houses dating from the Middle Minoan III phase (approximately 1670–1620 BCE) preserved up to a height of two stories. On their walls was an extraordinary series of paintings. Landscapes dominate. In a small ground-floor room, a rocky landscape known as the Spring Fresco occupies almost the entire wall surface (fig. **4.9**). The craggy terrain undulates dramatically, its dark outline filled with rich washes of red, blue, and ocher—colors that were probably present in the island's volcanic soils—with swirling black lines adding texture within. Sprouting from its surface, lilies flower in vivid red trios, while swallows dart between them, painted in a few graceful black lines.

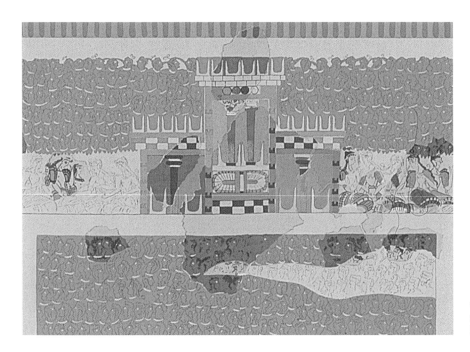

4.7. *Grandstand Fresco*, from Knossos, Crete. ca. 1500 BCE Archaeological Museum, Iráklion, Crete

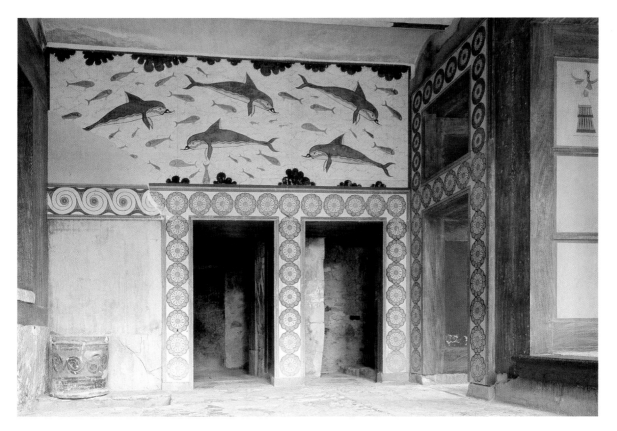

4.8. The Queen's Megaron. ca. 1700–1300 BCE, from Knossos, Crete. Archaeological Museum, Iráklion, Crete

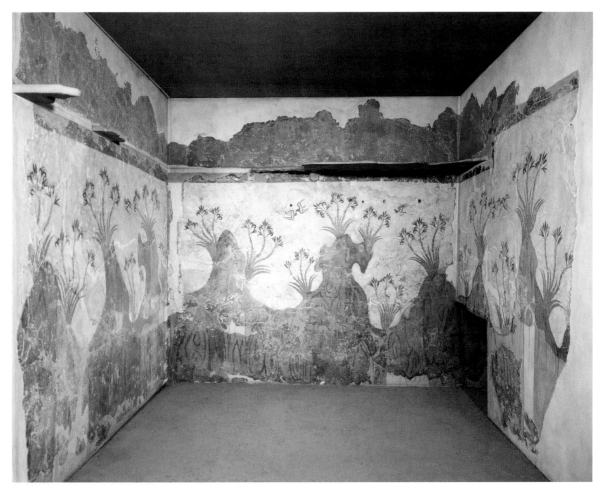

4.9. *Spring Fresco*. Fresco from Akrotiri, Thera. ca. 1600–1500 BCE. National Archaeological Museum, Athens

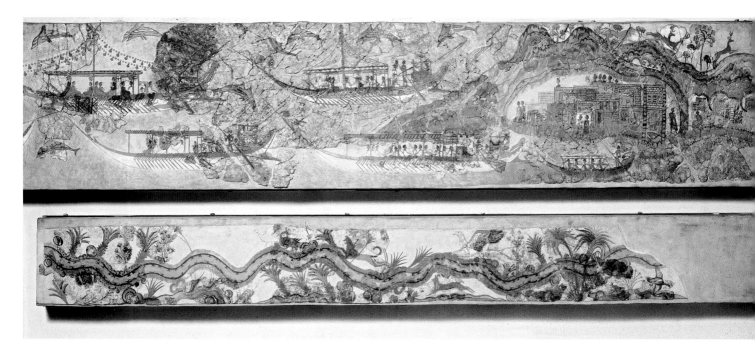

4.10. *Flotilla Fresco*, from Akrotiri, Thera. ca. 1600–1500 BCE. National Archaeological Museum, Athens

In other rooms at Akrotiri, humans are inserted into the landscape, often life-size, and sometimes smaller, as in a painting that decorated the upper section of at least three walls in a large second floor room (fig. **4.10**). The scene reflects the town's role as a harbor: A fleet of ships ferries passengers between islands, set within a sea full of leaping dolphins. The ships vary, some under sail and some rowed by oarsmen, but all are carefully described by the painter's brush. The same is true of the islands, each of which has a port city with detailed stone architecture. Crowds of people watch the spectacle from streets, rooftops, and windows. The painting may represent an actual event—a memorable expedition to a foreign land, perhaps, or an annual festival.

Minoan Pottery

Like the wall paintings, Minoan painting on pottery was inspired by the natural world of the Aegean. Minoan potters sensitively painted their vessels with lively organic forms that enhance the curving shapes of the vases. By the Middle and Late Minoan periods, pottery was manufactured on the wheel, allowing for a variety of rounded forms and many sizes. While large and rough vessels were used for storage, the finest wares, which were often very thin-walled, were made for palace use.

KAMARES WARE An organic approach to pottery appears in the shape of the vase in figure **4.11**, of the Middle Minoan II period (about 1800 BCE), which came from Phaistos in southern Crete. Its neck curves upward into a beak shape, which the vase painter has emphasized by giving it an eye. The vase is decorated with bold curvilinear forms in white, red, orange, and yellow against a black background. This style, known as Kamares

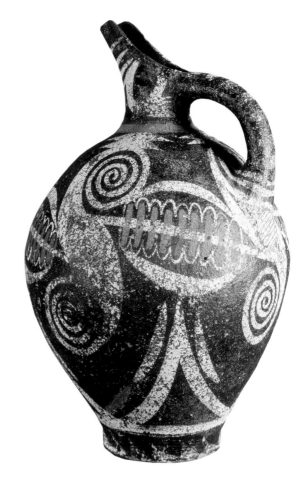

4.11. Beaked jug (Kamares ware), from Phaistos. ca. 1800 BCE. Height $10\frac{5}{8}''$ (27 cm). Archaeological Museum, Iráklion, Crete

ware, first appears at the beginning of the Middle Minoan phase and was named after the cave on Mount Ida where it was first discovered. The painted forms are abstract and endow the vessel with a feeling of life and movement.

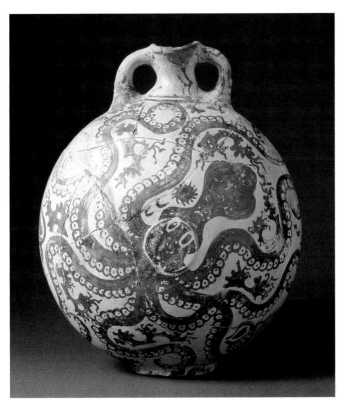

4.12. *Octopus Vase*, stirrup jar from Palaikastro, Crete. ca. 1500 BCE. Height 11″ (28 cm). Archaeological Museum, Iráklion, Crete

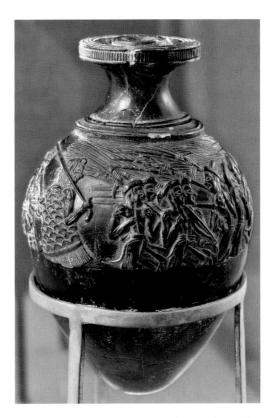

4.13. *Harvester Vase*, from Hagia Triada. ca. 1500–1450 BCE. Stone/steatite. Width 4½″ (11.3 cm). Archaeological Museum, Iráklion, Crete

MARINE MOTIFS Marine motifs became even more prevalent in the slightly more recent Minoan pottery of the Late Minoan IB phase. A vivid example of this "marine style" is a stirrup jar, which has two round handles flanking its narrow spout, decorated with a wide-eyed black octopus with swirling tentacles, contrasted against the eggshell-colored clay (fig. **4.12**). Clumps of algae float in the spaces between the tentacles. As with Minoan wall paintings, an extraordinarily dynamic and naturalistic quality characterizes the painting. Moreover, the painting's forms express the shape of the vessel they decorate: The sea creature's rounded contours emphasize the jar's swollen belly, while the curves of its tentacles echo the curved handles at the neck. Exactly beneath the spout, the end of a tentacle is curled to define a circle of the same size as the jar's opening.

Carved Minoan Stone Vessels

From an early date, Minoan artists also crafted vessels of soft stone, either from black steatite (serpentine), which was locally available, or from stones imported from other Aegean islands. They carved it with tools of a harder stone, hollowing out the interior with a bow-driven drill and then finishing surfaces with an abrasive, probably emery, from the Cycladic island of Naxos. Traces of gold reveal that the stone was then gilded. Archeologists suppose that many of these stone vessels had a ceremonial use. Fragments of such works were discovered at Hagia Triada on the southern side of Crete, including the black steatite vessel illustrated here (fig. **4.13**). This type of

vessel is called a **rhyton (plural rhyta)**: It has a large hole at the top and a smaller hole at the base, and was used for pouring liquid offerings or drinking.

Only the upper part of the rhyton in figure 4.13, called the *Harvester Vase*, survives. Twenty-seven slim, muscular men, mostly nude to the waist and clad in flat caps and pants, seem to move around the vessel with lively rhythm and raucous energy. Their dynamic movement echoes the animated imagery on Minoan pots and wall paintings. Hoisting long-handled tools over their shoulders, four bare-headed singers bellow with all their might. Their leader's chest is so distended that his ribs press through his skin. A single long-haired male in a scaly cloak, holding a staff, seems to head the procession. The leader of the singers holds a *sistrum*, a rattle that originated in Egypt. The detail of the sistrum and the composite depiction of the men's bodies provide evidence of contact between Crete and Egypt.

Interpretations of the scene depend partly on identifying the tools carried by the crowd and the objects suspended from their belts. If they are hoes and bags of seed corn, then the subject may be a sowing festival; if, instead, they are winnowing forks and whetstones, it is more likely a harvest festival. Alternatively, some scholars see the scene as a warriors' triumph, while still others see a representation of forced labor. In the absence of further evidence, either archeological or written, debates about the meaning of the image will certainly continue.

Another magnificent rhyton in the shape of a bull's head comes from Knossos, and dates to the Second Palace period

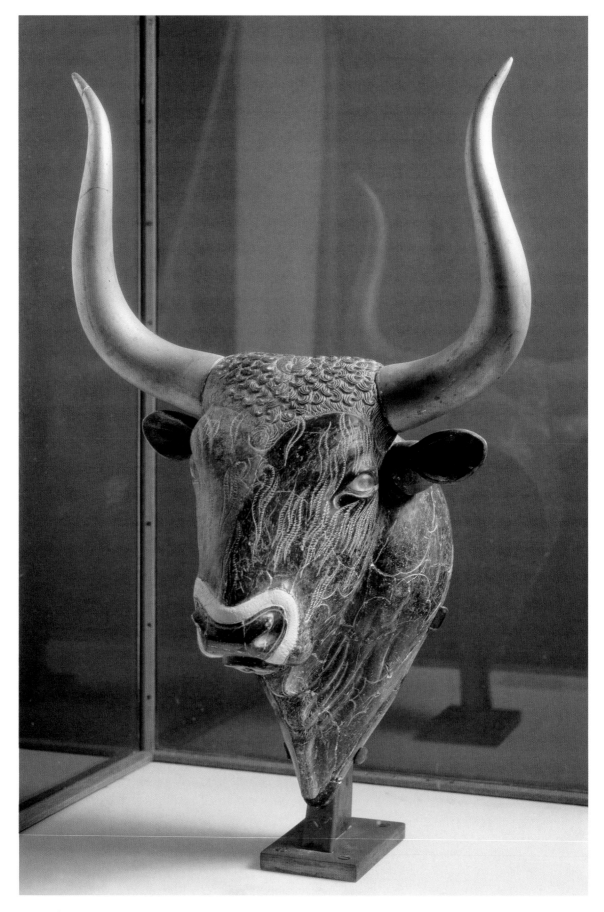

4.14. Rhyton in the shape of a bull's head, from Knossos. ca. 1500–1450 BCE. Serpentine, steatite, crystal, and shell inlay (horns restored). Height 8⅛″ (20.6 cm). Archaeological Museum, Iráklion, Crete

(about 1500–1450 BCE) (fig. **4.14**). Like the *Harvester Vase*, it is carved from steatite, with white shell inlaid around the muzzle. For the eye, the artist inserted a piece of rock crystal, painted on the underside with a red pupil, black iris, and white cornea, so that it has a startlingly lifelike appearance. The horns, now restored, were of gilded wood. Light incisions dusted with white powder evoke a shaggy texture and variegated color in the animal's fur. The vessel was filled through a hole in the neck, and a second hole below the mouth served as a spout. Similar vessels were discovered elsewhere in Crete, for instance at the Palace at Zakros, on the east coast of Crete. Egyptian tomb paintings of about the same time (1500–1450 BCE) depict Cretans carrying bull-headed rhyta, suggesting that the civilizations with which they traded identified Minoans with such vessels. The prevalence of the bull motif, coupled with evidence of altars decorated with horns, suggest that bulls played a part in Minoan religious ritual. Rhyta are often found smashed to pieces. Although later vandals or earthquakes might account

ART IN TIME

ca. 1792–1750 BCE —Babylon ruled by Hammurabi

ca. 1700–1400 BCE—Minoan Construction of the Second Palace at Knossos

ca. 1628 —Volcanic eruption on Thera

ca. 1500–1450 BCE—*Octopus Vase*, an example of Minoan "marine style" pottery

ca. 1450 BCE —Earthquake demolishes Knossos and other Minoan centers; Mycenaeans invade Crete

for such damage, their smashed state suggests that ceremonial vessels were ritually destroyed after use.

Religious life on Minoan Crete centered on natural places deemed sacred, such as caves, mountain peak tops, or groves. No temples or large cult statues have been discovered. Archeologists did find two small-scale **faience** statuettes from the Middle Minoan III phase (about 1650 BCE) at Knossos. One example shows a female figure raising a snake in each hand and wearing a headdress topped by a feline creature (fig. **4.15**). She wears a flounced skirt similar to those worn by women in the *Grandstand Fresco* (fig. 4.7), and bares her breasts. Her tiny waist is another feature that appears consistently in Minoan representations of humans, like the men on the *Harvester Vase* (fig. 4.13). In some ancient religions, snakes are associated with earth deities and male fertility, just as the bared breasts of this statuette suggest fecundity. Moreover, the statuettes were found in pits known as the Temple Repositories. These were sunk in the floor of a room on the west side of the central court. The statuettes' placement there, and accompanying remnants of furniture from the shrine, have led scholars to associate them with a mother goddess, yet they could just as easily have been ritual attendants.

Late Minoan Art

Scholars are still debating what brought Minoan civilization to an end. Some have argued that the eruption of the volcano on the island of Thera may have hastened the culture's decline. Recent discoveries and dating of the volcanic ash from this eruption, however, indicate that the civilization on Crete survived this natural disaster, though it may have been weakened by it. About 1450 BCE (Late Minoan II), the palaces at Crete were taken over by invaders from the Greek mainland, whom archeologists call Mycenaeans. They established themselves in the palace at Knossos until around 1375 BCE, when Knossos was destroyed and the Mycenaeans abandoned most of the sites of Crete. During the period of their rule, however, the artists at Knossos worked in styles that had developed in Minoan times.

The fragmentary *Toreador Fresco* dates from the Mycenaean occupation of Knossos (Late Minoan II–IIIA), and

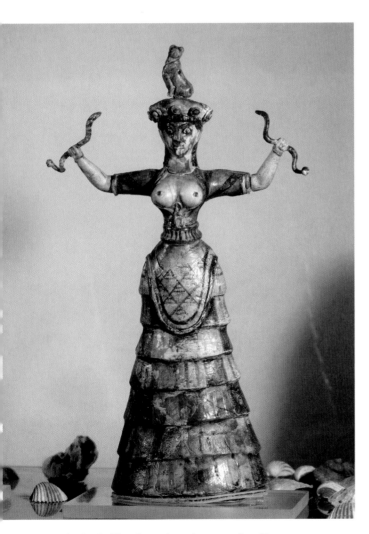

4.15. *Snake Goddess*, from the palace complex, Knossos. ca. 1650 BCE. Faience. Height 11⅝" (29.5 cm). Archaeological Museum, Iráklion, Crete

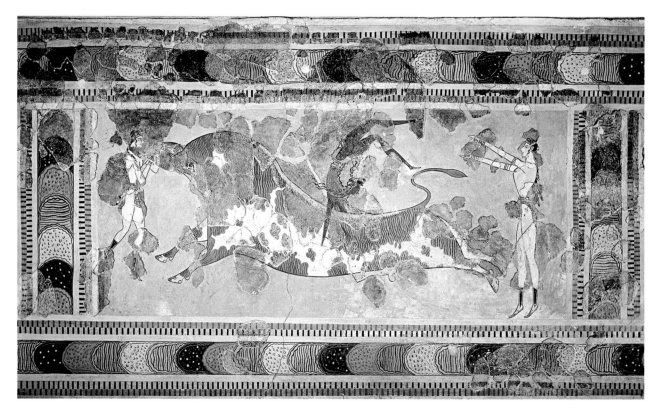

4.16. *The Toreador Fresco*, from the palace complex, Knossos. ca. 1550–1450 BCE (restored). Height including upper border approx. 24½″ (62.3 cm). Archaeological Museum, Iráklion, Crete

appears to have been one of a series that decorated an upper room in the northeast part of the palace (fig. **4.16**). Scholars have interpreted this bull-leaping scene as a ritual game in which performers vaulted over a bull's back. Against a deep blue background, a white-skinned figure clad in a kilt clasps the horns of a huge bull, painted with sinuous contours at a full gallop. Behind the bull, a similar white-skinned figure stands on tiptoe with arms outstretched, while above the bull's back, a dark-skinned figure performs a backward somersault. The figures have long limbs and improbably small waists, yet they are painted in true profile. The painting's washes of color and animated though somewhat stylized poses demonstrate the continuity of Minoan practice into the Late period.

Scholars continue to debate the meaning of this painting. Although most agree that bull jumping had a ritual function, the purpose of the activity and the identity of the participants is unclear. Following the widespread Mediterranean convention for distinguishing gender by skin tone, Evans identified the light-skinned figures as female and the darker one as male. Others have seen all three figures as sequential representations of the same person, taking part in a coming of age initiation ceremony in which boys emerge masculine from their earlier "feminine" guise. Many scholars see the presence of women in prominent roles in Minoan imagery as evidence of their importance in ritual activities.

MYCENAEAN ART

By the time the Mycenaeans conquered Crete, they had been building cities of their own on the Greek mainland since the start of the Late Helladic period. They probably made early contact with Minoan Crete, which had important influences on their own culture. Once again, the material remains offer the best clues about this culture. From the dating of Mycenaean sites and the objects discovered in them, archeologists place the height of the culture between about 1500 BCE and 1200 BCE (Late Helladic III). The most imposing remains are the citadels at sites that Homer named: Mycenae, Pylos, and Tiryns. The culture takes its name from the first of these, the legendary home of Agamemnon, the king who led the Greek forces in Homer's Trojan War.

Architecture: Citadels

At the beginning of the Second Palace Period on Crete, growing settlements throughout the Greek mainland, including at Mycenae itself (fig. **4.17**), centered around large structures known as citadels (when fortified) or palaces. In some of them, most particularly Pylos on the southern coast of the Peloponnesian region (see map 4.1), clay tablets have been found inscribed with a second early writing system. Dubbed Linear B because of its linear character and because it drew, in part, from earlier Minoan Linear A, the system was decoded by Michael Ventris in 1952. The tablets proved to have been inventories and archival documents, and the language of Linear B is now considered an early form of Greek. The inhabitants of these Late Bronze Age sites, therefore, were the precursors of the Greeks of more recent times.

The Linear B tablets refer to a *wanax* ("lord" or "king"), suggesting something of a Mycenaean social order. Mycenaean citadels and palaces may have incorporated royal residences. Many of them were gradually enclosed with imposing exterior walls, often expanded and improved in several building phases, and constructed so as to exploit the topography of the site.

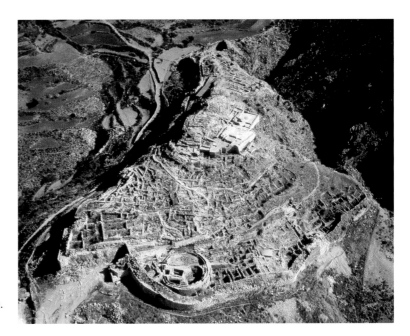

4.17. Aerial view of Mycenae, Greece.
ca. 1600–1200 BCE

These fortifications were constructed of large stone blocks laid on top of each other, creating walls that were at times 20 feet thick. These walls, and tunnels leading from them to wells that would provide water during a siege, have led scholars to regard the Mycenaeans as quite different from the Minoans, with a culture focused primarily on warfare.

The contrast is often stated in terms that imply an essential character difference between nature-loving Minoans and war-mongering Mycenaeans. We should note, however, that the fortifications date to after the destruction of Minoan centers, so the Mycenaeans may have been responding to a new set of political and social circumstances. Homer's characterizations of the kings of this era and, in fact, his entire narrative of the Trojan War, only reinforced modern ideas about the Mycenaeans as warlike. The poet himself described the city of Tiryns, set on a rocky outcropping in the plain of Argos in the northeastern Peloponnesus, as "Tiryns of the Great Walls." The inhabitants here fortified their citadel in several stages around 1365 BCE (figs. **4.18, 4.19**).

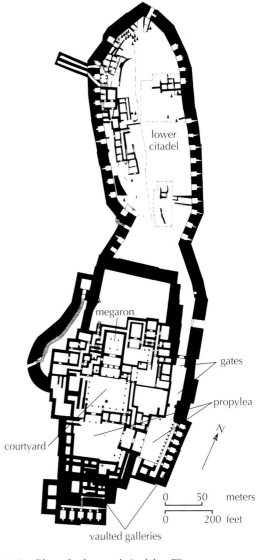

4.19. Plan of palace and citadel at Tiryns,
Greece. ca. 1400–1200 BCE

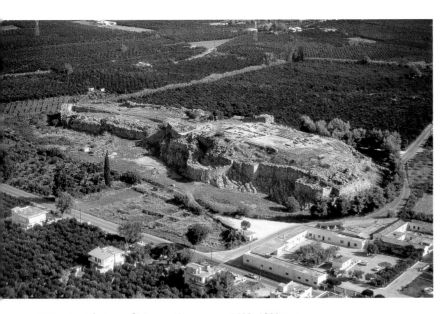

4.18. Aerial view of Tiryns, Greece. ca. 1400–1200 BCE

Cyclopean Masonry

The fortifications at Tiryns, Mycenae, and elsewhere were built of massive blocks of limestone, each weighing as much as 5 tons. For most of the wall, the blocks were hardly trimmed, and were thus irregularly shaped (or polygonal), wedged together with smaller stones and packed clay, but no mortar. This form of construction seems to be heavily influenced by Hittite construction at sites such as Bogazköy, Anatolia (see fig. 2.23). At entrances or other highly visible places, such as the Lion Gate (see fig. 4.22), builders sometimes used a technique known today as ashlar masonry. Blocks of conglomerate stone—incorporating pebbles and sediments—were cut with a saw and then *dressed*, that is, smoothed, with a hammer, and laid in regular courses.

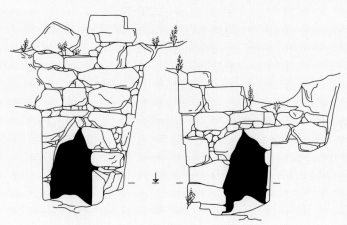

Drawing showing cyclopean masonry construction

Like the slightly later walls at Mycenae, those at Tiryns were built of massive blocks of limestone, weighing as much as 5 tons. For most of the wall, the blocks were irregularly shaped (or polygonal), wedged together with smaller stones and fragments of pottery. At entrances or other highly visible places, the stones might be saw-cut and dressed, or smoothed with a hammer. In its final form, the outer wall at Tiryns was a full 20 feet thick, and a second inner wall was just as impressive. Centuries later, the Greeks were so awed by the massiveness of these walls that they declared them the work of the Cyclopes, a mythical race of one-eyed giants. Even today, the walls are termed "Cyclopean." (See *Materials and Techniques*, above.)

The fortifications at Tiryns were carefully designed to manipulate a visitor's approach to the residents' military advantage, as the slightly earlier Hittite fortifications also did (see fig. 2.23). A narrow walled ramp circled the walls, so that an aggressor approaching in a clockwise direction would have the nonshield-bearing side vulnerable to attack by defenders on the walls. If an aggressor reached the entrance, two sets of fortified **propylons** (gateways) presented further obstacles, between which the attacker could be trapped and attacked from above. Within the walls, rooms and passages known as **casemates** provided storage for weapons. They also offered safety for townspeople or soldiers during an attack (fig. **4.20**). The gallery at Tiryns was built using a **corbel** technique: The stones are laid so that each course of masonry projects slightly beyond the course below it, until the span is covered when the walls meet in an irregular arch (fig. **4.21**). When, as here, a corbel is used to roof an entire space, it is called a **corbel vault**.

A corbel arch was also used to great effect at the Lion Gate at Mycenae of about 1250 BCE. The Lion Gate formed a principal entrance into the citadel at Mycenae, and was built when the city walls were enlarged to improve its defenses (fig. **4.22**). Two massive stone posts support a huge lintel to form the opening. Above the lintel, a corbel arch directs the weight of the heavy wall to the strong posts below it. The corbel thus relieves the weight resting on the vast stone lintel, which itself weighs 25 tons; it is known as a relieving triangle. To seal the resulting gap, a triangular grey limestone slab was inserted above the lintel, carved with a huge pair of animals, probably lionesses (though they may be sphinxes or griffins). They stand in a **heraldic pose**, mirror images of each other, with their front paws on altars of a Minoan style, and flanking a tapering Minoan style column. Dowel holes in their necks suggest that their heads were added in wood or a different stone, such as steatite or white marble. At almost 10 feet high, this relief is the first large-scale sculpture known on the Greek mainland. The column between the animals may have supported another element of some kind. The lionesses function as guardians, and their tense, muscular bodies, and symmetrical design suggest an influence from the Near East. The concept of animal guardians at the gate of a palace may have been suggested by similar structures such as the Hittite Lion Gate at Bogazköy, Anatolia (fig. 2.23). Mycenaeans ventured all over the Mediterranean, including Egypt and Anatolia, and Hittite records suggest contact with a people who may have been the Mycenaeans.

The walls of Mycenaean citadels protected a variety of buildings (see fig. 4.17). These interior structures were built of rubble

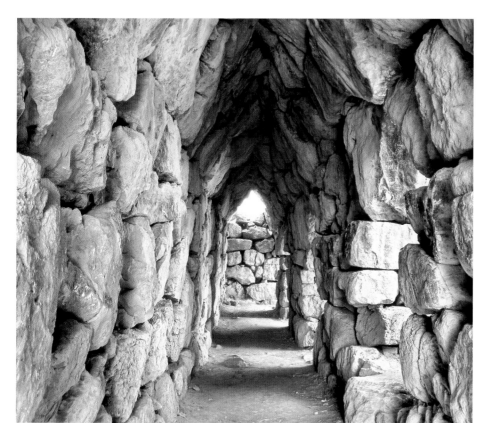

4.20. Corbeled casemate at Tiryns, Greece. ca. 1400–1200 BCE

4.21. Drawing: Corbel arch

in a timber framework, as in Minoan palaces, sometimes faced with limestone. The dominant building was a **megaron**, a large rectangular audience hall. At Tiryns (see fig. 4.19) the megaron lay adjacent to an open courtyard. Two columns defined a deep porch that led into a vestibule and then into the hall. The hall contained a throne and a large central hearth of stuccoed clay, surrounded by four columns supporting the roof beams. Above

the hearth, the ceiling was either left open to the sky or covered by a raised roof, allowing smoke to escape and light to enter.

The design of a megaron is essentially an enlarged version of simple houses of earlier generations; its ancestry can be traced back to Troy in 3000 BCE. A particularly well-preserved example of a megaron survives at the southern Peloponnesian palace of Pylos of about 1300 BCE. There, the hearth is set into a plastered

4.22. The Lion Gate, Mycenae, Greece. ca. 1250 BCE

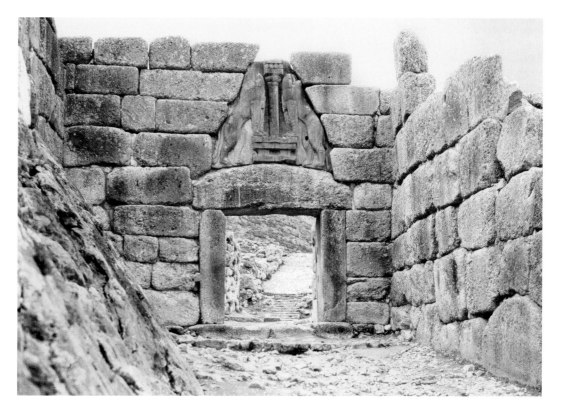

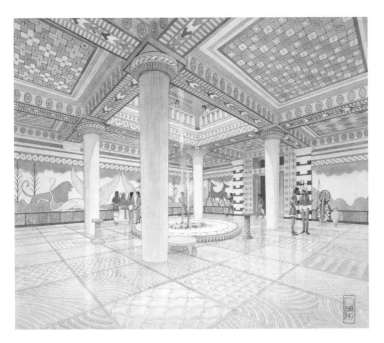

4.23. Reconstruction of megaron at Pylos, ca. 1300–1200 BCE

floor decorated to resemble flagstones of varied ornamental stone (fig. **4.23**). A rich decorative scheme of wall paintings and ornamental carvings enhanced the megaron's appearance. The throne stands against the northeast wall, flanked on either side

by painted griffins, similar to those decorating the throne room at Knossos, elaborated under Mycenaean rule. Other elements of the decoration, such as the shape of the columns and the ornament around the doorways, reveal Minoan influence at Pylos.

Mycenaean Tombs and Their Contents

At the end of the Middle Helladic period at Mycenae, the ruling elite began to bury their dead in deep rectangular shafts, marking them at ground level with stones shaped like stelai. The burials were distributed in two groups (known as Grave Circles A and B), which later generations eventually set off and monumentalized with a low circular wall. As time passed, the elite built more dramatic tombs, in a round form known as a *tholos*. Over 100 tholoi are known on the mainland, nine of them near Mycenae.

One of the best preserved and largest of these tombs is at Mycenae. Dubbed the "Treasury of Atreus," after the head of the clan that Homer placed at Mycenae, it dates to about 1250 BCE (Late Helladic III B). A great pathway, or *dromos*, lined with ashlar masonry, carefully cut and fitted, led to a spectacular entrance (fig. **4.24**). The door slopes inward, in a style associated with Egyptian construction. Flanking the opening were columns of Egyptian green marble, carved with spirals and zigzags (fig. **4.25**). Above the doorway, small columns framed decorative marble bands that concealed a relieving triangle over the lintel.

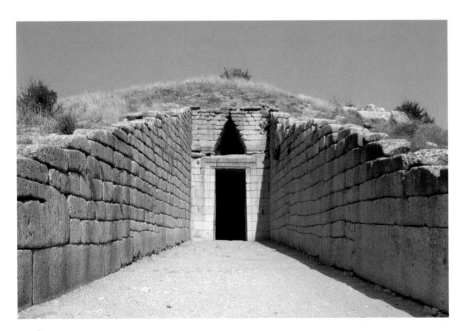

4.24. "Treasury of Atreus," Mycenae, Greece. ca. 1300–1250 BCE

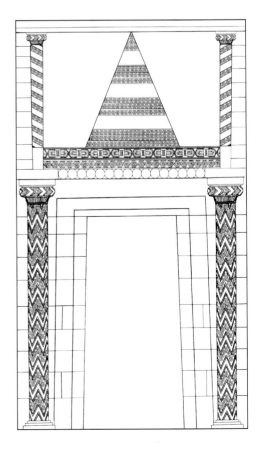

4.25. Reconstruction of the facade of "Treasury of Atreus," Mycenae, Greece. ca. 1300–1250 BCE

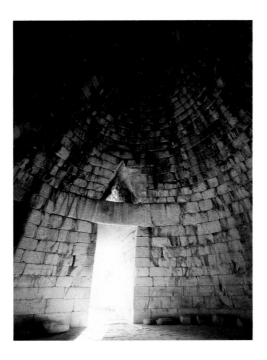

The tomb itself consisted of a large circular chamber excavated into sloping ground and then built up from ground level with a corbel vault: Courses of ashlar blocks protruded beyond one another up to a capstone (fig. **4.26**). When built in rings rather than parallel walls (as at Tiryns, fig. 4.21), the corbel vault results in a beehive profile for the stone roof. Earth covered the structure, helping to stabilize the layers of stone and creating a small hill, which was encircled with stones. The vault rose 43 feet over a space 48 feet in diameter. Such a large unsupported span would not be seen again until the Pantheon of Roman times. The ashlar blocks of the vault may once have been decorated with gilded rosettes to resemble a starry sky. To one side of the main room, a small rectangular chamber contained subsidiary burials.

METALWORK Like the Great Pyramids of Egypt, these monumental *tholos* tombs exalted the dead by drawing attention to themselves. As a result, they also attracted robbers throughout the ages, and the grave goods that once filled the "Treasury of Atreus" have long been dispersed. Many of the earlier shaft graves also contained lavish burial goods, ranging from luxurious clothing and furniture to fine weaponry. On excavating Grave Circle A, Schliemann discovered five extraordinary death masks of hammered gold, covering the faces of dead males. Although far from naturalistic, each mask displays a distinct treatment of physiognomy: Some are bearded while others are clean-shaven. This suggests that the masks were somewhat individualized to correspond to the deceased's appearance. On finding the example illustrated in figure **4.27** in 1876, Schliemann told the press, "I have gazed into the face of Agamemnon." Since modern archeology places the mask between 1600 and 1500 BCE, and the Trojan War—if it happened—would date to about 1300–1200 BCE, this would certainly not be a mask of Agamemnon. But the mask may

represent a Mycenaean king of some stature, given the expense of the materials and the other objects found near it. Among the weapons in the graves were finely made ornamental bronze dagger blades. Such blades were often inlaid with spirals or figural scenes in gold, silver, and **niello** (a sulfur alloy that bonds with silver when heated, to produce a shiny black

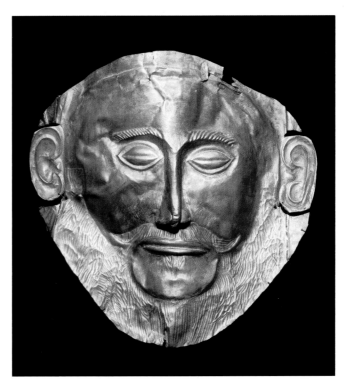

4.27. *Mask of Agamemnon*, from a shaft grave in Circle A, Mycenae. ca. 1600–1500 BCE. Gold. Height 12″ (35 cm). National Archaeological Museum, Athens

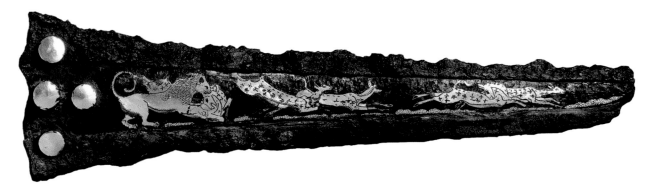

4.28. Inlaid dagger blade, from shaft grave IV, Grave Circle A, Mycenae, Greece. ca. 1600–1550 BCE. Length 9⅜″ (23.8 cm). National Archaeological Museum, Athens

metallic finish). The example in figure **4.28** depicts a lion preying on gazelles; the lion's predatory strength is associated with the dagger's owner.

THE VAPHIO CUPS While the burial method used in the shaft graves is distinctively Mycenaean, the treasures found within them raise an interesting question about the interactions between Minoans and Mycenaeans. Many objects show Minoan influence, while others appear so Minoan that they must have come from Crete or been created by Cretan craftsmen. Two gold cups from a Mycenaean tomb at Vaphio near Sparta, in the southern Peloponnesus, are particularly intriguing (fig. **4.29**). Probably crafted between 1500 and 1450 BCE, the cups are made of two skins of gold: The outer layer was embossed with scenes of bull-catching—a theme with Minoan roots—while the inner lining is smooth. A cylindrical handle was riveted to one side. On one cup, bull-trappers try to capture the animal with nets, while on the other, a cow set out to pasture is a lure to entice a bull into

captivity. The subject matter of the cups suggests that they refer to one another, yet they are not, strictly speaking, a pair. One cup has an upper border framing the scene, but the other does not, and stylistic analyses suggest that each cup was crafted by a different artist. Where the cups or the artists originated is a matter of debate. For some, the "finer" cup (with the pasture scene) is Minoan on account of its peaceful quality, and the other a more violent Mycenaean complement made by a Mycenaean—or a Minoan—artist. What the cups underline is how little we understand about the interplay between, and the movements of, Minoan and Mycenaean artists, and, indeed, how arbitrary and subjective our attempts to distinguish between them may be.

Sculpture

As in Crete, Mycenaean religious architecture apparently consisted of modest structures set apart from the palaces. At these small shrines the Mycenaeans worshipped a wide variety of gods. Names recorded on Linear B tablets indicate that some of

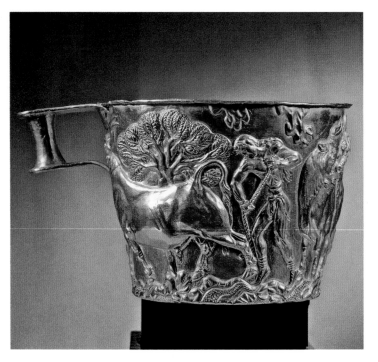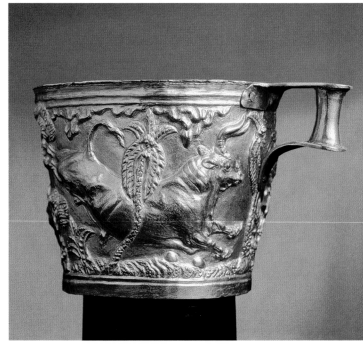

4.29. *Vaphio Cups.* ca. 1500–1450 BCE. Gold. National Archaeological Museum, Athens

these gods, such as Poseidon, are the predecessors of the later Olympian gods of Greece. The Greek Poseidon was the god of the sea, a divinity who must have been of some importance to the seafaring Mycenaeans.

Free-standing sculptures are rare, but one small, finely carved ivory group depicting two kneeling women with a young child was found in a shrine next to the palace at Mycenae in 1939 (fig. **4.30**). The women wear flounced skirts similar to the one worn by the Minoan *Snake Goddess* (fig. 4.15), suggesting that the work came from Crete or was carved by an artist from Crete working on the Greek mainland for Mycenaean patrons. But the material is ivory that probably originated in Syria or Egypt, documenting Mycenaean trade links. The figures' intertwined limbs and the child's unsettled pose describe a transient moment that will change in an instant. For some scholars, the close physical interaction among the figures suggests that this small object is a rendering of a family group, including grandmother, mother, and child. Others argue that it represents three separate divinities, one of whom takes the form of a child.

This tiny sculpture is made of imported ivory in a Minoan style for a Mycenaean patron. Along with the Treasury of Atreus, with its echoes of Egypt, and the Lion Gate, a blend of Minoan and Near Eastern influences, this object and others that survive from Bronze Age Greece reveal a culture with contacts throughout the Mediterranean. Whether those contacts came as a result of war or trade, the culture of Mycenaean Greece was receptive to the ideas and forms of other regions. Despite its warlike and dynamic character, Mycenaean civilization collapsed around 1200 or 1100 BCE, probably in the chaos caused by the arrival of new peoples on the Greek mainland. Whether or not the inhabitants of these powerful citadels actually took part in the legendary 10-year-long siege of Troy in Asia Minor, their descendents believed they did. For the Greeks, for the poet Homer, the Mycenaean Age was an age of heroes.

ART IN TIME

ca. 1600–1500 BCE—Mycenaean death masks of hammered gold

ca. 1500–1200 BCE—Height of Mycenaean culture

ca. 1290–1224 BCE—Rule of ancient Egyptian pharaoh Ramses II

ca. 1250 BCE—Construction of the Lion Gate at Mycenae

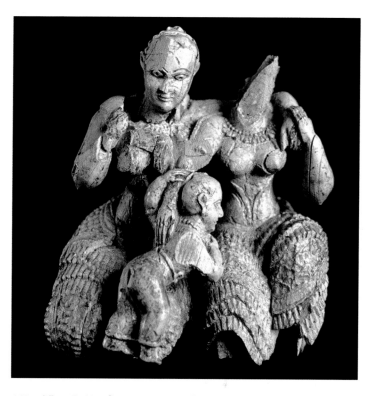

4.30. *Three Deities*, from Mycenae. 14th–13th century BCE. Ivory. Height 3″ (7.5 cm). National Archaeological Museum, Athens. Ministry of Culture Archaeological Receipts Fund. 7711

SUMMARY

The Mediterranean Sea was a highway that brought the various civilizations of antiquity into contact with one another for both trade and war. During the third and second millennia BCE, several closely related but distinct cultures developed on the islands and peninsulas in and adjacent to the Aegean Sea. These include the Cycladic culture, named for islands north of Crete; the Minoan culture, which constructed and decorated so-called palaces on Crete; and the Mycenaean culture, which left behind remarkable citadels and grave goods on the Greek mainland. The distinct art forms produced by each of these groups provide insights into the practices and ideals of ancient Aegean peoples.

EARLY CYCLADIC ART

The most characteristic art forms of the Cycladic islands of the third millennium BCE are carved marble figures of women and musicians. Although both the meaning and the function of these sculptures are obscure, the clean geometry and smooth surfaces of their abstracted forms hold great appeal for modern viewers.

MINOAN ART

Despite over a hundred years of archeological research on Crete and other sites in the Aegean, Minoan culture remains mysterious. The large and complex palaces that dominated the landscape of Crete probably served as administrative and ritual centers as well as residences. These structures were adorned with numerous frescoes and wall paintings and other decorative elements that represent, among other things, the natural world in lively, animated forms. Minoan pottery, sculpture, and ritual objects, which demonstrate organic and dynamic compositions, exhibit a high degree of craftsmanship.

MYCENAEAN ART

The Mycenaeans were named for the fortified settlement of Mycenae in the Peloponnesian region of mainland Greece. Their citadels—with huge walls, massive fortifications, and defensive layouts—suggest a culture concerned with defense, if they were not overtly warlike themselves. Nevertheless, the luxurious objects placed in Mycenaean burial sites and the lavish adornment of their palaces reveal that this group was open to influences from around the Mediterranean. Minoan, Egyptian, and Mesopotamian elements all contributed to Mycenaean art.

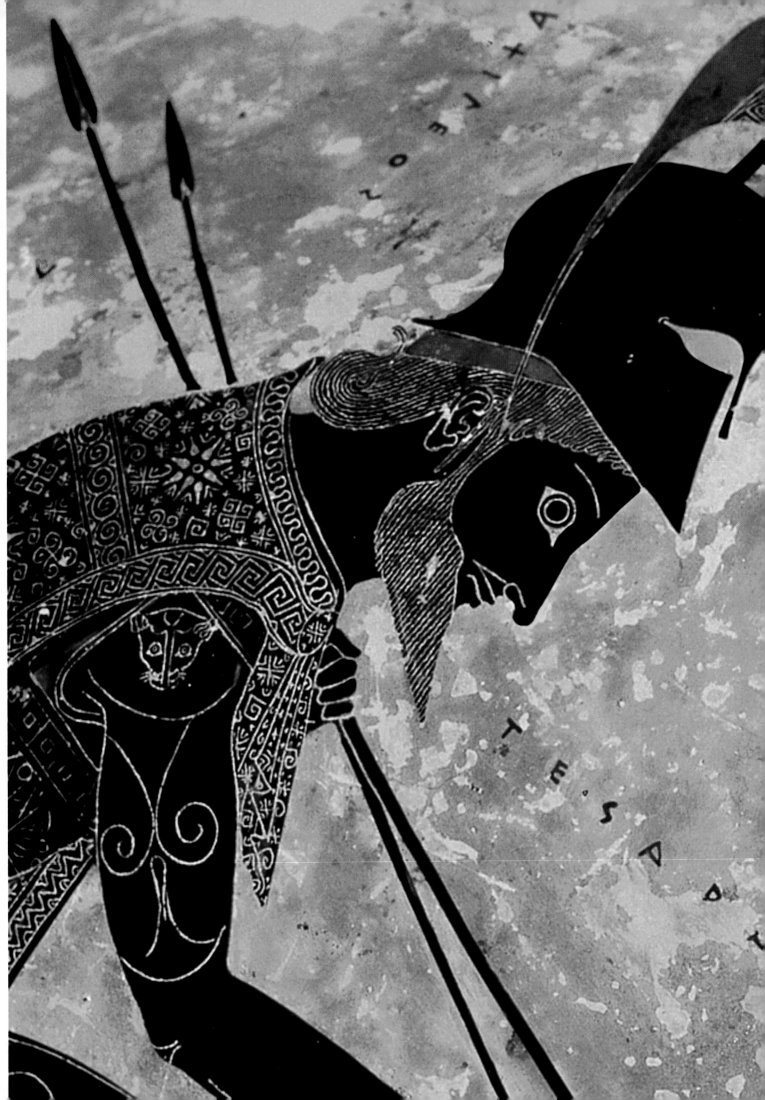

Greek Art

NO MATTER HOW ACCOMPLISHED THEY MIGHT BE, THE WORKS OF ART we have discussed so far seem alien to us. The ancient cultures that produced them were so different from our own that we find few references in those works to our own time. Greek architecture, sculpture, and painting, however, are immediately recognizable as the ancestors of

Western civilization, despite their debts to earlier art. A Greek temple reminds us of countless government buildings, banks, and college campuses; a Greek statue recalls countless statues of our own day; and a Greek coin is little different from those we use today. This is neither coincidental nor inevitable. Western civilization has carefully constructed itself in the image of the Greek and Roman worlds. For an art historian trying to understand the visual culture of those worlds, this presents a special challenge: It is tempting to believe that something familiar on the surface holds the same significance for us as it did for the Greeks or the Romans, but scholars have discovered time and time again that this is a dangerous fallacy.

Another complication in studying Greek art arises because there are three separate, and sometimes conflicting, sources of information on the subject. First, there are the works themselves—reliable, but only a small fraction of what once existed. Second, there are Roman copies of Greek originals, especially sculptures. These works tell us something about important pieces that would otherwise be lost to us, but copies pose their own problems. Without the original, we cannot determine how faithful the copy is, and sometimes multiple copies present several versions of a single original. To make things even more

complicated, a Roman copyist's notion of a copy was quite different from ours. A Roman copy was not necessarily intended as a strict imitation, but allowed for interpreting or adapting the work according to the taste or skill of the copyist or the wishes of the patron. Moreover, the quality of some Greek sculpture owed much to surface finish, which, in a copy, is entirely up to the copyist. If the original was bronze and the copy marble, the finish would differ dramatically. In some rare cases, apparent copies are of such high quality that we cannot be sure that they really are copies.

The third source of information about Greek works is literature. The Greeks were the first Western people to write at length about their own artists. Roman writers incorporated Greek accounts into their own; many of these have survived, although often in fragmentary condition. These written sources offer a glimpse of what the Greeks themselves considered their most important achievements in architecture, sculpture, and painting. This written testimony has helped us to identify celebrated artists and monuments, though much of it deals with works that have not survived. In other cases, surviving Greek works that strike us as among the greatest masterpieces of their time are not mentioned at all in literature. Reconciling the literature with the copies and the original works, and weaving these strands into a coherent picture of the development of Greek art, has been the difficult task of archeologists and ancient art historians for several centuries.

Detail of figure 5.26, *Achilles and Ajax Playing Dice*

The Greek Gods and Goddesses

All early civilizations and preliterate cultures had creation myths to explain the origin of the universe and humanity's place in it. Over time, these myths evolved into complex cycles that represent a comprehensive attempt to understand the world. The Greek gods and goddesses, though immortal, behaved in very human ways. They quarreled, and had children with each other's spouses and often with mortals as well. They were sometimes threatened and even overthrown by their own children. The principal Greek gods and goddesses, with their Roman counterparts in parentheses, are given below.

ZEUS (Jupiter): son of Kronos and Rhea; god of sky and weather, and king of the Olympian deities. After killing Kronos, Zeus married his sister HERA (Juno) and divided the universe by lot with his brothers: POSEIDON (Neptune) was allotted the sea, and HADES (Pluto) was allotted the Underworld, which he ruled with his queen PERSEPHONE (Proserpina).

Zeus and Hera had several children:

ARES (Mars), the god of war

HEBE, the goddess of youth

HEPHAISTOS (Vulcan), the lame god of metalwork and the forge

Zeus also had numerous children through his love affairs with other goddesses and with mortal women, including:

ATHENA (Minerva), goddess of crafts, including war, and thus of intelligence and wisdom. A protector of heroes, she became the patron goddess of Athens, an honor she won in a contest with Poseidon. Her gift to the city was an olive tree, which she caused to sprout on the Akropolis.

APHRODITE (Venus), the goddess of love, beauty, and female fertility. She married Hephaistos, but had many affairs. Her children were HARMONIA, EROS, and ANTEROS (with Ares); HERMAPHRODITOS (with Hermes); PRIAPOS (with Dionysos); and AENEAS (with the Trojan prince Anchises).

APOLLO (Apollo), with his twin sister ARTEMIS, god of the stringed lyre and bow, who therefore both presided over the civilized pursuits of music and poetry, and shot down transgressors; a paragon of male beauty, he was also the god of prophecy and medicine.

ARTEMIS (Diana), with her twin brother, APOLLO, virgin goddess of the hunt and the protector of young girls. She was also sometimes considered a moon goddess with SELENE.

DIONYSOS (Bacchus), the god of altered states, particularly that induced by wine. Opposite in temperament to Apollo, Dionysos was raised on Mount Nysa, where he invented winemaking; he married the princess Ariadne after the hero Theseus abandoned her on Naxos. His followers, the goatish satyrs and their female companions, the nymphs and humans who were known as maenads (bacchantes), were given to orgiastic excess. Yet there was another, more temperate side to Dionysos' character. As the god of fertility, he was also a god of vegetation, as well as of peace, hospitality, and the theater.

HERMES (Mercury), the messenger of the gods, conductor of souls to Hades, and the god of travelers and commerce.

The great flowering of ancient Greek art was just one manifestation of a wide-ranging exploration of humanistic and religious issues. Artists, writers, and philosophers struggled with common questions, still preserved in a huge body of works. Their inquiries cut to the very core of human existence, and have formed the backbone of much of Western philosophy. For the most part, they accepted a pantheon of gods, whom they worshiped in human form. (See *Informing Art*, above.) Yet they debated the nature of those gods, and the relationship between divinities and humankind. Did fate control human actions, or was there free will? And if so, what was the nature of virtue?

Greek thinkers conceived of many aspects of life in dualistic terms. Order (*cosmos*, in Greek) was eternally opposed to disorder (*chaos*), and both poles permeated existence. Civilization, which was, by definition, Greek, stood in opposition to an uncivilized world beyond Greek borders; all non-Greeks were "barbarians," named for the nonsensical sound of their languages to Greek ears ("bar-bar-bar-bar"). Reason, too, had its opposite: the irrational, mirrored in light and darkness, in man and woman. In their literature and in their art, the ancient Greeks addressed the tension between these polar opposites.

THE EMERGENCE OF GREEK ART: THE GEOMETRIC STYLE

The first Greek-speaking groups came to Greece about 2000 BCE. These newcomers brought with them a new culture that soon evolved to encompass most of mainland Greece, as well as the Aegean Islands and Crete. By the first millennium BCE the Greeks had colonized the west coast of Asia Minor and Cyprus. In this period we distinguish three main subgroups: the Dorians, centered in the Peloponnese; the Ionians, inhabiting Attica, Euboea, the Cyclades, and the central coast of Asia Minor; and the Aeolians, who ended up in the northeast Aegean (see map 5.1). Despite their cultural differences and their geographical dispersal, the Greeks had a strong sense of kinship, based on language and common beliefs. From the mid-eighth through the mid-sixth centuries BCE, there was a wave of colonization as the Greeks expanded across the Mediterranean and as far as the Black Sea. At this time, they founded important settlements in Sicily and southern Italy, collectively known as Magna Graecia, and in North Africa.

After the collapse of Mycenaean civilization, art became largely nonfigural for several centuries. In the eighth century BCE, the oldest Greek style that we know in the arts developed,

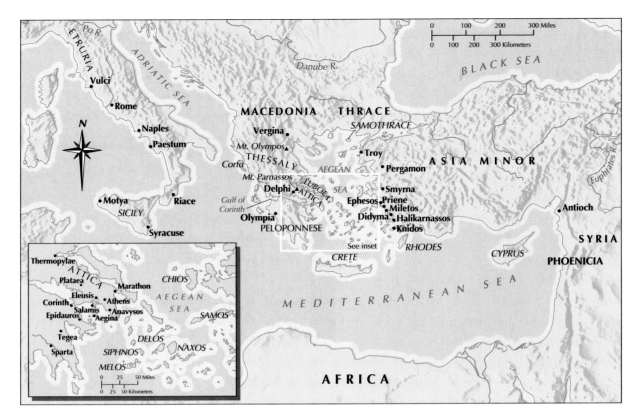

Map 5.1. The Ancient Greek World

known today as the Geometric. Images appeared at about the time the alphabet was introduced (under strong Near Eastern influence). It was contemporaneous, too, with the work of the poet Homer (or a group of poets), who wrote the lasting epic poems *The Iliad* and *The Odyssey*, tales of the Trojan War and the return of one of its heroes, Odysseus, home to Ithaka. We also have works in painted pottery and small-scale sculpture in clay and bronze. The two forms are closely related: Pottery was often adorned with the kinds of figures found in sculpture.

Geometric Style Pottery

As quickly as pottery became an art form, Greek potters began to develop an extensive, but fairly standardized, repertoire of vessel shapes (fig. **5.1**). Each type was well adapted to its function, which was reflected in its form. As a result, each shape presented unique challenges to the painter, and some became specialists at decorating certain types of vases. Larger pots often attracted the most ambitious craftsmen because they provided a more generous field on which to work. Making and decorating

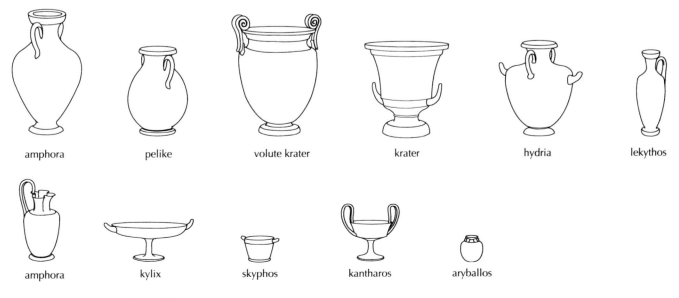

amphora pelike volute krater krater hydria lekythos

amphora kylix skyphos kantharos aryballos

5.1. Some common Greek vessel forms

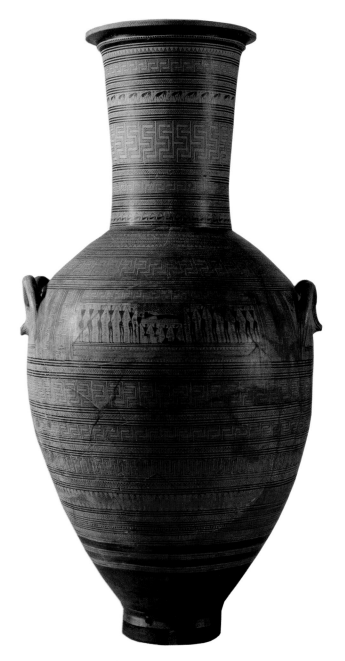

placed the ashes of their cremated dead inside vases, choosing the vase's shape according to the sex of the deceased. A woman's remains were buried in a *belly-handled amphora*, a type of vase more commonly used for storing wine or oil; a man's ashes were placed in a *neck-amphora*. A *krater*, a large bowl-like vessel in which Greeks normally mixed wine with water, had also been used as a burial marker since the early first millennium (see fig. 5.1). The shape of the example illustrated here shows that the deceased was a woman; its sheer monumentality indicates that she was a woman of considerable means.

The amphora is a masterpiece of the potter's craft. At over 5 feet tall, it was too large to be thrown in one piece. Instead, the potter built it up in sections, joined with a clay slip. A careful proportional scheme governed the vessel's form: Its width measures half of its height and the neck measures half the height of the body. The artist placed the handles so as to emphasize the widest point of the body. Most of the vase's decoration is given over to geometric patterns dominated by a *meander pattern*, also known as a *maze* or *Greek key pattern* (fig. **5.3**), a band of rectangular scrolls, punctuated with bands of lustrous black paint at the neck, the shoulder, and the base. The geometric design reflects the proportional system of the vase's shape. Single meander patterns run in bands toward the top and bottom of the neck; the triple meander encircling the neck at the center emphasizes its length. The double and single meanders on the amphora's body appear stocky by contrast, complementing the body's rounder form. Above the triple meander on the neck, deer graze, one after the other, in an identical pattern circling the vase. This animal frieze prefigures the widespread use of the motif in the seventh century BCE. At the base of the neck, they recline, with their heads turned back over their bodies, like an animate version of the meander pattern itself, which moves ever forward while turning back upon itself.

5.2. Late Geometric belly-handled amphora by the Dipylon Master, from the Dipylon Cemetery, Athens. ca. 750 BCE. Height 5′1″ (1.55 m). National Archaeological Museum, Athens

vases were complex processes, usually performed by different artisans. At first painters decorated their wares with abstract designs, such as triangles, "checkerboards," and concentric circles. Toward 800 BCE human and animal figures began to appear within the geometric framework, and in the most elaborate examples these figures interacted in narrative scenes.

The vase shown here, from a cemetery near the later Dipylon gate in the northwestern corner of Athens, dates to around 750 BCE (fig. **5.2**). Known as the Dipylon Vase, it was one of a group of unusually large vessels used as grave monuments. Holes in its base allowed liquid offerings (libations) to filter down to the dead below. In earlier centuries, Athenians had

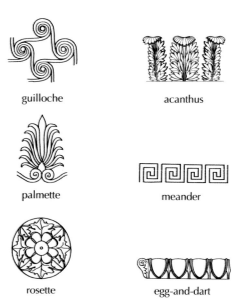

guilloche

acanthus

palmette

meander

rosette

egg-and-dart

5.3. Common Greek ornamental motifs

In the center of the amphora, framed between its handles, is a narrative scene. The deceased lies on a bier, beneath a checkered shroud. Flanking her are standing figures with their arms raised above their heads in a gesture of lamentation; an additional four figures kneel or sit beneath the bier. Rather than striving for naturalism, the painter used solid black geometric forms to construct human bodies. A triangle represents the torso, and the raised arms extend the triangle beyond the shoulders. The scene itself represents the *prothesis*, part of the Athenian funerary ritual when the dead person lay in state and public mourning took place. A lavish funeral was an occasion to display wealth and status, and crowds of mourners were so desirable that families would hire professional mourners for the event. Thus the depiction of a funeral on the burial marker is not simply journalistic reportage but a visual record of the deceased person's high standing in society.

Archeologists have found Geometric pottery in Italy and the Near East as well as in Greece. This wide distribution is a sign of the important role of not only the Greeks but also the Phoenicians, North Syrians, and other Near Eastern peoples as agents of diffusion all around the Mediterranean. What is more, from the second half of the eighth century onwards, inscriptions on these vases show that the Greeks had already adapted the Phoenician alphabet to their own use.

Geometric Style Sculpture

A small, bronze sculptural group representing a man and a centaur dates to about the same time as the funerary amphora, and there are distinct similarities in the way living forms are depicted in both works of art (fig. **5.4**). Thin arms and flat, triangular chests contrast with more rounded buttocks and legs. The heads are spherical forms, with beards and noses added. The artist cast the group in one piece, uniting them with a common base and their entwined pose. The group was probably found in the sanctuary at Olympia. Judging by its figurative quality, and by the costliness of the material and technique, it was probably a sumptuous votive offering. The figures obviously interact, revealing the artist's interest in narrative, a theme that persists throughout the history of Greek art. Whether the artist was referring to a story known to his audience is hard to say. The figures' helmets tell us that their encounter is martial, and the larger scale of the man may suggest that he will be the victor in the struggle. Many scholars believe he represents Herakles, son of Zeus and a Greek hero, who fought centaurs many times in the course of his mythical travails.

THE ORIENTALIZING STYLE: HORIZONS EXPAND

Between about 725 and 650 BCE, a new style of pottery and sculpture emerged in Greece that reflects strong influences initially from the Near East and later from Egypt. Scholars know this as the Orientalizing period, when Greek art and culture rapidly absorbed a host of Eastern motifs and ideas, including

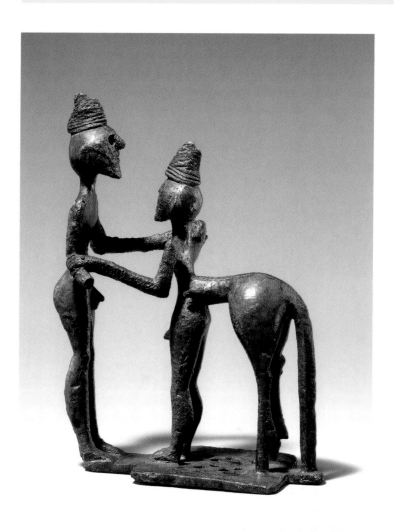

5.4. *Man and Centaur*, perhaps from Olympia. ca. 750 BCE. Bronze. Height $4\frac{3}{8}''$ (11.1 cm). The Metropolitan Museum of Art, New York. Gift of J. Pierpont Morgan, 1917. 17.190.2072

hybrid creatures such as griffins and sphinxes. This absorption of Eastern ideas led to a vital period of experimentation, as painters and sculptors mastered new forms.

Miniature Vessels

The Orientalizing style replaced the Geometric in many Greek city-states, including Athens. One of the foremost centers of its production, though, was Corinth, at the northeastern gateway to the Peloponnese. This city became a leader in colonizing ventures in the west and came to dominate the trade in exports. Corinthian workshops had a long history of pottery production.

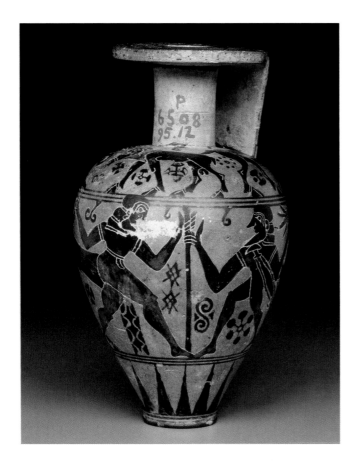

5.5. The Ajax Painter. Aryballos (perfume jar). Middle Protocorinthian IA, 690–675 BCE. Ceramic. Height 2⁷⁄₈″ (7.3 cm), diameter 1³⁄₄″ (4.4 cm). Museum of Fine Arts, Boston. Catharine Page Perkins Fund. Photograph © 2006, Museum of Fine Arts, Boston. 95.12

5.6. Geometric tripod cauldron from Olympia. 8th century. Height 2′1¹⁄₂″ (65 cm). Olympia Museum

Vase painters learned to make a refined black gloss slip, which they used to create silhouette or outline images. They could also incise the slip to add detail and vivacity to their work. They particularly specialized in crafting miniature vessels like the vase shown here, which is a Proto-Corinthian *aryballos* or perfume jar, dating to about 680 BCE (fig. **5.5**). Archeologists have discovered vessels like this one throughout the Greek world, left in sanctuaries as dedications to the gods, or buried as grave goods. Despite its small size, intricate decoration covers the vase's surface. Around the shoulder stalks a frieze of animals, reminiscent of Near Eastern animal motifs and of the early example seen on the Dipylon Vase (see figs. 2.25 and 5.2). Bands of real and imaginary animals are a hallmark of Corinthian and other Orientalizing wares, covering later vases from top to bottom. A *guilloche pattern* ornaments the handle, and meander patterns cover the edge of the mouth and the handle (see fig. 5.3). The principal figural frieze offers another early example of pictorial narrative, but the daily life scenes of Geometric pottery have yielded to the fantastic world of myth. On one side, a stocky nude male wielding a sword runs toward a vase on a stand. On the side shown here, a bearded male struggles to wrest a scepter or staff from the grasp of a centaur. According to one theory, the frieze represents a moment in Herakles' conflict with a band of centaurs on Mount Pholoë. In Greek mythology, centaurs were

notoriously susceptible to alcohol, and the mixing bowl for wine represented on the other side may indicate the reason for their rowdiness. Others interpret the "Herakles" figure as Zeus, brandishing his thunderbolt or lightning. No matter how one reads this scene, there is no doubt that it was meant to evoke a mythological reality.

BRONZE TRIPODS During the Geometric period, Greeks would sometimes set up bronze tripod cauldrons in sanctuaries as dedications to the gods (fig. 5.6). The gesture was an act of piety, but it was also a way of displaying wealth, and some of the tripod cauldrons reached monumental proportions. From the early seventh century BCE, a new type of monumental vessel was introduced—the Orientalizing cauldron. Around the edge of the bowl, bronze-workers might attach *protomes*, images of sirens (winged female creatures), and griffins—both were fantasy creatures that were known in the Near East. The cast *protome* shown here, from the island of Rhodes, is a magnificently ominous creature, standing watch over the dedication (fig. **5.7**). The boldly upright ears and the vertical knob on top of the head contrast starkly with the strong curves of the neck, head, eyes, and mouth, while its menacing tongue is silhouetted in countercurve against the beak. The straight lines appear to animate the curves, so that the dangerous hybrid seems about to spring.

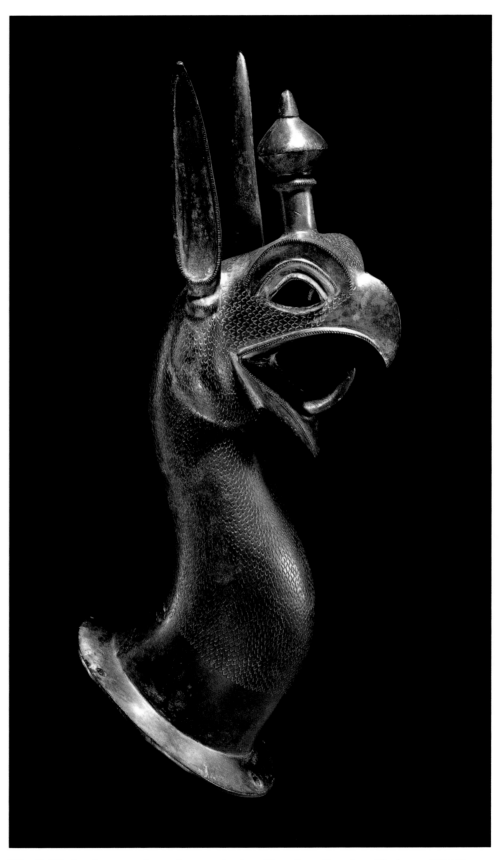

5.7. Griffin-head protome from a bronze tripod-cauldron, from Kameiros, Rhodes. ca. 650 BCE. Cast bronze. The British Museum, London

ARCHAIC ART: ART OF THE CITY-STATE

During the course of the seventh and sixth centuries BCE, the Greeks appear to have refined their notion of a *polis*, or city-state. Once merely a citadel, the place of refuge in times of trouble, the city came to represent a community and an identity. City-states, as they are known, were governed in several different ways, including monarchy (from *monarches*, "sole ruler"), aristocracy (from *aristoi* and *kratia*, "rule of the best"), tyranny (from *tyrannos*, "despot"), oligarchy (from *oligoi*, "the few," a small ruling elite), and, in Athens, democracy (from *demos*, "the people"). The road to democracy moved slowly, starting with Solon's reforms at the end of the sixth century in Athens. Even by the time of Perikles' radical democratic reforms of 462 BCE, women played no direct role in civic life, and slavery was the accepted practice in Athens, as it was everywhere in the Greek world. With the changing ideal of the city-state came a change in its physical appearance.

The Rise of Monumental Temple Architecture

At some point in the seventh century BCE, Greek architects began to design temples using stone rather than wood. The earliest were probably built at Corinth, in a style known as Doric, named for the region where it originated. From there the idea spread across the isthmus that connects the Peloponnesos to the mainland and up the coast to Delphi and the island of Corfu, then rapidly throughout the Hellenic world. The Ionic style soon developed on the Aegean Islands and the coast of Asia Minor. The Corinthian style did not develop until the fourth century BCE (see page 142). Greeks recognized the importance of this architectural revolution at the time: Architects began to write treatises on architecture—the first we know of—and the personal fame they achieved through their work has lasted to this day.

Writing in Roman times, the architect Vitruvius described the Doric and Ionic styles, and his discussions of them have been central to our understanding of Greek architecture. However, our readings of his text have been mediated through early modern commentators and illustrators, who wrote of Doric and Ionic "orders" rather than "types," which is a better translation of Vitruvius' "*genera.*" The distinction is important: "Order" suggests an immutable quality, a rigid building code, when in fact we find a subtle but rich variation in surviving Greek architecture.

The essential, functioning components of Doric and Ionic temples are very similar, though they may vary according to the size of the building or regional preferences (fig. 5.8). The nucleus of the building—in fact, its reason for existing—is its main chamber, its **cella** or *naos*. This chamber housed an image of the god to whom the temple was dedicated. Often, interior columns lined the cella walls and helped to support the roof, as well as visually framing the cult statue. Approaching the cella is a porch or **pronaos**, and in some cases a second porch was added behind the cella, making the design more symmetrical and providing space for religious paraphernalia. In large temples, a colonnade or **peristyle** surrounds the central unit of cella and porches, and the building is known as a **peripteral temple**. The peristyle commonly consists of six to eight columns at front and back, and usually 12 to 17 along the sides, counting the corner columns twice; the very largest temples of Ionian Greece had a double colonnade.

The peristyle added more than grandeur: It offered worshipers shelter from the elements. Being neither entirely exterior nor entirely interior space, it also functioned as a transitional zone, between the profane world outside and the sanctity of the cella. Some temples were set in sacred groves, where the columns, with their strong vertical form, integrated the temple with its environment. Echoed again inside the cella, the columns also integrated the exterior and interior of the building. Most Greek temples are oriented so that the entrance faces east, toward the rising sun. East of the temple is usually the altar, the truly indispensable installation for the performance of ritual. It was on the altar that Greeks performed sacrifices, standing before the cult statue and the worshiping community of the Greek polis.

Differences between the Doric and Ionic styles are apparent in a head-on view, or elevation. Many of the terms Greeks used to describe the parts of their buildings, shown in figure 5.9, are still in common usage today. The building proper rests on an elevated platform, normally approached by three steps, known as the **stereobate** and **stylobate**. A **Doric column** consists of the shaft, usually marked by shallow vertical grooves, known as *flutes*, and the *capital*. The capital is made up of the flaring, cushionlike **echinus** and a square tablet called the **abacus**. The *entablature*, which includes all the horizontal elements that rest on the columns, is subdivided into the *architrave* (a row of stone blocks directly supported by the columns); the *frieze*, made up of alternating triple-grooved **triglyphs** and smooth or sculpted *metopes*; and a projecting horizontal cornice, or *geison*, which may include a gutter (*sima*). The architrave in turn supports the triangular **pediment** and the roof elements (the raking geison and raking sima).

Ionic temples tend to rest on an additional leveling course, or *euthynteria*, as well as three steps. An **Ionic column** differs from a Doric column in having an ornate base of its own, perhaps used at first to protect the bottom from rain. Its shaft is more slender, with less tapering, and the capital has a double scroll or *volute* below the abacus, which projects strongly beyond the width of the shaft. The Ionic column lacks the muscular quality of its

5.8. Ground plan of a typical Greek peripteral temple (after Grinnell)

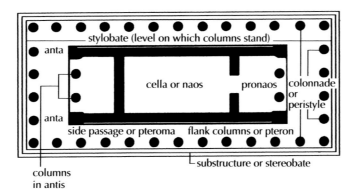

stylobate (level on which columns stand)

anta

cella or naos pronaos

anta

colonnade or peristyle

side passage or pteroma flank columns or pteron

substructure or stereobate

columns in antis

mainland cousin. Instead, it evokes a growing plant, something like a formalized palm tree, and this it shares with its Egyptian predecessors, though it may not have come directly from Egypt. Above the architrave, the frieze is continuous, rather than broken up visually into triglyphs and metopes.

Whether Doric or Ionic, the temple structure was built of stone blocks fitted together without mortar, requiring that they be precisely shaped to achieve smooth joints. Where necessary, metal dowels or clamps fastened the blocks together. With rare

exceptions, columns were made up of sections, called **drums**. The shaft was fluted after the entire column was assembled and in position. The roof was made of terra-cotta tiles over wooden rafters, and wooden beams were used for the ceiling. Fire was a constant threat.

Just how either style came to emerge in Greece, and why they came together into succinct systems so quickly, are still puzzling questions. Remains of the oldest surviving temples show that the main features of the Doric style were already

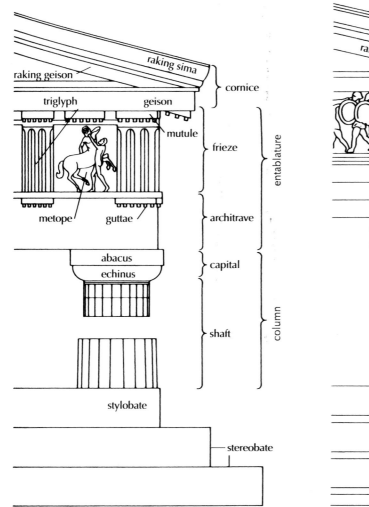

raking geison

raking sima

cornice

triglyph geison

mutule

frieze

metope guttae

architrave

abacus

echinus

capital

shaft

entablature

column

stylobate

stereobate

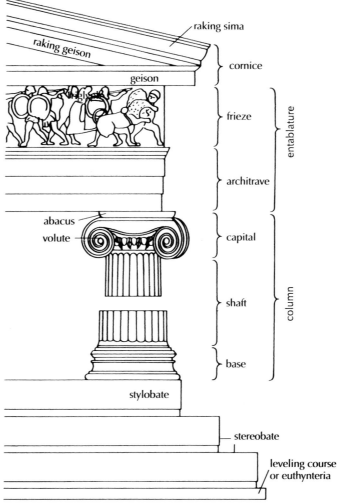

raking geison

raking sima

cornice

geison

frieze

architrave

abacus

volute

capital

shaft

base

entablature

column

stylobate

stereobate

leveling course or euthynteria

5.9. Doric and Ionic styles in elevation

well established soon after 600 BCE. Early Greek builders in stone seem to have drawn upon three sources of inspiration: Mycenaean and Egyptian stone architecture, and pre-Archaic Greek architecture in wood and mud brick. It is possible that the temple's central unit, the cella and porch, derived from the plan of the Mycenaean megaron (see fig. 4.19), either through continuous tradition or by way of revival. If true, this relationship may reflect the revered place of Mycenaean culture in later Greek mythology. The shaft of the Doric column tapers upward, not downward like the Minoan-Mycenaean column. This recalls fluted half-columns in the funerary precinct of Djoser at Saqqara (see fig. 3.6), of over 2,000 years earlier. Moreover, the very notion that temples should be built of stone and have large numbers of columns was an Egyptian one, even if Egyptian temples were designed for greater internal traffic. Scholars assume that the Greeks learned many of their stone-cutting and masonry techniques from the Egyptians, as well as some knowledge of architectural ornamentation and geometry. In a sense, a Greek temple with its peristyle of columns might be viewed as the columned court of an Egyptian sanctuary turned inside out.

Some scholars see the development of Doric architecture as a petrification (or turning to stone) of existing wooden forms, so that stone form follows wooden function. According to this view, at one time triglyphs masked the ends of wooden beams, and the droplike shapes below, called **guttae** (see fig. 5.9), are the descendants of wooden pegs that held them in place. Metopes evolved out of boards that filled gaps between the triglyphs to guard against weather. **Mutules** (flat projecting blocks), for their part, reflect the rafter ends in wooden roofs. Some derivations are more convincing than others, however. The vertical subdivisions of triglyphs hardly seem to reflect the forms of three half-round logs, as scholars suggest, and column flutings need not be developed from tool marks on a tree trunk, since Egyptian builders also fluted their columns and yet rarely used timber for supporting members. The question of how far stylistic features can be explained in terms of function faces the architectural historian again and again.

DORIC TEMPLES AT PAESTUM The early evolution of Doric temples is evident in two unusually well-preserved examples located in the southern Italian polis of Paestum, where a Greek colony flourished during the Archaic period. Both temples are dedicated to the goddess Hera, wife of Zeus; the Temple of Hera II, however, was built almost a century after the Temple of Hera I, the so-called Basilica (fig. 5.10). The differences in their proportions are striking. The Temple of Hera I (on the left, fig. 5.10) appears low and sprawling—and not just because so

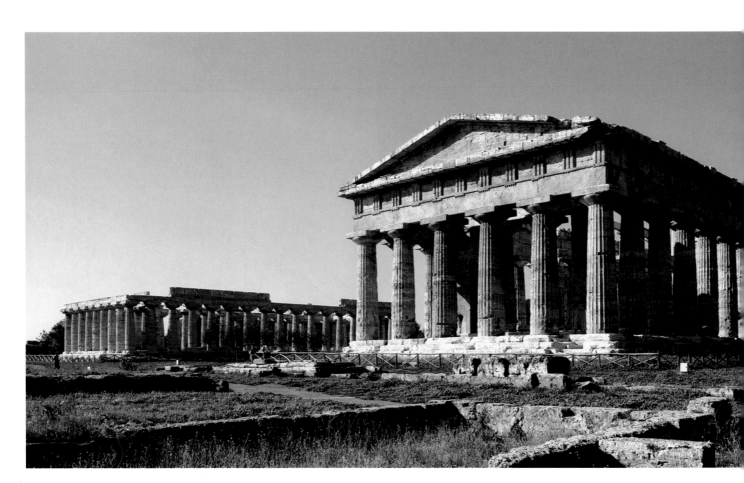

5.10. The Temple of Hera I ("Basilica"), ca. 550 BCE, and the Temple of Hera II ("Temple of Poseidon"), ca. 500 BCE. Paestum

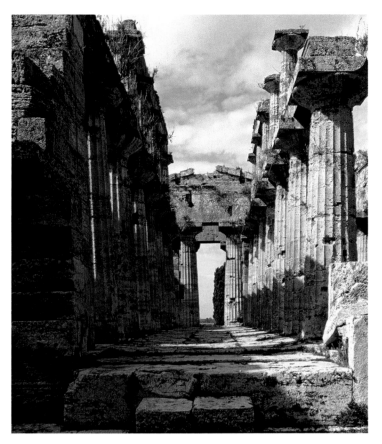

5.11. Interior, Temple of Hera II. ca. 500 BCE

much of the entablature is missing—whereas the Temple of Hera II looks tall and compact. This is partly because the temple of Hera I is *enneastyle* (with nine columns across the front and rear), while the later temple is only *hexastyle* (six columns). Yet it is also the result of changes to the outline of the columns. On neither temple are the column shafts straight from bottom to top. About a third of the way up, they bulge outward slightly, receding again at about two thirds of their height. This swelling effect, known as **entasis**, is much stronger on the earlier Temple of Hera I. It gives the impression that the columns bulge with the strain of supporting the superstructure and that the slender tops, although aided by the widely flaring, cushionlike capitals, can barely withstand the crushing weight. The device adds an extraordinary vitality to the building—a sense of compressed energy waiting to be released.

The Temple of Hera II is among the best preserved of all Doric temples (fig. **5.11**), and shows how the ceiling was supported in a large Doric temple. Inside the cella, the two rows of columns each support a smaller set of columns in a way that makes the tapering seem continuous despite the architrave in between. Such a two-story interior is first found at the Temple of Aphaia at Aegina around the beginning of the fifth century BCE. That temple is shown here in a reconstruction drawing (fig. **5.12**), which illustrates the structural system in detail.

5.12. Sectional view (restored) of the Temple of Aphaia, Aegina

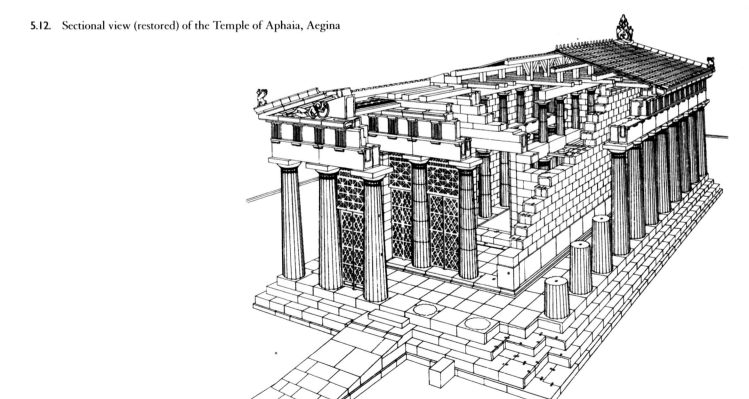

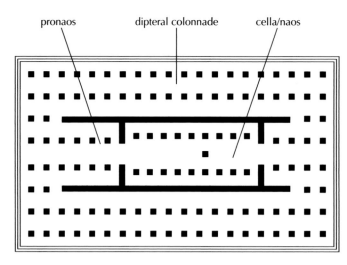

pronaos dipteral colonnade cella/naos

5.13. Restored plan of the Temple of Artemis at Ephesos, Turkey. ca. 560 BCE

EARLY IONIC TEMPLES The Ionic style first appeared about a half-century after the Doric. With its vegetal decoration, it seems to have been strongly inspired by Near Eastern forms. The closest known parallel to the Ionic capital is the *Aeolic* capital, found in the region of Old Smyrna, in eastern Greece, and in the northeast Aegean, itself apparently derived from North Syrian and Phoenician designs. The earliest Ionic temples were constructed in Ionian Greece, where leading cities erected vast, ornate temples in open rivalry with one another. Little survives of these early buildings. The Temple of Artemis at Ephesos gained tremendous fame in antiquity, and numbered among the seven wonders of the ancient world. The Ephesians hired Theodoros to work on its foundations in about 560 BCE, shortly after he and another architect, Rhoikos, had designed a vast temple to Hera on the island of Samos. The architects, Chersiphron of Knossos and Metagenes, his son, wrote a treatise on their building. Like the temple on Samos, the temple at Ephesos was *dipteral*, with two rows of columns surrounding it (fig. **5.13**). Along with the vegetal capitals, this feature emphasized the forestlike quality of the building. The Temple of Artemis was larger than Hera's temple, and it was the first monumental building to be constructed mostly of marble. These Ionic colossi had clear symbolic value: They represented their respective city's bid for regional leadership.

Stone Sculpture

According to literary sources, Greeks carved very simple wooden sculptures of their gods in the eighth century BCE, but since wood deteriorates, none of them survive. Yet, in about 650 BCE, sculptors, like architects, made the transition to working in stone, and so began one of the great traditions of Greek art. The new motifs that distinguished the Orientalizing style from the Geometric had reached Greece mainly through the importation of ivory carvings and metalwork from the Near East, reflecting Egyptian influences as well. But these transportable objects do not help to explain the rise of monumental stone architecture and sculpture, which must have been based on careful, on-the-spot study of Egyptian works and the techniques used to produce them. The opportunity for just such a close study was available to Greek merchants living in trading camps in the western Nile delta, by permission of the Egyptian king Psammetichus I (r. 664–610 BCE).

KORE AND KOUROS Early Greek statues clearly show affinities with the techniques and proportional systems used by Egyptian sculptors. Two are illustrated here, one a small female figure of about 630 BCE, probably from Crete (fig. **5.14**), the other a life-size nude male youth of about 600 BCE (fig. **5.15**), known as the New York Kouros because it is displayed in the Metropolitan Museum of Art. Like their Egyptian forerunners (see figs. 3.11 and 3.12), the statues are rigidly frontal, and conceived as four distinct sides, reflecting the form of the block from which they were carved. The female statue stands with feet placed firmly together, her left arm by her side, and her right arm held up to her breast. Like Menkaure, the Greek male youth is slim and broad-shouldered; he stands with his left leg forward, and his arms by his sides, terminating in clenched fists. His shoulders, hips, and knees are all level. Both figures have stylized, wiglike hair like their Egyptian counterparts, but there are significant differences. First, the Greek sculptures are truly free-standing, separated from the back slab that supports Egyptian stone figures. In fact, they are the earliest large stone images of the human figure in the history of art that can stand on their own. More than that, Greek sculptures incorporated empty space (between the legs, for instance, or between arms and torso), whereas Egyptian figures remained immersed in stone, with the empty spaces between forms partly filled. Early Greek

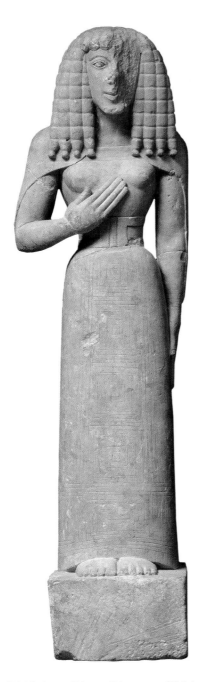

5.14. *Kore (Maiden)*. ca. 630 BCE. Limestone. Height 24$\frac{1}{2}$"
(62.3 cm). Musée du Louvre, Paris

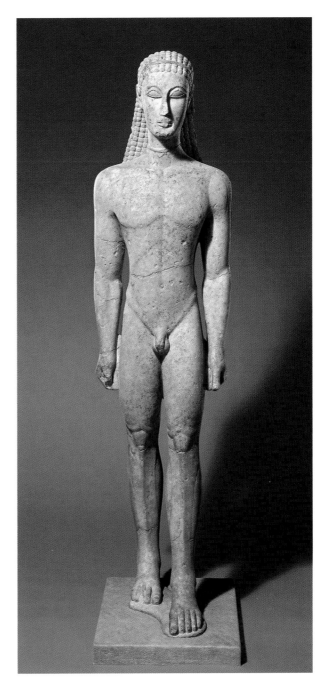

5.15. *Kouros (Youth)*. ca. 600–590 BCE. Marble. Height 6'1$\frac{1}{2}$"
(1.88 m). The Metropolitan Museum of Art, New York

sculptures are also more stylized than their Egyptian fore-bears. This is most evident in the large staring eyes, empha-sized by bold arching eyebrows, and in the linear treatment of the anatomy: The male youth's pectoral muscles and rib cage appear almost to have been etched onto the surface of the stone, rather than modeled like Menkaure's. Like most early Greek female sculptures, this one is draped. She wears a close-fitting garment which reveals her breasts but conceals her hips and legs; in fact, the skirt has more in common with Egyptian block statues than with Queen Khamerernebty

(see fig. 3.12). While the Greek female statue and Menkaure are clothed, the male youth is nude. These conventions reflect the fact that public nudity in ancient Greece was acceptable for males, but not for females.

Dozens of Archaic sculptures of this kind survive through-out the Greek world. Some were discovered in sanctuaries and cemeteries, but most were found in reused contexts, which com-plicates any attempt to understand their function. Scholars describe them by the Greek terms for maiden (**kore**, plural *korai*) and youth (**kouros**, plural *kouroi*). These terms gloss over the

difficulty of identifying them more precisely. Some are inscribed, with the names of artists ("'So-and-so' made me") or with dedications to various deities, chiefly Apollo. These, then, were votive offerings. But in most cases we do not know whether they represent the donor, a deity, or a person deemed divinely favored, such as a victor in athletic games. Those placed on graves may have represented the person buried beneath; yet in rare cases a kouros stands over a female burial site.

No clear effort was made to individualize the statues as portraits, so they can represent the dead only in a general sense. It might make most sense to think of the figures as ideals of physical perfection and vitality shared by mortals and immortals alike, given meaning by their physical context. What is clear is that only the wealthy could afford to erect them, since many were well over life size and carved from high quality marble. Indeed, the very stylistic cohesion of the sculptures may reveal their social function: By erecting a sculpture of this kind, a wealthy patron declared his or her status and claimed membership in ruling elite circles.

DATING AND NATURALISM The Archaic period stretches from the mid-seventh century to about 480 BCE. Within this time frame, there are few secure dates for free-standing sculptures. Scholars have therefore established a dating system based upon the level of naturalism in a given sculpture. According to this system, the more stylized the figure, the earlier it must be. Comparing figures 5.15 and **5.16** illustrates how this model works. An inscription on the base of the latter identifies it as the funerary statue of Kroisos, who had died a hero's death in battle. Like all such figures, it was painted, and traces of color can still be seen in the hair and the pupils of the eyes. Instead of the sharp planes and linear treatment of the New York Kouros (fig. 5.15), the sculptor of the kouros from Anavysos modeled its anatomy with swelling curves; looking at it, a viewer can imagine flesh and sinew and bones in the carved stone. A greater plasticity gives the impression that the body could actually function. The proportions of the facial features are more naturalistic as well. In general, the face has a less masklike quality than the New York Kouros, though the lips are still drawn up in an artificial smile, known as the *Archaic smile*, that is not reflected in the eyes. Based on these differences, scholars judge the Anavysos Kouros more "advanced" than the New York Kouros, and date it some 75 years later. Given the later trajectory of Greek sculpture, there is every reason to believe that this way of dating Archaic sculpture is more or less accurate (accounting for regional differences and the like). All the same, it is worth emphasizing that it is based on an assumption—that sculptors, or their patrons, were striving toward naturalism—rather than on factual data.

The kore type appears to follow a similar pattern of development to the kouros. With her blocklike form and strongly accented waist, for instance, the kore of figure **5.17** seems a direct descendant of the kore in figure 5.14. On account of her heavy woolen garment (or *peplos*), she is known as the *Peplos Kore*. The left hand, which once extend-

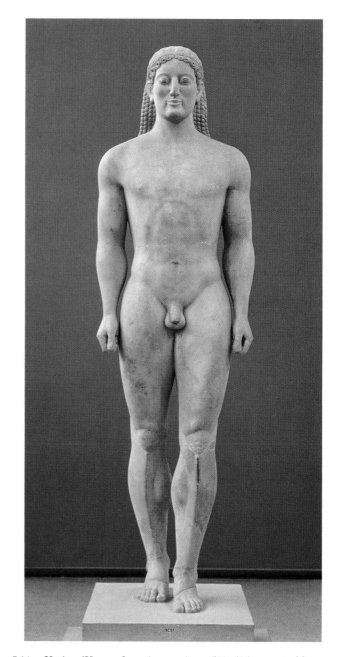

5.16. *Kroisos (Kouros from Anavysos).* ca. 540–525 BCE. Marble. Height 6′4″ (1.9 m). National Museum, Athens

ed forward to offer a votive gift, must have given the statue a spatial quality quite different from that of the earlier kore figure. Equally new is the more organic treatment of the hair, which falls over the shoulders in soft, curly strands, in contrast to the stiff wig in figure 5.14. The face is fuller, rounder, and the smile gentler and more natural than any we have seen so far, moving from the mouth into the cheeks. Scholars therefore place this statue a full century later than the work shown in figure 5.14.

All the same, there is more variation in types of kore than in types of kouros. This is partly because a kore is a clothed figure and therefore presents the problem of how to relate body and drapery. It is also likely to reflect changing habits or local styles of dress. The kore of figure **5.18**, from about a decade later than the *Peplos Kore*, has none of the latter's severity. Both were

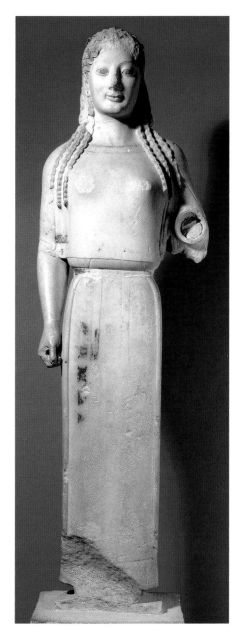

5.17. *Kore in Dorian Peplos*, known as *Peplos Kore*. ca. 530 BCE. Marble. Height 48″ (122 cm). Akropolis Museum, Athens

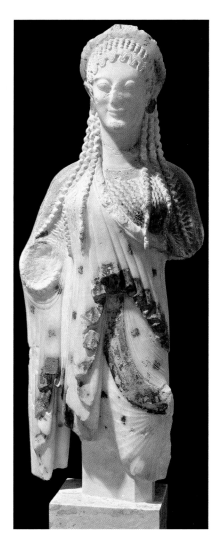

5.18. *Kore*, from Chios (?). ca. 520 BCE. Marble. Height 21⅞″ (55.3 cm). Akropolis Museum, Athens

found on the Akropolis of Athens, but she probably came from Chios, an island of Ionian Greece. Unlike the korai discussed so far, this kore wears the light Ionian *chiton* under the heavier diagonally-shaped *himation*, which replaced the peplos in fashion. The layers of the garment still loop around the body in soft curves, but the play of richly differentiated folds, pleats, and textures has almost become an end in itself. Color played an important role in such works, and it is fortunate that so much of it survives in this example.

Architectural Sculpture: The Building Comes Alive

Soon after the Greeks began to build temples in stone, they also started to decorate them with architectural sculpture. Indeed,

early Greek architects such as Theodoros of Samos were often sculptors as well, and sculpture played an important role in helping to articulate architecture and to bring it to life. Traces of pigment show that these sculptures were normally vividly painted—an image that is startlingly at odds with our conception of ancient sculpture as pristine white marble.

The Egyptians had been covering walls and columns with reliefs since the Old Kingdom. Their carvings were so shallow (for example, see fig. 3.29) that they did not break the continuity of the surface and had no weight or volume of their own. Thus they were related to their architectural setting in the same sense as wall paintings. This is also true of the reliefs on Assyrian, Babylonian, and Persian buildings (for example, see figs. 2.21 and 2.22).

In the Near East, however, there was another kind of architectural sculpture, which seems to have begun with the Hittites: the guardian monsters protruding from the blocks that framed the gateways of fortresses or palaces (see fig. 2.23). This tradition may have inspired, directly or indirectly, the carving over the Lion Gate at Mycenae (see fig. 4.22).

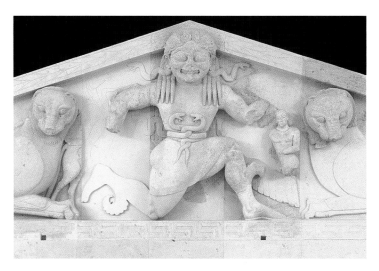

5.19. Central portion of the west pediment of the Temple of Artemis at Corfu, Greece. ca. 600–580 BCE. Limestone. Height 9′2″. (2.8 m). Archaeological Museum, Corfu, Greece

THE TEMPLE OF ARTEMIS, CORFU That the Lion Gate relief is, conceptually, an ancestor of later Greek architectural sculpture is clear when one considers the facade of the early Archaic Temple of Artemis on the island of Corfu, built soon after 600 BCE (figs. **5.19** and **5.20**). There, sculpture is confined to a triangle between the ceiling and the roof, known as the *pediment*. This area serves as a screen, protecting the wooden rafters behind it from moisture. The pedimental sculpture is displayed against this screen.

Technically, these carvings are in high relief, like the guardian lionesses at Mycenae. However, the bodies are so strongly undercut that they are nearly detached from the background, and appear to be almost independent of their architectural setting. Indeed, the head of the central figure actually overlaps the frame; she seems to emerge out of the pediment toward a viewer. This choice on the sculptor's part heightens the impact of the figure and strengthens her function. Although the temple was dedicated to Artemis, the figure

represents the snake-haired Medusa, one of the Gorgon sisters of Greek mythology. Medusa's appearance was so monstrous, so the story went, that anyone who beheld her would turn to stone. With the aid of the gods, Perseus beheaded her, guiding his sword by looking at her reflection in his shield.

Traditionally, Medusa has been thought of as a protective visual device, but recent approaches argue that she served as a visual commentary on the power of the divinity. She is conceived as a mistress of animals exemplifying the goddess' power and her dominance over Nature. Two large feline creatures flank Medusa, in a heraldic arrangement known from the Lion Gate at Mycenae, and from many earlier Near Eastern examples. To strengthen the sculptures' message, the artist included narrative elements in the pediment as well. In the spaces between and behind the main group, the sculptor inserted a number of subsidiary figures. On either side of Medusa are her children, the winged horse Pegasus, and Chrysaor, who will be born from drops of her blood, shed when Perseus decapitates her. Logically speaking, they cannot yet exist, since Medusa's head is still on her shoulders; and yet their presence in the heraldic arrangment alludes to the future, when Perseus will have claimed the Gorgon's power as his own—just as the sculptor has here, in the service of Artemis. The sculptor has fused two separate moments from a single story, in what is known as a *synoptic narrative*, bringing the story to life. Two additional groups filled the pediment's corners, possibly depicting Zeus and Poseidon battling the giants (a gigantomachy), a mortal race who tried to overthrow the gods. Like the central figures, they strike a cautionary note, since the gods destroyed them for their overreaching ambitions.

With their reclining pose, the felines fit the shape of the pediment comfortably. Yet in order to fit Pegasus and Chrysaor between Medusa and the felines, and the groups into the corners, the sculptor carved them at a significantly smaller scale than the dominant figures. Later solutions to the pediment's awkward shape suggest that this one, which lacks unity of scale, was not wholly satisfactory.

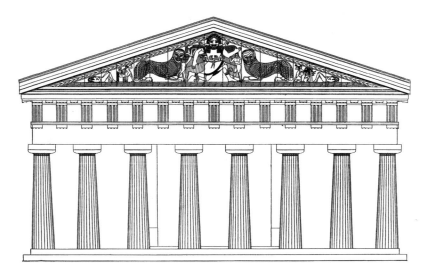

5.20. Reconstruction drawing of the west front of the Temple of Artemis at Corfu (after Rodenwaldt)

Aside from filling the pediment, Greeks might affix free-standing figures, known as **acroteria** (often of terra cotta) above the corners and center of the pediment, softening the severity of its outline (see fig. 5.21). Greek sculptors also decorated the frieze. In Doric temples, such as at Corfu, where the frieze consists of triglyphs and metopes, they would often decorate the latter with figural scenes. In Ionic temples, the frieze was a continuous band of painted or sculpted decoration. Moreover, in Ionic buildings, female statues or **caryatids** might substitute for columns to support the roof of a porch, adding a further decorative quality (see figs. 5.21 and 5.53).

THE SIPHNIAN TREASURY, DELPHI These Ionic features came together in a treasury built at Delphi shortly before 525 BCE by the people of the Ionian island of Siphnos. Treasuries were like miniature temples, used for storing votive gifts; typically, they had an ornate quality. Although the Treasury of the Siphnians no longer stands, archeologists have been able to create a reconstruction from what survives (figs. **5.21** and **5.22**). Supporting the architrave of the porch were two caryatids. Above the architrave is a magnificent sculptural frieze. The detail shown here (fig. 5.22) depicts part of the mythical battle of the Greek gods against the giants, who had challenged divine authority. At the far left, the two lions who pull the chariot of the mother goddess Cybele tear apart an anguished giant. In front of them, Apollo and Artemis advance together, shooting arrows into a phalanx of giants. Their weapons were once added to the sculpture in metal. Stripped of his armor, a dead giant lies at their feet. As in the Corfu pediment, the tale is a cautionary one, warning mortals not to aim higher than their natural place in the order of things. Though the subject is mythical, its depiction offers a wealth of detail on contemporary weaponry and military tactics.

Astonishingly, the relief is only a few inches deep from front to back. Within that shallow space, the sculptors (more than one hand is discernible) created several planes. The arms and legs of those nearest a viewer are carved in the round. In the second and third layers, the forms become shallower, yet even those farthest from a viewer do not merge into the background. The resulting relationships between figures give a dramatic sense of the turmoil of battle and an intensity of action not seen before in narrative reliefs.

As at Corfu, the protagonists fill the sculptural field from top to bottom, enhancing the frieze's power. This is a dominant characteristic of Archaic and Classical Greek art, and with time, sculptors executing pedimental sculpture sought new ways to

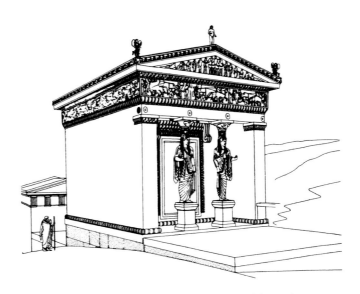

5.21. Reconstruction drawing of the Treasury of the Siphnians. Sanctuary of Apollo at Delphi. ca. 525 BCE

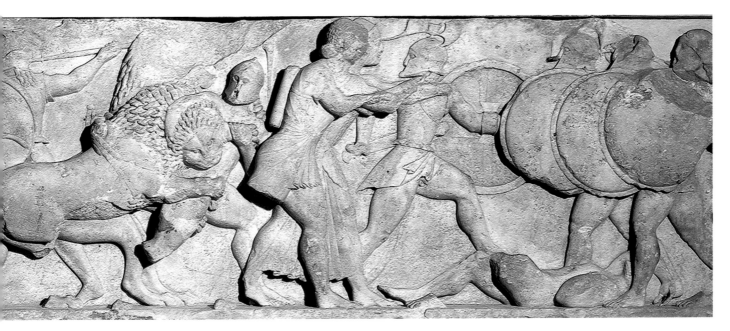

5.22. *Battle of the Gods and Giants,* from the north frieze of the Treasury of the Siphnians, Delphi. ca. 530 BCE. Marble. Height 26″ (66 cm). Archaeological Museum, Delphi

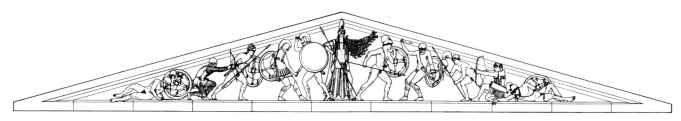

5.23. Reconstruction drawing of the east pediment of the Temple of Aphaia, Aegina (after Ohly)

fill the field while retaining a unity of scale. Taking their cue, perhaps, from friezes such as that found on the Siphnian Treasury, they introduced a variety of poses, and made great strides in depicting the human body in naturalistic motion. This is well illustrated in the pediments of the Temple of Aphaia at Aegina, an island in the Saronic Gulf visible from Attica (see fig. 5.12).

PEDIMENTS OF THE TEMPLE OF APHAIA AT AEGINA. The Temple of Aphaia's original east pediment was probably destroyed by the Persians when they took the island in 490 BCE. The Aeginetans commissioned the present one (fig. **5.23**) after defeating the Persians at the battle of Salamis in 480 BCE. It depicts the first sack of Troy, by Herakles and Telamon, king of Salamis. The west pediment, which dates from about 510–500 BCE, depicts the second siege of Troy (recounted in *The Iliad*) by Agamemnon, who was related to Herakles. The pairing of subjects commemorates the important role played by the heroes of Aegina in both battles—and, by extension, at Salamis, where their navy helped win the day. The elevation of historical events to a universal plane through allegory was typical of Greek art.

The figures of both pediments are fully in the round, independent of the background that they decorate. Those of the east pediment were found in pieces on the ground. Scholars continue to debate their exact arrangement, but the relative position of each figure within the pediment can be determined with reasonable accuracy. Since the designer introduced a wide range of action poses for the figures, their height, *but not their scale*, varies to suit the gently sloping sides of the pedimental field (fig. 5.23). These variances in height can be used to determine the figures' original positions. In the center stands the goddess Athena, presiding over the battle between Greeks and Trojans that rages on either side of her. Kneeling archers shoot across the pediment to unite its action. The symmetrical arrangement of the poses on the two halves of the pediment creates a balanced design, so that while each figure has a clear autonomy, it also exists within a governing ornamental pattern.

If we compare a fallen warrior from the west pediment (fig. **5.24**) with its counterpart from the later east pediment (fig. **5.25**) we see some indication of the extraordinary advances sculptors made toward naturalism during the decades that separate them. As they sink to the ground in death, both figures present a clever solution to filling the awkward corner space. Yet while the earlier figure props himself up on one arm, only a precariously balanced shield supports the later warrior, whose full weight seems to pull him irresistibly to the ground.

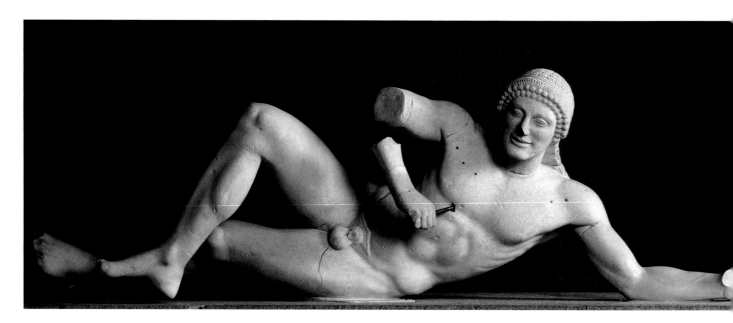

5.24. Dying Warrior, from the west pediment of the Temple of Aphaia. ca. 500–490 BCE. Marble. Length 5'2½" (1.59 m). Staatliche Antikensammlungen und Glyptothek, Munich

Both sculptors aimed to contort the dying warrior's body in the agonies of his death: The earlier sculptor crosses the warrior's legs in an awkward pose, while the later sculptor more convincingly twists the body from the waist, so that the left shoulder moves into a new plane. Although the later warrior's anatomy still does not fully respond to his pose (note, for instance, how little the pectorals stretch to accommodate the strenuous motion of the right arm), his body is more modeled and organic than the earlier warrior's. He also breaks from the head-on stare of his predecessor, turning his gaze to the ground that confronts him. The effect suggests introspection: The inscrutable smiling mask of the earlier warrior yields to the suffering and emotion of a warrior in his final moments.

Vase Painting: Art of the Symposium

In vase painting, the new Archaic style would replace the Orientalizing phase as workshops in Athens and other centers produced extremely fine wares, painted with scenes from mythology, legend, and everyday life. The vases illustrated in these pages were used to hold wine, but were not meant for everyday use. The Greeks generally poured their wine from plainer, unadorned vases. Decorated vases were reserved for important occasions, like the symposium *(symposion)*, an exclusive drinking party for men and courtesans; wives and other respectable citizen women were not included. Participants reclined on couches around the edges of a room, and a master of ceremonies filled their cups from a large painted mixing bowl (a krater) in the middle of the room. Music, poetry, storytelling, and word games accompanied the festivities. Often the event ended in lovemaking, which is frequently depicted on drinking cups. Yet there was also a serious side to symposia, as described by Plato and Xenophon, centering on debates about politics, ethics, and morality. The great issues that the Greeks pondered in their philosophy, literature, and theater—the nature of virtue, the value of an individual man's life, or mortal relations with the gods, to name a few—were mirrored in, and prompted by, the images with which they surrounded themselves.

After the middle of the sixth century BCE, many of the finest vessels bear signatures of the artists who made them, indicating the pride that potters and painters alike took in their work. In many cases, vase painters had such distinctive styles that scholars can recognize their work even without a signature, and modern names are used to identify them. Dozens of vases (in one instance, over 200) might survive by the same hand, allowing scholars to trace a single painter's development over many years.

The difference between Orientalizing and Archaic vase painting is largely one of technique. On the aryballos from Corinth (see fig. 5.5), the figures appear partly as solid silhouettes, partly in outline, or as a combination of the two. Toward the end of the seventh century BCE, influenced by Corinthian products, Attic vase painters began to work in the **black-figured technique**: The entire design was painted in black silhouette against the reddish clay; and then the internal details were incised into the design with a needle. Then, white and purple were painted over the black to make chosen areas stand out. The technique lent itself to a two-dimensional and highly decorative effect. This development marks the beginning of an aggressive export industry, the main consumers of which were the Etruscans. Vast numbers of black-figured vases were found in Etruscan tombs. Thus, although in terms of conception these vases (and later red-figured vessels) represent a major chapter in Greek (and specifically Athenian) art, if we think about their actual use, painted vases can be considered a major component of Etruscan culture, both visual and funerary.

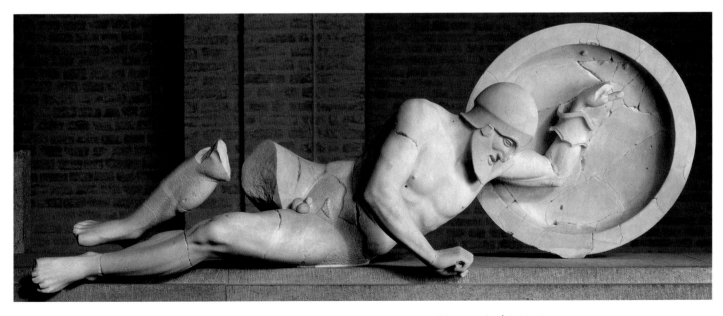

5.25. Dying Warrior, from the east pediment of the Temple of Aphaia. ca. 480 BCE. Marble. Length 6′ (1.83 m). Staatliche Antikensammlungen und Glyptothek, Munich

A fine example of the black-figured technique is an Athenian amphora signed by Exekias as both potter and painter, dating to the third quarter of the sixth century BCE (fig. **5.26**). The painting shows the Homeric heroes Achilles and Ajax playing dice. The episode does not exist in surviving literary sources, and its appearance here points to the wide field of traditions that inspired Exekias. The two figures lean on their spears; their shields are stacked behind them against the inside of a campaign tent. The black silhouettes create a rhythmical composition, symmetrical around the table in the center. Within the black paint, Exekias has incised a wealth of detail, focusing especially upon the cloaks of the warriors; their intricately woven texture contrasts with the lustrous blackness of their weapons.

The extraordinary power of this scene derives from the tension within it. The warriors have stolen a moment of relaxation during a fierce war; even so, poised on the edge of their stools, one heel raised as if to jump at any moment, their poses are edgy. An inscription in front of Ajax, on the right, reads "three," as if he is calling out his throw. Achilles, who in his helmet slightly dominates the scene, answers with "four," making him the winner. Yet many a Greek viewer would have

understood the irony of the scene, for when they return to battle, Achilles will die, and Ajax will be left to bear his friend's lifeless body back to the Greek camp, before falling on his own sword in despair. Indeed, Exekias himself would paint representations of the heroes' tragic deaths. This amphora is the first known representation of the gaming scene, which subsequently became very popular, suggesting that individual vase paintings did not exist in artistic isolation; painters responded to one another's work in a close and often clever dialogue.

Despite its decorative potential, the silhouettelike black-figured technique limited the artist to incision for detail. Toward the end of the sixth century BCE, painters developed the reverse procedure, leaving the figures red and filling in the background. This **red-figured technique** gradually replaced the older method between 520 and 500 BCE. The effects of the change would be felt increasingly in the decades to come, but they are already discernible on an amphora of about 510–500 BCE, signed by Euthymides (fig. **5.27**). No longer is the scene so dependent on profiles. The painter's new freedom with the brush translates into a freedom of movement in the dancing revelers he represents. They cavort in a range of poses, twisting their bodies and showing off Euthymides' confidence in rendering human anatomy. The shoulder blades of the central figure, for instance, are not level, but instead reflect the motion of his raised arm. The turning poses allow Euthymides to tackle foreshortening, as he portrays the different planes of the body (the turning shoulders, for instance) on a single surface. This was an age of intensive and self-conscious experimentation; indeed, so pleased was Euthymides with his painting that he inscribed it with a taunting challenge to a fellow painter, "As never Euphronios." On a slightly later *kylix* (wine cup) by Douris, dating to 490–480 BCE, Eos, the goddess of dawn, tenderly lifts the limp body of her dead son, Memnon, whom Achilles killed after their mothers sought the intervention of Zeus (fig. **5.28**). Douris traces the contours of limbs beneath the drapery, and balances vigorous outlines with more delicate secondary strokes, such as those indicating the anatomical details of Memnon's body. The dead weight of Memnon's body contrasts with the lift of Eos' wings, an ironic commentary, perhaps, on how Zeus decided between the two warriors by weighing their souls on a scale that tipped against Memnon. After killing him, Achilles stripped off Memnon's armor as a gesture of humiliation, and where the figures overlap in the image, the gentle folds of Eos' flowing chiton set off Memnon's nudity. His vulnerability in turn underlines his mother's desperate grief at being unable to help her son.

At the core of the image is raw emotion. Douris tenderly exposes the suffering caused by intransigent fate, and the callousness of the gods who intervene in mortal lives. As we saw on the pediment from Aegina, depictions of suffering, and how humans respond to it, are among the most dramatic developments of late Archaic art. In this mythological scene, Athenians may have seen a reflection of themselves during the horrors of the Persian Wars. Indeed, the vase is brought into the realm of everyday life by its inscription, with the signatures of both painter and potter, as well as a dedication typical of Greek vases: "Hermogenes is beautiful."

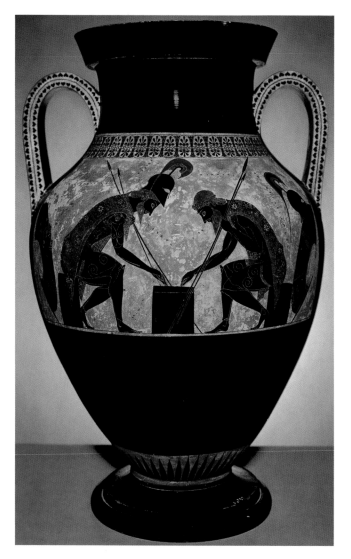

5.26. *Achilles and Ajax Playing Dice.* Black-figured amphora signed by Exekias as painter and potter. ca. 540–530 BCE. Height 2′ (61 cm). Vatican Museums

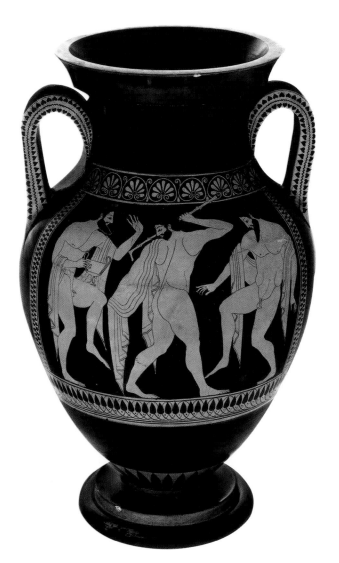

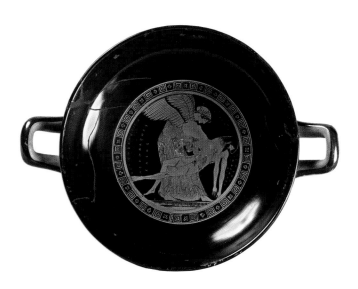

ART IN TIME

7th century BCE**—Doric and Ionic styles develop**

600 BCE**—Temple of Artemis, Corfu**

early 6th century BCE—Sappho's poetry flourishes

ca. 500 BCE**—Red-figured vase-painting technique becomes popular**

490 BCE—Greeks defeat the Persians at the Battle of Marathon

5.27. Euthymides. *Dancing Revelers*. Red-figured amphora. ca. 510–500 BCE. Height 2′ (60 cm). Museum Antiker Kleinkunst, Munich

5.28. Douris Painter. *Eos and Memnon*. Interior of an Attic red-figured kylix. ca. 490–480 BCE. Diameter 10$\frac{1}{2}$″ (26.7 cm). Musée du Louvre, Paris

THE CLASSICAL AGE

The beginning of the fifth century BCE brought crisis. A number of Ionian cities rebelled against their Persian overlords. After Athens came to their support, the Persians invaded the Greek mainland, under the leadership of Darius I. At the Battle of Marathon in 490, a contingent of about 10,000 Athenians, with a battalion from nearby Plataea, repulsed a force of about 90,000 Persians. Ten years later, an even larger force of Persians returned under Darius' son, Xerxes I. Defeating a Spartan force at Thermopylae, they took control of Athens, burning and pillaging temples and statues. The Greeks fought the Persians again at Salamis and Plataea in 480–479, finally defeating them. These battles were defining, watershed moments for the Greeks, who first faced destruction in their cities, and then emerged triumphant and confident after the horrors of Persian invasion. At least in Athens, the Persian destruction of public monuments and space are visible in the archeological record, and, for archeologists and art historians, signals the end of the Archaic period and the emergence of the Classical era.

The struggle against the Persians was a major test for the recently established Athenian democracy, which emerged victorious and more integrated at the end of the war. Athens also became the leader of a defensive alliance against the Persians, which evolved quickly into a political and economic empire that facilitated many architectural and artistic projects. Scholars describe the period stretching from the end of the Persian Wars to the death of Alexander the Great in the late fourth century as the Classical Age. This was the time when the playwrights whose names are still so familiar—Aristophanes, Aeschylus, Sophocles, and Euripides—were penning comedies and tragedies for performance in religious festivals, and thinkers like Socrates and Plato, and then Aristotle, engaged in their philosophical quests. Perhaps the most influential political leader of the day was Perikles, who came to the forefront of Athenian public life in the mid-fifth century BCE, and played a critical role in the city's history until his death in 429 BCE. An avid patron of the arts, he focused much of his attention on beautifying the city's highest point or Akropolis.

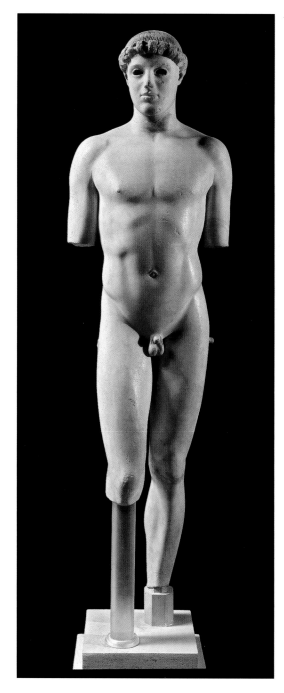

5.29. *Kritios Boy*. ca. 480 BCE. Marble. Height 46″ (116.7 cm). Akropolis Museum, Athens

Classical Sculpture

Among the many statues excavated from the debris the Persians left behind after sacking the Athenian Akropolis in 480 BCE, there is one kouros that stands apart (fig. **5.29**). Sometimes attributed to the Athenian sculptor Kritios, the work has come to be known as the *Kritios Boy*. Archeologists can date it to shortly before the Persian attack on account of its findspot, and it differs significantly from the Archaic kouroi discussed above (see figs. 5.15 and 5.16), not least because it is the first known statue that stands in the full sense of the word. Although the earlier figures are in an upright position—instead of reclining, sitting, kneeling, or running—their stance is really an arrested

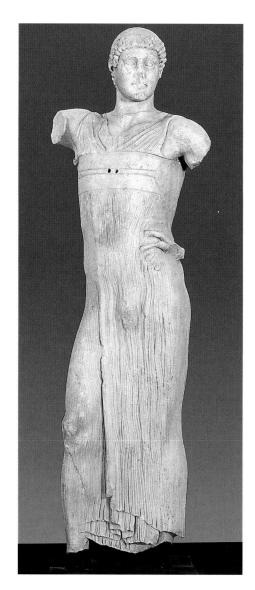

5.30. Charioteer from Motya, Sicily. ca. 450–440 BCE. Marble. Museo Giuseppe Whitaker, Motya

walk, with the weight of the body resting evenly on both legs. This pose is unnaturalistic and rigid. Like earlier kouroi, the *Kritios Boy* has one leg forward, yet an important change has occurred. The sculptor has allowed the youth's weight to shift, creating a calculated asymmetry in the two sides of his body. The knee of the forward leg is lower than the other, the right hip is thrust down and in, and the left hip up and out. The axis of the body is not a straight vertical line, but a reversed S-curve. Taken together, these small departures from symmetry indicate that the weight of the body rests mainly on the left leg, and that the right leg acts as a prop to help the body keep its balance.

The *Kritios Boy* not only stands; he stands at ease. The artist has masterfully observed the balanced asymmetry of this relaxed natural stance, which is known to art historians as **contrapposto** (Italian for "counterpoise"). The leg that carries the main weight is called the engaged leg, the other, the free leg. This simple observation led to radical results, for with it came a recognition that if one part of the body is engaged in a task, the other parts respond. Bending the free knee results in a slight swiveling of

the pelvis, a compensating curvature of the spine, and an adjusting tilt of the shoulders. This unified approach to the body led artists to represent movement with a new naturalism. Indeed, even though the *Kritios Boy* is at rest, his muscles suggest motion, and the sculpture has life; he seems capable of action. At the same time, the artist recognized that strict adherence to nature would not always yield the desired result. So, as in the later Parthenon (see pages 132 and 134), refinements are at work in the *Kritios Boy*. The sculptor exaggerated the line of muscles over the pelvis in order to create a greater unity between thighs and torso, and a more fluid transition from front to back. This emphasized the sculpture's three-dimensionality, and encouraged a viewer to move around the figure.

The innovative movement in the musculature gives a viewer the sense, for the first time, that muscles lie beneath the surface of the marble's skin, and that a skeleton articulates the whole as a real organism. A new treatment of the flesh and the marble's surface add to this impression. The flesh has a sensuousness, a softness that is quite alien to earlier kouroi, and the sculptor worked the surface of the marble to a gentle polish.

Gone, also, is the Archaic smile, presumably as a result of close observation of a human face. The face has a soft fleshiness to it, especially marked around the chin, which will be characteristic of sculpture in the early Classical period. The head is turned slightly away from the front, removing the direct gaze of earlier kouroi and casting the figure into his own world of thought.

We see a similar sensuousness in a sculpture discovered in the Greco-Punic settlement of Motya in western Sicily (see map 5.1 and fig. **5.30**). Like the *Kritios Boy*, it represents a youth standing in a sinuous contrapposto, his head turned from a frontal axis. This youth wears the tunic of a charioteer, with a wide chest band. The sculptor has used the fine fabric to "mask" the full curves of the body, revealing the flesh while simultaneously concealing it.

The *Kritios Boy* marks a critical point in Greek art. One of the changes it engendered was a whole-hearted exploration of the representation of movement, and this was a hallmark of early Classical sculpture. A magnificent nude bronze dating to about 460–450 BCE, recovered from the sea near the coast of Greece, illustrates this well (fig. **5.31**).

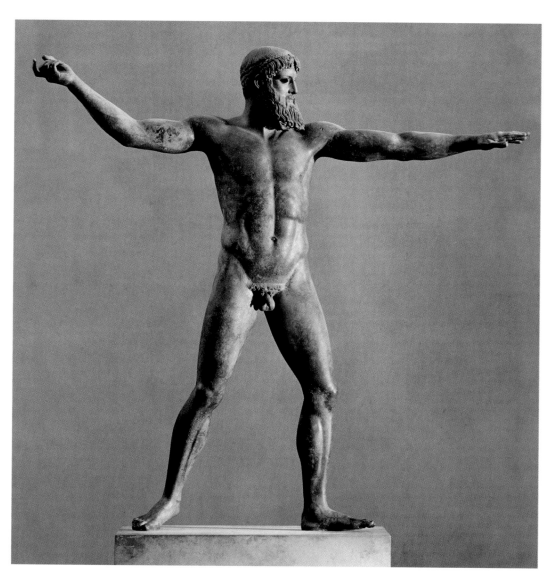

5.31. *Zeus or Poseidon.* ca. 460–450 BCE. Bronze. Height 6′10″ (1.9 m). National Archaeological Museum, Athens. Ministry of Culture Archaeological Receipts Fund. 15161

The Indirect Lost-Wax Process

The Zeus or Poseidon (fig. 5.31) is one of the earliest surviving Greek statues that was made by the indirect lost-wax process. This technique enables sculptors to create spatially freer forms than they can in stone. Projecting limbs are made separately and soldered onto the torso, and no longer need be supported by unsightly struts. Compare, for example, the freely outstretched arms of the Zeus with the strut extending from hip to drapery on the *Knidian Aphrodite* (fig. 5.60).

The Egyptians, Minoans, and early Greeks had often made statuettes of solid bronze using the *direct* lost-wax process. The technique was simple. The sculptor modeled his figure in wax; covered it with clay to form a mold; heated out the wax; melted copper and tin in the ratio of 9 parts to 1 in a crucible; and poured this alloy into the space left by the "lost wax" in the clay mold. Yet because figures made in this way were solid, the method had severe limitations. A solid-cast life-size statue would have been prohibitively expensive, incredibly heavy, and prone to developing unsightly bubbles and cracks as the alloy cooled. So from the eighth through the sixth centuries BCE, the Greeks developed the indirect lost-wax method, which allowed statues to be cast hollow and at any scale.

First, the sculptor shaped a core of clay into the basic form of the intended metal statue. He then covered the clay core with a layer of wax to the thickness of the final metal casting, and carved the details of the statue carefully in the wax. The figure was then sectioned into its component parts—head, torso, limbs, and so on. For each part, a heavy outer layer of clay was applied over the wax and secured to the inner core with metal pegs. The package was then heated to melt the wax, which ran out. Molten metal—usually bronze, but sometimes silver or gold—was then poured into the space left by this "lost wax." When the molten metal cooled, the outer and inner molds were broken away, leaving a metal casting—the statue's head, torso, arm, or whatever. The sculptor then soldered these individual sections together to create the statue. He completed the work by polishing the surface, chiseling details such as strands of hair and skin folds, and inlaying features such as eyes, teeth, lips, nipples, and dress patterns in ivory, stone, glass, copper, or precious metal.

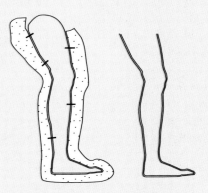

The indirect lost-wax process

At almost 7 feet tall, it depicts a spread-eagle male figure in the act of throwing. Scholars identify it either as Zeus casting a thunderbolt, or Poseidon, god of the sea, hurling his trident. In a single figure, the sculptor captures and contrasts vigorous action and firm stability. The result is a work of outright grandeur, revealing the god's awe-inspiring power. The piece shows off not only the artist's powers of observation and understanding of bodies in motion, but also an extraordinary knowledge of the strengths of bronze, which allowed the god's arms to be stretched out without support. (See *Materials and Techniques*, above.) Some ten years later, in about 450 BCE, Myron created a bronze statue of a discus thrower, the *Diskobolos,* which earned great renown in its own time. Like most Greek sculptures in bronze, it is known to us only from Roman copies (fig. 5.32) (See end of Part I, *Additional Primary Sources.*) If the bronze Zeus or Poseidon suggested impending motion by portraying the moment before it occurred, Myron condensed a sequence of movements into a single pose, achieved through a violent twist of the torso that brings the arms into the same plane as the legs. The pose conveys the essence of the action by presenting the coiled figure in perfect balance.

THE *DORYPHOROS*: IDEALS OF PROPORTION AND HARMONY Within half a century of the innovations witnessed in the *Kritios Boy*, sculptors were avidly exploring the body's articulation. One of those sculptors was Polykleitos of Argos, whose most famous work, the *Doryphoros* (*Spear Bearer*) (fig. **5.33**), is known to us through numerous Roman copies. In this sculpture, the contrapposto is much more emphatic than in the *Kritios Boy*, the turn of the head more pronounced. The artist seems to delight in the possibilities it offers, examining exactly how the anatomy on the two sides of the body responds to the pose. The "working" left arm balances the "engaged" right leg in the forward position, and the relaxed right arm balances the "free" left leg. Yet, in the sculpture, Polykleitos did more than study anatomy. He explored principles of commensurability, *symmetria*, where part related to part, and all the parts to the whole. He also addressed *rhythmos* (composition and movement). Through the *Doryphoros*, Polykleitos proposed an ideal system of proportions, not just for the individual elements of the body but for their relation to one another and to the body as a whole. According to one ancient writer, it came to be known as his *kanon* (**canon** meaning "rule" or "measure"). (See end of Part I, *Additional Primary Sources.*)

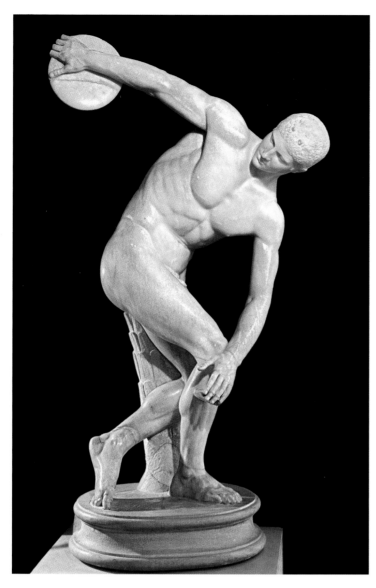

5.32. *Diskobolos (Discus Thrower).* Roman marble copy after a bronze original of ca. 450 BCE by Myron. Life-size. Museo delle Terme, Rome

Egyptian artists had earlier aimed to establish guidelines for depiction based on proportion. Yet for Polykleitos, the search for an ideal system of proportions was more than an artist's aid: It was rooted in a philosophical quest for illumination, and based in a belief that harmony (*harmonia*)—in the universe, as in music and in all things—could be expressed in mathematical terms. Only slightly later than this sculpture, Plato would make numbers the basis of his doctrine of ideal forms, and acknowledge that the concept of beauty was commonly based on proportion. Philosophers even referred to works of art to illustrate their theories. Beauty was more than an idle conceit for Classical Athenians; it also had a moral dimension. Pose and expression reflected character and feeling, which revealed the inner person and, with it, *arete*

(excellence or virtue). Thus contemplation of harmonious proportions could be equated with the contemplation of virtue. (See *Primary Source*, page 127.)

We cannot know how much of the Doryphoros' original appearance is lost in the copy-making process: Bronze and marble differ greatly in both texture and presence. Surviving Greek bronzes are extremely rare, and when a pair of

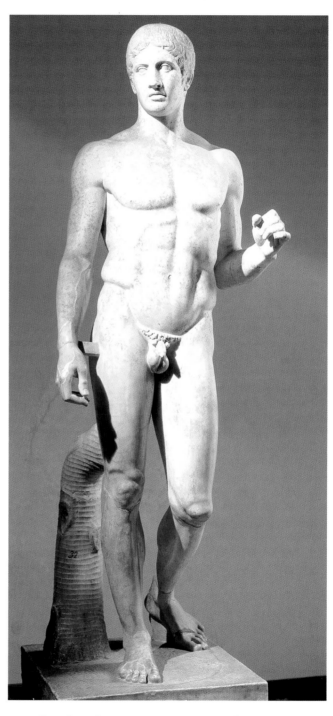

5.33. *Doryphoros (Spear Bearer).* Roman copy after an original of ca. 450–440 BCE by Polykleitos. Marble. Height 6′6″ (2 m). Museo Archeologico Nazionale, Naples

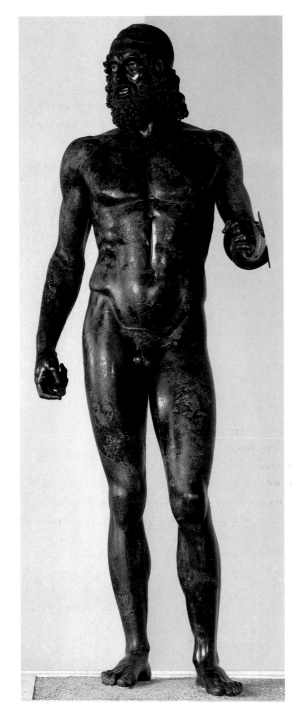

5.34. Riace Warrior A, found in the sea off Riace, Italy. ca. 450 BCE. Bronze. Height 6'8" (2.03 m). Museo Archeologico, Reggio Calabria, Italy

light, a bronze surface reflects it, and this led sculptors to explore a variety of surface textures—for hair and skin, for instance. Different materials could be added for details: These statues have ivory and glass-paste eyes, bronze eyelashes, and copper lips and nipples. Statue A (known as the *Riace Warrior A*), shown here, has silver teeth. Just who these figures represented is still unknown: a pair of heroes, perhaps, or warriors. They may have formed part of a single monument. Though they strike similar poses, the men have differing body types, which has led some scholars to date them apart and attribute them to two separate sculptors. They could just as easily be the work of a single artist exploring the representation of character and age.

THE SCULPTURES OF THE TEMPLE OF ZEUS, OLYMPIA The challenge of filling the shape of a temple pediment may well have helped to fuel the urge to understand human motion. The Temple of Aphaia at Aegina suggests as much; here the designer filled the elongated triangle with figures in a variety of different poses, from standing to reclining. The two pediments of the Temple of Zeus at Olympia are highpoints of the early Classical style. They were carved about 460 BCE, perhaps by Ageladas of nearby Argos, and have been reassembled in the local museum at Olympia. Spoils from a victory of Elis over its neighbor Pisa in 470 BCE provided funds for the temple's construction. The east pediment reflects the victory, with mythology providing an analogy for current events, as at Aegina. The subject is Pelops' triumph over Oinomaos, king of Pisa, in a chariot race for which the prize was the hand of the ruler's daughter, Hippodameia. Pelops (for whom the Peloponnesos is named) held a position of special importance to the Greeks, for he was thought to have founded the games at Olympia. But because he won by trickery, he and his descendants, who included Agamemnon, King of Mycenae, lived under a curse. His example, therefore, served as a warning to Olympic contestants as they paraded past the temple.

The west pediment represents the struggle of the Lapiths, a tribe from Thessaly, with the Centaurs (a *centauromachy*) (fig. **5.35**). Centaurs were the offspring of Ixion, king of the Lapiths, and Hera, whom he tried to seduce while in Olympos. In punishment for his impiety, Ixion was chained forever to a fiery wheel in Tartarus. As half-brothers of the Lapiths, the centaurs were invited to the wedding of the Lapith king Peirithoös and Deidameia. Unable to tolerate alcohol, the centaurs became drunk and got into a brawl with the Lapiths, who subdued them with the aid of Peirithoös' friend Theseus.

At the center of the composition stands the commanding figure of Apollo. His outstretched right arm, the strong turn of his head, and his powerful gaze show his active engagement in the drama, as he wills the Lapiths' victory. At the same time, his calm, static pose removes him from the action unfolding around him; he does not physically help. To the left of Apollo, the Centaur king, Eurytion, has seized Hippodameia. Both figures' forms are massive and simple, with soft contours and undulating surfaces. The artist has entangled them in a com-

over–life-size figures was found in the sea near Riace, Italy, in 1972, they created a sensation (fig. **5.34**). As figure 5.34 illustrates, the state of preservation is extremely good, and shows off to advantage the extraordinarily fine workmanship. In the fifth century BCE, bronze was the material of choice for free-standing sculptures, and sculptors used a refined version of the lost-wax technique familiar to Near Eastern artists. The process differs radically from cutting away stone, since the technique is additive (the artist builds the clay model in the first phase of the process.) Further, where marble absorbs

PRIMARY SOURCE

Aristotle (384–322) BCE

The Politics, from Book VIII

The Politics is a counterpart to Plato's Republic, *a treatment of the constitution of the state. Books VII and VIII discuss the education prescribed for good citizens. Drawing is included as a liberal art—that is, a skill not only useful but also conducive to higher activities. Yet painting and sculpture are said to have only limited power to move the soul.*

There is a sort of education in which parents should train their sons, not as being useful or necessary, but because it is liberal or noble.... Further, it is clear that children should be instructed in some useful things—for example, in reading and writing—not only for their usefulness, but also because many other sorts of knowledge are acquired through them. With a like view they may be taught drawing, not to prevent their making mistakes in their own purchases, or in order that they may not be imposed upon in the buying or selling of articles [works of art], but perhaps rather because it makes them judges of the beauty of the human form. To be always seeking after the useful does not become free and exalted souls....

The habit of feeling pleasure or pain at mere representations is not far removed from the same feeling about realities; for example, if any one delights in the sight of a statue for its beauty only, it necessarily follows that the sight of the original will be pleasant to him. The objects of no other sense, such as taste or touch, have any resemblance to moral qualities; in visible objects there is only a little, for there are figures which are of a moral character, but only to a slight extent, and all do not participate in the feeling about them. Again, figures and colours are not imitations, but signs, of character, indications which the body gives of states of feeling. The connexion of them with morals is slight, but in so far as there is any, young men should be taught to look.... at [the works] of Polygnotus, or any other painter or sculptor who expresses character.

SOURCE: *THE POLITICS* BY ARISTOTLE, ED. BY STEPHEN EVERSON (NY: CAMBRIDGE UNIVERSITY PRESS, 1988)

pact group, full of interlocking movements, which is quite different from the individual conflicts of the Aegina figures. Moreover, the artist expressed their struggle in more than action and gesture: Anguish is mirrored in the face of the Centaur, whose pain and desperate effort contrast vividly with the calm on the young bride's face. In setting the centaurs' evident suffering against the emotionlessness of the Lapiths, the pediment draws a clear moral distinction between the bestial Centaurs and the humans, who share in Apollo's remote nobility. Apollo, god not only of music and poetry but also of light and reason, epitomizes rational behavior in the face of adversity. By partaking in divine reason, humans triumph over animal nature. This conflict between the rational and the irrational, order and chaos, lay at the heart of Greek art, both in its subject matter and in its very forms. It exposes the Greeks' sense of themselves, representing civilization in the face of barbarianism—always neatly encapsulated in the Persians.

Like the west pediment, the east pediment may have a had a topical relevance, encouraging fair play among the Olympic competitors. The metopes were certainly topical, since they depict the labors of Herakles, Pelops' great-grandson, who according to legend laid out the stadium at Olympia. Narrative scenes had been a

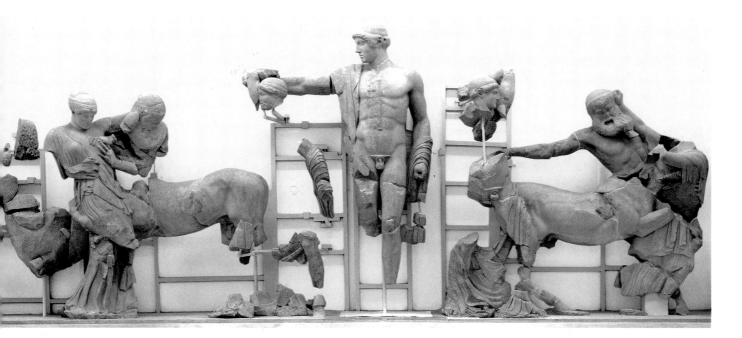

5.35. Photographic reconstruction (partial) of the *Battle of the Lapiths and Centaurs*, from the west pediment of the Temple of Zeus at Olympia. ca. 460 BCE. Marble, slightly over life-size. Archaeological Museum, Olympia

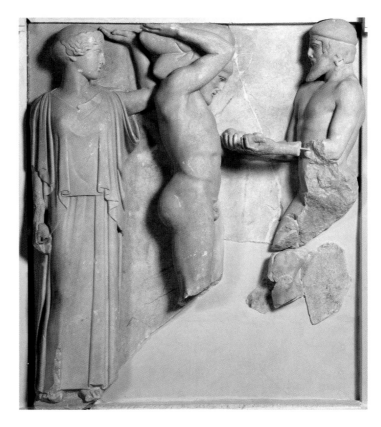

5.36. *Atlas Bringing Herakles the Apples of the Hesperides.* ca. 460 BCE. Marble. Height 63″ (160 cm). Archaeological Museum, Olympia

feature of metopes since the early sixth century BCE, but at Olympia the pictorial and dramatic possibilities are fully exploited for the first time. The example illustrated here, which was featured prominently over the entrance on the east side of the temple, shows Atlas returning to Herakles with the apples of the Hesperides (fig. **5.36**). Atlas was one of the Titans, the race of gods before the Olympians, and it was his charge to hold the Earth on his shoulders. By agreeing to hold the world for him, Herakles persuaded Atlas to go to the gardens of the Hesperides to fetch the apples in fulfillment of one of his labors. On returning, Atlas refused to accept his burden back, until Herakles cheated him into doing so. The metope shows Herakles supporting a cushion (which held the globe) on his shoulders, with the seemingly effortless support of a young Athena. He looks on almost in astonishment as he tries to conjure up a way to trick Atlas into giving up the apples. This is not the grim combat so characteristic of Archaic Greek art (as we saw in figs. 5.24 and 5.25); the burly Herakles has taken on the thoughtful air that is central to the Classical spirit. The figures have all the characteristics of early Classical sculpture: "doughy" faces, an economy of pose and expression, and simple, solemn drapery.

Architecture and Sculpture on the Athenian Akropolis

The Athenian Akropolis had been a fortified site since Mycenaean times, around 1250 BCE (figs. **5.37** and **5.38**). During the Archaic period, it was home to at least one sizeable temple dedicated to the city's patron goddess, Athena, as well as several smaller temples or treasuries, and numerous statues. In 480 BCE, the Persians demolished the buildings and tore down the statues. For over 30 years, the Athenians left the sacred monuments in ruins, as a solemn reminder of the Persians' ruthlessness. In the mid-fifth century BCE, however, this changed with the emergence of Perikles into political life. Perikles' ambitions for Athens included making the city—with a population of about 150,000—the envy of the Mediterranean world. His projects, which the democratic assembly approved, began on the Akropolis. Individually and collectively, the structures there have come to exemplify the Classical phase of Greek art at its height (see *Primary Source*, page 131). In these monuments, artists continued to grapple with ways of creating harmony through principles of commensurability.

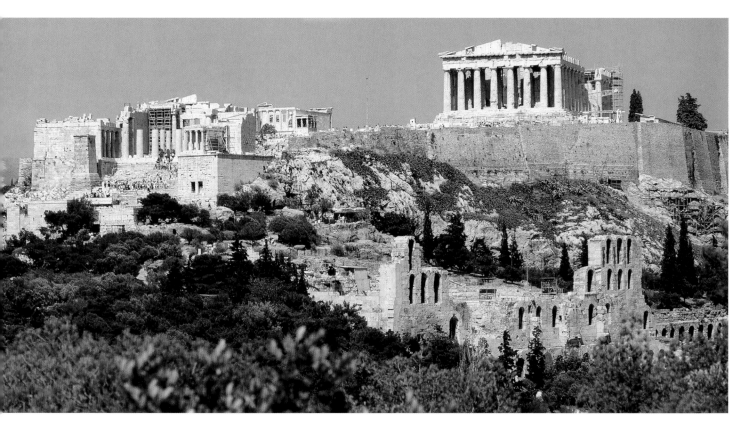

5.37. Akropolis (view from the west), Athens. The Propylaea, 437–432 BCE; with the Temple of Athena Nike, 427–424 BCE

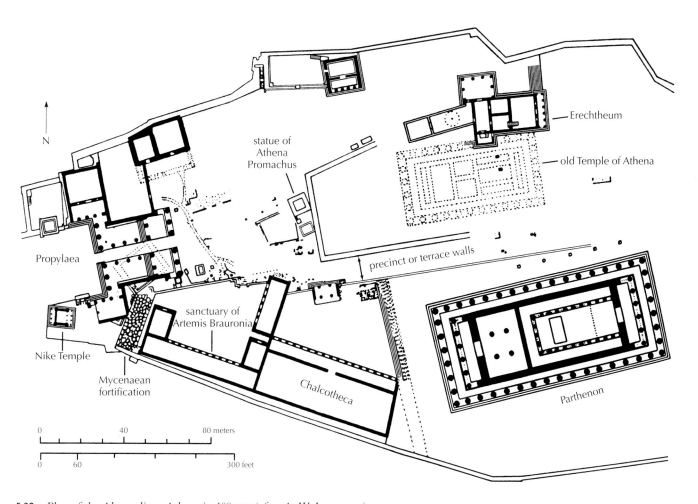

5.38. Plan of the Akropolis at Athens in 400 BCE (after A. W. Lawrence)

THE PARTHENON The dominant temple on the Akropolis, and the only one to be completed before the onset of the Peloponnesian War, is the Parthenon (fig. **5.39**), a structure conceived to play a focal role in the cult of Athena on the Akropolis. There is no evidence that it was used directly for cult practices; there is no altar to the east, which was the principal focus of Greek ritual practice and cult. The chief center of cult practice remained on the site of the Erechtheion, north of the Parthenon (see fig. 5.53). Built of gleaming white marble from the nearby Mount Pentelikon, the Parthenon stands on a prominent site on the southern flank of the Akropolis. It dominates the city and the surrounding countryside, a brilliant landmark against the backdrop of mountains to the north, east, and west. Contemporary building records, and a biography of Perikles written by Plutarch, show that two architects named Iktinos and Kallikrates oversaw its construction in the short interval between 447 and 432 BCE. To meet the expense of building the largest and most lavish temple of its time on the Greek mainland, Perikles resorted in part to funds collected from the Delian League, a group of states allied with Athens for mutual defense against the Persians. Perhaps the Persian danger no longer seemed real; still, the use of these funds weakened Athens' position in relation to its allies. Centuries later, Greek writers still remembered accusations against Perikles for adorning the city "like a harlot with precious stones, statues, and temples costing a thousand talents."

Regardless of one's preference for Archaic or Classical proportions, when read against the architectural vocabulary of Classical Greece the Parthenon is an extraordinarily sophisticated building (fig. 5.39). Its parts are fully integrated with one another, so that its spaces do not seem to be separated, but to melt into one another. Likewise, architecture and sculpture are so intertwined that discussion of the two cannot be disentangled. The temple stood near the culminating point of a grand procession that would wind its way through the city and onto the Akropolis during the Panathenaic festival in Athena's honor, and as magnificent as it was to observe from a distance, it was also a building to be experienced. Imitating the grandiose temples of Archaic Ionia, the Parthenon featured an octastyle (8-column) arrangement of its narrow ends. It was unusually wide, offering a generous embrace and enough space for an interior arrangement of a U-shaped colonnade and an enormous statue of Athena, the work of the famed sculptor Pheidias. She stood with one hand supporting a personification

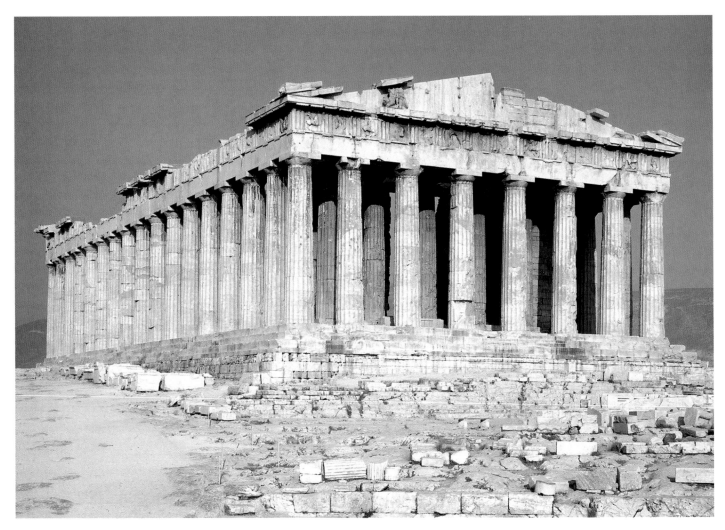

5.39. Iktinos and Kallikrates. The Parthenon (view from the west). Akropolis, Athens. 447–432 BCE

Plutarch (ca. 46–after 119 CE)

Parallel Lives of Greeks and Romans, from the lives of Perikles and Fabius Maximus

A Greek author of the Roman period, Plutarch wrote Parallel Lives *to show that ancient Greece matched or exceeded Rome in its great leaders. Comparing Perikles (d. 429 BCE) with Fabius Maximus (d. 203 BCE), he concludes that Perikles' buildings surpass all the architecture of the Romans. Plutarch is the only ancient source to say that Pheidias was the overseer of Perikles' works.*

But that which brought most delightful adornment to Athens, and the greatest amazement to the rest of mankind; that which alone now testifies for Hellas that her ancient power and splendour, of which so much is told, was no idle fiction—I mean his construction of sacred edifices. . . . For this reason are the works of Perikles all the more to be wondered at; they were created in a short time for all time.

Each one of them, in its beauty, was even then and at once antique; but in the freshness of its vigour it is, even to the present day, recent and newly wrought. Such is the bloom of perpetual newness, as it were, upon these works of his, which makes them ever to look untouched by time, as though the unfaltering breath of an ageless spirit had been infused into them.

His general manager and general overseer was Pheidias, although the several works had great architects and artists besides. Of the Parthenon, for instance, with its cella of a hundred feet in length, Kallicrates and Iktinus were the architects. . . .

By the side of the great public works, the temples, and the stately edifices, with which Perikles adorned Athens, all Rome's attempts at splendour down to the times of the Caesars, taken together, are not worthy to be considered, nay, the one had a towering preeminence above the other, both in grandeur of design, and grandeur of execution, which precludes comparison.

SOURCE: *PLUTARCH'S LIVES*, VOL. 3, TR. BY BERNADOTTE PERRIN (CAMBRIDGE: HARVARD UNIVERSITY PRESS, 1916)

of Victory, and a shield resting against her side. The figure was made of ivory and gold (a combination known as *chryselephantine*), supported on a wooden armature (fig. **5.40**). It was extraordinarily valuable, and the building's forms drew visitors in to view it. Like all peripteral temples, the encircling colonnade gave the impression that the temple could be approached from all sides. Entry to the cella was mediated through a prostyle porch of six columns (where the columns stand in front of the side walls, rather than between them). A similar arrangement mediated access to the Ionic opisthonaos (rear room) of the building. The porches are unusually shallow. This allowed light into the cella, which otherwise came in through two large windows on either side of the main entrance to the cella. In its combination of a well-lit interior and the rational articulation of the interior space with a colonnade, the Parthenon breaks with traditions and initiates a new interest in the embellishment of interior space.

Compared with the Temple of Hera II at Paestum (see fig. 5.10, right), the Parthenon appears far less massive, despite its greater size. One of the reasons for this is a lightening and an adjusting of proportions since the Archaic period. The columns are much more slender, their tapering and entasis less pronounced, and the capitals are smaller and less flaring. The diameter of the columns was determined in part by practical necessity: Both for convenience and economy, the architects reused many drums from the unfinished first Parthenon. Yet how the columns related to the rest of the building was a matter for new design. The spacing of the columns, for instance, is wider than in earlier buildings. The entablature is lower in relation to the height of the columns and to the temple's width, and the cornice projects less. The load carried by the Parthenon columns seems to have decreased, and as a result the supports appear able to fulfill their task with a new sense of ease.

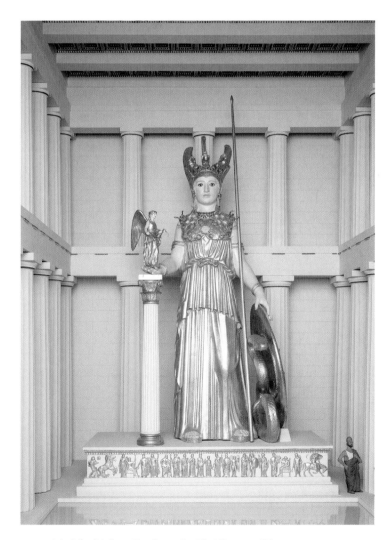

5.40. Model of *Athena Parthenos*, by Pheidias. ca. 438 BCE. Royal Ontario Museum, Toronto

The governing principle behind the proportion was a ratio of 9 : 4 or $2x + 1 : x$. Thus, for instance, the eight (x) columns across the facades are answered by seventeen ($2x + 1$) columns along the sides. Additionally, the ratio of the spacing between each column to the diameter at the lowest point of the column was also 9 : 4. It was not just a matter of design convenience, but an attempt to produce harmony through numerical relationships. Libon of Elis first used this proportional scheme in the Temple of Zeus at Olympia. The formula was used pervasively throughout the Parthenon, though never dogmatically, always allowing for minor adjustments.

Despite the relative precision the formula dictated, intentional departures from the strict geometric regularity of the design were built into the Parthenon (and other temples). For instance, the columns are not vertical, but lean in toward the cella (the corner columns in two directions), and the space between the corner column and its neighbors is smaller than the standard interval adopted for the colonnade as a whole. Moreover, the stepped platform on which the temple rests is not fully horizontal, but bows upward, so that the center of the long sides is about four inches higher than the corners. This curvature is reflected up through the temple's entablature, and every capital of the colonnade is slightly distorted to fit the bowed architrave. That these irregularities were intentional is beyond doubt, as masons tailor-made individual blocks to accommodate them. Exactly why they were desirable is less clear.

When these irregularities were first introduced into temple architecture, some 100 years earlier, they may have been intended to solve drainage problems. Yet in the Parthenon, they are so exaggerated that scholars consider them to be corrections of optical illusions. For instance, when viewed from a distance, absolutely straight horizontals appear to sag, but if the horizontals curve upward, they look straight. When seen close up, a long straight line seems to curve like the horizon; by exaggerating the curve, the architects could make the temple appear even larger than it was. These two apparently contradictory theories could work in tandem, since there would be different optical distortions depending on a viewer's vantage point. What is certain is that these refinements give the temple a dynamic quality that might otherwise be lacking. Rather than sitting quietly on its platform, the swelling forms give the building an energy, as if it were about to burst out of its own skin; through the refinements, the temple comes alive.

The Parthenon is often viewed as the perfect embodiment of Classical Doric architecture. Although this may be the impression from the outside, it is far from true. At architrave level within the peristyle, a continuous sculpted frieze runs around all sides of the building, in a variation of the Ionic style (see fig. 5.9). Moreover, while most of the temple's columns are Doric, four tall, slender columns in the rear room were Ionic. Even if Doric is the dominant style, Ionic is clearly present.

THE PARTHENON SCULPTURES The largest group of surviving Classical sculptures comes from the Parthenon, which had a more extensive decorative program than any previous temple. The sculptures have a vivid and often unfortunate history. The temple was converted into a church, probably in the sixth century CE, and much of the decoration on the sacred east side was destroyed or vandalized. In 1687, cannon fire from Venetian forces ignited ammunition that the Turkish forces were storing in the temple. The west pediment figures survived the explosion, but not the war's aftermath. A crane used in the process of removing the sculptures, so that the Venetian commander could take them back to Venice, dropped the figures, shattering them. Over 100 years later, Lord Elgin, British ambassador to Constantinople, removed what he could of the temple's decoration and shipped it to England between 1801 and 1803. In 1816, needing money, he sold them to an ambivalent British Museum. The Elgin Marbles, as they are known, are housed today in a purposely constructed wing of the museum, and stand at the heart of a heated debate on the repatriation of national treasures. Other fragments of the Parthenon's sculptural decoration are on display in museums throughout Europe.

Thirteen years before the explosion in the Parthenon, an artist named Jacques Carrey was traveling in Athens as part of the retinue of the French ambassador to the Ottoman court. He executed a series of drawings of surviving Parthenon sculptures, which have become invaluable resources for understanding the decorative program as a whole (fig. **5.41**). Primarily from these drawings and from literary sources, we know that the west pediment portrayed the divine struggle between Athena and Poseidon for Athens. The east pediment represented the birth of Athena from the head of Zeus, in the presence of other deities. All but the central figures survive, and Carrey's drawing allows for a confident reconstruction of their arrangement. Bursting from the left corner is the upper body of Helios, the sun god, whose rearing horses draw him into view. Balancing him in the right corner, Selene, the moon goddess, or Nyx, the night, sinks away with her horses. These celestial gods define the day's passing, and together they place the scene in an eternal cosmic realm. To the right of Helios is a nude male figure in a semi-reclining position, thought to be Dionysos (fig. **5.42**). On the other side of the pediment is a closely knit group of three female deities, usually identified as Hestia, Dione, and Aphrodite (fig. **5.43**).

As a group, the pediment figures are strikingly impressive. Like the architecture into which they are embedded, their forms are strong and solid, yet their implied power contrasts with their languid poses and gains strength from the contrast. The nude male figure's power resides in the simple force and naturalism of his anatomy, giving him the appearance of a figure sculpted with an easy confidence. The female group is a masterpiece of swirling drapery, which disguises the sheer bulk of the marble. The garments cling to their

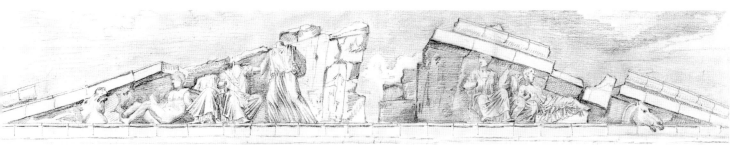

5.41. Jacques Carrey. Drawings of the east pediment of the Parthenon. 1674 CE. Bibliothèque Nationale, Paris

5.42. Dionysos from the east pediment of the Parthenon. ca. 438–432 BCE. Marble, over–life-size. The British Museum, London

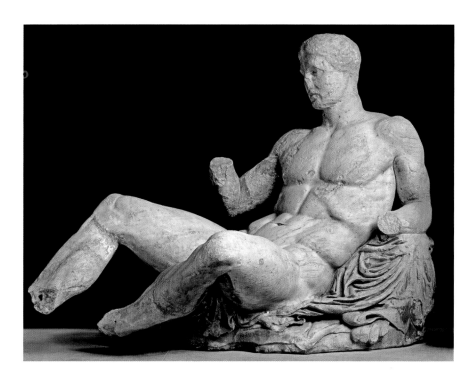

5.43. Three Goddesses, from the east pediment of the Parthenon. ca. 438–432 BCE. Marble, over life-size. The British Museum, London

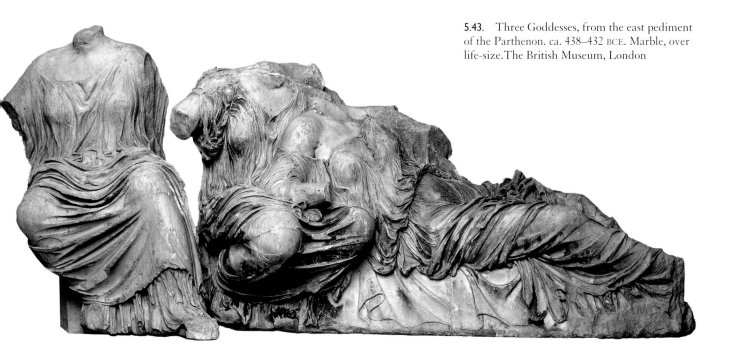

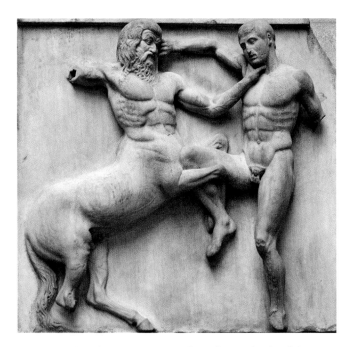

5.44. Lapith and Centaur, metope from the south side of the Parthenon. ca. 440 BCE. Marble. Height 56″ (142.2 cm). The British Museum, London

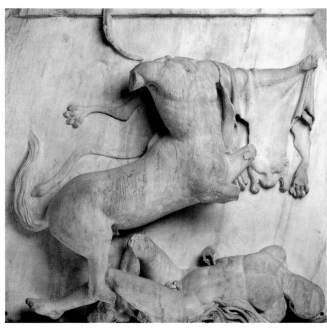

5.45. *Lapith and Centaur,* metope from the south side of the Parthenon. ca. 440 BCE. Marble. Height 56″ (142.2 cm). The British Museum, London

bodies beneath in a "wet look," both concealing and revealing them. Yet here drapery does not follow the lines of the body so much as struggle with them, twisting around the legs in massive folds. The effect is extraordinary: Although a viewer can only see the deities from a frontal vantage point, as if the figures were two-dimensional, the curves of the deeply cut folds echo their forms *in section* (i.e., along a plane made by an imaginary vertical slice from front to back), and thereby broadcast their three-dimensionality. The sculptor could better express Nature through the appearance of truth than through truth itself. This optical device is a sculptural equivalent of the deliberate distortions in the temple's architecture.

Running the whole way around the building (rather than just at the ends) was a full program of metopes, numbering 92 in all, depicting scenes of violent action. On the west side, the metopes showed the battle of the Greeks against the Amazons (an *Amazonomachy*), a mythical race ruled by their warrior women. Metopes on the north side portrayed the Sack of Troy (the *Ilioupersis*), the conclusion of the Trojan War, when the Greeks fought the Trojans over the abduction of Helen, wife of Menelaus, brother of the king of Mycenae. On the east side, the gods fought the giants, as they did on the Temple of Artemis at Corfu. Little survives of any of these pictorial cycles. The metopes of the south side, however, are relatively well preserved, and mostly depict the battle of the Lapiths and the Centaurs. The four cycles come together to form a meaningful whole: All depict the tension between the civilized and uncivilized worlds, between order and chaos; and all are therefore allegories for the Athenian victory over the Persians. Historical fact is cloaked in the guise of myth, where the triumph of order over chaos has a preordained inevitability.

The quality of the metopes varies dramatically, and reminds us of the vast crews of workers who must have been engaged in completing the Parthenon in such a short period: The two pediments and frieze were executed in less than 10 years (ca. 440–432 BCE). One can usefully compare, for instance, the awkward twists of figure **5.44** with the balletlike choreography of figure **5.45**. Both artists aimed to fill the sculptural field, and both sought to intertwine the wrestling figures—yet with radically different results.

A visitor to the Parthenon could see the pediments and metopes from a distance, but to see the frieze, a viewer had to come closer and walk parallel to the building. In a continuous sculpted band, some 525 feet long (see fig. **5.46**), the frieze depicts a procession, moving from west to east, propelling the viewer around the building. Horsemen jostle with musicians, water carriers, and sacrificial beasts, overlapping to create the illusion of a crowd, even though the relief is only inches deep. Frenzied animals emphasize the calm demeanor of the figures (fig. **5.47**), who have the ideal proportions of the *Doryphoros.*

The most problematic aspect of the relief is the detail in figure **5.48**, from the center of the east end of the temple. Five unidentified figures are represented, three of them young. Two of the young figures carry cushioned stools on their heads, while the third, in a group with one of the adults,

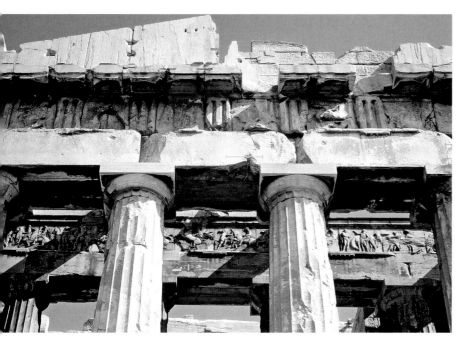

5.46. Frieze above the western entrance of the cella of the Parthenon. ca. 440–432 BCE. Marble. Height 43″ (109.3 cm).

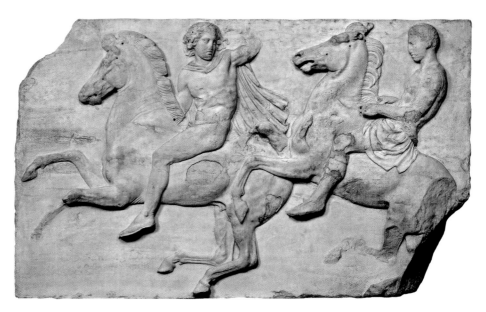

5.47. *Horsemen,* from the west frieze of the Parthenon. ca. 440–432 BCE. Marble. Height 43″ (109.3 cm). The British Museum, London

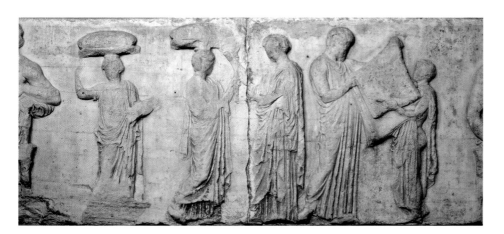

5.48. East frieze of the Parthenon. ca. 440 BCE. Marble, height 43″ (109.3 cm). The British Museum, London

The Parthenon Frieze: A New Interpretation

The center portion of the east end of the Parthenon has long troubled scholars. The seated figures to the left and right of this center area are carved on a larger scale than the rest of the figures. They clearly represent the Olympian gods. If the rest of the frieze represents the Panathenaic procession, then the whole frieze, and the east end in particular, conspicuously lacks a unity of place (that is, the action unfolds in more than one place). A recent theory solves this problem by placing the entire frieze in the realm of myth. In this interpretation, the scene in question depicts the three daughters of King Erechtheus. According to Athenian myth, the oracle at Delphi demanded the death of one of his daughters if Athens was to be saved from its enemies. Here, one of the daughters calmly receives the garment in which she is to be sacrificed. The myth had obvious resonance for Athens after its victory over the Persians, and the playwright Euripides made it the subject of a tragedy. This theory is highly controversial, and hinges on whether the younger figure to the right is a girl or a boy, as scholars increasingly believe. Whatever the solution to this problem, the iconography of the frieze integrated Athenians and divine space, time, and ritual practice in a unity that reflected the Athenians' sense of superiority and self-confidence. The problem of the frieze is exacerbated by the discovery, during the building's recent preservation and reconstruction, that the pronaos featured another frieze in its upper well. Nothing survives of this frieze, but if it was thematically connected with the frieze around the cella, we are lacking a crucial piece of evidence for a secure identification and interpretation of the iconography.

handles a piece of cloth. According to the traditional view, the cloth is a new robe for Athena, woven by Athenian girls and women and depicting Athena's triumph against the giants in the gigantomachy. The procession is the Panathenaic procession, part of a festival held annually to honor Athena in the presence of the other Olympian gods, and which was celebrated on a grander scale every four years. The figures and their groupings are typical of the participants in these processions, and the frieze represents an idealized event, rather than a specific moment. Some scholars have suggested that this "heroicized" representation honors the 192 Athenians slain at the battle of Marathon (the first important Greek victory over the Persians, when approximately 6,400 Persians were killed), on the basis that the frieze may originally have had a like number of equestrian figures. The earlier Parthenon, a structure started after 490 BCE and burned by the Persians, had honored their sacrifice. If this view is correct and the frieze represents the Panathenaic procession, it is remarkable in that it exalts mortal Athenians by depicting them in a space usually reserved for divine and mythological scenes. For an alternative interpretation of the late frieze, see *The Art Historian's Lens*, above.

THE PHEIDIAN STYLE The Parthenon sculptures have long been associated with the name of Pheidias, who, according to the Greek biographer Plutarch, was chief overseer of all the artistic projects Perikles sponsored. (See *Primary Source*, page 131.) By the time Perikles hired him, Pheidias's huge sculpture of Athena Parthenos, and a second chryselephantine colossus of a seated Zeus in the Temple of Zeus at Olympia, aroused extreme admiration, not only due to their religious roles, but also because of their vast size and the sheer value of the materials employed. Pheidias was also responsible for an equally large bronze sculpture of Athena that stood on the Akropolis facing the Propylea. These are the only works directly attributed to his hand, and none of them survives; small-scale copies made in later times convey little of their original majesty. He may have worked personally on the Parthenon's architectural sculpture, which undoubtedly involved a large number of masters, but he may have simply been a very able supervisor. We therefore know very little about Pheidias's artistic style.

Nevertheless, Pheidias has come to be associated with the Parthenon style, which is often synonymous with the "Pheidian style." The term conveys an ideal that was not merely artistic but also philosophical: The idealized faces and proportions of the Athenians elevate them above the uncivilized world in which they operate. They share the calmness of the gods, who are aware of, yet aloof from, human affairs as they fulfill their cosmic roles.

Given the prominence of the Parthenon, it is hardly surprising that the Pheidian style should have dominated Athenian sculpture until the end of the fifth century and beyond, even though large-scale sculptural enterprises gradually dwindled because of the Peloponnesian War. It is clearly evident in one of the last of these projects, a balustrade built around the small Temple of Athena Nike on the Akropolis in about 410–407 BCE (see fig. 5.52). Like the Parthenon frieze, it shows a festive procession, but the participants are not citizens of Athens but winged personifications of Victory (*Nikai*). One Nike is taking off her sandals, indicating that she is about to step on holy ground (fig. **5.49**). Her wings keep her stable, so that she performs this normally awkward act with elegance and ease. The Pheidian style is most evident in the deeply cut folds of her "wet look" garments, which cling to her body and fall in deep, wild swags between her legs.

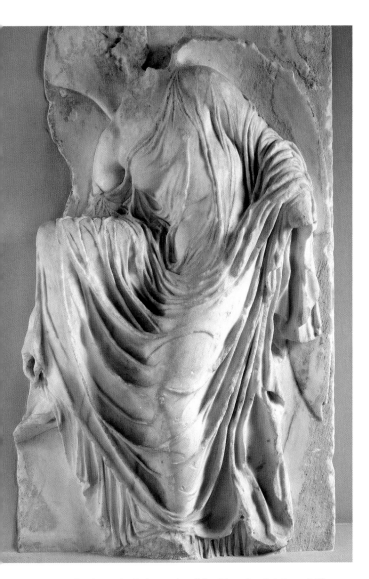

5.49. *Nike,* from the balustrade of the Temple of Athena Nike. ca. 410–407 BCE. Marble. Height 42″ (106.7 cm). Akropolis Museum, Athens

THE PROPYLAEA During the year that the Parthenon was dedicated, 437 BCE, Perikles commissioned another costly project: the monumental entry gate at the western end of the Akropolis, called the Propylaea (see fig. 5.37). Mnesikles was the architect in charge, and he completed the main section in five years; the remainder was abandoned with the onset of the Peloponnesian War. The entire structure was built of marble and included refinements similar to those used in the Parthenon. Mnesikles ably adapted elements of a Doric temple to a totally different task, and to an irregular and steeply rising site. Conceived on two levels, the design transforms a rough passage among rocks into a magnificent entrance to the sacred precinct. Only the eastern porch (or facade) is in fair condition today. It resembles a Classical Doric temple front, except for the wide opening between the third and fourth columns, which allowed traffic to pass onto the Akropolis; this feature appears often in Ionian architecture. Flanking the western

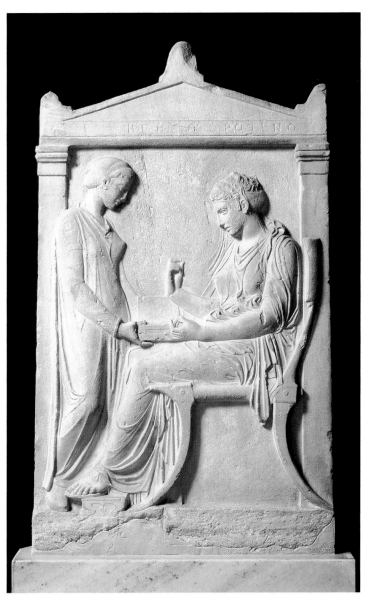

5.50. *Grave Stele of Hegeso.* ca. 410–400 BCE. Marble. Height 59″ (150 cm). National Archaeological Museum, Athens

On the Grave Stele of Hegeso (fig. **5.50**), also from the last years of the fifth century BCE, the Pheidian style is again recognizable in the drapery, but also in the smooth planes of the idealized faces, and in the quiet mood of the scene. The artist represented the deceased woman seated on an elegant chair, in a simple domestic scene that became standard for sculpted and painted funerary markers for young women. She has picked a piece of jewelry from a box held by a girl servant and seems to contemplate it. The delicacy of carving is especially clear in the forms farthest away from a viewer, such as the servant's left arm, or the veil behind Hegeso's right shoulder. Here the relief merges with the background, strengthening the illusion that the background is empty space rather than a solid surface. This stele is a particularly fine example of a type of memorial that Athenian sculptors produced in large numbers from about 425 BCE onward. Their export must have helped to spread the Pheidian style throughout the Greek world.

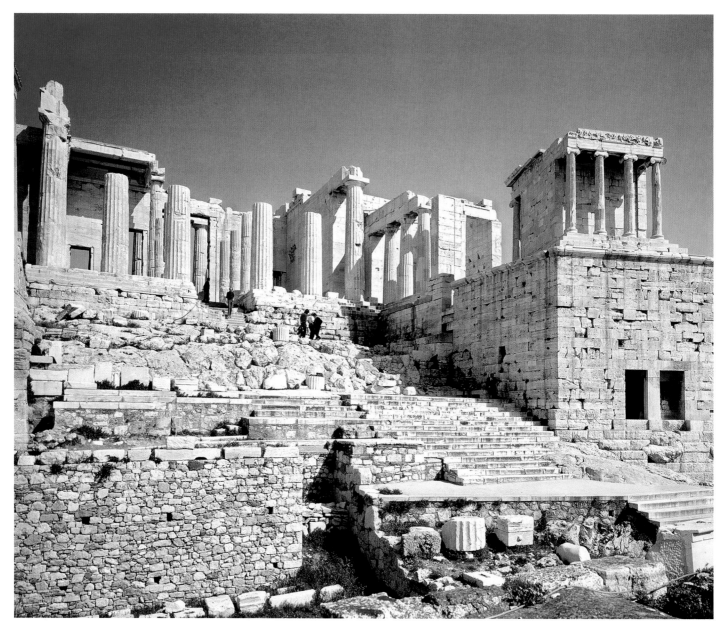

5.51. Mnesikles. The Propylaea, 437–432 BCE (view from the west). Akropolis, Athens

porch (fig. **5.51**) were two wings, of unequal size because of constraints imposed by the terrain (fig. 5.38). The larger one to the north contained a picture gallery *(pinakotheke),* the first known instance of a public room specially designed for the display of paintings. Placed along the central passageway through the Propylaea were two rows of slender Ionic columns, echoing the Ionic columns in the Parthenon.

THE TEMPLE OF ATHENA NIKE The architects who designed the Parthenon and the Propylea included Ionic elements for a reason that may have had as much to do with politics as with design. In pre-Classical times, the only Ionic structures on the Greek mainland had been small treasuries, like the Siphnian Treasury (fig. 5.21), built by eastern Greek

states at Delphi in their regional styles. When Athenian architects used the Ionic style, Perikles may have been making a deliberate symbolic gesture, attempting to unite the disparate regions of Greece in an international style. The Akropolis, in fact, houses the finest surviving examples of the Ionic style. One is the small Temple of Athena Nike, to the south of the Propylaea (fig. **5.52**). It was probably built between 427 and 424 BCE from a design prepared 20 years earlier by Kallikrates to celebrate the Athenian victory over the Persians. The decorative quality of the Ionic style, with proportions that are finer than those found in the Doric style, made it a natural choice for the little, jewel-like building. Standing on a projecting bastion, it was the first structure that a visitor to the Akropolis would see.

THE ERECHTHEION A second, larger Ionic temple stood alongside the Parthenon. The Erechtheion was built between 421 and 405 BCE, and was probably another of Mnesikles' projects (fig. **5.53**). As with the Propylaea, the architect had to deal with a difficult terrain: Not only did the site slope, but it already accommodated various shrines associated with the mythical founding of Athens that could not be moved. Beneath it, for instance, was the spot where, so the Athenians believed, Poseidon and Athena competed for custody of Athens, a contest depicted on the east pediment of the Parthenon (see fig. 5.41). In addition to the olive tree that Athena gave the city in the contest, the temple included the saltwater pool that sprang up where Poseidon threw his trident. The Erechtheion was therefore designed to serve several religious functions at once. Its highly irregular plan included four rooms, as well as a basement on the western side (see fig. 5.38). The main, eastern room was dedicated to Athena Polias (Athena as the City Goddess) and contained the old cult image, an amorphous piece of olive wood that was the most sacred object of cult in Athens; the western room was sacred to Poseidon. Another room held a cult of Erechtheus, a legendary king of Athens who promoted the worship of Athena and for whom the building is named.

Instead of a west facade, the Erechtheion has two porches attached to its flanks. A very large one dedicated to Poseidon faces north and served as the main entrance, while a smaller one juts out toward the Parthenon. The latter is the famous

ART IN TIME

ca. 480 BCE—*Kritios Boy*

 478 BCE—Delian League founded

 458 BCE—Aeschylus writes the trilogy *Oresteia*

ca. 447 BCE—Perikles orders construction of Parthenon

431–404 BCE—Peloponnesian War

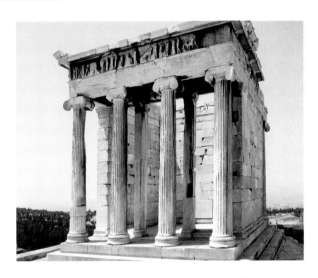

5.52. Temple of Athena Nike. 421–405 BCE (view from the east). Akropolis, Athens

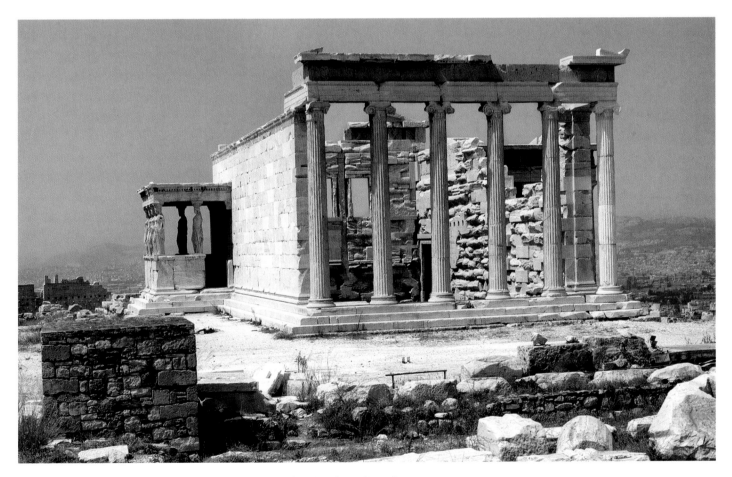

5.53. The Erechtheion. 421–405 BCE (view from the southeast). Akropolis, Athens.

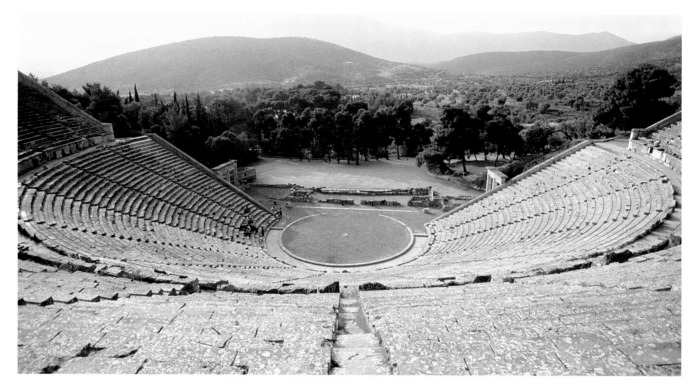

5.54. Theater, Epidauros. Early third to second centuries BCE

Porch of the Maidens (see fig. 5.53, left), so named because its roof is supported by six caryatids on a high parapet, instead of by columns. Vitruvius wrote that these figural columns represented the women of Caryae, a city-state in the Peloponnese that formed an alliance with the Persians in the Persian Wars. When the war was over, the triumphant Greeks killed the men of Caryae, and took the women as slaves, forcing them nonetheless to retain their fine clothing and other marks of their former status as a visible reminder of their shame. Thus, Vitruvius continues, architects designed images of these women to bear the burden of their state's dishonor in perpetuity. Vitruvius' explanation for the origin of caryatids is inconsistent with the fact that they appear in Greek architecture well before the Persian Wars in the Siphnian Treasury; but it

may reveal an added significance of the caryatids for the Athenians after the war. The Erechtheion's pediments remained bare, perhaps for lack of funds at the end of the Peloponnesian War, and little survives of the sculptural frieze. However, the carving on the bases and capitals of the columns and on the frames of doorways and windows, is extraordinarily delicate and rich. Indeed, according to stone inscriptions detailing construction expenses for the building, it cost more than the temple's figural sculpture.

Although they were built over several decades, the buildings of the Periklean Akropolis were clearly intended as a programmatic unit. The solid, stately forms of the Doric Parthenon and Propylea complemented the lighter, more decorative style of the Temple of Athena Nike and the Erechtheion.

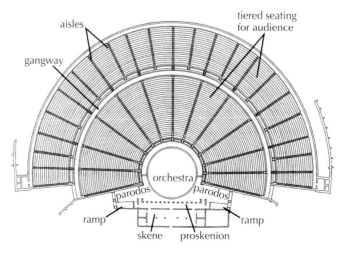

5.55. Plan of the Theater, Epidauros (after Picard-Cambridge)

THE LATE CLASSICAL PERIOD

By the end of the fifth century BCE, Athens' supremacy was on the wane. Conflict between Athens and the Peloponnesian cities of Corinth and Sparta had begun in about 460 BCE, and gradually escalated into the great Peloponnesian War of 431–404, which Athens lost. During the fourth century, the Greek city-states were constantly at odds with one another. In 338, Philip II, who had acceded to power in the kingdom of Macedon, to the north, exploited Greek disunity by invading Greece, and decisively defeated the Athenians and Thebans at the Battle of Chaironeia in central Greece.

Late Classical Architecture: Civic and Sacred

Two noteworthy changes in monumental architecture occurred in the late fifth and fourth centuries. One was a shift in emphasis: As well as constructing temples, architects explored a wide range of building types. Many of these building types—stoas, meeting houses for the council, and the like—had long existed, but now took on grander form. Theaters, for instance, became more formalized. They had long been part of the religious landscape of Greek cities, since choral performances and, later, plays were central to sacred festivals of Dionysos. The basic prerequisites for a theater were a hillside, on which an audience could sit (the *cavea*), and a level area for the performance (the *orchestra*).

THE THEATRE AT EPIDAUROS These essentials gradually took on architectural form, leading to the magnificent stone theater in the sanctuary of the healing god Asklepios at Epidauros (figs. **5.54** and **5.55**). The theater was constructed in the early third century BCE, and the upper tier was not completed until the second century. Row upon row of stone seats lined the sloping hillside, covering slightly more than a semicircle. To facilitate entry and circulation, the seats were grouped in wedge-like sections (*cunei*), separated by staircases; a wide horizontal corridor divides the upper and lower sections. Action took place in the level circle at the center, behind which a stage building (*skene*) served as a backdrop and contained utility rooms for storage and dressing. This form is familiar to every theatergoer, even today, a testament to its success. Because it was open to the sky, no roof supports obstructed viewing of the performance, and many of the seats offered spectacular views across the landscape as well. Yet perhaps the most astonishing feature of the theater is its extraordinary acoustics, which can still be experienced: Its funnel shape carries even the slightest whisper audibly up to the highest points of the auditorium.

THE MAUSOLEUM AT HALIKARNASSOS In Halikarnassos (present-day Bodrum, in southwest Turkey; see map 5.1), this tendency toward monumentalization resulted in a vast tomb built for Mausolos by his wife and sister Artemisia. Mausolos ruled Caria from 377 to 353 BCE as satrap for the Persians. Such was the renown of this sepulcher in antiquity that it was counted among the seven wonders of the ancient world, and by Roman imperial times its title, the Mausoleum, had become the term used to describe any monumental tomb. Designed by Pytheos of

Priene, the tomb stood reasonably intact until the thirteenth century CE, when an earthquake brought down the upper sections. Then, in the late fifteenth and early sixteenth centuries, the Knights of St. John used the remains as a source of squared stone to refortify the local castle. Still later, in 1857, the British archeologist Charles Newton excavated the site and removed many sculptural fragments to the British Museum. Danish excavations have continued to yield important information at the site, and when coupled with literary evidence, these permit reconstructions, though none has met with universal approval (see end of Part I, *Additional Primary Sources*). One hypothesis appears in figure **5.56**. The tomb was rectangular in plan, and soared 140 feet high in at least three sections, covered with sculpture. The sections included a high podium, an Ionic colonnade, and a pyramidal roof, where steps climbed to a platform supporting a statue of Mausolos or one of his ancestors in a chariot.

The grouping of these elements within a single monument is further evidence of a growing diversity in architecture. They may also have had a propagandistic function. The Mausoleum celebrated Mausolos as hero-founder of Halikarnassos. It combined the monumental tomb-building tradition of Lycia with a Greek peristyle and sculpture, and an Egyptian pyramid. It may therefore have expressed Carian supremacy in the region and the symbiosis of Greek and non-Greek civilizations that might be achieved through founding a Carian empire headed by Halikarnassos.

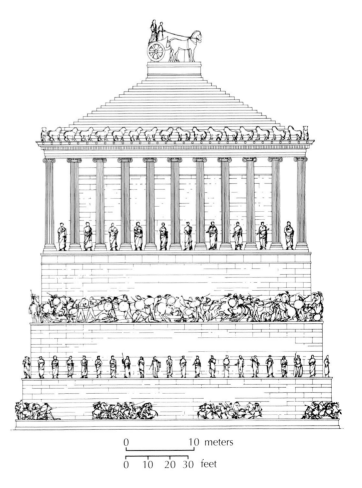

0 10 meters

0 10 20 30 feet

5.56. Reconstruction drawing of the Mausoleum at Halikarnassos. ca. 359–351 BCE. (From H. Colvin)

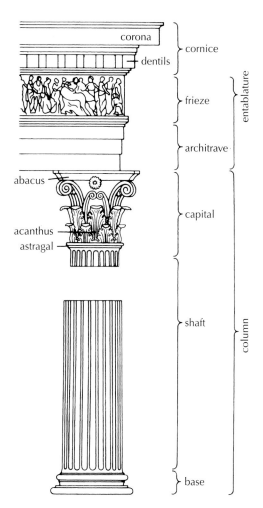

5.57. Corinthian style in elevation

CORINTHIAN CAPITAL The other major change in architecture that took place in the late fifth century BCE was the development of the **Corinthian capital** (fig. 5.57). The Corinthian capital was an elaborate substitute for the Ionic. Writing about four centuries later in Italy, Vitruvius ascribed its invention to the metalworker Kallimachos. Its shape is an inverted bell covered with the curly shoots and leaves of an acanthus plant, which seem to sprout from the top of the column shaft. At first, Corinthian capitals were only used in temple interiors, perhaps because of the conservative nature of Greek architecture, or because of the perceived sanctity of its vegetal forms. It was not until the second century BCE that Corinthian columns appeared on the exteriors of buildings. The capital in figure 5.58 belongs to a circular shrine or *tholos* at Epidauros designed by Polykleitos the Younger. The circular form of the shrine was a symptom of the preoccupation with new types of buildings. Its elaborate interior continues the tradition, begun with the Parthenon, of stressing the articulation of interior space.

LATE CLASSICAL SCULPTURE The Pheidian style, with its apparent confidence in the transcendence of the Athenian city-state, did not survive the devastating defeat of Athens in the Peloponnesian War. At the end of the fifth century, a clear shift in mood is visible in sculpture, which seems to reflect a new—and less optimistic—view of man's place in the universe.

Scholars have attempted to match surviving sculptures with several of the fourth-century sculptors named in literary sources. Among them was Skopas of Paros. According to the Roman writer Pliny, he was one of four masters chosen to work on the Mausoleum of Halikarnassos, and his dynamic style has been recognized in some parts of a frieze from the tomb depicting the battle of the Greeks and the Amazons. He is best known, though, for the way he infused emotion into the faces of those he depicted. A fragmentary head from a pediment of the Temple of Athena Alea at Tegea of about 340 BCE is either by Skopas himself, or an artist deeply influenced by his work (fig. 5.59). A lionskin covering the head identifies it as either Herakles or his son Telephos. The smooth planes and fleshy treatment of the face are characteristic of Classical art, as seen on the Parthenon. What is new, however, is how the sculptor cut the marble away sharply over the eyes toward the bridge of the nose to create a dark shadow. At the outer edge, the eyelid bulges out to overhang the eye. This simple change charges the face with a depth of emotion not seen before, enhanced by the slightly parted lips and the sharp turn of the head.

PRAXITELES If the Greeks were less confident of their place in the late Classical period, they were also less certain of their relationship to fate and the gods. This is reflected in the

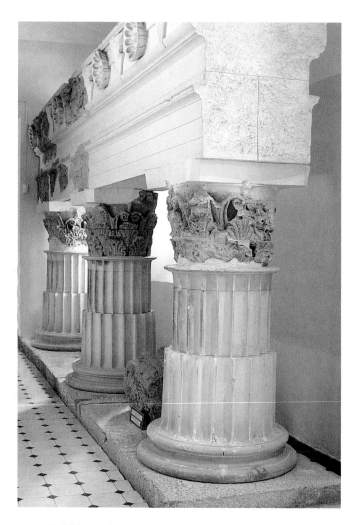

5.58. Polykleitos the Younger. Corinthian capital, from the Tholos at Epidauros. ca. 350 BCE. Museum, Epidauros, Greece

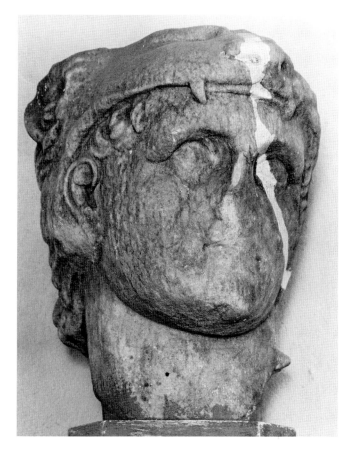

5.59. Head of Herakles or Telephos, from the west pediment of the Temple of Athena Alea, Tegea. ca. 340 BCE. Marble. Height 1′1/2″ (31.75 cm). Stolen from the Archaeological Museum, Tegea

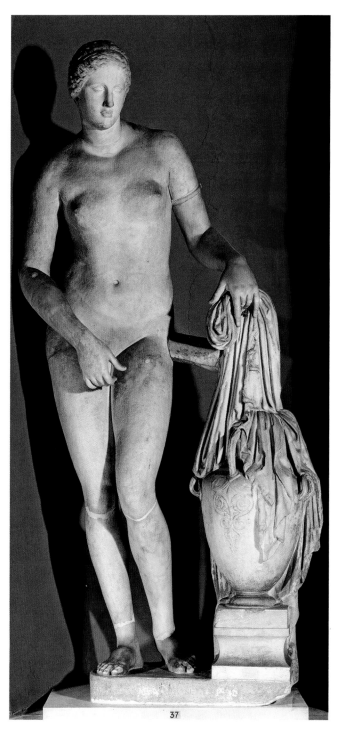

5.60. *Aphrodite of Knidos.* Roman copy after an original of ca. 340–330 BCE by Praxiteles. Marble. Height 6′8″ (2 m). Musei Vaticani, Rome

work of Praxiteles, who was at work at roughly the same time as Skopas. He executed a number of statues of divinities, choosing marble as a material over bronze. Where fifth-century artists had stressed the gods' majesty, Praxiteles bestowed on them a youthful sensuousness that might, perhaps, suggest their wilful capriciousness toward humans. His most famous work is a sculpture of Aphrodite, dating to about 340–330 BCE (fig. **5.60**). Pliny records that the people of Kos commissioned a nude statue of Aphrodite from the master sculptor, but rejected it in favor of a draped version. The inhabitants of Knidos purchased the nude statue, and profited from the risk: Her fame spread fast, and visitors came from far and wide to see her. (See end of Part I, *Additional Primary Sources*.) Perhaps it was her nudity that drew so much attention: She was the first nude monumental statue of a goddess in the Greek world. Yet even if until this point artists had reserved female nudity principally for representations of slaves or courtesans, the clinging drapery of the fifth century had exposed almost as much of the female anatomy as it concealed. Her appeal may have resided just as much in the blatant eroticism of her image as in her nudity. A viewer catches Aphrodite either as she is about to bathe or as she is rising from her bath. With her right hand, she covers her genitals in a gesture of modesty, while grasping for a robe with her left. Her head is slightly turned, so she does not engage a viewer's gaze directly, but a viewer is made complicit with the

sculpture, willingly or not, by having inappropriately witnessed the goddess in her nudity. Perhaps, in her capriciousness, Aphrodite intended to be surprised as she bathed; the uncertainty for a viewer augments the erotic quality of the image. By some accounts, the Knidians displayed Praxiteles' sculpture in a circular shrine with entrances at front and back, so visitors could view her from all sides.

Praxiteles' Aphrodite is known to us only through Roman copies. More complicated is a group representing Hermes holding

the infant Dionysos (fig. **5.61**). The Roman writer Pausanias mentions seeing such a statue by Praxiteles in the Temple of Hera at Olympia, where this marble was found in 1877. It is of such high quality that art historians have long regarded it as a late work by Praxiteles himself. Now, however, most scholars believe it to be a fine copy of the first century BCE because of the strut support and unfinished back; analysis of the tool marks on the surface of the marble support this date. Still, the group has all the characteristics of Praxitelean sculpture. Hermes is more slender in proportion than Polykleitos' *Doryphoros* (see fig. 5.33), and the contrapposto is so exaggerated as to have become a fully relaxed and languid curve of the torso. The anatomy, so clearly defined on the *Doryphoros*, is blurred to suggest a youthful sensuousness rather than athletic prowess. The surface treatment of the marble is masterful, contrasting highly polished skin with rough, almost expressionistic hair. The group has a humorous quality typical of Praxiteles' work as well: The messenger god originally dangled a bunch of grapes in front of Dionysos, whose keen interest and attempts to reach for

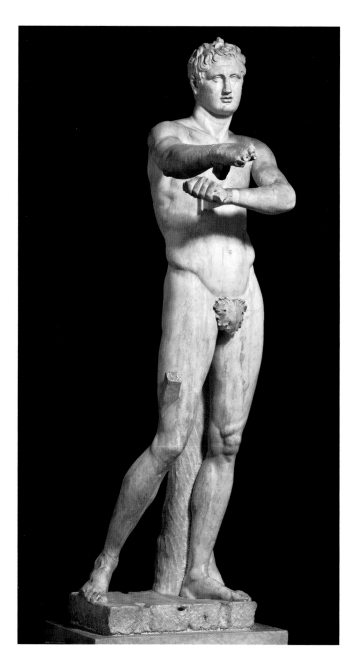

5.62. *Apoxyomenos (Scraper)*. Roman marble copy, probably after a bronze original of ca. 330 BCE by Lysippos. Height 6′9″ (2.1 m). Musei Vaticani, Rome

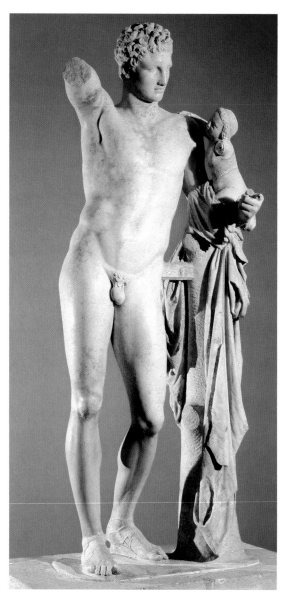

5.61. *Hermes*. Roman copy after an original of ca. 320–310 BCE by Praxiteles. Marble. Height 7′1″ (2.16 m). Archaeological Museum, Olympia

them foretell his eventual role as the god of wine. Yet, depending upon a viewer's mood (or worldview), Hermes' distant gaze may also hold a callous disregard for the child's efforts.

LYSIPPOS A third great name in fourth-century sculpture is Lysippos, who had an extremely long career. It may have begun as early as about 370 BCE and continued almost to the end of the century. Known from Roman copies, his *Apoxyomenos* (a youth scraping oil from his skin with a strigil) dates to about 330 BCE and is in clear dialogue with Polykleitos' *Doryphoros* (fig. **5.62**; see fig. 5.33). Lysippos prefers more slender proportions for his athlete, calculating the length of the head as one-eighth of the body's length, rather than one-seventh as Polykleitos had (see end of Part I, *Additional Primary Sources*). The *Apoxyomenos* leans further back into his contrapposto, too—a sign of Praxiteles' influence—and the diagonal line of the free leg suggests freedom of movement.

Most innovative, however, is the positioning of the athlete's arms. The outstretched arm reaches forward into a viewer's space. Since the arm is foreshortened in a frontal view, it entices the viewer to move around the sculpture to understand the full range of the action; Lysippos thereby breaks the primacy of the frontal view for a standing figure. The athlete's left arm bends around to meet the right at chest height, so the sculpture deliberately contains space within its composition. Lysippos challenges the stark opposition between sculpture and its environment; the two begin to merge. This device is symptomatic of a new interest in illusionism in the late Classical and Hellenistic ages.

Painting in the Late Classical Age

Written sources name some of the famous painters of the Classical age, and reveal a good deal about how painting evolved, but they rarely include enough detail to describe what it looked like. The great age of Greek painting began early in the Classical period with Polygnotos of Thasos and his collaborator, Mikon of Athens, who both worked as sculptors as well. Polygnotos introduced several innovations into painting, including the "representation of emotion and character [and the] use of patterns of composition," which became as central to Classical painting as they were to sculpture. He was also first to depict women in transparent drapery, and to forgo the notion of a single ground-line, placing figures instead at varying levels in a landscape setting.

The depiction of figures at different levels seems to have influenced a contemporary vase painter, known today as the Niobid Painter, whose name vase is shown in figure **5.63**. In the myth illustrated on this calyx krater (a wine-mixing bowl), Apollo and Artemis, sibling gods of hunting, shoot down the sons and daughters of Niobe, who had foolishly boasted that she had more and more beautiful children than their mother, Leto. Each of the figures has his or her own ground-line, which undulates to suggest a rocky terrain. Artemis and Apollo stand above two of their

victims, who are sprawled over boulders, but it seems clear that we should understand that the terrain recedes into the distance.

Significant technical differences separated wall painting from red-figured vase painting. Much closer to wall painting was a medium reserved almost exclusively for funerary purposes: white-ground vase painting. Artists working in this technique painted a wide range of colors onto a white slip background, and favored a type of oil flask used in funerary rituals, known as a *lekythos*. The example illustrated here dates to the last quarter of the fifth century BCE, and scholars attribute it to the Reed Painter (fig. **5.64**). A disconsolate young man sits on

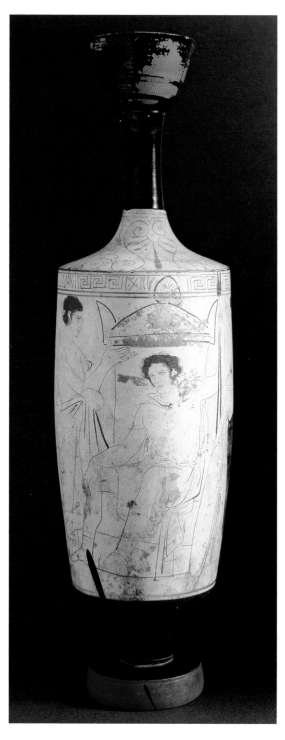

5.64. Reed Painter. White-ground lekythos. ca. 425–400 BCE. National Archaeological Museum, Athens

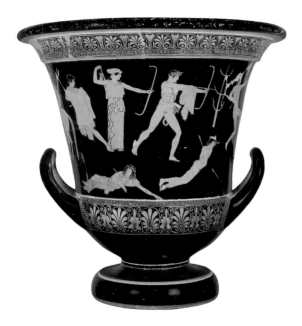

5.63. Niobid Painter. Red-figured calyx krater, from Orvieto. ca. 460–450 BCE. Musée du Louvre, Paris

the steps of a tomb. A woman on the right holds his helmet, while a second man stands to the left with one arm raised in a gesture of farewell. Black outlines define the scene, filled with washes of vivid color. Some blue still survives on parts of the tomb and the seated man's cloak, and brown in the figures' hair, but most of the colors have long vanished, since fugitive paints sufficed for a vessel not intended for prolonged or repeated use. The freedom of the technique allowed the painter to explore foreshortening and depth, and to achieve a remarkably expressionistic effect with a few fluid lines. The deceased man's deepset brooding eyes give some indication of the kind of emotion painters could capture. In view of its artistic advantages, one might expect wider use of the white-ground technique. Such, however, was not the case. Instead, from the mid-fifth century on, the impact of monumental painting gradually eclipsed vase painting. In some cases, vase painters tried to reproduce large-scale compositions, and their success was limited.

THE AGE OF ALEXANDER AND THE HELLENISTIC PERIOD

In 336 BCE, Philip II of Macedon died. His kingdom passed to his son Alexander. Alexander the Great is one of the romantic figures of history, renowned for his military genius, personal charm, and prowess. Upon coming into power, he embarked upon a great campaign of conquest, conquering Egypt and then the Persians, before continuing on to Mesopotamia, and into present-day Afghanistan. In 323 BCE, having founded over 70 cities, he died at the age of 33. His conquests dramatically changed the face of the Greek world, expanding it into unknown areas, creating new political alignments, and breaking down cultural boundaries.

Alexander the Great died without appointing a successor. The years following his death were fraught with struggles among members of his family and his generals, as each tried to establish himself as Alexander's sole successor; none succeeded. By about 275 BCE, Alexander's lands had coalesced into three main kingdoms, which would dominate the Mediterranean until the Romans gradually assumed control. Ptolemy inherited Egypt and founded a dynasty that reigned until Octavian, later the Roman emperor Augustus, defeated Cleopatra VII in 31 BCE. In the east, the Seleucid family captured Babylon in 312 BCE.

From Syria they ruled a kingdom which, at its largest, extended from present-day western Turkey through to Afghanistan. They lost control of a small pocket of territory around Pergamon to the Attalids, who bequeathed their city to the Romans in 133 BCE. By 64 BCE, the Seleucid kingdom had shrunk to a small area in northern Syria, and then came under Roman control. Most sought after was Alexander's ancestral Macedon, which fell into the hands of the Antigonids in 276 BCE, who controlled it until the Roman conquest in 168 BCE. Within these kingdoms, powerful cities grew—among them, Alexandria, Antioch, and Pergamon—with teeming populations drawn from all over the new Greek world. They vied with one another for cultural preeminence, and art played a large part in the rivalry. Hellenistic culture was dramatically different from that of Classical times. The expansion of Greek dominance meant that Greek cultural institutions were imposed over a vast territory; yet those institutions commingled with the strong cultural traditions of the indigenous peoples to create a rich and diverse society.

Architecture: The Scholarly Tradition and Theatricality

Within the cultural centers of the Hellenistic world, academies emerged, fostering avid debate among scholars in a wide range of fields. They engaged, among other things, in a close analysis of the arts, and developed canons by which they could judge works of literature, art, and architecture. In architecture, this led, predictably, to a heightened interest in systems of proportions, recorded in architectural treatises by practitioners of the day. Vitruvius asserts that the leading protagonist in this movement was Pytheos, an architect from Priene, who may have been one of the architects responsible for the Mausoleum of Halikarnassos (see fig. 5.56). His treatise, like most, does not survive, but Vitruvius notes that he was especially dismissive of the Doric style because problems with the spacing of corner triglyphs made the style impossible to impose without

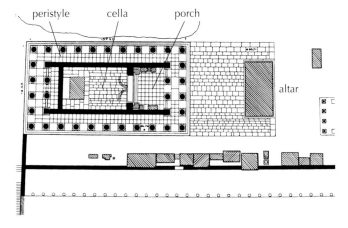

5.65. Pytheos, plan of Temple of Athena, Priene. 334 BCE

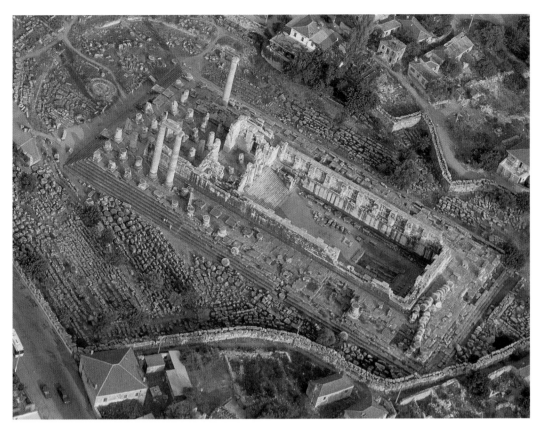

5.66. Paionios of Ephesos and Daphnis of Miletos. Temple of Apollo. Didyma, Turkey. Begun 313 BCE

compromise. Pytheos worked instead in the Ionic style, as seen in his temple to Athena at Priene, dedicated in 334 BCE (fig. **5.65**). The temple's colonnade had 6 columns by 11 and a grid of squares, each 6 by 6 Attic feet (each Attic foot is slightly longer than the English foot), that dictated the proportions of all of its component elements.

Proportions controlled the elevation as well: For instance, the columns were 43 Attic feet high and the entablature was 7 feet high—for a total of 50 feet, half the external length of the cella. Unlike the Parthenon and other classical temples, in the Temple of Athena at Priene there were no deviations from the rule, and no refinements. The temple is a work of the intellect, the product of a didactic tradition, rather than a compromise between theory and practice. In fact, Vitruvius faults Pytheos precisely for his inability to differentiate between the two.

At the same time as this scholarly tradition flourished, the relaxation of architectural guidelines and the combination of architectural types that had occurred in the late Classical period heralded another development in the Hellenistic period. This was a new penchant for dramatic siting, impressive vistas, and surprise revelations. Scholars have termed this movement theatricality, and it balanced and complemented the scholarly tradition. As the glory of Athens declined, the Athenians and other Greeks came to think of themselves less as members of a city-state and more as individuals; architecture, in turn, began to cater more and more to a personal experience, often manipulating visitors toward a meaningful revelation.

THE TEMPLE OF APOLLO, DIDYMA Begun in about 300 BCE and still unfinished by the end of the Roman period, the Temple of Apollo at Didyma is good example of architectural theatricality (figs. **5.66** and **5.67**). The huge temple was built on the site and the scale of an archaic temple destroyed by the Persians in 494 BCE. Its ground plan and design appear to have been established by the renowned Hellenistic architects Paionios of Ephesos and Daphnis of Miletos.

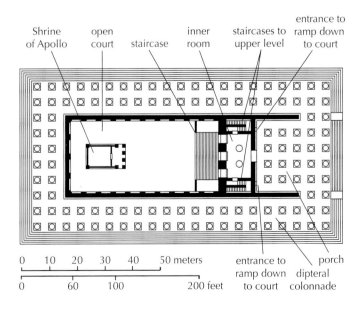

5.67. Plan of Paionios of Ephesos and Daphnis of Miletos, Temple of Apollo, Didyma, Turkey. Begun 313 BCE

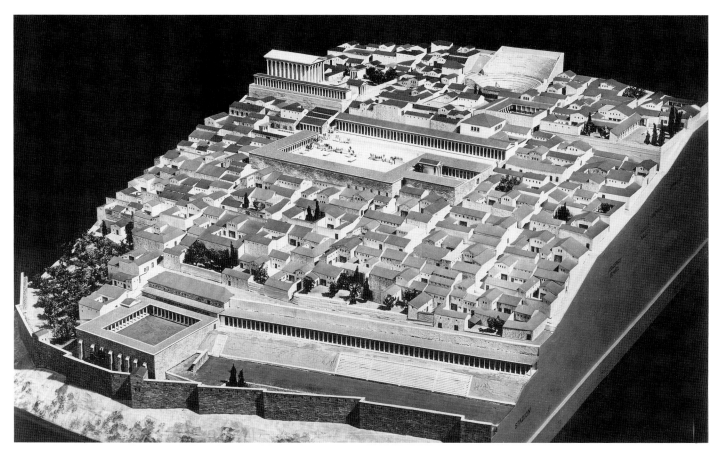

5.68. Model of the city of Priene, 4th century BCE and later. Staatliche Museen, Berlin.

The temple stood in a grove of sacred trees and from the outside appeared very similar to other large-scale Ionic buildings of the area. Placed on a high stylobate, seven massive steps above ground level, the temple was surrounded by two rows of tall columns. A visitor would naturally expect the temple's interior to repeat the format of canonical Greek religious buildings such as the Parthenon, but, in fact, the temple's architects constantly defied these expectations, as visitors were led to dramatic vistas, perhaps intended to heighten the religious experience.

Although the temple appeared to be accessible from all sides, its steps were far too high for comfortable climbing. Instead, visitors climbed a set of shallower steps at the front, entering the porch through vast columns, set to mimic the forest of trees around the building. As expected, an opening led to the cella, but this cella stood at approximately 5 feet off the ground, making access impossible. On this platform, scholars believe, the oracular priestess uttered her prophecies, pronouncing to those standing below in the porch. For those wishing to enter further into the building, the path led to the right or left of this elevated opening, where dark barrel-vaulted tunnels led downward. For a Greek visitor, a barrel-vaulted tunnel suggested a cave, or a dark interior, yet these passages did not lead to a covered interior cella, but a vast open courtyard drenched with bright sunshine: A revelation, it must have seemed, after the confinement of the tunnels.

At the end of this courtyard was the shrine itself, a small and simple Ionic building dedicated to Apollo. Near the shrine were sacred laurel bushes and a spring of holy water. Turning back from the shrine, the visitor faced another astonishing sight: The tunnels through which he or she had entered the courtyard were dwarfed by comparison with a wide, steep staircase leading up to a pair of towering engaged Corinthian columns. These may have signaled that the room that lay beyond them was the innermost sanctuary where the priestess resided. Just who this visitor might be is uncertain, since little is known of the goings-on inside Greek temples, yet the processional quality of this inner staircase and the large scale of the inner courtyard suggest the possibility that large crowds of worshipers would have gathered there to witness ritual ceremonies. Also unknown is the function of small staircases leading off from the sanctuary and up to the roof that covered the colonnades. Building inscriptions describe them as "labyrinths," and indeed the ceiling above them is carved with a brightly painted meander pattern (see fig. 5.3), the Egyptian hieroglyphic sign for a maze. Maintenance needs may explain their existence, but a role in a revelatory drama in honor of Apollo could do so just as well. As a whole, the temple manipulated visitors along unexpected paths, and offered constant surprises. This theatricality was a feature of a number of other buildings of this time.

The Temple of Apollo is remarkable for another reason besides the surprise experience it offered. Inside the courtyard under a strong raking light, archeologists unexpectedly discovered diagrams incised (so lightly they were barely visible) upon its walls. These etchings revealed scale drawings for aspects of the building's design, ranging from capital decoration to column entasis. They provide an extremely rare insight into the design process in Greek building, which is otherwise poorly understood. These etchings suggest that a building's design was drawn onto its existing surfaces as it rose, and was then polished off as those surfaces were properly finished. This temple's chance incompletion preserved the design drawings in place.

City Planning

Early Greek cities such as Athens grew organically, transforming gradually from small settlements to larger urban developments. Streets were typically winding, and building blocks were irregular. From the seventh century BCE onwards, colonization offered an opportunity to conceive cities as a whole, and to assess different types of city planning. Hippodamos of Miletos was the first to write a treatise on the subject, advocating grid planning—that is, laying out the streets of a city in intersecting horizontals and verticals, a pattern still used in many Western cities today. For an architect, the rectilinear grid offered the advantage of regularity; for an inhabitant of the city, it meant a new ease of orientation. Hippodamos designed the Piraeus, near Athens, in the mid-fifth century BCE, with a grid plan. When the inhabitants of Priene relocated their city to avoid flooding, in approximately 350 BCE, the grid plan of their new city was therefore nothing new (fig. **5.68**). As the model demonstrates, the rigid grid plan ignored the city's sloping terrain. Some longitudinal axes through the city had staircases to climb straight, steep inclines. Although stairs would have helped pedestrians navigate hilly streets, they must have been impassable by wheeled vehicles.

PERGAMON: A THEATRICAL PLAN A visitor to the city of Pergamon would have had a dramatically different experience. There, in the early second century BCE, Eumenes II, ruler of Pergamon, and his architects avoided a grid as they planned an expansion of the city (fig. **5.69**). The residential areas lay mainly on the plain of the Kaikos River; nearby was the towering Akropolis. The new design followed and exploited the dramatic rise in terrain from one to the other, apparently assigning symbolic meaning to the ascent as well. On the lower levels were the amenities of everyday life, such as the market place. As the road climbed the southern slope of the Akropolis, it passed through vaulted entrance tunnels to emerge at three *gymnasia* (schools); the first was for boys, the second for ephebes (adolescents aged 15–17), and the third and highest for young men. Further up the road were sanctuaries to Hera and Demeter, both important goddesses for the city.

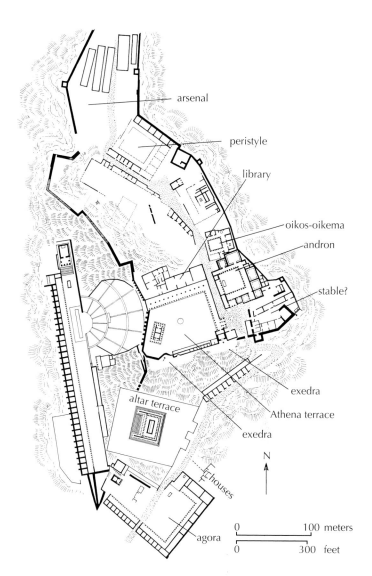

5.69. Plan of Pergamon, Turkey

The road snaked on, following the terrain, past an *agora* or marketplace from earlier times, now chiefly used for legal and political purposes, to the Akropolis proper, where a magnificent altar court was dedicated to the supreme god, Zeus (see figs. 5.73 and 5.74). Further up and to the east was a shrine for the Hero Cult, a Heroön. A long portico temporarily obscured any view of the great crescendo of the journey up to the Akropolis; passing through it, a visitor entered the sanctuary of Athena, where the city's oldest temple stood, and, alongside it, Eumenes' famous library, with a larger than life-size version in marble of Athena Parthenos. This sanctuary marked the privileged place of learning in Pergamene culture. On its own, the temple was not remarkable. Yet it took meaning from the symbolic journey necessary to reach it. From the sanctuary, a visitor could look out over the steep cavea or seating area of the Theater of Dionysos across the plain's breathtaking panorama. Behind and beyond the sanctuary, to the northeast, were the royal residence and barracks for the guard. Like the sanctuary, the residence offered magnificent views of the river and the receding countryside, and cool breezes

blowing through the valley and up to the Akropolis must have provided relief from the fierce summer sun. At every turn, the city's design took into account a visitor's experience. Its impressive vistas and sudden surprises are hallmarks of the theatricality found in Hellenistic architecture.

Hellenistic Sculpture: Expression and Movement

The Hellenistic period saw dramatic changes in Greek sculpture as well as in city designs. Fourth-century sculptors had led the way in expressing emotion and exploring three-dimensional movement, and Hellenistic artists made further radical strides in these directions. Both result in heightened drama and viewer involvement. That said, one can make only broad generalizations about Hellenistic sculpture, as it is notoriously difficult to date and to attribute to a firm place of origin. Often it is style alone that leads scholars to ascribe a sculpture to this period. Even that is not always straightforward: Although there is good evidence of a dialogue between them, sculptors were working throughout such a vast territory that numerous local influences were at play, making the body of material much less unified than Classical sculpture.

PORTRAITURE One of the earliest developments in sculpture in this period was an interest in portraiture. If individuals were depicted at all in the Archaic period, they were represented by

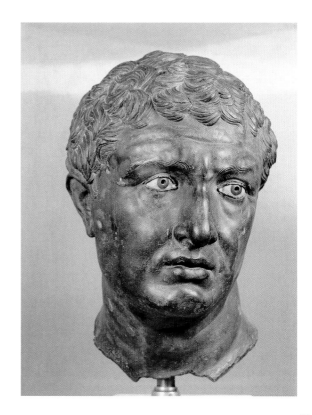

5.71. *Portrait Head,* from Delos. ca. 80 BCE. Bronze. Height 12³⁄₄″ (32.4 cm). National Archaeological Museum, Athens. Ministry of Culture Archaeological Receipts Fund. 14612

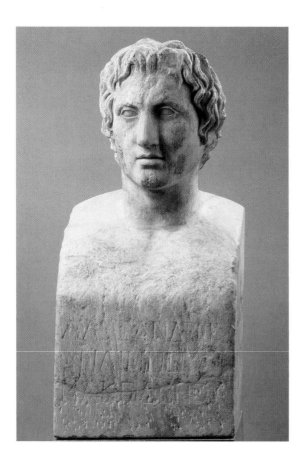

5.70. Lysippos. *Portrait of Alexander the Great, the "Azara herm."* Marble. Height 27″ (68 cm). Roman copy after an original of the late 4th century BCE. Musée du Louvre, Paris

the all-purpose figures of kouroi and korai. Individual likenesses were unknown in art of the Classical period, which sought a timeless ideal. A copy of a famous sculpture of Perikles dating from about 425 BCE, for instance, differs from the idealized youths of the Parthenon frieze only in that the Perikles is bearded and wears a helmet. Later, in the mid-fourth century, portraiture became a major branch of Greek sculpture, and it continued to flourish in Hellenistic times. One of the catalysts for this change was Alexander the Great himself. Recognizing the power of a consistent visual image, he retained Lysippos to sculpt his portraits, allowing no other sculptor to do so. No surviving original preserves Lysippos' touch, but scholars consider the so-called "Azara herm" to be relatively faithful to its model (fig. **5.70**). To be sure, there is an idealized quality about the face: Its planes are smooth, especially around the brow. Yet individuality comes through in the unruly hair, raised at the front in Alexander the Great's characteristic cowlick (or *anastole*), and in the twist of the head on the neck, which takes the portrait out of a timeless realm and animates it with action. Moreover, the general does not engage with a viewer, but has a distant and passionate gaze. These characteristics would come to be emblematic of Alexander the Great, and Hellenistic and Roman generals would adopt them as attributes in their own portraiture. With this portrait of Alexander, the individual comes to inhabit the sculpture, and portraiture as a genre began to develop.

As with so many Greek sculptures, original Hellenistic portraits are extremely rare. One is a vivid bronze head from Delos, a work of the early first century BCE (fig. **5.71**). Unlike the Romans, the Greeks did not isolate an individual's personality in bust portraits, but considered it to animate the full body. Thus this head is just a fragment of a full-length statue. The man's identity is not known. He may have been a trader: The island of Delos was a lively trading port, and many merchants there became extremely wealthy. This portrait fuses the heroic qualities of Alexander's likeness—the whimsical turn of the head, for instance, and the full head of hair—with uneven surfaces. The fluid modeling of the somewhat flabby features, the uncertain mouth, and the furrowed brows suggest an introspective individual—though, as with Egyptian portraiture, it is risky to read psychological traits into works of another culture.

Hellenistic sculptors, like architects, seem to have wanted to engage their audience in the experience of their work, and favored dramatic subjects depicted with full emotion. The dying trumpeter, preserved in a Roman copy, is an early example (fig. **5.72**). The sculpture probably belonged on one of two statue bases found in the Sanctuary of Athena on the Akropolis of Pergamon, and it commemorated Attalos I's defeat of the Gauls in about 233 BCE. Gone is the Classical tradition of referring to the enemy by analogy with a mythological conflict (see figs. 5.44 and 5.45). Instead, the sculptor carefully identifies the enemy as a Gaul through his bushy hair and moustache, and by the torque, or braided gold band, that he wears around his neck. Gone, too, is any attempt to suggest the inferiority of the vanquished. The Gaul dies nobly,

sinking quietly to the ground or struggling to prop himself up, as blood pours from a wound in his chest. His body is powerful, his strength palpable. He faces his agonies alone, mindless of any viewer. A viewer, in turn, is drawn in by the privateness of the moment, and drawn around the sculpture by the pyramidal composition and the foreshortening witnessed from every angle. The dying trumpeter was probably one sculpture in a group, but the victor, so present in Classical battle scenes, was absent. The monument celebrates the conqueror's valor by exalting the enemy he overcame; the greater the enemy, the greater the victory. The Roman writer Pliny records a famous sculpture by Epigonos of a trumpet player, and it is likely that this Roman copy reflects that work. If so, Epigonos must have been a leading figure in the emotional and dramatic style of the Hellenistic period.

DRAMATIC VICTORY MONUMENTS Sculptures decorating the Great Altar of Zeus at Pergamon exemplify the highly emotional, dramatic style at its height (figs. 5.73 and 5.74). The monument dates to about 180 BCE, when Eumenes II, son and successor of Attalos I, built it to commemorate territorial victories over Pontos and Bithynia and the establishment of a grand victory festival, the *Nikephoria*. The altar stood high on a podium within a large rectangular enclosure surrounded by an Ionic colonnade. A wide staircase at the front provided access. The altar and its enclosure, which both go by the name of the Great Altar, originally stood on a terrace on the Pergamene Akropolis. A German team excavated the monument from 1878 to 1886, and its entire west front, with the great flight of stairs leading to its entrance, has

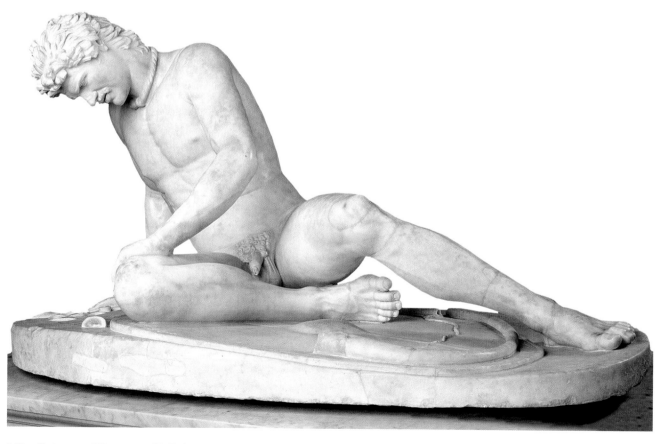

5.72. Epigonos of Pergamon (?). *Dying trumpeter*. Perhaps a Roman copy after a bronze original of ca. 230–220 BCE, from Pergamon, Turkey. Marble, life-size. Museo Capitolino, Rome

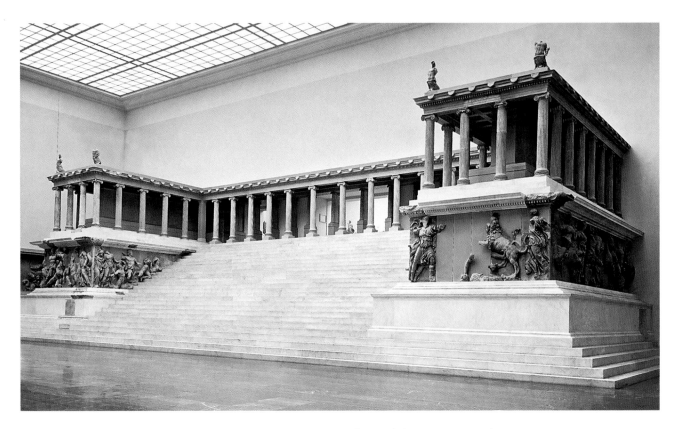

5.73. The west front of the Great Altar of Zeus at Pergamon (restored). Staatliche Museen zu Berlin, Preussischer Kulturbesitz, Antikensammlung

been reconstructed in Berlin (fig. **5.73**). The vast enclosure belongs to a long Ionian tradition of massive altars, but the Pergamene altar is by far the most elaborate of those that survive. Its boldest feature is a frieze encircling the base, which extends over 400 feet in length and over 7 feet in height. Its subject, the battle of the gods and giants, was a frequently used theme in architectural sculpture. Here, as before, it worked allegorically, symbolizing Eumenes' victories. Never before, however, had the subject been treated so extensively or so dramatically. About 84 figures crowd the composition, interspersed with numerous animals. This was no mean feat: The sculptors must have relied upon research by scholars (such as Krates of Mallos, a renowned Stoic theoretician and literary critic), working in the Pergamene library, to identify protagonists for this great battle. They may also have assisted with creating a balanced and meaningful composition, for despite the chaotic appearance of the mélée, clear guiding principles lurk behind it. Scholars still struggle to understand the principles fully, even though inscriptions preserve the names of some of the gods on the molding in the entablature above the frieze. The giants' names appear on the base molding. On the eastern frieze, facing the great Propylon into the sanctuary and the rising sun, were the Olympian gods. The most prominent position belonged to Athena, patron goddess of Pergamon. On the south, drenched in sun, were heavenly lights such as Helios; on the shadowy north

were divinities of the night. Deities of the earth and sea were on the west. Compositional parallels unified the four sides. The frieze is direct evidence of the Hellenistic scholarly tradition at work.

On the other hand, the frieze is deeply imbued with Hellenistic theatricality. The figures are carved so deeply, and in places so forcefully undercut, that they are almost in the round. On the staircase, they seem to spill out onto the steps and climb alongside an ascending visitor. The high relief creates a vivid interplay of light and dark. Muscular bodies rush at each other, overlapping and entwined (fig. **5.74**). The giants' snaky extremities twist and curl, echoed in their deeply drilled tendrils of ropelike hair. Wings beat and

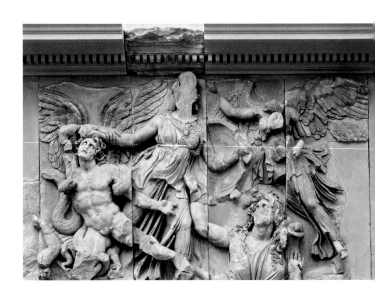

5.74. *Athena and Alkyoneus,* from the east side of the Great Frieze of the Great Altar of Zeus at Pergamon ca. 166–156 BCE. Marble. Height 7′6″(2.29 m). Staatliche Museen zu Berlin, Preussischer Kulturbesitz, Antikensammlung

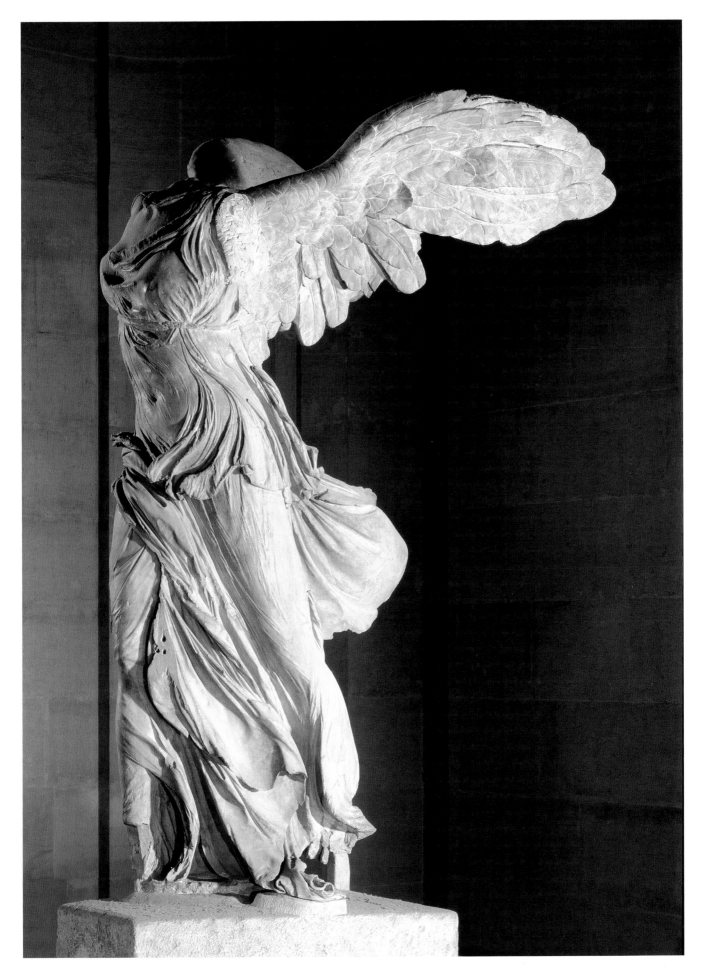

5.75. Pythokritos of Rhodes (?). *Nike of Samothrace*. ca. 190 BCE. Marble. Height 8′ (2.44 m). Musée du Louvre, Paris

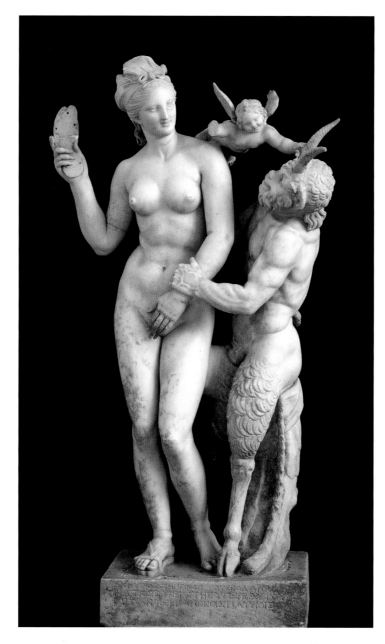

5.76. *Aphrodite, Pan, and Eros.* Marble. ca. 100 BCE. Height 4¼′ (1.32 m). National Archaeological Museum, Athens

garments blow furiously in the wind or twist and wind around those they robe, not to reveal the anatomy beneath but to create motion; wings and garments have a life of their own and a texture that contrasts with the smoothness of the giants' flesh. The giants agonize in the torment of their defeat, their brows creased in pain, their eyes deepset in an exaggerated style reminiscent of Skopas. A writhing motion pervades the entire design, and links the figures in a single continuous rhythm. This rhythm, and the quiet classicism of the gods' faces, so starkly opposed to the giants' faces, create a unity that keeps the violence of the struggle from exploding its architectural frame—but only just. For the first time in the long tradition of its depiction, a viewer has a visceral sense of what a terrible cosmic crisis this battle would be.

The weight and solidity of the great **gigantomachy** make it a fitting frieze for its place on the building's platform. A second, lighter frieze encircled the inside of the colonnade, and may have been executed at a slightly later date. This frieze portrays the life of Telephos, son of Herakles and legendary founder of Mysia, the region of Pergamon.

Dramatic location and style combine in another victory monument of the early second century BCE, the Nike (Victory) of Samothrace (fig. **5.75**). The sculpture probably commemorates the naval victories of Eudamos, an admiral in command of the fleet at Rhodes, over Antiochos the Great and the forces of his Seleucid kingdom in 190 BCE. Both the Rhodian marble of the sculpture's base, and a variety of evidence from inscriptions, suggest that the sculpture comes from Rhodes, and may well be

the work of the renowned artist Pythokritos from that island. The victory goddess is probably landing on the prow of a ship, as if to bestow a crown of victory upon Eudamos. Alternatively, she could be about to take flight. Her massive wings soar out behind her, stretching the limits of the marble's tensile strength. The lift of the wings makes the whole statue appear weightless, despite the great mass of stone. In a new variant of the contrapposto, neither leg holds the body's full weight. It is the wings, and the drapery, that give such energy to the sculpture. The drapery swirls around the goddess's body, exposing her anatomy and stressing the sensuous curves of her body. Yet it has its own function as well: The swirling drapery suggests the headwind she struggles against, which, in turn, balances the rushing forward thrust of her arrival. The drapery, in a sense, creates the environment around the figure.

This sculpture is a rare instance of a monument being found, in 1863, in its original location—in the Sanctuary of the Great Gods at Samothrace. The stone prow stood high on a terrace overlooking the theater and the sea, within a pool of water that must have reflected the Nike's white marble forms. The pool was raised above a second water basin filled with rocks, to evoke a coastline.

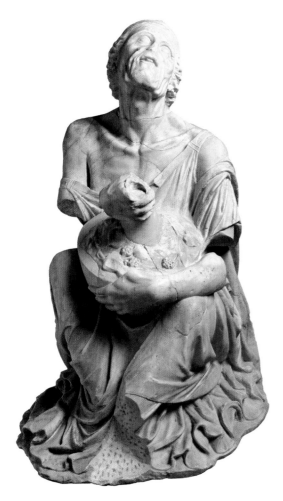

5.77. *Drunken Old Woman*. Roman copy of an original of late 3d or late 2d century BCE. Marble. Height 3′ (0.92 m). Glyptothek, Munich

PLAYFULNESS IN SCULPTURE Scholars use the term *baroque* to describe the extreme emotions, extravagant gestures, and theatrical locations that characterize the Great Altar of Zeus and the Nike of Samothrace. The term was first used to describe seventeenth-century CE art, and scholars of Hellenistic art borrowed it on recognizing similarities between the two styles. With its extraordinarily dramatic qualities, the Hellenistic baroque style has tended to eclipse the many other contemporary movements in sculpture. One of these other movements is a penchant for works of a light hearted and sometimes faintly erotic quality. They appear to be a reaction to the weightiness of the baroque style, and sometimes they have an element of parody to them, suggesting that the sculptor hoped to reduce the grand themes of the Classical and baroque styles to a comical level. These works are somewhat inadequately described by the term *rococo*, which is also borrowed from scholarship on later European art. Some of these works represent amorous interactions between divine or semidivine and human figures. In the example shown here, dating to about 100 BCE, Aphrodite wields a slipper to fend off the advances of a lecherous Pan, the half-man, half-goat god of the forests (fig. **5.76**). Eros hovers mischievously between them. With her sensuous roundness and her modest hand gesture, the goddess clearly recalls Praxiteles' bathing Aphrodite on Knidos (see fig. 5.60). Here, the erotic possibilities that Praxiteles dangled provocatively in the air are unambiguously answered, and by a humorously undesirable partner. Rather than grasping for her drapery to preserve her dignity, the majestic Aphrodite is reduced to grabbing a slipper in self-defense.

HELLENISTIC REALISM Scholars have sometimes grouped these light hearted sculptures together with a series of works depicting unidealized and realistic everyday life. Their genre is known as *Hellenistic realism*, and a sculpture of a drunken old woman illustrates it well (fig. **5.77**). Known from Roman copies, this piece has at times been ascribed to Myron of Thebes, who may have worked at Pergamon. The evidence is slim, and the figure may be a better fit with the cultural context of Alexandria, where realism seems to have been particularly prevalent. The woman is crouched on the ground, clasping a wine bottle, her head flung far back. Wrinkles cover her face, and the skin on her exposed shoulder and chest sags

J. J. Winckelmann and *The* Apollo Belvedere

Despite the best efforts of contemporary art historians, many assessments of art today are deeply informed by a notion of beauty rooted in Greek classicism. This bias has been present through the ages since antiquity; but its abiding power is also the legacy of a pioneering German antiquarian, Johann Joachim Winckelmann, who is often called the father of art history. Born in Stendal in Prussia in 1717, Winckelmann studied in Halle and Jena before becoming librarian for Count Heinrich von Bünau near Dresden. It was in von Bünau's library that he gained an education in the visual arts, which led to his first publication, *Reflections on the Imitation of Greek Works of Art in Painting and Sculpture*, in 1755. In that same year he moved to Rome, and was soon appointed librarian and advisor to Cardinal Alessandro Albani. In 1764, after the publication of his seminal *History of Art of Antiquity*, he became papal antiquary and director of antiquities in Rome. *Unpublished Antiquities*, of 1767, was his last work before his rather ignominious death a year later at the hands of a petty criminal.

The impact of his works has been enormous. He was first, for instance, to determine that most Greek sculptures (which he often conflated with their Roman copies) represented not historical figures but mythological characters. Even more significant was his contention that Greek art captured an ideal beauty that transcended Nature. He established a model for the development of art that divided art history into periods that coincided with political events. The Older Style was the precursor to the High or Sublime Style. Next came the Beautiful Style, and finally the Style of the Imitators. In ancient art, these correspond to the Archaic, fifth-century Classical, Late Classical, and Hellenistic and Roman periods. This progression from rise to eventual decline still lies at the heart of most studies of art history, regardless of the era. When it came to assigning works of art to these phases, Winckelmann was, in a sense, trapped by his own scheme. Reluctant to allot works he admired to the "decline" phase of Hellenistic and Roman art, he often dated sculptures much too early; such was the case with the *Laocoön* (see page 179), which he placed in the fourth century BCE, and The *Apollo Belvedere*, which he considered a Greek original.

The *Apollo Belvedere* was first discovered in the fifteenth century, and quickly made its way into the collection of Pope Julius II. It represents the god in an open pose, with his left arm outstretched, perhaps to hold a bow. Winckelmann was only one of many antiquarians to be profoundly moved by the statue. Combined in its form he perceived both power and desirability, and he penned a rhapsodic description of it that is tinged with eroticizing overtones. "I forget all else at the sight of this miracle of art," he wrote. "My breast seems to enlarge and swell with reverence." Few scholars share his enthusiasm for the piece today. Its significance for art

historians resides more in its modern reception — the role it played for admiring Renaissance artists, for instance — than in its place in ancient culture. As for its date, most scholars now identify it as a second-century CE copy or interpretation of a Greek original, sometimes attributed to Leochares, who worked at the end of the fourth century BCE.

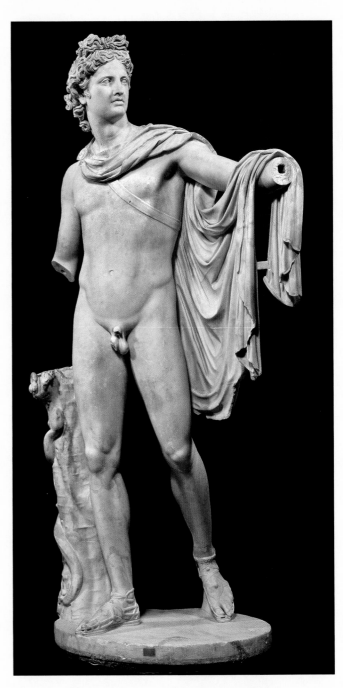

Apollo Belvedere. Roman marble copy, probably of a Greek original of the late 4th century BCE. Height 7'4" (2.3 m). Musei Vaticani, Rome

with age. Her garment flows around her, forming a solid pyramid out of which she seems to rise. She wears a buckled tunic, which identifies her as a member of an affluent social class. Other sculptures of this kind focus on the ravaging effects of a rustic life on the poor—an old shepherdess, for instance; yet in

this sculpture, the artist explores drunkenness and old age. Without further insights into the cultural context for the image, it is hard to know if the sculptor intended to offer a sympathetic view of his subject, exalting her nobility, or to engage in a hard social commentary.

5.78. *The Abduction of Persephone.* Detail of a wall painting in Tomb I, Vergina, Macedonia. ca. 340–330 BCE

Hellenistic Painting

It was in the fourth century BCE that Greek wall painting came into its own. Pliny names a number of leading artists, but no surviving painting can be attributed to them to give proof to his words (see *Primary Source*, page 230). All the same, paintings are preserved in Macedonian tombs, several of which have come to light and keep being discovered in northern Greece (in the region of Macedonia). They offer a tantalizing glimpse of what painters could accomplish. Discovered recently, in 1976, these tombs are of great importance because they contain the only relatively complete Greek wall paintings to come to light. The section shown here illustrates the abduction of Persephone (fig. **5.78**), and comes from a small tomb at Vergina, dating to about 340–330 BCE. The subject is appropriate to the funereal setting. Pluto, ruler of the underworld, abducts Persephone to be his queen. Thanks to

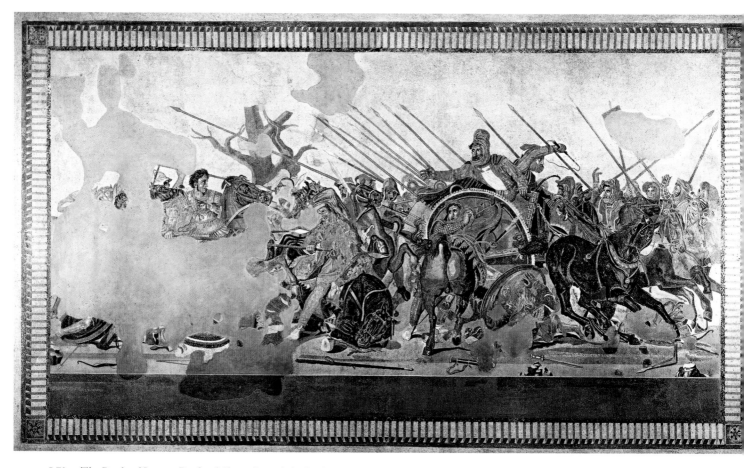

5.79. *The Battle of Issos* or *Battle of Alexander and the Persians*. ca. 100 BCE.
Mosaic copy from Pompeii of a Hellenistic painting of ca. 315 BCE. 8′11″ × 16′9¹/₂″
(2.7 × 5.1 m). Museo Archeologico Nazionale, Naples

Zeus' intervention, Persephone would be allowed to return to the world of the living for six months of every year. Here, the artist has chosen the moment when Pluto seizes Persephone into his speeding chariot, her handmaiden rearing back in fright and horror. This is the dramatic moment, before Persephone knows that Zeus will find a compromise, when her futile struggle seems the only possible escape from the underworld. The painting captures all of the drama of the myth. Persephone flings her body backward, while the chariot rushes onward with her captor; their bodies cross as a sign of their conflict. The chariot plunges toward a viewer, its wheel sharply foreshortened. Masterful brushwork animates the scene. With swift flourishes, the artist sends hair and drapery flying in the air, and lends plasticity to the figures' garments. Hatchwork rounds out the bodies' flesh, as on the arms and shoulders. The colors are brilliant washes, with shading for texture. Literary sources attribute the discovery of *shading* (the modulation of volume by means of contrasting light and shade), known as *skiagraphia,* to a painter named Apollodorus, who was using the technique perhaps as early as the fifth century BCE. They also associate spatial perspective with Agatharchos and the art of stage scenery during the heyday of Athenian drama. The exploration and perfection of both devices during the course of the fourth century illustrate the fascination with illusionism at this time.

Roman copies and imitations also provide a general sense of what Greek wall painting might have looked like. According to Pliny, at the end of the fourth century BCE, Philoxenos of Eretria painted Alexander the Great's victory over Darius III at Issos. This subject is shown in an exceptionally large and masterful floor mosaic from a Pompeian house of about 100 BCE (fig. **5.79**). The scene depicts Darius and the fleeing Persians on the right and, in the badly damaged left-hand portion, the figure of Alexander. It is likely that this is a close copy of a Hellenistic painting from the late fourth century BCE. The picture follows the four-color scheme (yellow, red, black, and white) that is known to have been widely used at that time. (See *Primary Source*, page 230.) The crowding, the air of frantic excitement, the powerfully modeled and foreshortened forms, and the precise shadows place the scene in the fourth century, as does the minimal treatment of landscape, suggested by a single barren tree to the left of center.

SUMMARY

After waves of immigration, invasion, and colonization, Greek culture emerged by about the eighth century BCE. Centered in mainland Greece, the Aegean Islands, and Crete—but by the mid-sixth century BCE extending into southern Italy, northern Africa, and coastal Asia Minor—the disparate Greeks were united by a shared language and common beliefs. The first known practitioners of analytical thought, ancient Greeks struggled with philosophical questions that endure today. The dualism of the world, and humans' place in it, became a longstanding theme in all their arts. Because so much of Western society is inspired by Greece, these artworks may seem comfortably familiar. Yet it is essential not to impose our own interpretations, for these works often held radically different meanings for the Greeks. We must instead look to the archeological and literary records, placing Greek artworks within the proper contexts to understand their true significance.

Throughout more than seven centuries, devastating wars with their own and neighboring peoples continually shaped Greek culture and art. Trade and travel were common through extensive networks crisscrossing Asia Minor and the Mediterranean region. Fluid exchanges brought new influences, which Greek artists admired and absorbed, just as Greek culture itself affected those in distant lands.

GEOMETRIC PERIOD

About the eighth century BCE, the Greeks began developing a repertoire of pottery forms whose painted decoration shows the oldest known Greek style: the Geometric style. Characteristic rectilinear meanders and geometric patterns cover the so-called *Dipylon Vase* of about 750 BCE. Adding a narrative quality to this funerary amphora are images of animals and humans. Sculptors also modeled similar small figures in clay and bronze. Many painted vases bear inscriptions, and, indeed, this was the era of Homer's epic writings and the introduction of the alphabet.

ORIENTALIZING STYLE

Between 725 and 650 BCE, nascent Greek city-states grew prosperous, and citizens sought luxury commodities from trade partners in Asia Minor, the East, and Egypt. Greek artists rapidly assimilated Eastern influences, experimenting with new techniques and developing an orientalizing style. The port city of Corinth dominated ceramic production, and vase painters developed a black gloss slip to create outlined and silhouetted images with incised details. Sirens, griffins, and other Eastern mythical motifs abound on both miniature and monumental vessels.

ARCHAIC PERIOD

The beginnings of democracy emerged as Athens pushed to the forefront amid Greece's powerful and increasingly well-defined city-states. During this period of intense creativity, the great traditions of monumental stone sculpture and temple architecture appeared. Inspired by Egyptian examples, sculptors and builders experimented with proportional systems and adorned structures with larger than life-size figures. The two temples dedicated to Hera at Paestum and the Temple of Artemis at Ephesos show the development of the Doric and Ionic styles as well as that of a relatively standard temple plan, with its central cella and porch. Large-scale sculpture enlivened architecture, notably the Temple of Artemis and the later Temple of Aphaia, whose pediments reveal artists' search for solutions to fitting lively narrative scenes into the awkward triangular space. Meanwhile, increasingly naturalistic and free-standing figures such as kouroi and korai are testaments to the Greek preoccupation with representing ideals of physical perfection. Vase painting saw important advancements as well, including the black-figured and red-figured techniques.

THE CLASSICAL AGE

Athens faced crises in the fifth century BCE when it was threatened by devastating Persian invasions. Yet out of the destruction of war, the city rebuilt itself into a political and economic empire. The ambitious statesman Perikles greatly influenced Athenian society and politics, and soon all the arts flourished, from the vivid tragedies of Aeschylus to the profound philosophies of Plato to the sophisticated architecture of Iktinos and Kallikrates. Sculptors made great strides in the naturalistic representation of the human form; the contrapposto stance of the *Kritios Boy* marks a critical point in Greek art, and sculptors took up the challenge of showing realistic movement in both stone and bronze. In sculptural programs for the Temple of Zeus at Olympia and the Athenian Akropolis, artists continued to explore complex narrative and dualistic themes.

Under Perikles' direction, Athens emerged from the ruins of war as the showplace of the Mediterranean region. The brilliance of the Parthenon reflects the splendor of the city at this time. On the sacred site of the Akropolis, the Parthenon—with its refined proportions, extraordinary sculpture, and pleasing harmony—has come to represent the height of Classical Greek art. Construction was also underway on other monuments of the Akropolis, including the Propylaea, the Temple of Athena Nike, and the Erechtheion, although such grand building projects dwindled with the onset of the Peloponnesian War.

THE LATE CLASSICAL PERIOD

The Peloponnesian War of 431–404 BCE brought an end to Athenian supremacy. It was followed by a century of internecine fighting among Greek city-states and, finally, the invasion of Greece by Philip II of Macedon in 338 BCE. Noteworthy during this period was the elaboration of a wider range of existing architectural types, such as meeting houses, theaters, and mausoleums. The Corinthian capital also developed from the Ionic style. The uncertain, somewhat pessimistic, mood of the age is best reflected in sculpture. The works of Praxiteles convey the capriciousness of the gods toward humans, whereas Lysippos' *Apoxyomenos* breaks into a viewer's space with its outstretched, foreshortened arm. Intense emotion and illusionistic depictions of space became hallmarks of wall and vase painting as well, seen especially on funerary vases painted with the white-ground technique.

THE AGE OF ALEXANDER AND THE HELLENISTIC PERIOD

Alexander took control in 336 BCE upon the death of his father, Philip II, and the vast kingdom he created expanded Greek influence. Rivalries after Alexander's death in 323 BCE resulted in three separate kingdoms—the Ptolemaic, the Seleucid, and the Macedonian—each with powerful cities teeming with diverse societies. With the dissolution of city-states, Greeks increasingly saw themselves as individuals, and the arts, once again, reflect this new outlook.

The plans of buildings, such as the Temple of Apollo at Didyma and of the city of Pergamon, offered a more personal experience via unexpected paths, breathtaking panoramas, and dramatic theatricality. Hellenistic sculpture also favored heightened drama and increased viewer involvement, building on Late Classical works. Emotional subjects and dramatic realism prevailed; portraiture developed as a genre and flourished thanks to the patronage of Alexander the Great. Wall paintings display masterful brushwork, delicate shading, and spatial perspective.

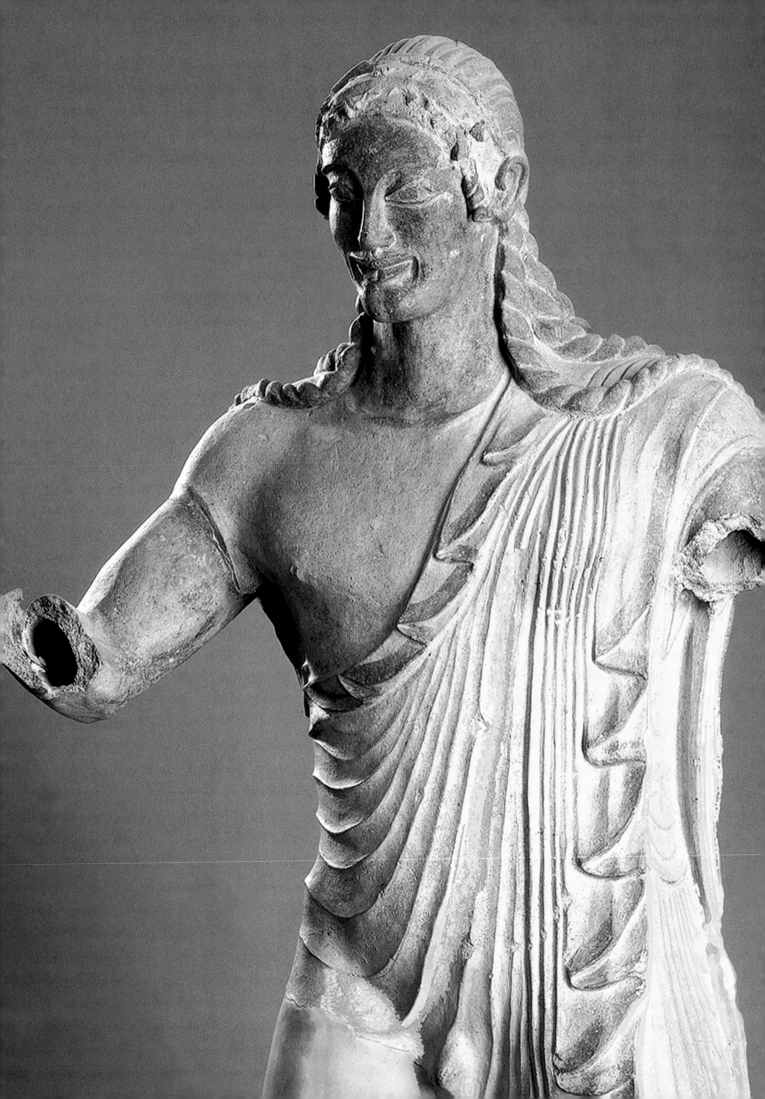

Etruscan Art

ARLY ETRUSCAN CULTURE, KNOWN AS VILLANOVAN, APPEARED ON THE
Italian peninsula in the tenth century BCE. Exactly who the Etruscans
were remains a mystery; even in antiquity, writers disputed their origins.
The Classical Greek historian Herodotus believed that the Etruscans had
left their homeland of Lydia in Asia Minor in about 1200 BCE. By his account, they

settled in what is now Tuscany, Umbria, and Lazio, roughly in
the area between present-day Florence and Rome (see map 6.1).
Others claimed the Etruscans were an indigenous people.
Wherever they came from, the Etruscans had strong cultural
links with both Asia Minor and the ancient Near East. In fact,
their visual culture is a rich blend of distinctly Etruscan traits
and influences from the east and from Greece. Etruscans were
sailors and merchants who traveled throughout the Mediter-
ranean, and since from the eighth century BCE Greek city-states
had established colonies in Italy, contact between these cultures
was inevitable. Toward the end of the eighth century they
began to use the Greek alphabet, which makes it possible to
read their inscriptions, that survive in the thousands; but since
their language is unrelated to any other, we cannot always
understand their meaning.

The Etruscans reached the height of their power in the sev-
enth and sixth centuries BCE, coinciding with the Archaic age in
Greece. Because of the close relationship between Etruscan art
forms and those of Greece, scholars define the stylistic periods
of Etruscan art with terms that are similar to those of Greek art
(see table on next page). Their cities rivaled those of the Greeks;
their fleet dominated the western Mediterranean and protected
a vast commercial network that competed with the Greeks and

Phoenicians; and their territory extended from the lower Po
Valley in the north as far as Naples in the south. But, like the
Greeks, the Etruscans never formed a unified nation. They
remained a loose federation of individual city-states, united by a
common language and religion, but given to conflict and slow
to unite against a common enemy. This may have been one
cause of their gradual downfall. In 474 BCE, the Etruscan fleet
was defeated by the navy of its archrival, Syracuse. And during
the later fifth and fourth centuries BCE, one Etruscan city after
another fell to the Romans. By 270 BCE, all of the Etruscan city-
states had lost their independence to Rome, although many con-
tinued to prosper, if we are to judge by the splendor of their
tombs during this period of political struggle.

The bulk of our information about Etruscan culture comes
from art, and especially from the numerous monumental
tombs that they furnished with sculptures and paintings. The
objects from these funerary structures attest to the reputation
of the Etruscans as fine sculptors and metalworkers. Large
numbers of Attic painted vases have also been found in these
tombs, offering great insight into the history of Greek art, and
demonstrating the close trade ties that Etruscans had with
Greece. The tombs themselves provide us with information
about Etruscan building practices, and they are often painted
with scenes that offer a glimpse of Etruscan life. All of these art
forms were passed on to the Romans, who transformed them
for their own purposes.

Detail of figure 6.16, *Apollo*

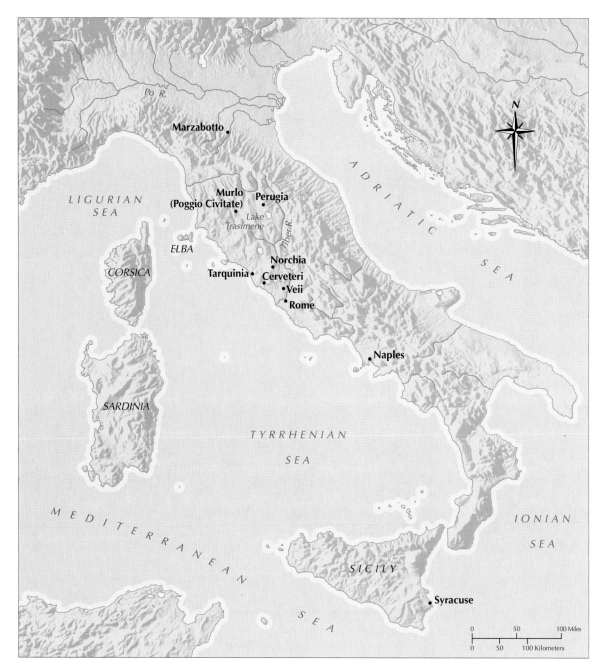

Map 6.1. Italy in Etruscan Times

FUNERARY ART

As with burials elsewhere in prehistoric Europe, Italian Iron Age burials were modest. The deceased were either buried in shallow graves or cremated and the ashes, contained in a pottery vessel or cinerary urn, placed in a simple pit. Buried with some of the dead were offerings of weapons for men and jewelry and weaving implements for women. Early in the seventh century BCE, as Etruscans began to bury their dead in family groups, funerary customs for both men and women became more elaborate, and the tombs of the wealthy were gradually transformed into monumental structures.

Tombs and Their Contents

Named for the amateur archeologists who excavated it, the Regolini-Galassi Tomb at Cerveteri is an early example of this more elaborate burial practice, dating to the so-called Orientalizing phase of the mid-seventh century, when Etruscan arts show a marked influence of Eastern motifs. Etruscans carved their tombs out of the local volcanic stone or formed mounds called *tumuli*. These were grouped together outside the living spaces of Etruscan towns to create a *city of the dead*, or

PERIODS OF ETRUSCAN ART

ca. 700–600 BCE—Orientalizing Period

ca. 600–480 BCE—Archaic Period

ca. 480–300 BCE—Classical Period

ca. 300 BCE—Etruscan culture is slowly absorbed into Roman culture

necropolis. In this example, the long *dromos* (plural, *dromoi*) or pathway leading into the tomb is roofed with corbeled vaults built of horizontal, overlapping courses of stone blocks, similar to the casemates at Tiryns (see fig. 4.20). Among the grave goods found in the Regolini-Galassi Tomb was a spectacular **fibula** (fig. **6.1**). A fibula resembled a brooch or a decorative safety pin, and often served to hold a garment together at the neck. At 11 ½ inches in length, this magnificent example is a *tour de force* of the goldsmith's art (see *Materials and Techniques*, page 164) and justifies the fame Etruscan goldsmiths enjoyed in antiquity. Covering the lower leaflike portion are 55 gold ducks in the round. On the upper portion, which is shaped as a three-quarter-moon, pacing lions are defined in repoussé. The workmanship is probably Etruscan, but the animal motifs suggest the Etruscans were familiar with the art works of Near Eastern cultures (see fig. 2.11). The profile pose and erect stance of the lions in repoussé may derive from Phoenician precedents. Also found in tombs of this time are precious objects imported from the ancient Near East, such as ivories.

The Regolini-Galassi Tomb is but one of many "tumulus tombs" or mounds built at necropoli near Cerveteri over the course of several centuries until about 100 BCE (fig. **6.2**). The local stone of the region is a soft volcanic rock known as *tufa*, which is easy to cut and hardens after prolonged exposure to the air. Those responsible for building the *tumuli* would excavate into bedrock, cutting away a path and burial chambers. They used the excavated stone to build a circular retaining wall around the tomb chambers, and piled up soil above it. There were often several *dromoi* (pathways) in a single mound, leading to independent networks of chambers (fig. **6.3**).

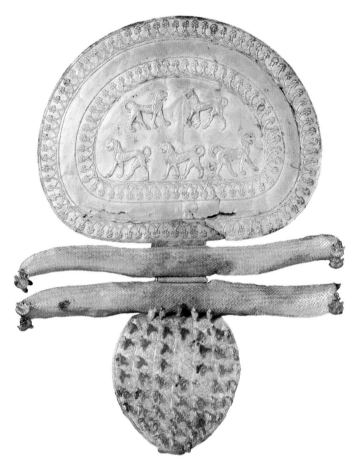

6.1. Fibula from Regolini-Galassi Tomb, Cerveteri. Gold. ca. 670–650 BCE. 11½″ long. Musei Vaticani, Museo Gregoriano Etrusco, Città del Vaticano, Rome

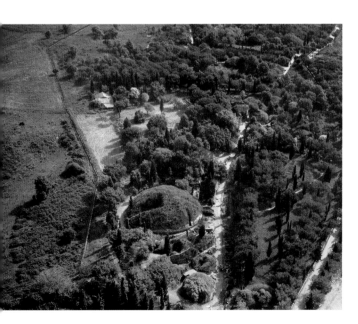

6.2. Aerial view of part of Banditaccia Cemetery. 7th–2d centuries BCE. Cerveteri, Italy

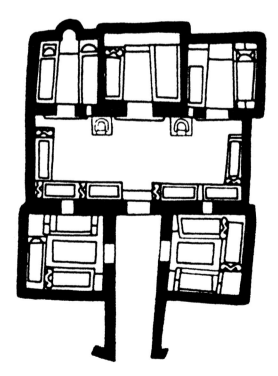

6.3. Plan of Tomb of the Shields and Chairs. ca. 550–500 BCE. Cerveteri, Italy

Etruscan Gold-Working

Early in their history, the Etruscans became talented metalworkers, with special proficiency in gold working. The goldsmith responsible for the fibula in figure 6.1 was a master of two complex techniques: filigree and granulation.

Filigree is the art of soldering fine gold wires—singly or twisted together into a rope—onto a gold background. The goldsmith used this process to outline the ornamental decoration and two-dimensional animals on the fibula's surface. Etruscan artists were so expert that they could even create open-work designs independent of a back-plate.

Granulation describes the process of soldering tiny gold balls or grains onto a background. Skilled Etruscan artists worked with grains as small as .004 of an inch (.14 mm), using them to decorate large areas, or to define linear or geometric patterns. Alternatively, they might employ them in conjunction with embossed designs, or in a mass to create a silhouette against the background; finally, they might cover the background with grains, leaving a design in silhouette.

Mastery of granulation was lost in early medieval Europe, as tastes changed and different gold-working techniques were preferred. Various methods are used today, but scholars do not know how Etruscan goldsmiths prepared the grains. Perhaps they placed fragments of gold in a crucible, separating the fragments with charcoal. When heated, the gold would melt into separate balls, kept apart by the charcoal, which was then removed. Alternatively, they may have poured molten gold into water from a height, or into a charcoal-filled vessel. When the liquid metal reached the water, it would cool into solid form; pouring it from a height would assure that tiny grains would form into small balls. For all but the simplest designs (which were applied straight to the background),

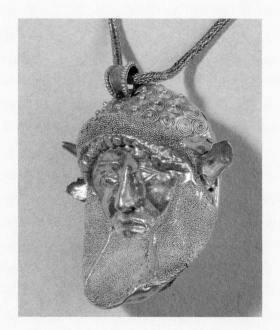

Pendant representing the head of Acheloos, decorated with granulation. 6th century BCE. Louvre, Paris

the grains were probably arranged in a design engraved on a stone or metal plate. The goldsmith then lowered a piece of adhesive-covered papyrus or leather, fixed to the end of a tube, over the design, to pick up the grains. They could then be treated with solder and transferred to the gold back-plate.

The layout of the burial chambers could vary widely, and scholars have tended to believe that these dwellings of the dead evoked the plans of contemporary houses. This may be true, but it is impossible to confirm given the scant evidence for Etruscan residences. In any case, sculptors often carved chairs or beds out of the rock to furnish the chambers. A late example, the Tomb of the Reliefs at Cerveteri, has everything the dead might want in the afterlife, applied in stucco onto the walls (fig. **6.4**). The piers and the wall surfaces between the niches are covered with reproductions of weapons, armor, household implements, and small domestic animals. Two damaged busts may once have represented the dead or underworld deities. While the concept of burying items that would be of service in the afterlife is reminiscent of Egyptian funerary practice, replicas of actual items differ markedly from what is found in Egyptian tombs.

Decoration of a very different kind enlivened the tombs of the necropolis further north at Tarquinia. Here, where tombs consist of chambers sunk into the earth with a steep underground *dromos* leading to each, vibrant paintings cover the walls. Painted onto the plaster while it was wet, these images

offer a glimpse into the activities enjoyed by the deceased. Pictured here is a scene from the Tomb of Hunting and Fishing, dating to about 530–520 BCE (fig. **6.5**) during the Archaic period. At one end of the low chamber is a marine panorama. In the vast expanse of water and sky, fishermen cast fishing lines from a boat, as brightly colored dolphins leap through the waves. A sling-shot artist stands on a rocky promontory and aims his fire at large birds in bright red, blue, and yellow that swoop through the sky. Unlike Greek landscape scenes, where humans dominate their surroundings, here the figures are just one part of a larger scheme. The exuberance of the colors and gestures, too, are characteristically Etruscan. All the same, here as in most tombs, the treatment of drapery and anatomy reveals that Etruscan tomb painters were deeply influenced by developing Greek painting. In fact, great numbers of Attic painted vases were discovered in Etruscan tombs.

The Etruscan artist seems to have conceived of the scene as a view from a tent or hut, defined by wide bands of color at cornice level and roofed with a light tapestry. Hanging from the cornice are festive garlands of the kind probably used during funerary rituals. In many tombs, the gable is filled

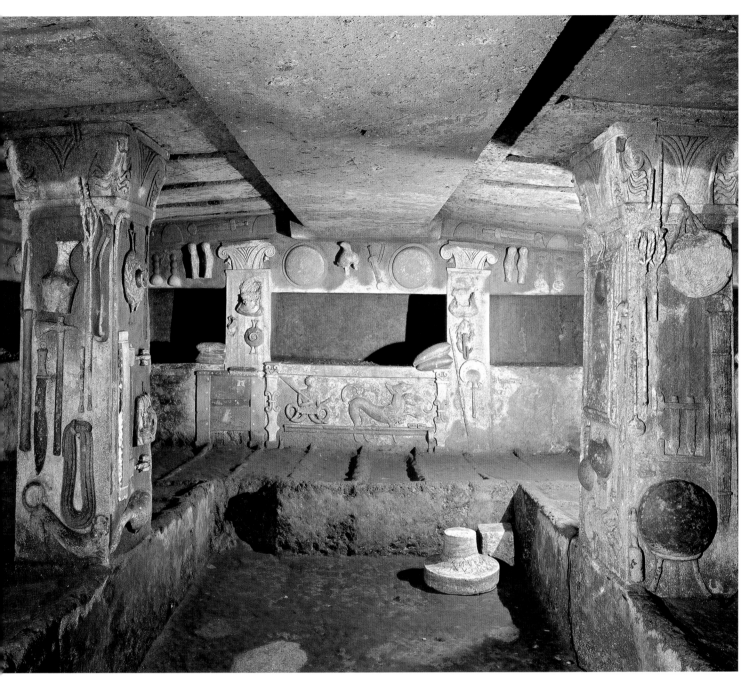

6.4. Burial chamber, Tomb of the Reliefs. 3rd century BCE. Cerveteri, Italy

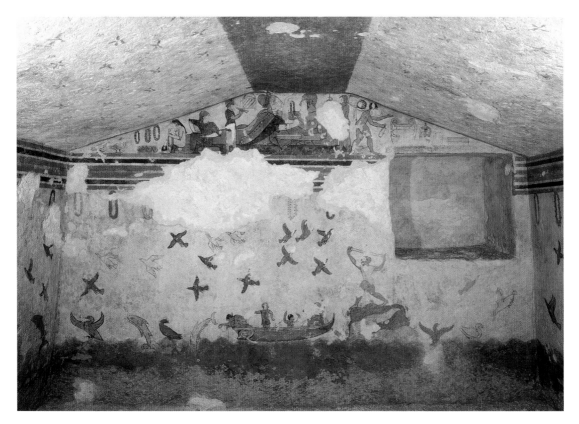

6.5. Tomb of Hunting and Fishing. ca. 520 BCE. Tarquinia, Italy

with images of animals—leopards, sometimes, or fantastic hybrids—perhaps used as guardian figures to ward off evil. Above this scene, a man and woman recline together at a banquet, where musicians play their instruments and servants wait on them. One draws wine from a large mixing bowl, or krater, while another makes wreaths. In contrast to Greek drinking parties (*symposia*), which were reserved for men and courtesans, Etruscan scenes of banqueting include

respectable women who recline together with men. Paintings of banquets appear frequently in Etruscan tombs; athletic games were another common subject, as were scenes with musicians and dancers, such as the lively example illustrated here from the Tomb of the Triclinium, dating to about 470–460 BCE (fig. **6.6**).

The deeper purpose of these paintings is less clear. They may record and perpetuate rituals observed on the occasion of

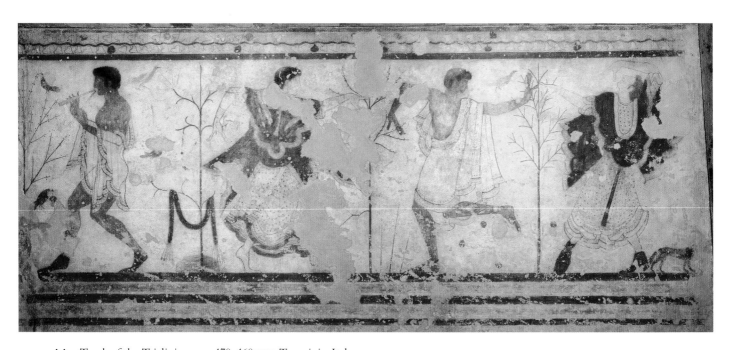

6.6. Tomb of the Triclinium. ca. 470–460 BCE. Tarquinia, Italy

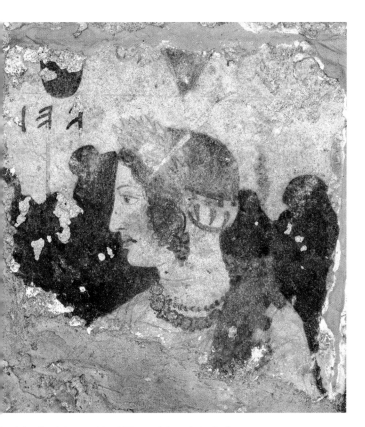

6.7. Tomb of Orcus. 350–300 BCE. Tarquinia, Italy

ART IN TIME

ca. 600s–500s BCE—The height of Etruscan power

ca. 520 BCE—Etruscan terra-cotta sarcophagi from Cerveteri

ca. 518—Construction of the Persian palace at Persepolis begins

ca. 480–336 BCE—Classical period in Greece

270 BCE—All Etruscan city-states had lost their independence to Rome

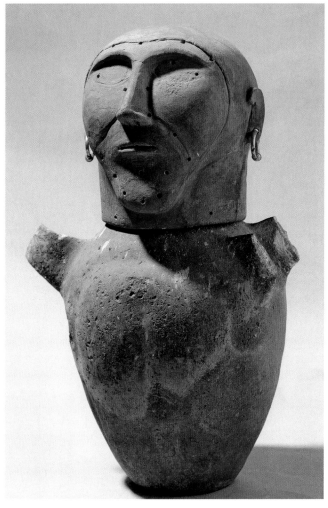

6.8. Human-headed cinerary urn. ca. 675–650 BCE. Terra cotta, height 25½″ (64.7 cm). Museo Etrusco, Chiusi, Italy

the funeral (the games, in fact, are probably the forerunners of Roman gladiatorial contests). Or, like Egyptian tomb paintings, they may have served as provisions for the afterlife of the deceased. At the heart of the problem of interpretation lies our general ignorance about Etruscan beliefs concerning death and the afterlife. Roman writers described them as a highly religious people, and their priests are known to have read meaning into the flight of birds in different sectors of the sky. Yet, as mysterious as these paintings are, they constitute a large part of our evidence for understanding Etruscan beliefs. In a few tombs, the paintings seem to reflect Greek myths, but in a sense these paintings merely compound the problem, since we cannot be sure whether the Etruscans intended the same meaning as Greek artists.

However we interpret these images of the archaic and classical times, it is clear that a distinct change in the content of tomb paintings begins in the late classical period during the fourth century BCE. The Tomb of Orcus at Tarquinia, dating to the second half of the fourth century BCE, illustrates this well (fig. **6.7**). The fragmentary painting depicts the head of a noble woman, whom an inscription identifies as a member of the Velcha family. Her pale face is silhouetted against a dark cloud, and the exuberant palette of the earlier period, with its bright reds and yellows, gives way to a somber range of darker colors. At this time, funerary images are often set in a shadowy underworld, or depict processions taking the deceased to a world of the dead. An overwhelming sense of sadness now replaces the energetic mood of the Archaic and Classical period. It is possible that dark subjects reflected difficult times. During the latter part of the fourth century BCE, the Romans conquered

Etruscan cities and forced them into subordination. In some tombs of this later period, ominous demons of death appear, painted green and blue.

Similar changes appear in the containers used for the remains of the dead. In the Orientalizing period, the pottery urns traditionally used for ashes gradually took on human shapes (fig. **6.8**). The lid became a head, perhaps intended to represent the deceased, and body markings appeared on the

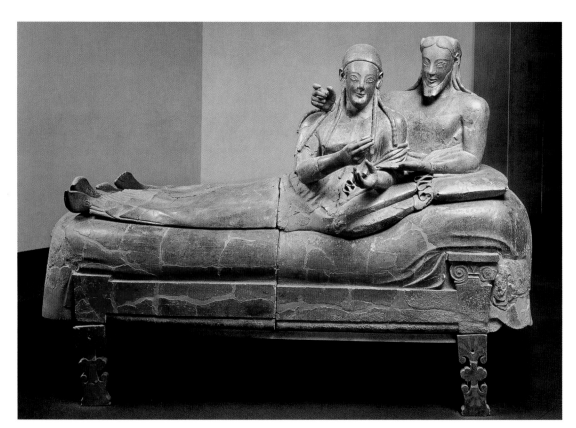

vessel itself. Hair and jewelry may have been attached where holes appear in the terra-cotta surface. Sometimes the urn was placed on a sort of throne in the tomb, which may have indicated a high status for the deceased.

In Cerveteri, two monumental sarcophagi of the Archaic period were found, molded in terra cotta in two separate halves. One of them, dating to about 520 BCE, is shown here

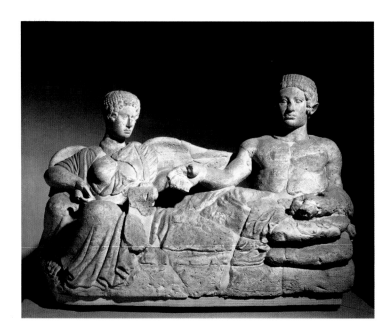

6.10. *Youth and Female Demon.* Cinerary container. Early 4th century BCE. Stone (*pietra fetida*), length 47″ (119.4 cm). Museo Archeologico Nazionale, Florence

(fig. **6.9**). The lid is shaped like a couch, and reclining side by side on top are full-length sculptures of a man and woman, presumably a married couple. Instead of a pillow, a wineskin (a soft canteen made from an animal skin) cushions the woman's left elbow, and the man has his arm around her shoulders. Both figures once held out objects in their hands—a cup or an *alabastron* (a perfume container), perhaps, or an egg, symbol of eternity. Despite the constraints of the Archaic style, with its abstract forms and rigid poses, the soft material allows the sculptor to model rounded forms and capture the extraordinary directness and vivacity that are characteristic of Etruscan art. The entire work was once painted in bright colors, which have been revealed more clearly in a recent cleaning.

The change in mood, from optimistic to somber, that characterizes tomb paintings between the fifth and fourth centuries is just as apparent in funerary objects, as can be seen if we compare the sarcophagus in figure 6.9 with a cinerary container made of soft stone soon after 400 BCE (fig. **6.10**). As in wall paintings of this period, a woman sits at the foot of the couch. Yet she is not the young man's wife. Her wings identify her as demon from the world of the dead, and the scroll in her left hand may record his fate. He wears his mantle pulled down around his waist, in the Etruscan style. The two figures at either end of the couch create a balanced composition, but the separation of the figures marks a new mood of melancholy associated with death, which each individual must face alone. Still, wealthy Etruscans continued to bury their dead together in family tombs, and the familial context for cinerary urns like this one must have gone some way toward mitigating the isolation of death (fig. **6.11**). Moreover, while cinerary urns of this

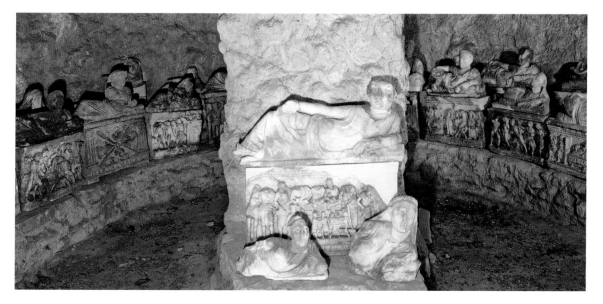

6.11. Funerary urns in the Inghirami Tomb. Hellenistic period. Volterra, Italy

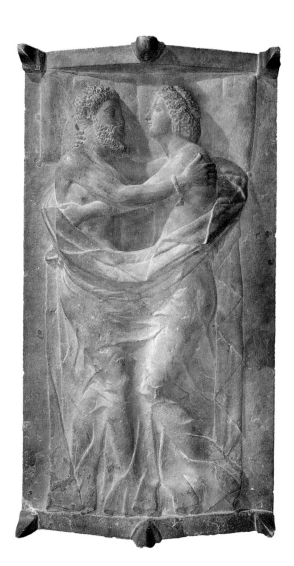

6.12. Sarcophagus lid of Larth Tetnies and Thanchvil Tarnai. ca. 350–300 BCE. Marble, length 7′ (2.13 m). Museum of Fine Arts, Boston. Gift of Mrs. Gardner Brewer, © 2006, Museum of Fine Arts, Boston. 86.145 a-b

kind were typical, most with a single figure reclining on the lid, a few grander sarcophagi survive. On the lid of one are carved a man and woman in a tender embrace, lying under a sheet as if in their marital bed (fig. **6.12**). The coiffures and beard reflect Greek fashion, and the sides of the chest feature battle scenes influenced by Greek iconography, yet the finished product is definitively Etruscan.

ARCHITECTURE

According to Roman writers, the Etruscans were masters of architectural engineering, town planning, and surveying. Almost certainly, the Romans learned from them, especially in the areas of water management (drainage systems and aqueducts) and bridge building, but how much they learned is hard to determine, since little Etruscan or early Roman architecture is still standing. Built predominantly with wood or mud brick, these structures typically did not survive. Additionally, many Etruscan towns lie beneath existing Italian hill towns, and permanent materials used in their building have often been reused.

Etruscan cities generally sat on hilltops close to a navigable river or the sea. In some places, massive defensive walls were added, from the seventh century BCE on. A late example of civic architecture survives from the city of Perugia, where sections of a fortification wall and some of its gates still stand. The best known of these is the Porta Marzia (the Gate of Mars) of the second century BCE, the upper portion of which is encased in a later wall (fig. **6.13**). It is an early example of a *voussoir* arch, built out of a series of truncated wedge-shaped stones called **voussoirs** set in a semicircle using a disposable wooden framework during construction. Once they were in place, they were remarkably strong; any downward thrust from above (the weight of the wall over the void, for instance) merely strengthened their bond by pressing them more tightly against one

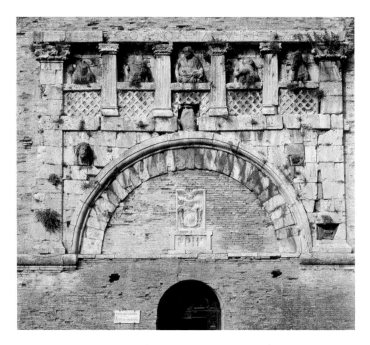

6.13. Porta Marzia. 2d century BCE. Perugia, Italy

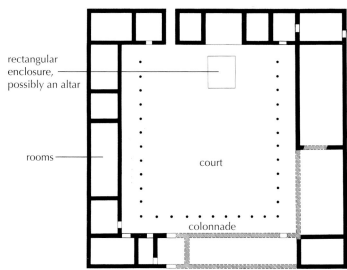

6.14. Plan of residential complex. 6th century BCE. Murlo (*Poggio Civitate*), Italy

another. Above the arch, and separated by engaged pilasters, sculpted figures of Tinia (the Etruscan equivalent of Zeus or Jupiter) and his sons (equivalent to Castor and Pollux) with their horses look out over a balustrade. The arch is visual proof of the confluence of cultures so prevalent in the Mediterranean in the last centuries before the Common Era.

City Planning

The hilltops of Etruria did not lend themselves to grid planning, yet there is good evidence at sites like Marzabotto that when the Etruscans colonized the flatlands of the Po Valley in northern Italy, from the sixth century BCE on, they laid out newly founded cities as a network of streets. These centered on the intersection of two main thoroughfares, one running north and south (the *cardo*) and one running east and west (the *decumanus*). The resulting four quarters could be further subdivided or expanded, according to need. This system seems to reflect the religious beliefs that made the Etruscans divide the sky into regions according to the points of the compass. The Romans also

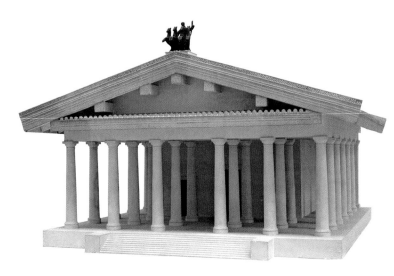

adopted it for the new colonies they founded throughout Italy, western Europe, and North Africa, and for military camps.

Little survives of the houses that composed Etruscan towns. Unlike tombs, they were built with a packed-earth technique (pisé) similar to wattle and daub or adobe, with only the base made of stone. Even these stone footprints are hard to discern, since the hilltops favored by the Etruscans have been inhabited more or less continually since their days. In a few places, however, the remains of monumental building complexes have been excavated. These may have been palaces or large villas. An especially fine example existed at Poggio Civitate (present-day Murlo) in the sixth century BCE, where numerous rooms framed a large central courtyard (fig. **6.14**). This kind of architecture may be the conceptual forerunner of typically Roman atrium houses (see fig. 7.50).

Temples were built of mud brick and wood, and once again only the stone foundations have survived. Early temples consisted of little more than modest rectangular *cellas* (rectangular rooms for holding cult figures). Later temples were profoundly influenced by the innovative design of the massive Temple of Jupiter Optimus Maximus on the Capitoline Hill in Rome, ruled at the time by Etruscan kings (see fig. 7.1). As a result, they are characterized by a tall base, or podium, with steps only on the front (fig. **6.15**). The steps lead to a deep porch, supported by rows of columns, and to the cella beyond, which was often subdivided into three compartments. The roof, made of terracotta tiles, hung well over the walls in wide eaves, to protect the mud bricks from rain.

6.15. Reconstruction of an Etruscan temple, as described by Vitruvius. Museo delle Antichità Etrusche e Italiche, Università di Roma "La Sapienza"

ART IN TIME

ca. 1000 BCE—Appearance of Etruscan culture on the
 Italian peninsula
500s BCE—Etruscans begin colonizing the flatlands south
 of Rome
447–432 BCE—Construction of the Parthenon in Athens
331 BCE—Defeat of the Persians by Alexander the Great
**200s BCE—Surviving Etruscan gate, the Porta Marzia,
 built in Perugia**

SCULPTURE

As with their Greek counterparts, Etruscan temples were highly ornate, but where Greeks used marble to adorn their temples, Etruscans had little access to this material. The decoration on Etruscan temples usually consisted of brightly painted terracotta plaques that covered the architrave and the edges of the roof, protecting them from dampness. After about 400 BCE, Etruscan artists sometimes designed large-scale terra-cotta groups to fill the pediment above the porch. The most dramatic use of sculpture, however, was on the ridgepole—the horizontal beam at the crest of a gabled roof. Terra-cotta figures at this height depicted not only single figures but narratives. One of the most famous surviving temple sculptures comes from Veii, a site some 14 miles north of Rome. Both Roman texts and archeological evidence indicate that Veii was an important sculptural center by the end of the sixth century BCE.

Dynamism in Terra Cotta and Bronze

The late sixth-century Temple at Veii was probably devoted to Menrva, Aritimi, and Turan. Four life-size terra-cotta statues crowned the ridge of the roof. (Similar examples appear in the reconstruction model, fig. 6.15.) They formed a dynamic and interactive group representing the contest of Hercle (Hercules) and Aplu (Apollo) for the sacred hind (female deer) in the presence of other deities. The best preserved of the figures is Aplu (fig. **6.16**). He wears a mantle with curved hem later known to Romans as a toga. The drapery falls across his form in ornamental patterns and exposes his massive body, with its sinewy, muscular legs. The stylistic similarity to contemporary Greek kouros and kore figures signals the influence Greek sculpture must have had on the Etruscans. But this god moves in a hurried, purposeful stride that has no equivalent in free-standing Greek statues of the same date. Rendered in terra cotta, which allowed greater freedom for the sculptor to experiment with poses, this is a purely Etruscan energy. These sculptures have been attributed to a famous Etruscan sculptor, Vulca of Veii, known from Latin literary sources.

6.16. *Apollo (Aplu)*, from Veii. ca. 510 BCE. Terra cotta, height 5′9″ (1.75 m). Museo Nazionale di Villa Giulia, Rome

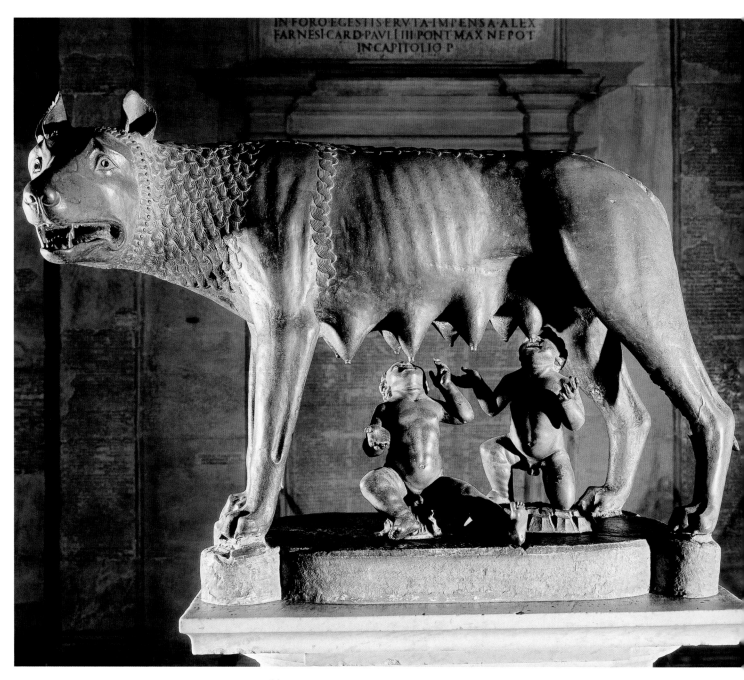

6.17. *She-Wolf.* ca. 500 BCE. Bronze, height 33½″ (85 cm). Museo Capitolino, Rome

Etruscan sculptors also demonstrated extraordinary skill as bronze casters. One of the most renowned works of Etruscan sculpture is the bronze *She-Wolf* now housed in the Capitoline Museum in Rome (fig. **6.17**). It dates from the fifth century BCE, and almost certainly, judging by its workmanship, it was made by an Etruscan artist. The stylized, patterned treatment of the wolf's mane and hackles sets off the smoothly modeled muscularity of her body, tensed for attack. Simple lines add to her power: The straight back and neck contrast with the sharp turn of the head toward a viewer, highlighting her ferocity. So polished is the metal's surface that it almost seems wet; her fangs seem to glisten. The early history and subject matter of this statue is unknown. However, evidence suggests that it was highly valued in later antiquity, particularly by the Romans. According to legend, Rome was founded in 753/52 BCE by the twin brothers Romulus and Remus, descendants of refugees from Troy in Asia Minor. Abandoned as babies, they were nourished by a she-wolf in the wild. Later Romans may have seen in this Etruscan bronze a representation of their legendary mother wolf. The early fourth-century CE emperor Maxentius built a grand palace in Rome, and there, in a large *exedra* (alcove) framed by a walkway, archeologists found a statue base with fittings that exactly match the footprints of the she-wolf. The twin babies Romulus and Remus beneath her were added between 1471 and 1473, probably by Antonio Polaiuolo, to resemble Roman coin representations of the lactating she-wolf with the babies.

The Etruscan concern with images of the dead might lead us to expect an early interest in portraiture. Yet the features of funerary images such as those in figures 6.9 and 6.10 are stylized rather than individualized. Not until a century later, toward 300 BCE, did individual likenesses begin to appear in Etruscan sculpture. Greek portraiture may have influenced the change, but terra cotta, the material of so much Etruscan sculpture, lent itself to easy modeling of distinctive facial features. Some of the finest Etruscan portraits are heads of bronze statues, such as the portrait of a boy illustrated here (fig. **6.18**). The artist was a master of his craft, exploiting the full range of surface finishes possible in bronze, from the rough eyebrows to the striated locks of hair to the smooth, modeled flesh.

A life-size bronze sculpture of an orator known today as *L'Arringatore* (the *Orator*) shows how impressive these full length sculptures once were (fig. **6.19**). Most scholars place this sculpture in the early years of the first century BCE. It comes from Lake Trasimene, in the central Etruscan territory, and

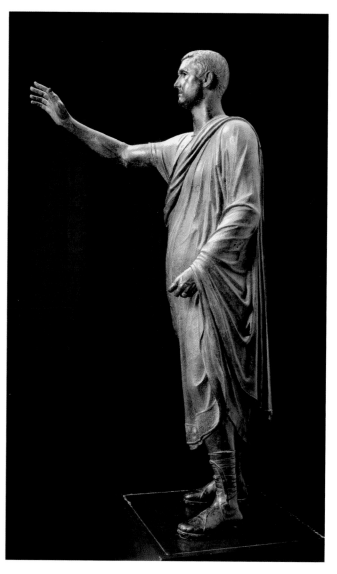

6.18. *Portrait of a Boy.* Early 3rd century BCE. Bronze, height 9″ (23 cm). Museo Archeologico Nazionale, Florence

6.19. *Aule Meteli (L'Arringatore).* Early 1st century BCE. Bronze, height 71″ (280 cm). Museo Archeologico Nazionale, Florence

bears an Etruscan inscription that includes the name Aule Meteli (*Aulus Metellus* in Latin), presumably the name of the person it represents. The inscription shows that the workmanship is Etruscan, yet the high boots mark the subject as a Roman, or at least an official appointed by the Romans. The raised arm, a gesture that denotes both address and salutation, is common to hundreds of Roman statues. The sculpture raises inevitable questions about the roles of artist and patron in the conquered Etruscan territories. The high quality of the casting and finishing of these bronze works bears out the ancient Etruscans' fame as metalworkers. Their skill is hardly surprising in a land whose wealth was founded on the exploitation of copper, iron, and silver deposits.

From the sixth century BCE on, Etruscans produced large numbers of bronze statuettes, mirrors, and other objects for domestic use and for export. The backs of mirrors were often engraved with scenes taken from Etruscan versions of Greek myths devoted to the loves of the gods. Such amorous subjects were entirely appropriate for objects used for self-admiration.

The design on the back of a mirror created soon after 400 BCE (fig. **6.20**) is of a different genre, and shows how the Etruscans adapted Greek traditions as their own. Within an undulating wreath of vines stands a winged old man, one foot raised upon a rock. An inscription identifies him as the seer Chalchas, an Etruscan version of the Greek seer Chalchas known from Homer's *Iliad*. Yet this is the full extent of the borrowing, for the winged genius is engaged in a pursuit that was central to Etruscan ritual: He is gazing intently at the liver of a sacrificial animal, searching for omens or portents.

The Etruscans believed that the will of the gods was expressed through signs in the natural world, such as thunderstorms or, as we have seen, the flight of birds, or even the entrails of sacrificed animals. In fact, they viewed the liver as a sort of microcosm, divided into sections that corresponded to the 16 regions of the sky. By reading natural signs, those priests who were skilled in the arts of *augury*, as this practice was called, could determine whether the gods approved or disapproved of their acts. These priests enjoyed great prestige and power, and long after Etruscan culture had been subordinated to the Romans, they continued to thrive. The Romans themselves consulted them before any major public or private event. As the Roman philosopher and statesman Seneca wrote: "This is the difference between us and the Etruscans. . . . Since they attribute everything to divine agency, they are of the opinion that things do not reveal the future because they have occurred, but that they occur because they are meant to reveal the future." Mirrors, too, were valued for their ability to reveal the future, which is probably why this scene is represented here.

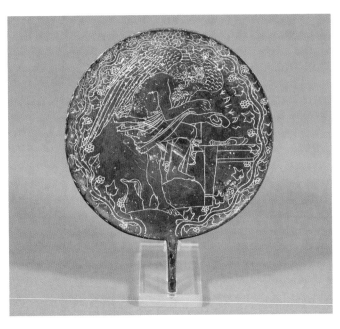

6.20. Engraved back of a mirror. ca. 400 BCE. Bronze, diameter 6″ (15.3 cm). Musei Vaticani, Museo Gregoriano Etrusco, Città del Vaticano, Rome

SUMMARY

Etruscan culture appeared on the Italian peninsula around 1000 BCE. The ancient Etruscans were skilled sailors and merchants whose wealth was founded on the exploitation of available copper, iron, and silver deposits. Most of what survives today comes from their numerous tombs. Artists crafted objects ranging from small-scale jewelry to life-size figures. Some of the objects are made from materials—such as ivory—that were acquired through trade. Etruscan priests enjoyed great prestige and power, even after their culture had become subordinate to that of the Romans.

FUNERARY ART

The Etruscans began to bury their dead in family groups early in the seventh century BCE. Over time, tomb construction for the wealthy became more monumental. Many tombs were carved out of local volcanic stone and included spectacular grave goods, including precious objects of gold and ivory. Some tombs were decorated with vibrant wall paintings, and housed beguiling funerary objects such as terra-cotta sarcophagi that depict reclining figures.

ARCHITECTURE

Etruscan cities generally sat on hilltops close to a navigable river or the sea. There is good evidence that some cities in the flatlands were laid out as a network of streets, a system adopted by the Romans. Very little Etruscan architecture is still standing, since their houses and temples were built of packed earth and mud brick. However, a rare example of their civic architecture does survive in a stone gate in the city of Perugia.

SCULPTURE

The Etruscans embellished their temples with terra-cotta decorations. Common decorations included brightly painted plaques and groupings of sculpted figures. Fine sculptures in bronze also survive, reflecting the masterful talents of Etruscan metalworkers.

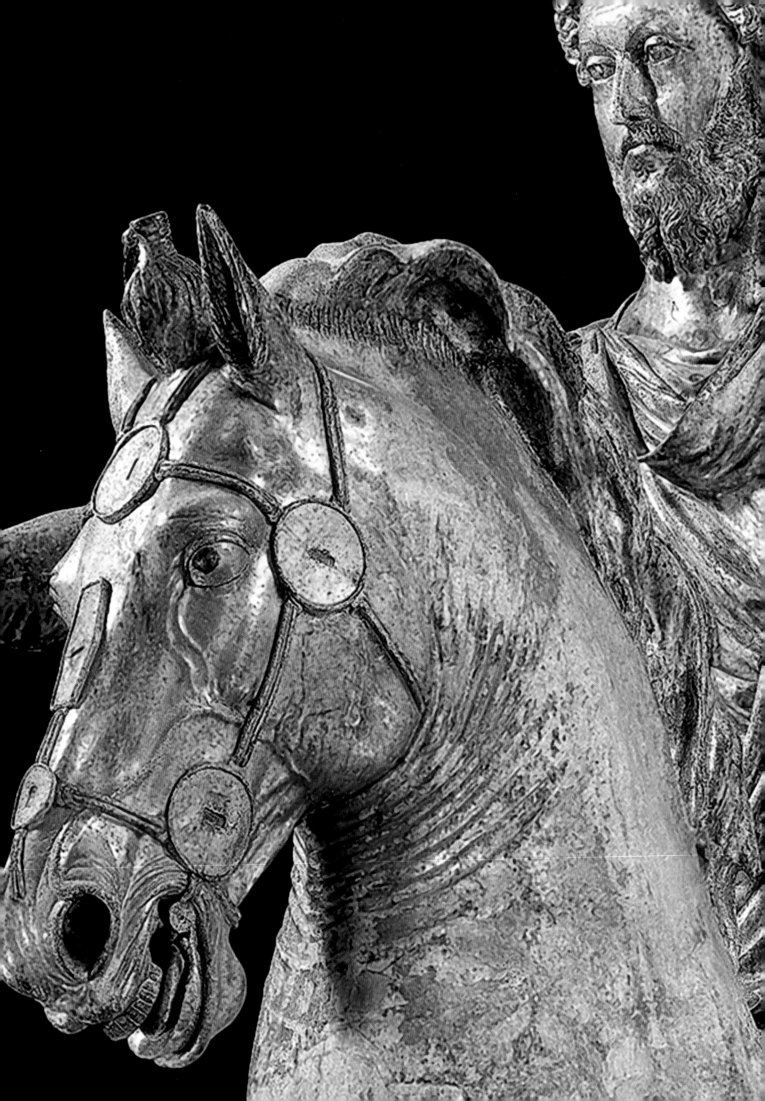

Roman Art

O F ALL THE CIVILIZATIONS OF THE ANCIENT WORLD, THE MOST
accessible to modern scholars is the culture of ancient Rome. A vast
literary legacy, ranging from poetry and histories to inscriptions
that recorded everyday events, reveals a great deal about Roman
culture. The Romans also built vast numbers of monuments throughout their

empire, which are extraordinarily well preserved. Yet there are few questions more difficult to address than "What is Roman art?"

Much of Roman public art draws heavily on Greek styles, both Classical and Hellenistic. In the nineteenth and early twentieth centuries, influenced by early art historians like Winckelmann (see *The Art Historian's Lens*, page 179), art connoisseurs exalted Greek classicism as the height of stylistic achievement, and they considered Roman art derivative, the last chapter, so to speak, of Greek art history. This view changed radically in the ensuing years, especially as pure connoisseurship began to give way to other branches of art history. Scholars are now more interested, for instance, in the roles of a work of art in its social and political contexts. Yet regardless of how one judges artists in Rome for drawing so consistently on Greek styles, it was by no means the only style at play in the Roman world. There were phases of distinct "Egypto-mania" in Rome, for instance; and works of art created in the provinces or by the nonelite have their own style, as do those of late antiquity.

Roman art was the art of both Republic and Empire, the art of a small city that became a vast empire. It is an art created by Roman artists, but also by Greeks; the greatest architect of Trajan's time may have been from Damascus. Perhaps the most

Detail of figure 7.21, *Equestrian Statue of Marcus Aurelius*

useful way to think of Roman art is to see it as an art of *syncretism*—an art that brings diverse elements together to produce something entirely new, with an extremely strong message-bearing potential. Syncretism was a profoundly Roman attitude, and was probably the secret to Rome's extraordinarily successful expansion. From the very start, Roman society was unusually tolerant of non-Roman traditions, as long as they did not undermine the growing state. The populations of newly conquered regions were not, on the whole, subordinated to Roman custom, and many were eventually accorded the rights of citizenship. Their gods were hospitably received in the capital. Roman civilization integrated countless other cultures, leading to a remarkably diverse world.

EARLY ROME AND THE REPUBLIC

According to Roman legend, Romulus founded the city of Rome in 753/52 BCE, in the region known as Latium, on a site near the Tiber River. But archeological evidence shows that people had lived there since about 1000 BCE. From the eighth to the sixth centuries BCE, Rome expanded under a series of kings. This "regal period" ended with a series of Etruscan kings who substantially improved the city. They built the first defensive wall around the settlement, drained and filled the swampy plain of the Forum, and built a vast temple on the Capitoline Hill, thus making an urban center out of what had been little

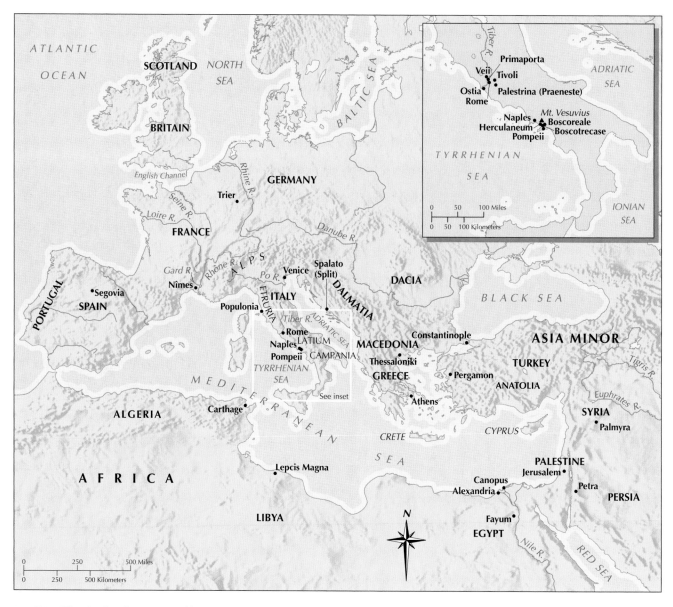

Map 7.1. The Ancient Roman World

more than a group of villages. The kings established many of Rome's lasting institutions, such as the priesthoods and the Roman techniques of warfare. In about 509 BCE, according to literary sources, the Romans expelled the last of the Etruscan kings. During the following century, the Roman elite gradually established the Republic, with an unwritten constitution.

Under the Republic, a group of elected magistrates, headed by two consuls, and with a Senate serving as an advisory council, managed the affairs of the growing state. A series of popular uprisings lasting over the next 200 years led to greater rights and representation for the nonelite. All Roman men who owned the required level of property were obliged to enter the army, and indeed military service was a prerequisite for political office. During the course of the Republic, Rome gradually took control of the Italian peninsula. First Rome and its ally, the Latin League, destroyed the southern Etruscan city of Veii in 396 BCE. The Gauls, from the north, sacked Rome in 390 BCE,

but this seems only to have spurred Rome on to greater conquest. More than 40 years later, the Latin cities lost their independence, and by 275 BCE Rome controlled all of Italy, including the Greek colonies of the south. It soon engaged in the first of the three Punic (Latin for "Phoenician") Wars against the North African city of Carthage. The wars ended with the decisive razing of the city in 146 BCE. During the second century all of Greece and Asia Minor also came under Roman control. This led to the dramatic influx of Greek art and culture into Rome.

From about 133 BCE to 31 BCE, the Late Republic was in turmoil. Factional politics, mob violence, assassination, and competition among aristocratic families, led to the breakdown of the constitution and to civil war. Julius Caesar became perpetual dictator in 46 BCE, a position that other senators were unable to tolerate. Two years later, he was assassinated in Rome's Senate house. His heir, Octavian, took vengeance on the assassins, Brutus and Cassius, and then eliminated his own

Recognizing Copies: The Case of the Laocoön

In one of the most powerful passages of the *Aeneid*, Vergil describes the punishment of Laocoön. According to legend, Laocoön was a priest at the time of the Trojan War. He warned the Trojans against accepting the wooden horse, the famous gift that hid invading Greeks within. The goddess Minerva, on the side of the Greeks, punished Laocoön by sending two giant serpents to devour him and his sons. Vergil describes the twin snakes gliding out of the sea to the altar where Laocoön was conducting a sacrifice, strangling him in their terrible coils, turning sacrificer into sacrificed. (See end of Part I *Additional Primary Sources*.)

In January of 1506, a sculptural group depicting Laocoön and his sons writhing in the coils of snakes was unearthed on the Esquiline Hill in Rome. Renaissance humanists immediately hailed the group as an original Greek sculpture describing this brutal scene. It was, they thought, the very sculpture praised by Pliny the Elder in his *Natural History* (completed in 77 CE). Pliny believed the Laocoön that stood in Titus' palace to be the work of three sculptors from Rhodes: Hagesandros, Polydorus, and Athenodorus. Within the year after its discovery on the Esquiline Hill, the group had become the property of Pope Julius II, who installed it in his sculpture gallery, the Belvedere Courtyard in the Vatican. The sculpture quickly became a focus for contemporary artists, who both used it as a model and struggled to restore Laocoön's missing right arm (now bent behind him in what is considered the correct position). Its instant fame derived in part from the tidy convergence of the rediscovered sculpture with ancient literary sources: The masterpiece represented a dramatic moment in Rome's greatest epic and was described by a reputable Roman author.

The Laocoön group caught the rapt attention of the eighteenth-century art historian J. J. Winckelmann (see *The Art Historian's Lens*, page 156). He recognized a powerful tension between the subjects' agonizing death throes and a viewer's pleasure at the work's extraordinary quality. Such was his admiration that he could only see the piece as a Classical work, and dated it to the fourth century BCE; any later and it would be Hellenistic, a period that he characterized as a time of artistic decline. So began a wide debate on not only the date of the sculpture but also its originality. For many scholars, the writhing agony of the Trojan priest and his sons bears all the hallmarks of the Hellenistic baroque style, as seen in the gigantomachy (the war between gods and giants) of the Great Altar of Zeus at Pergamon (see figs. 5.73 and 5.74). A masterpiece of the Hellenistic style, it should date to the third or second century BCE. On the other hand, evidence from inscriptions links the three artists named by Pliny to sculptors at work in the mid-first century BCE, making the

sculpture considerably later and removing it from the apogee of the Hellenistic age. Yet there are cases of artists' names being passed down through several generations, and it is not at all clear that the group is in fact the sculpture Pliny admired.

Pliny specified that Laocoön was sculpted from a single piece of marble, and this sculpture is not; even more telling is the fact that a slab of Carrara marble—which was not available until the reign of Augustus (r. 27 BCE–14 CE)—is incorporated into the altar at the back. Is the sculpture then an early imperial work? Or is this much-lauded masterpiece a Roman copy of a Hellenistic work? If so, does that reduce its status? As if this were not debate enough, a recent contention takes Laocoön out of the realm of antiquity altogether, identifying it instead as a Renaissance work by none other than Michelangelo. Evidence cited includes a pen study by the artist depicting a male torso resembling Laocoön's, dating to 1501. At this point, all that can be said with certainty about Laocoön is that the tidy picture imagined by sixteenth-century admirers has become considerably murkier.

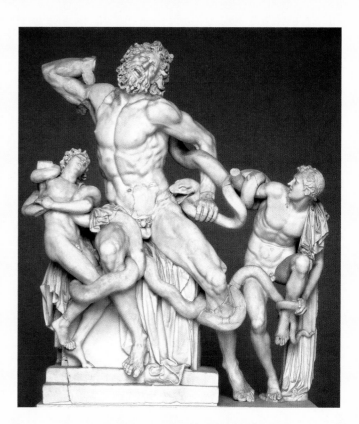

Laocoön Group, 1st century CE. Marble. Height 7′ (2.1 m). Musei Vaticani, Museo Pio Clementino, Cortile Ottagono, Città del Vaticano, Rome

rival for power, Mark Antony. In 27 BCE, the Senate named Octavian as Augustus Caesar, and he became *princeps*, or first citizen. History recognizes him as the first Roman emperor. During the course of the Republic, and continuing into the Empire, magistrates commissioned works of architecture and sculpture to embellish the city as well as to enhance their own careers. Designs of both architecture and sculpture were strongly influenced by conquests abroad and by the development of new building technologies in Rome.

Architecture: The Concrete Revolution

It is probably fair to say that Roman architecture has had a more lasting impact on western building through the ages than any other ancient tradition. It is an architecture of power, mediated through the solidity of its forms, and through the experience of those forms. Roman builders were clearly indebted to Greek traditions, especially in their use of the Doric, Ionic, and Corinthian styles, yet the resultant buildings were decidedly Roman.

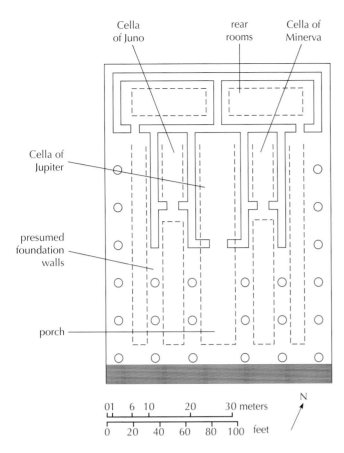

Cella of Juno rear rooms Cella of Minerva

Cella of Jupiter

presumed foundation walls

porch

01 6 10 20 30 meters

0 20 40 60 80 100 feet

N

7.1. Restored plan of Temple of Jupiter Optimus Maximus, Capitoline Hill, Rome. Dedicated ca. 509 BCE

The great Temple of Jupiter Optimus Maximus on the Capitoline Hill was the first truly monumental building of Rome (fig. **7.1**). Its construction began under two sixth-century BCE kings, Tarquinius the Ancient and Tarquinius the Proud, but the temple was dedicated by one of Rome's first consuls. The temple was built on a monumental scale, new to the Italian peninsula, but evoking the massive Ionic temples of eastern Greece. It stood on a high masonry platform, with steps leading up to the facade. Six wooden columns marked the front, and six columns flanked each side. Two rows of columns supported the roof over a deep porch. Later Roman historians tell us that an Etruscan artist, Vulca of Veii, crafted a vast terra-cotta acroterion for the peak of the pediment, representing Jupiter in a four-horse chariot. Three parallel cellas with walls of wood-framed mud brick accommodated cult statues of Jupiter, Juno, and Minerva, and recent excavations suggest that there were two additional rooms arranged across the rear, accessed from the lateral colonnades. Greek influence is evident in the rectilinear forms, the use of columns, and a gabled roof; yet the high podium and the emphatic frontal access set it apart. These features would characterize most Roman temples in the following centuries.

Although the practice of borrowing Greek forms began early in the Republic, it was particularly marked during the period of Rome's conquest of Greece, when architects imitated Greek building materials as well as essential architectural forms. After celebrating a triumph over Macedonia in 146 BCE, the general Metellus commissioned Rome's first all-marble temple and

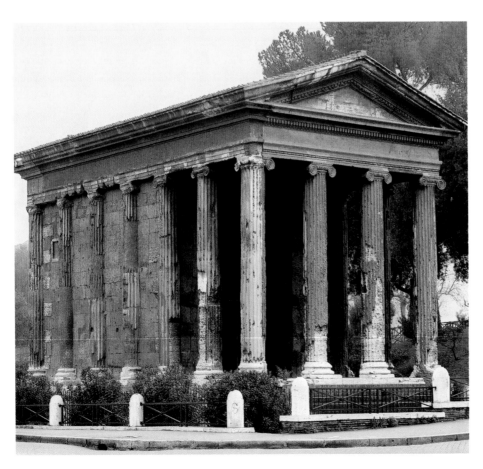

7.2. Temple of Portunus, Rome. ca. 80–70 BCE

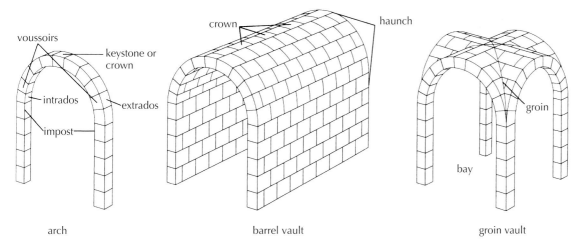

7.3. Arch, barrel vault, and groin vault

hired a Greek architect, Hermodorus, for the job. It no longer survives, but was probably close in form to the remarkably well-preserved temple to the harbor god Portunus, near the Tiber, often misnamed the Temple of Fortuna Virilis (fig. **7.2**). Dating from 80 to 70 BCE, the temple is in the Italic style: It stands on a podium, and engaged lateral columns (instead of a true peristyle) emphasize the frontal approach. All the same, the Ionic columns have the slender proportions of Classical Greek temples, and a white marble stucco covering their travertine and tufa shafts, bases, and capitals deliberately evoked the translucent marbles used by Greek architects.

Roman architects quickly combined the rectilinear forms so characteristic of Greek architecture with the curved form of the **arch** (fig. **7.3**). An arch might be free-standing, a monument in its own right, or applied to a building, often to frame an entrance. True arches are assembled with wedge-shaped voussoirs, as seen in the Etruscan Porta Marzia at Perugia (see fig. 6.13), and are extremely strong, in contrast to corbeled arches (see fig. 4.20). Voussoir arches were not a Roman or an Etruscan invention: Egyptian builders had used them, as well

as their extension, the **barrel vault,** as early as about 2700 BCE, but mainly in underground tombs and utilitarian buildings, rather than for monumental public buildings. Mesopotamian builders employed them for city gates and perhaps other purposes as well, and Greeks architects used them for underground structures or simple gateways. The Romans, however, put them to widespread use in public buildings, making them one of the hallmarks of Roman building.

It was the development of concrete, however, that was a catalyst for the most dramatic changes in Roman architecture. Concrete is a mixture of mortar and pieces of aggregate such as tufa, limestone, or brick. At first, Roman architects used it as fill, between walls or in podiums. Yet on adding *pozzolana* sand to the mortar, they discovered a material of remarkable durability (which would even cure under water), and they used it with growing confidence from the second century BCE onward. Despite its strength, it was not attractive to the eye, and builders concealed it with facings of stone, brick, and plaster (fig. **7.4**). These facings had no structural role. They changed with the passing years, and therefore provide archeologists

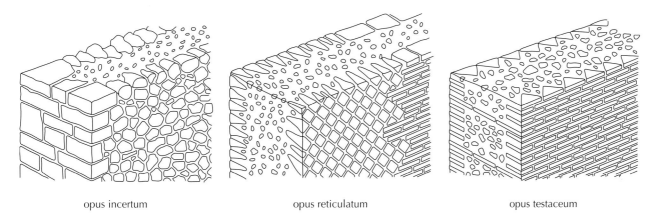

opus incertum opus reticulatum opus testaceum

7.4. Diagram illustrating Roman concrete facings. Left: *opus incertum*, used mainly in 2nd to early 1st centuries BCE. Middle: *opus reticulatum*, used in 1st century BCE and 1st century CE. Right: *opus testaceum*, used from mid-1st century CE onward

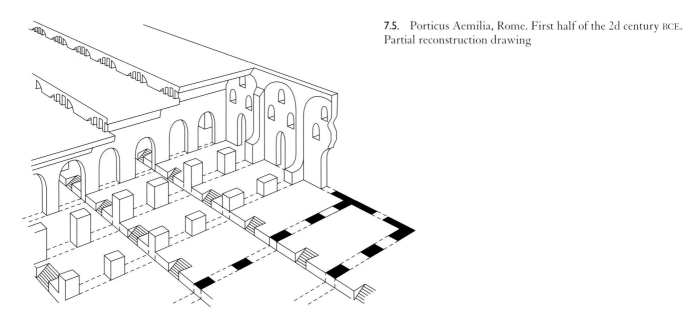

with an invaluable tool for dating Roman buildings. The advantages of concrete were quickly evident: It was strong and cheap, and could be worked by relatively unskilled laborers. It was also extraordinarily adaptable. By constructing wooden frameworks into which the concrete would be poured, builders could mold it to shapes that would have been prohibitively time-consuming, if not outright impossible to make using cut stone, wood, or mud brick. In a sense, the history of Roman architecture is a dialogue between the traditional rectilinear forms of the Greek and early Italic post-and-lintel traditions on the one hand, and the freedoms afforded by this malleable material on the other.

Two quite different Republican structures demonstrate concrete's advantages. The Porticus Aemilia of the early second century BCE is the earliest known building in Rome constructed entirely of concrete. Named after the magistrates who contracted for its earliest phase, it was a huge warehouse in Rome's commercial port area, used to sort and then store goods offloaded from river boats. Its dimensions were simply staggering: It stretched 1,600 Roman feet along the Tiber and was 300 feet deep. As the partial reconstruction in figure **7.5** illustrates, the architects took advantage of the new material to create a remarkably open interior space. Soaring barrel vaults roofed 50 transverse corridors, built in four rising sections to accommodate the sloping terrain. Arches pierced the walls supporting the vaults, so that workers could see easily from one storage area to the next, and air could circulate freely.

East of Rome, in the foothills of the Apennines, the town of Palestrina (ancient Praeneste) was home to another masterpiece of concrete construction (figs. **7.6** and **7.7**). The spectacular

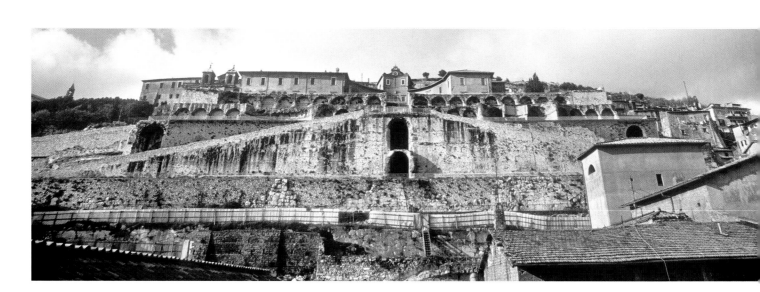

7.6. Sanctuary of Fortuna Primigenia, Praeneste (Palestrina). Early 1st century BCE

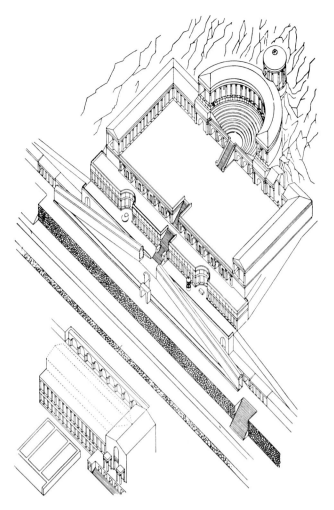

7.7. Axonometric reconstruction of the Sanctuary of Fortuna Primigenia, Praeneste

sanctuary to the goddess Fortuna Primigenia, dated to the late second or early first century BCE, was an oracular center where priests interpreted divine will by drawing lots. Here, architects used concrete to mold structures over the entire surface of a hillside and to craft spaces that controlled and heightened a visitor's experience. The sanctuary ascended in seven levels. At the bottom stood an early temple, a basilica (see page 224), and a senate house for civic meetings. The upper terraces rose in a grand crescendo around a central axis, established by a series of statue niches and staircases. A visitor climbed lateral staircases to the third terrace, where steep covered ramps, roofed with sloping barrel vaults, led upward. A bright shaft of daylight beckoned from the end of the ramp, where an open landing provided the first of several stunning views across the countryside.

On the fourth level were the altars, framed within colonnaded *exedrae*. Barrel vaults roofed the colonnades, inscribing a half-circle both horizontally and vertically (*annular* barrel vaults). Their curved forms animate the straight lines, since columns set in a semicircle shift their relationship to the environment with every step a visitor takes. A wide central staircase leads still farther upward to the next level. After the confinement of the ramps, its steps were exposed, giving a sense of vulnerability. On this level were shops, where sou-

venirs and votive objects were probably on sale. A visitor on this terrace stood directly over the voids of the barrel vaults below, suggesting a tremendous confidence in the structure. The next terrace was a huge open court, surrounded on three sides by double colonnades. The visitor continued to a small theater topped by a double annular colonnade. Here religious performances took place against the magnificent backdrop of the *campagna* beyond, and in full sight of the goddess, whose circular temple crowned the complex. Its diminutive size drew grandeur from the vast scale of the whole—all accomplished with concrete. The hugely versatile material plays easily with the landscape, transforming nature to heighten a visitor's religious experience.

If scholars are correct in assigning the sanctuary's construction to the early first century BCE, it may well belong to the dictatorship of Sulla (82–79 BCE), who won an important civil war victory against his enemies at Palestrina. It is even possible that he commissioned the complex as an offering to Fortuna and a monument to his own fame. What is certain is that the first century BCE was a turning point in the use of architecture for political purposes. One of the most magnificent buildings of this time was the vast theater complex of Pompey, which would remain Rome's most important theater in antiquity.

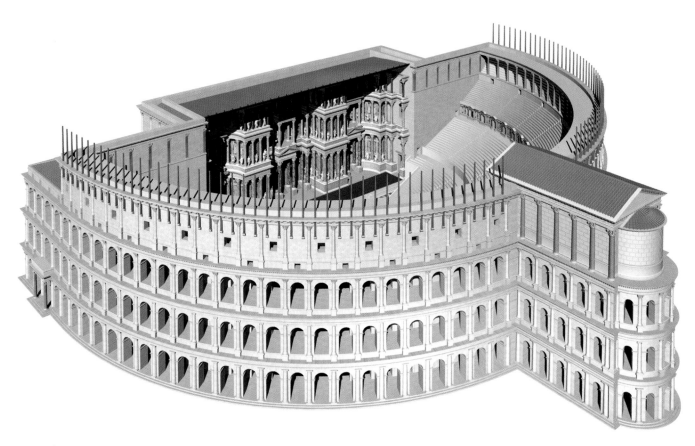

7.8. Theater Complex of Pompey, Rome. Dedicated in 55 BCE. Provisional reconstruction by James E. Packer and John Burge

Like Sulla, and Julius Caesar after him, Pompey maneuvered his way into a position of sole authority in Rome and used architecture to express and justify his aconstitutional power. To commemorate his conquests, he conceived of a theater on the Field of Mars, just outside the northern city boundary, dedicated to his patron goddess Venus Victrix (the Conqueror) (fig. **7.8**). Traces of its superstructure are embedded in later buildings on the site, and its curved form is still reflected in the street plan. Moreover, its ground plan is inscribed on an ancient marble map of the city, carved in the early third century CE, and new excavations directed by James Packer promise to uncover more of its vaulted substructure. The reconstruction in figure 7.8 is therefore provisional, a combination of archeological evidence and conjecture; it is likely to change as new evidence emerges. In some respects, Pompey's theater resembled its Greek forbears, with sloping banks of seats in a semicircular arrangement, a ground-level orchestra area, and a raised stage for scenery. In other significant ways, however, it was radically different. It was not, for instance, nestled into a preexisting hillside. Instead, the architect created an artificial slope out of concrete, rising on radially disposed barrel vaults, which buttressed one another for a strong structure. Concrete, in other words, gave the designer freedom to build independent of the

landscape. The curved seating *cavea*, moreover, was a true half-circle, rather than the extended half-circle of Greek theaters. At the summit of the cavea were three shrines and a temple dedicated to Venus. The curved facade held statues personifying the nations Pompey had subdued. Beyond the theater, and adjoining it behind the stage building, porticoes defined a vast garden containing valuable works of art, such as sculptures, paintings, and tapestries, many of which had been brought to Rome from Greece. These public gardens were Pompey's gift to the people of Rome—an implicit way of winning favor.

Pompey's theater-portico complex dwarfed the smaller, scattered buildings that individual magistrates had commissioned up to that point. It was also Rome's first permanent theater. As in Greece, plays were an essential component of religious ceremonies, and the buildings that accommodated them had always been built of wood, assembled for the occasion and then dismantled. In fact, elite Romans spoke out against the construction of permanent theaters on moral grounds. Pompey circumvented such objections by claiming that his theater was merely an appendage to the temple of Venus at its summit, and in building the complex he set the precedent for the great forum project of Julius Caesar, and the imperial fora that would follow (see page 203).

Sculpture

RELIEF SCULPTURE Like architecture, sculpture often commemorated specific events, as it did in the ancient Near East (see figs. 2.20 and 2.21). Classical Greek sculpture disguised historical events in mythical clothing—a combat of Lapiths and Centaurs, for instance, or Greeks and Amazons (see figs. 5.44, 5.45, and 5.47)—and this convention broke down only slightly in the Hellenistic period. The Romans, by contrast, did represent actual events, developing a form of sculpture long known as historical relief—although many were not historically accurate. The reliefs shown in figure **7.9** probably decorated a base for a statuary group, which scholars place near the route of triumphal processions through Rome. Once known as the Altar Base of Domitius Ahenobarbus, it is now sometimes called the Base of Marcus Antonius. One long sec-

tion shows a *census*, a ceremony during which individuals recorded property with the state to establish qualification for military service. On the left side, soldiers and civilians line up to be entered into the census. Two large figures flanking an altar represent a statue of Mars, god of war, and the officiating censor, who probably commissioned the monument. Attendants escort a bull, a sheep, and a pig to sacrifice at an altar, marking the closing ceremony of the Census.

Belonging to the same monument, the remaining reliefs depict a *thiasos* (procession) across the sea for the marriage of the sea-god Neptune and a sea-nymph, Amphitrite. But these reliefs are in an entirely different style. The swirling motion of the marriage procession and its Hellenistic forms contrast dramatically with the overwhelmingly static appearance of the census relief and the stocky proportions of its figures. Moreover, the

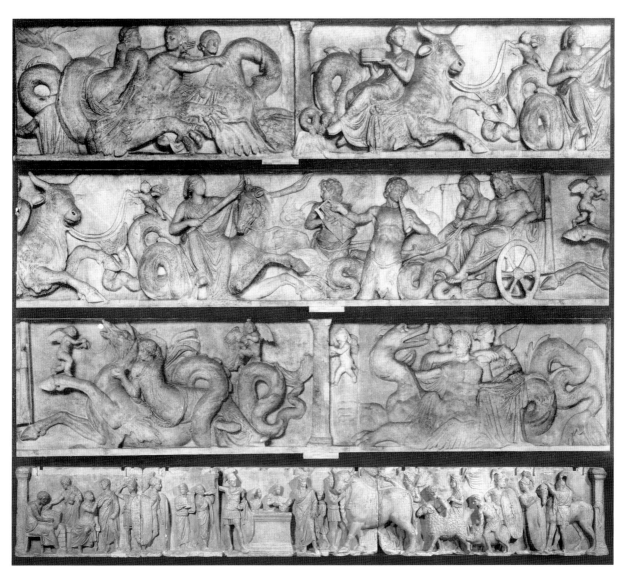

7.9. Sculptural reliefs from statue base, showing sea thiasos and census. So-called Altar of Domitius Ahenobarbus or Statue Base of Marcus Antonius. Late 2d to early 1st century BCE. Marble. Musée du Louvre, Paris, and Glyptothek, Staatliche Antikensammlungen, Munich

Cicero (106–43 BCE)

Letters to Atticus I. 9–10 (67 BCE, Rome)

Marcus Tullius Cicero was a leading politician and orator in Rome during the turbulent days of the late Republic. He is known through his extensive writings, which include orations, rhetorical and philosophical treatises, and letters. Like many other Roman statesmen, he filled his many houses and villas with works of Greek art, either original or copied. Atticus was his childhood friend, who maintained communication with Cicero after moving to Athens and served as his purchasing agent for works of art.

IX

Cicero to Atticus, Greeting

Your letters are much too few and far between, considering that it is much easier for you to find someone coming to Rome than for me to find anyone going to Athens. Besides, you can be surer that I am at Rome than I can be that you are in Athens. The shortness of this letter is due to my doubts as to your whereabouts. Not knowing for certain where you are, I don't want private correspondence to fall into a stranger's hands.

I am awaiting impatiently the statues of Megaric marble and those of Hermes, which you mentioned in your letter. Don't hesitate to send anything else of the same kind that you have, if it is fit for my Academy. My purse is long enough. This is my little weakness; and what I want especially are those that are fit for a Gymnasium. Lentulus promises his ships. Please bestir yourself about it. Thyillus asks you, or rather has got me to ask you, for some books on the ritual of the Eumolpidae.

SOURCE: *CICERO, LETTERS TO ATTICUS*, IN 3 VOLS. TR. BY E.O. WINSTEDT (1912–1918)

panels are carved out of different marbles. Scholars suppose that the sea-thiasos sections were not original to this context, but were brought as spoils from Greece to grace a triumphal monument—proof, as it were, of conquest. The census relief, by contrast, was carved in Rome to complement the thiasos. Together, the reliefs may represent the patron's proud achievements.

FREE-STANDING SCULPTURE Romans put Greek sculpture to other uses as well. In a series of letters, Cicero, a lawyer and writer of the mid-first century BCE, asks his friend Atticus in Athens to send him sculptures to decorate his villa. (See *Primary Source*, above.) Requests such as this, scholars believe, were not unusual: The gradual conquest of Greece in the second century BCE had led to a fascination with Greek works of art, which had flooded into Rome as booty. So intense was the fascination, in fact, that in the late first century BCE, the poet Horace commented ironically, "Greece, having been conquered, conquered her wild conqueror, and brought the arts into rustic Latium." Paraded through the streets of Rome as part of the triumphal procession, the works of art ended their journey by decorating public spaces, such as the Theater Portico of Pompey (see fig. 7.8).

These glistening bronze and marble works provoked reaction. For most, it seems, they were a welcome sign of Rome's cultural advance, more visually pleasing than indigenous sculptures in less seductive materials like terra cotta. A few strident voices spoke out against them. Most vociferous was Cato ("The Moralist"), for whom traditional Roman art forms symbolized the staunch moral and religious values that had led to, and justified, Rome's political ascent. Whatever his objections, elite Romans assembled magnificent collections of Greek art in their homes, and through their display they could give visual expression to their erudition. The Villa of the Papyri in Herculaneum preserved an extensive collection *in situ*, partially reconstructed in the Getty Museum in Malibu, California. When Greek originals were not available, copyists provided alternatives in the styles of known Greek artists. (See *Materials and Techniques*, page 188 and *The Art Historian's Lens*, page 179.) The stylistic borrowings also had a bold political dimension, showing that Rome had bested the great cultures of Greece.

PORTRAIT SCULPTURE Literary sources reveal that the Senate and People of Rome honored successful political or military figures by putting their statues on public display, often in the Roman Forum, the civic heart of the city. The custom began in the early Republic and continued until the end of the Empire. Many of the early portraits were bronze and have perished, melted down in later years for coinage or weaponry. A magnificent bronze male head dating to the late fourth or early third century BCE, a mere fragment of a full-length figure, gives a tantalizing sense of how these statues once looked (fig. **7.10**). At the time of its discovery in the sixteenth century, antiquarians dubbed it "Brutus," after the founder and first consul of the Republic. Strong features characterize the over-life-size portrait: a solid neck, a square jaw accentuated by a short beard, high cheek-bones, and a firm brow. The image derives its power not from Classical idealization or the stylized qualities of, for instance, the portrait of an Akkadian ruler (see fig. 2.12), but from the creases and furrows that record a life of engagement. The slight downward turn of the head may indicate that it once belonged to an equestrian portrait, raised well above a viewer.

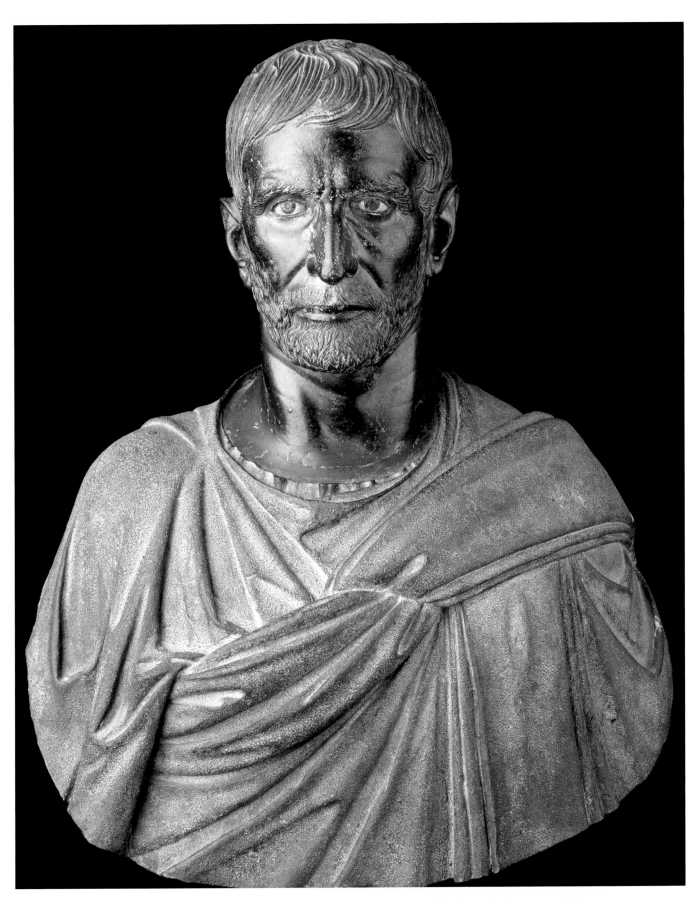

7.10. *Brutus.* Late 4th or early 3rd century BCE. Bronze. Slightly over life-size. Museo del Palazzo dei Conservatori, Rome

Copying Greek Sculptures

In order to satisfy a growing demand for Greek sculptures, artists set up copying workshops in Athens and Rome, where they produced copies of famous "masterpieces." Some of these copies may have been relatively close replicas of the originals; others were adaptations, where the copyist's own creativity came freely into play. Given the paucity of surviving Greek originals, it is often difficult for scholars to determine the appearance of the original, and thus to distinguish replica from adaptation. One clue to recognizing a marble copy (a true replica or a free adoption) of a bronze original is to look for the use of struts to strengthen the stone, since marble has a different tensile strength from bronze (see the tree trunk and the strut at the hip in fig. 5.33).

Scholars have long believed that Roman copyists used a pointing machine, similar to a kind that was used in the early nineteenth century, but evidence from unfinished sculptures now suggests a different technique, known as triangulation, using calipers. By establishing three points on the model, and the same three points on a new block of stone, an artist can calculate and transfer any other point on the model sculpture to a new place on the copy. The sculptor takes measurements from each of the three points on the original to a fourth new point, and, using those measurements, makes arcs with the calipers from each of the three points on the new block of stone. Where the arcs intersect is the fourth point (see figure) on the copy. In order to alter the scale from original to copy, the artist simply multiplies or divides the measurements. Having taken a number of points in this way, the sculptor cuts away the stone between the points, using a chisel. The accuracy of the resultant copy depends upon how many points the sculptor takes.

The triangulation process

The majority of Republican portraits date to the end of the second century and the first century BCE, and were carved from stone. Most represent men at an advanced age (fig. **7.11**). Wrinkles cover their faces, etching deep crags into their cheeks and brows. Distinguishing marks—like warts, a hooked nose, or a receding hairline—are played up rather than smoothed over. In the example illustrated here, the man's bald head was once covered, suggesting that he was represented as a priest. Although there is no way of knowing what the sitter looked like, the images appear overly realistic, so that scholars term the style **veristic**, from the Latin *verus*, meaning "true." For a twenty-first-century viewer, these images are anything but idealized. Yet it is worth bearing in mind that each culture constructs its own ideals. To Romans, responsibility and experience came with seniority, and most magistracies had minimum age requirements. An image marked by age therefore conveyed the requisite qualities for winning votes for political office.

Where the impetus to produce likenesses came from is a mystery that scholars have been anxious to solve. Some trace it to a Greek custom of placing votive statues of athletes and other important individuals in sacred precincts, and indeed some Roman portraits were executed in a Hellenic style. Hellenistic ruler portraits played a part too; portraits of Pompey have the

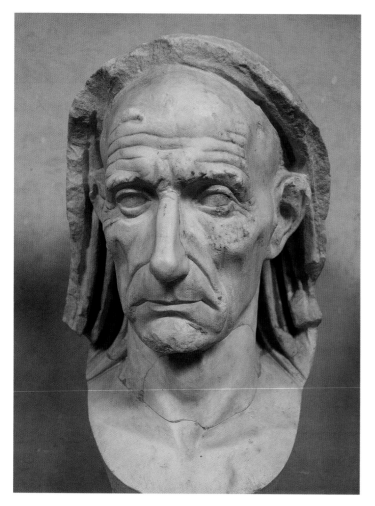

7.11. Veristic male portrait. Early 1st century BCE. Marble. Life-size. Musei Vaticani, Rome.

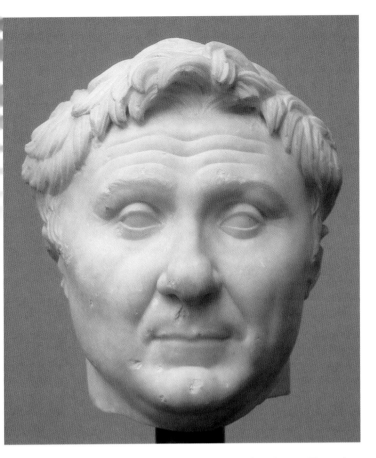

7.12. *Pompey*. Claudian copy of a portrait of ca. 50 BCE. From the Licinian tomb on Via Salaria, Rome. Ny Carlsberg Glyptothek, Copenhagen

ART IN TIME

ca. 509 BCE—The Romans turn against the monarchy, expelling the last kings

ca. 484–425 BCE—Life of the Greek historian Herodotus

ca. 300 BCE—**Roman bronze head, *Brutus***

by 275 BCE—All of Italy controlled by Rome

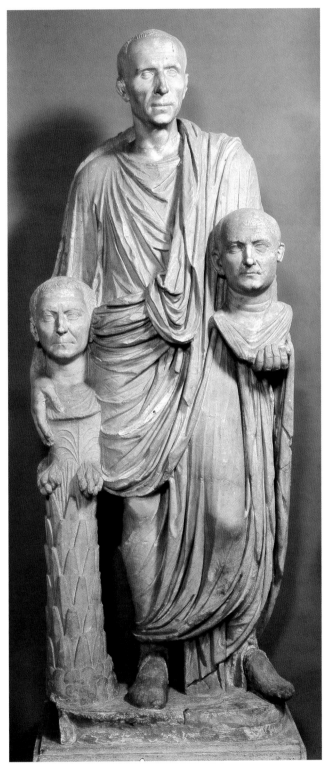

7.13. Togate male portrait with busts. Late 1st century BCE. Marble. Life-size. Museo Montemartini, Rome

tousled hair of Alexander the Great, and his trademark cowlick, to evoke the youthful leader's charisma (fig. **7.12**, and see fig. 5.70). For others, its roots lie in an Italic practice of storing ancestral masks in the home to provide a kind of visual genealogy, in a society where a good pedigree was the most reliable stepping-stone to success in a public career. Polybius, a Greek historian of the mid-second century BCE, recounts that before burying a family member, living relatives would wear these ancestral masks in a funerary procession, parading the family's history in front of bystanders (See *Primary Source*, page 190). His words have often been used to explain the statue illustrated in figure **7.13**, representing a male figure in a toga carrying two portrait busts. Yet, although the sculpture probably *is* commemorative, the three-dimensional busts are quite distinct from masks. Somewhat ironically, the figure's own head does not belong to the statue, but comes from another sculpture altogether.

Scholars can rarely give a name to individuals portrayed in this type of Republican portrait. Inscriptions identifying the subject are scarce, and the coin portraits that help to identify later public figures only appear from the mid-first century BCE on. By contrast, we can readily identify individuals represented in a related class of monument. In the late Republic and Augustan periods, emancipated slaves commissioned group portraits in relief, which

Polybius (ca. 200–ca. 118 BCE)

Histories, from Book VI

Polybius was a Greek historian active during the Roman conquest of his homeland. His Histories *recount the rise of Rome from the third century* BCE *to the destruction of Corinth in 146* BCE. *In Book VI he considers cultural and other factors explaining Rome's success.*

Whenever any illustrious man dies, ... they place the image of the departed in the most conspicuous position in the house, enclosed in a wooden shrine. This image is a mask reproducing with remarkable fidelity both the features and complexion of the deceased. On the occasion of public sacrifices they display these images, and decorate them with much care, and when any distinguished member of the family dies they take them to the funeral, putting them on men who seem to them to bear the closest resemblance to the original in stature and carriage. These representatives wear togas, with a purple border if the deceased was a consul or praetor, whole purple if he was a censor, and embroidered with gold if he had celebrated a triumph or achieved anything similar. They all ride in chariots preceded by the fasces, axes, and other insignia ... and when they arrive at the rostra they all seat themselves in a row on ivory chairs. There could not easily be a more ennobling spectacle for a young man who aspires to fame and virtue. For who would not be inspired by the sight of the images of men renowned for their excellence, all together and as if alive and breathing? ... By this means, by this constant renewal of the good report of brave men, the celebrity of those who performed noble deeds is rendered immortal. ... But the most important result is that young men are thus inspired to endure every suffering for the public welfare in the hope of winning the glory that attends on brave men.

SOURCE: *POLYBIUS: THE HISTORIES*, VOL. 3, TR. BY W.R. PATON (CAMBRIDGE, MA: HARVARD UNIVERSITY PRESS, 1923)

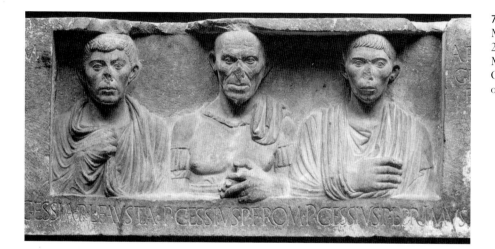

7.14. Funerary relief of the Gessii. ca. 50 BCE. Marble. Height × width × depth, $25^9/_{16} \times 80^1/_2 \times 13^3/_8''$ (65 × 204.5 × 34 cm). Museum of Fine Arts, Boston, Archibald Cary Coolidge Fund. Photograph © 2006, Museum of Fine Arts, Boston. 37.100

they mounted on roadside funerary monuments (fig. **7.14**). The figures are usually shown in shoulder-length truncated busts, surrounded by a long rectangular frame. The very fact that they are depicted visually reflects their freed status; other visual cues reinforce it, such as a ring, either painted or carved on a man's hand, or the joined right hands of a man and woman, symbolizing marriage, which was not legal among slaves. An inscription names the figures and records their status as freed persons. In this example, the freed slaves' one-time owner appears in the center of the relief.

Painting

Lamentably few free-standing portraits come from known archeological contexts. As well as placing portraits in homes and public places, Romans appear to have displayed them in tombs. Tombs were more than just lodging places for the dead. They were the focus of routine funerary rituals, and during the course of the Republic they became stages for displaying the feats of ancestors in order to elevate family status. Paintings, both inside and out, served this purpose well.

A tomb on the Esquiline Hill in Rome yielded a fragmentary painting of the late fourth or early third century BCE, depicting scenes from the conflict between the Romans and a neighboring tribe, the Samnites (fig. **7.15**). A toga-clad figure

7.15. Esquiline tomb painting. Late 4th or early 3rd century BCE. $34^1/_2 \times 17^3/_4''$ (87.6 × 45 cm). Museo Montemartini, Rome

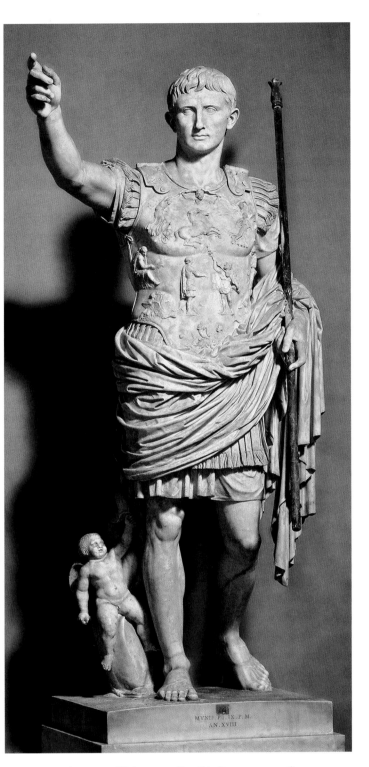

7.16. *Augustus of Primaporta.* Possibly Roman copy of a statue of ca. 20 CE. Marble. Height 6′8″ (2.03 m). Musei Vaticani, Braccio Nuovo, Rome

the subject matter to the relief sculptures discussed previously. Literary sources state that Roman generals made a practice of commissioning panel paintings of their proudest military moments, which they might display in a triumphal procession before installing them in a public building such as a temple.

THE EARLY EMPIRE

The last century of the Republic witnessed a gradual breakdown of order in Rome, as ambitious individuals vied for sole authority in the city. Julius Caesar's assassination on the Ides of March of 44 BCE was a last-ditch effort to safeguard the constitution. In 27 BCE, the Senate declared Octavian as Augustus Caesar. Insisting that the Republic was restored, he ushered in a new era of peace. In fact, with Augustus, monarchy was reintroduced to Rome, and would endure through several dynasties, with only periodic challenges, until the gradual transfer of power to Constantinople (beginning in about 330 CE). The birth of the Roman Empire brought a period of greater stability to the Mediterranean region than had previously been known. Roman domination continued to spread, and at its largest extent in the time of Trajan (98–117 CE) the Empire stretched through most of Europe, as far north as northern England, through much of the Middle East including Armenia and Assyria, and throughout coastal North Africa. Romanization spread through these regions. Roman institutions—political, social, and religious—mingled with indigenous ones, leading to a degree of homogenization through much of the Roman world. Increasingly, the emperor and his family became the principal patrons of public art and architecture in Rome. Often, these public monuments stressed the legitimacy of the imperial family.

Portrait Sculpture

When Julius Caesar was assassinated, his adopted son and heir, Octavian, was only 18 years old. By the time he had avenged Caesar and overpowered Mark Antony and Cleopatra, he was no more than 35. The veristic portrait style so characteristic of the Republic would have done little to capture his youthful charisma; in fact, it might well have served to underline the aconstitutional nature of his authority in Rome. As Pompey had before him, Octavian turned instead to a more Hellenizing style. Until his death in his late seventies, his portraits depict him as an ageless youth, as seen in the Primaporta statue, discovered in the house of his wife Livia at Primaporta (fig. **7.16**).

on the upper right is labeled Quintus Fabius, and may have been the tomb's owner. He holds out a spear to the Samnite Fannius on the left, who wears golden greaves and loincloth. Behind Fannius is a crenelated city wall, and in the lower registers are scenes of battle and parlay. The labels in the upper register suggest that the images record specific events, relating

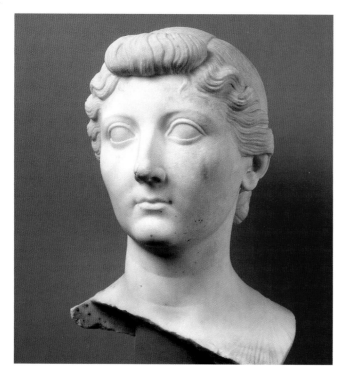

7.17. Portrait of Livia, from the Fayum. After 14 CE. Marble. Ny Carlsberg Glyptothek, Copenhagen

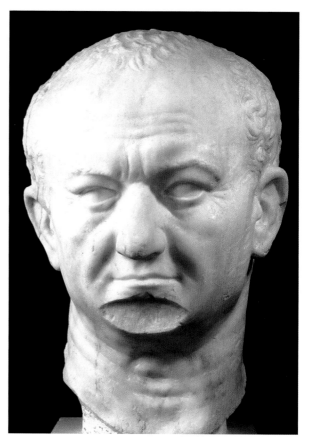

7.18. *Portrait of Vespasian.* ca. 75 CE. Marble. Life-size. Museo Nazionale Romano

The emperor appears in battle dress with his arm raised in a gesture of address. The portrait appears to combine a series of references to previous works of art and historical events in an effort to strengthen Augustus' claim to authority.

Both the contrapposto stance, and the smooth features of his face, are strongly reminiscent of Polykleitos' Doryphoros (see fig. 5.33). The resemblance is so strong that we can assume that Augustus turned deliberately to this well-known image. There was good reason for this kind of imitation: The Classical Greek style evoked the apogee of Athenian culture, casting Augustan Rome as Greece's successor (and conqueror) in cultural supremacy. The style was chosen for other members of the imperial family as well, such as Livia, whose portraits resemble images of Greek goddesses (fig. 7.17). Even Augustus' hair is similar to that of the Doryphoros—except, that is, at the front, where the locks part slightly over the center of the brow, a subtle reference to Alexander the Great, another youthful general, whose cowlick was such a distinctive feature of his portraits (see fig. 5.70).

Next to Augustus' right ankle, a cupid playfully rides a dolphin, serving as a strut to strengthen the marble. Most Romans would have recognized that Cupid, or Eros, the son of Venus, symbolized Augustus' claim of descent from the goddess of love through his Trojan ancestor Aeneas. The dolphin would

have evoked the sea, and specifically the site off the coast of Actium where Augustus had prevailed over Mark Antony and Cleopatra. By associating Augustus with historical or divine figures, these references projected an image of earthly and divinely ordained power, thereby elevating the emperor above other politicians.

The iconography of Augustus' breastplate serves a similar purpose by calling attention to an important diplomatic victory in 20 BCE, when the Parthians returned standards that they had captured, to Roman shame, in 53 BCE. A figure usually identified as Tiberius, Augustus' eventual successor, or the god Mars, accepts the Roman standards from a Parthian soldier, possibly Phraates IV, the Parthian king. Celestial gods and terrestrial personifications frame the scene, giving the event a cosmic and eternal significance. This diplomatic victory took on momentous proportions in Augustan propaganda. The scene suggests that the portrait dates to about 19 BCE. The emperor is barefoot, which usually denotes divine status. Later in the Roman period, or in the Eastern Empire, emperors might be depicted as gods while still alive, but with Caesar's legacy still fresh in Roman minds, it is not likely that Augustus would have been so presumptuous. Some scholars conclude that the statue is a posthumous copy of a bronze original dating to about 20 BCE.

The Primaporta Augustus offers a good example of a tendency in Roman art to express a message through references to earlier works. Naturally, not all Romans would have understood all the references in any given work, but the frequency of visual "quotations" suggests that Romans, like many other ancient peoples, were extremely visually astute. In fact, the history of Roman portraiture, as with many other branches of Roman art, is one of constant association with, and negation of, (or conscious turning away from) past images. Portraits of Augustus' dynastic successors, for instance, look very much like the first emperor from whom they drew their authority, even though they were rarely (or at best distantly) related by blood. With the emperor Vespasian, founder of the Flavian dynasty, there was a return to a more veristic style of portrait (fig. **7.18**). Scholars reason that this maneuver was part of a deliberate attempt to restore social order when he came into power in 69 CE, after a year of civil war. A soldier by background, Vespasian justified his authority through his military success, and appealed to the rank and file through this harshly matter-of-fact image. Several years later, Trajan's portraits revived the classicism associated with Augustus, imitating his full cap of hair and the smooth planes of his face, to portray a man frozen in eternal middle. age. His successor, Hadrian, took the Greek style even further. Nicknamed "The Greekling" for his admiration of Greek culture, he adopted the full beard that was characteristic of Greek philosophers (fig. **7.19**); ancient reports that he was trying to conceal scars from acne are unlikely to be

true. It was in his reign that sculptors began to carve the pupils and irises of the eyes, rather than painting them.

Imperial portraits such as these exist in great multitudes. On the whole, they fall into a number of types, suggesting that there was a master portrait, often executed for a specific occasion, that would be copied for dissemination within and outside of Rome; sculptors would copy these copies, in turn, leading to a ripple effect around the empire. Nonimperial portraits also survive in great numbers. Scholars can rarely identify them, but date them on the basis of similarities with members of the imperial family. When dealing with female portraits, hairstyles are especially useful since they change relatively rapidly. Livia's relatively simple coiffure, with a roll, or *nodus*, at the front (see fig. 7.17) is a far cry from the towering hairstyle of Domitia Longina, wife of Domitian, one of Vespasian's sons (fig. **7.20**). Built around a framework, her hair was a masterpiece in itself, and its representation in sculpture reflected her status, as well as affording the sculptor a valuable opportunity to explore contrasts of texture between skin and hair, and to drill deep into the marble for a strong play of light and shadow.

Beginning in the second half of the second century CE, Roman portraits gradually take on a more abstract quality. It is especially marked in the treatment of the eyes, whose heavy lids lend them a remote quality. This is perceptible in a spectacular gilded bronze portrait of Marcus Aurelius, which survived the melting pot in the medieval period because Christians misidentified it as Constantine the Great, champion

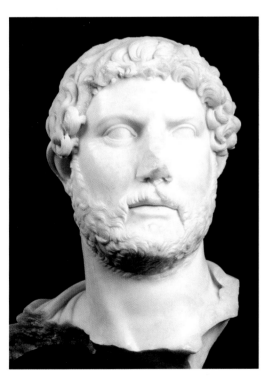

7.19. *Portrait of Hadrian.* After 117 CE. Marble. Museo Nazionale Romano, Rome

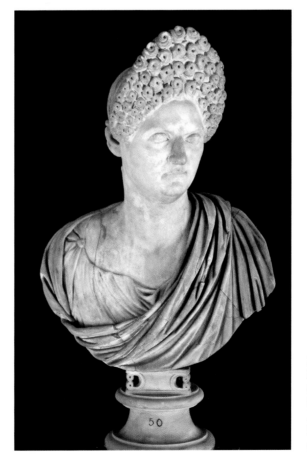

7.20. *Portrait of Domitia Longina.* Late 1st century CE. Marble. Height 2′ (.608 m). Courtesy of San Antonio Museum of Art, San Antonio, Texas. Gift of Gilbert M. Denman, Jr.

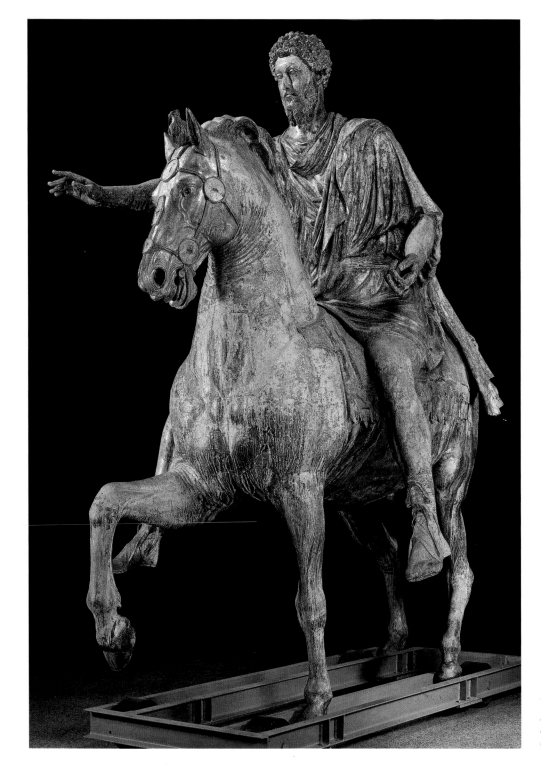

7.21. *Equestrian Statue of Marcus Aurelius.* 161–180 CE. Bronze, over–life-size. Museo del Palazzo dei Conservatori, Rome

of Christianity (fig. **7.21**). With one arm outstretched in a gesture of mercy, the emperor sits calmly astride a spirited horse, whose raised front leg once rested on a conquered barbarian. Like the portrait of Hadrian and the vast majority of second- and third-century male portraits, Marcus Aurelius is bearded. Like Hadrian, too, Marcus Aurelius was interested in philosophy, and his Stoic musings still survive as the "Meditations," and such abstract concerns are reflected in the sculpture of the time. For example, abstract qualities are clear in an exquisite marble portrait of Marcus Aurelius' wife Faustina the Younger (fig. **7.22**). While her features appear subtly idealized,

her eyelids fall in languid fashion over her pupils. The patterned, decorative treatment of her hair underlines the stylized quality of the whole. Just as Marcus Aurelius' military cloak establishes his public role as a general, so Faustina's tunic and cloak were signs of the modesty befitting a Roman matron. The empress bore her husband two sons, and they accompanied him on his military campaigns, thereby earning her the title Mother of the Camps. Her life embodied the cardinal feminine virtues, for which her husband later consecrated her a goddess: piety to home and family, as well as fertility, modesty, and fidelity.

Relief Sculpture

The Republican practice of commissioning narrative reliefs to record specific events continued well into the Empire. They were mounted on public buildings and monuments, such as the *Ara Pacis Augustae*, or Altar of Augustan Peace (fig. **7.23**). The Senate and People of Rome vowed the altar in 13 BCE on the occasion of Augustus' safe return from Spain and Gaul, and it was dedicated in 9 BCE. It stood inside a marble enclosure, which was open to the sky and richly sculpted over its entire surface. On east and west sides, flanking two entrances, relief panels represent allegorical figures, or personifications, and figures from Rome's legendary past. On the west end, a fragmentary panel shows a she-wolf suckling the infants Romulus and Remus, under the watchful eyes of the shepherd Faustulus, who discovered and adopted them. In a second relief, Aeneas (or perhaps, according to a recent interpretation, Numa, second

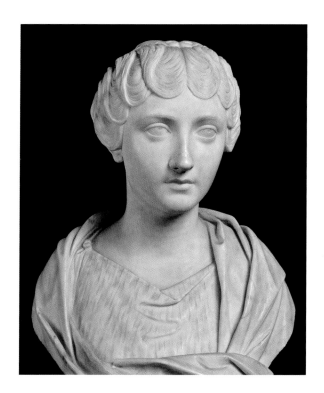

7.22. *Portrait of Faustina the Younger.* ca. 147–148 CE. Marble. Height 23⅝" (60 cm). Museo Capitolino, Rome.

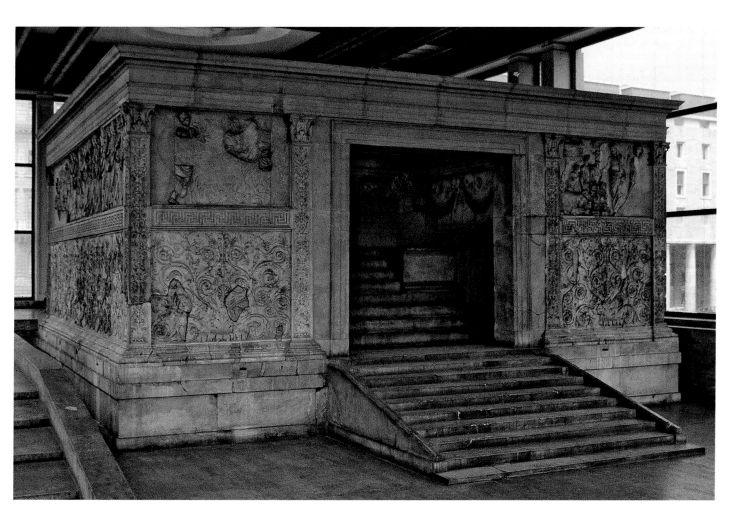

7.23. Ara Pacis Augustae, west facade. 13–9 BCE. Marble. Width of altar approx. 35′ (10.7 m). Museum of the Ara Pacis, Rome

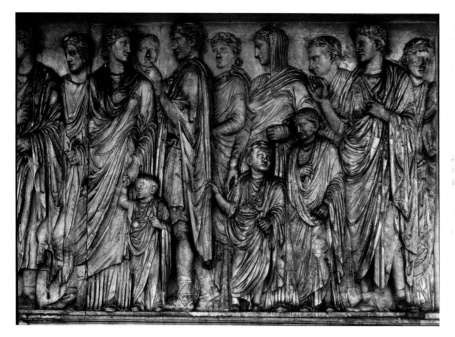

7.24. Ara Pacis Augustae, Imperial Procession south frieze. 13–9 BCE. Marble. Height 63″ (1.6 m). Rome

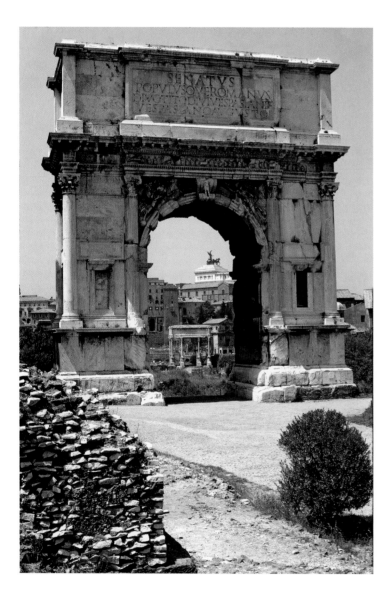

7.25. Arch of Titus, Rome. ca. 81 CE. Marble

king of Rome) makes a sacrifice at an altar of roughly hewn stones. At the east end, a relief depicting the goddess Roma seated on her weapons balances a panel with a female figure (the goddess Venus or Ceres, perhaps, or Peace, Iatlia, or Mother Earth) embodying the notion of peace. Together, the panels express the message of peace that Augustus was intent on promoting, in contrast with the bleakness of the preceding civil wars. The same message was implicit in the acanthus relief that encircles the enclosure in a lower register. Vegetation unfurls in rich abundance, populated with small creatures such as lizards and frogs.

On north and south sides, the upper register contains continuous procession friezes that portray specific members of the imperial family interspersed with the college of priests and senators (fig. **7.24**). The friezes seem to record a particular event—a sacrifice, perhaps, or the moment of the altar's dedication. A large gap in the relief falls exactly on the figure of Augustus, whose action, if depicted, would probably have revealed the occasion. Still, the friezes are significant for a number of reasons. In their superficial resemblance to the Greek Parthenon frieze (see figs. 5.46–5.48) they bear witness, once again, to the preference for Greek styles in the age of Augustus. They also include a number of eminent women from the imperial family,

including Livia, and small children. One scholar has convincingly argued that their inclusion represents the importance of family and dynasty, as well as a reference to moral legislation the emperor enacted to curb adultery and promote childbirth among the elite.

Reliefs also decorated free-standing arches. Triumphant generals first erected arches during the Republic, though no early examples survive. Through the ages, many of the arches celebrated triumphs, but they also served as commemorative monuments for the dead. Their enduring impact on western architecture is readily understandable: As with free-standing columns, their chief *raison d'être* was to express a visual message. Often they stood at or near an entrance to a public space, and framed the transition, or *liminal* area (from *limen*, Latin for "threshold") between one place and another. Many societies consider liminal spaces unsettling and in need of protection; the lamassu of Mesopotamia, one might note, guarded doorways (see fig. 2.19). The Arch of Titus, son and successor of Vespasian, stands at the far eastern end of the Roman Forum. It is the earliest surviving free-standing arch in Rome, though a good portion of it is the product of Valadier's restoration from 1822 to 1824 (fig. **7.25**). The arch may have been a triumphal monument, but given that its inscription and a small relief panel describe Titus specifically as a god, it is more likely that it commemorates his apotheosis (or divinization) after his death in 81 CE. Its principal sculptural relief panels are located within the bay, and both refer to the triumph after the conquest of Jerusalem in 70 CE. In one of them, soldiers carry booty through the streets, including a seven-branched menorah (a Jewish candelabra) and other sacred objects taken from the Temple in Jerusalem (fig. **7.26**). The panel marks an important move toward illusionism in the portrayal of space. Two ranks of figures appear, carved in different levels of relief. The sculptor cut the background figures in such shallow relief that they seem to fade into the distance. The procession breaks away abruptly at the sides, so that it seems to continue beyond a viewer's line of sight. On the right, it disappears through a triumphal arch, placed at an oblique angle to the background so that only the nearer half actually emerges in relief, giving the illusion of spatial depth. The panel even bulges out slightly at the center, so that it seems to turn right in front of a viewer situated inside the arch's bay, making the viewer a part of the action. In the other panel, Titus rides in triumph in a chariot, raised above a teeming crowd, signified, again, through differing levels of relief

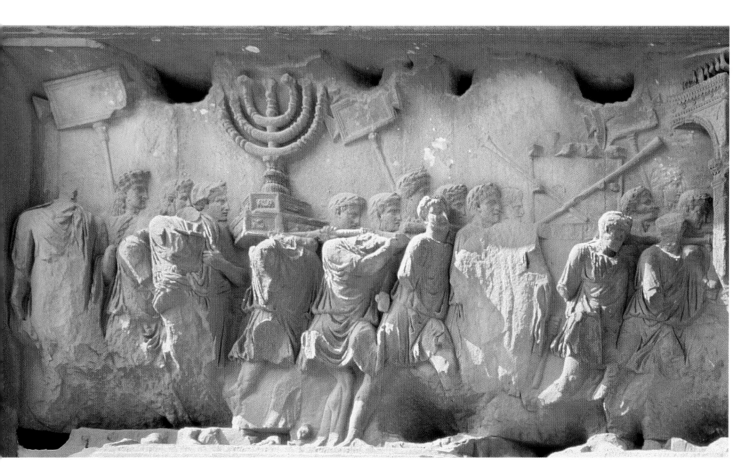

7.26. Relief in bay of Arch of Titus, showing procession of spoils from the Temple in Jerusalem. ca. 81 CE. Marble. Height 7′10″ (2.39 m). Rome

Josephus (37/8–ca. 100 CE)

The Jewish War, from Book VII

The Jewish soldier and historian Josephus Flavius was born Joseph Ben Matthias in Jerusalem. He was named commander of Galilee during the uprising of 66–70 CE against the Romans in the reign of Nero. After surrendering, he won the favor of the general Titus Flavius Sabinus Vespasian and took the name Flavius as his own. Josephus moved to Rome, where he wrote an account of the war (75–79 CE) and Antiquities of the Jews *(93 CE). The following passage from his history of the rebellion describes the triumphal procession into Rome following the Sack of Jerusalem in 70 CE, which is depicted on the Arch of Titus (figs. 7.26, 7.27).*

It is impossible to give a worthy description of the great number of splendid sights and of the magnificence which occurred in every conceivable form, be it works of art, varieties of wealth, or natural objects of great rarity. For almost all the wondrous and expensive objects which had ever been collected, piece by piece, from one land and another, by prosperous men—all this, being brought together for exhibition on a single day, gave a true indication of the greatness of the Roman Empire. For a vast amount of silver and gold and ivory, wrought into every sort of form, was to be seen, giving not so much the impression of being borne along in a procession as, one might say, of flowing like a river. Woven tapestries were carried along, some dyed purple and of great rarity, others having varied representations of living figures embroidered on them with great exactness, the handiwork of Babylonians. Transparent stones, some set into gold crowns, some displayed in other ways, were borne by in such great numbers that the conception which we had formed of their rarity seemed pointless. Images of the Roman gods, of wondrous size and made with no inconsiderable workmanship, were also exhibited, and of these there was not one which was not made of some expensive material....

The rest of the spoils were borne along in random heaps. The most interesting of all were the spoils seized from the temple of Jerusalem: a gold table weighing many talents, and a lampstand, also made of gold, which was made in a form different from that which we usually employ. For there was a central shaft fastened to the base; then spandrels extended from this in an arrangement which rather resembled the shape of a trident, and on the end of each of these spandrels a lamp was forged. There were seven of these, emphasizing the honor accorded to the number seven among the Jews. The law of the Jews was borne along after these as the last of the spoils. In the next section a good many images of Victory were paraded by. The workmanship of all of these was in ivory and gold. Vespasian drove along behind these and Titus followed him; Domitian rode beside them, dressed in a dazzling fashion and riding a horse which was worth seeing.

SOURCE: J. J. POLLITT. *THE ART IN ROME, C. 753* B.C.–A.D. *337,* SOURCES AND DOCUMENTS. (NJ: CAMBRIDGE UNIVERSITY PRESS, 1983)

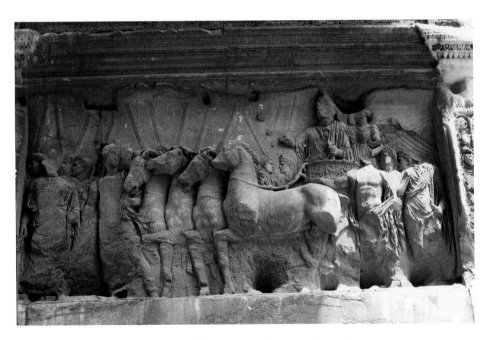

7.27. Relief in bay of Arch of Titus, showing Titus riding in triumph

(fig. **7.27**). The horses appear in profile, but the chariot is frontal, giving the illusion that the procession is coming toward a viewer before turning sharply. Standing behind the emperor, a personification of victory crowns him for his success. Additional personifications—Honor and Virtue, perhaps or Roma—accompany the chariot. Their presence, and the absence of Vespasian, whom the Jewish historian Josephus places in the scene, sound a cautionary note for those who would read Roman visual narratives as historically accurate depictions of events. (See *Primary Source,* above.) These narratives are constructed to express a version of events that serves the patron's ideology.

The exploration of space and narrative strategies come into full bloom in the Column of Trajan (fig. **7.28**). The column was erected between 106 and 113 CE in small court to the west of Trajan's Forum (see figs. 7.33 and 7.35), and its base would serve as a burial chamber for his ashes after his death in 117. Soaring about

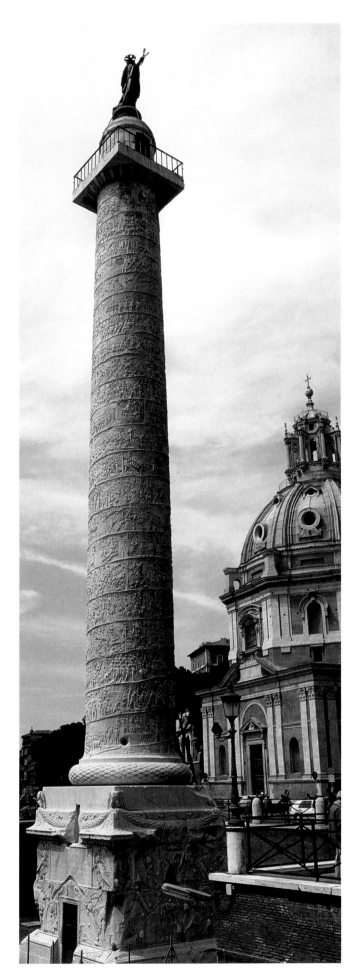

150 Roman feet high, it supported a gilded statue of the emperor, lost in medieval times. Winding through the interior of its shaft was a spiral staircase leading to a viewing platform, from which a visitor could look out over Trajan's extraordinary building complex. Free-standing columns had been used as commemorative monuments in Greece from Hellenistic times on, but the sheer scale of Trajan's Column, and its role as a belvedere, make it nothing short of a world wonder. Its design is often credited to Apollodorus, who served as Trajan's military architect. However, art historians have tended to focus not on the engineering feat it represents, but on the 656-foot-long continuous narrative relief that winds around the column in a counterclockwise direction, celebrating the emperor's victorious campaigns against the Dacians (in present-day Romania).

The narrative begins with the Roman army's crossing of the Danube to reach Dacian territory (fig. **7.29**). The river appears as a large personification. To the left are riverboats loaded with supplies and a Roman town on a rocky bank. A second band shows Trajan speaking to his soldiers, and soldiers building fortifications. In the third, soldiers construct a garrison camp and bridge as the Roman cavalry sets out on a reconnaissance mission; and in the fourth, foot soldiers cross a stream while, to the right, the emperor addresses his troops in front of a Dacian fortress. These scenes are a fair sampling of events shown on the column. Among the more than 150 episodes, combat occurs only rarely. The geographic, logistic, and political aspects of the campaign receive more attention, much as they do in Julius Caesar's literary account of his conquest of Gaul.

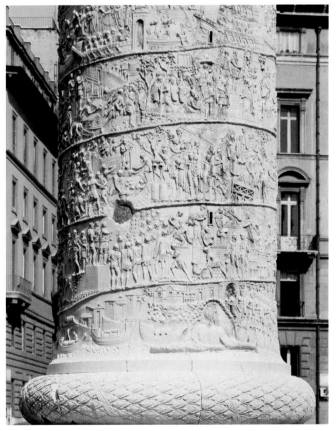

7.28. Column of Trajan, Rome. 106–113 CE. Marble. Height 125′ (38 m)

7.29. Lower portion of the Column of Trajan, Rome. 106–113 CE. Marble. Height of relief band approx. 50″ (127 cm)

Individual scenes are not distinctly separate from one another. Sculptors placed trees and buildings in such a way as to suggest divisions, but the scenes still merge into a continuous whole, with important protagonists, such as Trajan, appearing multiple times. Visual continuity was thus preserved without sacrificing the coherence of each scene. Although Assyrian and Egyptian artists created visual narratives of military conquests, this relief is by far the most ambitious composition so far in terms of the number of figures and the density of the narrative. Understanding it is a complicated matter. Continuous illustrated **rotuli** (scrolls) make a likely inspiration for the composition, except that none survive from the time before the column's construction. More problematic is how a viewer was supposed to read the narrative. In order to follow its sequence, one has to keep turning around the column, head inclined upwards. Above the fourth or fifth turn, details become hard to make out with the naked eye, even if the addition of paint made the sculpture more vivid.

It might have been possible to view the upper spirals from balconies on surrounding buildings in antiquity, but the format would still have required encircling motion. These problems have led scholars to propose strategies for reading the narrative. They have long noted that the relief is formulaic; that is, a fairly limited number of stock scenes are repeated again and again. These include, for instance, sacrifice scenes, the emperor addressing his troops, or soldiers constructing forts and dismantling enemy cities. Though the scenes are not identical, they are similar enough to be readily recognized at a distance, making the upper spirals more legible. The designer may also have aligned important and representative scenes on the cardinal axes of the column, so that a viewer could grasp an abbreviated version of the whole from a single standpoint. Yet there is always the possibility that the designer intended viewers to have to turn around the column in order to read its narrative. The column was, one recalls, Trajan's tomb, and an encircling motion would be entirely consistent with a widespread Roman funerary ritual known as the *decursio*, in which visitors to a tomb walked around it to protect the dead buried within, to keep harmful spirits in the grave, and to pay perpetual homage to the deceased.

Exactly when the classicizing phase of Roman sculpture, still so evident on the Column of Trajan, starts to yield to the more abstract qualities of Late Antiquity is a matter of some debate. A critical turn may have occurred with the column base of Antoninus Pius and his wife Faustina the Elder. Antoninus died in 161 CE. His successors, Marcus Aurelius and Lucius Verus, erected a 50-foot porphyry column in his honor, surmounted by his statue. Its white marble base is all that survives. One side bears an inscription. On another, a winged figure bears the emperor and his wife to the heavens, while personifi-

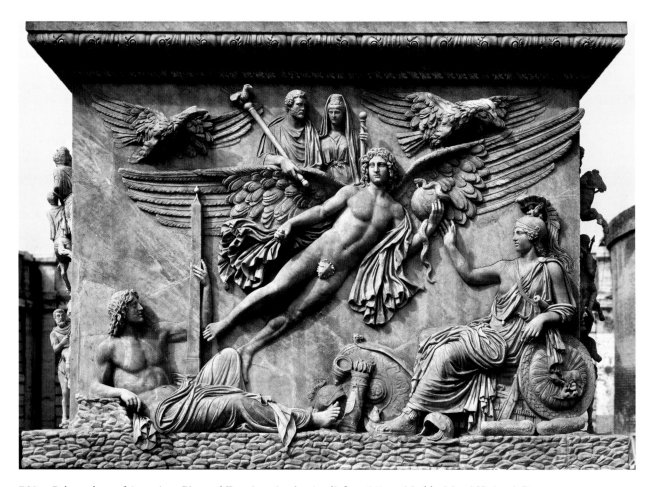

7.30. Column base of Antoninus Pius and Faustina. *Apotheosis* relief. ca. 161 CE. Marble. Musei Vaticani, Rome

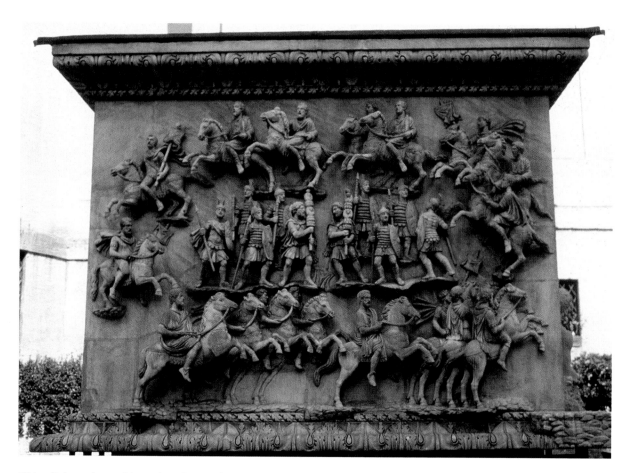

7.31. Column base of Antoninus Pius and Faustina. *Decursio* relief. ca. 161 CE. Marble. Musei Vaticani, Rome

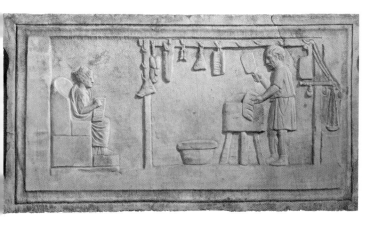

7.32. Funerary relief of a butcher and a woman. Mid-2d century CE. Marble. $13\frac{1}{2}'' \times 26\frac{1}{2}''$ (34.5 × 67.3 cm). Staatliche Kunstsammlungen, Dresden

cations of the Field of Mars (where the cremation took place) and Rome look on (fig. **7.30**). The figures have lithe, Classical proportions, and their faces are idealized, with smooth, even planes and ageless features. On the two remaining sides of the base, Roman cavalry men ride in a counterclockwise circle around a group of infantry men, in nearly identical scenes that probably represent the ritual walk around the funerary pyre, the *decursio* (fig. **7.31**). The sculptural style of these scenes is quite unlike the apotheosis scene. The soldiers have stocky, squat proportions, and the action unfolds in a bird's-eye perspective, while the soldiers are viewed from the side. Both of these factors find parallels in sculpture commissioned in the provinces and in nonelite circles. Figure **7.32** gives an example of a nonelite style, in a funerary relief commemorating a butcher and a woman. The image has a flatness that is quite different from the illusionistic treatment of space on the panels of the Arch of Titus (see figs. 7.26 and 7.27) The figures are stocky, and the butcher's head is large in proportion to his body. The artist's priority was probably legibility: The panel would have been mounted on the facade of a tomb and needed to be legible from a distance. The linear treatment of the image and the boldness of forms served this goal well. The introduction of these qualities into imperial commissions in Rome signals a change in the way messages were expressed in state art.

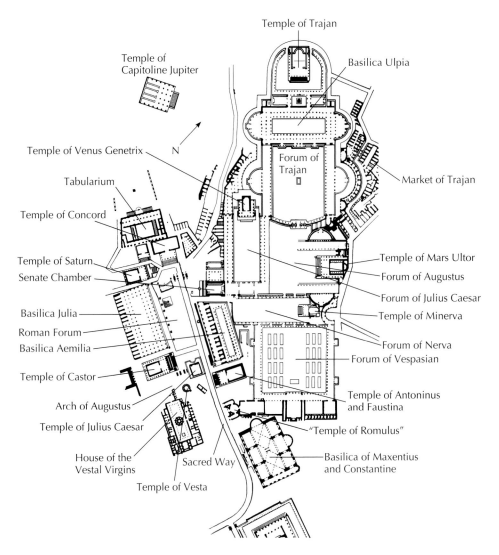

7.33. Plan of the Imperial Forums, Rome

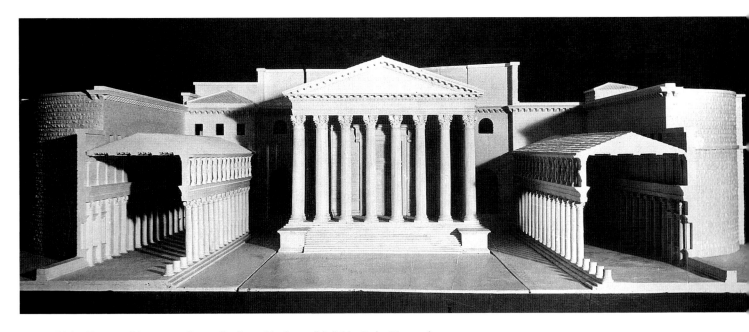

7.34. Forum of Augustus, Rome. Dedicated in 2 BCE. Model by Italo Gismondo

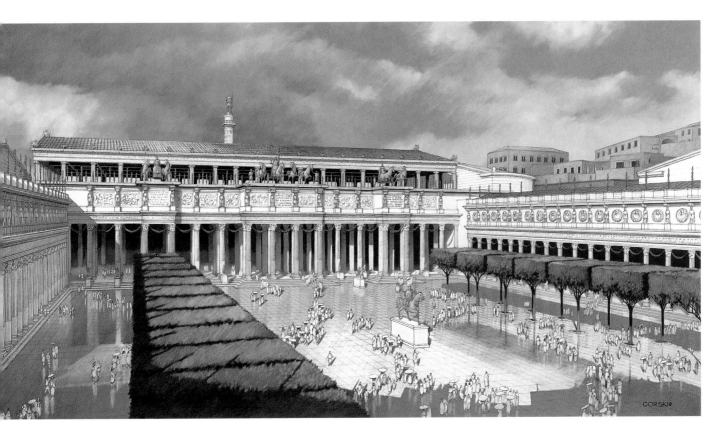

7.35. Forum of Trajan, Rome. Restored view by Gilbert Gorski

Architecture

Pompey's theater complex was the first of a series of huge urban interventions by Rome's autocrats designed to curry favor with the populace. Julius Caesar and Augustus each followed it with a forum, setting a tradition that Vespasian, Domitian, and Trajan all followed. As the plan in figure **7.33** reveals, these forums were closely connected to each other topographically and drew significance from their proximity. A visitor entered the Forum of Augustus directly from that of his divinized ancestor Caesar, cementing the connection immediately. Augustus' Forum consisted of a large open plaza with porticoes lining the long sides (fig. **7.34**). At the end of the plaza was a large temple to Mars the Avenger, which Augustus had vowed after Caesar's assassination. When compared with the free forms of the Sanctuary of Fortuna at Praeneste, Augustus' Forum is overwhelmingly rectilinear and classically inspired, as was most Augustan architecture. This deliberate choice evoked the pinnacle of Greek achievement in fifth-century Athens, and the effect was underlined through the pervasive use of marble, made available from

newly opened quarries at Carrara. Sculpture filled the complex. The porticoes housed full-length, labeled portraits of great men from Rome's legendary past and recent history, suggesting a link between the past and the present. In the attic of the porticoes, engaged **caryatids** (supporting columns in the shape of draped female figures) flanked shields decorated with heads of Jupiter Ammon (god of the Sahara, sometimes described as Alexander the Great's father). The carved women replicated the figures on the south porch of the Erechtheion on the Athenian Akropolis, where Augustus' architects were engaged in restoration work. Augustus' Forum took on many functions previously accommodated by Rome's historic buildings such as the Temple of Capitoline Jupiter, and by diverting state activities and rituals to an arena associated with his name, Augustus unambiguously placed himself at the head of Roman public life.

The largest of all the imperial fora was Trajan's, financed with the spoils of his wars against the Dacians. Recently published reconstructions of the complex give some sense of its former magnificence (fig. **7.35**). Located alongside Augustus'

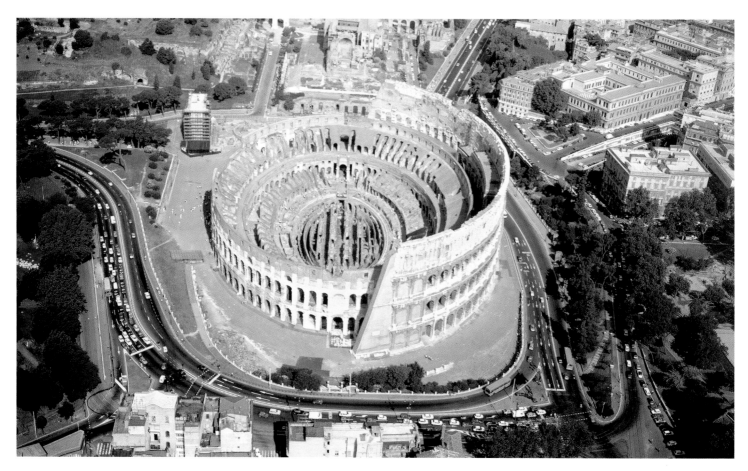

7.36. Colosseum, Rome. 72–80 CE

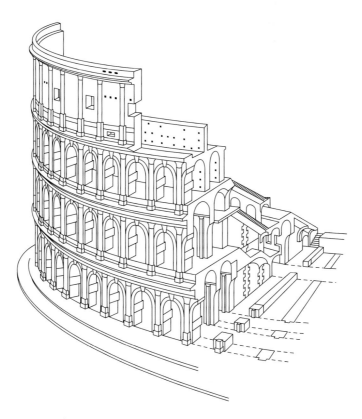

7.37. Colosseum, sectional view

Forum, it adapted many of that forum's features to new effect. In place of the caryatids in the portico attics, for instance, were statues of captive Dacians carved from exotic marbles. Beyond a basilica at the far end, two libraries and a temple defined a small courtyard, where Trajan's Column stood (see figs. 7.28 and 7.29). The Forum's message is clear: The Dacian Wars brought Rome great benefit. As in so many societies, the ruling elite hoped to dispel the starker realities of war through visual propaganda.

As well as constructing a magnificent forum in the name of peace, Vespasian was the first to construct a permanent amphitheater in Rome for the gladiatorial games that were so central to Roman entertainment (figs. **7.36, 7.37,** and **7.38**). Earlier gladiatorial shows had taken place in the Roman Forum, with temporary wooden bleachers for spectators. Vespasian died before completing the Colosseum, and his son Titus inaugurated it in 80 CE with over 100 days of games, at a cost of over 9,000 animal lives. In terms of sheer mass, it was one of the largest single buildings anywhere: It stood 159 feet high, 616 feet 9 inches long, and 511 feet 11 inches wide, and could hold 45,000 to 50,000 spectators. Concrete, faced with travertine, was the secret of its success. In plan, 80 radial barrel-vaulted wedges ringed an oval arena. Each barrel vault buttressed the next,

ART IN TIME

ca. 20 CE—**The original *Augustus of Primaporta***
23/24–79 CE—Pliny the Elder; wrote *Natural History*
106–113 CE—**The Column of Trajan erected in Rome**
117–125 CE—**Construction of the Pantheon in Rome**

making the ring remarkably stable. The wedges sloped down from the outside to the ringside to support seating, as in Pompey's theater, and accommodated within the wedges were countless stairways and corridors, designed to ensure the smooth flow of traffic to and from seating areas and the arena. During the hottest days, sailors stationed nearby could rig huge canvas sheets over the seating areas to provide shade. Dignified and monumental, the exterior reflects the structure's interior organization. Eighty arched entrances led into the building, framed with engaged Tuscan columns (which resembled Doric columns but had simple bases). On the second story, Ionic columns framed a second set of arches, and engaged Corinthian pilasters flanked blind arcades in the third.

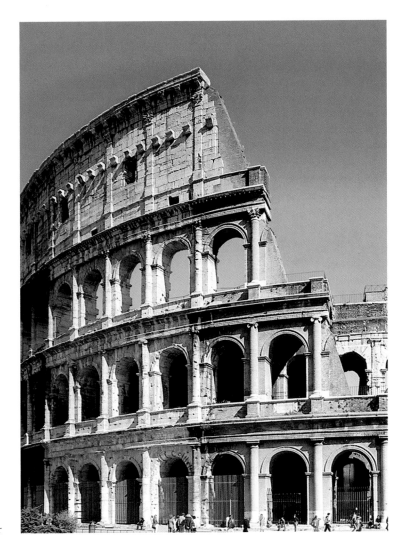

7.38. Colosseum, exterior

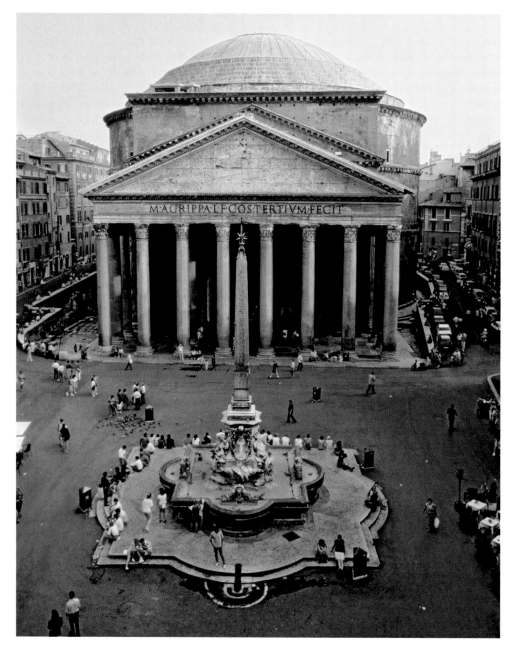

7.39. Pantheon, Rome. 117–125 CE

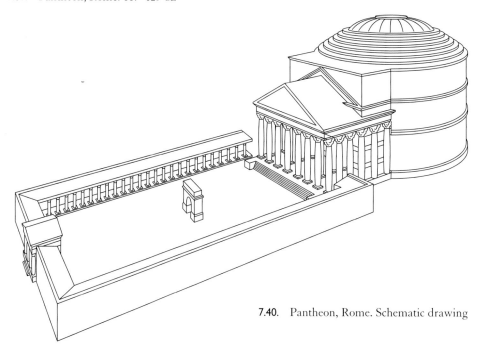

7.40. Pantheon, Rome. Schematic drawing

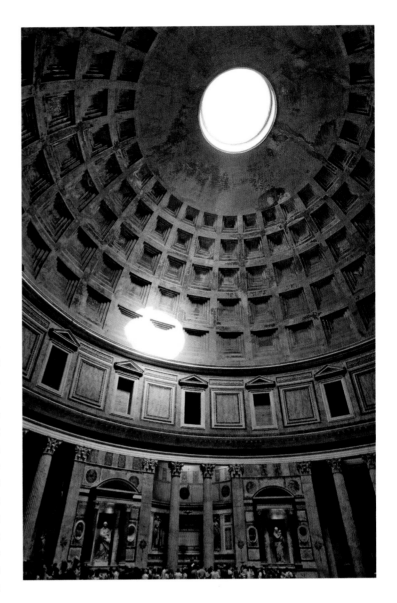

Of all the masterpieces Roman architects accomplished with concrete, the Pantheon is perhaps the most remarkable (fig. **7.39**). As its name suggests, the temple was consecrated to all the gods. In origin this was a Hellenistic concept, and it included living and deceased members of the ruling family among the gods. Augustus' right-hand man, Agrippa, had built the first Pantheon on the site. A fire in 80 CE destroyed this temple, and Domitian built a reconstruction, which perished after a lightning strike. The existing Pantheon is the work of Hadrian's architect, or perhaps even Hadrian himself, since he was an accomplished architect. As an act of piety, Hadrian chose to leave Agrippa's name in the inscription. The building dates between 117 and 125 CE, and its form appears to be quite different from the preceding temples. One of the best-preserved pagan temples of Rome, it owes this status to its transformation into a church in the early seventh century CE. All the same, the temple's surroundings have changed sufficiently through the ages to alter a visitor's experience of the building quite profoundly.

In Roman times, the Pantheon stood, raised on a podium, at the south end of a large rectangular court (fig. **7.40**). Porticoes framed the three remaining sides of the court and extended on the south right up to the sides of the temple's pedimented porch. In doing so, they hid the temple's circular drum from view. A visitor approaching the temple's broad octastyle facade would have been struck by the forest of massive monolithic grey and pink granite columns soaring upward; but in most other respects, the temple's form would have been extremely familiar, evoking an expectation of a rectangular cella beyond the huge bronze doors, sheltering a large cult statue. Yet a surprise was in store. On stepping across the threshold, all that was perceptible was a glowing shaft of light, slicing through the shadows from high overhead (figs. **7.41** and **7.42**). As the visitor's eyes slowly grew accustomed to the darkness, a vast circular hall took form, with seven large niches at ground level at the cardinal points. Engaged pilasters and bronze grilles decorated an attic level, and high above soared an enormous dome, pierced with a 27-foot hole or **oculus** onto the sky. Dome and drum are of equal height, and the total interior height, 143 feet, is also the dome's

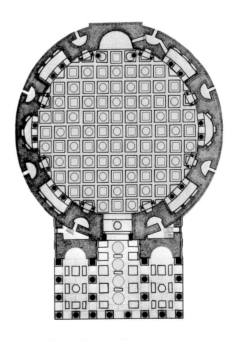

7.42. Plan of the Pantheon

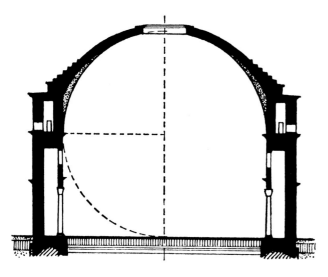

7.43. Transverse section of the Pantheon

diameter (fig. **7.43**). Many viewers in antiquity would have associated the resultant sphere with notions of eternity and perfection, and the dome's coffered surface, once emblazoned with bronze rosettes, must have evoked a starry night sky.

For a visitor entering the cella, there was no obvious cue to point out where to go, except toward the light at the center. In fact, the dome's **coffers** only make sense perspectively from directly beneath the oculus. Once a visitor reached the center, molded space and applied decoration combined to provide a stunning effect. Beginning in the Renaissance, scholars have found fault with the Pantheon's architect for neglecting to align the ribs between the dome coffers with the pilasters in the attic zone and the ground-floor columns. Yet, the absence of continuous vertical lines between top and bottom means that, visually speaking, the dome is not anchored. The optical effect is that it hovers unfettered above the visitor—who feels, paradoxically, both sheltered and exposed. The dome seems to be in perpetual motion, spinning overhead in the same way as the heavens it imitates. An all-but-imperceptible rise in the floor at the center exaggerates this sensation, which can incite an unnerving feeling similar to vertigo. A visitor's instinct, in response, is to take refuge in the safety of the curved wall. The building is all experience, and photographs do it no justice. This is the place, so literary sources relate, where Hadrian preferred to hold court, greeting foreign embassies and adjudicating disputes. The temple's form cast the emperor in his authoritative position as controller of his revolving universe. He must have appeared like a divine revelation before his guest, who was already awed and completely manipulated by the building that enclosed them.

The Pantheon is the extraordinary result of a developed confidence in the potential and strength of concrete. The architect carefully calibrated the aggregate as the building rose,

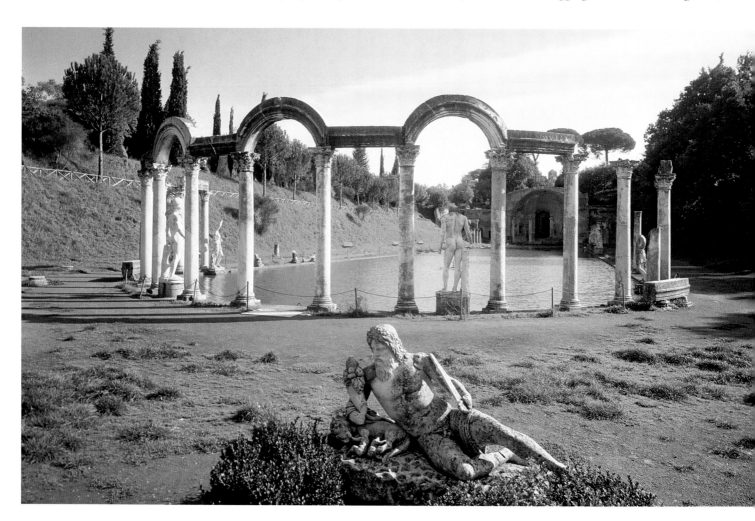

7.44. Scenic Canal, Hadrian's Villa at Tivoli, ca. 130–138 CE

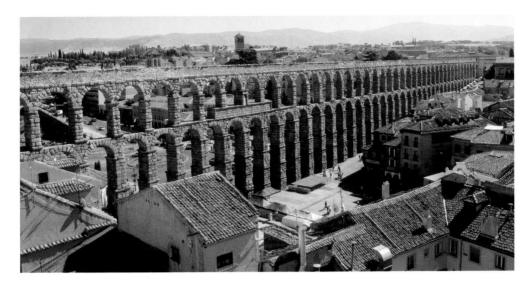

7.45. Aqueduct, Segovia. 1st or early 2d century CE

from travertine to tufa, then brick, and finally pumice, to reduce its weight. The dome's weight is concentrated on eight wide pillars between the interior alcoves, rather than resting uniformly on the **drum** (see fig. 7.42). The alcoves, in turn, with their screens of columns, visually reduce the solidity of the walls, and colored marbles on all the interior surfaces add energy to the whole. As in Trajan's Forum, the marbles were also symbolic. They underlined the vast reach of imperial authority, assuming trade with or control over Egypt (grey and rose-pink granite, porphyry), Phrygia (Phrygian purple and white stone), the island of Teos (Lucullan red and black stone), and Chemtou in Tunisia (Numidian yellow stone).

From the start of the Empire, the emperor's principal residence was on the Palatine Hill in Rome (from which the term "palace" derives). Yet, like many members of the elite, the emperor had several properties, many of which were outside of Rome. The most famous imperial property is the Villa of Hadrian at Tibur (present-day Tivoli). Built on the site of a Republican villa, this residence was a vast sprawling complex of buildings, some or all of which Hadrian may have designed himself. The villa's forms appear to follow the natural line of the landscape, but in fact massive earthworks rearranged the terrain to accommodate the architecture and to allow for impressive vistas, cool retreats, and surprise revelations. Water was a common feature, in pools and running channels, adding sound and motion, reflecting light, and offering coolness in the summer heat. Throughout the villa were mosaics, paintings, and sculptures. Some of these works of art may have been collected during the emperor's extensive travels, especially in Egypt and Greece. A desire to evoke the far-flung regions of the Empire may also have inspired some of the buildings: A fourth-century CE biography claims that Hadrian "built up his villa at Tibur in an extraordinary way, applying to parts of it the renowned names of provinces and places, such as the Lyceum, the Academy, the *prytaneum*, the Canopus, the *Poecile*, and Tempe. And so as to omit nothing, he even fashioned 'infernal regions.'" This statement has led modern scholars to give fanciful names to many parts of the villa. Few of them are based in archeological evidence, and they lead visitors to faulty conclusions about the buildings' functions. The canal shown in figure **7.44** has long been known as the Canopus, after a town in Egypt. Only recently have more neutral terms been proposed for the villa's components, in this case the "Scenic Canal."

ART AND ARCHITECTURE IN THE PROVINCES

The spread of Rome's authority over a wide geographical reach had a profound impact on artistic and architectural production in those areas as well. Since history is typically constructed by those in power, it is often hard to assess the reactions of local peoples to foreign control. To be sure, Roman rule brought some benefits. Roman engineers had mastered the art of moving water efficiently, and the new Roman aqueducts that sprang up in urban centers around the empire must have improved local standards of living immeasurably. A striking aqueduct still stands at Segovia in Spain, dating to the first or early second century CE (fig. **7.45**). It brought water from Riofrío, about 10 ½ miles (17 km) away, flowing for most of its length through an underground channel. Approaching the town, however, architects built a massive bridge stretching 2,666 feet (813 m) long and up to 98 feet (30 m) high to span a valley. One hundred and eighteen arches support the water channel, superimposed in two registers at the highest point. Like most provincial builders, the architects used a local stone, in this case a granite, assembled without mortar and left unfinished to give an air of strength. Despite the obvious advantages the aqueduct provided, it also illustrates how Roman architecture could effect dominion. The arches—such a quintessentially Roman form—march relentlessly across the terrain, symbolically conquering it with their step. Even the act of moving water was a conquest of a kind, a conquest of Nature.

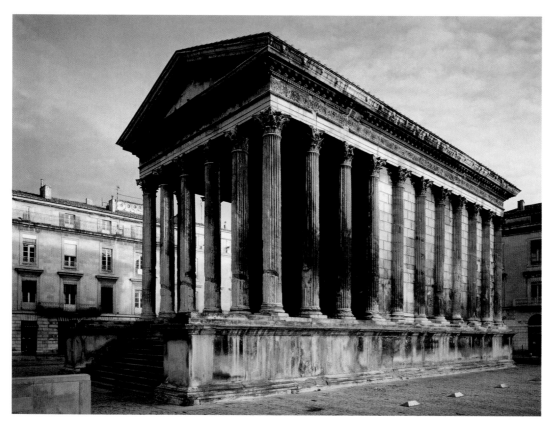

7.46. Maison Carrée, Nîmes. Early 2d century CE (?)

Romans carried their way of life with them across the Empire, constructing theaters and amphitheaters in a Roman style, and temples to accommodate their rituals. A well-preserved temple (fig. **7.46**) known as the Maison Carrée (Square House) survives in the French town of Nîmes (ancient Nemausus). A typical Roman temple, it stands on a high podium, with a frontal staircase. Six Corinthian columns across the front lead into a deep porch and to the cella; engaged columns decorate the cella's exterior walls. Reconstructing an inscription in bronze letters on its architrave from the evidence of dowel holes, scholars have long thought the temple to be dedicated to Rome and Augustus during the Augustan age. Acanthus scrolls in the frieze appeared to be reminiscent of the Ara Pacis, and the masonry style showed similarities to that of the Temple of Mars the Avenger in Augustus' Forum. Indeed, scholars considered the temple evidence for traveling workshops, practicing their craft in Rome and the provinces. Recent research has cast doubt on this view, however, illustrating the danger that historians may construct the very history they are looking for. As it turns out, the dowel holes could support any number of different inscriptions; and the module employed throughout the building only came into use under Trajan. The building could even be a temple dedicated to Trajan's wife, Plotina, known from literary sources.

In some cases, indigenous building traditions combined with Roman styles to powerful new effect. This appears to be the case with the extraordinary rock-cut facade known as El Khasneh, or the Treasury, at the site of Petra in present-day Jordan (fig. **7.47**). This facade is the first sight to greet a visitor who wanders through the long, twisting gorge known as the Siq, leading to the town center. The Nabataeans, a nomadic people who settled this area before the Romans took control in 106 CE, would bury their wealthy dead in tombs cut out of the rosy pink sandstone cliffs, and some scholars have seen El Khasneh as one of their monuments. Most agree, however, that it belongs to the Trajanic or Hadrianic period. Carved from the living rock, the monument resembles a temple facade, with six columns beneath an architrave decorated with floral designs and a pediment. In a second story, lateral columns support the angles of a broken pediment. Between them is a tholos with a conical roof, surmounted by an ornamental finial. In more recent times, locals imagined that pirates had stored their treasure in the finial, lending the monument its name; bullet holes show how they tried to knock it to the ground. The facade is a striking amalgamation of a Nabataean concept with Roman decorative features—the Corinthian column capitals, for instance, and the vegetal designs. The architectural elements are not structural, and this allows for a freedom and fantasy quality in the design, not unlike the fantasy vistas of Second Style wall paintings (see page 216). This playful treatment of once-structural elements became popular in the provinces and in Rome in the second century CE, and scholars sometimes describe it as a baroque phase, for its similarities to Italian baroque architecture. The monument's function may have

changed for Roman usage as well: Relief sculptures between the columns seem to represent figures from the cult of Isis, suggesting that it was a temple. In some cases, inscriptions and other written documents indicate who commissioned monuments in the provinces; the patron might be local, a Roman official, or even the emperor himself. More often, as in this case, there is no such evidence, which makes it hard to determine meaning in a choice of style.

Sculpture in the Roman provinces also has a distinctive look—the result, generally, of a merging of different traditions. The sculpture illustrated in figure **7.48** is a limestone funerary relief from Palmyra in Syria from the second half of the second century CE. It once sealed the opening to a burial within a characteristically Palmyrene monument, a tower tomb. An Aramaic inscription identifies the subject as Tibnan, an elite woman, who holds a small child in one arm. The language bespeaks her origin, and the strict frontality, large staring eyes, and local dress and headband set her apart from the elite women of Rome (see figs. 7.17, 7.20, and 7.22). All the same, the portrait has distinctly Roman qualities: Tibnan raises her right hand, for instance, to hold her veil, in a gesture that is well known in Rome (see fig. 7.14) and signified chastity (or *pudicitia*, defined as loyalty to one's husband). The portrait neatly encapsulates the dual identity of this provincial woman, who is both Roman and Palmyrene.

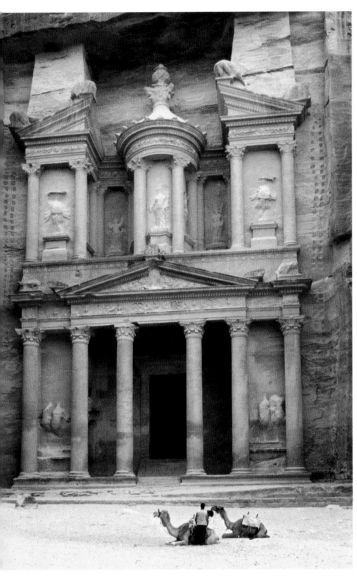

7.47. El Khasneh, Petra, Jordan. Probably early 2d century CE

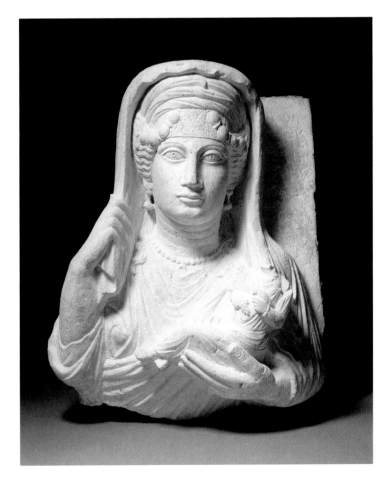

7.48. Funerary relief of Tibnan, from Palmyra, Syria. ca. 150–200 CE. Painted limestone. Musée du Louvre, Paris

Vitruvius

Vitruvius was a Roman architect who wrote a treatise on architecture during the time of Julius Caesar and Augustus. Scholars have used his comments on painting to reconstruct domestic decorative schemes, and to gain an understanding of the general development of Roman painting techniques and styles.

Book 7, Chapter 5: Correctness in Painting: General Remarks

1. In the remaining rooms, that is, the spring, autumn, and summer quarters, also in atria and peristyles, the ancients have established certain secure principles for painting, based on secure phenomena. For a painting is an image of that which exists or can exist, like those of people, buildings, ships, and other things with definite and certain bodies, of which examples may be found and depicted in imitation. On this principle, the ancients who established the beginnings of painting plaster first imitated the varieties and placement of marble veneers, then of cornices and the various designs of ochre inlay.

2. Later they entered a stage in which they also imitated the shapes of buildings, and the projection into space of columns and pediments, while in open spaces like exedrae, because of the extensive wall space, they painted stage sets in the tragic, comic, or satyric style, and adomed their walkways, because of their extensive length, with varieties of landscape, creating images from the known characteristics of various places. For ports, promontories, seashores, rivers, springs, straits, shrines, sacred groves, mountains, herds, and shepherds are depicted, some places are portrayed in monumental painting with the likenesses of the gods or the skillfully arranged narrations of myths, such as the Trojan battles, or the wanderings of Ulysses through various landscapes, and other subjects that have been created according to nature on similar principles.

3. But these paintings, which had taken their models from real things, now fall foul of depraved taste. For monsters are now painted in frescoes rather than reliable images of definite things. Reeds are set up in place of columns, as pediments, little scrolls, striped with curly leaves and volutes candelabra hold up the figures of aediculae, and above the pediments of these, several tender shoots, sprouting in coils from roots, have little statues nestled in them for no reason, or shoots split in half, some holding little statues with human heads, some with the heads of beasts.

4. Now these things do not exist nor can they exist nor have they ever existed, and thus this new fashion has brought things to such a pass that bad judges have condemned the right practice of the arts as lack of skill. How, pray tell, can a reed really sustain a roof, or a candelabrum the decorations of a pediment, or an acanthus shoot, so soft and slender, loft a tiny statue perched upon it, or can flowers be produced from roots and shoots on the one hand and figurines on the other? Yet when they see these deceptions, people never criticize them, but rather take delight in them, nor do they ever notice whether any of these things are possible or not. Minds beclouded by feeble standards of judgment are unable to recognize what exists in accordance with authority and the principles of correctness. Neither should pictures be approved that are not likenesses of the truth, nor, if they are made elegant through art, is that any reason why favorable judgment should immediately be passed on them, not unless their subjects follow sound principles without interference. . . .

But it will not be out of place to reveal why false reasoning wins out over truth: the ancients invested their labor and energy in competition to win approval for their skill, but now, [fresco painters] pursue approval through the deployment of colors and their elegant appearance, and whereas refinement of craftsmanship once increased the reputation of works, now sovereign extravagance makes it no longer desirable.

The greatest body of painting to survive from the Roman world is wall painting (see page 214). Yet the sands of Fayum, in Lower Egypt, have preserved a magnificent group of painted portraits, once attached over the faces of the embalmed, mummified bodies of the dead (fig. **7.49**). The earliest of them appear to date from the second century CE. Artists painted them on wooden panels in a technique known as **encaustic**, which involves suspending pigments in hot wax. The mixture can be opaque and creamy, like oil paint, or thin and translucent. The medium is extremely durable, and the panels retain an extraordinary freshness; the wax also gives them a luster that brings them vividly to life. Their quality varies dramatically. At their best, these portraits have a haunting immediacy, largely the result of the need to work quickly before the hot wax set. The woman pictured here wears a deep crimson tunic and a wealth of jewelry. Rows of black circles denote the ringlets of her hair, bound with a golden diadem. Her appearance is Roman, yet the portrait itself speaks of her local identity, since she was buried in the Egyptian, not the Roman, fashion.

DOMESTIC ART AND ARCHITECTURE

The Romans are one of the few ancient peoples to leave abundant evidence of domestic architecture and its decoration. The burial of the cities of Pompeii and Herculaneum after the eruption of Vesuvius in 79 CE, so tragic for those who perished, preserved an invaluable legacy for the archeologist; and such was the durability of Roman domestic construction that houses survive elsewhere as well, as far afield as Morocco and Jordan. Their unusually good state of preservation has meant that houses buried by Vesuvius have dominated scholarly discussion, as they will here; yet although Roman houses around the empire have many common qualities, they also differ from one region to the next, to cater, for instance, to local climates. In any given region, there were also discrepancies between the dwellings of the very rich and the very poor. One should be cautious, therefore, about conceiving of a "typical" Roman house.

Scholars describe elite Roman houses by their Latin name, *domus*, known from Vitruvius and other ancient writing (see end of Part I *Additional Primary Sources*). The most distinctive

feature of a single-family dwelling is an **atrium**, a square or oblong central hall lit by an opening in the roof, answered by a shallow pool, or *impluvium*, in the ground to collect rainwater. This kind of house may owe its origin, in part at least, to elite Etruscan residences like the complex at Murlo (see fig. 6.14). The atrium was the traditional place for keeping portraits of ancestors. Its airy quality confers an element of grandeur upon

ART IN TIME

early 100s CE—*Aqueduct built at Segovia, Spain*

ca. 46–120 CE—*Life of the Greek biographer Plutarch*

early 100s CE—**Construction of El Khasneh in Petra, Jordan**

100s CE—**The earliest painted portraits from the Fayum, Lower Egypt**

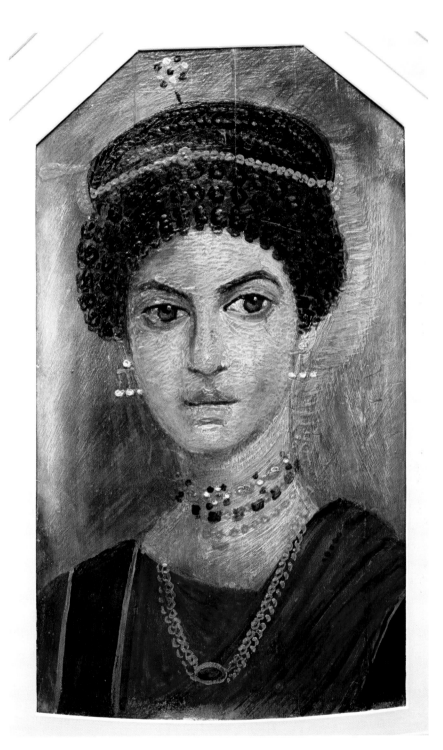

7.49. Portrait of a Woman, from Hawara in the Fayum, Lower Egypt. ca. 110–130 CE. Encaustic on wooden panel. Royal Museum of Scotland. © Trustees of the National Museum of Scotland

the house, visible here in the House of the Vettii (fig. **7.50**). Other rooms, such as bedrooms (*cubicula*), are grouped around the atrium, which often leads on to a **tablinum**, the principal reception room, where family records were kept. Beyond the tablinum is a garden, surrounded by a colonnade (the **peristyle**). Additional rooms might be attached at the back of the house. Walls facing the street did not typically have windows, but one should not be misled into believing that Roman houses were particularly private. Rooms flanking the entryway were frequently used as shops, and the front door often stood open. Roman society was based on a client–patron relationship, and clients routinely visited their patrons in their homes. The householder also conducted business in his home, even, at times, in the cubicula. A visitor's access to the different parts of the house depended on his relationship with the owner, however, and most visitors would be greeted in the larger central rooms.

In Rome and its port city Ostia there are many surviving examples of **insulae** (literally "islands"), or city blocks. These are less elegant than the houses described previously, and have many features of a present-day apartment block. An insula was generally a good-sized concrete-and-brick building (or chain of buildings) around a small central court. On the ground floor were shops and taverns open to the street; above were living quarters for numerous families. Some had as many as five stories, with balconies above the second floor.

Compared with Greek painting, Roman domestic painting survives in great abundance. Most of it is wall painting, and it comes mainly from Pompeii and Herculaneum, and also from Rome and its environs. Examples of Roman paintings mostly

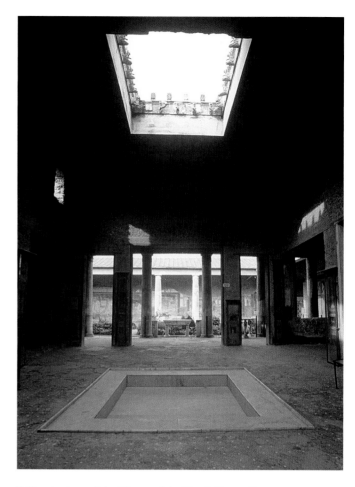

7.50. Atrium of the House of the Vettii, Pompeii. 2d century BCE–79 CE

August Mau (1840–1909 produced what remains the scheme that underpins all stylistic analysis of Pompeian decor: he divided the wall painting into four 'Styles,' each representing a phase in the chronology of Pompeian painting, from the second century BCE to the final eruption in 79 CE.

1. 'The First, or Incrustation, style': the wall is painted (and moulded in stucco) to imitate masonry blocks, no figured scenes. Second century BCE.

2. 'The Second, or Architectural, style': characteristically featuring illusionistic architectural vistas. c.100—15 BCE.

3. 'The Third, or Ornate, style': the vistas here give way to a delicate decorative scheme, concentrating on formal ornament. c.15 BCE.—50 CE.

4. 'The Fourth, or Intricate, style': a more extravagant painterly style, parading the whole range of decorative idioms. c.50 CE.

7.51. August Mau's Four Styles of Pompeian wall painting

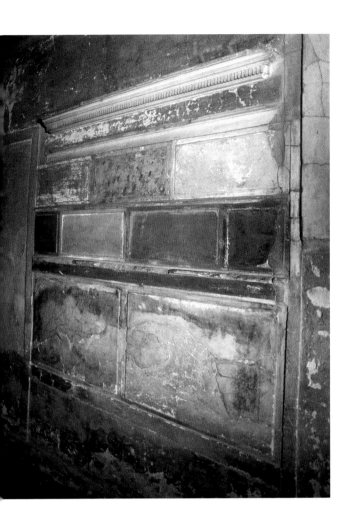

7.52. First Style painting in the Samnite House, Herculaneum. Late 2d century BCE

date to a span of less than 200 years, from the end of the second century BCE to the late first century CE. Given the public character of a domus, these paintings were more than mere decoration: They also testified to a family's wealth and status.

Basing his analysis partly on Vitruvius' discussion of painting, the late nineteenth-century German art historian August Mau distinguished four phases of Roman wall painting (fig. **7.51**). The four styles are not canonical, but have proved useful as general guidelines. (See *Primary Source*, page 212.) In the First Style, dating to the late second century BCE, artists used paint and stucco to imitate expensive colored marble paneling, as in the Samnite House at Herculaneum (fig. **7.52**). Examples of this style have also survived in the eastern Mediterranean. Starting about 100 BCE, Second Style painters sought to open up the flat expanse of the wall by including architectural features and figures. In a room in the Villa of the Mysteries just outside Pompeii, dating from about 60 to 50 BCE, the lower part of the wall, beneath the dado, and the upper section above the cornice level, are painted in rich mottled colors to resemble exotic stone (fig. **7.53**). In between, figures interact as if on a narrow ledge set against a deep red background, articulated by upright strips of black resembling stylized columns.

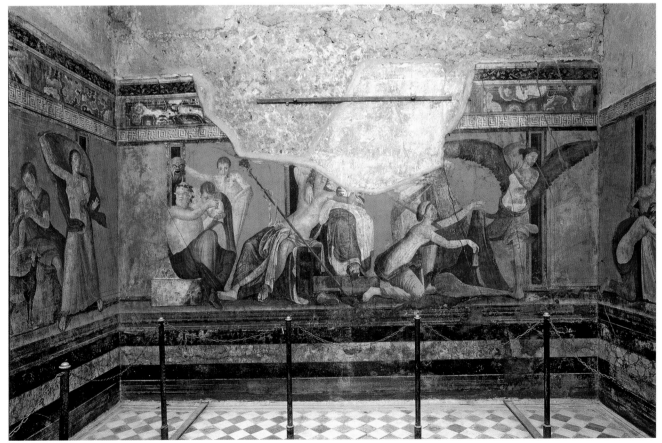

7.53. Second Style wall painting from the Villa of the Mysteries, Pompeii. *Scenes of Dionysiac Mystery Cult*. ca. 60–50 BCE

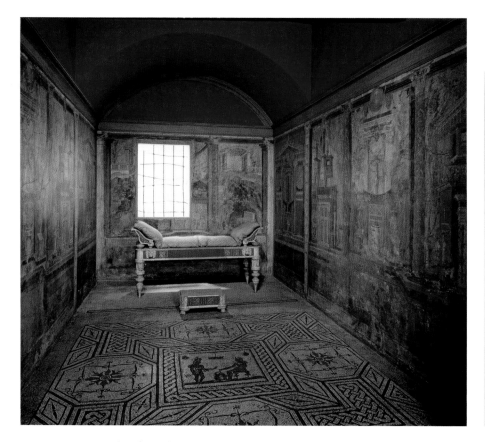

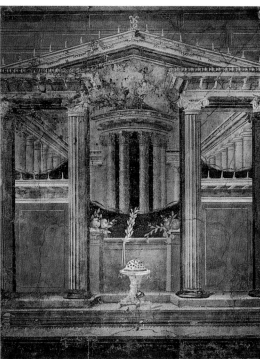

7.54. Second Style wall painting from the Villa of Publius Fannius Synistor at Boscoreale, near Pompeii. Mid-1st century BCE. Fresco on lime plaster. Height: 8'8½" × Length 19'7⅛" × width 10'11½" (265.4 × 583.9 × 334 cm). The Metropolitan Museum of Art, New York, Rogers Fund, 1903 (03.14.13)

The figures are engaged in various rites associated with the Dionysiac mysteries, one of the so-called mystery religions originating in Greece. The scene may represent an initiation into womanhood or marriage, conducted in the presence of Dionysos and Ariadne with a train of satyrs and sileni. The solidity of the near life-size figures, the bold modeling of their bodies in paint, and their calm but varied poses lend a quiet power and vivid drama to the room.

In some cases, Second Style artists employed architectural vistas to open the wall onto a fantasy realm, suggesting another world beyond the room. This movement may reflect architectural backdrops in contemporaneous theaters. An example from the Villa of Publius Fannius Synistor at Boscoreale, near Pompeii, now reconstructed in the Metropolitan Museum of Art in New York, illustrates this effect well (fig. **7.54**). A painted parapet wall runs around the lower part of the surface.

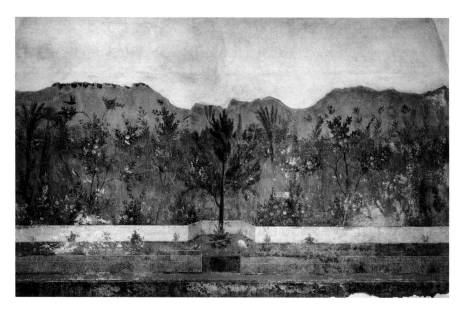

7.55. Wall painting of garden, from the Villa of Livia at Primaporta. ca. 20 BCE. Museo delle Terme, Rome

Resting on it are columns, supporting a cornice. These architectural features make up a foreground. Receding away from it, in a range of different perspectives, stoas and tholoi and scenic gazebos mingle with one another in a maze of architectural fantasy, flooded with light to convey a sense of open space. A viewer struggles to disentangle the structures from one other; their size and spatial relationships are hard to determine. The world of the painting is a world inaccessible to those who view it, hovering just out of reach. In the Villa of Livia at Primaporta, the world beyond the trellis fence and low garden wall is an idyll of nature, a garden filled with flowers, fruit trees, and birds (fig. **7.55**). Although its lushness beckons, this garden is another fantasy world made only for looking. A different form of perspective is in use here, known as atmospheric perspective: As plants and animals recede into the background, their forms become less distinct, suggesting distance.

The Third Style dominated wall decoration from about 20 BCE until at least the middle of the first century CE. In this phase, artists abandoned illusionism in favor of solid planes of intense colors like black and red, often articulated with attenuated architectural features and imitation panel paintings. A good example comes from the Villa of Agrippa Postumus at Boscotrecase, of about 10 BCE (fig. **7.56**). Slender columns sit on a narrow ledge and define a delicate *aedicula* (a small, shrine-like structure), but they are pure decoration. There is no pretence of structural integrity. The Fourth Style, which prevailed at the time of the eruption of Vesuvius, was the most intricate of the four, uniting aspects of all three preceding styles to create an extravagant effect. The Ixion Room in the House of the Vettii (fig. **7.57**) combines imitation marble paneling, framed mythological scenes resembling panel pictures set into the wall, and fantastic architectural vistas receding into space.

7.56. Third Style wall painting from Villa of Agrippa Postumus, Boscotrecase. ca. 10 BCE. Fresco on lime plaster. Height: 91¾″ (233.05 cm). Metropolitan Museum of Art, New York, Rogers Fund, 1970 (20.192.1)

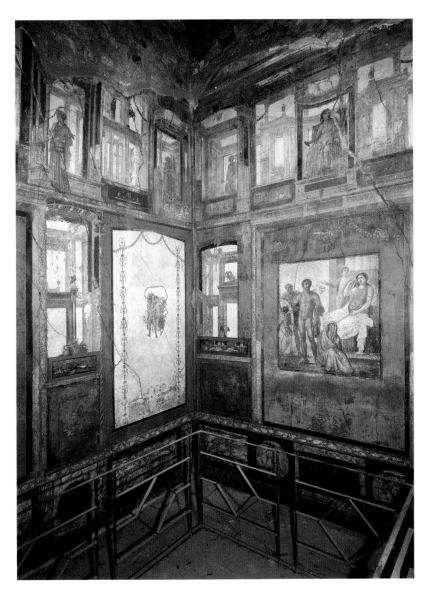

7.57. Fourth Style wall painting, Ixion Room, House of the Vettii, Pompeii. 63–79 CE

Philostratus (170–247 CE)

The Imagines

The Greek author Philostratus lived and taught in Athens and Rome in the third century CE. His work distinguishes him as a Sophist, a practitioner of rhetoric. The Imagines is a series of discussions of paintings, purportedly belonging to a wealthy collector in Neapolis (present-day Naples). Whether or not the paintings really existed is relatively unimportant, since the text was not designed to be a set of descriptions, but to teach students methods for viewing.

Xenia 1

It is a good thing to gather figs and also not to pass over in silence the figs in this picture. Purple figs dripping with juice are heaped on vine-leaves: and they are depicted with breaks in the skin, some just cracking open to disgorge their honey, some split apart, they are so ripe. Near them lies a branch, not bare, by Zeus, or empty of fruit, but under the shade of its leaves are figs, some still green and 'untimely', some with wrinkled skin and over-ripe, and some about to turn, disclosing the shining juice, while on the tip of the branch a sparrow buries its bill in what seems the very sweetest of the figs. All the ground is strewn with chestnuts, some of which are rubbed free of the burr, others lie quite shut up, and others show the burr breaking at the lines of division. See, too, the pears on pears, apples on apples, both heaps of them and piles of ten, all fragrant and golden. You will say that their redness has not been put on from the outside, but has bloomed from within. Here are gifts of the cherry tree, here is fruit in clusters heaped in a basket, and the basket is woven, not from alien twigs, but from branches of the plant itself. And if you look at the vine-sprays woven together and at the clusters hanging from them and how the grapes stand out one by one, you will certainly hymn Dionysos and speak of the vine as 'Queenly giver of grapes'. You would say that even the grapes in the painting are good to eat and full of winey juice. And the most charming point of all this is: on a leafy branch is yellow honey already within the comb and ripe to stream forth if the comb is pressed; and on another leaf is cheese new curdled and quivering; and there are bowls of milk not merely white but gleaming, for the cream floating upon it makes it seem to gleam.

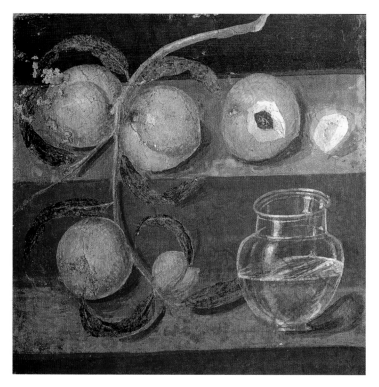

7.58. Still life painting of peaches and water jar, from Herculaneum. ca. 50 CE. Museo Archeologico Nazionale, Naples

Framed within these Fourth Style designs there might be **still life** panels, which usually take the form of *trompe l'oeil* niches or cupboards, presenting objects on shelves. A twenty-first century viewer finds little unusual about this, yet visual studies of mundane, inanimate objects are not otherwise known until the early modern period. The driving force in these Roman paintings was not a narrative, as in many paintings of the time, but a close analysis of life. The example illustrated here depicts green peaches and a jar half filled with water (fig. **7.58**). Touches of white paint capture the effect of light playing on the surface of the jar and the water within, and shadows form around the peaches. The shadows fall in different directions, suggesting that the artist was more interested in using them to forge a spatial relationship between the peaches and their surroundings than to indicate a single source of light. It is possible, too, that the painting reflects the movement of shadow as the artist worked.

Like the Ixion painting in the House of the Vettii (see fig. 7.57), many Roman paintings were of Greek themes. The few painters' names that are recorded show that at least some of them were of Greek origin. There are also sufficient cases of paintings (or individual elements of paintings) closely resembling one another to indicate that artists used copybooks; in some cases, they may have been working from a Greek original, adapting the image freely to their own purposes. The Alexander Mosaic in the House of the Faun is a possible instance of a famous Greek painting being copied in Pompeii, albeit into a different medium (see fig. 5.79). Given the scarcity of Greek mural paintings, however, it is a rare case when a clear connection can be demonstrated between Greek original and Roman copy. Given the evident innovation in Roman painting in general, there is no reason to suppose that Roman artists were not fully capable of creating their own compositions and narratives when they chose. In recent years, scholarship has become less preoccupied with tracing Greek influences in Roman paintings, and more focused on ways in which ensembles of paintings affected experience or dictated

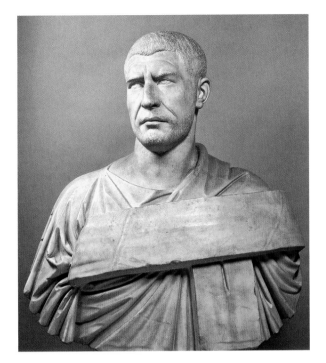

7.59. Portrait of Philip the Arab. 244–249 CE. Marble. Life-size. Musei Vaticani, Braccio Nuovo, Città del Vaticano, Rome

ART IN TIME

60–50 BCE—**Paintings from the Villa of the Mysteries, outside Pompeii**

79 CE—Vesuvius erupts

movement throughout a house and expressed the owner's status. In fact, there exists a genre of ancient literature known as *ekphrasis* that is a learned exposition on the subject of a real or imagined painting. (See *Primary Source*, page 218.) On the basis of these writings, scholars believe that homeowners sometimes conceived their paintings as conversation pieces for their guests, who might discuss them as they dined. Designing a painting program, then, takes on a new level of importance for what it might subtly disclose about the patron's erudition, status, or aspirations.

THE LATE EMPIRE

Portrait Sculpture

During Marcus Aurelius' reign, incursions at the empire's German and Danubian borders were a constant threat. Succeeding him in 180 CE, his son Commodus was assassinated in 192 CE. The imperial administration then hit an all-time low when, in 193 CE, the throne was auctioned off to the highest bidder. After a brief respite under the Severan dynasty, Rome entered a half century of civil war, when a long succession of emperors came to power and quickly fell through violence. Imperial portraits of this time share a harsh, soldierly quality, intended to appeal to where the power lay. Beards and hair are cropped short, with individual strands of hair often etched with a quick chip of the chisel that scholars term negative carving (fig. **7.59**). The twist of the head, the furrowed brow and the generally careworn features present the army with a man of action as their leader.

Imperial authority was finally restored in the reign of Diocletian (r. 284–305 CE). His approach was to impose rigid order on all aspects of civil as well as military life. Recognizing the emperor's vulnerability, he also chose to divide authority among four rulers, known as the tetrarchs. Two were senior emperors, the Augusti; and two juniors, the Caesars. Terms of power were to be limited, and the Caesars were to succeed the Augusti. To this period date two porphyry sculptural groups now immured in the Basilica of San Marco in Venice, probably originally mounted on columns (fig. **7.60**). Each group shows

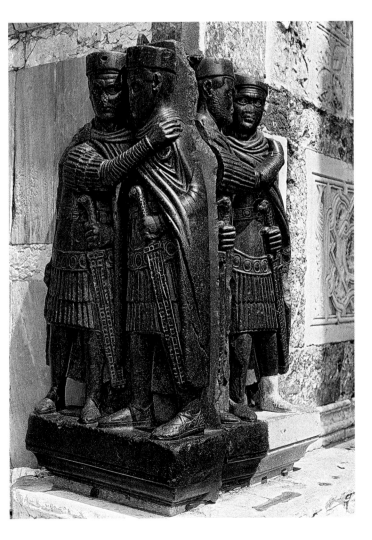

7.60. Portrait group of the Tetrarchs. ca. 305 CE. Porphyry. Height 51″ (129.5 cm). Basilica of San Marco, Venice

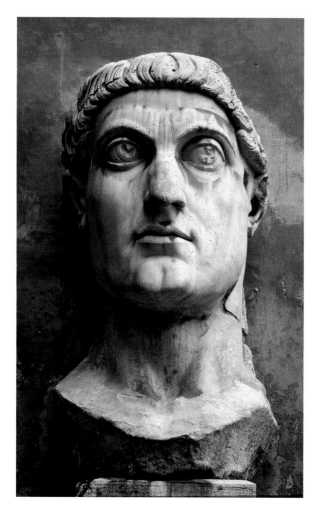

two men in elaborate military dress, with flat Pannonian caps and bird-headed sword hilts. The figures are locked in a close embrace, and they are all but indistinguishable from one another (except that in each group, one is bearded, the other close-shaven). Their proportions are squat and unnaturalistic, their facial features abstract rather than individualized. The portraits suggest that authority resides in the office of emperor, not in the individual who holds the office. The sameness of the portraits underlines the tetrarchs' equality, while their embrace stresses unanimity and solidarity. The choice of material speaks volumes too: Porphyry, a hard Egyptian stone of deep purple color, had long been reserved for imperial portraits.

In the early fourth century, with the gradual dissolution of the tetrarchy, Constantine the Great rose to power, overcoming his chief rival, Maxentius, at the battle of Milvian Bridge in Rome in 312. The colossal head of figure **7.61** is one fragment of a vast seated portrait that once occupied an apse in a huge basilica (see figs. 7.68 and 7.69). The head alone is 8 feet tall, and the dominant feature of the face is the eyes, which are disproportionately large. Deeply carved, they gaze into a faraway distance; combined with the stiff frontality of the face, they give the image an abstract and iconic quality. Some scholars associate changes like these with a new spirituality in the later Empire, exemplified by Constantine's adherence to Christianity. Perhaps the eyes gaze at something beyond this world; perhaps they are a window to the soul. At the same time, a soft modeling to the cheeks and mouth renders the portrait more naturalistic than its tetrarchic predecessors. Moreover, the full cap of hair, and the absence of a beard, appear to be direct references to Trajan and Augustus, great emperors of the past whose achievements still gave the office its authority.

7.61. *Portrait of Constantine the Great.* Early 4th century CE. Marble. Height 8′ (2.4 m). Museo del Palazzo dei Conservatori, Rome

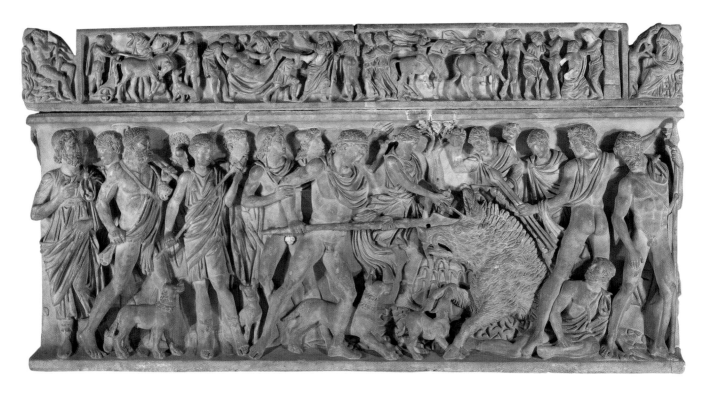

7.62. *Meleager Sarcophagus.* ca. 180 CE. Marble. Galleria Doria Pamphili, Rome

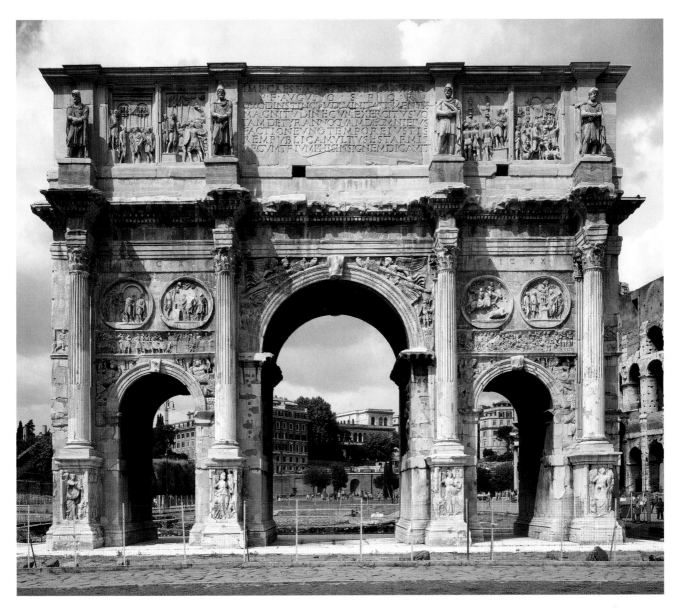

7.63. Arch of Constantine, Rome. 312–315 CE

Relief Sculpture

The second century CE witnessed a shift in funerary custom among Romans. Inhumation gradually took the place of cremation for all but the imperial family, who continued to be cremated. This led to a greatly increased demand for marble sarcophagi in place of cinerary urns, and they were decorated with a profusion of designs, which were soon passed from shop to shop, probably in pattern books of some kind. Preferences changed over time. For example, under Marcus Aurelius, patrons favored battle sarcophagi. Later, in the third century, biographical and historical scenes preserved aspects of the deceased's life. The most popular scenes were taken from Greek mythology. Their purpose may have been to glorify the deceased through visual analogy to the legendary heroes of the past; they may equally have expressed the owner's erudition. Figure **7.62** illustrates a moment from the myth of Meleager. In Homer's account, Meleager saved Calydon from a ferocious boar, sent by Artemis to ravage his father's land; he then died in a battle over its pelt. Meleager was an example of noble *virtus*, or manly prowess. For his heroism and death in the service of country, he earned immortality. The relief's style owes much to Greek sculpture, but the crowding of the entire surface with figures is entirely Roman.

In 315 CE, the Senate and People of Rome dedicated the triple-bayed Arch of Constantine near the Colosseum to celebrate Constantine's ten-year anniversary and conquest of Maxentius (fig. **7.63**). One of the largest imperial arches, what makes it most unusual is that little of the sculptural relief that covers its

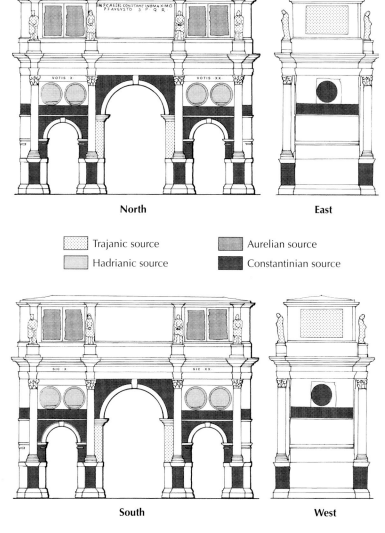

North

East

Trajanic source

Aurelian source

Hadrianic source

Constantinian source

South

West

7.64. Arch of Constantine, Rome. Schematic drawing showing reused sculpture

surface was designed for this monument (fig. **7.64**). The free-standing Dacian captives on the attic probably originated in Trajan's Forum, as did the Great Trajanic Frieze on the ends of the attic and inside the central bay. Eight hunting and sacrifice tondi above the lateral bays once belonged to a Hadrianic monument, and eight Aurelian panels on the attic may have decorated an arch to Marcus Aurelius. When the Arch was constructed, sculptors recarved the heads of earlier emperors to resemble Constantine and his co-emperor Licinius a modern restoration replaced some of them with heads of Trajan.

Scholars describe sculptural and architectural borrowings of this kind by the modern term **spolia**, derived from the Latin *spolium*, meaning "hide stripped from an animal," a term primarily used for spoils taken in war. No ancient testimony survives to acknowledge or explain the practice, and the spolia raise all manner of questions—such as how Romans perceived the stripping of one monument in favor of another, and what became of the original monument, presuming that it was still standing. In a renowned assault on Late Antique sculpture in the 1950s, art historian Bernard Berenson condemned the use of spolia as evidence of a pervasive decline in form in Late Antiquity, which he attributed to a mass exodus of craftsmen and artists from a city tottering on the brink of destruction. Other scholars, assuming that Romans recognized style differences as we do, see the spolia as part of a legitimation ideology, suggesting that they expressed the qualities of "emperorness." By leaning on the reputations and successes of "good" rulers of the past, Constantine may have hoped to harness the reputations that they had earned during their lifetimes, as well the nostalgic idealization that had accrued to those reputations through intervening years. Constantine had every reason to legitimize his authority: Maxentius had been a formidable opponent, with

his efforts to reposition Rome at the center of the Empire through a policy of revivalism. Moreover, as the first openly Christian emperor, Constantine risked alienating a pagan Senate. If this interpretation is correct, it is not entirely dissimilar from readings of the Republican statue base, partly made up of Greek reliefs, as seen in figure 7.9.

To complement the borrowed pieces, Constantinian artists carved bases for the columns that flank the bays, a continuous relief to encircle the arch just above the lateral bays, and roundels for the sides of the arch. The scene illustrated here depicts Constantine speaking to the Senate and people of Rome from the speaker's platform or **rostrum** in the Forum, after his entry into Rome in 312 CE (fig. **7.65**). Figures crowd the scene. Their heads are disproportionately large, their bodies stocky, and their poses unnaturally rigid. Lines carved on the flat surface render anatomical details in place of modeling. The artist eschewed the devices used on the Arch of Titus panels to give an illusion of depth; a second row of heads arranged above the first indicates recession (see figs. 7.26 and 7.27). Berenson judged the style of the Constantinian reliefs just as harshly as the act of spoliation. Yet their abstract quality makes them unusually legible from a distance, which is how they would have been seen. A careful order governs the composition, with the emperor occupying the center and shown fully frontal; other figures turn and focus attention on him. Buildings in the background are sufficiently distinct to make the setting recognizable even today as the Roman Forum. The artists chose to privilege the message-bearing potential of the reliefs over any attempt at illusionism or naturalism.

Architecture

By the time of the late Empire, architects in Rome had more or less abandoned the straightforward use of post-and-lintel construction. Their interests appear to have focused instead on exploring the interior spaces that concrete made possible. Column, architrave, and pediment took on decorative roles, superimposed on vaulted brick-and-concrete cores. Imperial bath buildings demonstrate this well. By the beginning of the third century CE, public baths were a long-established tradition in Roman life. Emperors had routinely embellished the city with baths as an act of benefaction. Romans who did not have private baths within their own homes expected to bathe publicly most days, but the baths served other functions as well. They became a place of social interaction, where business might be conducted and the wealthy might flaunt their troops of slaves. The Baths of Caracalla, built between 211

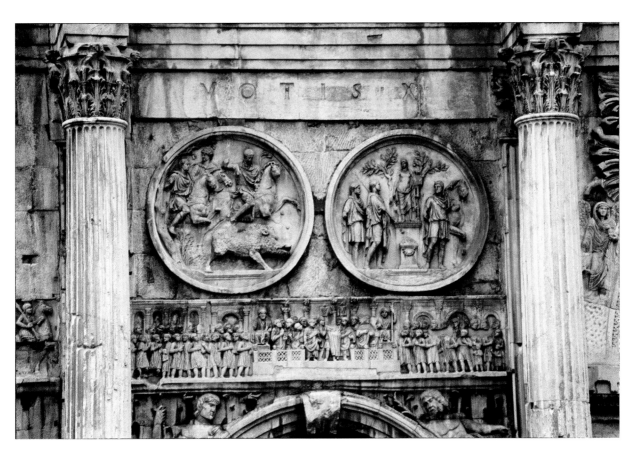

7.65. Constantinian relief from Arch of Constantine, Rome

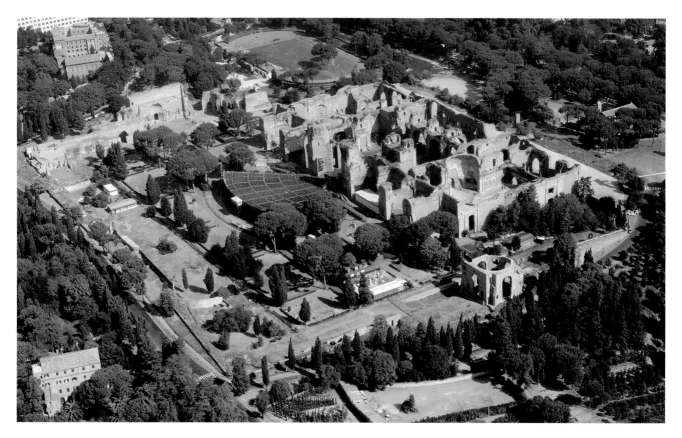

7.66. Baths of Caracalla, Rome, ca. 211–216 CE

and 216 CE, were the most extensive and lavish of their kind (figs. **7.66** and **7.67**). Set within a rectangular perimeter wall, they included the essentials for bathing facilities: a cold room (*frigidarium*), a circular hot room (*caldarium*), and a warm room (*tepidarium*), as well as a vast swimming pool (*natatio*), changing rooms, and exercise areas (*palaestra*). Lecture halls, libraries, and temples made for a multifaceted experience within its walls. By the time of the construction of Caracalla's baths, the general layout of a bath complex had become standardized. So had the technology necessary to heat the warm

rooms. Their floors were raised above the ground on brick piers, and hot air was directed from a furnace into the open space between. This is known as a *hypocaust* system. All the same, the sheer scale of Caracalla's complex must have been astounding: The principal block measured an immense 656 feet (220 m) by 374 feet (114 m). The largest room, the frigidarium, was roofed with three vast groin vaults. Luscious marble panels revetted the walls, and sculptures set in alcoves animated the halls.

The design was influential. When Maxentius commissioned a vast basilica for the center of Rome, the architects looked to the massive uninterrupted spaces of the bath buildings for inspiration. Basilicas (from the Greek *basileus*, meaning "king") had a long history in Rome. Since the Republic, they had served as civic halls, and they soon became a standard feature of Roman towns. One of their chief functions was to provide a dignified setting for the courts of law that dispensed justice in the name of the emperor. Vitruvius prescribed principles for their placement and proportions, but in practice they never conformed to a single type and varied from region to region. The Basilica of Maxentius (figs. **7.68** and **7.69**) was built on an even grander scale than the Baths of Caracalla and was probably the largest roofed interior in Rome. It was divided into three aisles, of which only the north one still stands. Transverse barrel vaults covered the lateral aisles, and the wider, taller central aisle was covered with three massive groin vaults. Since a groin vault, like a canopy,

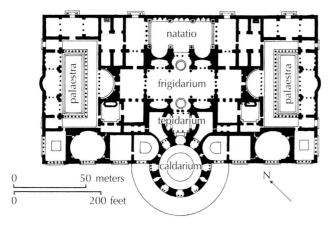

7.67. Plan of Baths of Caracalla, Rome. ca. 211–216 CE

has its weight and thrust concentrated at the four corners (see fig. 7.3), the upper walls of the nave could be pierced by a large clerestory. As a result, the interior of the basilica must have had a light and airy quality despite its enormous size. The building had two entrances: through a transverse vestibule at the east end, and through a stepped doorway on the south, leading from the Roman Forum. Apses faced each of the entrances. On overcoming Maxentius, Constantine

ART IN TIME

late second century CE—**Cival War disrupts imperial authority**
211–216 CE—**Construction of the Baths of Caracalla in Rome**
fourth century CE—**Constantine the Great**
315 CE—**Dedication of the Arch of Constantine in Rome**

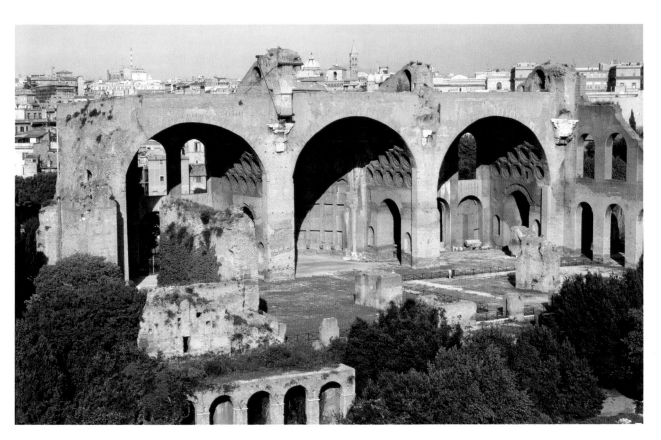

7.68. Basilica of Maxentius, renamed Basilica of Constantine. ca. 307 CE. Rome

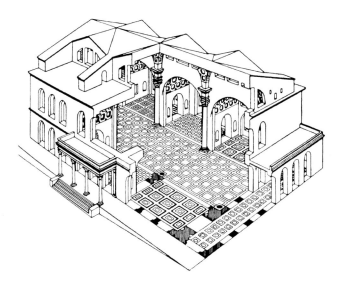

7.69. Basilica of Maxentius, renamed Basilica of Constantine. Reconstruction (after Huelsen)

expropriated the basilica, giving it his own name and placing his colossal portrait in the western apse (see fig. 7.61). Expropriations of this kind were not uncommon in Rome, and show how critical it was to have a physical presence in the city.

LATE ROMAN ARCHITECTURE IN THE PROVINCES

By the early second century, Roman emperors were no longer exclusively from Italy; Trajan came from Spain and Septimius Severus was from North Africa. Both emperors embellished their native cities with new construction. Severus' home, Lepcis Magna, in present-day Libya, remains remarkably well preserved. The emperor was responsible for a grand new forum there, and a magnificent basilica with a long central aisle closed by an apse at either end (fig. **7.70**).

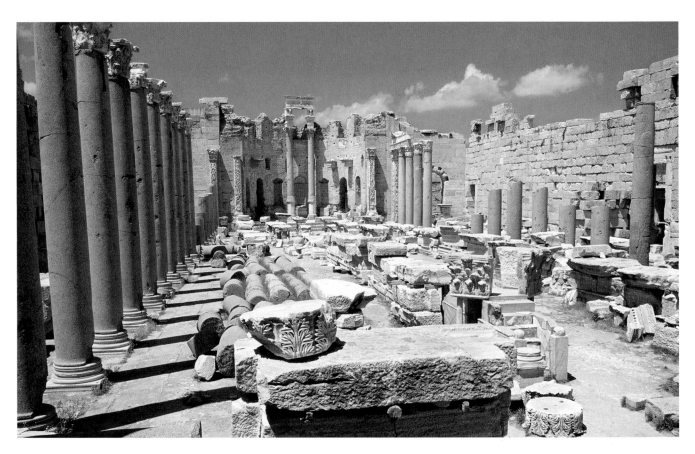

7.70. Basilica, Lepcis Magna, Libya. Early 3rd century CE

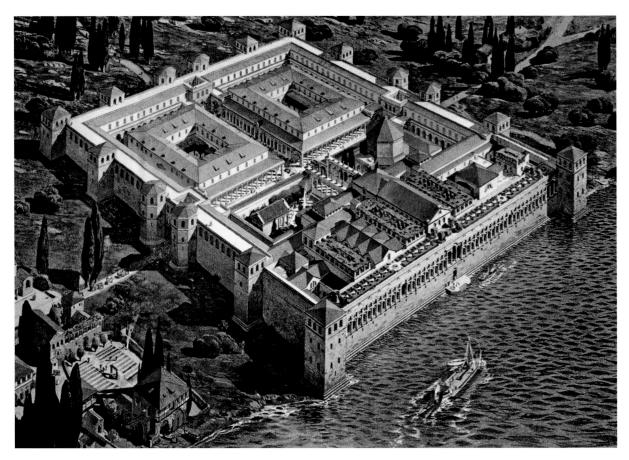

7.71. Palace of Diocletian, Spalato, Croatia. ca. 300 CE

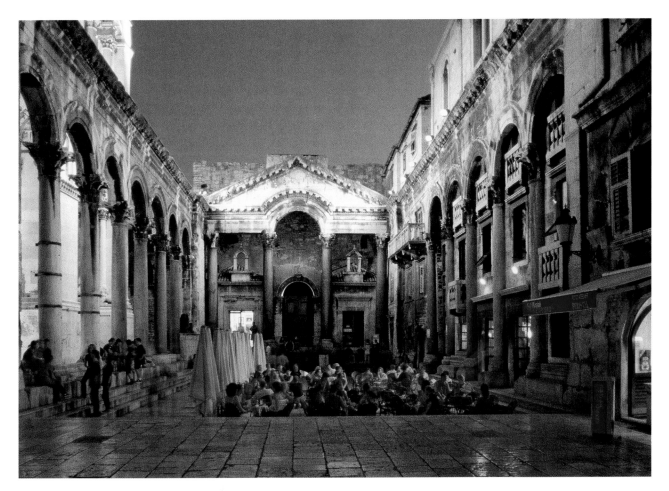

7.72. Peristyle, Palace of Diocletian, Spalato, Croatia. ca. 300 CE

Colonnades in two stories provide access to the side aisles, which were lower than the nave to permit clerestory windows in the upper part of the wall. The wooden ceiling has long since perished.

Developments in Roman architecture after Diocletian came to power appear to go hand-in-hand with the profound changes he made to society. Nowhere is this more obvious than in his palace at Spalato (in Croatia) overlooking the Adriatic Sea, built for his abdication in 305 CE (figs. **7.71** and **7.72**). Although intended as a residence, it is essentially a military fort, with defensive walls, gates, and towers. As in a military camp, two intersecting colonnaded streets stretched between the gates and divided the rectangular space enclosed within the walls, measuring about 650 by 500 feet (198 by 152 m), into four major blocks. The street from the main gate led to a sunken peristyle court. Columns on two sides support arcuated lintels, used only sporadically since the early Empire and popular in

Late Antiquity. They direct a visitor's gaze to the far end of the court, where a frame is achieved between the two central columns by setting an arcuated lintel within a pediment. It was here that the former emperor made his public appearances. Behind this grand entrance was a vestibule, opening on to the audience hall. To the left of the peristyle court was a large octagonal mausoleum, now used as a cathedral. Loosely based upon the Pantheon (see figs. 7.39 to 7.43), this type of imperial mausoleum would be one of the prototypes for Christian martyria, burial places of martyred saints. To the right of the court was a small temple dedicated to Jupiter, Diocletian's patron god. The topographical relationship between mausoleum and temple implied an equivalency between emperor and god.

When Diocletian divided authority between the tetrarchs, each of them established a capital in a different region of the empire and embellished it with appropriate grandeur. Constantius Chlorus, father of Constantine the Great, made his seat

ART IN TIME

ca 300 CE—Diocletian builds his palace in
Spalato (Croatia)

early fourth century CE—Constantius Chlorus constructs a basilica
in Trier, Germany

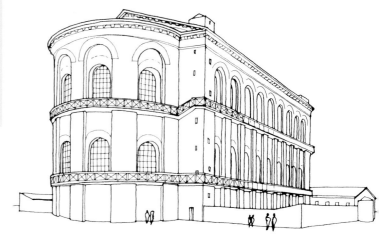

7.73. Basilica of Constantius Chlorus, Trier, Germany.
Early 4th century CE

at Trier, in present-day Germany. There he, too, constructed a basilica, which now functions as a church (figs. **7.73** and **7.74**). In its design, the Classical forms have dissolved entirely, leaving vast abstract expanses in both solid and void. The great mass of its walls is broken by elongated arches, serving now as visual buttresses framing the windows, beneath which were balconies. As vast as the interior was, the architect directed his skill toward achieving the illusion of even greater dimensions. The windows in the apse are significantly smaller than those in the side walls, and the apse ceiling is lower than the ceiling over the main hall. Both devices give the appearance that the apse recedes much farther into the distance than it actually does. Not only did this make the building appear grander, but the apse was where the emperor—or his image—would hold sway, and the altered dimensions would have had the effect of making him appear significantly larger than life. The vocabulary of Roman building had changed, in other words, but it was still an architecture of power.

During the course of about a millennium, Rome grew from a small city to the capital of a massive, culturally diverse empire. Those years witnessed huge developments in architecture, due as much to changes in technology as to political motivations. Post-and-lintel construction combined with the free forms made possible by concrete, and then dissolved in favor of new abstract concepts of space. In the provinces, architecture brought some improvements in standards of living, but it also helped to secure Roman control, exerting a constant Roman presence far from the center of administration. Sculpture and painting abounded within public and private buildings. Often sculpture carried a strong political message, its style chosen to best reinforce its content. As with architecture, an abstract style came to dominate sculpture in late antiquity, due perhaps to an increased spirituality and to a change in concepts of rulership. A wealth of surviving houses and paintings reveals that art played a powerful role in the home as well as in more public places, projecting an image of its patron for others to see.

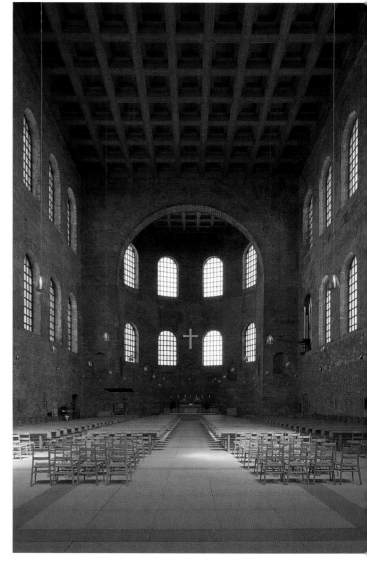

7.74. Interior of Basilica of Constantius Chlorus, Trier, Germany.
Early 4th century CE

SUMMARY

During the course of about a millennium, Rome grew from a small city to the capital of a massive and culturally diverse empire. Those years witnessed major developments in architecture, due as much to changes in technology as to political motivations. In the provinces, architecture brought some improvements in standards of living, but also helped to secure Roman control, exerting a constant Roman presence far from the center of administration. Painting and sculpture abounded within public and private buildings—sculpture often carrying a strong political message, its style chosen to best reinforce its content.

THE REPUBLIC

Roman builders were indebted to Greek predecessors, especially in the use of the Doric, Ionic, and Corinthian styles. Roman architects, however, used forms—such as the arch—that made their buildings decisively Roman. The use of concrete as a building material was exploited fully by the Romans, and its use allowed them to create remarkably open interior spaces, as seen in the Porticus Aemilia. Political leaders also used architecture, as well as sculpture, to express and justify their power and to commemorate specific events.

THE EARLY EMPIRE

During the age of Augustus, Roman portrait sculpture turned from the earlier veristic style of the Republic to a more classicizing style associated with ancient Greece. Augustus was portrayed as an ageless youth throughout his reign, and later emperors Trajan and Hadrian continued this stylistic tradition. The practice of commissioning narrative reliefs to record specific events remained popular, as seen in the Ara Pacis and the Column of Trajan. Early imperial masterpieces of concrete construction include the Colosseum and the Pantheon, both in Rome.

ART AND ARCHITECTURE IN THE PROVINCES

As ancient Rome's authority spread over a wide geographical reach, it had a great impact on the art, architecture, and daily life of those regions. Roman rule brought practical benefits, such as aqueducts to move water. It also introduced a way of life that included frequent public entertainments and Roman religious practices, both of which are reflected in the theaters, amphitheaters, and temples constructed from one end of the Empire to the other.

DOMESTIC ART AND ARCHITECTURE

When the eruption of Mt. Vesuvius buried the cities of Pompeii and Herculaneum, it also preserved a wealth of houses, wall paintings, mosaics, and everyday objects. This invaluable legacy reveals that art played a powerful role in the home as well as in more public places, projecting an image of its patron for others to see. Roman houses also survive in places as far afield as Morocco and Jordan as well as in Ostia, Italy.

THE LATE EMPIRE

Not long after the death of Marcus Aurelius, the Roman Empire entered a period of instability that lasted almost 100 years, until the reign of the emperor Diocletian. In late antiquity, an abstract style came to dominate Roman architecture and sculpture, possibly due to an increased interest in spirituality, and to changing concepts of rulership. An example of this change is a porphyry statuary group representing the four emperors of the Tetrarchy, now in Venice.

LATE ROMAN ARCHITECTURE IN THE PROVINCES

Some rulers who reigned during the later years of the Roman Empire were born or lived outside Italy. Septimius Severus, who came from Lepcis Magna in Libya, embellished his native city with new structures, and Diocletian built a fortified palace at Spalato in Croatia. During the Tetrarchy, the four emperors ruled the Empire from four capitals outside of Rome, and they furnished these cities with new public buildings, such as Constantius Chlorus' basilica in Trier, Germany.

The Code of Hammurabi

Epilogue

Hammurabi, the Protecting King Am I.

I have not withdrawn myself from the men, whom Bel gave to me, the rule over whom Marduk gave to me, I was not negligent, but I made them a peaceful abiding-place. I expounded all great difficulties, I made the light shine upon them. With the mighty weapons which Zamama and Ishtar entrusted to me, with the keen vision with which Ea endowed me, with the wisdom that Marduk gave me, I have uprooted the enemy above and below (in north and south), subdued the earth, brought prosperity to the land, guaranteed security to the inhabitants in their homes; a disturber was not permitted.

The great gods have called me, I am the salvation-bearing shepherd, whose staff is straight, the good shadow that is spread over my city; on my breast I cherish the inhabitants of the land of Sumer and Akkad; in my shelter I have let them repose in peace; in my deep wisdom have I enclosed them. That the strong might not injure the weak, in order to protect the widows and orphans, I have in Babylon the city where Anu and Bel raise high their head, in E-Sagil, the Temple, whose foundations stand firm as heaven and earth, in order to declare justice in the land, to settle all disputes, and heal all injuries, set up these my precious words, written upon my memorial stone, before the image of me, as king of righteousness.

The king who rules among the kings of the cities am I. My words are well considered; there is no wisdom like mine. By the command of Shamash, the great judge of heaven and earth, let righteousness go forth in the land: by the order of Marduk, my lord, let no destruction befall my monument. In E-Sagil, which I love, let my name be ever repeated; let the oppressed, who have a case at law, come and stand before this my image as king of righteousness; let him read the inscription, and understand my precious words: the inscription will explain his case to him; he will find out what is just, and his heart will be glad, so that he will say: . . .

SOURCE: *WORLD CIVILIZATIONS ONLINE CLASSROOM,* "THE CODE OF HAMMURABI." TR. LW KING, 1910. ED. RICHARD HOOKER, 1996, WWW.WSU.EDU:8080/~DEE

A Hymn to Aten

This text was inscribed on a tomb in Amarna, the capital established by Ahkenaten. It gives voice to the character of Ahkenaten's belief in the Aten (disk) of the sun. This is the opening stanza.

> Earth brightens when you dawn in lightland,
> When you shine as Aten of daytime;
> As you dispel the dark,
> As you cast your rays,
> The Two Lands are in festivity.

> Awake they stand on their feet,
> You have roused them;
> Bodies cleansed, clothed,
> The arms adore your appearance.
> The entire land sets out to work,
> All beasts browse on their herbs;
> Trees, herbs are sprouting,
> Birds fly from their nests.
> Their wings greeting your *ka.*
> All flocks frisk on their feet,
> All that fly up and alight,
> They lived when you dawn for them,
> Ships fare north, fare south as well,
> Roads lie open when you rise;
> The fish in the river dart before you,
> Your rays are in the midst of the sea.

SOURCE: AMELIE KUHRT *THE ANCIENT NEAR EAST,* VOL. I. (LONDON: ROUTLEDGE, 1995)

Pliny the Elder (23–79 CE)

Natural History

The earliest preserved history of art appears in the work of the Roman naturalist and historian Pliny, who lived at the beginning of the Roman Imperial period and died in the eruption of Mount Vesuvius that destroyed Pompeii. Pliny says nothing about vase painting. For him the great era of painting began in the fifth century BCE, and its high point came in the fourth century BCE. Pliny lists the names and works of many artists who are otherwise unknown today. His anecdotes reveal the primacy placed on illusionism by Greeks and Romans. Pliny's work influenced Renaissance writers of art history, including Ghiberti and Vasari.

from Book 35 (on Greek painting)

The origin of painting is obscure. . . . All, however, agree that painting began with the outlining of a man's shadow; this was the first stage, in the second a single colour was employed, and after the discovery of more elaborate methods this style, which is still in vogue, received the name of monochrome. . . .

Four colours only—white from Melos, Attic yellow, red from Sinope on the Black Sea, and the black called "atramentum"—were used by Apelles, Action, Melanthios and Nikomachos in their . . . works; illustrious artists, a single one of whose pictures the wealth of a city could hardly suffice to buy. . . .

Apollodoros of Athens [in 408–405 BCE] was the first to give his figures the appearance of reality. [He] opened the gates of art through which Zeuxis of Herakleia passed [in 397 BCE]. The story runs that Parrhasios and Zeuxis entered into competition, Zeuxis exhibiting a picture of some grapes, so true to nature that the birds flew up to the wall of the stage. Parrhasios then displayed a picture of a linen curtain,

realistic to such a degree that Zeuxis, elated by the verdict of the birds, cried out that now at last his rival must draw the curtain and show his picture. On discovering his mistake he surrendered the prize to Parrhasios, admitting candidly that he had deceived the birds, while Parrhasios had deluded himself, a painter. . . .

Apelles of Kos [in 332–329 BCE] excelled all painters who came before or after him. He of himself perhaps contributed more to painting than all the others together; he also wrote treatises on his theory of art. . . .

Nikomachos' . . . pupils were his brother Ariston, his son Aristeides and Philoxenos of Eretria, who painted for king Kassander the battle between Alexander and Dareios, a picture second to none [compare fig. 5.79].

from Book 34 (on bronze)

Besides his Olympian Zeus, a work which has no rival, Pheidias made in ivory the Athena at Athens, which stands erect in the Parthenon. . . . He is rightly held to have first revealed the capabilities of sculpture and indicated its methods.

Polykleitos . . . made an athlete binding the diadem about his head, which was famous for the sum of one hundred talents which it realized. This . . . has been described as "a man, yet a boy": the . . . spearbearer [see fig. 5.33] as "a boy, yet a man." He also made the statue which sculptors call the "canon," referring to it as to a standard from which they can learn the first rules of their art. He is the only man who is held to have embodied the principles of his art in a single work. . . . He is considered to have brought the scientific knowledge of statuary to perfection, and to have systematized the art of which Pheidias had revealed the possibilities. It was his peculiar characteristic to represent his figures resting their weight on one leg; . . .

Myron . . . [made an] athlete hurling the disk [see fig. 5.32], a Perseus, . . . and the Herakles which is near the great Circus in the temple of the great Pompeius. . . . He was more productive than Polykleitos, and a more diligent observer of symmetry. Still he too only cared for the physical form, and did not express the sensations of the mind. . . .

Lysippos produced more works than any other artist, possessing, as I have said, a most prolific genius. Among them is the man scraping himself [see fig. 5.62]. . . . In this statue the Emperor Tiberius took a marvelous delight, . . . he could not refrain from having the statue removed into his private chamber, substituting another in its place. . . . His chief contributions to the art of sculpture are said to consist in his vivid rendering of the hair, in making the heads smaller than older artists had done, and the bodies slimmer and with less flesh, thus increasing the apparent height of his figures. There is no word in Latin for the canon of symmetry which he was so careful to preserve, bringing innovations which had never been thought of before into the square canon of the older artists, and he often said that the difference between himself and them was that they represented men as they were, and he as they appeared to be. His chief characteristic is extreme delicacy of execution even in the smallest details.

from Book 36 (on marble)

The art of [marble] sculpture is much older than that of painting or of bronze statuary, both of which began with Pheidias. . . .

Praxiteles . . . outdid even himself by the fame of his works in marble. . . . Famous . . . throughout the whole world, is the Aphrodite which multitudes have sailed to Knidos to look upon [see fig. 5.60]. He had offered two statues of Aphrodite for sale at the same time, the second being a draped figure, which for that reason was preferred by the people of Kos with whom lay the first choice; the price of the two figures was the same, but they flattered themselves they were giving proof of a severe modesty. The rejected statue, which was bought by the people of Knidos, enjoys an immeasurably greater reputation. King Nikomedes subsequently wished to buy it from them, offering to discharge the whole of their public debt, which was enormous. They, however, preferred to suffer the worst that could befall, and they showed their wisdom, for by this statue Praxiteles made Knidos illustrious. . . .

Bryaxis, Timotheos, and Leochares were rivals and contemporaries of Skopas, and must be mentioned with him, as they worked together on the Mausoleion [fig. 5.56]. This is the tomb erected by Artemisia in honour of her husband Mausolos, . . . and its place among the seven wonders of the world is largely due to these great sculptors. The length of the south and north sides is 163 feet; the two facades are shorter, and the whole perimeter is 440 feet; its height is 25 cubits [37 1/2 feet], and it has thirty-six columns. . . . The sculptures of the eastern front are carved by Skopas, those on the north by Bryaxis, on the south by Timotheos, and on the west by Leochares. . . . Above the colonnade is a pyramid, of the same height as the lower structure, consisting of twenty-four retreating steps rising into a cone. On the apex stands a chariot and four horses in marble made by Pythis. . . .

SOURCE: *THE ELDER PLINY'S CHAPTERS ON THE HISTORY OF ART.* TR. K. JEX-BLAKE. (LONDON, NY: MACMILLAN, 1896)

Vergil (70–19 BCE)

The Aeneid, from Book II

Vergil was among the greatest Latin poets and the chief exponent of the Augustan age in literature. The Aeneid is an epic poem about the hero Aeneas, who fled Troy when it was destroyed by the Greeks and settled in Italy. Book II tells of the fall of Troy, including the punishment by Minerva of Laocoön for trying to warn the Trojans against the trick wooden horse. The sculptural rendition of Laocoön shown in The Art Historian's Lens, *page 179, closely resembles Vergil's description.*

Laocoön, by lot named priest of Neptune,
was sacrificing then a giant bull
upon the customary altars, when
two snakes with endless coils, from Tenedos
strike out across the tranquil deep. . . .

They lick their hissing jaws with quivering tongues.
We scatter at the sight, our blood is gone.
They strike a straight line toward Laocoön.
At first each snake entwines the tiny bodies
of his two sons in an embrace, then feasts
its fangs on their defenseless limbs. The pair
next seize upon Laocoön himself,
who nears to help his sons, carrying weapons.
They wind around his waist and twice around
his throat. They throttle him with scaly backs;
their heads and steep necks tower over him.
He struggles with his hands to rip their knots,
his headbands soaked in filth and in dark venom,
while he lifts high his hideous cries to heaven,
just like the bellows of a wounded bull.

SOURCE: *THE AENEID OF VIRGIL*. TR. ALLEN MANDLEBAUNI. (NY: BANTAM BOOKS, A DIVISION OF RANDOM HOUSE INC., 1971)

Vitruvius (1st Century BCE)

On Architecture

Vitruvius, like Pliny, was a Roman writer who admired the achievements of the Greeks. He was an architect under Julius Caesar and Augustus, and his treatise on architecture (ca. 35–25 BCE) reflects the classicizing taste of his time. Vitruvius' work was a principal source for Renaissance architects seeking the revival of antiquity. His account of the origin of the Greek Styles is partly mythic, partly rational conjecture. His suggestions for appropriate domestic spaces for people of different professions and status have helped scholars reconstruct the rituals of Roman life.

Book 6, Chapter 5: Correctness (Decor)

Once these things have been set out with regard to the regions of the heavens, then it is time to note also by what principles the personal areas of private buildings should be constructed for the head of the family and how public areas should be constructed with outsiders in mind as well. Personal areas are those into which there is no possibility of entrance except by invitation, like cubicula, triclinia, baths and the other rooms that have such functions. Public areas are those into which even uninvited members of the public may also come by right, that is, vestibules, cavaedia, peristyles, and any rooms that may perform this sort of function.

And so, for those of moderate income, magnificent vestibules, tablina, and atria are unnecessary, because they perform their duties by making the rounds visiting others, rather than having others make the rounds visiting them. ... for moneylenders and tax collectors public rooms should be more commodious, better looking, and well secured, but for lawyers and orators they should be more elegant, and spacious enough to accommodate meetings. For the most prominent citizens, those who should carry out their duties to the citizenry by holding honorific titles and magistracies, vestibules should be constructed that are lofty and lordly, the atria and peristyles at their most spacious, lush gardens and broad walkways refined as properly befits their dignity.

Book 4, Chapter 1: The Discovery of Symmetries

[Greeks in Ionia] decided to build a temple for Panionian Apollo like the ones they had seen in Achaea, and they called this temple "Doric" because they had first seen a temple of this type in the cities of the Dorians.

6. When they had decided to set up columns in this temple, lacking symmetries for them, and seeking principles by which they might make these columns suitable for bearing loads yet properly attractive to behold, they measured a man's footprint and compared it with his height. When they discovered that for a man, the foot is one-sixth of his height, they applied this ratio to the column, and whatever diameter they selected for the base of the column shaft, they carried its shaft, including the capital, to a height six times that amount. Thus the Doric column came to exhibit the proportion, soundness, and attractiveness of the male body.

7. After this, the Ionians also built a temple to Diana, seeking a new type of appearance, they applied the same ratio based on footprints to a woman's slenderness, and began making the diameter of the columns measure one-eighth their height, so that their appearance would be more lofty. Instead of a shoe, they put a spira underneath as a base, and for the capital, as if for hair, they draped volutes on either side like curled locks. The front they adorned with moldings and festoons arranged in the place of tresses, and they let flutes down the whole trunk of the column to mimic, in matronly manner, the folds of a stola. Thus they derived the invention of columns from two sets of criteria: one manly, without ornament, and plain in appearance, the other of womanly slenderness, ornament, and proportion.

8. Later generations, more advanced in the elegance and subtlety of their aesthetic judgment, who delighted in more attenuated proportions, established that the height of the Doric column should be seven times the measure of its diameter, and the Ionic column should be nine times the width. For that type of column is called Ionic, because it was first made by the Ionians.

Discovery of Corinthian Symmetries

Now the third type, which is called Corinthian, imitates the slenderness of a young girl, because young girls, on account of the tenderness of their age, can be seen to have even more slender limbs and obtain even more charming effects when they adorn themselves. 9. It is said that the invention of this type of capital occurred in the following manner. A young Corinthian girl of citizen rank, already of marriageable age, was struck down by disease and passed away. After her burial, her nurse collected the few little things in which the girl

had delighted during her life, and gathering them all in a basket, placed this basket on top of the grave. So that the offering might last there a little longer, she covered the basket with a roof tile.

This basket, supposedly, happened to have been put down on top on an acanthus root. By springtime, therefore, the acanthus root, which had been pressed down in the middle all the while by the weight of the basket, began to send out leaves and tendrils, and its tendrils, as they grew up along the sides of the basket, turned outward, when they met the obstacle of the corners of the roof tile, first they began to curl over at the ends and finally they were induced to create coils at the edges.

Book 4, Chapter 2: Architectural Ornament

The craftsmen of old, … placed joists that protruded from the interior walls to the outer edges [of the buildings]. … Subsequently they decided that these projecting joists should be cut off where they protruded beyond the plane of the walls, and because the result looked unattractive to them, they fitted plaques in front of the cuttings, which were shaped as triglyphs are made today, and they painted these with blue wax so that the cut ends of the joists would not offend the viewer.

And thus the covered sections of the joists in Doric works began to take on the arrangement of the triglyphs and, between the joists, the metopes.

3. Afterward various architects in various other buildings extended the projecting beams perpendicular to the triglyphs and leveled off the projections. From this, just as triglyphs derived from the arrangement of beams, so from the projection of the rafters the principle of mutules beneath the cornice was discovered. This is generally what happens in stone and marble works, in which the mutules are reshaped by slanted cutting, because they are an imitation of the rafters. … Thus, for Doric works the principle underlying the triglyphs and mutules was derived from these imitations.

SOURCE: VITRUVIUS: TEN BOOKS ON ARCHITECTURE. TR. INGRID D. ROWLAND; COMMENTARY THOMAS NOBLE HOWE. (NY: CAMBRIDGE UNIVERSITY PRESS, 1999)

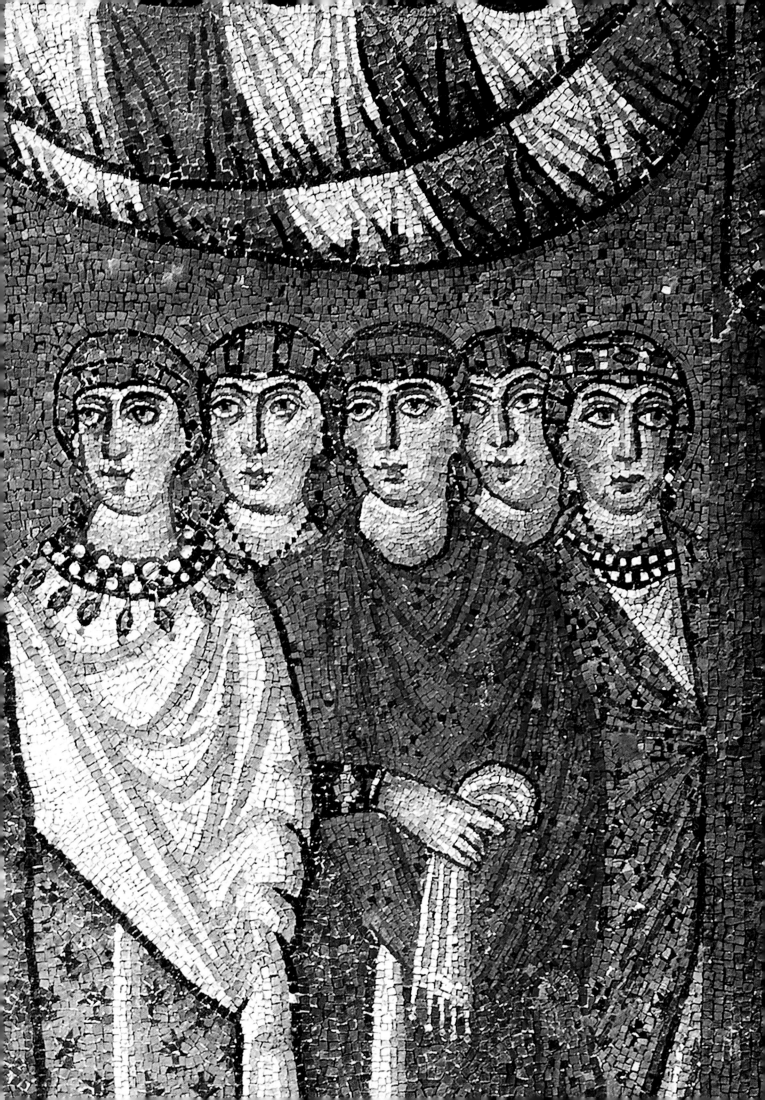

Early Christian and Byzantine Art

A S ROMAN AUTHORITY WANED, A NEW SOCIETY—WITH A VERY different outlook and set of values—took root in the soil of Rome. This new culture was formed in part by Roman traditions, but also by the energies and customs of many indigenous non-Roman groups. The values and institutions of this new culture were largely shaped by a single

religious movement that began in the ancient Near East: Christianity.

This culture of Early Christianity—shaped by Rome, by migrations of Northern European peoples, and by Christian faith and institutions—lasted a thousand years. Later historians, looking back from the Renaissance, when Roman forms were deliberately being revived, called this civilization medieval; they saw the Middle Ages as an epoch between themselves and the ancient world. (The term "medieval" is derived from the Latin *med(ium) aev(um)*, thus a synonym for the Middle Ages.) The chronological limits of the Middle Ages are somewhat fluid, but for many historians, the conversion of Constantine the Great in 312 marks the beginning of the Middle Ages, while the Renaissance in the 1400s marks its end.

The unified political structure that Rome had created in the Mediterranean began to break apart by the fourth century CE, with the result that separate imperial centers were established for the eastern half of the Empire (mostly North Africa and western Asia, but also the Balkans) and the western half (Italy and the rest of western Europe). (See map 8.1.) While for much of the medieval period, the Eastern Empire, or Byzantine Empire, retained its central authority, the West had no such centralized power. Until the seventh century, the Eastern Empire attempted to control the West, however ineffectively,

Detail of figure 8.26, *Empress Theodora and Her Attendants*

but by the end of the seventh century, the Eastern Empire itself was being challenged by the militant force of Islam. The Western Empire then fractured further into smaller kingdoms.

New religious expressions arose to address the spiritual crisis that accompanied the instability of Late Roman political institutions. The Late Roman Empire was home to a vast melting pot of creeds—including the ancient faith of Judaism, Christianity, Mithraism, Manichaeism, and Gnosticism, to name a few. These competing faiths shared several features, including an emphasis on divine revelation through a chief prophet or messiah and the hope of salvation. Of these religions, Christianity—centering on the life and teachings of Jesus of Nazareth—became the most widespread and influential. It spread first to Greek-speaking communities, notably to Alexandria, in Egypt, then reached the Latin-speaking world by the end of the second century. The Gospels of Matthew, Mark, Luke, and John, our principal source of information about Jesus' life, were probably written in the late first century, some decades after Jesus' death. The Gospels present him as a historical person and as the Son of God and Messiah or the "Anointed One." The eloquence and significance of Christ's teachings, the miracles attributed to him, and his innate goodness were considered signs of his divinity. The Roman authorities, viewing Jesus' teaching as subversive, had him arrested, tried, and ultimately punished and executed by crucifixion. As the faith spread, the Romans believed Christians

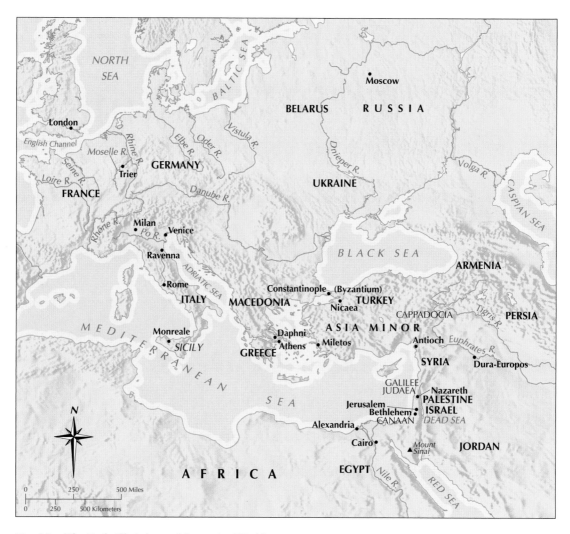

Map 8.1. The Early Christian and Byzantine Worlds

threatened the status quo, and intermittently persecuted them. Still, by 300 CE, nearly one-third of Rome was Christian, though the new faith continued to have little standing until the conversion of Constantine the Great in 312.

In that year, Constantine was battling his fellow Tetrarch, Maxentius, for control of the Western Empire. According to his biographer, Bishop Eusebius of Caeserea, Constantine claimed to have had a dream in which Christ himself assured him of his victory over Maxentius, which took place at the Milvian Bridge in Rome in 312. This is the triumph commemorated by the Arch of Constantine (see fig. 7.63). After this, Constantine accepted the Christian faith and, having consolidated imperial power, promoted Christianity throughout the Empire. Constantine began building important structures and convening Church councils. He claimed that his political authority was granted by God, and placed himself at the head of the Church as well as of the state. His choice to accept and promote Christianity was a turning point in history, as it resulted in the union of Christianity with the legacy of the Roman Empire. The charac-

ter of the Middle Ages—and thus of the rest of European history—depended directly on Constantine's decision.

Constantine also decided to build a new capital for the Roman Empire at the strategically located Greek town of Byzantium, which was renamed Constantinople (present-day Istanbul). Distant from the ancient pagan centers of Rome, the new capital in the rich Eastern provinces was in the heart of the most thoroughly Christianized region of the Empire. Constantine certainly did not anticipate it, but within a century of this event, Rome had divided into two halves: an Eastern Empire, of which Constantinople was the capital, and a Western Empire centered at Rome. Yet imperial might and wealth were concentrated in Constantinople, enriching and protecting the Eastern Empire. In the West, imperial authority was less effective in the face of new challenges, as non-Roman groups first invaded and then settled in Europe. The two empires grew apart, in their institutions and in the practice of their common faith.

Into the vacuum of power left by the decline of imperial institutions in the West stepped the Bishop of Rome. Deriving

his authority from Saint Peter, the Pope, as the Bishop of Rome became known, claimed to be the head of the universal Christian Church, although his Eastern counterpart, the patriarch of Constantinople, disputed this claim. Differences in doctrine and liturgy continued to develop until eventually the division of Christendom into a Western or Catholic Church and an Eastern or Orthodox Church became all but final. The Great Schism, or final break, between the two churches occurred in the eleventh century.

The religious separation of East and West profoundly affected the development of Christian art in the Late Roman Empire. *Early Christian* does not, strictly speaking, designate a style. It refers, rather, to any work of art produced by or for Christians during the time prior to the splitting off of the Eastern Church from the Western Church, that is, roughly during the first five centuries after the birth of Jesus. *Byzantine*, on the other hand, designates not only the art of the Eastern Roman Empire but also its specific culture and style, which was linked to the imperial court of Constantinople.

Both Early Christian and Byzantine art have their origins in Rome. But the art forms of Early Christian art differ from those of the Greek and Roman world. Whereas the ancients expressed the physical presence of their gods in naturalistic sculpture and paintings, early Christian artists explored a different vision. In the service of their new faith, Early Christian artists concentrated on symbolic representation, using physical means to express a spiritual essence. Early Christian art refined the increasingly stylized and abstracted art forms of the Late Roman Empire into a visual language that could express both profoundly spiritual and unmistakably secular power. It became the basis for later art forms in both Western Europe and Byzantium during the Middle Ages.

EARLY CHRISTIAN ART

Christian Art before Constantine

We do not know when or where the first Christian works of art were produced. None of the surviving paintings or sculptures can be dated earlier than about 200 CE. In fact, we know little about Christian art before the reign of Constantine the Great. This is hardly accidental. It is in Rome that we have the greatest concentration of the earliest surviving works, yet before Constantine, Rome was not yet the center of the faith. Older and larger Christian communities existed in the great cities of North Africa and the Near East, such as Alexandria and Antioch, but we only have hints of what Christian places of worship there and in centers such as Syria and Palestine might have looked like.

THE ART OF THE CATACOMBS The painted decoration of the Roman **catacombs**, underground burial places, is the only sizable body of material we have from which to study the earliest Christian art. The burial rite and the safeguarding of the tomb were of vital concern to early Christians, whose faith rested on salvation, the hope of eternal life in paradise. As such,

paintings in catacombs tell us a good deal about the spirit of the communities that commissioned them.

The ceiling of one of the more elaborate chambers in the catacomb of Santissimi Pietro e Marcellino (fig. **8.1**), in Rome, is decorated in a style that is at once formal and uncomplicated. Fixed borders control the overall organization; a central medallion or circle contains the figure of a shepherd, who is flanked by sheep and carries a lamb across his shoulders. The circle is connected to four **lunettes** (semicircular spaces), and in the four corners are single figures with outstretched, raised arms. The style of painting reflects Roman murals, both in the landscape settings and in the use of linear devices to divide the scenes into compartments (see the Villa of Livia at Primaporta, fig. 7.55, or the Ixion Room of the House of the Vettii, fig. 7.57). But the representations seem sketchier, less grounded in natural observation than their Roman relatives. The differences are partly due to the nature of the subterranean spaces, their use, and their meaning.

Catacombs would have been used only occasionally beyond the actual circumstance of burial, perhaps for a commemorative celebration. This is one reason why the wall paintings do not show much detail and care of execution. Another reason for the sketchiness of these paintings is that their primary value is symbolic. Consistent with the biblical prohibition against image making, as specified in the Second Commandment of the Old Testament (see end of Part II *Additional Primary Sources*), Christ is generally not represented in the catacombs, except by metaphor. The shepherd with a sheep on his shoulder is a potent allusion to Christ, since in a number of biblical accounts Christ refers to himself as the Good Shepherd, concerned for the well-being of his flock and willing to sacrifice himself in order to guarantee the salvation of those who follow him (Luke 15: 4–6; John 10: 1–18). This Good Shepherd metaphor also builds on Old Testament references, as in Psalm 23:

> The Lord is my shepherd, I shall not want.
> He makes me lie down in green pastures;
> he leads me beside still waters;
> he restores my soul.…
> Surely goodness and mercy shall follow me
> all the days of my life,
> and I shall dwell in the house of the Lord
> for ever.

The Old Testament correlation reflects the fact that many of the converts to the new faith were Jewish.

The four lunettes around the Good Shepherd form a cycle dedicated to the Old Testament prophet Jonah. Here too, the symbolic references to Christian beliefs about Christ are clear: Just as it is a principle of faith that Jonah spent three days within the belly of the whale, so Christ is supposed to have spent three days in the tomb, and just as Jonah was released with unharmed body, so Christ was resurrected from his tomb in physical wholeness. Recent converts would probably have felt comfortable knowing that didactic aspects of their old faith could find a sympathetic response in the new religion. Jonah's

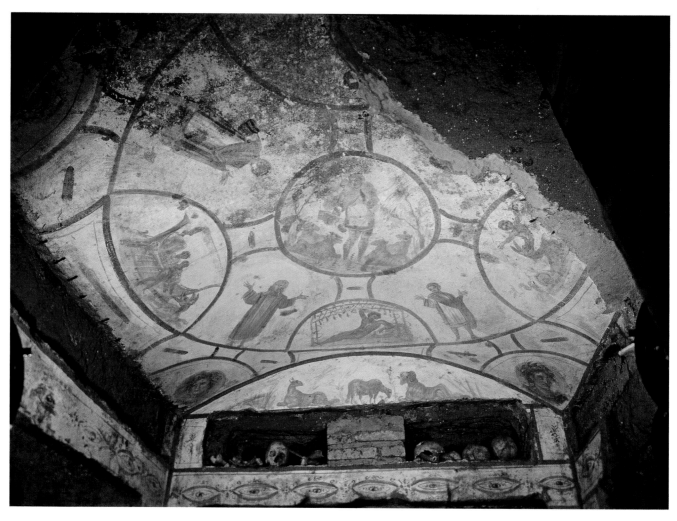

8.1. Painted ceiling. 4th century CE. Catacomb of Santissimi Pietro e Marcellino, Rome

story is presented as a **prefiguration** (foreseeing) of events in Christ's life, thus assigning the Old Testament story the role of prophecy and the New Testament one its fulfillment. As Christian thinkers increasingly analyzed the prophetic relationship of the Old Testament to the New, they developed a virtual system of concordances, called **typology**, that was to have far-reaching significance.

The painted ceiling in Santissimi Pietro e Marcellino also borrows imagery from classical sources. The Good Shepherd himself is a reminder of pagan symbols of charity in the form of ancient sculptures of men carrying sacrificial animals on their shoulders. The posture of Jonah, reclining under the gourd bush, benefiting from God's beneficence, derives from Roman pagan mythological representations of Endymion, a youth so beautiful that he was rewarded with eternal and undisturbed sleep. So, as with their Jewish counterparts, former practitioners of pagan religions who had converted to Christianity would also have been familiar with some of the images and ideas expressed in Early Christian art.

Both the Good Shepherd and Jonah are associated with messages of comfort, reminding us that Early Christian art develops during the turmoil of Rome's decline, a time of political, social, and economic instability. The allure of the new

religion must have been profound indeed, suggesting that things of this world were of less significance than those of a future world, which offered the hope of eternal peace. The four standing figures between the lunettes are **orants** (worshipers), represented in what had long been the standard pose of prayer, signifying the virtues of faith and piety that will make personal salvation possible.

One might question the extent to which the Christian use of pagan and Jewish subjects had a political agenda. After all, on some level, to borrow forms from other cultures and religions and to use them for new purposes are acts of appropriation. By adopting forms used by an older, more established culture, Christians expressed their ambition to dominate that culture—indeed, to supplant it. Such appropriation becomes more systematic as the new religion of Christianity becomes increasingly powerful.

SCULPTURE Sculpture seems to have played a secondary role in Early Christian art. The biblical prohibition of graven images was thought to apply with particular force to large cult statues, idols worshiped in pagan temples. In order to avoid the taint of idolatry, therefore, Christian sculpture had to shun life-

size representations of the human figure. Sculpture thus developed in an antimonumental direction: away from the spatial depth, naturalism, and massive scale of Graeco-Roman sculpture and toward shallow, small-scale forms and lacelike surface decoration.

The earliest works of Christian sculpture are **sarcophagi**, stone coffins, which from the middle of the third century on were produced for the more important members of the Church. They evolved from the pagan examples that had replaced cinerary urns in Roman society around the time of Hadrian. Before the time of Constantine, their decoration consisted mostly of a repertory of familiar themes from the catacombs. Examples of these can be seen on the marble sarcophagus of the mid-third century from Santa Maria Antiqua in Rome (fig. 8.2). On the left are the scenes of Jonah: the ship, the sea monster, and the reclining prophet. Jonah's well-chiseled anatomy and the elegance of his pose remind us of the Classical sources that must have served as a model for the artist. So too, the Good Shepherd, though stylized, reminds of us of Classical statuary in that he is able to distribute weight well enough to manage with some comfort the burden of the sheep he carries. Again, the orant in the center, with hands upraised in prayer, is a subject we have seen in catacomb painting. The seated figure holding a scroll derives from antique representations of writers or philosophers and is another of the metaphoric references to Christ, in this case to his role as teacher. On the right is a scene of baptism. The figure being baptized may be Christ himself. If so, this might indicate an increased movement toward narrative, since baptism was an event in the life of Jesus (see *Informing Art*, page 240), and a willingness to represent him directly. On the other hand, the figure appears to be generic, nonindividualized, virtually childlike in its proportions. This generic representation could be a result of both a fear of making an idolatrous image and an interest in expressing the more essential nature of the scene, from which a portrait of the person of Christ would detract.

ART IN TIME

- ca. 29—Crucifixion of Jesus of Nazareth
- 200—Earliest datable Christian art
- 256—Dura-Europos falls to Persians
- **ca. 270—Sarcophagus at Santa Maria Antigua**
- 312—Roman emperor Constantine converts to Christianity

THE HOUSE CHURCH Although we have little archeological evidence of the places where Early Christians gathered, literary accounts, including biblical references, suggest that Christians met regularly to celebrate their shared belief in Christ as the Son of God and Savior and to observe some type of Eucharist, or spiritual union, with him by the partaking of consecrated bread and wine (representing Christ's flesh and blood) in remembrance of the Last Supper, at which Jesus and his disciples enjoyed a final communal meal. Such gatherings of Christians probably originally took place in private homes and were only later replaced by public spaces designed specifically for Christian worship. This situation is perhaps to be expected, both because Christianity was something of an underground religion and because other religions seem also to have used private houses as gathering places, for instance the Villa of the Mysteries in Pompeii (see fig. 7.53).

A remarkable archeological find of the 1920s in the Syrian town of Dura-Europos allows us to see what must have been a typical Christian meeting place. Dura-Europos was a Roman town on the upper Euphrates. In 256 CE, in order to protect itself from imminent attack by the Persians under Shapur I, who was trying to expand the territories he controlled by means of conquest (see Chapter 2), the town strengthened its protective walls, which involved filling in some streets adjacent to those walls in order to form a defensive bunker. Buried as a result, and thus preserved, were a number of buildings, including a Jewish synagogue and a house that was used for Christian rituals.

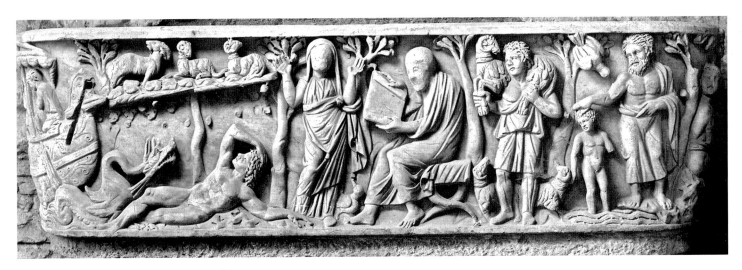

8.2. Sarcophagus. ca. 270 CE. Marble, 1'11¼" × 7'2" (5.45 × 2.2 m). Santa Maria Antiqua, Rome

The Life of Jesus

Events in the life of Jesus, from his birth through his ascension to heaven, are traditionally grouped in cycles, each with numerous episodes. The scenes most frequently depicted in European art are presented here.

Incarnation Cycle and The Childhood of Jesus

These episodes concern Jesus' conception, birth, infancy, and youth.

Annunciation. The archangel Gabriel tells Mary that she will bear God's son. The Holy Spirit, shown usually as a dove, represents the Incarnation, the miraculous conception.

Visitation. The pregnant Mary visits her older cousin Elizabeth, who is to bear John the Baptist and who is the first to recognize the divine nature of the baby Mary is carrying.

Nativity. At the birth of Jesus, the Holy Family—Mary, his foster father, Joseph, and the Christ Child—is usually depicted in a stable or, in Byzantine representations, in a cave.

Annunciation to the Shepherds and Adoration of the Shepherds. An angel announces the birth of Jesus to shepherds in the field at night. The shepherds then go to the birthplace to pay homage to the child.

Adoration of the Magi. The Magi, wise men from the East (called the Three Kings in the Middle Ages), follow a bright star for 12 days until they find the Holy Family and present their gifts to Jesus.

Presentation in the Temple. Mary and Joseph take the infant Jesus to the Temple in Jerusalem, where Simeon, a devout man, and Anna, a prophetess, foresee Jesus' messianic mission (his mission as Savior) and martyr's death.

Massacre of the Innocents and Flight into Egypt. King Herod orders all male children under the age of two in and around Bethlehem to be killed in order to preclude his being murdered by a rival newborn king spoken of in a prophecy. The Holy Family flees to Egypt.

Public Ministry Cycle

Baptism. John the Baptist baptizes Jesus in the Jordan River, recognizing Jesus' incarnation as the Son of God. This marks the beginning of Jesus' ministry.

Calling of Matthew. The tax collector Matthew becomes Jesus' first disciple (apostle) when Jesus calls to him, "Follow me."

Jesus Walking on the Water. During a storm, Jesus walks on the water of the Sea of Galilee to reach his apostles in a boat.

Raising of Lazarus. Jesus brings his friend Lazarus back to life four days after Lazarus's death and burial.

Delivery of the Keys to Peter. Jesus names the apostle Peter his successor by giving him the "keys" to the Kingdom of Heaven.

Transfiguration. As Jesus' closest disciples watch, God transforms Jesus into a dazzling vision and proclaims him to be his own son.

Cleansing the Temple. Jesus clears the Temple in Jerusalem of money changers and animal traders.

Passion Cycle

The Passion (from passio, Latin for "suffering") cycle relates Jesus' death, resurrection from the dead, and ascension to heaven.

Entry into Jerusalem. Welcomed by crowds as the Messiah, Jesus triumphantly rides an ass into the city of Jerusalem.

Last Supper. At the Passover seder, Jesus tells his disciples of his impending death and lays the foundation for the Christian rite of the Eucharist: the taking of bread and wine in remembrance of Christ. (Strictly speaking, Jesus is called Jesus until he leaves his earthly physical form, after which he is called Christ.)

Jesus Washing the Disciples' Feet. Following the Last Supper, Jesus washes the feet of his disciples to demonstrate humility.

Agony in the Garden. In Gethsemane, the disciples sleep while Jesus wrestles with his mortal dread of suffering and dying.

Betrayal (Arrest). The disciple Judas Iscariot takes money to identify Jesus to Roman soldiers. Jesus is arrested.

Denial of Peter. As Jesus predicted, Peter, waiting outside the high priest's palace, denies knowing Jesus three times as Jesus is being questioned by the high priest Caiaphas.

Jesus before Pilate. Jesus is questioned by the Roman governor Pontius Pilate regarding whether or not he calls himself King of the Jews. Jesus does not answer. Pilate reluctantly condemns him.

Flagellation (Scourging). Jesus is whipped by Roman soldiers.

Jesus Crowned with Thorns (The Mocking of Christ). Pilate's soldiers mock Jesus by dressing him in robes, crowning him with thorns, and calling him King of the Jews.

Carrying of the Cross (Road to Calvary). Jesus carries the wooden Cross on which he will be executed from Pilate's house to the hill of Golgotha, which means "the place of the skull."

Crucifixion. Jesus is nailed to the Cross by his hands and feet, and dies after great physical suffering.

Descent from the Cross (Deposition). Jesus' followers lower his body from the Cross and wrap it for burial. Also present are the Virgin Mary, the apostle John, and in some accounts, Mary Magdalen.

Lamentation (*Pietà* or *Vesperbild*). The grief-stricken followers gather around Jesus' body. In the *Pietà*, his body lies in the lap of the Virgin.

Entombment. The Virgin Mary and others place the wrapped body in a sarcophagus, or rock tomb.

Descent into Limbo (Harrowing of Hell or Anastasis in the Orthodox Church). Christ descends to hell, or limbo, to free deserving souls who have not heard the Christian message—the prophets of the Old Testament, the kings of Israel, and Adam and Eve.

Resurrection. Christ rises from the dead on the third day after his entombment.

The Marys at the Tomb. As terrified soldiers look on, Christ's female followers (the Virgin Mary, Mary Magdalen, and Mary, mother of the apostle James the Greater) discover the empty tomb.

Noli Me Tangere, Supper at Emmaus, and the Doubting of Thomas.

In three episodes during the 40 days between his resurrection and ascent into heaven, Christ tells Mary Magdalen not to touch him (*Noli me tangere*), shares a supper with his disciples at Emmaus, and invites the apostle Thomas to touch the lance wound in his side.

Ascension. As his disciples watch, Christ is taken into heaven from the Mount of Olives.

8.3. Model of the Baptistery, the Christian Meeting House (*domus ecclesiae*) at Dura-Europos, Syria. Before 256 CE. Yale University Art Gallery, New Haven, CT

The house is in most ways a typical two-story Roman *domus*. A large room opened onto the atrium and would have served as a community assembly room, while another space was apparently reserved for baptism, judging by a font that takes up an entire wall of the room (fig. **8.3**). The font is covered by a stone canopy, and frescoed scenes decorate the lunette on the end wall under the canopy and also the side walls. Some of the subjects represented are familiar: In the lunette is a Good Shepherd balancing a sheep on his shoulders with his flock before him, and, at the bottom left, now barely visible, are figures of Adam and Eve. Represented on the side wall are three women holding candles who proceed toward a stone sarcophagus: This scene represents the three Marys at the Tomb (see *Informing Art*, page 240) who, when approaching the tomb of Christ (as described in Matthew 28:1–10), meet an angel who tells them that the tomb is empty because the entombed Christ has risen.

The representations on the wall of the Dura-Europos house can be connected with those found in Early Christian catacombs and on sarcophagi through shared imagery, such as the depictions of the Good Shepherd and Adam and Eve. Such images indicate a general concern for issues of death and retribution, resurrection and salvation. The inclusion here of Adam and Eve reminds the viewer of the Original Sin, committed by Adam and passed from one generation to the next, from which humankind will be redeemed as a result of Christ's sacrificial death and his resurrection, which the scene of the Marys visiting his empty tomb emphasizes. The association of these funerary subjects with baptism was a logical pairing for Christians, who

view baptism as a rebirth into the new faith, just as they see physical death as a rebirth into everlasting life. Even when artists were experimenting with how best to depict entirely new subject matter, those responsible for its creation, whether artists or patrons, applied an overwhelming conceptual consistency to Christian art during the first several centuries of the Christian era. This was perhaps a result of the new religion's need for didactic representations that could be readily understood.

Christians in other areas of the Empire also used the type of *domus ecclesiae*, or **house church**, seen at Dura-Europus. In Rome itself we know of 25 private houses—and undoubtedly there were more—reserved as places of Christian worship, although most of them were destroyed by the later building of churches on their sites.

Christian Art after Official Recognition of Christianity

The building of churches on the sites of what once were private houses used for Christian worship reflects a change in the nature of Christianity during the fourth century from an alternative religion to the official religion endorsed by the emperor Constantine. Almost overnight, an impressive architectural setting had to be created for the new official faith, so that the Church might be visible to all. Constantine himself devoted the full resources of his office to this task. Within a few years an astonishing number of large, imperially sponsored churches arose, not only in Rome but also in Constantinople, in the Holy Land, and at other important sites.

THE CHRISTIAN BASILICA The most important Constantinian church structures were a type of **basilica**, and this form provided the basic model for the development of church architecture in Western Europe. The Early Christian basilica owes its essential features to imperial basilicas, such as the Basilica Ulpia (see fig. 7.33). As with the imperial basilicas, it is characterized by a long **nave** flanked by side aisles and lit by **clerestory** windows, with an **apse** (though only at one end) and a trussed wooden roof. The Roman basilica was a suitable model since it combined the spacious interior needed to accommodate a large number of people with (perhaps most important) imperial associations that proclaimed the privileged status of Christianity. As the largely civil functions of the Roman basilica were quite different from its new uses as a house of worship, the Roman-style basilica had to be redesigned to acknowledge these changes. Therefore, the longitudinal plan of the basilica was given a new focus: the **altar** was placed in front of the semicircular apse, normally at the eastern end of the nave. The significance of the altar's placement in the east, where the sun rises, reminds us that Christianity inherited many divine attributes from other religions. In this case, Christ shares an imagery with the Roman god Apollo, in his manifestation as sun-god.

The greatest Constantinian church was Old St. Peter's Basilica in Rome (figs. **8.4** and **8.5**). It was torn down and replaced by the present St. Peter's Basilica, in the Vatican, during the sixteenth and seventeenth centuries, but its appearance is preserved in a seventeenth-century album of copies of earlier drawings (fig. **8.6**), and there are literary descriptions as well. Together these sources give us a clear idea of the original plan for the church. Begun as early as 319 and finished by 329, Old St. Peter's was built on the Vatican Hill next to a pagan burial ground. It stood directly over the grave of St. Peter, which was marked by a shrine covered with a **baldacchino**, a canopy that designates a place of honor. As such, Old St. Peter's served as the apostle's **martyrium**, a building that housed sacred relics or the remains of a holy person. The location of St. Peter's burial spot was the focus of the church, and due to site restrictions, its apse was at the west end of the church, an unusual feature. Rituals were conducted from a portable altar placed before the shrine, using gold and silver implements donated by the emperor himself. (See *Primary Source*, page 244.)

To enter the church the congregation first crossed a colonnaded court, the **atrium**, which was added toward the end of the fourth century; this feature derived from the Roman basilica. Congregants then passed through the **narthex**, an entrance hall, into the church itself. The steady rhythm of the nave colonnade would have pulled them toward the **triumphal arch**, which framed the shrine of St. Peter and the apse beyond. The shrine stood at the junction of the nave and the **transept**, a separate space placed perpendicular to the nave and aisles. Spaces at the end of the transept, marked off by columns, might have served to prepare items used during church rites and to hold offerings brought by the faithful.

The main focus of Christian liturgy, a body of rites prescribed for public worship, was, and is, the Mass, which includes the sacrament of Communion, the symbolic reenactment on the altar of Jesus' sacrifice. The Early Christian basilica encouraged attention to the altar, making it the focal point of the church by placing it opposite the entrance and at the end of a long nave. Even beyond this general emphasis on the altar, Old St. Peter's gave special prominence to the altar zone through this church's special, additional function as a martyrium.

8.4. Plan of Old St. Peter's, Rome, ca. 324–400 CE. (after Frazer)

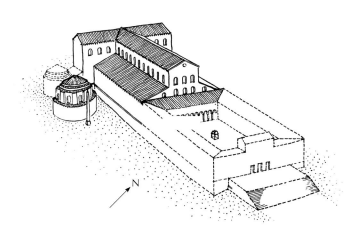

8.5. Reconstruction of Old St. Peter's, Rome, as it appeared ca. 400. (after Krautheimer)

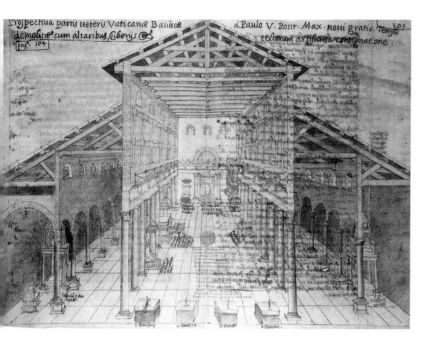

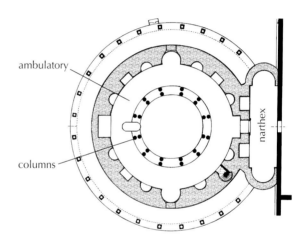

8.7. Plan of Santa Costanza, Rome. ca. 350 CE

Although today we think of the practice of religion as an open one, in the early church only those who had proven themselves full-fledged Christians could witness the complete performance of the liturgy. It was through baptism that *catechumens*, those receiving instruction in preparation for their initiation into the new religion, became full-fledged Christians. Before baptism, they could hear, but not see, parts of the Mass. Even today, Christians refer to this as the "mystery" of the Mass.

CENTRAL-PLAN STRUCTURES Buildings of round or polygonal shape capped by a dome entered the tradition of Christian architecture in Constantine's time. Roman emperors had built similar structures to serve as monumental tombs or mausoleums, such as the one Diocletian had built for himself at his palace at Spalato (see fig. 7.71). Not surprisingly, therefore, the Early Christian **central-plan building** was often associated with funerary functions, as was Santa Constanza, in Rome, the mausoleum of Constantine's daughter Constantia (figs. **8.7** and **8.8**). Built over a catacomb, it was originally attached to the now-ruined basilican church of St. Agnes Outside the Walls. The focus of the building is on the central space, illuminated by clerestory windows, over which rises a dome supported by twelve pairs of columns. Four of the arches of this colonnade stand slightly higher than the others and suggest a cross

8.8. Interior (view through ambulatory into rotunda), Santa Costanza, Rome

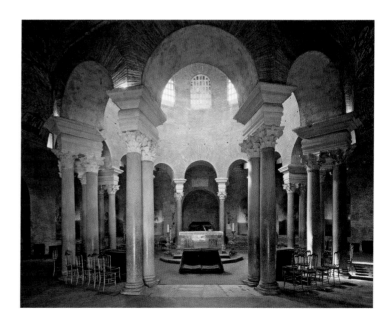

The Book of the Popes (Liber Pontificalis)

From the Life of Pope Sylvester I

This text is an official history of the Roman papacy from St. Peter (d. ca. 64 CE) to the twelfth century. Its biographies of the early popes were compiled from archival documents. What follows, for example, is a list of gifts to Old St. Peter's by Emperor Constantine in the time of Pope Sylvester I (314–335 CE). Lavish imperial donations such as these set a standard that subsequent popes and other prelates continued to match.

Constantine Augustus built the basilica of blessed Peter, the apostle, and laid there the coffin with the body of the holy Peter; the coffin itself he enclosed on all sides with bronze. Above he set porphyry columns for adornment and other spiral columns which he brought from Greece. He made a vaulted apse in the basilica, gleaming with gold, and over the body of the blessed Peter, above the bronze which enclosed it, he set a cross of purest gold. He gave also 4 brass candlesticks, 10 feet in height, overlaid with silver, with figures in silver of the acts of the apostles, 3 golden chalices, 20 silver chalices, 2 golden pitchers, 5 silver pitchers, a golden paten with a turret of purest gold and a dove, a golden crown before the body, that is a chandelier, with 50 dolphins, 32 silver lamps in the basilica, with dolphins, for the right of the basilica 30 silver lamps, the altar itself of silver overlaid with gold, adorned on every side with gems, 400 in number, a censer of purest gold adorned on every side with jewels.

SOURCE: CAECILIA DAVIS-WEYER, *EARLY MEDIEVAL ART 300–1150*, (UPPER SADDLE RIVER, NJ: PRENTICE HALL, 1ST ED., 1971)

inscribed within a circle. The significance of the cross in a funerary context results from its association with Christ, who, though martyred on a cross, rose victorious over death. The Cross was meaningful to all Christians but particularly to the family of Constantine, whose personal conversion was a result of his vision of the Cross, which had signaled his victory at the Battle of the Milvian Bridge in 312. The sarcophagus of Constantia was originally placed under the eastern, more-elevated arch. Encircling the building is an **ambulatory**, a ring-shaped aisle, covered by a barrel vault (see fig. 7.3).

Central-plan and basilican structures are not as different as would first seem. In fact, a section of a central-plan building parallels a section of a basilican church in that both have a high central space with a clerestory flanked by a lower aisle. While the basilica plan stretches this form so that emphasis is on the end of the building, the central plan, as seen in Santa Costanza, spins the section on axis, accentuating the center. You can see this clearly by comparing figures 8.6 and 8.8.

MERGING THE BASILICAN AND CENTRAL PLANS

Since Constantine continued to follow Roman imperial traditions even as he accepted the tenets of Christianity, it is not surprising that when he supported the construction of buildings in the Holy Land to mark places significant in the life of Jesus, he chose plans based on Roman imperial building types, thus accentuating his ambitions for his new religion. The basilican Church of the Holy Sepulchre (fig. **8.9**), in Jerusalem, marked the location where St. Helena, mother of Constantine, had found the True Cross (that is, the cross on which Jesus was crucified as opposed to those crosses on which the thieves who were sentenced to death along with Christ were crucified). Beyond the basilica was the Rotunda of the Anastasis (Greek for "resurrection"), built over the tomb where Christ's body is reputed to have lain for the three days before his resurrection. Although the Constantinian building was subsequently destroyed and later rebuilt in a somewhat different form, this

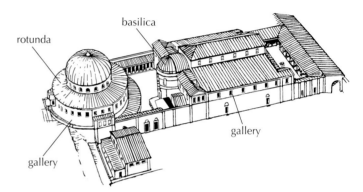

8.9. Reconstruction, Church of the Holy Sepulchre, Jerusalem, as it appeared ca. 350 CE (after Conant). $3'10\frac{1}{2}'' \times 8'$ (1.2 × 2.4 m)

aisled basilica included a **gallery**, a second story placed over the side aisles of a church, increasing the space available for the throngs of pilgrims that flocked to key sites. The apse was ringed with twelve columns, which Eusebius, Constantine's confidant and biographer, equated with Jesus' twelve apostles. In the Anastasis rotunda, too, there would have been a gallery, but in all other ways this rotunda has the same silhouette as Santa Constanza. Both have ambulatories formed by columns arranged around a domed central space, although unlike Santa Constanza's masonry dome, the dome of the Anastasis rotunda was probably made of wood. The similarity of form is not surprising. Both were products of the benefaction of the imperial family and both served funereal functions. As such, their roots in imperial mausoleums are appropriate, even as their forms become conveyors of new meaning. The Church of the Holy Sepulchre complex shares with Old St. Peter's a desire to combine the congregational aspects of a Roman basilica with a martyium in a monument that eulogizes the deceased whom it commemorates—Christ himself.

ARCHITECTURAL DECORATION: WALL MOSAICS

The rapid growth of large-scale Christian architecture had a revolutionary effect on Early Christian pictorial art. All of a sudden, huge wall surfaces had to be covered with images worthy of their monumental framework. Out of this need emerged a great new art form, the Early Christian wall mosaic, which to a large extent replaced the older and cheaper medium of mural painting (see *Materials and Techniques*, page 246). The challenge of inventing a body of Christian imagery produced an extraordinary creative outpouring. Great pictorial cycles of subjects selected from the Old and New Testaments were spread over the nave walls, the triumphal arch, and the apse. These cycles must have drawn on sources that reflected the whole range of Graeco-Roman painting as well as the artistic traditions that surely had developed in the Christian communities of North Africa and the Near East.

Decoration of fourth-century churches is largely fragmentary or known only from literary accounts; it is only in fifth-century churches that we can see the full development of mosaic-decorated Christian structures. Three structures in which the mosaic program is largely complete are the Mausoleum of Galla Placidia and the Orthodox Baptistry, both in Ravenna, and the church of Santa Maria Maggiore, in Rome.

During the fifth century the late Empire was threatened at all its borders by migrating tribes. Even the capital of the Western Empire at Rome was vulnerable. So the emperor Honorius moved it north, first to Milan, and when that city was besieged in 402, to Ravenna on the Adriatic coast, thought to be more easily defendable than inland sites.

The Mausoleum of Galla Placidia (fig. **8.10**) was named after Honorius' sister (who ruled the Empire as regent) because it was believed that she was buried there, though it is likely that it was begun as a chapel dedicated to the martyr St. Lawrence. Its central plan takes the form of a **Greek cross**, that is, a cross with arms of equal length. The exterior brick walls of the building, although perhaps originally covered, were always much simpler than the rich interior. Having left the everyday world behind, the visitor would encounter a shimmering realm of light and color where precious marble surfaces and glittering mosaics evoke the spiritual splendor of the Kingdom of God. To some extent the building is analogous to the ideal Christian, simple in external body and glorious in inner spirit, an analogy certainly not missed by Early Christians.

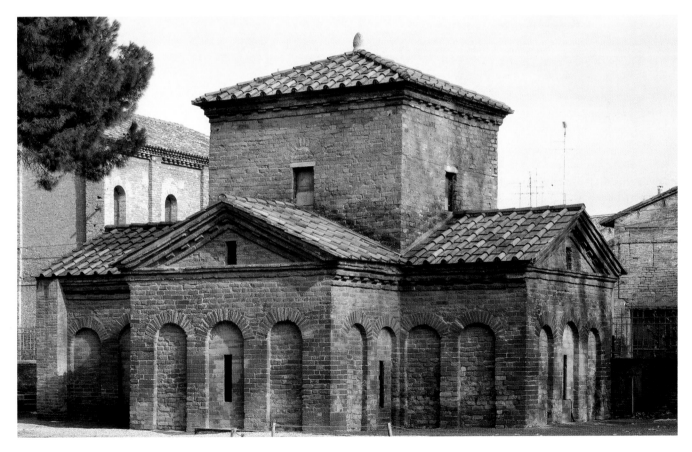

8.10. Mausoleum of Galla Placidia, Ravenna. 425–450 CE

Mosaics

Mosaics—designs composed of small pieces of colored material set in plaster or mortar—had been used by the Sumerians as early as the third millennium BCE to decorate architectural surfaces. The Hellenistic Greeks used pebbles and the Romans, using small cubes of marble called **tesserae**, had refined the technique to the point that it could be used to copy paintings, as seen in *The Battle of Alexander* (see fig. 5.79). Although most Roman mosaics were for floors, the Romans also produced wall mosaics, but these were usually reserved for special purposes, for example in fountain rooms or outdoor spaces where fresco would be vulnerable to deterioration.

The extensive and complex wall mosaics of Early Christian art are essentially without precedent. The color scale of Roman mosaics, although rich in gradations, lacked brilliance, since it was limited to the kinds of colored marble found in nature. Early Christian mosaics, by contrast, consist of tesserae made of colored glass, which the Romans had known but never fully exploited. Glass tesserae offered colors, including gold, of far greater range and intensity than marble tesserae. Moreover, the shiny, somewhat irregular faces of glass tesserae, each set slightly askew from its neighbor, act as tiny reflectors, so that the overall effect is like a glittering, immaterial screen rather than a solid, continuous surface. All these qualities made glass mosaic the ideal material for the new architectural aesthetic of Early Christian basilicas.

Glass for tesserae was made by combining sand, soda or potash, and lime with metallic oxides, which determined the resultant hues. Hardened sheets of glass were marked off and cut into tesserae of approximately cubic shape. For gold mosaics, gold leaf was placed on a sheet of glass, then glass, still in liquid form, was applied over it and heat applied to bond the glass layers, effectively embedding the gold leaf within glass.

The mosaic process was labor intensive, not only to create the design, but also to set the tesserae. Hundreds of thousands of tesserae were needed to cover a church interior, and setting them required skill and training. The process typically began by applying multiple layers of plaster (about 3 inches thick in all) to a wall. Recent investigations have shown that mosaics were generally prepared *in situ*. A drawing was done directly on the surface to be decorated, which was then painted in order to create a guide for the design. Red was used in areas that were to be covered with gold, since red added richness to the gold ground.

Tesserae were then laid into still-fresh plaster, which was sufficiently soft so that at least half the surface of the tesserae could be submerged; a secure attachment was thus guaranteed. The process required deliberate planning, since only the section of wall that could be finished in a day, roughly the time it would take for plaster to dry, would receive the final coat of plaster into which the tesserae were set.

Some medieval treatises distinguish between *pictores imaginarii* (mosaic painters) and *musearii* (mosaic workers), suggesting a hierarchy in the division of labor. Under any circumstances, mosaic production was a costly enterprise; it has been estimated that it was at least four times more expensive than wall painting. Clearly the aesthetic advantages of mosaics, as well as their durability, were thought sufficient to justify the expense.

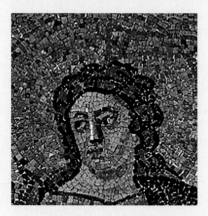

Detail of Good Shepherd, figure 8.12

The barrel vaults and dome of the Mausoleum of Galla Placidia (fig. **8.11**) are covered with luxurious leaflike decoration and fields of stars. Above the vaults, apostles flank a pair of doves and fountains, symbolic of souls drinking from the waters of paradise. In one lunette, St. Lawrence is beside the flame-racked grill on which he was martyred. A cabinet holding books, identified as the four Gospels, reminds us that Lawrence was martyred for refusing to surrender the riches of the Church, here represented as books, to Roman authorities. That books would be equated with treasure is perhaps not surprising, for, as we shall see, they were luxurious objects that played a vital function within the Church. The books also remind us that Christians referred to themselves as people of the Book, a designation they shared with the earlier Hebrew and later Moslem faiths.

Another lunette contains a mosaic of the Good Shepherd seated in a fully realized landscape (fig. **8.12**), expanding the central subject of so many catacomb paintings by its more elaborate and more formal treatment. Here the Good Shepherd is a young man with many of his attributes adopted from imperial art. His

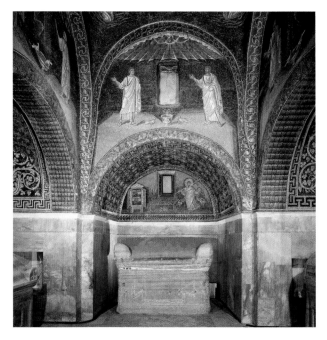

8.11. Interior, Mausoleum of Galla Placidia, Ravenna

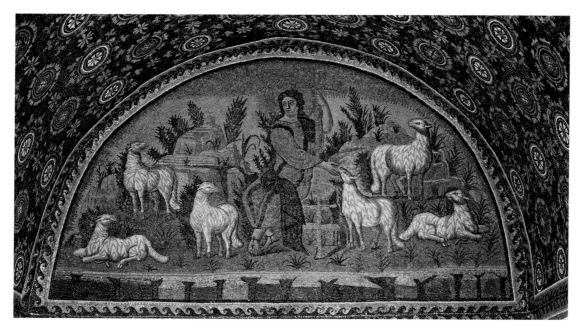

8.12. *Good Shepherd.* Mosaic. Mausoleum of Galla Placidia, Ravenna

halo comes from representations of the emperor as sun-king, and his gold robes and purple scarf are traditional signifiers of royal stature. These attributes are appropriate to a commission by the imperial family, but equally significant is the way formal features further the message, and perhaps here there is a paradox. While Christ, with realistically modeled face and flowing hair and garments, sits comfortably in a lush landscape with sky-blue background, the prevalence of gold denies naturalism to the scene. The paradox is that Christ is at once human, imperial, and of this world, and yet also beyond it, existing within a glimmering ethereal realm of which he is a natural part. Roman mural painting used illusionistic devices to suggest a reality beyond the surface of the wall (see fig. 7.55), whereas Early Christian mosaics used the glitter of gold tesserae to create a luminous realm filled with celestial beings, symbols, or narrative action. Thus, Early Christian mosaics transform the illusionistic tradition of ancient painting with the new Christian message.

The Early Christian architecture we have examined thus far suggests that vital forces enlivened preexisting forms in order to make them serve new functions. Such is also the case with the **baptistery**, which from its early roots in the rather improvisory adaptation of a room in the Christian House of Dura-Europos developed into a distinctive and significant architectural form. The Orthodox Baptistery in Ravenna (fig. **8.13**) is an octagonal building erected about 400 CE, which was heightened and domed about fifty years later. The central plan of the Orthodox Baptistery recalls antique mausoleums, while the eight sides of the building symbolically embody the connection between baptism and death: The world began on the eighth day following the Creation, and Christ was resurrected on the eighth day of the Passion. In the early Church, baptism occurred only once a year, at midnight on Easter Sunday, the day of the Resurrection, and only after the new Christian had endured a long period of indoctrination as a catechumen. Even at Dura-Europos (see fig. 8.3), the confluence of death and resurrection is evident in the subjects represented, many of them, it will be recalled, appearing in the catacombs.

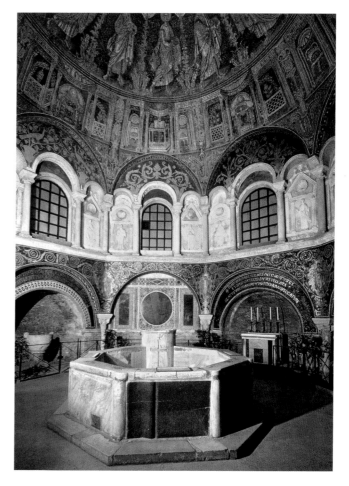

8.13. Orthodox Baptistery, Ravenna. ca. 400–458 CE

Like the interior of the Mausoleum of Galla Placidia, the interior of the Orthodox Baptistery is exultant in the marble walls of its lower reaches and in the stuccowork and mosaics above (fig. **8.14**). Old Testament prophets in stucco look down at the visitor from around the drum of the building, while above, gold-clad apostles proceed across an unnaturally blue background offering their crowns of martyrdom. In the center of the dome and within a gold medallion, Christ is baptized; to the right a pagan river god acknowledges Christ's divinity. The decorations, glittering in the candlelit night, must have made a profound impression on the converts being baptized in the font beneath the dome, for they saw depicted immediately above them the link between their own experiences and that of the Son of God.

Central in both rank and decoration among the Early Christian churches in which a full mosaic program can be described is the basilica of Santa Maria Maggiore in Rome (fig. **8.15**). Built between 432 and 440, this was the first church dedicated to Mary, begun only a year after she was declared the *Theotokos* (Greek for "the bearer of god") by the Council of Ephesus.

The apse is a later replacement, but the general outline of the original building and much of the mosaic decoration survive. These mosaics include the triumphal arch decoration and more than half of the 42 mosaic panels that were placed above the classically inspired entablature of the nave colonnade. These panels were framed by pilasters and colonettes. Sadly, much of this architectural decoration is now missing.

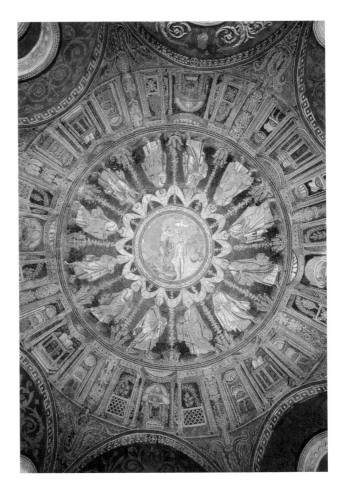

8.14. Dome mosaics, Orthodox Baptistery, Ravenna. ca. 458

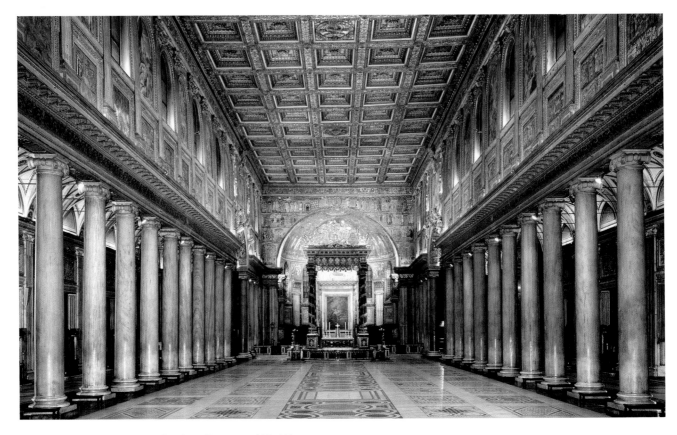

8.15. Interior, Santa Maria Maggiore, Rome. ca. 432–440 CE

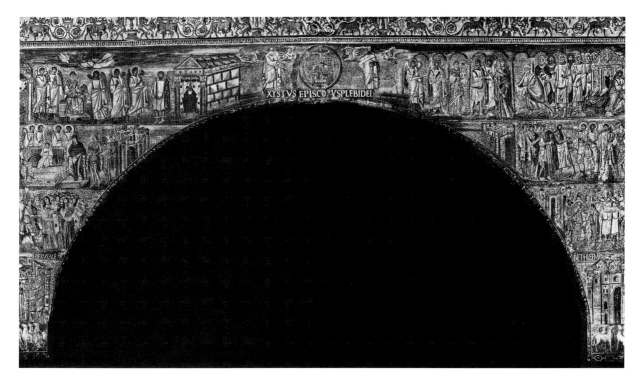

8.16. Triumphal arch. Mosaic. Santa Maria Maggiore, Rome

An enthroned Virgin in the original apse was framed by the triumphal arch, which contains stories from Jesus' infancy, an appropriate introduction to Mary's astonishing person because of her involvement in those episodes (fig. **8.16**). On one side is the Annunciation of Jesus' birth, the Adoration of the Magi, and the Massacre of the Innocents, which is when Herod, the Roman-designated ruler of Palestine, ordered the killing of first-born boys in Bethlehem, after the birth of Jesus, since it had been predicted that one of them would usurp his power. Included on the right side are scenes from the Flight into Egypt and the Magi before Herod, explaining their hope of visiting the Christ child.

The panels above the nave colonnade illustrate scenes from the Old Testament. They combine narration with a concern for structured symmetry. For instance, in the left half of *The Parting of Lot and Abraham* (fig. **8.17**), Abraham, his son Isaac, and the rest of his family depart for the land of Canaan. On the right, Lot and his clan, including his two small daughters, turn toward the city of Sodom. The artist who designed this scene from Genesis 13 faced the same task as the ancient Roman sculptors of the Column of Trajan (see fig. 7.28). He needed to condense complex actions into a form that could be read at a distance. In fact, he employed many of the same shorthand devices, such as the formulas for house, tree, and city, and the device of showing a crowd of people as a cluster of heads, rather like a bunch of grapes.

In the Trajanic reliefs, these devices were used only to the extent that they allowed the artist to portray actual historical events. The mosaics in Santa Maria Maggiore, by contrast,

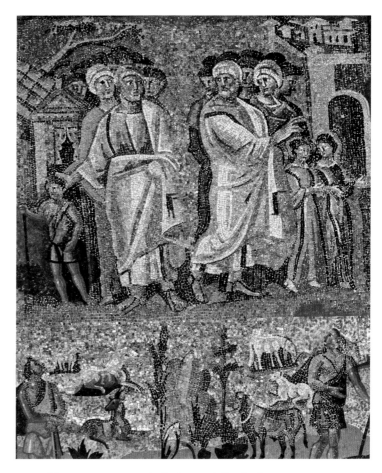

8.17. *The Parting of Lot and Abraham* and *Shepherds in a Landscape*. Santa Maria Maggiore, Rome. Mosaic

depict the history of human salvation, beginning with the Old Testament scenes along the nave and ending with the life of Jesus as the Messiah on the triumphal arch. For those who read the Bible literally, the scheme is not only a historical cycle but also a symbolic program that presents a higher reality—the Word of God. Hence the artist was not concerned with the details of historical narrative. Glances and gestures were more important than realistic movement or three-dimensional form. In *The Parting of Lot and Abraham*, the symmetrical composition, with its gap in the center, makes clear the significance of this parting. Abraham represents the way of righteousness, while Sodom, which was destroyed by the Lord, signifies the way of evil. Beneath *The Parting of Lot and Abraham* is a classically inspired but thoroughly transformed landscape, its shepherds placed on a green ground, while their sheep, as if on little islands, float in gold surroundings.

What were the visual sources of the mosaic compositions at Santa Maria Maggiore and other churches like it? These were certainly not the first depictions of scenes from the Bible. For certain subjects, such as the Last Supper, models could have been found among the catacomb murals, but others, such as the story of Joshua, may have come from illustrated manuscripts, to which, since they were portable, art historians have assigned an important role as models.

ILLUSTRATED BOOKS Because Christianity was based on the Word of God as revealed in the Bible, early Christians, the self-designated people of the Book, sponsored duplication of sacred texts on a large scale. What did the earliest Bible illustrations look like? Because books are frail things, we have only indirect evidence of their history in the ancient world. It begins in Egypt with scrolls made from the papyrus plant, which is like paper but more brittle (see pages 73–74; fig. 3.40). Papyrus scrolls were produced throughout antiquity. Not until the second century BCE, in late Hellenistic times, did a better material become available. This was **parchment** (bleached animal hide) or **vellum** (a type of parchment noted for its fineness), both of which last far longer than papyrus. They were strong enough to be creased without breaking and thus made possible the kind of bound book we know today, technically called a **codex**, which appeared sometime in the late first century CE.

Between the second and the fourth centuries CE, the vellum codex gradually replaced the papyrus roll. This change had an important effect on book illustration. Scroll illustrations seem to have been mostly line drawings, since layers of pigment would soon have cracked and come off during rolling and unrolling. Although parchment and vellum were less fragile than papyrus, they too were fragile mediums (see *The Art Historian's Lens*, page 251). Nevertheless, the codex permitted the use of rich colors, including gold. Hence it could make book illustration—or, as we usually say, **manuscript illumination**—the small-scale counterpart of murals, mosaics, and panel pictures. Some questions are still unanswered. When, where, and how quickly did book illumination develop? Were most of the subjects biblical, mythological, or historical? How much of a carryover was there from scroll to codex?

One of the earliest surviving books that illustrate the Bible is an early fifth-century fragment, the so-called *Quedlinburg Itala* (fig. **8.18**). The fragment is from an illustrated Book of Kings (one of the 39 books of the Old Testament) that has been calculated to have originally contained some 60 illustrations, each image probably comprising multiple scenes. On the **folio** (manuscript leaf) reproduced here, four scenes depict Saul's meeting with Samuel after the defeat of Amalekites (I Samuel 15:13–33), each scene framed so as to accentuate the overall unity of the composition. The misty landscape, architectural elements, and sky-blue and pink background recall the antique Roman tradition of atmospheric illusionism of the sort we met at Pompeii (see fig. 7.55).

Visible under the flaking paint in this badly damaged fragment are written instructions to the artist, part of which read, "You make the prophet speaking facing King Saul sacrificing." Apparently the artist was left free to interpret pictorially these written instructions, suggesting the lack of an illustrated model.

Particularly intriguing is the fact that the artist of the Quedlinburg fragment worked together in a Roman **scriptorium** (a workshop for copying and illustrating manuscripts) with an artist who illustrated Vergil's *Aeneid* and *Georgics*, the so-called *Vatican Vergil*, named after the collection in which it is housed today (fig. **8.19**). We might well ask if this is evidence of non-Christian artists working for Christian patrons and to what

8.18. Scenes from the Book of Kings, *Quedlinburg Itala*, ca. 425–450 CE. Tempera on vellum, 12 × 18″ (30.5 × 45.8 cm). Staatliche Bibliothek, Berlin

The Cotton Library Fire

Manuscripts are fragile works of art. Executed on parchment or vellum, which are organic materials, they are subject to damage by either overly dry or overly humid conditions and by insects. Manuscripts that are popular and receive a great deal of use can tear or wear thin. Dealers, even today, often cut up manuscripts, since they can sell individual pages more easily than a whole manuscript and for more money. And it is not uncommon to find old manuscript parchment reused for a variety of purposes, including lampshades and other decorative items. Given their fragility, it is remarkable that so many precious manuscripts survive.

No event demonstrates the vulnerability of manuscripts more poignantly than the fire that damaged the collection of Sir Robert Bruce Cotton (1571–1631), a founder of the Society of Antiquaries, who, in addition to manuscripts, collected books, other works of art, and coins. Included in Cotton's manuscript collection was a unique example of the Anglo-Saxon poem *Beowulf* (see page 314), written around 1000 CE, the *Lindisfarne Gospels* (see fig. 10.6), and the *Utrecht Psalter* (see fig. 10.15).

Cotton's heirs donated his library to the English nation in 1700, and in 1729 it was moved to another location because the building in which it had been housed was considered unsafe. Ironically, two years later many of the manuscripts were destroyed in a tragic fire at the new location. An account written in the following year records that of the original 952 manuscripts, 114 were "lost, burnt, or entirely spoiled," while 98 others were severely damaged. Included in the latter category was a fifth-century manuscript, written in Greek and probably made in Alexandria, of the Old Testament book of Genesis, notable both for the number of its illustrations and for their high quality. It was one of the most significant works of the Early Christian period. Only fragments of 129 folios survive from the manuscript's original 221 folios, which included about 339 illuminations. Art historians Kurt Weitzmann and Herbert Kessler have undertaken an exhaustive and convincing descriptive reconstruction of the manuscript, but brilliant as their analysis might be, the loss of so many original illuminations is incalculable.

Art historians feel a particular anguish for the fate of the *Cotton Genesis* because it was one of only two known manuscripts dedicated to Genesis alone. The other is the *Vienna Genesis* (see fig. 8.35). Why Genesis received such exhaustive treatment is the subject of some controversy, fueled by suppositions that are difficult to prove without the evidence of the missing folios from the *Cotton Genesis*. (The *Vienna Genesis* also survives as a mere fragment containing some 24 single leaves.) John Lowden has suggested that the two Genesis manuscripts were very unusual, indeed experimental trials undertaken at a time when the Church's early interest in confronting paganism was beginning to shift to a greater concern for supporting orthodox Christian teaching. For Lowden, the *Cotton Genesis* might have been a guide for the instruction of Christian orthodoxy.

A further loss for art historians is information about what role manuscripts played in the transmission of images and motifs. We know the *Cotton Genesis* was in Venice in the early thirteenth century, when it served as a model for a series of mosaics in the Church of San Marco in Venice. The manner and process used to transfer ideas that had their origins in the Early Christian period to later generations might be easier to understand if the *Cotton Genesis* could be seen in its original form.

Virtually from the moment the charred manuscripts cooled, attempts have been made to restore some of the Cotton manuscripts and conserve those fragments not suitable for restoration. These attempts were intensified after 1753 when the Cotton Library became one of the first collections to be housed in the newly established British Museum. Recently scholars have applied modern scientific techniques to study some of the Cotton manuscripts. By illuminating individual folios from behind with a fiber-optic light, letters formerly obscured have become visible. And computer imaging has been used to replace the missing letters of some manuscripts. However, no system is likely to be devised that can restore the aesthetic vitality or artistic integrity of a manuscript such as the *Cotton Genesis*. It is one thing to know what subjects were depicted in the manuscript; it is another thing altogether to be able to see and appreciate the products of scribes and artists who worked more than 1,600 years ago.

extent pagan motifs might have been carried over to Christian subjects, or perhaps even the other way around.

Like the Quedlinburg fragment, the *Vatican Vergil* reflects the Roman tradition of illusionism and is closely linked in style to the mosaics of the contemporaneous Santa Maria Maggiore. The picture, separated from the rest of the page by a heavy frame, is like a window, and in the landscape—similar to that in the *Quedlinburg Itala* on being set off by the pink and blue sky—we find the remains of deep space, perspective, and the play of light and shade. The illustration is balanced by beautifully executed letters, which hover over the page like a curtain.

Perhaps it is not accidental that the illusionism in both the *Quedlinburg Itala* and the *Vatican Vergil* reminds us so much of

8.19. Miniature from the *Vatican Vergil*. Early 5th century CE. Tempera on vellum, $8\frac{5}{8} \times 7\frac{1}{4}''$ (21.9 × 19.6 cm). Biblioteca Apostolica Vaticana, Rome

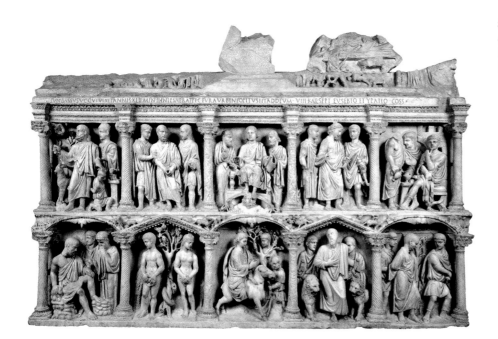

8.20. *Sarcophagus of Junius Bassus.* ca. 359 CE. Marble, 3′10½″ × 8′ (1.2 × 2.4 m). Museo Storico del Capitolino di San Pietro, Rome

the art of Rome during its glory days, nor that so many architectural features of the contemporaneous Santa Maria Maggiore are so classicizing. All of these works were produced in Rome just when that city was under direct threat; the emphasis on Rome's historic splendor might well have proven comforting during difficult times. However, the political reality was far different from the lofty ambitions of artists and patrons. Rome was sacked by the Visigoths in 410 and, as noted, the capital of the Western Empire was moved farther north, settling first in Milan, then finally in Ravenna.

SCULPTURE As we have seen, the increase in standing of Christianity had a profound effect on artistic production, moving Christian art from a modest and private sphere to a public and official arena. As Early Christian architecture and its decoration began to demonstrate increasing monumentality as a result of its dependence on Roman imperial traditions, so too Early Christian sculpture became more impressive. This is apparent in a fine Early Christian stone coffin, the *Sarcophagus of Junius Bassus*.

The richly carved *Sarcophagus of Junius Bassus* (fig. **8.20**) was made for a prefect of Rome who died in 359 at age 42 and who, an inscription tells us, had been "newly baptized." The front, divided by columns into ten compartments, contains a mixture of Old and New Testament scenes. In the upper register we see (from left to right) the Sacrifice of Isaac, St. Peter Taken Prisoner, Christ Enthroned between Saints Peter and Paul, and Jesus before Pontius Pilate (this last scene composed of two compartments). In the lower register are the Suffering of Job, the Temptation of Adam and Eve, Jesus' Entry into Jerusalem, Daniel in the Lions' Den, and St. Paul Led to his Martyrdom.

Clearly the status of Christianity has changed when a major state official proclaims, both in inscription and through representation, his belief in Christianity. The depictions of Peter and Paul, the veritable official saints of the city of Rome—each saint is commemorated by a major basilica in the city—can be

related to Junius Bassus' role as a high-ranking government official. Authoritative as well is Christ's place in the central scenes of each register. In the top register, Christ is enthroned with his feet treading on a personification of Coelus, the Roman pagan god of the heavens, as he dispenses the law to his disciples. Thus, he appropriates one of the emperor's formal privileges and the prefect's as his surrogate. Below this compartment, he enters Jerusalem in triumph. As compared to the earliest Christian representations, such as the Santa Maria Antiqua sarcophagus, Christ is now depicted directly, not through allusion alone, and his imperial nature is thereby accentuated. Daniel in the Lions' Den, the Sacrifice of Isaac, and Adam and Eve are subjects that appeared in earlier representations in catacombs. Daniel's salvation is a type for Christ as well as for all Christians who hope for divine salvation; Abraham's willingness to sacrifice his beloved son Isaac parallels God's sacrifice of his only begotten son and at the same time speaks of salvation by divine grace; Adam and Eve refer to the Original Sin that led to Christ's sacrificial death and his resurrection. Thus old methods of explication are combined with new manifestations of Christianity's important role in society, particularly by stressing Christ's imperial nature.

The style of the sarcophagus also relies on imperial convention. This is most evident in the elements of classicism that are expressed, such as the placement within deep, space-filled niches of figures that recall the dignity of Greek and Roman sculpture. Other classicizing features include the way that the figures seem capable of distributing weight, the draperies that reveal the bodies beneath them, and the narrative clarity. However, beneath this veneer of classicism we recognize doll-like bodies with large heads and a passive air in scenes that would otherwise seem to call for dramatic action. It is as if the events and figures are no longer intended to tell their own story but to call to mind a larger symbolic meaning that unites them.

The reliance on classicizing forms on the *Sarcophagus of Junius Bassus* reminds us that Early Christian art appears

throughout the Mediterranean basin in what we think of as the Classical world. During the first five centuries after Jesus' death, the art of the entire area was more or less unified in content and style. Increasing political and religious divisions in the region, however, began to affect artistic production so that it is appropriate to recognize the appearance, or perhaps better stated, the growth of another branch of Christian art that we label Byzantine.

BYZANTINE ART

Early Byzantine Art

There is no clear-cut geographical or chronological line between Early Christian and Byzantine art. West Roman and East Roman—or as some scholars prefer to call them, Western and Eastern Christian—traits are difficult to separate before the sixth century. Until that time, both geographical areas contributed to the development of Early Christian art. As the Western Empire declined, however, cultural leadership tended to shift to the Eastern Empire. This process was completed during the reign of Justinian, who ruled the Eastern Empire from 527 to 565. Under the patronage of Justinian, Constantinople became the artistic as well as the political capital of the Empire. Justinian himself was a man of strongly Latin orientation, and he almost succeeded in reuniting Constantine's domain. The monuments he sponsored have a grandeur that justifies the claim that his era was a Golden Age, as some have labeled it.

The political and religious differences between East and West became an artistic division as well. In Western Europe, Celtic and Germanic peoples inherited the civilization of Late Antiquity, of which Early Christian art had been a part, but they transformed it radically. The East, in contrast, experienced no such break. Late Antiquity lived on in the Byzantine Empire, although Greek and other Eastern Mediterranean elements came increasingly to the fore at the expense of the Roman heritage. Even so, a sense of tradition played a central role in the development of Byzantine art.

ARCHITECTURE AND ITS DECORATION Ironically, the greatest number of early Byzantine monuments survives today not in Constantinople, where much has been destroyed, but on Italian soil, in Ravenna. That town, as we have seen, had become the capital of the West Roman emperors at the beginning of the fifth century. At the end of the century it was taken by Theodoric, king of the Ostrogoths, whose tastes were patterned after those of Constantinople, where he had lived for an extended period. The Ostrogothic rule of Ravenna ended in 540, when the Byzantine general Belisarius conquered the city for Justinian. Ravenna became an exarchate, or provincial capital, the main stronghold of Byzantine rule in Italy. Thus, Ravenna serves as a kind of microcosm of the transformation and divisions of the later Roman Empire.

The most important building of the early Byzantine period, begun in 526 under Ostrogothic rule, was the church of San Vitale. Built chiefly during the 540s and completed in 547, it

ART IN TIME

319–329—Old St. Peter's Basilica constructed

330—Constantinople becomes capital of Roman Empire

390s—The *Confessions* of St. Augustine

395—Roman Empire divides into Eastern and Western halves

402—Honorius moves capital of Western Roman Empire to Ravenna

400s—Construction in Ravenna of Mausoleum of Galla Placidia and Orthodox Baptistery

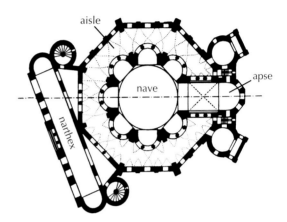

8.21. Plan of San Vitale, Ravenna. 526–547 CE

represents a Byzantine building of a type derived mainly from Constantinople. The octagonal plan (figs. **8.21** and **8.22**) with a circular core ringed by an ambulatory is a descendant of the mausoleum of Santa Costanza in Rome (see fig. 8.7), but other aspects of the building show the influence of the Eastern Empire, where domed churches of various kinds had been built during the previous century. Compared to Santa Costanza, San Vitale is both larger in scale and significantly richer in

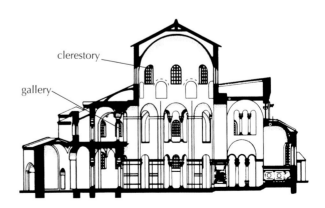

8.22. Section of San Vitale, Ravenna

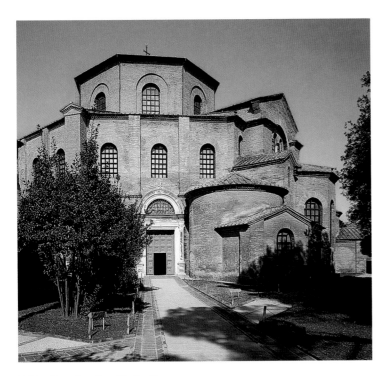

8.23. Exterior, San Vitale, Ravenna

The plan of San Vitale shows only remnants of the longitudinal axis of the Early Christian basilica: toward the east, a cross-vaulted compartment for the altar, backed by an apse; and on the other side, a narthex. How did it happen that the East favored a type of church building (as distinct from baptisteries and mausoleums) so different from the basilica and—from the Western point of view—so ill adapted to Christian ritual? After all, had not the design of the basilica been backed by the authority of Constantine himself? Scholars have suggested a number of reasons: practical, religious, and political. All of them may be relevant, but none is fully persuasive. In any event, from the time of Justinian, domed, central-plan churches dominated the world of Orthodox Christianity as thoroughly as the basilican plan dominated the architecture of the medieval West.

At San Vitale the odd, nonsymmetrical placement of the narthex, which has never been fully explained, might be a key to helping us understand how the building functioned. Some have suggested that the narthex is turned to be parallel to an atrium, the axis of which was determined by site limitations. Others see it as a conscious design feature that accentuates the transition between the exterior and interior of the church. Whatever the reason, in order to enter the building visitors were forced to change axis, shifting to the right or left in order to align themselves with the main apse. The alteration of the journey into the building is unsettling, almost disorienting, an effect heightened by passing from the lighted area of the narthex to the shaded ambulatory, and then into the high and luminous domed center space. The passage from physical to spiritual realms so essential to worship is manifest as a separation between the external world and the internal space of the building.

spatial effect (fig. 8.23). In particular, below the clerestory, the nave wall turns into a series of semicircular niches that penetrate the ambulatory and thus link that surrounding aisle to the nave in a new and intricate way (fig. 8.24). The movement around the center space is thus enlivened so that the decorated surfaces seem to pulsate. The aisle itself has a second story, the galleries, which may have been reserved for women. This reflects a practice in a number of Eastern religions, including some forms of Judaism, where it is current even today. Large windows on every level are made possible by a new economy in the construction of the vaulting—hollow clay tubes allowing for a lighter structure—and the interior is flooded with light.

The complexity of the architecture of the interior is matched by its lavish decoration. San Vitale's link with the Byzantine court can be seen in two prominent mosaics flanking the altar (figs. 8.25 and 8.26). They depict Justinian and his empress,

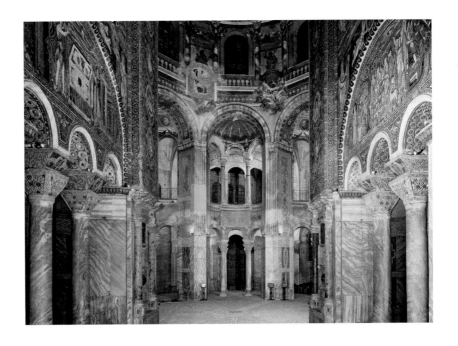

8.24. Interior (view from the apse), San Vitale, Ravenna

Theodora, accompanied by officials, the local clergy, and ladies-in-waiting, about to enter the church, as if it were a palace chapel. In these large panels, the design of which most likely came from an imperial workshop, we find an ideal of beauty that is very different from the squat, large-headed figures we met in the art of the fourth and fifth centuries. The figures are tall and slim, with tiny feet and small almond-shaped faces dominated by huge eyes. They seem capable only of making ceremonial gestures and displaying magnificent costumes. There is no hint of movement or change. The dimensions of time and earthly space, suggested

ART IN TIME

- 451—Europe invaded by Attila the Hun
- 476—Fall of Ravenna to Ostrogoths
- 525–565—Justinian rules Eastern Roman Empire
- 540—End of Ostrogothic rule of Ravenna
- **558—Taller dome built for Hagia Sophia in Constantinople**
- 726—Iconoclastic Controversy begins

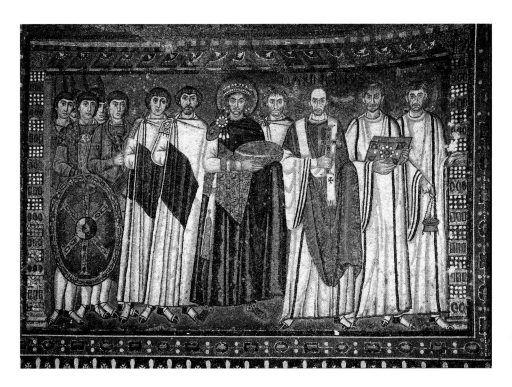

8.25. *Emperor Justinian and His Attendants.* ca. 547 CE. Mosaic. San Vitale, Ravenna

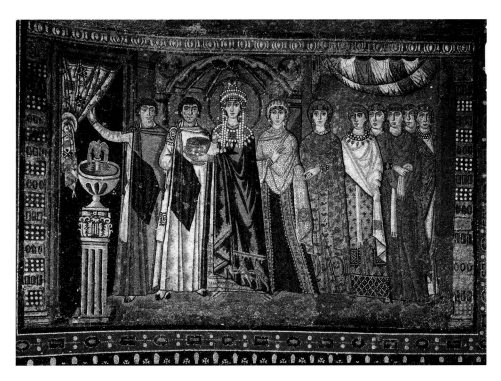

8.26. *Empress Theodora and Her Attendants.* ca. 547 CE. Mosaic. San Vitale, Ravenna

by a green ground, give way to an eternal present in the form of a golden otherworldly setting. Hence, the solemn, frontal images seem to belong as much to a celestial court as to a secular one. The quality of soaring slenderness that endows the figures with an air of mute exaltation is shared by the mysterious interior space of San Vitale, which these figures inhabit.

The union of political and spiritual authority expressed in these mosaics reflects the "divine kingship" of the Byzantine emperor and honors the royal couple as donors of the church. It is as though the mosaic figures are in fact participating in the liturgy, even though the empress and emperor are actually thousands of miles away. The embroidery on the hem of Theodora's mantle shows the three Magi carrying their gifts to Mary and the newborn King, and like them the imperial couple bring offerings. Justinian brings bread and Theodora a chalice, undoubtedly references to the Eucharist and Jesus' sacrifice of his own flesh and blood to redeem humanity. The emperor is flanked by 12 companions, the imperial equivalent of the 12 apostles. Moreover, Justinian is portrayed in a manner that recalls Constantine, that first Christian emperor: The shield with Christ's monogram equates Justinian's conquest of Ravenna with the divinely inspired Constantinian triumph that ultimately led to the founding of Constantinople, the court to which Justinian was heir.

Among the surviving monuments of Justinian's reign in Constantinople, the most important by far is Hagia Sophia (Church of Holy Wisdom) (figs. **8.27** and **8.28**). The first church on that site was commissioned by Constantine but destroyed in 532 during rioting that almost deposed the emperor, who immediately rebuilt the church, a sign of the continuity of his imperial authority. Completed in only five years, Hagia Sophia achieved such fame that the names of the architects, too, were remembered: Anthemius of Tralles, an expert in geometry and the theory of statics and kinetics; and Isidorus of Miletus, who taught physics and wrote on vaulting techniques. The dome collapsed in the earthquake of 558, and a new, taller one was built from a design by Isidorus' nephew. After the Turkish conquest in 1453, the church became a mosque. The Turks added four minarets and extra buttresses to the exterior at that time (see fig. **8.28**), as well as large medallions with Islamic invocations on the interior (fig. **8.29**). In the twentieth century, after the building was turned into a museum, some of the mosaic decoration that was largely hidden under whitewash was uncovered.

8.27. Anthemius of Tralles and Isidorus of Miletus. Plan of Hagia Sophia, Istanbul. 532–537 CE. (after V. Sybel)

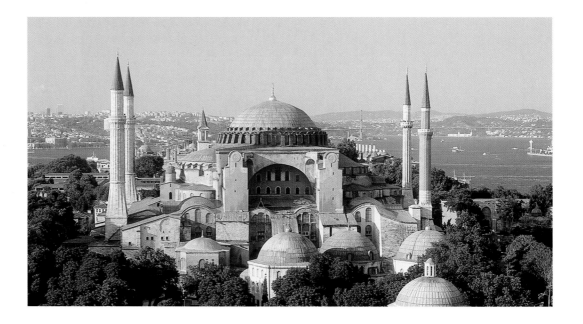

8.28. Exterior, Hagia Sophia, Istanbul

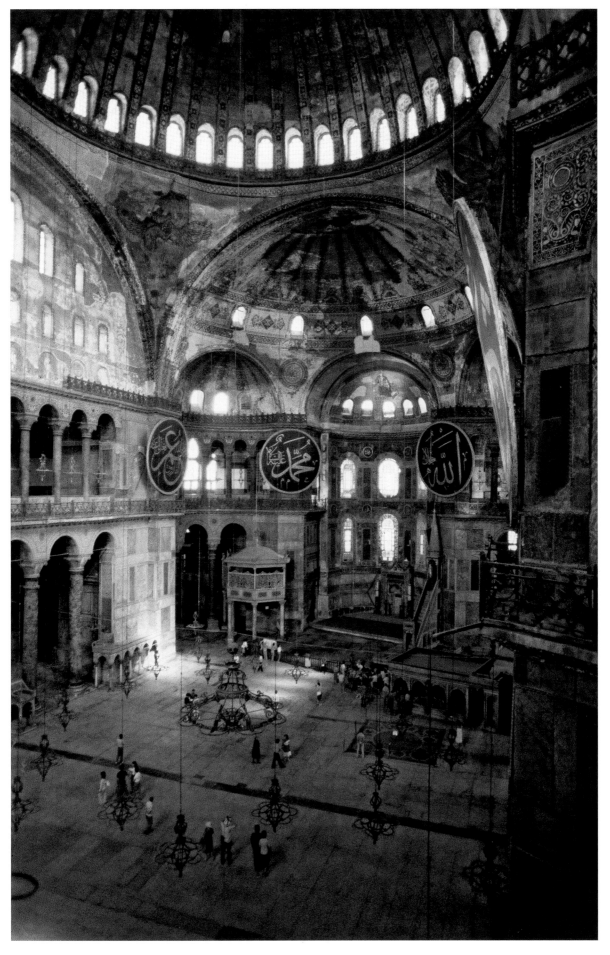

8.29. Interior, Hagia Sophia, Istanbul

Procopius of Caesarea (6th Century)

From Buildings

Procopius was a historian during the reign of Emperor Justinian. He wrote an entire book (ca. 550 CE) about the fortifications, aqueducts, churches, and other public buildings constructed by Justinian throughout the Byzantine Empire. The book begins with the greatest of these, Hagia Sophia (see figs. 8.27–8.32).

The emperor, disregarding all considerations of expense, raised craftsmen from the whole world. It was Anthemius of Tralles, the most learned man in the discipline called engineering, that ministered to the emperor's zeal by regulating the work of the builders and preparing in advance designs of what was going to be built. He had as partner another engineer called Isidore, a native of Miletus.

So the church has been made a spectacle of great beauty, stupendous to those who see it and altogether incredible to those who hear of it. It subtly combines its mass with the harmony of its proportions, having neither any excess nor any deficiency, inasmuch as it is more pompous than ordinary [buildings] and considerably more decorous than those which are huge beyond measure; and it abounds exceedingly in gleaming sunlight. You might say that the [interior] space is not illuminated by the sun from the outside, but that the radiance is generated within, so great an abundance of light bathes this shrine all round. In the middle of the church there rise four man-made emi-nences which are called piers, two on the north and two on the south, each pair having between them exactly four columns. The eminences are built to a great height. As you see them, you could suppose them to be precipitous mountain peaks. Upon these are placed four arches so as to form a square, their ends coming together in pairs and made fast at the summit of those piers, while the rest of them rise to an immense height. Two of the arches, namely those facing the rising and the setting sun, are suspended over empty air, while the others have beneath them some kind of structure and rather tall columns. Above the arches the construction rises in a circle. Rising above this circle is an enormous spherical dome which makes the building exceptionally beautiful. It seems not to be founded on solid masonry, but to be suspended from heaven by that golden chain and so covers the space. All of these elements, marvellously fitted together in mid-air, suspended from one another and reposing only on the parts adjacent to them, produce a unified and most remarkable harmony in the work, and yet do not allow the spectators to rest their gaze upon any one of them for a length of time, but each detail readily draws and attracts the eye to itself. Thus the vision constantly shifts round, and the beholders are quite unable to select any particular element which they might admire more than all the others. No matter how much they concentrate their attention on this side and that, and examine everything with contracted eyebrows, they are unable to understand the craftsmanship and always depart from there amazed by the perplexing spectacle.

SOURCE: *THE ART OF THE BYZANTINE EMPIRE, 312–1453:* SOURCES AND DOCUMENTS BY CYRIL MANGO (UPPER SADDLE RIVER, NJ: PRENTICE HALL, 1ST ED., 1972)

Hagia Sophia has the longitudinal axis of an Early Christian basilica, but the central feature of the nave is a vast, squarish space crowned by a huge dome (see fig. 8.27). At either end are half-domes, so that the nave takes the form of a great ellipse. Attached to the half-domes are semicircular apses with open **arcades**, series of arches, similar to those in San Vitale. One might say, then, that the dome of Hagia Sophia has been placed over a central space and, at the same time, inserted between the two halves of a divided central-plan church. The dome rests on four arches that carry its weight to the piers, large, upright architectural supports, at the corners of the square. Thus the brilliant gold-mosaic walls below these arches, pierced with windows, have no weight-bearing function at all and act as mere curtains. The transition from the square formed by the arches to the circular rim of the dome is achieved by spherical triangles called **pendentives** (fig. **8.30**). Hence we speak of the entire unit as a dome on pendentives. This device, along with a new technique for building domes using thin bricks embedded in mortar, permits the construction of taller, lighter, and more economical domes than the older method of placing the dome on a round or polygonal base as, for example, in the Pantheon (see fig. 7.39).

Where or when the dome on pendentives was invented we do not know. Hagia Sophia is the earliest example we have of its use on a monumental scale, and it had a lasting impact. It became a basic feature of Byzantine architecture and, later, of Western architecture as well. Given the audacity of Hagia Sophia's design, it is not surprising that its architects were not described as builders, but rather as theoretical scientists, renowned for their knowledge of mathematics and physics. Its massive exterior, firmly planted upon the earth like a great mound, rises by stages to a height of 184 feet—41 feet taller than the Pantheon—and therefore its dome, though its diameter is somewhat smaller (112 feet), stands out far more boldly in its urban setting.

Once we are inside Hagia Sophia (see fig. 8.29), all sense of weight disappears. Nothing remains but a space that inflates, like so many sails, the apses, the pendentives, and the dome itself. The first dome, the one that fell in 558, was less steep than the present one, and one imagines that the sense of swelling form and heaving surface would originally have been even more intense than it is today. Here the architectural aesthetic we saw taking shape in Early Christian architecture has achieved a new, magnificent dimension.

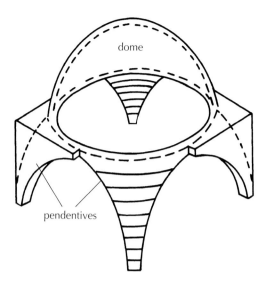

8.30. Dome on pendentives

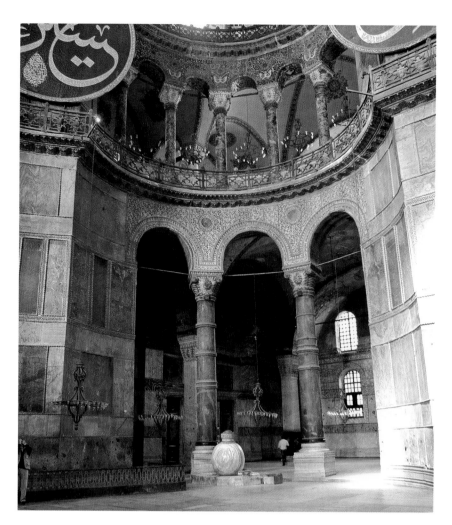

8.31. Arcade and capitals, Hagia Sophia, Istanbul

Even more than before, light plays a key role. The dome seems to float—"like the radiant heavens," according to a contemporary description—because it rests upon a closely spaced row of windows; light, both real and reflected, virtually separates the dome from the arches on which it rests. So many openings pierce the nave walls that the effect is akin to the transparency of lace curtains. The golden glitter of the mosaics must have completed the "illusion of unreality." Its purpose is clear. As Procopius, the court historian to Justinian, wrote: "Whenever one enters this church to pray, he understands at once that it is not by any human power or skill, but by the influence of God, that this work has been so finely turned. And so his mind is lifted up toward God and exalted, feeling that He cannot be far away, but must especially love to dwell in this place that He has chosen." (See *Primary Source*, page 258.) We can sense the new aesthetic even in ornamental details such as moldings and capitals (fig. 8.31). The scrolls, acanthus leaves, and similar decorations are motifs derived from classical architecture, but their effect here is radically different. The heavily patterned butterfly-marble facing of the piers denies their substantiality, and instead of actively cushioning the impact of heavy weight on the shaft of the column, the capital has become like an open-work basket of starched lace, the delicate surface pattern of which belies the strength and solidity of the stone. The contrast between the decoration of these structural members and their weight-bearing function accentuates the viewer's disorientation, an effect that would only have been increased if the interior of the building were viewed from aisle or gallery (fig. 8.32). In fact, it is from there that most congregants would have experienced the building during religious services, with no opportunity to take in or understand the entire structure.

The guiding principle of Graeco-Roman architecture had been to express a balance of opposing forces, rather like the balance within the contrapposto of a Classical statue. The result was a muscular display of active and passive members. In comparison, the material structure of Byzantine architecture, and to some extent of Early Christian architecture as well, is subservient to the creation of immaterial space. Walls and vaults seem like weightless shells, their actual thickness and solidity hidden rather than emphasized. And the glitter of the mosaics must have completed the illusion of unreality, fitting the spirit of these interiors to perfection.

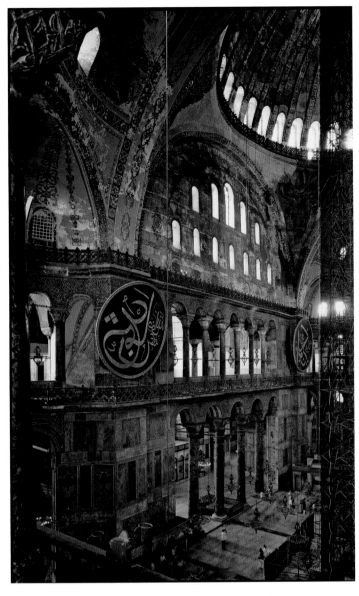

8.32. Interior (view from south aisle facing northwest),
Hagia Sophia, Istanbul

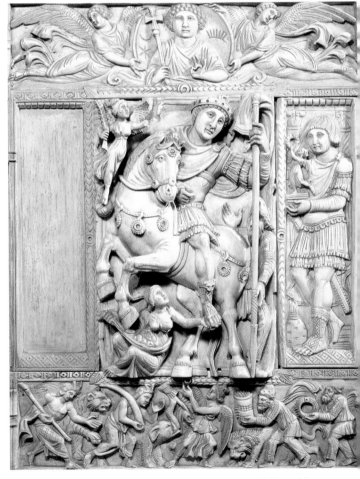

8.33. *Justinian as Conqueror.* ca. 525–550 CE. Ivory, $13\frac{1}{2} \times 10\frac{1}{2}''$
(34.2 × 26.8 cm). Musée du Louvre, Paris

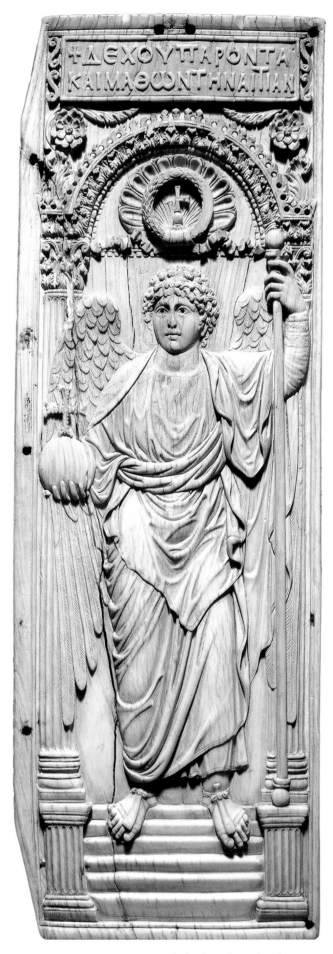

8.34. *The Archangel Michael.* Leaf of a diptych. Early 6th century CE. Ivory, $17 \times 5\frac{1}{2}$″ (43.3×14 cm). The British Museum, London

SCULPTURE Beyond architectural decorations and some sarcophagi, early Byzantine sculpture consists mainly of reliefs in ivory and silver, which survive in considerable numbers. Vestiges of classicism are apparent in the beautifully carved diptych of *Justinian as Conqueror*, which celebrates the emperor's victories in Italy, North Africa, and Asia (fig. **8.33**). The subject restates in Christian terms the allegorical scene on the breastplate of the *Augustus of Primaporta* (see fig. 7.16). The figure of Victory appears twice: above the emperor, to his right, and as a statuette held by the Roman officer at the left, who no doubt was mirrored in the missing panel at the right. Scythians, Indians, even lions and elephants, representing the lands conquered by Justinian, offer gifts and pay homage, while a figure personifying Earth supports Justinian's foot to signify the emperor's dominion over the entire world. His role as triumphant general and ruler of the empire is blessed from heaven (note the sun, moon, and star) by Christ, whose image is in a medallion carried by two heraldically arranged angels. The large head and bulging features of Justinian brim with the same energy as his charging steed. He is a far cry from the calm philosopher portrayed on the equestrian statue of Marcus Aurelius (fig. 7.21) from which the image is derived.

An ivory relief of *The Archangel Michael* (fig. **8.34**), also from the time of Justinian, looks back to earlier classical ivories. It may have been paired with a missing panel showing Justinian, who, it has been suggested, commissioned it. The inscription above has the prayer "Receive these gifts, and having learned the cause …," which would probably have continued on the missing leaf with a plea to forgive the owner's sins, apparently a reference to the emperor's humility. In any event, this ivory must have been done around 520–530 by an imperial workshop in Constantinople.

The majestic archangel is a descendant of the winged Victories of Graeco-Roman art, down to the rich drapery revealing lithe limbs (see fig. 5.49), and recalls the Victories on the ivory plaque of *Justinian as Conqueror* (see fig. 8.33). Here classicism has become an eloquent vehicle for Christian content. The power the angel heralds is not of this world, nor does he inhabit an earthly space. The niche he occupies has lost all three-dimensional reality. The angel's relationship to it is purely symbolic and ornamental, so that, given the position of the feet on the steps, he seems to hover rather than stand. From the ankles down he seems to be situated between the columns, while his arms and wings are in front of them. It is this disembodied quality, conveyed through harmonious forms, that makes the Archangel Michael's presence so compelling. The paradox of a believable figure represented naturalistically but existing within an ambiguous, indeed impossible, setting connects this work with other products of Justinian's court, such as those buildings where solid structures serve to create ephemeral spaces.

ILLUSTRATED BOOKS Illustrated books of the early Byzantine period also contain echoes of Graeco-Roman style adapted to religious narrative. The most important example,

the *Vienna Genesis* (fig. **8.35**), containing a Greek text of the first book of the Bible, has a richness similar to the mosaics we have seen. White highlights and fluttering drapery that clings to the bodies animate the scene. The book was written in silver (now tarnished black) and decorated with brilliantly colored miniatures on dyed-purple vellum, that color being reserved for the imperial court. Although some scholars have suggested that an imperial scriptorium in Constantinople produced the manuscript, recent research points to Syria as the more likely source because there are parallels to manuscripts produced in Syria and to some mosaics that survive there as well.

Our page shows a number of scenes from the story of Jacob. In the center foreground Jacob wrestles with the angel and then receives the angel's blessing. Hence the picture does not show just a single event but a whole sequence. The scenes take place along a U-shaped path, so that progression in space becomes progression in time. This method, known as **continuous narration**, goes back as far as ancient Egypt and Mesopotamia. Its appearance in miniatures such as this may reflect earlier illustrations made in scroll rather than book form, although this hypothesis has been highly contested. The picture certainly looks like a frieze turned back upon itself. For

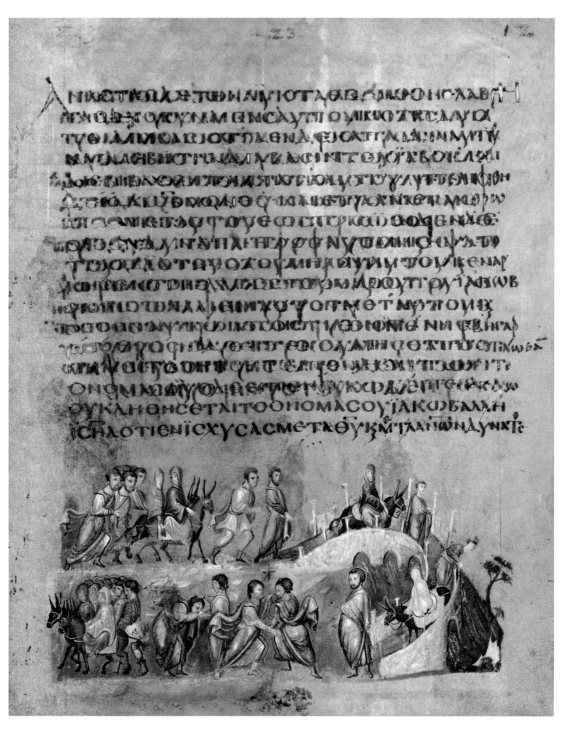

8.35. *Jacob Wrestling the Angel,* from the *Vienna Genesis.* Early 6th century CE. Tempera and silver on dyed vellum, $13\frac{1}{4} \times 9\frac{1}{2}''$ (33.6 × 24.1 cm). Österreichische Nationalbibliothek, Vienna

manuscript illustration, continuous narrative makes the most economical use of space. The painter can pack a maximum number of scenes into a small area, and the picture as a running account can be read like lines of text, rather than as a window that requires a frame.

ICONS The religious **icon** (from the Greek word *eikon*, meaning "image") provided another focus for representation at the time of Justinian. Icons generally took Christ, the Enthroned Madonna, or saints as their principal subjects and were objects of personal as well as public veneration. From the beginning they were considered portraits, for such pictures had developed in Early Christian times out of Graeco-Roman portrait panels. The issue that they might be considered idols led to arguments about their appropriateness and their power. (See *Primary Source*, page 266.) These discussions related to the contemporaneous debates on the dual nature of Christ as God and man, at once both spiritual and physical—debates that Byzantine emperors had no qualms about joining. One of the chief arguments in favor of image production was the claim that Christ had appeared with the Virgin to St. Luke and permitted him to paint their portrait together, and that other portraits of Christ or of the Virgin had miraculously appeared on earth by divine command. These "true" sacred images were considered to have been the sources for the later ones made by human artists, permitting a chain of copies and copies of copies, which has often made it difficult for art historians to date them.

Icons functioned as living images to instruct and inspire the worshiper. Because the actual figure—be it Christ, Mary, a saint, or an angel—was thought to reside in the image, icons were believed to be able to intercede on behalf of the faithful. They were reputed to have miraculous healing properties, and some were carried into battle or placed over city gates, effectively offering totemic protection to their communities. In describing an icon of the archangel Michael, the sixth-century poet Agathias writes: "The wax remarkably has represented the invisible. … The viewer can directly venerate the archangel [and] trembles as if in his actual presence. The eyes encourage deep thoughts; through art and its colors the innermost prayer of the viewer is passed to the image."

Little is known about the origins of icons, since most early examples were intentionally destroyed by those who believed they led to idolatry; hence icons are scarce. The irony of this is particularly poignant, since early icons were painted in **encaustic**, the medium in which pigment is suspended in hot wax, chosen for its durability.

Many of the surviving early examples come from the Monastery of Saint Catherine at Mount Sinai, Egypt, the isolated desert location of which aided the survival of numerous objects. An icon of *Christ* (fig. **8.36**), generally dated to sometime in the sixth century but with later repainting, is magnificent for its freshness of color and vibrancy of brushstroke. Its link with Graeco-Roman portraiture is clear not only from the use of encaustic but also from the gradations of light and shade in Christ's face and on his neck, reminiscent of the

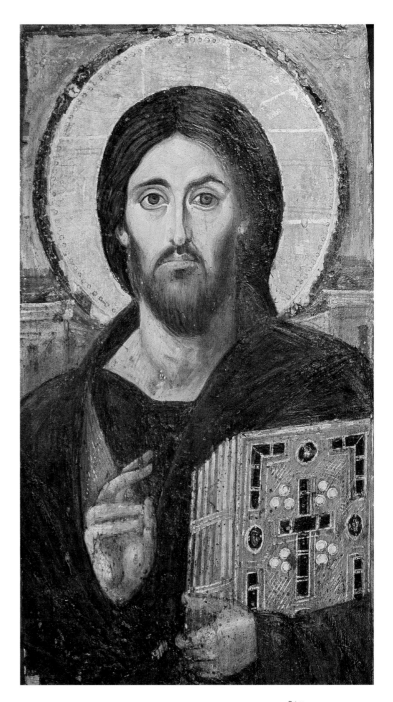

8.36. *Christ.* 6th century CE. Encaustic on panel, 34 × 17⅞″ (84 × 45.5 cm). Monastery of St. Catherine, Mount Sinai, Egypt

treatment of the woman in our Roman Fayum portrait, also in encaustic (see fig. 7.49). The combination of a frontal, unflinching gaze, establishing a direct bond with the viewer, with the lively and lifelike modeling of the face suggests the kind of dichotomy between spiritual and physical that we have seen in so much early Byzantine art. That dichotomy is accentuated here by the enormous gold halo hovering over an architectural background. It is as if the walls retreat into the background in response to the halo and in order to allow space for Christ.

An icon of the *Virgin and Child Enthroned Between Saints and Angels* (fig. **8.37**) is striking for the variety of styles used to represent the different figure types. The Virgin and Christ are large,

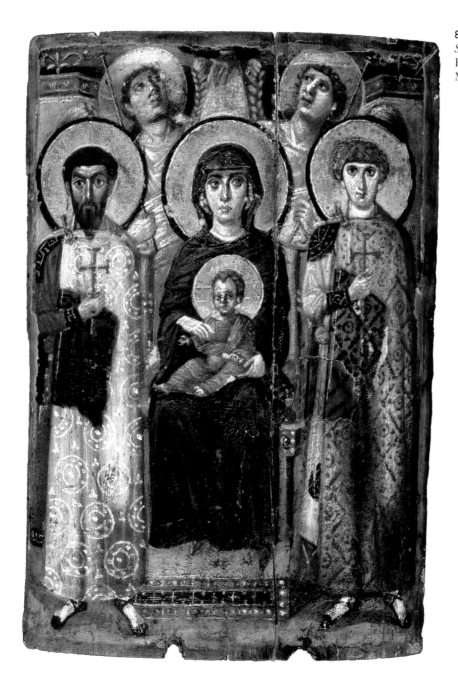

8.37. *Virgin and Child Enthroned Between Saints and Angels.* Late 6th century CE. Encaustic on panel, 27 × 19⅜" (68.5 × 49.2 cm). Monastery of St. Catherine, Mount Sinai, Egypt

their modeled faces help convey with some delicacy their solidity, while the two warrior saints, probably Theodore on the left and George (or Demetrios) on the right, recall the stiff figures that accompany Justinian in San Vitale (see fig. 8.25). Typical of early icons, however, their heads are too large for their doll-like bodies. Behind are two almost ethereal angels looking skyward; both resemble Roman representations. It is typical of the conservative icon tradition that an artist would remain faithful to his varied sources in order to preserve the likenesses of the holy figures; yet it is also possible that different styles in the same work are considered appropriate for the differing religious roles the portrayed personages play. For example, the Virgin's pose signals that for the Byzantines the Madonna was the regal mother, the Theotokos, while the stiff formality of the soldier saints is appropriate to represent stalwart defenders of the faith.

The Iconoclastic Controversy

After the time of Justinian, the development of Byzantine art—not only painting but sculpture and architecture as well—was disrupted by the Iconoclastic Controversy. The conflict, which began with an edict promulgated by the Byzantine emperor Leo III in 726 prohibiting religious images, raged for more than a hundred years between two hostile groups. The image destroyers, *Iconoclasts*, led by the emperor and supported mainly in the eastern provinces, insisted on a literal interpretation of the biblical ban against graven images because their use led to idolatry. They wanted to restrict religious art to abstract symbols and plant or animal forms. Their opponents, the *Iconophiles*, were led by the monks and were particularly centered in the western provinces, where the imperial edict remained ineffective for the most part. The strongest argument

in favor of icons was Neo-Platonic: Because Christ and his image are inseparable, the honor given to the image is transferred to him. (See *Primary Source*, page 266.)

The roots of the argument went very deep. Theologically, they involved the basic issue of the relationship of the human and the divine in the person of Christ. Moreover, some people resented that for many, icons had come to replace the Eucharist as the focus of lay devotion. Socially and politically, the conflict was a power struggle between Church and State, which in theory were united in the figure of the emperor. The conflict came during a low point in Byzantine power, when the Empire had been greatly reduced in size by the rise of Islam. Iconoclasm, it was argued, was justified by Leo's victories over the Arabs, who were themselves, ironically, Iconoclasts. The controversy caused an irreparable break between Catholicism and the Orthodox faith, although the two churches remained officially united until 1054, when the pope excommunicated the Eastern patriarch for heresy.

If the edict barring images had been enforced throughout the Empire, it might well have dealt Byzantine religious art a fatal blow. It did succeed in greatly reducing the production of sacred images, but it failed to wipe it out entirely, so there was a fairly rapid recovery after the victory of the Iconophiles in 843. The *Khludov Psalter* (fig. **8.38**) was produced soon after that date, perhaps in Constantinople and for use in the Hagia Sophia; its illustrations not only make the case for why images should be permitted, they also liken the Iconoclasts, identified by inscription, with the crucifiers of Jesus, whose vinegar-soaked sponge is equated with the implements used to whitewash icons.

Middle Byzantine Art

While we know little for certain about how the Byzantine artistic tradition managed to survive from the early eighth to the mid-ninth century, iconoclasm seems to have brought about a renewed interest in secular art, which was not affected by the ban. This may help to explain the astonishing appearance of antique motifs in the art of the Middle Byzantine period, sometimes referred to as the Second Golden Age. Hence there was a fairly rapid recovery after the victory of the Iconophiles. A

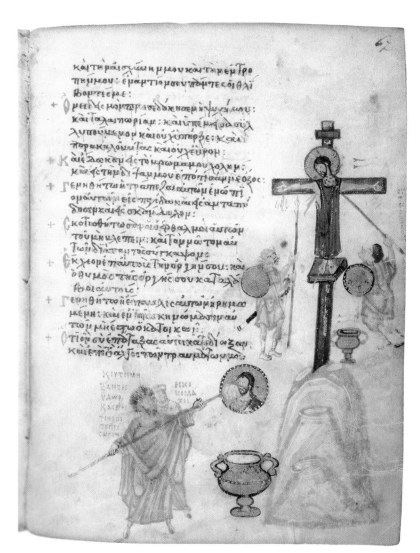

8.38. *The Crucifixion and Iconoclasts,* from the *Khludov Psalter.* After 843 CE. Tempera on vellum, $7^{3}/_{4} \times 6''$ (19.5 × 15 cm). State Historical Museum, Moscow

St. Theodore the Studite (759–826 CE)

From Second and Third Refutations of the Iconoclasts

Theodore of the Stoudios Monastery in Constantinople was a principal defender of icons against the Iconoclasts. St. Theodore refuted their charges of idolatry by examining how an image is and is not identical to its prototype (the person portrayed). Some of his arguments reflect the Neo-Platonic theory expounded by Plotinus that the sense-world is related to the divine by emanation.

The holy Basil [St. Basil the Great, ca. 329–379 CE] says, "The image of the emperor is also called 'emperor,' yet there are not two emperors, nor is his power divided, nor his glory fragmented. Just as the power and authority which rules over us is one, so also the glorification which we offer is one, and not many. Therefore the honor given to the image passes over to the prototype." In the same way we must say that the icon of Christ is also called "Christ," and there are not two Christs; nor in this case is the power divided, nor the glory fragmented. The honor given the image rightly passes over to the prototype.

Every image has a relation to its archetype; the natural image has a natural relation, while the artificial image has an artificial relation. The natural image is identical both in essence and in likeness with that of which it bears the imprint: thus Christ is identical with His Father in respect to divinity, but identical with His mother in respect to humanity. The artificial image is the same as its archetype in like-

ness, but different in essence, like Christ and His icon. Therefore there is an artificial image of Christ, to whom the image has its relation.

It is not the essence of the image which we venerate, but the form of the prototype which is stamped upon it, since the essence of the image is not venerable. Neither is it the material which is venerated, but the prototype is venerated together with the form and not the essence of the image.

If every body is inseparably followed by its own shadow, and no one in his right mind could say that a body is shadowless, but rather we can see in the body the shadow which follows, and in the shadow the body which precedes: thus no one could say that Christ is imageless, if indeed He has a body with its characteristic form, but rather we can see in Christ His image existing by implication and in the image Christ plainly visible as its prototype.

By its potential existence even before its artistic production we can always see the image in Christ; just as, for example, we can see the shadow always potentially accompanying the body, even if it is not given form by the radiation of light. In this manner it is not unreasonable to reckon Christ and His image among things which are simultaneous.

If, therefore, Christ cannot exist unless His image exists in potential, and if, before the image is produced artistically, it subsists always in the prototype: then the veneration of Christ is destroyed by anyone who does not admit that His image is also venerated in Him.

SOURCE: *ON THE HOLY ICONS.* TR. CATHERINE P. ROTH. (CRESTWOOD, NY: ST. VLADIMIR'S SEMINARY PRESS, 1981)

revival of Byzantine artistic traditions, as well as of classical learning and literature, followed the years of iconoclasm and lasted from the late ninth to the eleventh century. This revival, spearheaded by Basil I the Macedonian, was underscored by the reopening of the university in Constantinople.

ILLUSTRATED BOOKS A rather remarkable example of the antique revival is the *Joshua Roll* (fig. **8.39**), illustrated in Constantinople in the middle of the tenth century. Some art historians have seen these illustrations of the Old Testament hero Joshua's victories in the Holy Land as alluding to recent Byzantine military successes against the Muslims there. But there are problems correlating the historical events with the date of the manuscript based on stylistic criteria. It is possible that the manuscript projects aspirations more than it reflects accomplishments. That the manuscript takes the form of a scroll, that archaic type of manuscript that had been replaced by the codex a full eight centuries earlier (see pages 250–251), is remarkable. Whether or not scholars who argue that the manuscript is an accurate copy of an earlier scroll are correct, the drawn rather than painted style and the elegantly disposed figures in landscapes and against cityscapes give us some idea of what antique examples must have looked like. That such an obsolete, indeed impractical, vehicle as the scroll, whether an original or a copy, was chosen for such a lavish enterprise illustrates why scholars have referred to this period as a renaissance, crediting much of its vigor to Constantine VII.

Emperor in name only for most of his life, he devoted his energies instead to art and scholarship.

David Composing the Psalms (fig. **8.40**) is one of eight full-page scenes in the mid-tenth century *Paris Psalter*. Illustrating David's life, these scenes introduce the Psalms, which David was thought to have composed. Not only do we find a landscape that recalls Pompeian murals (see fig. 7.55), but the figures, too, clearly derive from Roman models. David himself could well be mistaken for Orpheus charming the beasts with his music. His companions are even more surprising, since they are allegorical figures that have nothing to do with the Bible. The young woman next to David is the personification of Melody, the one coyly hiding behind a pillar is the mountain nymph Echo, and the male figure with a tree trunk personifies the mountains of Bethlehem.

Once again style promotes meaning in the way consciously Classical forms herald the revival of image making after iconoclasm. But despite the presence of revivalist aspects, the late date of the picture is evident from certain qualities of style, such as the crowded composition of space-consuming figures and the abstract zigzag pattern of the drapery covering Melody's legs. In truth, one might well ask to what extent and how, despite Iconoclasm, antique methods and forms survived—that is, how much of what we see is the result of continuities rather than revivals.

SCULPTURE Monumental sculpture, as we saw earlier, disappeared from the fifth century on. In Byzantine art, large-scale

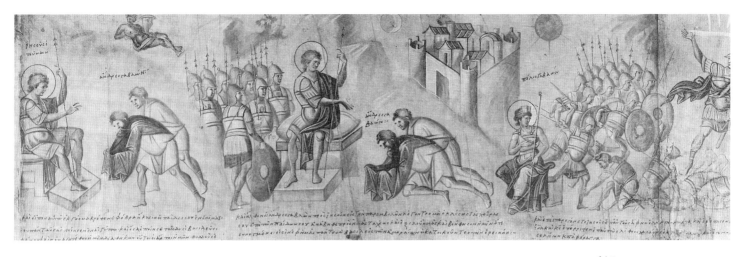

8.39. Page with *Joshua and the Emissaries from Gibeon*, from the *Joshua Roll*. ca. 950 CE. Tempera on vellum. Height 12¼″ (31 cm). Biblioteca Apostolica Vaticana, Rome. (Cod. Palat. grec. 431)

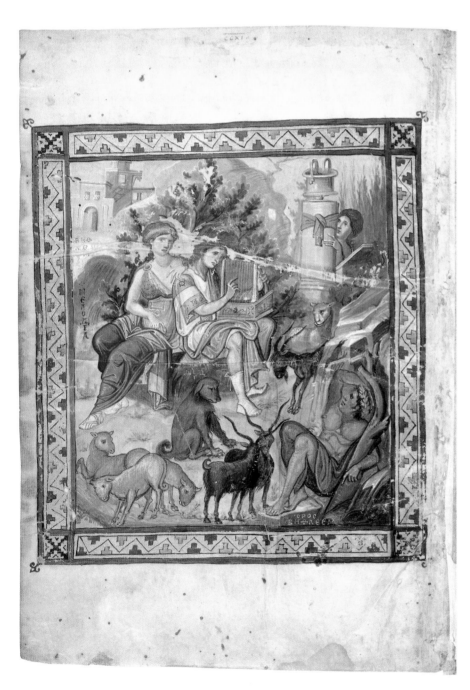

8.40. *David Composing the Psalms,* from the *Paris Psalter.* ca. 950 CE. Tempera on vellum, 14⅛ × 10¼″ (36 × 26 cm). Bibliothèque Nationale, Paris

statuary died out with the last imperial portraits, and stone carving was confined almost entirely to architectural ornament. But small-scale reliefs, especially in ivory and metal, continued to be produced in large numbers with a variety of content, style, and purpose. The *Harbaville Triptych* (fig. **8.41**), named after a recent owner, is a portable shrine in ivory with two hinged wings of the kind a high official might carry for his private worship while traveling; despite its monumental presence, it is less than 10 inches high. In the upper half of the center panel we see Christ Enthroned. Flanking him are John the Baptist and the Virgin, who plead for divine mercy on behalf of humanity. This scene, the so-called **deësis**, is a theme of relatively recent Byzantine invention. Below are five apostles arranged in strictly frontal view. Only in the upper tier of each wing of the triptych is this formula relaxed. There we find an echo of Classical contrapposto in the poses of the military saints in the top registers of the lateral panels. It is possible that we are

looking at a continuity of the approach we saw in the early icon of the *Virgin and Child Enthroned between Saints and Angels* from Mount Sinai (see fig. 8.37), whereby different figure types require different representational modes. Here, the active poses of the military saints contrast with the elegant restraint of the other holy figures, whereas in the Mount Sinai icon the angels have the active poses and the military saints are static.

Refinement and control also mark the attitude of the figures on the ivory of *Christ Crowning Romanos and Eudokia* (fig. **8.42**), where the authority of the two haloed figures is confirmed by their divine election as emperor and empress. Once again there is some stylistic opposition, perhaps even tension: The body-revealing drapery of Christ contrasts with the stiff, patterned garments of the imperial figures; and the ample space that surrounds Christ contrasts with the ambiguous one between the flanking figures and the elevated podium on which Christ stands. Unequivocal, however, and as with the *Justinian as Conqueror* ivory (see fig. 8.33), is the message of a relationship between a pious emperor and his god, beneficial to both parties. The imperial couple's elevated relationship to Christ recalls that of John the Baptist and Mary on the *Harbaville Triptych* (see fig. 8.41).

ARCHITECTURE AND ITS DECORATION Byzantine architecture never produced another structure to match the scale of Hagia Sophia. The churches built after the Iconoclastic Controversy were initially modest in scale and usually monastic, perhaps reflecting the fact that monks had been important in arguing against iconoclasm; later monasteries erected in

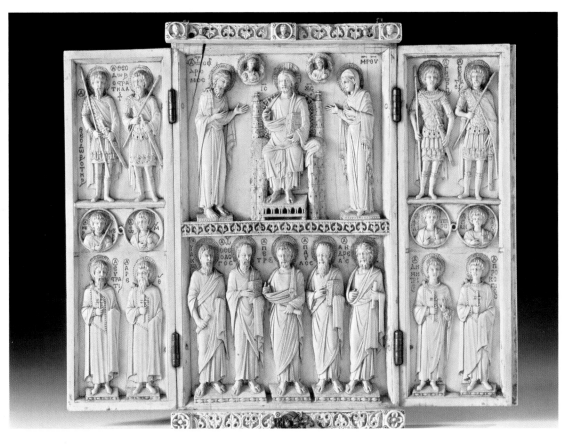

8.41. *The Harbaville Triptych.* Late 10th century CE. Ivory, 9½ × 11″ (24.1 × 28 cm). Musée du Louvre, Paris

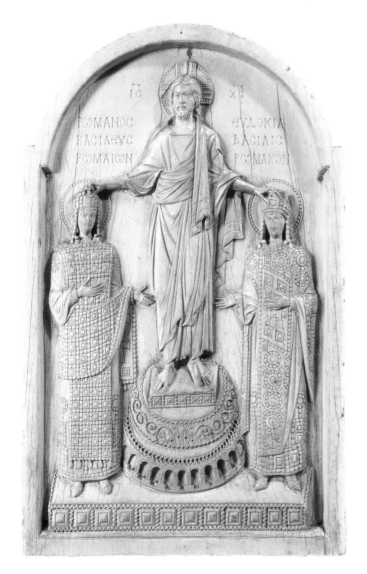

8.42. *Christ Crowning Romanos and Eudokia* ("Romanos Ivory"). 945–949 CE. Ivory, $9^3/_4 \times 6^1/_8$" (24.6 × 15.5 cm). Cabinet des Médailles, Bibliothèque Nationale, Paris

Constantinople under imperial patronage were much larger and served social purposes as schools and hospitals. The monastic Church of the Dormition at Daphni, in Greece, follows the usual Middle Byzantine plan of a Greek cross contained within a square, but with a narthex added on one side and an apse on the other (fig. **8.43**). The central feature is a dome on a cylinder, or **drum**. The drum raises the dome high above the rest of the building and demonstrates a preference for elongated proportions. The impact of this verticality, however, strikes us fully only when we enter the church. The tall, narrow compartments produce both an unusually active space and a sense almost of compression (fig. **8.44**). This feeling is

8.44. Interior (facing west), Church of the Dormition, Daphni, Greece

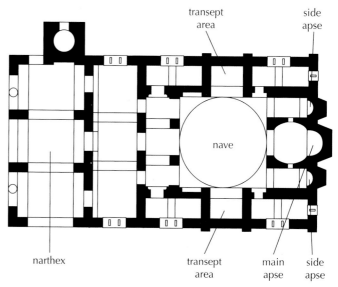

8.43. Plan of Church of the Dormition, 11th century CE. Daphni, Greece.

dramatically relieved as we raise our glance toward the luminous pool of space beneath the dome, which draws us around and upward (fig. **8.45**). The suspended dome of Hagia Sophia is clearly the conceptual precedent for this form.

The mosaics inside the church at Daphni are some of the finest works of the Second Golden Age. They show a classicism that merges harmoniously with the spiritualized ideal of

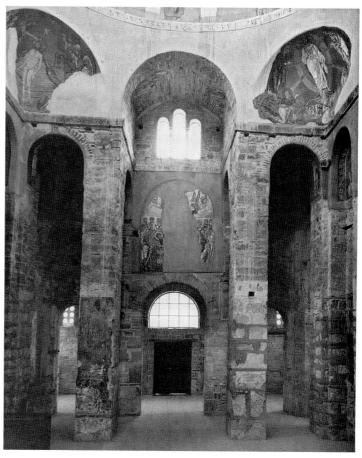

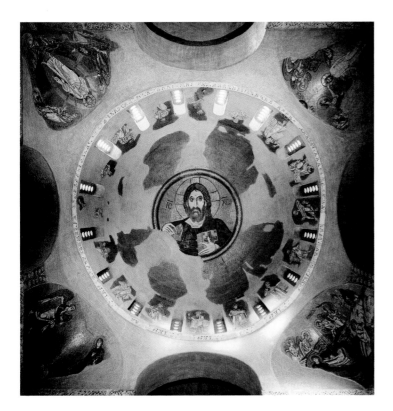

human beauty we encountered in the art of Justinian's reign. For instance, the classical qualities of the *Crucifixion* mosaic (fig. **8.46**), on the east wall of the north transept arm of the church, are deeply felt, yet they are also completely Christian. There is no attempt to create a realistic spatial setting, but the composition has a balance and clarity that are truly monumental. Classical, too, is the heroic nudity of Christ and the statuesque dignity of the two flanking figures, which make them seem extraordinarily organic and graceful compared to the stiff poses in the Justinian and Theodora mosaics at San Vitale (see figs. 8.25 and 8.26).

The most important aspect of the classical heritage in Middle Byzantine depiction, however, is emotional rather than physical. This is evident in the new interest in depicting the crucified Christ, that is, the Christ of the Passion. In the Daphni *Crucifixion* mosaic, Christ is flanked by the Virgin and St. John. The gestures and facial expressions of all three figures convey a restrained and noble suffering. We cannot say when and where this human interpretation of the Savior first appeared, but it seems to have developed in the wake of the Iconoclastic Controversy. There are, to be sure, a few earlier examples of it, but none of them appeals to the emotions of the viewer so powerfully as the Daphni *Crucifixion*. To have introduced this compassionate view of Christ into sacred depiction was perhaps the greatest achievement of Middle Byzantine art. Early Christian art lacked this quality entirely. It stressed the Savior's divine wisdom and power rather than his sacrificial death. Hence, Early Christian artists depicted the Crucifixion only rarely and without pathos, though with a similar simplicity.

Alongside the new emphasis on the Christ of the Passion, the Second Golden Age gave importance to the image of Christ the Pantocrator, an oversize, awesome (though heavily

restored) mosaic image of which stares down from the center of the dome at Daphni against a gold background (see fig. 8.45). The Pantocrator is Christ as both Judge and Ruler of the Universe, the All-Holder who contains everything. The type descends from images of the bearded Zeus. The bearded face of Jesus first appears during the sixth century, and we have already seen an early example in the icon from Mount Sinai (see fig. 8.36). Once again tradition and innovation mark Middle Byzantine achievements.

These two mosaic images are part of a larger comprehensive program that served a special spiritual function. (See end of Part II *Additional Primary Sources*). Otto Demus, writing in 1948, felicitously described Middle Byzantine churches such as the one at Daphni as a cosmos, the dome representing the heavens, while the vaults and the **squinches**, those devices, similar to pendentives, used to cut the corners of the square space below to make a transition to the cylinder above, signify the Holy Land (see fig. 8.44). The walls and supports below form the earthly world. Thus, there is a hierarchy of level, increasing verticality being equated with degrees of holiness, a sense of which is reinforced by the physical experience of the building's upward spiral pull. The beholder is on the lowest level; the

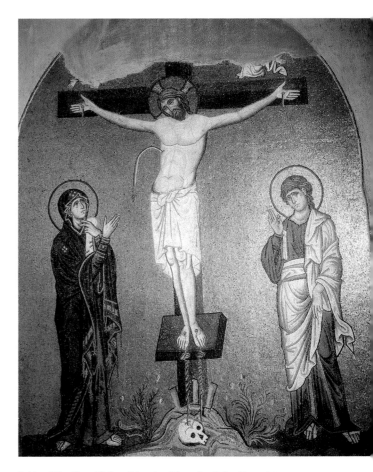

8.46. *The Crucifixion.* Mosaic. Church of the Dormition, Daphni, Greece

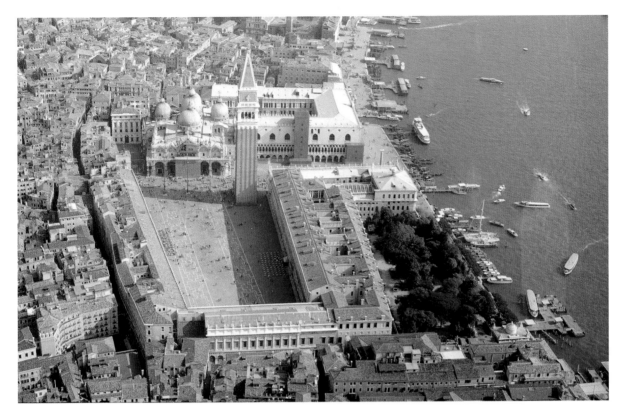

8.47. St. Mark's (aerial view). Begun 1063 CE. Venice

saints are on the walls and supports (visible in fig. 8.44); events in the life of Jesus that took place in the Holy Land, including the Annunciation, Nativity, Baptism, and Transfiguration, are on the vaults and squinches (fig. 8.45 shows the Annunciation in the lower left squinch, while the other scenes move around in a counterclockwise direction); and the Pantocrator is in the dome above (see fig. 8.45). Taken together, these representations illustrate the Orthodox belief in the Incarnation as the redemption of original sin and the triumph over death.

The movement around the building to witness the Christological cycle, which depicts the events of Christ's life, makes viewers, in effect, symbolic pilgrims to the Holy Land and is combined with a vertical momentum, a virtual journey heavenward. The impression is quite different from the experience of viewers in a Western basilica, even if both attempt to define a spiritual journey through architectural means and in aesthetic terms. In both, passage through space is a means to a goal, but when Orthodox and Western churches are compared, the manner and direction of movement is very different indeed. The largest and most lavishly decorated church of the period that still survives is St. Mark's in Venice (figs. **8.47** and **8.48**), begun in 1063, only nine years after the official schism between the Western (Catholic) and Eastern (Orthodox) churches. The church was so extensive, employing five domes in place of Daphni's single dome, that the classical system used at Daphni had to be expanded here. The present structure replaced two earlier churches of the same name on the site; it is modeled on the Church of the Holy Apostles in Constantinople, which had been rebuilt by Justinian after the riot of 532 and was later

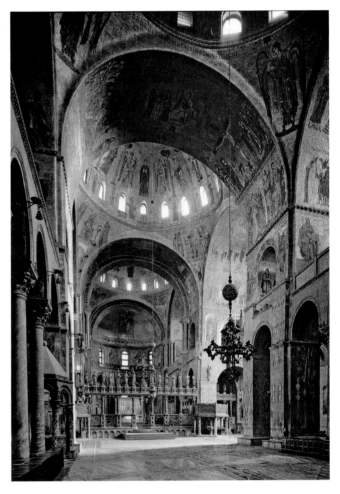

8.48. Interior, St. Mark's, Venice

ART IN TIME

1180–1190—Apse mosaics, Cathedral Moreale

 1204—Fourth Crusade captures and sacks Constantinople

 1215—King John of England signs *Magna Carta*

 1261—Constantinople regains independence

 1453—End of Byzantine Empire

destroyed. The Venetians had long been under Byzantine rule, and they remained artistically dependent on the East for many years after they had become politically and commercially powerful in their own right. Their wish to emulate Byzantium, and Constantinople in particular, is evidence of the great sway that culture and city still held.

At St. Mark's the Greek-cross plan is emphasized, since each arm of the cross has a dome of its own. These domes are not raised on drums. Instead, they are encased in bulbous wooden helmets covered by gilt copper sheeting and topped by ornate **lanterns** (small structures often used to admit light into the enclosed spaces below), so that the domes appear taller and more visible at a distance. (They make a splendid landmark for seafarers.) The spacious interior shows that St. Mark's was meant for the people of a large city rather than a small monastic community such as Daphni.

The Byzantine manner, transmitted to Italy, was called the "Greek style" there. Sometimes it was carried by models from Constantinople, but most often it was brought directly by visiting Byzantine artists. At St. Mark's, Byzantine artists and the locals trained by them executed the mosaics. The "Greek style" appears in a number of magnificent churches and monasteries in Sicily, a former Byzantine holding that was taken from the Muslims by the Normans in 1091 and then united with southern Italy. The Norman kings considered themselves the equals of the Byzantine emperors and proved it by calling in teams of mosaicists from Constantinople to decorate their splendid religious buildings. The mosaics at the Cathedral of Monreale (fig. **8.49**), the last Byzantine mosaics to be executed, are in a thoroughly Byzantine style, although the selection and distribution of their subjects are largely Western. The wall surfaces these

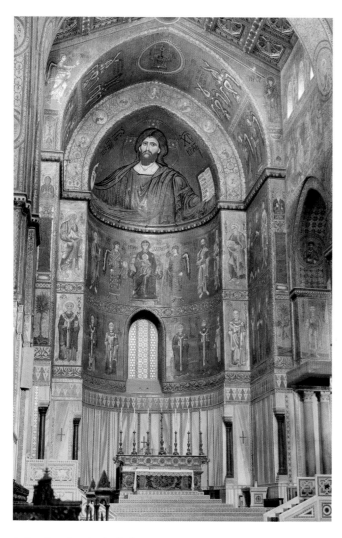

8.49. Interior, Cathedral. ca. 1180–1190 CE. Monreale, Italy

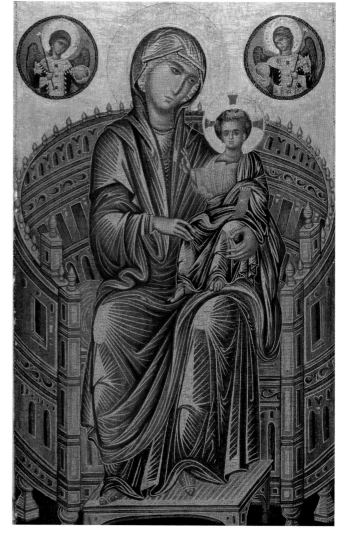

8.50. *Madonna Enthroned.* Late 13th century. Tempera on panel, $32^{1}/_{8} \times 19^{3}/_{8}$″ (81.9 × 49.3 cm). National Gallery of Art, Washington, D.C. Andrew Mellon Collection. 1937.1.1

Biblical and Celestial Beings

Much of Western art refers to biblical persons and celestial beings. Their names appear in titles of paintings and sculpture and in discussions of subject matter. The following is a brief guide to some of the most commonly encountered persons and beings in Christian art.

Patriarchs. Literally, patriarchs are the male heads of families, or rulers of tribes. The Old Testament patriarchs are Abraham, Isaac, Jacob, and Jacob's 12 sons. The word *patriarch* may also refer to the bishops of the five chief bishoprics of Christendom: Alexandria, Antioch, Constantinople, Jerusalem, and Rome.

Prophets. In Christian art, the word *prophets* usually refers to the Old Testament figures whose writings were seen to foretell the coming of Christ. The so-called major prophets are Isaiah, Jeremiah, and Ezekiel. The minor prophets are Hosea, Joel, Amos, Obadiah, Jonah, Micah, Nahum, Habakkuk, Zephaniah, Haggai, Zechariah, and Malachi.

Trinity. Central to Christian belief is the doctrine of the *Trinity* which states: that One God exists in Three Persons: Father, Son (Jesus Christ), and Holy Spirit. The Holy Spirit is often represented as a dove.

Holy Family. The infant Jesus, his mother Mary (also called the Virgin or the Virgin Mary), and his foster father, Joseph, constitute the *Holy Family*. Sometimes Mary's mother, St. Anne, appears with them.

John the Baptist. The precursor of Jesus Christ, John the Baptist is regarded by Christians as the last prophet before the coming of the Messiah, in the person of Jesus. John baptized his followers in the name of the coming Messiah; he recognized Jesus as that Messiah when he saw the Holy Spirit descend on Jesus when he came to John to be baptized. John the Baptist is not the same person as John the Evangelist, one the the 12 apostles.

Evangelists. There are four: Matthew, Mark, Luke, and John—each an author of one of the Gospels. Matthew and John were among Jesus' 12 apostles. Mark and Luke wrote in the second half of the first century CE.

Apostles. The apostles are the 12 disciples of Jesus Christ. He asked them to convert the "nations" to his faith. They are Peter (Simon Peter), Andrew, James the Greater, John, Philip, Bartholomew, Matthew, Thomas, James the Less, Jude (or Thaddaeus), Simon the Canaanite, and Judas Iscariot. After Judas betrayed Jesus, his place was taken by Matthias. St. Paul (though not a disciple) is also considered an apostle.

Disciples. See **Apostles.**

Angels and Archangels. Beings of a spiritual nature, angels are spoken of in the Old and New Testaments as having been created by God to be heavenly messengers between God and human beings, heaven, and earth. Mentioned first by the apostle Paul, archangels, unlike angels, have names: Michael, Gabriel, and Raphael. In all, there are seven archangels in the Christian tradition.

Saints. Persons are declared saints only after death. The pope acknowledges sainthood by canonization, a process based on meeting rigid criteria of authentic miracles and beatitude, or blessed character. At the same time, the pope ordains a public cult of the new saint throughout the Catholic Church. A similar process is followed in the Orthodox Church.

Martyrs. Originally, the word *martyr* (from the Greek meaning "witness") referred to each of the apostles. Later, it signified those persecuted for their faith. Still later, the term was reserved for those who died in the name of Christ.

mosaics covered are vast, the largest to be decorated in this technique, and the artists adapted their figure types and subjects to a Western building and Western subjects. Masterful indeed is the way the Pantocrator of a Byzantine domed church now controls the space of the apse and the way registers of figures lining the walls define, indeed clarify in a very un-Byzantine way, the basilica form. Christ's open book contains the text "I am the light of the world … " in Greek on one page and in Latin on the other, the schism of language being united through art.

Late Byzantine Art

In 1204 Byzantium suffered an almost fatal defeat when the armies of the Fourth Crusade, instead of warring against the Turks, captured and sacked the city of Constantinople. For more than 50 years, the core of the Eastern Empire remained in Western hands. Byzantium, however, survived this catastrophe. In 1261 it regained its independence, which lasted until the Turkish conquest in 1453. The fourteenth century saw a last flowering of Byzantine painting under a series of enlightened rulers.

ICONS The Crusades decisively changed the course of Byzantine art through bringing it into contact with the West. The impact is apparent in the *Madonna Enthroned* (fig. **8.50**), which unites elements of East and West, so that its authorship

has been much debated. Because icons were objects of veneration, and because they embodied sacredness, they had to conform to strict rules, with fixed patterns repeated over and over again. As a result, most icons are noteworthy more for exacting craftsmanship than artistic inventiveness. Although painted at the end of the thirteenth century, our example reflects a much earlier type (see fig. 8.37). There are echoes of Middle Byzantine style in the graceful pose, the play of drapery folds, and the tender melancholy of the Virgin's face. But these elements have become abstract, reflecting a new taste and style in Late Byzantine art. The highlights on the drapery that resemble sunbursts are not a new development, yet they seem more rigid and stylized than in Middle Byzantine examples. Faces are carefully modeled with gentle highlights and suave shading. The linear treatment of drapery in combination with the soft shading of hands and faces continues the long-established Byzantine pattern of having naturalistic and antinaturalistic aspects play off each other in the same work.

The total effect is neither flat nor spatial, but transparent—so that the shapes look as if they were lit from behind. Indeed, the gold background and highlights are so brilliant that even the shadows never seem wholly opaque. This all-pervading radiance, we will recall, first appears in Early Christian mosaics (see, for example, fig. 8.17). Panels such as

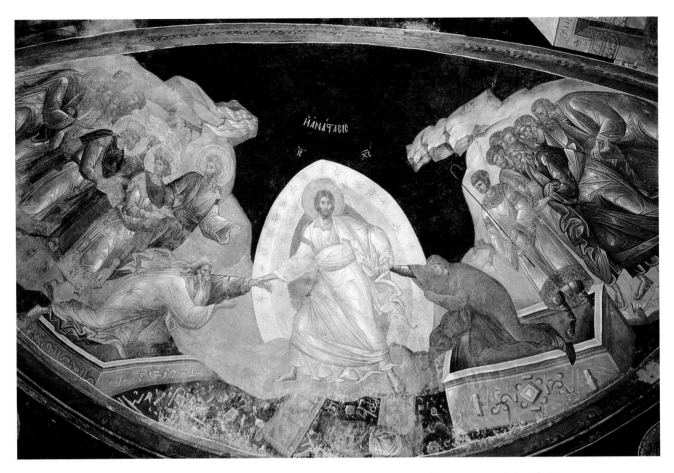

8.51. *Anastasis.* ca. 1310–1320 CE. Fresco. Kariye Camii (Church of the Savior in the Chora Monastery), Istanbul

the *Madonna Enthroned* may therefore be viewed as the aesthetic equivalent of mosaics and not simply as the descendants of the panel-painting tradition. In fact, some of the most precious Byzantine icons are miniature mosaics attached to panels, and our artist may have been trained as a mosaicist rather than as a painter.

Although many details relate this icon to Byzantine works, particularly from Constantinople, there is growing evidence that it was produced by a Western artist in emulation of Byzantine painting. For example, the manner in which the Enthroned Virgin presents the Christ Child is Byzantine, while the blessing gesture of Christ is Western. The red background of the angels in medallions is also a feature not found in Byzantium, but rather in the West. An origin in Cyprus, then ruled by the French, has been suggested, but where this work might have been painted remains a very open question. Whatever its origin, the *Madonna Enthroned* points to a profound shift in the relation between the two traditions: After 600 years of borrowing from Byzantium, Western art has begun to contribute something in return.

MOSAICS AND MURAL PAINTING The finest surviving cycles of Late Byzantine mosaics and paintings are found in Istanbul's Kariye Camii, the former Church of the Savior in the Chora Monastery. (*Kariye* is the Turkish adaptation of the

ancient Greek word *chora*, which refers to the countryside, that is, outside the city walls; *camii* denotes a mosque, to which the building was converted after the Turkish conquest, although the site is now a museum.) These particular mosaics and paintings represent the climax of the humanism that emerged in Middle Byzantine art. Theodore Metochites, a scholar and poet who was prime minister to the emperor Andronicus II, restored the church and paid for its decorations in the beginning of the fourteenth century.

The wall paintings in the mortuary chapel attached to Kariye Camii are especially impressive. Some have suggested that because of the Empire's greatly reduced resources, murals often took the place of mosaics, but at Kariye Camii they exist on an even footing and may even have been designed by the same artist. The main scene depicts the traditional Byzantine image of the *Anastasis* (fig. **8.51**), the event just before the Resurrection, which Western Christians call the Descent into Limbo or the Harrowing of Hell, clearly a fitting subject for the funerary setting. Surrounded by a **mandorla**, a radiant almond shape, Christ has vanquished Satan and battered down the gates of Hell. (Note the bound Satan at his feet, in the midst of a profusion of hardware; the two kings to the left are David and Solomon.) The central group of Christ raising Adam and Eve from the dead has tremendous dramatic force; Christ

moves with extraordinary physical energy, tearing Adam and Eve from their graves, so that they appear to fly through the air—a magnificently expressive image of divine triumph.

Such dynamism had been unknown in the Early Byzantine tradition, although the emotional force of Middle Byzantine painting might well have prepared the way for the vivacity of the Kariyi Camii representations. Coming in the fourteenth century, this Late Byzantine style shows that 800 years after Justinian, when the Anastasis first appeared as a subject, Byzantine art still had all its creative powers. Thus, despite the diverse uses it served, its long chronological spread, and the different cultures and wide geographic areas it spanned, Byzantine art continued to preserve long-established traditions. Indeed, its durability verges on the immutable.

SUMMARY

Aweakened Roman Empire faced threats along its borders and during this time of turmoil many people sought solace in a variety of new religions. Principal among them was Christianity. It enjoyed special status during the rule of Constantine, a Christian convert who created a new capital for the Roman Empire at Constantinople. Eventually this move led to a split of the empire into separate Western and Eastern regions.

There is no clear-cut geographical, chronological, or stylistic line between Early Christian and Byzantine art before the sixth century. Among the earliest surviving works of Christian art are sarcophagi, wall mosaics, and illustrated books. Significant Christian architecture appears only when Christianity became an officially sanctioned religion. Byzantine artists shared many of the concerns of their Early Christian colleagues in the Western empire, particularly for nonnaturalistic, symbolic representations. However, Classical systems of representation continued to be admired and employed.

EARLY CHRISTIAN ART

Although early centers of the Christian faith included cities along the eastern Mediterranean, the greatest concentration of surviving works is found in Rome. These include painted decorations from the catacombs, the underground burial places of early Christians. After the conversion of Emperor Constantine, many new and impressive Christian structures were built. Particularly significant was the transformation of the Roman basilica form so that it was suitable for Christian worship, as can be seen in Old St. Peter's Basilica. Also important is the development of central-plan buildings. Two examples are the Mausoleum of Galla Placidia and the Orthodox Baptistery, both in Ravenna, which became the capital of the Western Empire in 402. Although often relying on Roman artistic forms and subjects, Early Christian artists used them for new purposes that were in keeping with the values and goals of the new religion.

BYZANTINE ART

During Justinian's rule, Constantinople became the artistic and political capital of the Eastern Empire. The grand monuments of this time, such as Hagia Sophia, are a reflection of what some have called a Golden Age. Many outstanding works also survive in Ravenna, such as the church of San Vitale, which is decorated with a famed series of mosaics. A sense of tradition played a strong role in the development of Byzantine art, and even works from later centuries—whether icons, illustrated books, or small-scale reliefs—reflect a concern for continuity as much as for change.

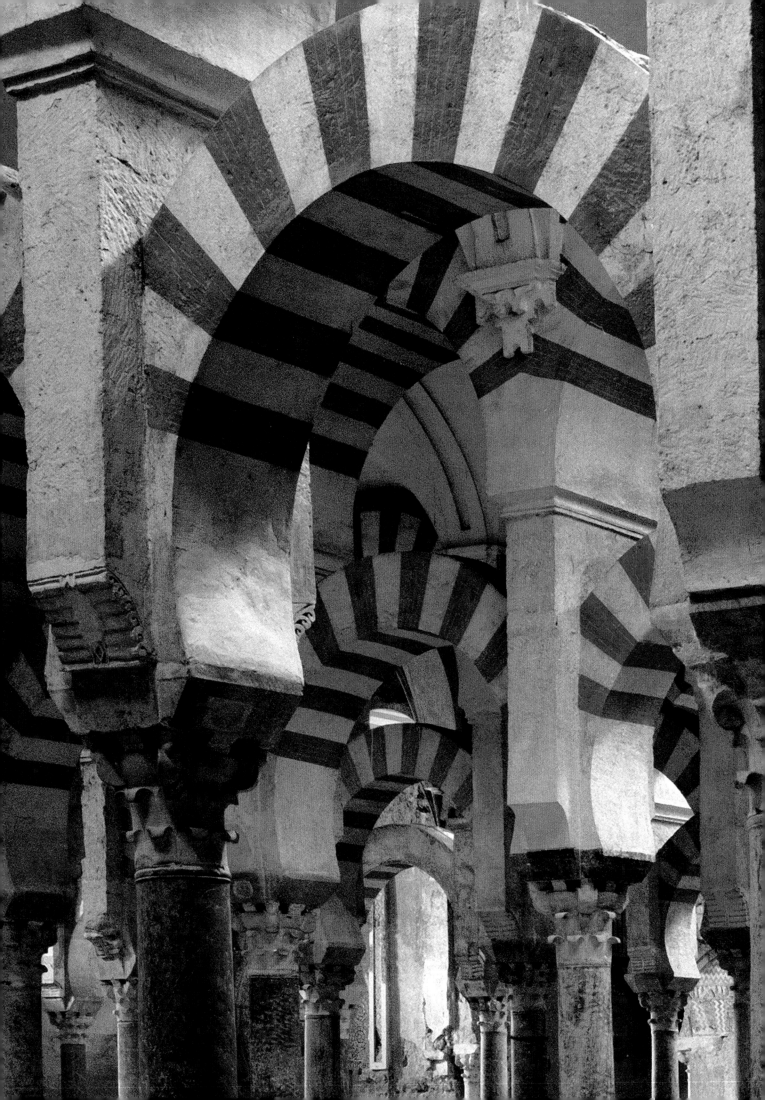

Islamic Art

THE RELIGION KNOWN AS ISLAM TOOK FORM IN THE EARLY SEVENTH century on the Arabian peninsula (see *Informing Art*, page 278). A scant 30 years after the death of its founder, the Prophet Muhammad (also known as the Messenger), in 632, Arab warriors had carried the new faith into much of today's Middle East. A century after the death of

the Prophet, Islam had spread across Africa into Spain in the west, and into the Indus valley and Central Asia in the east (map 9.1). The original Arab adherents of Islam were eventually augmented by Berbers, Visigoths, Turks, and Persians, and the complexity of today's Islamic world existed almost from the beginning. As this phenomenal expansion took place, the inevitable clashing and combining of old cultures with the new religion gave birth to what was to become a vibrant tradition of Islamic art.

Examining the formation of Islamic art gives us an intriguing look at the phenomenon of *syncretism* in art history, the process whereby a new artistic tradition emerges as a creative combination of previously existing artistic ideas under the impetus of a new ideology. Just as the first Christian art developed out of a mixture of various preexisting Classical and Near Eastern artistic ideas adapted to serve the needs of religious and then princely patrons (see Chapter 8), so the new Islamic art first took form as a series of appropriations of preexisting Graeco-Roman, Byzantine Christian, and Sasanian forms molded into a new synthesis, in the service both of the new Islamic religion and Islamic princes.

The vast geographical and chronological scope of Islamic art means that it cannot be encompassed in simple definitions. Islam, the religion, is a significant element in Islamic culture,

Detail of Figure 9.8, Great Mosque of Córdoba

but Islamic art is far more than a religious art; it encompasses secular elements and elements frowned upon, if not actually forbidden, by some Islamic theologians. As with all art, Islamic art encompasses and reflects the consistencies and the contradictions of the society and culture that give it life.

With all of its individual styles of time and place, and with the various sectarian differences within Islam, Islamic art has certain unifying themes. The first of these is reverence for the Word—the Qur'an—and for the language of the Word—Arabic—as reflected in the art of beautiful writing. From the angular, horizontal **kufic** alphabet of early Islam (fig. **9.1**) to complex cursive styles developed in later times, Islamic art, both secular and religious, shows a remarkable affinity for the written word, be it scripture or secular narrative poetry (see *Primary Source*, page 280). A second theme is the development of artistic expression independent of the human figure. Given the mistrust of figural images in many Islamic religious traditions, we see in Islamic art sophisticated and complex vocabularies of vegetal, floral, and geometric designs used in conjunction with beautiful writing. A third theme is the equality of genres. To understand and appreciate Islamic art we need to discard the notion of the primacy of (figural) painting and (figural) sculpture in the European tradition. In the Islamic world, the arts of ceramics, metalware, weaving, and carving in precious materials rank with other mediums in an artistic spectrum devoid of the formal hierarchy that in the West led to a distinction between "fine

Islam and Its Messenger

Islam (an Arabic word denoting submission to God's will) is the predominant religion of a vast area of the world extending across Africa, Europe, and Asia, with many different ethnicities, cultures, languages, and forms of social and political organization. *Muslims* (those who submit) believe that Muhammad (ca. 570–632), an orphaned member of a major tribal group from the city of Mecca in the western Arabian peninsula, was chosen by God (in Arabic, *Allah*) to serve as God's Messenger, or Prophet, to humanity. Muhammad is said to have received the Word of God as a series of poetical recitations (in Arabic, *Qur'an*), brought to him by the archangel *Jibra'il* (Gabriel). Muhammad memorized and recited these poetic verses, and taught them to his followers. Organized into *sura* (chapters) and finally written down after the death of Muhammad in 632, these prayers, stories, exhortations, and commandments constitute the Qur'an, Islam's sacred book. The Qur'an, together with official collections of *hadith* (remembrances) of the exemplary life of Muhammad as the Messenger, form the basis of Islamic religious practice and law.

While the Prophet quickly gained adherents, those in power in Mecca were threatened by the challenges the new faith posed to their political and economic power, and in 622 he was forced to leave Mecca with a few of his followers, moving to the city of Medina some 190 miles to the north. Muhammad's community, in constant conflict with the Meccans to the south, continued to grow, and more revelations were received. The Prophet's house in Medina, constructed in the form of an open square, became the prototype for countless mosques in subsequent centuries.

Islam was defined by Muhammad as the culmination of a prophetic tradition that began with God's covenant with Ibrahim (Abraham). The Qur'an prominently mentions many of the major figures of the Hebrew Bible, such as Ibrahim, Musa (Moses), and Sulayman (Solomon), as well as the prophet 'Isa (Jesus) and his mother Maryam (Mary). Islamic belief is fundamentally very simple: To become a Muslim, one repeats with conviction the phrase, "There is no God but God; Muhammad is the Messenger of God." This Affirmation of Faith is the first of the so-called Five Pillars of Islam. The others are prayer (the five daily prayers and the major weekly prayer at noon on Friday, the Muslim Day of Congregation), fasting (abstention from food and drink during daylight hours during the lunar month of Ramadan), pilgrimage (in Arabic, *hajj*, a journey to Mecca during the lunar month of Dhu'l Hijja), and charity (institutionalized as a formal system of tithing, intended to benefit the sick and needy of the Islamic community).

In addition, Islam proclaimed three other tenets that were to have a major impact on art. The first was the protected status of the "People of the Book"—Jews and Christians—in Muslim society, as ordained by God in the Qur'an. The second, based on several anecdotes from the Prophet's life, is a profound mistrust of certain images—pictures and statues of humans and animals—as potentially idolatrous, a point of view Islam shares with Judaism, and which occasionally influences the history of Christian art as well. The third, held in common with Judaism and contrasting markedly with the Christianity of that time, was a high regard for literacy and the individual's reading and study of scripture, coupled through most of Islamic history with a reverence for the written alphabet—in the case of Islam, the Arabic alphabet, which in early Islam used an angular form of script known as *kufic* (see fig. 9.1). The beauty of the script, with its contrasting thin and thick lines, written from right to left in an almost rhythmic visual cadence, was deemed appropriate for the poetic words of God himself. These three factors, taken in the general context of Islamic belief and early Islamic political history, were to have a profound effect on the molding of the Islamic artistic tradition.

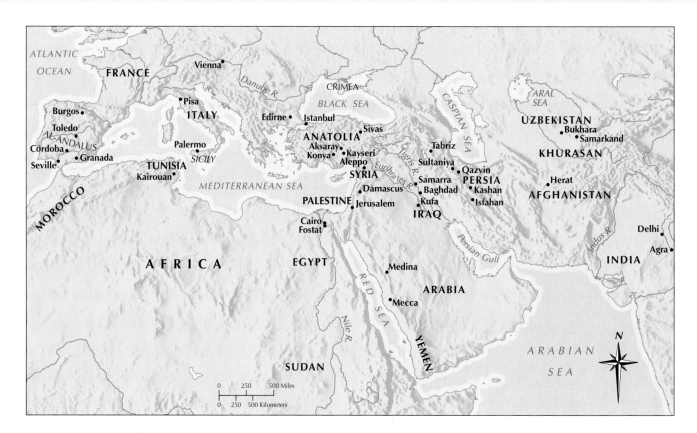

Map 9.1. The Islamic World

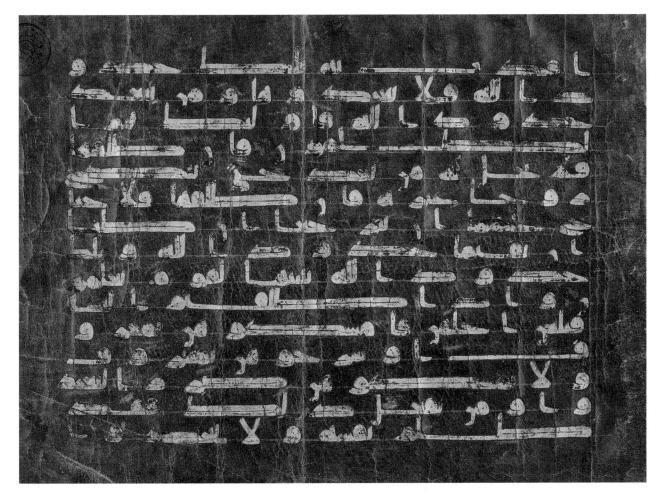

9.1. Page with kufic script from an Abbasid Qur'an, probably from Tunisia. 9th century. Ink, color, gold and silver on dyed blue vellum, 11¼ × 14¾″ (28.6 × 37.5 cm). Courtesy of the Arthur M. Sackler Museum. Harvard University Museums, Cambridge, MA, Francis Burr Memorial Fund, 1967.23

arts" and "decorative arts." In this sense, looking at Islamic art can be both enlightening and liberating.

THE FORMATION OF ISLAMIC ART

Islamic art first took form as a series of appropriations of pre-existing Graeco-Roman, Byzantine Christian, and Sasanian forms. These were molded into a new synthesis to serve the needs of the new Islamic religion and the desires and political goals of Islamic princes. The appropriation and adaptation of preexisting forms in the service of the emerging Islamic culture is particularly apparent in architecture.

Religious Architecture

The new religion required certain types of distinctive buildings, such as a place for community prayers that was visually identified with the new faith. The new Islamic rulers required dwellings appropriate to their power and wealth. Eventually the faith required commemorative buildings that memorialized great rulers, holy men, or historic events. Ultimately,

Islamic architecture developed a rich variety of forms and genres, and a distinctive repertoire of decoration that became emblematic of the faith itself.

DOME OF THE ROCK The earliest major Islamic building to have survived into our time, the Dome of the Rock in Jerusalem (fig. **9.2**), is a case in point. After the Arabian cities of Mecca and Medina, Jerusalem was the holiest Islamic site. For the first Muslims, the Temple Mount in Jerusalem marked the place where God tested Ibrahim's faith by demanding the sacrifice of his first-born son Ismail. From the same site, according to later Islamic legend, the Prophet was taken by Gabriel on a *mi'raj* (spiritual journey) to experience both Heaven and Hell, Muhammad being the only mortal allowed to see these places before death.

It is far from coincidence that the Dome of the Rock is built on Mount Moriah in Jerusalem, a place that originally was the site of the First (Solomon's) and Second (Herod's) Temples, the geographic center of the Jewish faith. It is also far from coincidence that the domed silhouette and ringlike plan of the Dome

Muhammad Ibn Mahmud Al-Amuli
(Iran, 14th Century)

From *Nafâ'is al-Funûn* (The Beauty of Knowledge)

Countless Islamic adages and anecdotes testify to the importance and beauty of elegant writing, the only art form to which Islamic theologians gave their unqualified approval. Al-Amuli's encyclopedic treatise on knowledge praises the art of beautiful writing as the fulfillment of God's will, bringing respect and honor to the practitioner.

The art of writing is an honourable one and a soul-nurturing accomplishment; as a manual attainment it is always elegant, and enjoys general approval; it is respected in every land; it rises to eminence and wins the confidence of every class; being always held to be of high rank and dignity, oppression cannot touch it, and it is held

in remembrance in every country, and every wall is adorned by its hand. Honour enough for it in this connexion is that the Lord of Lords, whose names are hallowed in His incontrovertible Revelation, swore—"By the pen, and what they write (Qur. lxviii.1), and He spake these words: "Recite! Thy Lord is the most generous, who hath taught by means of the pen, Hath taught man what he knew not" (Qur. xcvi. 3–5).

> It is honour and exaltation enough for the writing pen
> For ever, that it was by the pen that God swore

The Prophet (peace be upon him!) said: "Beauty of handwriting is incumbent upon you, for it is one of the keys of man's daily bread." A wise man has said: "Writing is a spiritual geometry, wrought by a material instrument."

SOURCE: SIR THOMAS W. ARNOLD *PAINTING IN ISLAM: A STUDY OF THE PLACE OF PICTORIAL ART IN MUSLIM CULTURE,* (NY: DOVER, 1965)

of the Rock (fig. **9.3**) echo the form of the sixth-century Byzantine shrine of the Holy Sepulcher, marking the burial place of Jesus, just a few hundred yards to the west. The Dome of the Rock was constructed by artists and craftspeople, many of whom were undoubtedly local Christians or new converts to Islam, probably under orders from the Muslim caliph (from the Arabic *khalifa*, meaning "successor") Abd al-Malik sometime around the year 690. Erected on a holy place that was also one of the highest points in the city, it eloquently proclaimed that Jerusalem was under the control of Islam.

A closer look at the building shows both the nature of early Islamic syncretism and the impact of the Messenger's views on the visual arts. The ground plan of the building (see fig. 9.3), with its two ambulatories around the central bare rock, ideal for organizing visits of large numbers of pilgrims to the shrine, recalls not only the Holy Sepulcher but also central-plan domed churches from late Roman times. Just to the south of the Dome of the Rock, providing a place for prayer directly next to the shrine, was an equally venerable and revered Islamic structure, the communal prayer hall known

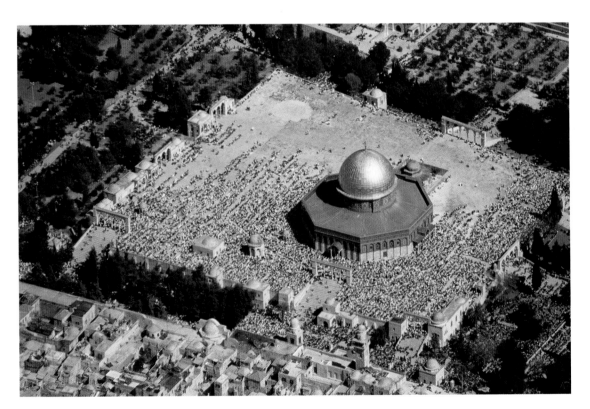

9.2. The Dome of the Rock, Jerusalem. ca. 690 and later

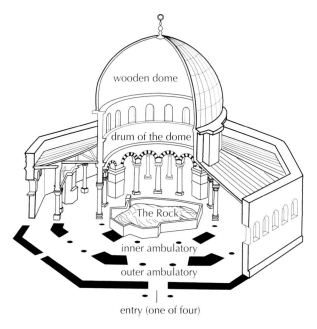

9.3. Cutaway drawing, Dome of the Rock, Jerusalem

Of all of the pillars of Islam, the religious duty of prayer proved the most important in the development of Islamic architecture. In major cities such as Damascus, the Arab Umayyad caliphs of early Islam either built or converted from preexisting structures the first great buildings for Muslim public worship called **mosques** in English (from the Arabic *masjid*, meaning "place of prostration"). These first mosques, designed to contain the entire male population of a city during the noonday prayer on Friday, recall the form of the Messenger's house in Medina, with a rectangular courtyard, usually surrounded by covered arcades, and a larger hypostyle (many-columned) hall on the **qibla**, the side facing Mecca. The architecture emphasized the equality of all Muslims before God and the absence in Islam of ordained clergy: There is little *axiality* in the early Arab mosques—no long straight pathway leading to an architectural focus visible throughout the structure. With prayer occurring directly between each worshiper and God, and no ordained clergy or canonized saints to provide intercession, the interior space of the early mosque was essentially determined by practicality, not by ceremony. Thus there was no place for music or processions; many doors were placed

today as the al-Aqsa Mosque. The dome of the shrine itself was a well-established symbol for the vault of heaven, especially appropriate given the ultimate goal of the Messenger's mystical and spiritual journey. The columns and capitals, recycled from Classical monuments, convey an impression of tradition and permanence, wealth and power, to Muslim and non-Muslim alike.

The original mosaic decoration (fig. **9.4**) consisted of Arabic script, repeating geometric motifs, and highly stylized vegetal and floral elements. Eventually, these design elements would form a distinctively Islamic repertoire of decoration. One was Arabic script used in the many religious inscriptions. Two others were a vocabulary of scrolling vines, leaves, and flowers distantly based on nature, and another a repertoire of repeating geometric patterns. Both vocabularies were staples of late Classical and Sasanian art. A fourth set of motifs consisted of jewels and jeweled objects, symbols of royalty. But in marked contrast to the Graeco-Roman and Christian religious art traditions, nowhere in the Dome of the Rock do the forms of humans or animals appear. The inscriptions in the Dome of the Rock, taken from the Qur'an, were carefully chosen to underline the importance of the building itself, its symbolic location in a city holy to Jews and Christians as well as Muslims, and its place within a religion and society that saw itself as the culmination of the two earlier scriptural traditions, and which accorded tolerance and acceptance of both Christians and Jews.

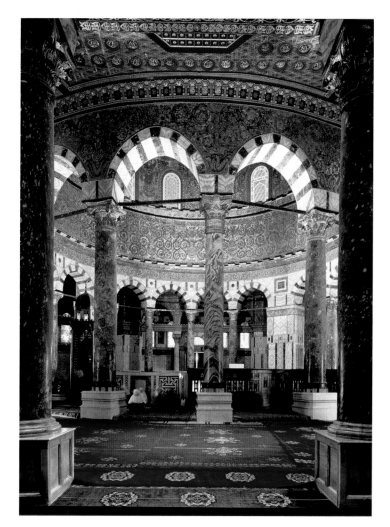

9.4. Interior, Dome of the Rock, Jerusalem

ART IN TIME

632 CE—Death of the prophet Muhammad

**ca. 690—Construction of the Dome of the Rock
in Jerusalem**

ca. 700—*Lindisfarne Gospels* **produced in England**

By 700s—Islam reaches Spain and Central Asia

for maximum convenience of the daily coming and going of worshipers; and a large centralized or axial space, so important for the drama of the Christian Mass, was deemed unnecessary. A simple **minbar** (pulpit) served for the delivery of sermons after the Friday noon prayer, and an empty **mihrab** (niche) in the qibla wall was added to indicate the direction of Mecca (fig. **9.5**). Mats of grass or rushes, and later woolen carpets, often covered the floors. These provided a clean place for the standing, bowing, kneeling, and prostration, with the brief touching of the forehead to the ground, while reciting prayers, that constitute the essence of Islamic worship. Oil lamps provided illumination for the dawn and late evening prayers. Pools or fountains in the courtyard allowed for the ceremonial washing of hands and feet required before prayers. In later times, a tower, known in English as a **minaret**, advertised the presence of the mosque and served as a place from which to broadcast the call to prayer given five times a day by a *muezzin,* an individual usually selected for the beauty and power of his voice. And in some mosques a small platform called a **dikka** provided a place for the muezzin to chant prayers aloud.

Secular Architecture

The advent of Islam did not mean the end of secular art in the Near East. The early Islamic princely patrons, Arabs from the Umayyad ruling house, in addition to establishing the canonical form of the Islamic house of prayer, were also quickly seduced by the splendor of Sasanian and Graeco-Roman princely art. Although their urban palaces have not survived, they also constructed luxurious and secluded palaces out in the desert, away from the metropolitan centers, and some of these have been rediscovered in relatively recent times. In addition to walled residences for ruler and courtiers in the traditional hollow square form of the Roman military encampment, the Umayyads built large and sumptuous bathhouses with halls for entertainment, often lavishly furnished with mosaic floors in a late Roman style and decorated with pictorial and sculptural images of luxury. Among the subjects depicted were the royal hunt, court musicians (fig. **9.6**), the enjoyment of Roman-style baths, dancing courtesans, scenes from everyday life, and images of ancient derivation denoting fertility, sexuality, and kingly prowess. The puritanical demands of religion thus immediately came into conflict with the age-old symbols of royal wealth, luxury, and entertainment. So great was the embedded power of the artistic imagery of kingship in the Middle East that it quickly made an impact on the material culture of the new Islamic ruling elite.

THE DEVELOPMENT OF ISLAMIC STYLE

By 750, the Umayyad dynasty based in Roman Syria had been supplanted by the Abbasid dynasty centered in Mesopotamia. Here the new caliphs built their capital, called Baghdad, on the Tigris River, and later a vast palace city to the north of Baghdad at Samarra. The original Round City of Baghdad, the site of

9.5. Cutaway of a generic Arab hypostyle mosque

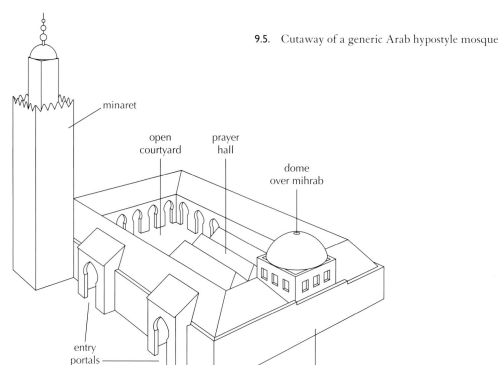

minaret

open
courtyard

prayer
hall

dome
over mihrab

entry
portals

qibla
wall

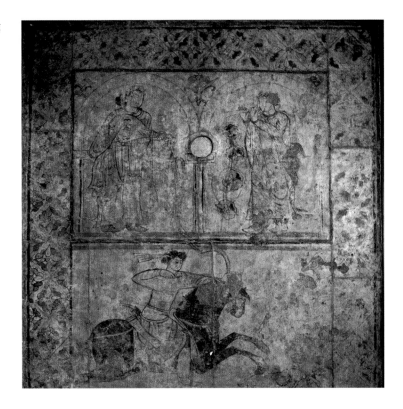

9.6. Floor fresco depicting two court musicians and a mounted hunter, from Qasr al-Hayr (West). ca. 730. National Museum, Damascus

which lies under the present-day city, was largely abandoned and destroyed long before the Mongols sacked the city in 1258, but its powerful memory lived on in Arabic poetry and prose literature. Samarra's impressive mud-brick ruins still stretch for miles along the Tigris. Under Abbasid rule over the now-extensive Islamic empire the building of mosques in newly conquered areas proceeded apace.

Religious Architecture

Chief among the new structures were the large Abbasid congregational mosques that both practically and symbolically served as religious gathering places for prayers, sermons, and religious education. Large examples, many now in ruins, were built all over Iraq, and in Egypt and elsewhere. An archetypal example is the largely ninth-century congregational mosque at Kairouan, a city in what is now Tunisia established under the Abbasids.

GREAT MOSQUE OF KAIROUAN Based like all major Arab mosques on the house of the Prophet in Medina and the four-square Mediterranean courtyard house, examples of which today still surround the structure, the Great Mosque of Kairouan consists of a rectangular courtyard surrounded by covered halls, a large hypostyle prayer hall, and a towering minaret (fig. **9.7**). Two domes mark the area: in front of the mihrab and

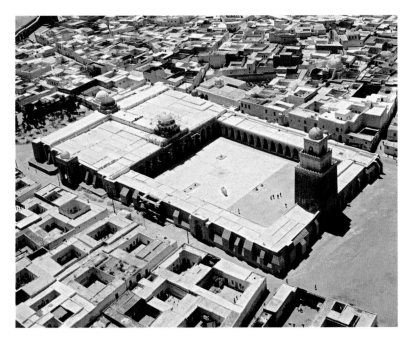

9.7. Aerial view of the Great Mosque of Kairouan, Tunisia. 8th century and later

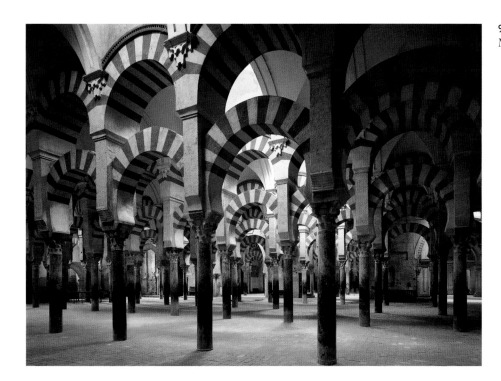

in the middle of the prayer hall facing the court. This aside, the multitude of entrances on three sides of the building, built in order to facilitate entry and exit for the five daily prayers, free the building from the domination of a central axis for processions of clergy; it is thus the very opposite of the early Christian basilican church, organized for priestly and theatrical ritual. The simplicity of the mosque reflects the simplicity of Islamic prayer. The mosque's lack of both axiality and uninterrupted interior space stems from the essential lack of hierarchy among worshipers and the absence of an ordained clergy in Islam. Each worshiper prays directly to God using a simple ritual formula usually completed in a few minutes. Artistic attention was lavished on the mihrab, of carved marble and ceramic tiles, and the minbar, elaborately carved of Indian teak. In the Kairouan mosque, a carved wooden screen, primarily a product of security rather than ritual needs, encloses a small area near the mihrab called the **maqsura**, where the ruler could pray alone.

GREAT MOSQUE OF CÓRDOBA Even farther to the west, in Spain, where the sole surviving prince of the exterminated Umayyad house founded an independent state after 750, a brilliant center of Islamic culture developed in the city of Córdoba, in the southern part of Spain, al-Andalus (now Andalusia). By the tenth century, the Great Mosque of Córdoba, after a series of embellishments and enlargements, had become one of the most beautiful Islamic houses of worship. A typical Arab hypostyle hall, the Córdoba mosque in its interior became after several expansions a virtual forest of columns (fig. **9.8**). Its characteristic "horseshoe" arcades are composed of arches using alternating red and white **voussoirs**, and include the additional element of one set of arches superimposed above another on elongated imposts. This creates an impression of almost limitless space—this space is,

however, composed of relatively small architectural elements repeated again and again. Compared with a Christian structure like Hagia Sophia (see figs. 8.28 and 8.29) or Old St. Peter's (see figs. 8.4 and 8.5), Córdoba has an equally large interior area, but there is no centralized space for the sacred theater of the Christian rite. The mosque interior, including the maqsura area around the mihrab, was lavishly decorated with mosaic and carved stone. Tenth-century marble grilles (fig. **9.9**) on the qibla wall present early examples of what we sometimes call **geometric arabesque**: The artist carves out of marble what is essentially a single straplike line that intertwines, creating a characteristic openwork screen of stars and polygons. In the beauty of such artistic geometry many Muslims see a reflection of God's creative hand in the universe.

In addition to providing a community prayer hall, the institutional operations of the great Islamic mosques such as the Great Mosque of Córdoba also often incorporated schools and universities, public baths, hospitals and medical schools, soup kitchens for the poor, hostels for travelers and merchants, public clocks (knowing the correct time was essential for the variable timing of the five daily prayers), public toilets, and fountains serving as the public water supply for the immediate area. Endowments known as *waqf*, based on the income from rental properties, supported the many functions of mosques. Waqfs were also established for social-service institutions and for shrines that were founded independently of mosques. Artistic votive gifts made to such institutions, such as Qur'an manuscripts, lamps, beautiful wooden furniture, carpets, and other objects, were in theory protected in perpetuity, becoming part of the waqf itself. As a consequence, such institutions often became great magnets for works of art, accumulating over time important libraries and collections of beautiful furnishings.

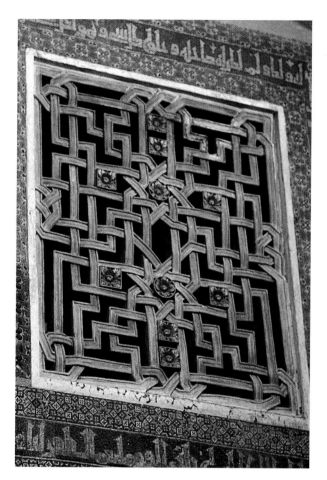

9.9. Carved stone grille on qibla wall of
Great Mosque of Córdoba. Mid-10th century

ART IN TIME

**700s CE—Construction begins on Great Mosque at
Córdoba, Spain**

750—Abbasid dynasty supplants Umayyad dynasty

1000s—Berber armies raze Medina al-Zahra

1215—*Magna Carta* signed by King John of England

1258—Mongols sack Baghdad

By 1300s—Almohad capital of Seville falls to kings of Castile

Luxury Arts

On the outskirts of Córdoba the Umayyads built another huge
Islamic palace city, known as Medina al-Zahra. A ruin today,
the palace complex once included royal workshops for luxury
objects such as silk textiles and carved ivory, used as symbols of
royal wealth and power and given as royal ceremonial gifts.
A small, domed *pyxis* (ivory box) made there for a tenth-century
Umayyad prince (fig. **9.10**) incorporates in its decoration a
microcosm of Islamic royal imagery and symbolism, including
depictions of falconry and hunting, sports, and court musicians,
set amid lush carved vegetal ornament and a kufic inscription
frieze. Such lavish objects had a symbolic importance far
beyond their practical use as containers for jewelry or cosmetics.
Their complex, many-layered iconography and their impor-
tance and symbolism as royal gifts continue to be studied by
scholars today.

In the eleventh century, Berber armies serving the Almoravid
dynasty from North Africa razed Medina al-Zahra to its founda-
tions; although they and their successors, the Almohads, built sig-
nificant monuments in the Maghreb (present-day Morocco and
northwestern Africa) and in al-Andalus. But the growing and
continual pressure of the Christian reconquest from the north
saw a dramatic decline in Muslim power in Spain. By the four-
teenth century, the Almohad capital of Seville had fallen to the

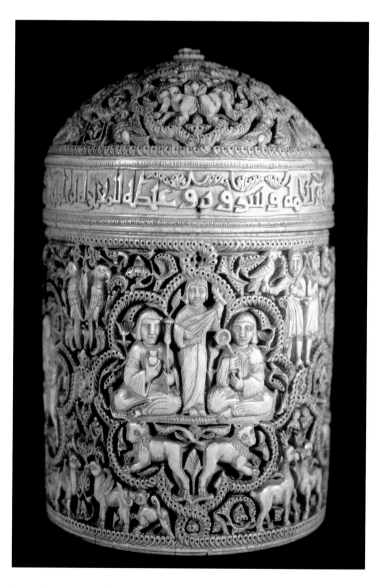

9.10. Ivory casket of al-Mughira, from Córdoba, ca. 960. Height 6″
(15 cm), diameter 3″ (8 cm). Musée du Louvre, Paris, Inv. 4068

ART IN TIME

242–272 CE—Sasanian ruler Shapur I builds audience hall at
Ctesiphon, Iraq

Early 900s CE—Islamic tombs built in Bukhara for Persian
Samanid dynasty

Mid-1000s—Seljuk Turkish invaders begin rule

kings of Castile, and Muslims working under Christian rule,
known as *Mudejares,* continued Islamic artistic traditions under
Christian patronage. (See *The Art Historian's Lens,* page 287.)

ISLAMIC ART AND THE PERSIAN INHERITANCE

In the central and western Islamic lands, from Spain to the west-
ern Mediterranean littoral, Islamic arts developed within the
geography and culture of the Graeco-Roman tradition; in the
east, however, the situation was in many respects quite different.
In Mesopotamia and Iran, the Arab Muslim conquerors encoun-
tered the cultural sphere of the Sasanians, the heirs to over a thou-
sand years of Persian civilization with an impressive tradition
of art and architecture. This tradition included royal imagery of
ceremonial pomp, warfare, and the royal sport of hunting
(see fig. 2.21), as well as large and impressive palace buildings.

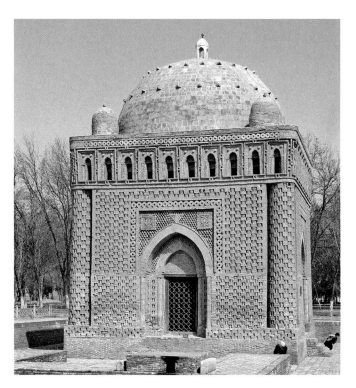

9.12. Tomb of the Samanids, Bukhara, Uzbekistan. ca. 901

Architecture

In the eastern Islamic world, following pre-Islamic architectur-
al practice, brick rather than stone was the most common
masonry construction material. In place of cylindrical columns,
massive brick piers often provided vertical structural support
in buildings, and heavy vaults rather than tiled wooden-beam
roofs were often chosen to cover interior spaces. Islamic archi-
tecture in Mesopotamia, Iran, and Central Asia reflects the
available materials, earlier cultural traditions, and even the cli-
mate of those regions in distinctive ways. It also provides a curi-
ous blending of secular and religious buildings; just as the open
arcaded courtyard helps to define both mosque and palace in
the Islamic west, another form, known as the *iwan,* came to
define both royal and religious structures in the east.

THE FOUR-IWAN MOSQUE One of the first large vaulted
brick structures with one open side, known as an **iwan**, was con-
structed by the Sasanian ruler Shapur I as an audience hall for
his royal palace at Ctesiphon in Mesopotamia (see fig. 2.32). The
form seems originally to have symbolized royal authority in
Iran, and under Islam it eventually was incorporated into a new
type of prayer structure, the **four-iwan mosque**, by placing one
massive brick recess in the middle of each of the sides of the rec-
tangular courtyard (fig. **9.11**). From the twelfth century onward
the four-iwan courtyard was a standard feature of both mosques
and religious schools of a type known as *madrasa* throughout
Iran and Islamic Central Asia. In most of Iran, as in
Mesopotamia, brick was the preferred building material, and the
vaults of Iranian mosques were supported by heavy brick piers.

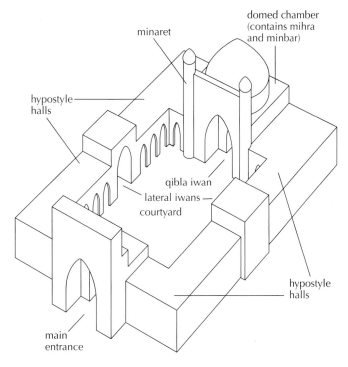

domed chamber
(contains mihra
and minbar)

minaret

hypostyle
halls

qibla iwan

lateral iwans

courtyard

hypostyle
halls

main
entrance

9.11. Cutaway of a generic Persian four-iwan mosque

Spanish Islamic Art and Europe in the Middle Ages

In 711 the combined Arab and Berber forces of the Muslim commander Tariq ibn Ziyad crossed over the straits of Gibraltar and by 716 most of Spain was in Muslim hands. Under the rule of the Umayyad dynasty (751–1017), Córdoba became the capital of a prosperous, tolerant, and powerful Muslim kingdom in Spain, in which Christians and Jews played important roles in cultural life. During the eleventh and twelfth centuries, in the aftermath of the fall of the Umayyads, successive Berber invasions from North Africa, first by the Almoravids and then the Almohads, brought new Muslim dynastic patrons into Spain, who oversaw splendid new artistic production. But they also suffered a series of military defeats at the hands of the strengthening Christian powers in the north. Of the several small Islamic kingdoms that formed in the twilight of Muslim rule in Spain, one in particular, that of the Nasrids, ruling in Granada from 1230 to 1492, saw a last glorious flowering of the arts before its defeat by the Castilians and Aragonese united under Ferdinand and Isabella.

The dominant Muslim style in the arts of southern Spain affected artistic production of non-Muslims in many complex ways. From the tenth through the twelfth centuries, in the hardscrabble mountainside principalities of the Christian north, Christian builders built small churches and monasteries in the **mozarab** style, using the horseshoe arches, alternating colored voussoirs, and mosaics of colored stone they had seen in the Muslim south. At the same time, in the northern monasteries, artist monks illustrated manuscripts of the *Commentaries on the Apocalypse* of Beatus of Liebana with paintings that also reflected the dominant Muslim style. Beyond the Pyrenees, along the medieval pilgrimage roads into France, aspects of the Muslim style even influenced French Romanesque art; the twelfth-century wooden doors of Le Puy Cathedral in France bore an elaborate kufic inscription in Arabic: *mashallah*—"may God protect this place."

After the Christian Reconquest of central southern Spain gained momentum in the last part of the thirteenth century, artisans among the conquered Muslim peoples living under Christian rule, known as *Mudejares*, working under Catholic patrons, continued to produce works of art—buildings, carpets, ceramic wares, and ivories among them—in the Muslim style. The greatest monument of Mudejar art is the fourteenth-century Alcazar or royal palace of King Pedro of Castile in Seville,

the style of which is remarkably similar to that of the Alhambra (see fig 9.27), then being built in nearby Granada. Also noteworthy are the surviving Mudejar synagogues of Córdoba, Granada, and Toledo; with its Hebrew inscriptions intermingling with those in Arabic, the decoration of the Toledan synagogue of Samuel Halevy Abulafia, popularly known as El Tránsito (ca. 1360) follows the Muslim style closely. It appears to demonstrate that important elements of the Arabic-speaking Jewish population of Spain at the time felt themselves fully invested in the dominant artistic culture.

Nationalist European scholars once preferred to ignore or to deprecate this intermingling of cultures in medieval Spain, but recent scholarship together with recent exhibitions have brought about renewed interest in the Spanish Muslim impact on Europe and in the nature of the flowering of Christian and Jewish culture during the period of *convivencia* (living together) in medieval Muslim Spain. The final expulsion of Muslims and Jews from Spain by the ethnic cleansing of Ferdinand and Isabella in the early sixteenth century brought most of this productive symbiosis to an unhappy end.

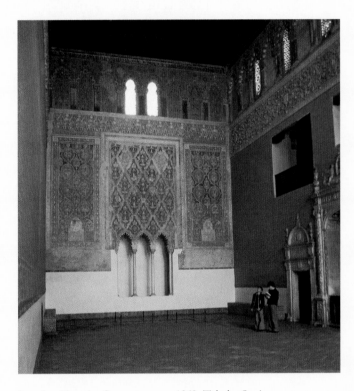

Interior, Transito Synagogue, ca. 1360. Toledo, Spain

TOMB OF THE SAMANIDS In the aftermath of the Arab conquest of Iran, the Persian cultural tradition gradually reasserted itself in many ways. One of the earliest surviving Islamic dynastic tombs was built in the early tenth century for the Persian Samanid dynasty in Bukhara, an eastern city beyond the Oxus River, today in Uzbekistan (fig. **9.12**). This small cubical structure is in basic concept a hemispherical dome on four massive piers, evidently derived in part from the form of a Sasanian fire temple used for Zoroastrian worship. The dome is supported on the square chamber by means of four squinches in

the corners, while the readily available and relatively humble material of brick is used to brilliant effect, with various surface textures recalling woven reeds, kufic inscriptions, and what look like engaged columns in the corners. While the Messenger had opposed all shrines and the prominent tomb structures of kings and saints, which he viewed as suggestive of polytheism or idolatry, the symbolism associated with dynastic kingship and the veneration of major religious figures in Islam meant that tombs and shrines were to figure prominently in the history of architecture throughout the Islamic world.

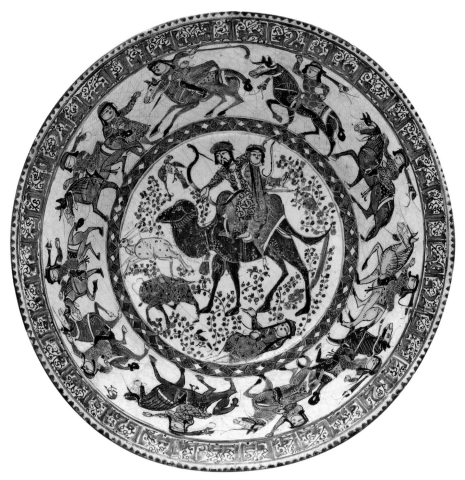

9.13. *Mina'i* dish with story of Bahram Gur and Azadeh, from Iran. ca. 1200. Polychrome overglaze enamels on white composite body. Diameter: 8½″ (22.2 cm); width: 3¹³⁄₁₆″ (9.7 cm). The Metropolitan Museum of Art, New York. Purchase, Rogers Fund and gift of the Schiff Foundation, 1957 (57.36.13)

Figural Art Forms in Iran

The Iranian part of the Islamic world had inherited a rich tradition of material culture, and the successive rulers of Iran, whether themselves Arab, Persian, Turkish, or Mongol in ancestry, fell under the seductive spell of the Persian heritage, which they combined with their Islamic beliefs and traditions. From the prosperous cities of tenth- and eleventh-century Iran there have survived beautiful ceramic wares decorated with maxims, good wishes, or prayers in beautiful calligraphy with figural and vegetal decoration, as well as some exceptional silk textiles and metal objects. The Seljuk Turkish invaders, who ruled Iran from the mid-eleventh century onward, not only built great mosques and tomb structures, but also ruled over a prosperous urban culture that among other things produced one of the richest known traditions of decorated ceramics. Using figural images of all kinds in a multitude of sophisticated techniques, including the use of a metallic pigment known as *luster* fired over the glaze and polychrome enamel decoration known as *mina'i*, these ceramic wares incorporated for middle-class patrons a very diverse repertoire of scenes from Persian romances and mythology, themes from sufism (the Islamic mystical religious tradition), and the now-familiar Islamic royal images of hunting and other courtly pleasures.

A favorite story finding its way into ceramics, metalwork, and book illustration was that of the royal hunter Bahram Gur and his skeptical girlfriend, the harpist Azadeh. A mina'i plate shows two episodes of continuous narrative, with Azadeh on the camel with her royal lover, and then pushed off the beast after making a remark belittling the hero's marksmanship (fig. **9.13**).

Also noteworthy was the practice of inlaying precious metals into brass or bronze, often incorporating human and animal images. This art form apparently began in Khurasan (the northeastern part of old Iran) in the twelfth century and gradually found its way west into upper Mesopotamia by the early thirteenth century. The full repertoire of royal themes is represented in these opulent objects, in which on occasion even the letters of the inscriptions themselves take on human forms (fig. **9.14**). Also created under the Iranian Seljuks were stucco relief sculptures incorporating the human figure. To what do we owe this burst of figural art in seeming contradiction to strict Islamic dogma? Practical rather than dogmatic, Iranians under the Seljuks apparently believed that figural images did not necessarily have to be identified with polytheism or idolatry, but could capably serve both secular and religious purposes without morally corrupting the viewer.

THE CLASSICAL AGE

In the center of the Islamic world, in what some scholars term its classical age (roughly 800–1250), the power and influence of Mesopotamia gradually waned with the decline of the Abbasid caliphate. In 969, the Fatimids, a North African Arab dynasty proclaiming descent from the Messenger's daughter Fatima, conquered Fostat, the Abbasids' major city in Egypt, and founded as their new capital the nearby city of Cairo. The Fatimids were Shi`ites—Muslims who believed that only descendants of Muhammad could legitimately lead the Islamic community. They took their name from the term *shi`at `Ali* ("the party of `Ali"), Muhammad's son-in-law, husband of Fatima and father of the Prophet's grandsons Hasan and Husein. Shi`ite Muslims themselves were divided into several major and many minor sects, all of which opposed the basic political tenets of Sunni or Orthodox Islam, where having the blood of the Messenger was not a prerequisite for holding political power.

The rise of the Fatimids in the tenth century coincided with a gradual weakening of the Abbasid power and a decline in the caliphate authority, based in Baghdad. By the eleventh century, the Seljuk Turks had moved westward out of Central Asia to gain control first in Iran and then in northern Mesopotamia and Asia Minor; around the same time, in 1099, the Norman warriors of the First Crusade captured Jerusalem. The Seljuks were Sunni Muslims; they fostered arts of all kinds and supported Sunni doctrine with the founding of many madrasa colleges for the teaching of Sunni law. In the late twelfth century, another Sunni dynasty, the Ayyubids, drove the infidel Christians out of Jerusalem, and for a brief time also oversaw important developments in the arts.

The Fatimid Artistic Impact

Under the Fatimids Egypt experienced a major artistic revival. The eleventh-century city walls of Cairo, incorporating the latest cutting-edge military technology, were constructed with stone stripped from the outer parts of the Pyramids in nearby Giza. Two great urban palaces, decorated with figural images of music, dance, the hunt, and royal ritual, were constructed within the city, and elaborate parades and ceremonial processions proclaimed the dynasty's power. Not one but two congregational mosques were constructed in Cairo under Fatimid rule, and smaller mosques served individual neighborhoods of the city, which by the twelfth century had expanded beyond its original walls.

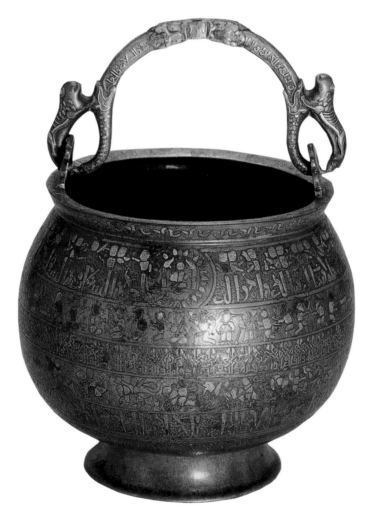

9.14. Muhammad ibn abd al-Wahid (caster) and Masud ibn Ahmad al-Naqqash (inlayer). 1163 CE. Cast bronze alloy bucket, inlaid with silver and copper, Herat. The State Hermitage Museum, St. Petersburg, Inv. no. IR 2268

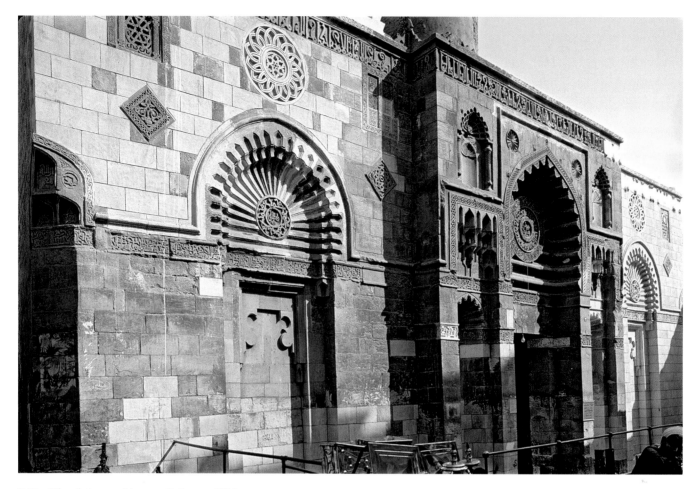

9.15. The al-Aqmar Mosque, Cairo. ca. 1026

AL-AQMAR MOSQUE Among the most beautiful of the Fatimid mosques in Cairo is the small mosque known as al-Aqmar (fig. **9.15**), built by a Fatimid noble. It was skillfully constructed on an irregular plot of land, with its off-axis facade corresponding to the original street. In addition to the carved stone, Arabic inscriptions, and ornamental niches, we see to either side of the main portal a developed form of **muqarnas**, the distinctive geometric, almost crystalline faceted decoration, composed of small nichelike forms, that eventually became an iconic form of Islamic decoration from the Atlantic to beyond the Oxus.

TEXTILES AND IVORIES Under the Fatimids, a thriving maritime commerce between Egypt and Italy left its mark in the Islamic artistic influence on twelfth-century Italian architecture in such port cities as Palermo, Salerno, Amalfi, and Pisa. In addition, preexisting traditions of weaving, much of it carried on by indigenous Coptic Christians, continued to flourish along with new textiles incorporating silk imported from Iran or China. In the twelfth century, Muslim artisans working in Palermo in Sicily, newly conquered by the Normans, created the elaborate embroidered cape of King Roger II (r. 1095–1154), with inscriptions in Arabic praising the Catholic ruler (fig. **9.16**). It was used

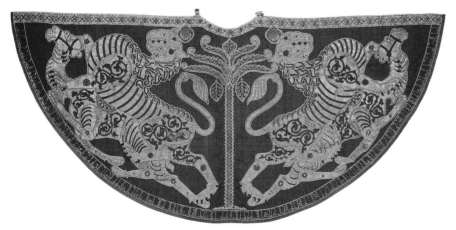

9.16. Cloak of Roger II of Sicily. Red silk cape embroidered with silk and pearls. 12th century. Diameter 11′3″ (342 cm). Made in Palermo for the coronation of Roger II in 1133–1134. Kunsthistoriches Museum, Vienna

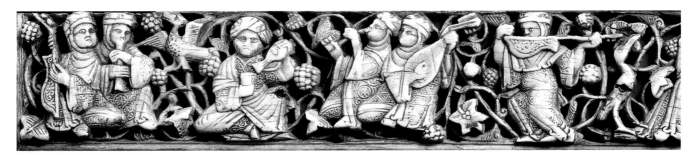

9.17. Detail of carved ivory frame with court scenes. Egypt. 12th century. 17³⁄₄ × 14¹⁄₃″ (44.9 × 36.5 cm). Staatliche Museen Preussischer Kulturbesitz, Museum für Islamische Kunst, Berlin, I.6375

for many centuries in Habsburg coronations. Along with remarkable luster-painted ceramics, textiles, rock crystal, and glassware, Fatimid artists produced carved ivory objects significant both for their beauty and for the insights they provide into Fatimid court life. One of these, an ivory frame now in Berlin (fig. **9.17**), shows a multitude of energetic figures engaged in dancing, music making, hunting, wrestling, and drinking what can only be supposed to be wine, whose prohibition in the Qur'an did not preclude its use or depiction in the private customs and art of Islamic palaces.

The Ayyubids and the Seljuk Turks of Asia Minor

It was during the Seljuk Turkish rule over central and northern Palestine, in 1099, that European warriors of the First Crusade captured Jerusalem, which remained briefly in Christian hands until its recapture in 1187 by the Ayyubid sultan Salah ad-Din, known in the West as Saladin. The period of the Crusades was to last until the fourteenth century, when all but the last vestiges of Crusader kingdoms disappeared from the eastern Mediterranean. Artistic cross-fertilization between Catholic Europe and the Muslim Middle East developed extensively during the entire period, and persisted long after the Crusaders departed. The Ayyubids, a Kurdish dynasty originating in northern Syria, reconquered greater Syria and Egypt for Sunni Islam in the twelfth century, and their brief reign, ending in the mid-thirteenth century, produced a remarkable record of accomplishment in architecture and the arts. Ayyubid military architecture, such as the citadels of Aleppo and Cairo, embodied the latest military technology, and was to inspire many a European castle constructed in the Romanesque and Gothic eras. Under the Ayyubids the arts of inlaid metalwork, ceramics, and enameled glassware also flourished.

To the east, in the twilight of its glory, the ancient Abbasid capital of Baghdad experienced by the early thirteenth century a revival in the arts of the book. Such artists as Yahya ibn al-Wasiti produced miniature paintings remarkable for their humor, their observations of everyday life, and their insights into human foibles (fig. **9.18**).

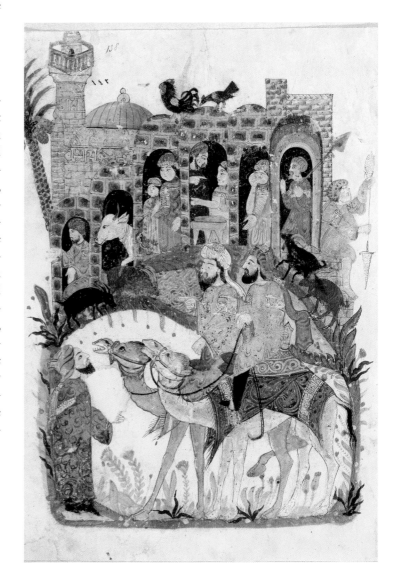

9.18. Yahya ibn Mahmud al-Wasiti. *Scene in an Arab Village,* illustration from a *Maqamat* manuscript. ca. 1237. Opaque watercolors on paper, 13³⁄₄ × 10¹⁄₄″ (34.8 × 26 cm). Bibliothèque Nationale, Paris. MS. arabe 5847, folio 138 r

To the north, the Seljuk Turks had finally entered the Asia Minor heartland of the Byzantine Empire after 1071. In the following 200 years under their rule, with the full participation of the artistic talents of both Muslim and Christian communities in the prosperous urban centers of Asia Minor, art and architecture flourished under what were known as the Seljuks of Rum (Rome). Craftspeople and artists from Iran, as well as from Syria and Egypt, served the lavish patronage of the Seljuk sultans.

THE CARAVANSARAY The largest buildings constructed by the Seljuks in Asia Minor are a type of fortified wayside inn, warehouse, and stables known in Turkish as *han* and in the West as *caravansaray*. Built at regular intervals along the main caravan routes linking the cities of Asia Minor, these buildings usually consisted of an outer court and a vaulted

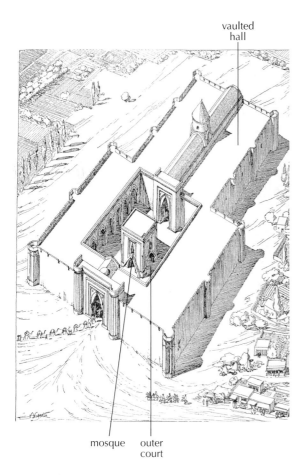

9.19. Sultan Han, Kayseri-Sivas Road, ca. 1229 Turkey. Drawing by Albert Gabriel, *Monuments Turcs d'Anatolie* (Paris, E. Boccard, 1931, p. 99)

inner hall. The outer court had stables for pack animals, a bath for travelers, a small mosque, and a kitchen. The inner hall, where goods could be stored and travelers slept, often had a tall dome on squinches, the pyramidal exterior of which could be seen along the highway from a great distance. The largest and most handsome of the Asia Minor hans, the Sultan Han built between the cities of Konya and Aksaray around 1229 by Sultan Alaeddin Keykubad, has beautifully carved doorways to the courtyard and vaulted hall, and evidently employed in its construction the services of both local and Syrian stonecarvers. A similiar Sultan Han built by the same ruler on the Kayseri-Sivas road (fig. **9.19**) and dozens of others are still today found in Turkey. They facilitated commerce throughout Asia Minor, where beautifully constructed and elaborately decorated mosques, madrasas, and palaces were built throughout the twelfth and thirteenth centuries.

LATER CLASSICAL ART AND ARCHITECTURE

By the second decade of the thirteenth century, in the Islamic lands of Central Asia, Iran, Egypt, Syria, and Asia Minor, reports began to arrive of an ominous power rising in the east. The eventual triumph of the Mongol successors of Genghis Khan brought devastation to much of the Islamic world east of the Mediterranean. Some areas, such as Asia Minor, emerged relatively unscathed. Others, such as the central Asian city of Bukhara (sacked and burned in 1220) and the Abbasid capital of Baghdad (sacked and destroyed in 1258), suffered untold losses in architectural monuments and artistic goods, as well as the even more serious destruction of infrastructure, such as irrigation canals, roads, and social services. By the end of the thirteenth century the western Mongol rulers, known as Il-Khans, had converted to Islam, and their patronage and that of their successors brought about in Iran and its surrounding areas yet another period of artistic flowering, in which artists of western Asia were exposed to new artistic inspiration from China, flowing west through the Mongol domains on what historians now call the Silk Road, a 5,000 mile network of caravan routes from Honan (present-day Luoyang) through the Islamic world to Europe.

The Mongol rule in Central Asia and Iran was short-lived, but the artistic legacy of the Mongols continued under the Timurids, who by the late fourteenth century had established their empire in the former Mongol lands and produced a brilliant court tradition, the legacy of which was eventually felt from the eastern Mediterranean to central India. Far to the west and south, after 1260, Sunni Mamluks in Syria and Egypt, inheritors of the Fatimid Shi`ite capital of Cairo, set about their own symbolic appropriation of the land, with a new architecture of tall domes and complex minarets, and an artistic economy that mixed the Turkic tastes of the ruling class with indigenous Egyptian traditions. Trade between Cairo and Italy was brisk, and Mamluk artistic production sometimes even reflected the commercial attractiveness of Mamluk artistic goods in Europe.

Mongol Patronage

In the realms of art and architecture, the Mongols built on what had come before them. Later Arab book illustration, centered in Baghdad, found its legacy by the beginning of the fourteenth century in a new focus of Mongol patronage in Tabriz, the western Mongol capital in northwest Iran. Artists in Tabriz produced painting in a new style incorporating aspects of Chinese brush-painting and the vision of Chinese landscape. In other Mongol centers, Chinese motifs and raw materials contributed to a revival of silk weaving, and preexisting traditions of inlaid metalwork and luster-painted ceramics developed in new directions. As with almost all foreigners who have conquered Iran from the time of Alexander the Great, the Mongol rulers quickly became Persianized, commissioning illustrated manuscripts of the Persian national epic, the *Shah-nameh* or "Book of Kings," and building four-iwan brick mosques and high-domed tomb structures in the Persian style. The nature of Mongol patronage in Iran can be seen in the tomb structure built by the Il-Khan Oljeytu (r. 1304–1317). The son of a Sunni father and a Christian mother, Oljeytu founded a new capital in Sultaniya, bringing artists and builders from all over his realms to embellish it. At the center of his capital stands a huge structure with a massive pointed dome covered with turquoise blue tiles, the royal mausoleum of Oljeytu (fig. **9.20**). With its painted interior

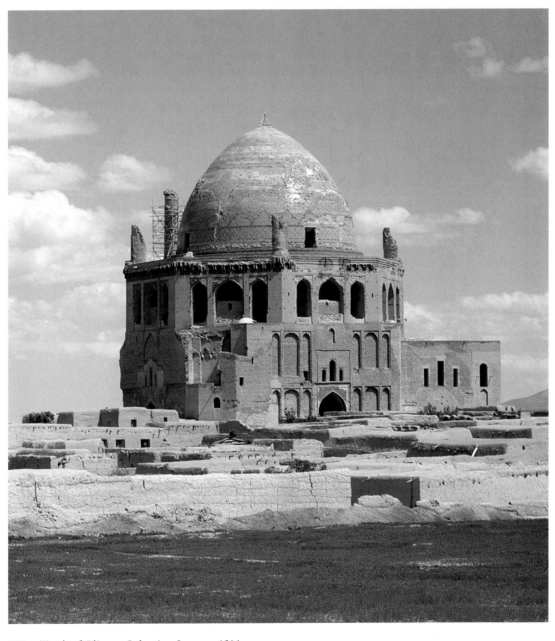

9.20. Tomb of Oljeytu, Sultaniya, Iran. ca. 1314

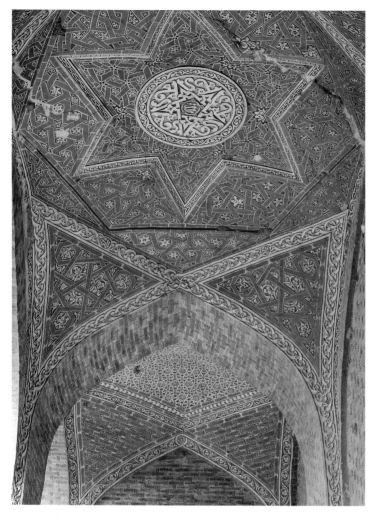

decoration of carved and painted stucco (fig. **9.21**) and elaborate tile decoration, it has unprecedented size and scale for an Islamic shrine or tomb. This great domed building in Sultaniya represents the grandiose artistic aspirations of the Il-Khans, as well as their enlightened patronage of artistic innovation within the preexisting Persian traditions.

Timurid Patronage

After the death of the last ruler of the short-lived Il-Khan dynasty in 1337, Iran and Islamic Central Asia broke up into smaller principalities, one of which, the Jalayrid dynasty, kept the tradition of Mongol painting alive in Tabriz and Baghdad. By the late fourteenth century another Turko-Mongol power had risen beyond the Oxus, this time under the rule of the strategic genius Timur (r. ca. 1370–1405), known in the West as Tamerlane.

ARCHITECTURE AND ITS DECORATION In his capital city of Samarkand, Timur built in the 1390s a gigantic congregational mosque, the largest four-iwan mosque in the Iranian tradition, and his palace of Aq Saray in his nearby birthplace was built on an equally gargantuan scale. The artistic aspirations of the Timurid dynasty reached their climax in the fifteenth century. At Herat, which became the main capital under the rule of Timur's son Shah Rukh (r. 1405–1447), his grandson Baysunghur founded a royal library—in fact, a royal design studio—that in addition to producing beautiful books decorated with illuminations, miniature paintings, and calligraphy, served as a central source of designs for many other artistic media, drawing on the artistic legacy of the Jalayrids as well as the arts of China and Central Asia.

9.21. Interior, Tomb of Oljeytu, Iran. Permission from Hans and Sonia Seherr-Thoss, *Design and Color in Islamic Architecture* (Washington, DC, 1968, p. 105)

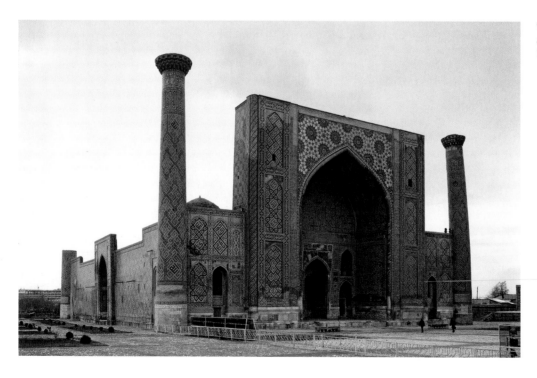

9.22. Madrasa of Ulugh Beg ca. 1435. Samarkand, Uzbekistan

To the north in Samarkand, in present-day Uzbekistan, another of Timur's grandsons, Ulugh Beg, founded (ca. 1420) a major astronomical observatory as well as one of the most important of Timurid madrasa colleges (fig. **9.22**). Ulugh Beg's college has a massive iwan before the main portal and two cylindrical minarets. Elaborate, carefully constructed mosaics of colored tiles in geometric and vegetal patterns lavishly decorate the entire facade. Ceramic building decoration in Central Asia under the Timurids and their immediate predecessors developed a rich variety and a complexity equaled but never surpassed in the subsequent history of art in greater Iran.

BOOK ILLUSTRATION It was in Herat, in the twilight of the Timurid dynasty at the end of the fifteenth century, that the long and complex history of Persian book painting saw one of its most glorious chapters. In the 1480s and 1490s, the great master Behzad and his colleagues brought about a series of refinements in Islamic painting that have become legendary. Behzad himself had not only a sensitivity to the lyrical and heroic themes of Persian poetical texts, but a keen eye for the world around him. In many of his paintings made to illustrate poetical texts, such as this illustration from a manuscript of the *Bostan (Poetic Garden)* of Sa'di, it is the everyday heart of Herat that we see so masterfully depicted (fig. **9.23**). In a scene outside a mosque, the high point of view allows us to look into the courtyard, while at the doorway a rich man encounters a beggar, and another man washes at a fountain. Behzad's spatial and narrative clarity, using a high point of view, overlapping in ingenious ways to give a sense of three dimensions while portraying all of his protagonists in the same scale, bring a new power to these small paintings, the small size of which does not restrict their generous pictorial space, complex settings, and large cast of characters.

Mamluk Patronage

In the central Islamic lands, only one power had successfully repulsed the Mongol invasions of the thirteenth century. When the last Ayyubid ruler of Egypt died in 1250, his wife married her husband's leading general, a Mamluk or slave soldier of Kipchak Turkish origin named Baybars, who became sultan, or ruler, in 1260. That year, at the battle of Ain Jalut (in what is now northern Israel), a Mamluk army defeated the Il-Khan's Mongol troops. As a result, Egypt and much of Syria remained free of Mongol rule under the various Mamluk dynasties, which ruled from Cairo and Damascus, from 1250 until the conquest of Cairo by the Ottoman Turks in 1517.

ARCHITECTURE It is easy to see an evolutionary progression from the art of Egypt in Fatimid and then Ayyubid times into the Mamluk reign. Mamluk patronage was at times quite lavish, and most of the artistic character of today's Cairo comes from the Mamluk period. Working within the confines of often irregularly shaped plots of urban land in the crowded Egyptian metropolis, builders under Mamluk patronage created mosques, madrasas, tombs, and a distinctive combination of public library and public water fountain. These works are characterized by a new style of elaborately decorated high domes, complex multibalconied minarets, and lavish decoration incorporating both carving and multicolored marble mosaic paneling. As Sunni Muslims living in the shadow of the Shi`ite Fatimid past, the Turkish-speaking Mamluks, often unable to speak or write Arabic, not only built mosques, but also a very large number of madrasas or institutions of Sunni higher education to serve the local populace.

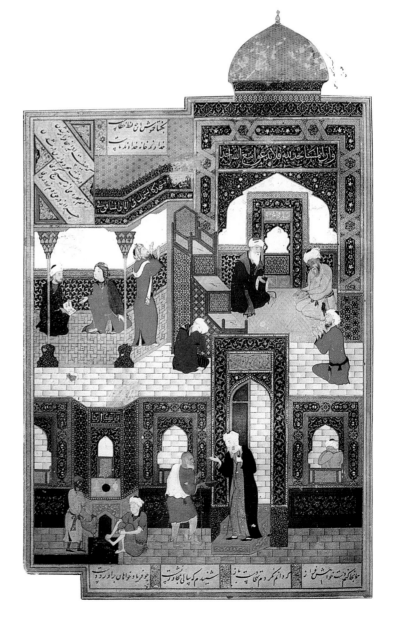

9.23. Behzad. *A Poor Man Refused Admittance to a Mosque*, from a manuscript of the *Bostan* (collection of narrative poems) of Sa`di, from Herat. 1486 CE. Opaque watercolors, ink, and gold on paper. Page dimension 12 × 8¹⁄₂″ (30.5 × 21.5 cm). General Egyptian Book Organization, Cairo, Adab Farsi 908. National Library of Egypt, Cairo

The largest and most impressive of these is the madrasa and tomb of Sultan Hasan (fig. **9.24**). It was constructed between 1354 and 1361 by the otherwise undistinguished Mamluk sultan Nasir ad-Din al-Hasan, into whose state coffers had flowed a torrent of riches as a result of the high mortality of the mid-century Black Death, which left many large estates without heirs. Designed as four separate colleges within one building (fig. **9.25**), each devoted to one of the four major schools of Islamic jurisprudence, the mammoth structure houses a mosque in the qibla iwan of its huge four-iwan courtyard, as well as classrooms, dormitory rooms, and, on the south side behind the qibla wall, the gigantic domed tomb of Sultan Hasan himself. Decorated with varicolored marble mosaic paneling, with spectacular carved portals, bronze doors inlaid with silver and gold, and furnishings such as a marble minbar and

muezzin platform and a walnut Qur'an lectern inlaid with ebony and ivory, the madrasa and tomb of Sultan Hasan show the artistic aspirations of the Mamluks to be equal to those of their Mongol rivals to the northeast in size, expense, and beauty. Right down to the Ottoman conquest in 1517, Mamluk patrons in Egypt and Syria continued to produce a large number of beautiful buildings, including the famous tombs that today crowd Cairo's Northern Cemetery.

ENAMELED GLASS, METALWORK, AND CARPETS

Mamluk patronage in Syria and Egypt also inherited a tradition of making enameled glass that had begun under the Ayyubids. By the early fourteenth century, Mamluk glass vessels enameled with bright colors had become world-famous. Various Mamluk nobles commissioned glass oil lamps destined to be hung in

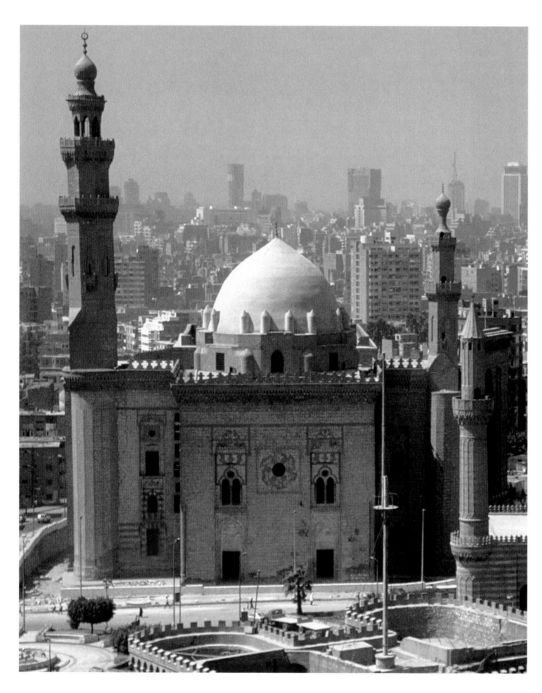

9.24. Madrasa-mosque-mausoleum complex of Sultan Hasan, Cairo. ca. 1354–1361

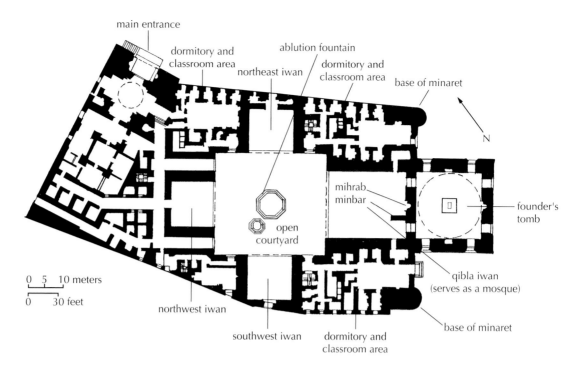

main entrance

dormitory and
classroom area

ablution fountain

northeast iwan

dormitory and
classroom area

base of minaret

N

mihrab
minbar

founder's
tomb

open
courtyard

qibla iwan
(serves as a mosque)

northwest iwan

base of minaret

southwest iwan

dormitory and
classroom area

0 5 10 meters

0 30 feet

9.25. Plan of the complex of Sultan Hasan, Cairo

their tombs and mosques, and artists incorporated the patrons' blazons, or coats of arms, in the decoration (fig. **9.26**). Under the Mamluks, by around 1300, the art of inlaying silver and gold into bronze and brass also reached its apogee in Islamic art. In later Mamluk times, from the fifteenth century onward, the Mamluk realms saw the production of spectacular carpets that were exported to Europe, where like the enameled glass, they were highly prized. (See *Materials and Techniques*, page 300.)

Nasrid Patronage: The Alhambra

By the mid-fourteenth century most of Muslim al-Andalus had fallen to the Christian Reconquest; Seville and Córdoba were part of the Castilian domains, and only the mountain kingdom of Granada in the south in the shadow of the Sierra Nevada remained under Muslim control, ruled by the Nasrid dynasty. On a flat hill towering over the city of Granada, the Nasrid monarchs built a palace known to them as al-Qasr al-Hamra (The Red Palace) and to history as the Alhambra. Originally conceived, as most Islamic palaces were, as a series of pavilions and smaller buildings constructed around one or more garden courtyards, the Alhambra was designed as a royal palace that incorporated metaphors for Paradise on earth. The inscriptions on its walls, some of which were written by one of the great Arab poets of the time, form a hymn of praise to the palace itself. Although what remains of the Alhambra today is only a small fragment of the original palace, the rest having been consumed by a mammoth Renaissance palace and an equally huge Franciscan monastery, the most beautiful of the Alhambra's surviving courtyards, known as the Court of the Lions, gives us a vivid picture of the elegance, beauty,

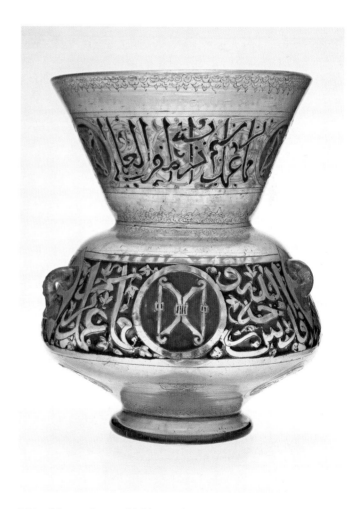

9.26. Mosque lamp with blazon, from Cairo. ca. 1285. Enameled, stained, and gilded glass. Height: $10^{1}/_{3}''$ (26.2 cm), Width: $8^{1}/_{4}''$ (21 cm). Metropolitan Museum of Art, New York. Gift of J. Pierpont Morgan. 1919 17.190.985

The Oriental Carpet

No artistic product of the Islamic world has become better known outside its original home than the pile carpet, popularly called the oriental carpet. Carpets are heavy textiles meant to be used essentially in the form in which they leave the weaver's loom. That is, they are not cut or tailored, and they are usually woven as complete artistic works, not as goods sold by the yard. Their uses vary extensively from floor covering to architectural decoration, from cushions and bolsters to bags and sacks of all sizes and shapes, and from animal trappings to religious objects (prayer rugs that provide a clean place for Muslim prayer). They can be used as secular or religious wall decoration. Carpet weaving is a deeply embedded art in the culture of many Islamic societies. It is a part of the socialization of young women, who form the bulk of Islamic artist-weavers. It is found not only in nomadic encampments and villages, but also in urban commercial weaving establishments and, in former times, in special workshops that functioned directly under court patronage in Islamic lands.

There are several different techniques for weaving Islamic carpets, but the best-known is the *pile carpet*, in which row after horizontal row of individual knots of colored wool are tied on vertical pairs of *warp yarns*, and each row of knots is then beaten in place by a *beater*, a tool that resembles a combination of a comb and a hammer, and subsequently locked in place by the passing of one or more horizontal *weft yarns*. The ends of each knot protrude vertically on the upper or "right" side of the carpet, giving it a thick pile surface, at once highly reactive to light, conducive to rich color effects, and providing excellent insulation from cold floors or the earthen ground of a nomad's tent.

The carpet form probably arose originally among pre-Islamic nomadic peoples in Central Asia. The bulk of surviving early Islamic carpets, thought to have been woven from the thirteenth through the fifteenth centuries, show connections in both design and technique to a nomadic past. In the fifteenth century, the *carpet design revolution* led to the pro-

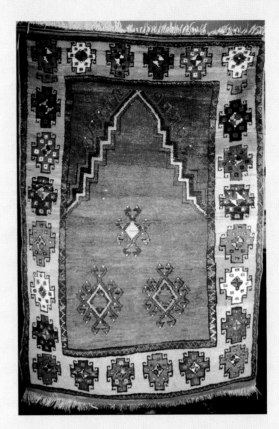

Village carpet in geometric design, Konya area, Turkey. 18th or 19th century. Private Collection. Courtesy of Gerard Paquin.

duction of Islamic carpets in designs that were created by court artists, and then translated into instructions for carpet weavers. These carpets were often used by royalty or given as gifts to royalty.

The design of a carpet, like that of picture made on an ink-jet printer, is created out of a grid of colored dots consisting of small individual knots of colored wool that when viewed together form a design. Some carpets are fairly coarse in weave, and use a long pile; such carpets tend to use bold geometric designs and brilliant colors. Other carpets, such as those produced after designs by court or commercial artists, may use a much finer weave (in extreme cases, more than 2,000 knots in a square inch) and a short pile to reproduce curvilinear ornamental designs, calligraphy, or even depictions of humans and animals (see fig. 9.32) in large carpets. The symbolism of carpets on all levels may be extremely complex, varying from totemic designs of tribal significance to complex figural designs with arcane religious or secular meanings.

Exported to Europe since the fourteenth century, Islamic pile carpets have historically formed an East–West cultural bridge. In Europe they not only decorated the palaces of the nobility and the houses of wealthy urban merchants, but were also used in churches, religious shrines, and as a part of both secular and religious ceremonies. Islamic carpets, as prized works of art and signs of status and wealth, were frequently depicted in European paintings (see figs. 14.16, 14.23, and 20.36). Carpet weaving continues to flourish in the Middle East today. The taste and demand for Islamic carpets in both East and West has actually increased in the late twentieth and early twenty-first century.

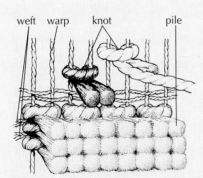

weft warp knot pile

Rows of individual knots, tied over two vertical warps, are tied, cut, and tightly hammered in place and locked in by a pair of horizontal wefts

The symmetrical knotting structure used in many Turkish and Transcaucasian carpets

and luxury of the Nasrid court (fig. **9.27**). In the center of the court, a large stone basin carried on the backs of twelve lions holds a playing fountain, the pressurized water coming from the distant mountains. From the basin, four water channels reflecting the four rivers of Paradise carry the water into four pavilions on the sides of the courtyard. In its elaborately carved stucco, once vividly polychromed, and in its delicate and elaborate muqarnas and intricate inscriptions carried on slender multiple or single columns, the richly textured and almost gravity-defying architecture of the Alhambra creates an awesome impression. The Alhambra was to influence artistic consciousness for centuries to come, finding artistic heirs in both sixteenth-century Morocco and in nineteenth-century Europe and the United States.

THE THREE LATE EMPIRES

In later Islamic times three large empires formed major centers of Islamic artistic accomplishment: the Ottoman, the Safavid, and the Mughal. At the end of the thirteenth century, in a corner of Asia Minor just a few dozens of kilometers from the Byzantine capital of Constantinople, a vassal of the declining Seljuk sultanate named Osman (r. ca. 1281–1324) established a tiny frontier principality hosting warriors eager to expand the

ART IN TIME

1258 CE—Mongols sack and destroy Baghdad

By end of 1200s—Western Mongol rulers converted to Islam

Mid-1300s—Most of Muslim al-Andalus fallen to Christian Reconquest

1354–1391—**The Alhambra, the Court of Lions**

1486—**Behzad's illustrations for the *Bostan***

realms of Islam at the expense of the Christians. From this seed grew a mighty empire, which by the mid-sixteenth century had almost turned the Mediterranean into a Turkish lake, ruling from Cairo to the outskirts of Vienna, and from Algiers to northwestern Iran. It lasted until 1922. At the beginning of the sixteenth century, five decades after the Ottomans had conquered Constantinople and made it their capital, a charismatic Shi`ite warrior from northwestern Iran, the Safavid prince Ismail (r. 1501–1524) founded another great empire. In its successive capitals of Tabriz, Qazvin, and Isfahan, the Safavid state was to bring many genres of art to new levels of accomplishment and reputation within the Islamic world. Until the

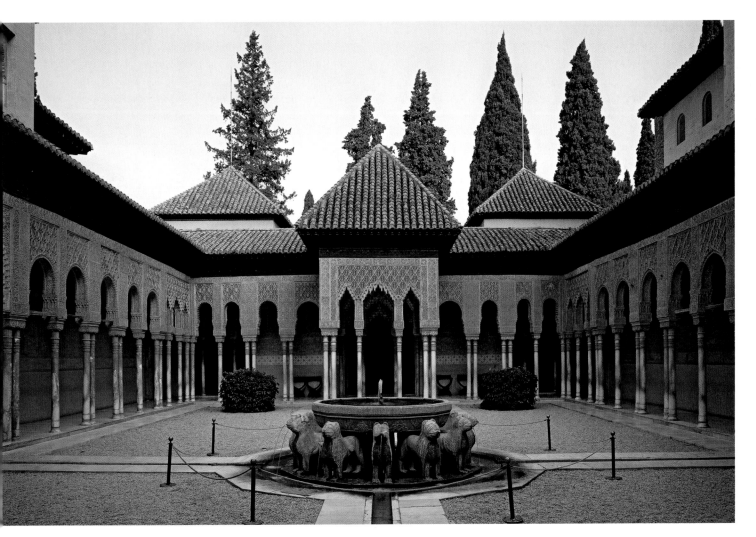

9.27. Court of the Lions, Alhambra, Mid-14th century. Granada, Spain

middle of the eighteenth century, the Safavids remained major rivals of the Ottomans, and their distinctive styles in architecture, book painting, and the applied arts of carpets and textiles, influenced their neighbors to both west and east. In 1526 a Turkish prince from Central Asia named Babur (r. 1526–1530) invaded northern India. After a series of reverses and recoveries, Babur's grandson Akbar the Great (r. 1556–1605) firmly established the Mughal dynasty in the subcontinent. Through the next century and a half, the fabled palaces and monuments of the Mughal capital cities of Delhi, Agra, and Fatehpur Sikri, visited by Muslim and European travelers alike, became a byword throughout the world for the beauty, luxury, and opulence of the Islamic arts.

The Ottomans in Europe and Asia

At first there was little to distinguish what became known as the Ottoman Empire (in Italy, Osman was known as "Ottomano") from more than a dozen other small Islamic states that filled the vacuum of the collapsing Seljuk power in Asia Minor. But by 1357 the Ottomans had crossed the Dardanelles, a narrow strait between Europe and Asia, into the Balkans, and eventually by 1453 they had claimed the elusive prize of Constantinople itself, the second Rome and the capital of eastern Christianity. In this, their capital city, popularly renamed Istanbul, and in their summer and military capital of Edirne, 120 miles farther west into Europe, the Ottomans used their enormous economic power to patronize art and architecture on an unprecedented scale.

ARCHITECTURE To their Topkapı Palace in Istanbul flocked artists from Iran, Egypt, the Balkans, and even from Western Europe, while in the sixteenth century the architect known to posterity as Sinan the Great presided over an architectural establishment that saw the erection of hundreds of bridges, hans, madrasas, palaces, baths, markets, and mosques. The great imperial mosques of the Ottomans paid homage to the traditional Arab mosque by incorporating an atriumlike arcaded courtyard into their design. However, for the Ottomans the vast interior space and daring engineering of Justinian's Hagia Sophia (see figs. 8.31 and 8.32), in combination with their own well-developed traditions, provoked an architectural response that made the Ottoman mosques, often built in climates with extensive rainfall and winter snows, vastly different from mosques of the Arab or Iranian traditions. In 1572, Sinan built for Sultan Selim II (r. 1566–1574) in Edirne a huge imperial mosque that the architect considered his masterpiece (fig. 9.28). The courtyard with surrounding arcades and central fountain recalls the typical Arab mosque plan, but the huge lead-covered dome and the four pencil-thin triple-balconied minarets proclaim the Ottoman architecture style, while the vast interior, with its eight huge piers supporting a dome almost 197 feet high and over 108 feet in diameter, shows a unified and clearly delineated space (fig. 9.29) at once completely different from the Arab hypostyle mosque with its fragmented space, and from the Hagia Sophia with its mysterious structural and spatial ambiguity. In Sinan's buildings, the structural components—the muscles and sinews, as it were—rather

9.28. Sinan the Architect. Cutaway of the mosque of Selim II (Selimiye), 1569–1574. Edirne, Turkey

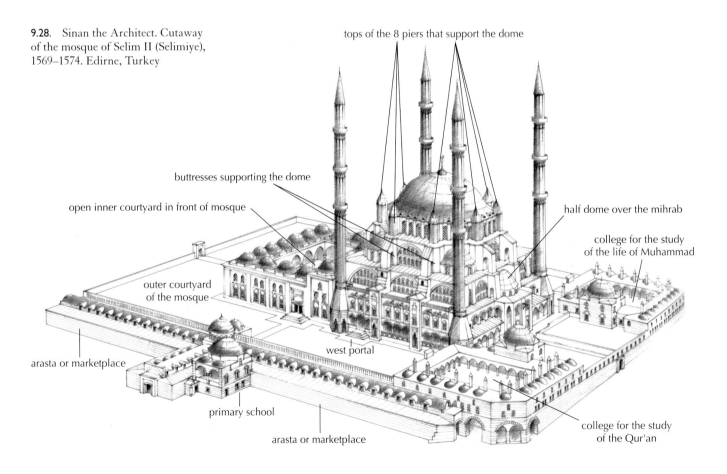

tops of the 8 piers that support the dome

buttresses supporting the dome

open inner courtyard in front of mosque

half dome over the mihrab

college for the study of the life of Muhammad

outer courtyard of the mosque

west portal

arasta or marketplace

primary school

arasta or marketplace

college for the study of the Qur'an

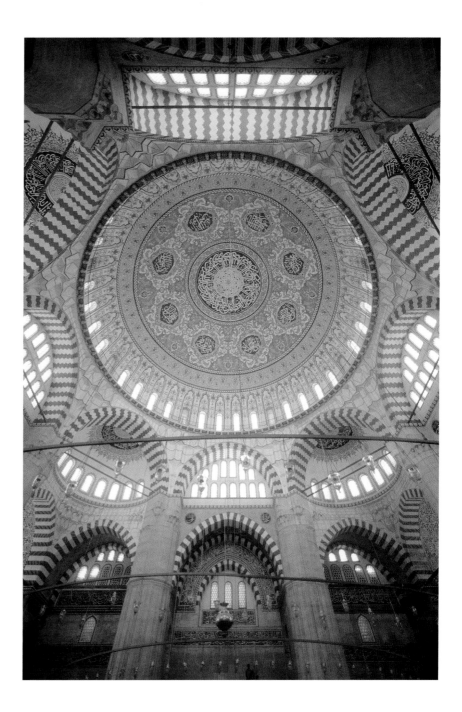

than being hidden, are a primary source of the buildings' visual appeal. The Ottomans preferred an austere exterior of bare whitish stone contrasting with the dark-gray lead sheets used for waterproofing the domes and semidomes of their structures, while the interiors frequently incorporated beautiful polychrome tiles with designs of strikingly naturalistic flowers (see *Primary Source*, page 302).

THE OTTOMAN COURT STYLE The Ottomans, like the Timurids before them, developed by 1500 a royal design studio, which they called the "house of design," that served as the central focus of royal artistic patronage. It reached its zenith under the patronage of Süleyman I, "The Magnificent" (r. 1520–1566), his son Selim II (r. 1566–1574), and grandson

Murad III (r. 1576–1595). Among the many artistic innovations to emerge from this complex of artists working in almost every conceivable medium and genre is a style of ornament called by some *saz*, taking its name from a legendary enchanted forest, and by others *hatayi*—that is, "from Cathay," or "China." Created in part by an emigré artist from Tabriz named Shah Kulu, who became head of the Ottoman royal studio by the mid-sixteenth century, the style is typified by energetic and graceful compositions of curved leaves and complex floral palmettes linked by vines that appear to overlap and penetrate each other, sometimes embellished with birds or strange antelopelike creatures. The saz or hatayi style is found in ceramic wares, manuscript illumination, carpets, silk textiles, a series of freehand drawings executed for the albums of royal collectors, and some remarkable

The Ottoman Sultan Selim II (1524–1574)

An Order from the Imperial Court

By spring of 1572 the building of the sultan's mosque in Edirne was well underway. From the royal palace, the sultan took a very close interest in the progress of affairs, an approach that seems to have bordered on micromanagement. He even dictated what inscriptions were to be placed in what locations in the building.

To the Architect in Chief:

For the inscriptions that are currently needed for my noble mosque in Edirne that I have ordered to be built, you have requested the services of the calligrapher Molla Hasan. Now this individual has been retained and dispatched for the above-mentioned business. I have ordered that, upon receipt and by fulfillment of this order, you show him the places in the noble mosque where he will prepare suitable and appropriate inscriptions, whether they be executed on tiles, or be simple painted inscriptions.

Conveyed though the Chief Tile-Maker

The 8th of Muharrem, 980 (May 21, 1572)

SOURCE: AHMED REFIK. MIMAR SINAN. TR. WALTER DENNY. (ISTANBUL: KANAAT KUTUPHANESI, 1931)

blue and turquoise paintings on tile, probably from the hand of Shah Kulu himself (fig. **9.30**). Ottoman ceramics and silks were exported in large quantities to Russia and Europe, where along with the much-prized carpets from Asia Minor they were quickly absorbed into European material culture.

The Safavid Period in Iran

Shortly after 1500, Ismail, a young and charismatic prince descended from a family of venerated Shi`ite clerics in northwestern Persia, declared himself the Safavid *shah* (king) of Iran. Quickly overrunning much of the formerly Timurid domains, the young ruler established his capital in the city of Tabriz in northwestern Iran, formerly the capital of two provincial Turkmen dynasties, precariously close to the eastern reaches of the Sunni Ottoman Empire. There, under Ismail (r. 1501–1523) and his successor Tahmasp (r. 1523–1576), who in 1548 moved his capital to the strategically more secure Qazvin to the east, the arts flourished.

BOOK ILLUSTRATION AND CARPETS: TABRIZ

Early in the sixteenth century, the aged painter Behzad was brought from the east to Tabriz, where his style, combined with the indigenous Turkmen painting style of pre-Safavid times, brought about a remarkable artistic synthesis. In the hands of one of the great geniuses of Islamic art, the Turkmen-born artist Sultan-Muhammad—it was not uncommon for artists in royal ateliers to incorporate honorifics like *shah* (king), *sultan* (ruler), or *aqa* (noble) into their names—the new Safavid style of miniature painting reached new heights in expressiveness as well as technique. One of the painter's most appealing creations is an illustration painted with opaque watercolors on paper in Tabriz around 1529 for a royal manuscript of a *divan,* or collection of poems, by the fourteenth-century poet Hafiz, utilizing the theme of heavenly and earthly intoxication, a favorite motif of mystical Persian poetry (fig. **9.31**). A group of elderly professors from

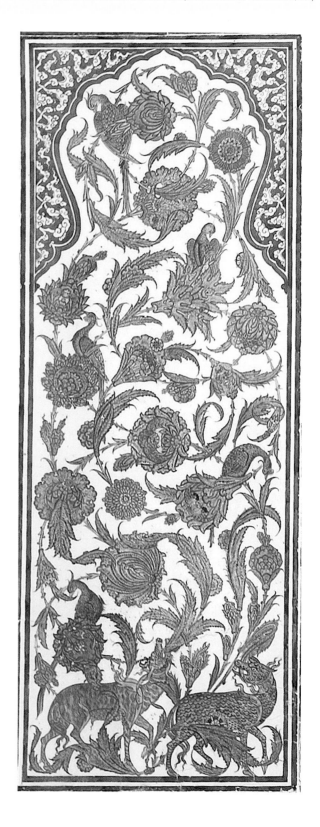

9.30. Tile painted in hatayi style with saz design, by Shah Kulu. ca. 1525–1550. Cobalt and turquoise underglaze painting on composite fritware body covered with white slip, 50 × 19″ (127 × 48.5 cm). Topkapı Palace Museum, Istanbul

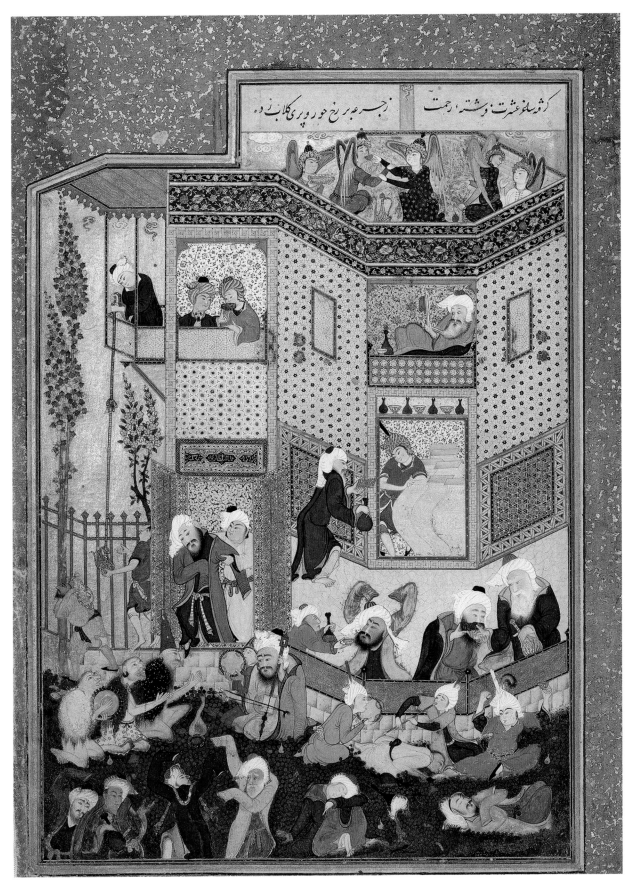

9.31. Sultan-Muhammad. *Allegory of Heavenly and Earthly Drunkenness*, from a *Divan* (collection of lyric poems) by Hafiz, from Tabriz. ca. 1529. Opaque watercolors, ink, and gold on paper, 11⅜ × 8½″ (28.9 × 21.6 cm). Promised Gift of Mr. and Mrs. Stuart Cary Welch Jr. Partially owned by Metropolitan Museum of Art, New York, and the Arthur Sackler Museum, Harvard University, 1988 (1988 430)

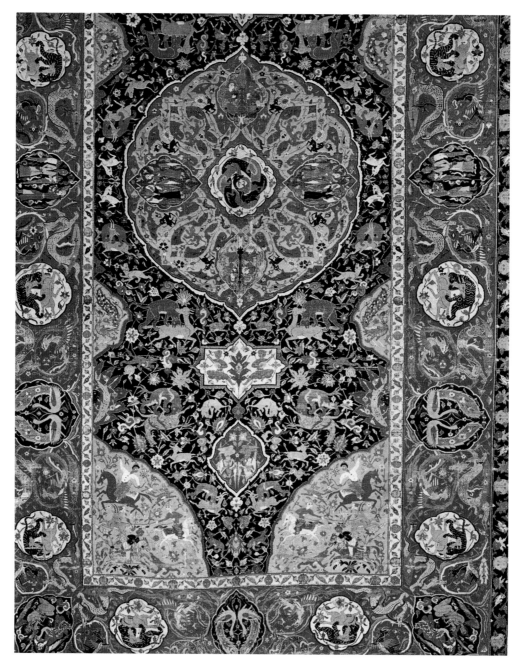

9.32. Detail of the Sanguszko figural-design carpet, from Iran. ca. 1575–1600.
Wool pile knotted on cotton warp and weft; entire carpet 19′ 8″ × 10′ 8″ (6.4 × 3.3 m).
Private collection

a religious college are shown in various stages of disorderly intoxication, accompanied by servants, some fawning and others apparently terrified, while a group of strangely attired and caricatured musicians provides background music. On the roof of the building angels join in the revelry, while on the balcony the pie-eyed poet himself struggles to write his poem. Using an incredibly fine brush stroke, and a thick white application of paint to create the textures of the white silk Safavid turbans, with their characteristic colored batonlike ornaments sticking out the top, Sultan Muhammad has created a work that reminds us that Islam-

ic civilization is no stranger to humor or to the enjoyment of a good time, both metaphorically and literally.

The new style in book painting, with its brilliant colors, expressive faces, and great variety of body types, often set in a landscape filled with flowers or a lavish architectural setting, was immediately transferable to other mediums. A carpet woven somewhere in the Safavid domains in the second half of the sixteenth century shows the application of the figural style of miniature painting to a symbolically complex composition of royal and heavenly motifs (fig. **9.32**). It incorporates the royal hunt, the enjoyment of

wine in a paradiselike setting, and a host of birds and animals. These forms are subject to a complex layering of symbolism, often intermingling the sacred and the profane, that reflects the strong role of Sufi mysticism in Safavid culture, as well as an age-old Persian love of wine, poetry, and beautiful possessions.

ARCHITECTURE: THE PLANNED CITY OF ISFAHAN

By the beginning of the seventeenth century, the Safavid capital had been moved once again to the old city of Isfahan in the Persian heartland. There the energetic and powerful Abbas I (r. 1588–1629) laid out to the south of the original city center of Isfahan a new city with large public spaces and broad avenues, with palaces for the nobility and a quarter for Armenian Christian merchants. The splendor and prosperity of Isfahan drew commerce and curious travelers from all over the world, and the luxury goods sold in its bazaars, from

silks and ceramics to metalware and carpets, together with the beauty of its gardens and the richness of its inhabitants, led to a famous Persian adage: "Isfahan is half the World." At one end of a huge open square known as the **maidan**, itself oriented with the North Star, Shah Abbas built his Royal Mosque (fig. **9.33**). Because the qibla lies to the southwest, facing Mecca, the mosque has to be at an entirely different orientation than the maidan. An ingenious 45-degree turn beyond the main portal deftly accomplishes a directional accommodation, leading into the huge open courtyard of the mosque, with its enormous domed chamber behind the qibla iwan, all visible surfaces completely covered in brilliantly colored tiles.

The shops that line the sides of the maidan all contributed rents to the waqf or endowment of the mosque, and in the middle of the west side of the maidan, Shah Abbas built a palace from the balcony of which he could watch processions and

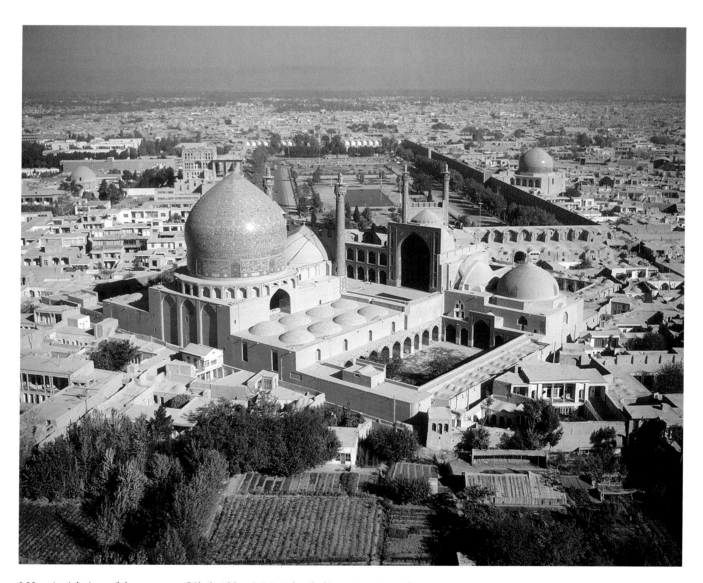

9.33. Aerial view of the mosque of Shah Abbas I (Masjid-i Shah), 1611–1616. Isfahan

sporting events in the square itself. The rest of the planned city of Isfahan consisted in large part of spacious gardens surrounding the pavilionlike palaces of the Safavid nobility.

The Mughal Period in India

In 1526 Babur, who claimed descent from the Mongol Timur (hence the name "Mughal"), defeated a combined army of Hindu princedoms in northern India to establish the Mughal dynasty in the subcontinent. Although India had an Islamic presence in Delhi since around 1200, the Mughal empire was to bring a new flowering of Islamic art and architecture to the subcontinent. Centered in the capital cities of Agra, Delhi, and Fatehpur-Sikri, the Mughal style built on an artistic combination of Central Asian, Safavid Persian, and indigenous Hindu art and culture. Under Babur's grandson Akbar the Great (r. 1556–1605), himself an unusually capable and charismatic ruler, the Mughal style in the arts took on its distinctive form. Akbar himself was a remarkably tolerant ruler, fascinated by Hinduism, interested in Persian poetry and art, and a patron of one of the major Indian Sufi orders. Under his patronage a royal studio of Persian and native painters blended their traditions to form a new style of miniature painting. In addition, Central Asian, Persian, and local builders and craftspeople blended their architectural styles and techniques together to create a new Mughal style in architecture, and the three Mughal capital cities were the scene of building and the production of works of art on a mammoth scale.

In a sense, the Mughal art of India revels in extremes—the largest and the smallest of Islamic miniature paintings, the largest but also the most finely woven small Islamic carpets, the most spectacular of all Islamic tomb structures, and the most extravagant Islamic jewelry and fanciful hardstone carving, are all to be found in India under the Mughals.

BOOK ILLUSTRATION A miniature painting in opaque watercolors on paper of a *darbar,* or ceremonial audience, of the Mughal emperor Jahangir (r. 1605–1627), probably completed around 1620 by the court artists Manohar and Abul Hasan, shows the characteristics of the Mughal style (fig. **9.34**). The Mughals liked realistic pictures of current events; each of the faces in the crowd is a true portrait, and almost every individual can be identified by comparison with individual portraits made around the same time. Along with this specificity, extended to the visiting black-clad European monk and even to the smiling elephant, is a love of opulent detail, while space is created in the time-honored Islamic fashion by the use of a high point of view and an overlapping technique.

9.34. Manohar and Abul Hasan. *Ceremonial Audience of Jahangir,* from a *Jahangir-nama* manuscript, northern India. ca. 1620. Opaque watercolors and ink on paper, $13^{3}/_{4} \times 7^{7}/_{8}$" (35 × 20 cm). Museum of Fine Arts, Boston. Frances Bartlett Donation of 1912 and Picture Fund. Photograph © 2006 Museum of Fine Arts, Boston, 14654

DECORATIVE ARTS A different side of Mughal art is seen in a wine cup fashioned from translucent white jade (fig. **9.35**) for the emperor Shah Jahan (r. 1628–1657). The delicately petaled blossom that forms the bowl of the cup gently tapers to the handle in the form of a bearded mountain goat from Kashmir. Despite the hardness of the stone, which had to be shaped by grinding for hundreds of hours, millimeter by millimeter, the finished product has the freshness of a flower itself. The same attention to botanical realism can be seen in floral decoration in many Mughal mediums, from textiles and carpets to carved and inlaid marble.

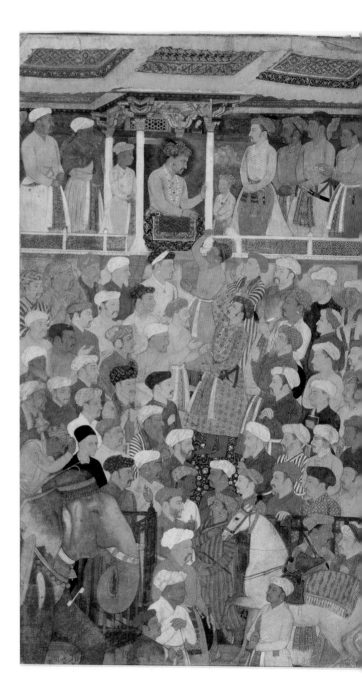

Spain → Asia; strong regional characteristics

Brilliant use of color, balance between
 design + form.

rich surface beauty

Islamic: refers to both religious + secular
 Overall characteristics:
 — calligraphy, beautiful writing
 — preference for covering surfaces w/ patterns,
 geometric/floral/vegetal; create
 sense of unending repetition =
 contemplation of the infinite nature of God

 — non-representational / representational
 figuration / imagery important in secular art
 in courtly contexts.

 — royal patronage important: mosques, furnishings were
 the responsibility of the ruler + high court
 officials
 • way of showing supremacy of the ruler, his state.

 — generally anonymous artists (ex. mss.)

Late Islam:

3 major empires or states

an international period

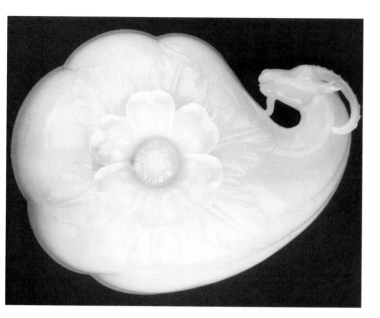

9.35. Wine cup of Shah Jahan, from northern India. Mid-17th century. White jade, $2\frac{1}{4} \times 6\frac{3}{4}''$ (5.7 × 17.14 cm). Victoria and Albert Museum, London

ART IN TIME

1453 CE—Ottomans claim Constantinople as their capital

1501—Prince Ismail founds Safavid empire in Iran

1556–1605—Akbar the Great rules Mughal India

1616—Death of English playwright William Shakespeare

1650—Completion of Taj Mahal in Agra, India

ARCHITECTURE: TAJ MAHAL The most famous of all Mughal works is doubtless the Taj Mahal, a royal tomb in Agra completed around 1650 by Shah Jahan in memory of his deceased wife Mumtaz Mahal (fig. **9.36**). The building has the ground plan of a Timurid garden kiosk or palace from Central Asia, while the central dome recalls that of the Royal Mosque of Isfahan (see *Primary Source*, page 308). The snowy white marble is lavishly inlaid with colored semi-precious stones in the form of flowers, vines, and beautiful cursive inscriptions. Set at one end of an elaborate quadripartite formal garden with four axial pools in the Persian style, the Taj Mahal is far more than a royal tomb or a dynastic monument. The inscriptions evoke the metaphor of the gardens of Paradise that are promised to devout believers in the Qur'an, and the domed building is a self-conscious evocation of the throne of God, re-created in an earthly version of divine Paradise.

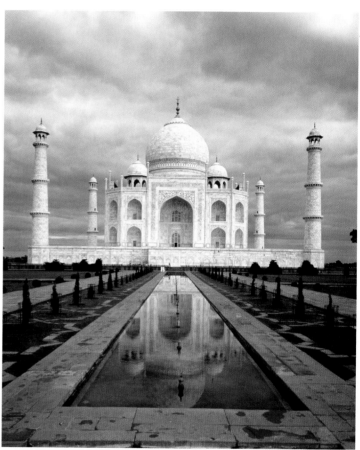

9.36. The Taj Mahal, Agra, India. ca. 1650

CONTINUITY AND CHANGE IN ISLAMIC ART

In the eighteenth and nineteenth centuries, the great traditions of Islamic art continued through tumultuous periods of change. Economic decline led to a diminution in the royal patronage that produced some of the most spectacular works of earlier periods, but stylistic traditions in every major area of the Islamic world continued to live on, despite political and economic dislocation, European colonialism, and the increase of factory-made goods in everyday life. Art of all kinds in a huge variety of mediums flourishes throughout the Islamic world in many countries today, largely ignored even by historians who are specialists in Islamic art because they are trained to look at the works of earlier periods. Slowly, through encounters with new mediums and genres, with the pervasive American-European tradition of the later twentieth century, and through reencounters with their own historical past, Muslim artists are creating new traditions that seek to express what almost every artistic tradition has always embodied in almost every time—new creativity in the context of a rich and meaningful past.

Abd Al-Hamid Lahori (d. 1654)

From *Padshah Nama (Book of the Emperor)*

Abd al-Hamid Lahori was the official court historian to Shah Jahan, who built the Taj Mahal as a monument to the memory of his beloved wife Mumtaz Mahal. The Padshah Nama *was written in three volumes, each corresponding to a decade in Shah Jahan's reign. Before he could finish the third volume Lahori was taken ill, and the work was completed by his younger colleague Muhammad Waris in 1657. This excerpt is from a much longer discussion of the building of the monument, together with an elaborate description of the tomb itself, the outbuildings, and the surrounding gardens.*

At the beginning of the fifth year of the exalted accession (January, 1632), the excavation was started for the laying of the foundation of this sublime edifice, which is situated overlooking the Jumna river flowing adjacent to the north. And when the spade-wielders with robust arms and hands strong as steel, had with unceasing effort excavated down to the water-table, the ingenious masons and architects of astonishing achievements most firmly built its foundation with stone and mortar up to the level of the ground.

And on top of this foundation there was raised a kind of platform of brick and mortar in one solid block, measuring 374 cubits long by 140 wide and 16 high, to serve as the plinth of this exalted mausoleum—which evokes a vision of the heavenly gardens of Rizwan and epitomizes, as it were, the holy abodes of Paradise.

And from all parts of the empire, there were assembled great numbers of skilled stonecutters, lapidaries, and inlayers, each an expert in his art, who commenced work along with other craftsmen. . . . In the middle of this platform plinth—which ranks [in magnificence] with the heavenly Throne of God—there was constructed another solid and level platform. In the center of the second platform, the building of this heaven-lofty and Paradise-like mausoleum was constructed on the plan of a Baghdadi octagon, 70 cubits in diameter, on a base plinth one cubit in height.

Situated in the exact center of the building, the domed hall over the sepulcher of that recipient of divine grace has been finished with white marble within and without. From the floor to the curvature, the hall under the dome is octagonal in shape, with a diameter of 22 cubits. The curvature is ornamented with *muqarnas* motifs, while from the cornice to the inner summit of the dome, which is at a height of 32 yards from the floor of the building, there are arranged marble slabs cut in a geometric molded pattern. . . .

SOURCE: W. E. BEGLEY AND Z. A. DESAI, *TAJ MAHAL: THE ILLUMINED TOMB.* TR. BY W. E. BEGLEY AND Z. A. DESAI (CAMBRIDGE MA: AGA KAHN PROGRAM FOR ISLAMIC ARCHITECTURE, 1989)

SUMMARY

ISLAMIC ART

As Islam spread, the clashing and combining of this new religion with old cultures led to a vibrant tradition of Islamic art. Due to its vast geographical and chronological scope, Islamic art cannot be defined simply, but it does have certain unifying themes. These include the development of artistic expression independent of the human figure, which leads Islamic artists to use sophisticated vocabularies of vegetable, floral, and geometric designs. Another theme is the equality of genres; there is no hierarchy that separates "fine arts" from "decorative arts." Thus, ceramic making, metalware making, weaving, and carving are all equivalent in rank, and they are equal in rank with work in other mediums as well.

THE FORMATION OF ISLAMIC ART

Islamic art began as a series of appropriations of Graeco-Roman, Byzantine Christian, and Sasanian forms. The new religion of Islam required distinctive buildings, such as places for community prayers, that led to a rich variety of architecture emblematic of the faith itself. The Dome of the Rock in Jerusalem is one important early example. Other examples of Islamic architecture include hypostyle mosques and secular buildings, such as palaces and bathhouses.

THE DEVELOPMENT OF ISLAMIC STYLE

The Abbasid dynasty was centered in Mesopotamia. Its rulers, who supplanted the Umayyad dynasty, built new structures at Baghdad, Samarra, and elsewhere. Among these new structures were large mosques, including the Great Mosque of Kairouan. Farther to the west—in an independent state founded by an Umayyad survivor—Córdoba, Spain, became a brilliant center of Islamic culture and home to another great mosque.

ISLAMIC ART AND THE PERSIAN INHERITANCE

In eastern Islamic lands, Arab Muslim conquerors encountered the Sasanians, heirs to the cultural traditions of Persian civilization. Combining these traditions with their own Islamic beliefs and traditions led to the construction of large and impressive palace buildings, whose vaulted brick structures were different from the stone structures in central and western Islamic lands. A prosperous urban culture also arose that produced one of the richest known traditions of decorated ceramics.

THE CLASSICAL AGE

As Mesopotamia's power waned as the center of the Islamic world, the Fatimids rose in importance, founding a new capital at Cairo. Under their rule, Egypt saw a major artistic revival. New city walls, mosques, and palaces were built; earlier traditions of weaving flourished; and artists produced

carved ivory objects. The period of the Crusades—a time of artistic cross-fertilization between Catholic Europe and the Muslim Middle East—saw the achievements of both Ayyubid and Seljuk architecture and art.

LATER CLASSICAL ART AND ARCHITECTURE

By the end of the 1200s, the western Mongol rulers—who had devastated much of the Islamic world east of the Mediterranean—had converted to Islam. They and their successors brought about in Iran another period of artistic flowering. This legacy continued under the Timurids, whose patronage led to masterworks of architecture and book illustration. Elsewhere, in the Islamic lands of Syria and Egypt, Mamluk patronage led to elaborate architectural structures and highly prized glassmaking, metalwork, and carpet making. By the mid-1300s, the mountain kingdom of Granada on the Iberian peninsula was the only part of the former Muslim al-Andalus to remain under Muslim control. Here, the Nasrid monarchs constructed a famed "Red Palace," known to history as the Alhambra.

THE THREE LATE EMPIRES AND CONTINUITY AND CHANGE IN ISLAMIC ART

In later times, three large Islamic empires formed major artistic centers. The mighty empire of the Ottomans, which eventually conquered Constantinople, built elaborate mosques and the Topkapı Palace. The Safavids, major rivals of the Ottomans, developed distinctive artistic styles in book illustration, carpet making, and architecture. And in the Indian subcontinent, the Mughals built their own opulent palaces and monuments, including the Taj Mahal. Large-scale royal patronage declined in the eighteenth and nineteenth centuries, but stylistic traditions continued in every area, and today Muslims continue to produce new artistic traditions.

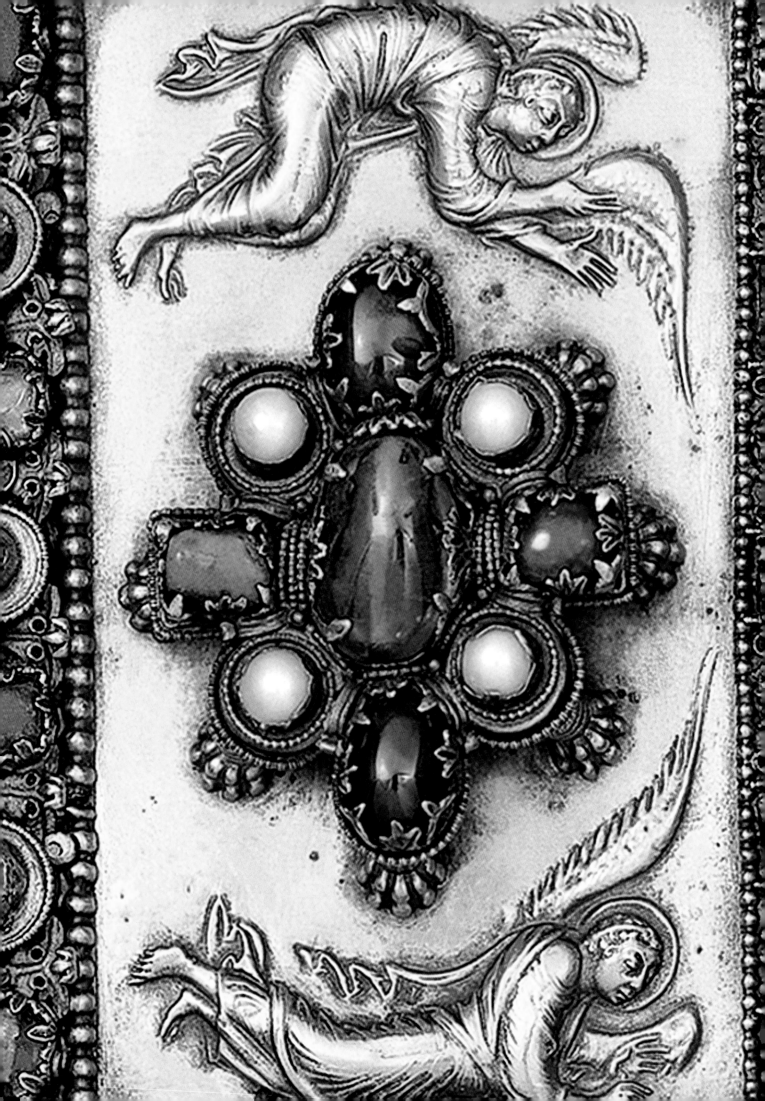

Early Medieval Art

THE TERM EARLY MEDIEVAL IS SOMETHING OF A CATCHALL PHRASE USED to describe the art of a number of cultures and a variety of regions in Western Europe after the Fall of Rome (476 CE) until the eleventh century (see map 10.1). Significant in Rome's demise was the power asserted by migrating Germanic peoples (including Franks, Visigoths, Ostrogoths, and

Saxons), who moved into and through Europe and eventually established permanent settlements both north of the Alps and in Italy, Spain, and southern France. These were clearly tumultuous times, as invaders clashed and eventually mixed with local inhabitants, including the Celts, the descendents of the Iron Age peoples of Europe. (*Celt* is a confusing term, since it is also used to define tribal groups who occupied Britain and Ireland between the fifth and twelfth centuries.) As the invaders established permanent settlements, they adopted many customs traditional to the areas they inhabited. Overlaid on this mix of customs were Roman traditions, including those of Christianity, which in many cases had been adopted by indigenous local tribes when they were conquered by Rome.

The allure of Christianity—for both its spiritual message and for the structure it imposed on a fragmented society in times of turmoil—once again proved momentous. Conversion from pagan worship, however, was now less an individual decision (as it had been in the Early Christian period) than a social one. Often, when a tribal leader decided to convert to Christianity, his subjects converted with him, virtually en masse, as occurred in Reims on Christmas Day in 496, when 3,000 Franks were baptized along with Clovis, their king.

The Church emerged as a force vitally important for European unification; even so, loyalty to family and clan continued to govern social and political alliances. Strong chiefs assumed leadership and established tribal allegiances and methods of exchange, both economic and political, that would eventually result in the development throughout Europe of a system of political organization known as *feudalism*. These social and political alignments eventually led to a succession of ruling dynasties governed by strong leaders who were able to increase the areas under their dominion. These dynasties (principally the Carolingian and Ottonian) were ambitious to reestablish a centralized authority, absent in Europe after the fall of Rome. The attempt to provide a stable political structure was based, if not in the reality of the Roman Empire, then at least in the ideals embodied in its legacy.

The art that resulted from this cultural interchange is a vibrant and vital mix. Artistic methods, materials, and traditions, brought with migration, were combined with those customs that predominated in the regions where tribes settled. Much of this art is marked by elaborate patterns of interlocking and interwoven designs that decorate sumptuous objects of personal adornment, reflecting their owners' social position. Eventually the Church assumed increasing importance in commissioning works of art, and there was a shift of emphasis in the types of objects produced. The Church built and decorated many houses of worship and established a large number of

Detail of figure 10.16, *Lindau Gospels*

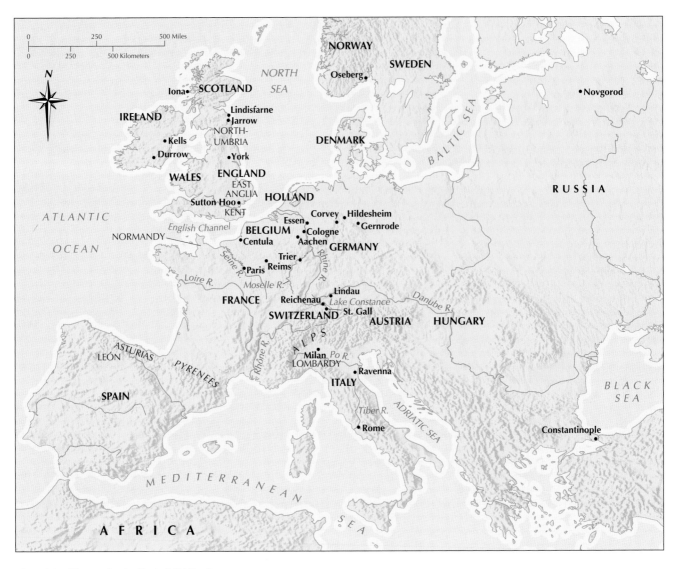

Map 10.1. Europe in the Early Middle Ages

monastic communities. Within the monasteries, scriptoria made elaborately decorated books, which were sent off with missionaries as aids in their efforts to convert and educate.

Carolingian and Ottonian artists expressed the imperial ambitions of their leaders by building churches and designing architectural complexes that consciously emulated Rome. Roman-derived Early Christian basilicas served as models for a large number of buildings north of the Alps. Court-related artists also produced copies of ancient books. And three-dimensional sculpture, an art form virtually abandoned after the fall of Rome, once again attracted the attention of artists and their patrons. Thus, out of an amalgam of diverse and conflicting forces, and as new social and cultural entities developed, an art emerged that is as varied as it is exciting.

ANGLO-SAXON AND VIKING ART

The widespread migrations of peoples transformed Europe. In 376, the Huns, who had advanced beyond the Black Sea from Central Asia, became a serious threat to Europe. They pushed the Germanic Visigoths westward into the Roman Empire

from the Danube. Then in 451, under Attila (d. 453), they invaded Gaul, present-day France and Germany, and its resident Celts. Also in the fifth century, the Angles and Saxons from today's Denmark and northern Germany invaded the British Isles, which had been colonized for centuries by Celts. Many of these Germanic tribes developed into virtual kingdoms: the Visigoths in Spain, the Burgundians and Franks in Gaul, the Ostrogoths and Lombards in Italy. The Vikings controlled Scandinavia and ventured afar, a result of their might as sailors.

The Germanic peoples brought with them art forms that were portable: weaving, metalwork, jewelry, and woodcarvings. Artistic production in these mediums required training and skill of execution, and metalwork in particular had intrinsic value, since it was often made of gold or silver and inlaid with precious stones. Metalworkers had high social status, a measure of respect for their labor and for the value of the objects they produced. (See *Materials and Techniques*, facing page.) In some Germanic folk legends metalworkers have abilities so remarkable that they are described as magical. Numerous small-scale objects reflect the vitality of artistic forms

Metalwork

Metal was a precious commodity in the Middle Ages. Even in the ancient world patterns of interchange and colonization can be related to exploration for desirable metals for example, the Greek settlements in Italy and Roman settlements in Spain were a result of a desire for metals. Popular metals employed in the early Middle Ages included gold, silver, copper, iron, and bronze. The many ways that metals could be worked was undoubtedly one of their most compelling features. They could be flattened, drawn thin, or made into an openwork **filigree** design. And they could be cast, engraved, punched, stamped, and decorated with colored stones, glass, or enamels.

The large gold buckle from the Sutton Hoo ship burial (see fig. 10.1) contains nearly a pound of gold, although it is only one among many gold pieces found in the burial site. That so much early medieval metalwork from gravesites is gold reflects the value attached to the metal. In addition, gold is not harmed by contact with either earth or water (whereas silver and other metals are subject to progressive destruction when exposed to the elements). Although gold had been obtained in Europe through mining since Roman times, the most common method of acquiring it was by collecting nuggets or small grains from rivers and streams (called *placer* or *alluvial* gold). The Rhine, Tiber, Po, Rhone, and Garonne rivers, along which the Germanic tribes settled, were major sources of this type of gold, which medieval writers refer to as "sand" gold.

Sutton Hoo's gold buckle is decorated with **granulation**, beads of gold bonded to the surface, as well as **inlaid niello**, the dark material that sets off the intricate interlace designs composed of lines and dots. Niello is a sulfur alloy of silver, copper, or lead that, when heated, fuses with the metal that surrounds it, in this case the gold, and produces a nearly black substance. The shiny dark niello serves to emphasize the brilliance of the gold and to accentuate the details of the intricate patterns.

A medieval treatise written by the monk Theophilus in Germany in the early twelfth century explains the way inlaid niello was polished. First the artist smooths the niello with a soft stone dampened with saliva; then, using a piece of limewood, the artist rubs it with a powder of ground soft stone and saliva. After that, as Theophilus explains:

> For a very long time, lightly rub the niello with this piece of wood and the powder, continually adding spittle so that it remains moist, until it becomes bright all over. Then take some wax from the hollow of your ear, and, when you have wiped the niello dry with a fine linen cloth, you smear this all over it and rub lightly with a goatskin or deerskin until it becomes completely bright.

—THEOPHILUS, *DE DIVERSIS ARTIBUS.* TR. C. R. DODWELL
AS *THEOPHILUS: THE VARIOUS ARTS.* LONDON: NELSON, 1961, P. 92.

The Sutton Hoo purse lid (fig. 10.3) and hinged clasps (fig. 10.2) are also notable for their **cloisonné** decoration. Cloisonné is an ancient technique, used as early as the second millennium BCE in the eastern Mediterranean. Individual metal strips or *cloisons* (French for "partitions") are attached on edge to a baseplate as little walls to form cells that enclose glass or gems. For the Sutton Hoo jewelry red garnets are

used extensively. In fact, the Sutton Hoo jewelry includes more than 4,000 individual garnets. Colored glass, often arranged in checkered patterns, is also used in these pieces; on the main field of the hinged clasps, *cloisons* enclose colored glass to form a step pattern, which enhances the overall decorative effect.

Many of the decorative devices and materials employed in Anglo-Saxon metalwork were later used by Irish metalworkers. A spectacular example is the *Tara Brooch,* an accidental find made by a child playing by the seashore in County Meath, Ireland, in 1850. The brooch is a kind of stickpin used to join two pieces of a garment together. An incredible amount of decoration—including spirals, bird, animal and human heads, and interlace patterns—is compressed on a piece of jewelry of just over three and a half inches in diameter. Panels of gold filigree, consisting of fine soldered wire, are combined on the back of the brooch with silver plaques with inlaid spiral designs in copper. A braided wire attachment was possibly a safety chain.

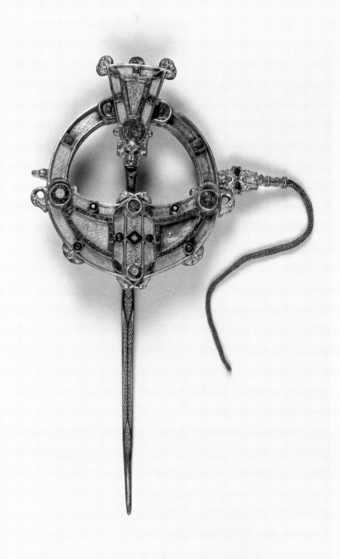

Tara Brooch, from Bettystown, County Meath, Ireland. 8th century. Gilt, bronze, glass, and enamel. Diameter 3⅝″ (8.7 cm). National Museum of Ireland, Dublin

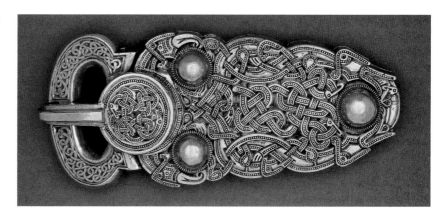

10.1. Golden buckle, from the Sutton Hoo ship burial. First half of 7th century. Gold. Length: 5¼ (13.4 cm). The British Museum, London. Courtesy of the Trustees

produced by these migrating peoples, demonstrating an aesthetic that is quite different from the tradition that derives from Greece and Rome, yet equally rich in myth and imagery.

The Animal Style

The artistic tradition of the Germanic peoples, referred to by some scholars as the **animal style** because of its heavy use of stylized animal-like forms, merged with the intricate ornamental metalwork of the Celts, producing a unique combination of abstract and organic shapes, of formal discipline and imaginative freedom.

SHIP BURIAL, SUTTON HOO, ENGLAND An Anglo-Saxon ship burial in England follows the age-old tradition of burying important people with their personal effects. This custom may reflect a concern for the afterlife, or it may simply be a way to honor the dead. The double ship burial at Sutton Hoo (*hoo* is Anglo-Saxon for "headland" or "promontory") is of a seventh-century Anglian king (generally thought to be King Raedwald, who died around 625). Military gear, silver and enamelware, official royal regalia, gold coins, and objects of personal adornment are all part of the entombment. Scholars have long noted that the Anglo-Saxon poem *Beowulf,* so concerned with displays of royal responsibility and obligation, includes a description of a ship fitted out for a funeral that is reminiscent of the Sutton Hoo burial. The funeral is that of

Beowulf's father, King Scyld:

> They stretched their beloved lord in his boat,
> laid out by the mast, amidships,
> the great ring-giver. Far-fetched treasures
> were piled upon him, and precious gear.
> I never heard before of a ship so well furbished
> with battle tackle, bladed weapons
> and coats of mail. The massed treasure
> was loaded on top of him: it would travel far
> on out into the ocean's sway.
>
> —Translated by Seamus Heaney, *Beowulf. A New Verse Translation.* New York: Farrar, Straus & Giroux, 2000

Although *Beowulf* describes events that predate the Sutton Hoo find by at least a century, the poem was probably not composed until a century or more after that burial. So, while *Beowulf* should not be taken as a documentary account, it does suggest a royal context within which to appreciate the Sutton Hoo site.

Intricate animal-style design covers a large gold buckle from Sutton Hoo (fig. **10.1**). Two interlaced biting snakes decorate the stud to which the tongue is attached. That stud is in turn affixed to a plaque with intertwined serpents and eagle heads covering virtually every available space. It has been traditional for scholars to refer to the need to decorate all surfaces as an expression of *horror vacui*, a fear of empty space. But this

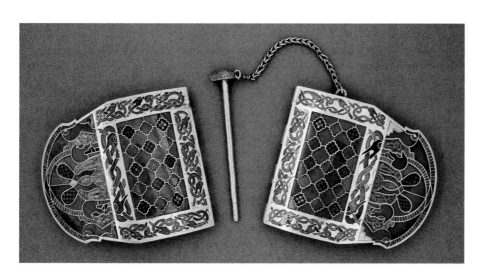

10.2. Hinged clasps, from Sutton Hoo ship burial. First half of 7th century. Gold with garnets and enamels. Length: 5″ (12.7 cm). The British Museum, London. Courtesy of the Trustees

designation imposes our contemporary values on a culture alien to them. Unlike the Greeks and Romans, who used spatial illusionism to animate their art, Germanic and Celtic artists used intricate patterns to enliven the surface of their precious objects. Although the designs seem confusing and claustrophobic to us, there is a consistent and intentional tightness in the way the patterns hold together.

A pair of hinged clasps (fig. **10.2**) from the burial also contains intertwined serpents, here functioning as framing devices for a diagonally oriented checkerboard field of garnets and glass set in gold. At the end of each clasp is a curved plaque on which crouch boars back to back, admittedly difficult to decipher. So tightly integrated into the design are these animals that it is difficult to decide if the plaque curves to allow for the representation of the boars or if the animals' backs hunch in response to the shape of the clasp.

A gold, enamel, and garnet purse cover (fig. **10.3**) was also found at Sutton Hoo. Its original ivory or bone background does not survive and has been replaced. Each of four pairs of symmetrical motifs has its own distinctive character, an indication that they were assembled from different sources. One, the standing man between facing animals in the lower row, has a very long history indeed. We first saw him in Mesopotamian art more than 3,200 years earlier (see fig. 2.10). The upper design, at the center, is of more recent origin. It consists of fighting animals whose tails, legs, and jaws are elongated into bands that form a complex interweaving pattern. The fourth design, on the top left and right, uses interlacing bands as an ornamental device. The combination of these bands with the animal style, as shown here, seems to have been invented not long before our purse cover was made.

The Sutton Hoo objects are significant for the way they illustrate the transmission of motifs and techniques through the migration of various peoples. They show evidence of cultural interchange with Germanic peoples, combined with evidence of Scandinavian roots, but there are other noteworthy connections as well. King Raedwald was reputed to have made offerings to Christ, as well as to his ancestral pagan gods. A number of the objects discovered at Sutton Hoo make specific reference to Christianity, including silver bowls decorated with a cross, undoubtedly the result of trade with the Mediterranean. There is also a set of spoons inscribed with the names of Saul and Paul, perhaps a reference to Christian conversion (Saul changed his name to Paul on his conversion). Is it too much to wonder, as some scholars have done, if the crosses inscribed in the glass checkerboards on the Sutton Hoo clasps (see fig. 10.2) are a conscious reference to the new religion? These clasps, although executed in the patterns of Anglo-Saxon style, take the form of fasteners very like those seen in Roman gear. In fact, Roman and Byzantine articles accompany other objects of local manufacture that copy imperial forms in the Sutton Hoo graves. This has been cited as evidence that the chieftain buried at Sutton Hoo consciously presented himself as a Roman ruler.

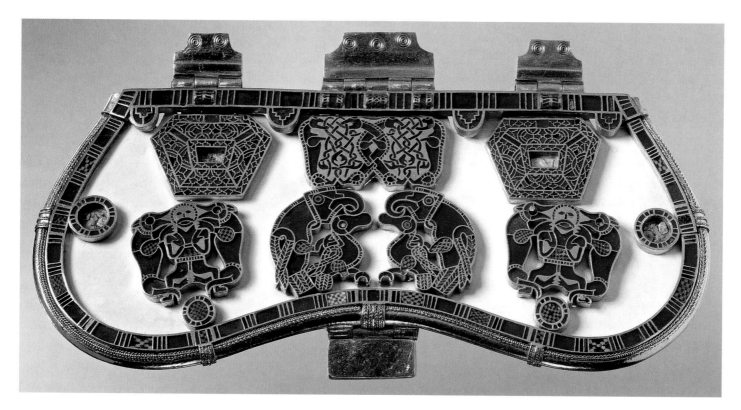

10.3. Purse cover, from the Sutton Hoo ship burial. First half of 7th century. Gold with garnets and enamels. Length: 8″ (20.3 cm). The British Museum, London. Courtesy of the Trustees

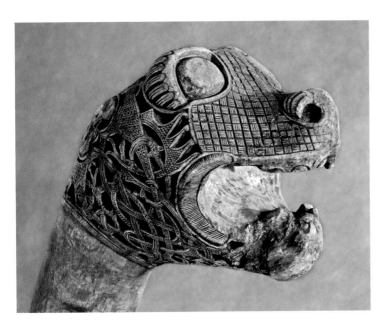

10.4. *Animal Head,* from the Oseberg ship burial. ca. 834 CE. Wood, height approx. 5″ (12.7 cm). © Museum of Cultural History, University of Oslo, Norway

The chief medium of the animal style was clearly metalwork, in a variety of materials and techniques. Such articles, small, durable, and often of exquisitely refined craftsmanship, were eagerly sought after, which accounts for the rapid diffusion of the animal-style repertoire of forms. These forms spread not only geographically but also from one material to another, migrating from metal into wood, stone, and even paint. They were used to convey a variety of messages, some clearly pagan and others Christian.

SHIP BURIAL, OSEBERG, NORWAY A splendid animal head of the early ninth century (fig. **10.4**) displays all the characteristics of the animal style. It is the decorated end of a wood post recovered from a buried Viking ship at Oseberg, in southern Norway. The practice of burying important people in ships seems to have begun in Scandinavia, where the animal style flourished longer than it did anywhere else, long beyond the Germanic-Nordic migrations in the region. The term Viking is a misleading one, since it derives from the Old Norse *Vinkingr,* which means sea pirate or raider; thus, these people were really only "Vikings" when they went *"a viking"* out of their own coastal waters to England or Russia, for instance.

The Oseberg ship was not a raiding vessel, but rather a pleasure craft, used for sailing in calm waters. Two women, placed on beds within a burial chamber, were interred within the ship, which also included oars, a ramp, an elaborately carved cart, sleds, and the skeletons of at least ten horses. Grave robbers stole whatever jewelry and metalwork, which is presumed to have been significant, that accompanied the deceased in the buried vessel.

Recent scientific studies using dendrochronology (the analysis of the growth rings of trees or wooden objects) date the Oseberg ship burial to 834. One of the women buried at Oseberg is often identified as Queen Asa, wife of Gudröd the Magnificent (ca. 780–820), because it is assumed that only a royal personage would have the resources to commission objects of such richness, but recent scholarship questions the royal nature of the burial.

Five wood posts decorated with snarling monsters looking like mythical sea dragons were found in the buried ship. Their actual function is not known, although suggestions include the possibility that they were carried in processions or used for cult functions or some ritual purposes. The basic shape of the head in figure 10.4 is surprisingly realistic, as are such details as the teeth, gums, and nostrils. Interlacing and geometric patterns cover the head, with deep undercutting and rounded forms accentuating these surface designs. Although the origins of the patterns employed here are found within Germanic and Anglo-Saxon motifs, they have been forcefully adapted to fit the animal head's dynamic curving forms.

HIBERNO-SAXON ART

During the early Middle Ages, the Irish (called Hibernians after the Roman name for Ireland, *Hibernia*) were the spiritual and cultural leaders of Western Europe. They had never been part of the Roman Empire, thus the missionaries who carried Christianity to them from England in the fifth century found a Celtic society that was barbarian by Roman standards. But the Irish readily accepted Christianity, which brought them into contact with Mediterranean civilization. However, they adapted what they had received in ways that reflected their unique circumstances.

Because the institutional framework of the Roman Church was essentially urban, it did not suit the rural Irish way of life. Irish Christians preferred to follow the example of the desert saints of Egypt and the Near East, who had sought spiritual perfection in the solitude of the wilderness, where groups of them founded the earliest monasteries. Thus, Irish monasteries were established in isolated, secluded areas, even on islands off the mainland, and such places required complete self-sufficiency. By the fifth century, monasticism had spread north into Italy, across the Continent and throughout western Britain and Ireland.

Manuscripts

Irish monasteries soon became centers of learning and the arts, with much energy spent copying literary and religious texts. They also sent monks abroad to preach to nonbelievers and to found monasteries in northern Britain and Europe, from present-day France to Austria. Each monastery's scriptorium became an artistic center for developing its style. Pictures illustrating biblical events held little interest for the Irish monks, but they devoted great effort to decorative embellishment. The finest of these manuscripts belong to the *Hiberno-Saxon style*— a style that combines Christian with Celtic and Germanic elements and that flourished in the monasteries of Ireland as well

as those founded by Irish monks in Saxon England. These Irish monks helped speed the conversion to Christianity in Europe north of the Alps. Throughout Europe they made the monastery a cultural center and thus influenced medieval civilization for several hundred years.

In order to spread the message concerning Christ, the kingdom of God, and salvation—called the *Gospel*—the Irish monasteries had to produce by hand copies of the Bible and other Christian books in large numbers. Every manuscript copy was looked upon as a sacred object containing the Word of God, and its beauty needed to reflect the importance of its contents. Irish monks must have been familiar with Early Christian illuminated manuscripts, but here, too, they developed an independent tradition instead of simply copying the older manuscripts. The earliest Hiberno-Saxon illuminators retained only the symbols of the four evangelists from the imagery in Early Christian manuscripts, perhaps because these symbols could be readily translated into their ornamental style. The four symbols—the man or angel (St. Matthew), the lion (St. Mark), the ox (St. Luke), and the eagle (St. John)—derive from the Old Testament Book of Ezekiel (1:5–14) and the Apocalypse of St. John the Evangelist (4:6–8) and were assigned to the four evangelists by St. Jerome and other early commentators.

The illustration of the symbol of St. Matthew in the *Book of Durrow* (fig. **10.5**) shows how ornamental pattern can animate a figure even while accentuating its surface decoration. The body of the figure, composed of framed sections of checkerboard pattern, recalls the ornamental quality of the Sutton Hoo clasps (see fig. 10.2). The addition of a head, which confronts us directly, and feet, turned to the side, transform the decorative motifs into a human figure. Active, elaborate patterns, previously seen in metalwork, are here employed to demonstrate that St. Matthew's message is precious. Irish scribes and artists were revered for their abilities and achievements. A medieval account relates how, after his death, an Irish scribe's talented hands were preserved as relics capable of performing miracles.

THE LINDISFARNE GOSPELS Thanks to a later **colophon** (a note at the end of a manuscript), we know a great deal about the origin of the *Lindisfarne Gospels,* produced in Northumbria, England, including the names of the translator (Aldred) and the scribe (Bishop Eadfrith), who presumably painted the illuminations as well. (See *Primary Source*, page 318.) Given the high regard in which Irish scribes and artists were held, it is not surprising that a bishop is credited with writing and decorating this manuscript. In Irish monasteries monks were divided into three categories: juniors (pupils and novice monks), working brothers (engaged in manual labor), and seniors (the most experienced monks), who were responsible for copying sacred books.

The Lindisfarne Cross page (fig. **10.6**) is a creation of breathtaking complexity. Working with the precision of a jeweler, the miniaturist poured into the geometric frame animal interlace so dense and yet so full of movement that the fighting beasts on the Sutton Hoo purse cover (see fig. 10.3) seem simple

ART IN TIME

400s CE—Angles and Saxons invade British Isles

451—Attila the Hun invades Europe

476—The Fall of Rome

ca. 570—Birth of the Prophet Muhammad in Mecca

First half of 600s—Double ship burial at Sutton Hoo, England

in comparison. In order to achieve this effect, the artist had to work within a severe discipline as though he were following specific rules. The smallest motifs and the largest patterns were worked out in advance of painting. Ruler and compass were used to mark the page with a network of grid lines and with points, both drawn and pricked. In applying paint, the artist followed his drawing exactly. No mark is allowed to interfere

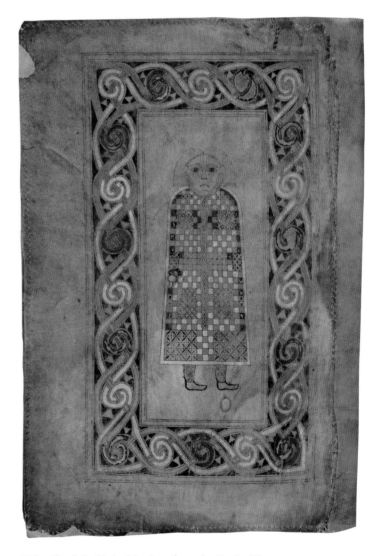

10.5. *Symbol of Saint Matthew,* from the *Book of Durrow.* ca. 680 CE. Tempera on vellum, $9^5/_8 \times 6^1/_8''$ (24.7 × 15.7 cm). Trinity College, Dublin

The Lindisfarne Gospels

Colophon

Colophons are notes written at the end of some manuscripts recording who wrote them, when, for whom, etc. The colophon at the end of the Lindisfarne Gospels (ca. 700 CE) was written some 250 years after the text, but most scholars believe that its information is accurate. It names the scribe, the binder, the maker of the metal ornaments on the binding, and the author of the English translation of the Latin text, but no painter. The painting seems to have been done by Eadfrith, the scribe.

Eadfrith, Bishop of the Lindisfarne Church, originally wrote this book, for God and for Saint Cuthbert and . . . for all the saints whose relics are in the Island. And Ethelwald, Bishop of the Lindisfarne islanders, impressed it on the outside and covered it—as he well knew how to do. And Billfrith, the anchorite, forged the ornaments which are on it on the outside and adorned it with gold and with gems and also with gilded-over silver—pure metal. And Aldred, unworthy and most miserable priest, glossed it in English between the lines with the help of God and Saint Cuthbert. . . .

SOURCE: COTTON MS NERO, D. IV. THE BRITISH LIBRARY

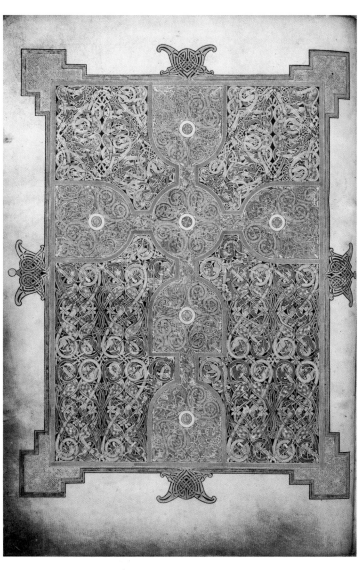

10.6. Cross page, from the *Lindisfarne Gospels*. ca. 700 CE. Tempera on vellum, 13½ × 9¼″ (34.3 × 23.5 cm). The British Library, London

with either the rigid balance of individual features or the overall design. The scholar Françoise Henry has suggested that artists conceived of their work as "a sort of sacred riddle" composed of abstract forms to be sorted out and deciphered. Organic and geometric shapes had to be kept separate. Within the animal compartments, every line had to turn out to be part of an animal's body. Other rules concerned symmetry (notice how the illustration can be bisected horizontally, vertically, and on the diagonal), mirror-image effects, and repetitions of shapes and colors. Only by intense observation can we enter into the spirit of this mazelike world. It is as if these biting and clawing monsters are subdued by the power of the Cross, converted to Christian purpose just as were the Celtic tribes themselves.

Several factors came together to foster the development of the Hiberno-Saxon style: the isolation of the Irish, the sophistication of their scriptoria in the secluded monastic environments, and the zealous desire to spread the word of Christianity. In time and with more contact with the Continent—Rome, in particular—Hiberno-Saxon art reflected new influences. The illustration of Matthew in the *Lindisfarne Gospels* (fig. **10.7**) is striking by comparison with the Matthew from the *Book of Durrow* (see fig. 10.5), made only a generation or two earlier. In the *Lindisfarne Gospels*, Matthew studies his text intently, and the artist suggests a sense of space by turning the figure and the bench on an angle to indicate depth, whereas in the *Book of Durrow*, the saint stares out frontally at the reader with his hands at his sides. There are no other figures in the *Book of Durrow* image, whereas the tied-back curtain in the Lindisfarne manuscript reveals an unidentified figure, whom some scholars identify as Moses holding the Old Testament and some as Christ holding the New. Also, whereas Matthew in the *Book of Durrow* wears a costume of flat patterns, the Lindisfarne Matthew wears clothes marked by folds; a dark undergarment is distinguished from a lighter toga, suggesting a pliant material that responds to the body beneath it.

How do we explain this change? We know that in the seventh and eighth centuries the Irish had increased contact with Rome and came to adopt Roman liturgical practices. For example, the abbot of the monastery of Jarrow, near Lindisfarne, is reported to have returned from Rome at the end of the seventh

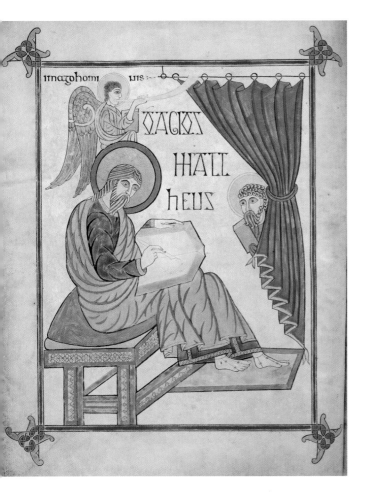

10.7. *St. Matthew,* from the *Lindisfarne Gospels.* ca. 700 CE. Tempera on vellum, 13½ × 9¼″ (34.3 × 23.5 cm). British Library, London (MS Cotton Nero D. 4)

century with a host of manuscripts. Artists at Jarrow probably used the illuminations in these manuscripts as models. The illustration of the prophet Ezra restoring the Bible from the *Codex Amiatinus* (fig. **10.8**) is undoubtedly an adaptation of Roman illuminations available at the monastery. The artist depicts the book cupboard, table, bench, and footstool by using oblique angles, which convey a sense of perspective, as if the objects recede into depth. So, too, do the shading in the drapery and the shadow of the inkwell on the floor promote a sense of depth. The artist also used color blending (evident on Ezra's garments and on his hands, face, and feet) to model form. Notice, in particular, how Ezra's cushion seems to have been depressed by the weight of his body, lending further substance to the prophet's figure.

Some scholars have suggested that Eadfrith, the illustrator of the Lindisfarne Matthew (see fig. 10.7), referred to the same Roman manuscript that inspired the Ezra artist, who produced a more faithful interpretation of it. Indeed, identical poses and parallel features such as the bench are too conspicuous to be ignored. However, Eadfrith was eager, or perhaps felt required, to maintain some Hiberno-Saxon traditional devices;

unlike the Ezra artist, he decorated the bench with multiple patterns and suggested depth in the drapery by juxtaposing near complementary colors, playing off the reddish folds against the greenish cloth. Eadfrith employed the same rigid outline, geometric decoration, and flat planes of color that he used for the manuscript's nonfigural pages, such as the Cross page (see fig. 10.6).

THE BOOK OF KELLS The Hiberno-Saxon manuscript style reached its climax a hundred years after the *Lindisfarne Gospels* in the *Book of Kells,* the most elaborate codex of Celtic art. It was probably made, or at least begun, at the end of the eighth or the beginning of the ninth century at the monastery on the island of Iona, off the western coast of Scotland, which had been founded by Irish monks in the sixth century. The book's name derives from the Irish monastery of Kells, where the manuscript was housed from the late ninth century until the seventeenth century. Its many pages reflect a wide array of influences from the Mediterranean to the English Channel.

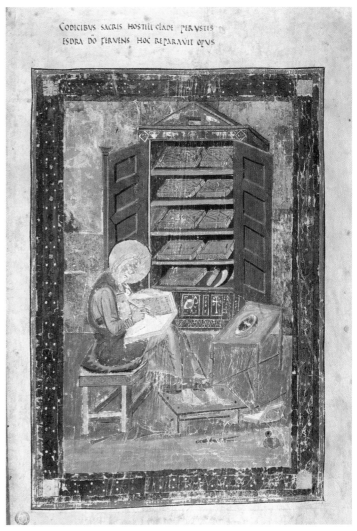

10.8. *Ezra Restoring the Bible,* from the *Codex Amiatinus.* Early 8th century. Tempera on vellum, 20 × 13½″ (50.5 × 34.3 cm). Biblioteca Medicea Laurenziana, Florence

The Chi Rho Iota monogram page illustrates Christ's initials, *XPI*, in Greek (fig. **10.9**). Alongside them appear the words *Christi autem generatio,* or "now this is how the birth of Christ came about," heralding the beginning of the Book of Matthew (1:18), in which the birth of Jesus is celebrated. The Chi Rho Iota page has much the same swirling design as the Cross page from the *Lindisfarne Gospels,* and a viewer can also see parallels to contemporary jewelry, such as the *Tara Brooch* (see *Materials and Techniques*, page 313).

On the Chi Rho Iota page, the rigid geometry of the Lindisfarne Cross page and the *Tara Brooch* has been relaxed somewhat, and for the first time images of humans are incorporated into the design. The very top of the X-shaped Chi sprouts a recognizable face, while along its shaft are three angels with wings. And in a touch of enchanting fantasy, the tendril-like P-shaped Rho ends in a human head that has been hypothesized to be a representation of Christ. More surprising still is the introduction of the natural world. Nearly hidden in the ornamentation, as if playing a game of hide-and-seek, are cats and mice, butterflies, even otters catching fish. No doubt they performed a symbolic function for medieval readers, even if the meaning is not apparent to us. The richness and intricacy of the illustration compels concentration, establishing a direct connection between the viewer and the image in much the same way as does the fixed, direct gaze of the holy figure in an Early Byzantine icon. In each work, icon and manuscript illumination, the power of the image is so strong that the viewer virtually enters into its realm, forgetting the world outside its frame.

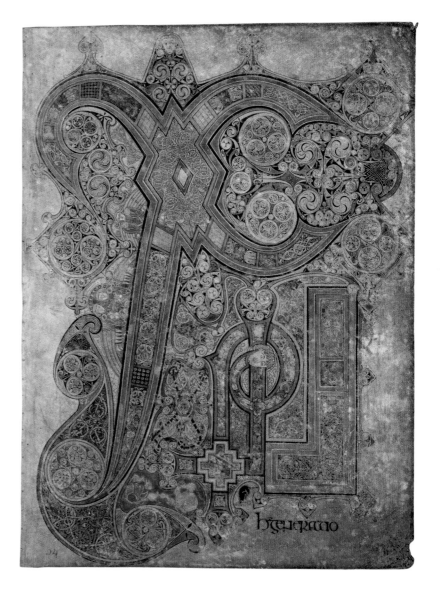

10.9. Chi Rho Iota page, from *Book of Matthew* (1:18), from the *Book of Kells*. ca. 800 CE. Ink and pigments on vellum, 13 × 9¹⁄₂″ (33 × 24.1 cm). Trinity College Library, Dublin

CAROLINGIAN ART

During the late eighth century a new empire developed out of the collection of tribes and kingdoms that dominated northern continental Europe. This empire, which united most of Europe from the North Sea to Spain and as far south as Lombardy in northern Italy, was founded by Charlemagne, who ruled as king of the Franks from 768. Pope Leo III bestowed on him the title of emperor of Rome in St. Peter's basilica on Christmas Day in the year 800, pronouncing him successor to Constantine, the first Christian emperor. Although Charlemagne was able to resist the pope's attempts to assert his authority over the newly created Catholic empire, there was now an interdependence of spiritual and political authority, of church and state, that would define the history of Western Europe for many centuries.

The emperors were crowned in Rome, but they did not live there. Charlemagne built his capital at the center of his power, in Aachen (Aix-la-Chapelle), located in what is now Germany and close to France, Belgium, and the Netherlands. The period dominated by Charlemagne and his successors, roughly from 768 to 877, is labeled Carolingian (derived from Charlemagne's Latin name, *Carolus Magnus*, meaning "Charles the Great"). Among Charlemagne's goals were to better the administration of his realm and the teaching of Christian truths. He summoned the best minds to his court, including Alcuin of York, the most learned scholar of the day, to restore ancient Roman learning and to establish a system of schools at every cathedral and monastery. The emperor took an active hand in this renewal, which went well beyond a mere interest in the old books to include political objectives. He modeled his rule after the Roman Empire under Constantine and Justinian—rather than their pagan predecessors—and proclaimed a *renovatio imperii romani*, a "renewal of imperial Rome," his efforts aided by the pope who had crowned him Holy Roman Emperor. The artists working for Charlemagne and other Carolingian rulers consciously sought to emulate Rome; by combining their admiration for antiquity with native northern European features, they produced original works of art of the highest quality.

Sculpture

A bronze *Equestrian Statue of a Carolingian Ruler* (fig. **10.10**), once thought to be Charlemagne himself but now generally assigned to his grandson Charles the Bald, conveys the political objectives of the Carolingian dynasty. The ruler, wearing imperial robes, sits as triumphantly on his steed as if he were on a throne. In his hand is an orb signifying his domination of the world. The statue is probably modeled on a now lost antique Roman equestrian statue of Theodoric, which Charlemagne had brought from Ravenna for the courtyard of his imperial palace. There are other possible sources, including a bronze equestrian statue of Marcus Aurelius (see fig. 7.21), mistakenly thought to represent Constantine, the first Christian Emperor, and thus also an appropriate model for the ambitious Charlemagne.

The Carolingian statue is not a slavish copy of its antique model. Compared to the statue of Marcus Aurelius, it is simpler, less cluttered with detail, in order to communicate the significant message that the Carolingian rulers were heirs to the Roman imperial throne. What is most striking is the difference in size: Marcus Aurelius stands more than 11 feet high, while the Carolingian figure does not reach 10 inches. Yet the diminutive statue expresses as much majesty and dignity as the more monumental example. Given the metalwork tradition of the Franks, the miniaturization is not only appropriate, but might in itself suggest value. Unfortunately, we do not know the audience for the work or how it was used, though its smallness could relate to portability.

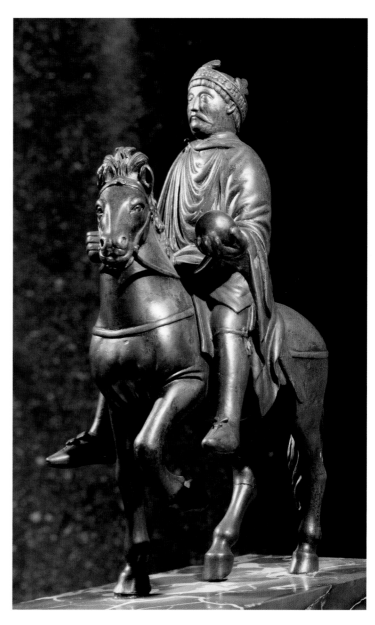

10.10. *Equestrian Statue of a Carolingian Ruler* (Charles the Bald?). 9th century. Bronze. Height 9$\frac{1}{2}$″ (24.4 cm). Musée du Louvre, Paris

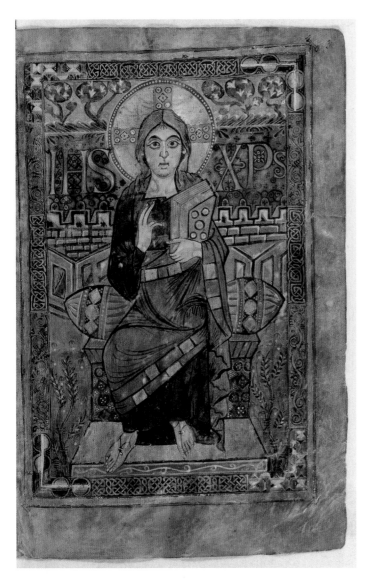

10.11. *Christ Enthroned,* from the *Godescalc Gospels (Lectionary).* 781–783 CE. Tempera on vellum, 12⅝ × 8¼″ (32.4 × 21.2 cm). Bibliothèque Nationale, Paris

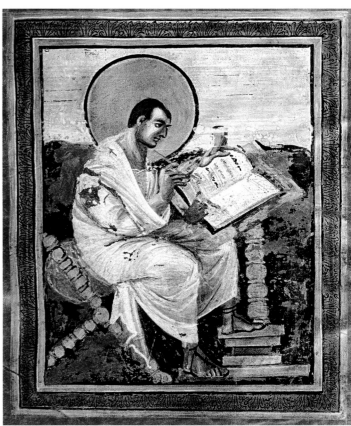

10.12. *St. Matthew,* from the *Gospel Book of Charlemagne (Coronation Gospels).* ca. 800–810 CE. Ink and colors on vellum, 13 × 10″ (33 × 25.4 cm). Kunsthistorisches Museum, Vienna

Illuminated Books

Charlemagne's interest in promoting learning and culture required the production of large numbers of books by his scriptoria. He established an "academy" at his court and encouraged the collecting and copying of many works of ancient Roman literature. In fact, the oldest surviving texts of many Classical Latin authors are found in Carolingian manuscripts that were long considered of Roman origin. This very page is printed in letters the shapes of which derive from the script in Carolingian manuscripts. The fact that these letters are known today as Roman rather than Carolingian is the result of this confusion.

THE GODESCALC GOSPELS One of the earliest manuscripts created in Charlemagne's imperial scriptoria is the *Godescalc Gospels,* named after the monk who signed his name to the book; it is generally thought to reflect manuscripts and objects that Charlemagne brought back with him from Rome. The manuscript's most compelling image is of a monumental enthroned Christ (fig. **10.11**), whose large staring eyes communicate directly with the viewer. His purple garments denote imperial stature. (Purple was the color of royalty in the Roman world.) The concentration on imperial imagery reflects Charlemagne's personal ambitions, which were to be realized about 20 years later, when he received the title of Holy Roman Emperor in 800. Hard lines and swirling patterns around the knees suggest where drapery falls over the body, and white lines on the hands, neck, and face indicate highlights. It is as if the artist is attempting to emulate Roman modeling, but does so in a northern manner, by using linear patterns.

Christ sits within an enclosed garden, a motif reminiscent of Roman painting (see fig. 7.55), but transformed here into flat decorative elements, almost like the designs on a carpet. The outlined letters of Christ's name and the frame, composed of interlace patterns, are reminiscent of metalwork (see figs. 10.1–10.3) and Hiberno-Saxon illuminations (see figs. 10.5–10.7). A great painter has fused the heritage of Rome with the decorative devices traditionally employed by northern European artists.

This manuscript includes a dedicatory poem commemorating the baptism of Charlemagne's sons by Pope Hadrian in Rome in 781. By bringing his sons to Rome to be baptized Charlemagne acknowledged the authority of the pope in ecclesiastical matters; in turn, the pope placed himself and all of Western Christianity under the protection of the emperor.

THE GOSPEL BOOK OF CHARLEMAGNE The *Gospel Book of Charlemagne* (also known as the *Coronation Gospels*, because later German emperors swore on this book during their coronations) is said to have been found in Charlemagne's tomb and is thought to have been produced at his court. Looking at the page with St. Matthew (fig. **10.12**), we can hardly believe that such a work could have been executed in northern Europe and less than a generation after the *Godescalc Gospels*. Were it not for the large golden halo, the evangelist might almost be mistaken for the portrait of a Classical author, such as the one of Menander (fig. **10.13**) painted at Pompeii almost eight centuries earlier. Since the artist shows himself so fully conversant with the Roman tradition of painting and since his manner of painting is so clearly Mediterranean, some scholars claim that he must have come from Byzantium or Italy. This is evident throughout the work, from the painterly modeling of the forms to the acanthus ornament on the wide frame, which makes the picture seem like a window.

THE GOSPEL BOOK OF ARCHBISHOP EBBO OF REIMS Less reflective of Classical models, but equally reliant on them, is a miniature painted some three decades later for the *Gospel Book of Archbishop Ebbo of Reims* (fig. **10.14**). The subject is once again St. Matthew, and the pose is similar to that in the *Gospel Book of Charlemagne*, but this picture is filled with a vibrant energy that sets everything into motion. The thickly painted drapery swirls about the figure, the hills heave upward, and the architecture and vegetation seem tossed about by a whirlwind. Even the acanthus pattern on the frame assumes a strange, flamelike character. The evangelist has been transformed from a Roman author setting down his thoughts into a man seized with the frenzy of divine inspiration, a vehicle for recording the Word of God. The way the artist communicates this energy, particularly through the expressive use of flickering line, employing his brush as if it were a pen, recalls the endless interlaced movement in the ornamentation of Hiberno-Saxon manuscripts (see figs. 10.6, 10.9).

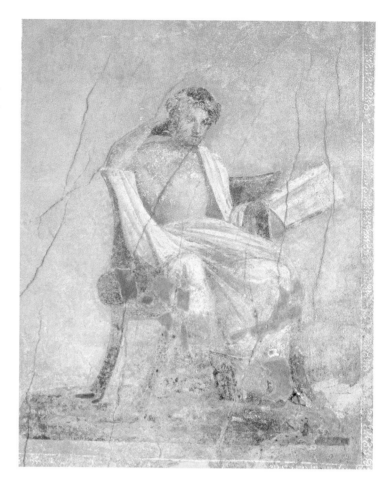

10.13. *Portrait of Menander.* ca. 70 CE. Wall painting. House of Menander, Pompeii

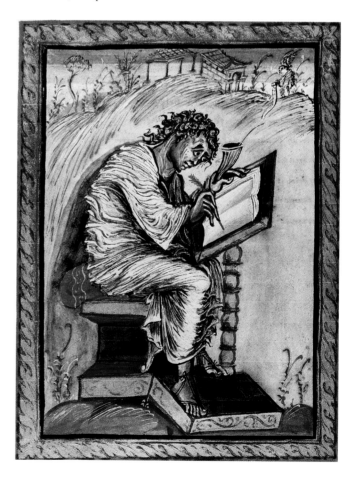

10.14. *St. Matthew,* from the *Gospel Book of Archbishop Ebbo of Reims.* 816–835 CE. Ink and colors on vellum, 10¼ × 8¾″ (26 × 22.2 cm). Bibliothèque Municipale, Épernay, France

THE UTRECHT PSALTER The imperial scriptorium at Reims responsible for the *Ebbo Gospels* also produced perhaps the most extraordinary of all Carolingian manuscripts, the *Utrecht Psalter* (fig. **10.15**). A *psalter* is an Old Testament book containing psalms, hymns to God that were traditionally believed to have been written by King David. Here, in the *Utrecht Psalter*, energetic form is expressed with pen drawings. That the artist has followed a much older model is indicated by the architectural and landscape settings of the scenes, which recall the Column of Trajan (see fig. 7.29). Another indication is the use of Roman capital lettering, which had gone out of general use several centuries before. The rhythmic quality of the draftsmanship, however, gives these sketches an expressive unity that could not have been present in earlier pictures. Without this rhythmic quality, the drawings of the *Utrecht Psalter* would carry little conviction, for the poetic language of the psalms does not lend itself to illustration in the same way as the narrative portions of the Bible. Perhaps we can attribute the drawn rather than painted style to the influence of an antique scroll that no longer survives.

The artist represented the psalms by taking each phrase literally and then visualizing it in some way. Thus the top of our page illustrates, "Let them bring me unto thy holy hill, and to thy tabernacles" (Psalms 43:3). Toward the bottom of the page, we see the Lord reclining on a bed, flanked by pleading angels. The image is based on the words, "Awake, why sleepest thou, Oh Lord?" (Psalms 44:23). On the left, the faithful crouch before the Temple ("for . . . our belly cleaveth unto the earth" [Psalms 44:25]), and at the city gate in the foreground they are killed ("as sheep for the slaughter"[Psalms 44:22]). In the hands of a less imaginative artist, this procedure could well have turned into a tiresome game; here it has the force of great drama. The wonderfully rhythmic and energetic quality of the draftsmanship renders these sketches both coherent and affecting.

THE LINDAU GOSPELS COVER The style of the Reims School is also apparent in the reliefs on the front cover of the *Lindau Gospels* (fig. **10.16**). Given the Carolingian investment in preserving and embellishing the written word, the cover was a fittingly sumptuous protection for a book. This master-

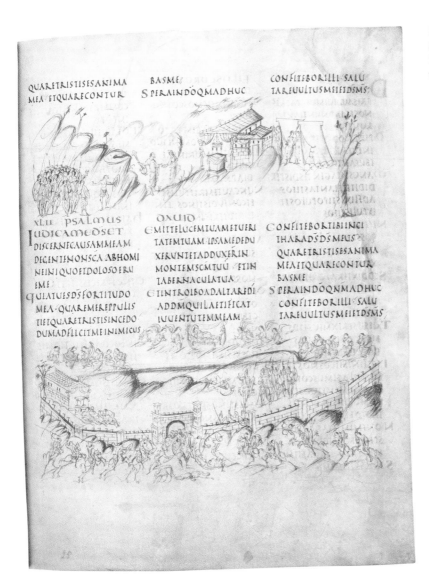

10.15. Illustrations to Psalms 43 and 44, from the *Utrecht Psalter*. ca. 820–832 CE. Ink on vellum, $13 \times 9\frac{7}{8}$" (33 × 25 cm). University Library, Utrecht, the Netherlands

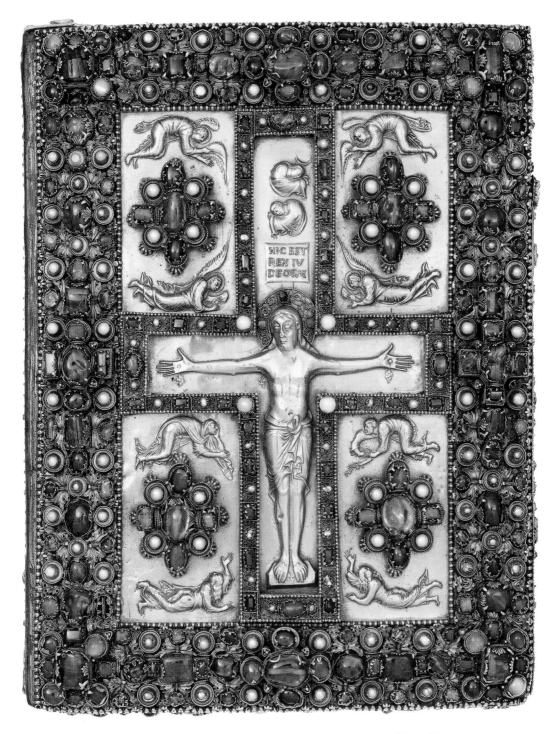

10.16. Front cover of binding, *Lindau Gospels*. ca. 870 CE. Gold and jewels, 13³/₄ × 10¹/₂″ (35 × 26.7 cm). The Pierpont Morgan Library, New York

piece of the goldsmith's art, dating from the third quarter of the ninth century, shows how splendidly the Germanic metalwork tradition was adapted to the Carolingian revival of the Roman Empire. The clusters of semiprecious stones are not mounted directly on the gold ground but raised on claw feet or arcaded **turrets** (towerlike projections), so that light can penetrate from beneath to bring out their full brilliance. The crucified Christ betrays no hint of pain or death. He seems to stand rather than to hang, his arms spread out in a solemn gesture.

Architecture

Although relatively few Carolingian buildings survive, excavations demonstrate a significant increase in building activity during the Carolingian period, a reflection of the security and prosperity enjoyed during Charlemagne's reign. As was the

case with his painters, Charlemagne's architects sought to revive the splendor of the Roman Empire, which they did by erecting buildings whose models were largely from Rome and Ravenna, both of which Charlemagne visited. While Rome had been the capital of the Empire, Ravenna had been a Christian imperial outpost, thus a worthy prototype for what Charlemagne hoped to create in his own land.

PALACE CHAPEL OF CHARLEMAGNE, AACHEN

Toward the end of the eighth century, Charlemagne erected the imperial palace at Aachen. Prior to this time, Charlemagne's court was itinerant, moving from place to place as the political situation required. To signify Charlemagne's position as a Christian ruler, architects modeled his palace complex on Constantine's Lateran Palace in Rome. Charlemagne's palace included a basilica, called the Royal Hall, which was linked to the Palace Chapel (fig. **10.17**). The plan for the Palace Chapel was probably inspired by the Church of San Vitale in Ravenna, which the emperor saw firsthand (see figs. 8.21–8.24). It was designed by Odo of Metz, probably the earliest architect north of the Alps known to us by name. Einhard, Charlemagne's trusted adviser and biographer, supervised the project.

The debt to San Vitale is especially clear in cross section (fig. **10.18**; compare with fig. 8.22). The chapel design is by

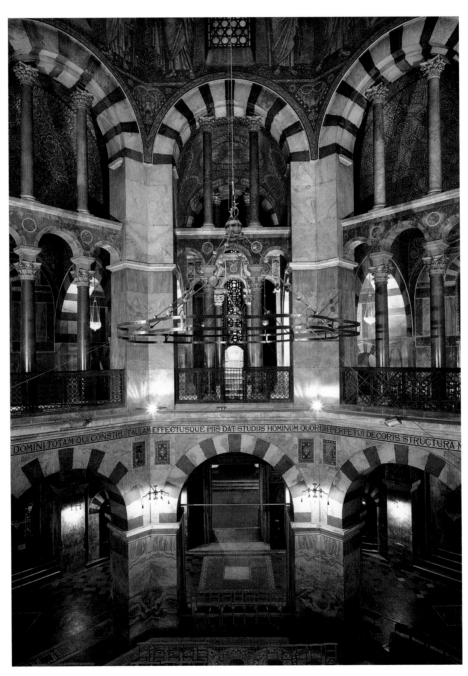

10.17. Odo of Metz. Interior of the Palace Chapel of Charlemagne, 792–805 CE. Aachen, Germany

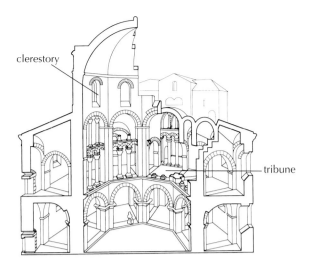

10.18. Section of the Palace Chapel of Charlemagne (after Kubach)

An even more elaborate westwork formed part of one of the greatest basilican churches of Carolingian times: the Abbey Church of Saint-Riquier at the Monastery of Centula in northeastern France. The monastery was rebuilt in 790 by Abbot Angilbert, a poet and scholar of Charlemagne's court. The monastery was destroyed long ago, but we know its design from descriptions, drawings, and prints, such as the engraving reproduced here (fig. **10.19**). The monastery included not only the abbey church, dedicated to Saint-Riquier, but also two chapels, one dedicated to St. Mary, the other to St. Benedict, founder of the Benedictine order, whose rule the monks followed. (See *Primary Source*, page 328.)

Benedict of Nursia established his order in 529 when he founded a monastery in Monte Cassino, south of Rome. Benedict's rules required monks to labor, study, and pray, providing for both the sound administration of the

no means a mere echo of San Vitale but a vigorous reinterpretation of it. Piers and vaults are impressively massive compared with San Vitale, while the geometric clarity of the spatial units is very different from the fluid space of the earlier structure. To construct such a building on northern soil was a difficult undertaking. Columns and bronze gratings were imported from Italy, and expert stonemasons must have been hard to find. The columns are placed within the arches of the upper story, where they are structurally unnecessary, but where they accentuate a sense of support and create opportunities to offer Roman details. San Vitale had been designed to be ambiguous, to produce an otherworldly interior space. Aachen, by comparison, is sturdy and sober. The soft, bulging curvilinear forms of San Vitale's arcades are replaced with clear-cut piers at Aachen. They make manifest their ability to support the heavy weight of Aachen's dome, while the dome at San Vitale seems light and to hover above the interior space of the building.

Equally important is Odo's scheme for the western entrance, now largely obscured by later additions and rebuilding. At San Vitale, the entrance consists of a broad, semidetached narthex with twin stair turrets, placed at an odd angle to the main axis of the church. At Aachen, these elements are molded into a tall, compact unit, in line with the main axis and attached to the chapel itself. This monumental structure, known as a **westwork** (from the German *westwerk*), makes one of its first appearances here.

Charlemagne placed his throne in the **tribune** (the gallery of the westwork), behind the great opening above the entrance. From here the emperor could emerge into the view of people assembled in the atrium below. The throne faced an altar dedicated to Christ, who seemed to bless the emperor from above in the dome mosaic. Thus, although contemporary documents say very little about its function, the westwork seems to have served initially as a royal compartment or chapel.

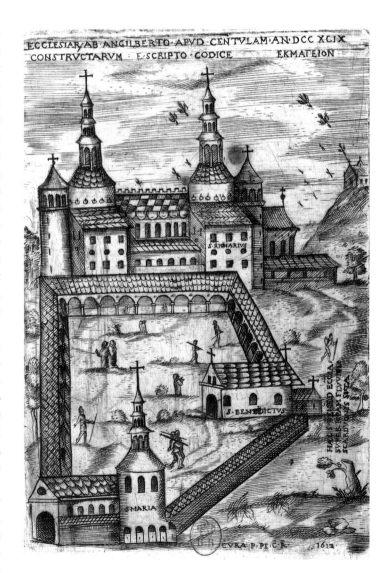

10.19. Abbey Church of Saint-Riquier, Monastery of Centula, France. Dedicated ca. 790. A 1673 engraving after a 1612 view by Petau, from an 11th-century manuscript illumination. Bibliothèque Nationale, Paris

Hariulf (ca. 1060–1143)

From *History of the Monastery of Saint-Riquier*

Hariulf was a monk at Saint-Riquier until 1105, when he became abbot of St. Peter's at Oudenbourg in Belgium.

The church dedicated to the Saviour and St. Richarius ... was among all other churches of its time the most famous. ... The eastern tower is close to the sepulcher of St. Richarius. ... The western tower is especially dedicated to the Savior. ...

If one surveys the place, one sees that the largest church, that of St. Richarius, lies to the north. The second, somewhat smaller one, which has been built in honor of our Lady on this side of the river, lies to the south. The third one, the smallest, lies to the east. The cloisters of the monks are laid out in a triangular fashion, one roof extending from St. Richarius' to St. Mary's, one from St. Mary's to St. Benedict's and one from St. Benedict's to St. Richarius'. ... The monastery is so arranged that, according to the rule laid down by St. Benedict, all arts and all necessary labors can be executed within its walls. The river flows through it, and turns the mill of the brothers.

SOURCE: CAECILIA DAVIS-WEYER, *EARLY MEDIEVAL ART 300–1150* (UPPER SADDLE RIVER, NJ: PRENTICE HALL, 1ST ED., 1971)

monastery and the spiritual needs of individual monks. (See end of Part II, *Additional Primary Sources*.) By the ninth century, largely due to support from Charlemagne, Benedict's rules for monastic life had been accepted by monasteries across Europe. Charlemagne recognized that the orderliness of the rules was consistent with his broader goal to provide

10.20. Westwork, Abbey Church. Late 9th century CE, with later additions. Corvey, Germany

stability through a sound, working system of governance, both civil and religious.

The three buildings of the monastery at Centula are connected by a covered walkway, forming a triangular **cloister** (an open court surrounded by a covered arcaded walk, used for meditation, study, and exercise). This shape has symbolic significance, reflecting this particular monastery's dedication to the Holy Trinity. The plan of Saint-Riquier reads as a traditional basilica with a central nave flanked by side aisles and terminating in a transept and apse. In fact, Charlemagne sent to Rome for drawings and measurements of traditional basilicas to guide his local builders. In elevation, however, Saint-Riquier's multiple towers provide vertical accents that are very different from the longitudinal silhouette of the Early Christian basilica, such as Old St. Peter's (see fig. 8.5).

The westwork of Saint-Riquier balanced the visual weight of the transept and east end of the church; it also provided additional room for the liturgical needs of a large community, which numbered some 300 monks, 100 novices, and numerous staff. Twenty-five relics related to Christ were displayed in the westwork entrance, and above that was an upper chapel dedicated to the Savior. On feast days, and in particular, on Easter, the community positioned itself here for the beginning of an elaborate processional liturgy. Thus, to some extent the westwork functioned as a separate commemorative building, the conceptual equivalent of the Early Christian mausoleum and martyrium, but now attached to a basilican church.

ABBEY CHURCH, CORVEY Saint-Riquier was widely imitated in other Carolingian monastery churches. The best-preserved surviving example is the abbey church at Corvey (fig. **10.20**), built in 873–885. Except for the upper stories, which date from around 1146, the westwork retains much of its original appearance. It is impressive not only because of its height but also because of its expansive surfaces, which emphasize the clear geometry and powerful masses of the exterior. The westwork provided a suitably regal entrance, which may well be its greatest significance. But the westwork had functional benefits too. At Corvey musical notation

scratched on the walls of the gallery reminds us that the boys choir would have been positioned here, its voices spreading upward as well as throughout the church.

PLAN OF A MONASTERY, ST. GALL The importance of monasteries in the culture of the early medieval period and their close link with the imperial court are evident in the plan for a monastery at St. Gall in Switzerland (fig. **10.21**). The plan exists in a large, unique drawing on five sheets of parchment sewn together and is preserved in the chapter library at St. Gall. This drawing was sent by Abbot Haito of Reichenau to Gozbert, the abbot of St. Gall, for "you to study only," as an aid to him in rebuilding his monastery. We may therefore regard it as a model or ideal plan, to be modified to meet local needs.

The monastery plan shows a complex, self-contained unit filling a rectangle about 500 by 700 feet and providing a logical arrangement of buildings based on their function. From the west end of the monastery, the main entrance path passes between stables and a hostelry toward a gate. This admits the visitor to a colonnaded semicircular **portico** (porch) flanked by two round towers forming a westwork that would have

loomed above the low outer buildings. The plan emphasizes the church as the center of the monastic community. This church is a traditional basilica (see figs. 8.4–8.6), with an apse at each end. The nave and aisles, which contain many other altars, do not form a single continuous space but are subdivided into compartments by screens. There are numerous entrances: two beside the western apse, others on the north and south flanks.

This arrangement reflects the functions of a monastery church, which was designed for the liturgical needs of the monks rather than for a lay congregation. Adjoining the church to the south is an arcaded cloister, around which are grouped the monks' dormitory (on the east side), a refectory (dining hall) and kitchen (on the south side), and a cellar. The three large buildings north of the church are a guesthouse, a school, and the abbot's house. To the east are the infirmary, a chapel, and quarters for novices (new members of the community), the cemetery (marked by a large cross), a garden, and coops for chickens and geese. On the south side are workshops, barns, and other service buildings.

The St. Gall plan was laid out using a **module** (standard unit). This module, expressed as parts or multiples of $2\frac{1}{2}$ feet,

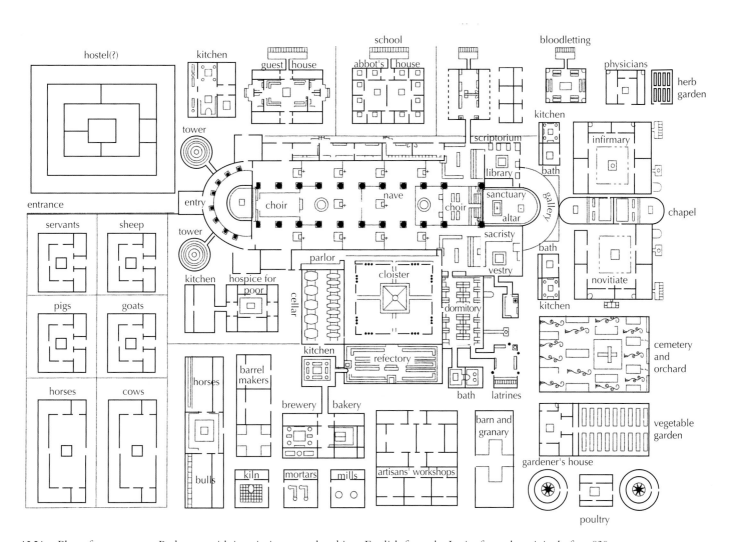

10.21. Plan of a monastery. Redrawn, with inscriptions translated into English from the Latin, from the original of ca. 820 CE. Red ink on parchment, $28 \times 44\frac{1}{8}$" (71.1 × 112.1 cm). Stiftsbibliothek, St. Gall, Switzerland

St. Angilbert (ca. 750–814)

From *Customary for the Different Devotions*

Angilbert, a member of Charlemagne's court, became lay abbot of Saint-Riquier in 781 and sponsored the monastery's rebuilding. His description reveals how the resident monks moved from one part of the basilica to another while chanting the devotions prescribed in The Rule *of St. Benedict.*

When the brethren have sung Vespers and Matins at the altar of the Savior, then one choir should descend on the side of the holy Resurrection, the other one on the side of the holy Ascension, and

having prayed there the processions should in the same fashion as before move singing toward the altars of St. John and St. Martin. After having prayed they should enter from both sides through the arches in the middle of the church and pray at the holy Passion. From there they should go to the altar of St. Richarius. After praying they should divide themselves again as before and go to the altars of St. Stephen and St. Lawrence and from there go singing and praying to the altar of the Holy Cross. Thence they should go again to the altar of St. Maurice and through the long gallery to the church of St. Benedict.

SOURCE: CAECILIA DAVIS-WEYER, *EARLY MEDIEVAL ART 300–1150* (ENGLEWOOD CLIFFS, NJ: PRENTICE HALL, 1ST ED., 1971)

can be found throughout the plan, from the division of the church to the length of the cemetery plots. The imposition of a module on the plan of St. Gall is a tangible manifestation both of the administrative orderliness and stability so sought after by Charlemagne and the aims of monasticism, as defined by Benedict of Nursia's *Rule*.

Unfortunately, stability proved elusive. Upon the death of Charlemagne's son, Louis I, in 840, a bitter battle arose among Louis's sons for the empire built by their grandfather. The brothers eventually signed a treaty in 843 dividing the empire into western, central, and eastern parts: Charles the Bald became the West Frankish King, founding the French Carolingian dynasty in what became modern France; Louis the German became the East Frankish King, ruling an area roughly that of today's Germany; and Lothair I became the Holy Roman Emperor, ruling the middle area running from the Netherlands down to Italy. The distribution of the Carolingian domain among Louis's heirs weakened the empire, brought a halt to Carolingian cultural efforts, and eventually exposed continental Europe to attack by the Moslems from the south, the Slavs and Magyars from the east, and the Vikings from north. The Vikings invaded northwestern France and through a land grant from Charles the Bald occupied the area now known as Normandy.

Although political stability ultimately eluded Charlemagne's heirs, the artists of the Carolingian period had been able to create an enduring art that combined the northern reliance on decoration—on surface, pattern, and line—with the Mediterranean concern for solidity and monumentality. Carolingian art was to serve as a worthy model for emulation by artists and patrons when the revival of Charlemagne's vision of a united and stable Europe would reappear during the next centuries.

OTTONIAN ART

When the last East Frankish monarch died in 911, the center of political power consolidated in the eastern portion of the former Carolingian empire, in an area roughly equivalent to modern Germany, under German kings of Saxon descent. Beginning with Henry I, these kings pushed back invaders, reestablished an effective central government, improved trade

and the economy, and began a new dynasty, called Ottonian after its three principal rulers: Otto 1, Otto II, and Otto III. During the Ottonian period, which lasted from 919 to 1024, Germany was the leading nation of Europe politically and artistically. German achievements in both areas began as revivals of Carolingian traditions but soon developed an original character.

The greatest of the Ottonian kings, Otto I, revived the imperial ambitions of Charlemagne. After marrying the widow of a Lombard king in 951, he extended his rule over most of what is now northern Italy. Then, in 962, he was crowned emperor by Pope John XII, at whose request he conquered Rome. The emperor later deposed this pope for conspiring against him.

Architecture

Among the most pressing concerns of the Ottonian emperors was the reform of the Church, which had become corrupt and mismanaged. They did this by establishing closer alliances with the papacy and by fostering monastic reforms, which they supported by sponsoring many new religious buildings. The renewal of impressive building programs effectively revived the architectural ambitions of their Carolingian predecessors, at the same time conveying and furthering the Ottonians' aspirations to restore the imperial glory of Christian Rome.

NUNNERY CHURCH OF ST. CYRIAKUS, GERNRODE

One of the best-preserved Ottonian churches was built in 961 for the nunnery at Gernrode (fig. **10.22**), founded by Gero, margrave (military governor) under Otto I. The church was dedicated to St. Cyriakus and relied on the basic form of the Early Christian basilica (see figs. 8.4–8.6), which had also dominated architectural planning during the Carolingian period (see page 328). However, at St. Cyriakus, a gallery, not present in the Early Christian basilica, has been inserted between the nave arcade and the clerestory. A series of columns and piers divide the gallery in such a way that the piers of the gallery are positioned over the piers of the nave arcade. This provides a series of repeated vertical accents, effectively dividing the building into vertical sections.

This emphasis on verticality is different from the overwhelming effect of horizontality that characterizes Early Christian buildings and indicates a trend that will be significant in the later development of medieval architecture. Neither the origin nor the intended function of the gallery is clear. Some scholars have noted similarities to galleried Byzantine churches, such as two fifth-century examples in Salonika in Greece. It is possible that the gallery at St. Cyriakus contained altars, as was the case in the galleried westworks of Carolingian churches, such as at Corvey (see fig. 10.20). They also might have provided space for the choir, another parallel to the use of Corvey's gallery (see page 329).

ST. MICHAEL'S AT HILDESHEIM The most ambitious patron of architecture and art in the Ottonian age was Bernward, who became bishop of Hildesheim after having been court chaplain. Bernward was also tutor of Otto III during the regency of his

ART IN TIME

785 CE—Construction starts on Great Mosque at
Córdoba Spain

ca. 820–832—*Utrecht Psalter* produced in France

843—Charlemagne's three grandsons divide his empire

mother the Empress Theophano, wife of Otto II and a Byzantine princess in her own right. Bernward's chief monument is the Benedictine abbey church of St. Michael's at Hildesheim. The plan of this monastic church (fig. **10.23**) derives from that of Saint-Riquier at Centula (see fig. 10.19). With its two choirs and side entrances, it also recalls the monastery church of the St. Gall plan (see fig. 10.21). However, in St. Michael's the symmetry is carried much further. There are two identical transepts, each with a tower,

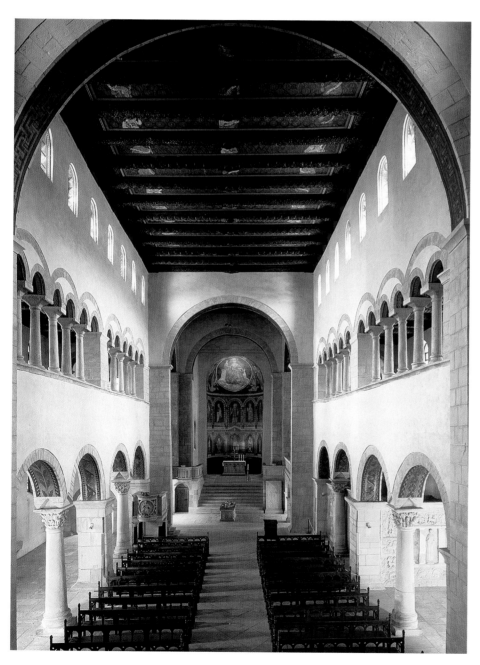

10.22. Interior, looking east, Church of St. Cyriakus. Founded 961 CE. Gernrode, Germany

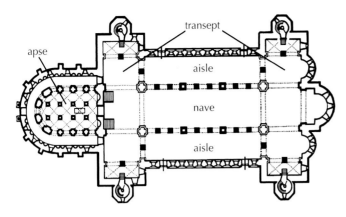

10.23. Reconstructed plan. Abbey Church of St. Michael's. 1001–1033 CE. Hildesheim, Germany. (after Beseler)

Thus, as in the St. Gall plan, a modular system governs the division of spaces. The module can also be seen on the exterior of the building, which reads as a series of cubes arranged by stacking. The first and third units correspond with the entrances, thus echoing the axis of the transepts. Moreover, since the aisles and nave are unusually wide in relation to their length, the architect's intention must have been to achieve a harmonious balance between the longitudinal and horizontal axes throughout the structure.

St. Michael's was severely damaged during the Second World War, but the restored interior (see fig. 10.25), with its great expanse of wall space between the arcade and clerestory, retains the majestic feeling of the original design. (The capitals of the columns date from the twelfth century; the painted wooden ceiling from the thirteenth.) The western choir is especially interesting. The architect raised its floor above the level of the rest of the church to make room for a half-buried basement chapel, or **crypt**. Monks could enter the crypt (apparently a special sanctuary for relics of the saint) from both the transept and the west. Arched openings pierced the walls and linked the crypt with the U-shaped ambulatory wrapped around it. The ambulatory originally must have been visible above ground, where it enriched the exterior of the choir, since there were windows in

where the transept and the nave cross, and a pair of stair turrets at the end of each transept (fig. **10.24**; see also 10.23). But the supports of the nave arcade, instead of being uniform, consist of pairs of columns separated by square piers (fig. **10.25**). This alternating system divides the arcade into three equal units, each with three openings. These units are equal in length to the width of the transepts, which are similarly divided into three compartments.

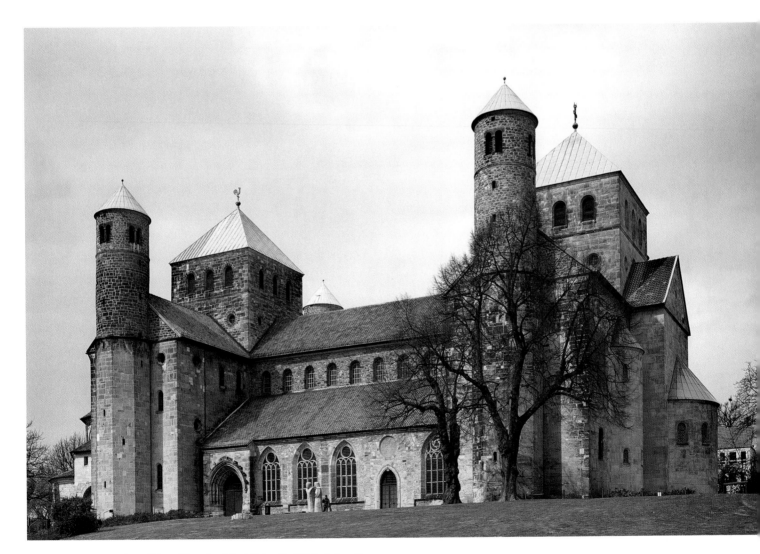

10.24. Exterior, Abbey Church of St. Michael's. Hildesheim, Germany

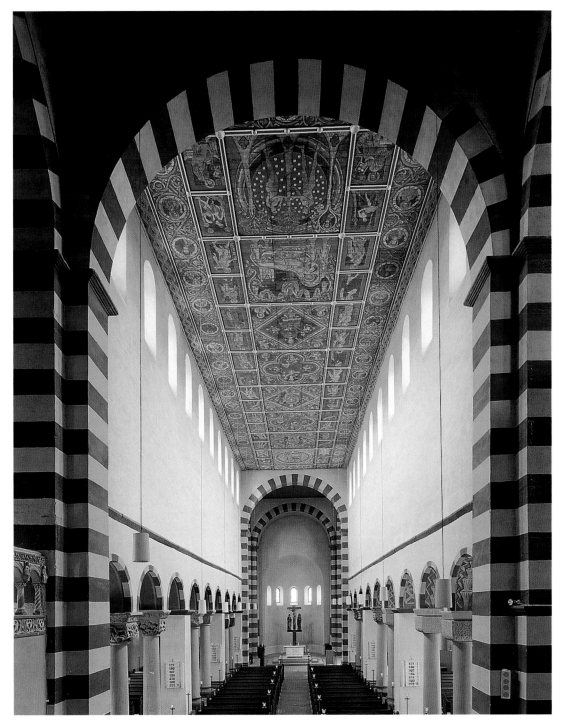

10.25. Interior, with view toward the apse (after restoration of 1950–1960), Abbey Church of St. Michael's. Hildesheim, Germany

its outer wall. Such crypts with ambulatories, usually housing the venerated tomb of a saint, had been introduced into Western church architecture during Carolingian times, and there is a crypt under the apse at St. Cyriakus at Gernrode. However, the design of St. Michael's is distinguished by the crypt's large scale and its careful integration with the rest of the building.

Metalwork

The Ottonian emperors' reliance on church authority to strengthen their own governmental rule encouraged them not only to build new churches but also to provide sumptuous works of art to decorate them. The works they and their cohorts sponsored were richly appointed and executed in expensive, often precious materials.

BRONZE DOORS OF BISHOP BERNWARD, HILDESHEIM

For St. Michael's at Hildesheim, Bernward commissioned a pair of extensively sculptured bronze doors (figs. **10.26** and **10.27**) that were finished in 1015, the year the crypt was consecrated. According to his biographer, Thangmar of Heidelberg,

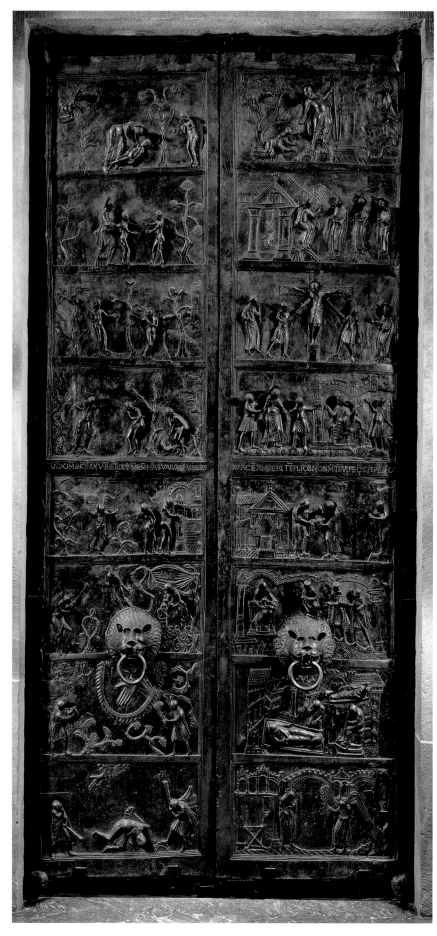

10.26. Doors of Bishop Bernward, Hildesheim Cathedral (originally made for Abbey Church of St. Michael's, Hildesheim). 1015 CE. Bronze, height approx. 16′ (4.8 m). Hildesheim, Germany

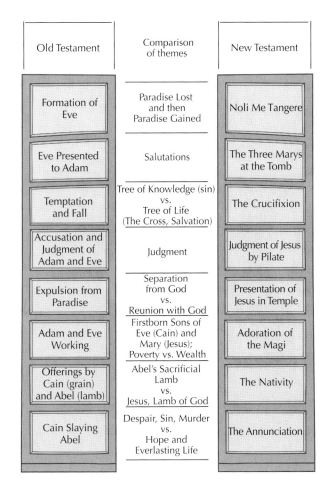

Old Testament	Comparison of themes	New Testament
Formation of Eve	Paradise Lost and then Paradise Gained	Noli Me Tangere
Eve Presented to Adam	Salutations	The Three Marys at the Tomb
Temptation and Fall	Tree of Knowledge (sin) vs. Tree of Life (The Cross, Salvation)	The Crucifixion
Accusation and Judgment of Adam and Eve	Judgment	Judgment of Jesus by Pilate
Expulsion from Paradise	Separation from God vs. Reunion with God	Presentation of Jesus in Temple
Adam and Eve Working	Firstborn Sons of Eve (Cain) and Mary (Jesus); Poverty vs. Wealth	Adoration of the Magi
Offerings by Cain (grain) and Abel (lamb)	Abel's Sacrificial Lamb vs. Jesus, Lamb of God	The Nativity
Cain Slaying Abel	Despair, Sin, Murder vs. Hope and Everlasting Life	The Annunciation

10.27. Schematic diagram of the scenes on the Doors of Bishop Bernward.

Bernward excelled in the arts and "distinguished himself remarkably in the science of metalwork and the whole art of building." So, he must have been closely involved in the project. The idea for the doors may have come to him as a result of his visit to Rome, where he could have seen ancient Roman (and perhaps Byzantine) doors of bronze or wood. He would also certainly have been aware of the bronze doors that Charlemagne had commissioned for his palace chapel at Aachen.

The doors at Hildsheim are considered by many scholars to be the first monumental sculptures created by the lost-wax process since antiquity (see *Materials and Techniques*, page 124). Each door was cast as one piece and measures over 16 feet high. They are also the first doors since the Early Christian period to have been decorated with stories. Our detail (fig. **10.28**) shows God accusing and judging Adam and Eve after they have committed the Original Sin of eating the forbidden fruit in the Garden of Eden. (This story is known as the Temptation and Fall.) Below it, in inlaid letters notable for their classical Roman character, is part of the inscription, with the date and Bernward's name. The inscription was added around 1035, when the doors were moved from the monastery of St. Michael and attached to the westwerk of Hildesheim Cathedral, where they would have been

seen by a larger public than in the monastic setting of St. Michael's. The new prominent setting indicates how valued they were in their own time.

The composition most likely derives from a manuscript illumination, since there are very similar scenes in medieval Bibles. Yet this is no mere imitation. The story is conveyed with splendid directness and expressive force. The accusing finger of the Lord, seen against a great void, is the focal point of the drama. It points to a cringing Adam, who passes the blame to Eve, who in turn passes it to the serpent at her feet.

The subjects on the left door are taken from the Old Testament and those on the right from the New Testament (see fig. 10.26). The Old Testament stories are presented chronologically from top to bottom, while the New Testament scenes move in reverse order, from bottom to top, suggesting the message of the Christian Bible is uplifting. When read as horizontal pairs, the panels deliver a message of the origin and redemption of sin through a system of **typology**, whereby Old Testament stories prefigure New Testament ones. For example, the *Temptation and Fall* (fig. **10.29**) is opposite the *Crucifixion*. In the center of the left panel is the tree whose fruit led to the Original Sin; in the center of the right panel is the cross on which Jesus was crucified, which medieval Christians believed was made from the wood of the tree from Eden and was therefore the instrument for redemption from the sin of that original act. Compositional similarities between the two scenes stress their typological relationship: In the left panel Adam and Eve's hands that flank the cross-shaped tree establish a visual parallel to the spears the soldiers use to pierce Christ's body on the right panel.

Eve plays a particularly significant role on the doors; in fact, the narrative begins with her formation, not with the creation of Adam, as might be expected. In the *Temptation and Fall*, Eve's attitude and gesture parallel those of the serpent at the right, who, like Eve, offers an apple. This parallel makes explicit Eve's role as seductive agent, accentuated by the way she holds the apple so closely to her chest that it almost appears as if she were grasping her breast rather than the fruit. With this gesture Eve's guilt in humankind's exile from Paradise is emphasized and her sexuality underscored.

While Early Christian writers had considered Eve responsible for the Original Sin, during the Ottonian period references to her guilt multiply and become more vigorous. This might be a result of efforts by Bishop Bernward and others to reform the morality of the clergy in an effort to restore the vow of celibacy to priests and monks, some of whom were known to allow their wives and children to cohabit monasteries. Thus, the burden of clerical immorality is, in effect, assigned to Eve, the first woman and the first seductress.

COLUMN OF BISHOP BERNWARD, HILDESHEIM

Those who visited St. Michael's at Hildesheim and those who lived in the monastery would have recognized Bernward's doors as a precious object suitable for a building with imperial associations, if only because it reminded them of doors made

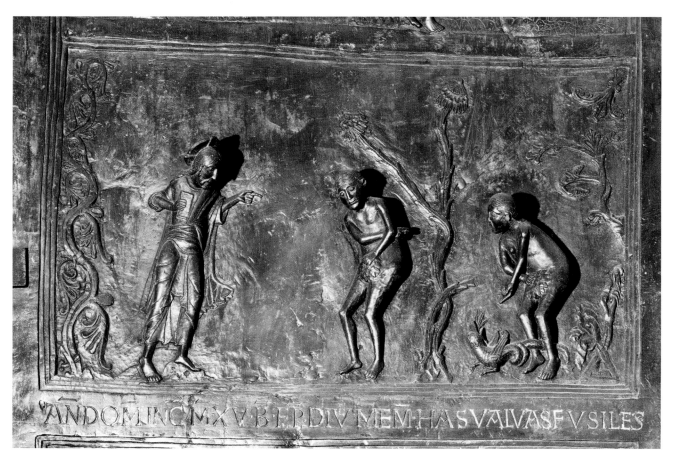

10.28. *Accusation and Judgment of Adam and Eve,* from the Doors of Bishop Bernward. Bronze, approx. 23 × 43″ (58.3 × 109.3 cm). Hildesheim, Germany

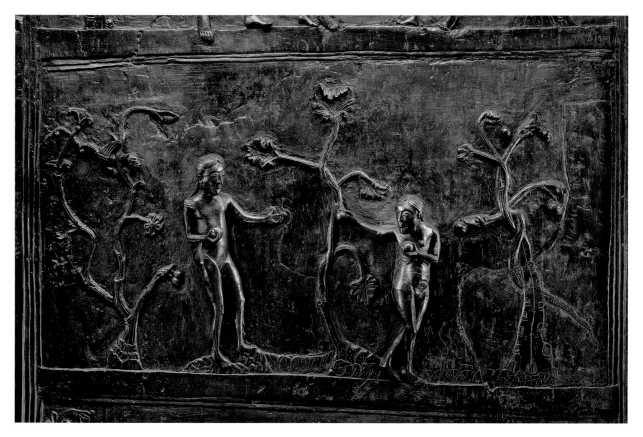

10.29. *Temptation and Fall,* from the Doors of Bishop Bernward. Bronze, approx. 23 × 43″ (58.3 × 109.3 cm). Hildesheim, Germany

for Charlemagne in Aachen and other bronze doors in Rome. Bernward made the allusions to Rome explicit when he commissioned for St. Michael's a bronze column with spiraling reliefs depicting Jesus' life (fig. **10.30**). Bernhard's column, which stands today in the transept of the cathedral, is a strong reminder of the Column of Trajan (see fig. 7.28) though it is only a tenth the size of the Roman example. The bishop was clearly pushing the Ottonian message of continuity with the ancient Roman emperors.

Ivories and Manuscripts: Conveyors of Imperial Grandeur

The right of the Ottonian monarchs to call themselves Roman emperors was challenged by Byzantine rulers, who continued to claim that title as their own even though the division of the Roman Empire into Eastern and Western empires was complete by the end of the fourth century. When Otto II married the Byzantine princess Theophano, Otto was able to use the full title Holy Roman Emperor with impunity. While early Ottonian illuminators faithfully replicated features of Carolingian manuscripts for the court school, later Ottonian manuscripts, as well as ivories, blend Carolingian and Byzantine elements into a new style of extraordinary scope and power. Byzantine artists working for the court provided an impetus for new ways of presenting both religious and imperial images. Ottonian manuscripts indicate an increasing interest on the part of artists and patrons in narrative cycles of Jesus' life, which is the period's most important contribution to the field of iconography.

CHRIST BLESSING OTTO II AND THEOPHANO An ivory of *Christ Blessing Emperor Otto II and Empress Theophano* (fig. **10.31**) commemorated their coronation and presents it as divinely sanctioned. In composition and style the ivory is quite similar to the Byzantine ivory of *Christ Crowning Romanos and Eudokia* (see fig. 8.42), carved a generation or so earlier. The composition of both works is identical: A long-haired, bearded Christ (identified by a halo inscribed with a cross) is elevated in the center of each panel and anoints the empress and emperor, who flank him. In both ivories the imperial costumes are composed of similar elaborate geometric surface decorations. This similarity argues for the Otto II ivory being an eastern import, as does the inscription, which seems to be the work of a Greek using both Greek and Latin letters. However, because Otto's costume is not accurate for a Byzantine ruler's coronation, and because the inscription tell us that the donor—who huddles in front of Otto's stool and grasps the leg of the larger stool that supports Christ—was an Ottonian bishop known to be a resident in Italy, it is more likely that the ivory was produced within Ottonian lands in Italy. No matter where this work was produced, it demonstrates the interest of the Ottonian court in importing Byzantine style as well as objects, thus establishing on another level a connection to the art of the Mediterranean. Here again, the king is presented as the Holy Roman emperor, a divinely ordained ruler.

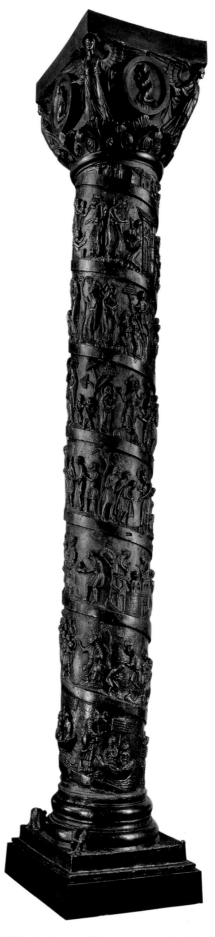

10.30. Column of Bishop Bernward, Hildesheim Cathedral (originally made for Abbey Church of St. Michael's). 1015–1022 CE. Bronze. Height 12′5″ (3.8 m). Hildescheim, Germany

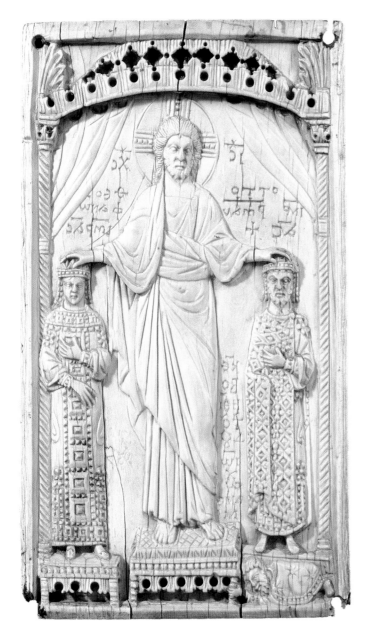

10.31. *Christ Blessing Emperor Otto II and Empress Theophano.* 982–983 CE. Ivory, $7^1/_8 \times 4''$ (18.3 × 10.3 cm). Musée du Moyen Âge (Cluny), Paris

The manuscript is dated around 1000, not long after Otto III was crowned king of Germany at Aachen in 986 and Holy Roman Emperor at Rome in 993. The way Otto is represented visually in the manuscript thus parallels historical facts; he is presented here as rightful and worthy heir to Roman and Byzantine emperors as well as to Charlemagne, and his imperial dignity is enhanced by association with Christ, a reverse of the case of Early Christian depictions, in which Christ is ennobled in the fashion of a Roman emperor. The soft pastel hues of the background recall the illusionism of Graeco-Roman landscapes and the *Quedlinburg Itala* fragment (see fig. 8.18). Such a style shows that the artist was probably aware of Roman, as well as Byzantine, manners of representation.

The *Gospel Book of Otto III* contains one of the most extensive sets of illustrations of the life of Christ. The scene of *Jesus Washing the Feet of St. Peter* (fig. **10.33**) once again contains strong echoes of ancient painting, transmitted through Byzantine art. The architectural frame around Jesus is a late descendant of the kind of architectural perspectives we saw in Roman wall painting (see figs. 7.52 and 7.56), and the intense gold background reminds us of Byzantine painting and mosaics, which the Ottonian artist has put to new use. What was an architectural vista in the mural from Boscoreale (see fig. 7.54) now becomes the Heavenly City, the House of the Lord, filled with golden celestial space in contrast with the atmospheric earthly space outside.

The figures have also been transformed. In ancient art this composition, in which a standing figure extends an arm to a seated supplicating figure and is watched by bystanders and assisted by others was used to depict a doctor treating a patient. Here the emphasis has shifted from physical to spiritual action. Not only do glances and gestures convey this new kind of action, but so too does scale. Jesus and his apostle Peter, the most animated figures, are larger than the rest, and Jesus' "active" arm is longer than his "passive" one. And the eight apostles, who are compressed into a tiny space and merely watch, have less physical substance than the fanlike Early Christian crowd from which this grouping derives (see fig. 8.17). The blending of Classical and Byzantine elements results in a new style of expressive abstraction.

A miniature of *St. Luke* from the *Gospel Book of Otto III* (fig. **10.34**) is a symbolic image of overwhelming grandeur despite its small size. Unlike depictions of evangelists in Carolingian manuscripts (see figs. 10.12 and 10.14), St. Luke is not shown writing. Instead, his Gospel lies completed on his lap. The evangelist seems to be as much a part of the mystical scene as he is its presenter. Enthroned on two rainbows, Luke holds aloft an awesome cluster of clouds from which tongues of light radiate in every direction. Within it we see his symbol, the ox, surrounded by five Old Testament prophets and an outer circle of angels. At the bottom, two lambs drink the life-giving waters that spring from beneath his feet. The key to the design is in the inscription: *Fonte patrum ductas bos agnis elicit undas* (From the source of the fathers, the ox brings forth a flow of water for the lambs). The Ottonian artist has truly "illuminated" the meaning of this terse phrase.

THE GOSPEL BOOK OF OTTO III Produced for the son of Otto II and Theophano, the *Gospel Book of Otto III* (fig. **10.32**) communicates an imperial grandeur equal to that of the coronation ivory of his parents. The emperor displays the imperial regalia—a crown, an eagle scepter, and a cross-inscribed orb—while his throne is decorated with imperial lions. Representatives of the two domains that he controls—the military and the ecclesiastical—flank him, reminiscent of Justinian's placement in the center of the same domains in the San Vitale mosaic (see fig. 8.25). On the facing folio, the four geographical parts of the realm—Slavinia, Germania, Gallia, and Roma—offer homage. Their stances recall traditional representations of the Magi offering gifts to Christ, such as the scene decorating Theodora's robe in the mosaic at San Vitale in Ravenna (see fig. 8.26)

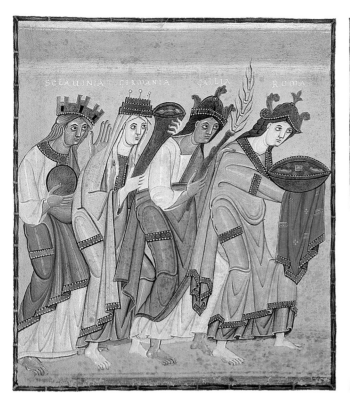

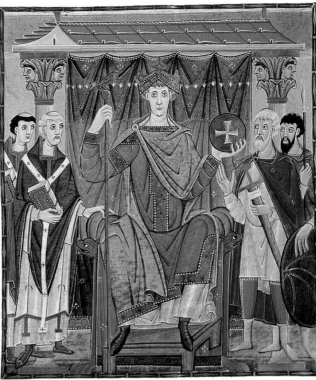

10.32. *Otto III Receiving the Homage of the Four Parts of the Empire* and *Otto III Between Church and State,* from the *Gospel Book of Otto III.* ca. 1000 CE. Tempera on vellum. Each folio 13 × 9 ³⁄₈″ (33 × 23.8 cm). Staatsbibliothek, Munich

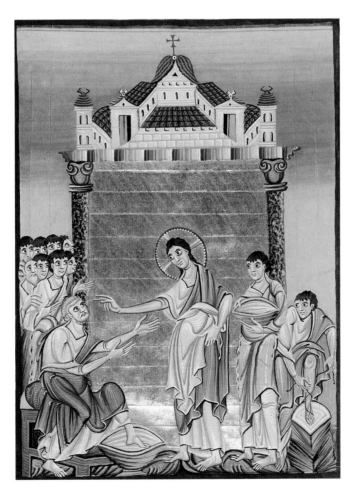

10.33. *Jesus Washing the Feet of St. Peter,* from the *Gospel Book of Otto III.* ca. 1000 CE. Tempera on vellum, 13 × 9³⁄₈″ (33 × 23.8 cm). Staatsbibliothek, Munich

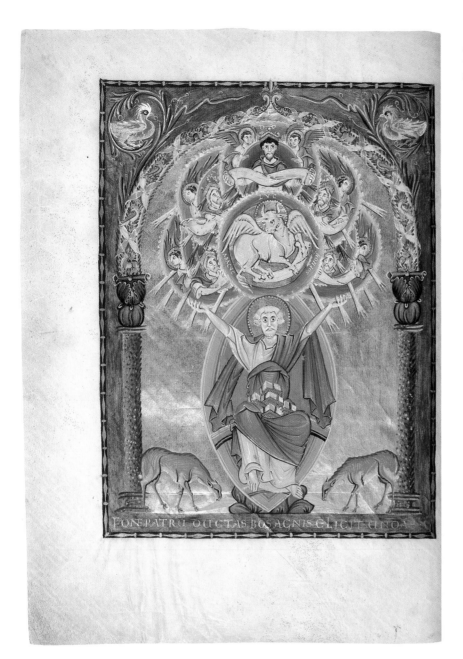

10.34. *St. Luke,* from the *Gospel Book of Otto III.* ca. 1000 CE. Tempera on vellum, 13 × 9⅜″ (33 × 23.8 cm). Staatsbibliothek, Munich

Sculpture

Large-scale and free-standing sculpture was rare in the early Middle Ages, in part because of the lingering fear of idol worship and because the general interest in producing portable objects virtually precluded its production. However, during the Ottonian period the scale of sculpture increased (witness Bernward's doors for St. Michael's at Hildesheim), and even many small-scale works demonstrate an imposing monumentality.

THE GERO CRUCIFIX The *Gero Crucifix* (fig. **10.35**), named for Archbishop Gero of Cologne, who commissioned it around 970, is an example of a large-scale work—it is in fact life-size—with a monumental presence, indicative of the major transformation that Ottonian sculptors were able to achieve even when dealing with traditional subjects. How this happens is evident if we compare the *Gero Crucifix* with the Christ on the cover of the Lindau Gospels (see fig. 10.16). The two works are separated by little more than a hundred years but show marked contrast. The *Gero Crucifix* presents a sculptural image of the crucified Christ that is new to Western art, an image filled with deep feeling for Christ's suffering. Made of painted and gilded oak, it is carved in powerfully rounded forms. Particularly striking is the forward bulge of the heavy body, which emphasizes the physical strain on the arms and shoulders, making the pain seem almost unbearable. The face, with its deeply incised, angular features, is a mask of agony from which all life has fled.

How did the Ottonian sculptor arrive at this bold conception? The *Gero Crucifix* was clearly influenced by Middle Byzantine art, which had created the compassionate view of Christ on the Cross in other mediums (see fig. 8.46). Yet, that source alone is not enough to explain the results. It remained for the Ottonian artist to translate the Byzantine image into large-scale sculptural terms and to replace its gentle pathos with expressive realism. Even though there were some clerics who rekindled the deep-rooted fear of idolatry, they could not restrain the newly found emphasis on the humanity of Christ or the increasing interest in relics. In fact, there is a space in the back of the head of the Gero Christ to hold the Host (the bread or wafer taken during that part of the Mass referred to as Communion), transforming the sculpture into a **reliquary** (a container to enshrine holy remnants or relics).

ART IN TIME

911 CE—Last East Frankish monarch dies

962—Otto I crowned as Holy Roman Emperor

1015—**Bernward bronze doors completed for St. Michael's at Hildesheim, Germany**

10.35. The *Gero Crucifix*. ca. 970 CE. Painted and gilded wood. Height 6'2" (1.88 m). Cathedral. Cologne, Germany

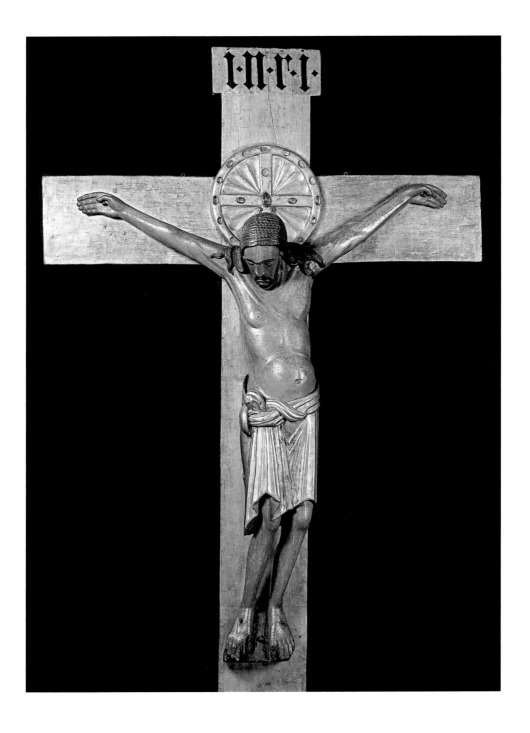

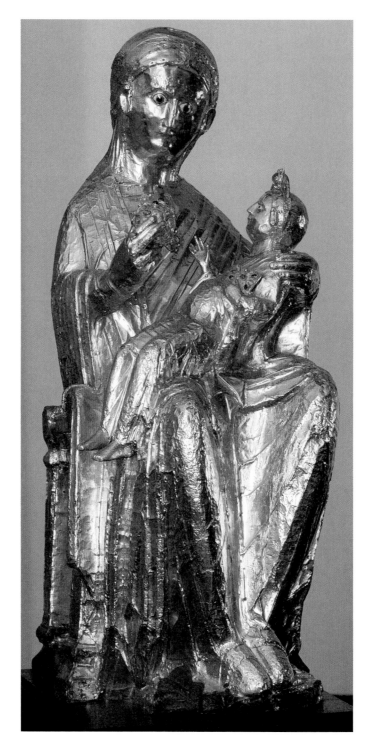

10.36. *Virgin of Essen*. ca. 980 CE. Gold over wood, enamel, filigree, and gems. Height 29½″ (75.6 cm). Cathedral Treasury, Essen, Germany

THE VIRGIN OF ESSEN The *Virgin of Essen* (fig. **10.36**), given to the Cathedral of Essen around 980 by Abbess Matilda, granddaughter of Otto I, almost surely was designed as a reliquary, although that is hard to establish definitively since its original wooden core does not survive. All that is left is the exterior covering of gold sheets. Matilda also donated two—and possibly three—gold, enamel, and jeweled crosses to the cathedral. This rich treasure, glittering on candlelit altars, would have made an impressive display and signaled the church's patronage by a member of the imperial family. The *Virgin of Essen* is one of the earliest free-standing sculptures of the Virgin Mary. The golden apple Mary holds symbolizes her typological status as the new Eve; thus the sculpture is related conceptually to the message on Bernward's bronze doors (see fig. 10.26).

Despite the tender, almost doll-like figures of Mary and Christ, the *Virgin of Essen* has a commanding presence. This is due to Mary's frontal pose, her large staring eyes, and the brilliance of the gold, which is enhanced by the gems, enamels, and filigree that decorate the apple and Christ's book and halo. Linear details, such as drapery folds, and facial features are suppressed to place emphasis on the figure's corporeality. Thus, the Essen Madonna has moved away from the earlier Germanic concentration on line and surface effect. Despite her small size—less than $2\frac{1}{2}$ feet high—the simplification of form and the concentration on abstract shapes result in a marked movement toward monumentality, which also characterized the *Gero Crucifix*. These works herald new aesthetic aims that will dominate eleventh-century sculpture throughout Europe.

SUMMARY

EARLY MEDIEVAL ART

Western Europe was home to a number of cultures after the Fall of Rome. Migrations and invasions were common, and groups frequently clashed and mixed with one another. Overlaid on this mix were Roman traditions, including Christianity. Over time, the Church became an important force of European unification, and strong political leaders led a succession of ruling dynasties, including the Carolingian and the Ottonian. The art resulting from the cultural interchanges of the early Middle Ages is vibrant and varied. Artists created intricate and sumptuous metalwork, built and adorned churches and monastic structures, and produced elaborately decorated books.

ANGLO-SAXON AND VIKING ART

Among the widespread migrations across Europe in the 300s and 400s were those of the Germanic peoples, whose art, including metalwork and jewelry, was portable. Their skillfully executed objects were often made of gold or silver and included precious stones. The artistic tradition of these peoples— sometimes referred to as the "animal style" because of its use of stylized animal-like forms— mixed with other traditions to produce unique objects such as those found in an Anglo-Saxon ship burial at Sutton Hoo, England.

HIBERNO-SAXON ART

During the early Middle Ages, Irish monasteries became centers of learning and the arts, with special attention devoted to copying and decorating literary and religious texts. The finest of these manuscripts belong to the Hiberno-Saxon style, which combines Christian, Celtic, and Germanic elements. Outstanding examples include the *Lindisfarne Gospels* and the *Book of Kells*.

CAROLINGIAN ART

A new empire developed in Europe in the late 700s. Founded by Charlemagne, this Carolingian empire would eventually unite lands from the North Sea to Spain to northern Italy. Artists who worked for Charlemagne and his successors during this Carolingian period combined admiration for antiquity with native northern European features. High-quality works of the time include bronze sculptures and illuminated books. An increase in architectural projects reposition—including the imperial palace at Aachen and the abbey church of Saint-Riquier—also reflect the security and prosperity of the time.

OTTONIAN ART

After the last Carolingian monarch died, German kings of Saxon descent consolidated political power in the eastern portion of the empire. These rulers pushed back invaders, reestablished an effective central government, and began a new dynasty: the Ottonian. A pressing concern of these leaders was Church reform. Impressive building programs of the time include the Benedictine abbey church of St. Michael's at Hildesheim. Ottonian artists produced ivories and manuscripts that blended Carolingian and Byzantine elements, and they showed an increased interest in large-scale sculpture.

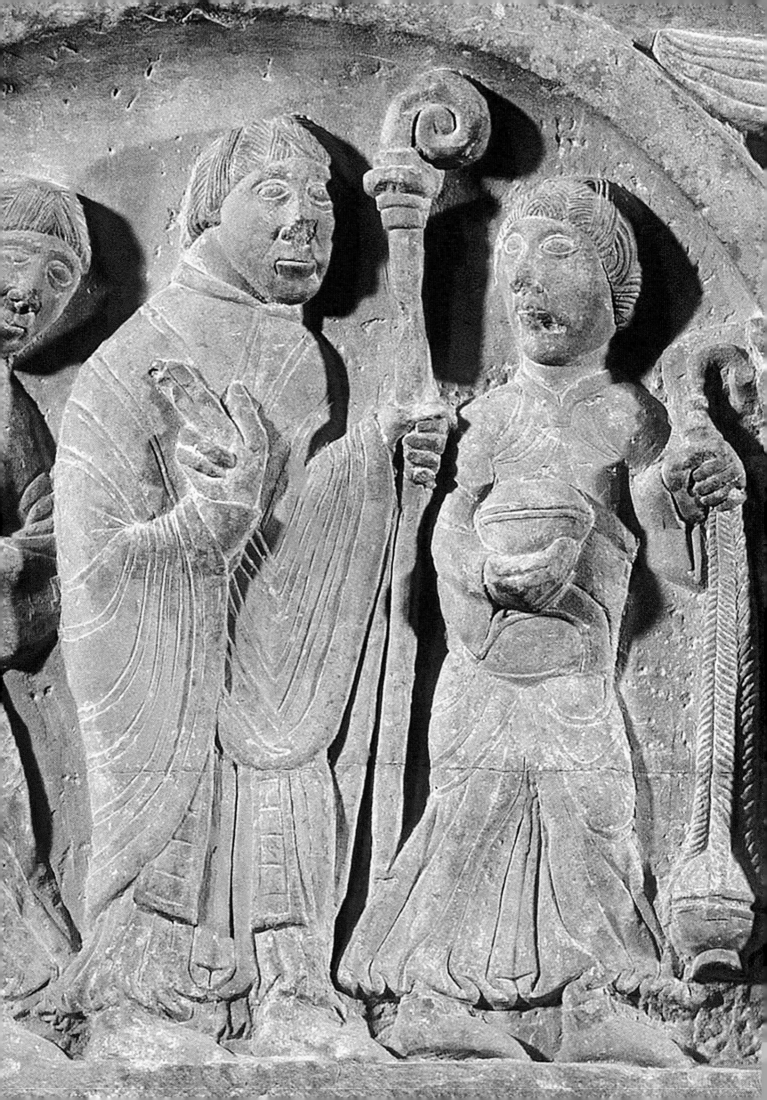

Romanesque Art

ROMANESQUE MEANS, LITERALLY, "IN THE ROMAN MANNER." WE USE THIS stylistic term today to identify the art of much of the eleventh and twelfth centuries. The borrowing of details or specific features from the antique past does not distinguish Romanesque art from the art of other post-Classical periods, for Early Christian, Byzantine, Carolingian,

and Islamic art also relied heavily on Rome for their formal and expressive languages. However, in Romanesque art, the aesthetic integrity and grandeur of the Roman model survive in a more vital and compelling form than in any previous period of art history. Even after the turmoil and displacement experienced in the Roman Empire during Late Antiquity and the early Middle Ages, the power and glory that Rome represented in its enduring monuments continued to provide an appealing model. Yet Rome was not the period's only inspiration: Romanesque artists tapped sources in Carolingian and Ottonian art, and were influenced by Early Christian, Byzantine, Celtic-Germanic, and Islamic traditions as well.

As opposed to Carolingian and Ottonian art, which developed principally in response to the culture and programs of the royal courts, Romanesque art sprang up all over Western Europe at about the same time and in a variety of regional styles that are nevertheless closely related. What welded this variety into a coherent style was not any single force but several factors.

For one thing, Christianity was close to triumph everywhere in Europe. The Vikings, still largely pagan in the ninth and tenth centuries when their raids terrorized the British Isles and the Continent, had finally entered the Catholic fold, not only in Normandy but in Scandinavia as well. Meanwhile,

in 1031 the caliphate of Córdoba had broken up into many small Muslim states, opening the way for Christian conquest of the Iberian peninsula.

Another factor was the growing spirit of religious enthusiasm. The year 1000—the millennium—had come and gone without the apocalyptic end of the world that many had predicted from their reading of the book of Revelation in the Bible. Chapter 20 of this New Testament book, written about 50 years after Jesus' death, prophesizes that the Second Coming, when Christ will return to earth and end the world as we know it, was to occur after 1,000 years. Scholars have suggested that many people, fearing the dreaded end of days, reacted to the approach of the year 1000 with terror and to its smooth passing with great relief and, in some quarters, a heightened spirituality. This was demonstrated by the large number of people making pilgrimages to sacred sites, by repeated Christian Crusades against the Muslims in the Holy Land, and by an increase in the number and size of monasteries, which also reflected the general growth in population and an increase in prosperity.

Equally important was the reopening of the Mediterranean trade routes by the navies of Venice, Genoa, Amalfi, Pisa, and Rimini (see map 11.1). The revival of trade and travel linked Europe commercially and culturally, stimulating the flowering of urban life. The new pace of religious and secular life is vividly described in pilgrim guides of the time.

Detail of figure 11.20, *Sarcophagus of Doña Sancha*

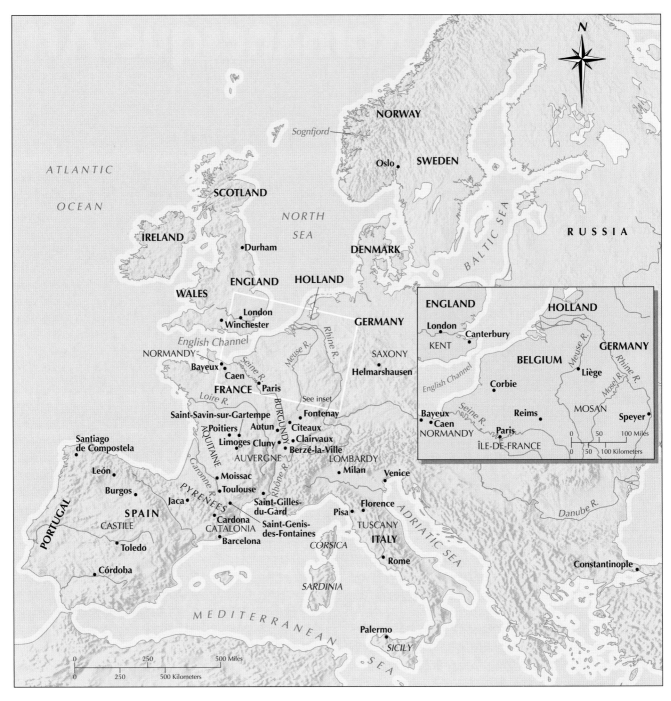

Map 11.1. Europe in the Romanesque Period

At the end of the early medieval period, Europe was still largely an agricultural society. A decentralized political and social system, known today as *feudalism,* had developed, mainly in France and Germany, where it had deep historical roots. In this system, landowning lords granted some of their property to knights (originally, these were cavalry officers). In return for these fiefs, or *feuds,* as the land parcels were called, the knights gave military and other service to their lords, to whom they were linked through a complex system of personal bonds—termed *vassalage*—that extended all the way to the king. A large class of generally downtrodden, virtually powerless peasants (*serfs*) worked the land itself. Towns that had shrunk in size during the migrations and invasions of the early

Middle Ages—Rome, for instance, with about 1 million people in 300 CE had fallen to less than 50,000 at one point, and some smaller cities were deserted altogether—started to regain their former importance. New towns sprang up everywhere, achieving independence via charters that enumerated a town's privileges and immunities in return for a feudal lord's guarantee of protection

These social changes were also made possible by technological advances in agriculture, such as improved milling machinery and better iron plows that dug deeper furrows. For the first time since the fall of Rome, farmers could grow more food than they needed for themselves. In many ways, then, Western Europe between 1050 and 1200 became a great

deal more "Roman-esque" than it had been since the sixth century. It recaptured some of the trade patterns, the urban quality, and the military strength of ancient imperial times. To be sure, there was no central political authority, for Europe was still divided into small units ruled by powerful families. Even the king of France controlled not much more than the area around Paris. However, some monasteries came to rival the wealth and power of kings, and the central spiritual authority of the pope acted as a unifying force throughout Europe. In 1095 Pope Urban II called for the First Crusade to liberate the Holy Land from Muslim rule and to aid the Byzantine emperor against the advancing Turks. The army of Crusaders was far larger than a secular ruler could have raised for the purpose.

This First Crusade managed to win Jerusalem after three years, but later crusades were generally disastrous. The Second Crusade (1147–1149), which was called for by St. Bernard of Clairvaux after the fall of Edessa to the Turks, succeeded only in capturing Lisbon from the Arabs, while the Third Crusade, begun in 1189, failed to reconquer Jerusalem from the sultan Saladin, who had taken it two years earlier. The Fourth and final major Crusade did little to hinder the advance of Islam; its sole result was the fall of Constantinople in 1204.

This brief historical account underscores the number of institutions, organizations and systems that helped to create European stability. Monasticism, feudalism, urbanism, commerce, pilgrimage, crusade, papacy, and the royal court all played their roles by setting into motion internationalizing forces that affected the transmission of artistic forms. Population growth and the increase in the number of new settlements stimulated building activity, much of it for Christian use. The development of better tools, such as saws to cut stone, resulted in improved masonry techniques. Many new constructions were made of well-cut, straight-edged blocks of stone and were monumental, built on a scale that rivaled the achievements of Rome. The heavy walls created solid and durable structures that convey a sense of enclosure and security, and the stone vaults covering these buildings enhanced their stability. These vaults, as well as the proliferation of architectural sculpture, consciously emulated the Roman manner of construction and design. Embellishing churches and monasteries with reliquaries and other adornments, including illuminated manuscripts, provided for the needs of both the local population and pilgrims.

FIRST EXPRESSIONS OF ROMANESQUE STYLE

Although Romanesque art quickly spread throughout Europe, its first appearances occur in a zone running from Lombardy in Italy through southern France and into northern Spain, into the region of Catalonia. Even today, stone-vaulted buildings decorated with wall arcades and architectural sculpture, which are characteristic features of this early phase, survive in great numbers in these regions.

Architecture

The most striking feature of Romanesque art is the amazing increase in building activity. An eleventh-century monk, Raoul Glaber, conveys the enthusiasm for building that characterizes the period:

> ... there occurred throughout the world, particularly in Italy and in Gaul, a rebuilding of church basilicas ... each Christian people strove against the others to erect nobler ones. It was as if the whole earth, having cast off the old by shaking itself, were clothing itself everywhere in the white mantle of the church.
>
> E.G. Holt, *A Documentary History of Art*. Vol. I, 1957, p. 18.

These churches were not only more numerous than those of the early Middle Ages, they were also larger, more richly ornamented, and more "Roman-looking." Their naves had stone vaults instead of wooden roofs, and their exteriors were decorated with both architectural ornament and sculpture. Romanesque monuments of the first importance are distributed over an area that might well have represented the Catholic world: from northern Spain to the Rhineland, from the Scottish-English border to central Italy.

CHURCH OF SANT VINCENÇ, CARDONA An excellent example of an early phase of Romanesque architecture is the collegiate church of Sant Vincenç (fig. **11.1**), built within the walled confines of the castle at Cardona on the southern flank of the Catalan Pyrenees. The church, begun in 1029 and consecrated in 1040, is straightforward both in plan and in elevation. A barrel-vaulted nave creates a continuous space marked off by transverse arches into units of space called **bays**. The domed bay in front of the **chancel**, the part of the church containing the altar and seats for the clergy and choir, focuses attention on the ceremonial heart of the church. Blind niches in the chancel walls establish a rhythmic variety that is accentuated in the nave by the staggered cadence of massive **compound piers**, solid masonry supports with rectangular projections attached to their four faces. The projections reflect the different structural elements that combine to support the building. One projection rises the full height of the nave to support the transverse arch, another forms the arch that extends across the side aisle, and two others connect to the arches of the nave arcade.

Sant Vincenç's vertical integration of piers and vault is undoubtedly derived from the desire to unify the elevation in early medieval buildings, for example the Carolingian chapel at Aachen (see fig. 10.17) and the Ottonian church at Gernrode (see fig. 10.22). However, the wall planes of the Ottonian church appear flat by comparison to the angular surfaces of Sant Vincenç, where the clarity of articulation endows the building with a heightened sense of unity and harmony. The compound pier is, in fact, a major architectural innovation of the Romanesque period. Limited light and robust stone construction create an interior at once sheltering and inspiring; the sober arrangement of simple yet powerful forms is masterfully realized.

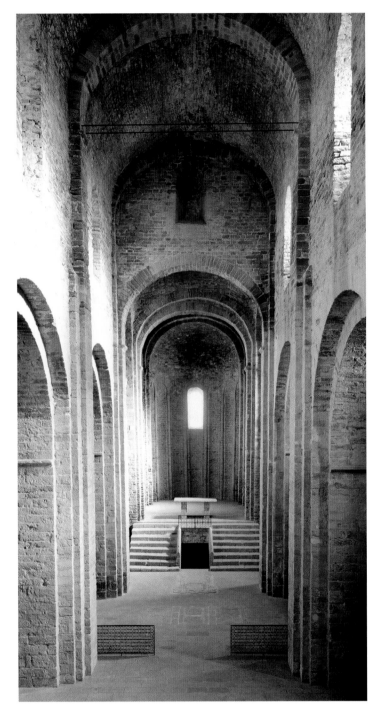

11.1. Nave and choir (looking east), Sant Vincenç. ca. 1029–1040. Cardona, Spain

Monumental Stone Sculpture

The revival of monumental stone sculpture in the Romanesque era is as significant as the architectural achievements of the period. Free-standing statues had all but disappeared from Western art after the fifth century, and stone relief survived only as architectural ornament or surface decoration, while three-dimensional sculpture was rare. Thus, the only sculptural tradition that continued through the early medieval period was that of sculpture-in-miniature: small reliefs and occasional statuettes in metal or ivory. In works such as the bronze doors of Bishop Bernward (see fig. 10.26), Ottonian art had enlarged the small scale of this tradition but had not changed its spirit. Moreover, its truly large-scale sculptural efforts, such as the *Gero Crucifix* (see fig. 10.35), were limited almost entirely to wood.

LINTEL AT SAINT-GENIS-DES-FONTAINES The marble lintel at Saint-Genis-des-Fontaines, on the French side of the Pyrenees, is dated by inscription to between 1020 and 1021 (fig. **11.2**). It spans the doorway of the church and is one of the earliest examples of Romanesque figurative sculpture. The inscription cites the leaders of two stabilizing institutions of the period, *Rotberto Rege* (King Robert) and *Willelmus Aba* (Abbot William), the former a feudal lord and the latter the leader of a monastery. The central motif, Christ in Majesty supported by angels, is flanked by six apostles; each apostle holds a book and stands under an arcade. Christ's mandorla is formed by two intersecting circles. One symbolizes the Earth and the other the heavens, the two realms over which he presides.

The Saint-Genis lintel is modest in size, only about 2 feet high by 7 feet long. The reliance on line to indicate facial features, drapery folds, and ornamental decoration is reminiscent of early medieval manuscript illuminations and reaches as far back as the Hiberno-Saxon period (see fig. 10.7). The carving, with flat surfaces marked by incision, resembles the minor arts, particularly ivory and metalwork. This can be verified by comparing some of the patterns (for example, the beading around the arches) with metalwork techniques (see fig. 10.1). The correlation explains where carvers might have found their sources of inspiration after centuries during which stone sculpture had been virtually abandoned.

Although the figures are rendered with individualized hairstyles and facial features and with a variety of gestures, they are clearly stylized. Each conforms to the frame around him so that it is difficult to decide if the figures are governed by their frames or if the arches swell in response to the figures. The equilibrium between frame and figure parallels the harmonious balance between structure and decoration that characterizes early Romanesque buildings such as Sant Vincenç at Cardona.

MATURE ROMANESQUE

Early Romanesque experiments in sturdy construction, which relied on the skills of masons and sculptors, led to buildings that employed both more sculpture and increasingly sophisticated vaulting techniques. Sculptural decoration was arranged into complicated and didactic iconographic programs. Romanesque architecture and sculpture continue to convey messages of security and spirituality, employing a consistent aesthetic approach that is also visible in the manuscripts and metalwork produced during the period. As Romanesque art developed, it spread throughout Europe becoming a pan-European art.

Pilgrimage Churches and Their Art

Among the most significant social phenomena of eleventh- and twelfth-century Europe was the increased ability of people of all classes to travel. While some journeys were a result

of expanded trade, others, such as a crusade or pilgrimage, were ostensibly for religious purposes. Individual pilgrims made journeys to holy places for different reasons, but most shared the hope that they would find special powers or dispensations as a result of their journey. Pilgrimage was not a Romanesque invention. As early as the late fourth century, Egeria, a Spanish pilgrim to Jerusalem, chronicled her visit to the locations central to Christ's life, among them the Church of the Holy Sepulcher (see fig. 8.9). Special, often miraculous, powers associated with these holy sites were transferred to *relics*, those body parts of holy persons or objects that had come in contact with Christ, his close followers (see end of Part II, *Additional Primary Sources*), or other holy figures, particularly his mother, the Virgin Mary.

Partly due to the Muslim conquest of the Holy Land, travel there was difficult during the Middle Ages. This led, on the one hand, to the zeal for crusade and, on the other, to the veneration of places within Europe that had important relics or that had been the site of special events. Rome, in particular, became a popular pilgrimage site, beneficiary of the aura of sanctity surrounding SS. Peter and Paul, both of whom lived and were buried there (see page 242). So did Santiago de Compostela on the Iberian peninsula. Cultural anthropologists have attempted to explain the incredible popularity and significance of pilgrimage to the medieval world as well as to our own. They claim that when pilgrims embark on their journey they enter a special transitional

ART IN TIME

1020/21 CE—Marble lintel at Saint-Genis-des-Fontaines, France

ca. 1026—Construction of the al-Aqmar mosque, Cairo

1031—The Caliphate of Córdoba breaks up

1040—Consecration of church of Sant Vicenç in Cardona, Spain

zone where social norms and hierarchies are replaced with a sense of shared experience. This creates a temporary condition of community, in which people of disparate backgrounds and social levels can communicate as equals. The appeal of an escape from daily concerns is particularly understandable after a period of social turmoil. The buildings and objects pilgrims saw and experienced fostered this sense of community.

SANTIAGO DE COMPOSTELA The tomb of St. James at Santiago de Compostela in northwest Spain marked the most westerly point of Christian Europe. According to tradition, the apostle James (*Santiago* in Spanish) had preached Christianity on the Iberian peninsula and returned there under dramatic circumstances after his death. Reports of the tomb's miraculous power attracted large numbers of pilgrims from all over Europe. Many had to brave a difficult

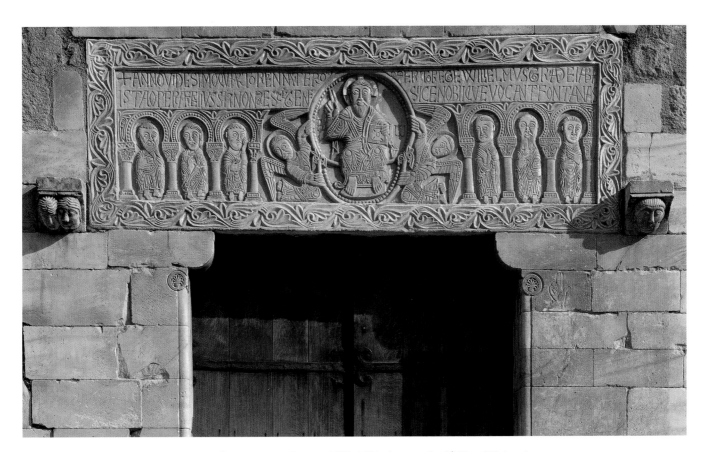

11.2. Lintel of west portal, Saint-Genis-des-Fontaines, France. 1020–1021. Approx. 2 × 7′ (61 × 213.4 cm)

From *Pilgrim's Guide*
to *Santiago de Compostela*

The Pilgrim's Guide, *written in the mid-twelfth century, gives a vivid account of the routes and what was to be met along them by pilgrims traveling to the shrine of the apostle James in Compostela (see map 11.2). It also provides interesting information on the personnel in charge of the construction of the shrine at the cathedral in Santiago de Compostela.*

There are four roads which, leading to Santiago, converge to form a single road at Puente la Reina, in Spanish territory. One crosses Saint-Gilles [see fig. 11.32], Montpellier, Toulouse [see figs. 11.6–11.9] and the pass of Somport; another goes through Notre-Dame of Le Puy, Sainte-Foy of Conques and Saint-Pierre of Moissac [see figs. 11.13, 11.14]; another traverses Sainte-Marie-Madeleine of Vézelay, Saint-Léonard in the Limousin as well as the city of Périgueux; still another cuts through Saint-Martin of Tours, Saint-Hilaire of Poitiers, Saint-Jean-d'Angély, Saint-Eutrope of Saintes and the city of Bordeaux. . . .

One needs three more days of march, for people already tired, to traverse the Landes of the Bordelais.

This is a desolate region deprived of all good: there is here no bread, wine, meat, fish, water or springs; villages are rare here. The sandy and flat land abounds none the less in honey, millet, panic-grass, and wild boars. If perchance you cross it in summertime, guard your face diligently from the enormous flies that greatly abound there and which are called in the vulgar wasps or horseflies; and if you do not watch your feet carefully, you will rapidly sink up to the knees in the sea-sand copiously found all over.

Having traversed this region, one comes to the land of Gascon rich in white bread and excellent red wine. . . . The Gascons are fast in words, loquacious, given to mockery, libidinous, drunkards, prodigal in food. . . . However, they are well-trained in combat and generous in the hospitality they provide for the poor. . . .

They have the habit of eating without a table and of drinking all of them out of one single cup. In fact, they eat and drink a lot, wear rather poor clothes, and lie down shamelessly on a thin and rotten straw litter, the servants together with the master and the mistress.

On leaving that country, . . . on the road of St. James, there are two rivers. . . . There is no way of crossing them without a raft. May their ferrymen be damned! . . . They have the habit of demanding one coin from each man, whether poor or rich, whom they ferry over, and for a horse they ignominiously extort by force four. . . . When boarding . . . one must be most careful not to fall by chance into the water. . . .

Many times the ferryman, having received his money, has such a large troop of pilgrims enter the boat that it capsizes and the pilgrims drown in the waves. Upon which the boatmen, having laid their hands upon the spoils of the dead, wickedly rejoice.

The Stonecutters of the Church [of St. James] and the Beginning and Completion of Their Work

The master stonecutters that first undertook the construction of the basilica of the Blessed James were called Master Bernard the elder—a marvelously gifted craftsman—and Robert, as well as other stonecutters, about fifty in number, who worked assiduously under the most faithful administration of Don Wicart, the head of the chapter Don Segeredo, and the abbot Don Gundesindo, during the reign of Alphonso king of Spain and during the bishopric of Don Diego I, a valiant soldier and a generous man.

The church was begun in the year 1116 of the era. . . . And from the year that the first stone of the foundations was laid down until such a time that the last one was put in place, forty-four years have elapsed.

SOURCE: *THE PILGRIM'S GUIDE TO SANTIAGO DE CAMPOSTELA*, ED. AND TR. WILLIAM MELCZER (NY: ITHACA PRESS, 1993)

sea journey or an exhausting crossing of the Pyrenees Mountains in order to reach the apostle's tomb at Compostela. (See *Primary Source*, above.) Some years during the twelfth century tens of thousands made the journey. The difficulty of the journey added to its allure. Since much of Spain was under Muslim control, pilgrims considered the trip to Santiago equivalent to a journey to the Muslim-held Holy Land.

The Cathedral at Santiago de Compostela had much to offer those brave hearts sufficiently fortunate to reach their goal. The plan of the church (fig. **11.3**) includes side aisles that run uninterruptedly around the church and form an ambulatory around the apse. Visitors used these aisles to circumambulate the church, even when the religious offices were being celebrated in the nave and crossing. **Apsidioles**, or small apse-like chapels, arranged along the eastern walls of the transepts and around the apse, provide multiple opportunities to display the relics that pilgrims had come to venerate. As pilgrims approached the nave from the west entrance and walked through the building, they were conscious of marching step by step toward their goals in the apses, altars, and reliquaries at the east end of the church.

Passage through the cathedral was thus a microcosm of the longer journey the pilgrims has taken on the open road, and the cathedral might readily be called a **pilgrimage plan** church. Although not all pilgrimage churches have this same plan, a group of great churches of varying sizes and details, using the same pilgrimage plan as Santiago de Compostela, were built along the roads leading to Compostela. A major church built using this pilgrimage plan is situated on each of the four main roads leading through France: Saint-Martin at Tours (on the road from Paris), Saint-Martial at Limoges (on the road from Vézelay), Sainte-Foy at Conques (on the road from Le Puy), and Saint-Sernin at Toulouse (on the road from Saint-Gilles-du-Gard). (See map 11.2.)

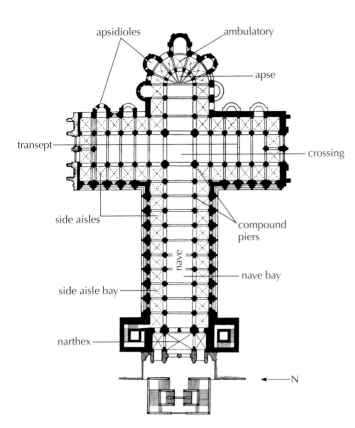

11.3. Plan of Cathedral of Santiago de Compostela, Spain (after Dehio)

apsidioles

ambulatory

apse

transept

crossing

side aisles

compound piers

nave

nave bay

side aisle bay

narthex

N

In truth, in this church no fissure or fault is found; it is admirably constructed, grand, spacious, bright, of proper magnitude, harmonious in width, length and height, of admirable and ineffable workmanship, built in two storys, just like a royal palace. For indeed, whoever visits the naves of the gallery, if he goes up sad, after having seen the perfect beauty of this temple, he will be made happy and joyful.

Paula Gerson, Annie Shaver Crandell, Alison Stoves and Jeanne Krochalis, *Pilgrim's Guide to Santiago de Compostela: A Critical Edition*, II. London, 1998, pp. 69–71.

The synthesis of emotional and spiritual response described in the *Pilgrim's Guide* results from the Romanesque builders' ability to fuse structure and aesthetics. In another section of his book, the *Guide*'s author notes with admiration the quality of the stonework, as "hard as marble." By using a simile that compares the stone used to build the cathedral with the quintessential building material of the Classical past, he clearly expresses a fact that viewers today can also appreciate, that in both detail and execution Santiago de Compostela emulates the nobility and dignity of Roman architecture.

The plan of Santiago de Compostela (see fig. 11.3) is composed of multiple modular units. It recalls the system of architectural composition based on additive components that was employed during the early Middle Ages (see pages 329–332). The bays of the nave and the transept are half the size of the square crossing, and the square bays of the side aisles are in turn a quarter the size of the crossing and thus half the size of the nave bays. The building's elevation (fig. **11.4**) mirrors the clarity of its plan. As at Sant Vincenç at Cardona (see fig. 11.1), the four colonnettes of the compound piers reflect the building's structural elements. However, there is less wall surface in the Santiago de Compostela nave, and **colonnettes**, small attached columns, more richly articulate the compound piers.

So as not to weaken the barrel vaults at their springing, precisely where they would need the most support, Santiago de Compostela was built without a clerestory. Diffused light, subtle and atmospheric, filters into the nave through the side aisles and the galleries above. What function the galleries might have served is much debated. Conceivably they provided overflow space for the large numbers of pilgrims who visited the church, particularly on feast days, and indeed the famous *Pilgrim's Guide*, written around 1130, mentions the presence of altars in the galleries. But the galleries also provide for an elegantly elaborated interior, as the *Pilgrim's Guide* also makes clear:

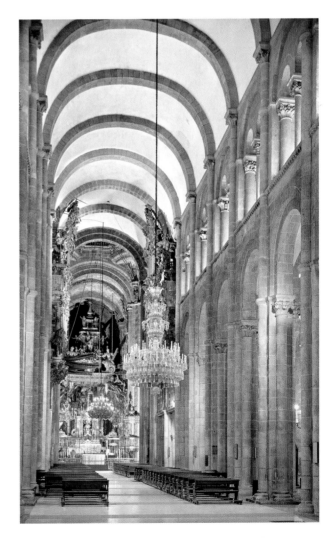

11.4. Nave, Santiago de Compostela, Spain. ca. 1075–1120

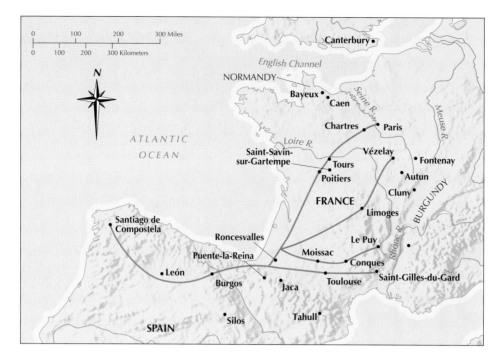

Map 11.2. The Pilgrimage Routes to Santiago de Compostela

RELIQUARIES A twelfth-century casket, today in the Metropolitan Museum of Art in New York (fig. **11.5**), is typical of the kinds of decorated reliquaries that pilgrims saw on their journeys to Compostela and Rome. This one was probably made in Limoges, a major stop on the road to Compostela and a center of enamel production, where there was a large church built in the pilgrimage plan. The material and the bold areas of flat color, evident in both the foliage and the symbols of the four evangelists, relate this work to the tradition of migration and early medieval metalwork (see fig. 10.3). The method of manufacture is **champlevé**, which was derived from the cloisonné technique (see page 313). Instead of cells formed from thin strips of metal attached to a support, as with cloisonné, the metal surface of champlevé is gouged out to create compartments that contain the colored enamel. The preciousness of the enamel on the gilt copper of our reliquary and its lavish decoration suit its exceptional and holy contents, thought to be relics of St. Martial, identified by inscription on the other side of the box, since the reliquary comes from a church dedicated to him in Champagnat, about 60 miles from Limoges.

CHURCH OF SAINT-SERNIN, TOULOUSE The plan of Saint-Sernin, at Toulouse (fig. **11.6**) in southwestern France and on the pilgrimage road, is nearly identical to that of Santiago de Compostela (see fig. 11.3) aside from

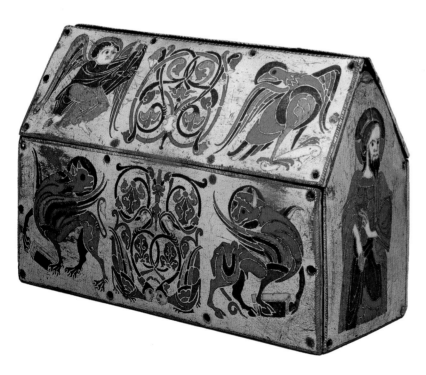

11.5. Reliquary casket with symbols of the four Evangelists. ca. 1150. Champlevé enamel on gilt copper, $4\frac{7}{8} \times 7\frac{7}{16} \times 3\frac{3}{8}''$ (12.4 × 18.9 × 8.5 cm). The Metropolitan Museum of Art, New York. Gift of J. Pierpont Morgan, 1917 (17.190.685-687, 695, 710-711)

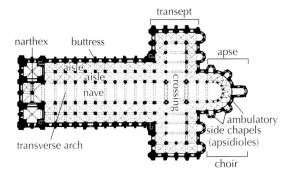

11.6. Plan of Saint-Sernin, Toulouse. ca. 1070–1120. France (after Conant)

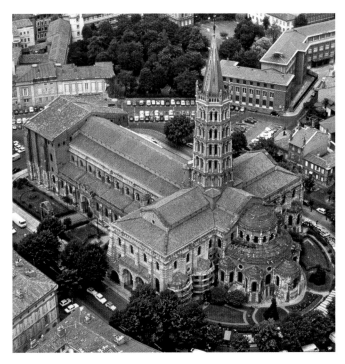

11.7. Saint-Sernin, Toulouse (aerial view)

having two aisles, not one, on either side of the nave. This arrangement is reminiscent of Old St. Peter's Basilica (see fig. 8.4), and it is certainly possible that Saint-Sernin's architects had that Roman basilica in mind when designing this building.

On the exterior of Saint-Sernin (fig. 11.7), the relationship of elements is enhanced by the different roof levels, which set off the nave and transept against the inner and outer aisles, the apse, the ambulatory, and its radiating chapels. The effect is increased by the buttresses, which reinforce the walls between the windows in order to contain the outward thrust of the vaults, while decorative framing emphasizes the structure of the windows. (The crossing tower was completed several centuries later, in a different style, and is taller than originally intended. The two facade towers, unfortunately, were never finished and remain as mere stumps, not visible in fig. 11.7.)

Inside the nave (fig. 11.8), vaults, arches, engaged columns, and pilasters are all firmly knit together into a coherent order that recaptures the vocabulary and syntax of ancient Roman architecture to a remarkable degree. Yet the nave of Saint-Sernin no longer expresses the physical, muscular forces of Graeco-Roman architecture. The columns seem driven upward by some tremendous, unseen pressure, as if hastening to meet the transverse arches that subdivide the barrel vault of the nave. Beauty and engineering are once again inseparable in achieving this effect.

Clearly the architectural effort at Saint-Sernin required detailed, systematic planning. Vaulting the nave to eliminate the fire hazard of a wooden roof was not only a practical necessity, it also challenged architects to make the House of the Lord grander. Since a vault becomes more difficult to sustain the farther it is from the ground, every resource had to be strained to enable the nave to be as tall as possible. Here, as at Compostela, galleries were built over the inner aisles, and they counterbalance the lateral pressure of the nave vault. Saint-Sernin reminds us that architecture, like politics, is the art of the possible. Its success, here as elsewhere, is measured by how far the architect has explored the limits of what

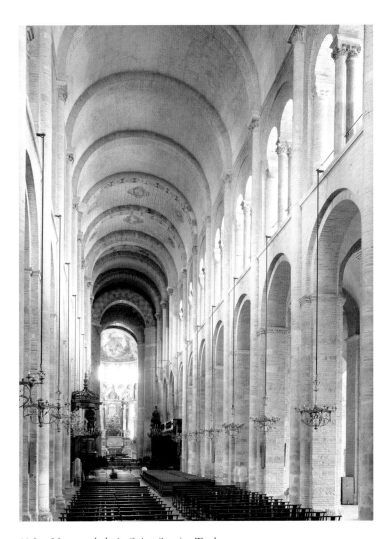

11.8. Nave and choir, Saint-Sernin, Toulouse

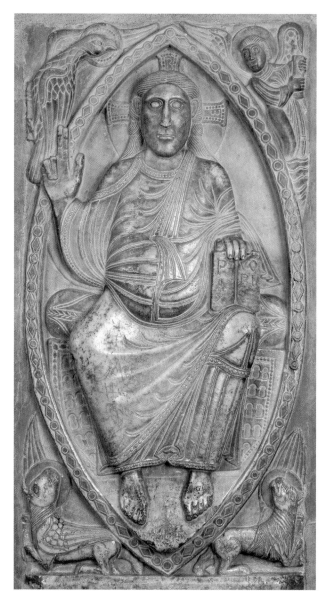

11.9. *Christ in Majesty (Maiestas Domini).* ca. 1096.
Marble. Height 50″ (127 cm). Saint-Sernin, Toulouse

seemed possible, both structurally and aesthetically, under those particular conditions.

SCULPTURE AT SAINT-SERNIN Both Saint-Sernin and Santiago de Compostela have stone sculptures decorating their interiors and their portals. A series of large marble plaques, currently placed in the ambulatory of Saint-Sernin, date to the years immediately preceding 1100. Six of these plaques depict angels and apostles, while one represents a seated Christ, the *Christ in Majesty* (fig. **11.9**). Although their original location is not certain, the plaques most likely decorated the zone around the altar and shrine of St. Sernin, thus embellishing an area deemed particularly holy by pilgrims.

The shallow relief and many decorative effects of the Christ plaque recall earlier metalwork and ivory objects (see figs. 10.16, 10.31). The extensive use of double lines, some creating raised sections, some impressed ones, enhances the figure's vol-umetric presence. The treatment also brings to mind manuscript illumination, particularly Carolingian and Ottonian examples, but also Byzantine ones. In the arrangement of the figure, the play of linear drapery folds, and the variety of ornamental devices, we are not far from the Christ of the *Godescalc Gospels* (see fig. 10.11), which was in Saint-Sernin during the Middle Ages.

The figure of Christ, somewhat more than half life-size, was not meant to be viewed exclusively at close range. Its impressive bulk and weight make it prominent even from a considerable distance. This emphasis on volume hints at what may have been the main inspiration behind the revival of large-scale sculpture. A stone-carved image, being solid and three-dimensional, is far more "real" than a painted one. To a cleric steeped in abstract theology, this might seem irrelevant or even dangerous, but for unsophisticated lay worshipers, by contrast, imposing sculpture must have had great appeal.

Cluniac Architecture and Sculpture

During the time when the sculptural decoration of Saint-Sernin was executed, that church was under the auspices of monks from the great Benedictine monastery of Cluny. Cluny was responsible for a network of dependencies; its "daughter" houses, spread across Europe, numbered more than 1,400. This is evidence of the order's influence and growth. The Cluniac order could determine papal elections and call for crusades against the Muslims. The rise and spread of various monastic orders was significant for the development of Romanesque art, but none was more important than Cluny.

ABBEY CHURCH OF CLUNY The rapid growth of the Cluniac order can also be seen in the fact that its original basilica church of about 910 was replaced with an ample one that itself was replaced only about 75 years later, in 1088, by the largest Romanesque church ever built, the third abbey church of Cluny (fig. 11.10). Unfortunately Cluny III, as it is known, was destroyed after the French Revolution, and only the south transept (the one to the right in the plan), and the octagonal tower remain from what was once the most impressive massing of towers in all of Europe. The auspicious use of towers in Carolingian buildings such as Saint-Riquier (see fig. 10.19) here reached its culmination. The apsidioles,

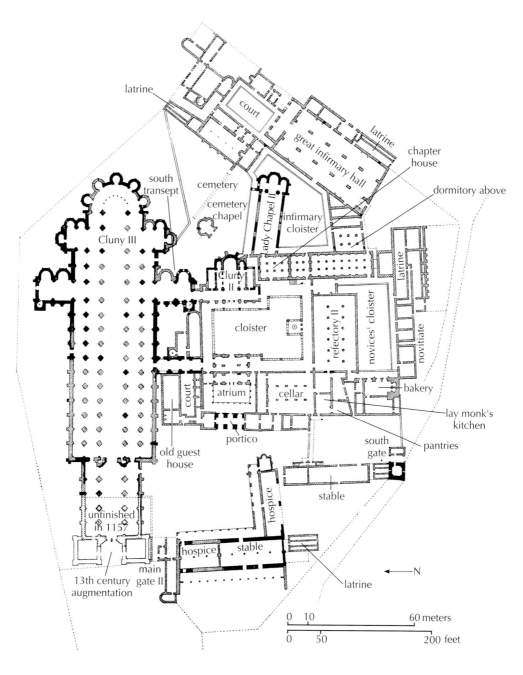

11.10. Gunzo and others. Plan of Monastery of Cluny (Cluny III), France (after Conant). ca. 1088–1130. Darkened areas represent the actual scant remains

apses, and towers at the east end of Cluny created a monumental gathering of ever-higher forms. Individual elements functioned together in built harmony (fig. **11.11**); the south transept with octagonal tower at its crossing is on the left in this reconstruction).

The proportions of Cluny III were based on ratios of "perfect" numbers and on musical harmonies, reminding us of the importance of music to the medieval church. Monks chanted their prayers in the church eight times a day and Gunzo, one of the architects of Cluny III, was noted for his musicianship. A benefit of stone-vaulted buildings was their acoustic resonance; this feature might well have encouraged the widespread use of stone vaulting or at least made the heavy financial investment acceptable to the community. Even today it is a moving experience to hear Gregorian chants sung beneath the vaults of a Romanesque church.

The interior of Cluny III (fig. **11.12**) was as elegant as it was huge, its vaults reaching 100 feet. Below the clerestory,

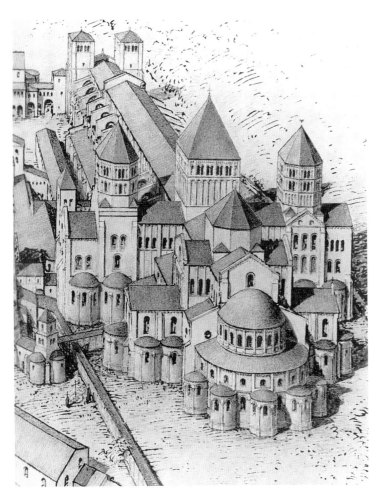

11.11. Reconstruction of Abbey Church of Cluny (Cluny III), from east. (after Conant)

and in place of a gallery, is a **triforium**, the series of three-arched openings (one series per bay); it creates a space within the wall that lightens the wall both physically and visually. The clerestory and triforium are connected by pilaster strips with Corinthian capitals, reminiscent of Roman architectural decoration. What is not Roman is the use of slightly pointed arches in the nave arcade, a device thought to derive from contact with Islamic culture (see fig. 9.12). By eliminating the center part of the rounded arch, which responds the most to the pull of gravity, the two halves of a pointed arch brace each other. Because the pointed arch exerts less outward pressure than the semicircular arch, not only can it be made steeper, but the walls can be pierced and made lighter.

MONASTERY OF MOISSAC The priory of Saint-Pierre at Moissac, located on the pilgrimage road close to Toulouse and also under the direction of Cluny, was another important center of Romanesque art. The cloister, adjacent to the church and reserved for use by its monks, was formed by four covered passageways arranged around an open garden (fig. **11.13**). Protected from the elements, the monks could practice their spiritual exercises here. The cloister was central to monastic life and physically occupied a central position within the monastic complex, as is seen in the St. Gall and Cluny plans. Seventy-six sculptured capitals decorate this private zone. While they include both Old Testament and New Testament stories, many are decorated with foliage, birds, animals, and monstrous creatures.

Although the Romanesque period is far removed chronologically from the Early Christian aversion to image making, even during this period there were those who objected to the corruptive powers of visual representation. One of them was St. Bernard of Clairvaux, a member of the Cistercian order, a reform movement of Benedictines, created around 1100 as a reaction to the increasing economic and political successes of Cluny. In truth, it is hard to correlate the worldly achievements of a monastery such as those at Moissac or Cluny—the wealth they acquired and the political clout they exercised—with the values to which monks traditionally aspired, which were based on the renunciation of earthly pleasures in favor of the pursuit of spiritual ideals. The pictorial representation of Christian themes was often justified by a famous saying: *Quod legentibus scriptura, hoc idiotis ... pictura*. Translated freely, it means that painting conveys the Word of God to the unlettered. Although St. Bernard did not object specifically to the teaching role of art, he had little use for church decoration and he would surely have disapproved of Moissac cloister's excesses which were clearly meant to appeal to the eye as well as the spirit. In a letter of 1127 to Abbot William of Saint-Thierry concerning the decoration of Cluniac churches, St. Bernard condemned art made for contemplation by monks. (See *Primary Source*, p. 358).

If the Moissac monks had a profusion of sculpture to engage them, so too did pilgrims and layfolk visiting the

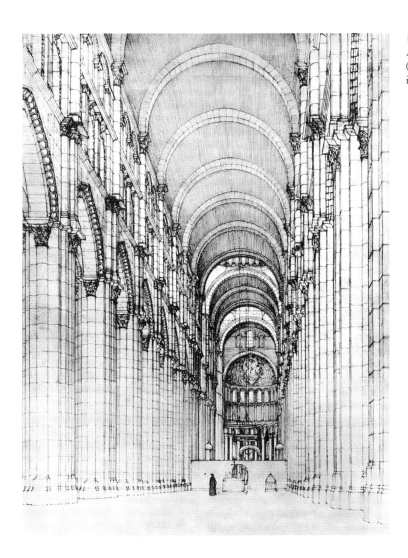

11.12. Reconstruction of Abbey Church of Cluny (Cluny III), nave and interior. (after Conant)

11.13. Cloister, Priory of Saint-Pierre. ca. 1100. Moissac, France

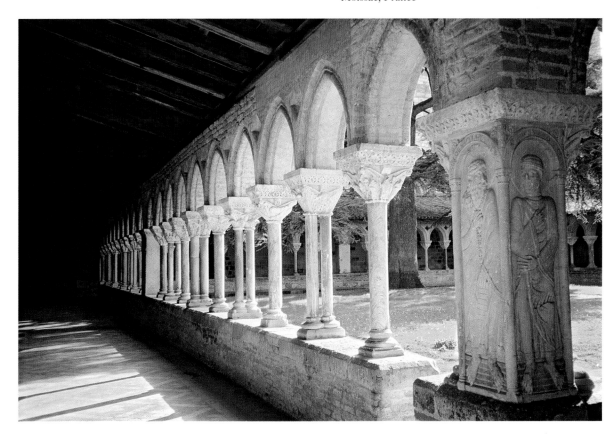

St. Bernard of Clairvaux (1090–1153)

From *Apologia to Abbot William of Saint-Thierry*

Bernard of Clairvaux was a member of the Cistercians, an ascetic order founded in the eleventh century in opposition to the increasing opulence of the Benedictines. His letter to the Benedictine Abbot William of Saint-Thierry of about 1127 denounces all monastic luxury, especially the presence of art in cloisters. Like many others, Bernard believed that monks were spiritually superior to the "carnal" layfolk and so should not need material inducements to devotion.

As a monk, I put to monks the same question that a pagan used to criticize other pagans: "Tell me, priests," he said, "what is gold doing in the holy place?" I, however, say, . . . "Tell me, poor men, if indeed you are poor men, what is gold doing in the holy place?" For certainly bishops have one kind of business, and monks another. We [monks] know that since they [bishops] are responsible for both the wise and the foolish, they stimulate the devotion of a carnal people with material ornaments because they cannot do so with spiritual ones. But we who have withdrawn from the people, we who have left behind all that is precious and beautiful in this world for the sake of Christ, we who regard as dung all things shining in beauty, soothing in sound, agreeable in fragrance, sweet in taste, pleasant in touch—in short, all material pleasures—. . . whose devotion, I ask, do we strive to excite in all this? . . .

Does not avarice cause all this? Money is sown with such skill that it may be multiplied. The very sight of these costly but wonderful illusions inflames men more to give than to pray. In this way wealth is derived from wealth. Eyes are fixed on relics covered with gold and purses are opened. The thoroughly beautiful image of some male or female saint is exhibited and that saint is believed to be the more holy the more highly colored the image is. People rush to kiss it, they are invited to donate, and they admire the beautiful more than they venerate the sacred. What do you think is being sought in all this? The compunction of penitents, or the astonishment of those who gaze at it? O vanity of vanities! The Church is radiant in its walls and destitute in its poor. It serves the eyes of the rich at the expense of the poor. The curious find that which may delight them, but those in need do not find that which should sustain them.

But apart from this, in the cloisters, before the eyes of the brothers while they read—what is that ridiculous monstrosity doing, an amazing kind of deformed beauty and yet a beautiful deformity? What are the filthy apes doing there? The fierce lions? The monstrous centaurs? The creatures, part man and part beast? The striped tigers? The fighting soldiers? The hunters blowing horns? You may see many bodies under one head, and conversely many heads on one body. On one side the tail of a serpent is seen on a quadruped, on the other side the head of a quadruped is on the body of a fish. Over there an animal has a horse for the front half and a goat for the back; here a creature which is horned in front is equine behind. In short, everywhere so plentiful and astonishing a variety of contradictory forms is seen that one would rather read in the marble than in books, and spend the whole day wondering at every single one of them than in meditating on the law of God. Good God! If one is not ashamed of the absurdity, why is one not at least troubled at the expense?

SOURCE: CONRAD RUDOLPH, *THE "THINGS OF GREATER IMPORTANCE": BERNARD OF CLAIRVAUX'S APOLOGIA AND THE MEDIEVAL ATTITUDE TOWARD ART.* (PHILADELPHIA: UNIVERSITY OF PENNSYLVANIA PRESS, 1990)

monastery's church of Saint-Pierre. Its elaborately sculptured portal (fig. **11.14**) was executed almost a generation after the cloister was finished. It displays the parts of a typical Romanesque portal (fig. **11.15**). Christ in Majesty takes center stage in the **tympanum**, the lunette above the lintel of the portal. He is shown during his Second Coming, when he returns to Earth after the apocalyptic end of days, as described in the book of Revelation (4:1–8), in order to judge mortals as saved or damned. In accord with the biblical account, Christ is attended by four beasts, which accompany two angels and 24 elders, while wavy lines beneath their feet represent "the sea of glass like crystal." The elders, relatively small compared with the other figures, and many of them gesticulating, can barely contain their excitement in the face of the remarkable vision. Abstraction and activity characterize the style of carving, in which quivering lines, borders of meandering ribbon patterns, and fluttering drapery offset a hierarchy of scale and pose. The use of abstraction in the service of religious zeal has parallels in earlier medieval art, for example the manuscript illuminations of the *Ebbo Gospels* (see fig. 10.14) and the *Utrecht Psalter* (see fig. 10.15). At Moissac, however, the presentation is on a monumental and public scale.

Other parts of the Moissac portal are also treated sculpturally. Both the **trumeau** (the center post supporting the lintel) and the **jambs** (the sides of the doorway) have scalloped outlines (see fig. 11.14), modeled on a popular Islamic device. By borrowing forms from the art of Islam at Moissac and other churches, Christians were expressing their admiration and regard for Arab artistic achievements. At the same time, such acts of appropriation could also express the Christian ambition to dominate the Muslim enemy. The pilgrimage to Santiago was a similar manifestation of anti-Islamic feeling.

The scalloped outlines framing the doorway activate and dramatize the experience of entering the church. Human and animal forms are treated with flexibility; for instance, the spidery prophet on the side of the trumeau seems perfectly

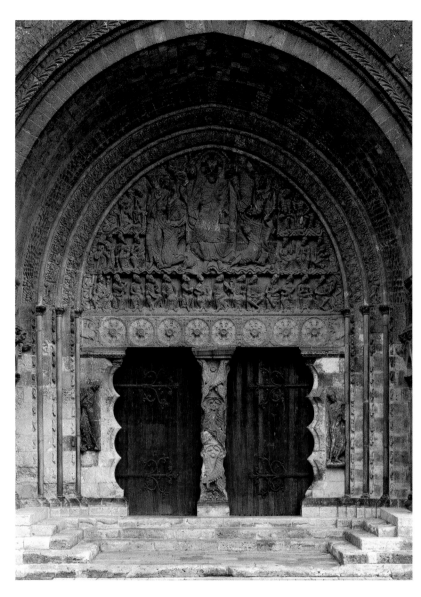

11.15. Romanesque portal ensemble

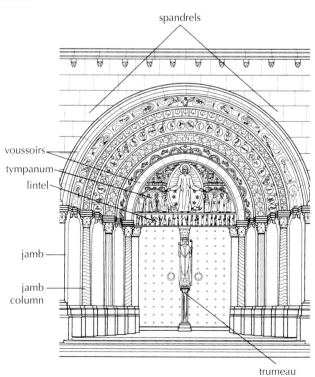

spandrels

voussoirs

tympanum

lintel

jamb

jamb column

trumeau

adapted to his precarious perch, even as he struggles to free himself from the stone (fig. **11.16**). With legs crossed in a graceful movement, he turns his head toward the interior of the church as he unfurls his scroll. The crossed lions that form a symmetrical zigzag on the face of the trumeau "animate" the shaft the same way the interlacing beasts of Irish miniatures (from which they are descended) enliven the spaces they inhabit.

We can trace the crossed lions through textiles to Persian metalwork, although not in this towerlike formation. Ultimately they descend from the heraldic animals of ancient Near Eastern art (see fig. 2.10). Yet we cannot account for their presence at Moissac in terms of their effectiveness as ornament alone. They belong to an extensive family of savage or monstrous creatures in Romanesque art that retain their demoniacal vitality even as they are forced to perform a supporting function. Their purpose is thus not only decorative but expressive; they embody dark forces that have been domesticated into guardian figures or banished to a position that holds them fixed

for all eternity, however much they may snarl in protest. One medieval bishop argued that seeing animals sculpted in churches would so terrify parishioners that they would be encouraged to refrain from sinful deeds.

A deep porch with lavishly sculptured lateral ends frames the Moissac portal. Within an arcade on the east flank (fig. **11.17**), we see the Annunciation to the Virgin, on the lower left, and to the right, the Visitation (when Mary visits her cousin Elizabeth, mother of John the Baptist, to announce that she is pregnant) and the Adoration of the Magi in the top two panels under the arches. Other events from the early life of Jesus are on the frieze above. All of the figures have the same thin limbs and eloquent gestures as the prophet on the trumeau. Note, in particular, the wonderful play of hands in the Visitation and Annunciation. (The angel of the Annunciation is a modern replacement.). On the west flank, not illustrated here, is a representation of the vice of *luxuria* (lust) presented as antithetical to the virtue of the Virgin Mary. The juxtaposition recalls the pairing during the early Middle Ages of Eve's sinfulness with Mary's purity (see fig. 10.26). The messages at Moissac are patently didactic, meant both to command and to enlighten. When visitors on the pilgrim road faced the deep portal of the church they were virtually surrounded by the sculptural program, and this intensified the liminal experience of crossing into the church. The journey into the church became a veritable rite of passage, transformative both physically and spiritually.

CATHEDRAL OF SAINT-LAZARE, AUTUN Close to Cluny and dependent on it was the Cathedral of Saint-Lazare at Autun. The tympanum of its west portal (fig. **11.18**) represents the Last Judgment, the most awe-inspiring scene in Christian art. This scene depicts Christ after his Second Coming as he separates those who will be eternally saved from those who are damned. His figure, much larger than any other, dominates the tympanum. The sculptor, Gislebertus, whose signature appears immediately under the feet of Christ in the center of the tympanum, treats the subject with extraordinary force. Gislebertus is only one of a number of Romanesque sculptors with distinct artistic personalities who are known to us by name. His style is sufficiently individual to enable scholars to posit convincingly that he trained at Cluny before his elevation to master's rank at Autun.

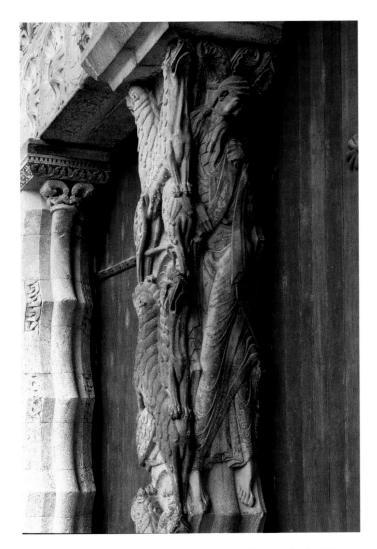

11.16. Trumeau and jambs, south portal, Church of Saint-Pierre, Moissac

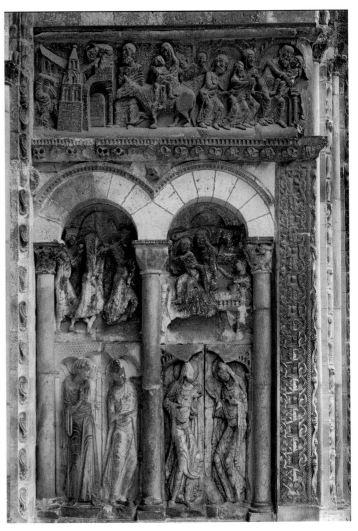

11.17. East flank, south portal, Church of Saint-Pierre, Moissac

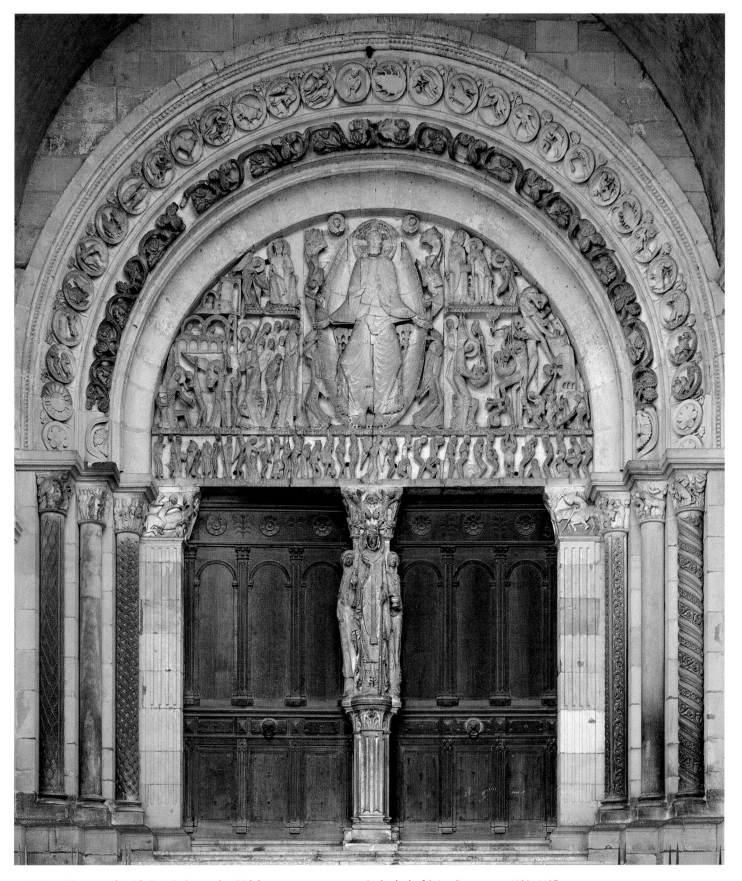

11.18. West portal, with *Last Judgment* by Gislebertus on tympanum, Cathedral of Saint-Lazare. ca. 1120–1135. Autun, France

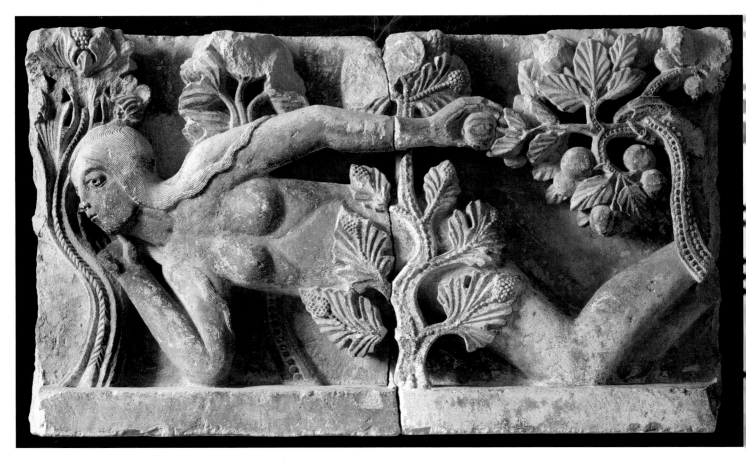

11.19. Gislebertus. *Eve*, right half of lintel, north portal from Cathedral of Saint-Lazare, Autun. 1120–1132. 28$\frac{1}{2}$ × 51" (72.4 × 129.5 cm). Musée Rolin, Autun

On the left side of the tympanum, apostles observe the weighing of souls, which takes place on the right side. Four angels in the corners sound the trumpets of the Apocalypse. At the bottom, the dead rise from their graves, trembling with fear; some are already beset by snakes or gripped by huge, clawlike hands. Above, their fate quite literally hangs in the balance, with devils yanking at one end of the scales and angels at the other. The saved souls cling like children to the angels for protection before their ascent to the Heavenly Jerusalem (far left), while the condemned, seized by grinning devils, are cast into the mouth of Hell (far right). These nightmarish devils are human in general outline, but they have birdlike legs, furry thighs, tails, pointed ears, and savage mouths. The hierarchical, abstract, and patterned representation of Christ conveys his formidable power more effectively than any naturalistic image could. No visitor who had "read in the marble" (to quote St. Bernard of Clairvaux) could fail to enter the church in a chastened spirit.

The Last Judgment, with its emphasis on retribution, was a standard subject for the tympana of Romanesque churches. It was probably chosen because medieval judgment was dispensed in front of the church portal, *ante ecclesium*. Thus, actual judicial proceedings paralleled the divine judgment represented here. Trial was by *ordeal*, whereby the accused established innocence only by withstanding grueling physical tests. The ordeals must, in reality, have been as terrifying as the scenes depicted on the tympanum.

The outer **archivolt** (a molded band forming an arch) surrounding the west tympanum on Autun's cathedral is composed of medallions containing calendar scenes, comprised, in typical medieval fashion, of the signs of the zodiac and the corresponding labors of the months. The calendar serves to place the fearsome events of the Last Judgment within cosmological time, that is, within the physical realm that all of us occupy on earth.

The north portal of the cathedral was dismantled in the eighteenth century but Gislebertus's *Eve* (fig. **11.19**), a fragment of the lintel, survives in the Musée Rolin. It demonstrates the master's incredibly expressive range. The relief was balanced on the other side of the lintel by a representation of Adam. Once again the choice of subjects undoubtedly relates to the portal's liturgical function, since public penitential rites took place in front of the north portal. Adam and Eve's sin—the original one, after all—was mentioned in the penitential liturgy, in which sinners, seeking forgiveness for their transgressions, participated. In the relief, Eve's delicate gestures of grasping the fruit and touching her cheek as if in contemplation result in a beguiling, sensual silhouette. Her posture is not merely the consequence of the narrow horizontal space she occupies; rather, her pose emulates a slithering earthbound serpent, so she is temptress as well as tempted. As we saw on the bronze doors of Bishop Bernward at Hildesheim (see fig. 10.26), in medieval eyes Eve symbolized the base enchantments embodied by all worldly women, though not all regions of Romanesque Europe saw women so negatively.

SARCOPHAGUS OF DOÑA SANCHA Worldly women are not always represented as debased subjects in the Middle Ages, as a viewer can see in the stone sarcophagus created around 1120 to house the remains of Doña Sancha, a princess of the kingdom of Aragon, in northern Spain. Aragon had strong ties to Cluny; about 50 years before Sancha's sarcophagus was carved, her brother, King Sancho Ramírez, undertook a Cluniac reform of the monasteries in his kingdom. This was part of his efforts to strengthen Christian foundations in Spain, a reaction to the Muslim presence on the Iberian peninsula. Sancha was active in supporting her brother's efforts.

At the center of one side of the *Sarcophagus of Doña Sancha* (fig. **11.20**), two angels support a nude figure in a mandorla, representing the soul of the deceased being lifted to heaven, an appropriate subject for a funerary monument. On the left, three clerics under an arch perform a Mass for the dead, and on the right, two women, probably Sancha's sisters, stand under an arch and flank the enthroned princess. The arrangement in this right panel, which proclaims the dignity and importance of the larger central figure of Sancha, relies on an antique tradition, seen, for example, on the fourth-century *Sarcophagus of Junius Bassus* (see fig. 8.20).

On the other side of the sarcophagus are three mounted figures, each under an arch. Two armed horsemen confront each other, while the third straddles a lion and grasps its open jaws with his hands. The most compelling interpretation of the confronted horsemen identifies them as combatants in the struggle between good and evil, a common subject in Christian art. The lion rider in the right arcade has variously been identified as the long-haired Samson or the youthful David, both Old Testament prototypes for the Christian struggle over evil. The stone sarcophagus connects Sancha's tomb with Early Christian precedents (see figs. 8.2, 8.20); so too, the iconographic program relates it to Early Christian methods of argument.

Sancha was a major personage in her kingdom at a time when the Aragonese kings struggled to conquer Spain from the Muslims, who held sway over much of the Iberian peninsula. That scenes of battle, even ones that can be symbolically or allegorically interpreted, were considered appropriate for the sarcophagus of a woman is a mark of the culture of Romanesque Spain, which one scholar has called "a society organized for war." Many legends sprang up about women's roles in the defense of newly conquered Christian territories. The pressing needs for settlement and permanent organization required

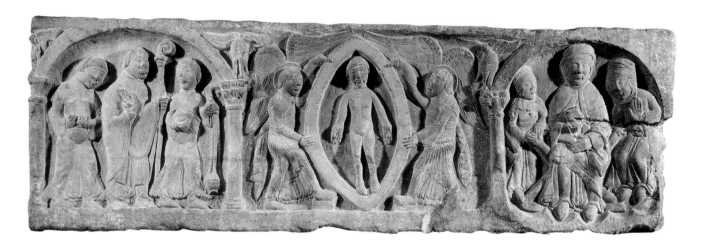

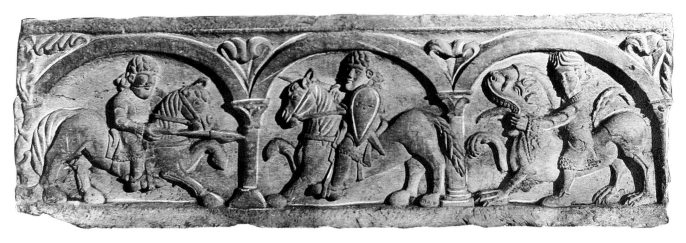

11.20. *Sarcophagus of Doña Sancha,* front and back sides. ca. 1120. Stone, 25.8 × 78.74″ (65 × 200 cm). Monastério de las Benedictinas, Jaca, Spain

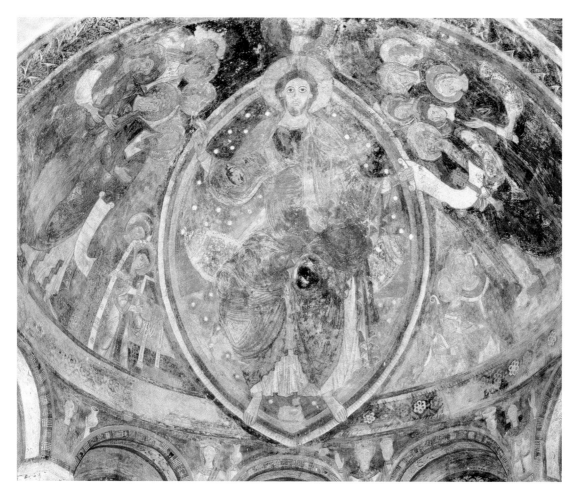

11.21. *Christ and Apostles*. Painting in the apse. Early 12th century. Priory of Berzé-la-Ville, France

women to engage actively in the acquisition and exchange of land and other properties at a time when their men were away on military campaigns.

Doña Sancha herself assumed enormous responsibilities within the court and kingdom. These included the management of large estates, which she held in her own right, and for some years she was administrator of the bishopric of Pamplona, a remarkable assignment for a woman. If Sancha were an isolated instance of a woman of power enjoying special prestige, it would not add much to our knowledge of the Romanesque period. But in fact, women in eleventh- and twelfth-century Spain played an inordinately important role in the formation of political structures, and as commissioners of works of art.

The triumphal aspirations represented on Sancha's sarcophagus are balanced by the sensitive representation of the soul, whose tender expression suggests hope as well as anxiety, common human responses when contemplating death. Notice how the center group is the only one not covered by an arch, a strategy that emphasizes a sense of upward thrust and hence suggests a heavenly journey.

Cluniac Wall Painting

Because the destruction of Cluny's buildings resulted in the loss of its wall paintings, we can best appreciate what these might have looked like by examining allied monuments. A good one for this purpose is the priory of Berzé-la-Ville

THE BERZÉ-LA-VILLE APSE The early twelfth-century priory of Berzé-la-Ville, just a few miles southeast of Cluny, was built as a retreat for Cluny's abbot, and the apse paintings in its chapel (fig. **11.21**) emulate those in the church of the motherhouse. Christ in Majesty occupies the center of the composition, surrounded by the apostles. The elongated faces and the graceful manner in which drapery is pulled across limbs impart delicacy and elegance to the images; patterns of rhythmic concentric lines and bright highlights indicate the multiple folds in the cloth. Although these devices ultimately derive from Byzantine sources, such as the *Paris Psalter* (see fig. 8.40), the path by which they were acquired was indirect, coming from Byzantine art in Italy, not Constantinople. The library at Cluny was rich in Italo-Byzantine manuscripts, and Cluniac manuscript illumination also favors this style.

Cistercian Architecture and Art

As we have seen, Cluny's very success made it the subject of criticism, particularly by the Cistercians, whose motherhouse was at Cîteaux in Burgundy. In addition to prayer, the Cistercians devoted themselves to hard work, which helped guarantee their own great success. Sound economic planning, skill in agriculture and husbandry, and wealthy benefactors furthered their cause. At a time of rising urban growth, the serenity of the isolated sites of their monasteries must also have been attractive. The Cistercian order and its style spread across

11.22. Plan of Fontenay Abbey, France

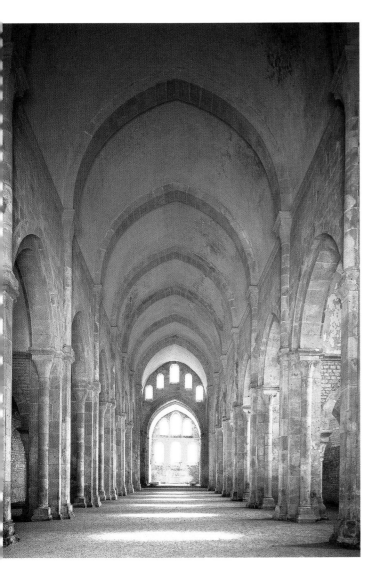

11.23. Nave, Abbey Church, Fontenay. 1139–1147

Europe, and by the end of the twelfth century the Cistercians controlled nearly 700 monasteries. Cistercian architecture in its simplicity contrasts markedly with the architecture of the Cluniac order.

ABBEY CHURCH AT FONTENAY The abbey church at Fontenay, not far from Cîteaux, was begun in 1139, a generation after St. Bernard founded a monastery there. It is the best-preserved Cistercian church built in the first half of the twelfth century. Fontenay exemplifies the Cistercian reliance on simple and unadorned forms in contrast to the opulence promulgated by Cluny. In its orderliness, the plan of simple geometric shapes (fig. **11.22**) builds on monastic schemes dating as far back as the St. Gall drawing (see fig. 10.21). By comparison to the expansive plan of Cluny (see fig. 11.10), where the huge abbey church dominated a sprawling complex, Fontenay is precise, a pure and tightly controlled equilibrium balancing all of its constituent parts.

The east end of the church at Fontenay is unembellished by apses, and no towers were planned. Since Cistercians permitted neither sculpture nor wall painting, the interior of the church (fig. **11.23**) lacks applied decoration. Clerestory and gallery are suppressed. However, in their own terms, the clean lines of the pointed transverse arches that define the nave and openings into the side aisles, and the pattern of unframed windows, create an elegant refinement. The simple forms are at once graceful and moving. Once again, the church serves as a safe, tranquil, and spiritual refuge from worldly burdens, although different in effect from the protective enclosures that other Romanesque churches offer (see figs. 11.1, 11.4, and 11.8).

Other Benedictine Architecture and Wall Painting

The Benedictine abbey church of Saint-Savin-sur-Gartempe is of a type known as a **hall church** (fig. **11.24**). The nave vault lacks transverse arches. Its weight rests directly on the nave arcade, which is supported by a majestic set of columns. The nave is fairly well lit, for the two aisles are carried almost to the same height as the nave, and their outer walls have generous windows.

Although Saint-Savin-sur-Gartempe has a luxurious sculptural program and a rich doorway, the hall church was designed particularly to offer a continuous surface for murals. *The Building of the Tower of Babel* (fig. **11.25**) is part of an extensive cycle of Old Testament scenes on the vault. It is an intensely dramatic design, crowded with strenuous action. God himself, on the far left, participates directly in the narrative, addressing the builders of the huge structure. He is counterbalanced, on the right, by the giant Nimrod, leader of the project, who frantically hands blocks of stone to the masons atop the tower. The entire scene becomes a great test of strength between God and mortals. The heavy, dark contours and the emphatic gestures make the composition easy to read from the floor below. Elsewhere in the church the viewer can see New Testament scenes and scenes from the lives

of local saints. Although paintings in Romanesque churches were not necessarily the norm, they were common features. Many frescoes no longer exist as a result of restoration programs. (See *The Art Historian's Lens*, page 368.)

Book Illustration

As in the early Middle Ages, manuscript production in the Romanesque period continued to be largely the responsibility of monastic scriptoria under the supervision of monks. Manuscripts produced by Cluniac scriptoria are stylistically similar to wall painting in Cluniac churches and often express concerns remarkably akin to those of the period's architects and sculptors. Those produced in Cistercian scriptoria are particularly inventive, often based on the observation of daily life. Many manuscripts produced at Cîteaux show strong English influence, and some were perhaps executed by English illuminators. The interrelationship of monastic communities accounts for a consistency of manuscript production across various regions during the Romanesque period. Some manuscripts produced in northern France, Belgium, and southern England are so related in style that at times we cannot be sure on which side of the English Channel a given manuscript was produced.

THE CLUNY LECTIONARY The *Pentecost* (fig. **11.26**), an illumination from the *Cluny Lectionary*, represents the descent of the Holy Spirit on the apostles after the Resurrection of Christ. As in the apse fresco at Berzé-la-Ville (see fig. 11.21), once again a viewer sees highlighted drapery tautly drawn across limbs. Other stylistic features also recall Byzantine

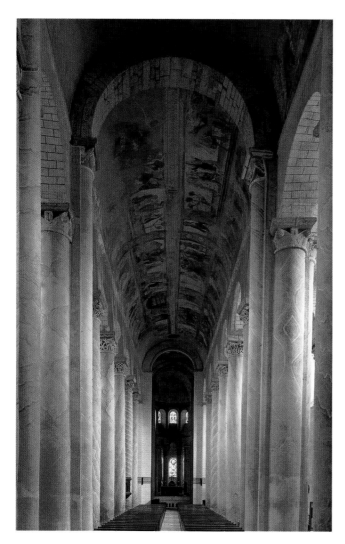

11.24. Choir ca. 1060–1075 and nave ca. 1095–1115. Saint-Savin-sur-Gartempe, France

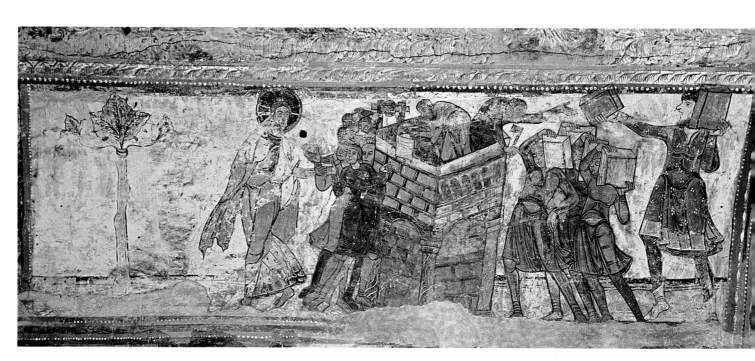

11.25. *The Building of the Tower of Babel.* Early 12th century. Detail of painting on the nave vault, Saint-Savin-sur-Gartempe, France

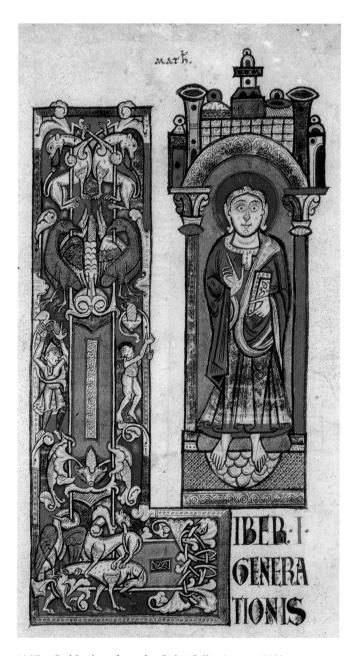

11.26. *Pentecost*, from the *Cluny Lectionary*. Early 12th century. Tempera on vellum, 9 × 5″ (22.9 × 12.7 cm). Bibliothèque Nationale, Paris, France

beginning of his Gospel, next to an embellished letter L, the first letter of *Liber,* meaning "book." Figures, animals, foliage, and decorative patterns conform to the shape of the letter, recalling the way Romanesque sculptured figures correspond to their frames (see fig. 11.2).

In contrast to the small, freely disposed figures and animals in the initial, the figure of Matthew confronts us directly. Although he fills the available space of the architectural setting, a number of features deny his solidity. The heavy outlines and bold colors are reminiscent of enamelwork (see fig. 11.5) and, in combination with a variety of juxtaposed patterns, serve to flatten the image. These devices demonstrate to what extent forms popular during the early Middle Ages remained vital.

devices. The delicate, classicizing faces of some of the prophets evoke Middle Byzantine painting (see figs. 8.39 and 8.40), and the other faces with long moustaches falling over ample beards recall the Byzantine manner of representing saints and prophets (see fig. 8.41). Even Christ at the top of the folio is presented in his typical Byzantine role as Pantocrator. The apostle distinguished by his central placement is Peter, the same saint who receives the scroll from Christ in the Berzé-la-Ville apse painting. Since Cluny was dedicated to St. Peter, it was only logical to stress his importance, but there is a political message as well. Cluny's foundation charter states that the monastery was answerable only to Rome and the pope, heir to Peter's throne, and not to any king or emperor. This special privilege assured Cluny enormous power and ultimately its success as well.

THE CODEX COLBERTINUS The illustration of *St. Matthew* from the *Codex Colbertinus* (fig. **11.27**) is similar in concept and pose to a number of Romanesque carvings, particularly the pier reliefs from the Moissac cloister (see fig. 11.13). The manuscript was made at that monastery, or nearby, just when sculptors were at work in the cloister. Matthew appears at the

11.27. *St. Matthew*, from the *Codex Colbertinus*. ca. 1100. Tempera on vellum, 7½ × 4″ (19 cm × 10.16 cm). Bibliothèque Nationale, Paris, France

Preserving and Restoring Architecture

The conservation and the preservation of any work of art are delicate tasks. In the case of architecture, the issues to be considered are particularly acute since, in addition to aesthetic criteria, restorers must take into account a building's function. What does one do, for example, with a building originally built to satisfy functions that are no longer relevant? Such is the question with medieval castles and palaces, as well as with churches located in areas where population shifts have reduced the size of their parishes. Should these buildings be retrofitted for new uses, even if that transforms their original character?

The restoration of Romanesque buildings poses some special problems. In many regions of Europe virtually every village has its own Romanesque church, but diocesan and governmental institutions have difficulty in obtaining the funds to preserve them. Moreover, Romanesque architecture is characterized by its great variety. Thus, a one-size-fits-all approach to restoration, which might be efficient on a practical level, only erases the essential distinctions that give Romanesque its exceptional quality.

Art historian C. Edson Armi has written penetratingly about recent restorations of Romanesque churches in the Burgundy region of France.* Although the French Restoration Service has a long tradition of intervention to save historic buildings, it does not have the resources to maintain all needy monuments. Increasingly, it has had to focus on simply reacting to severe problems, often when it is too late to correct them. Additionally, the service has a pattern of applying a universal, rather than a specific, approach to the restoration of buildings. In the mid-twentieth century it was fashionable to clean the surfaces of Romanesque churches within an inch of their lives, and restorers indiscriminately removed any surface coverings—sometimes including original ones—to expose underlying stone or brick. It was thought that by exposing the original materials and structure, the building's true expressive nature would be revealed.

By late in the last century the pendulum had swung the other way, and the norm was to plaster both interior and exterior surfaces of Romanesque churches—in some cases the same ones that had been completely stripped only a generation or so earlier. While it is true that during the Middle Ages the surfaces of buildings, whether of brick or stone, were often covered with plaster, this was not always the case. Armi demonstrates how recent interventions have covered up valuable evidence of original materials and structure, information that would help an architectural historian "appreciate large issues like the concept, process and history of a building." Since Armi has shown that a mason's techniques are as distinctive as a painter's or a sculptor's, the lost information could well be key to placing a building in its art historical context. Armi proposes early preservation programs to prevent the need for severe reconstructions that are often based more on conjecture than on fact. Before undertaking any project, he would require modern restorers to acquire a sound understanding of the historical and architectural situation of individual buildings and regions. He proposes that review committees participate in decisions about the restoration of important buildings. Armi has been guided by standards established in the 1964 Venice International Congress of Architects and Technicians of Historic Monuments, which require that whatever is done to a building demonstrates "respect for original material and authentic documents . . . and must stop at the point where conjecture begins." Any restorations "must be distinguishable from the original so that restoration does not falsify the artistic or historic evidence."

We also need to ask to what extent one should accept or reject previous changes to buildings. Is it always important to get back to the hypothetical origin of a building, or is it appropriate to consider buildings as entities that change over time? Is there an ideal moment that restorers should aim to preserve? When is it proper to remove a later addition to a building and when should that addition be preserved? A case in point is the apse of the Early Christian basilica of Santa Maria Maggiore (see pages 248–249). The original fifth-century apse was destroyed when a new one was added in 1290; during the next 35 years leading artists of the day decorated the apse with magnificent mosaics. Certainly in this case, to restore the building to its fifth-century state would produce a loss much greater than any advantage obtained by recreating original forms.

*C. EDSON ARMI, "REPORT ON THE DESTRUCTION OF ROMANESQUE ARCHITECTURE IN BURGUNDY," *JOURNAL OF THE SOCIETY OF ARCHITECTURAL HISTORIANS*, VOL. 55, 1996, PP. 300–327.

THE CORBIE GOSPEL BOOK In its monumentality, the image of *St. Mark* from an early twelfth-century gospel book produced at Corbie (fig. **11.28**) can also be likened to Romanesque sculpture. The active pose and zigzag composition bear comparison with the prophet on the Moissac trumeau (see fig. 11.16). The twisting movement of the lines, not only in the figure of Mark but also in the winged lion, the scroll, and the curtain, also recalls Carolingian miniatures of the Reims School, such as the *Ebbo Gospels* (see fig. 10.14).

This resemblance helps us see the differences between them as well. In the Romanesque manuscript, every trace of Classical illusionism has disappeared. The fluid modeling of the Reims School, with its suggestion of light and space, has been replaced here by firm contours filled in with bright, solid colors. As a result, the three-dimensional aspects of the picture are reduced to overlapping planes. Yet by sacrificing the last remnants of modeling in terms of light and shade, the Romanesque artist has given his work a clarity and precision that had not been possible in Carolingian or Ottonian times. Here, the representational, the symbolic, and the decorative elements of the design are fully integrated.

GREGORY'S MORALIA IN JOB Although in principle Cistercian manuscripts were to be decorated only with nonfigurative initials of single colors, in actuality a number of beautiful and fascinating manuscripts were produced for the order. It is not easy to explain why an exception was made for this genre of art, although it might be because official statutes against the decoration of manuscripts were not established until 1134. (Some scholars claim these statutes date from 1152.) Pope Gregory's *Moralia*

ART IN TIME

Mid-1000s CE—Seljuk Turkish invaders begin their rule of Iran

ca. 1075–1120—Cathedral built at Santiago de Compostela, Spain

1099—The First Crusade warriors capture Jerusalem

By end of 1100s—Cistercians control nearly 700 monasteries

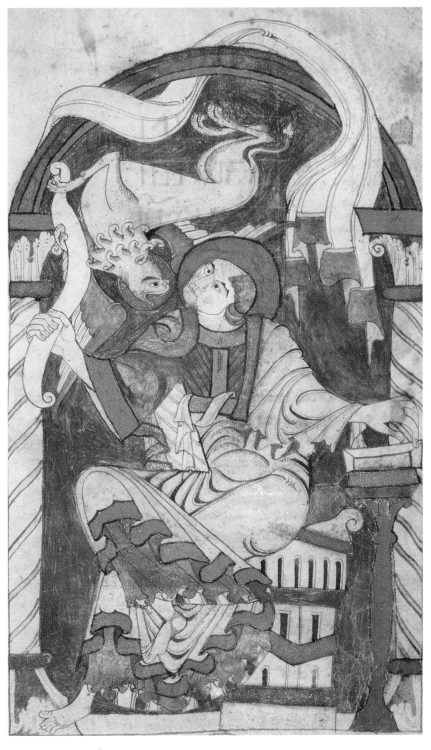

11.28. *St. Mark*, from a Gospel Book produced at the Abbey at Corbie. Early 12th century. Tempera on vellum, $10^3/_4 \times 7^7/_8''$ (27.3 cm × 20 cm). Bibliothèque Municipale, Amiens, France

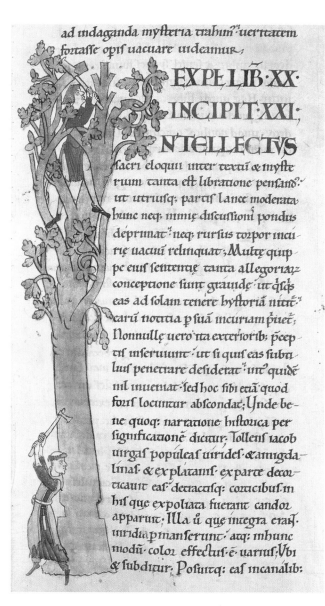

ad indaganda mysteria trahim^{us} uertitatem
fortasse opis uacuare uideamur;

EXPL LIB·XX·
INCIPIT·XXI;
NTELLECTVS
sacri eloquii inter textu & myste
rium tanta est libratione pensans?·
ut utriusq; partis lance moderata
hunc neq; nimie discussioni pondus
deprimat?·neq; rursus torpor incu
rie uacuu relinquat;·Multe quip
pe eius sententie tanta allegoriaz
conceptione sunt grauide·ut qsqs
eas ad solam tenere hystoriā nititr·
earu noticia p suā incuriam puet;
Nonnulle uero nta exterioribs pcep
tis inseruiunt·ut si quis eas subti
lius penetrare desiderat· intus quidē
nil inueniat·sed hoc sibi etiā quod
foris loquuntur abscondat;Unde be
ne quoq; narratione hystorica per
significatione dicitur; Tollens iacob
uirgas populeas uirides·&amigda
linas· & explatanis· ex parte decor
ticauit eas·detractisq; corticibus in
his que expoliata fuerant candor
apparuit; Illa u que integra eras
uiridia pmanserunt· atq; in hunc
modū color effectus ē uarius;Vbi
& subditur; Posuitq; eas in canalibs:

11.29. *Initial I*, from Gregory the Great's *Moralia in Job*. 1111. Tempera on vellum, 21 × 6″ (53.34 × 15.24 cm). Bibliothèque Municipale, Dijon, France

in Job, produced in 1111 at Cîteaux, is a charming example (fig. **11.29**). The manuscript contains decorated initials, depicting some of the monastery's daily activities, including the initial "I," formed by a tree, which a lay brother and a monk work together to fell. The bright, flat colors and patterned foliage of the tree contrast with seemingly naturalistic details. The monk's garment, his bunched trousers, and the dagger suspended on his belt convey the workaday quality of monastic life. In the second half of the twelfth century, with few exceptions, Cistercian manuscripts received only very simple decorations, apparently as a result of the statutes prohibiting elaborate adornments.

GOSPEL BOOK OF ABBOT WEDRICUS The style of the miniature of St. John from the *Gospel Book of Abbot Wedricus* (fig. **11.30**) has been linked with both northern France and England, and its linear draftsmanship was influenced by Byzantine art. Note the ropelike loops of drapery, the origin of

which can be traced to such works as the *Crucifixion* at Daphni (see fig. 8.46) and, even further back, to the *Archangel Michael* ivory (see fig. 8.34). The energetic rhythm unifying the composition of the Corbie style (see fig. 11.28) has not been lost entirely, however. The controlled dynamics of every contour, both in the main figure and in the frame, unite the varied elements of the composition. This quality of line betrays its ultimate source: the Celtic-Germanic heritage.

If we compare the Abbot Wedricus miniature of St. John with the Cross page from the *Lindisfarne Gospels* (see fig. 10.6), we see how much the interlacing patterns of the early Middle Ages have contributed to the design of the St. John page. The drapery folds and the clusters of floral ornament have an impulsive yet disciplined liveliness that echoes the intertwined snakelike monsters of the animal style (even though the foliage is derived from the classical acanthus), and the human figures are based on Carolingian and Byzantine

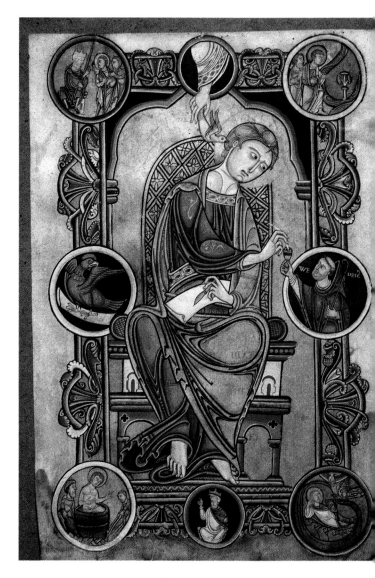

11.30. *St. John the Evangelist*, from the *Gospel Book of Abbot Wedricus*. ca. 1147. Tempera on vellum, 14 × 9½″ (35.5 × 24.1 cm). Société Archéologique et Historique, Avesnes-sur-Helpe, France

models. The unity of the page is conveyed not only by the forms but by the content as well. St. John inhabits the frame so thoroughly that we could not remove him from it without cutting off his ink supply (offered by the donor of the manuscript, Abbot Wedricus), his source of inspiration (the dove of the Holy Spirit in the hand of God), or his symbol (the eagle), all located in medallions on the page borders. The other medallions, less closely linked with the main figure, show scenes from the life of St. John.

REGIONAL VARIANTS OF ROMANESQUE STYLE

Although consistent aesthetic aims expressed across mediums link the art of diverse areas of Europe during the Romanesque period, a variety of distinct regional approaches can also be identified. These distinct approaches appear in regions of what is now France as well as in other parts of Europe, such as Tuscany in Italy, the Meuse Valley, Germany, and England. Regional variety in Romanesque art reflects the political conditions of eleventh- and twelfth-century Western Europe, which was governed by a feudal, though loose, alliance of princes and dukes. Language differences also help account for regional diversity. For example, even within France a number of languages were spoken, among them *langue d'oc*, the language of southwestern France, and *langue d'oïl*, the language of the center and north. Different regions had different artistic sources available to artists and patrons. In Germany and other parts of northern Europe, Ottonian art provided compelling models, while in Italy and southern France, where antique survivals were numerous, artists borrowed and transformed Roman forms in order to realize Romanesque aesthetic aims. In England, which through conquest had become the domain of Norman dukes in 1066, the artwork of French Normandy provided models.

Western France: Poitou

A so-called school of sculptural decoration appears during the Romanesque period in the region known as Poitou, part of the Duchy of Aquitaine in southwestern France. A notable example is Notre-Dame-la-Grande in Poitiers, seat of the lords of Aquitaine.

NOTRE-DAME-LA-GRANDE, POITIERS The broad screen-like facade of Notre-Dame-la-Grande (fig. **11.31**) offers an expanded field for sculptural decoration. Elaborately bordered arcades house large seated or standing figures. Below them a wide band of relief carving stretches across the facade. The Fall of Adam and Eve appears with scenes from the life of Mary, including the Annunciation and Nativity, once again juxtaposing Eve and Mary (see pages 335, 342). Next to the representation of Adam and Eve, an inscription identifies an enthroned figure as Nebuchadnezzar, the king of Babylon mentioned in the Old Testament. The *Play of Adam*—a twelfth-century medieval drama of a type that was traditionally performed in churches—probably served as the source

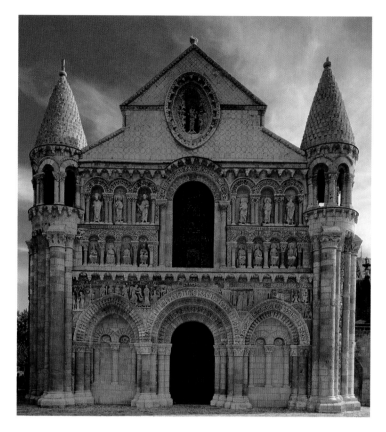

11.31. West facade, Notre-Dame-la-Grande, Early 12th century. Poitiers, France

for the choice and arrangement of figures at Notre-Dame-la-Grande. Beside Nebuchadnezzar, centered above the arch on the left of the portal, there are four figures carrying either scrolls or books on which are inscribed lines from the Adam play, in which Adam and Eve figure prominently and Nebuchadnezzar is also mentioned.

Essential to the rich sculptural effect is the deeply recessed doorway, without tympanum but framed by a series of arches with multiple archivolts. The conical helmets of the towers nearly match the height of the **gable** (the triangular wall section at the top of the facade), which rises above the actual level of the roof behind it. The gable contains a representation of Christ with angels, their height in the composition denoting their heavenly place. The sculptural program spread out over this entire area is a visual exposition of Christian doctrine intended as a feast for the eyes as well as the mind.

Southeastern France: Provence

In the French region of Provence, south of Burgundy, Romanesque art benefited from its proximity to Italy. The name *Provence* derives from its ancient designation as *Provincia Romana* in recognition of close political and cultural connections to Rome, and even today vestiges of Roman art and architecture abound in the region, such as the Maison Carrée in Nîmes (see fig. 7.46).

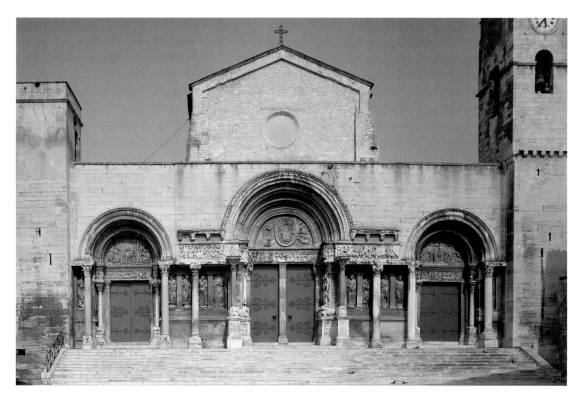

11.32. West facade, Saint-Gilles-du-Gard, France. Mid-12th century

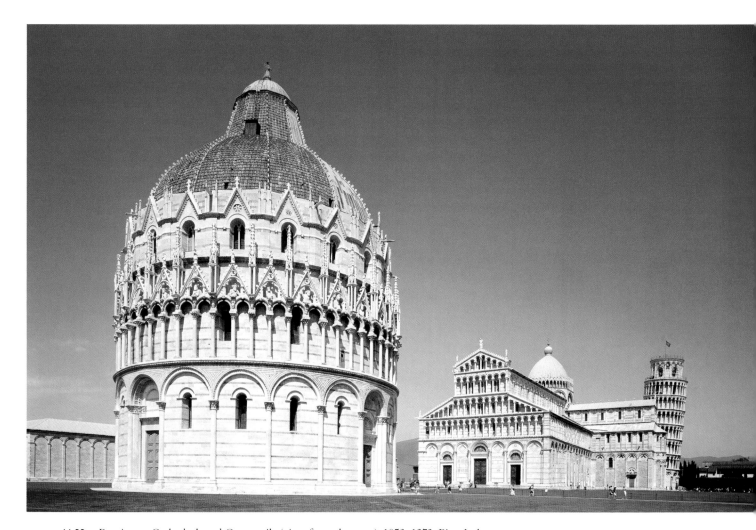

11.33. Baptistery, Cathedral, and Campanile (view from the west). 1053–1272. Pisa, Italy

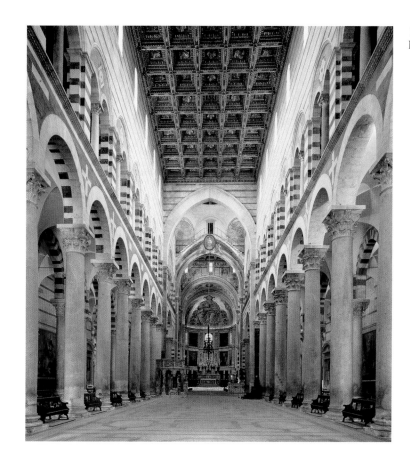

SAINT-GILLES-DU-GARD The facade of the abbey church of Saint-Gilles-du-Gard (fig. **11.32**), like Notre-Dame-la-Grande in Poitiers, screens the church. The inspiration for Saint-Gilles-du-Gard's facade, composed of three arches, can be found in the Roman triumphal arch (see fig. 7.65), connecting ancient triumphal imagery with the important liminal function of entering the church. Given contemporary concerns for Christian victory, in particular the struggle to conquer the Muslims, the formal association between the facade and a Roman triumphal monument must have seemed particularly fitting. The depiction of Jesus' triumphal entry into Jerusalem on the lintel supporting the left tympanum would have had special meaning to contemporary viewers, who were aware that the town of Saint-Gilles on the Rhone River estuary was a principal site of embarkation for French crusaders on their way to the Holy Land.

Tuscany

During the Romanesque period, Tuscany, a region in northwestern Italy divided into several independent city-states, chief of which were Pisa, Florence, Prato, and Livorno, continued what were basically Early Christian architectural forms. However, they added decorative features inspired by Roman architecture.

PISA CATHEDRAL The most famous monument of the Italian Romanesque owes its fame to an accident. Because of poor foundations, the Leaning Tower of Pisa in Tuscany, designed by the sculptor Bonanno Pisano (active 1174–1186), began to tilt even before it was completed (fig. **11.33**). This type of free-standing tower, or **campanile**, appears in Italy as early as the ninth or tenth century. The tradition of the detached cam-

panile remained so strong in Italy that towers hardly ever became an integral part of the church itself. The complex at Pisa includes a church and a circular, domed baptistery to the west. The ensemble of buildings, built on an open site north of the city, reflects the wealth and pride of the city-republic of Pisa after its naval victory over the Muslims at Palermo in 1062.

The Pisa Baptistery was begun in 1153 by Diotisalvi but everything above the arcaded first level was reworked a century later. Throughout the Middle Ages, Tuscany remained conscious of its antique heritage. The idea of a separate baptistery relies on Early Christian precedents, for example the Orthodox Baptistery at Ravenna (see fig. 8.13). The round form of the Pisa Baptistery and its original cone vault also reflect the structure of the Rotunda of the Anastasis in Jerusalem (see fig. 8.9). The comparison would undoubtedly have been comprehensible to Pisans, whose seamen profited by carrying pilgrims and crusaders to the Holy Land. Once again, the opportunity for increased trade and travel, the lure of pilgrimage, and the ongoing struggle against the Muslims in Iberia and the eastern Mediterranean were decisive forces in shaping Romanesque monuments.

The basic plan of Pisa Cathedral is that of an Early Christian basilica, but it has been transformed into a **Latin cross** (where three arms are of equal length and one is longer) by the addition of transept arms that resemble small basilicas with apses of their own. A dome marks the crossing. The rest of the church has a wooden roof except for the aisles (four in the nave, two in the transept arms), which have **groin vaults**, formed when two barrel vaults intersect. The interior (fig. **11.34**) has somewhat taller proportions than an Early Christian basilica, because there are galleries over the aisles as well

severely geometric lines. The triple arches of the second-story blind arcades, with their triumphal-arch design, are extraordinarily Classical in proportion and detail.

SAN MINIATO AL MONTE, FLORENCE The magnificent site of the Benedictine monastery of San Miniato al Monte overlooking the city of Florence reflects that monastery's grandeur during the Middle Ages. The gabled facade of the church (fig. **11.36**) coincides with the shape of the wooden-roofed and aisled basilica. Like the Baptistery of San Giovanni, and begun only a few years after it, geometric precision governs the arrangement of the facade's green-and-white marble covering. Although the treatment of surface and the materials employed are distinctive to Tuscany, the organization of elements compares with Romanesque arrangements elsewhere. The individual, additive units decorating Florentine Romanesque buildings parallel the compartmentalized bays in pilgrimage churches (see figs. 11.4 and 11.8) also and the way French Romanesque portals (see figs. 11.14, 11.31, 11.32) are composed of individual units that maintain their identities though functioning in unison. Roman elements in conscious revival—here the use of marble and the repeated arches that rest on columns topped with Corinthian capitals—unite many of these Romanesque works as well.

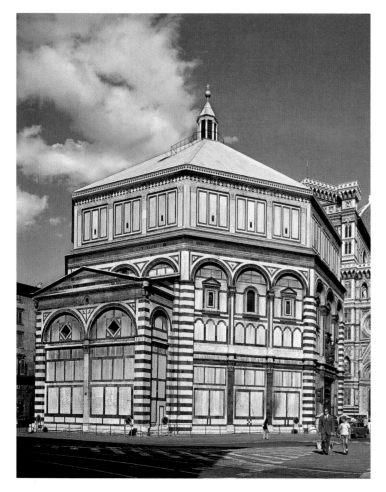

11.35. Baptistery of San Giovanni. ca. 1060–1150. Florence, Italy

as a clerestory. Yet the Classical columns supporting the nave and aisle arcades still recall types that would fit comfortably in an Early Christian basilica (see fig. 8.6).

A deliberate revival of the antique Roman style in Tuscan architecture was the use of a multicolored marble "skin" on the exteriors of churches. Little of this inlay is left today on the ancient monuments of Rome because much of it was literally "lifted" to decorate later buildings. However, the interior of the Pantheon still gives us some idea of what this must have looked like (see fig. 7.41). Pisa Cathedral and its companions are covered in white marble inlaid with horizontal stripes and ornamental patterns in dark-green marble. This decorative scheme is combined with blind arcades and galleries. The result is a richness very different from austere Early Christian exteriors.

BAPTISTERY OF SAN GIOVANNI, FLORENCE In Florence, which was to outstrip Pisa commercially and artistically, the greatest achievement of the Tuscan Romanesque is the baptistery of San Giovanni (fig. **11.35**) opposite the Cathedral (see fig. 13.11). It is a domed, octagonal building of impressive size, begun in the middle of the eleventh century. The symbolic significance of the eight-sided structure continues a long tradition in baptistery design (see page 248). The green-and-white marble paneling is typical of the Florentine Romanesque in its

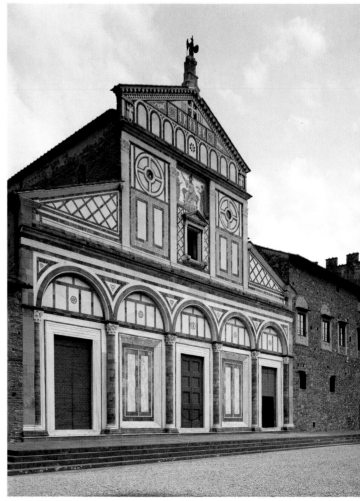

11.36. Facade, San Miniato al Monte, 1062–1150. Florence, Italy

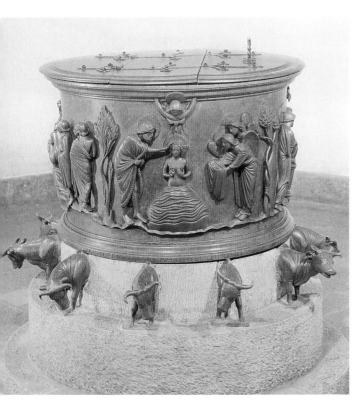

11.37. Renier of Huy. Baptismal Font. 1107–1118. Bronze. Height 25″ (63.5 cm). Saint-Barthélemy, Liège, Belgium

The Meuse Valley: Mosan Style

An important group of Romanesque sculptors, who excelled in metalwork, operated in the valley of the Meuse River, which runs from northeastern France into present-day Belgium and Holland. This region had been the home of the classicizing Reims style in Carolingian times (see figs. 10.14–10.16), and during the Romanesque period an awareness of Classical sources pervades its art, called Mosan. Abbott Hellinus of Liège commissioned a bronze baptismal font for the church of Notre-Dame-aux-Fonts in Liège (fig. **11.37**). The generally accepted attribution to Renier of Huy, the earliest Mosan artist whose name we know, is largely circumstantial. The font, completed by 1118 and today in the church of Saint-Barthélemy, is a remarkable achievement: Cast in one piece, it is over 2 feet high and 3 ½ feet in diameter. The vessel rested on 12 oxen, like Solomon's basin in the Temple at Jerusalem as described in the Old Testament book of I Kings: "And he made the molten sea . . . It stood upon twelve oxen . . . and all their hinder parts were inward." Christian writers described Solomon's basin as a prototype for the baptismal font and the twelve oxen as precursors of the apostles.

The reliefs are about the same height as those on bronze doors of Bishop Bernward at Hildesheim (see fig. 10.26). Instead of the rough expressive power of the Ottonian panel, however, the viewer sees a harmonious balance of design, a subtle control of the sculptured surfaces, and an understanding of

organic structure that are surprisingly Classical in a medieval work. The figure seen from the back (beyond the tree on the left), with its graceful movement and Greek-looking drapery, might almost be taken for an ancient work. Renier also expressed his interest in antique form through the use of bronze, rejecting the monumentality implicit in stone sculpture. The strong northern European metalwork tradition now serves to convey Classical values, so alien to early medieval metalworkers who had previously dominated the art of this area.

The Romanesque antique revival in the Mosan region has a special character, quite different from the abstract, decorative qualities that characterize the work of other regions, demonstrating that while Romanesque art shares a common interest in reviving Classical forms, there was great variety in the way that classicism was expressed. The Liège font and other Mosan sculptures are carved in high relief or are fully three dimensional, with convincing anatomical details and proportions. Yet, Mosan sculptures, like Romanesque works in other regions, are not naturalistic; it is the concern for idealism that here produces Classical forms.

Germany

In Germany, the traditions of the Holy Roman Empire functioned as filters for the revival of Roman forms. As a result, German Romanesque architecture, centered in the Rhineland, relied for its organization and formal vocabulary on buildings patronized by Carolingian and Ottonian rulers.

SPEYER CATHEDRAL The Cathedral of Speyer, which contained tombs of the Holy Roman Emperors, was consecrated in 1061. It included a timber-roof nave, not unlike those of Carolingian and Ottonian buildings (fig. **11.38**). A major rebuilding of the cathedral in 1080 added groin vaults to the nave (fig. **11.39**), providing a solution to a problem that had limited Romanesque builders: While the barrel vault used in the churches we have previously examined offered an aesthetically pleasing, acoustically resonant, and fire-resistant space, it limited the amount of light that could enter the nave. The problem was that the weakest part of the vault, the **springing**—the point where the arch rises from its support—was precisely the point where clerestory windows were needed. There had been exceptional buildings that included clerestories, such as Sant Vincenç at Cardona (see fig. 11.1) and the abbey church at Cluny (see fig. 11.12). But Sant Vincenç's windows are limited in number and scale, and at Cluny it was necessary to employ a series of devices, including pointed arches and enlarged buttresses, to provide adequate support for the high barrel vault.

The builders of Speyer Cathedral solved this problem with the groin vault. (See *Materials and Techniques*, page 378.) The groin vault, which had been used so effectively by the Romans (see page 378), efficiently channeled thrust onto four corner points. This allowed for open space under each arch, which could be used for window openings without diminishing the strength of the vault. The erection of groin vaults in the nave of

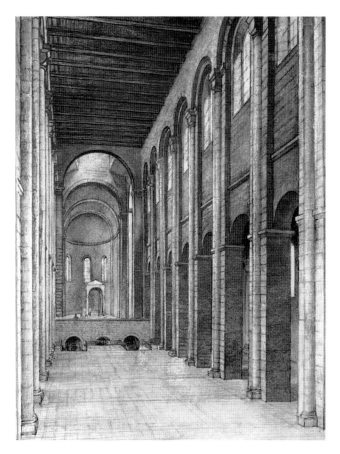

11.38. Reconstruction of interior of Speyer Cathedral, Germany. ca. 1030–1061. (after Conant)

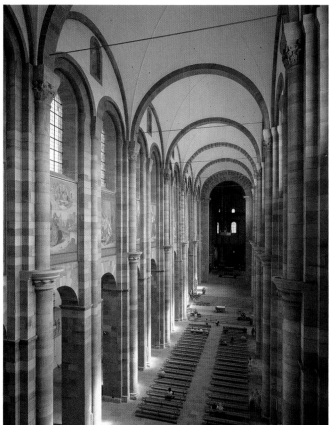

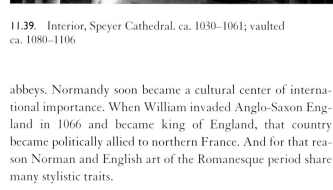

11.39. Interior, Speyer Cathedral. ca. 1030–1061; vaulted ca. 1080–1106

Speyer Cathedral was accompanied by an enlargement of its clerestory windows. Romanesque builders knew the technology of groin-vault construction and had previously employed groin vaults to cover lower spaces, in side aisles and in crypts, as at Pisa (see page 373), but apparently they found them daunting to build on a large scale. Speyer represents a genuine breakthrough in building technology. The scale of the church is so great that it dwarfs every other church of the period.

The individual groin-vaulted bays at Speyer form a chain of compartmentalized units of space. Each groin vault comprises two bays of the original nave. Colonnettes attached to alternate piers articulate the distribution of weight necessary to support the vaults. The use of these compound piers aligns Speyer with Romanesque buildings of other regions (see figs. 11.1, 11.4, and 11.8). The alternating support system establishes a rhythm that must have struck a familiar chord in Germany. It had appeared in the Ottonian buildings of Gernrode (see fig. 10.22) and Hildesheim (see fig. 10.25), although in these buildings such a system was purely aesthetic.

Normandy and England

Farther north, in Normandy, Christianity was strongly supported by the Norman dukes and barons, former Vikings who had turned Normandy into a powerful feudal domain that included the allegiance of abbots and bishops as vassals in return for grants of land. Duke William II of Normandy actively promoted monastic reform and founded numerous abbeys. Normandy soon became a cultural center of international importance. When William invaded Anglo-Saxon England in 1066 and became king of England, that country became politically allied to northern France. And for that reason Norman and English art of the Romanesque period share many stylistic traits.

THE BAYEUX TAPESTRY The complex relationship between the Normans and the English is hinted at in the *Bayeux Tapestry* (fig. **11.40** and fig. **11.41**). In actuality it is not a tapestry at all, since it is not woven, but rather, an embroidered linen frieze 230 feet long. The fifty surviving scenes record the events, culminating in 1066, when William the Conqueror crossed the English Channel to claim the throne of England upon the death of King Edward the Confessor. According to the narrative of the tapestry, Harold, an Anglo-Saxon earl, had retracted his oath of fealty to William in order to accept the throne offered him by the English nobles. William retaliated by invading England, and his Norman troops vanquished the English as Harold fell in battle. Since a Norman patron presumably commissioned the "tapestry," the story is told from the conquerors' perspective, yet its manufacture has generally been credited to English needlewomen, justly famous during the Middle Ages for the skill of their artisanry.

The *Bayeux Tapestry* exhibits the same monumentality and profound interest in narrative that we saw in the illuminations

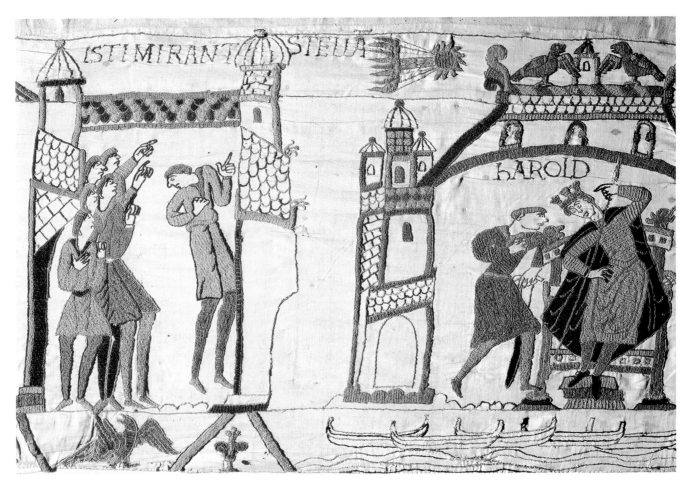

11.40. *Crowds Gaze in Awe at a Comet as Harold Is Told of an Omen.* Detail of the *Bayeux Tapestry*. ca. 1066–1183. Wool embroidery on linen. Height 20″ (50.7 cm). Centre Guillaume le Conquérant, Bayeux, France

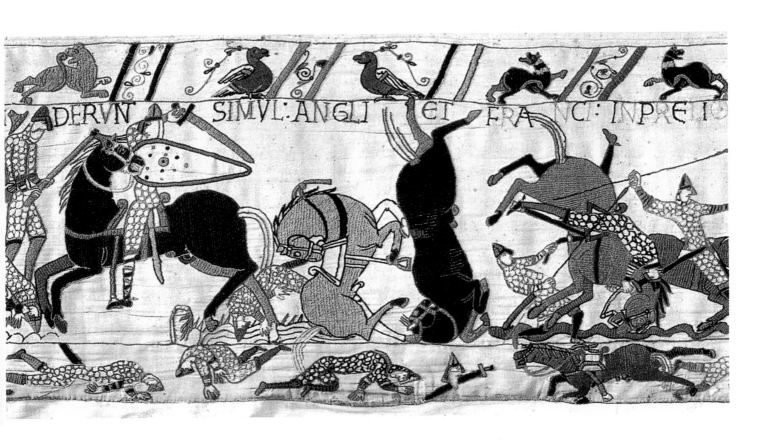

11.41. *The Battle of Hastings.* Detail of the *Bayeux Tapestry*. Wool embroidery on linen. Height 20″ (50.7 cm). Centre Guillaume le Conquérant, Bayeux, France

Vaulting

Vaulting is a technique for covering buildings that is based on the principles of **arcuation**, that is, construction that uses the arch form (a). Although vaulting was used in Mesopotamia, Egypt, and Greece, it was the Etruscans and Romans who first exploited the vault for expressive and aesthetic purposes (see pages 224–225). While most early medieval buildings were covered with timber roofs, during the Romanesque period vaulting became the dominant roofing type. Its reintroduction in the eleventh century was a major component of the revival of Roman artistic forms during the Romanesque period. Although Roman vaults were principally made of concrete, medieval vaults were usually made either of rubble or masonry, bound with mortar.

The erection of stone vaults in medieval buildings required enormous effort and great expense, but the benefits were numerous. They included fire resistance, particularly important for buildings illuminated by candles and for tall structures that attracted lightning. The history of medieval buildings is largely a history of fires. Widespread attacks by Vikings, Magyars, and Muslims also made stronger buildings desirable. In addition, stone vaulting provides excellent acoustics, a significant consideration for churches in which the liturgy was chanted. No less important than these practical benefits were the aesthetic ones: Vaulted buildings appear dignified and monumental, and they provide an unambiguous sense of enclosure. There are many types of vaults: barrel, quadrant, groin, ribbed, and the dome.

The **barrel vault**, essentially an arch projected in depth, is the most basic form (b). This was the first type exploited by medieval builders because it lent itself to covering rectangular basilicas. Unfortunately the barrel vault creates dark spaces, since opening up the nave walls with clerestory windows weakens the vault at its most vulnerable point, the **springing**. It is here at the base of the arch that the force of gravity, which is channeled through the arch, results in lateral forces pushing sideways. This outward thrust needs to be contained, usually by building thick walls to buttress the vault.

In Romanesque churches with wide side aisles, architects were faced with the problem of transferring the thrust of the barrel vault across the side aisles to the outer walls. They were able to do this by vaulting the galleries over the aisles with **quadrant vaults** (half-barrel vaults), which buttress the barrel vault of the nave. These buildings were also dark, with light entering only from windows at the ends of the barrel vaults and in the side walls, filtered through aisle and gallery before reaching the nave.

The introduction of the **groin vault** provided for more luminous structures that required less building material; thus buildings became lighter in both senses of the word. A groin vault is formed when two barrel vaults intersect (c); the thrust of each vault is countered by the vault running perpendicular to it. (The term *groin* refers to the junction where the vaults intersect.) Thrust is thus channeled to four corner points, allowing for windows or other openings in the wall under each of the intersecting arches.

The **ribbed vault**, introduced at Durham Cathedral, was probably invented as a decorative device (d); only later did architects and masons appreciate its structural advantages. Larger stones are placed on the groins of the vault to form diagonal arches. These function as a fixed scaffold to support the vault's curved panels, called **webs**, which essentially fill the spaces between the ribs. Ribbed vaults were easier to construct and required less centering than unribbed vaults; their webs could be built of lighter material, since the ribbed groins channeled the major lateral thrust more efficiently.

Romanesque masons also employed the **dome**, which is essentially an arch rotated on axis to form a vault (e). In Romanesque churches, domes cover centralized buildings or mark significant elements, for example the area where the transept crosses the nave. Vaults are not easy to construct and Romanesque vaults were heavy: Often more than a foot thick, each could weigh several tons. Arcuation is a dynamic system with all its elements interlocked; as a result, the vault is stable only when it is complete. During construction it needs to be supported by a wooden framework, called a **centering**. Once the vault is built and the buttresses are in place, the vault becomes self-supporting and the centering can be removed. The widespread use of the vault and its progressive refinement during the Romanesque period represent significant achievements, which proved to be crucial for the continued development of medieval building, particularly during the Gothic period.

Vault Forms: (a) arch; (b) barrel vault; (c) groin vault; (d) ribbed groin vault; (e) dome

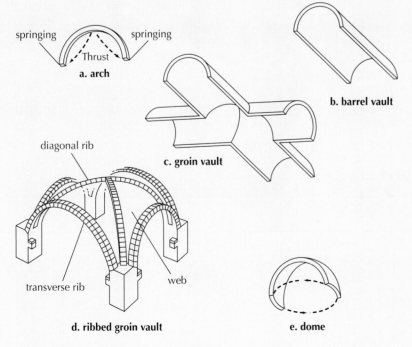

springing springing
Thrust
a. arch

b. barrel vault

diagonal rib

c. groin vault

transverse rib web

d. ribbed groin vault

e. dome

of the *Gospel Book of Abbot Wedricus* (see fig. 11.30), which, as noted, is a manuscript linked to both Normandy and England. The designer of the tapestry has integrated narrative and ornament with complete ease. Two border strips frame the main frieze; while some of the images of these margins are decorative, others offer commentary on the tapestry's continuous narrative. In one scene (see fig. 11.40) an aide announces to a recently crowned Harold the appearance of an amazing natural phenomenon, represented in the upper border as a spinning star leaving its fiery trail. The inscription ISTI MIRANT STELLA ("These men marvel at the star") records the brilliant apparition of Halley's Comet in 1066, during the days immediately following Harold's coronation. To the medieval viewer, the prophetic significance of the natural event would have been clear, especially when viewed after the fact. Beneath Harold, ghostly boats await the Normans, who are preparing to cross the English Channel. The scene foreshadows the violent events to come.

Although the *Bayeux Tapestry* does not use the pictorial devices of classical painting, such as foreshortening and overlapping (see fig. 5.79), it presents a vivid and detailed account of warfare in the eleventh century as well as a hint of the Normans as builders of fortresslike castles. The massed forms of the Graeco-Roman scene are replaced by a new kind of individualism that makes each figure a potential hero, whether by force or by cunning. Note how the soldier who has fallen from the horse with its hind legs in the air is, in turn, toppling his foe by yanking at the saddle girth of his mount. The kinship with the Corbie gospel book manuscript (see fig. 11.28) is noticeable in the lively somersaults of the horses, so like the pose of the lion in the miniature. In the Middle Ages, since the religious and secular spheres were not sharply distinguished from each other, the same pictorial devices were employed to represent both. The energy and linear clarity of the *Bayeux Tapestry* and the Corbie gospel book remind the viewer of the monumental figures of Romanesque sculpture.

DURHAM CATHEDRAL Norman architecture is responsible for a great breakthrough in structural engineering, which took place in England, where William made donations to build in a Norman style after his conquest of the country. Durham Cathedral, begun in 1093, is among the largest churches of medieval Europe (fig. **11.42**). Its nave is one-third wider than Saint-Sernin's, and its overall length (400 feet) is also greater. The nave may have been designed to be vaulted from the start. The vault over its eastern end had been completed by 1107, in a remarkably short time, and the rest of the nave was vaulted by 1130 (fig. **11.43**).

This vault is of great interest. As the earliest systematic use of a ribbed groin vault over a three-story nave, it marks a basic advance beyond Speyer. Looking at the plan (see fig. 11.42),

ART IN TIME

ca. 1066–1083 CE—Fabrication of the *Bayeux Tapestry*

1093—Construction begins on Durham Cathedral, England

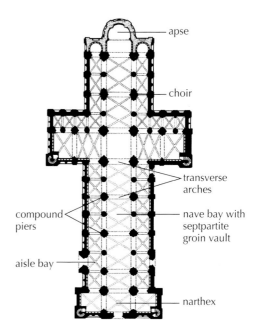

11.42. Plan of Durham Cathedral, England. 1093–1130. (after Conant)

we see that the aisles consist of the usual almost-square groin-vaulted compartments. The bays of the nave, separated by strong transverse arches, are oblong and also groin-vaulted so that the ribs of each bay form a double-X design. Each vault of the nave is thus divided into seven sections These vaults are referred to as *septpartite* (or seven-part) groin vaults. Since the nave bays are twice as long as the aisle bays, transverse arches occur only at the odd-numbered piers of the nave arcade (see fig. 11.43). The piers therefore alternate in size. Unlike Speyer Cathedral (see fig. 11.39), where a colonnette was added to every other nave pier to strengthen it, at Durham the odd-numbered piers are intrinsically different from the even-numbered ones. The larger odd-numbered ones are compound, with bundles of column and pilaster shafts attached to a square or oblong core, while the even-numbered ones are thinner and cylindrical.

The outward thrust and weight of the whole vault are concentrated at six securely anchored points on the gallery level from which the ribs spring. The ribs were needed to provide a stable skeleton for the groin vault, so that the curved surfaces

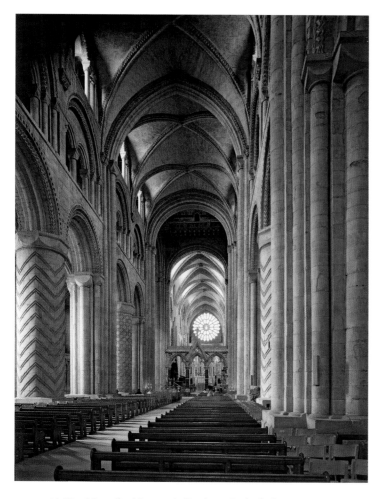

11.43. Nave (looking east), Durham Cathedral

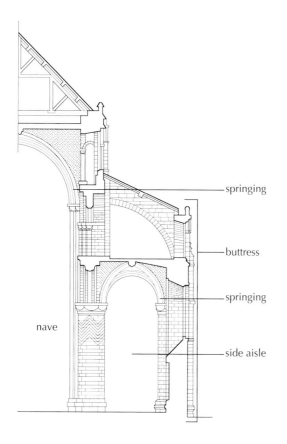

springing

buttress

springing

nave

side aisle

11.44. Transverse section of Durham Cathedral (after Acland)

between them could be filled in with masonry of a minimal thickness. Thus both weight and thrust were reduced. They were carried downward to the outer wall of the aisles by buttresses (fig. **11.44**). This flexible system resulted in more efficient vault erection and greater economy of construction. We do not know whether this ingenious scheme was actually invented at Durham, but it could not have been devised much earlier, for it is still in an experimental stage. While the transverse arches at the crossing are round, those to the west of it are slightly pointed, indicating an ongoing search for improvements (see fig. 11.43).

The ribbed groin-vault system had other advantages as well. From an aesthetic standpoint, the nave at Durham is among the finest in all Romanesque architecture. The sturdiness of the alternating piers makes a splendid contrast to the dramatically lit, sail-like surfaces of the vault. This relatively lightweight, flexible system permits broad expanses of great height to be covered with fireproof vaulting and yet retain the ample lighting of a clerestory. Durham exhibits great structural strength; even so, the decoration incised in its round piers, each different from the other, and the pattern established by the vault ribs hark back to the Anglo-Saxon love of decoration and interest in surface pattern (see figs. 10.1–10.3).

SAINT-ÉTIENNE, CAEN The abbey church of Saint-Étienne at Caen (fig. **11.45**) was founded by William the Conqueror a year or two after his invasion of England in 1066, but it took over a hundred years to complete. Over this period of time the fruits of Durham Cathedral's ribbed groin-vault system matured. The west facade (fig. **11.46**) offers a striking contrast with Notre-Dame-la-Grande in Poitiers (see fig. 11.31) and other Romanesque facades (figs. 11.15, 11.18, 11.32). The west-work proclaims this an imperial church. Its closest ancestors are Carolingian churches, such as the abbey church at Corvey (see fig. 10.20), built under royal patronage. Like them, it has a minimum of decoration. Four huge buttresses divide the front of the church into three vertical sections. The thrust upward continues in the two towers, the height of which would be impressive even without the tall helmets, which are later additions. Saint-Étienne is cool and composed, encouraging viewers to appreciate its refined proportions, a feature shared with many other Romanesque buildings.

On the interior of Saint-Étienne (fig. **11.47**), the nave was originally planned to have a wooden ceiling, as well as galleries and a clerestory, but after the experience of Durham, it became possible in the early twelfth century to build a groined nave vault, with only slight changes in the wall design. The bays of the nave here are approximately square (see fig. 11.45), whereas

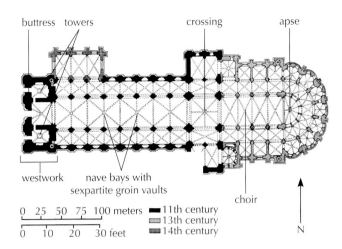

11.45. Plan of Saint-Étienne. Begun 1068. Caen, France

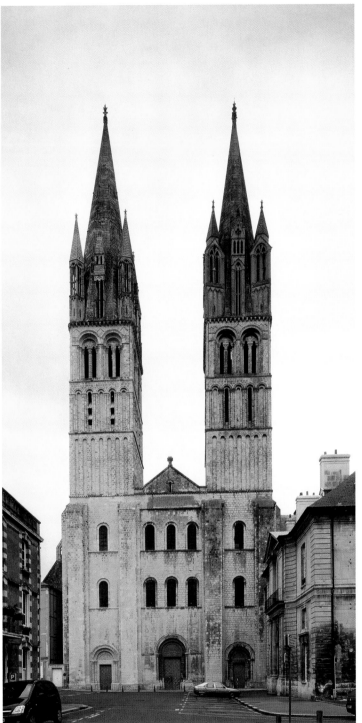

11.46. West facade, Saint-Étienne. Caen, France

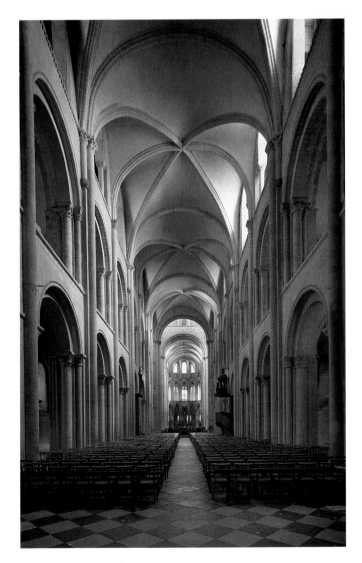

11.47. Nave, Saint-Étienne. Vaulted ca. 1115–1120. Caen, France

at Durham they were oblong. Therefore, the double-X rib pattern could be replaced by a single X with an additional transverse rib, which produced a *sexpartite* (or six-part) groin vault, with six sections instead of seven. These vaults are no longer separated by heavy transverse arches but instead by simple ribs. The resulting reduction in weight also gives a stronger sense of continuity to the nave vault as a whole and produces a less emphatic alternation of piers. Compared with Durham, the nave of Saint-Étienne has an airy lightness.

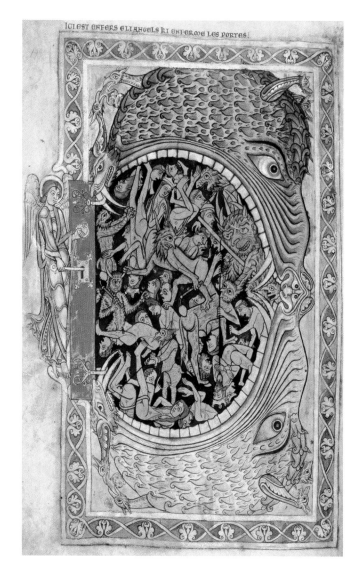

11.48. *Mouth of Hell*, from the *Winchester Psalter*. ca. 1150. From Winchester, England. Tempera on vellum, $12\frac{3}{4} \times 9''$ (32.5 × 23 cm). The British Library, London (MS Cotton Nero D.4)

THE PARADOXICAL MEANING OF ROMANESQUE

Durham and Caen mark the culmination of Romanesque architectural experiments. The improved economic conditions and political stability of Europe, outlined at the beginning of this chapter, had their rewards in the secure structures built in the twelfth century. However, the architecture's defensive qualities also suggest a paradox: As much as the stalwart, powerfully built buildings express a new-found confidence, they also reveal lingering apprehension. The terrifying Last Judgment scenes (see fig. 11.18) and other Romanesque visions of monsters and diabolical beings attest to this anxiety. A folio of the *Winchester Psalter* (fig. **11.48**), produced in England during the middle of the twelfth century, depicts a large hell mouth: The heavy arched jaws of the devil's head contain monstrous forms devouring sinners of all

classes. The inscription, written in Anglo-Norman French, translates as "Here is hell and the angels who lock the doors." The heavy walls and repeated enclosures that govern so much Romanesque sculpture and architecture have their counterpart in this representation. The serene cadence of the heavily outlined and decorated frame serves to enclose and control the frightening image.

The manuscript was commissioned by Henry of Blois, bishop of Winchester, who had been a monk at Cluny and collected antique sculpture and Byzantine paintings on his journeys to Rome. The *Winchester Psalter* exemplifies how international artistic forces functioned during the Romanesque period to help create a vision expressive of the hopes and fears of a society yearning for protection from dark elements. It is instructive that, in the end, assistance from a heavenly being—the angel who locks the hell-mouth door—is required to contain the potent forces of evil.

SUMMARY

ROMANESQUE ART

Much of Western European art of the eleventh and twelfth centuries is identified as Romanesque. This term means "in the Roman manner," but Romanesque architects and artists were also influenced by Carolingian, Byzantine, Islamic, and other traditions. Population growth, increased trade and travel, and new settlements all stimulated building activity, much of it for Christian use. In fact, the monumental structures of the period—stone-vaulted constructions decorated with architectural sculptures—were built on a scale that rivaled the achievements of Rome.

FIRST EXPRESSIONS OF ROMANESQUE STYLE

Romanesque art sprang up at a time when the Continent had no central political authority, and it exists in a variety of closely related regional styles. Its first appearances occur in parts of Italy, France, and Spain. An excellent example of early Romanesque architecture is the church of Sant Vincenç in Cardona, Spain, which demonstrates a mastery of stone vaulting techniques. Figurative sculpture—such as the marble lintel at Saint-Genis-des-Fontaines, France—is also a significant achievement of the period.

MATURE ROMANESQUE

Buildings of the mature Romanesque style—such as the Cathedral of Santiago de Compostela in Spain and the priory of Saint-Pierre at Moissac, France—employed both more sculpture and increasingly sophisticated vaulting techniques. As the Romanesque style matured and developed, it spread throughout Europe. The aesthetic concepts employed by its builders and sculptors are also visible in manuscripts, metalwork, and wall paintings of the period, including those at the church of Saint-Savin-sur-Gartempe.

REGIONAL VARIANTS OF ROMANESQUE STYLE

Regional variety in Romanesque art reflects the political conditions of a continent governed by a loose feudal alliance of princes and dukes. Different regions had different artistic sources available to them, and distinct approaches appeared in parts of France, Italy, Germany, and England. Examples include Pisa Cathedral in Italy and Speyer Cathedral in Germany. The famed *Bayeux Tapestry* exemplifies the complex relationship between English and Norman art of the period.

THE PARADOXICAL MEANING OF ROMANESQUE

The secure structures built across Western Europe during the Romanesque period reflect improving economic conditions and political stability. However, the defensive qualities of the architecture—as well as the terrifying visions seen in illuminated manuscripts of the period—also suggest society's lingering anxieties and yearning for protection.

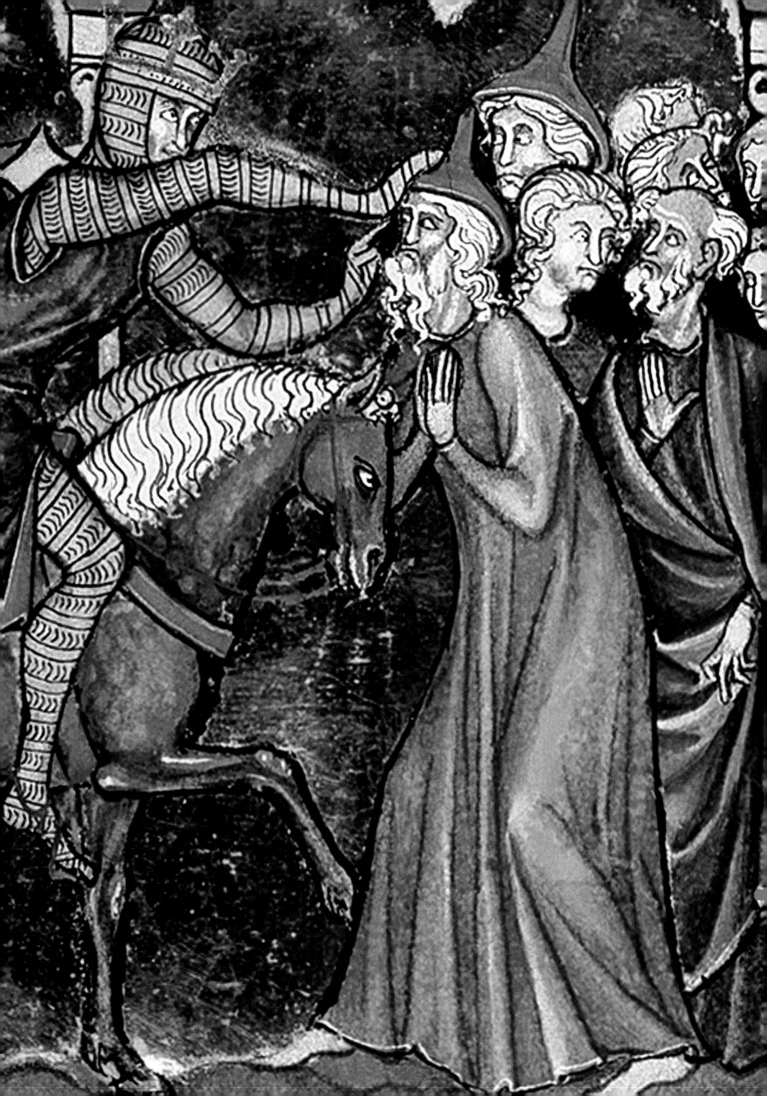

Gothic Art

WE TEND TO THINK OF HISTORY AS THE UNFOLDING OF EVENTS in time without sufficient awareness of their unfolding in space. We visualize history as a stack of chronological layers, or periods, each one having a specific depth that corresponds to its duration. For the more remote past, where our sources of information

are scanty, this simple image works reasonably well. It becomes less satisfactory as we draw closer to the present and our knowledge is more precise. Thus, we cannot define the Gothic era in terms of chronology alone; we must consider its changing surface area as it expands geographically as well.

At the start, about 1140, this geographical area was small indeed. It included only the province known as the Île-de-France (Paris and vicinity), the royal domain of the French kings. (See map 12.1.) A hundred years later, most of Europe, from Sicily to Iceland, had adopted the Gothic style, with only a few Romanesque pockets left here and there. By 1400, however, the Gothic area had begun to shrink. It no longer included Italy, and by 1550 it had disappeared almost entirely, except in England. The Gothic layer, then, has a rather complicated shape. Its depth ranges from close to 400 years in some places to only 150 in others. Moreover, this shape does not emerge with equal clarity in all the visual arts.

The term **Gothic** was used in the sixteenth century to describe a style of buildings thought to have descended from the Goths, those tribes that occupied northern Europe during the early Middle Ages. Although the ancestry of the style is not as direct as these early writers claimed, they were accurate about its geography, since the style is most recognizable north

Detail of figure 12.39, *Nahash the Ammonite Threatening the Jews at Jabesh*

of the Alps. As Gothic art spread from the Île-de-France to the rest of the country and then through all of Europe, it was referred to as *opus modernum* (modern work) or *opus francigenum* (French work). These designations are significant, because they tell us that in its own time the style was viewed as innovative and as having its origins in France. In the course of the thirteenth century, the new style gradually lost its imported flavor, and regional variety began to reassert itself.

For a century—from about 1150 to 1250, during the Age of the Great Cathedrals—architecture played the dominant role in the formation of a coherent Gothic style. In addition to religious buildings, secular architecture—including castles, palaces, and civic buildings, such as hospitals—also flourished during the Gothic period. Gothic sculpture was at first severely architectural in spirit but became more independent after 1200. Early Gothic sculpture and painting reflect the discipline of their monumental setting, while Late Gothic architecture and sculpture strive for more picturesque effects.

Artistic developments roughly parallel what was happening in the political arena, for the Gothic was a distinctive period not only artistically but politically as well. Aided by advances in cannons and the iron crossbow, princes and kings were able to conquer increasingly large territories, which were administered for them by vassals, who in turn collected taxes to support armies and navies. In France, the Capetian line at first ruled only the fertile territory of the Île-de-France, but by 1300

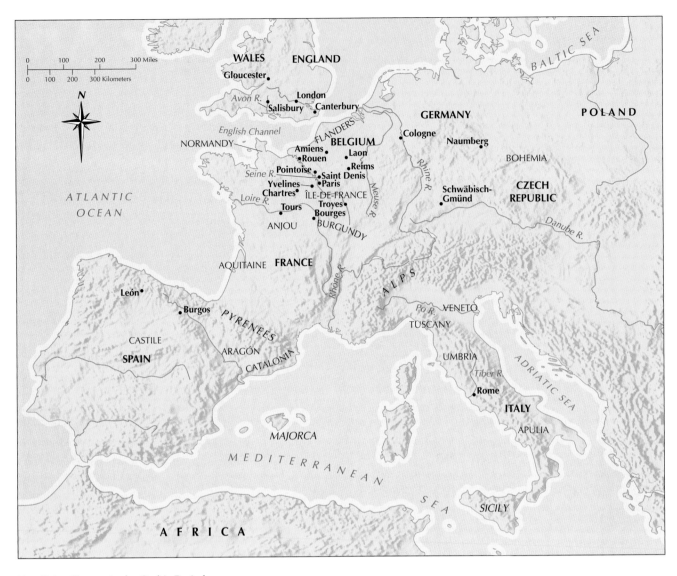

Map 12.1. Europe in the Gothic Period

it had added much of the land previously held by the Count of Flanders, as well as Bourges, Tours, and Amiens—all of which were to become the sites of important Gothic cathedrals—and the central provinces of the Auvergne and the southern provinces of Languedoc. King Philip Augustus, who reigned from 1180–1223, was able to quadruple the size of the royal domain and, at the same time, concentrate authority in the figure of the king. The French kings also acquired Normandy from England. This gave rise to the conflicting claims over the kingship of France known as the Hundred Years' War (1339–1453), which consolidated a growing sense of nationalism on both sides of the English Channel. While much Gothic art seems to develop in a logical and indeed progressive manner, the Hundred Years' War, with its shifting alliances and threats to economic and social stability, interrupted the progress of art in some areas of Europe.

Germany remained a collection of independent city-states ruled by electors, who were responsible for, among other things, choosing kings. The powers of German kings were therefore severely limited. Supported by shifting alliances with the papacy, the kings of France and England emerged as the leading powers at the expense of the Germans in the early thirteenth century, which was generally a time of peace and prosperity. After 1290, however, the balance of power quickly broke down.

The growth of urban centers and the increasing importance of cathedrals, the seats of bishops, are formative features of the Gothic period. In the century before the death of King Louis IX in 1270, there were 80 cathedrals built in France, many of them new foundations. Universities developed out of cathedral schools as the principal centers of learning, thus taking on the role previously played by monasteries. The university provided instruction in theology, philosophy, law, and medicine, those areas of study deemed necessary for *universitas litterarum* (universal learning). At the same time literature written in the vernacular (as opposed to Latin) begins to emerge, making it accessible to a broader public. It was during the thirteenth century that French became an official state language. Romanesque art had been predominantly a rural and monastic art, while Gothic art, by contrast, becomes increasingly cosmopolitan.

Urban growth was both the result and cause of economic, social, and demographic changes. Agriculture became more efficient, with increased acreage under cultivation, and surplus production provided commodities for sale and purchase. This produced, in turn, a money economy based on investment, profit, and trade, in place of barter. Money rather than personal services now directed social interchange, and the increased amount of it in circulation produced a veritable middle class, living in cities, which were the centers of trade and commerce. Once out from under the feudal yoke, merchants and artists of this middle class were free to form guilds to control the production and distribution of goods and services. A general and significant increase in population also spurred urban growth. Roughly 42 million people occupied Europe around the year 1000; by 1300, the population had reached about 73 million.

During the thirteenth century Catholicism found in St. Thomas Aquinas its greatest intellect since St. Augustine and St. Jerome some 850 years earlier. Aquinas, an Italian theologian, studied in Cologne and taught in Paris. His method of argument, called **scholasticism**, used reason to understand and explain faith. Scholasticism had a profound effect on European thought; its harmonization of rationalism and spirituality effectively sanctioned the systematic study of all natural phenomena as expressions of divine truths. Gothic builders shared qualities with the Scholastics. They brought the logic and clarity of engineering principles to bear on revelation, using physical forces to create a concord of spiritual experiences in much the same way the Scholastics used elucidation and clarification to build their well-constructed arguments.

EARLY GOTHIC ART IN FRANCE

It is not clear why Gothic art first appeared in the Île-de-France, the area around Paris. Some scholars believe that because this region had not developed a strong local style during the Romanesque period, it was particularly open to innovation and influence from other areas. Others have suggested that it was a result of a concerted effort on the part of the kings of France to aggrandize themselves, since it was here that their domains were located. Certainly the Île-de-France is fortuitously positioned, near the center of France and thus accessible to the south and west, where major sculptural programs flourished during the Romanesque period, and adjacent to Normandy, where many structural innovations, including the ribbed groin vault, had been introduced to France (see pages 380–381).

Saint-Denis: Suger and the Beginnings of Gothic Architecture

The study of Gothic art begins with an examination of the rebuilding of the royal Abbey Church of Saint-Denis just outside the city of Paris. The rebuilding of this historic church was undertaken between 1137 and 1144 by its abbot, Suger. His ambitious building program was designed to emphasize the relationship between Saint-Denis and the French monarchy. The kings of France, who belonged to the Capetian line, derived their authority from a Carolingian tradition. However, they had less power than the nobles who, in theory, were their vassals. The only area the king ruled directly was the Île-de-France, and even there his authority was often challenged. Not until the early twelfth century did royal power begin to expand, and Suger, as chief adviser to King Louis VI, helped shape this process. It was Suger who forged the alliance between the monarchy and the Church. This union brought the bishops of France (and the cities under their authority) to the king's side; the king, in turn, supported the papacy in its struggle against the German emperors.

Suger also engaged in spiritual politics. By giving the monarchy religious significance and glorifying it as the strong right arm of justice, he sought to rally the nation behind the king. The Abbey Church of Saint-Denis was a key element in his plan. The church, founded in the late eighth century, enjoyed a dual prestige. It was the shrine of Saint Denis, the Apostle of France and its patron saint, as well as the chief memorial of the Carolingian dynasty. Both Charlemagne and his father, Pepin, were consecrated as kings at Saint-Denis. It was also the burial place of the kings Charles Martel, Pepin, and Charles the Bald. Suger aspired to make the abbey the spiritual center of France, a pilgrimage church to outshine all others and to provide a focal point for religious as well as patriotic emotion. To achieve this goal, the old structure had to be rebuilt and enlarged. The great abbot himself wrote two accounts of the church and its rebuilding. (See *Primary Sources*, pages 388 and 390.)

AMBULATORY AND CHOIR The ambulatory and radiating chapels surrounding the arcaded apse (figs. **12.1** and **12.2**) are familiar elements from the Romanesque pilgrimage choir (compare figs. 11.3 and 11.6), but at Saint-Denis they have been integrated in a new way. The choir is as rationally planned and constructed as any Romanesque church, yet the

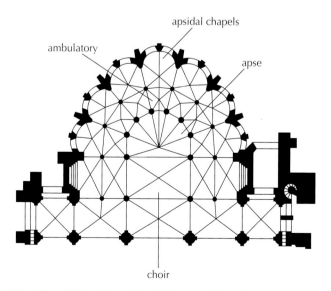

12.1. Plan of the choir and ambulatory, Abbey Church of Saint-Denis, France. 1140–1144 (Peter Kidson)

Suger of Saint-Denis (1081–1151)

From *On the Consecration of the Church of Saint-Denis*

Abbot Suger left two accounts of his rebuilding of the Abbey Church of Saint-Denis: a booklet that describes the entire campaign from its conception to the consecration of the new east end on June 11, 1144; and a record of the precious outfittings, including the stained-glass windows, in a review of his accomplishments as abbot. In these excerpts from the first text (1144–1147), Suger justifies his enlargement of the Carolingian building with reference to its overcrowding on religious holidays, and he recounts the auspicious discovery of a local quarry and the appearance of the workers needed to execute his project. After rebuilding the west end of the Carolingian church, he destroyed its eastern apse and built a much larger, more elaborate choir over the old crypt. Suger notes as his principal innovation the radiating chapels filled with stained-glass windows.

Through a fortunate circumstance—the number of the faithful growing and frequently gathering to seek the intercession of the Saints—the [old] basilica had come to suffer grave inconveniences. Often on feast days, completely filled, it disgorged through all its doors the excess of the crowds as they moved in opposite directions, and the outward pressure of the foremost ones not only prevented those attempting to enter from entering but also expelled those who had already entered. At times you could see that no one among the countless thousands of people because of their very density could move a foot; that no one, because of their very congestion, could [do] anything but stand like a marble statue, stay benumbed or, as a last resort, scream. The distress of the women was so great and so intolerable that you could see how they cried out horribly, how several of them, lifted by the pious assistance of men above the heads of the crowd, marched forward as

though upon a pavement; and how many others, gasping with their last breath, panted in the cloisters of the brethren to the despair of everyone.

Through a gift of God a new quarry, yielding very strong stone, was discovered such as in quality and quantity had never been found in these regions. There arrived a skillful crowd of masons, stonecutters, sculptors and other workmen, so that—thus and otherwise—Divinity relieved us of our fears and favored us with Its goodwill by comforting us and by providing us with unexpected [resources]. I used to compare the least to the greatest: Solomon's riches could not have sufficed for his Temple any more than did ours for this work had not the same Author [God] of the same work abundantly supplied His attendants. The identity of the author and the work provides a sufficiency for the worker.

Upon consideration, then, it was decided to remove that vault, unequal to the higher one, which, overhead, closed the apse containing the bodies of our Patron Saints, all the way [down] to the upper surface of the crypt to which it adhered; so that this crypt might offer its top as a pavement to those approaching by either of the two stairs, and might present the chasses [reliquaries] of the Saints, adorned with gold and precious gems, to the visitors' glances in a more elevated place. Moreover, it was cunningly provided that—through the upper columns and central arches which were to be placed upon the lower ones built in the crypt—the central nave of the old [church] should be equalized, by means of geometrical and arithmetical instruments, with the central nave of the new addition; and, likewise, that the dimensions of the old side-aisles should be equalized with the dimensions of the new side-aisles, except for that elegant and praiseworthy extension, in [the form of] a circular string of chapels, by virtue of which the whole [church] would shine with the wonderful and uninterrupted light of most luminous windows, pervading the interior beauty.

SOURCE: *ABBOTT SUGER ON THE ABBEY CHURCH OF SAINT-DENIS AND ITS ART TREASURES*, ED. AND TR. ERWIN PANOFSKY, (PRINCETON, NJ: PRINCETON UNIVERSITY PRESS, 1946)

entire plan is held together by a new kind of geometric order (see fig. 12.1). Seven nearly identical wedge-shaped units fan out from the center of the apse. Instead of being in separate apsidioles, the chapels merge to form, in effect, a second ambulatory. We experience this double ambulatory not as a series of individual compartments but as a continuous space, the shape of which is outlined by the network of slender arches, ribs, and columns that sustains the vaults. Ribbed groin vaulting based on the pointed arch is used throughout. By this date, the pointed arch (which can be "stretched" to reach any desired height regardless of the width of its base) has become an essential part of the ribbed groin vault, which is no longer restricted to square or near-square compartments. It has a new flexibility that allows it to cover areas of almost any shape, such as the trapezoids and pentagons of this ambulatory.

What most distinguishes the interior of Saint-Denis (see fig. 12.2) from earlier church interiors is its lightness, in both senses of the word. The architectural forms seem graceful, almost

weightless, compared to the massive solidity of Romanesque architecture. The fluid spaciousness of Saint-Denis' choir results from its slim columns, whose use was made possible by the relative lightness of the vaults they needed to support. In addition, the windows are so large that they are no longer openings cut into a wall but, in effect, translucent walls, filled with stained glass. What makes this abundance of light possible are heavy buttresses that jut out between the chapels to contain the outward pressure of the vaults. In the plan (see fig. 12.1), they look like stubby arrows pointing toward the center of the apse. No wonder, then, that the interior appears so airy, since the heaviest parts of the structural skeleton are relegated to the exterior. The impression would be even more striking if we could see all of Suger's choir, for the upper part of the apse, rising above the double ambulatory, had very large, tall windows. Unfortunately, later transformations of the building destroyed the choir's original effect.

In describing Suger's ambulatory and choir, we have also described the essentials of Gothic architecture. Yet none of the

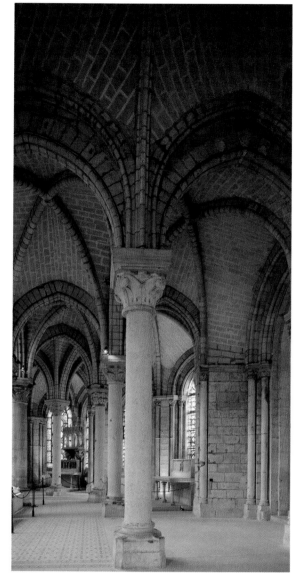

12.2. Ambulatory, Abbey Church of Saint-Denis

This symbolic interpretation of light and numerical harmony was well established in Christian thought long before Suger's time. It derived from the writings of a sixth-century Greek theologian who, in the Middle Ages, was mistakenly believed to have been Dionysius the Areopagite, an Athenian disciple of St. Paul, who is mentioned in the New Testament book of Acts. In France, the writer Dionysius was identified with St. Denis, since the saint's name in Latin is Dionysius. Not surprisingly, Suger attached great authority to the writings of Dionysius, which were available to him in the library at Saint-Denis; Dionysian light-and-number symbolism particularly appealed to him

At the heart of Suger's mystical intent for Saint-Denis was the belief that the material realm is the steppingstone for spiritual contemplation and thus that dark, jewel-like light filtering through the church's stained-glass windows would transport the viewer to "some strange region of the universe which neither exists entirely in the slime of earth nor entirely in the purity of Heaven." The success of the choir design at Saint-Denis, therefore, derives not only from its architectural qualities but also from its extraordinary psychological impact. Vistors, it seems, were overwhelmed by both, and within a few decades the new style had spread far beyond the Île-de-France.

SUGER AND THE MEDIEVAL ARCHITECT Although Suger was not an architect, there is no contradiction between his lack of professional training and his claim of responsibility for the technical advances and resultant style of "his" new church. In the twelfth century the term *architect* had a very different meaning from the modern one. To the medieval mind, the overall leader of the project could be considered its architect. Even God, as creator of the universe, was sometimes represented as an architect employing builders' tools. After all, the function of a church is not merely to enclose a maximum of space with a minimum of material, but also to embody and convey religious ideas. For the master who built the choir of Saint-Denis, the technical problems of vaulting must have been inseparable from issues of form and its meaning. The design includes elements that express function without actually performing it. An example is the slender shafts (**responds**) that seem to transfer the weight of the vaults to the church floor.

In order to know what concepts to convey, the medieval builder needed the guidance of religious authority. At a minimum, such guidance might be a simple directive to follow some established model. Suger, however, took a more active role, proposing objectives to which his master masons must have been singularly responsive. Close collaboration between patron and architect or master builder had of course occurred before—between Djoser and Imhotep (Chapter 3), Perikles and Pheidias (Chapter 5)—just as it does today.

CONSTRUCTING SAINT-DENIS Building Saint-Denis was an expensive and complex task that required the combined resources of church and state. Suger used stone from quarries near Pontoise for the ambulatory columns and lumber from the forest of Yvelines for the roof. Both had to be transported by land and river, which was a slow and costly

elements that make up its design is really new. The pilgrimage choir plan, the pointed arch, and the ribbed groin vault can be found in regional schools of the French and Anglo-Norman Romanesque. However, they were never combined in the same building until Suger—as he himself tells us—brought together artisans from many different regions for Saint-Denis. We must not conclude from this, however, that Gothic architecture was merely a synthesis of Romanesque traits. Otherwise we would be hard pressed to explain the new spirit, particularly the quest for luminosity, that strikes us so forcibly at Saint-Denis. Suger's account of the rebuilding of his church stresses luminosity as the highest value achieved in the new structure. Thus, Suger suggests, the "miraculous" light that floods the choir through the "most sacred" stained-glass windows becomes the Light Divine, a revelation of the spirit of God. Suger also claims that **harmony**, the perfect relationship among parts in terms of mathematical proportions or ratios, is the source of all beauty, since it exemplifies the laws by which divine reason made the universe.

Suger of Saint-Denis (1081–1151)

From *On What Was Done Under His Administration*

Saint-Denis was a Benedictine abbey, though its church was open to layfolk and attracted them in large numbers. The ostentatious embellishment of the church was the type of material display deplored by St. Bernard of Clairvaux. Suger's descriptions of it, recorded between 1144 and 1149, suggest a sensuous love of precious materials, but also a belief that contemplation of these materials could lead the worshiper to a state of heightened spiritual awareness. Like the Byzantine rationale for icons, the notion of "anagogical" transportation to another dimension is indebted to Neo-Platonism.

We insisted that the adorable, life-giving cross should be adorned. Therefore we searched around everywhere by ourselves and by our agents for an abundance of precious pearls and gems. One merry but notable miracle which the Lord granted us in this connection we do not wish to pass over. For when I was in difficulty for want of gems and could not sufficiently provide myself with more (for their scarcity makes them very expensive): then, lo and behold, [monks] from three abbeys of two Orders—that is, from Cîteaux and another abbey of the [Cistercian] Order, and from Fontevrault offered us for sale an abundance of gems such as we had not hoped to find in ten years, hyacinths, sapphires, rubies, emeralds, topazes. Their owners had obtained them from Count Thibaut for alms; and he in turn had received them, through the hands of his brother Stephen, King of England [r. 1135–1154], from the treasures of his uncle, the late King [Henry I, r. 1100–1135], who had amassed them throughout his life in wonderful vessels. We, however, freed from the worry of searching for gems, thanked God and gave four hundred pounds for the lot though they were worth much more.

We hastened to adorn the Main Altar of the blessed Denis where there was only one beautiful and precious frontal panel from Charles the Bald [843–877], the third Emperor; for at this [altar] we had been offered to the monastic life.

The rear panel, of marvelous workmanship and lavish sumptuousness (for the barbarian artists were even more lavish than ours), we ennobled with chased relief work equally admirable for its form as for its material. Much of what had been acquired and more of such ornaments of the church as we were afraid of losing—for instance, a golden chalice that was curtailed of its foot and several other things—we ordered to be fastened there.

Often we contemplate these different ornaments both new and old. When the loveliness of the many-colored gems has called me away from external cares, and worthy meditation has induced me to reflect, transferring that which is material to that which is immaterial, on the diversity of the sacred virtues: then it seems to me that I see myself dwelling, as it were, in some strange region of the universe which neither exists entirely in the slime of the earth nor entirely in the purity of Heaven; and that, by the grace of God, I can be transported from this inferior to that higher world in an anagogical manner.

We [also] caused to be painted, by the exquisite hands of many masters from different regions, a splendid variety of new windows.

Because [these windows] are very valuable on account of their wonderful execution and the profuse expenditure of painted glass and sapphire glass, we appointed an official master craftsman for their protection and repair.

SOURCE: *ABBOTT SUGER ON THE ABBEY CHURCH OF SAINT-DENIS AND ITS ART TREASURES*, ED. AND TR. ERWIN PANOFSKY, (PRINCETON, NJ: PRINCETON UNIVERSITY PRESS, 1946)

process. The master builder probably employed several hundred stonemasons and two or three times that many laborers. Advances in technology spurred by warfare made possible improved construction techniques that were essential for building the new rib vaults. Especially important were better cranes powered by windlasses, treadwheels that used counterweights, and double pulleys for greater efficiency. These devices could be put up and taken down with ease, allowing for lighter scaffolding suspended from the wall instead of resting on the ground.

WEST FACADE Although Abbot Suger planned to rebuild all of Saint-Denis, the only part of the church that he saw completed, other than the ambulatory and choir, was the west facade. The overall design of the Saint-Denis west facade (fig. **12.3**) derived from Norman Romanesque facades. A comparison between Saint-Denis and Saint-Étienne at Caen (see fig. 11.46) reveals a number of shared basic features. These include the pier buttresses that reinforce the corners of the towers and divide the facade vertically into three main parts, the placement of the portals, and the three-story arrangement. However, Saint-Denis's three portals are far larger and more richly carved than those at Saint-Étienne at Caen or any other Norman Romanesque church. From this we can conjecture that Abbot Suger attached considerable importance to the sculptural decoration of Saint-Denis, although his account of the church does not discuss it at length.

The rich sculptural decoration included carved tympana, archivolts, and jambs. The arrangement recalls the facades of southwestern France, such as at Moissac (see fig. 11.14) and the carved portals of Burgundy, such as at Autun (see fig. 11.18). These correlations corroborate Suger's claim that his workforce included artists from many regions. Unhappily, the trumeau figure of St. Denis and the statue-columns of the jambs were removed in 1770 and 1771, when the central portal was enlarged. A few years later, during the French Revolution, a mob attacked the heads of the remaining figures and melted down the metal doors. As a result of

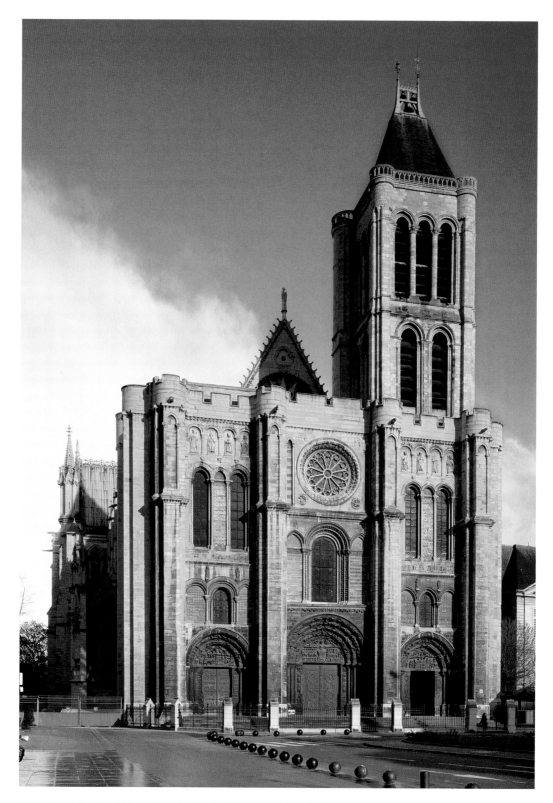

12.3. West facade, Abbey Church of Saint-Denis. ca. 1137–1140.

these ravages and a series of clumsy restorations undertaken during the eighteenth and nineteenth centuries, we can gain only a general view of Suger's ideas about the role of sculpture at Saint-Denis. To envision what the Saint-Denis west portal originally looked like we turn to the Cathedral of Chartres, where some of the Saint-Denis sculptors subsequently worked.

Chartres Cathedral

Toward 1145 the bishop of the town of Chartres, who was a friend of Abbot Suger and shared many of his ideas, began to rebuild a cathedral in the new style, dedicated to Notre-Dame ("Our Lady," the Virgin Mary). Fifty years later a fire destroyed all but the eastern crypt and the west facade. (See end of Part II, *Additional Primary Sources*.)

WEST FACADE The surviving west facade (fig. **12.4**), in many ways reminiscent of Saint-Denis, is divided into units of two and three and is a model of clarity. Yet, because construction proceeded in stages and was never entirely finished, the harmony of the result is evolutionary rather than systematic. For example, the two west towers, though similar, are by no means identical. Moreover, their **spires**, the tall towers with tapering roofs, are very different: The spire on the left in figure 12.4 dates from the early sixteenth century, nearly 300 years later than its mate.

To judge from old drawings of Saint-Denis, the Chartres jambs (figs. **12.5** and **12.6**) are so similar to those of the original Saint-Denis portals that the same sculptors must have worked on both buildings. Tall figures attached to columns flanked the doorways of both cathedrals. Figures had appeared on the jambs or trumeaux of Romanesque portals (see figs. 11.14 and 11.16), but they were reliefs carved from the masonry of the doorway. The Chartres jamb figures, in contrast, are essentially

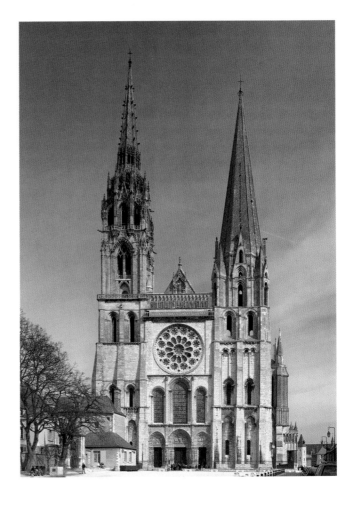

12.4. West facade, Cathedral of Notre-Dame. Chartres, France. (Left spire is from 16th century.) ca. 1145–1220

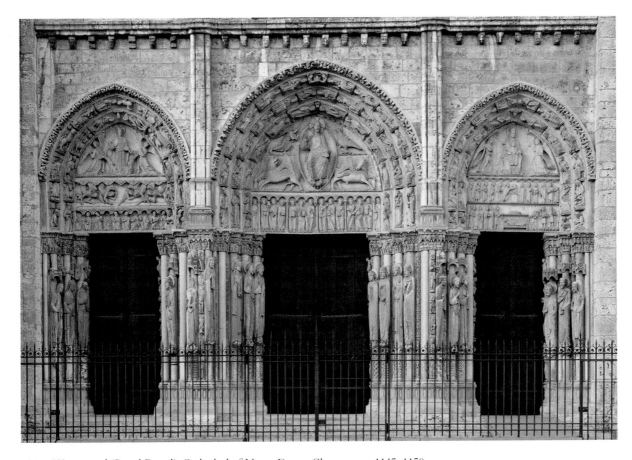

12.5. West portal (Royal Portal), Cathedral of Notre-Dame. Chartres. ca. 1145–1150

statues, each with its own axis. They could, in theory at least, be detached from their supports. This is a development of truly revolutionary importance and could apparently be taken only by borrowing the cylindrical shape of the column for the human figure. That the figures are round gives them a more convincing presence than any we have seen in Romanesque architectural sculpture, and their heads show a gentle, human quality that indicates a naturalistic trend in Gothic sculpture.

On the west portal of Chartres naturalism appears to spring from a reaction against the fantastic and demoniacal aspects of Romanesque art, a response that may be seen in the solemn spirit of the figures and their increased physical bulk. This is apparent by comparing the Christ of Chartres's center tympanum (see fig. 12.5) with his counterpart in the tympanum at Moissac (see fig. 11.14.) It also appears in the discipline of the symbolic program underlying the entire sculptural scheme at Chartres. While an understanding of the subtler aspects of this program requires a knowledge of the theology that would have been taught by leading scholars of the day at the Chartres Cathedral School, its main elements can be readily understood.

The jamb statues form a continuous sequence linking all three portals (see fig. 12.5). Together they represent the prophets, kings, and queens of the Bible. Their purpose is to acclaim the rulers of France as the spiritual descendants of Old Testament royalty and to stress the harmony of spiritual and secular rule, of priests (or bishops) and kings—ideals previously put forward by Abbot Suger. Above the main doorway symbols of the four evangelists flank Christ in Majesty. The apostles are below, while the 24 elders occupy the two outer archivolts. Although the components are similar to those of the Moissac tympanum, the effect at Chartres is calm and comforting whereas at Moissac the effect was dramatic and unsettling. The right-hand tympanum at Chartres shows Christ's Incarnation: the Birth, the Presentation in the Temple, and the infant Christ Child on the lap of the Virgin, who symbolizes the Church. The design achieves compositional and thematic unity by elevating Christ in the center of each register: on the manger, on an altar, and on the lap of his mother. In the surrounding archivolts, representations of the liberal arts as human wisdom pay homage to the divine wisdom of Christ. Finally, in the left-hand tympanum, we see the timeless Heavenly Christ (or perhaps the Christ of the Ascension) framed by the ever-repeating cycle of the year: the signs of the zodiac and their earthly counterparts, the labors of the 12 months.

Laon Cathedral

Because the mid–twelfth-century church that stood behind the west facade of Chartres Cathedral was destroyed by fire in 1194, we must turn to the Cathedral of Notre-Dame at Laon to appreciate an Early Gothic interior. This cathedral was begun just before 1160.

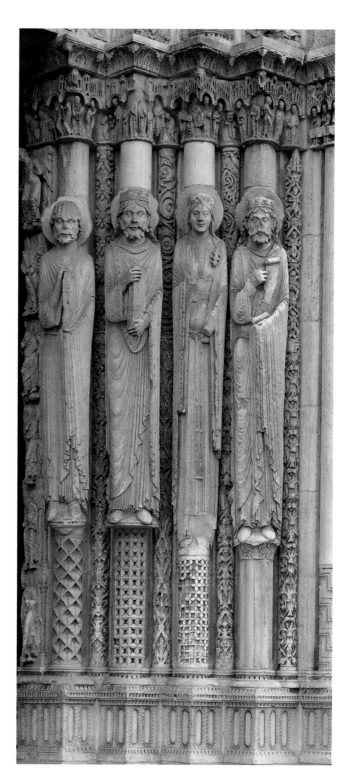

12.6. Jamb statues, west portal, Cathedral of Notre-Dame, Chartres

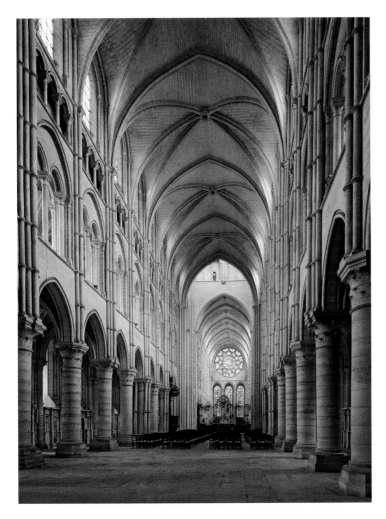

12.7. Nave, Cathedral of Notre-Dame, Laon, France. ca. 1160–1210

NAVE The interior elevation of Laon Cathedral (fig. **12.7**) includes a nave arcade, gallery, triforium, and clerestory, all features found in Romanesque architecture but never together in the same building. The stacking of four levels is a Gothic innovation and lightens the weight of the walls. The elevation develops logically and harmoniously: The single opening of the nave arcade is doubled in the gallery, then triple arches follow in the triforium, while a broad clerestory window balances the single nave arcade opening that began the vertical sequence. The rhythmical arrangement articulates a heightened sense of verticality, while the multiple openings allow increased light to enter the nave, directly from the clerestory and indirectly through galleries and side aisles.

Sexpartite nave vaults over squarish bays at Laon continue the kind of structural experimentation begun by the Norman Romanesque builders of Saint-Étienne at Caen (see fig. 11.45) and Durham Cathedral (see fig. 11.42). Laon uses the pointed ribbed vaults, pioneered in the western bays of the nave at Durham, throughout the building. Alternating bundles of shafts rising along the wall reflect the nature of the sexpartite vaults above: Clusters of five colonnettes indicate where transverse arches cross the nave, while three colonnettes adorn the

intermediate piers. Although the system develops from Romanesque building practice (see pages 347 and 349), the elements seem more delicate in the Gothic building. By contrast, Romanesque interiors such as Saint-Sernin (see fig. 11.8) and Durham Cathedral (see fig. 11.43) emphasize the great effort required to support the weight of the vaults.

A change in program at Laon reveals the evolving objectives of this cathedral's designers. At the east end of the nave, where the building work began, clustered shafts were added to piers as well as to the wall. In the later more westerly nave bays, the round piers are plain. Instead of the staggered rhythm created by the earlier alternating pier arrangement, the change produced a more flowing effect. However, the tradeoff for the increased uniformity of the new arrangement was a loss of structural explicitness.

Cathedral of Notre-Dame at Paris

The plan of the Cathedral of Notre-Dame at Paris is recorded as having been begun in 1163, only a few years after Notre-Dame at Laon, although there is evidence that it might have been started as early as the mid-1150s. Notre-Dame, Paris is extraordinarily compact and achieves a unity not present in either Romanesque buildings or earlier Gothic ones (fig. **12.8**).

NAVE In the nave, the transept barely exceeds the width of the facade. As at Saint-Denis (see fig. 12.1), the double ambulatory of the choir continues directly into the aisles, but there are no radiating chapels. This stress on uniformity in the plan finds a parallel in the treatment of the elevation; despite the use of sexpartite vaults, there is no alternating system of supports. As at Laon (see fig. 12.7), the Paris elevation was originally four-part, though oculi were inserted in place of the arcaded triforium. Stylish as this change might have been when the building was begun, a thirteenth-century reconstruction completely

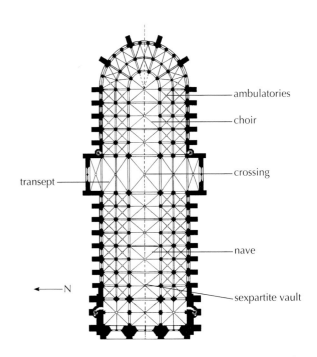

12.8. Plan, Cathedral of Notre-Dame, Paris. ca. 1155–ca. 1250

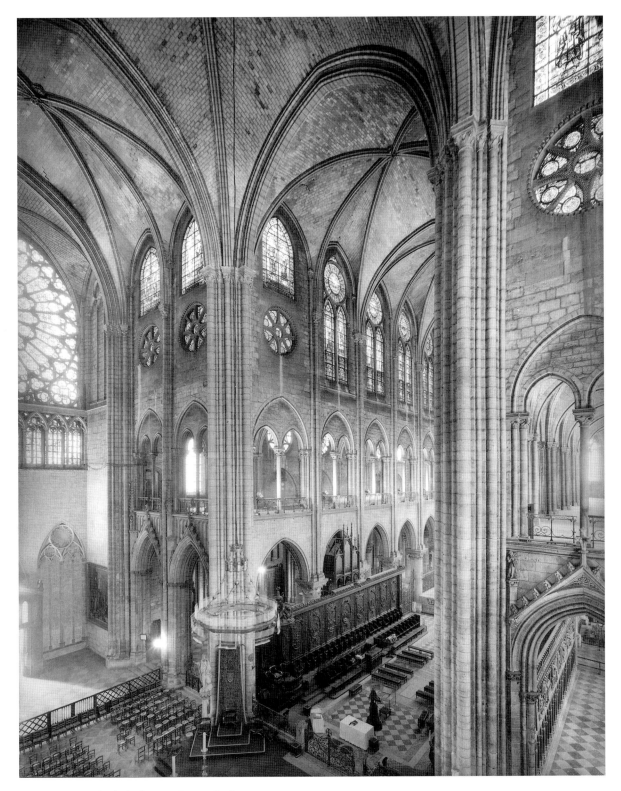

12.9. Nave, Cathedral of Notre-Dame, Paris

eliminated the triforium in order to enlarge the clerestory windows. Because a few bays were returned to their original four-part elevation in a nineteenth-century restoration, we can compare the original and the remodeled elevations (fig. **12.9**). The design change reveals a continuing desire to reduce wall surface and increase the amount of light entering the building. The large clerestory windows and the light and slender forms produce nave walls that seem amazingly thin. This creates the effect of weightlessness.

Like uniformity in the plan, the vertical emphasis of the interior is a clear Gothic trait. It depends not only on the actual proportions of the nave, but also on a constant and repeated accentuation of upward momentum and the apparent ease with which a sense of height is attained.

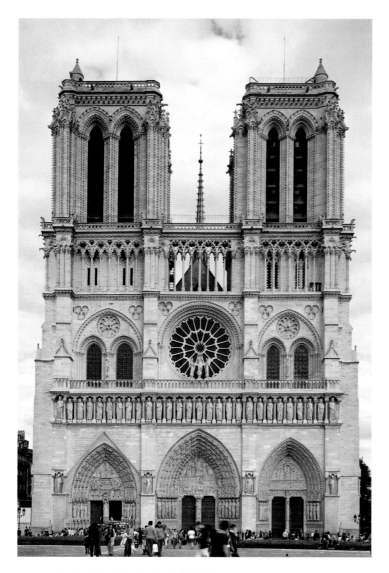

12.10. West facade, Cathedral of Notre-Dame, Paris. ca. 1200–1250

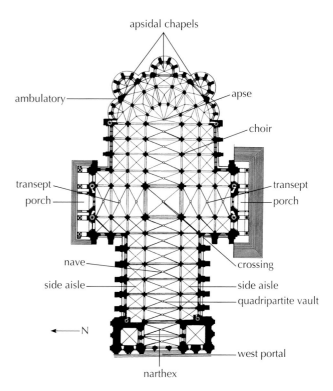

12.11. Plan, Cathedral of Notre-Dame (as rebuilt after 1194), Chartres

WEST FACADE The most monumental aspect of the exterior of Notre-Dame in Paris is its west facade (fig. **12.10**). It retains its original appearance, except for the sculpture, which was badly damaged during the French Revolution and is largely restored. All of its details are integrated into a coherent whole. Here the meaning of Suger's emphasis on harmony, geometric order, and proportion are even more evident than at Saint-Denis itself and go well beyond the achievement of the Chartres Cathedral west portal.

This formal discipline is also apparent in the placement of the sculpture, which no longer shows the spontaneous growth typical of the Romanesque. Instead, it has been assigned a precise role within the architectural framework. At the same time, the cubic solidity of the facade has been moderated by lacelike arcades and window perforations, which break down the continuity of the wall surfaces so that the total effect is of a weightless openwork screen.

HIGH GOTHIC ART IN FRANCE

The political and economic stability of France during the thirteenth century encouraged the continued growth of cities, an ideal climate for producing monumental architecture.

Some art historians have seen the integration of structure and design in Early Gothic art as a series of experiments that were resolved during the High Gothic period. This is undoubtedly true to some extent, but art during the thirteenth century also demonstrates an interest in pursuing refinements that synthesize engineering and aesthetics. Thus, High Gothic art is as much a continuation of Early Gothic experiments as it is their culmination. It is during this time that the names of architects, who previously had been largely anonymous, proliferate, a reflection of the value placed on their achievements and of an increasing interest in personal identity. This concern for the individual also reflects a changing class structure in which those engaged in trade and commerce become more independent.

The Rebuilding of Chartres Cathedral

The rebuilding of Chartres Cathedral after the fire of 1194 (see page 393) marks the next step in the development of Gothic architecture. The new building was largely completed within the astonishingly brief span of 26 years. Its crypt houses Chartres's most important possession: remnants of a tunic said to have been worn by the Virgin Mary, to whom the cathedral is dedicated, at the time of Jesus' nativity. The relic, which miraculously survived the great fire of 1194, had drawn pilgrims from all over Europe.

The fire also spared the west facade and portals, and the decision to conserve these architectural features, which, at the time of the fire, were nearly 50 years old and certainly out of fashion, is

worth noting. After initial despair at the damage wrought by the fire, civic and ecclesiastical authorities animated their followers by interpreting the fire as an expression of the will of the Virgin herself that a new and more glorious cathedral be built. Since the west end of the church, like the famous relic of the Virgin, had also been spared, it too was treated as a relic worthy of preservation. Recognizing the divine plan in what otherwise would have been disheartening circumstances helped fuel enthusiasm for rebuilding and accounts for the rapid pace of construction.

To provide room for large numbers of visitors without disturbing worshipers, there is a wide aisle running the length of the nave and around the transept (fig. **12.11**). It is joined at the choir by a second aisle, forming an ambulatory that connects the apsidal chapels. Worshipers entered the building through the old west portal and passed through a relatively low narthex. It would have taken some time for their eyes to adjust to the darkness of the interior. Even the noise of daily life would have been shut out, and sounds within the building would have been at first eerily muffled. Once worshipers had recovered from this disorienting effect, they would have become aware of a glimmering light, which guided them into the cavernous church. The transition, both subtle and profound, accentuated the significance of entering the church. As with entries into

ART IN TIME

1137–1144—Rebuilding of Abbey Church of Saint-Denis,
outside Paris by Suger
1163—Construction begins on the Cathedral of
Notre-Dame at Paris

Romanesque and Byzantine churches (see pages 254, 360, and 363), a liminal, or transitional, zone signaled that visitors had left the temporal world behind. Patrons, designers, and builders of a religious edifice had again found meaningful physical forms to encourage and sustain powerful spiritual experiences.

NAVE Designed a generation after Notre-Dame in Paris, the rebuilt nave of Chartres Cathedral (fig. **12.12**) is the first masterpiece of the mature, or High Gothic, style. Several features distinguish this style (fig. **12.13**). By eliminating the gallery, the designers of Chartres imposed a three-part elevation on

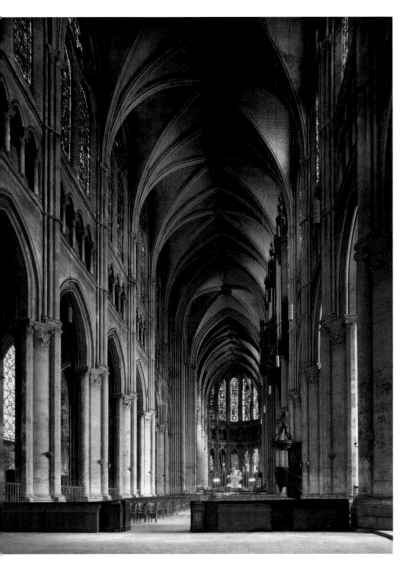

12.12. Nave and choir, Cathedral of Notre-Dame, Chartres. ca. 1194–1220

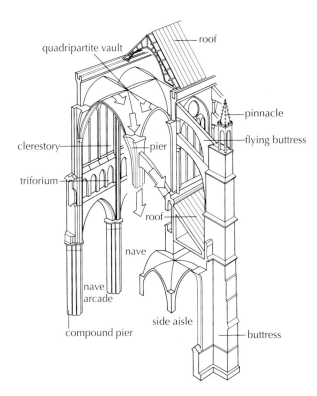

12.13. Axonometric projection of a High Gothic cathedral (after Acland)

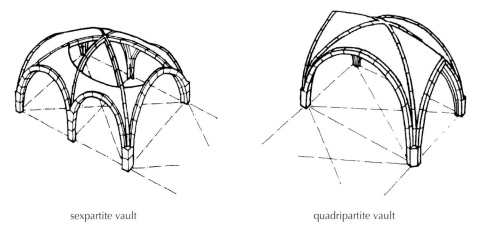

sexpartite vault · quadripartite vault

12.14. (a) Sexpartite vaulting and (b) quadripartite vaulting

the wall. Romanesque builders had used tripartite wall divisions (see figs. 11.12, 11.43, and 11.47), but the Chartres solution diminishes horizontality and treats the wall surface as a coherent vertical unit. (It was in an attempt to rival High Gothic buildings such as Chartres that the Early Gothic nave wall of Notre-Dame was reconfigured into a three-part elevation from its original Early Gothic four-part form [see fig. 12.9].) Shafts attached to the piers at Chartres stress the continuity of the vertical lines and guide our eye upward to the vaults, which appear as diaphanous webs stretched across the slender ribs. Quadripartite, or four-part, vaults now replace the sexpartite vaults of Early Gothic buildings (fig. **12.14**). Quadripartite vaults cover rectangular bays and, as a result, the builders did not need to worry any longer about an alternating system of supports. The quickened rhythm of shorter, rectangular bays intensifies the perceived pace of propulsion down the nave.

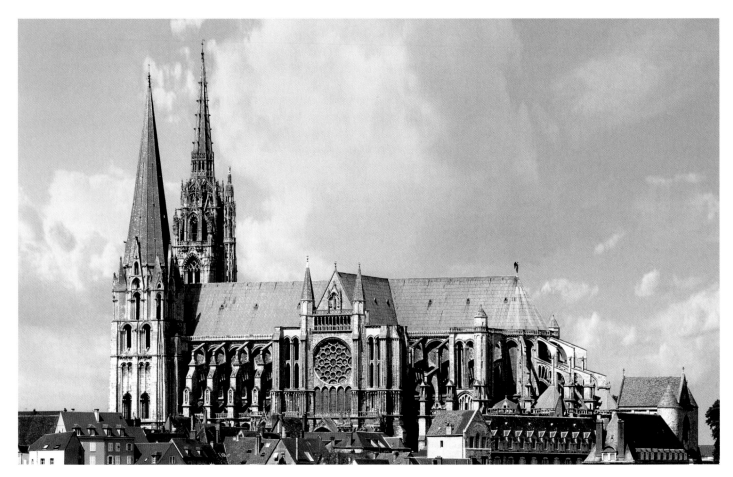

12.15. Cathedral of Notre-Dame, Chartres (from the south)

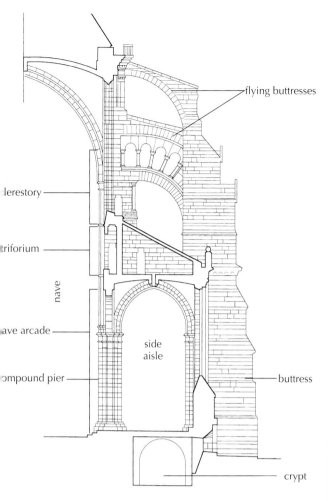

flying buttresses

clerestory

triforium

nave

nave arcade

compound pier

side aisle

buttress

crypt

12.16. Transverse section of Cathedral of Notre-Dame, Chartres (after Acland)

The openings of the pointed nave arcade are taller and narrower than before, and the clerestory is larger so that it is the same height as the nave arcade. Because there are so few walls, the vast interior space appears at first to lack clear boundaries.

BUTTRESSES In Chartres, as in Suger's choir at Saint-Denis, the buttresses (the heavy bones of the structural skeleton) are visible only outside the building (figs. **12.15–12.17**). The plan (see fig. 12.11) shows them as massive blocks of masonry that stick out from the building like a row of teeth. Above the aisles, these piers turn into **flying buttresses**—arched bridges that reach upward to the critical spots between the clerestory windows where the outward thrust of the nave vault is concentrated (see fig. 12.16). The flying buttresses were also designed to resist the considerable wind pressure on the high-pitched roof. This method of anchoring vaults, so characteristic of Gothic architecture, certainly owed its origin to functional considerations. Yet even the flying buttress is an integral aesthetic and expressive feature of the building (see fig. 12.17). Its shape could express both verticality and support (in addition to actually providing it) in a variety of ways, according to the designer's sense of style.

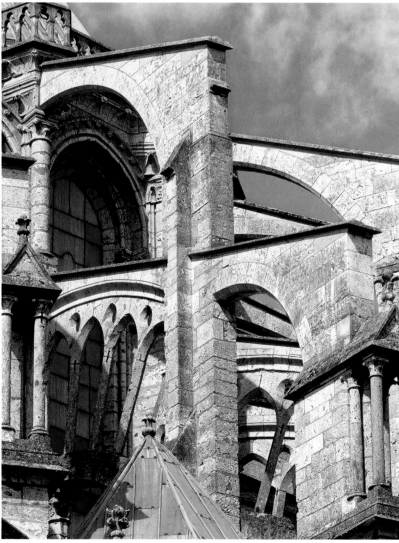

12.17. Flying buttresses, Cathedral of Notre-Dame, Chartres

Theophilus Presbyter (12th century)

De diversis artibus, from Book II: "The Art of the Worker in Glass"

"Theophilus" may have been the pseudonym of Roger of Helmarshausen, a Benedictine monk and metalworker. Metalwork is the subject of the third book of this treatise, following books on painting and stained glass. Theophilus' text, written in the twelfth century, is the first in the Western tradition to give a practitioner's account of the technology of art production.

Chapter 17: *Laying Out Windows*

When you want to lay out glass windows, first make yourself a smooth flat wooden board. Then take a piece of chalk, scrape it with a knife all over the board, sprinkle water on it everywhere, and rub it all over with a cloth. When it has dried, take the measurements of one section in a window, and draw it on the board with a rule and compasses. Draw as many figures as you wish, first with [a point made of] lead or tin, then with red or black pigment, making all the lines carefully, because, when you have painted the glass, you will have to fit together the shadows and highlights in accordance with [the design

on] the board. Then arrange the different kinds of robes and designate the color of each with a mark in its proper place; and indicate the color of anything else you want to paint with a letter.

After this, take a lead pot and in it put chalk ground with water. Make yourself two or three brushes out of hair from the tail of a marten, badger, squirrel, or cat or from the mane of a donkey. Now take a piece of glass of whatever kind you have chosen, but larger on all sides than the place in which it is to be set, and lay it on the ground for that place. Then you will see the drawing on the board through the intervening glass, and, following it, draw the outlines only on the glass with chalk.

Chapter 18: *Glass Cutting*

Next heat on the fireplace an iron cutting tool, which should be thin everywhere except at the end, where it should be thicker. When the thicker part is red-hot, apply it to the glass that you want to cut, and soon there will appear the beginning of a crack. If the glass is hard [and does not crack at once], wet it with saliva on your finger in the place where you had applied the tool. It will immediately split and, as soon as it has, draw the tool along the line you want to cut and the split will follow.

SOURCE: THEOPHILUS, *ON DIVERS ART: THE FOREMOST MEDIEVAL TREATISE ON PAINTING, GLASSMAKING, AND METALWORK,* TR. BY JOHN G. HAWTHORNE AND SYRIL STANLEY SMITH (NY: DOVER PUBLICATIONS, 1979)

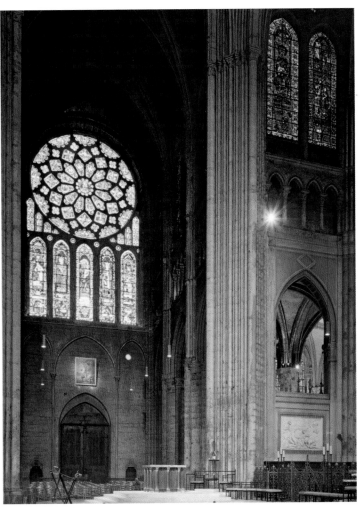

12.18. North transept, Cathedral of Notre-Dame, Chartres

The masonry techniques involved in constructing cathedrals required both brute labor and skill. *Freemasons*, those who worked in *freestone*, which has a uniform texture and can be chiseled without breaking, carved the individual blocks and set them together to form walls, both outer and inner. The intermediate space was filled with mortar and rough stones, a task which the less skilled *roughmasons* performed. The inner and outer walls were connected by tie-courses of finished freestone, which gave added strength to the walls.

STAINED GLASS Alone among all major Gothic cathedrals, Chartres still retains most of its more than 180 original stained-glass windows (fig. **12.18**). The magic of the jewel-like light from the clerestory is unforgettable to anyone who has experienced it. The windows admit far less light than one might expect. They act mainly as diffusing filters that change the quality of daylight, giving it the poetic and symbolic values so highly praised by Abbot Suger. The sensation of ethereal light dissolves the physical solidity of the church and, hence, the distinction between the temporal and the divine realms. This "miraculous light" creates the intensely mystical experience that lies at the heart of Gothic spirituality.

The majestic *Notre Dame de la Belle Verrière* (literally, "Our Lady of the beautiful window") at Chartres (fig. **12.19**) appears as a weightless form hovering effortlessly in indeterminate space. This window, the only one apart from those of the west facade to survive the 1194 fire, consists of hundreds of small pieces of tinted glass held together by strips of lead. Methods of medieval glassmaking limited the maximum size of these pieces, so the design could not simply be "painted on glass." Rather, the window was painted *with* glass. It was assembled

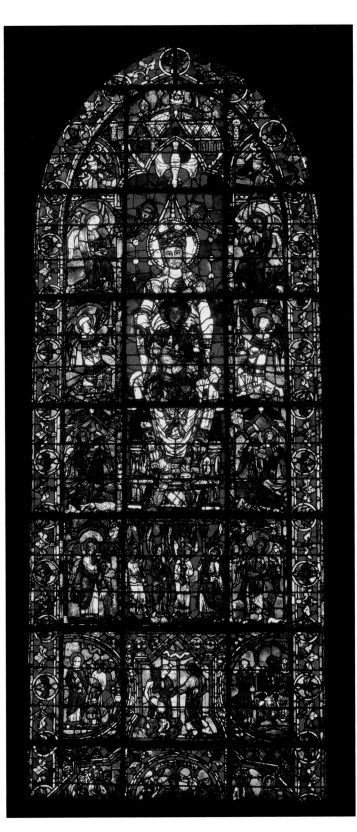

12.19. *Notre Dame de la Belle Verrière*. ca. 1170 (framing panels are 13th century). Stained-glass window, height approx. 14′ (4.27 m). Cathedral of Notre-Dame, Chartres

much like a mosaic or a jigsaw puzzle, out of odd-shaped fragments cut to fit the contours of the shapes. (See *Primary Source*, page 400.) This process encourages an abstract, ornamental style, which tends to resist any attempt at three-dimensional effects. Only in the hands of a great master could the maze of lead strips lead to such monumental forms. (See *Methods and Materials*, page 403.)

Given the way stained glass accentuates pattern and decorative effect, it is not surprising that it was so popular during the Middle Ages. Its brilliant surfaces are like the flat stones and enamelwork so highly prized in earlier periods (see fig. 10.2); enamel is in fact a kind of glass. The intensity with which the viewer engages with the image parallels the direct connection between viewer and object evident in much of the art of the earlier Middle Ages. Worthy comparisons with *Notre Dame de la Belle Verrière* are the Byzantine mosaics from the Church of the Dormition at Daphni (see figs. 8.45–8.46) for the way they command our attention and communicate directly with a viewer. Both use otherworldly light to convey spiritual messages: on the one hand, filtered through stained glass, and on the other, reflected off gold-glass mosaics.

The stained-glass workers who filled the windows of the great Gothic cathedrals also had to face difficulties arising from the enormous scale of their work. The task required a degree of orderly planning that had no precedent in medieval painting. Only architects and stonemasons knew how to deal with this problem, and it was their methods that the stained-glass workers borrowed in mapping out their own designs. Gothic architectural design relied on a system of geometric relationships to establish numerical harmony (see *The Art Historian's Lens*, page 402); the same rules could be used to control the design of stained-glass windows or even an individual figure.

The drawings in a notebook compiled about 1240 by Villard de Honnecourt, who traveled widely and documented the major buildings he examined, provide some insight into this procedure. (See end of Part II, *Additional Primary Sources*.) What we see in his *Wheel of Fortune* (fig. **12.20**) is not the final version of the design but the system of circles and triangles on which the artist based the image. Another drawing, from the same notebook, the *Front View of a Lion* (fig. **12.21**), illustrates the fundamental importance of such geometric schemes. According to the inscription, Villard portrayed the animal from life. However, a closer look shows that he was able to do so only after he had laid down a geometric pattern: a circle for the face (the dot between the eyes is its center) and a second, larger circle for the body. To Villard, then, drawing from life meant something far different from what it does to us. It meant filling in an abstract framework with details based on direct observation.

TRANSEPTS AND THEIR SCULPTURE Each of the transept arms of Chartres Cathedral has three deeply recessed and lavishly decorated portals, five **lancets** (tall, narrow windows crowned by a sharply pointed arch), and an immense **rose window**, the large medallion of glass in the center of the facade (see figs. 12.15 and 12.18). The wall of these north and south facades has little solidity; it is so heavily pierced as to be nearly skeletal.

Modules and Proportions

Just as musicologists have tried to reconstruct original performance practice during the Middle Ages, so too architectural historians have tried to find the underlying systems that govern the design and construction of medieval buildings, so that they can understand the methods and intentions of medieval builders. How medieval architects and masons decided on the measurements and patterns they employed is a fascinating topic that has been explored by architectural historians since the nineteenth century. Few medieval documents explain how individual architects went about establishing the specific relationships they used, so scholars have to measure buildings and analyze those measurements in order to decipher the systems that were used to design them. The task is not always easy. The medieval yardstick was not the same in all regions, as it was the responsibility of local authorities to control measurement; so, for example, a specific measure in Paris was often different from the measure used in another French town.

The most basic method of establishing a proportional order in building was to either multiply or divide a unit of measure, a system employed in the ninth century in the St. Gall monastery plan (see fig. 10.21), and in later buildings, such as the cathedrals of Santiago de Compostela (see fig. 11.3) and Saint-Sernin in Toulouse (see fig. 11.6), where the square at the crossing of the nave is halved to determine the size of the nave bays and quartered for aisle bays. Medieval architects also employed more complicated proportional schemes. For example, by taking the diagonal of a square and rotating it, a designer could produce a rectangle with a consistent proportional relationship based on the square root of 2 (1.414);

that is, the proportion of the shorter side of the rectangle to its longer side is 1:1.414. This proportional system had been used throughout antiquity, appearing, for example, in Vitruvius' writings (see end of Part II, *Additional Primary Sources*.). The design tools an architect would have needed to produce shapes using these proportions were simply a right angle, a measuring rod, and a compass or a string, which could be used to rotate diagonals and thus form arches.

Art historians have also attempted to understand the philosophical and symbolic significance of medieval systems of measurements. In his analysis of the Gothic cathedral, Otto von Simson described how St. Augustine—whose fifth-century writings were of singular importance throughout the Middle Ages—saw modulation as producing a whole and perfect system that, in effect, reflects the order of the universe. Augustine relies on the biblical description (Wisdom of Solomon 11:21) of an omnipotent God who "hast ordered all things in measure, and number, and weight." For Augustine the employment of ratios in art, as well as in music, not only produces beauty but also allows us to appreciate the divine order. Architectural historians have demonstrated that figures from Platonic geometry, including the pentagon, the equilateral triangle, and the square, were also understood and employed by medieval builders. For Plato, these shapes were associated with the elements that form the cosmos. Thus, once again medieval architects found a physical system that expressed the perfection and wholeness of the universe.

Since the plans and elevations of Gothic cathedrals were viewed as mirrors of divine truths, these buildings can be appreciated as a union of engineering and theology, structure and meaning. Undoubtedly, for the medieval mind, the mathematics needed to plan medieval buildings and the symbolism of the proportions and geometry employed were inseparable.

12.20. Villard de Honnecourt. *Wheel of Fortune.* ca. 1240. Ink on vellum. Bibliothèque Nationale, Paris

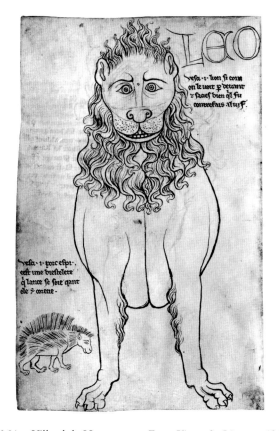

12.21. Villard de Honnecourt. *Front View of a Lion.* ca. 1240. Ink on vellum. Bibliothèque Nationale, Paris

Stained Glass

Colored glass was not new in the thirteenth century, when it was used to spectacular effect in the windows of Gothic churches. It can be traced back more than 3,000 years to Egypt, and abundant evidence indicates that the Romans employed thin translucent sheets of glass in their buildings. Literary accounts, supported by some surviving examples, also describe colored glass in Early Christian, Byzantine, Muslim, and early medieval buildings.

In the twelfth-century artist's handbook *De diversis artibus*, the monk Theophilus Presbyter described in great detail the technique for making stained glass (see *Primary Source*, page 400). It required a molten mixture of silica (basically sand), potash (to lower the temperature at which silica melts), and lime (a stabilizer), plus the addition of metal oxides to color or "stain" the glass: The addition of cobalt oxide resulted in blue glass, copper oxide in red, and manganese oxide in purple. The glassworker heated the mixture in a wood-fired furnace and either poured it into molds to cool or shaped it by blowing air through a tube to form the soft glass mixture into an oval ball or cylinder, which he then cut open and flattened.

On a wooden board that had previously been covered with chalk, a designer created a drawing the same size as the window to be filled. Individual pieces of colored glass were cut with hot iron rods to fit the drawing and then arranged on it. Finer details, such as facial features and drapery folds, were then painted on with lead oxides, and the glass was placed in a wood-fired kiln to fuse the painted on designs with the glass. Individual glass pieces were fitted together into malleable lead strips called **cames**. To permanently hold the composition in place, it was attached to an iron frame secured within the window opening. In the early twelfth century, the iron frame formed a grid of squares of about 2 feet on each side (see fig. 12.19). By the thirteenth century, glaziers employed complicated shapes, including circles, lozenges, and quatrefoils, to create increasingly complex designs (see fig. 12.34).

Stained-glass production was a costly, time-consuming, and labor-intensive activity with a marked division of labor. The artisans who made the glass supported the work of the glaziers who designed and produced the windows.

Although stained glass appears throughout Europe (see fig. 12.59), the most significant achievements in glass were made in northern Europe. To produce stained glass required abundant wood, both for firing the furnaces and kilns and for making potash, and it was in the north where there were sufficient forests to support a glassmaking industry. It was also in the north where the value of light entering a building could best be appreciated.

The effect of multicolored refracted light playing off surfaces and across spaces virtually transforms Gothic buildings. Glaziers needed to consider how individual windows could harmoniously relate to the buildings that enframed them and to a larger iconographic and aesthetic program. At Chartres, for example, blue glass predominates in the north transept rose window, while red, which admits less light, predominates in the southern rose window. Since southern light is much stronger than northern, the effect of the two roses is balanced in relation to the amount of natural light entering the building. Stained glass also provided the means to relate stories and images and to imbue them with metaphoric form. The thirteenth-century writer William Durandus of Mende, in his *Rationale divinorum officiorum,* wrote that "the windows of the church are the Holy Scriptures, which expel the wind and the rain, that is all things hurtful, but transmit the light of the true Sun, that is God, into the hearts of the faithful," while St. Bernard of Clairvaux (see page 356) explained that light could pass through glass without damaging it, just as the word of God had penetrated the womb of the Virgin Mary without violating it.

By the late thirteenth century the preference for colored glass had diminished and large areas of clear glass dominate church construction (see fig. 12.36). Where figures are employed, they remain quite vividly colored, but are isolated within large expanses of grayish **grisaille glass**, with yellow-stained glass used to represent architectural frames around the figures. This paler glass allows light to illuminate more fully the increasingly complex architectural details of later Gothic architecture.

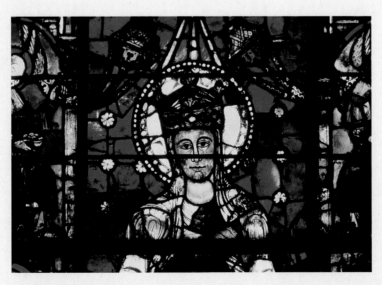

Detail from *Notre Dame de la Belle Verrière,* Cathedral of Notre-Dame, Chartres. ca. 1170

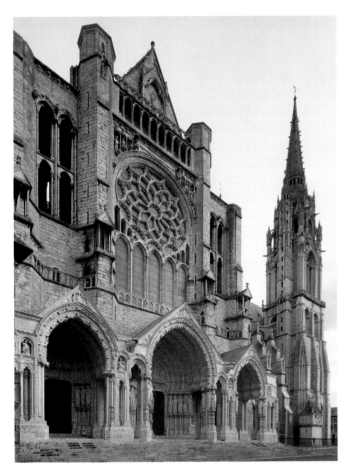

12.22. Portals, north transept, Cathedral of Notre-Dame, Chartres. ca. 1204–1230

On the earlier west facade, which holds the main entrance to the cathedral, the rose window, which was added after the 1194 fire, is composed of a grouping of holes cut out of the solid wall (see fig. 12.4). By comparison, thin membranes hold the glass of the north rose in place. Art historians use the terms **plate tracery** and **bar tracery** to describe the different methods of composition employed here. The bar tracery of the transept roses creates intricate decorative patterns and permits an increased amount of glass in relation to frame or wall surface.

The north transept (fig. **12.22**) is devoted to the Virgin Mary. She had already appeared over the right portal of the west facade in her traditional role as the Mother of God seated on the Throne of Divine Wisdom (see fig. 12.5). Her new prominence reflects the growing importance of the cult of the Virgin, which the Church had actively promoted since the Romanesque period. The growth of *Mariology,* as it is known, was linked to a new emphasis on divine love, embraced by the faithful as part of the more human view that increased in popularity during the Gothic era. The cult of the Virgin at Chartres developed special meaning about 1204, when the cathedral received the head of her mother, St. Anne, as a relic. This relic, in combination with the robe of the Virgin that had miraculously survived the fire of a decade earlier, gave Chartres exceptional status among those devoted to Mary.

The north tympanum of about 1210 depicts events associated with the Feast of the Assumption, when Mary was transported to Heaven (fig. **12.23**). These events are the Death (Dormition), Assumption, and Coronation of the Virgin, which, along with the Annunciation, became the most frequently portrayed subjects relating to her life. They identify Mary with the Church as

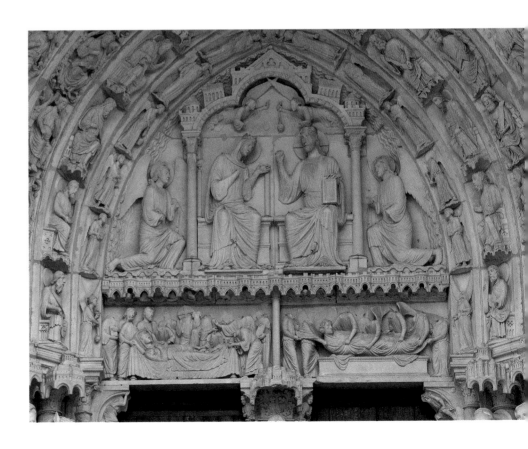

12.23. *Coronation of the Virgin* (tympanum), *Dormition and Assumption of the Virgin* (lintel), north portal, Cathedral of Notre-Dame, Chartres. ca. 1210

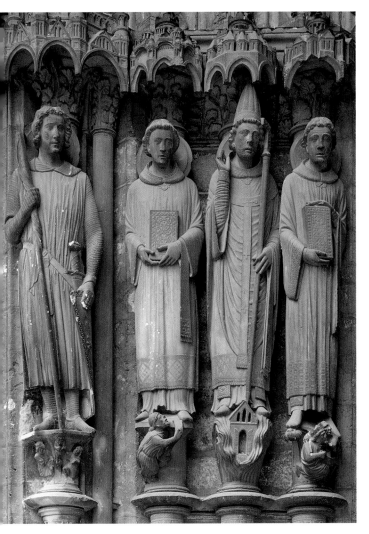

12.24. Jamb statues, south transept portal, Cathedral of Notre-Dame, Chartres. ca. 1215–1220. Left-most figure (St. Theodore) ca. 1230

(see fig. 12.6), though the heads are no longer strictly in line with the central axis of the body. By comparison, the knight on the left, St. Theodore, who was carved about ten or fifteen years later than his companions, stands at ease, in a semblance of classical *contrapposto*. His feet rest on a horizontal platform, rather than on a sloping shelf as before, and the axis of his body, instead of being straight, describes a slight but perceptible S-curve. Even more surprising is the wealth of carefully observed detail in his weapons and in the texture of his tunic and chain mail. Above all, there is the organic structure of the body. Not since imperial Roman times have we seen a figure as thoroughly alive as this. Yet the most impressive quality of the St. Theodore statue is not its naturalism but the serene, balanced image that it conveys. This ideal portrait of the Christian soldier expresses the spirit of the Crusades in its most elevated form.

Amiens Cathedral

The High Gothic style defined at Chartres reaches its climax a generation later in the interior of Amiens Cathedral (figs. **12.25 and 12.26**). Amiens was begun in 1220, two years after a fire destroyed an earlier cathedral on the site and while Chartres was still under construction; the nave was vaulted by 1236 and work on the choir continued for another 25 years. It is significant that we know the names of the cathedral's architects, Robert de Luzarches, Thomas de Cormont, and his son Renaud de Cormont, since it indicates a heightened social status of Gothic builders.

the Bride of Christ and the Gateway to Heaven, in addition to her traditional role as divine intercessor. She becomes not only Christ's companion, but also his Queen. Unlike earlier representations, many of which rely on Byzantine examples, these are of Western invention. The figures have a monumentality never found before in medieval sculpture. Moreover, the treatment is so pictorial that the scenes are independent of the architectural setting into which they are crammed.

Whereas the *Coronation of the Virgin* represents a relatively early phase of High Gothic sculpture, the jamb statues of the transept portals show a discernible evolution, even among themselves since they were carved at different times. The relationship of statue and column begins to dissolve. The columns are quite literally put in the shade by the greater width of the figures, by the strongly projecting canopies, and by the elaborately carved bases of the statues.

A good instance of this early dissolution of the relationship between statues and columns is seen on one of the south transept portal jambs (fig. **12.24**). The three saints on the right still echo the cylindrical shape of Early Gothic jamb statues

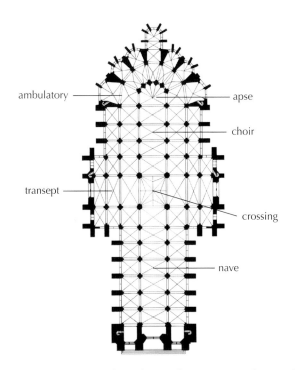

12.25. Robert de Luzarches, Thomas de Cormont, and Renaud de Cormont. Plan, Cathedral of Notre-Dame, Amiens. Begun 1220

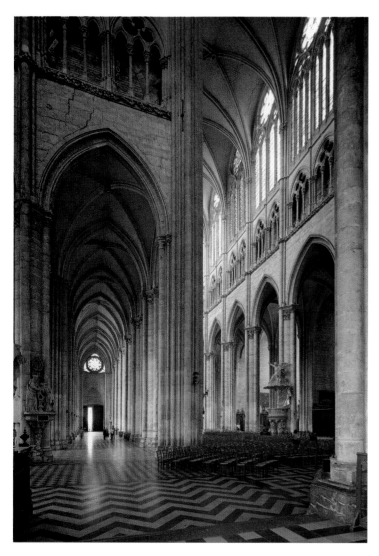

12.26. Nave and side aisle, Cathedral of Notre-Dame, Amiens

NAVE The breathtaking height of the nave (fig. 12.26) is the dominant achievement both technically and aesthetically at Amiens. We can see clearly the relatively swift and continuous progression toward verticality in French Gothic cathedral architecture by comparing the nave elevations of the Early Gothic Cathedral of Notre-Dame in Paris and the High Gothic cathedrals of Chartres and Amiens (fig. 12.27). The height of the Amiens nave arcade, greatly increased in proportion to the rest of the wall, creates a soaring effect; it alone is almost as high (70 feet) as the entire four-story elevation of Laon (78 feet). The complete nave rises 140 feet above the ground, while that at Chartres measures "only" 118 feet from floor to vault. Moreover, the width of the Amiens nave is narrower in proportion to its height; at Paris the ratio of nave width to height is 1:2.2 and at Chartres 1:2.4, while at Amiens it is 1:3. Thus the effect of soaring verticality increased in direct proportion to the narrowing of the nave. There is also increased vertical integration through the use of shafts that rise directly through the capitals of the piers. Moreover, the triforium and clerestory are connected visually by means of a central colonnette, so that the entire wall above the nave arcade is pulled together vertically. At Amiens the vaults are as taut and thin as membranes; skeletal construction is carried to its virtual limits.

Reims Cathedral

We can trace the same emphasis on verticality and translucency in the development of the High Gothic facade. The one at Reims Cathedral makes an instructive contrast with Notre-Dame in Paris, even though it was designed only about 30 years

12.27. Comparison of nave elevations in same scale (after Grodecki)

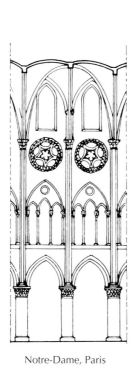

Notre-Dame, Paris

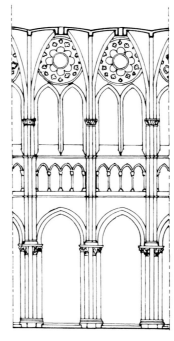

Chartres Cathedral

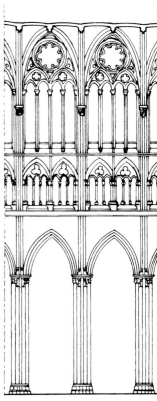

Amiens Cathedral

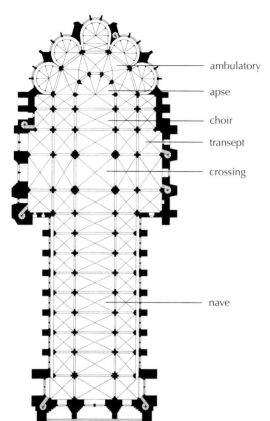

ambulatory

apse

choir

transept

crossing

nave

12.28. Plan, Cathedral of Notre-Dame,
Reims. ca. 1225–1290

later. Reims, as the coronation cathedral of the kings of France, was closely linked to Paris, where the kings held court. The two share many elements, including broad transepts that extend out from the body of the church only slightly, but they have been reshaped into very different ensembles (fig. **12.28**).

WEST FACADE The portals on the west facade of Reims Cathedral (fig. **12.29**), instead of being recessed as in Paris (see fig. 12.10), project forward as gabled porches, with windows in place of tympana above the doorways. The gallery of royal statues, which in Paris forms a horizontal band between the first and second stories, has been raised in Reims until it merges with the third-story arcade. Every detail except the rose window has become taller and narrower than before. **Pinnacles** (small pointed elements capping piers, buttresses, and other architectural forms) everywhere accentuate restless upward movement. The sculptural decoration, by far the most lavish of its kind, no longer remains in clearly marked-off zones, but has now spread to so many new perches, not only on the facade but on the flanks of the edifice as well, that the exterior begins to look like a dovecote for statues.

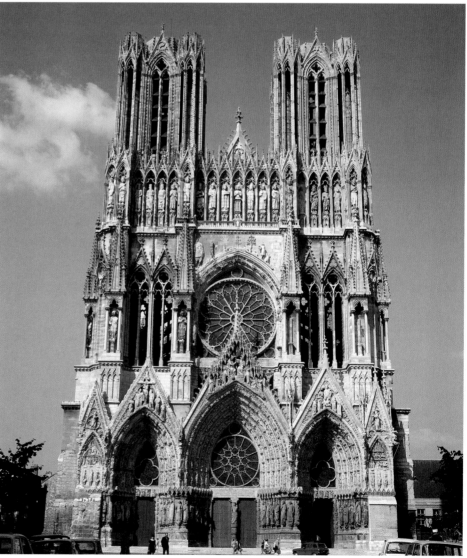

12.29. Cathedral of Notre-Dame,
Reims (from the west)

ART IN TIME

1180–1223 CE—Reign of French King Philip August

**1194—A fire destroys much of Chartres Cathedral
in France**

1252—Italian theologian Thomas Aquinas begins teaching
in Paris

WEST PORTAL SCULPTURE The jamb figures at Reims are not in their original positions because some sculptures were moved between the west facade and the transept portals. As a result, continuity of style and program is difficult to assess. However, we can study here individual sculptures of distinctive style and high quality. Gothic classicism (see page 405) reached its climax in some of these Reims statues. The most famous of them is the *Visitation* group (fig. **12.30**, the two figures on the right), which was carved between 1230 and 1233. It depicts the Virgin Mary announcing the news of her pregnancy to her cousin Elizabeth.

For a pair of jamb figures to enact a narrative scene such as this would have been inconceivable in Early Gothic sculpture, where individual figures remained isolated, even within unified programs. That the *Visitation* figures are now free to interact shows how far the column has receded into the background.

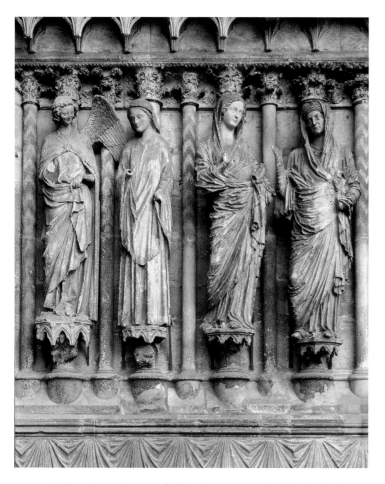

12.30. *Annunciation* and *Visitation*, west portal, Cathedral of Notre-Dame, Reims. ca. 1230–1265

The S-curve, resulting from the pronounced *contrapposto*, is much more obvious here than in the St. Theodore from Chartres (see fig. 12.24) and dominates both the side and the front views of the figures. The figures gesture at each other as they communicate across the space that separates them, an engagement with open space that recalls the more active role taken on by space in High Gothic architecture, too.

Horizontal folds of cloth pulled across the women's abdomens emphasize the physical bulk of their bodies. Mary and Elizabeth remind us so strongly of ancient Roman matrons that we might wonder if the artist was inspired by large-scale Roman sculpture (compare fig. 7.13). A surviving Roman gate attests to the Roman presence in Reims, and excavations during the last century established that the first cathedral on the site was built over Roman baths. That Roman models might have been available to the Reims sculptors is thus a real possibility.

Because of the vast scale and time frame of the sculptural program at Reims (and at other cathedrals as well), it was necessary to employ a variety of sculptors working in distinct styles. Two of these styles, both clearly different from the classicism of the *Visitation*, appear in the *Annunciation* group (fig. 12.30, the two figures on the left). The difference in style within a single group derives from the fact that the angel Gabriel and the Virgin were not originally intended as a pair, but were installed next to each other, as we see them today. The Virgin, from between 1240 and 1245, has a rigidly vertical axis, and her garments form straight, tubular folds meeting at sharp angles. This severe style was probably invented about 1220 by the sculptors of the west portals of Notre-Dame in Paris; from there it traveled to Reims as well as Amiens. The angel, in contrast, is remarkably graceful and was carved at least a decade later than the Virgin of the *Annunciation*, between 1255 and 1265. The tiny, round face framed by curly locks, the emphatic smile, the strong S-curve of the slender body, and the rich drapery of this "elegant style" spread far and wide during the following decades. In fact, it soon became the standard formula for Gothic sculpture. Its effect will be seen for many years to come, not only in France but also abroad.

RELIEF SCULPTURE A mature example of the elegant style is the Old Testament group of *Melchizedek and Abraham* (fig. **12.31**), carved shortly after the middle of the thirteenth century, for the interior west wall of Reims Cathedral. These sculptures were probably conceived in relation to the royal coronation ceremonies held in the Cathedral. Abraham and Melchizedek were chosen as subjects because they are Old Testament sacred leaders, and the scene emphasizes that earthly power is bestowed through and in the service of the Church. Abraham, in the costume of a medieval knight, recalls the vigorous realism of the St. Theodore at Chartres (see fig. 12.24) in the attention the sculptor invested in his garments and trappings. Melchizedek, however, shows clearly his proximity to the angel of the Reims *Annunciation* (see fig. 12.30) in his even more elaborately curled hair and beard and the ample draperies that nearly swallow the body among the play of folds. Deep recesses and sharply projecting ridges show a new awareness of the effects of

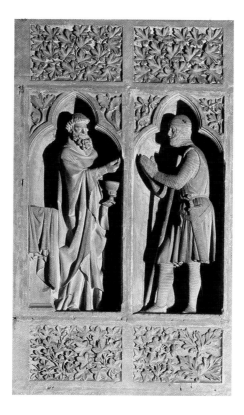

12.31. *Melchizedek and Abraham*, interior west wall, Cathedral of Notre-Dame, Reims. ca. 1260–1270

light and shadow that are as pictorial as they are sculptural. This pictorialism is also apparent in the way the figures interact, despite being placed in deep niches. The realism of these figures is heightened by the foliage that occupies the framing elements around them, representing specific and recognizable plants, which include oak and fig leaves as well as acorns.

References to the increasing realism of Gothic sculpture need qualification, since Gothic realism was never systematic.

Rather, it was a *realism of particulars*, focused on specific details rather than on overall structure. Its most characteristic products are not only the classically oriented jamb statues and tympanum compositions of the early and mid-thirteenth century, but also small-scale carvings, such as the *Labors of the Months* and the *Signs of the Zodiac* in **quatrefoil** (four-lobed) frames on the facade of Amiens Cathedral (fig. **12.32**). The same subjects appear on Romanesque and early Gothic portals, but at

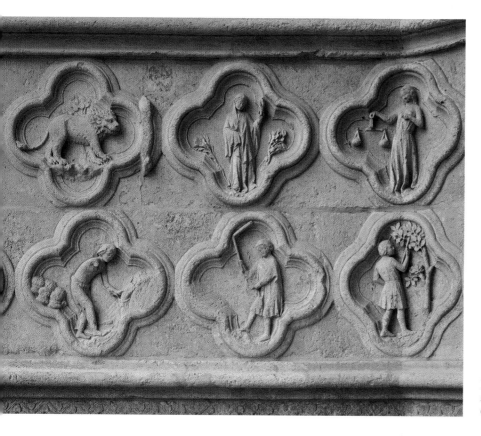

12.32. *Signs of the Zodiac* (Leo, Virgo, and Libra) and *Labors of the Months* (July, August and September), west facade, Amiens Cathedral. ca. 1220–1230

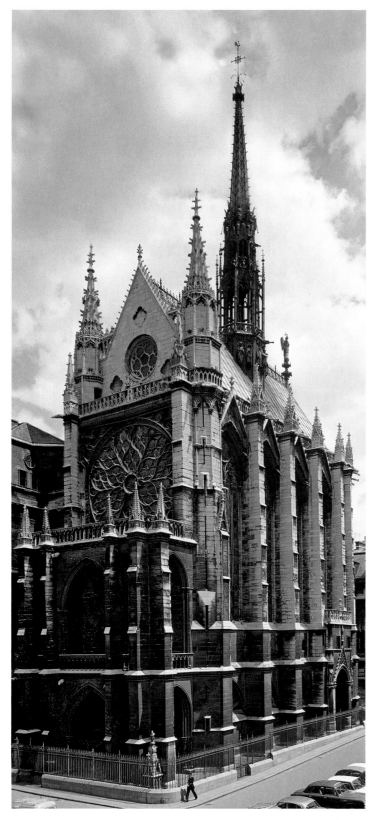

12.33. Sainte-Chapelle, Paris (from the southwest). 1241–1248. (Rose window, late 15th century)

Amiens they demonstrate a delightful observation of everyday life. The sculptor was clever in arranging individual scenes within the decorative quatrefoils, a shape difficult to master compositionally.

The High Gothic cathedrals of France represent a concentrated effort rarely seen before or since. The huge cost of these truly national monuments was borne by donations collected from all over the country and from all classes of society. These cathedrals express the merging of religious and patriotic fervor that had been Abbot Suger's goal. However, the great expense and forced taxation required to construct these buildings did produce vehement objections, and in 1233, for example, construction of Reims Cathedral was suspended as a result of civil unrest directed against the cathedral authorities and was not resumed for another three years. The cessation of building activity helps explain the variety of styles at Reims. By the middle of the thirteenth century the wave of enthusiasm for large-scale projects had passed its crest. Work on the vast structures now proceeded at a slower pace. New projects were fewer and generally far less ambitious. As a result, the highly organized teams of masons and sculptors that had formed at the sites of the great cathedrals during the preceding decades gradually broke up into smaller units.

RAYONNANT OR COURT STYLE

One of those who still had the will and means to build on an impressive scale during the mid-thirteenth century was King Louis IX (known as St. Louis following his canonization in 1297, fewer than 30 years after his death). Under the king's governance and as a result of a treaty with the English that resulted in French control of Normandy, the map of Louis's possessions begins to take on the shape of present-day France. The increasing importance of the monarchy and the rising importance of Paris, where the court was located, is reflected in the degree to which Louis was able to define a court style; our sense of Paris as an artistic center effectively begins under St. Louis.

Sainte-Chapelle

St. Louis's mark on the stylistic evolution of Gothic is most dramatically seen in his court chapel, called the Sainte-Chapelle, which was designed by 1241 and completed within seven years (fig. **12.33**). The two-story building comprises a ground floor, a relatively low chapel for court officials, and an upper floor to which the royal family had direct access from their quarters in the palace. In essence, the building is a type of palatine chapel for which Charlemagne's building at Aachen (see fig. 10.17) serves as an early prototype.

The impetus for the building's construction was Louis's acquisition from his cousin, the emperor of Constantinople, of the Crown of Thorns and other relics of Christ's Passion, including a part of the True Cross, the iron lance, the sponge, and a nail. Such sacred relics required a glorious space for their display. Rich colors, elaborate patterns, and extensive amounts of gold cover Sainte-Chapelle's walls, vaults, and other structural members (fig. **12.34**). This decoration complements the

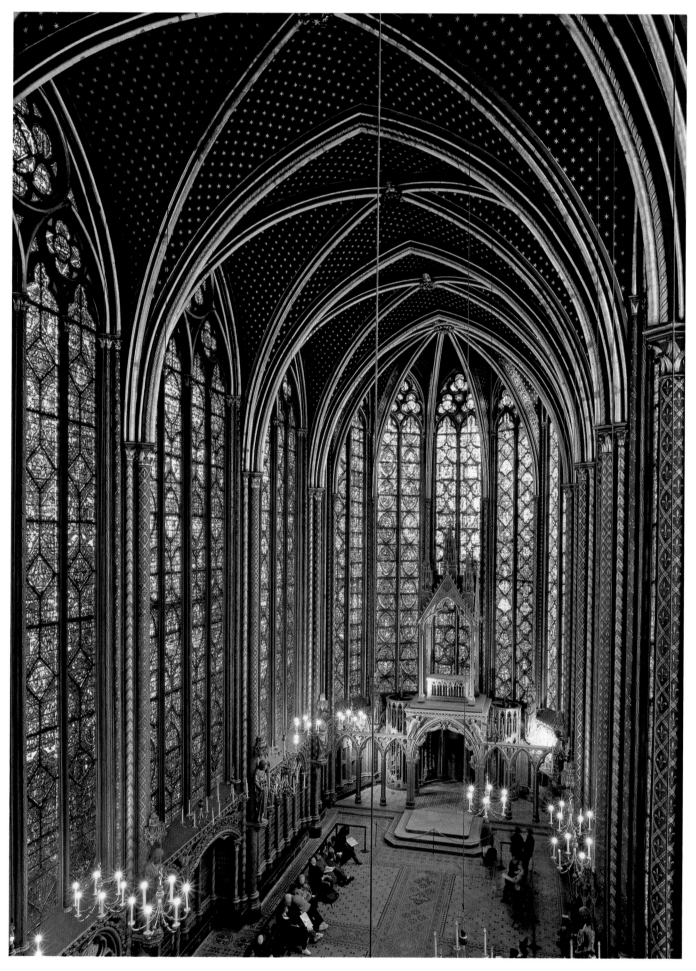

12.34. Interior of upper chapel, Sainte-Chapelle

stained glass that constitutes most of the surface of the chapel. Above the altar, an elevated shrine, destined to frame and display the sacred relics, was left open at the back so that filtered light would bathe the venerated objects on display. The delicate glass cage of a building, jewel-like in the intensity of the colored light that enters it, functions in effect as a monumental reliquary. The tall, thin lancets accentuate verticality to such a degree that the building conveys a sense of monumentality comparable to any cathedral despite its diminutive scale. On entering the building the viewer is virtually immersed within its aura of light, different from any normal experience of the physical world. Thus, as with the Hagia Sophia (see pages 256–259), spirituality is made manifest through the materiality of architecture and its decoration.

Sainte-Chapelle's exterior buttresses are relatively modest in scale, given the great amount of glass and the large size of the windows in proportion to the walls (see fig. 12.33). By keeping the buttresses close to the building, the builders kept to a minimum the shadows cast across the windows. In order to withstand the physical forces usually contained by more promi-

nent buttresses, two horizontal iron chains passing across the chapel's windows reinforce the structure, a remarkably effective solution to the structural and aesthetic problems the builders faced.

This phase of Gothic is often referred to as *rayonnant*, from the French *rayonner*, "to radiate light." The term derives from the prevalence of raylike bar tracery in buildings of the period, which originally appeared in rose windows and later began to appear throughout entire churches. The style, closely associated with the court, spread through the royal domain and then through much of Europe.

Saint-Urbain in Troyes

Saint-Urbain in Troyes (figs. **12.35** and **12.36**), built during the later years of the thirteenth century, was commissioned by Pope Urban IV (r. 1261–1264) to mark his birthplace and was dedicated to his patron saint. By eliminating the triforium and simplifying the plan, the designer created a delicate glass cage of only two stories; the slightly larger upper one is virtually all glass, much of it clear. The delicate tracery of the choir

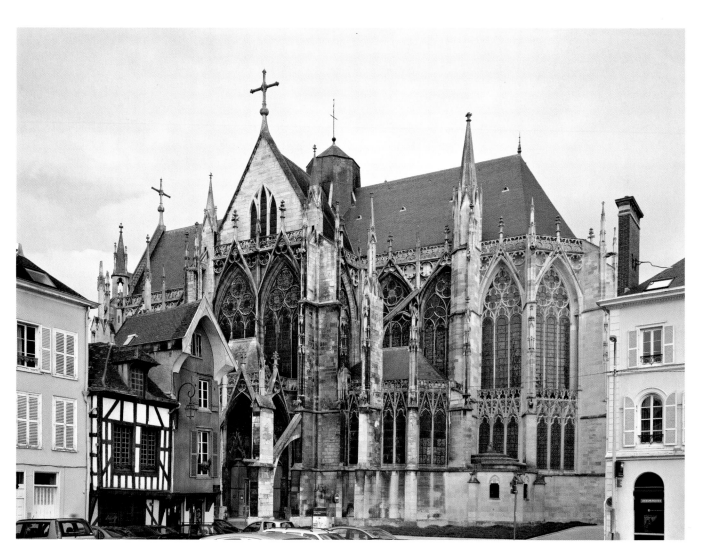

12.35. Saint-Urbain, Begun 1262. Troyes, France

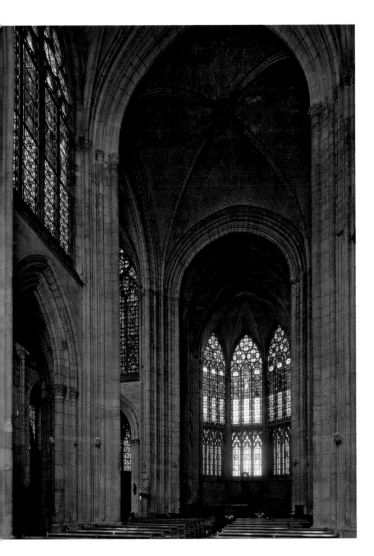

PSALTER OF BLANCHE OF CASTILE A psalter executed around 1230 for Blanche of Castile, mother of King Louis IX, shows these connections. The psalter (fig. **12.37**) was probably made during the period when Blanche served as regent (1226–1234) for Louis, who had inherited the throne at age 12 and could not reign in his own right for another six years. The range and intensity of colors (particularly of red and blue), the heavy outlines, and the placement of scenes within geometric shapes—here interlocked circles and semicircles—recall the treatment and arrangement of stained glass seen, for example, behind the shrine at Sainte-Chapelle (see fig. 12.34). The polished gold background of the illuminated page creates a dazzling display, not unlike the effect of light transmitted through glass.

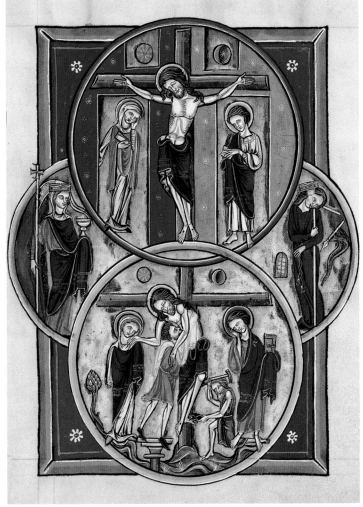

12.37. *Crucifixion and Deposition*, from the *Psalter of Blanche of Castile*. ca. 1230. Ink, tempera, and gold leaf on vellum. $7^{3}/_{4} \times 6''$ (19.9 × 15.4 cm). Bibliothèque de l'Arsenal, Paris. Res ms 1186

windows, which begin only 10 feet above the floor, emphasizes the effect of a screen dematerialized by light. Flying buttresses so thin as to be hardly noticeable support the building. The same spiny elegance characterizes the architectural ornament: Gables are fully detached from the window walls they are designed to support. The delicacy of Saint-Urbain leaves no doubt that the heroic age of the Gothic style is past. Refinement of detail, rather than monumentality, is now the chief concern.

Manuscript Illumination

Some authors have been concerned that the term *rayonnant* is appropriate only for architecture. Recognizing that there were also major achievements in the pictorial arts within Louis IX's court and in the upper echelons of aristocratic society, they prefer the term *court style,* which they use synonymously with *rayonnant* to define the art of this time. In fact, there are many connections between the building arts and the elaborate devotional works with exquisite miniatures produced for the personal enjoyment and education of the royal family and for others who were literate and could afford them. These products of French manuscript workshops disseminated the refined taste that made the court art of Paris the standard for all Europe.

12.38. *Scenes from the Apocalypse*, from a *Bible moralisée*. ca. 1225–1235. Ink, tempera, and gold leaf on vellum, $15 \times 10^{1}/_{2}''$ (38 × 26.6 cm). Pierpoint Morgan Library, New York

BIBLE MORALISÉE At about the same time as the *Psalter of Blanche of Castile*, a *Bible moralisée*, or **moralized Bible** (fig. **12.38**), in which a biblical image accompanies a relatively brief biblical text or a moralizing commentary in Latin or French, was also commissioned by the queen of France in a style comparable to the *Psalter of Blanche of Castile*. This manuscript is today divided between the Cathedral of Toledo, in Spain, and the Pierpoint Morgan Library, in New York, and originally comprised nearly 3,000 illustrated pages. There are a number of moralizing bibles of this type; the original one was probably invented for Blanche and produced a few years earlier than this example and, like this one, in Paris.

These bibles were made for the personal use of the kings and queens of France and were intended both as precious objects and guides for good conduct. The tone of these instructional guides is very much in keeping with the character and accomplishments of Louis, guided by his powerful and involved mother. Louis was an eager warrior for Christianity who organized and participated in two Crusades—he died in 1270 while on crusade in Tunisia—and he was both pious and compassionate.

The scenes on our page of this Bible are arranged in vertically stacked roundels, and once again the tall and narrow windows of Sainte-Chapelle (see fig. 12.34) offer a particularly clear parallel. The spaces around the roundels in the manuscript abound with flourishes and diaper patterns of repeated diamonds, analogous to the decoration surrounding the scenes in the Sainte-Chapelle windows.

PSALTER OF SAINT LOUIS Perhaps the closest parallel between painting and architectural form is the *Psalter of Saint Louis*, which was executed about 1260 (fig. **12.39**). The folio reproduced here illustrates 1 Samuel 11:2, in which Nahash the Ammonite threatens the Jews at Jabesh. The manucript's painted architecture is modeled directly on Sainte-Chapelle (see fig. 12.33). The illustration also recalls the canopies above the heads of jamb statues at Chartres (see fig. 12.24) and the arched twin niches that enclose the relief of *Melchizadek and Abraham* at Reims (see fig. 12.31). Against the two-dimensional background of the page, the figures stand out in relief by their smooth and skillful mod-

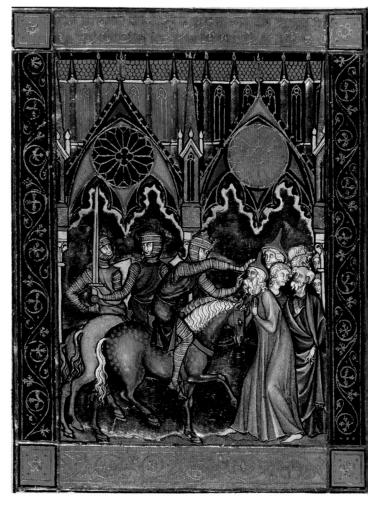

12.39. *Nahash the Ammonite Threatening the Jews at Jabesh*, from the *Psalter of St. Louis*. 1253–1270. Ink, tempera, and gold leaf on vellum. $5 \times 3^{1}/_{2}''$ (13.6 × 8.9 cm). Bibliothèque Nationale, Paris

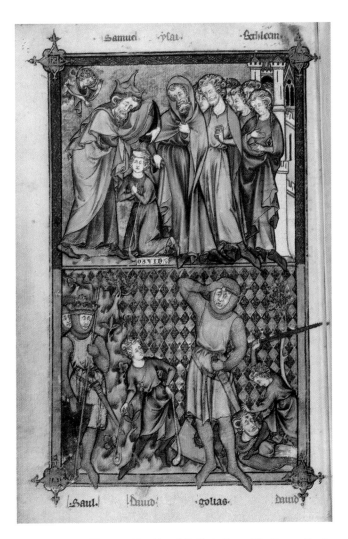

12.40. Master Honoré. *David and Goliath,* from *The Prayer Book of Philip IV the Fair*. 1296. Ink and tempera on vellum, $7^7/_8 \times 4^7/_8''$ (20.2 × 12.5 cm). Bibliothèque Nationale, Paris

eling. The outer contours are defined by heavy, dark lines, once again like the lead strips in stained-glass windows. The figures themselves display all the features of the elegant style invented by sculptors a few years earlier: graceful gestures, swaying poses, smiling faces, and neatly waved hair. (Compare the *Annunciation* angel in figure 12.30 and *Melchizedek and Abraham* in figure 12.31.) This miniature thus exemplifies the refined taste of the court art of Paris.

LATE GOTHIC ART IN FRANCE

Although Late Gothic art builds on earlier Gothic achievements, during this period artists felt free to deviate from previous patterns of development. Builders showed increased concern for unity of plan, but they also employed curvilinear and elaborate decorative forms that often undermined the clarity of structure so important in earlier Gothic works. Elaborate arrangements of overlapping and pierced planes produced

ART IN TIME

1241—Sainte-Chapelle, court chapel of French King Louis IX, designed

1265—Birth of Italian poet Dante, author of *The Divine Comedy*

1273—Emergence of the Hapsburgs; Rudolf I elected king

complex visual displays. Late Gothic manuscripts and sculptures are also highly decorated and are rich in surface treatment, accentuating their precious qualities.

Manuscript Illumination

Until the thirteenth century, illuminated manuscripts had been produced in monastic scriptoria. Now, along with many other activities that were once the special preserve of the clergy, manuscript production shifted to urban workshops organized by laypeople, the ancestors of the publishing houses of today. Here again the workshops of sculptors and stained-glass painters may have set the pattern. Paris was renowned as a center of manuscript production, and it is possible even today to identify the streets on which the workshops were clustered.

PRAYER BOOK OF PHILIP IV THE FAIR Some of these new, secular illuminators are known to us by name. Among them is Master Honoré of Paris, who in 1296 painted the miniatures in the *Prayer Book of Philip IV the Fair,* commissioned by the grandson of Louis IX (fig. **12.40**). Our illustration shows him working in a style derived from the *Psalter of Saint Louis* (see fig. 12.39). Here, however, the framework no longer dominates the composition. The figures have become larger and their relieflike modeling more pronounced, an effect achieved through gentle shifts of color and modulated white highlights, quite different from the flat planes of color so characteristic of earlier manuscripts. The figures do not appear to stand comfortably, since their turned-down feet are flattened against the page. However, the figures are allowed to overlap the frame, which helps to detach them from the flat pattern of the background and thus introduces a certain, though very limited, depth into the picture. The implication of space helps further the storytelling quality of the representation. In the lower scene, David and Goliath each appear twice; in an expressive detail, Goliath, as if in distress, brings his hand to his forehead even before David has released his shot.

HOURS OF JEANNE D'ÉVREUX The interest in depicting sculptural figures represented in depth was further developed by the illuminator Jean Pucelle in a tiny, private prayer book—called a **book of hours**—illuminated in Paris between 1325 and 1328 for Jeanne d'Évreux, queen of France

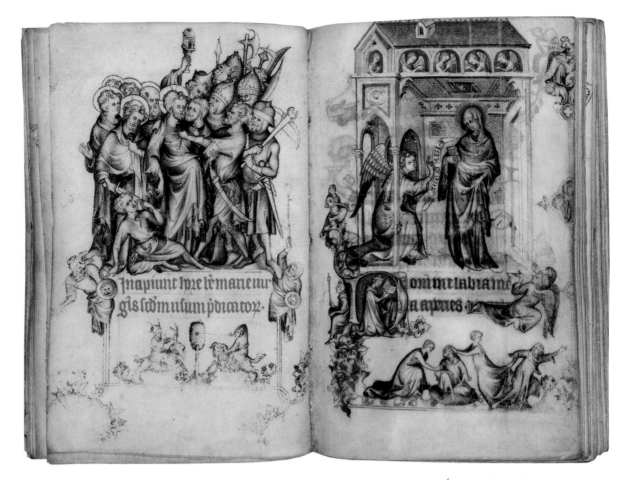

12.41. Jean Pucelle. *The Betrayal of Christ* and *Annunciation*, from the *Hours of Jeanne d'Évreux*. 1325–1328. Tempera and gold leaf on parchment. Each page, $3\frac{1}{2} \times 2\frac{7}{16}$ (8.9 × 6.2 cm). Shown larger than actual size. The Metropolitan Museum of Art, New York. The Cloisters Collection, Purchase, 1954 (54.1.2)

(fig. **12.41**). The *Annunciation* is represented on the right page and the *Betrayal of Jesus* on the left. The style of the figures recalls Master Honoré (see fig. 12.40), but the delicate **grisaille** (painting in gray) adds a soft roundness to the forms. This is not Pucelle's only contribution: The architectural interior reveals a spatial recession previously unknown in northern European painting. In the *Annunciation*, Gabriel kneels in an anteroom, while angels appear in the windows of an attic, from which the dove of the Holy Spirit descends.

In representing this new pictorial space, Jean Pucelle had to take into account the special needs of a manuscript page. The Virgin's chamber does not fill the entire picture surface. It is as though it were an airy cage floating on the blank background (note the supporting angel on the right), like the rest of the ornamental framework, so that the entire page forms a harmonious unit. Many of the details are peripheral to the religious purpose of the manuscript. The kneeling queen inside the initial D is surely meant to be Jeanne d'Évreux at her prayers; it is as if her intense devotions have produced a tangible vision of the Annunciation. The identity of the man with the staff next to her is unclear, although he appears to be a courtier listening to the lute player perched on the tendril above him. The combination of scenes is a commentary on experiences that become real even

if they lack physical substance: Music is at once actual and ephemeral, as is Jeanne's religious vision.

Other enchanting vignettes fill the page. A rabbit peers from its burrow beneath the girl on the left, and in the foliage leading up to the initial we find a monkey and a squirrel. These fanciful marginal designs—or **drôleries**—are a common feature of Northern Gothic manuscripts. They originated more than a century before Jean Pucelle in the regions along the English Channel. From there they quickly spread to Paris and the other centers of Gothic art. Their subjects include a wide range of motifs; fantasy, fable, and grotesque humor, as well as scenes of everyday life, which appear side by side with religious themes. The essence of *drôlerie* is its playfulness. In this special domain, the artist enjoys an almost unlimited freedom—comparable to a jester's—which accounts for the wide appeal of *drôleries* during the later Middle Ages.

The seeming innocence of Pucelle's *drôleries* nevertheless hides a serious purpose, which is particularly evident in the *drôlerie* at the bottom of the right-hand page, a type of illustration referred to as a **bas-de-page** (French for "bottom of the page"). The four figures are playing a game of tag called Froggy in the Middle, a reference to the *Betrayal of Jesus* on the opposite page. Below the *Betrayal of Jesus*, two knights on goats

joust at a barrel. This image not only mocks courtly chivalry but also refers to Jesus as a "scapegoat," and to the spear that pierced his side at the Crucifixion.

Sculpture

Portal sculpture, the principal interest of the Early and High Gothic periods, is of relatively little consequence during the Late Gothic period. Single figures, carved in the round, many of them cult figures, are now fully detached from any architectural setting. As the individual's importance in society increased, so individual sculpted figures became prominent. Sculptors' guilds were now well established. Two guild masters, appointed by the king, guaranteed that sculptors would fulfill the statutes that governed their corporation. In addition to stone carving, sculptors produced a significant number of precious objects in metal and ivory.

VIRGIN OF JEANNE D'ÉVREUX Pucelle's *Virgin of the Annunciation*, with its poised elegance, has a remarkable counterpart in the silver-gilt statue that the same patron offered to the Abbey of Saint-Denis in 1339 (fig. **12.42**). The elegance and refinement of the *Virgin of Jeanne d'Évreux* reminds us that metalwork—so significant during the earlier Middle Ages—continued

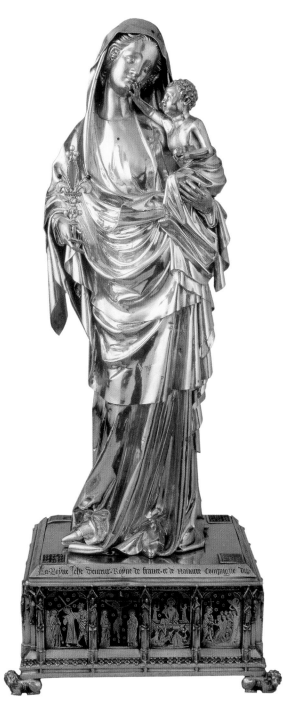

12.42. *Virgin of Jeanne d'Évreux*. 1339. Silver gilt and enamel, height 27½″ (68 cm). Musée du Louvre, Paris (Inv MR342; MR419)

VIRGIN OF PARIS In another early fourteenth-century sculpture of the Virgin, we see how traces of classicism increasingly disappear from Gothic sculpture, while elegance becomes a virtual end in itself. Thus the human figure of the *Virgin of Paris* (fig. **12.43**) in Notre-Dame Cathedral is now strangely abstract. It consists largely of hollows, and the projections are so reduced that a viewer sees them as lines rather than volumes. The statue is quite literally disembodied—its swaying stance bears little relation to Classical *contrapposto*, since it no longer supports the figure. Compared to such unearthly grace, the angel of the Reims *Annunciation* (see fig. 12.30) seems solid indeed; yet it contains the seed of the very qualities expressed so strikingly in the *Virgin of Paris*. Earlier instances of Gothic naturalism (see pages 409), which focused on particulars, survive here as a kind of intimate realism in which the infant Christ is no longer a savior-in-miniature facing the viewer but, rather, a human child playing with his mother's veil.

The elegant manner of this new style was encouraged by the royal court of France and thus had special authority. It is this graceful expressive quality, not realism or classicism, that is the essence of Gothic art. These Late Gothic sculptures might lack the epic quality of Early Gothic sculpture, but they are still impressive works that also relate to Late Gothic art in other mediums, such as ivory, as we shall now see.

SIEGE OF THE CASTLE OF LOVE The *Virgin of Jeanne d'Évreux* and the *Virgin of Paris* were made for a sophisticated audience that valued elegant and luxurious objects. These patrons

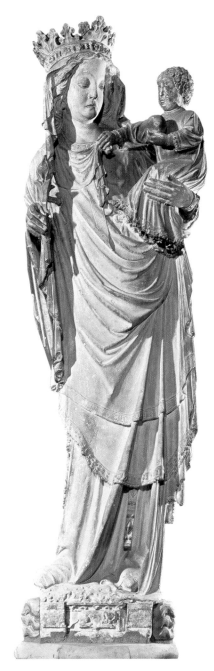

12.43. *Virgin of Paris*. Early 14th century. Stone. Notre-Dame, Paris

to be a valued medium. Even during the Early Gothic period, Abbot Suger made clear the expense that patrons were willing to invest in reliquaries, shrines, altar embellishments, and liturgical vessels. And, it has been calculated that the reliquary designed for the Crown of Thorns cost more than twice the construction expenses of the Sainte-Chapelle, which was built to house it.

In the *Virgin of Jeanne d'Évreux*, the graceful sway of the Virgin's body is counterbalanced by the harmonious way in which the drapery's vertical folds and soft curves play off each other. The Christ Child touches his mother's lips in a gesture both delicate and intimate. The inscription on the base of the statue recording the royal gift and the *fleur-de-lis*, symbol of French royalty, held by the Virgin, associate her royal stature with that of the donor.

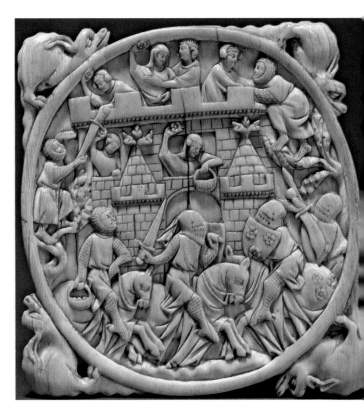

12.44. *Siege of the Castle of Love*. Back of a mirror. ca. 1320–1350. Ivory, $4\frac{1}{2} \times 4\frac{1}{4} \times \frac{1}{2}''$ (11.5 × 10.9 × 1.27 cm). Seattle Art Museum. Donald E. Frederick Memorial Collection (49.37)

also commissioned secular articles for their own use, many of which were made by the same artists who created religious images. Objects, in precious materials such as ivory, were often decorated with scenes from the romantic courtly literature that was popular at the time. These stories were recounted by troubadours, whose favorite subjects were the sweetness and the bitterness of love. The *Siege of the Castle of Love* (fig. **12.44**) is depicted on a fourteenth-century ivory mirror back, which originally held a polished metal disk on its other side. Knights, some on horseback, attack a castle inhabited by women. However, by conscious design the battle lacks intensity, since the equestrian at the left is more concerned with the women in the castle, who toss roses at their attackers, than he is with the combat taking place in front of him. In the upper right, a knight scales the castle walls, helped up by a lady within it. On the other side, a soldier climbs a tree in order to surrender his sword to a woman armed with roses.

The scene depicted is remarkably close to the thirteenth-century poem *Roman de la Rose* (*Romance of the Rose*) written in vernacular French by Guillaume de Lorris and Jean de Meung, in which a knight and his colleagues assault the Castle of Love. The fairytale quality of the ivory reflects the images in the poem, which describe a dream sequence. The story is an allegory, with the castle symbolizing women and the attack upon it a form of courtship. Thus, even if the battle represented here is a mock one, all parties have something to gain from it.

The courtly subject with women as its focus is clearly appropriate for this object, since the mirror is put to use in the cause of female personal adornment. Small mirrors like this were car-

ried by their owners, and some were suspended from belts. In fact, it was only in the twelfth century that cosmetics were reintroduced to Western Europe. Although they had been in common use in antiquity, they had fallen out of use after the fall of Rome. The Crusaders helped reestablish the habit of applying cosmetics, a result of their contact with the Eastern Mediterranean, where the custom had continued from antiquity.

This ivory was made in Paris, where a guild of makers of ivory combs and mirrors is documented at this time. The production of luxury ivories trails off after the middle of the fourteenth century, a result of the economic turmoil precipitated by the Hundred Years' War.

Architecture: The Flamboyant Phase

Although the beginnings of the Late, or *Flamboyant*, phase of Gothic architecture go back to the late thirteenth century, its growth was delayed by the Hundred Years' War (1338–1453) between France and England. Hence we do not meet any full-fledged examples of it until the early fifteenth century. *Flamboyant*, literally meaning "flamelike," refers to the undulating curves and reverse curves that are a main feature of Late Gothic bar tracery. Structurally, Flamboyant Gothic shows few significant developments of its own.

SAINT-MACLOU AT ROUEN What distinguishes Saint-Maclou at Rouen (fig. **12.45**) from Saint-Urbain at Troyes (see fig. 12.35) is the profusion of its ornament, which clearly announces the Flamboyant style. The church was designed by

12.45. Pierre Robin and Ambroise Harel. West facade, Saint-Maclou, Rouen, France. 1434–1490

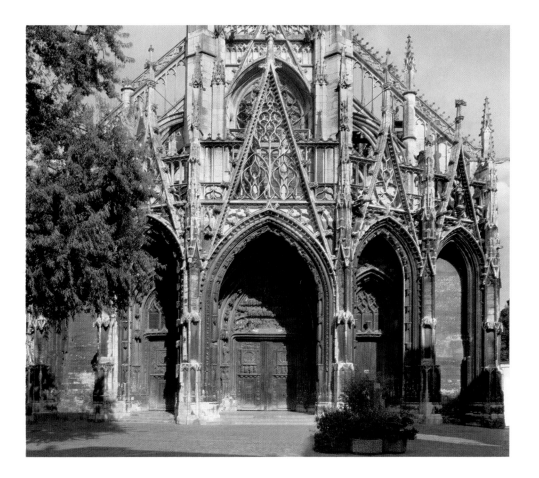

ART IN TIME

1325–1328 CE—Jean Pucelle illuminates a book of hours
for Jeanne d'Évreux, Queen of France
1339–1453—The Hundred Years' War between England
and France
1347—The Black Death begins to ravage the population
of Europe
1431—French heroine Joan of Arc burned at the stake

Pierre Robin in 1434; Ambroise Harel directed the workshop from 1467 to 1480, during which time a substantial portion of the west facade was built, although it was not completed until around 1490. The facade curves back on either side, allowing the central portal to project outward, establishing a hierarchy of forms, which variations in height accentuate.

Harel covered Saint-Maclou's structural skeleton with a web of decoration so dense and fanciful as to hide it almost completely. To locate the bones of the building within this picturesque tangle of lines becomes a fascinating game of hide-and-seek. Even a careful examination of the exterior of the building does not help to decipher the interior arrangement of the church. Repeated motifs, such as the pointed gable, appear both to emerge from the building and to soar above it. It is through the central gable, rather than above it, that the rose window appears. The gable, previously an element of enclosure (see figs. 12.22 and 12.29), is now so eaten into by shimmering tracery that it has become a purely decorative form used to create a lively if unsettling effect. The activation of architectural forms through spatial means is comparable to the interest in volume and depth exhibited by Late Gothic sculptors and painters.

THE SPREAD OF GOTHIC ART

The royal French style of the Paris region, with its refined taste, was enthusiastically received abroad, where it was adapted to a variety of local conditions. In fact, the Gothic monuments of England and Germany have become objects of such intense national pride since the early nineteenth century that Gothic was claimed as a native style in both countries. A number of factors contributed to the rapid spread of Gothic art. Among them were the skill of French architects and stone carvers and the prestige of French centers of learning, such as the Cathedral School of Chartres and the University of Paris. Still, one wonders whether any of these explanations really go to the heart of the matter. The basic reason for the spread of Gothic art was undoubtedly the persuasive power of the style itself. It kindled the imagination and aroused religious feeling even among people far removed from the cultural climate of the Île-de-France.

England

England was especially receptive to the new style, which developed there as the influence of Gothic forms from the Île-de-France melded with Anglo-Norman Romanesque features. A French architect who rebuilt the choir of Canterbury Cathedral introduced the French Gothic manner to England in 1175. Within less than 50 years, English Gothic developed a well-defined character of its own, known as the *Early English style*, which dominated the second quarter of the thirteenth century. Although there was a great deal of building during those decades, it consisted mostly of additions to existing Anglo-Norman structures. Many English cathedrals begun during the Romanesque period had remained unfinished; they were now completed or enlarged. As a result, we find few churches that are designed in the Early English style throughout.

SALISBURY CATHEDRAL The exception to the trend of multiple periods and styles in a single English Gothic church is Salisbury Cathedral (figs. **12.46–12.48**), begun in 1220, the same year as Amiens Cathedral. One sees immediately how different the exterior of Salisbury (see fig. 12.47) is from French Gothic churches (see figs. 12.10, 12.22, and 12.29) and how futile it would be to judge it by the same standards. Compactness and verticality have given way to a long, low, sprawling look. (The crossing tower, which provides a dramatic unifying accent, was built a century later than the rest and is much taller than originally planned.) Since height is not the main goal, flying buttresses are used only as an afterthought, not as integral design elements. The west facade is treated like a screen wall, wider than the church itself and divided into horizontal bands of ornament and statuary. The towers have shrunk to stubby **turrets** (small towers). The plan (see fig. 12.46), with its double transept, retains the segmented quality of the Romanesque, while the square east end derives from Cistercian architecture (see fig. 11.22).

As we enter the nave (see fig. 12.48), we recognize many elements familiar to us from French interiors of the time, such as Chartres Cathedral (see fig. 12.12). However, the English interpretation produces a very different effect. As on the facade, horizontal divisions dominate at the expense of the vertical. Hence we experience the nave wall not as a succession of vertical bays but as a series of arches and supports. These supports, carved of dark stone, stand out against the rest of the interior. This method of stressing their special function is one of the hallmarks of the Early English style. The use of bands of color also emphasizes horizontality.

Another distinctive feature is the steep curve of the nave vault. The ribs rise all the way from the triforium level. As a result, the clerestory gives the impression of being tucked away among the vaults. At Durham Cathedral, more than a

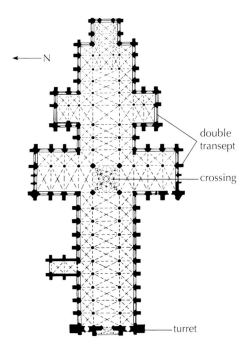

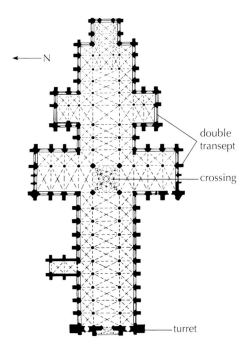

12.46. Plan of Salisbury Cathedral, England. 1220–1265

century earlier, the same treatment had been a technical necessity (see figs. 11.43, 11.44). Now it has become a matter of style, in keeping with the character of English Early Gothic as a whole. This character might be described as conservative in the positive sense. It accepts the French form but tones down its revolutionary aspects to maintain a strong sense of continuity with the Anglo-Norman past. In fact, French elements were integrated with a structure that was still based on thick walls with passages much like that found in Durham Cathedral. The contrast between the bold upward thrust of the fourteenth-century crossing tower at Salisbury and the leisurely horizontal progression throughout the rest of this thirteenth-century cathedral suggests that English Gothic had developed in a new direction during the intervening hundred years.

GLOUCESTER CATHEDRAL The change in the English Gothic becomes very clear if we compare the interior of Salisbury with the choir of Gloucester Cathedral, built in the

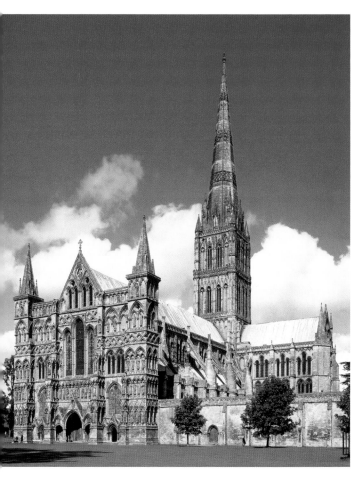

12.47. Salisbury Cathedral (from the southwest) (spire ca. 1320–1330)

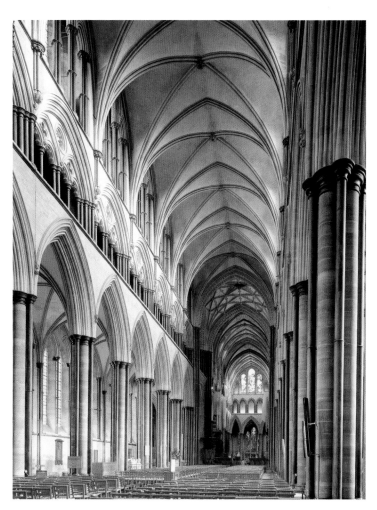

12.48. Nave, Salisbury Cathedral

bays so that the entire vault looks like one continuous surface. The ceiling reads as a canopy fluttering above the interior. This effect, in turn, emphasizes the unity of the interior space. Such elaboration of the classic four-part vault is characteristic of the Flamboyant style on the Continent as well (see pages 419–420), but the English started it earlier and carried it much further.

CHAPEL OF HENRY VII The Perpendicular Gothic style reaches its climax in the amazing hanging vault of Henry VII's Chapel at Westminster Abbey, built in the early years of the sixteenth century (fig. **12.50**). With its lanternlike knobs hanging from conical "fans," this chapel merges ribs and tracery patterns in a dazzling display of architectural pageantry. The complex vault patterns are unrelated to the structure of either the walls or the vaults themselves. Like the decorative features of Saint-Maclou in Rouen (see fig. 12.45), elaborate motifs obscure rather than clarify the architecture.

QUEEN MARY PSALTER As with Gothic architecture in England, manuscript illumination also shows an ambiguous relationship to French models. Some features are remarkably

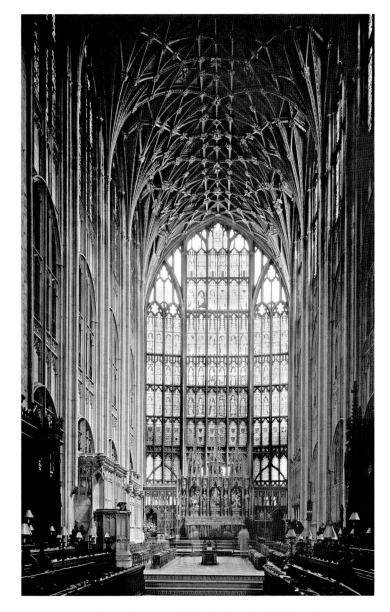

12.49. Choir, Gloucester Cathedral, England. 1332–1357

second quarter of the fourteenth century (fig. **12.49**). Gloucester is an outstanding example of English Late Gothic, also called the *Perpendicular Gothic style*. The name certainly fits, since we now find a dominant vertical accent that was absent in the English Early Gothic style. Vertical continuity is most evident at Gloucester in the responds that run in an unbroken line from the floor to the vault. In this respect, Perpendicular Gothic is much closer to French sources, but it includes so many uniquely English features that it would look out of place on the Continent. The repetition of small uniform tracery panels recalls the bands of statuary on the west facade at Salisbury (see fig. 12.47). The square end repeats the apses of earlier English churches, and the upward curve of the vault is as steep as in the nave of Salisbury (see fig. 12.48).

The ribs of the vaults, on the other hand, have taken on a new role. They have been multiplied until they form an ornamental network that screens the boundaries between the

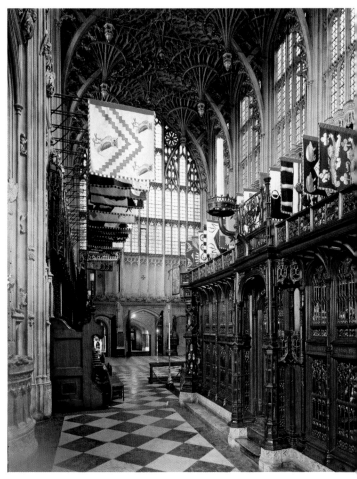

12.50. Chapel of Henry VII, Westminster Abbey, London, England. 1503–1519

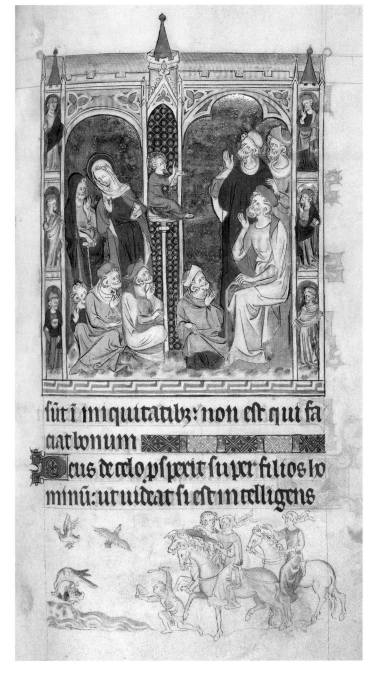

12.51. *Jesus Teaching in the Temple* and *Hunting Scene,* from the *Queen Mary Psalter*. ca. 1310–1320. Ink, tempera, and gold leaf on vellum, 7 × 4¹/₂″ (17.9 × 11.5 cm). British Library, London. By permission of the British Library (ROY.2.B.VIIf151)

akin to those in French works, while others seem more concerned with continuing traditional English forms and manner of representation. The *Queen Mary Psalter* (fig. **12.51**) contains about 1,000 separate images, including Old and New Testament scenes, illustrations of saints' lives, and hunting scenes. The folio illustrating *Jesus Teaching in the Temple* combines two types of painting, which appear throughout the manuscript. The main scene is a full-color illumination, with a decorative gold background and an architectural framework, while the *bas-de-page* is a tinted drawing. Despite the differences in technique, both scenes (and all the others in the manuscript) were created by a single artist, a remarkable achievement, particularly since this artist produced at least two other fully decorated books. Although scholars have suggested a general reliance on a French manner in the arrangement of the scenes, in the graceful, courtly sway of the figure, and in the inclusion of *bas-de-page* illustrations, the style of painting is more closely related to older English models. It is almost purely linear and there is very little evidence of shading.

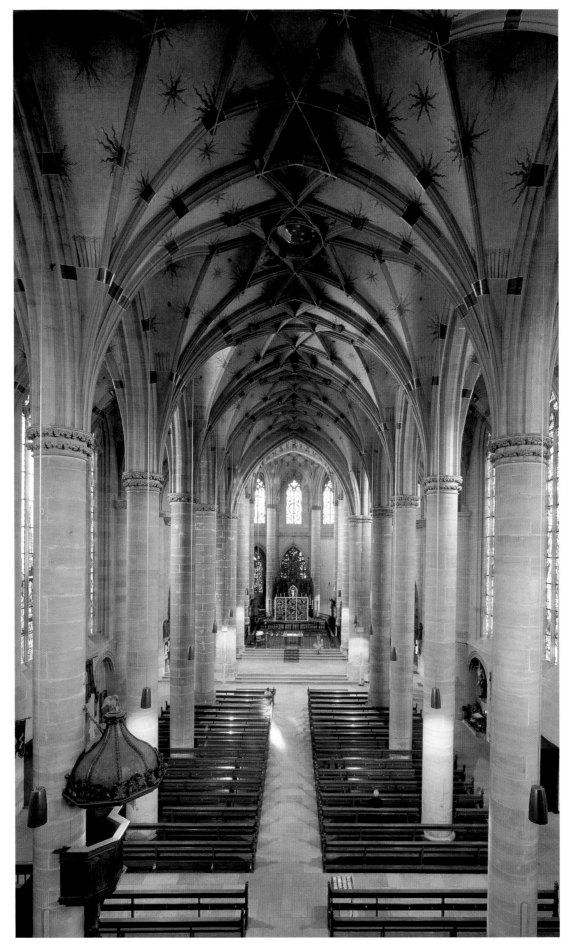

12.52. Heinrich Parler the Elder and Peter Parler (?). Nave and Choir, Heiligenkreuz, Schwäbish-Gmünd, Germany. Begun 1317

The *bas-de-page* represents an elegant equestrian couple out hawking. A female attendant on horseback and a boy servant on foot accompany them. The lively scene, taken from the daily life of the nobility, is filled with naturalistic details, from the falcon attacking a duck at the lower left, to the way the male rider engages his female companion, both of them pointing at the hunt scene in front of them. Their forward movement is propelled by the active, wavelike lines of the horses' manes and the servant's gestures. In the main scene, line also conveys meaning with sensitivity and precision. The soft lines of hair and cloth that frame the face of the Virgin Mary contrast strongly with the sharply curved lines of the hair and beards of the Jews gathered in the Temple to hear her son teach.

The iconographic connection between the vignette in the bottom margin and the biblical scene is not clear. What is clear is that scenes from the courtly world are interwoven, or at least coexist, with biblical history, as they did in French manuscripts of the same period. In the English manuscript, however, the marginal illustrations are serial; they continue from one page to the next, just as does the cycle of biblical events. It is not known for whom this manuscript was made, although there is general agreement that it must have been produced between about 1310 and 1320 and, given its splendor, must have been a royal commission. The most convincing theory posits that King Edward II (r. 1307–1327) commissioned the book for his queen, Isabella of France. The name by which the manuscript is known today results from the fact that it was given to Queen Mary Tudor in the sixteenth century.

Germany

In Germany, Gothic architecture took root a good deal more slowly than in England. Until the mid-thirteenth century, the Romanesque tradition, with its persistent Ottonian elements, remained dominant, despite the growing acceptance of Early Gothic features. From about 1250 on, however, the High Gothic of the Île-de-France had a strong impact on the Rhineland. Cologne Cathedral (begun in 1248) is an ambitious attempt to carry the full-fledged French system beyond the stage of Amiens. However, it was not completed until modern times. Nor were any others like it ever built. While some German sculptors relied on French models, others pursued a more independent course, unlike German architects. German Gothic sculptures are sometimes dramatic, sometimes poignant, and sometimes lifelike, but they always express deep, if sometimes restrained, emotion.

HEILIGENKREUZ IN SCHWÄBISH-GMÜND Especially characteristic of German Gothic is the hall church, or *Hallenkirche*. This type of church, with aisles and nave of the same height, stems from Romanesque architecture (see fig. 11.24). Although also found in France, it is in Germany where its possibilities were explored fully. Heiligenkreuz (Holy Cross) in Schwäbish-Gmünd (fig. 12.52) is one of many examples from central Germany. Heinrich Parler the Elder began Heiligenkreuz in 1317, although it is perhaps his son Peter who is responsible for the

enlarged choir of 1351. (Heinrich had at least two other sons, two grandsons, and a great-grandson who were also architects.) The space has a fluidity and expansiveness that enfolds us as if we were standing under a huge canopy, reminiscent of the effect at Gloucester Cathedral (see fig. 12.49). There is no clear sense of direction to guide us. And the unbroken lines of the pillars, formed by bundles of shafts that diverge as they turn into lacy ribs covering the vaults, seem to echo the continuous movement that we feel in the space itself.

NAUMBURG CATHEDRAL The growth of Gothic sculpture in Germany can be easily traced. From the 1220s on, German masters who had been trained in the sculpture workshops of the French cathedrals brought the new style back home. Because German architecture at that time was still mainly Romanesque, however, large statuary cycles like those at Chartres and Reims were not produced on facades, where they would have looked out of place. As a result, German Gothic sculpture tended to be less closely linked with its architectural setting. In fact, the finest work was often done for the interiors of churches.

This independence permitted a greater expressive freedom than in France. It is strikingly evident in the work of the Naumburg Master, an artist whose best-known work is the series of statues and reliefs made around 1255 for Naumburg Cathedral. The *Crucifixion* (fig. 12.53) forms the center of the choir screen; flanking it are statues of the *Virgin* and *John the Evangelist*. Enclosed by a deep, gabled porch, the three figures frame the opening that links the nave with the sanctuary. Rather than placing the group above the screen, as was usual, the sculptor brought the subject down to earth physically and emotionally. The suffering of Jesus thus becomes a human reality through the emphasis on the weight and volume of his body. Mary and John, pleading with the viewer, convey their grief more eloquently than ever before.

The pathos of these figures is heroic and dramatic, compared with the quiet lyricism of the Reims *Visitation* (see fig. 12.30). If the classical High Gothic sculpture of France may be compared with the calm restraint of Pheidias, the Naumburg Master embodies the temperamental counterpart of the strained physicality demonstrated in Hellenistic art (see fig. 5.72).

The same intensity dominates the Passion scenes, such as *The Kiss of Judas* (fig. 12.54), with its strong contrast between the meekness of Jesus and the violence of the sword-wielding St. Peter. Attached to the responds inside the choir are life-size statues of 12 nobles associated with the founding of the eleventh-century cathedral. The sculptures were made at a time when Bishop Dietrich II of Naumburg was attempting to raise funds to build a new choir for the cathedral. By highlighting the original building's generous benefactors, the bishop encouraged parishioners to support the new building campaign, to join the ranks of the cathedral's munificent sponsors. These men and women were not of the artist's own time—to him they were only names in a chronicle. Yet the pair *Ekkehard and Uta* (fig. 12.55) are as individual and realistic as if they had been portrayed from life. The gestures of their hands, the

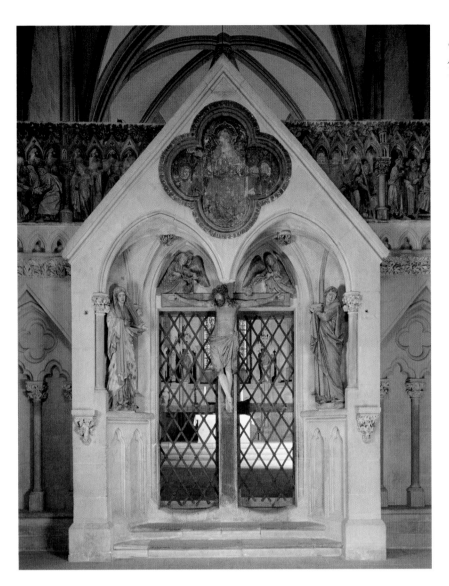

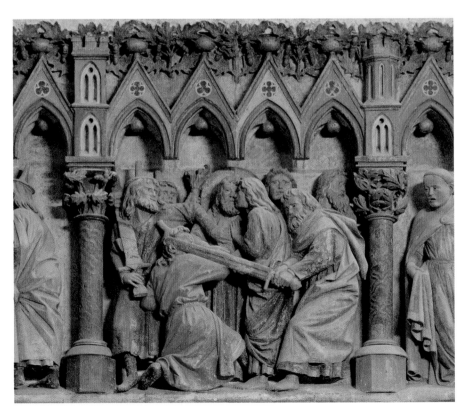

12.53. Naumburg Master. *Crucifixion,*
on the choir screen, and the *Virgin* and
John the Evangelist. ca. 1255. Stone.
Naumburg Cathedral, Germany

12.54. Naumburg Master. *The Kiss of
Judas,* on the choir screen. ca. 1255. Stone.
Naumburg Cathedral

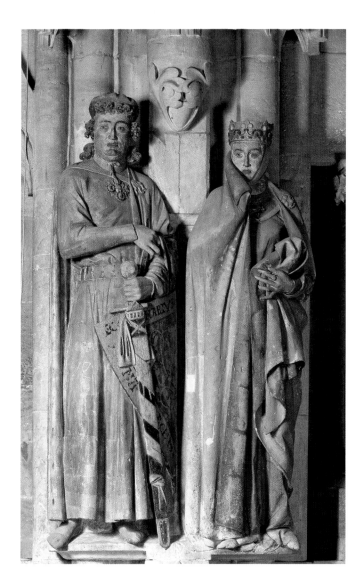

12.55. *Ekkehard and Uta*. ca. 1249–1255. Stone Naumburg Cathedral

Primary Sources.) Originally designed for private devotion, it is often referred to by the German term **andachtsbild** (contemplation image), since Germany played the leading part in its development. The most widespread type was a representation of the Virgin grieving over the dead Christ. It is called a **Pietà** after an Italian word derived from the Latin *pietas*, the root word for both "pity" and "piety." No such scene occurs in the scriptural accounts of the Passion. We do not know where or when the *Pietà* was invented, but it portrays one of the Seven Sorrows of the Virgin. It thus forms a tragic counterpart to the motif of the Madonna and Child, one of her Seven Joys.

The *Roettgen Pietà* (fig. **12.56**) is carved of wood and vividly painted. Like most such groups, this large cult statue was meant to be placed on an altar. The style, like the subject, expresses the emotional fervor of lay religiosity, which emphasized a personal relationship with God as part of the tide of mysticism that swept over fourteenth-century Europe. Realism here is purely a means to enhance the work's impact. The faces convey unbearable pain and grief; the wounds are exaggerated

handling of their drapery, and their fixed gazes communicate human qualities with great subtlety. Their individuality and specificity reminds us that the concern for the personal identity of individuals signaled important social changes during the Gothic period. The trend toward realism is not unique here and is reminiscent of what occurred at Reims Cathedral (see figs. 12.30 and 12.31). The inclusion of historical figures within a sacred space is unusual, and it is perhaps the fact that the persons represented were long dead that made them appropriate for representation here.

The paint that is still visible on Naumburg's interior sculpture helps us appreciate how Gothic sculpture might have looked originally. Gothic interiors, as can be seen in the restored Sainte-Chapelle, were elaborately painted. Exterior sculpture was also painted, but that paint rarely survives today.

THE ROETTGEN PIETÀ Gothic sculpture, as we have come to know it so far, reflects a desire to give a greater emotional appeal to traditional themes of Christian art. Toward the end of the thirteenth century, this tendency gave rise to a new kind of religious image. (See end of Part II, *Additional*

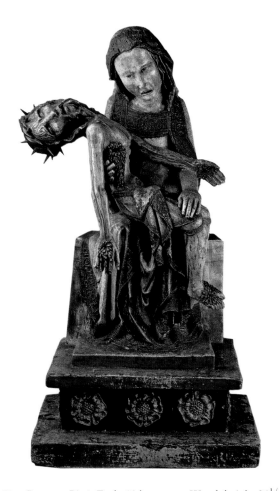

12.56. *Roettgen Pietà*. Early 14th century. Wood, height 34$\frac{1}{2}$″ (87.5 cm). Rheinisches Landesmuseum, Bonn

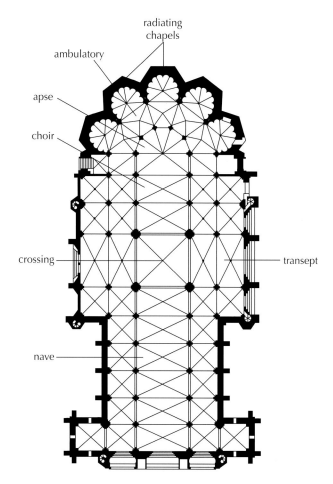

12.57. Plan, Cathedral of Santa María, León, Spain. Begun 1240s. (Drawing by Giroux after De los Rios)

Spain

During the Romanesque period Spanish artists had adopted the French manner of building and decoration in part to disassociate themselves from—and indeed to express their supremacy over—the Muslims with whom they shared the Iberian peninsula. This identification of French style with Christian conquest encouraged the reception of the Gothic style in Spain during the thirteenth century, when numerous Christian victories (principal among them the battle at Navas de Tolosa in 1212) drove the Muslims farther and farther south.

LEÓN The Cathedral of Santa María in León (figs. **12.57** and **12.58**), a city with a long history as a royal capital, recalls French High Gothic buildings associated with the monarchy, especially Reims Cathedral, the French coronation church (see pages 406–409). The east end of León, with its ambulatory and five radiating chapels, is particularly similar to the arrangement at Reims (see fig. 12.28), so much so that, although the specific identification of León's architect has been questioned, there has never been any doubt that he was French, nor that he knew the cathedral at Reims intimately. This reliance on a French model indicates a time lag, since León was not begun until the 1240s, some thirty years after Reims. León's elevation (fig. **12.59**) is

grotesquely; and the bodies and limbs are puppetlike in their thinness and rigidity. The purpose of the work clearly is to arouse so overwhelming a sense of horror and pity that the faithful will share in Christ's suffering and identify with the grief-stricken Mother of God. The ultimate goal of this emotional bond is a spiritual transformation that grasps the central mystery of God in human form through compassion (meaning "to suffer with").

At first glance, the *Roettgen Pietà* would seem to have little in common with *The Virgin of Paris* (see fig. 12.43), which dates from the same period. Yet they share a lean, "deflated" quality of form and exert a strong emotional appeal to a viewer. Both features characterize the art of northern Europe from the late thirteenth to the mid-fourteenth century. Only after 1350 do we again find an interest in weight and volume, coupled with a renewed desire to explore tangible reality as part of a change in religious outlook.

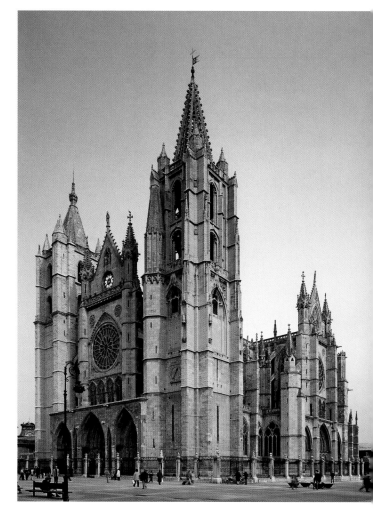

12.58. Exterior, Cathedral of Santa María, León

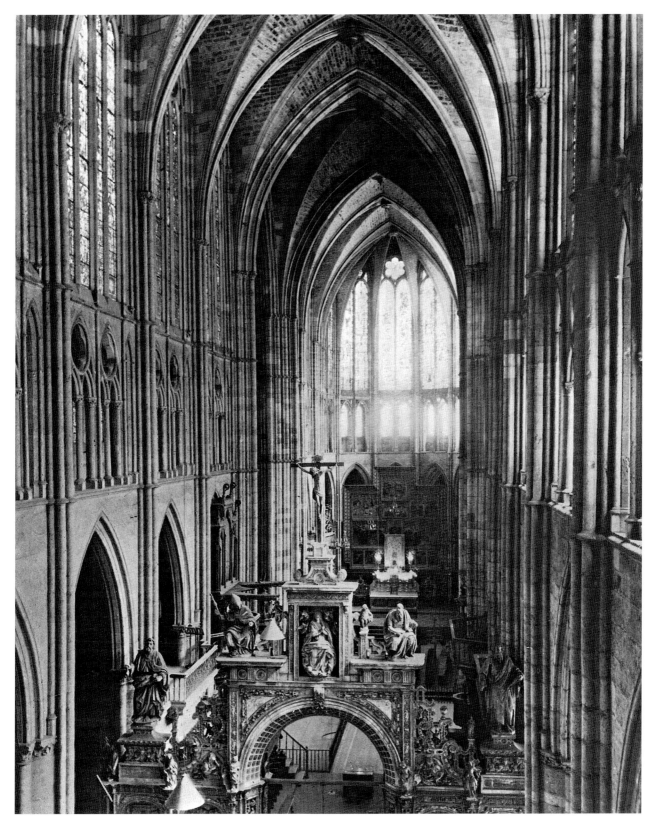

12.59. Interior, Cathedral of Santa María, León

more up to date and its tall, thin clerestory lancets recall Sainte-Chapelle (see fig. 12.34), completed in the same decade in which León was begun.

The association of León with French royal buildings is significant at this time. In 1230 Ferdinand III united the kingdoms of León and Castile. Despite unification, royal attentions continued to favor Burgos, capital of Castile, which had earlier been declared "mother and head" of all churches in the kingdom and where a Gothic cathedral in French style was begun in 1221. The Leónese promoted their historic rank as royal capital, more venerable than the rank of Burgos, through the building program of their new cathedral.

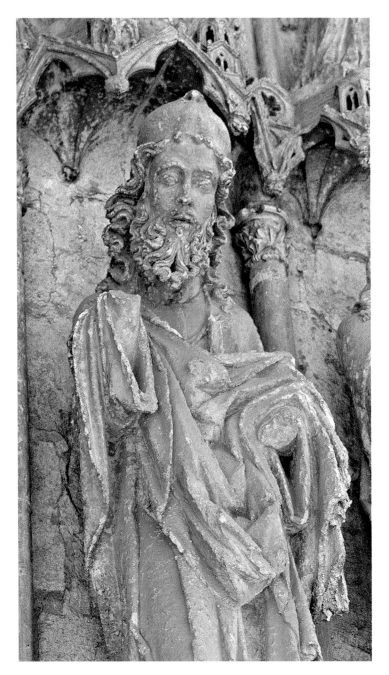

Although many of the jamb figures of the Cathedral of Santa María at León have been rearranged from their original locations, the sculptors' reliance on the French High Gothic manner of carving is clear. The figure of Simeon, the New Testament seer who recognized the infant Jesus as Redeemer (fig. **12.60**), carved in the last decades of the thirteenth century and placed on the right portal of the west facade, recalls sculptures from Reims (see figs. 12.30 and 12.31) in the elegant elongation of the body, the complicated and crisp folds of drapery, and the thick, wavy beard.

León is only one of a number of Spanish Gothic cathedrals that look to France for their inspiration. Toledo and Burgos, both cities with claims to royal status, also built buildings to designs that relied on French models and employed architects who undoubtedly came from France. Thus the royal origins of Gothic style were clearly not forgotten, even when the style was exported from France more than 100 years after it was conceived.

Italy: A Preview

In Italy, Gothic art was so distinctive as to stand apart from that of the rest of Europe. The growing concern for the individual that is expressed in the Gothic art we have studied so far will develop most fully in Italy and become the central focus of Gothic experimentations there. Gothic achievements in Italy are of such consequence in their own right and for the later development of Western art that they have been assigned their own chapter in this book, which follows. To some extent, there is an appealing symmetry in recognizing the strength of Italian contributions at the end of the Middle Ages. One of the defining differences in our discussion of the medieval world, as opposed to the ancient one, is that the center of gravity of European civilization had moved north of the Alps, to what had once been the northern boundaries of the Roman world. The shift north led to dramatic artistic interchanges during the early Middle Ages and throughout the Romanesque and Gothic periods. However, even as northern European art will continue to flourish in succeeding centuries, Italian art will once again occupy center stage.

12.60. Jamb statue of *Simeon,* south portal of west facade, Cathedral of Santa Maria, León. ca. 1280–1300

SUMMARY

GOTHIC ART

Gothic style began in the vicinity of Paris in the mid-1100s. Within a hundred years, most of Europe had adopted the style. A general increase in population, expanding urban centers, and the growing importance of cathedrals are all features of the Gothic period. European princes and kings conquered increasingly large territories at the time, and conflicting claims over kingship led to a series of long battles between France and England known as the Hundred Years' War. In some areas of Europe, these wars interrupted the progress of art. By 1400 the Gothic area had begun to shrink, and by 1550 it had disappeared almost entirely, except in England.

EARLY GOTHIC ART IN FRANCE

Architecture played a dominant role in the formation of a coherent Gothic style, and therefore our study begins with an examination of the royal Abbey Church of Saint-Denis. Built just outside Paris in the first half of the twelfth century, the graceful architectural forms and large windows are a contrast to the massive solidity of the Romanesque style. The compact and unified plan of the Cathedral of Notre-Dame at Paris is another important example of the early Gothic style.

HIGH GOTHIC ART IN FRANCE

The political and economic stability of France during the thirteenth century was an ideal climate for producing monumental architecture with impressive sculptural programs. The rebuilding of Chartres Cathedral after a fire marks a crucial step in the development of Gothic architecture. The French cathedrals of Amiens and Reims—with an emphasis on verticality and translucency—are also significant exemplars of the High Gothic.

RAYONNANT OR COURT STYLE

The increasing importance of the French monarchy and the rising significance of Paris are reflected in King Louis IX's court chapel, Sainte-Chapelle. This phase of Gothic art is often called *rayonnant,* from a French word meaning "to radiate light." The style, closely associated with the French court, spread throughout the royal domain and then through much of Europe. Connections are also apparent between the building arts and elaborate devotional works of the period such as the *Bible moralisée.*

LATE GOTHIC ART IN FRANCE

During the period of Late Gothic art, artists felt free to deviate from previous patterns of development. Builders used elaborate arrangements to produce complex visual displays as seen in the undulating curves of the *Flamboyant* style. Late Gothic painting—such as the book of hours created for Jeanne d'Évreux by Jean Pucelle—indicates a new interest in representing spatial depth, and in sculpture, individual sculpted figures became prominent.

THE SPREAD OF GOTHIC ART

The royal French style of the Paris region was enthusiastically received abroad, where it was adapted to a variety of local conditions. Its influence in England can be seen in cathedrals built at Salisbury and elsewhere and in the *Queen Mary Psalter.* In Germany, its influence is witnessed in sculptures made for Naumburg Cathedral and in the *Roettgen Pietà.* And the Cathedral of Santa María in León is an example of the importation of the French High Gothic to Spain.

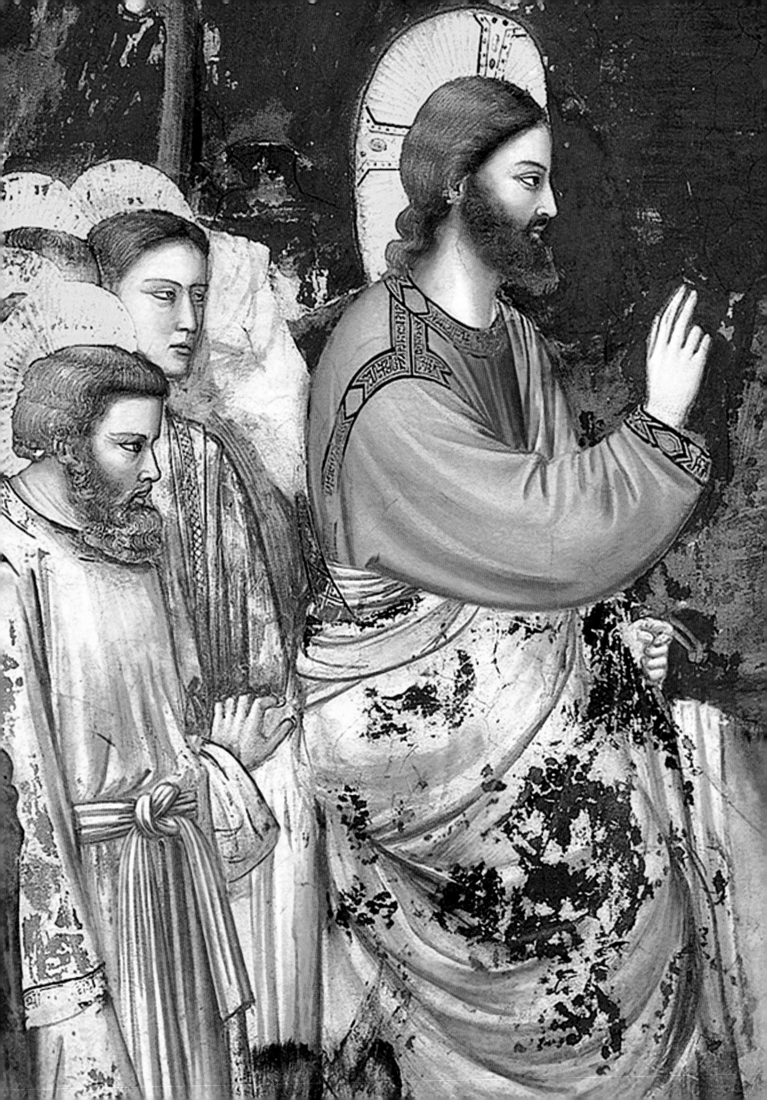

Art in Thirteenth- and Fourteenth-Century Italy

ALTHOUGH ITALIAN ARTISTS AND PATRONS SHARED CONCERNS WITH their contemporaries elsewhere in Europe, for geographic, historical, and economic reasons, the arts in Italy struck out in a different direction. Many of the innovations that would characterize the Italian Renaissance of the fifteenth and sixteenth centuries have their seeds in thirteenth and fourteenth-century Italy.

Throughout most of Europe in the thirteenth century, political and cultural power rested with landholding aristocrats. Products from their lands created wealth, and the land passed from one generation to the next. Although hereditary rulers controlled large regions, they usually owed allegiance to a king or to the Holy Roman emperor. But Italy had few viable kingdoms or strong central authorities. During most of the Middle Ages, Italian politics were dominated by the two international institutions of the Holy Roman Empire and the papacy. Usually, the emperors lived north of the Alps, and sheer distance limited their control in Italy. For much of the fourteenth century, Rome lacked a pope to command temporal power, as the papacy had moved to France. Hereditary rulers controlled southern Italy and the area around Milan, but much of Italy consisted of individual city-states, competing with each other for political influence and wealth. Among the most important of these were Florence, Siena, Pisa, and Venice.

Geography, particularly the long coastlines on the Mediterranean and Adriatic Seas, and long practice, had made Italy a trading center throughout the Middle Ages. By the thirteenth and fourteenth centuries, trade and paid labor for urban artisans had been long established. As the number of these new groups of merchants and artisans grew in the cities, their polit-

Detail of figure 13.20, Giotto, *Christ Entering Jerusalem*

ical power grew as well. The wealthiest and most influential cities, including Florence and Siena, were organized as representative republics. As a check on inherited power, some cities even excluded the landed aristocracy from participating in their political processes. Tensions erupted frequently between those who supported monarchical and aristocratic power, and thus supported the emperor, and those who supported the papacy and mercantile parties. In the cities of Florence, Venice, Pisa, and Siena, power tended to be concentrated in the hands of leading merchant families who had become wealthy through trade, manufacture, or banking. Members of these families would become the foremost patrons of artists in Italy.

Those artists developed their skills in a context that differed from the rest of Europe. Throughout the Middle Ages, Roman and Early Christian art served as an inspiration for Italian architects and sculptors, as is visible in such works as the Cathedral of Pisa (see fig. 11.33). In the mid-thirteenth century, the Holy Roman emperor Frederick II (1194–1250), who lived for a time in southern Italy, deliberately revived imperial Roman style to express his own political ambitions as heir to the Roman Empire. The other empire, Byzantium, kept a presence throughout Italy, too—through mosaics at Ravenna, Sicily, and Venice, and through the circulation of artists and icons such as the *Madonna Enthroned* (fig. 8.50). Added to these forces was the influence of the French Gothic style, introduced through the travels of artists and patrons.

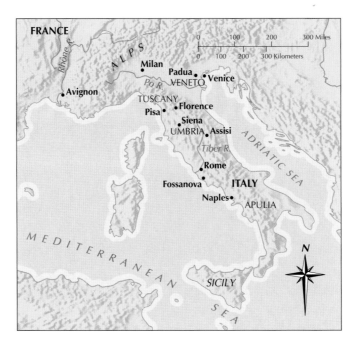

Map 13.1. Italy in the Thirteenth and Fourteenth Centuries

One of those travelers, the churchman, scholar, and poet Francesco Petrarch, exemplifies another aspect of fourteenth-century Italian culture: a growing interest in the creative works of individuals. Petrarch and his contemporaries, Dante Alighieri and Giovanni Boccaccio, belong to a generation of thinkers and writers who turned to the study of ancient works of literature, history, and art to seek out beautiful and correct forms. Petrarch also sought to improve the quality of written Latin, and thereby to emulate the works of the Roman authors Vergil and Cicero. This study of ancient thought and art led to a search for moral clarity and models of behavior, a mode of inquiry that came to be known as **humanism**. Humanists valued the works of the ancients, both in the literary and the visual arts, and they looked to the classical past for solutions to modern problems. They particularly admired Roman writers who championed civic and personal virtues, such as service to the state and stoicism in times of trouble. Humanists considered Roman forms the most authoritative, and, therefore, the most worthy of imitation, though Greek texts and ideas were also admired.

The study of the art of Rome and Greece would profoundly change the culture and the art of Europe by encouraging artists to look at nature carefully and to consider the human experience as a valid subject for art. These trends found encouragement in the ideals and theology of the mendicant orders, such as the Dominicans, who valued Classical learning, and the Franciscans, whose founder saw God in the beauty of Nature.

CHURCH ARCHITECTURE AND THE GROWTH OF THE MENDICANT ORDERS

International monastic orders, such as the Cistercians, made their presence felt in medieval Italy as in the rest of Europe. They were among the groups who helped to bring the technical and visual innovations of the French Gothic style to Italy. Italian Cistercian monasteries followed the practice, established in France, of building large, unadorned stone vaulted halls. These contrast starkly with the sumptuously adorned French Gothic cathedrals such as Reims (see fig. 12.29). Cistercians exercised control over the design of their monasteries to a great degree. The church of Fossanova, 60 miles south of Rome, represents the Cistercian plan transmitted to Italy (fig. **13.1**) from the headquarters churches in Burgundy. Consecrated in 1208, it is a vaulted basilica with somewhat abbreviated aisles that end in a squared chapel at the east end, as does the Cistercian church at Fontenay (fig. 11.23). Groin vaults cover the nave and the smaller spaces of the aisles, though the vaults are not ribbed as was the usual practice in Gothic buildings. Fossanova has no western towers and no tall spires. Interior spaces are spare and broadly proportioned rather than richly carved and narrow.

The simplicity of the architecture and the Cistercian reputation for reform made them an inspiration to the new mendicant movements that dominated Italy beginning in the thirteenth century and continuing through the Italian Renaissance. The

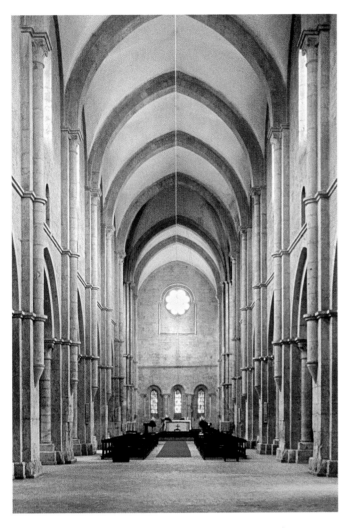

13.1. Nave and choir, Abbey Church of Fossanova, Italy.
Consecrated 1208

two major mendicant groups were the Franciscans and the Dominicans. They established international "orders," as did their monastic brethren, although their missions took a different form from those of traditional monks. Both orders were founded to minister to the lay populations in the rapidly expanding cities; they did not retreat from the world, but engaged with it. Each order built churches in the cities where sermons could be preached to crowds of people. The Dominicans, founded by Dominic de Guzmán in 1216, were especially concerned with combatting heresy. The Franciscan order, founded by Francis of Assisi in 1209, worked in the cities to bring deeper spirituality and comfort to the poor. Taking vows of poverty, Franciscans were committed to teaching the laity and to encouraging them to pursue spiritual growth. Toward this goal, they told stories and used images to explain and affirm the teachings of the Church. Characteristically, Franciscans urged the faithful to visualize events such as the Nativity in tangible ways, including setting up Nativity scenes (crèches) in churches as an aid to devotion.

The Franciscans at Assisi

The charismatic Francis died in 1226 and was named a saint two years later. His home town was the site of a huge basilica built in his honor. Its construction was sponsored by the pope, and was begun shortly after Francis's canonization in 1228. This multistoried structure became a pilgrimage site within a few years of its completion. The expansive walls of its simple nave (fig. 13.2) were decorated with frescoes on Old and New Testament themes and a cycle that explained and celebrated the

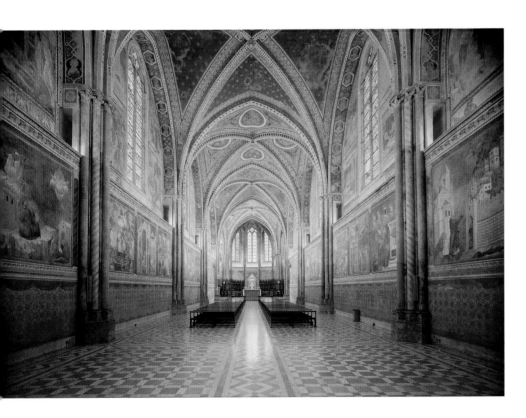

13.2. Interior of Upper Church, Basilica of San Francesco, Assisi. Begun 1228; consecrated 1253

achievements of Saint Francis. (See *Materials and Techniques*, page 438.) Scholars are still debating how many artists worked at Assisi from the 1290s to the early fourteenth century to complete this enormous cycle, but it appears that artists came here from Rome, Florence, Siena, and elsewhere. Assisi became a laboratory for the development of fourteenth-century Italian art. One of the most memorable of the many frescoes at Assisi depicts *Saint Francis Preaching to the Birds*, which was executed as part of a campaign of decoration in the church in the last decade of the thirteenth century or first part of the fourteenth century (fig. **13.3**). The whole cycle delineates Francis's life story based on a biography composed by his associates. One of the themes of Francis' life is his connection to Nature as a manifestation of God's workmanship; the story of Francis preaching to the birds exemplifies his attitude that all beings are connected. This fresco depicts Francis in his gray habit standing in a landscape and speaking to a flock of birds. To the astonished eyes of his companion, Francis appears to communicate to the birds, who gather at his feet to listen.

Trees establish the frame for the image as well as designate the location as outdoors; otherwise the background is a blue color, and little detail is provided. Francis and his companion are rendered naturalistically, as bulky figures in their

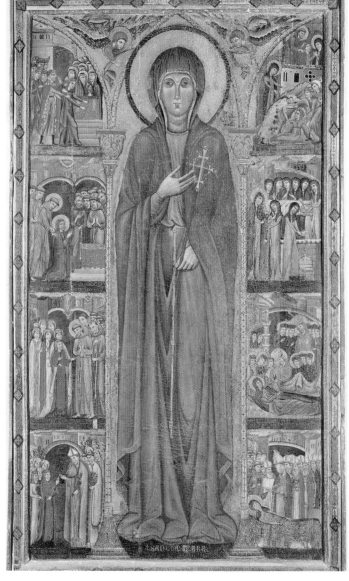

13.4. *Altarpiece of Saint Clare*. ca. 1280. Tempera on panel. $9 \times 5\frac{1}{2}'$ (2.73 × 1.65 m). Convent of Santa Chiara, Assisi

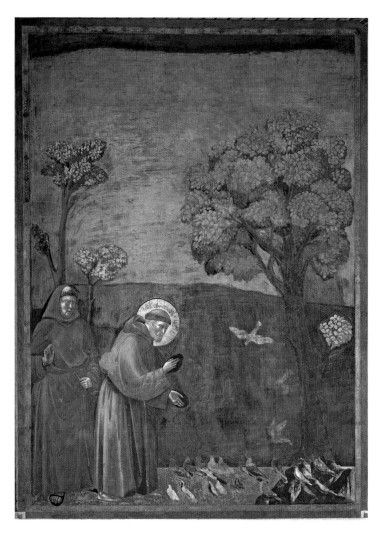

13.3. Anonymous. *Saint Francis Preaching to the Birds*. 1290s (?). Fresco from Basilica of San Francesco, Assisi

habits, as the artist describes light washing over their forms. Francis's figure becomes the focal point of the image, through his central position, the halo around his head, and his downward glance. His body language—the bent over stance, the movement of his hands—express his intense engagement with the birds as representatives of Nature. The simplicity of the composition makes the fresco easily legible and memorable.

The identity of the artist responsible for the frescoes in the nave of San Francesco is uncertain and controversial. One of the artists mentioned as a primary designer and painter is the Roman Pietro Cavallini, another is the Florentine Giotto di Bondone. But documentary evidence is lacking, and the opinions of connoisseurs fluctuate. Some scholars prefer to assign these frescoes to an anonymous master named for the paintings at Assisi. Whether through mutual influences or through competition with other artists, a new generation of painters comes of age at Assisi.

Franciscan women worshiped God through their vocations as nuns, though their convents and churches were less financially sound than many of the monasteries and churches of the friars. The nuns belonged to the branch of the Franciscans founded by his associate, Saint Clare, who was canonized in 1255. The church and convent she founded are still in service in Assisi, where an early example of an altarpiece to Saint Clare remains in place (fig. **13.4**). A tall rectangle of wood, painted in tempera, the altarpiece was executed around 1280. It is dominated by the figure of Saint Clare, dressed in the habit of her order, standing frontally and holding the staff of an abbess. Rather than a portrait with specific features, Clare's face has the large eyes and geometric arrangement of a Byzantine Madonna (see fig. 8.37), while her figure seems to exist in one plane. She is flanked on either side by eight tiny narratives that tell the story of her life, death, and miracles. These vignettes demonstrate her commitment to her vocation, her obedience to Francis and the Church, and her service to her fellow nuns. The narratives make little pretense at three-dimensional form or spatial structure, keeping the focus on the figures and their actions to convey the story. Franciscan preachers wrote sermons and treatises addressed to religious women encouraging them to meditate on Scripture through visualizing the events in very physical terms. (See end of Part II, *Additional Primary Sources*.)

Churches and Their Furnishings in Urban Centers

Franciscan churches began to appear all over Italy as the friars ministered to the spiritual lives of city dwellers. A characteristic example in Florence is the church of Santa Croce (Holy Cross), begun around 1295 (fig. **13.5** and **13.6**) The architect was probably the Tuscan sculptor Arnolfo di Cambio. Santa Croce shares some features with Gothic churches in Northern Europe, but has some distinctively Italian elements. This is a basilica with a mostly rectilinear eastern end, such as those found in Cistercian churches. Its proportions are broad and expansive rather than vertical. The nave arcade uses a Gothic pointed arch, while vertical moldings pull the eye up to the

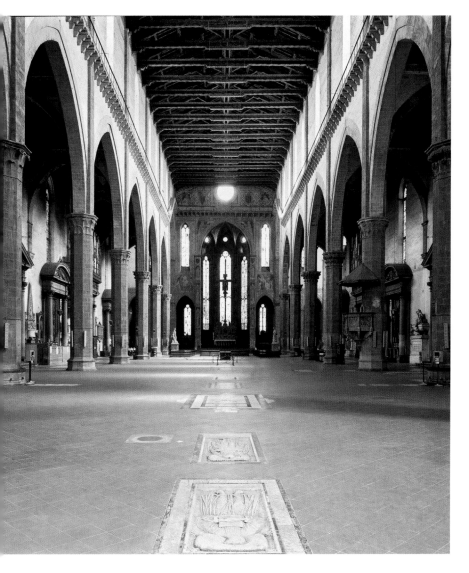

13.5. Nave and choir, Santa Croce, Florence. Begun ca. 1295

13.6. Plan of Santa Croce

Fresco Painting and Conservation

Fresco is a technique for applying paint to walls that results in an image that is both durable and brilliant. Frescoed surfaces are built up in layers: Over the rough wall goes a layer of rough lime-based plaster called *arriccio*. The artist then draws preliminary drawings onto this layer of plaster. Because they are done in red, these drawings are called *sinopie* (an Italian word derived from ancient Sinope, in Asia Minor, which was famous as a source of red brick earth pigment). Then a finer plaster called *intonaco* is applied in areas just large enough to provide for a day's worth of painting—the *giornata* (from *giorno,* the Italian word for "day"). While the plaster is still wet, the artist applies pigments suspended in lime water. As the plaster dries, the pigments bind to it, creating a *buon fresco,* literally a "good fresco." Plaster dries in a day, so only the amount of wet plaster that can be painted during that time can be applied. The work has to be done on a scaffold, so it is carried out from top to bottom, usually in horizontal strips about 4 to 6 feet long. As each horizontal level is completed, the scaffolding is lowered for the next level. To prevent chemical interactions with the lime of the plaster, some colors have to be applied *a secco* or dry; many details of images are applied this way as well. *Fresco secco* does not bond to the plaster as surely as *buon fresco* does, so it tends to flake off over time. Consequently, some frescoes have been touched up with tempera paints.

Although durability is the key reason for painting in fresco, over the centuries wars and floods have caused damage. Modern conservators have developed techniques for removing frescoes from walls and installing them elsewhere. After the River Arno flooded in 1966, many Florentine frescoes were rescued in this way, not only preserving the artworks but greatly increasing the knowledge and technology for this task. When a fresco is removed, a series of cuts are made around the image. Then a supporting canvaslike material is applied to the frescoed surface with a water-soluble glue. The surface to which the canvaslike material has been glued can then be pulled off gently and transferred to a new support to be hung elsewhere, after which the canvas can be removed.

Such removals have exposed many *sinopie*, such as the one shown here. The fresco, attributed to Francesco Traini (see fig. 13.32), was badly damaged by fire in 1944 and had to be detached from the wall in order to save what was left of it. This procedure revealed the plaster underneath, on which the composition was sketched out. These drawings, of the same size as the fresco itself, are much freer-looking in style than the actual fresco. They often reveal the artist's personal style more directly than the painted version, which was carried out with the aid of assistants.

Anonymous (Francesco Traini?). Sinopia drawing for *The Triumph of Death* (detail). Camposanto, Pisa

ceiling. Where one might expect the moldings to support a vaulted ceiling, however, Santa Croce uses wooden trusses to span the nave. The only vaults are at the apse and several chapels at the ends of the transept.

The choice to cover the nave with wood seems deliberate, as no structural reason accounts for it. There may be a regional preference for wooden ceilings, as the great Romanesque cathedral of Pisa also has a wooden roof. Santa Croce's broad nave with high arches is also reminiscent of Early Christian basilicas, such as Old Saint Peter's or Santa Maria Maggiore (see figs. 8.6 and 8.15). The wood roof at Santa Croce may have sprung from a desire to evoke the simplicity of Early Christian basilicas and thus link Franciscan poverty with the traditions of the early church.

One function of the wide spaces at Santa Croce was to hold large crowds to hear the friars' sermons. For reading Scripture at services and preaching, churchmen often commissioned monumental pulpits with narrative or symbolic images carved onto them. Several monumental pulpits were made by members of a family of sculptors from Pisa, including Nicola Pisano (ca. 1220/25–1284) and his son Giovanni Pisano (1265–1314). Though the two men worked at various sites throughout Italy, they executed important pulpits for the cathedral and the baptistery of Pisa.

For the Pisan baptistery, Nicola Pisano carved a hexagonal marble pulpit that he finished around 1260 (fig. **13**.7) Rising to about 15 feet high, so the assembly could both see and hear the speaker, the six sides of the pulpit rest on colored marble columns supporting classically inspired capitals. Above the capitals, carved into leaf shapes, small figures symbolizing the virtues stand between scalloped shaped arches, while figures of the prophets sit in the spandrels of these arches. Surprisingly, one of these figures (fig. **13**.8) is a male nude with a lion cub on his shoulder and a lion skin over his arm. Both his form

and the lion skin identify him as Hercules, the Greek hero, who stands here for the Christian virtue of Fortitude. His anatomy, his proportions, and his stance are probably the product of Nicola Pisano's study of Roman and Early Christian sculpture. Pisano had worked for Frederick II and at Rome, so his knowledge of ancient forms was deep. The nudity is not meant to be lascivious, but serves rather to identify the figure.

Nicola's study of the Roman past informs many other elements in his pulpit, including the narratives he carved for the six rectangular sides of the pulpit itself. These scenes from the life of Christ are carved in relief. The Nativity in figure **13.9** is a densely crowded composition that combines the Annunciation with the Birth of Christ. The relief is treated as a shallow box filled with solid convex shapes in the manner of Roman sarcophagi, which Pisa's monumental cemetery preserved in good numbers. The figures could almost be copied from the

Ara Pacis procession; the Virgin has the dignity and bearing of a Roman matron (see fig. 7.22). Pisano probably knew Byzantine images of the Nativity, for his iconography reflects that tradition. As the largest and most central figure, the reclining Virgin overpowers all the other elements in the composition. Around her, the details of the narrative or setting, such as the midwives washing the child and Joseph's wondering gaze at the events, give the relief a human touch. Nicola uses broad figures, wrapped in classicizing draperies, to give the scene gravity and moral weight.

When his son Giovanni Pisano carved a pulpit about 50 years later for the Cathedral of Pisa, he chose a different emphasis. Though of the same size and material, his relief of the Nativity from the cathedral pulpit (fig. **13.10**) makes a strong contrast to his father's earlier work. Depicting the Nativity and the Annunciation to the shepherds, Giovanni Pisano dwells on the landscape and animal elements: Sheep and trees fill the right edge of

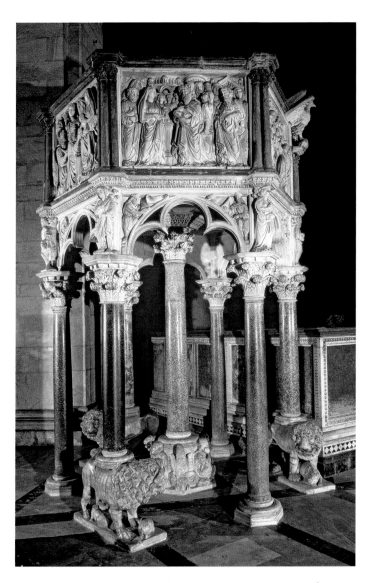

13.7. Nicola Pisano. Pulpit. 1259–1260. Marble. Height 15′ (4.6 m). Baptistery, Pisa

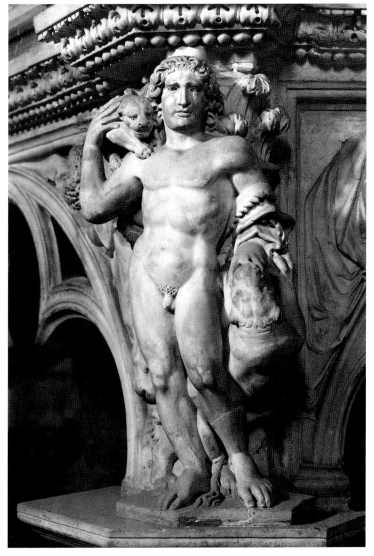

13.8. *Fortitude,* detail of the pulpit by Nicola Pisano. 1260

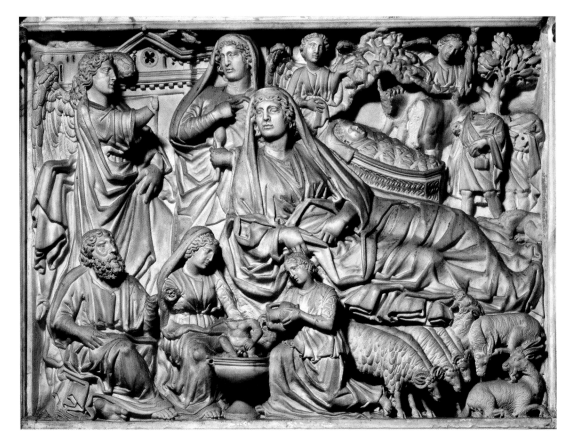

13.9. *Nativity,* detail of the pulpit by Nicola Pisano

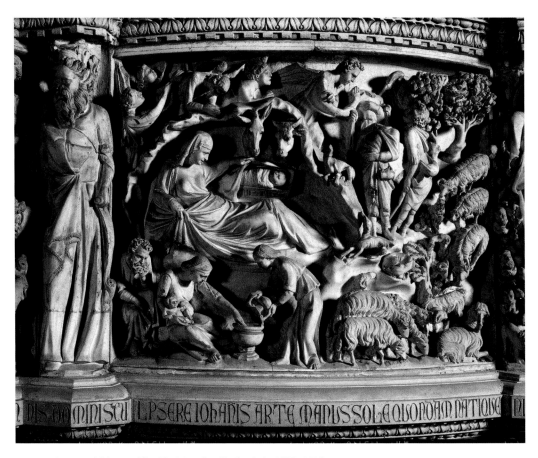

13.10. Giovanni Pisano. *The Nativity,* detail of pulpit. 1302–1310.
Marble. Pisa Cathedral

the composition, while the nativity itself takes place in a shallow cave. The Virgin still dominates the composition, but she is no longer a dignified matron. Instead, she is a young mother tending to her child. Her proportions are elongated rather than sturdy. Rather than echoing Roman or Classical models, Giovanni has studied contemporary French models to bring elegance and a detailed observation of nature to the image. Each of Giovanni's figures has its own pocket of space. Where Nicola's Nativity is dominated by convex, bulging masses, Giovanni's appears to be made up of cavities and shadows. The play of lights and darks in Giovanni's relief exhibits a dynamic quality that contrasts with the serene calm of his father's work.

Expanding Florence Cathedral

East of Pisa along the Arno, the increasing wealth of Florence inspired that town to undertake major projects for its cathedral and baptistery in order to compete with its neighbors. One of Nicola Pisano's students, Arnolfo di Cambio (ca. 1245–1302) was tapped to design a new cathedral for Florence to replace a smaller church that stood on the site. The cathedral was begun in 1296 (figs. **13.11**, **13.12**, and **13.13**). Such a project took the skills and energy of several generations, and the plan was modified more than once. Revisions of the plan were undertaken in 1357 by Francesco Talenti (active 1325–1369), who took over the project

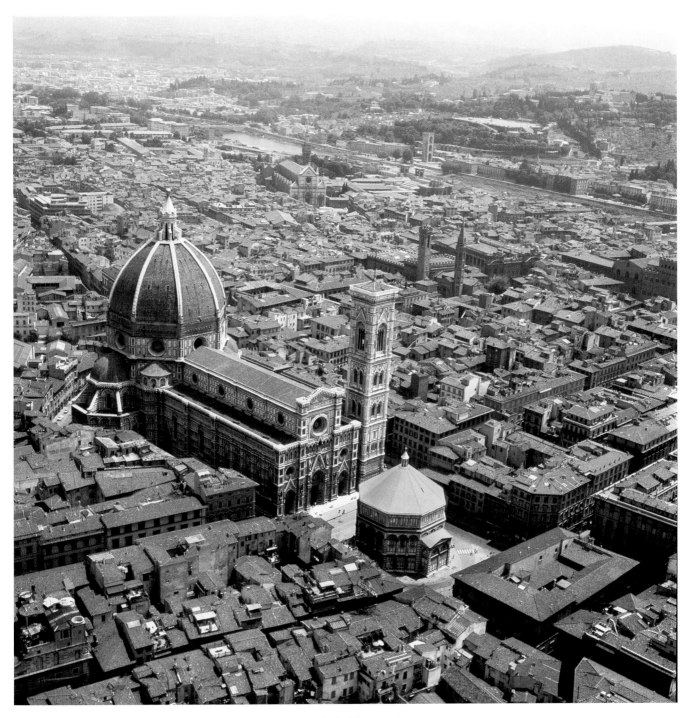

13.11. Florence Cathedral and Baptistery seen from the air. Cathedral begun 1296

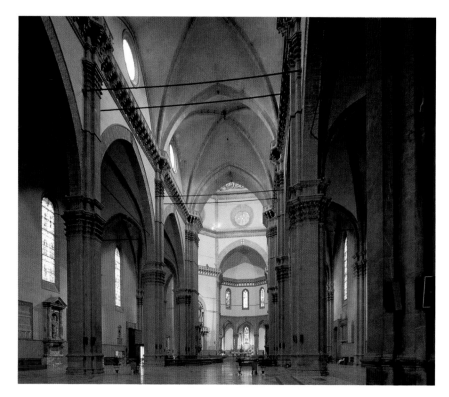

13.12. Nave and choir, Florence Cathedral

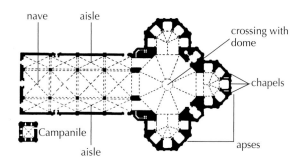

13.13. Plan of Florence Cathedral and Campanile

and dramatically extended the building to the east. By 1367, a committee of artists consulted by the overseers of the construction decided to cover the eastern zone with a high dome. The west facade and other portals continued to be adorned with sculpture throughout the Renaissance period, but the marble cladding on the building was not completed until the nineteenth century. Florence's *Duomo* was intended to be a grand structure that would not only serve as the spiritual center of the city, but as a statement of the city's wealth and importance.

Arnolfo's design was for a capacious basilica with a high arcade and broad proportions that contrast with contemporary Gothic structures in France (compare fig. 13.12 with fig. 12.26). The piers are articulated with leaf-shaped capitals and support flat moldings that rise to the clerestory level. Windows in the clerestory and aisles are relatively small, leaving much more wall surface than in French cathedrals. Although the original plan called for a trussed wooden roof in the Tuscan tradition,

by the mid-fourteenth century the plan had been altered to include ribbed groin vaults closer to the northern Gothic taste. The later plans enlarged the eastern zone to terminate in three faceted arms supporting an octagonal crossing that would be covered by a dome. (This design appears in the fresco in figure 13.33.) The scale of the proposed dome presented engineering difficulties that were not solved until the early fifteenth century. Instead of tall western towers incorporated into the facade, the cathedral has a *campanile* (bell tower) as a separate structure in the Italian tradition. The campanile is the work of the Florentine painter Giotto and his successors. If Florence's cathedral has Gothic elements in its vaults and arches, the foreign forms are tempered by local traditions.

In the heart of the city was the venerable Baptistery of Florence, built in the eleventh century on older foundations; the Florentines of the era believed it to be Roman and saw in its age the glory of their own past. Saint John the Baptist is the patron of Florence, so to be baptized in his baptistery meant that an individual not only became a Christian but also a citizen of Florence. In 1330, the overseers of the Baptistery commissioned another sculptor from Pisa, Andrea da Pisano (ca. 1295–1348; no relation to Nicola or Giovanni) to cast a new pair of bronze doors for the Baptistery. These were finished and installed in 1336 (fig. **13.14**). Cast of bronze and gilded, the project required 28 separate panels across the two panels of the door. They mostly represent scenes from the life of John the Baptist. Each vignette is framed by a Gothic quatrefoil, such as those found on the exteriors of French cathedrals. Yet within most of the four-lobed frames, Andrea provides a projecting ledge to support the figures and the landscape or architectural backgrounds. The relief of the Baptism of Christ demonstrates Andrea's clear compositional technique: Christ stands at the center, framed by

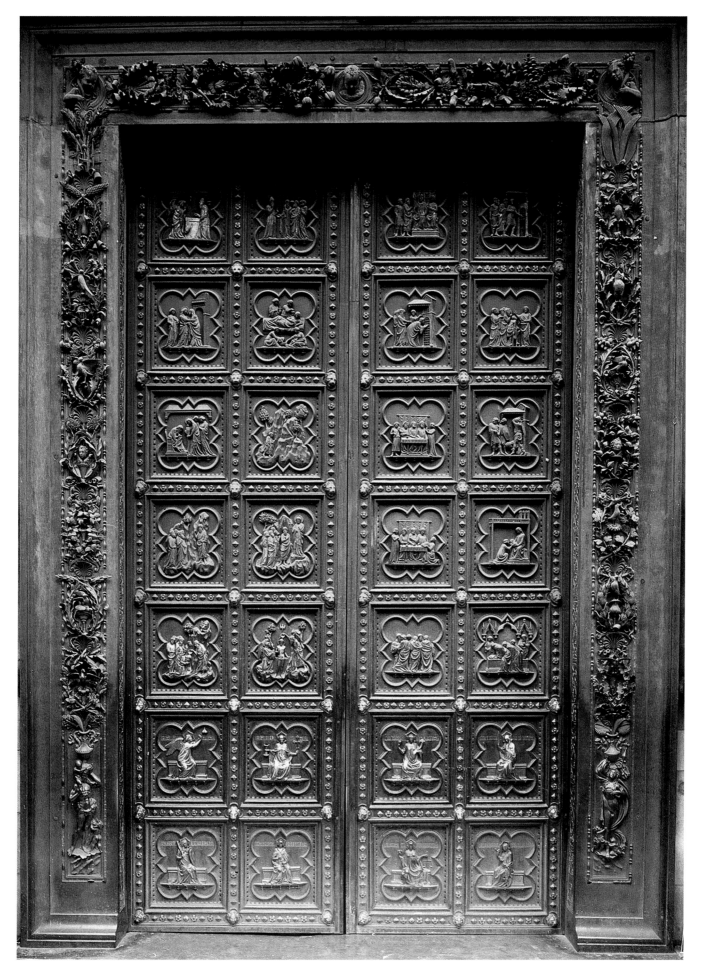

13.14. Andrea da Pisano. South doors, Baptistery of San Giovanni, Florence. 1330–1336. Gilt bronze

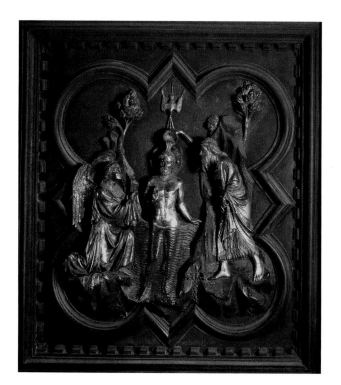

13.15. Andrea da Pisano. *The Baptism of Christ,* from the south doors, Baptistery of San Giovanni, Florence. 1330–1336. Gilt bronze

John on the right in the act of baptism and an angelic witness on the left (fig. **13.15**). The dove of the spirit appears above Christ's head. The emphasis is on the key figures, with little detail to distract from the main narrative; only a few small elements suggest the landscape context of the River Jordan.

Buildings for City Government: The Palazzo della Signoria

While the citizens of Florence were building the huge cathedral, the political faction that supported the papacy instead of the Holy Roman Empire consolidated its power in the city. The pro-papal party was largely composed of merchants who sought to contain the dynastic ambitions of aristocratic families who supported the emperor. The pro-papal group commissioned a large structure to house the governing council and serve as the symbol of the political independence of the city. The Palazzo della Signoria, also known as the *Palazzo Vecchio*, (fig. **13.16**) was probably also designed by Arnolfo di Cambio. It was begun in 1298 and completed in 1310, though it has been subject to later expansion and remodeling.

A tall, blocky, fortresslike structure, similar to fortified castles in the region, the Palazzo's stone walls are solid at the lowest level and rusticated for greater strength. The three stories of the structure are topped by heavy battlements and surmounted by a tall tower that serves not only as a symbol of civic pride, but as a defensive structure. It is slightly off-center for two reasons: The building rests on the foundations of an earlier tower, and its position makes it visible from a main street in the city. Boasting the highest tower in the city, the Palazzo della Signoria dominated the skyline of Florence and expressed the power of the communal good over powerful individual families.

PAINTING IN TUSCANY

As with other art forms in the thirteenth century, Italian painting's stylistic beginnings are different from those of the rest of Europe. Italy's ties to the Roman past and the Byzantine present would inspire Italian painters to render forms in naturalistic and monumental images. Throughout the Middle Ages, Byzantine mosaics and murals were visible to Italian artists. Venice had long-standing trading ties with the Byzantine Empire, and the Crusades had brought Italy in closer contact with Byzantium, including the diversion of the Fourth Crusade to Constantinople itself.

One result of the short-lived Latin occupation of Constantinople, from 1204 to 1261, was an infusion of Byzantine art forms and artists into Italy, which had a momentous effect on the development of Italian Gothic art. Later observers of the rapid changes that occurred in Italian painting from 1300 to 1550 described the starting point of these changes as the "Greek manner." Writing in the sixteenth century, Giorgio Vasari reported that in the mid-thirteenth century, "Some Greek painters were summoned to Florence by the government of the city for no other purpose than the revival of painting in their midst, since that art was not so much debased as altogether lost." Vasari assumes that medieval Italian painting was all but nonexistent and attributes to Byzantine art great influence over the development of Italian art in the thirteenth century. Italian artists were

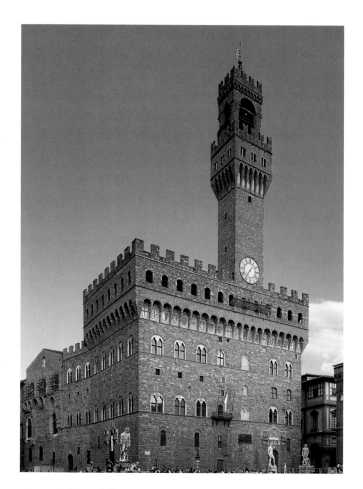

13.16. Palazzo della Signoria (Palazzo Vecchio), Florence. Begun 1298

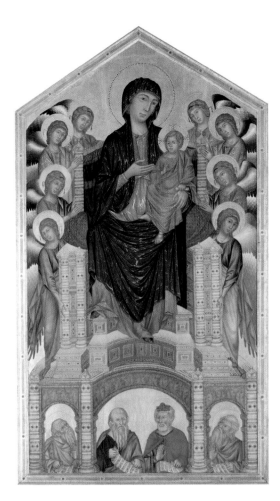

13.17. Cimabue. *Madonna Enthroned*. ca. 1280–1290. Tempera on panel, 12′7¹⁄₂″ × 7′4″ (3.9 × 2.2 m). Galleria degli Uffizi, Florence

ART IN TIME

1204—Fourth Crusade results in sacking of Constantinople
1226—Death of Francis of Assisi
1260—Nicola Pisano's Pisa Pulpit
1291—Turks expel Crusaders from Holy Land

Later artists in Renaissance Italy, such as Lorenzo Ghiberti (see chapter 15) and Giorgio Vasari (see chapter 16) claimed that Cimabue was the teacher of Giotto di Bondone (ca. 1267–1336/37), one of the key figures in the history of art. If so, Giotto learned the "Greek Manner" in which Cimabue worked. Many scholars believe Giotto was one of the artists working at Assisi, so he probably also knew the work of the Roman painter Pietro Cavallini. Giotto also worked in Rome where examples of both ancient and Early Christian art were readily available for study. Equally important, however, was the influence of the Pisani—Nicolo and Giovanni—with their blend of classicism and Gothic naturalism combined in an increased emotional content. (See figs. 13.9 and 13.10.)

We can see Giotto's relationship to, but difference from, his teacher Cimabue in a tall altarpiece of the *Madonna Enthroned*, which he painted around 1310 for the Church of All Saints (Ognissanti) in Florence (fig. **13.18**). Like Cimabue's Santa Trinità Madonna, Giotto depicts the Queen of Heaven and her son

able to absorb the Byzantine tradition far more thoroughly in the thirteenth century than ever before. When Gothic style began to influence artists working in this Byzantinizing tradition, a revolutionary synthesis of the two was accomplished by a generation of innovative and productive painters in Tuscan cities.

Cimabue and Giotto

One such artist was Cimabue of Florence (ca. 1250–after 1300), whom Vasari claimed had been apprenticed to a Greek painter. His large panel of the *Madonna Enthroned* (fig. **13.17**) was painted to sit on an altar in the Church of Santa Trinità in Florence; the large scale of the altarpiece—it is more than 12 feet high—made it the devotional focus of the church. Its composition is strongly reminiscent of Byzantine icons, such as the *Madonna Enthroned* (see fig. 8.50), but its scale and verticality are closer to the Saint Clare altarpiece (fig. 13.4) than to any Byzantine prototype. Mary and her son occupy a heavy throne of inlaid wood, which is supported by flanks of angels at either side and rests on a foundation of Old Testament prophets. The brilliant blue of the Virgin's gown against the gold leaf background makes her the focal point of the composition. Like Byzantine painters, Cimabue uses linear gold elements to enhance her dignity, but in his hands the network of gold lines follows her form more organically. The severe design and solemn expression is appropriate to the monumental scale of the painting.

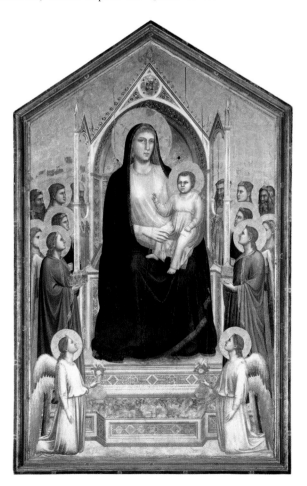

13.18. Giotto. *Madonna Enthroned*. ca. 1310. Tempera on panel, 10′8″ × 6′8″ (3.3 × 2 m). Galleria degli Uffizi, Florence

enthroned among angels against a gold background. The Virgin's deep blue robe and huge scale bring a viewer's eye directly to her and to the Christ Child on her lap. All the other figures gaze at them, both signaling and heightening their importance. Unlike his teacher, Giotto renders the figures bathed in light, so that they appear to be solid, sculptural forms. Where Cimabue turns light into a network of golden lines, Giotto renders a gradual movement from light into dark, so that the figures are molded as three-dimensional objects.

The throne itself is based on Italian Gothic architecture, though here it has become a nichelike structure. It encloses the Madonna on three sides, setting her apart from the gold background. The possibility of space is further suggested by the overlapping figures, who seem to stand behind one another instead of floating around the throne. Its lavish ornamentation includes a feature that is especially interesting: the colored marble surfaces of the base and of the quatrefoil within the gable. Such illusionistic stone textures had been highly developed by ancient painters (see fig. 7.52), and its appearance here is evidence that Giotto was familiar with whatever ancient murals could still be seen in medieval Rome.

THE SCROVEGNI CHAPEL IN PADUA Giotto's innovations in the area of light and space were accompanied by a gift for storytelling, especially in the fresco cycles he completed. Although scholars are not certain that he was among the artists who painted the nave frescoes at Assisi, his fresco cycles share formal and narrative characteristics with those images. Of

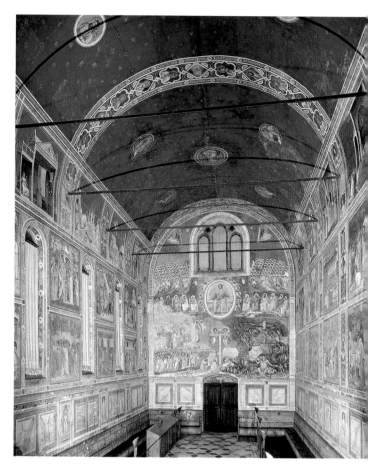

13.19. Interior, Arena (Scrovegni) Chapel. 1305–1306. Padua, Italy

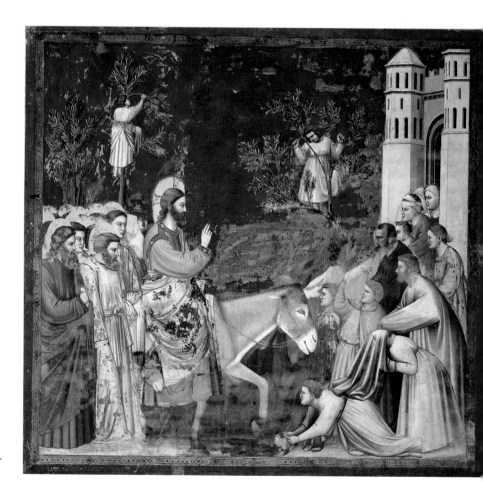

13.20. Giotto. *Christ Entering Jerusalem.* 1305–1306. Fresco. Arena (Scrovegni) Chapel. Padua, Italy

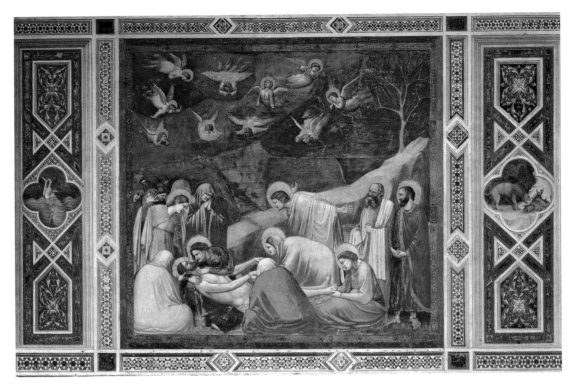

13.21. Giotto. *The Lamentation*. 1305–1306. Fresco. Arena (Scrovegni) Chapel. Padua, Italy

Giotto's surviving murals, those in the Scrovegni Chapel in Padua, painted in 1305 and 1306, are the best preserved and most famous. The chapel was built next to the palace of a Paduan banker, Enrico Scrovegni. (It is also known as the Arena Chapel because of its proximity to a Roman arena.) The structure itself is a one-room hall covered with a barrel vault. (fig. **13.19**)

Giotto and his workshop painted the whole chapel from floor to ceiling in the fresco technique. A blue field with gold stars symbolic of heaven dominates the barrel vault, below which the walls are divided into three registers or horizontal rows. Each register contains rectangular fields for narrative scenes devoted mainly to the life of Christ. The scenes begin at the altar end of the room with the Annunciation and culminate in the Last Judgment at the west end of the chapel. Along the length of the wall, the top register depicts stories of the early life of Mary and her parents; the center register focuses on stories of Christ's public life and miracles; and the lowest register depicts his Passion, Death, and Resurrection. Below the narratives the walls resemble marble panels interspersed with statues, but everything is painted.

Among the scenes from his public life is the *Christ Entering Jerusalem*, the event commemorated by Christians on Palm Sunday (fig. **13.20**). Giotto's handling of the scene makes a viewer feel so close to the event that his contemporaries must have had the sense of being a participant instead of an observer. He achieves this effect by having the entire scene take place in the foreground of his image, and by taking the viewer's position in the chapel into account as he designed the picture. Furthermore, Giotto gives his forms such a strong three-dimensional quality that they almost seem as solid as sculpture. The rounded forms create the illusion of space in which the actors exist.

Giotto gives very little attention to the setting for this event, except for the trees in which children climb and the gate of the city on the right. His large simple forms, strong grouping of figures, and the limited depth of his stage give his scenes a remarkable coherence. The massed verticals of the block of apostles on the left contrast with the upward slope of the crowd welcoming Christ on the right; but Christ, alone in the center, bridges the gap between the two groups. His isolation and dignity, even as he rides the donkey toward the city where he will die, give the painting a solemn air.

Giotto's skill at perfectly matching composition and meaning may also be seen in the scenes on the lowest level register, which focus on the Passion. A viewer gazing at these frescoes sees them straight on, so the painter organizes these scenes to exploit that relationship. One of the most memorable of these paintings depicts the Lamentation, the moment of last farewell between Christ and his mother and friends (fig. **13.21**). Although this event does not appear in the gospels, by the end of the Middle Ages versions of this theme had appeared in both Byzantine and in Western medieval art.

The tragic mood of this Lamentation, found also in religious texts of the era, is created by the formal rhythm of the design as much as by the gestures and expressions of the participants. The low center of gravity and the hunched figures convey the somber quality of the scene as do the cool colors and bare sky. With extraordinary boldness, Giotto sets off the frozen grief of the human mourners against the frantic movement of the weeping angels among the clouds. It is as if the figures on the ground were restrained by their obligation to maintain the stability of the composition, while the angels, small and weightless as birds, are able to move—and feel—freely.

Once again the simple setting heightens the impact of the drama. The descending slope of the hill acts as a unifying element that directs attention toward the heads of Christ and the Virgin,

which are the focal point of the scene. Even the tree has a twin function. Its barrenness and isolation suggest that all of nature shares in the sorrow over Christ's death. Yet it also carries a more precise symbolic message: It refers to the Tree of Knowledge, which the sin of Adam and Eve had caused to wither and which was to be restored to life through Christ's sacrificial death.

Giotto's frescoes at the Arena Chapel established his fame among his contemporaries. In the *Divine Comedy*, written around 1315, the great Italian poet Dante Alighieri mentions the rising reputation of the young Florentine: "Once Cimabue thought to hold the field as painter, Giotto now is all the rage, dimming the luster of the other's fame." (See end of Part II, *Additional Primary Sources*.) Giotto continued to work in Florence for 30 years after completing the Arena Chapel frescoes, in 1334 being named the architect of the Florentine cathedral, for which he designed the *campanile* (bell tower) (see figs. 13.11 and 13.13). His influence over the next generation of painters was inescapable and had an effect on artists all over Italy.

Siena: Devotion to Mary in Works by Duccio and Simone

Giotto's slightly older contemporary, Duccio di Buoninsegna of Siena (ca. 1255–before 1319) directed another busy and influential workshop in the neighboring Tuscan town of Siena. The city of Siena competed with Florence on a number of fronts—military, economic, and cultural—and fostered a distinct identity and visual tradition. After a key military victory and the establishment of a republic directed by the *Nove* (the Nine), Siena took the Virgin Mary as its protector and patron, and dedicated its thirteenth-century cathedral to her. This cathedral, substantially completed by 1260, displays several features of the new style of Gothic architecture from France: Its arcade rests on compound piers like those in French cathedrals, and the ceiling was vaulted. Its facade (see fig. **13.22**) was entrusted to the sculptor Giovanni Pisano in 1284, though he left it incomplete when he departed in 1295. The facade reveals French elements, too, such as the pointed gables over tympanums defining the three portals, the blind arcades above the outer portals, and the sculpted figures of prophets and other figures who stand on platforms between the portals and on the turrets at the outer edges of the facade.

A fine example of Sienese devotion to Mary may be seen in a small panel of the *Virgin and Child* that Duccio painted around 1300 (fig. **13.23**). Still in its original frame, this wonderfully preserved painting has recently entered the Metropolitan Museum of Art in New York from a private collection. Small in scale, the painting depicts the Mother and son in a tender relationship: She supports the Christ

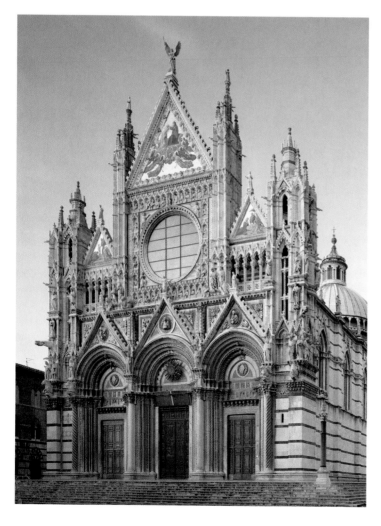

13.22. Siena Cathedral, completed ca. 1260. Facade. Lower sections ca. 1284–1299 by Giovanni Pisano

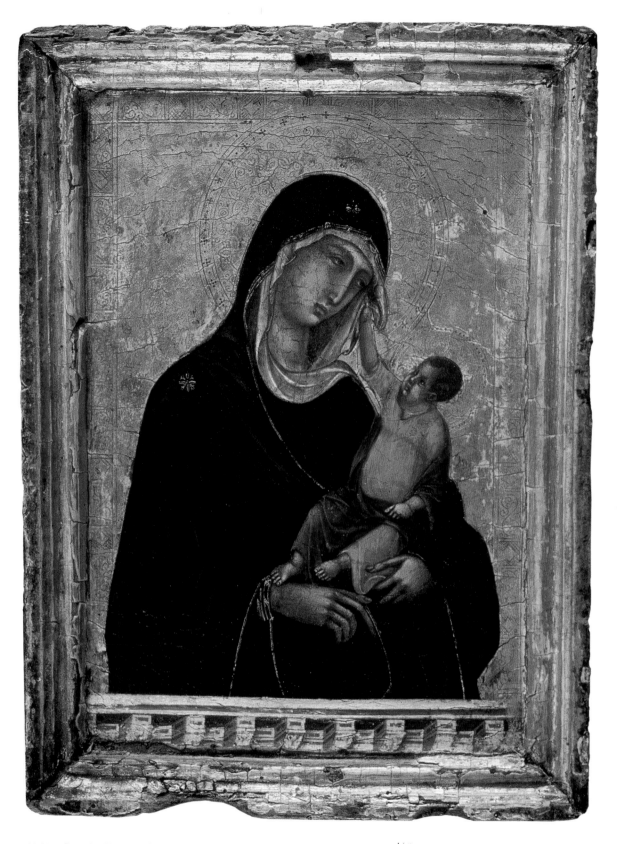

13.23. Duccio, *Virgin and Child*. ca. 1300. Tempera and gold on wood. $11 \times 8\frac{1}{4}''$ (28×20.8 cm) Metropolitian Museum of Art, New York. Purchase Rogers Fund, Walter and Lenore Annenberg Foundation Gift, Lila Acheson Wallace Gift, Annette de la Renta Gift, Harris Brisbane Dick, Fletcher, Louis V. Bell, and Dodge Funds, Joseph Pulitzer Bequest, several members of the Chairman's Council Gifts, Elaine L. Rosenberg and Stephenson Family Foundation Gifts, 2003 Benefit Fund, and other gifts and funds from various donors, 2004. (2004.442)

The Social Work of Images

The report of the celebrations held in Siena when Duccio's *Maestà* was installed in the cathedral attests to the importance of this painting for the entire community. It was a source of pride for the citizens of Siena, but also a powerful embodiment of the Virgin's protection of the city. Although modern audiences expect to find and react to works of art hanging in museums, art historians have demonstrated that art served different purposes in late medieval Europe. Few in the West today believe that a work of art can influence events or change lives. But in fourteenth-century Europe, people thought about images in much more active terms. Art could be a path to the sacred or a helper in times of trouble.

During a drought in 1354, for example, the city fathers of Florence paraded a miracle-working image of the Virgin from the village of Impruneta through the city in hopes of improving the weather. People with illness or health problems venerated a fresco of the Annunciation in the church of the Santissima Annunziata in Florence; they gave gifts to the image in hopes of respite from their problems. When the plague came to Florence, artists were commissioned to paint scenes depicting Saint Sebastian and other saints who were considered protectors against this deadly disease.

Images were also called upon for help outside the sacred space of the church. Continuing a tradition begun in the fourteenth century, street corners in Italy are often adorned with images of the Virgin to whom passersby may pray or show respect. Candles may be lit or gifts offered to such images in hopes of the Virgin's assistance. Art historians are also studying how works of art functioned among late medieval populations to forge bonds among social groups and encourage group identity. For example, outside the confines of monasteries, groups of citizens formed social organizations that were dedicated to a patron saint, whose image would be an important element of the group's identity.

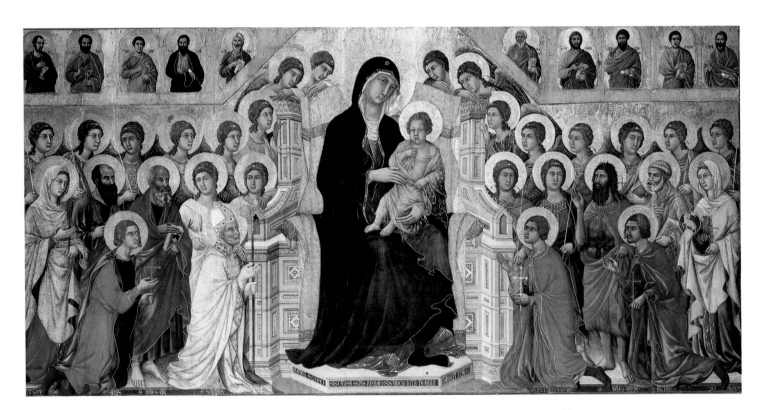

13.24. Duccio. *Madonna Enthroned,* center of the *Maestà Altar.* 1308–1311. Tempera on panel, height 6′10¹⁄₂″ (2.1 m). Museo dell'Opera del Duomo, Siena

Child in her arms as he reaches up to pull on her veil. His small scale in relation to his mother makes him seem very vulnerable. Duccio has washed both figures in a warm light that softens the contours and suggests three-dimensional forms, but he sets these figures against a brilliant gold background that contrasts vividly with the Virgin's blue gown. Her wistful glance at her tiny child gives the painting a melancholy effect.

Duccio was commissioned by the directors of Siena's cathedral to paint the large altarpiece for the high altar, called the *Maestà* as it depicts the Virgin and Child in majesty (fig. **13.24**). Commissioned in 1308, the *Maestà* was installed in the cathedral in 1311 amidst processions and celebrations in the city. (See *Primary Source*, page 456, and *The Art Historian's Lens*, above.) Duccio's signature at the base of the throne expresses his pride in the work: "Holy Mother of God,

be the cause of peace to Siena, and of life to Duccio because he has painted you thus."

In contrast to the intimate scale of the Metropolitan's *Virgin and Child*, here Duccio creates a regal image on a large scale. Members of her court surround the enthroned Virgin and Child in the *Maestà* in a carefully balanced arrangement of saints and angels. She is by far the largest and most impressive figure, swathed in the rich blue reserved for her by contemporary practice. Siena's other patron saints kneel in the first row, each gesturing and gazing at her figure. The Virgin may seem much like Cimabue's, since both originated in the Greek manner, yet Duccio relaxes the rigid, angular draperies of that tradition so that they give way to an undulating softness. The bodies, faces, and hands of the many figures seem to swell with three-dimensional life as the painter explores the fall of light on their forms. Clearly the heritage of Hellenistic-Roman illusionism that had always been part of the Byzantine tradition, however submerged, inspired Duccio to a profound degree. Nonetheless, Duccio's work also reflects contemporary Gothic sensibilities in the fluidity of the drapery, the appealing naturalness of the figures, and the glances by which the figures communicate with each other. The chief source of this Gothic influence was probably Giovanni Pisano, who was in Siena from 1285 to 1295 as the sculptor-architect in charge of the cathedral facade, although there is evidence that Duccio may have traveled to Paris, where he would have encountered French Gothic style directly.

In addition to the principal scene, the *Maestà* included on its front and on its back numerous small scenes from the lives of Christ and the Virgin. In these panels, Duccio's synthesis of Gothic and Byzantine elements gives rise to a major new development: a new kind of picture space and, with it, a new treatment of narrative. The *Annunciation of the Death of the Virgin* (fig. **13.25**), from the front of the altarpiece, represents two figures enclosed by an architectural interior implied by foreshortened walls and ceiling beams to create and define a space that the figures may inhabit. But Duccio is not interested simply in space for its own sake. The architecture is used to integrate the figures within the drama convincingly. In a parallel scene to the Annunciation (see fig. 13.27, for comparison), this panel depicts the angel Gabriel returning to the mature Virgin to warn her of her impending death. The architecture enframes the two figures separately, but places them in the same uncluttered room. Despite sharing the space, each figure is isolated. Duccio's innovative use of architecture to enhance the narrative of his paintings inspired his younger French contemporary Jean Pucelle, who adapted this composition for the *Annunciation* in the *Hours of Jeanne d'Évreux* (fig. 12.41).

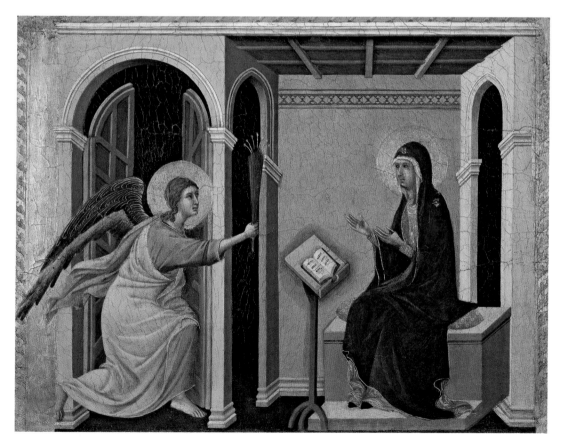

13.25. Duccio. *Annunciation of the Death of the Virgin,* from the *Maestà Altar*

Agnolo di Tura del Grasso

From his Chronicle

Duccio's Maestà *(fig. 13.24) stood on the main altar of Siena Cathedral until 1506, when it was removed to the transept. It was sawed apart in 1771, and some panels were acquired subsequently by museums in Europe and the United States. This local history of about 1350 describes the civic celebration that accompanied the installation of the altarpiece in 1311.*

These paintings [the *Maestà*] were executed by master Duccio, son of Nicolò, painter of Siena, the finest artist to be found anywere at his time. He painted the altarpiece in the house of the Muciatti outside the gate toward Stalloreggi in the suburb of Laterino. On the 9th of June [1311], at midday, the Sienese carried the altarpiece in great devotion to the cathedral in a procession, which included Bishop Roger of Casole, the entire clergy of the cathedral, all monks and nuns of the city, and the Nine Gentlemen [Nove] and officials of the city such as the podestà and the captain, and all the people. One by one the worthiest, with lighted candles in their hands, took their places near the altarpiece. Behind them came women and children with great devotion. They accompanied the painting up to the cathedral, walking in procession around the Campo, while all the bells rang joyfully. All the shops were closed out of devotion, all through Siena many alms were given to the poor with many speeches and prayers to God and to his Holy Mother, that she might help to preserve and increase the peace and well being of the city and its jurisdiction, as she was the advocate and protection of said city, and deliver it from all danger and wickedness directed against it. In this way the said altarpiece was taken into the cathedral and placed on the main altar. The altarpiece is painted on the back with scenes from the Old Testament and the Passion of Jesus Christ and in front with the Virgin Mary and her Son in her arms and many saints at the sides, the whole decorated with fine gold. The alterpiece cost 3000 gold florins.

SOURCE: TERESA G. FRISCH, *GOTHIC ART 1140–C 1450.* (ENGLEWOOD CLIFFS, NJ: PRENTICE HALL, 1971.)

The architecture keeps its space-creating function even in the outdoor scenes on the back of the *Maestà,* such as in *Christ Entering Jerusalem* (fig. **13.26**), a theme that Giotto had treated only a few years before in Padua. Where Giotto places Christ at the center of two groups of people, Duccio places him closer to the apostles and on one side of the composition. He conveys the diagonal movement into depth not by the figures, which have the same scale throughout, but by the walls on either side of the road leading to the city, by the gate that frames the welcoming crowd, and by the buildings in the background. Where Giotto reduces his treatment of the theme to a few figures and a bare backdrop, Duccio includes not only detailed architectural elements but also many children climbing trees to gather palms leaves as well

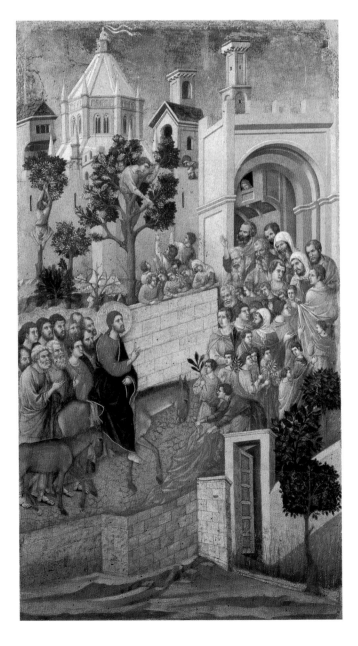

13.26. Duccio. *Christ Entering Jerusalem,* from the back of the *Maestà Altar.* 1308–1311. Tempera on panel, 40½ × 21⅛″ (103 × 53.7 cm). Museo dell'Opera del Duomo, Siena

as figures peering at the crowd in the streets from their first-floor windows. Duccio gives a viewer a more complete description of the event than Giotto, whose work stresses the doctrinal and psychological import of the moment. The goals of the two painters differ, and so do the formal means they use to achieve them.

Duccio trained the next generation of painters in Siena. One distinguished disciple was Simone Martini (ca. 1284–1344), who also worked in Assisi but spent the last years of his life in Avignon, the town in southern France that served as the residence of the popes during most of the fourteenth century. In 1333 the directors of the Siena Cathedral commissioned Simone to make another altarpiece to complement Duccio's *Maestà*. His *Annunciation* (fig. 13.27) preserves its original pointed and cusped arch format in its restored frame and suggests what has been lost in the dismemberment of the *Maestà*, which had a similar Gothic frame. Simone's altarpiece depicts the Annunciation flanked by two local saints set against a brilliant gold ground. To connect her visually to *Maestà*, Simone's Virgin sits in a similar cloth-covered throne and wears similar garments.

The angel Gabriel approaches Mary from the left to pronounce the words "*Ave Maria Gratia Plenum Dominus Tecum*" ("Hail Mary, full of grace, the Lord is with you"). Simone renders the words in relief on the surface of his painting, covering them in the same gold leaf that transforms the scene into a heavenly vision. Simone adds an element of doubt to this narrative, as the Virgin responds to her visitor with surprise and pulls away from him. The dove of the Holy Spirit awaits her momentous decision to agree to the charge given her to become the mother of the Christ Child and begin the process of Salvation. Like Giotto, Simone has reduced the narrative to its simplest terms, but like Duccio, his figures have a lyrical elegance that lifts them out of the ordinary and into the realm of the spiritual.

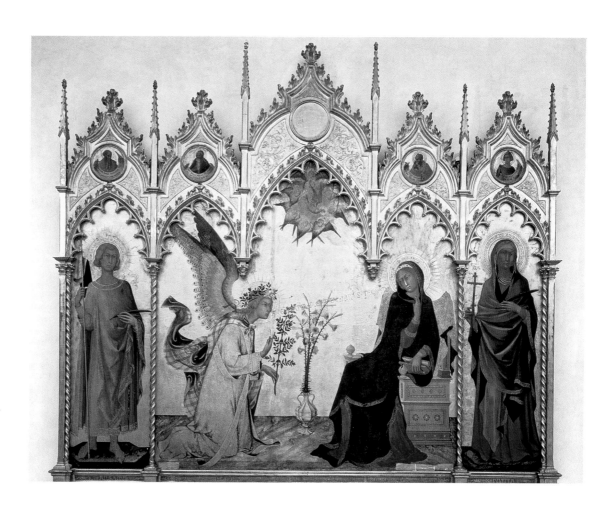

13.27. Simone Martini. *Annunciation*. ca. 1330. Tempera on panel. 10′ × 8′9″ (3 × 2.7 m). Galleria degli Uffizi, Florence.

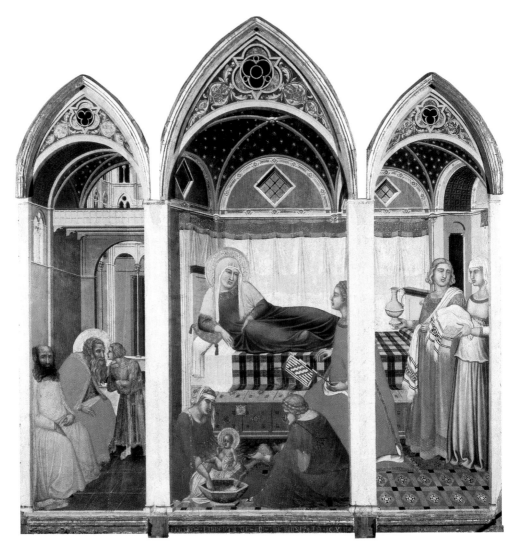

13.28. Pietro Lorenzetti. *Birth of the Virgin.* 1342. Tempera on panel, $6'1\frac{1}{2}'' \times 5'11\frac{1}{2}''$ (1.9 × 1.8 m). Museo dell'Opera del Duomo, Siena

Pietro and Ambrogio Lorenzetti

Another altarpiece commissioned for the cathedral at Siena takes a more down to earth approach. This is the *Birth of the Virgin* (fig. **13.28**) painted in 1342 by Pietro Lorenzetti (active ca. 1306–1348). Pietro and his brother Ambrogio (active ca. 1317–1348) learned their craft in Siena, though their work also shows the influence of Giotto. Pietro has been linked to work at Assisi, and Ambrogio went so far as to enroll in the painter's guild of Florence in the 1330s. Like Simone's, Pietro's altarpiece is a triptych though it has lost its original frame. In this triptych, the painted architecture has been related to the real architecture of the frame so closely that the two are seen as a single system. Moreover, the vaulted room where the birth takes place occupies two panels and continues unbroken behind the column that divides the center from the right wing. The left wing represents a small chamber leading to a Gothic courtyard. Pietro's achievement of spatial illusion here is the outcome of a development that began three decades earlier in the work of Duccio. Pietro treats

the painting surface like a transparent window *through* which—not *on* which—a viewer experiences a space comparable to the real world. Following Duccio's example, Pietro uses the architecture in his painting to carve out boxes of space that his figures may inhabit, but he is also inspired by Giotto's technique of giving his figures such mass and weight that they seem to create their own space. His innovation served the narrative and liturgical needs of Siena Cathedral by depicting another key moment in the life of the Virgin, which was also an important feast day in the Church. Saint Anne rests in her childbed, while midwives attend the newly born Virgin and other women tend to the mother. The figure of the midwife pouring water for the baby's bath seems to derive from the figure seen from the back in Giotto's *Lamentation* (fig. 13.21). The father, Joachim, waits for a report of the birth outside this room. The architectural divisions separate the sexes in the same way the architecture in Duccio's *Annunciation of the Death of the Virgin* (fig. 13.25) separates the angel from Mary.

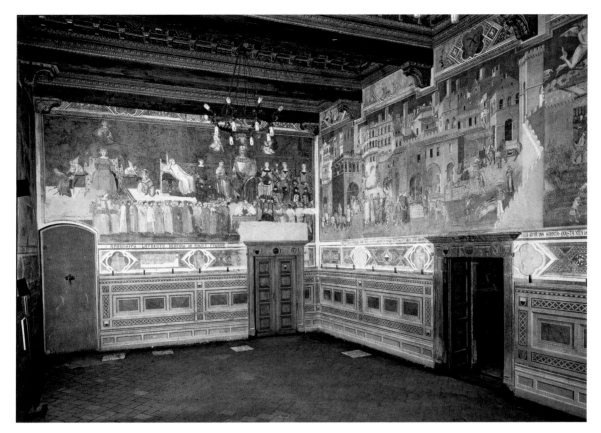

13.29. Ambrogio Lorenzetti. *The Allegory of Good Government* (left). *Good Government in the City,* and portion of *Good Government in the Country* (right). 1338–1340. Frescoes in the Sala della Pace, Palazzo Pubblico, Siena

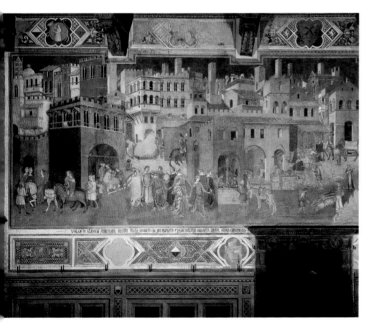

13.30. Ambrogio Lorenzetti. *Good Government in the City*

GOOD AND BAD GOVERNMENT Pietro's brother, Ambrogio Lorenzetti, combined these same influences in a major project for the city hall of Siena, executed between 1338 and 1340. The ruling Council of Nine (Nove) commissioned for their meeting hall an allegorical fresco contrasting good and bad government. The aim of this project was to be salutary, for as they deliberated, they would see in these frescoes the effects of both. While the negative example of the effects of Bad Government has been severely damaged, the frescoes that depict the positive example of Good Government are remarkably well preserved (fig. **13.29**). On the short wall of the room, Ambrogio depicted the *Allegory of Good Government* as an assembly of virtues who support the large enthroned personification of the city. To the left another enthroned figure personifies Justice, who is inspired by Wisdom. Below the virtues stand 24 members of the Sienese judiciary under the guidance of Concord. On the long wall, the fresco of *Good Government in the City* (fig. **13.30**) bears an inscription praising Justice and the many benefits that derive from her. (See *Primary Source*, page 456.) Ambrogio paints an architectural portrait of the city of Siena in this fresco. To show the life of a well-ordered city-state, the artist fills the streets and houses with teeming activity. The bustling crowd gives the architectural vista its striking reality by introducing the human scale. On the right, outside the city walls, *Good Government in the Country* provides a view of the

PRIMARY SOURCE

Inscriptions on the Frescoes in the Palazzo Pubblico, Siena

The first inscription is painted in a strip below the fresco of Good Government (see figs. 13.29 and 13.30), which is dated between 1338 and 1340. The second is held by the personification of Security, who hovers over the landscape in figure 13.28.

Turn your eyes to behold her,
you who are governing, [Justice] who is portrayed here,
crowned on account of her excellence,
who always renders to everyone his due.
Look how many goods derive from her
and how sweet and peaceful is that life

of the city where is preserved
this virtue who outshines any other.
She guards and defends
those who honor her, and nourishes and feeds them.
From her light is born
Requiting those who do good
and giving due punishment to the wicked.

Without fear every man may travel freely
and each may till and sow,
so long as this commune
shall maintain this lady [Justice] sovereign,
for she has stripped the wicked of all power.

SOURCE: RANDOLPH STARN AND LOREN PARTRIDGE, *ARTS OF POWER: THREE HALLS OF STATE IN ITALY, 1300–1600.* (BERKELEY: UNIVERSITY OF CALIFORNIA PRESS, 1992)

Sienese farmland, fringed by distant mountains (fig. **13.31**) and overseen by a personification of Security. It is a true landscape—the first since ancient Roman times (see fig. 7.55). The scene is full of sweeping depth yet differs from Classical landscapes in its orderliness, which gives it a domesticated air. The people here have taken full possession of Nature: They have terraced the hillsides with vineyards and patterned the valleys with the geometry of fields and pastures. Ambrogio observes the peasants at their seasonal labors; this scene of rural Tuscan life has hardly changed during the past 600 years.

Artists and Patrons in Times of Crisis

Ambrogio's ideal vision of the city and its surroundings offers a glimpse at how the citizens of Siena imagined their government and their city at a moment of peace and prosperity. The first three decades of the fourteenth century in Siena, as in Florence, had been a period of political stability and economic expansion, as well as of great artistic achievement. In the 1340s, however, both cities suffered a series of catastrophes whose effects were to be felt for many years.

Constant warfare led scores of banks and merchants into bankruptcy; internal upheavals shook governments, and there were repeated crop failures and famine. Then, in 1348, the pandemic of bubonic plague—the Black Death—that spread throughout Europe wiped out more than half the population of the two cities. It was spread by hungry, flea-infested rats that swarmed into cities from the barren country-side in search of food. Popular reactions to these events were mixed. Many people saw them as signs of divine wrath, warnings to a sinful humanity to forsake the pleasures of this

earth. In such people, the Black Death intensified an interest in religion and the promise of heavenly rewards. To others, such as the merry company who entertain each other by telling stories in Boccaccio's *Decameron,* the fear of death intensified the desire to enjoy life while there was still time. (See end of Part II, *Additional Primary Sources.*)

Late medieval people were confronted often with the inevitability and power of death. A series of frescoes painted on the walls of the Camposanto, the monumental cemetery building next to Pisa Cathedral, offers a variety of responses to death. Because of its somber message, the fresco was once dated after the outbreak of the plague, but recent research has pushed it closer to the 1330s. The painter of this enormous fresco is not known, though some scholars attribute the work to a Pisan artist named Francesco Traini (documented ca. 1321–1363). The huge fresco cycle, which was damaged in 1944 as a result of bombings in the Second World War, included a powerful *Last Judgment* and an image called *The Triumph of Death,* which asserts that death comes to all, rich or poor, saint or sinner. In a particularly dramatic detail (fig. **13.32**), the elegantly costumed men and women on horseback have suddenly come upon three decaying corpses in open coffins. Even the animals are terrified by the sight and smell of rotting flesh. Only the hermit Saint Macarius, having renounced all earthly pleasures, points out the lesson of the scene. His scroll reads: "If your mind be well aware, keeping here your view attentive, your vainglory will be vanquished and you will see pride eliminated. And, again, you will realize this if you observe that which is written." As the hermits in the hills above make clear, the way to salvation is through renunciation of the world in favor of the

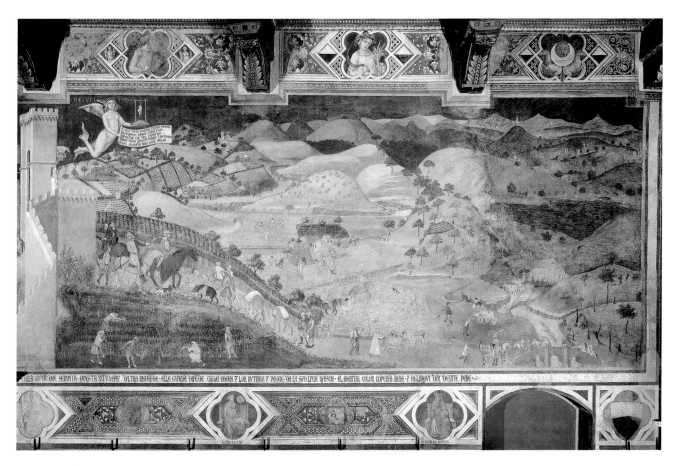

13.31. Ambrogio Lorenzetti. *Good Government in the Country*

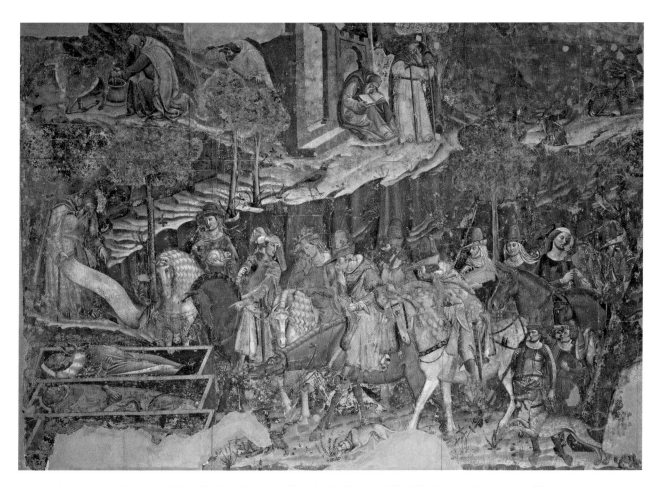

13.32. Anonymous (Francesco Traini?). *The Triumph of Death* (detail). ca. 1325–1350. Fresco. Camposanto, Pisa

spiritual life. In the center of the fresco lie dead and dying peasants who plead with Death, "the medicine for all pain, come give us our last supper." Further to the right are courtiers in a delightful landscape enjoying earthly pleasures as a figure of Death swoops down and angels and devils fight over the souls of the deceased in the sky overhead. The artist's style recalls the realism of Ambrogio Lorenzetti, although the forms are harsher and more expressive.

The Lorenzetti brothers were probably among the thousands of people throughout Tuscany who perished in the Black Death of 1348. Scholars have conjectured about the impact of the plague on the artists and patrons of works of art in the second half of the fourteenth century. We can assume that many painters died, so there weren't as many practitioners of this craft. Documentary research reveals that the number of endowed chapels, tombs, and funeral masses rose as people worried about their mortality. Many such burials and endowments were made in mendicant churches, such as the Franciscan Santa Croce and the Dominican Santa Maria Novella in Florence.

At Santa Maria Novella, a Florentine merchant named Buonamico Guidalotti, who died in 1355, provided funds in his will for a new chapter house for the Dominican community in which he could be buried. The chapel served as a meeting room for the friars and as such was painted with frescoes expressing the role of Dominicans in the struggle for salvation. A fresco on one of the walls of the Guidalotti chapel, painted by Andrea Bonaiuti (also known as Andrea da Firenze, active 1346–1379) between 1365 and 1367, depicts the actions of Dominicans to assure the access of the faithful to heaven, hence its title, *The Way of Salvation* (fig. **13.33**). In the lower section of the fresco, spiritual and temporal leaders gather before a representation of the then unfinished Cathedral of Florence. Groups of Dominicans preach to the laity and convert heretics, amidst black and white dogs (a punning reference to the order—the "Domini canes" or the dogs of the Lord). On the upper right some heedless aristocrats enjoy the pleasures of the senses, while at the center, a Dominican shows the more spiritually minded the path to heaven, whose gate is guarded by Saint Peter. Andrea's fresco reveals the influence both

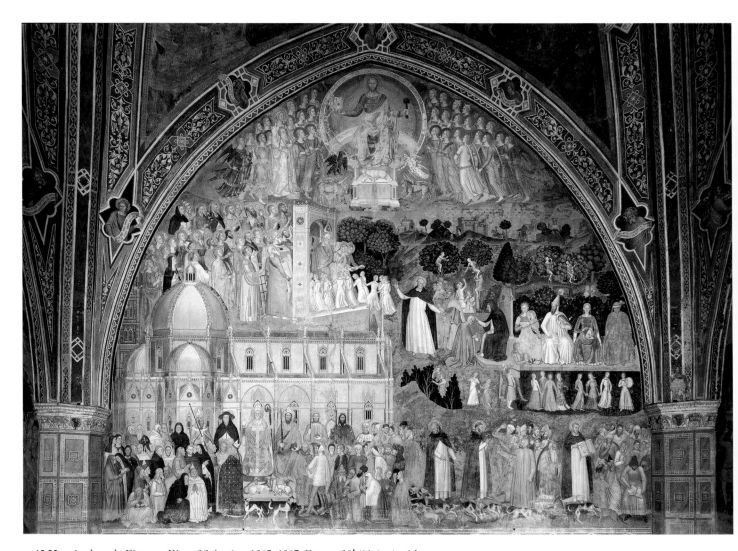

13.33. Andrea da Firenze, *Way of Salvation*. 1365–1367. Fresco. 38′ (11.6 m) wide. Guidalotti Chapel, Santa Maria Novella, Florence

of Ambrogio Lorenzetti's *Good Government* (see fig. 13.29) and the fresco on the walls of the cemetery near Pisa Cathedral (see fig. 13.32), but in its symmetry and sense of order, it seeks clarity rather than illusion and serenity rather than emotion.

Florence, however, did not complete its cathedral in the fourteenth century, and it was not to enjoy the calm atmosphere portrayed in Andrea's fresco. The plague returned in 1363, the political elite clashed with the papacy, and an uprising among the working classes created social and economic turmoil. The wealthier classes restored their power in 1381. Florence overcame these disasters to flourish in the fifteenth century as a center of economic energy, political astuteness, and cultural leadership. As the fifteenth century began, a new generation of Florentine artists would look to the art of Giotto and his contemporaries in their search for new forms of visual expression.

NORTHERN ITALY

Such political struggles did not distress the city of Venice in the fourteenth century. Unlike Florence, riven by warring factions, fourteenth-century Venice enjoyed political stability. Since 1297, the city had closed off membership in the merchant oligarchy that participated in government, and the city's leader (the Doge) was elected from this group. As a result, neither Venetian palaces nor their communal buildings required the defensive architecture seen in Florentine structures, such as the Palazzo della Signoria (fig. 13.16). A somewhat different atmosphere existed in Milan, west of Venice in Lombardy, where an aristocratic government lay in the hands of a single family with great dynastic

ambitions. In Lombardy, the political and cultural connections were with Northern Europe, with important results for the type and the style of art produced there.

Venice: Political Stability and Sumptuous Architecture

The differing political situations in Florence and Venice affected palace design. Whereas the Florentine palace was stolid and impenetrable, the palace in Venice is airy and open, full of windows and arcades that are anything but defensible. Venetian architects borrowed from Gothic and Islamic precedents in an elegant display of the city's wealth and security. When a larger meeting space was needed for the Great Council, the city decided to enlarge the Doge's Palace near San Marco in 1340 (fig. **13.34**). Work continued here until the mid-fifteenth century. In contrast to the fortresslike Palazzo della Signoria in Florence, the Doge's Palace is open at the base, the weight of its upper stories resting on two stories of pointed arcades. The lower arcade provides a covered passageway around the building, the

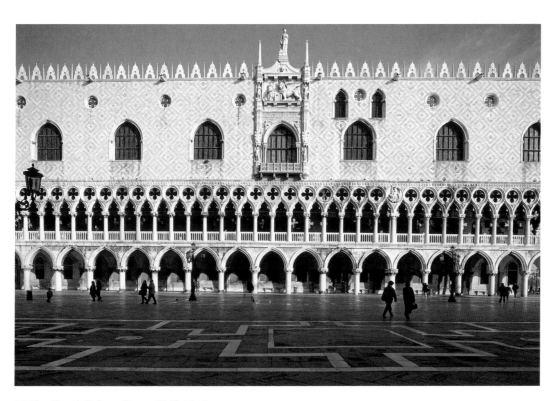

13.34. Doge's Palace. Begun 1340. Venice

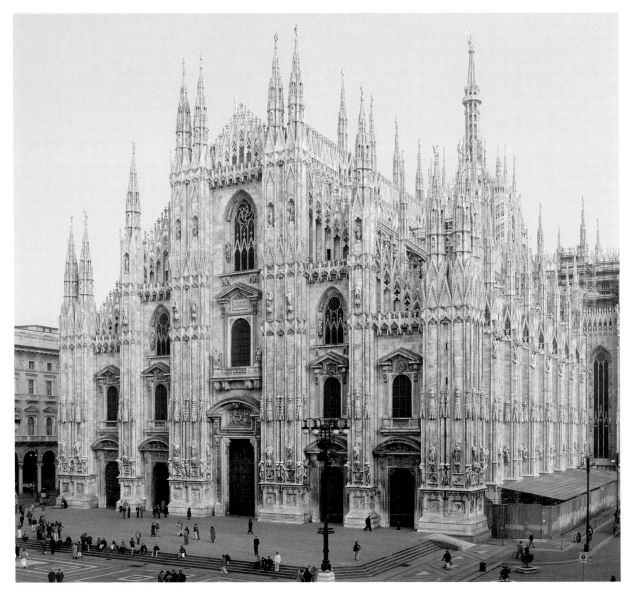

13.35. Milan Cathedral. Begun 1386

upper a balcony. The lavish moldings and the quatrefoils of the arcades give the structure an ornamental feel that is accented by the doubling of the rhythm of the upper arcade. The walls of the structure are ornamented with stonework in a diamond pattern, making them both visually lighter and more ornate.

Milan: The Visconti Family and Northern Influences

To the West and North of Venice, Lombardy had a different political structure and a closer relationship with Gothic France, which found expression in its visual arts. In Lombardy, the Visconti family had acquired great wealth from the products of this richly agricultural region. Besides controlling Lombardy, the Visconti positioned themselves among the great families of Europe through marriage ties to members of the Italian and European nobility. By 1395, Giangaleazzo

Visconti had been named Duke of Milan, had married the daughter of the King of France, and wed their daughter to Louis, Duke of Orleans.

Fourteenth-century projects in Milan reflect these ties to Northern Europe. The city, its archbishop, and Giangaleazzo Visconti joined together to build a new cathedral in 1386, though it required more than a century to complete. Milan Cathedral is the most striking translation of French Gothic forms in Italy (fig. **13.35**). While local architects began the project, architects from France and Germany, who were experts in raising tall Gothic structures, were consulted about the design and its implementation. Yet the local preferences for wide interior spaces and solid structure resulted in double aisles and a rejection of flying buttresses. (Compare with figs. 12.15 and 12.17.) The facade defines the interior spaces: The stepped heights of the inner and outer aisles can be clearly read, despite the profusion of vertical moldings on the exterior. The continu-

ous solid mass of the aisle walls seems hardly diminished by the mass of triangular points and turrets along the roofline. Later in the fifteenth and sixteenth centuries more antique-inspired elements such as pediments and pilasters were set into the Gothic facade.

The authoritarian nature of Visconti rule in Milan may be seen in a commission of Giangaleazzo's uncle Bernabò Visconti for his tomb (fig. **13.36**). Though now in a museum, Bernabò's Equestrian Monument originally stood over the altar of a church in Milan. Completed around 1363 by the local sculptor Bonino da Campione (active ca. 1357–1397), the marble structure includes a sarcophagus that supports a sculpted figure of Bernabò on horseback. The figure stands rather than sits on the horse, forcefully commanding the space over the high altar of the church. The idea of the equestrian image of a ruler goes back to antiquity, with the equestrian portrait of Marcus Aurelius (fig. 7.21) visible in Rome throughout the Middle Ages.

ART IN TIME

1271–1295—Marco Polo travels to China

1277—Visconti control Milan

1386—Milan Cathedral begun

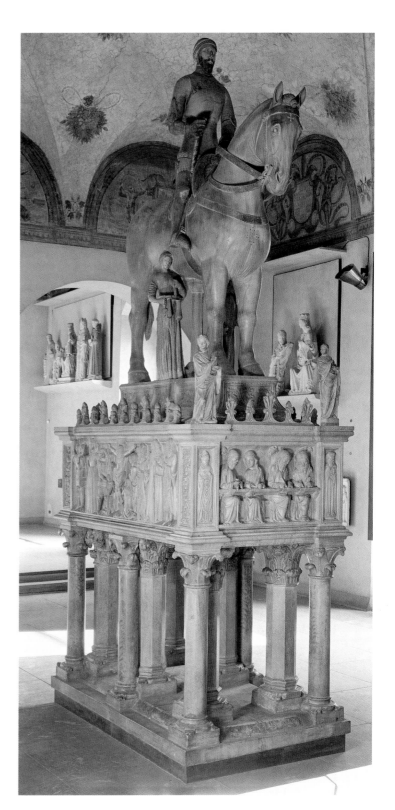

13.36. Tomb of Bernabò Visconti. Before 1363. Marble. 19′8″ (6 m). Castello Sforzesco, Milan

The aristocracy of Europe claimed for themselves the prerogative of equestrian imagery. In this sculpture, Bernabò is rigid and formal in his bearing; originally the figure was covered with silver and gold leaf to further enhance its impressiveness. Yet Bonino's treatment of the horse, with its sensitive proportions and realistically observed anatomy, point to a Lombard interest in the natural depiction of form, which may be a result of Lombard contact with contemporary French art.

While promoting the building of Milan Cathedral and during his own campaign to be named duke, Giangaleazzo Visconti commissioned illuminated manuscripts, as did his French peers. His *Book of Hours* was painted around 1395 by Giovannino dei Grassi (active ca. 1380–1398) with numerous personal representations and references to the duke. The page in figure **13.37** opens one of David's Psalms with an illuminated initial D wherein King David appears. David is both the author of the text and a good biblical exemplar of a ruler. An unfurling ribbon ornamented with the French *fleur-de-lis* forms the D; shields at the corners bear the Visconti emblem of the viper. Below the text appears a portrait of Giangaleazzo in the profile arrangement that was familiar from ancient coins. Although this portrait is naturalistic, it is set into an undulating frame that supports the rays of the sun, another Visconti emblem. Around the portrait Giovannino has painted images of stags and a hunting dog, with great attention to the accurate rendering of these natural forms. Such flashes of realism set amidst the splendor of the page reflect both the patron and the artist's contribution to the developing International Gothic style. Commissioning such lavish books was an expression of the status and power that Giangaleazzo attempted to wield. His ambition to bring most of northern Italy under his control would profoundly affect the arts in Tuscany in the early fifteenth century.

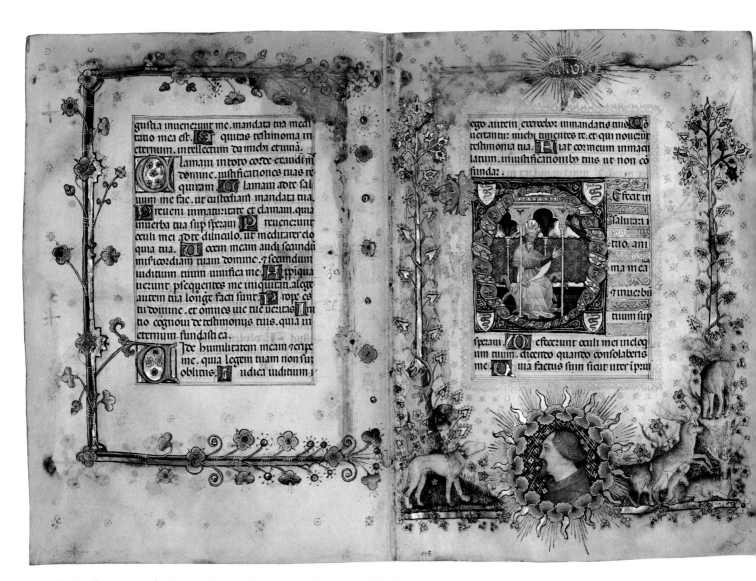

13.37. Giovannino dei Grassi, *Hours of Giangaleazzo Visconti*. ca. 1395. Tempera and gold on parchment. $9\frac{3}{4}'' \times 6\frac{7}{8}''$ (24.7 × 17.5 cm). Banco Rari, Biblioteca Nazionale, 397 folio 115/H, Florence

SUMMARY

Thirteenth- and fourteenth-century Italian art had its roots in both Byzantine forms and Italian artists' contacts with Roman and Early Christian precedents. It is often the product of commissions by mercantile communities and urban patriciates rather than great aristocratic patrons. The activity of the mendicant orders inspired a new spirituality in these urban centers; their vivid preaching accompanied commissions of narrative imagery to speak more directly to their lay audience.

CHURCH ARCHITECTURE AND THE GROWTH OF THE MENDICANT ORDERS

One product of the mendicants' mission to preach was the building of large urban churches where sermons could be delivered. These structures took advantage of Northern Gothic innovations that allowed for large interior spaces and tall proportions, but often followed local preferences for wooden roofs, solid wall surfaces, and facades without towers. Inside these churches, sculpted forms enhanced worshipers' experience by representing sacred stories in direct and legible terms. On pulpits and on portals, sculptors in Italy made narrative scenes that drew inspiration from Roman art forms or from Northern Gothic styles. Inspired by mendicant ideas, they created memorable images of holy figures in human situations to stimulate the devotion of city dwellers.

PAINTING IN TUSCANY

For this same audience, painters developed new techniques to represent the natural world. Starting from the close study of Byzantine painting traditions that were themselves rooted in ancient styles, thirteenth- and fourteenth-century Italian painters explored ways to create images that more closely reflected nature than had earlier medieval art. This generation of artists explored techniques for consistently representing the fall of light on three-dimensional forms and for creating the illusion of space within their paintings. These techniques were used to enhance the spiritual impact of the sacred figures they painted and to tell sacred stories more effectively. The innovations of fourteenth-century painters like Giotto and Duccio provided a visual language of naturalism from which artists all over Europe could profit.

NORTHERN ITALY

The northern Italian centers of Venice and Milan developed individual forms of Gothic art. Venice's political situation and mercantile connections with the Far East and Middle East brought to that city a taste for architectural forms with sumptuous surfaces and open arcades. Ruled by an ambitious dynasty, Milan looked more to Northern Europe. Its cathedral reflects a closer study of French Gothic architecture than any other in Italy, and the artistic commissions of their rulers imitate the tastes of the French aristocracy.

The Holy Bible

Exodus 20: 1–5

Exodus, the second book of the Old Testament, is one of five books tradition-ally attributed to Moses (these five, called the Pentateuch, form the Hebrew Torah). Exodus tells of the departure of the Jews from Egypt in the thirteenth century BCE. In Chapter 20, God speaks to Moses on Mount Sinai and gives him the Ten Commandments. The second commandment pertains to images.

And the Lord spoke all these words: I am the Lord thy God, who brought thee out of the land of Egypt.

Thou shalt not have strange gods before me.

Thou shalt not make to thyself a graven thing, nor the likeness of any thing that is in heaven above, or in the earth beneath, nor of those things that are in the waters under the earth.

Thou shalt not adore them, nor serve them.

Pope Gregory I (r. 590–604)

From a letter to Serenus of Marseille

Bishop Serenus apparently was moved to discourage excessive acts of devotion to paintings in his church by having the images destroyed. In this letter of 600 CE, Pope Gregory the Great reprimands him, reminding him that images serve to teach those who cannot read. This remained the standard defense of figural painting and sculpture in the Western church throughout the Middle Ages.

Word has reached us that you have broken the images of the saints with the excuse that they should not be adored. And indeed we heartily applaud you for keeping them from being adored, but for break-ing them we reproach you. To adore images is one thing; to teach with their help what should be adored is another. What Scripture is to the edu-cated, images are to the ignorant, who see through them what they must accept; they read in them what they cannot read in books. This is espe-cially true of the pagans. And it particularly behooves you, who live among pagans, not to allow yourself to be carried away by just zeal and so give scandal to savage minds. Therefore you ought not to have broken that which was placed in the church not in order to be adored but solely in order to instruct the minds of the ignorant. It is not without reason that tradition permits the deeds of the saints to be depicted in holy places.

SOURCE: CAECIIA DAVIS-WEYER, *EARLY MEDIEVAL ART 300–1150*. (ENGLEWOOD CLIFFS, NJ: PRENTICE HALL, 1ST ED., 1971)

Nicholas Mesarites (ca. 1163–after 1214)

From *Description of the Church of the Holy Apostles*

The Church of the Holy Apostles in Constantinople, destroyed in the fifteenth century, was decorated with mosaics by the artist Eulalios in the twelfth cen-tury. This account of the mosaics was written by the poet Constantinus Rhodius toward the end of his life. The description is extremely lively, if slightly incomplete. (Certain standard subjects are omitted.) It essentially describes the program of the Twelve Great Feasts found in Middle and Late Byzantine mosaic and mural cycles.

The whole inner space has been covered with a mixture of gold and glass, as much as forms the domed roof and rise above the hollowed arches, down to [the revetment of] multicolored marbles and the second cornice. Represented here are the deeds and venerable forms which narrate the abasement of the Logos [Divine Word, God] and His presence among us mortals.

The first miracle is that of Gabriel bringing to a virgin maiden [the tidings of] the incarnation of the Logos and filling her with divine joy.

The second is that of Bethlehem and the cave, the Virgin's giving birth without pain, the Infant, wrapped in swaddling clothes, reclin-ing—O wonder—in a poor manger, the angels singing divine hymns, the rustic lyre of the shepherds sounding the song of God's nativity.

The third is the Magi hastening from Persia to do homage to the all-pure Logos.

The fourth is Simeon, the old man, bearing the infant Christ in his arms. And that strange old prophetess Anna foretelling for all to hear the deeds which the infant was destined to accomplish [The Presenta-tion in the Temple].

The fifth is the Baptism received from the hands of John by the stream of Jordan; the Father testifying to the Logos from above, and the Spirit coming down in the guise of a bird.

Sixth, you may see Christ ascending the thrice-glorious mount of Tabor together with a chosen band of disciples and friends, altering His mortal form; His face shining with rays more dazzling than those of the sun, His garments a luminous white [The Transfiguration].

Next, you may see the widow's son, who had been brought on a bier to his tomb, returning alive and joyful to his house [The Raising of the Widow's Son of Nain].

Then again, Lazarus, who had been laid in his grave and had rotten four days long leaping out of his tomb like a gazelle and returning once more to mortal life after escaping corruption.

Next, Christ mounted on a colt proceeding to the city of the God-slayers, the crowds, with branches and palm leaves acclaiming Him as the Lord when he arrives at the very gates of Zion.

In addition to all the above wonders, you will see Judas, that wretched man, betraying his Lord and teacher to be murdered by an evil and abominable people.

The seventh [actually, the eleventh] spectacle you will see among all these wonders is Christ's Passion [The Crucifixion]. Christ naked, stretched out on the cross between two condemned criminals, his hands and feet pierced with nails, hanging dead upon the wood of the cross and this in the sight of His mother, the pure Virgin, and the dis-ciple who is present at the Passion [St. Luke].

SOURCE: CYRIL MANGO, *THE ART OF THE BYZANTINE EMPIRE, 312–1453: SOURCES AND DOCUMENTS*. (ENGLEWOOD CLIFFS, NJ: PRENTICE HALL, 1ST ED., 1972)

The Qur'an: God's Promise of Paradise to Good Muslims (Sura 55 ["The All-Merciful"]: 45–78)

In this famous poetical passage from the Qur'an, with its dramatic repetition of a rhetorical challenge to those who would deny God's word, Paradise is pic-tured as a place where all of the sensual pleasures renounced by pious Muslims on Earth will be enjoyed on a higher and more spiritual level in the heavenly gardens that are promised to those who follow God's commandments.

But such as fears the Station of his Lord,
for them shall there be two gardens—
O which of your Lord's bounties will you and you deny?
Abounding in branches—
O which of your Lord's bounties will you and you deny?
Therein two fountains of running water—
O which of your Lord's bounties will you and you deny?
therein of every fruit two kinds—

O which of your Lord's bounties will you and you deny?
reclining upon couches lined with brocade,
the fruits of the gardens night to gather—
O which of your Lord's bounties will you and you deny?
therein maidens restraining their glances,
untouched before them by any man or jinn—
O which of your Lord's bounties will you and you deny?
lovely as rubies, beautiful as coral—
O which of your Lord's bounties will you and you deny?
Shall the recompense of goodness be other than goodness?
O which of your Lord's bounties will you and you deny?
And besides these shall be two gardens—
O which of your Lord's bounties will you and you deny?
green, green pastures—
O which of your Lord's bounties will you and you deny?
therein two fountains of gushing water
O which of your Lord's bounties will you and you deny?
Therein fruits, and palm-trees, and pomegranates—
O which of your Lord's bounties will you and you deny?
therein maidens good and comely—
O which of your Lord's bounties will you and you deny?
houris clustered in cool pavilions—
O which of your Lord's bounties will you and you deny?
untouched before them by any man or jinn,
O which of your Lord's bounties will you and you deny?
reclining upon green cushions and lovely drugged
O which of your Lord's bounties will you and you deny?
Blessed by the name of thy Lord, majestic and splendid.

SOURCE: QUR'AN, SURA 55, TR. A. J. ARBERRY (NY: SIMON AND SCHUSTER, 1955)

St. Benedict of Nursia (ca. 480–ca. 553)

From *The Rule*

Monastic communities generally had a rule, or set of regulations, prescribing the discipline of their members' daily life. The Rule *written by St. Benedict for his community at Monte Cassino in southern Italy was admired by Pope Gregory the Great and by Charlemagne, who obtained an exact copy of it when he visited Monte Cassino in 787.* The Rule *requires complete renunciation of the world in order to maintain a routine of collective prayer and chanting seven times a day, plus about four hours of reading and meditating on the Bible, and some manual labor.*

Chapter 16: *The Day Office*

The prophet says: "Seven times daily I have sung Your praises" (Ps. 119:164). We will cleave to this sacred number if we perform our monastic duties at Lauds, Prime, Tierce, Sext, None, Vespers and Compline.

Chapter 17: *The number of psalms said in the Day Office*

Three psalms are to be chanted for Prime, each with a separate Gloria. An appropriate hymn is sung, before the psalms. . . . After the psalms a lesson from the apostle is recited, and the Hour is finished with the versicle, the Kyrie and dismissal. The Hours of Tierce, Sext and None are to be conducted in the same order.

Chapter 22: *How the monks are to sleep*

All the monks shall sleep in separate beds. . . . If possible they should all sleep in one room. However, if there are too many for this, they will be grouped in tens or twenties, a senior in charge of each group. Let a candle burn throughout the night. They will sleep in their robes, belted but with no knives, thus preventing injury in slumber. The monks then will always be prepared to rise at the signal and hurry to the Divine Office. But they must make haste with gravity and modesty.

The younger brothers should not be next to each other. Rather their beds should be interspersed with those of their elders. When they arise for the Divine Office, they ought encourage each other, for the sleepy make many excuses.

Chapter 48: *Daily manual labor*

Idleness is an enemy of the soul. Therefore, the brothers should be occupied according to schedule in either manual labor or holy reading. . . . From Easter to October, the brothers shall work at manual labor from Prime until the fourth hour. From then until the sixth hour they should read. After dinner they should rest (in bed) in silence. However, should anyone desire to read, he should do so without disturbing his brothers.

None should be chanted at about the middle of the eighth hour. Then everyone shall work as they must until Vespers. If conditions dictate that they labor in the fields (harvesting), they should not be grieved for they are truly monks when they must live by manual labor, as did our fathers and the apostles. Everything should be in moderation, though, for the sake of the timorous. . . .

All shall read on Saturdays except those with specific tasks. If anyone is so slothful that he will not or cannot read or study, he will be assigned work so as not to be idle.

Chapter 53: *The reception of guests*

The kitchen of the abbot and guests should be separate from that of the community so as not to disturb the brothers, for the visitors, of whom there are always a number, come and go at irregular hours. . . .

No one may associate or converse with guests unless ordered. If one meets or sees a guest, he is to greet him with humility . . . and ask a blessing. If the guest speaks, the brother is to pass on, telling the guest that he is not permitted to speak.

Chapter 55: *Clothing and shoes*

Each monk needs only two each of tunics and cowls, so he will be prepared for night wear and washing. Anything else is superfluous and should be banished. . . .

Bedding shall consist of a mattress, coverlet, blanket and pillow. The abbot will make frequent inspections of the bedding to prevent hoarding. Any infractions are subject to the severest discipline and, so that this vice of private ownership may be cut away at the roots, the abbot is to furnish all necessities: cowl, tunic, shoes, stockings, belt, knife, pen, needle, towel and writing tablet.

Chapter 57: *Artisans and craftsmen*

Craftsmen present in the monastery should practice their crafts with humility, as permitted by the abbot. But if anyone becomes proud of his skill and the profit he brings the community, he should be taken from his craft and work at ordinary labor. This will continue until he humbles himself and the abbot is satisfied. If any of the works of these craftsmen are sold, the salesman shall take care to practice no fraud. . . .

In pricing, they should never show greed, but should sell things below the going secular rate.

Chapter 66: *The porter of the monastery*

The monastery should be planned, if possible, with all the necessities—water, mill, garden, shops—within the walls. Thus the monks will not need to wander about outside, for this is not good for their souls.

SOURCE: ANTHONY C. MEISEL, *THE RULE OF ST. BENEDICT.* TR. M. L. DEL MASTRO. (DOUBLEDAY, A DIVISION OF RANDOM HOUSE, INC., 1975)

From Pilgrim's Guide
to Santiago de Compostela

The Pilgrim's Guide, *written in the mid-twelfth century, describes notable sites along the routes to the shrine of the apostle James in Compostela (see map 11.2). The description of Sainte-Madeleine (the church of St. Mary Magdalen) at Vézelay recounts a medieval legend that Mary Magdalen journeyed to France after Christ's death and died in Aix-en-Provence.*

On the route that through Saint-Léonard stretches towards Santiago, the most worthy remains of the Blessed Mary Magdalene must first of all be rightly worshipped by the pilgrims. She is . . . that glorious Mary who, in the house of Simon the Leprous, watered with her tears the feet of the Savior, wiped them off with her hair, and anointed them with a precious ointment while kissing them most fervently. . . . It is she who, arriving after the Ascension of the Lord from the region of Jerusalem . . . went by sea as far as the country of Provence, namely the port of Marseille.

In that area she led for some years . . . a celibate life and, at the end, was given burial in the city of Aix. . . . But, after a long time, a distinguished man called Badilon, beatified in monastic life, transported her most precious earthly remains from that city to Vézelay, where they rest up to this day in a much honored tomb. In this place a large and most beautiful basilica as well as an abbey of monks were established. Thanks to her love, the faults of the sinners are here remitted by God, vision is restored to the blind, the tongue of the mute is untied, the lame stand erect, the possessed are delivered, and unspeakable benefices are accorded to many. Her sacred feast is celebrated on July 22.

SOURCE: *THE PILGRIM'S GUIDE TO SANTIAGO DE COMPOSTELA.* ED. AND TR. WILLIAM MELCZER. (NY: ITALICA PRESS, 1993)

Robert de Torigny (d. 1186)

From *Chronicle*

Chartres Cathedral burned twice in the twelfth century, in 1134 and 1194. This contemporary notice of the rebuilding of the west front (see fig. 12.4) in the 1140s stresses the participation of masses of lay volunteers. This kind of piety was later referred to as the "cult of the carts."

In this same year, primarily at Chartres, men began, with their own shoulders, to drag the wagons loaded with stone, wood, grain, and other materials to the workshop of the church, whose towers were then rising. Anyone who has not witnessed this will not see the like in our time. Not only there, but also in nearly the whole of France and Normandy and in many other places, [one saw] everywhere penance and the forgiveness of offenses, everywhere mourning and contrition. One might observe women as well as men dragging [wagons] through deep swamps on their knees, beating themselves with whips, numerous wonders occurring everywhere, canticles and hymns being offered to God.

SOURCE: *CHARTES CATHEDRAL.* ED. ROBERT BRANNER. (NY: W.W. NORTON AND CO., 1969)

Villard De Honnecourt (13th Century)

From *Sketchbook*

The first inscription below addresses the user of Villard's Sketchbook *and suggests what the book might be for. The others appear on the leaves shown in figures 12.20 and 12.21.*

Villard de Honnecourt greets you and begs all who will use the devices found in this book to pray for his soul and remember him. For in this book will be found sound advice on the virtues of masonry and the uses of carpentry. You will also find strong help in drawing figures according to the lessons taught by the art of geometry.

Here is a lion seen from the front. Please remember that he was drawn from life. This is a porcupine, a little beast that shoots its quills when aroused. Here below are the figures of the Wheel of Fortune, all seven of them correctly pictured.

SOURCE: *THE SKETCHBOOK OF VILLARD HONNECOURT.* ED. THEODORE BOWIE. (BLOOMINGTON, IN: INDIANA UNIVERSITY, 1962)

Anonymous

From *Meditations on the Life of Christ*

This late thirteenth-century text, addressed to a Franciscan nun, represents a longstanding tendency to embellish the New Testament account of Christ's life with apocryphal detail. Unlike earlier such embellishments, this one dwells especially on the emotions of the participants in the story. From the twelfth century on, worshipers (especially women) were encouraged to experience Scripture through visualization and emotion rather than as words alone. In its purpose, the Meditations *is related to such representations as in figure 12.56.*

Attend diligently and carefully to the manner of the Deposition. Two ladders are placed on opposite sides of the cross. Joseph [of Arimathea] ascends the ladder placed on the right side and tries to extract the nail from His hand. But this is difficult and it does not seem possible to do it without great pressure on the hand of the Lord. The nail pulled out, John makes a sign to Joseph to extend the said nail to him, that the Lady [Virgin Mary] might not see it. Afterwards Nicodemus extracts the other nail from the left hand and similarly gives it to John. Nicodemus descends and comes to the nail in the feet. Joseph supported the body of the Lord: happy indeed is this Joseph, who deserves thus to embrace the body of the Lord! The nail in the feet pulled out, Joseph descends part way, and all receive the body of the Lord and place it on the ground. The Lady supports the head and shoulders in her lap, the Magdalen the feet at which she had formerly found so much grace. The others stand about, all making a great bewailing over Him: all most bitterly bewail Him, as for a first-born son.

After some little time, when night approached, Joseph begged the Lady to permit them to shroud Him in linen cloths and bury Him. She strove against this, saying, "My friends, do not wish to take my Son so soon; or else bury me with Him." She wept uncontrollable tears; she looked at the wounds in His hands and side, now one, now the other; she gazed at His face and head and saw the marks of the thorns, the tearing of His beard, His face filthy with spit and blood, His shorn head; and she could not cease from weeping and looking at Him. The hour growing late, John said, "Lady, let us bow to Joseph and Nicodemus and allow them to prepare and bury the body of our Lord." She resisted no longer, but blessed Him and permitted Him to be prepared and shrouded. The Magdalen seemed to faint with sorrow. She gazed at the feet, so wounded, pierced, dried out, and bloody: she wept with great bitterness. Her heart could hardly remain in her body for sorrow; and it can well be thought that she would gladly have died, if she could, at the feet of the Lord.

SOURCE: *MEDITATIONS ON THE LIFE OF CHRIST.* TR. ISA RAGUSA. (PRINCETON, NJ: PRINCETON UNIVERSITY PRESS, 1961)

Giovanni Boccaccio (1313–1375)

Decameron, from "The First Day"

The young people who tell the 100 stories of Boccaccio's Decameron have fled Florence to escape the bubonic plague. At the beginning of the book, Boccaccio describes the horror of the disease and the immensity of the epidemic, as well as the social dissolution it produced.

The years of the fruitful Incarnation of the Son of God had attained to the number of one thousand three hundred and forty-eight, when into the notable city of Florence, fair over every other of Italy, there came the death-dealing pestilence, through the operation of the heavenly bodies or of our own iniquitous doings, being sent down upon mankind for our correction by the just wrath of God.... In men and women alike there appeared, at the beginning of the malady, certain swellings, either on the groin or under the armpits, whereof some waxed to the bigness of a common apple, others to the size of an egg, and these the vulgar named plague-boils. From these two parts the aforesaid death-bearing plague-boils proceeded, in brief space, to appear and come indifferently in every part of the body; wherefrom, after awhile, the fashion of the contagion began to change into black or livid blotches....

Well-nigh all died within the third day from the appearance of the aforesaid signs, this one sooner and that one later, and for the most part without fever or other complication. ... The mere touching of the clothes or of whatsoever other thing had been touched or used by the sick appeared of itself to communicate the malady to the toucher. ...

Well-nigh all tended to a very barbarous conclusion, namely, to shun and flee from the sick and all that pertained to them.... Some there were who conceived that to live moderately and keep oneself from all excess was the best defense; they lived removed from every other, taking refuge and shutting themselves up in those houses where none were sick and where living was best.... Others, inclining to the contrary opinion, maintained that to carouse and make merry and go about singing and frolicking and satisfy the appetite in everything possible and laugh and scoff at whatsoever befell was a very certain remedy for such an ill....

The common people (and also, in great part, the middle class) fell sick by the thousand daily and being altogether untended and unsuccored, died well-nigh all without recourse. Many breathed their last in the open street, by day and by night, while many others, though they died in their homes, made it known to the neighbors that they were dead rather by the stench of their rotting bodies than otherwise; and of these and others who died all about, the whole city was full.... The consecrated ground not sufficing for the burial of the vast multitude of corpses there were made throughout the churchyards, vast trenches, in which those who came were laid by the hundred, being heaped up therein by layers, as goods are stowed aboard ship....

So great was the cruelty of heaven that, between March and the following July, it is believed for certain that upward of a hundred thousand human beings perished within the walls of the city of Florence. ... Alas, how many great palaces, how many goodly houses, how many noble mansions, once full of families, of lords and of ladies, remained empty even to the meanest servant! How many memorable families, how many ample heritages, how many famous fortunes were seen to remain without lawful heir! How many valiant men, how many fair ladies, how many sprightly youths, breakfasted in the morning with their kinsfolk, comrades and friends and that same night supped with their ancestors in the other world!

SOURCE: GIOVANNI BOCCACCIO. *THE DECAMERON*. TR. JOHN PAYNE, REV. CHARLES S. SINGLETON. (BERKELEY, CA: UNIVERSITY OF CALIFORNIA PRESS, 1984)

Petrarch (1304–1374)

Sonnet from the *Rime Sparse*, n. 77. (Translation by A. S. Kline).

The humanist Petrarch encountered the unattainable Laura in Avignon, and immortalized his love for her in many sonnets. This poem, number 77 from his Rime Sparse (Scattered Rhymes), describes his reaction to a portrait of Laura painted by his friend, the Sienese painter Simone Martini. The portrait itself does not survive, but Petrarch's words make a comparison between the fourteenth-century painter and the famous Greek Sculptor, Polyclitus. Such learned references to the ancients in service of human emotion parallels the innovations of visual artists who explored the emotional content of religious narratives.

Polyclitus gazing fixedly a thousand years
with the others who were famous in his art,
would not have seen the least part
of the beauty that has vanquished my heart.

But Simone must have been in Paradise
(from where this gentle lady came)
saw her there, and portrayed her in paint,
to give us proof here of such loveliness.

This work is truly one of those that might
be conceived in heaven, not among us here,
where we have bodies that conceal the soul.

Grace made it: he could work on it no further
when he'd descended to our heat and cold,
where his eyes had only mortal seeing.

SOURCE: PETRARCH. THE CANZONIERE, SONNET 77. TR. A.S. KLINE. HTTP://WWW. TONYKLINE.CO.UK

Dante Alighieri (1265–1321)

The Divine Comedy: Purgatory, from Canto X

In the first circle of Purgatory are those guilty of the sin of pride. Dante meets a famous manuscript illuminator who has learned the vanity of pride and the fleeting nature of fame, illustrated by the rapidity with which Giotto eclipsed Cimabue.

"Oh!" I said, "*you* must be that Oderisi,
honor of Gubbio, honor of the art
which men in Paris call 'Illuminating.'"

"The pages Franco Bolognese paints,"
he said, "my brother, smile more radiantly;
his is the honor now—mine is far less.

Less courteous would I have been to him,
I must admit, while I was still alive
and my desire was only to excel.

For pride like that the price is paid up here;
I would not even be here, were it not
that, while I still could sin, I turned to God.

Oh, empty glory of all human power!
How soon the green fades from the topmost bough,
unless the following season shows no growth!

Once Cimabue thought to hold the field
as painter; Giotto now is all the rage,
dimming the lustre of the other's fame."

SOURCE: *DANTE ALIGHIERI'S DIVINE COMEDY*. TR. MARK MUSA. (BLOOMINGTON, IN: INDIANA UNIVERSITY, 1986)

Glossary

ABACUS. A slab of stone at the top of a Classical capital just beneath the architrave.

ABBEY. (1) A religious community headed by an abbot or abbess. (2) The buildings that house the community. An abbey church often has an especially large choir to provide space for the monks or nuns.

ACADEMY. A place of study, the word coming from the Greek name of a garden near Athens where Plato and, later, Platonic philosophers held philosophical discussions from the 5th century BCE to the 6th century CE. The first academy of fine arts was the Academy of Drawing, founded 1563 in Florence by Giorgio Vasari. Later academies were the Royal Academy of Painting and Sculpture in Paris, founded 1648, and the Royal Academy of Arts in London, founded 1768. Their purpose was to foster the arts by teaching, by exhibitions, by discussion, and occasionally by financial aid.

ACANTHUS. (1) A Mediterranean plant having spiny or toothed leaves. (2) An architectural ornament resembling the leaves of this plant, used on moldings, friezes, and Corinthian capitals.

ACROTERION (pl. **ACROTERIA**). Decorative ornaments placed at the apex and the corners of a pediment.

ACRYLIC. A plastic binder medium for pigments that is soluble in water. Developed about 1960.

ACTION PAINTING. In Abstract art, the spontaneous and uninhibited application of paint, as practiced by the avant-garde from the 1930s through the 1950s.

AERIAL PERSPECTIVE. See *perspective.*

AISLE. The passageway or corridor of a church that runs parallel to the length of the building. It often flanks the nave of the church but is sometimes set off from it by rows of piers or columns.

ALBUMEN PRINT. A process in photography that uses the proteins found in eggs to produce a photographic plate.

ALLA PRIMA. A painting technique in which pigments are laid on in one application with little or no underpainting.

ALTAR. A mound or structure on which sacrifices or offerings are made in the worship of a deity. In a Catholic church, a tablelike structure used in celebrating the Mass.

ALTARPIECE. A painted or carved work of art placed behind and above the altar of a Christian church. It may be a single panel or a *triptych* or a *polytych*, both having hinged wings painted on both sides. Also called a reredos or retablo.

ALTERNATE SYSTEM. A system developed in Romanesque church architecture to provide adequate support for a *groin-vaulted nave* having *bays* twice as long as the side-aisle bays. The *piers* of the nave *arcade* alternate in size; the heavier *compound piers* support the main nave vaults where the *thrust* is concentrated, and smaller, usually cylindrical, piers support the side-aisle vaults.

AMAZON. One of a tribe of female warriors said in Greek legend to dwell near the Black Sea.

AMBULATORY. A covered walkway. (1) In a basilican church, the semicircular passage around the apse. (2) In a central-plan church, the ring-shaped aisle around the central space. (3) In a cloister, the covered colonnaded or arcaded walk around the open courtyard.

AMPHITHEATER. A double theater. A building, usually oval in plan, consisting of tiers of seats and access corridors around the central theater area.

AMPHORA (pl. **AMPHORAE**). A large Greek storage vase with an oval body usually tapering toward the base. Two handles extend from just below the lip to the shoulder.

ANDACHTSBILD. German for "devotional image." A picture or sculpture with imagery intended for private devotion. It was first developed in Northern Europe.

ANIMAL STYLE. A style that appears to have originated in ancient Iran and is characterized by stylized or abstracted images of animals.

ANNULAR. From the Latin word for "ring." Signifies a ring-shaped form, especially an annular barrel vault.

ANTA (pl. **ANTAE**). The front end of a wall of a Greek temple, thickened to produce a pilasterlike member. Temples having columns between the antae are said to be "*in antis.*"

APOCALYPSE. The Book of Revelation, the last book of the New Testament. In it, St. John the Evangelist describes his visions, experienced on the island of Patmos, of Heaven, the future of humankind, and the Last Judgment.

APOSTLE. One of the twelve disciples chosen by Jesus to accompany him in his lifetime and to spread the gospel after his death. The traditional list includes Andrew, Bartholomew, James the Greater (son of Zebedee), James the Lesser (son of Alphaeus), John, Judas Iscariot, Matthew, Peter, Philip, Simon the Canaanite, Thaddaeus (or Jude), and Thomas. In art, however, the same twelve are not always represented, since "apostle" was sometimes applied to other early Christians, such as St. Paul.

APSE. A semicircular or polygonal niche terminating one or both ends of the nave in a Roman basilica. In a Christian church, it is usually placed at the east end of the nave beyond the transept or choir. It is also sometimes used at the end of transept arms.

APSIDIOLE. A small apse or chapel connected to the main apse of a church.

AQUATINT. A print processed like an etching, except that the ground or certain areas are covered with a solution of asphalt, resin, or salts that, when heated, produces a granular surface on the plate and rich gray tones in the final print. Etched lines are usually added to the plate after the aquatint ground is laid.

AQUEDUCT. Latin for "duct of water." (1) An artificial channel or conduit for transporting water from a distant source. (2) The overground structure that carries the conduit across valleys, rivers, etc.

ARCADE. A series of arches supported by piers or columns. When attached to a wall, these form a blind arcade.

ARCH. A curved structure used to span an opening. Masonry arches are generally built of wedge-shaped blocks, called *voussoirs*, set with their narrow sides toward the opening so that they lock together. The topmost *voussoir* is called the *keystone*. Arches may take different shapes, such as the pointed Gothic arch or the rounded Classical arch.

ARCHBISHOP. The chief bishop of an ecclesiastic district.

ARCHITECTURAL ORDER. An architectural system based on the column and its entablature, in which the form of the elements themselves (capital, shaft, base, etc.) and their relationship to each other are specifically defined. The five Classical orders are the Doric, Ionic, Corinthian, Tuscan, and Composite.

ARCHITRAVE. The lowermost member of a classical entablature, such as a series of stone blocks that rest directly on the columns.

ARCHIVOLT. A molded band framing an arch, or a series of such bands framing a tympanum, often decorated with sculpture.

ARCUATION. The use of arches or a series of arches in building.

ARIANISM. Early Christian belief, initiated by Arius, a 4th-century CE priest in Alexandria. It was later condemned as heresy and suppressed, and it is now largely obscure.

ARRICCIO. A coating of rough plaster over a stone or cement wall that is used as a smooth base or ground (support) in fresco painting.

ART BRUT. Meaning "raw art" in French, *art brut* is the direct and highly emotional art of children and the mentally ill that served as an inspiration for some artistic movements in Modern art.

ASHLAR MASONRY. Carefully finished stone that is set in fine joints to create an even surface.

ATRIUM. (1) The central court or open entrance court of a Roman house. (2) An open court, sometimes colonnaded or arcaded, in front of a church.

ATTIC. A low upper story placed above the main cornice or entablature of a building and often decorated with windows and pilasters.

AUTOCHROME. A color photograph invented by Louis Lumière in 1903 using a glass plate covered with grains of starch dyed in three colors to act as filters and then a silver bromide emulsion.

AUTOMATIC DRAWING. A technique of drawing in Modern art whereby the artist tries to minimize his or her conscious and intellectual control over the lines or patterns drawn, relying instead on subconscious impulses to direct the drawing.

AVANT-GARDE. Meaning "advance force" in French, the artists of the avant-garde in 19th- and 20th-century Europe led the way in innovation in both subject matter and technique, rebelling against the established conventions of the art world.

BACCHANT (fem. **BACCHANTE**). A priest or priestess of the wine god, Bacchus (in Greek mythology, Dionysus), or one of his ecstatic female followers, who were sometimes called maenads.

BALDACCHINO. A canopy usually built over an altar. The most important one is Bernini's construction for St. Peter's in Rome.

BALUSTRADE. (1) A railing supported by short pillars called balusters. (2) Occasionally applied to any low parapet.

BANQUET PIECE. A variant of the still life, the banquet piece depicts an after-meal scene. It focuses more on tableware than food and typically incorporates a vanitas theme.

BAPTISTRY. A building or a part of a church in which the sacrament of baptism is administered. It is

often octagonal in design, and it contains a baptismal *font*, or a receptacle of stone or metal that holds the Holy Water for the rite.

BARREL VAULT. A vault formed by a continuous semicircular arch so that it is shaped like a half-cylinder.

BAR TRACERY. A style of tracery in which glass is held in place by relatively thin membranes.

BAS-DE-PAGE. Literally "bottom of the page." An illustration or decoration that is placed below a block of text in an illuminated manuscript.

BASE. (1) The lowermost portion of a column or pier, beneath the shaft. (2) The lowest element of a wall, dome, or building or occasionally of a statue or painting.

BASILICA. (1) In ancient Roman architecture, a large, oblong building used as a public meeting place and hall of justice. It generally includes a nave, side aisles, and one or more apses. (2) In Christian architecture, a longitudinal church derived from the Roman basilica and having a nave, an apse, two or four side aisles or side chapels, and sometimes a narthex. (3) Any one of the seven original churches of Rome or other churches accorded the same religious privileges.

BATTLEMENT. A parapet consisting of alternating solid parts and open spaces designed originally for defense and later used for decoration. See *crenelated.*

BAY. A subdivision of the interior space of a building. Usually a series of bays is formed by consecutive architectural supports.

BELVEDERE. A structure made for the purpose of viewing the surroundings, either above the roof of a building or freestanding in a garden or other natural setting.

BENEDICTINE ORDER. Founded at Monte Cassino in 529 CE by St. Benedict of Nursia (ca. 480–ca. 553). Less austere than other early orders, it spread throughout much of western Europe and England in the next two centuries.

BIBLE MORALISÉE. A type of illustrated Bible in which each page typically contains four pairs of illustrations representing biblical events and their related lessons.

BISHOP. The spiritual overseer of a number of churches or a diocese. His throne, or cathedra, placed in the principal church of the diocese, designates it as a cathedral.

BLACK-FIGURED. A style of ancient Greek pottery decoration characterized by black figures against a red background. The black-figured style preceded the red-figured style.

BLIND ARCADE. An arcade with no openings. The arches and supports are attached decoratively to the surface of a wall.

BLOCK BOOKS. Books, often religious, of the 15th century containing woodcut prints in which picture and text were usually cut into the same block.

BODEGÓNES. Although in modern Spanish *bodegón* means "still life," in 17th-century Spain, *bodegónes* referred to genre paintings that included food and drink, as in the work of Velázques.

BOOK COVER. The stiff outer covers protecting the bound pages of a book. In the medieval period, they were frequently covered with precious metal and elaborately embellished with jewels, embossed decoration, etc.

BOOK OF HOURS. A private prayer book containing the devotions for the seven canonical hours of the Roman Catholic church (matins, vespers, etc.), liturgies for local saints, and sometimes a calendar. They were often elaborately illuminated for persons of high rank, whose names are attached to certain extant examples.

BRACKET. A stone, wooden, or metal support projecting from a wall and having a flat top to bear the weight of a statue, cornice, beam, etc. The lower part

may take the form of a scroll; it is then called a scroll bracket.

BROKEN PEDIMENT. See *pediment.*

BRONZE AGE. The earliest period in which bronze was used for tools and weapons. In the Middle East, the Bronze Age succeeded the Neolithic period in ca. 3500 BCE and preceded the Iron Age, which commenced ca. 1900 BCE.

BRUSH DRAWING. See *drawing.*

BUON FRESCO. See *fresco.*

BURIN. A pointed metal tool with a wedged-shaped tip used for engraving.

BUTTRESS. A projecting support built against an external wall, usually to counteract the lateral thrust of a vault or arch within. In Gothic church architecture, a *flying buttress* is an arched bridge above the aisle roof that extends from the upper nave wall, where the lateral thrust of the main vault is greatest, down to a solid pier.

BYZANTIUM. City on the Sea of Marmara, founded by the ancient Greeks and renamed Constantinople in 330 CE. Today called Istanbul.

CAESAR. The surname of the Roman dictator, Caius Julius Caesar, subsequently used as the title of an emperor; hence, the German Kaiser and the Russian czar (tsar).

CALLIGRAPHY. From the Greek word for "beautiful writing." (1) Decorative or formal handwriting executed with a quill or reed pen or with a brush. (2) A design derived from or resembling letters and used to form a pattern.

CALOTYPE. Invented in the 1830s, calotype was the first photographic process to use negatives and positive prints on paper.

CALVARY. The hill outside Jerusalem where Jesus was crucified, also known as *Golgotha.* The name *Calvary* is taken from the Latin word *calvaris,* meaning skull; the word *Golgotha* is the Greek transliteration of the word for "skull" in Aramaic. The hill was thought to be the spot where Adam was buried and was thus traditionally known as "the place of the skull." See *Golgotha.*

CAMEO. A low relief carving made on agate, seashell, or other multilayered material in which the subject, often in profile view, is rendered in one color while the background appears in another, darker color.

CAMERA OBSCURA. Latin for "dark room." A darkened enclosure or box with a small opening or lens on one wall through which light enters to form an inverted image on the opposite wall. The principle had long been known but was not used as an aid in picture making until the 16th century.

CAMES. Strips of lead in stained-glass windows that hold the pieces of glass together.

CAMPAGNA. Italian word for "countryside." When capitalized, it usually refers to the countryside near Rome.

CAMPANILE. From the Italian word *campana,* meaning "bell." A bell tower that is either round or square and is sometimes free-standing.

CAMPOSANTO. Italian word for "holy field." A cemetery near a church, often enclosed.

CANON. A law, rule, or standard.

CANOPY. In architecture, an ornamental, rooflike projection or cover above a statue or sacred object.

CAPITAL. The uppermost member of a column or pillar supporting the architrave.

CARDINAL. In the Roman Catholic church, a member of the Sacred college, the ecclesiastical body that elects the pope and constitutes his advisory council.

CARMELITE ORDER. Originally a 12th-century hermitage claimed to descend from a community of hermits established by the prophet Elijah on Mt.

Carmel, Palestine. In the early 13th century it spread to Europe and England, where it was reformed by St. Simon Stock and became one of the three great mendicant orders.

CARTHUSIAN ORDER. An order founded at Chartreuse, France, by Saint Bruno in 1084; known for its very stringent rules. See *Chartreuse.*

CARTOON. From the Italian word *cartone,* meaning "large paper." (1) A full-scale drawing for a picture or design intended to be transferred to a wall, panel, tapestry, etc. (2) A drawing or print, usually humorous or satirical, calling attention to some action or person of popular interest.

CARVING. (1) The cutting of a figure or design out of a solid material such as stone or wood, as contrasted to the additive technique of modeling. (2) A work executed in this technique.

CARYATID. A sculptured female figure used in place of a column as an architectural support. A similar male figure is an *atlas* (pl. *atlantes*).

CASEMATE. A chamber or compartment within a fortified wall, usually used for the storage of artillery and munitions.

CASSONE (pl. *CASSONI*). An Italian dowry chest often highly decorated with carvings, paintings, inlaid designs, and gilt embellishments.

CASTING. A method of duplicating a work of sculpture by pouring a hardening substance such as plaster or molten metal into a mold.

CAST IRON. A hard, brittle iron produced commercially in blast furnaces by pouring it into molds where it cools and hardens. Extensively used as a building material in the early 19th century, it was superseded by steel and ferroconcrete.

CATACOMBS. The underground burial places of the early Christians, consisting of passages with niches for tombs and small chapels for commemorative services.

CATALOGUE RAISONNÉ. A complete list of an artist's works of art, with a comprehensive chronology and a discussion of the artist's style.

CATHEDRA. The throne of a bishop, the principal priest of a diocese. See *cathedral.*

CATHEDRAL. The church of a bishop; his administrative headquarters. The location of his *cathedra* or throne.

CELLA. (1) The principal enclosed room of a temple used to house an image. Also called the *naos.* (2) The entire body of a temple as distinct from its external parts.

CENTERING. A wooden framework built to support an arch, vault, or dome during its construction.

CENTRAL-PLAN CHURCH. (1) A church having four arms of equal length. The crossing is often covered with a dome. Also called a Greek-cross church. (2) A church having a circular or polygonal plan.

CHAMPLEVÉ. An enameling method in which hollows are etched into a metal surface and filled with enamel.

CHANCEL. The area of a church around the altar, sometimes set off by a screen. It is used by the clergy and the choir.

CHAPEL. (1) A private or subordinate place of worship. (2) A place of worship that is part of a church but separately dedicated.

CHARTREUSE. French word for a Carthusian monastery (in Italian, Certosa). The Carthusian Order was founded by St. Bruno (ca. 1030–1101) at Chartreuse near Grenoble in 1084. It is an eremitic order, the life of the monks being one of silence, prayer, and austerity.

CHASING. (1) A technique of ornamenting a metal surface by the use of various tools. (2) The procedure used to finish a raw bronze cast.

CHÂTEAU (pl. **CHÂTEAUS** or **CHÂTEAUX**). French word for "castle," now used to designate a large country house as well.

CHEVET. In Gothic architecture, the term for the developed and unified east end of a church, including choir, apse, ambulatory, and radiating chapels.

CHEVRON. A V-shaped decorative element that, when used repeatedly, gives a horizontal, zigzag appearance.

CHIAROSCURO. Italian word for "light and dark." In painting, a method of modeling form primarily by the use of light and shade.

CHOIR. In church architecture, a square or rectangular area between the apse and the nave or transept. It is reserved for the clergy and the singing choir and is usually marked off by steps, a railing, or a choir screen. Also called the *chancel.*

CHOIR SCREEN. A screen, frequently ornamented with sculpture and sometimes called a *rood screen*, separating the choir of a church from the nave or transept. In Orthodox Christian churches it is decorated with icons and thus called an *iconostasis.*

CHRISTOLOGICAL CYCLE. A series of illustrations depicting the life of Jesus Christ.

CIRE-PERDU PROCESS. The lost-wax process of casting. A method in which an original is modeled in wax or coated with wax, then covered with clay. When the wax is melted out, the resulting mold is filled with molten metal (often bronze) or liquid plaster.

CISTERCIAN ORDER. Founded at Cîteaux in France in 1098 by Robert of Molesme with the objective of reforming the Benedictine Order and reasserting its original ideals of a life of severe simplicity.

CITY-STATE. An autonomous political unit comprising a city and the surrounding countryside.

CLASSICISM. Art or architecture that harkens back to and relies upon the style and canons of the art and architecture of ancient Greece or Rome, which emphasize certain standards of balance, order, and beauty.

CLERESTORY. A row of windows in the upper part of a wall that rises above an adjoining roof. Its purpose is to provide direct lighting, as in a basilica or church.

CLOISONNÉ. An enameling method in which the hollows created by wires joined to a metal plate are filled with enamel to create a design.

CLOISTER. (1) A place of religious seclusion such as a monastery or nunnery. (2) An open court attached to a church or monastery and surrounded by an ambulatory. Used for study, meditation, and exercise.

CLUNIAC ORDER. Founded at Cluny, France, by Berno of Baume in 909. It had a leading role in the religious reform movement in the Middle Ages and had close connections to Ottonian rulers and to the papacy.

CODEX (pl. **CODICES**). A manuscript in book form made possible by the use of parchment instead of papyrus. During the 1st to 4th centuries CE, it gradually replaced the *rotulus*, or "scroll," previously used for written documents.

COFFER. (1) A small chest or casket. (2) A recessed, geometrically shaped panel in a ceiling. A ceiling decorated with these panels is said to be coffered.

COLLAGE. A composition made of cut and pasted scraps of materials, sometimes with lines or forms added by the artist.

COLONNADE. A series of regularly spaced columns supporting a lintel or entablature.

COLONNETTE. A small, often decorative, column that is connected to a wall or pier.

COLOPHON. (1) The production information given at the end of a book. (2) The printed emblem of a book's publisher.

COLOR-FIELD PAINTING. A technique of Abstract painting in which thinned paints are spread onto an unprimed canvas and allowed to soak in with minimal control by the artist.

COLOSSAL ORDER. Columns, piers, or pilasters in the shape of the Greek or Roman orders but that extend through two or more stories rather than following the Classical proportions.

COLUMN. An approximately cylindrical, upright architectural support, usually consisting of a long, relatively slender shaft, a base, and a capital. When imbedded in a wall, it is called an engaged column. Columns decorated with wraparound reliefs were used occasionally as freestanding commemorative monuments.

COMPOSITE IMAGE. An image formed by combining different images or different views of the subject.

COMPOUND PIER. A pier with attached pilasters or shafts.

CONCRETE. A mixture of sand or gravel with mortar and rubble invented in the ancient Near East and further developed by the Romans. Largely ignored during the Middle Ages, it was revived by Bramante in the early 16th century for St. Peter's.

CONTÉ CRAYON. A crayon made of graphite and clay used for drawing. Produces rich, velvety tones.

CONTINUOUS NARRATION. Portrayal of the same figure or character at different stages in a story that is depicted in a single artistic space.

CONTRAPPOSTO. Italian word for "set against." A composition developed by the Greeks to represent movement in a figure. The parts of the body are placed asymmetrically in opposition to each other around a central axis, and careful attention is paid to the distribution of weight.

CORBEL. (1) A bracket that projects from a wall to aid in supporting weight. (2) The projection of one course, or horizontal row, of a building material beyond the course below it.

CORBEL VAULT. A vault formed by progressively projecting courses of stone or brick, which eventually meet to form the highest point of the vault.

CORINTHIAN STYLE. An ornate Classical style of architecture, characterized in part by columns combining a fluted shaft with a capital made up of carved acanthus leaves and scrolls (*volutes*).

CORNICE. (1) The projecting, framing members of a classical pediment, including the horizontal one beneath and the two sloping or "raking" ones above. (2) Any projecting, horizontal element surmounting a wall or other structure or dividing it horizontally for decorative purposes.

COUNTER-REFORMATION. The movement of self-renewal and reform within the Roman Catholic church following the Protestant Reformation of the early 16th century and attempting to combat its influence. Also known as the Catholic Reform. Its principles were formulated and adopted at the Council of Trent, 1545–1563.

COURT STYLE. See *Rayonnant.*

CRENELATED. Especially in medieval Europe, the up-and-down notched walls (*battlements*) of fortified buildings and castles; the *crenels* served as openings for the use of weapons and the higher *merlons* as defensive shields.

CROMLECH. From the Welsh for "concave stone." A circle of large upright stones probably used as the setting for ritual ceremonies in prehistoric Britain.

CROSSHATCHING. In drawing and etching, parallel lines drawn across other parallel lines at various angles to represent differences in values and degrees of shading. See also *hatching.*

CROSSING. The area in a church where the transept crosses the nave, frequently emphasized by a dome or crossing tower.

CROSS SECTION. (1) In architecture, a drawing that shows a theoretical slice through a building along an imagined plane in order to reveal the design of the structure. (2) An imagined slice through any object along an imagined plane in order to reveal its structure.

CRYPT. A space, usually vaulted, in a church that sometimes causes the floor of the choir to be raised above that of the nave; often used as a place for tombs and small chapels.

CUNEIFORM. The wedge-shaped characters made in clay by the ancient Mesopotamians as a writing system.

CURTAIN WALL. A wall of a modern building that does not support the building; the building is supported by an underlying steel structure rather than by the wall itself, which serves the purpose of a facade.

CYCLOPEAN. An adjective describing masonry with large, unhewn stones, thought by the Greeks to have been built by the Cyclopes, a legendary race of one-eyed giants.

DAGUERREOTYPE. Originally, a photograph on a silver-plated sheet of copper, which had been treated with fumes of iodine to form silver iodide on its surface and then after exposure developed by fumes of mercury. The process, invented by L. J. M. Daguerre and made public in 1839, was modified and accelerated as daguerreotypes gained popularity.

DECALCOMANIA. A technique developed by the artist Max Ernst that uses pressure to transfer paint to a canvas from some other surface.

DEËSIS. From the Greek word for "entreaty." The representation of Christ enthroned between the Virgin Mary and St. John the Baptist, frequent in Byzantine mosaics and depictions of the Last Judgment. It refers to the roles of the Virgin Mary and St. John the Baptist as intercessors for humankind.

DENTIL. A small, rectangular, tooth-like block in a series, used to decorate a classical entablature.

DIKKA. An elevated, flat-topped platform in a mosque used by the muezzin or cantor.

DIORITE. An igneous rock, extremely hard and usually black or dark gray in color.

DIPTYCH. (1) Originally a hinged, two-leaved tablet used for writing. (2) A pair of ivory carvings or panel paintings, usually hinged together.

DIPYLON VASE. A Greek funerary vase with holes in the bottom through which libations were poured to the dead. Named for the cemetery near Athens where the vases were found.

DISGUISED SYMBOLISM. "Hidden" meaning in the details of a painting that carry a symbolic message.

DOLMEN. A structure formed by two or more large, upright stones capped by a horizontal slab. Thought to be a prehistoric tomb.

DOME. A true dome is a vaulted roof of circular, polygonal, or elliptical plan, formed with hemispherical or ovoidal curvature. May be supported by a circular wall or drum and by pendentives or related constructions. Domical coverings of many other sorts have been devised.

DOME VAULT. The arched sections of a dome that, joined together, form the rounded shape of a dome. See *dome, vault,* and *arch.*

DOMINICAN ORDER. Founded as a mendicant order by St. Dominic in Toulouse in 1220.

DOMUS. Latin word for "house." A detached, one-family Roman house with rooms frequently grouped around two open courts. The first court, called the *atrium*, was used for entertaining and conducting business. The second court, usually with a garden and surrounded by a *peristyle* or colonnade, was for the private use of the family.

DONOR. The patron or client at whose order a work of art was executed; the donor may be depicted in the work.

DORIC STYLE. A simple style of Classical architecture, characterized in part by smooth or fluted column shafts and plain, cushionlike capitals, and a frieze of *metopes* and *triglyphs.*

DRAWING. (1) A work in pencil, pen and ink, charcoal, etc., often on paper. (2) A similar work in ink or wash, etc., made with a brush and often called a brush drawing. (3) A work combining these or other techniques. A drawing may be large or small, a quick sketch or an elaborate work. Among its various forms are a record of something seen, a study for another work, an illustration associated with a text, and a technical aid.

DRESSED STONE. A masonry technique in which exposed stones are finished, or dressed, to produce a surface that is smooth and formal.

DRÔLERIES. French word for "jests." Used to describe the lively animals and small figures in the margins of late medieval manuscripts and in wood carvings on furniture.

DRUM. (1) A section of the shaft of a column. (2) A circular-shaped wall supporting a dome.

DRYPOINT. A type of *intaglio* printmaking in which a sharp metal needle is use to carve lines and a design into a (usually) copper plate. The act of drawing pushes up a burr of metal filings, and so, when the plate is inked, ink will be retained by the burr to create a soft and deep tone that will be unique to each print. The burr can only last for a few printings. Both the print and the process are called drypoint.

EARTHWORKS. Usually very large scale, outdoor artwork that is produced by altering the natural environment.

ECHINUS. In the Doric or Tuscan Order, the round, cushionlike element between the top of the shaft and the abacus.

ELEVATION. (1) An architectural drawing presenting a building as if projected on a vertical plane parallel to one of its sides. (2) Term used in describing the vertical plane of a building.

EMBLEM BOOK. A reference book for painters of Christian subjects that provides examples of objects and events associated with saints and other religious figures.

EMBOSSING. A metalworking technique in which a relief design is raised by hammering into the back side of a metal sheet.

EMPIRICISM. The philosophical and scientific idea that knowledge should be attained through observation and the accumulation of evidence through repeatable experiments.

ENAMEL. (1) Colored glassy substances, either opaque or translucent, applied in powder form to a metal surface and fused to it by firing. Two main techniques developed: champlevé (from the French for "raised field"), in which the areas to be treated are dug out of the metal surface; and cloisonné (from the French for "partitioned"), in which compartments or cloisons to be filled are made on the surface with thin metal strips. (2) A work executed in either technique.

ENCAUSTIC. A technique of painting with pigments dissolved in hot wax.

ENGAGED COLUMN. A column that is joined to a wall, usually appearing as a half-rounded vertical shape.

ENGRAVING. (1) A means of embellishing metal surfaces or gemstones by incising a design on the surface. (2) A print made by cutting a design into a metal plate (usually copper) with a pointed steel tool known as a burin. The burr raised on either side of the incised line is removed. Ink is then rubbed into the V-shaped grooves and wiped off the surface. The plate, covered with a damp sheet of paper, is run through a heavy press. The image on the paper is the reverse of that on the plate. When a fine steel needle is used instead of a burin and the burr is retained, a drypoint engraving results, characterized by a softer line. These techniques are called, respectively, engraving and drypoint.

ENTABLATURE. (1) In a classical order, the entire structure above the columns; this usually includes architrave, frieze, and cornice. (2) The same structure in any building of a classical style.

ENTASIS. A swelling of the shaft of a column.

ENVIRONMENT. In art, environment refers to the Earth itself as a stage for Environmental art, works that can be enormously large yet very minimal and abstract. These works can be permanent or transitory. The term Earth art is also used to describe these artworks.

ETCHING. (1) A print made by coating a copperplate with an acid-resistant resin and drawing through this ground, exposing the metal with a sharp instrument called a *stylus*. The plate is bathed in acid, which eats into the lines; it is then heated to remove the resin and finally inked and printed on paper. (2) The technique itself is also called etching.

EUCHARIST. (1) The sacrament of Holy Communion, the celebration in commemoration of the Last Supper. (2) The consecrated bread and wine used in the ceremony.

EVANGELISTS. Matthew, Mark, Luke, and John, traditionally thought to be the authors of the Gospels, the first four books of the New Testament, which recount the life and death of Christ. They are usually shown with their symbols, which are probably derived from the four beasts surrounding the throne of the Lamb in the Book of Revelation or from those in the vision of Ezekial: a winged man or angel for Matthew, a winged lion for Mark, a winged ox for Luke, and an eagle for John. These symbols may also represent the evangelists.

FACADE. The principle face or the front of a building.

FAIENCE. (1) A glass paste fired to a shiny opaque finish, used in Egypt and the Aegean. (2) A type of earthenware that is covered with a colorful opaque glaze and is often decorated with elaborate designs.

FATHERS OF THE CHURCH. Early teachers and defenders of the Christian faith. Those most frequently represented are the four Latin fathers: St. Jerome, St. Ambrose, and St. Augustine, all of the 4th century, and St. Gregory of the 6th.

FERROCONCRETE. See *reinforced concrete*.

FERROVITREOUS. In 19th-century architecture, the combining of iron (and later steel) with glass in the construction of large buildings (e.g., railway stations, exhibition halls, etc.).

FIBULA. A clasp, buckle, or brooch, often ornamented.

FILIGREE. Delicate decorative work made of intertwining wires.

FINIAL. A relatively small, decorative element terminating in a gable, pinnacle, or the like.

FLAMBOYANT GOTHIC. A style of Late Gothic architecture in which the bar tracery supporting the strained glass windows is formed into elaborate pointed, often flamelike, shapes.

FLUTING. In architecture, the ornamental grooves channeled vertically into the shaft of a column or *pilaster*. They may meet in a sharp edge, as in the Doric style, or be separated by a narrow strip or fillet, as in the Ionic, Corinthian, and composite styles.

FLYING BUTTRESS. An arch or series of arches on the exterior of a building, connecting the building to detached pier buttresses so that the thrust from the roof vaults is offset.

FOLIO. A leaf of a manuscript or a book, identified so that the front and the back have the same number, the front being labeled *recto* and the back *verso*.

FONT. (1) In printing, a complete set of type in which the letters and numbers follow a consistent design and style. (2) The stone or metal container that holds the Holy Water in a baptistry.

FORESHORTENING. A method of reducing or distorting the parts of a represented object that are not parallel to the picture plane in order to convey the impression of three dimensions as perceived by the human eye.

FORMALISM. The emphasis in art on form; i.e, on line, shape, color, composition, etc. rather than on subject matter. Hence, art from any era may be judged on the basis of its formal elements alone.

FORUM (pl. **FORA**). In an ancient Roman city, the main public square, which was a public gathering place and the center of judicial and business activity.

FOUR-IWAN MOSQUE. A mosque with a rectangular interior courtyard designed with a large vaulted chamber or recess open to the courtyard on each side.

FRANCISCAN ORDER. Founded as a mendicant order by St. Francis of Assisi (Giovanni de Bernardone, ca. 1181–1226). The order's monks aimed to imitate the life of Christ in its poverty and humility, to preach, and to minister to the spiritual needs of the poor.

FRESCO. Italian word for "fresh." Fresco is the technique of painting on plaster with pigments ground in water so that the paint is absorbed by the plaster and becomes part of the wall itself. *Buon fresco* is the technique of painting on wet plaster; *fresco secco* is the technique of painting on dry plaster.

FRIEZE. (1) A continuous band of painted or sculptured decoration. (2) In a Classical building, the part of the entablature between the architrave and the cornice. A Doric frieze consists of alternating triglyphs and metopes, the latter often sculptured. An Ionic frieze is usually decorated with continuous relief sculpture.

FRONTALITY. Representation of a subject in a full frontal view.

FROTTAGE. The technique of rubbing a drawing medium, such as a crayon, over paper that is placed over a textured surface in order to transfer the underlying pattern to the paper.

GABLE. (1) The triangular area framed by the cornice or eaves of a building and the sloping sides of a pitched roof. In Classical architecture, it is called a *pediment*. (2) A decorative element of similar shape, such as the triangular structures above the portals of a Gothic church and sometimes at the top of a Gothic picture frame.

GALLERY. A second story placed over the side aisles of a church and below the clerestory. In a church with a four-part elevation, it is placed below the triforium and above the nave arcade.

GENIUS. A winged semi-nude figure, often purely decorative but frequently personifying an abstract concept or representing the guardian spirit of a person or place.

GENRE. The French word for "kind" or "sort." In art, a genre scene is a work of art, usually a painting, depicting a scene from everyday, ordinary life.

GEOMETRIC ARABESQUE. Complex patterns and designs usually composed of polygonal geometric forms, rather than organic flowing shapes; often used as ornamentation in Islamic art.

GESSO. A smooth mixture of ground chalk or plaster and glue used as the basis for tempera painting and for oil painting on panel.

GESTURE PAINTING. A technique in painting and drawing where the actual physical movement of the artist is reflected in the brush stroke or line as it is seen in the artwork. The artist Jackson Pollock is particularly associated with this technique.

GIGANTOMACHY. From Greek mythology, the battle of the gods and the giants.

GILDING. (1) A coat of gold or of a gold-colored substance that is applied mechanically or chemically to surfaces of a painting, sculpture, or architectural decoration. (2) The process of applying this material.

GIORNATA. Because fresco painting dries quickly, artists apply only as much wet plaster on the wall as can be painted in one day. That amount of work is called the *giornata*, from the Italian word *giorno*, meaning "day." So, *giornata* means "one day's work."

GISANT. In a tomb sculpture, a recumbent effigy or representation of the deceased. At times, the gisant may be represented in a state of decay.

GLAZE. (1) A thin layer of translucent oil color applied to a painted surface or to parts of it in order to modify the tone. (2) A glassy coating applied to a piece of ceramic work before firing in the kiln as a protective seal and often as decoration.

GLAZED BRICK. Brick that is baked in a kiln after being painted.

GLORIOLE (or **GLORY**). The circle of radiant light around the heads or figures of God, Christ, the Virgin Mary, or a saint. When it surrounds the head only, it is called a *halo* or *nimbus*; when it surrounds the entire figure with a large oval, it is called a *mandorla* (the Italian word for "almond"). It indicates divinity or holiness, though originally it was placed around the heads of kings and gods as a mark of distinction.

GOLD LEAF. (1) Gold beaten into very thin sheets or "leaves" and applied to illuminated manuscripts and panel paintings, to sculpture, or to the back of the glass tesserae used in mosaics. (2) *Silver leaf* is also used, though ultimately it tarnishes. Sometimes called gold foil, silver foil.

GOLGOTHA. From the word in Aramaic meaning "skull," Golgotha is the hill outside Jerusalem where the Crucifixtion of Jesus Christ took place; it is also known as Calvary. See *Calvary*.

GORGON. In Greek mythology, one of three hideous female monsters with large heads and snakes for hair. Their glance turned men to stone. Medusa, the most famous of the Gorgons, was killed by Perseus only with help from the gods.

GOSPEL. (1) The first four books of the New Testament. They tell the story of Christ's life and death and are ascribed to the evangelists Matthew, Mark, Luke, and John. (2) A copy of these, usually called a Gospel Book, often richly illuminated.

GRANULATION. A technique of decoration in which metal granules, or tiny metal balls, are fused to a metal surface.

GRATTAGE. A technique in painting whereby an image is produced by scraping off paint from a canvas that has been placed over a textured surface.

GREEK CROSS. A cross with four arms of equal length arranged at right angles.

GREEK-CROSS CHURCH. A church designed using the shape of an equal-armed Greek cross; it has a central room with four equally sized rooms extending outward from the main room.

GRISAILLE. A monochrome drawing or painting in which only values of black, gray, and white are used.

GRISAILLE GLASS. White glass painted with gray designs.

GROIN VAULT. A vault formed by the intersection of two barrel vaults at right angles to each other. A groin is the ridge resulting from the intersection of two vaults.

GROUND-LINE. The line, actual or implied, on which figures stand.

GROUND PLAN. An architectural drawing presenting a building as if cut horizontally at the floor level. Also called a *plan*.

GUTTAE. In a Doric entablature, small peglike projections above the frieze; possibly derived from pegs originally used in wooden construction.

HALL CHURCH. See *hallenkirche*.

HALLENKIRCHE. German word for "hall church." A church in which the nave and the side aisles are of the same height. The type was developed in Romanesque architecture and occurs especially frequently in German Gothic churches.

HALO. In painting, the circle or partial circle of light depicted surrounding the head of a saint, angel, or diety to indicate a holy or sacred nature; most common in medieval paintings but also seen in more modern artwork. Also called a *nimbus*.

HAPPENING. A type of art that involves visual images, audience participation, and improvised performance, usually in a public setting and under the loose direction of an artist.

HATAIJI STYLE. Meaning literally "of Cathay" or "Chinese"; used in Ottoman Turkish art to describe an artistic pattern consisting of stylized lotus blossoms, other flowers, and sinuous leaves on curving stems.

HATCHING. A series of parallel lines used as shading in prints and drawings. When two sets of crossing parallel lines are used, it is called *crosshatching*.

HERALDIC COMPOSITION. A design that is symmetrical around a central axis.

HIERATIC SCALE. An artistic technique in which the importance of figures is indicated by size, so that the most important figure is depicted as the largest.

HIEROGLYPH. A symbol, often based on a figure, animal, or object, standing for a word, syllable, or sound. These symbols form the early Egyptian writing system, and are found on ancient Egyptian monuments as well as in Egyptian written records.

HIGH RELIEF. See *relief*.

HÔTEL. French word for "hotel" but used also to designate an elegant town house.

HOUSE CHURCH. A place for private worship within a house; the first Christian churches were located in private homes that were modified for religious ceremonies.

HUMANISM. A philosophy emphasizing the worth of the individual, the rational abilities of humankind, and the human potential for good. During the Italian Renaissance, humanism was part of a movement that encouraged study of the classical cultures of Greece and Rome; often it came into conflict with the doctrines of the Catholic church.

HYPOSTYLE. A hall whose roof is supported by columns.

ICON. From the Greek word for "image." A panel painting of one or more sacred personages, such as Christ, the Virgin, or a saint, particularly venerated in the Orthodox Christian church.

ICONOCLASM. The doctrine of the Christian church in the 8th and 9th centuries that forbade the worship or production of religious images. This doctrine led to the destruction of many works of art. The iconoclastic controversy over the validity of this doctrine led to a division of the church. Protestant churches of the 16th and 17th centuries also practiced iconoclasm.

ICONOGRAPHY. (1) The depicting of images in art in order to convey certain meanings. (2) The study of the meaning of images depicted in art, whether they be inanimate objects, events, or personages. (3) The content or subject matter of a work of art.

ILLUSIONISM. In artistic terms, the technique of manipulating pictorial or other means in order to cause the eye to perceive a particular reality. May be used in architecture and sculpture, as well as in painting.

IMPASTO. From the Italian word meaning "to make into a paste"; it describes paint, usually oil paint, applied very thickly.

IN ANTIS. An architectural term that indicates the position of the columns on a Greek or Roman building when those columns are set between the junction of two walls.

INCISION. A cut made into a hard material with a sharp instrument.

INLAID NIELLO. See *niello*.

INSULA (pl. **INSULA**). Latin word for "island." (1) An ancient Roman city block. (2) A Roman "apartment house": a concrete and brick building or chain of buildings around a central court, up to five stories high. The ground floor had shops, and above were living quarters.

INTAGLIO. A printing technique in which the design is formed from ink-filled lines cut into a surface. Engraving, etching, and drypoint are examples of intaglio.

INTONACO. The layer of smooth plaster on which paint is applied in fresco painting.

IONIC STYLE. A style of Classical Greek architecture that is characterized in part by columns that have fluted shafts, capitals with volutes (scrolls), and a base; a continuous frieze is also characteristic.

IWAN. A vaulted chamber in a mosque or other Islamic structure, open on one side and usually opening onto an interior courtyard.

JAMBS. The vertical sides of an opening. In Romanesque and Gothic churches, the jambs of doors and windows are often cut on a slant outward, or "splayed," thus providing a broader surface for sculptural decoration.

JAPONISME. In 19th-century French and American art, a style of painting and drawing that reflected the influence of the Japanese artworks, particularly prints, that were then reaching the West.

JESUIT ORDER. The "Society of Jesus" was founded in 1534 by Ignatius of Loyola (1491–1556) and was especially devoted to the service of the pope. The order was a powerful influence in the struggle of the Catholic Counter-Reformation with the Protestant Reformation and was also very important for its missionary work, disseminating Christianity in the Far East and the New World. The mother church in Rome, Il Gesù, conforms in design to the preaching aims of the new order.

KEEP. (1) The innermost and strongest structure or central tower of a medieval castle, sometimes used as living quarters, as well as for defense. Also called a donjon. (2) A fortified medieval castle.

KEYSTONE. The highest central stone or voussoir in an arch; it is the final stone to be put in place, and its weight holds the arch together.

KITSCH. A German word for "trash," in English *kitsch* has come to describe a sensibility that is vulgar and sentimental, in contrast to the refinement of "high" art or fine art.

KORE (pl. **KORAI**). Greek word for "maiden." An Archaic Greek statue of a standing, draped female.

KOUROS (pl. **KOUROI**). Greek word for "male youth." An Archaic Greek statue of a standing, nude youth.

KRATER. A Greek vessel, of assorted shapes, in which wine and water are mixed. A *calyx krater* is a bell-shaped vessel with handles near the base; a *volute krater* is a vessel with handles shaped like scrolls.

KUFIC. One of the first general forms of Arabic script to be developed, distinguished by its angularity; distinctive variants occur in various parts of the Islamic worlds.

KUNSTKAMMEN (German, pl. **KUNSTKAMMERN**; in Dutch, **KUNSTKAMER**). Literally this is a room of art. Developed in the 16th century, it is a forerunner of the museum—a display of paintings and objects of natural history (shells, bones, etc.) that formed an encyclopedic collection.

KYLIX. In Greek and Roman antiquity, a shallow drinking cup with two horizontal handles, often set on a stem terminating in a foot.

LABORS OF THE MONTHS. The various occupations suitable to the months of the year. Scenes or figures illustrating these were frequently represented in illuminated manuscripts. Sometimes scenes of the labors of the months were combined with signs of the zodiac.

LAMASSU. An ancient Near Eastern guardian of a palace; often shown in sculpture as a human-headed bull or lion with wings.

LANCET. A tall, pointed window common in Gothic architecture.

LANDSCAPE. A drawing or painting in which an outdoor scene of nature is the primary subject.

LANTERN. A relatively small structure crowning a dome, roof, or tower, frequently open to admit light to an enclosed area below.

LAPITH. A member of a mythical Greek tribe that defeated the Centaurs in a battle, scenes from which are frequently represented in vase painting and sculpture.

LATIN CROSS. A cross in which three arms are of equal length and one arm is longer.

LAY BROTHER. One who has joined a monastic order but has not taken monastic vows and therefore belongs still to the people or laity, as distinguished from the clergy or religious.

LEKYTHOS (pl. **LEKYTHOI**). A Greek oil jug with an ellipsoidal body, a narrow neck, a flanged mouth, a curved handle extending from below the lip to the shoulder, and a narrow base terminating in a foot. It was used chiefly for ointments and funerary offerings.

LIBERAL ARTS. Traditionally thought to go back to Plato, they comprised the intellectual disciplines considered suitable or necessary to a complete education and included grammar, rhetoric, logic, arithmetic, music, geometry, and astronomy. During the Middle Ages and the Renaissance, they were often represented allegorically in paintings, engravings, and sculpture.

LINTEL. In architecture, a horizontal beam of any material that is held up by two vertical supports.

LITHOGRAPH. A print made by drawing a design with an oily crayon or other greasy substance on a porous stone or, later, a metal plate; the design is then fixed, the entire surface is moistened, and the printing ink that is applied adheres only to the oily lines of the drawing. The design can then be transferred easily in a press to a piece of paper. The technique was invented ca. 1796 by Aloys Senefelder and quickly became popular. It is also widely used commercially, since many impressions can be taken from a single plate.

LOGGIA. A covered gallery or arcade open to the air on at least one side. It may stand alone or be part of a building.

LONGITUDINAL SECTION. A cross section of a building or other object that shows the lengthwise structure. See *cross section*.

LOUVERS. A series of overlapping boards or slats that can be opened to admit air but are slanted so as to exclude sun and rain.

LOW RELIEF. See *relief*.

LUNETTE. (1) A semicircular or pointed wall area, as under a vault, or above a door or window. When it is above the portal of a medieval church, it is called a *tympanum*. (2) A painting, relief sculpture, or window of the same shape.

MADRASA. An Islamic religious college.

MAESTÀ. Italian word for "majesty," applied in the 14th and 15th centuries to representations of the Madonna and Child enthroned and surrounded by her celestial court of saints and angels.

MAGICO-RELIGIOUS. In art, subject matter that deals with the supernatural and often has the purpose of invoking those powers to achieve human ends, e.g., prehistoric cave paintings used to ensure a successful hunt.

MAGUS (pl. **MAGI**). (1) A member of the priestly caste of ancient Media and Persia. (2) In Christian literature, one of the three Wise Men or Kings who came from the East bearing gifts to the newborn Jesus.

MANDORLA. A representation of light surrounding the body of a holy figure.

MANIERA. In painting, the "Greek style" of the 13th century that demonstrated both Italian and Byzantine influences.

MANUSCRIPT ILLUMINATION. Decoration of handwritten documents, scrolls, or books with drawings or paintings. Illuminated manuscripts were often produced during the Middle Ages.

MAQSURA. A screened enclosure, reserved for the ruler, often located before the *mihrab* in certain important royal Islamic mosques.

MARTYRIUM (pl. **MARTYRIA**). A church, chapel, or shrine built over the grave of a Christian martyr or at the site of an important miracle.

MASTABA. An ancient Egyptian tomb, rectangular in shape, with sloping sides and a flat roof. It covered a chapel for offerings and a shaft to the burial chamber.

MATRIX. (1) A mold or die used for shaping a ceramic object before casting. (2) In printmaking, any surface on which an image is incised, carved, or applied and from which a print may be pulled.

MAUSOLEUM. (1) The huge tomb erected at Halikarnassos in Asia Minor in the 4th century BCE by King Mausolos and his wife Artemisia. (2) A generic term for any large funerary monument.

MEANDER. A decorative motif of intricate, rectilinear character applied to architecture and sculpture.

MEDIUM (pl. **MEDIUMS**). (1) The material or technique in which an artist works. (2) The vehicle in which pigments are carried in paint, pastel, etc.

MEGALITH. From the Greek *mega*, meaning "big," and *lithos*, meaning "stone." A huge stone such as those used in cromlechs and dolmens.

MEGARON (pl. **MEGARONS** or **MEGARA**). From the Greek word for "large." The central audience hall in a Minoan or Mycenaean palace or home.

MENHIR. A megalithic upright slab of stone, sometimes placed in rows by prehistoric peoples.

MESOLITHIC. Transitional period of the Stone Age between the Paleolithic and the Neolithic.

METOPE. The element of a Doric frieze between two consecutive triglyphs, sometimes left plain but often decorated with paint or relief sculpture.

MIHRAB. A niche, often highly decorated, usually found in the center of the *qibla* wall of a mosque, indicating the direction of prayer toward Mecca.

MINARET. A tower on or near a mosque, varying extensively in form throughout the Islamic world, from which the faithful are called to prayer five times a day.

MINBAR. A type of staircase pulpit, found in more important mosques to the right of the mihrab, from which the Sabbath sermon is given on Fridays after the noonday prayer.

MINIATURE. (1) A single illustration in an illuminated manuscript. (2) A very small painting, especially a portrait on ivory, glass, or metal.

MINOTAUR. In Greek mythology, a monster having the head of a bull and the body of a man who lived in the Labyrinth of the palace of Knossos on Crete.

MODEL. (1) The preliminary form of a sculpture, often finished in itself but preceding the final casting or carving. (2) Preliminary or reconstructed form of a building made to scale. (3) A person who poses for an artist.

MODELING. (1) In sculpture, the building up of a figure or design in a soft substance such as clay or wax. (2) In painting and drawing, producing a three-dimensional effect by changes in color, the use of light and shade, etc.

MODULE. (1) A segment of a pattern. (2) A basic unit, such as the measure of an architectural member. Multiples of the basic unit are used to determine proportionate construction of other parts of a building.

MOLDING. In architecture, any of various long, narrow, ornamental bands having a distinctive profile that project from the surface of the structure and give variety to the surface by means of their patterned contrasts of light and shade.

MONASTIC ORDER. A religious society whose members live together under an established set of rules.

MONOTYPE. A unique print made from a copper plate or other type of plate from which no other copies of the artwork are made.

MOSAIC. Decorative work for walls, vaults, ceilings, or floors composed of small pieces of colored materials, called *tesserae*, set in plaster or concrete. Romans, whose work was mostly for floors, used shaped pieces of colored stone. Early Christians used pieces of glass with brilliant hues, including gold, and slightly irregular surfaces, producing an entirely different glittering effect.

MOSQUE. A building used as a center for community prayers in Islamic worship; it often serves other functions including religious education and public assembly.

MOTIF. A visual theme, a motif may appear numerous times in a single work of art.

MOZARAB. Term used for the Spanish Christian culture of the Middle Ages that developed while Muslims were the dominant culture and political power on the Iberian peninsula.

MUQARNAS. A distinctive type of Islamic decoration consisting of multiple nichelike forms usually arranged in superimposed rows, often used in zones of architectural transition.

MURAL. From the Latin word for wall, *murus*. A large painting or decoration either executed directly on a wall (fresco) or done separately and affixed to it.

MUSES. In Greek mythology, the nine goddesses who presided over various arts and sciences. They are led by Apollo as god of music and poetry and usually include Calliope, muse of epic poetry; Clio, muse of history; Erato, muse of love poetry; Euterpe, muse of music; Melpomene, muse of tragedy; Polyhymnia, muse of sacred music; Terpsichore, muse of dancing; Thalia, muse of comedy; and Urania, muse of astronomy.

MUTULES. A feature of Doric architecture, mutules are flat rectangular blocks found just under the cornice.

NAOS. See *cella*.

NARTHEX. The transverse entrance hall of a church, sometimes enclosed but often open on one side to a preceding atrium.

NATURALISM. A style of art that aims to depict the natural world as it appears.

NAVE. (1) The central aisle of a Roman basilica, as distinguished from the side aisles. (2) The same section of a Christian basilican church extending from the entrance to the apse or transept.

NECROPOLIS. Greek for "city of the dead." A burial ground or cemetery.

NEOLITHIC. The New Stone Age, thought to have begun ca. 9000–8000 BCE. The first society to live in settled communities, to domesticate animals, and to cultivate crops, it saw the beginning of many new skills, such as spinning, weaving, and building.

NEW STONE AGE. See *neolithic*.

NIELLO. Dark metal alloys applied to the engraved lines in a precious metal plate (usually made of gold or silver) to create a design.

NIKE. The ancient Greek goddess of victory, often identified with Athena and by the Romans with Victoria. She is usually represented as a winged woman with windblown draperies.

NIMBUS. See *halo*.

NOCTURNE. A painting that depicts a nighttime scene, often emphasizing the effects of artificial light.

NONOBJECTIVE PAINTING. In Abstract art, the style of painting that does not strive to represent objects, including people, as they would appear in everyday life or in the natural world.

OBELISK. A tall, tapering, four-sided stone shaft with a pyramidal top. First constructed as *megaliths* in ancient Egypt, certain examples have since been exported to other countries.

OCULUS. The Latin word for "eye." (1) A circular opening at the top of a dome used to admit light. (2) A round window.

ODALISQUE. Turkish word for "harem slave girl" or "concubine."

OIL PAINTING. (1) A painting executed with pigments mixed with oil, first applied to a panel prepared with a coat of gesso (as also in tempera painting), and later to a stretched canvas primed with a coat of white paint and glue. The latter method has predominated since the late 15th century. Oil painting also may be executed on paper, parchment, copper, etc. (2) The technique of executing such a painting.

OIL SKETCH. A work in oil painting of an informal character, sometimes preparatory to a finished work.

OLD STONE AGE. See *paleolithic*.

OPTICAL IMAGES. An image created from what the eye sees, rather than from memory.

ORANT. A standing figure with arms upraised in a gesture of prayer.

ORCHESTRA. (1) In an ancient Greek theater, the round space in front of the stage and below the tiers of seats, reserved for the chorus. (2) In a Roman theater, a similar space reserved for important guests.

ORTHODOX. From the Greek word for "right in opinion." The Eastern Orthodox church, which broke with the Western Catholic church during the 5th century CE and transferred its allegiance from the pope in Rome to the Byzantine emperor in Constantinople and his appointed patriarch. Sometimes called the Byzantine church.

ORTHOGONAL. In a perspective construction, an imagined line in a painting that runs perpendicular to the picture plane and recedes to a vanishing point.

ORTHOSTATS. Upright slabs of stone constituting or lining the lowest courses of a wall, often in order to protect a vulnerable material such as mud-brick.

PALAZZO (pl. **PALAZZI**). Italian word for "palace" (in French, palais). Refers either to large official buildings or to important private town houses.

PALEOLITHIC. The Old Stone Age, usually divided into Lower, Middle, and Upper (which began about 35,000 BCE). A society of nomadic hunters who used stone implements, later developing ones of bone and flint. Some lived in caves, which they decorated during the latter stages of the age, at which time they also produced small carvings in bone, horn, and stone.

PALETTE. (1) A thin, usually oval or oblong board with a thumbhole at one end, used by painters to hold and mix their colors. (2) The range of colors used by a particular painter. (3) In Egyptian art, a slate slab, usually decorated with sculpture in low relief. The small ones with a recessed circular area on one side are thought to have been used for eye makeup. The larger ones were commemorative objects.

PANEL. (1) A wooden surface used for painting, usually in tempera, and prepared beforehand with a layer of gesso. Large altarpieces require the joining together of two or more boards. (2) Recently, panels of Masonite or other composite materials have come into use.

PANTHEON. From *pan*, Greek for "all," and *theos*, Greek for "god." A Hellenistic Greek or Roman temple dedicated to all of the gods; in later years, often housing tombs or memorials for the illustrious dead of a nation.

PANTOCRATOR. A representation of Christ as ruler of the universe that appears frequently in the dome or apse mosaics of Byzantine churches.

PAPYRUS. (1) A tall aquatic plant that grows abundantly in the Near East, Egypt, and Abyssinia. (2) A paperlike material made by laying together thin strips of the pith of this plant and then soaking, pressing, and drying the whole. The resultant sheets were used as writing material by the ancient Egyptians, Greeks, and Romans. (3) An ancient document or scroll written on this material.

PARCHMENT. From Pergamon, the name of a Greek city in Asia Minor where parchment was invented in the 2nd century BCE. (1) A paperlike material made from bleached animal hides used extensively in the Middle Ages for manuscripts. Vellum is a superior type of parchment made from calfskin. (2) A document or miniature on this material.

PASSION. (1) In ecclesiastic terms, the events of Jesus' last week on earth. (2) The representation of these events in pictorial, literary, theatrical, or musical form.

PASTEL. (1) A soft, subdued shade of color. (2) A drawing stick made from pigments ground with chalk and mixed with gum water. (3) A drawing executed with these sticks.

PEDESTAL. An architectural support for a statue, vase, column, etc.

PEDIMENT. (1) In Classical architecture, a low gable, typically triangular, framed by a horizontal cornice below and two raking cornices above; frequently filled with sculpture. (2) A similar architectural member used over a door, window, or niche. When pieces of the cornice are either turned at an angle or interrupted, it is called a *broken pediment*.

PELIKE. A Greek storage jar with two handles, a wide mouth, little or no neck, and resting on a foot.

PENDENTIVE. One of the concave triangles that achieves the transition from a square or polygonal opening to the round base of a dome or the supporting drum.

PERFORMANCE ART. A type of art in which performance by actors or artists, often interacting with the audience in an improvisational manner, is the primary aim over a certain time period. These artworks are transitory, perhaps with only a photographic record of some of the events.

PERIPTERAL. An adjective describing a building surrounded by a single row of columns or colonnade.

PERISTYLE. (1) In a Roman house or *domus*, an open garden court surrounded by a colonnade. (2) A colonnade around a building or court.

PERPENDICULAR STYLE. The third style of English Gothic architecture, in which the bar tracery uses predominantly vertical lines. The fan vault is also used extensively in this style.

PERSPECTIVE. A system for representing spatial relationships and three-dimensional objects on a flat two-dimensional surface so as to produce an effect similar to that perceived by the human eye. In *atmospheric* or *aerial* perspective, this is accomplished by a gradual decrease in the intensity of color and value and in the contrast of light and dark as objects are depicted as farther and farther away in the picture. In color artwork, as objects recede into the distance, all colors tend toward a light bluish-gray tone. In *scientific* or *linear* perspective, developed in Italy in the 15th century, a mathematical system is used based on orthogonals receding to vanishing points on the horizon. Transversals intersect the orthogonals at right angles at distances derived mathematically. Since this presupposes an absolutely stationary viewer and imposes rigid restrictions on the artist, it is seldom applied with complete consistency. Although traditionally ascribed to Brunelleschi, the first theoretical text on perspective was Leon Battista Alberti's *On Painting* (1435).

PHILOSOPHES. Philosophers and intellectuals of the Enlightenment, whose writings had an important influence upon the art of that time.

PHOTOGRAM. A shadowlike photograph made without a camera by placing objects on light-sensitive paper and exposing them to a light source.

PHOTOGRAPH. The relatively permanent or "fixed" form of an image made by light that passes through the lens of a camera and acts upon light-sensitive substances. Often called a print.

PHOTOMONTAGE. A photograph in which prints in whole or in part are combined to form a new image. A technique much practiced by the Dada group in the 1920s.

PIAZZA (pl. **PIAZZE**). Italian word for "public square" (in French, place; in German, platz).

PICTURE PLANE. The flat surface on which a picture is painted.

PICTURESQUE. Visually interesting or pleasing, as if resembling a picture.

PIER. An upright architectural support, usually rectangular and sometimes with capital and base. When columns, pilasters, or shafts are attached to it, as in many Romanesque and Gothic churches, it is called a compound pier.

PIETÀ. Italian word for both "pity" and "piety." A representation of the Virgin grieving over the dead Christ. When used in a scene recording a specific moment after the Crucifixion, it is usually called a Lamentation.

PIETRA SERENA. A limestone, gray in color, used in the Tuscany region of Italy.

PILASTER. A flat, vertical element projecting from a wall surface and normally having a base, shaft, and capital. It has generally a decorative rather than a structural purpose.

PILGRIMAGE CHOIR. The unit in a Romanesque church composed of the apse, ambulatory, and radiating chapels.

PILGRIMAGE PLAN. The general design used in Christian churches that were stops on the pilgrimage routes throughout medieval Europe, characterized by having side aisles that allowed pilgrims to ambulate around the church. See *pilgrimage choir*.

PILLAR. A general term for a vertical architectural support that includes columns, piers, and pilasters.

PILOTIS. Pillars that are constructed from *reinforced concrete* (*ferroconcrete*).

PINNACLE. A small, decorative structure capping a tower, pier, buttress, or other architectural member. It is used especially in Gothic buildings.

PLAN. See *ground plan*.

PLATE TRACERY. A style of tracery in which pierced openings in an otherwise solid wall of stonework are filled with glass.

PLEIN-AIR. Sketching outdoors, often using paints, in order to capture the immediate effects of light on landscape and other subjects. Much encouraged by the Impressionists, their *plein-air* sketches were often taken back to the studio to produce finished paintings, but many *plein-air* sketches are considered masterworks.

PODIUM. (1) The tall base upon which rests an Etruscan or Roman temple. (2) The ground floor of a building made to resemble such a base.

POLYTYCH. An altarpiece or devotional work of art made of several panels joined together, often hinged.

PORCH. General term for an exterior appendage to a building that forms a covered approach to a doorway.

PORTA. Latin word for "door" or "gate."

PORTAL. A door or gate, usually a monumental one with elaborate sculptural decoration.

PORTICO. A columned porch supporting a roof or an entablature and pediment, often approached by a

number of steps. It provides a covered entrance to a building and a connection with the space surrounding it.

POST AND LINTEL. A basic system of construction in which two or more uprights, the posts, support a horizontal member, the lintel. The lintel may be the topmost element or support a wall or roof.

POUNCING. A technique for transferring a drawing from a cartoon to a wall or other surface by pricking holes along the principal lines of the drawing and forcing fine charcoal powder through them onto the surface of the wall, thus reproducing the design on the wall.

POUSSINISTES. Those artists of the French Academy at the end of the17th century and the beginning of the 18th century who favored "drawing," which they believed appealed to the mind rather than the senses. The term derived from admiration for the French artist Nicolas Poussin. See *Rubénistes*.

PREDELLA. The base of an altarpiece, often decorated with small scenes that are related in subject to that of the main panel or panels.

PREFIGURATION. The representation of Old Testament figures and stories as forerunners and foreshadowers of those in the New Testament.

PRIMITIVISM. The appropriation of non-Western (e.g., African, tribal, Polynesian) art styles, forms, and techniques by Modern era artists as part of innovative and avant-garde artistic movements; other sources were also used, including the work of children and the mentally ill.

PRINT. A picture or design reproduced, usually on paper and often in numerous copies, from a prepared wood block, metal plate, stone slab, or photograph.

PRONAOS. In a Greek or Roman temple, an open vestibule in front of the *cella*.

PRONK. A word meaning ostentatious or sumptuous; it is used to refer to a still life of luxurious objects.

PROPYLAEUM (pl. **PROPYLAEA**). (1) The often elaborate entrance to a temple or other enclosure. (2) The monumental entry gate at the western end of the Acropolis in Athens.

PROVENANCE. The place of origin of a work of art and related information.

PSALTER. (1) The book of Psalms in the Old Testament, thought to have been written in part by David, king of ancient Israel. (2) A copy of the Psalms, sometimes arranged for liturgical or devotional use and often richly illuminated.

PULPIT. A raised platform in a church from which the clergy delivers a sermon or conducts the service. Its railing or enclosing wall may be elaborately decorated.

PUTTO (pl. **PUTTI**). A nude, male child, usually winged, often represented in classical and Renaissance art. Also called a cupid or amoretto when he carries a bow and arrow and personifies Love.

PYLON. Greek word for "gateway." (1) The monumental entrance building to an Egyptian temple or forecourt consisting either of a massive wall with sloping sides pierced by a doorway or of two such walls flanking a central gateway. (2) A tall structure at either side of a gate, bridge, or avenue marking an approach or entrance.

QIBLA. The direction toward Mecca, which Muslims face during prayer. The qibla wall in a mosque identifies this direction.

QUADRANT VAULT. A half-barrel vault designed so that instead of being semicircular in cross-section, the arch is one-quarter of a circle.

QUADRA RIPORTATE. Painted scenes depicted in panels on the curved ceiling of a vault.

QUATREFOIL. An ornamental element composed of four lobes radiating from a common center.

RADIATING CHAPELS. Term for chapels arranged around the ambulatory (and sometimes the transept) of a medieval church.

RAYONNANT. The style of Gothic architecture, described as "radiant," developed at the Parisian court of Louis IX in the mid-13th century. Also referred to as *court style*.

READYMADE. An ordinary object that, when an artist gives it a new context and title, is transformed into an art object. Readymades were important features of the Dada and Surrealism movements of the early 20th century.

RED-FIGURED. A style of ancient Greek ceramic decoration characterized by red figures against a black background. This style of decoration developed toward the end of the 6th century BCE and replaced the earlier *black-figured* style.

REFECTORY. (1) A room for refreshment. (2) The dining hall of a masonry, college, or other large institution.

REFORMATION. The religious movement in the early 16th century that had for its object the reform of the Catholic church and led to the establishment of Protestant churches.

REGISTER. A horizontal band containing decoration, such as a relief sculpture or a fresco painting. When multiple horizontal layers are used, registers are useful in distinguishing between different visual planes and different time periods in visual narration.

REINFORCED CONCRETE. Concrete that has been made stronger, particularly in terms of tensile strength, by the imbedding of steel rods or steel mesh. Introduced in France ca. 1900. Many large modern buildings are only feasible through the use of reinforced concrete.

RELIEF. (1) The projection of a figure or part of a design from the background or plane on which it is carved or modeled. Sculpture done in this manner is described as "high relief" or "low relief" depending on the height of the projection. When it is very shallow, it is called *schiacciato*, the Italian word for "flattened out." (2) The apparent projection of forms represented in a painting or drawing. (3) A category of printmaking in which lines raised from the surface are inked and printed.

RELIQUARY. A container used for storing or displaying relics.

RESPOND. (1) A half-pier, pilaster, or similar element projecting from a wall to support a lintel or an arch whose other side is supported by a free-standing column or pier, as at the end of an arcade. (2) One of several pilasters on a wall behind a colonnade that echoes or "responds to" the columns but is largely decorative. (3) One of the slender shafts of a compound pier in a medieval church that seems to carry the weight of the vault.

RHYTON. An ancient drinking or pouring vessel made from pottery, metal, or stone, and sometimes designed in a human or animal form.

RIB. A slender, projecting, archlike member that supports a vault either transversely or at the groins, thus dividing the surface into sections. In Late Gothic architecture, its purpose is often primarily ornamental.

RIBBED VAULT. A style of vault in which projecting surface arches, known as ribs, are raised along the intersections of segments of the vault. Ribs may provide architectural support as well as decoration to the vault's surface.

ROMANESQUE. (1) The style of medieval architecture from the 11th to the 13th centuries that was based upon the Roman model and that used the Roman rounded arch, thick walls for structural support, and relatively small windows. (2) Any culture or its artifacts that are "Roman-like."

ROOD SCREEN. A partition in a church on which a crucifix (rood) is mounted and that separates the public nave area from the choir. See also *choir screen*.

ROSE WINDOW. A large, circular window with stained glass and stone tracery, frequently used on facades and at the ends of transepts in Gothic churches.

ROSTRUM (pl. **ROSTRA**). (1) A beaklike projection from the prow of an ancient warship used for ramming the enemy. (2) In the Roman forum, the raised platform decorated with the beaks of captured ships from which speeches were delivered. (3) A platform, stage, or the like used for public speaking.

ROTULUS (pl. **ROTULI**). The Latin word for scroll, a rolled written text.

RUBBING. A reproduction of a relief surface made by covering it with paper and rubbing with pencil, chalk, etc. Also called frottage.

RUBÉNISTES. Those artists of the French Academy at the end of the 17th century and the beginning of the 18th century who favored "color" in painting because it appealed to the senses and was thought to be true to nature. The term derived from admiration for the work of the Flemish artist Peter Paul Rubens. See *Poussinistes*.

RUSTICATION. A masonry technique of laying rough-faced stones with sharply indented joints.

SACRA CONVERSAZIONE. Italian for "holy conversation." A composition of the Madonna and Child with saints in which the figures all occupy the same spatial setting and appear to be conversing or communing with one another.

SACRISTY. A room near the main altar of a church, or a small building attached to a church, where the vessels and vestments required for the service are kept. Also called a *vestry*.

SALON. (1) A large, elegant drawing or reception room in a palace or a private house. (2) Official government-sponsored exhibition of paintings and sculpture by living artists held at the Louvre in Paris, first biennially, then annually. (3) Any large public exhibition patterned after the Paris Salon.

SANCTUARY. (1) A sacred or holy place or building. (2) An especially holy place within a building, such as the cella of a temple or the part of a church around the altar.

SARCOPHAGUS (pl. **SARCOPHAGI**). A large coffin, generally of stone, and often decorated with sculpture or inscriptions. The term is derived from two Greek words meaning "flesh" and "eating."

SATYR. One of a class of woodland gods thought to be the lascivious companions of Dionysos, the Greek god of wine (or of Bacchus, his Roman counterpart). They are represented as having the legs and tail of a goat, the body of a man, and a head with horns and pointed ears. A youthful satyr is also called a faun.

SAZ. Meaning literally "enchanted forest," this term describes the sinuous leaves and twining stems that are a major component of the *hatayi* style under the Ottoman Turks.

SCHIACCIATO. Italian for "flattened out." Describes low relief sculpture used by Donatello and some of his contemporaries.

SCIENTIFIC PERSPECTIVE. See *perspective*.

SCRIPTORIUM (pl. **SCRIPTORIA**). A workroom in a monastery reserved for copying and illustrating manuscripts.

SCROLL. (1) An architectural ornament with the form of a partially unrolled spiral, as on the capitals of the Ionic and Corinthian orders. (2) A form of written text.

SCUOLA. Italian word for school. In Renaissance Venice it designated a fraternal organization or confraternity dedicated to good works, usually under ecclesiastic auspices.

SECCO (or **A SECCO**). See *fresco secco* under *fresco*.

SECTION. An architectural drawing presenting a building as if cut across the vertical plane at right angles to the horizontal plane. A *cross section* is a cut along the

transverse axis. A *longitudinal section* is a cut along the longitudinal axis.

SELECTIVE WIPING. The planned removal of certain areas of ink during the etching process to produce changes in value on the finished print.

SEXPARTITE VAULT. See *vault.*

SFUMATO. Italian word meaning "smoky." Used to describe very delicate gradations of light and shade in the modeling of figures. It is applied especially to the work of Leonardo da Vinci.

SGRAFFITO ORNAMENT. A decorative technique in which a design is made by scratching away the surface layer of a material to produce a form in contrasting colors.

SHAFT. In architecture, the part of a column between the base and the capital.

SIBYLS. In Greek and Roman mythology, any of numerous women who were thought to possess powers of divination and prophecy. They appear on Christian representations, notably in Michelangelo's Sistine ceiling, because they were believed to have foretold the coming of Christ.

SIDE AISLE. A passageway running parallel to the nave of a Roman basilica or Christian church, separated from it by an arcade or colonnade. There may be one on either side of the nave or two, an inner and outer.

SILENI. A class of minor woodland gods in the entourage of the wine god, Dionysos (or Bacchus). Like Silenus, the wine god's tutor and drinking companion, they are thick-lipped and snub-nosed and fond of wine. Similar to satyrs, they are basically human in form except for having horses' tails and ears.

SILKSCREEN PRINTING. A technique of printing in which paint or ink is pressed through a stencil and specially prepared cloth to produce a previously designed image. Also called serigraphy.

SILVER LEAF. See *gold leaf.*

SILVERPOINT. A drawing instrument (stylus) of the 14th and 15th centuries made from silver; it produced a fine line and maintained a sharp point.

SILVER SALTS. Compounds of silver—bromide, chloride, and iodide—that are sensitive to light and are used in the preparation of photographic materials. This sensitivity was first observed by Johann Heinrich Schulze in 1725.

SINOPIA (pl. *SINOPIE*). Italian word taken from "Sinope," the ancient city in Asia Minor that was famous for its brick-red pigment. In fresco paintings, a full-sized, preliminary sketch done in this color on the first rough coat of plaster or *arriccio.*

SITE-SPECIFIC ART. Art that is produced in only one location, a location that is an integral part of the work and essential to its production and meaning.

SKETCH. A drawing, painting, or other artwork usually done quickly, as an aid to understanding and developing artistic skills; sometimes a sketch may lead to a more finished work of art.

SOCLE. A portion of the foundation of a building that projects outward as a base for a column or some other device.

SPANDREL. The area between the exterior curves of two adjoining arches or, in the case of a single arch, the area around its outside curve from its springing to its keystone.

SPHINX. (1) In ancient Egypt, a creature having the head of a man, animal, or bird and the body of a lion; frequently sculpted in monumental form. (2) In Greek mythology, a creature usually represented as having the head and breasts of a woman, the body of a lion, and the wings of an eagle. It appears in classical, Renaissance, and Neoclassical art.

SPIRE. A tall tower that rises high above a roof. Spires are commonly associated with church architecture and are frequently found on Gothic structures.

SPOLIA. Latin for "hide stripped from an animal." Term used for (1) spoils of war and (2) fragments of architecture or sculpture reused in a secondary context.

SPRINGING. The part of an arch in contact with its base.

SQUINCHES. Arches set diagonally at the corners of a square or rectangle to establish a transition to the round shape of the dome above.

STANZA (pl. **STANZE**). Italian word for "room."

STEEL. Iron modified chemically to have qualities of great hardness, elasticity, and strength.

STELE. From the Greek word for "standing block." An upright stone slab or pillar, sometimes with a carved design or inscription.

STEREOBATE. The substructure of a Classical building, especially a Greek temple.

STEREOSCOPE. An optical instrument that enables the user to combine two photographs taken from points of view corresponding to those of the two eyes. The combined single image has the depth and solidity of ordinary binocular vision. First demonstrated by Sir Charles Wheatstone in 1838.

STILL LIFE. A term used to describe paintings (and sometimes sculpture) that depict familiar objects such as household items and food.

STILTS. Term for pillars or posts supporting a superstructure; in 20th-century architecture, these are usually of ferroconcrete. Stilted, as in stilted arches, refers to tall supports beneath an architectural member.

STOA. In Greek architecture, a covered colonnade, sometimes detached and of considerable length, used as a meeting place or promenade.

STOIC. A member of a school of philosophy founded by Zeno about 300 BCE and named after the stoa in Athens where he taught. Its main thesis is that man should be free of all passions.

STRUCTURAL STEEL. Steel used as an architectural building material either invisibly or exposed.

STUCCO. (1) A concrete or cement used to coat the walls of a building. (2) A kind of plaster used for architectural decorations, such as cornices and moldings, or for sculptured reliefs.

STUDY. A preparatory sketch, drawing, painting, or other artwork that is used by an artist to explore artistic possibilities and solve problems before a more finished work is attempted. Often studies come to be regarded as finished works of art.

STYLOBATE. A platform or masonry floor above the stereobate forming the foundation for the columns of a Greek temple.

STYLUS. From the Latin word "stilus", the writing instrument of the Romans. (1) A pointed instrument used in ancient times for writing on tablets of a soft material such as clay. (2) The needlelike instrument used in drypoint or etching.

SUBLIME. In 19th-century art, the ideal and goal that art should inspire awe in a viewer and engender feelings of high religious, moral, ethical, and intellectual purpose.

SUNKEN RELIEF. Relief sculpture in which the figures or designs are modeled beneath the surface of the stone, within a sharp outline.

SUPERIMPOSED ORDERS. Two or more rows of columns, piers, or pilasters placed above each other on the wall of a building.

SYMPOSIUM. In ancient Greece, a gathering, sometimes of intellectuals and philosophers to discuss ideas, often in an informal social setting, such as at a dinner party.

TABERNACLE. (1) A place or house of worship. (2) A canopied niche or recess built for an image. (3) The portable shrine used by the ancient Jews to house the Ark of the Covenant.

TABLEAU VIVANT. A scene, usually derived from myth, the Bible, or literary sources, that is depicted by people standing motionless in costumes on a stage set.

TABLINUM. The Latin word meaning "writing tablet" or "written record." In a Roman house, a room at the far end of the atrium, or between the atrium and the second courtyard, used for keeping family records.

TEMPERA PAINTING. (1) A painting made with pigments mixed with egg yolk and water. In the 14th and 15th centuries, it was applied to panels that had been prepared with a coating of gesso; the application of gold leaf and of *underpainting* in green or brown preceded the actual tempera painting. (2) The technique of executing such a painting.

TENEBRISM. The intense contrast of light and dark in painting.

TERRA COTTA. Italian word for "baked earth." (1) Earthenware, naturally reddish-brown but often glazed in various colors and fired. Used for pottery, sculpture, or as a building material or decoration. (2) An object made of this material. (3) Color of the natural material.

TESSERA (pl. **TESSERAE**). A small piece of colored stone, marble, glass, or gold-backed glass used in a mosaic.

THEATER. In ancient Greece, an outdoor place for dramatic performances, usually semicircular in plan and provided with tiers of seats, the orchestra, and a support for scenery.

THEATINE ORDER. Founded in Rome in the 16th century by members of the recently dissolved Oratory of Divine Love. Its aim was to reform the Catholic church, and its members pledged to cultivate their spiritual lives and to perform charitable works.

THERMAE. A public bathing establishment of the ancient Romans that consisted of various types of baths and social gymnastic facilities.

THOLOS. A building with a circular plan, often with a sacred nature.

THRUST. The lateral pressure exerted by an arch, vault, or dome that must be counteracted at its point of greatest concentration either by the thickness of the wall or by some form of buttress.

TONDO. A circular painting or relief sculpture.

TRACERY. (1) Ornamental stonework in Gothic windows. In the earlier or plate tracery, the windows appear to have been cut through the solid stone. In bar tracery, the glass predominates, the slender pieces of stone having been added within the windows. (2) Similar ornamentation using various materials and applied to walls, shrines, façades, etc.

TRANSEPT. A cross arm in a basilican church placed at right angles to the nave and usually separating it from the choir or apse.

TRANSVERSALS. In a perspective construction, transversals are the lines parallel to the picture plane (horizontally) that denote distances. They intersect orthogonals to make a grid that guides the arrangement of elements to suggest space.

TREE OF KNOWLEDGE. The tree in the Garden of Eden from which Adam and Eve ate the forbidden fruit that destroyed their innocence.

TREE OF LIFE. A tree in the Garden of Eden whose fruit was reputed to give everlasting life; in medieval art it was frequently used as a symbol of Christ.

TRIBUNE. A platform or walkway in a church constructed overlooking the *aisle* and above the *nave.*

TRIFORIUM. The section of a nave wall above the arcade and below the clerestory. It frequently consists of a blind arcade with three openings in each bay. When the gallery is also present, a four-story elevation results, the triforium being between the gallery and clerestory. It may also occur in the transept and the choir walls.

TRIGLYPH. The element of a Doric frieze separating two consecutive metopes and divided by grooves into three sections.

TRIPTYCH. An altarpiece or devotional picture, either carved or painted, with one central panel and two hinged wings.

TRIUMPHAL ARCH. (1) A monumental arch, sometimes a combination of three arches, erected by a Roman emperor in commemoration of his military exploits and usually decorated with scenes of these deeds in relief sculpture. (2) The great transverse arch at the eastern end of a church that frames altar and apse and separates them from the main body of the church. It is frequently decorated with mosaics or mural paintings.

TROIS CRAYONS. The use of three colors, usually red, black, and white, in a drawing; a technique popular in the 17th and 18th centuries.

TROMPE L'OEIL. Meaning "trick of the eye" in French, it is a work of art designed to deceive a viewer into believing that the work of art is reality, an actual three-dimensional object or scene in space.

TROPHY. (1) In ancient Rome, arms or other spoils taken from a defeated enemy and publicly displayed on a tree, pillar, etc. (2) A representation of these objects, and others symbolic of victory, as a commemoration or decoration.

TRUMEAU. A central post supporting the lintel of a large doorway, as in a Romanesque or Gothic portal, where it is frequently decorated with sculpture.

TRUSS. A triangular wooden or metal support for a roof that may be left exposed in the interior or be covered by a ceiling.

TURRET. (1) A small tower that is part of a larger structure. (2) A small tower at a corner of a building, often beginning some distance from the ground.

TUSCHE. An inklike liquid containing crayon that is used to produce solid black (or solid color) areas in prints.

TYMPANUM. (1) In Classical architecture, a recessed, usually triangular area often decorated with sculpture. Also called a *pediment*. (2) In medieval architecture, an arched area between an arch and the lintel of a door or window, frequently carved with relief sculpture.

TYPOLOGY. The matching or pairing of pre-Christian figures, persons, and symbols with their Christian counterparts.

UNDERPAINTING. See *tempera painting*.

VANISHING POINT. The point at which the orthogonals meet and disappear in a composition done with scientific perspective.

VANITAS. The term derives from the book of Ecclesiastes I:2 ("Vanities of vanities, …") that refers to the passing of time and the notion of life's brevity and the inevitability of death. The vanitas theme found expression especially in the Northern European art of the 17th century.

VAULT. An arched roof or ceiling usually made of stone, brick, or concrete. Several distinct varieties have been developed; all need buttressing at the point where the lateral thrust is concentrated. (1) A barrel vault is a semicircular structure made up of successive arches. It may be straight or annular in plan. (2) A groin vault is the result of the intersection of two barrel vaults of equal size that produces a bay of four compartments with sharp edges, or groins, where the two meet. (3) A ribbed groin vault is one in which ribs are added to the groins for structural strength and for decoration. When the diagonal ribs are constructed as half-circles, the resulting form is a domical ribbed vault. (4) A sexpartite vault is a ribbed groin vault in which each bay is divided into six compartments by the addition of a transverse rib across the center. (5) The normal Gothic vault is quadripartite with all the arches pointed to some degree. (6) A fan vault is an elaboration of a ribbed groin vault, with elements of tracery using cone-like forms. It was developed by the English in the 15th century and was employed for decorative purposes.

VEDUTA (pl. **VEDUTE**). A view painting, generally a city landscape.

VELLUM. See *Parchment*.

VERISTIC. From the Latin *verus*, meaning "true." Describes a hyperrealistic style of portraiture that emphasizes individual characteristics.

VESTRY. A chamber in a church where the vestments (clerical garbs) and sacramental vessels are maintained. Also called a *sacristy*.

VICES. Often represented allegorically in conjunction with the seven virtues, they include Pride, Envy, Avarice, Wrath, Gluttony, Lust, and Sloth, though others such as Injustice and Folly are sometimes substituted.

VILLA. Originally a large country house but in modern usage a lso a detached house or suburban residence.

VIRTUES. The three theological virtues, Faith, Hope, and Charity, and the four cardinal ones, Prudence, Justice, Fortitude, and Temperance, were frequently represented allegorically, particularly in medieval manuscripts and sculpture.

VOLUTE. A spiraling architectural element found notably on Ionic and Composite capitals but also used decoratively on building façades and interiors.

VOTIVE. A devotional image used in the veneration or worship of a deity or saint.

VOUSSOIR. A wedge-shaped piece of stone used in arch construction.

WASH. A thin layer of translucent color or ink used in watercolor painting and brush drawing, and occasionally in oil painting.

WATERCOLOR PAINTING. Painting, usually on paper, in pigments suspended in water.

WEBS. Masonry construction of brick, concrete, stone, etc. that is used to fill in the spaces between groin vault ribs.

WESTWORK. From the German word *Westwerk*. In Carolingian, Ottonian, and German Romanesque architecture, a monumental western front of a church, treated as a tower or combination of towers and containing an entrance and vestibule below and a chapel and galleries above. Later examples often added a transept and a crossing tower.

WING. The side panel of an altarpiece that is frequently decorated on both sides and is also hinged, so that it may be shown either open or closed.

WOODCUT. A print made by carving out a design on a wooden block cut along the grain, applying ink to the raised surfaces that remain, and printing from those.

WROUGHT IRON. A comparatively pure form of iron that is easily forged and does not harden quickly, so that it can be shaped or hammered by hand, in contrast to molded cast iron.

WUNDERKAMMER (pl. **WUNDERKAMMERN**). Literally a "room of wonders." This forerunner of the museum developed in the 16th century. Such rooms displayed wonders of the world, often from exotic, far off places. The objects displayed included fossils, shells, coral, animals (bones, skins, etc.), and gems in an effort to form an encyclopedic collection. See *kunstkammen*.

ZIGGURAT. From the Assyrian word *ziqquratu*, meaning "mountaintop" or "height." In ancient Assyria and Babylonia, a pyramidal mound or tower built of mud-brick forming the base for a temple. It was often either stepped or had a broad ascent winding around it, which gave it the appearance of being stepped.

ZODIAC. An imaginary belt circling the heavens, including the paths of the sun, moon, and major planets and containing twelve constellations and thus twelve divisions called signs, which have been associated with the months. The signs are Aries, the ram; Taurus, the bull; Gemini, the twins; Cancer, the crab; Leo, the lion; Virgo, the virgin; Libra, the balance; Scorpio, the scorpion; Sagittarius, the archer; Capricorn, the goat; Aquarius, the waterbearer; and Pisces, the fish. They are frequently represented around the portals of Romanesque and Gothic churches in conjunction with the Labors of the Months.

Books for Further Reading

This list is intended to be as practical as possible. It is therefore limited to books of general interest that were printed over the past 20 years or have been generally available recently. However, certain indispensable volumes that have yet to be superseded are retained. This restriction means omitting numerous classics long out of print, as well as much specialized material of interest to the serious student. The reader is thus referred to the many specialized bibliographies noted below.

REFERENCE RESOURCES IN ART HISTORY

1. BIBLIOGRAPHIES AND RESEARCH GUIDES

Arntzen, E., and R. Rainwater. *Guide to the Literature of Art History*. Chicago: American Library, 1980.

Barnet, S. *A Short Guide to Writing About Art*. 8th ed. New York: Longman, 2005.

Ehresmann, D. *Architecture: A Bibliographical Guide to Basic Reference Works, Histories, and Handbooks*. Littleton, CO: Libraries Unlimited, 1984.

———. *Fine Arts: A Bibliographical Guide to Basic Reference Works, Histories, and Handbooks*. 3d ed. Littleton, CO: Libraries Unlimited, 1990.

Freitag, W. *Art Books: A Basic Bibliography of Monographs on Artists*. 2d ed. New York: Garland, 1997.

Goldman, B. *Reading and Writing in the Arts: A Handbook*. Detroit, MI: Wayne State Press, 1972.

Kleinbauer, W., and T. Slavens. *Research Guide to the History of Western Art*. Chicago: American Library, 1982.

Marmor, M., and A. Ross, eds. *Guide to the Literature of Art History 2*. Chicago: American Library, 2005.

Sayre, H. M. *Writing About Art*. New ed. Upper Saddle River, NJ: Pearson Prentice Hall, 2000.

2. DICTIONARIES AND ENCYCLOPEDIAS

Aghion, I. *Gods and Heroes of Classical Antiquity*. Flammarion Iconographic Guides. New York: Flammarion, 1996.

Boström, A., ed. *Encyclopedia of Sculpture*. 3 vols. New York: Fitzroy Dearborn, 2004.

Brigstocke, H., ed. *The Oxford Companion to Western Art*. New York: Oxford University Press, 2001.

Burden, E. *Illustrated Dictionary of Architecture*. New York: McGraw-Hill, 2002.

Carr-Gomm, S. *The Hutchinson Dictionary of Symbols in Art*. Oxford: Helicon, 1995.

Chilvers, I., et al., eds. *The Oxford Dictionary of Art*. 3d ed. New York: Oxford University Press, 2004.

Congdon, K. G. *Artists from Latin American Cultures: A Biographical Dictionary*. Westport, CT: Greenwood Press, 2002.

Cumming, R. *Art: A Field Guide*. New York: Alfred A. Knopf, 2001.

Curl, J. *A Dictionary of Architecture*. New York: Oxford University Press, 1999.

The Dictionary of Art. 34 vols. New York: Grove's Dictionaries, 1996.

Duchet-Suchaux, G., and M. Pastoureau. *The Bible and the Saints*. Flammarion Iconographic Guides. New York: Flammarion, 1994.

Encyclopedia of World Art. 14 vols., with index and supplements. New York: McGraw-Hill, 1959–1968.

Fleming, J., and H. Honour. *The Penguin Dictionary of Architecture and Landscape Architecture*. 5th ed. New York: Penguin, 1998.

———. *The Penguin Dictionary of Decorative Arts*. New ed. London: Viking, 1989.

Gascoigne, B. *How to Identify Prints: A Complete Guide to Manual and Mechanical Processes from Woodcut to Inkjet*. New York: Thames & Hudson, 2004.

Hall, J. *Dictionary of Subjects and Symbols in Art*. Rev. ed. London: J. Murray, 1996.

———. *Illustrated Dictionary of Symbols in Eastern and Western Art*. New York: HarperCollins, 1995.

International Dictionary of Architects and Architecture. 2 vols. Detroit, MI: St. James Press, 1993.

Langmuir, E. *Yale Dictionary of Art and Artists*. New Haven: Yale University Press, 2000.

Lever, J., and J. Harris. *Illustrated Dictionary of Architecture, 800–1914*. 2d ed. Boston: Faber & Faber, 1993.

Lucie-Smith, E. *The Thames & Hudson Dictionary of Art Terms*. New York: Thames & Hudson, 2004.

Mayer, R. *The Artist's Handbook of Materials and Techniques*. 5th ed. New York: Viking, 1991.

———. *The HarperCollins Dictionary of Art Terms & Techniques*. 2d ed. New York: HarperCollins, 1991.

Murray, P., and L. Murray. *A Dictionary of Art and Artists*. 7th ed. New York: Penguin, 1998.

———. *A Dictionary of Christian Art*. New York: Oxford University Press, 2004, © 1996.

Nelson, R. S., and R. Shiff, eds. *Critical Terms for Art History*. Chicago: University of Chicago Press, 2003.

Pierce, J. S. *From Abacus to Zeus: A Handbook of Art History*. 7th ed. Englewood Cliffs, NJ: Pearson Prentice Hall, 2004.

Reid, J. D., ed. *The Oxford Guide to Classical Mythology in the Arts 1300–1990*. 2 vols. New York: Oxford University Press, 1993.

Shoemaker, C., ed. *Encyclopedia of Gardens: History and Design*. Chicago: Fitzroy Dearborn, 2001.

Steer, J. *Atlas of Western Art History: Artists, Sites, and Movements from Ancient Greece to the Modern Age*. New York: Facts on File, 1994.

West, S., ed. *The Bulfinch Guide to Art History*. Boston: Little, Brown, 1996.

———. *Portraiture*. Oxford History of Art. New York: Oxford University Press, 2004.

3. INDEXES, PRINTED AND ELECTRONIC

ARTbibliographies Modern. 1969 to present. A semiannual publication indexing and annotating more than 300 art periodicals, as well as books, exhibition catalogues, and dissertations. Data since 1974 also available electronically.

Art Index. 1929 to present. A standard quarterly index to more than 200 art periodicals. Also available electronically.

Avery Index to Architectural Periodicals. 1934 to present. 15 vols., with supplementary vols. Boston: G. K. Hall, 1973. Also available electronically.

BHA: Bibliography of the History of Art. 1991 to present. The merger of two standard indexes: *RILA* (*Répertoire International de la Littérature de l'Art/International Repertory of the Literature of Art*, vol. 1. 1975) and *Répertoire d'Art et d'Archéologie* (vol. 1. 1910). Data since 1973 also available electronically.

Index Islamicus. 1665 to present. Multiple publishers. Data since 1994 also available electronically.

The Perseus Project: An Evolving Digital Library on Ancient Greece and Rome. Medford, MA: Tufts University, Classics Department, 1994.

4. WORLDWIDE WEBSITES

Visit the following websites for reproductions and information regarding artists, periods, movements, and many more subjects. The art history departments and libraries of many universities and colleges also maintain websites where you can get reading lists and links to other websites, such as those of museums, libraries, and periodicals.

http://www.aah.org.uk/welcome.html Association of Art Historians

http://www.amico.org Art Museum Image Consortium

http://www.archaeological.org Archaeological Institute of America

http://archnet.asu.edu/archnet Virtual Library for Archaeology

http://www.artchive.com

http://www.art-design.umich.edu/mother/ Mother of all Art History links pages, maintained by the Department of the History of Art at the University of Michigan

http://www.arthistory.net Art History Network

http://artlibrary.vassar.edu/ifla-idal International Directory of Art Libraries

http://www.bbk.ac.uk/lib/hasubject.html Collection of resources maintained by the History of Art Department of Birkbeck College, University of London

http://classics.mit.edu The Internet Classics Archive

http://www.collegeart.org College Art Association

http://www.constable.net

http://www.cr.nps.gov/habshaer Historic American Buildings Survey

http://www.getty.edu Including museum, five institutes, and library

http://www.harmsen.net/ahrc/ Art History Research Centre

http://icom.museum/ International Council of Museums

http://www.icomos.org International Council on Monuments and Sites

http://www.ilpi.com/artsource

http://www.siris.si.edu Smithsonian Institution Research Information System

http://whc.unesco.org/ World Heritage Center

5. GENERAL SOURCES ON ART HISTORY, METHOD, AND THEORY

Andrews, M. *Landscape and Western Art*. Oxford History of Art. New York: Oxford University Press, 1999.

Barasch, M. *Modern Theories of Art: Vol. 1, From Winckelmann to Baudelaire. Vol. 2, From Impressionism to Kandinsky*. New York: 1990–1998.

———. *Theories of Art: From Plato to Winckelmann*. New York: Routledge, 2000.

Battistini, M. *Symbols and Allegories in Art*. Los Angeles: J. Paul Getty Museum, 2005.

Baxandall, M. *Patterns of Intention: On the Historical Explanation of Pictures*. New Haven: Yale University Press, 1985.

Bois, Y.-A. *Painting as Model*. Cambridge, MA: MIT Press, 1993.

Broude, N., and M. Garrard. *The Expanding Discourse: Feminism and Art History*. New York: Harper & Row, 1992.

———., eds. *Feminism and Art History: Questioning the Litany*. New York: Harper & Row, 1982.

Bryson, N., ed. *Vision and Painting: The Logic of the Gaze*. New Haven: Yale University Press, 1983.

———., et al., eds. *Visual Theory: Painting and Interpretation*. New York: Cambridge University Press, 1991.

Chadwick, W. *Women, Art, and Society*. 3d ed. New York: Thames & Hudson, 2002.

D'Alleva, A. *Methods & Theories of Art History*. London: Laurence King, 2005.

Freedberg, D. *The Power of Images: Studies in the History and Theory of Response*. Chicago: University of Chicago Press, 1989.

Gage, J. *Color and Culture: Practice and Meaning from Antiquity to Abstraction*. Berkeley: University of California Press, 1999.

Garland Library of the History of Art. New York: Garland, 1976. Collections of essays on specific periods.

Goldwater, R., and M. Treves, eds. *Artists on Art, from the Fourteenth to the Twentieth Century*. 3d ed. New York: Pantheon, 1974.

Gombrich, E. H. *Art and Illusion*. 6th ed. New York: Phaidon, 2002.

Harris, A. S., and L. Nochlin. *Women Artists, 1550–1950*. New York: Random House, 1999.

Holly, M. A. *Panofsky and the Foundations of Art History*. Ithaca, NY: Cornell University Press, 1984.

Holt, E. G., ed. *A Documentary History of Art: Vol. 1, The Middle Ages and the Renaissance. Vol. 2, Michelangelo and the Mannerists. The Baroque and the Eighteenth Century. Vol. 3, From the Classicists to the Impressionists*. 2d ed. Princeton, NJ: Princeton University Press, 1981. Anthologies of primary sources on specific periods.

Johnson, P. *Art: A New History*. New York: HarperCollins, 2003.

Kemal, S., and I. Gaskell. *The Language of Art History.* Cambridge Studies in Philosophy and the Arts. New York: Cambridge University Press, 1991.

Kemp, M., ed. *The Oxford History of Western Art.* New York: Oxford University Press, 2000.

Kleinbauer, W. E. *Modern Perspectives in Western Art History: An Anthology of Twentieth-Century Writings on the Visual Arts.* Reprint of 1971 ed. Toronto: University of Toronto Press, 1989.

Kostof, S. A. *History of Architecture: Settings and Rituals.* 2d ed. New York: Oxford University Press, 1995.

Kruft, H. W. *A History of Architectural Theory from Vitruvius to the Present.* Princeton, NJ: Princeton Architectural Press, 1994.

Kultermann, U. *The History of Art History.* New York: Abaris Books, 1993.

Langer, C. *Feminist Art Criticism: An Annotated Bibliography.* Boston: G. K. Hall, 1993.

Laver, J. *Costume and Fashion: A Concise History.* 4th ed. The World of Art. London: Thames & Hudson, 2002.

Lavin, I., ed. *Meaning in the Visual Arts: Views from the Outside: A Centennial Commemoration of Erwin Panofsky (1892–1968).* Princeton, NJ: Institute for Advanced Study, 1995.

Minor, V. H. *Art History's History.* Upper Saddle River, NJ: Pearson Prentice Hall, 2001.

Nochlin, L. *Women, Art, and Power, and Other Essays.* New York: HarperCollins, 1989.

Pächt, O. *The Practice of Art History: Reflections on Method.* London: Harvey Miller, 1999.

Panofsky, E. *Meaning in the Visual Arts.* Reprint of 1955 ed. Chicago: University of Chicago Press, 1982.

Penny, N. *The Materials of Sculpture.* New Haven: Yale University Press, 1993.

Pevsner, N. *A History of Building Types.* Princeton, NJ: Princeton University Press, 1976.

Podro, M. *The Critical Historians of Art.* New Haven: Yale University Press, 1982.

Pollock, G. *Differencing the Canon: Feminist Desire and the Writing of Art's Histories.* New York: Routledge, 1999.

———. *Vision and Difference: Femininity, Feminism, and the Histories of Art.* New York: Routledge, 1988.

Prettejohn, E. *Beauty and Art 1750–2000.* New York: Oxford University Press, 2005.

Preziosi, D., ed. *The Art of Art History: A Critical Anthology.* New York: Oxford University Press, 1998.

Rees, A. L., and F. Borzello. *The New Art History.* Atlantic Highlands, NJ: Humanities Press International, 1986.

Roth, L. *Understanding Architecture: Its Elements, History, and Meaning.* New York: Harper & Row, 1993.

Sedlmayr, H. *Framing Formalism: Riegl's Work.* Amsterdam: G+B Arts International, © 2001.

Smith, P., and C. Wilde, eds. *A Companion to Art Theory.* Oxford: Blackwell, 2002.

Sources and Documents in the History of Art Series. General ed. H. W. Janson. Englewood Cliffs, NJ: Prentice Hall. Anthologies of primary sources on specific periods.

Sutton, I. *Western Architecture.* New York: Thames & Hudson, 1999.

Tagg, J. *Grounds of Dispute: Art History, Cultural Politics, and the Discursive Field.* Minneapolis: University of Minnesota Press, 1992.

Trachtenberg, M., and I. Hyman. *Architecture: From Prehistory to Post-Modernism.* 2d ed. New York: Harry N. Abrams, 2002.

Watkin, D. *The Rise of Architectural History.* Chicago: University of Chicago Press, 1980.

Wolff, J. *The Social Production of Art.* 2d ed. New York: New York University Press, 1993.

Wölfflin, H. *Principles of Art History: The Problem of the Development of Style in Later Art.* Various eds. New York: Dover.

Wollheim, R. *Art and Its Objects.* 2d ed. New York: Cambridge University Press, 1992.

PART ONE: THE ANCIENT WORLD

GENERAL REFERENCES

Baines, J., ed. *Civilizations of the Ancient Near East.* 4 vols. New York: Scribner, 1995.

Boardman, J., ed. *The Oxford History of Classical Art.* New York: Oxford University Press, 2001.

De Grummond, N., ed. *An Encyclopedia of the History of Classical Archaeology.* Westport, CT: Greenwood, 1996.

Fine, S. *Art and Judaism in the Greco-Roman World: Toward a New Jewish Archaeology.* New York: Cambridge University Press, 2005.

Holliday, P. J. *Narrative and Event in Ancient Art.* New York: Cambridge University Press, 1993.

Redford, D. B., ed. *The Oxford Encyclopedia of Ancient Egypt.* 3 vols. New York: Oxford University Press, 2001.

Stillwell, R. *The Princeton Encyclopedia of Classical Sites.* Princeton, NJ: Princeton University Press, 1976.

Tadgell, C. *Origins: Egypt, West Asia and the Aegean.* New York: Whitney Library of Design, 1998.

Van Keuren, F. *Guide to Research in Classical Art and Mythology.* Chicago: American Library Association, 1991.

Wharton, A. J. *Refiguring the Post-Classical City: Dura Europos, Jerash, Jerusalem, and Ravenna.* New York: Cambridge University Press, 1995.

Winckelmann, J. J. *Essays on the Philosophy and History of Art.* 3 vols. Bristol, England: Thoemmes, 2001.

Wolf, W. *The Origins of Western Art: Egypt, Mesopotamia, the Aegean.* New York: Universe Books, 1989.

Yegül, F. K. *Baths and Bathing in Classical Antiquity.* Architectural History Foundation. Cambridge, MA: MIT Press, 1992.

CHAPTER 1. PREHISTORIC ART

Bahn, P. G. *The Cambridge Illustrated History of Prehistoric Art.* New York: Cambridge University Press, 1988.

Chauvet, J.-M., É. B. Deschamps, and C. Hilaire. *Dawn of Art: The Chauvet Cave.* New York: Harry N. Abrams, 1995.

Clottes, J. *Chauvet Cave.* Salt Lake City: University of Utah Press, 2003.

———. *The Shamans of Prehistory: Trance and Magic in the Painted Caves.* New York: Harry N. Abrams, 1998.

Cunliffe, B., ed. *The Oxford Illustrated Prehistory of Europe.* New York: Oxford University Press, 1994.

Fitton, J. L. *Cycladic Art.* London: British Museum Press, 1999.

Fowler, P. *Images of Prehistory.* New York: Cambridge University Press, 1990.

Leroi-Gourhan, A. *The Dawn of European Art: An Introduction to Paleolithic Cave Painting.* New York: Cambridge University Press, 1982.

Ruspoli, M. *The Cave of Lascaux: The Final Photographs.* New York: Harry N. Abrams, 1987.

Sandars, N. *Prehistoric Art in Europe.* 2d ed. New Haven: Yale University Press, 1992.

Saura Ramos, P. A. *The Cave of Altamira.* New York: Harry N. Abrams, 1999.

Twohig, E. S. *The Megalithic Art of Western Europe.* New York: Oxford University Press, 1981.

White, R. *Prehistoric Art: The Symbolic Journey of Mankind.* New York: Harry N. Abrams, 2003.

CHAPTER 2. ANCIENT NEAR EASTERN ART

Amiet, P. *Art of the Ancient Near East.* New York: Harry N. Abrams, 1980.

Aruz, J., ed. *Art of the First Cities: The Third Millennium B.C. from the Mediterranean to the Indus.* Exh. cat. New York: Metropolitan Museum of Art; Yale University Press, 2003.

Collon, D. *Ancient Near Eastern Art.* Berkeley: University of California Press, 1995.

———. *First Impressions: Cylinder Seals in the Ancient Near East.* Chicago: University of Chicago Press, 1987.

Crawford, H. *The Architecture of Iraq in the Third Millennium B.C.* Copenhagen: Akademisk Forlag, 1977.

Curtis, J., and N. Tallis. *Forgotten Empire: The World of Ancient Persia.* Exh. cat. London: British Museum, 2005.

Frankfort, H. *The Art and Architecture of the Ancient Orient.* 5th ed. Pelican History of Art. New Haven: Yale University Press, 1997.

Goldman, B. *The Ancient Arts of Western and Central Asia: A Guide to the Literature.* Ames: Iowa State University Press, 1991.

Harper, P. O., ed. *The Royal City of Susa: Ancient Near Eastern Treasures in the Louvre.* New York: Metropolitan Museum of Art; Dist. by Harry N. Abrams, 1992.

Leick, G. *A Dictionary of Ancient Near Eastern Architecture.* New York: Routledge, 1988.

Lloyd, S. *The Archaeology of Mesopotamia: From the Old Stone Age to the Persian Conquest.* Rev. ed. New York: Thames & Hudson, 1984.

Moscati, S. *The Phoenicians.* New York: Abbeville Press, 1988.

Oates, J. *Babylon.* Rev. ed. London: Thames & Hudson, 1986.

Reade, J. *Mesopotamia.* 2d ed. London: Published for the Trustees of the British Museum by the British Museum Press, 2000.

Zettler, R., and L. Horne, eds. *Treasures from the Royal Tombs of Ur.* Exh. cat. Philadelphia: University of Pennsylvania, Museum of Archaeology and Anthropology, 1998.

CHAPTER 3. EGYPTIAN ART

Aldred, C. *The Development of Ancient Egyptian Art, from 3200 to 1315 B.C.* 3 vols. in 1. London: Academy Editions, 1972.

———. *Egyptian Art.* London: Thames & Hudson, 1985.

Arnold, D., and C. Ziegler. *Building in Egypt: Pharaonic Stone Masonry.* New York: Oxford University Press, 1991.

———. *Egyptian Art in the Age of the Pyramids.* New York: Harry N. Abrams, 1999.

Bothmer, B. V. *Egyptian Art: Selected Writings of Bernard V. Bothmer.* New York: Oxford University Press, 2004.

Davis, W. *The Canonical Tradition in Ancient Egyptian Art.* New York: Cambridge University Press, 1989.

Edwards, I. E. S. *The Pyramids of Egypt.* Rev. ed. Harmondsworth, England: Penguin, 1991.

Egyptian Art in the Age of the Pyramids. New York: Metropolitan Museum of Art; Dist. by Harry N. Abrams, 1999.

Grimal, N. *A History of Ancient Egypt.* London: Blackwell, 1992.

Mahdy, C., ed. *The World of the Pharaohs: A Complete Guide to Ancient Egypt.* London: Thames & Hudson, 1990.

Malek, J. *Egypt: 4000 Years of Art.* London: Phaidon, 2003.

———. *Egyptian Art. Art & Ideas.* London: Phaidon, 1999.

Mendelssohn, K. *The Riddle of the Pyramids.* New York: Thames & Hudson, 1986.

Parry, D. *Engineering the Pyramids.* Stroud, England: Sutton, 2004.

Robins, G. *The Art of Ancient Egypt.* Cambridge, MA: Harvard University Press, 1997.

Schaefer, H. *Principles of Egyptian Art.* Oxford: Clarendon Press, 1986.

Schulz, R., and M. Seidel. *Egypt: The World of the Pharaohs.* Cologne: Könemann, 1998.

Smith, W., and W. Simpson. *The Art and Architecture of Ancient Egypt.* Rev. ed. Pelican History of Art. New Haven: Yale University Press, 1999.

Tiradritti, F. *Ancient Egypt: Art, Architecture and History.* London: British Museum Press, 2002.

Walker, S. and P. Higgs, eds. *Cleopatra of Egypt: From History to Myth.* Exh. cat. Princeton, NJ: Princeton University Press, 2001.

Wilkinson, R. *Reading Egyptian Art: A Hieroglyphic Guide to Ancient Egyptian Painting and Sculpture.* New York: Thames & Hudson, 1992.

CHAPTER 4. AEGEAN ART

Akurgal, E. *The Aegean, Birthplace of Western Civilization: History of East Greek Art and Culture, 1050–333 B.C.* Izmir, Turkey: Metropolitan Municipality of Izmir, 2000.

Barber, R. *The Cyclades in the Bronze Age.* Iowa City: University of Iowa Press, 1987.

Dickinson, O. T. P. K. *The Aegean Bronze Age.* New York: Cambridge University Press, 1994.

Elytis, O. *The Aegean: The Epicenter of Greek Civilization.* Athens: Melissa, 1997.

German, S. C. *Performance, Power and the Art of the Aegean Bronze Age.* Oxford: Archaeopress, 2005.

Getz-Preziosi, P. *Sculptors of the Cyclades.* Ann Arbor: University of Michigan Press, 1987.

Graham, J. *The Palaces of Crete.* Rev. ed. Princeton, NJ: Princeton University Press, 1987.

Hampe, R., and E. Simon. *The Birth of Greek Art from the Mycenean to the Archaic Period.* New York: Oxford University Press, 1981.

Higgins, R. *Minoan and Mycenaean Art.* Rev. ed. The World of Art. New York: Oxford University Press, 1981.

Hood, S. *The Arts in Prehistoric Greece.* Pelican History of Art. New Haven: Yale University Press, 1992.

———. *The Minoans: The Story of Bronze Age Crete.* New York: Praeger, 1981.

Hurwit, J. *The Art and Culture of Early Greece, 1100–480 B.C.* Ithaca, NY: Cornell University Press, 1985.

McDonald, W. *Progress into the Past: The Rediscovery of Mycenaean Civilization.* 2d ed. Bloomington: Indiana University Press, 1990.

Preziosi, D., and L. Hitchcock. *Aegean Art and Architecture.* New York: Oxford University Press, 1999.

Renfrew, C. *The Cycladic Spirit: Masterpieces from the Nicholas P. Goulandris Collection.* London: Thames & Hudson, 1991.

Vermeule, E. *Greece in the Bronze Age.* Chicago: University of Chicago Press, 1972.

CHAPTER 5. GREEK ART

Beard, M. *The Parthenon.* Cambridge, MA: Harvard University Press, 2003.

Beazley, J. D. *Athenian Red Figure Vases: The Archaic Period: A Handbook*. The World of Art. New York: Thames & Hudson, 1991.

———. *Athenian Red Figure Vases: The Classical Period: A Handbook*. The World of Art. New York: Thames & Hudson, 1989.

———. *The Development of Attic Black-Figure*. Rev. ed. Berkeley: University of California Press, 1986.

———. *Greek Vases: Lectures*. Oxford and New York: Clarendon Press and Oxford University Press, 1989.

Boardman, J. *The Archaeology of Nostalgia: How the Greeks Re-Created Their Mythical Past*. London: Thames & Hudson, 2002.

———. *Athenian Black Figure Vases: A Handbook*. Corrected ed. The World of Art. New York: Thames & Hudson, 1991.

———. *Early Greek Vase Painting: 11th–6th Centuries B.C.: A Handbook*. The World of Art. New York: Thames & Hudson, 1998.

———. *Greek Art*. 4th ed., rev. and expanded. The World of Art. New York: Thames & Hudson, 1996.

———. *Greek Sculpture: The Archaic Period: A Handbook*. Corrected ed. The World of Art. New York: Thames & Hudson, 1991.

———. *Greek Sculpture: The Classical Period: A Handbook*. Corrected ed. New York: Thames & Hudson, 1991.

———. *The History of Greek Vases: Potters, Painters, and Pictures*. New York: Thames & Hudson, 2001.

Burn, L. *Hellenistic Art: From Alexander the Great to Augustus*. London: The British Museum, 2004.

Carpenter, T. H. *Art and Myth in Ancient Greece: A Handbook*. The World of Art. New York: Thames & Hudson, 1991.

Carratelli, G. P., ed. *The Greek World: Art and Civilization in Magna Graecia and Sicily*. Exh. cat. New York: Rizzoli, 1996.

Fullerton, M. D. *Greek Art*. New York: Cambridge University Press, 2000.

Hampe, R., and E. Simon. *The Birth of Greek Art*. Oxford: Oxford University Press, 1981.

Haynes, D. E. L. *The Technique of Greek Bronze Statuary*. Mainz am Rhein: P. von Zabern, 1992.

Himmelmann, N. *Reading Greek Art: Essays*. Princeton, NJ: Princeton University Press, 1998.

Hurwit, J. M. *The Acropolis in the Age of Pericles*. New York: Cambridge University Press, 2004.

———. *The Art & Culture of Early Greece, 1100–480 B.C.* Ithaca, NY: Cornell University Press, 1985.

Lawrence, A. *Greek Architecture*. Rev. 5th ed. Pelican History of Art. New Haven: Yale University Press, 1996.

Osborne, R. *Archaic and Classical Greek Art*. New York: Oxford University Press, 1998.

Papaioannou, K. *The Art of Greece*. New York: Harry N. Abrams, 1989.

Pedley, J. *Greek Art and Archaeology*. 2d ed. New York: Harry N. Abrams, 1997.

Pollitt, J. *The Ancient View of Greek Art: Criticism, History, and Terminology*. New Haven: Yale University Press, 1974.

———. *Art in the Hellenistic Age*. New York: Cambridge University Press, 1986.

———., ed. *Art of Ancient Greece: Sources and Documents*. New York: Cambridge University Press, 1990.

Potts, A. *Flesh and the Ideal: Winckelmann and the Origins of Art History*. New Haven: Yale University Press, 1994.

Rhodes, R. *Architecture and Meaning on the Athenian Acropolis*. New York: Cambridge University Press, 1995.

Richter, G. M. A. *A Handbook of Greek Art*. 9th ed. New York: Da Capo, 1987.

———. *Portraits of the Greeks*. Ed. R. Smith. New York: Oxford University Press, 1984.

Ridgway, B. S. *Hellenistic Sculpture: Vol. 1, The Styles of ca. 331–200 B.C.* Bristol, England: Bristol Classical Press, 1990.

Robertson, M. *The Art of Vase Painting in Classical Athens*. New York: Cambridge University Press, 1992.

Rolley, C. *Greek Bronzes*. New York: Philip Wilson for Sotheby's Publications; Dist. by Harper & Row, 1986.

Schefold, K. *Gods and Heroes in Late Archaic Greek Art*. New York: Cambridge University Press, 1992.

Smith, R. *Hellenistic Sculpture*. The World of Art. New York: Thames & Hudson, 1991.

Spivey, N. *Greek Art*. London: Phaidon, 1997.

Stafford, E. *Life, Myth, and Art in Ancient Greece*. Los Angeles: J. Paul Getty Museum, 2004.

Stansbury-O'Donnell, M. *Pictorial Narrative in Ancient Greek Art*. New York: Cambridge University Press, 1999.

Stewart, A. F. *Greek Sculpture: An Exploration*. New Haven: Yale University Press, 1990.

Whitley, J. *The Archaeology of Ancient Greece*. New York: Cambridge University Press, 2001.

CHAPTER 6. ETRUSCAN ART

Boethius, A. *Etruscan and Early Roman Architecture*. 2d ed. Pelican History of Art. New Haven: Yale University Press, 1992.

Bonfante, L., ed. *Etruscan Life and Afterlife: A Handbook of Etruscan Studies*. Detroit, MI: Wayne State University, 1986.

Borrelli, F. *The Etruscans: Art, Architecture, and History*. Los Angeles: J. Paul Getty Museum, 2004.

Brendel, O. *Etruscan Art*. Pelican History of Art. New Haven: Yale University Press, 1995.

Hall, J. F., ed. *Etruscan Italy: Etruscan Influences on the Civilizations of Italy from Antiquity to the Modern Era*. Provo, UT: Museum of Art, Brigham Young University, 1996.

Haynes, Sybille. *Etruscan Civilization: A Cultural History*. Los Angeles: J. Paul Getty Museum, 2000.

Richardson, E. *The Etruscans: Their Art and Civilization*. Reprint of 1964 ed., with corrections. Chicago: University of Chicago Press, 1976.

Spivey, N. *Etruscan Art*. The World of Art. New York: Thames & Hudson, 1997.

Sprenger, M., G. Bartoloni, and M. Hirmer. *The Etruscans: Their History, Art, and Architecture*. New York: Harry N. Abrams, 1983.

Steingräber, S., ed. *Etruscan Painting: Catalogue Raisonné of Etruscan Wall Paintings*. New York: Johnson Reprint, 1986.

Torelli, M., ed. *The Etruscans*. Exh. cat. Milan: Bompiani, 2000.

CHAPTER 7. ROMAN ART

Allan, T. *Life, Myth and Art in Ancient Rome*. Los Angeles: J. Paul Getty Museum, 2005.

Andreae, B. *The Art of Rome*. New York: Harry N. Abrams, 1977.

Beard, M., and J. Henderson. *Classical Art: From Greece to Rome*. New York: Oxford University Press, 2001.

Bowe, P. *Gardens of the Roman World*. Los Angeles: J. Paul Getty Museum, 2004.

Brilliant, R. *Commentaries on Roman Art: Selected Studies*. London: Pindar Press, 1994.

———. *My Laocoon: Alternative Claims in the Interpretation of Artworks*. University of California Press, 2000.

Claridge, A. *Rome: An Oxford Archaeological Guide*. New York: Oxford University Press, 1998.

D'Ambra, E. *Roman Art*. New York: Cambridge University Press, 1998.

———., comp. *Roman Art in Context: An Anthology*. Englewood Cliffs, NJ: Prentice Hall, 1993.

Davies, P. *Death and the Emperor: Roman Imperial Funerary Monuments from Augustus to Marcus Aurelius*. Austin: University of Texas Press, 2004.

Dunbabin, K. M. D. *Mosaics of the Greek and Roman World*. New York: Cambridge University Press, 1999.

Elsner, J. *Imperial Rome and Christian Triumph: The Art of the Roman Empire, A.D. 100–450*. New York: Oxford University Press, 1998.

Gazda, E. K. *Roman Art in the Private Sphere: New Perspectives on the Architecture and Decor of the Domus, Villa, and Insula*. Ann Arbor: University of Michigan Press, 1991.

Jenkyns, R., ed. *The Legacy of Rome: A New Appraisal*. New York: Oxford University Press, 1992.

Kleiner, D. *Roman Sculpture*. New Haven: Yale University Press, 1992.

———., and S. B. Matheson, eds. *I, Claudia: Women in Ancient Rome*. New Haven: Yale University Art Gallery, 1996.

Ling, R. *Ancient Mosaics*. London: British Museum Press, 1998.

———. *Roman Painting*. New York: Cambridge University Press, 1991.

Nash, E. *Pictorial Dictionary of Ancient Rome*. 2 vols. Reprint of 1968 2d ed. New York: Hacker, 1981.

Pollitt, J. J. *The Art of Rome, c. 753 B.C.– A.D. 337: Sources and Documents*. New York: Cambridge University Press, 1983.

Ramage, N., and A. Ramage. *The Cambridge Illustrated History of Roman Art*. Cambridge: Cambridge University Press, 1991.

———. *Roman Art: Romulus to Constantine*. 4th ed. Upper Saddle River, NJ: Pearson Prentice Hall, 2005.

Richardson, L. *A New Topographical Dictionary of Ancient Rome*. Baltimore, MD: Johns Hopkins University Press, 1992.

Rockwell, P. *The Art of Stoneworking: A Reference Guide*. Cambridge: Cambridge University Press, 1993.

Strong, D. E. *Roman Art*. 2d ed. Pelican History of Art. New Haven: Yale University Press, 1992.

Vitruvius. *The Ten Books on Architecture*. Trans. I. Rowland. Cambridge: Cambridge University Press, 1999.

Ward-Perkins, J. B. *Roman Imperial Architecture*. Reprint of 1981 ed. Pelican History of Art. New York: Penguin, 1992.

Zanker, P. *The Power of Images in the Age of Augustus*. Ann Arbor: University of Michigan Press, 1988.

PART TWO: THE MIDDLE AGES

GENERAL REFERENCES

Alexander, J. J. G. *Medieval Illuminators and Their Methods of Work*. New Haven: Yale University Press, 1992.

———., ed. *A Survey of Manuscripts Illuminated in the British Isles*. 6 vols. London: Harvey Miller, 1975–1996.

Avril, F., and J. J. G. Alexander, eds. *A Survey of Manuscripts Illuminated in France*. London: Harvey Miller, 1996.

Bartlett, R., ed. *Medieval Panorama*. Los Angeles: J. Paul Getty Museum, 2001.

Cahn, W. *Studies in Medieval Art and Interpretation*. London: Pindar Press, 2000.

Calkins, R. G. *Medieval Architecture in Western Europe: From A.D. 300 to 1500*. New York: Oxford University Press, 1998.

Cassidy, B., ed. *Iconography at the Crossroads*. Princeton, NJ: Princeton University Press, 1993.

De Hamel, C. *The British Library Guide to Manuscript Illumination: History and Techniques*. Toronto: University of Toronto Press, 2001.

———. *A History of Illuminated Manuscripts*. Rev. and enl. 2d ed. London: Phaidon Press, 1994.

Duby, G. *Art and Society in the Middle Ages*. Polity Press; Malden, MA: Blackwell Publishers, 2000.

Hamburger, J. *Nuns as Artists: The Visual Culture of a Medieval Convent*. Berkeley: University of California Press, 1997.

Katzenellenbogen, A. *Allegories of the Virtues and Vices in Medieval Art*. Reprint of 1939 ed. Toronto: University of Toronto Press, 1989.

Kazhdan, A. P. *The Oxford Dictionary of Byzantium*. 3 vols. New York: Oxford University Press, 1991.

Kessler, H. L. *Seeing Medieval Art*. Peterborough, Ont. and Orchard Park, NY: Broadview Press, 2004.

Pächt, O. *Book Illumination in the Middle Ages: An Introduction*. London: Harvey Miller, 1986.

Pelikan, J. *Mary Through the Centuries: Her Place in the History of Culture*. New Haven: Yale University Press, 1996.

Ross, L. *Artists of the Middle Ages*. Westport, CT: Greenwood Press, 2003.

———. *Medieval Art: A Topical Dictionary*. Westport, CT: Greenwood Press, 1996.

Schütz, B. *Great Cathedrals*. New York: Harry N. Abrams, 2002.

Sears, E., and T. K. Thomas, eds. *Reading Medieval Images: The Art Historian and the Object*. Ann Arbor: University of Michigan Press, 2002.

Sekules, V. *Medieval Art*. New York: Oxford University Press, 2001.

Snyder, J. *Medieval Art: Painting, Sculpture, Architecture, 4th–14th Century*. New York: Harry N. Abrams, 1989.

Stokstad, M. *Medieval Art*. Boulder, CO: Westview Press, 2004.

Tasker, E. *Encyclopedia of Medieval Church Art*. London: Batsford, 1993.

Watson, R. *Illuminated Manuscripts and Their Makers: An Account Based on the Collection of the Victoria and Albert Museum*. London and New York: V & A Publications; Dist. by Harry N. Abrams, 2003.

Wieck, R. S. *Painted Prayers: The Book of Hours in Medieval and Renaissance Art*. New York: George Braziller in association with the Pierpont Morgan Library, 1997.

Wixom, W. D. *Mirror of the Medieval World*. Exh. cat. New York: Metropolitan Museum of Art; Dist. by Harry N. Abrams, 1999.

CHAPTER 8. EARLY CHRISTIAN AND BYZANTINE ART

Beckwith, J. *Studies in Byzantine and Medieval Western Art*. London: Pindar Press, 1989.

Bowersock, G. W., ed. *Late Antiquity: A Guide to the Postclassical World*. Cambridge, MA: Belknap Press of Harvard University Press, 1999.

Demus, O. *Studies in Byzantium, Venice and the West*. 2 vols. London: Pindar Press, 1998.

Drury, J. *Painting the Word: Christian Pictures and Their Meanings*. New Haven and London: Yale University Press in association with National Gallery Publications, 1999.

Durand, J. *Byzantine Art*. Paris: Terrail, 1999.

Evans, H. C., ed. *Byzantium: Faith and Power, 1261–1557.* Exh. cat. New York and New Haven: Metropolitan Museum of Art; Yale University Press, 2004.

Galavaris, G. *Colours, Symbols, Worship: The Mission of the Byzantine Artist.* London: Pindar, 2005.

Grabar, A. *Christian Iconography: A Study of Its Origins.* Princeton, NJ: Princeton University Press, 1968.

Henderson, G. *Vision and Image in Early Christian England.* New York: Cambridge University Press, 1999.

Kalavrezou, I. *Byzantine Women and Their World.* Exh. cat. Cambridge, MA and New Haven: Harvard University Art Museums; Yale University Press, © 2003.

Kleinbauer, W. *Early Christian and Byzantine Architecture: An Annotated Bibliography and Historiography.* Boston: G. K. Hall, 1993.

Krautheimer, R., and S. Curcic. *Early Christian and Byzantine Architecture.* 4th ed. Pelican History of Art. New Haven: Yale University Press, 1992.

Lowden, J. *Early Christian and Byzantine Art.* London: Phaidon, 1997.

Maguire, H. *Art and Eloquence in Byzantium.* Princeton, NJ: Princeton University Press, 1981.

Mango, C. *The Art of the Byzantine Empire, 312–1453: Sources and Documents.* Reprint of 1972 ed. Toronto: University of Toronto Press, 1986.

Mark, R., and A. S. Çakmak, eds. *Hagia Sophia from the Age of Justinian to the Present.* New York: Cambridge University Press, 1992.

Matthews, T. *Byzantium from Antiquity to the Renaissance.* New York: Harry N. Abrams, 1998.

———. *The Clash of Gods: A Reinterpretation of Early Christian Art.* Princeton, NJ: Princeton University Press, 1993.

Milburn, R. *Early Christian Art and Architecture.* Berkeley: University of California Press, 1988.

Rodley, L. *Byzantine Art and Architecture: An Introduction.* New York: Cambridge University Press, 1994.

Simson, O. G. von. *Sacred Fortress: Byzantine Art and Statecraft in Ravenna.* Reprint of 1948 ed. Princeton, NJ: Princeton University Press, 1987.

Webster, L., and M. Brown, eds. *The Transformation of the Roman World* A.D. *400–900.* Berkeley: University of California Press, 1997.

Weitzmann, K. *Late Antique and Early Christian Book Illumination.* New York: Braziller, 1977.

CHAPTER 9. ISLAMIC ART

Asher, C. E. B. *Architecture of Mughal India.* New Cambridge History of India, Cambridge, England. New York: Cambridge University Press, 1992.

Atil, E. *The Age of Sultan Süleyman the Magnificent.* Exh. cat. Washington, DC: National Gallery of Art; New York: Harry N. Abrams, 1987.

———. *Renaissance of Islam: Art of the Mamluks.* Exh. cat. Washington, DC: Smithsonian Institution Press, 1981.

Behrens-Abouseif, D. *Beauty in Arabic Culture.* Princeton, NJ: Markus Wiener, 1998.

Bierman, I., ed. *The Experience of Islamic Art on the Margins of Islam.* Reading, England: Ithaca Press, 2005.

Blair, S., and J. Bloom. *The Art and Architecture of Islam 1250–1800.* Pelican History of Art. New Haven: Yale University Press, 1994.

Brookes, J. *Gardens of Paradise: The History and Design of the Great Islamic Gardens.* New York: New Amsterdam, 1987.

Burckhardt, T. *Art of Islam: Language and Meaning.* London: World of Islam Festival, 1976.

Creswell, K. A. C. *A Bibliography of the Architecture, Arts, and Crafts of Islam.* Cairo: American University in Cairo Press, 1984.

Denny, W. B. *The Classical Tradition in Anatolian Carpets.* Washington, DC: Textile Museum, 2002.

Dodds, J. D., ed. *al-Andalus: The Art of Islamic Spain.* Exh. cat. New York: Metropolitan Museum of Art; Dist. by Harry N. Abrams, 1992.

Erdmann, K. *Oriental Carpets: An Essay on Their History.* Fishguard, Wales: Crosby Press, 1976, © 1960.

Ettinghausen, R., O. Grabar, and M. Jenkins-Madina. *Islamic Art and Architecture, 650–1250.* 2d ed. Pelican History of Art. New Haven: Yale University Press, 2001.

Frishman, M., and H. Khan. *The Mosque: History, Architectural Development and Regional Diversity.* London: Thames & Hudson, 2002, © 1994.

Goodwin, G. *A History of Ottoman Architecture.* New York: Thames & Hudson, 2003, © 1971.

Grabar, O. *The Formation of Islamic Art.* Rev. and enl. ed. New Haven: Yale University Press, 1987.

Hillenbrand, R. *Islamic Architecture: Form, Function, and Meaning.* New York: Columbia University Press, 1994.

Komaroff, L., and S. Carboni, eds. *The Legacy of Genghis Khan: Courtly Art and Culture in Western Asia, 1256–1353.* Exh. cat. New York: Metropolitan Museum of Art; New Haven: Yale University Press, 2002.

Lentz, T., and G. Lowry. *Timur and the Princely Vision: Persian Art and Culture in the Fifteenth Century.* Exh. cat. Los Angeles: Los Angeles County Museum of Art; Washington, DC: Arthur M. Sackler Gallery; Smithsonian Institution Press, 1989.

Lings, M. *The Quranic Art of Calligraphy and Illumination.* 1st American ed. New York: Interlink Books, 1987, © 1976.

Necipoğlu, G. *The Age of Sinan: Architectural Culture in the Ottoman Empire.* Princeton, NJ: Princeton University Press, 2005.

———. *The Topkapı Scroll: Geometry and Ornament in Islamic Architecture.* Topkapı Palace Museum Library MS H. 1956. Santa Monica, CA: Getty Center for the History of Art and the Humanities, 1995.

Pope, A. U. *Persian Architecture: The Triumph of Form and Color.* New York: Braziller, 1965.

Robinson, F. *Atlas of the Islamic World Since 1500.* New York: Facts on File, 1982.

Ruggles, D. F. *Gardens, Landscape, and Vision in the Palaces of Islamic Spain.* University Park: Pennsylvania State University Press, 2000.

———., ed. *Women, Patronage, and Self-Representation in Islamic Societies.* Albany: State University of New York Press, 2000.

Tabbaa, Y. *The Transformation of Islamic Art During the Sunni Revival.* Seattle: University of Washington Press, 2001.

Thompson, J., ed. *Hunt for Paradise: Court Arts of Safavid Iran, 1501–1576.* Milan: Skira; New York: Dist. in North America and Latin America by Rizzoli, 2003.

———. *Oriental Carpets from the Tents, Cottages, and Workshops of Asia.* New York: Dutton, 1988.

Vernoit, S., ed. *Discovering Islamic Art: Scholars, Collectors and Collections, 1850–1950.* London and New York: I. B. Tauris; Dist. by St. Martin's Press, 2000.

Welch, S. C. *Imperial Mughal Painting.* New York: Braziller, 1978.

———. *A King's Book of Kings: The Shah-nameh of Shah Tahmasp.* New York: Metropolitan Museum of Art; Dist. by New York Graphic Society, 1972.

CHAPTER 10. EARLY MEDIEVAL ART

Backhouse, J. *The Golden Age of Anglo-Saxon Art, 966–1066.* Bloomington: Indiana University Press, 1984.

———. *The Lindisfarne Gospels: A Masterpiece of Book Painting.* London: British Library, 1995.

Barral i Altet, X. *The Early Middle Ages: From Late Antiquity to A.D. 1000.* Taschen's World Architecture. Köln and New York: Taschen, © 1997.

Conant, K. *Carolingian and Romanesque Architecture, 800–1200.* 4th ed. Pelican History of Art. New Haven: Yale University Press, 1992.

Davis-Weyer, C. *Early Medieval Art, 300–1150: Sources and Documents.* Reprint of 1971 ed. Toronto: University of Toronto Press, 1986.

Diebold, W. J. *Word and Image: An Introduction to Early Medieval Art.* Boulder, CO: Westview Press, 2000.

Dodwell, C. R. *Anglo-Saxon Art: A New Perspective.* Ithaca, NY: Cornell University Press, 1982.

———. *The Pictorial Arts of the West, 800–1200.* New ed. Pelican History of Art. New Haven: Yale University Press, 1993.

Graham-Campbell, J. *The Viking-age Gold and Silver of Scotland, A.D. 850–1100.* Exh. cat. Edinburgh: National Museums of Scotland, 1995.

Harbison, P. *The Golden Age of Irish Art: The Medieval Achievement, 600–1200.* New York: Thames & Hudson, 1999.

Henderson, G. *The Art of the Picts: Sculpture and Metalwork in Early Medieval Scotland.* New York: Thames & Hudson, 2004.

Kitzinger, E. *Early Medieval Art, with Illustrations from the British Museum.* Rev. ed. Bloomington: Indiana University Press, 1983.

Lasko, P. *Ars Sacra, 800–1200.* 2nd ed. Pelican History of Art. New Haven: Yale University Press, 1994.

Mayr-Harting, H. *Ottonian Book Illumination: An Historical Study.* 2 vols. London: Harvey Miller, 1991–1993.

Megaw, M. R. *Celtic Art: From Its Beginnings to the Book of Kells.* New York: Thames & Hudson, 2001.

Mosacati, S., ed. *The Celts.* Exh. cat. New York: Rizzoli, 1999.

Nees, L. *Early Medieval Art.* Oxford History of Art. New York: Oxford University Press, 2002.

Ohlgren, T. H., comp. *Insular and Anglo-Saxon Illuminated Manuscripts: An Iconographic Catalogue, c. A.D. 625 to 1100.* New York: Garland, 1986.

Rickert, M. *Painting in Britain: The Middle Ages.* 2d ed. Pelican History of Art. Harmondsworth, England: Penguin, 1965.

Stalley, R. A. *Early Medieval Architecture.* Oxford History of Art. New York: Oxford University Press, 1999.

Stone, L. *Sculpture in Britain: The Middle Ages.* 2d ed. Pelican History of Art. Harmondsworth, England: Penguin, 1972.

Webster, L., and J. Backhouse, eds. *The Making of England: Anglo-Saxon Art and Culture, A.D. 600–900.* Exh. cat. London: Published for the Trustees of the British Museum and the British Library Board by British Museum Press, 1991.

CHAPTER 11. ROMANESQUE ART

Bizzarro, T. *Romanesque Architectural Criticism: A Prehistory.* New York: Cambridge University Press, 1992.

Boase, T. S. R. *English Art, 1100–1216.* Oxford History of English Art. Oxford: Clarendon Press, 1953.

Cahn, W. *Romanesque Bible Illumination.* Ithaca, NY: Cornell University Press, 1982.

Davies, M. *Romanesque Architecture: A Bibliography.* Boston: G. K. Hall, 1993.

Focillon, H. *The Art of the West in the Middle Ages.* Ed. J. Bony. 2 vols. Reprint of 1963 ed. Ithaca, NY: Cornell University Press, 1980.

Hearn, M. F. *Romanesque Sculpture: The Revival of Monumental Stone Sculpture.* Ithaca, NY: Cornell University Press, 1981.

Mâle, E. *Religious Art in France, the Twelfth Century: A Study of the Origins of Medieval Iconography.* Bollingen series, 90:1. Princeton, NJ: Princeton University Press, 1978.

Minne-Sève, V. *Romanesque and Gothic France: Architecture and Sculpture.* New York: Harry N. Abrams, 2000.

Nichols, S. *Romanesque Signs: Early Medieval Narrative and Iconography.* New Haven: Yale University Press, 1983.

O'Keeffe, T. *Romanesque Ireland: Architecture and Ideology in the Twelfth Century.* Dublin and Portland, OR: Four Courts, 2003.

Petzold, A. *Romanesque Art.* Perspectives. New York: Harry N. Abrams, 1995.

Platt, C. *The Architecture of Medieval Britain: A Social History.* New Haven: Yale University Press, 1990.

Sauerländer, W. *Romanesque Art: Problems and Monuments.* 2 vols. London: Pindar, 2004.

Schapiro, M. *Romanesque Art.* New York: Braziller, 1977.

Stoddard, W. *Art and Architecture in Medieval France.* New York: Harper & Row, 1972, © 1966.

Stones, A., and J. Krochalis. *The Pilgrim's Guide to Santiago de Compostela: A Critical Edition.* 2 vols. London: Harvey Miller, 1998.

Toman, R. *Romanesque Architecture, Sculpture, Painting.* Cologne: Könemann, 1997.

Zarnecki, G. *Further Studies in Romanesque Sculpture.* London: Pindar, 1992.

CHAPTER 12. GOTHIC ART

Barnes, C. F. *Villard de Honnecourt, the Artist and His Drawings: A Critical Bibliography.* Boston: G. K. Hall, 1982.

Belting, H. *The Image and Its Public: Form and Function of Early Paintings of the Passion.* New Rochelle, NY: Caratzas, 1990.

Blum, P. *Early Gothic Saint-Denis: Restorations and Survivals.* Berkeley: University of California Press, 1992.

Bony, J. *French Gothic Architecture of the Twelfth and Thirteenth Centuries.* Berkeley: University of California Press, 1983.

Camille, M. *Gothic Art: Glorious Visions.* Perspectives. New York: Harry N. Abrams, 1997.

———. *The Gothic Idol: Ideology and Image Making in Medieval Art.* New York: Cambridge University Press, 1989.

———. *Sumptuous Arts at the Royal Abbeys of Reims and Braine.* Princeton, NJ: Princeton University Press, 1990.

Cennini, C. *The Craftsman's Handbook (Il Libro dell'Arte).* New York: Dover, 1954.

Coldstream, N. *Medieval Architecture.* Oxford History of Art. New York: Oxford University Press, 2002.

Erlande-Brandenburg, A. *Gothic Art.* New York: Harry N. Abrams, 1989.

Frankl, P. *Gothic Architecture.* Rev. by P. Crossley. Pelican History of Art. New Haven, CT: Yale University Press, 2001.

Frisch, T. G. *Gothic Art, 1140–c. 1450: Sources and Documents.* Reprint of 1971 ed. Toronto: University of Toronto Press, 1987.

Grodecki, L. *Gothic Architecture.* New York: Electa/Rizzoli, 1985.

———. *Gothic Stained Glass, 1200–1300*. Ithaca, NY: Cornell University Press, 1985.

Hamburger, J. F. *The Visual and the Visionary: Art and Female Spirituality in Late Medieval Germany*. Zone Books. Cambridge, MA: MIT Press, 1998.

Jantzen, H. *High Gothic: The Classic Cathedrals of Chartres, Reims, Amiens*. Reprint of 1962 ed. Princeton, NJ: Princeton University Press, 1984.

Kemp, W. *The Narratives of Gothic Stained Glass*. New York: Cambridge University Press, 1997.

Limentani Virdis, C. *Great Altarpieces: Gothic and Renaissance*. New York: Vendome Press; Dist. by Rizzoli, 2002.

Mâle, E. *Religious Art in France, the Thirteenth Century: A Study of Medieval Iconography and Its Sources*. Ed. H. Bober. Princeton, NJ: Princeton University Press, 1984.

Marks, R., and P. Williamson, eds. *Gothic: Art for England 1400–1547*. Exh. cat. London and New York: Victoria & Albert Museum; Dist. by Harry N. Abrams, 2003.

Murray, S. *Beauvais Cathedral: Architecture of Transcendence*. Princeton, NJ: Princeton University Press, 1989.

Panofsky, E. ed. and trans. *Abbot Suger on the Abbey Church of Saint-Denis and Its Art Treasures*. 2d ed. Princeton, NJ: Princeton University Press, 1979.

———. *Gothic Architecture and Scholasticism*. Reprint of 1951 ed. New York: New American Library, 1985.

Parnet, P., ed. *Images in Ivory: Precious Objects of the Gothic Age*. Exh. cat. Detroit, MI: Detroit Institute of Arts, © 1997.

Sandler, L. *Gothic Manuscripts, 1285–1385*. Survey of Manuscripts Illuminated in the British Isles. London: Harvey Miller, 1986.

Scott, R. A. *The Gothic Enterprise: A Guide to Understanding the Medieval Cathedral*. Berkeley: University of California Press, 2003.

Simson, O. von. *The Gothic Cathedral: Origins of Gothic Architecture and the Medieval Concept of Order*. 3d ed. Princeton, NJ: Princeton University Press, 1988.

Toman, R., ed. *The Art of Gothic: Architecture, Sculpture, Painting*. Cologne: Könemann, 1999.

Williamson, P. *Gothic Sculpture, 1140–1300*. New Haven: Yale University Press, 1995.

Wilson, C. *The Gothic Cathedral*. New York: Thames & Hudson, 1990.

PART THREE: THE RENAISSANCE THROUGH THE ROCOCO

GENERAL REFERENCES AND SOURCES

Campbell, L. *Renaissance Portraits: European Portrait-Painting in the 14th, 15th, and 16th Centuries*. New Haven: Yale University Press, 1990.

Chastel, A., et al. *The Renaissance: Essays in Interpretation*. London: Methuen, 1982.

Cloulas, I. *Treasures of the French Renaissance*. New York: Harry N. Abrams, 1998.

Cole, A. *Art of the Italian Renaissance Courts: Virtue and Magnificence*. London: Weidenfeld & Nicolson, 1995.

Gascoigne, B. *How to Identify Prints: A Complete Guide to Manual and Mechanical Processes from Woodcut to Inkjet*. New York: Thames & Hudson, 2004.

Grendler, P. F., ed. *Encyclopedia of the Renaissance*. 6 vols. New York: Scribner's, published in association with the Renaissance Society of America, 1999.

Gruber, A., ed. *The History of Decorative Arts: Vol. 1, The Renaissance and Mannerism in Europe. Vol. 2, Classicism and the Baroque in Europe*. New York: Abbeville Press, 1994.

Harbison, C. *The Mirror of the Artist: Northern Renaissance Art in its Historical Context*. New York: Harry N. Abrams, 1995.

Harris, A. S. *Seventeenth-Century Art and Architecture*. Upper Saddle River, NJ: Pearson Prentice Hall, 2005.

Hartt, F., and D. Wilkins. *History of Italian Renaissance Art*. 6th ed. Upper Saddle River, NJ: Pearson Prentice Hall, 2007.

Hopkins, A. *Italian Architecture: from Michelangelo to Borromini*. World of Art. New York: Thames & Hudson, 2002.

Hults, L. *The Print in the Western World*. Madison: University of Wisconsin Press, 1996.

Impey, O., and A. MacGregor, eds. *The Origins of Museums: The Cabinet of Curiosities in Sixteenth- and Seventeenth-Century Europe*. New York: Clarendon Press, 1985.

Ivins, W. M., Jr. *How Prints Look: Photographs with a Commentary*. Boston: Beacon Press, 1987.

Landau, D., and P. Parshall. *The Renaissance Print*. New Haven: Yale University Press, 1994.

Lincoln, E. *The Invention of the Italian Renaissance Printmaker*. New Haven: Yale University Press, 2000.

Martin, J. R. *Baroque*. Harmondsworth, England: Penguin, 1989.

Millon, H. A., ed. *The Triumph of the Baroque: Architecture in Europe, 1600–1750*. New York: Rizzoli, 1999.

Minor, V. H. *Baroque & Rococo: Art & Culture*. New York: Harry N. Abrams, 1999.

Norberg-Schultz, C. *Late Baroque and Rococo Architecture*. New York: Harry N. Abrams, 1983.

Olson, R. J. M. *Italian Renaissance Sculpture*. The World of Art. New York: Thames & Hudson, 1992.

Paoletti, J., and G. Radke. *Art in Renaissance Italy*. 3d ed. Upper Saddle River, NJ: Pearson Prentice Hall, 2006.

Payne, A. *Antiquity and Its Interpreters*. New York: Cambridge University Press, 2000.

Pope-Hennessy, J. *An Introduction to Italian Sculpture: Vol. 1, Italian Gothic Sculpture. Vol. 2, Italian Renaissance Sculpture. Vol. 3, Italian High Renaissance and Baroque Sculpture*. 4th ed. London: Phaidon Press, 1996.

Smith, J. C. *The Northern Renaissance*. Art & Ideas. London: Phaidon, 2004.

Snyder, J. *Northern Renaissance Art: Painting, Sculpture, the Graphic Arts, from 1350–1575*. 2d ed. New York: Harry N. Abrams, 2005.

Tomlinson, J. *From El Greco to Goya: Painting in Spain 1561–1828*. Perspectives. New York: Harry N. Abrams, 1997.

Turner, J. *Encyclopedia of Italian Renaissance & Mannerist Art*. 2 vols. New York: Grove's Dictionaries, 2000.

Vasari, G. *The Lives of the Artists*. Trans. with an introduction and notes by J. C. Bondanella and P. Bondanella. New York: Oxford University Press, 1998.

Welch, E. *Art in Renaissance Italy, 1350–1500*. New ed. Oxford: Oxford University Press, 2000.

Wiebenson, D., ed. *Architectural Theory and Practice from Alberti to Ledoux*. 2d ed. Chicago: University of Chicago Press, 1983.

Wittkower, R. *Architectural Principles in the Age of Humanism*. 5th ed. New York: St. Martin's Press, 1998.

CHAPTER 13. ART IN THIRTEENTH- AND FOURTEENTH-CENTURY ITALY

Bellosi, L. *Duccio, the Maestà*. New York: Thames & Hudson, 1999.

Bomford, D. *Art in the Making: Italian Painting Before 1400*. Exh. cat. London: National Gallery of Art, 1989.

Cole, B. *Studies in the History of Italian Art, 1250–1550*. London: Pindar, 1996.

Derbes, A. *The Cambridge Companion to Giotto*. New York: Cambridge University Press, 2004.

Kemp, M. *Behind the Picture: Art and Evidence in the Italian Renaissance*. New Haven: Yale University Press, 1997.

Maginnis, H. B. J. *The World of the Early Sienese Painter*. With a translation of the Sienese Breve dell'Arte del pittori by Gabriele Erasmi. University Park: Pennsylvania State University Press, 2001.

Meiss, M. *Painting in Florence and Siena after the Black Death: The Arts, Religion, and Society in the Mid-Fourteenth Century*. Princeton, NJ: Princeton University Press, 1978, © 1951.

Norman, D., ed. *Siena, Florence, and Padua: Art, Society, and Religion 1280–1400*. New Haven: Yale University Press in association with the Open University, 1995.

Schmidt, V., ed. *Italian Panel Painting of the Duecento and Trecento*. Washington, DC: National Gallery of Art; New Haven: Dist. by Yale University Press, 2002.

Stubblebine, J. H. *Assisi and the Rise of Vernacular Art*. New York: Harper & Row, 1985.

———. *Dugento Painting: An Annotated Bibliography*. Boston: G. K. Hall, 1983.

White, J. *Art and Architecture in Italy, 1250–1400*. 3d ed. Pelican History of Art. New Haven: Yale University Press, 1993.

CHAPTER 14. ARTISTIC INNOVATIONS IN FIFTEENTH-CENTURY NORTHERN EUROPE

Ainsworth, M. W., and K. Christiansen. *From Van Eyck to Bruegel: Early Netherlandish Painting in the Metropolitan Museum of Art*. New York: Metropolitan Museum of Art, 1998.

Blum, S. *Early Netherlandish Triptychs: A Study in Patronage*. Berkeley: University of California Press, 1969.

Chapuis, J., ed. *Tilman Riemenschneider, Master Sculptor of the Late Middle Ages*. Washington, DC: National Gallery of Art; New York: Metropolitan Museum of Art; New Haven: Dist. by Yale University Press, 1999.

Cuttler, C. *Northern Painting from Pucelle to Bruegel*. Fort Worth: Holt, Rinehart & Winston, 1991, © 1972.

De Vos, D. *Rogier van der Weyden: The Complete Works*. New York: Harry N. Abrams, 1999.

Dhanens, E. *Hubert and Jan van Eyck*. New York: Alpine Fine Arts Collection, 1980.

Dixon, L. *Bosch*. Art & Ideas. London: Phaidon, 2003.

Friedländer, M. *Early Netherlandish Painting*. 14 vols. New York: Praeger, 1967–1973.

Koldeweij, J., ed. *Hieronymus Bosch: New Insights into His Life and Work*. Rotterdam: Museum Boijmans Van Beuningen: NAi; Ghent: Ludion, 2001.

Mâle, E. *Religious Art in France, the Late Middle Ages: A Study of Medieval Iconography and Its Sources*. Princeton, NJ: Princeton University Press, 1986.

Muller, T. *Sculpture in the Netherlands, Germany, France, and Spain, 1400–1500*. Pelican History of Art. Harmondsworth, England: Penguin, 1966.

Nuttall, P. *From Flanders to Florence: The Impact of Netherlandish Painting, 1400–1500*. New Haven: Yale University Press, 2004.

Pächt, O. *Van Eyck and the Founders of Early Netherlandish Painting*. London: Harvey Miller, 1994.

Panofsky, E. *Early Netherlandish Painting*. 2 vols. New York: Harper & Row, 1971. Orig. published Cambridge, MA: Harvard University Press, 1958.

Williamson, P. *Netherlandish Sculpture 1450–1550*. London: V & A; New York: Dist. by Harry N. Abrams, 2002.

CHAPTER 15. THE EARLY RENAISSANCE IN ITALY

Ahl, D. C. *The Cambridge Companion to Masaccio*. New York: Cambridge University Press, 2002.

Aikema, B. *Renaissance Venice and the North: Crosscurrents in the Time of Bellini, Dürer and Titian*. Exh. cat. Milan: Bompiani, 2000.

Alberti, L. B. *On Painting*. Trans. C. Grayson, introduction and notes M. Kemp. New York: Penguin, 1991.

———. *On the Art of Building, in Ten Books*. Trans. J. Rykwert, et al. Cambridge, MA: MIT Press, 1991.

Ames-Lewis, F. *Drawing in Early Renaissance Italy*. 2d ed. New Haven: Yale University Press, 2000.

Baxandall, M. *Painting and Experience in Fifteenth-Century Italy: A Primer in the Social History of Pictorial Style*. 2d ed. New York: Oxford University Press, 1988.

Blunt, A. *Artistic Theory in Italy, 1450–1600*. Reprint of 1940 ed. New York: Oxford University Press, 1983.

Bober, P., and R. Rubinstein. *Renaissance Artists and Antique Sculpture: A Handbook of Sources*. New York: Oxford University Press, 1986.

Borsook, E. *The Mural Painters of Tuscany: From Cimabue to Andrea del Sarto*. 2d ed. Oxford: Oxford University Press, 1980.

Cole, B. *The Renaissance Artist at Work: From Pisano to Titian*. New York: Harper & Row, © 1983.

Fejfer, J. *The Rediscovery of Antiquity: The Role of the Artist*. Copenhagen: Museum Tusculanum Press, University of Copenhagen, 2003.

Gilbert, C. E. *Italian Art, 1400–1500: Sources and Documents*. Englewood Cliffs, NJ: Prentice Hall, 1980.

Goldthwaite, R. *Wealth and the Demand for Art in Italy, 1300–1600*. Baltimore, MD: Johns Hopkins University Press, 1993.

Gombrich, E. H. *Norm and Form: Studies in the Art of the Renaissance*. 4th ed. London: Phaidon, 1985.

———. *Symbolic Images: Studies in the Art of the Renaissance*. 3d ed. London: Phaidon, 1972.

Heydenreich, L., and W. Lotz. *Architecture in Italy, 1400–1500*. Rev. ed. Pelican History of Art. New Haven: Yale University Press, 1996.

Humfreys, P., and M. Kemp, eds. *The Altarpiece in the Renaissance*. New York: Cambridge University Press, 1990.

———, ed. *The Cambridge Companion to Giovanni Bellini*. New York: Cambridge University Press, 2004.

Huse, N., and W. Wolters. *The Art of Renaissance Venice: Architecture, Sculpture, and Painting, 1460–1590*. Chicago: University of Chicago Press, 1990.

Janson, H. W. *The Sculpture of Donatello*. 2 vols. Princeton, NJ: Princeton University Press, 1979.

Joannides, P. *Masaccio and Masolino: A Complete Catalogue*. New York: Harry N. Abrams, 1993.

Kempers, B. *Painting, Power, and Patronage: The Rise of the Professional Artist in the Italian Renaissance*. New York: Penguin, 1992.

Kent, D. V. *Cosimo de' Medici and the Florentine Renaissance: The Patron's Oeuvre*. New Haven: Yale University Press, © 2000.

Krautheimer, R., and T. Krautheimer-Hess. *Lorenzo Ghiberti*. Princeton, NJ: Princeton University Press, 1982.

Lavin, M. A. *Piero della Francesca*. Art & Ideas. New York: Phaidon, 2002.

Murray, P. *The Architecture of the Italian Renaissance*. New rev. ed. The World of Art. New York: Random House, 1997.

Pächt, O. *Venetian Painting in the 15th Century: Jacopo, Gentile and Giovanni Bellini and Andrea Mantegna*. London: Harvey Miller, 2003.

Panofsky, E. *Perspective as Symbolic Form*. New York: Zone Books, 1997.

———. *Renaissance and Renascences in Western Art*. Trans. C. S. Wood. New York: Humanities Press, 1970.

Pope-Hennessy, J. *Donatello*. New York: Abbeville Press, 1993.

———. *Italian Renaissance Sculpture*. 3d ed. New York: Oxford University Press, 1986.

Randolph, A. *Engaging Symbols: Gender, Politics, and Public Art in Fifteenth-Century Florence*. New Haven: Yale University Press, 2002.

Rosenberg, C. *The Este Monuments and Urban Development in Renaissance Ferrara*. New York: Cambridge University Press, 1997.

Saalman, H. *Filippo Brunelleschi: The Buildings*. University Park: Pennsylvania State University Press, 1993.

Seymour, C. *Sculpture in Italy, 1400–1500*. Pelican History of Art. Harmondsworth, England: Penguin, 1966.

Turner, A. R. *Renaissance Florence*. Perspectives. New York: Harry N. Abrams, 1997.

Wackernagel, M. *The World of the Florentine Renaissance Artist: Projects and Patrons, Workshop and Art Market*. Princeton, NJ: Princeton University Press, 1981.

Wood, J. M., ed. *The Cambridge Companion to Piero della Francesca*. New York: Cambridge University Press, 2002.

CHAPTER 16. THE HIGH RENAISSANCE IN ITALY, 1495–1520

Ackerman, J., *The Architecture of Michelangelo*. 2d ed. Chicago: University of Chicago Press, 1986.

Beck, J. H. *Three Worlds of Michelangelo*. New York: W. W. Norton, 1999.

Boase, T. S. R. *Giorgio Vasari: The Man and the Book*. Princeton, NJ: Princeton University Press, 1979.

Brown, P. F. *Art and Life in Renaissance Venice*. Perspectives. New York: Harry N. Abrams, 1997.

———. *Venice and Antiquity: The Venetian Sense of the Past*. New Haven: Yale University Press, 1997.

Chapman, H. *Raphael: From Urbino to Rome*. London: National Gallery; New Haven: Dist. by Yale University Press, 2004.

Clark, K. *Leonardo da Vinci*. Rev. and introduced by M. Kemp. New York: Penguin, 1993, © 1988.

Cole, A. *Virtue and Magnificence: Art of the Italian Renaissance Courts*. Perspectives. New York: Harry N. Abrams, 1995.

De Tolnay, C. *Michelangelo*. 5 vols. Some vols. rev. Princeton, NJ: Princeton University Press, 1969–1971.

Freedberg, S. *Painting in Italy, 1500–1600*. 3d ed. Pelican History of Art. New Haven: Yale University Press, 1993.

———. *Painting of the High Renaissance in Rome and Florence*. 2 vols. New rev. ed. New York: Hacker Art Books, 1985.

Goffen, R. *Renaissance Rivals: Michelangelo, Leonardo, Raphael, Titian*. New Heaven: Yale University Press, 2002.

Hall, M. B. *The Cambridge Companion to Raphael*. New York: Cambridge University Press, 2005.

Hersey, G. L. *High Renaissance Art in St. Peter's and the Vatican: An Interpretive Guide*. Chicago: University of Chicago Press, 1993.

Hibbard, H. *Michelangelo*. 2d ed. Boulder, CO: Westview Press, 1974, © 1974.

Kemp, M. *Leonardo*. New York: Oxford University Press, 2004.

———, ed. *Leonardo on Painting: An Anthology of Writings*. New York: Yale University Press, 1989.

Nicholl, C. *Leonardo da Vinci: Flights of the Mind*. New York: Viking Penguin, 2004.

Panofsky, E. *Studies in Iconology: Humanist Themes in the Art of the Renaissance*. New York: Harper & Row, 1972.

Partridge, L. *The Art of Renaissance Rome*. Perspectives. New York: Harry N. Abrams, 1996.

Rowland, I. *The Culture of the High Renaissance: Ancients and Moderns in Sixteenth Century Rome*. Cambridge: 1998.

Rubin, P. L. *Giorgio Vasari: Art and History*. New Haven: Yale University Press, 1995.

Steinberg, L. *Leonardo's Incessant Last Supper*. New York: Zone Books, 2001.

Wallace, W. *Michelangelo: The Complete Sculpture, Painting, Architecture*. Southport, CT: Hugh Lauter Levin, 1998.

Wölfflin, H. *Classic Art: An Introduction to the High Renaissance*. 5th ed. London: Phaidon, 1994.

CHAPTER 17. THE LATE RENAISSANCE AND MANNERISM

Ackerman, J. *Palladio*. Reprint of the 2d ed. Harmondsworth, England: Penguin, 1991, © 1966.

Barkan, L. *Unearthing the Past: Archaeology and Aesthetics in the Making of Renaissance Culture*. New Haven: Yale University Press, 1999.

Beltramini, G., and A. Padoan. *Andrea Palladio: The Complete Illustrated Works*. New York: Universe; Dist. by St. Martin's Press, 2001.

Ekserdjian, D. *Correggio*. New Heaven: Yale University Press, 1997.

Friedlaender, W. *Mannerism and Anti-Mannerism in Italian Painting*. Reprint of 1957 ed. Interpretations in Art. New York: Columbia University Press, 1990.

Goffen, R. *Titian's Women*. New Haven: Yale University Press, 1997.

Klein, R., and H. Zerner. *Italian Art, 1500–1600: Sources and Documents*. Reprint of 1966 ed. Evanston, IL: Northwestern University Press, 1989.

Kliemann, J., and M. Rohlmann. *Italian Frescoes: High Renaissance and Mannerism, 1510–1600*. New York: Abbeville Press, 2004.

Murphy, C. *Lavinia Fontana: A Painter and Her Patrons in Sixteenth-Century Bologna*. New Haven: Yale University Press, 2003.

Partridge, L. *Michelangelo—The Last Judgment: A Glorious Restoration*. New York: Harry N. Abrams, 1997.

Rearick, W. R. *The Art of Paolo Veronese, 1528–1588*. Cambridge: Cambridge University Press, 1988.

Rosand, D. *Painting in Sixteenth-Century Venice: Titian, Veronese, Tintoretto*. New York: Cambridge University Press, 1997.

Shearman, J. K. G. *Mannerism*. New York: Penguin Books, 1990, © 1967.

Smyth, C. H. *Mannerism and Maniera*. 2d ed. Bibliotheca artibus et historiae. Vienna: IRSA, 1992.

Tavernor, R. *Palladio and Palladianism*. The World of Art. New York: Thames & Hudson, 1991.

Valcanover, F., and T. Pignatti. *Tintoretto*. New York: Harry N. Abrams, 1984.

Wundram, M. *Palladio: The Complete Buildings*. Köln and London: Taschen, 2004.

CHAPTER 18. EUROPEAN ART OF THE SIXTEENTH CENTURY: RENAISSANCE AND REFORMATION

Bartrum, G. *Albrecht Dürer and His Legacy: The Graphic Work of a Renaissance Artist*. Princeton, NJ: Princeton University Press, 2002.

Baxandall, M. *The Limewood Sculptors of Renaissance Germany*. New Haven: Yale University Press, 1980.

Eichberger, D., ed. *Durer and His Culture*. New York: Cambridge University Press, 1998.

Harbison, C. *The Mirror of the Artist: Northern Renaissance Art in Its Historical Context*. Perspectives. New York: Harry N. Abrams, 1995.

Hayum, A. *The Isenheim Altarpiece: God's Medicine and the Painter's Vision*. Princeton, NJ: Princeton University Press, 1989.

Hitchcock, H.-R. *German Renaissance Architecture*. Princeton, NJ: Princeton University Press, 1981.

Hulse, C. *Elizabeth I: Ruler and Legend*. Urbana: Published for the Newberry Library by the University of Illinois Press, 2003.

Hutchison, J. C. *Albrecht Dürer: A Biography*. Princeton, NJ: Princeton University Press, 1990.

Jopck, N. *German Sculpture, 1430–1540: A Catalogue of the Collection in the Victoria and Albert Museum*. London: V & A, 2002.

Kavaler, E. M. *Pieter Bruegel: Parables of Order and Enterprise*. New York: Cambridge University Press, 1999.

Koerner, J. *The Moment of Self-Portraiture in German Renaissance Art*. Chicago: University of Chicago Press, 1993.

———. *The Reformation of the Image*. Chicago: University of Chicago Press, 2004.

Mann, R. *El Greco and His Patrons: Three Major Projects*. New York: Cambridge University Press, 1986.

Melion, W. *Shaping the Netherlandish Canon: Karel van Mander's Schilder-Boeck*. Chicago: University of Chicago Press, 1991.

Moxey, K. *Peasants, Warriors, and Wives: Popular Imagery in the Reformation*. Chicago: University of Chicago Press, 1989.

Osten, G. von der, and H. Vey. *Painting and Sculpture in Germany and the Netherlands, 1500–1600*. Pelican History of Art. Harmondsworth, England: Penguin, 1969.

Panofsky, E. *The Life and Art of Albrecht Dürer*. 4th ed. Princeton, NJ: Princeton University Press, 1971.

Smith, J. C. *Nuremberg: A Renaissance City, 1500–1618*. Austin: Published for the Archer M. Huntington Art Gallery by the University of Texas Press, 1983.

Stechow, W. *Northern Renaissance Art, 1400–1600: Sources and Documents*. Evanston, IL: Northwestern University Press, 1989, © 1966.

Van Mander, K. *Lives of the Illustrious Netherlandish and German Painters*. Ed. H. Miedema. 6 vols. Doornspijk, Netherlands: Davaco, 1993–1999.

Wood, C. *Albrecht Altdorfer and the Origins of Landscape*. Chicago: University of Chicago Press, 1993.

Zerner, H. *Renaissance Art in France: The Invention of Classicism*. Paris: Flammarion; London: Thames & Hudson, 2003.

CHAPTER 19. THE BAROQUE IN ITALY AND SPAIN

Avery, C. *Bernini: Genius of the Baroque*. London: Thames & Hudson, 1997.

Bissell, R. W. *Masters of Italian Baroque Painting: The Detroit Institute of Arts*. Detroit, MI: Detroit Institute of Arts in association with D. Giles Ltd., 2005.

Blunt, A. *Borromini*. Cambridge, MA: Harvard University Press, 1979.

———. *Roman Baroque*. London: Pallas Athene Arts, 2001.

Brown, B. L., ed. *The Genius of Rome, 1592–1623*. Exh. cat. London: Royal Academy of Arts; New York: Dist. in the United States and Canada by Harry N. Abrams, 2001.

Brown, J. *Francisco de Zurbaran*. New York: Harry N. Abrams, 1991.

———. *Painting in Spain, 1500–1700*. Pelican History of Art. New Haven: Yale University Press, 1998.

———. *Velázquez: The Technique of Genius*. New Haven: Yale University Press, 1998.

Dempsey, C. *Annibale Carracci and the Beginnings of Baroque Style*. 2d ed. Fiesole, Italy: Cadmo, 2000.

Enggass, R., and J. Brown. *Italy and Spain, 1600–1750: Sources and Documents*. Reprint of 1970 ed. Evanston, IL: Northwestern University Press, 1992.

Freedberg, S. *Circa 1600: A Revolution of Style in Italian Painting*. Cambridge, MA: Harvard University Press, 1983.

Garrard, M. D. *Artemisia Gentileschi: The Image of the Female Hero in Italian Baroque Art*. Princeton, NJ: Princeton University Press, 1989.

Haskell, F. *Patrons and Painters: A Study in the Relations Between Italian Art and Society in the Age of the Baroque*. Rev. and enl. 2d ed. New Haven: Yale University Press, 1980.

Kubler, G., and M. Soria. *Art and Architecture in Spain and Portugal and Their American Dominions, 1500–1800*. Pelican History of Art. Harmondsworth, England: Penguin, 1959.

Marder, T. A. *Bernini and the Art of Architecture*. New York: Abbeville Press, 1998.

Montagu, J. *Roman Baroque Sculpture: The Industry of Art*. New Haven: Yale University Press, 1989.

Nicolson, B. *Caravaggism in Europe*. Ed. L. Vertova. 3 vols. 2d ed., rev. and enl. Turin, Italy: Allemandi, 1989.

Posner, D. *Annibale Carracci*. 2 vols. London: Phaidon, 1971.

Smith, G. *Architectural Diplomacy: Rome and Paris in the Late Baroque*. Cambridge, MA: MIT Press, 1993.

Spear, R. E. *From Caravaggio to Artemisia: Essays on Painting in Seventeenth-Century Italy and France*. London: Pindar Press, 2002.

Spike, J. T. *Caravaggio*. Includes CD-ROM of all the known paintings of Caravaggio, including attributed and lost works. New York: Abbeville Press, © 2001.

Varriano, J. *Italian Baroque and Rococo Architecture*. New York: Oxford University Press, 1986.

Wittkower, R. *Art and Architecture in Italy, 1600–1750*. 4th ed. Pelican History of Art. New Haven: Yale University Press, 2000.

———. *Bernini: The Sculptor of the Roman Baroque*. 4th ed. London: Phaidon, 1997.

CHAPTER 20. THE BAROQUE IN FLANDERS AND HOLLAND

Alpers, S. *The Art of Describing: Dutch Art in the Seventeenth Century*. Chicago: University of Chicago Press, 1983.

———. *The Making of Rubens*. New Haven: Yale University Press, 1995.

Chapman, H. P. *Rembrandt's Self-Portraits: A Study in Seventeenth-Century Identity*. Princeton, NJ: Princeton University Press, 1990.

Fleischer, R., ed. *Rembrandt, Rubens, and the Art of Their Time: Recent Perspectives*. University Park: Pennsylvania State University, 1997.

Franits, W. E. *Dutch Seventeenth-Century Genre Painting: Its Stylistic and Thematic Evolution*. New Haven: Yale University Press, 2004.

Grijzenhout, F., ed. *The Golden Age of Dutch Painting in Historical Perspective*. New York: Cambridge University Press, 1999.

Hofrichter, F. F. *Haarlem: The Seventeenth Century*. Exh. cat. New Brunswick, NJ: Zimmerli Art Museum, 1982.

Kiers, J. and E. Runia, eds. *The Glory of the Golden Age: Dutch Art of the 17th Century*. 2 vols. Exh. cat. Rijksmuseum, Amsterdam: Waanders: 2000.

Logan, A. S. *Peter Paul Rubens: The Drawings*. Exh. cat. New York: Metropolitan Museum of Art; New Haven: Yale University Press, 2004.

Rosenberg, J. *Rembrandt: Life and Work*. Rev. ed. Ithaca, NY: Cornell University Press, 1980.

————., S. Slive, and E. ter Kuile. *Dutch Art and Architecture, 1600–1800*. 3d ed. New Haven: Yale University Press, 1997.

Salvesen, S., ed. *Rembrandt: The Master and His Workshop*. 2 vols. Exh. cat. New Haven: Yale University Press, 1991.

Schama, S. *The Embarrassment of Riches: An Interpretation of Dutch Culture in the Golden Age*. New York: Alfred A. Knopf, 1987.

Schwartz, G. *Rembrandt: His Life, His Paintings*. New York: Viking, 1985.

Slive, S. *Dutch Painting, 1600–1800*. Pelican History of Art. New Haven: Yale University Press, 1995.

————. *Frans Hals*. San Francisco: A. Wofsky Fine Arts, 1989.

————. *Frans Hals*. Exh. cat. Munich: Prestel-Verlag, 1989.

————. *Jacob van Ruisdael: A Complete Catalogue of His Paintings, Drawings, and Etchings*. New Haven: Yale University Press, 2001.

————. *Jacob van Ruisdael: Master of Landscape*. London: Royal Academy of Arts, 2005.

Stechow, W. *Dutch Landscape Painting of the Seventeenth Century*. Reprint of 1966 2d ed. Ithaca, NY: Cornell University Press, 1980.

Sutton, P. *The Age of Rubens*. Exh. cat. Boston: Museum of Fine Arts, 1993.

Vlieghe, H. *Flemish Art and Architecture, 1585–1700*. Pelican History of Art. New Haven: Yale University Press, © 1998.

Walford, F. *Jacob van Ruisdael and the Perception of Landscape*. New Haven: Yale University Press, 1992.

Westermann, M. *Art and Home: Dutch Interiors in the Age of Rembrandt*. Exh. cat. Zwolle: Waanders, 2001.

————. *Rembrandt*. Art & Ideas. London: Phaidon, 2000.

————. *A Worldly Art: The Dutch Republic 1585–1718*. Perspectives. New York: Harry N. Abrams, 1996.

Wheelock, A. K., ed. *Johannes Vermeer*. Exh. cat. New Haven: Yale University Press, 1995.

————., et al. *Anthony van Dyck*. Exh. cat. New York: Harry N. Abrams, 1990.

White, C. *Peter Paul Rubens*. New Haven: Yale University Press, 1987.

CHAPTER 21. THE BAROQUE IN FRANCE AND ENGLAND

Blunt, A. *Art and Architecture in France, 1500–1700*. 5th ed. Pelican History of Art. New Haven: Yale University Press, 1999.

————. *Nicolas Poussin*. London: Pallas Athene, 1995, © 1967.

Brusatin, M., et al. *The Baroque in Central Europe: Places, Architecture, and Art*. Venice: Marsilio, 1992.

Donovan, F. *Rubens and England*. New Haven: Published for The Paul Mellon Centre for Studies in British Art by Yale University Press, 2004.

Downes, K. *The Architecture of Wren*. Rev. ed. Reading, England: Redhedge, 1988.

Garreau, M. *Charles Le Brun: First Painter to King Louis XIV*. New York: Harry N. Abrams, 1992.

Kitson, M. *Studies on Claude and Poussin*. London: Pindar, 2000.

Lagerlöf, M. R. *Ideal Landscape: Annibale Carracci, Nicolas Poussin, and Claude Lorrain*. New Haven: Yale University Press, 1990.

Liechtenstein, J. *The Eloquence of Color: Rhetoric and Painting in the French Classical Age*. Berkeley: University of California Press, 1993.

Mérot, A. *French Painting in the Seventeenth Century*. New Haven: Yale University Press, 1995.

————. *Nicolas Poussin*. New York: Abbeville Press, 1990.

Röthlisberger, M. *Claude Lorrain: The Paintings*. 2 vols. New Haven: Yale University Press, 1961.

Summerson, J. *Architecture in Britain, 1530–1830*. Rev. 9th ed. Pelican History of Art. New Haven: Yale University Press, 1993.

Tinniswood, A. *His Invention So Fertile: A Life of Christopher Wren*. New York: Oxford University Press, 2001.

Verdi, R. *Nicolas Poussin 1594–1665*. London: Zwemmer in association with the Royal Academy of Arts, 1995.

Vlnas, V., ed. *The Glory of the Baroque in Bohemia: Essays on Art, Culture and Society in the 17th and 18th Centuries*. Prague: National Gallery, 2001.

Waterhouse, E. K. *The Dictionary of Sixteenth and Seventeenth Century British Painters*. Woodbridge, Suffolk, England: Antique Collectors' Club, 1988.

————. *Painting in Britain, 1530–1790*. 5th ed. Pelican History of Art. New Haven: Yale University Press, 1993.

Whinney, M. D. *Wren*. World of Art. New York: Thames & Hudson, 1998.

CHAPTER 22. THE ROCOCO

Bailey, C. B. *The Age of Watteau, Chardin, and Fragonard: Masterpieces of French Genre Painting*. New Haven: Yale University Press in association with the National Gallery of Canada, 2003.

Baillio, J. *Louise-Elisabeth Vigée-Lebrun 1755–1842*. Exh. cat. Fort Worth, TX: Kimbell Art Museum, 1982.

Brunel, G. *Boucher*. New York: Vendome, 1986.

————. *Painting in Eighteenth-Century France*. Ithaca, NY: Cornell University Press, 1981.

Cormack, M. *The Paintings of Thomas Gainsborough*. New York: Cambridge University Press, 1991.

Cuzin, J. P. *Jean-Honoré Fragonard: Life and Work: Complete Catalogue of the Oil Paintings*. New York: Harry N. Abrams, 1988.

François Boucher, 1703–1770. Exh. cat. New York: Metropolitan Museum of Art, © 1986.

Gaunt, W. *The Great Century of British Painting: Hogarth to Turner*. 2d ed. London: Phaidon, 1978.

Kalnein, W. von. *Architecture in France in the Eighteenth Century*. Pelican History of Art. New Haven: Yale University Press, 1995.

Levey, M. *Giambattista Tiepolo: His Life and Art*. New Haven: Yale University Press, 1986.

————. *Painting and Sculpture in France, 1700–1789*. New ed. Pelican History of Art. New Haven: Yale University Press, 1993.

————. *Painting in Eighteenth-Century Venice*. 3d ed. Pelican History of Art. New Haven: Yale University Press, 1993.

————. *Rococo to Revolution: Major Trends in Eighteenth-Century Painting*. Reprint of 1966 ed. The World of Art. New York: Thames & Hudson, 1985.

Links, J. G. *Canaletto*. Completely rev., updated, and enl. ed. London: Phaidon, 1994.

Mannings, D. *Sir Joshua Reynolds: A Complete Catalogue of His Paintings*. New Haven: Yale University Press, 2000.

Paulson, R. *Hogarth*. 3 vols. New Brunswick: Rutgers University Press, 1991–1993.

Penny, N., ed. *Reynolds*. Exh. cat. New York: Harry N. Abrams, 1986.

Pointon, M. *Hanging the Head: Portraiture and Social Formation in Eighteenth-Century England*. New Haven: Yale University Press, 1993.

Posner, D. *Antoine Watteau*. Ithaca, NY: Cornell University Press, 1984.

Rococo to Romanticism: Art and Architecture, 1700–1850. Garland Library of the History of Art. New York: Garland, 1976.

Rosenberg, P. *Chardin*. Exh. cat. London: Royal Academy of Art; New York: Metropolitan Museum of Art, 2000.

————. *From Drawing to Painting: Poussin, Watteau, Fragonard, David & Ingres*. Princeton, NJ: Princeton University Press, 2000.

Scott, K. *The Rococo Interior: Decoration and Social Spaces in Early Eighteenth-Century Paris*. New Haven: Yale University Press, 1995.

Sheriff, M. D. *The Exceptional Woman: Elisabeth Vigée-Lebrun and the Cultural Politics of Art*. Chicago: University of Chicago Press, 1996.

Wintermute, A. *Watteau and His World: French Drawing from 1700 to 1750*. Exh. cat. London: Merrell Holberton; New York: American Federation of Arts, 1999.

PART FOUR: THE MODERN WORLD

GENERAL REFERENCES

Arnason, H. H. *History of Modern Art: Painting, Sculpture, Architecture, Photography*. 5th ed. Upper Saddle River, NJ: Pearson Prentice Hall, 2004.

Atkins, R. *Artspoke: A Guide to Modern Ideas, Movements, and Buzzwords, 1848–1944*. New York: Abbeville Press, 1993.

Baigell, M. *A Concise History of American Painting and Sculpture*. Rev. ed. New York: Icon Editions, 1996.

Banham, R. *Theory and Design in the First Machine Age*. 2d ed. Cambridge, MA: MIT Press, 1980, © 1960.

Bearden, R., and H. Henderson. *A History of African-American Artists from 1792 to the Present*. New York: Pantheon, 1993.

Bergdoll, B. *European Architecture 1750–1890*. Oxford History of Art. New York: Oxford University Press, 2000.

Bjelajac, D. *American Art: A Cultural History*. Upper Saddle River, NJ: Pearson Prentice Hall, 2005.

Boime, A. *A Social History of Modern Art. Vol. 1, Art in the Age of Revolution, 1750–1800. Vol. 2, Art in the Age of Bonapartism, 1800–1815. Vol. 3, Art in the Age of Counterrevolution, 1815–1848*. Chicago: University of Chicago Press, 1987–2004.

Bown, M. C. *A Dictionary of Twentieth Century Russian and Soviet Painters 1900–1980s*. London: Izomar, 1998.

Campany, D., ed. *Art and Photography*. Themes and Movements. London: Phaidon, 2003.

Castelman, R. *Prints of the Twentieth Century: A History*. Rev. ed. London: Thames & Hudson, 1988.

Chiarmonte, P. *Women Artists in the United States: A Selective Bibliography and Resource Guide to the Fine and Decorative Arts, 1750–1986*. Boston: G. K. Hall, 1990.

Chilvers, I. *A Dictionary of Twentieth-Century Art*. New York: Oxford University Press, 1998.

Chipp, H., ed. *Theories of Modern Art: A Source Book by Artists and Critics*. Berkeley: University of California Press, 1968.

Colquhoun, A. *Modern Architecture*. New York: Oxford University Press, 2002.

Crary, J. *Techniques of the Observer: On Vision and Modernity in the Nineteenth Century*. Cambridge, MA: MIT Press, 1990.

Craven, W. *American Art: History and Culture*. New York: Harry N. Abrams, 1994.

Crook, J. *The Dilemma of Style: Architectural Ideas from the Picturesque to the Post Modern*. Chicago: University of Chicago Press, 1987.

Crow, T. *Modern Art in the Common Culture*. New Haven: Yale University Press, 1996.

Cummings, P. *Dictionary of Contemporary American Artists*. New York: St. Martin's Press, 1988.

Documents of Modern Art. 14 vols. New York: Wittenborn, 1944–1961. Anthologies of primary source material. Selected titles listed individually, below.

The Documents of Twentieth-Century Art. Boston: G. K. Hall. Anthologies of primary source material. Selected titles listed individually, below.

Doss, E. *Twentieth-Century American Art*. Oxford History of Art. New York: Oxford University Press, 2002.

Drucker, J. *The Century of Artists' Books*. New York: Granary Books, 2004.

Eisenman, S. *Nineteenth Century Art: A Critical History*. New York: Thames & Hudson, 2002.

Eitner, L. *An Outline of Nineteenth-Century European Painting: From David Through Cézanne*. 2 vols. New York: Harper & Row, 1986.

Elderfield, J., ed. *Modern Painting and Sculpture: 1880 to the Present at the Museum of Modern Art*. New York: Museum of Modern Art; Dist. by D.A.P./Distributed Art Publishers, 2004.

Evans, M. M., ed. *Contemporary Photographers*. 3d ed. New York: St. James Press, 1995.

Farrington, L. E. *Creating Their Own Image: The History of African-American Women Artists*. New York: Oxford University Press, 2005.

Frampton, K. *Modern Architecture: A Critical History*. 3d ed. New York: Thames & Hudson, 1992.

Frascina, F. and J. Harris, eds. *Art in Modern Culture: An Anthology of Critical Texts*. New York: Harper & Row, 1992.

Gaiger, J., ed. *Art of the Twentieth Century: A Reader*. New Haven: Yale University Press in association with the Open University, 2003.

————. *Frameworks for Modern Art*. New Haven: Yale University Press in association with the Open University, 2003.

Goldberg, R. *Performance Art: From Futurism to the Present*. Rev. and exp. ed. The World of Art. New York: Thames & Hudson, 2001.

Goldwater, R. *Primitivism in Modern Art*. Enl. ed. Cambridge: Harvard University Press, 1986.

Gray, J. *Action Art: A Bibliography of Artists' Performance from Futurism to Fluxus and Beyond*. Westport, CT: Greenwood Press, 1993.

Harrison, C., and P. Wood, eds. *Art in Theory, 1815–1900: An Anthology of Changing Ideas*. Malden, MA: Blackwell, 1998.

———. *Art in Theory, 1900–2000: An Anthology of Changing Ideas*. New ed. Malden, MA: Blackwell, 2003.

Heller, N. *Women Artists: An Illustrated History*. New York: Abbeville Press, 2003.

Hertz, R., ed. *Theories of Contemporary Art*. 2d ed. Englewood Cliffs, NJ: Prentice Hall, 1993.

———., and N. Klein, eds. *Twentieth-Century Art Theory: Urbanism, Politics, and Mass Culture*. Englewood Cliffs, NJ: Prentice Hall, 1990.

Hitchcock, H. R. *Architecture: Nineteenth and Twentieth Centuries*. 4th rev. ed. Pelican History of Art. New Haven: Yale University Press, 1987, © 1977.

Hughes, R. *American Visions: The Epic History of Art in America*. New York: Alfred A. Knopf, 1997.

Hunter, S., and J. Jacobus. *Modern Art: Painting, Sculpture, Architecture*. 3d rev. ed. New York: Harry N. Abrams, 2000.

Igoe, L. *250 Years of Afro-American Art: An Annotated Bibliography*. New York: Bowker, 1981.

Joachimides, C., et al. *American Art in the Twentieth Century: Painting and Sculpture, 1913–1933*. Exh. cat. Munich: Prestel, 1993.

Johnson, W. *Nineteenth-Century Photography: An Annotated Bibliography, 1839–1879*. Boston: G. K. Hall, 1990.

Kostelanetz, R. *A Dictionary of the Avant-Gardes*. New York: Routledge, 2001.

Lewis, S. *African American Art and Artists*. Berkeley: University of California Press, 1990.

Marien, M. *Photography: A Cultural History*. Upper Saddle River, NJ: Pearson Prentice Hall, 2002.

McCoubrey, J. *American Art, 1700–1960: Sources and Documents*. Englewood Cliffs, NJ: Prentice Hall, 1965.

Meikle, J. L. *Design in the USA*. Oxford History of Art. New York: Oxford University Press, 2005.

Modern Arts Criticism. 4 vols. Detroit, MI: Gale Research, 1991–1994.

Newhall, B. *The History of Photography from 1830 to the Present*. Rev. and enl. 5th ed. New York: Museum of Modern Art; Dist. by Bulfinch Press/Little, Brown, 1999.

Nochlin, L. *The Politics of Vision: Essays on Nineteenth-Century Art and Society*. New York: Harper & Row, 1989.

Osborne, H., ed. *Oxford Companion to Twentieth-Century Art*. Reprint. New York: Oxford University Press, 1990.

Patton, S. F. *African-American Art*. Oxford History of Art. New York: Oxford University Press, 1998.

Piland, S. *Women Artists: An Historical, Contemporary, and Feminist Bibliography*. Metuchen, NJ: Scarecrow Press, 1994.

Powell, R. J. *Black Art and Culture in the 20th Century*. New York: Thames & Hudson, 1997.

Robinson, Hilary. *Feminism-Art-Theory: An Anthology, 1968–2000*. Oxford and Malden, MA: Blackwell, 2001.

Rose, B. *American Art Since 1900*. Rev. ed. New York: Praeger, 1975.

———. *American Painting: The Twentieth Century*. New updated ed. New York: Rizzoli, 1986.

Rosenblum, N. *A World History of Photography*. 3rd ed. New York: Abbeville Press, 1997.

Rosenblum, R., and H. W. Janson. *19th Century Art*. Rev. and updated ed. Upper Saddle River, NJ: Pearson Prentice Hall, 2005.

Schapiro, M. *Modern Art: Nineteenth and Twentieth Centuries*. New York: Braziller, 1982.

Scharf, A. *Art and Photography*. Reprint. Harmondsworth, England: Penguin, 1995.

Sennott, S., ed. *Encyclopedia of 20th Century Architecture*. 3 vols. New York: Fitzroy Dearborn, 2004.

Stiles, K., and P. Selz. *Theories and Documents of Contemporary Art*. Berkeley: University of California Press, 1996.

Tafuri, M. *Modern Architecture*. 2 vols. New York: Rizzoli, 1986.

Taylor, J. *The Fine Arts in America*. Chicago: University of Chicago Press, 1979.

———., ed. *Nineteenth-Century Theories of Art*. California Studies in the History of Art. Berkeley: University of California Press, 1987.

Tomlinson, J. *Readings in Nineteenth-Century Art*. Upper Saddle River, NJ: Prentice Hall, 1995.

Upton, D. *Architecture in the United States*. New York: Oxford University Press, 1998.

Varnedoe, K., and A. Gopnik, eds. *Modern Art and Popular Culture: Readings in High and Low*. New York: Harry N. Abrams, 1990.

Waldman, D. *Collage, Assemblage, and the Found Object*. New York: Harry N. Abrams, 1992.

Weaver, M. *The Art of Photography, 1839–1989*. Exh. cat. New Haven: Yale University Press, 1989.

Wilmerding, J. *American Views: Essays on American Art*. Princeton, NJ: Princeton University Press, 1991.

Witzling, M., ed. *Voicing Our Visions: Writings by Women Artists*. New York: Universe, 1991.

CHAPTER 23. ART IN THE AGE OF THE ENLIGHTENMENT, 1750–1789

Bryson, N. *Tradition and Desire: From David to Delacroix*. Cambridge: Cambridge University Press, 1984.

———. *Word and Image: French Painting in the Ancient Régime*. Cambridge: Cambridge University Press, 1981.

Crow, T. *Painters and Public Life in Eighteenth-Century Paris*. New Haven: Yale University Press, 1985.

Eitner, L. E. A. *Neoclassicism and Romanticism, 1750–1850: Sources and Documents*. Reprint of 1970 ed. New York: Harper & Row, 1989.

Fried, M. *Absorption and Theatricality: Painting and Beholder in the Age of Diderot*. Chicago: University of Chicago Press, 1980.

Friedlaender, W. *David to Delacroix*. Reprint of 1952 ed. New York: Schocken Books, 1952.

Goncourt, E. de, and J. de Goncourt. *French Eighteenth-Century Painters*. Reprint of 1948 ed. Ithaca, NY: Cornell University Press, 1981.

Honour, H. *Neoclassicism*. Reprint of 1968 ed. London: Penguin, 1991.

Irwin, D. G. *Neoclassicism*. Art & Ideas. London: Phaidon, 1997.

Licht, F. *Canova*. New York: Abbeville Press, 1983.

Miles, E. G., ed. *The Portrait in Eighteenth-Century America*. Newark: University of Delaware Press, 1993.

Ottani Cavina, A. *Geometries of Silence: Three Approaches to Neoclassical Art*. New York: Columbia University Press, 2004.

Picon, A. *French Architects and Engineers in the Age of Enlightenment*. New York: Cambridge University Press, 1992.

Rebora, C., et al. *John Singleton Copley in America*. Exh. cat. New York: The Metropolitan Museum of Art, 1995.

Rosenblum, R. *Jean-Auguste-Dominique Ingres*. New York: Harry N. Abrams, 1990.

Rosenthal, M., ed. *Prospects for the Nation: Recent Essays in British Landscape, 1750–1880*. Studies in British Art. New Haven: Yale University Press, © 1997.

Saisselin, R. G. *The Enlightenment Against the Baroque: Economics and Aesthetics in the Eighteenth Century*. Berkeley: University of California Press, 1992.

Solkin, D. *Painting for Money: The Visual Arts and the Public Sphere in Eighteenth-Century England*. New Haven: Yale University Press, 1993.

Vidler, A. *The Writing of the Walls: Architectural Theory in the Late Enlightenment*. Princeton, NJ: Princeton Architectural Press, 1987.

Watkin, D., and T. Mellinghoff. *German Architecture and the Classical Ideal*. Cambridge: MIT Press, 1987.

CHAPTER 24. ART IN THE AGE OF ROMANTICISM, 1789–1848

Boime, A. *The Academy and French Painting in the Nineteenth Century*. New ed. New Haven: Yale University Press, 1986.

Brown, D. B. *Romanticism*. Art & Ideas. New York: Phaidon, 2001.

Chu, P. *Nineteenth-Century European Art*. Upper Saddle River, NJ: Pearson Prentice Hall, 2002.

Eitner, L. E. A. *Géricault: His Life and Work*. Ithaca, NY: Cornell University Press, 1982.

Hartley, K. *The Romantic Spirit in German Art, 1790–1990*. Exh. cat. London: South Bank Centre, © 1994.

Herrmann, L. *Nineteenth Century British Painting*. London: Giles de la Mare, 2000.

Honour, H. *Romanticism*. New York: Harper & Row, 1979.

Johnson, E. *The Paintings of Eugène Delacroix: A Critical Catalogue, 1816–1863*. 6 vols. Oxford: Clarendon Press, 1981–1989.

———. *The Paintings of Eugène Delacroix: A Critical Catalogue*. 4th supp. and reprint of 3d supp. New York: Oxford University Press, 2002.

Joll, E. The *Oxford Companion to J. M. W. Turner*. Oxford: Oxford University Press, 2001.

Koerner, J. *Caspar David Friedrich and the Subject of Landscape*. New Haven: Yale University Press, 1990.

Licht, F. *Goya: The Origins of the Modern Temper in Art*. New York: Harper & Row, 1983.

Middleton, R. *Architecture of the Nineteenth Century*. Milan: Electa, © 2003.

Noon, P. J. *Crossing the Channel: British and French Painting in the Age of Romanticism*. Exh. cat. London: Tate, 2003.

Novak, B. *Nature and Culture: American Landscape and Painting, 1825–1875*. Rev. ed. New York: Oxford University Press, 1995.

Novotny, F. *Painting and Sculpture in Europe, 1780–1880*. 3d ed. Pelican History of Art. New Haven: Yale University Press, 1992.

Pérez Sánchez, A., and E. A. Sayre. *Goya and the Spirit of Enlightenment*. Exh. cat. Boston: Bulfinch Press, 1989.

Roseblum, R. *Transformations in Late Eighteenth Century Art*. Princeton, NJ: Princeton University Press, 1967.

Tomlinson, J. *Goya in the Twilight of Enlightenment*. New Haven: Yale University Press, 1992.

Vaughn, W. *Romanticism and Art*. World of Art. London: Thames & Hudson, © 1994.

CHAPTER 25. THE AGE OF POSITIVISM: REALISM, IMPRESSIONISM, AND THE PRE-RAPHAELITES, 1848–1885

Adriani, G. *Renoir*. Cologne: Dumont; Dist. by Yale University Press, 1999.

Broude, N. *Impressionism: A Feminist Reading*. New York: Rizzoli, 1991.

Cachin, F., et al. *Cézanne*. Exh. cat. New York: Harry N. Abrams, 1995.

Cikovsky, N., and F. Kelly. *Winslow Homer*. Exh. cat. New Haven: Yale University Press, 1995.

Clark, T. J. *The Absolute Bourgeois: Artists and Politics in France, 1848–1851*. Berkeley: University of California Press, 1999, © 1973.

———. *The Painting of Modern Life: Paris in the Art of Manet and His Followers*. Rev. ed. Princeton, NJ: Princeton University Press, 1999.

Denvir, B. *The Chronicle of Impressionism: A Timeline History of Impressionist Art*. London: Thames & Hudson, 2000, © 1993.

———. *The Thames & Hudson Encyclopaedia of Impressionism*. New York: Thames & Hudson, 1990.

Elsen, A. *Origins of Modern Sculpture*. New York: Braziller, 1974.

Fried, M. *Courbet's Realism*. Chicago: University of Chicago Press, 1990.

———. *Manet's Modernism, or, The Face of Painting in the 1860s*. Chicago: University of Chicago Press, 1996.

Goodrich, L. *Thomas Eakins*. 2 vols. Exh. cat. Cambridge, MA: Harvard University Press, 1982.

Gray, C. *The Russian Experiment in Art, 1863–1922*. Rev. ed. The World of Art. New York: Thames & Hudson, 1986.

Hamilton, G. H. *Manet and His Critics*. Reprint of 1954 ed. New Haven, CT: Yale University Press, 1986.

Hares-Stryker, C., ed. *An Anthology of Pre-Raphaelite Writings*. New York: New York University Press, 1997.

Herbert, R. *Impressionism: Art, Leisure, and Parisian Society*. New Haven: Yale University Press, 1988.

Higonnet, A. *Berthe Morisot*. New York: Harper & Row, 1990.

House, J. *Impressionism: Paint and Politics*. New Haven: Yale University Press, 2004.

———. *Monet: Nature into Art*. New Haven: Yale University Press, 1986.

Jenkyns, R. *Dignity and Decadence: Victorian Art and the Classical Inheritance*. Cambridge, MA: Harvard University Press, 1991.

Kendall, R., and G. Pollock, eds. *Dealing with Degas: Representations of Women and the Politics of Vision*. New York: Universe, 1992.

———. *Degas: Beyond Impressionism*. Exh. cat. London: National Gallery; Chicago: Art Institute of Chicago; New Haven: Dist. by Yale University Press, 1996.

Krell, A. *Manet and the Painters of Contemporary Life*. The World of Art. New York: Thames & Hudson, 1996.

Lipton, E. *Looking into Degas*. Berkeley: University of California Press, 1986.

Mainardi, P. *Art and Politics of the Second Empire: The Universal Expositions of 1855 and 1867*. New Haven: Yale University Press, 1987.

———. *The End of the Salon: Art and the State in the Early Third Republic*. Cambridge: Cambridge University Press, 1993.

Miller, D., ed. *American Iconology: New Approaches to Nineteenth-Century Art and Literature*. New Haven: Yale University Press, 1993.

Needham, G. *Nineteenth-Century Realist Art*. New York: Harper & Row, 1988.

Nochlin, L., ed. *Impressionism and Post-Impressionism, 1874–1904: Sources and Documents*. Englewood Cliffs, NJ: Prentice Hall, 1976.

———. *Realism and Tradition in Art, 1848–1900: Sources and Documents*. Englewood Cliffs, NJ: Prentice Hall, 1966.

Novak, B. *American Painting of the Nineteenth Century: Realism and the American Experience*. 2d ed. New York: Harper & Row, 1979.

———. *Nature and Culture: American Landscape and Painting, 1825–1875*. New York: Oxford University Press, 1995.

Pollock, G. *Mary Cassatt: Painter of Modern Women*. New York: Thames & Hudson, 1998.

Prettejohn, E. *The Art of the Pre-Raphaelites*. Princeton, NJ: Princeton University Press, 2000.

Reff, T. *Manet and Modern Paris*. Exh. cat. Washington, DC: National Gallery of Art, 1982.

Rewald, J. *Studies in Impressionism*. New York: Harry N. Abrams, 1986, © 1985.

Rubin, J. H. *Impressionism*. Art & Ideas. London: Phaidon, 1999.

Spate, V. *Claude Monet: Life and Work*. New York: Rizzoli, 1992.

Tucker, P. H. *Claude Monet: Life and Art*. New Haven: Yale University Press, 1995.

———. *The Impressionists at Argenteuil*. Washington, DC: National Gallery of Art; Hartford, CT: Wadsworth Atheneum Museum of Art, 2000.

———. *Monet in the '90s: The Series Paintings*. Exh. cat. New Haven: Yale University Press, 1989.

Walther, I., ed. *Impressionist Art, 1860–1920*. 2 vols. Cologne: Taschen, 1996.

Weisberg, G. *Beyond Impressionism: The Naturalist Impulse*. New York: Harry N. Abrams, 1992.

CHAPTER 26. PROGRESS AND ITS DISCONTENTS: POST-IMPRESSIONISM, SYMBOLISM, AND ART NOUVEAU, 1880–1905

Brettell, R., et al. *The Art of Paul Gauguin*. Exh. cat. Boston: Little, Brown, 1988.

Broude, N. *Georges Seurat*. New York: Rizzoli, 1992.

Denvir, B. *Post-Impressionism*. The World of Art. New York: Thames & Hudson, 1992.

Dorra, H., ed. *Symbolist Art Theories: A Critical Anthology*. Berkeley: University of California Press, 1994.

Gibson, M. *The Symbolists*. New York: Harry N. Abrams, 1988.

Hamilton, G. H. *Painting and Sculpture in Europe, 1880–1940*. 6th ed. Pelican History of Art. New Haven: Yale University Press, 1993.

Herbert, R. L. *Georges Seurat, 1859–1891*. New York: Metropolitan Museum of Art; Dist. by Harry N. Abrams, 1991.

Hulsker, J. *The New Complete Van Gogh: Paintings, Drawings, Sketches: Revised and Enlarged Edition of the Catalogue Raisonné of the Works of Vincent van Gogh*. Amsterdam: J. M. Meulenhoff, 1996.

Mosby, D. *Henry Ossawa Tanner*. Exh. cat. New York: Rizzoli, 1991.

Schapiro, M. *Paul Cézanne*. New York: Harry N. Abrams, 1988.

———. *Vincent Van Gogh*. New York: Harry N. Abrams, 2000, © 1983.

Shiff, R. *Cézanne and the End of Impressionism: A Study of the Theory, Technique, and Critical Evaluation of Modern Art*. Chicago: University of Chicago Press, 1984.

Silverman, D. *Art Nouveau in Fin-de-Siècle France*. Berkeley: University of California Press, 1989.

Théberge, P. *Lost Paradise, Symbolist Europe*. Exh. cat. Montreal: Montreal Museum of Fine Arts, 1995.

Troy, N. J. *Modernism and the Decorative Arts in France: Art Nouveau to Le Corbusier*. New Haven: Yale University Press, 1991.

Varnedoe, K. *Vienna 1900: Art, Architecture, and Design*. Exh. cat. New York: Museum of Modern Art, 1986.

CHAPTER 27. TOWARD ABSTRACTION: THE MODERNIST REVOLUTION, 1904–1914

Bach, F., T. Bach, and A. Temkin. *Constantin Brancusi*. Exh. cat. Cambridge: MIT Press, 1995.

Behr, S. *Expressionism*. Movements in Modern Art. Cambridge: Cambridge University Press, 1999.

Bowlt, J. E., ed. *Russian Art of the Avant-Garde: Theory and Criticism, 1902–1934*. New York: Thames & Hudson, 1988.

Brown, M. *The Story of the Armory Show*. 2d ed. New York: Abbeville Press, 1988.

Duchamp, M. *Marcel Duchamp, Notes*. The Documents of Twentieth-Century Art. Boston: G. K. Hall, 1983.

Edwards, S. *Art of the Avant-Gardes*. New Haven: Yale University Press in association with the Open University, 2004.

Elderfield, J. *Henri Matisse: A Retrospective*. Exh. cat. New York: Museum of Modern Art; Dist. by Harry N. Abrams, 1992.

Golding, J. *Cubism: A History and an Analysis, 1907–1914*. 3d ed. Cambridge, MA: Harvard University Press, 1988.

Goldwater, R. *Primitivism in Modern Art*. Enl. ed. Cambridge, MA: Belknap Press, 1986.

Gordon, D. *Expressionism: Art and Idea*. New Haven: Yale University Press, 1987.

Green, C. *Cubism and Its Enemies*. New Haven: Yale University Press, 1987.

Heiting, M., ed. *August Sander, 1876–1964*. Köln and New York: Taschen, 1999.

Herbert, J. *Fauve Painting: The Making of Cultural Politics*. New Haven: Yale University Press, 1992.

Hoffman, K., ed. *Collage: Critical Views*. Ann Arbor, MI: UMI Research Press, 1989.

Kallir, J. *Egon Schiele: The Complete Works*. Exp. ed. New York: Harry N. Abrams, 1998.

Krauss, R. *The Originality of the Avant-Garde and Other Modernist Myths*. Cambridge: MIT Press, 1986.

Kuspit, D. *The Cult of the Avant-Garde Artist*. New York: Cambridge University Press, 1993.

Rosenblum, R. *Cubism and Twentieth-Century Art*. New York: Harry N. Abrams, 2001.

Rubin, W. S. *Picasso and Braque: Pioneering Cubism*. Exh. cat. New York: Museum of Modern Art, 1989.

Szarkowski, J., and M. Hambourg. *The Work of Atget*. 4 vols. New York: Museum of Modern Art, 1981–1985.

Taylor, B. *Collage: The Making of Modern Art*. London: Thames & Hudson, 2004.

Washton, R.-C., ed. *German Expressionism: Documents from the End of the Wilhelmine Empire to the Rise of National Socialism*. The Documents of Twentieth-Century Art. Boston: G. K. Hall, 1993.

Weiss, J. *The Popular Culture of Modern Art: Picasso, Duchamp and Avant Gardism*. New Haven: Yale University Press, 1994.

CHAPTER 28. ART BETWEEN THE WARS, 1914–1940

Adams, A. *Ansel Adams: Images, 1923–1974*. Foreword W. Stegner. Boston: New York Graphic Society, 1974.

Ades, D. *Photomontage*. Rev. and enl. ed. London: Thames & Hudson, 1986.

Arbaïzar, P. *Henri Cartier-Bresson: The Man, the Image and the World: A Retrospective*. New York: Thames & Hudson, 2003.

Bayer, H., et al., eds. *Bauhaus, 1919–1928*. Reprint of 1938 ed. Boston: New York Graphic Society, 1986.

Blaser, W. *Mies van der Rohe*. 6th exp. and rev. ed. Boston: Birkhauser Verlag, 1997.

Campbell, M., et al. *Harlem Renaissance: Art of Black America*. New York: Harry N. Abrams, 1987.

Chadwick, W., ed. *Mirror Images: Women, Surrealism, and Self-Representation*. Cambridge, MA: MIT Press, 1998.

Corn, W. *The Great American Thing: Modern Art and National Identity, 1915–1935*. Berkeley: University of California Press, 2001.

Curtis, W. *Modern Architecture Since 1900*. 3rd ed. New York: Phaidon, 1996.

Durozoi, G. *History of the Surrealist Movement*. Chicago: University of Chicago Press, 2002.

Fer, B., et al. *Realism, Rationalism, Surrealism: Art Between the Wars*. Modern Art—Practices and Debates. New Haven: Yale University Press, 1993.

Fiedler, J., ed. *Photography at the Bauhaus*. Cambridge, MA: MIT Press, 1990.

Foster, S. C., ed. *Crisis and the Arts: The History of Dada*. 10 vols. New York: G. K. Hall, 1996–2005.

Gale, M. *Dada & Surrealism*. Art & Ideas. London: Phaidon, 1997.

Gössel, P., and G. Leuthäuser. *Architecture in the Twentieth Century*. Cologne: Taschen, 1991.

Greenough, S., and J. Hamilton. *Alfred Stieglitz: Photographs and Writings*. New York: Little, Brown, 1999.

Haskell, B. *The American Century: Art & Culture, 1900–1950*. New York: W. W. Norton, 1999.

Hight, E. M. *Picturing Modernism: Moholy-Nagy and Photography in Weimar Germany*. Cambridge, MA: MIT Press, 1995.

Hitchcock, H. R., and P. Johnson. *The International Style*. With a new forward. New York: W. W. Norton, 1996.

Hochman, E. S. *Bauhaus: Crucible of Modernism*. New York: Fromm International, © 1997.

Hopkins, D. *Dada and Surrealism: A Very Short Introduction*. New York: Oxford University Press, 2004.

Kandinsky, W. *Kandinsky: Complete Writings on Art*. Orig. pub. in The Documents of Twentieth-Century Art. New York: Da Capo Press, 1994.

Krauss, R. *L'Amour Fou: Photography and Surrealism*. New York: Abbeville Press, 1985.

Kultermann, U. *Architecture in the Twentieth Century*. New York: Van Nostrand Reinhold, 1993.

Lane, B. *Architecture and Politics in Germany, 1918–1945*. New ed. Cambridge, MA: Harvard University Press, 1985.

Le Corbusier. *Towards a New Architecture*. Oxford: Architectural Press, 1997, © 1989.

Lodder, C. *Russian Constructivism*. New Haven: Yale University Press, 1983.

McEuen, M. A. *Seeing America: Women Photographers Between the Wars*. Lexington, KY: University Press of Kentucky, 2000.

Miró, J. *Joan Miró: Selected Writings and Interviews*. The Documents of Twentieth-Century Art. Boston: G. K. Hall, 1986.

Mondrian, P. *The New Art, the New Life: The Complete Writings*. Eds. and trans. H. Holtzmann and M. James. Orig. pub. in The Documents of Twentieth-Century Art. New York: Da Capo, 1993.

Motherwell, R., ed. *The Dada Painters and Poets: An Anthology*. 2d ed. Cambridge, MA: Harvard University Press, 1989.

Nadeau, M. *History of Surrealism*. Cambridge, MA: Harvard University Press, 1989.

Pevsner, N. *Pioneers of Modern Design: From William Morris to Walter Gropius*. 4th ed. New Haven: Yale University Press, 2005.

Phillips, C., ed. *Photography in the Modern Era: European Documents and Critical Writings, 1913–1940*. New York: Metropolitan Museum of Art; Aperture, 1989.

Roskill, M. *Klee, Kandinsky, and the Thought of Their Time: A Critical Perspective*. Urbana: University of Illinois Press, 1992.

Silver, K. E. *Esprit de Corps: The Art of the Parisian Avant-Garde and the First World War, 1914–1925*. Princeton, NJ: Princeton University Press, 1989.

Spiteri, R., ed. *Surrealism, Politics and Culture*. Aldershot, Hants., England and Burlington, VT: Ashgate, 2003.

Wood, P., ed. *Varieties of Modernism*. New Haven: Yale University Press in association with the Open University, 2004.

Wright, F. L. *Frank Lloyd Wright, Collected Writings*. 5 vols. New York: Rizzoli, 1992–1995.

CHAPTER 29. POST–WORLD WAR II TO POSTMODERN, 1945–1980

Archer, M. *Art Since 1960*. World of Art. New York: Thames & Hudson, 2002.

Ashton, D. *American Art Since 1945*. New York: Oxford University Press, 1982.

Atkins, R. *Artspeak: A Guide to Contemporary Ideas, Movements, and Buzzwords, 1945 to the Present*. New York: Abbeville Press, 1997.

Baker, K. *Minimalism: Art of Circumstance*. New York: Abbeville Press, 1989.

Battcock, G., comp. *Idea Art: A Critical Anthology*. New ed. New York: Dutton, 1973.

———, ed. *Minimal Art: A Critical Anthology*. Berkeley: University of California Press, 1995.

———, and R. Nickas, eds. *The Art of Performance: A Critical Anthology*. New York: Dutton, 1984.

Beardsley, J. *Earthworks and Beyond: Contemporary Art in the Landscape*. 3d ed. New York: Abbeville Press, 1998.

———, and J. Livingston. *Hispanic Art in the United States: Thirty Contemporary Painters and Sculptors*. Exh. cat. New York: Abbeville Press, 1987.

Burgin, V., ed. *Thinking Photography*. Communications and Culture. Houndsmills, England: Macmillan Education, 1990.

Carlson, M. A. *Performance: A Critical Introduction*. 2d ed. New York: Routledge, 2004.

Causey, A. *Sculpture Since 1945*. Oxford History of Art. New York: Oxford University Press, 1998.

Crane, D. *The Transformation of the Avant-Garde: The New York Art World, 1940–1985*. Chicago: University of Chicago Press, 1987.

Crow, T. *The Rise of the Sixties: American and European Art in the Era of Dissent*. London: Laurence King, 2005, © 1996.

Frascina, F. *Pollock and After: The Critical Debate*. 2d ed. New York: Routledge, 2001.

Gilbaut, S. *How New York Stole the Idea of Modern Art*. Chicago: University of Chicago Press, 1983.

———, ed. *Reconstructing Modernism: Art in New York, Paris, and Montreal, 1945–1964*. Cambridge: MIT Press, 1990.

Greenberg, C. *Clement Greenberg: The Collected Essays and Criticism*. 4 vols. Chicago: University of Chicago Press, 1986–1993.

Griswold del Castillo, R., ed. *Chicano Art: Resistance and Affirmation, 1965–1985*. Exh. cat. Los Angeles: Wight Art Gallery, University of California, 1991.

Hopkins, D. *After Modern Art: 1945–2000*. New York: Oxford University Press, 2000.

Joselit, D. *American Art Since 1945*. The World of Art. London: Thames & Hudson, 2003.

Landau, E. G., ed. *Reading Abstract Expressionism: Context and Critique*. New Haven: Yale University Press, 2005.

Leggio, J., and S. Weiley, eds. *American Art of the 1960s*. Studies in Modern Art, 1. New York: Museum of Modern Art, 1991.

Leja, M. *Reframing Abstract Expressionism: Subjectivity and Painting in the 1940s*. New Haven: Yale University Press, 1993.

Linder, M. *Nothing Less Than Literal: Architecture After Minimalism*. Cambridge, MA: MIT Press, 2004.

Lippard, L. R, ed. *From the Center: Feminist Essays on Women's Art*. New York: Dutton, 1976.

———. *Overlay: Contemporary Art and the Art of Prehistory*. New York: Pantheon, 1983.

Livingstone, M. *Pop Art: A Continuing History*. New York: Thames & Hudson, 2000.

Lucie-Smith, E. *Movements in Art Since 1945*. The World of Art. New York: Thames & Hudson, 2001.

McCarthy, D. *Pop Art*. Movements in Modern Art. Cambridge University Press, 2000.

McEvilley, T. *Sculpture in the Age of Doubt*. New York: School of Visual Arts; Allworth Press, 1999.

Meisel, L. K. *Photorealism at the Millennium*. New York: Harry N. Abrams, 2002.

Ockman, J., ed. *Architecture Culture, 1943–1968: A Documentary Anthology*. New York: Rizzoli, 1993.

Orvell, M. *American Photography*. The World of Art. New York: Oxford University Press, 2003.

Pincus-Witten, R. *Postminimalism into Maximalism: American Art, 1966–1986*. Ann Arbor, MI: UMI Research Press, 1987.

Polcari, S. *Abstract Expressionism and the Modern Experience*. New York: Cambridge University Press, 1991.

Rosen, R., and C. Brawer, eds. *Making Their Mark: Women Artists Move into the Mainstream, 1970–85*. Exh. cat. New York: Abbeville Press, 1989.

Ross, C. *Abstract Expressionism: Creators and Critics: An Anthology*. New York: Harry N. Abrams, 1990.

Sandler, I. *Art of the Postmodern Era: From the Late 1960s to the Early 1990s*. New York: Icon Editions, 1996.

———. *The New York School: The Painters and Sculptors of the Fifties*. New York: Harper & Row, 1978.

———. *The Triumph of American Painting: A History of Abstract Expressionism*. New York: Praeger, 1970.

Sayre, H. *The Object of Performance: The American Avant-Garde Since 1970*. Chicago: University of Chicago Press, 1990.

Seitz, W. *Abstract Expressionist Painting in America*. Cambridge, MA: Harvard University Press, 1983.

Self-Taught Artists of the 20th Century: An American Anthology. Exh. cat. San Franciso: Chronicle Books, 1998.

Sontag, S. *On Photography*. New York: Picador; Farrar, Straus & Giroux, 2001, © 1977.

Weintraub, L. *Art on the Edge and Over*. Litchfield, CT: Art Insights; Dist. by D.A.P., 1997.

Wood, P., et al. *Modernism in Dispute: Art Since the Forties*. New Haven: Yale University Press, 1993.

CHAPTER 30. THE POSTMODERN ERA: ART SINCE 1980

Barthes, R. *The Pleasure of the Text*. Oxford: Blackwell, 1990.

Belting, H. *Art History After Modernism*. Chicago: University of Chicago Press, 2003.

Broude, N., and M. Garrad., eds. *Reclaiming Female Agency: Feminist Art History After Postmodernism*. Berkeley: University of California Press, 2005.

Brunette, P., and D. Wills, eds. *Deconstruction and the Visual Arts: Art, Media, Architecture*. New York: Cambridge University Press, 1994.

Capozzi, R., ed. *Reading Eco: An Anthology*. Bloomington: Indiana University Press, © 1997.

Derrida, J. *Writing and Difference*. London: Routledge Classics, 2001.

Eco, U. *A Theory of Semiotics*. Bloomington: Indiana University Press, 1976.

Foster, H., ed. *The Anti-Aesthetic: Essays on Postmodern Culture*. New York: New Press; Dist. by W. W. Norton, 1998.

Ghirardo, D. *Architecture After Modernism*. New York: Thames & Hudson, 1996.

Harris, J. P. *The New Art History: A Critical Introduction*. New York: Routledge, 2001.

Jencks, C. *New Paradigm in Architecture: The Language of Post-Modernism*. New Haven: Yale University Press, 2002.

———., ed. *The Post-Modern Reader*. London: Academy Editions; New York: St. Martin's Press, 1992.

———. *What Is Post-Modernism?* 4th rev. ed. London: Academy Editions, 1996.

Lucie-Smith, E. *Art Today*. London: Phaidon, 1995.

Mitchell, W. J. T. *The Reconfigured Eye: Visual Truth in the Post-Photographic Era*. Cambridge, MA: MIT Press, 1992.

Norris, C., and A. Benjamin. *What Is Deconstruction?* New York: St. Martin's Press, 1988.

Papadakes, A., et al., eds. *Deconstruction: The Omnibus Volume*. New York: Rizzoli, 1989.

Paul, C. *Digital Art*. New York: Thames & Hudson, © 2003.

Pearman, H. *Contemporary World Architecture*. London: Phaidon, © 1998.

Risatti, H., ed. *Postmodern Perspectives*. Englewood Cliffs, NJ: Prentice Hall, 1990.

Senie, H. *Contemporary Public Sculpture: Tradition, Transformation, and Controversy*. New York: Oxford University Press, 1992.

Steele, J. *Architecture Today*. New York: Phaidon, 2001.

Thody, P. *Introducing Barthes*. New York: Totem Books; Lanham, MD: National Book Network, 1997.

Tomkins, C. *Post to Neo: The Art World of the 1980s*. New York: Holt, 1988.

Wallis, B., ed. *Art After Modernism: Rethinking Representation*. Documentary Sources in Contemporary Art, 1. Boston: Godine, 1984.

Index